The Grove Encyclopedia
of Islamic Art and Architecture

The Grove Encyclopedia of

Islamic Art and Architecture

Edited by

JONATHAN M. BLOOM AND SHEILA S. BLAIR

Volume III

MOSUL TO ZIRID

OXFORD

UNIVERSITY PRESS

2009

OXFORD
UNIVERSITY PRESS

Oxford University Press, Inc., publishes works that further
Oxford University's objective of excellence
in research, scholarship, and education.

Oxford New York
Auckland Cape Town Dar es Salaam Hong Kong Karachi
Kuala Lumpur Madrid Melbourne Mexico City Nairobi
New Delhi Shanghai Taipei Toronto

With offices in
Argentina Austria Brazil Chile Czech Republic France Greece
Guatemala Hungary Italy Japan Poland Portugal Singapore
South Korea Switzerland Thailand Turkey Ukraine Vietnam

Copyright © 2009 by Oxford University Press

Published by Oxford University Press, Inc.
198 Madison Avenue, New York, NY 10016
www.oup.com

Oxford is a registered trademark of Oxford University Press

The Library of Congress Cataloging-in-Publication Data

The Grove encyclopedia of Islamic art and architecture / edited by Jonathan M. Bloom and Sheila S. Blair.
v. cm.
Includes bibliographical references and index.
ISBN 978-0-19-530991-1 (alk. paper) --
ISBN 978-0-19-537304-2 (ebook)
1. Art, Islamic--Encyclopedias.
2. Architecture, Islamic--Encyclopedias.
I. Bloom, Jonathan (Jonathan M.)
II. Blair, Sheila S.
N6260.G75 2009
709.17'6703--dc22
2008028208

1 3 5 7 9 8 6 4 2

Printed in the United States of America
on acid-free paper

A Note on the Use of the Encyclopedia

This note is intended as a short guide to the basic editorial conventions adopted in this encyclopedia.

Abbreviations used in this encyclopedia are listed on pp. vii.

Alphabetization of headings, which are distinguished in bold typeface, is letter by letter up to the first comma (ignoring spaces, hyphens, accents and any parenthesized or bracketed matter); the same principle applies thereafter. Names beginning with "al-" or "el-" are alphabetized under the part of the name that follows this prefix.

Authors' names appear in the list of Contributors on pp. 455.

Bibliographies are arranged chronologically (within section, where divided) by order of year of first publication and, within years, alphabetically by authors' names. Some standard reference books have had their titles abbreviated, as have those of periodicals. These abbreviations appear in full on pp. xxix.

Biographical dates when cited in parentheses in running text at the first mention of a personal name indicate that the individual does not have an entry in the encyclopedia. The presence of parenthetical regnal dates for rulers, however, does not necessarily indicate the lack of a biography of that person.

Cross-references are distinguished by the use of small capital letters, with a large capital to indicate the letter of the entry to which the reader is directed, for example, "He succeeded MIR SAYYID ʿALI as director…" means that the entry is alphabetized under "M."

Illustrations to an article are indicated by "see fig." or "see color pl." in the running text. The former indicates a black-and-white illustration, which should appear on or near the page where the citation occurs. Color plates are grouped together within each volume, and therefore may be several pages away from the source article.

Abbreviations

GENERAL

A.	Art, Arts	Byz.	Byzantine
Acad.	Academy	*c.*	*circa* [about]
Add.	Additional, Addendum	CA	California
Afr.	African	cat.	catalogue
A.G.	Art Gallery	CE	Common Era
AH	Anno Hegirae	Cent.	Center, Central
A. Inst.	Art Institute	Cer.	Ceramic
Alb.	Albanian	cf.	confer [compare]
Alg.	Algerian	Chap., Chaps.	Chapter(s)
Amer.	American	Chin.	Chinese
An.	Annals	Chron.	Chronicle
Anatol.	Anatolian	cm	centimeter(s)
Anc.	Ancient	CO	Colorado
Annu.	Annual	Co.	Company; County
Anon.	Anonymous	Cod.	Codex, Codices
Ant.	Antique, Antiquities	Col., Cols.	Collection(s)
Anthol.	Anthology	Coll.	College
Anthropol.	Anthropology	Contemp.	Contemporary
Antiqua.	Antiquarian, Antiquaries	CT	Connecticut
app.	appendix	Cult.	Cultural, Culture
approx.	approximately	$	dollars
Arab.	Arabic	*d.*	died
Archaeol.	Archaeology	DC	District of Columbia
Archit.	Architecture, Architectural	Dec.	December, Decorative
Archv, Archvs	Archive, Archives	ded.	dedication, dedicated to
Armen.	Armenian	Dept.	Department
Asiat.	Asiatic	Derbys	Derbyshire
Assoc.	Association	Des.	Design
attrib.	attribution, attributed to	destr.	destroyed
Aug.	August	diam.	diameter
AZ	Arizona	Dir.	Director(ate)
Azerbaij.	Azerbaijani	diss.	dissertation
b.	born	Distr.	District
B.A.	Bachelor of Arts	Div.	Division
BCE	Before Common Era	Doc.	Document(s)
Bibl.	Biblical	Dr.	Doctor
bibliog.	bibliography	ed.	editor, edited by
bk, bks	book, books	edn.	edition
Bldg	Building	eds.	editors
BP	Before Present	e.g.	*exempli gratia* [for example]
Brit.	British	Egyp.	Egyptian
Bull.	Bulletin	Enc.	Encyclopedia

Eng.	English	Ltd.	Limited
esp.	especially	m	meter
etc.	*etcetera* [and so on]	M.A.	Master of Arts
exh.	exhibition	MA	Massachusetts
ff.	following pages	Mag.	Magazine
F.A.	Fine Arts	MD	Maryland
facs.	facsimile	ME	Maine
fasc.	fascicle	Med.	Medieval
Feb.	February	MI	Michigan
fig.	figure (illustration)	Misc.	Miscellaneous
figs.	figures	mm	millimeter(s)
FL	Florida	MN	Minnesota
fl.	*floruit* [he flourished]	Mnmt, Mnmts	Monument(s)
fol., fols.	folio(s)	MO	Missouri
Fr.	French	Mod.	Modern
ft	foot, feet	MS., MSS.	manuscript(s)
g	gram(s)	MT	Montana
GA	Georgia	Mt.	Mount
Gal., Gals.	Gallery, Galleries	Mus.	Museum
Gen.	General		North Carolina
Ger.	German		NC
Gr.	Greek	n.d.	no date
h.	height	NJ	New Jersey
ha	hectare	NM	New Mexico
Heb.	Hebrew	no., nos.	number(s)
HI	Hawaii	Nov.	November
Hist.	History, Historical	n.p.	no place (of publication)
i.e.	*id est* (that is)	nr.	near
IL	Illinois	n. s.	new series
illus.	illustrated, illustration	NT	National Trust
Imp.	Imperial	NY	New York
IN	Indiana	Occas.	Occasional
incl.	includes, including	Oct.	October
Ind.	Indian	OH	Ohio
Inst.	Institute	OK	Oklahoma
intro.	introduction, introduced by	OR	Oregon
inv.	inventory	Ott.	Ottoman
Iran.	Iranian	p., pp.	page(s)
Islam.	Islamic	PA	Pennsylvania
J.	Journal	Pap.	Paper(s)
Jan.	January	Pers.	Persian
jr.	junior	Ph.D.	Doctor of Philosophy
kg	kilogram(s)	pl., pls.	plate(s)
km	kilometre(s)	Port.	Portuguese
KY	Kentucky	priv.	private
£	libra, librae (pound, pounds sterling)	pt.	part
		pubd.	published
l.	length	*R*	reprint
LA	Louisiana	*r*	*recto*
Lat.	Latin	*r.*	*regit* [ruled]
Lib.	Library	Ref.	Reference

repr.	reprint(ed), reproduced	Stud.	Study, Studies
rest.	restored	suppl.	supplement, supplementary
rev.	revision, revised by	trans.	translation, translated by
RI	Rhode Island	Turk.	Turkish
Rt Hon.	Right Honorable	TX	Texas
Rus.	Russian	UNESCO	United Nations Educational, Scientific and Cultural Organization
S.	San, Santa, Santo, Sant', São [Saint]		
Sept.	September	US	United States
Ser.	Series	USA	United States of America
Soc.	Society	v	verso
Sp.	Spanish	VA	Virginia
sq.	square	vol., vols.	volume(s)
sr.	senior	vs.	versus
SS.	Saints, Santi	VT	Vermont
St.	Saint	w.	width

LOCATIONS

Abingdon Mus.
 Abingdon, Abingdon Museum
Ahmedabad, Calico Mus. Textiles
 Ahmedabad, Calico Museum of Textiles
Alexandria, Mus. F.A. & Cult.
 Alexandria, Museum of Fine Arts and Cultural
 Cent. Center
Algiers, Le Bardo
 Algiers, Le Bardo, Musée d'Ethnographie et de
 Préhistoire
Algiers, Mus. N. Ant.
 Algiers, Musée National des Antiquités
Algiers, Mus. N. A. & Trad. Pop.
 Algiers, Musée National des Arts et Traditions
 Populaires
Aligarh, Muslim U., Maulana
 Aligarh, Muslim University, Maulana Azad
 Azad Lib. Library
Amherst Coll., MA, Mead A. Mus.
 Amherst, MA, Amherst College, Mead Art
 Museum
Amman, N.G. F.A.
 Amman, National Gallery of Fine Arts
Ankara, Mimar Sinan U., Mus. Ptg & Sculp.
 Ankara, Mimar Sinan University, Museum of
 Painting and Sculpture
Ann Arbor, U. MI, Kelsey Mus.
 Ann Arbor, MI, University of Michigan,
 Kelsey Museum of Ancient and Medieval
 Archaeology
Athens, Benaki Mus.
 Athens, Benaki Museum

Augsburg, Maximilianmus.
 Augsburg, Maximilianmuseum
Austin, U. TX, Human Res. Cent. Gernsheim
Col,
 Austin, TX, University of Texas at Austin,
 Humanities Research Center, Gernsheim
 Collection
Austin, U. TX, Ransom Human Res. Cent.
 Austin, TX, University of Texas at Austin,
 Harry Hunt Ransom Humanities Research
 Center
Baghdad, Iraq Mus.
 Baghdad, Iraq Museum
Baghdad, N. Mus. Mod. A.
 Baghdad, National Museum of Modern Art
Baku, Azerbaijan Acad. Sci.
 Baku, Azerbaijan Academy of Sciences
Baku, Hist. Mus. Acad. Sci.
 Baku, Historical Museum of the Academy of
 Azerbaijan Sciences of Azerbaijan
Baku, Mus. Carpets & Applied A.
 Baku, Museum of Carpets and Applied Art
Baku, Shirvanshah Pal. Mus.
 Baku, Shirvanshah Palace Museum
Baltimore, MD, Johns Hopkins U., Lib.
 Baltimore, MD, Johns Hopkins University,
 John Garrett Work Garrett Rare Book Library
Baltimore, MD, Walters A.G.
 Baltimore, MD, Walters Art Gallery (from
 2001 Walters Art Museum)
Baltimore, MD, Walters A. Mus.
 Baltimore, MD, Walters Art Museum

Bamako, Mus. N.
Bamako, Musée National du Mali
Bamberg, Staatsbib.
Bamberg, Staatsbibliothek
Bankipur, Patna, Khuda Bakhsh Lib.
Bankipur, Patna, Khuda Bakhsh Oriental
Public Library
Barcelona, Cent. Cult. Fund. Caixa Pensions
Barcelona, Centre Cultural de la Fundació
Caixa de Pensions
Barcelona, Mus. Dioc.
Barcelona, Museu Diocesa
Basle, Ksthalle
Basle, Kunsthalle Basel
Bayreuth U., Iwalewa-Haus
Bayreuth, University of Bayreuth,
Iwalewa-Haus
Belgrade, Mus. Applied A.
Belgrade, Museum of Applied Art
Berlin, Mus. Islam. Kst
Berlin, Museum für Islamische Kunst
Berlin, Mus. Vlkerknd.
Berlin, Museum für Völkerkunde
Berlin, Staatl. Museen Preuss. Kultbes.
Berlin, Staatliche Museen Preussischer
Kulturbesitz
Berlin, Staatsbib.
Berlin, Staatsbibliothek zu Berlin Preussischer
Kulturbesitz
Berlin, Staatsbib. Preuss. Kultbes., Orientabt.
Berlin, Staatsbibliothek Preussischer
Kulturbesitz, Orientabteilung
Berlin, Pergamonmus.
Berlin, Pergamonmuseum
Berlin, Tiergarten, Kstgewmus.
Berlin, Kunstgewerbemuseum
Berne, Hist. Mus.
Berne, Historisches Museum
Bhopal, Archaeol. Mus.
Bhopal, State Archaeological Museum
Birmingham, Mus. & A.G.
Birmingham, City of Birmingham Museum
and Art Gallery
Bishkek, Kyrgyzstan Acad. Sci., Mus. Archaeol.
Inst. Hist.
Bishkek, Kyrgyzstan Academy of Sciences,
Museum of Archaeology of the Institute of
History
Bloomington, IN U.
Bloomington, IN, Indiana University

Bologna, Mus. Civ. Med.
Bologna, Museo Civico Medievale e del
Rinascimento
Bonn, Inst. Auslandsbezieh. Gal.
Bonn, Institut für Auslandsbeziehungen,
Galerie und Kontaktstelle
Bonn, Kst & Ausstellhal.
Bonn, Kunst- und Ausstellungshalle der
Bundesrepublik Deutschland
Boston, MA, Isabella Stewart Gardner Mus.
Boston, MA, Isabella Stewart Gardner Museum
Boston, MA, Mus. F. A.
Boston, MA, Museum of Fine Arts
Brunswick, ME, Bowdoin Coll. Mus. A.
Brunswick, ME, Bowdoin College Museum of
Art
Brussels, Mus. A. Juif Maroc.
Brussels, Musée d'art juif marocain
Brussels, Musées Royaux A. & Hist.
Brussels, Musées Royaux d'Art et d'Histoire
Budapest, Mus. Applied A.
Budapest, Museum of Applied Art
Bukhara, Hist. Mus.
Bukhara, History Museum
Bukhara, Reg. Mus.
Bukhara, Bukhara Regional Museum
Burgos, Mus. Arqueol. Prov.
Burgos, Museo Arqueológico Provincial
Burgos, Real Monasterio de las Huelgas, Mus.
Telas & Preseas
Burgos, Real Monasterio de las Huelgas,
Museo de Telas y Preseas
Bursa, Mus. Turk. & Islam. A.
Bursa, Museum of Turkish and Islamic Art
Cairo, Coptic Mus.
Cairo, Coptic Museum
Cairo, Mus. Islam. A.
Cairo, Museum of Islamic Art
Cairo, N. Lib.
Cairo, National Library
Calcutta, Birla Acad. A. & Cult.
Calcutta, Birla Academy of Art and Culture
Calcutta, Ind. Mus.
Calcutta, Indian Museum
Calcutta, Victoria Mem. Hall
Calcutta, Victoria Memorial Hall
Cambridge, King's Coll.
Cambridge, King's College
Cambridge, MA, Fogg
Cambridge, MA, Fogg Art Museum

Cambridge, MA, Harvard U. A. Mus.
 Cambridge, MA, Harvard University Art
 Museums
Cambridge, MA, Harvard U., Peabody Mus.
 Cambridge, MA, Harvard University, Peabody
 Museum of Archaeology and Ethnology
Cambridge, MA, Harvard U., Semit. Mus.
 Cambridge, MA, Harvard University, Semitic
 Museum
Cambridge, MA, Sackler Mus.
 Cambridge, MA, Arthur M. Sackler Museum
Canberra, N.G.
 Canberra, National Gallery of Australia
Chestnut Hill, MA, Boston Coll., McMullen Mus. A.
 Chestnut Hill, MA, Boston College,
 McMullen Museum of Art
Chicago, IL, A. Inst.
 Chicago, IL, Art Institute of Chicago
Chicago, U. Chicago, IL, Orient Inst. Mus..
 Chicago, IL, University of Chicago, Oriental
 Institute Museum
Chicago, U. Chicago, IL, Smart Mus. A.
 Chicago, IL, University of Chicago, David and
 Alfred Smart Museum of Art
Cincinnati, OH, A. Mus.
 Cincinnati, OH, Cincinnati Art Museum
Cividale del Friuli, Mus. Archeol. N.
 Cividale del Friuli, Museo Archeologico
 Nazionale
Clermont-Ferrand, Mus. Tapis & A. Textiles
 Clermont-Ferrand, Musée du Tapis et des Arts
 Textiles
Cleveland, OH, Mus. A.
 Cleveland, OH, Cleveland Museum of Art
Cologne, Röm.–Ger.-Mus.
 Cologne, Römisch–Germanisches-Museum
Cologny, Fond. Bodmer
 Cologny, Fondation Martin Bodmer
Copenhagen, Davids Saml.
 Copenhagen, Davids Samling
Copenhagen, Kon. Bib.
 Copenhagen, Kongelige Bibliotek
Copenhagen, Nmus.
 Copenhagen, Nationalmuseum
Córdoba, Mus. Arqueol.
 Córdoba, Museo Arqueológico
Corning, NY, Mus. Glass
 Corning, NY, Museum of Glass
Covarrubias, Mus. Parroq.
 Covarrubias, Museo Parroquial

Damascus, N. Mus.
 Damascus, National Museum of Damascus
Decatur, GA, Scott Coll., Dalton Gal.
 Decatur, GA, Agnes Scott College, Dalton
 Gallery
Detroit, MI, Inst. A.
 Detroit, MI, Detroit Institute of Arts
Dhaka, N. Mus. Bangladesh
 Dhaka, National Museum of Bangladesh
Doha, Mus. Islam. A.
 Doha, Museum of Islamic of Art
Dublin, Chester Beatty Lib.
 Dublin, Chester Beatty Library and Gallery of
 Oriental Art
Dublin, Hyde Gal.
 Dublin, Hyde Gallery
Dushanbe, Repub. Hist. Reg. & F. A. Mus.
 Dushanbe, Republican Historical, Regional
 and Fine Arts Museum
Dushanbe, Tajikistan Acad. Sci., Donish Inst.
 Hist., Archaeol. & Ethnog. Dushanbe,
 Tajikistan Academy of Sciences, Donish
 Institute of History, Archaeology and
 Ethnography
Düsseldorf, Hetjens-Mus.
 Düsseldorf, Hetjens-Museum
East Lansing, MI State U., Kresge A. Mus.
 East Lansing, MI, Michigan State University,
 Kresge Art Museum
Ecouen, Mus. Ren.
 Ecouen, Musée de la Renaissance,
 Château
Edinburgh, City A. Cent.
 Edinburgh, City Art Centre
Edinburgh, Royal Mus. Scotland
 Edinburgh, Royal Museum of Scotland
Erevan, Hist. Mus. Armenia
 Erevan, Historical Museum of Armenia
Evanston, IL, Northwestern U., Mary & Leigh
 Block Gal.Evanston, IL, Northwestern
 University, Mary and Leigh Block Gallery
Fez, Mus. Dar Batha
 Fez, Musée du Dar Batha
Florence, Bargello
 Florence, Museo Nazionale del Bargello
Florence, Mus. Stor. Sci.
 Florence, Istituto e Museo di Storia della
 Scienza di Firenze
Florence, Pitti
 Florence, Palazzo Pitti

Fort Worth, TX, Kimbell, A. Mus.
 Fort Worth, TX, Kimbell Art Museum
Frankfurt am Main, Mus. Ksthandwk
 Frankfurt am Main, Museum für
 Kunsthandwerk
Frankfurt am Main, Mus. Vlkerknd.
 Frankfurt am Main, Museum für Völkerkunde
Geneva, Fond. Martin Bodmer
 Geneva, Fondation Martin Bodmer
Geneva, Mus. A. & Hist.
 Geneva, Musée d'Art et d'Histoire
Geneva, Mus. Rath
 Geneva, Musée Rath
Glasgow, A.G. & Mus.
 Glasgow, Art Gallery and Museum
Glasgow, Burrell Col.
 Glasgow, Burrell Collection
Glasgow, Third Eye Cent.
 Glasgow, Third Eye Centre [Centre for
 Contemporary Art]
Göteborg, Röhsska Kstslöjdmus.
 Göteborg, Röhsska Konstslöjdmuseum
Granada, Mus. Alhambra
 Granada, Museo de la Alhambra
Granada, Mus. Arqueol. Prov.
 Granada, Museo Arqueológico Provincial
Granada, Mus. N. A. Hispmus.
 Granada, Museo Nacional de Arte
 Hispanomusulmán
Grenoble, Magasin-Cent. N. A. Contemp.
 Grenoble, Magasin-Centre National d'Art
 Contemporain
The Hague, Gemeentemus.
 The Hague, Haags Gemeentemuseum
Hamburg, Mus. Kst & Gew.
 Hamburg, Museum für Kunst und Gewerbe
Hamilton, Ont., A.G.
 Hamilton, Ont., Art Gallery of Hamilton
Hanau, Dt. Goldschmiedehaus
 Hanau, Deutsches Goldschmiedehaus
Hanover, NH, Dartmouth Coll., Hood Mus. A.
 Hanover, NH, Dartmouth College, Hood
 Museum of Art
Hildesheim, Pelizaeus-Mus.
 Hildesheim, Pelizaeus-Museum
Hildesheim, Roemer-Mus.
 Hildesheim, Roemer-Museum
Honolulu, HI, Acad. A.
 Honolulu, HI, Honolulu Academy of Arts
Houston, TX, A. & Hist. Trust col.
 Houston, TX, Art and History Trust
 Collection

Houston, TX, Menil Col.
 Houston, TX, Menil Collection
Huesca, Mus. Episc. & Capitular Arqueol.
Sagrada
 Huesca, Museo Episcopal y Capitular de
 Arqueología Sagrada
Hyderabad, Mittal Mus. Ind. A.
 Hyderabad, Jaqdish and Kamla Mittal
 Museum of Indian Art
Innsbruck, Tirol. Landesmus.
 Innsbruck, Tiroler Landesmuseum
 Ferdinandeum
Iowa City, U. IA Mus. A.
 Iowa City, IA, University of Iowa Museum of
 Art
Istanbul, Found. Cult. A.
 Istanbul, Foundation for Culture and Arts
Istanbul, Mil. Mus.
 Istanbul, Military Museum
Istanbul, Mimar Sinan U., Mus. Ptg & Sculp.
 Istanbul, Mimar Sinan University, Museum of
 Painting and Sculpture
Istanbul, Mus. F.A.
 Istanbul, Museum of Fine Art
Istanbul, Mus. Turk. & Islam. A.
 Istanbul, Museum of Turkish and Islamic Art
Istanbul, Pera Mus.
 Istanbul, Pera Museum
Istanbul, Sadberk Hanım Mus.
 Istanbul, Sadberk Hanım Museum
Istanbul, Sakıp Sabancı Mus.
 Istanbul, Sakıp Sabancı Museum
Istanbul, Topkapı Pal. Lib.
 Istanbul, Topkapı Palace Library
Istanbul, U. Lib.
 Istanbul, University Library
Ithaca, NY, Cornell U., Johnson Mus. A.
 Ithaca, NY, Cornell University, Herbert F.
 Johnson Museum of Art
Iznik, Archaeol. Mus.
 Iznik, Archaeological Museum
Jaipur, City Pal. Mus.
 Jaipur, City Palace Museum
Jaipur, Maharaja Sawai Man Singh II Mus.
 Jaipur, Maharaja Sawai Man Singh II
 Museum
Játiva, Mus. Mun.
 Játiva, Museo Municipal
Jerusalem, Gulbenkian Lib.
 Jerusalem, Gulbenkian Library
Jerusalem, Israel Mus.
 Jerusalem, Israel Museum

Jerusalem, Mayer Mus. Islam A.
 Jerusalem, L. A. Mayer Museum for Islamic
 Art
Kairouan, Mus. A. Islam.
 Kairouan, Musée d'Art Islamique
Kansas City, MO, Nelson–Atkins Mus. A.
 Kansas City, MO, Nelson–Atkins Museum of
 Art
Kansas City, MO, U. Missouri–Kansas City,
Gal. A.
 Kansas City, MO, University of Missouri
 Kansas City, Gallery of Art
Kassel, Hess. Landesmus.
 Kassel, Hessisches Landesmuseum
Khodzhent, Hist. & Reg. Mus.
 Khodzent, Historical and Regional
 Museum
Kiel, Schleswig-Holsteinische Landesbib.
 Kiel, Schleswig-Holsteinische
 Landesbibliothek
Konya, Mevlana Mus.
 Konya, Mevlana Museum
Kraków, N. A. Cols.
 Kraków, National Art Collections
Kraków, N. Mus.
 Kraków, National Museum
Krefeld, Dt. Textilmus.
 Krefeld, Deutsches Textilmuseum
Kuala Lumpur, Islam. A. Mus.
 Kuala Lumpur, Islamic Art Museum
Kuala Lumpur, Maybank A.G.
 Kuala Lumpur, Maybank Art Gallery
Kuwait City, Mus. Islam. A.
 Kuwait City, Museum of Islamic Art
Kuwait City, N. Mus.
 Kuwait City, National Museum
Lafayette, U. SWLA, A. Mus.
 Lafayette, LA, University of Southwestern
 Louisiana, University Art Museum
Lagos, N. Mus.
 Lagos, National Museum
Leeds, Royal Armouries
 Leeds, Royal Armouries Museum
Leiden, Bib. Rijksuniv.
 Leiden, Bibliotheek der Rijksuniversiteit
 Leiden
Leiden, Rijksmus. Vlkenknd.
 Leiden, Rijksmuseum voor Volkenkunde
Leipzig, Karl-Marx-U.
 Leipzig, Karl-Marx-Universität
Leipzig, Kstgewmus.
 Leipzig, Kunstgewerbemuseum

Leipzig, Ubib.
 Leipzig, Universitätsbibliothek der Universität
 Leipzig
León, Mus. A. Contemp.
 León, Museo de Arte Contemporáneo de
 Castilla y León (MUSAC)
Lisbon, Fund. Gulbenkian
 Lisbon, Fundação Calouste
 Gulbenkian
Lisbon, Mus. Gulbenkian
 Lisbon, Museu Calouste Gulbenkian
Ljubljana, Gal. Mod. A.
 Ljubljana, Gallery of Modern Art
London, Barbican A.G.
 London, Barbican Art Gallery
London, Barbican Cent.
 London, Barbican Centre
London, Bernheimer F.A. Ltd.
 London, Bernheimer Fine Art Ltd.
London, BL
 London, British Library
London, BL, Orient. & India
 London, British Library, Oriental and India
 Office Lib. Office Library
London, Burlington F.A. Club
 London, Burlington Fine Arts Club [no longer
 exists]
London, Camden A. Cent.
 London, Camden Arts Centre
London, Electrum Gal.
 London, Electrum Gallery
London, Hayward Gal.
 London, Hayward Gallery
London, India Office Lib.
 London, India Office Library
London, Iraqi Cult. Cent.
 London, Iraqi Cultural Centre
London, Islam. Cult. Cent.
 London, Islamic Cultural Centre
London, Leighton House A.G. & Mus.
 London, Leighton House Art Gallery and
 Museum
London, N.G.
 London, National Gallery
London, Queen's Gal.
 London, Queen's Gallery
London, RA
 London, Royal Academy of Arts
London, Royal Asiat. Soc.
 London, Royal Asiatic Society
London, Royal Geog. Soc.
 London, Royal Geographical Society

London, Savannah Gal. Mod. Afr. A.
 London, Savannah Gallery of Modern
 African Art
London, Serpentine Gal.
 London, Serpentine Gallery
London, Tower
 London, Tower of London
London, U. London, Courtauld Inst.
 London, University of London, Courtauld
 Institute of Art
London, U. London, SOAS, Brunei Gal.
 London, University of London, School of
 Oriental and African Studies, Brunei Gallery
London, V&A
 London, Victoria and Albert Museum
London, Wallace
 London, Wallace Collection
London, Whitechapel A.G.
 London, Whitechapel Art Gallery
Los Angeles, CA, Armand Hammer Mus. A.
 Los Angeles, CA, Armand Hammer Museum
 of Art and Cultural Center
Los Angeles, CA, Co. Mus. A.
 Los Angeles, CA, County Museum of Art
Los Angeles, UCLA, Fowler Mus. Cult. Hist.
 Los Angeles, CA, University of California,
 Fowler Museum of Cultural History
Los Angeles, UCLA, Wight A.G.
 Los Angeles, University of California, Freder-
 ick S. Wight Art Gallery
Lübeck, Mus. Kst & Kultgesch.
 Lübeck, Museum für Kunst und
 Kulturgeschichte der Hansestadt Lübeck
Lyon, Mus. Hist. Tissus
 Lyon, Musée Historique des Tissus
Maastricht, Bonnefantenmus.
 Maastricht, Bonnefantenmuseum
Maastricht, Schatkamer St-Servaasbasiliek
 Maastricht, Schatkamer van de
 Sint-Servaasbasiliek
Madrid, Inst. Valencia Don Juan
 Madrid, Instituto de Valencia de Don Juan
Madrid, Mus. Arqueol. N.
 Madrid, Museo Arqueológico Nacional
Madrid, Mus. Ejército
 Madrid, Museo del Ejército
Madrid, Mus. Galdiano
 Madrid, Museo Lázaro Galdiano
Madrid, Mus. N. Etnol.
 Madrid, Museo Nacional de Etnología
Madrid, Real Acad. Hist.
 Madrid, Real Academia de la Historia

Mainz, Gutenberg-Mus.
 Mainz, Gutenberg-Museum
Málaga, Mus. Arqueol. Prov.
 Málaga, Museo Arqueológico
 Provincial
Maldah Mus.
 Maldah, Museum
Malibu, CA, Getty Mus.
 Malibu, CA, J. Paul Getty Museum
Manchester, C.A.G.
 Manchester, City Art Gallery
Manchester, John Rylands U. Lib.
 Manchester, John Rylands University Library
 of Manchester
Manchester, U. Manchester, Whitworth A.G.
 Manchester, University of Manchester,
 Whitworth Art Gallery
Marrakesh, Badiʿ Pal. Mus.
 Marrakesh, Badiʿ Palace Museum
Marrakesh, Mus. Dar Si Saïd
 Marrakesh, Musée de Dar Si Saïd
Marseille, Bib. Mun.
 Marseille, Bibliothèque Municipale
Marseille, Cent. Vielle Charité
 Marseille, Centre de la Vieille Charité
Mashhad, Imam Riza Shrine Mus.
 Mashhad, Imam Riza Shrine Museum
Meknès, Mus. Dar Jamai & Pal.
 Meknès, Musée Dar Jamai et Palais
Melbourne, U. Melbourne, Ian Potter Mus. A.
 Melbourne, University of Melbourne, Ian
 Potter Museum of Art
Mexico City, Inst. N. Antropol. & Hist.
 Mexico City, Instituto Nacional de
 Antropología e Historia
Milan, Bib. Ambrosiana
 Milan, Biblioteca Ambrosiana
Milan, Mus. Poldi Pezzoli
 Milan, Museo Poldi Pezzoli
Milan, Pal. Reale
 Milan, Palazzo Reale
Milwaukee, WI, Marquette U., Haggerty
Mus. A.
 Milwaukee, WI, Marquette University, Patrick
 and Beatrice Haggerty Museum of Art
Minneapolis, MN, Inst. A.
 Minneapolis, MN, Minneapolis Institute of
 Arts
Moscow, Hist. Mus.
 Moscow, Historical Museum
Moscow, Mus. Orient. A.
 Moscow, Museum of Oriental Art

Moscow, Pushkin Mus. F.A.
Moscow, Pushkin Museum of
Fine Arts
Moscow, Tret'yakov Gal.
Moscow, Tret'yakov Gallery
Mumbai, Prince of Wales Mus.
Mumbai, Prince of Wales Museum
Munich, Residenzmus.
Munich, Residenzmuseum
Munich, Staatl. Mus. Vlkerknd.
Munich, Staatliches Museum für
Völkerkunde
Naples, Capodimonte
Naples, Museo e Gallerie Nazionali di
Capodimonte
Neuchâtel, Mus. Ethnog.
Neuchâtel, Musée d'Ethnographie de
Neuchâtel
Newcastle upon Tyne, Poly. Gal.
Newcastle upon Tyne, Polytechnic Gallery
New Delhi, Indira Gandhi N. Cent. A.
New Delhi, Indira Gandhi National Centre for
the Arts
New Delhi, N. Mus.
New Delhi, National Museum
New Delhi, Palette A. Gal.
New Delhi, Palette Art Gallery
New Haven, CT, Yale U. A.G.
New Haven, CT, Yale University Art Gallery
New York, Afr.-Amer. Inst.
New York, African-American Institute
New York, Altern. Cent. Int. A.
New York, Alternative Center for International
Arts
New York, Amer. Fed. A.
New York, American Federation of Arts
New York, Armen. Mus.
New York, Armenian Museum
New York, Asia House Gals.
New York, Asia House Galleries
New York, Asia Soc. Gals.
New York, Asia Society Galleries
New York, Brooklyn Mus.
New York, The Brooklyn Museum
New York, Cent. Afr. A.
New York, Center for African Art
New York, Columbia U., Cent. Iran Stud.
New York, Columbia University, Center for
Iranian Studies
New York, Cooper-Hewitt Mus.
New York, Cooper-Hewitt, National Design
Museum, Smithsonian Institution

New York, Frick
New York, Frick Collection
New York, Hisp. Soc. America
New York, Hispanic Society of America
New York, Iran. Inst.
New York, Iranian Institute [closed]
New York, Jew. Mus.
New York, The Jewish Museum
New York, Met.
New York, Metropolitan Museum of Art
New York, MOMA
New York, Museum of Modern Art
New York, Mus. Afr. A.
New York, Museum for African Art
New York, Pierpont Morgan Lib.
New York, Pierpont Morgan Library
New York, Pub. Lib.
New York, Public Library
New York U., Grey A.G.
New York, New York University, Grey Art
Gallery and Study Center
Niamey, Mus. N. Niger
Niamey, Musée National du Niger
Nice, Mus. Masséna
Nice, Musée Masséna
Northampton, MA, Smith A. Mus.
Northampton, MA, Smith College Museum of
Art
Nukus, Karakalpakiya Mus. A.
Nukus, Karakalpakiya Museum of Art
Offenbach am Main, Dt. Ledermus.
Offenbach am Main, Deutsches
Ledermuseum
Oldenburg, Stadtmus.
Oldenburg, Stadtmuseum
Ottawa, N.G.
Ottawa, National Gallery of Canada
Oxford, Ashmolean
Oxford, Ashmolean Museum
Oxford, Bodleian Lib.
Oxford, Bodleian Library
Oxford, MOMA
Oxford, Museum of Modern Art
Palermo, Gal. Reg. Sicilia
Palermo, Galleria Regionale della
Sicilia
Palm Beach, FL, Soc. Four A.
Palm Beach, FL, Society of the
Four Arts
Palo Alto, CA, Stanford U., Cantor Cent.
Visual A. Palo Alto, CA, Stanford University,
Cantor Center for the Visual Arts

Pamplona, Mus. Navarra
 Pamplona, Museo de Navarra
Paris, Assoc. Etude & Doc. Textiles Asie
 Paris, Association pour l'Etude et la
 Documentation des Textiles d'Asie
Paris, Bib. N.
 Paris, Bibliothèque Nationale
Paris, Gal. Mausart
 Paris, Galerie Mausart
Paris, Grand Pal.
 Paris, Grand Palais
Paris, Inst. Géog. N.
 Paris, Institut Géographique National
Paris, Inst. Monde Arab.
 Paris, Institut du Monde Arabe
Paris, Louvre
 Paris, Musée du Louvre
Paris, Mus. A. Afr. & Océan.
 Paris, Musée des Arts Africains et Océaniens
Paris, Mus. A. Déc.
 Paris, Musée des Arts Décoratifs
Paris, Mus. A. Juif Maroc.
 Paris, Musée d'art juif marocain
Paris, Mus. Cluny
 Paris, Musée de Cluny
Paris, Mus. Grévin
 Paris, Musée Grévin
Paris, Mus. Guimet
 Paris, Musée Guimet
Paris, Mus. Homme
 Paris, Musée de l'Homme
Paris, Mus. Orsay
 Paris, Musée d'Orsay
Pendzhikent, Roudaki Abuabdullo Repub. Hist.
 & Reg. Mus. Pendzhikent, Rudaki Abuabdullo
 Republican Historical and Regional Museum
Pforzheim, Schmuckmus.
 Pforzheim, Schmuckmuseum Pforzheim im
 Reuchlinhaus
Philadelphia, PA, Mus. A.
 Philadelphia, PA, Museum of Art
Philadelphia, U. PA, ICA
 Philadelphia, PA, University of Pennsylvania,
 Institute of Contemporary Art
Philadelphia, U. PA, Mus.
 Philadelphia, PA, University of Pennsylvania,
 University Museum
Pisa, Mus. N. S. Matteo
 Pisa, Museo Nazionale di S Matteo
Pittsburgh, PA, Carnegie Mus. A.
 Pittsburgh, PA, The Carnegie Museum
 of Art

Prague, Higher Council F.A.
 Prague, Higher Council of Fine Arts
Prague, Náprstek Mus.
 Prague, Náprstek Museum of Asian, African
 and American Culture
Prato, Cent. A. Contemp. Pecci
 Prato, Centro per l'Arte Contemporanea Luigi
 Pecci
Quedlinburg, Schlossmus.
 Quedlinburg, Schlossmuseum
Rabat, Bib. Gén. & Archvs
 Rabat, Bibliothèque Générale et Archives
Rabat, Mus. A. Maroc
 Rabat, Musée des Arts Marocains
Rampur, Raza Lib.
 Rampur, Raza Library
Reims, Maison Cult. André Malraux
 Reims, Maison de la Culture André Malraux
Richmond, VA Mus. F.A.
 Richmond, VA, Virginia Museum of Fine Arts
Riggisberg, Abegg-Stift.
 Riggisberg, Abegg-Stiftung
Rochester, U. Rochester, NY, Mem. A.G.
 Rochester, NY, University of Rochester,
 Memorial Art Gallery
Rome, Ist. It.-Afr.
 Rome, Istituto Italo-Africano
Rome, Pal. Espos.
 Rome, Palazzo delle Esposizioni
Rome, Vatican, Bib. Apostolica
 Rome, Vatican, Biblioteca Apostolica Vaticana
St. Louis, MO, A. Mus.
 St. Louis, MO, Art Museum
St. Petersburg, Acad. Sci., Inst. Orient. Stud.
 St. Petersburg, Academy of Sciences, Institute
 of Oriental Studies
St. Petersburg, Hermitage
 St. Petersburg, Hermitage Museum
St. Petersburg, Mus. Ethnog.
 St. Petersburg, Museum of Ethnography
St. Petersburg, Peter the Great Mus. Anthropol.
 & Ethnog. St Petersburg, Peter the Great
 Museum of Anthropology and Ethnography
St. Petersburg, Saltykov-Shchedrin Pub. Lib.
 St. Petersburg, M.E. Saltykov-Shchedrin
 Public Library
Saint-Raphaël, Mus. Archéol.
 Saint-Raphaël, Musée Archéologique
Salamanca, Mus. Dioc.
 Salamanca, Museo Diocesano
Salem, MA, Peabody Essex Mus.
 Salem, MA, Peabody Essex Museum

Salford, Mus. & A.G.
 Salford, Museum and Art Gallery
Samarkand, Afrasiab Mus.
 Samarkand, Afrasiab Museum
Samarkand, Ikramov Mus. Hist. Cult.
 & A. Uzbekistan Samarkand, A. Ikramov
 Museum of the History of Culture and Art of
 Uzbekistan
Samarkand, Inst. Archaeol.
 Samarkand, Institute of Archaeology
Samarkand, Mus. Hist.
 Samarkand, Museum of the History of
 Samarkand
Samarkand, Registan Mus.
 Samarkand, Registan Museum
San Diego, CA, Mus. A.
 San Diego, CA, San Diego Museum of Art
San Francisco, CA, de Young Mem. Mus.
 San Francisco, CA, M. H. de Young Memorial
 Museum
San Gimignano, Mus. Civ.
 San Gimignano, Museo Civico
Seattle, WA, A. Mus.
 Seattle, WA, Seattle Art Museum
Sèvres, Mus. N. Cér.
 Sèvres, Musée National de Céramique
Sharjah, Mus. Contemp. Arab A.
 Sharjah, Museum for Contemporary
 Arab Art
Sheffield, Mappin A.G.
 Sheffield, Mappin Art Gallery
Sheffield, Millennium Gals.
 Sheffield, Millennium Galleries
Shiraz, Pars Mus.
 Shiraz, Pars Museum
Sousse, Mus. Archéol.
 Sousse, Musée Archéologique
Springfield, MA, Mus. F.A.
 Springfield, MA, Museum of Fine Arts
Stockholm, Medelhavsmus.
 Stockholm, Medelhavsmuseum
Stockholm, Stat. Hist. Mus.
 Stockholm, Statens Historiska Museum
Stuttgart, Inst. Auslandsbeziehungen
 Stuttgart, Institut für Auslandsbeziehungen
Stuttgart, Linden-Mus.
 Stuttgart, Linden-Museum
Swansea, Vivian A.G. & Mus.
 Swansea, Glynn Vivian Art Gallery and
 Museum
Sydney, Powerhouse Mus.
 Sydney, Powerhouse Museum

Tangier, Mus. Kasbah
 Tangier, Musée de la Kasbah de Tanger
Tashkent, Alisher Navoi Lib.
 Tashkent, Alisher Navoi Library
Tashkent, Aybek Mus. Hist. Uzbekistan
 Tashkent, T. Aybek Museum of the History
 of the Peoples of Uzbekistan
Tashkent, Hist. Mus.
 Tashkent, History Museum
Tashkent, Inst. Hist. A.
 Tashkent, Institute of the History of Art
Tashkent, Khamza Inst. A.
 Tashkent, Khamza Institute for Knowledge
 of the Arts
Tashkent, Mus. A. Uzbekistan
 Tashkent, Tashkent Museum of the Arts
 of Uzbekistan
Tashkent, Orient. Inst. Lib.
 Tashkent, Oriental Institute Library
Tbilisi, Mus. Georgia
 Tbilisi, Museum of Art of Georgia
Tehran, Abgina Mus.
 Tehran, Abgina Museum
Tehran, Archaeol. Mus.
 Tehran, Archaeological Museum
Tehran, Ethnog. Mus.
 Tehran, Ethnographical Museum
Tehran, Gulistan Pal. Lib.
 Tehran, Gulistan Palace Library
Tehran, Mus. Contemp. A.
 Tehran, Museum of Contemporary Art
Tehran, Mus. Dec. A.
 Tehran, Museum of Decorative Arts
Tehran, Nigaristan Mus.
 Tehran, Nigaristan Museum
Tehran, N. Mus.
 Tehran, National Museum
Tenafly, NJ, Afr. A. Mus.
 Tenafly, NJ, African Art Museum of the
 S.M.A. Fathers
Tokyo, Met. A. Mus.
 Tokyo, Metropolitan Art Museum
Tokyo, Setagaya A. Mus.
 Tokyo, Setagaya Art Museum
Toronto, Royal Ont. Mus.
 Toronto, Royal Ontario Museum
Toulouse, Mus. Augustins
 Toulouse, Musée des Augustins
Trent, Mus. Dioc.
 Trent, Museo Diocesano
Tudela, Archv Mun.
 Tudela, Archivo Municipal de Tudela

Tunis, Mus. N. Bardo
 Tunis, Musée National du Bardo
Uppsala, Ubib.
 Uppsala, Uppsala Universitetsbibliothek
Ura Tyube, Hist. & Reg. Mus.
 Ura Tyube, Ura Tyube Historical and Regional
 Museum
Vaduz, Furusiyya A. Found.
 Vaduz, Furusiyya Art Foundation
Valladolid, Mus. Dioc. & Catedralicio
 Valladolid, Museo Diocesano y Catedralicio
Varanasi, Banaras Hindu U., Bharat Kala
Bhavan
 Varanasi, Banaras Hindu University, Bharat
 Kala Bhavan
Venice, Correr
 Venice, Museo Correr
Venice, Doge's Pal.
 Venice, Doge's Palace [Palazzo Ducale]
Vic, Mus. Episc.
 Vic, Museu Arqueologic Artistic Episcopal
Vienna, Hist. Mus.
 Vienna, Historisches Museum
Vienna, Hochsch. Angewandte Kst
 Vienna, Hochschule für Angewandte
 Kunst in Wien
Vienna, Ksthalle
 Vienna, Kunsthalle
Vienna, Ksthist. Mus., Samml Plastik &
Kstgew.
 Vienna, Kunsthistorisches Museum,
 Sammlung für Plastik und Kunstgewerbe
Vienna, Österreich. Mus. Angewandte Kst
 Vienna, Österreichisches Museum für
 Angewandte Kunst
Vienna, Österreich. Nbib.
 Vienna, Österreichische Nationalbibliothek

Vienna, Schatzkam.
 Vienna, Schatzkammer
Villeneuve d'Ascq, Mus. A. Mod. Nord
 Villeneuve d'Ascq, Musée d'Art Moderne du
 Nord
Washington, DC, Corcoran Gal. A.
 Washington, DC, Corcoran Gallery of Art
Washington, DC, Freer
 Washington, DC, Freer Gallery of Art
 [Smithsonian Inst.]
Washington, DC, Gal. Int. Monetary Fund
 Washington, DC, Gallery of the International
 Monetary Fund
Washington, DC, Lib. Congr.
 Washington, DC, Library of Congress
Washington, DC, N. Col. F. A.
 Washington, DC, National Collection of Fine
 Arts [closed 1980]
Washington, DC, N.G.A.
 Washington, DC, National Gallery of Art
Washington, DC, N. Mus. Afr. A.
 Washington, DC, National Museum of
 African Art [Smithsonian Inst.]
Washington, DC, N. Mus. Nat. Hist.
 Washington, DC, National Museum of
 Natural History [Smithsonian Inst.]
Washington, DC, Sackler Gal.
 Washington, DC, Arthur M. Sackler Gallery
Washington, DC, Textile Mus.
 Washington, DC, Textile Museum
Williamstown, MA, Clark A. Inst.
 Williamstown, MA, Sterling and Francine
 Clark Art Institute
Windsor Castle, Royal Lib.
 Windsor Castle, Royal Library
Zurich, Mus. Reitberg
 Zurich, Museum Rietberg

PERIODICALS

A. America
 Art in America
A. & Archaeol. Res. Pap.
 Art and Archaeology Research Papers (AARP)
A. Asia
 Arts of Asia
A. Asiatiques
 Arts asiatiques
A. & Auction
 Art and Auction

Abh. & Ber. Staatl. Mus. Vlkerknd., Dresden
 Abhandlungen und Berichte des Staatlichen
 Museums für Völkerkunde, Dresden
A. Bull.
 Art Bulletin
Acad. Inscr. & B.-Lett.: C. R. Séances
 Académie des inscriptions et belles-lettres:
 Comptes rendus des séances
Acta Asiat.
 Acta Asiatica

Acta Orient.
Acta orientalia
Acta Orientalia Acad. Sci. Hung.
Acta orientalia Academiae scientiarum
Hungaricae
A. & Déc.
Art et décoration
Afghanistan J.
Afghanistan Journal
Afghanistan Q.
Afghanistan Quarterly
Afghan Stud.
Afghan Studies
Afr. A.
African Arts
Afr. Archaeol. Rev.
African Archaeological Review
Afr. Bull.
Africana Bulletin
Africa: Inst. N. Archéol. & A.
Africa: Institut national d'archéologie et de
l'art
Africa: Riv. Trimest. Stud. & Doc. Ist. It. Africa &
Orient. Africa: Rivista Trimestrale di Studi e
Documentazione dell'Istituto Italiano per
l'Africa e l'Oriente
Afr. Lang. Rev.
African Language Review
A. Hist.
Art History
AION
[Annali dell'Istituto universitario orientale di
Napoli]
A. Islam.
Ars Islamica
A. & Islam. World
Arts and the Islamic World
A. J.
Art Journal
A. Libs J.
Art Libraries Journal
A. Med.
Arte medievale
Amer. Anthropol.
American Anthropologist
Amer. Craft
American Craft
Amer. J. Archaeol.
American Journal of
Archaeology

Amer. Numi. Soc. Mus. Notes
American Numismatic Society Museum
Notes
A. México
Artes de México
Anaquel Estud. Arab.
Anaquel de Estudios Arabes
An. Archéol. Arabes Syr.
Annales archéologiques arabes syriennes:
Revue d'archéologie et d'histoire
An. Archéol. Syrie
Annales archéologiques de Syrie: Revue
d'archéologie et d'histoire syriennes
Anatol. Stud.
Anatolian Studies: Journal of the British
Institute at Ankara
An. Inst. Etud. Orient. U. Alger
Annales de l'Institut d'études orientales de
l'Université d'Alger
An. Islam.
Annales islamologiques
Ankara Ü. İlâhiyat Fak. Yıllık Araştırmalar Derg.
Ankara üniversitesi ilâhiyat fakültesi yıllık
araştırmaları dergisi
Annu. Dept Ant. Jordan
Annual of the Department of Antiquities of
Jordan
Annu. Rev. Anthropol.
Annual Review of Anthropology
An. Sci.
Annals of Science
Anthol. Iran. Stud.
Anthology of Iranian Studies
Anthropol. Q.
Anthropological Quarterly
Ant. J.
Antiquities Journal
Ant. Welt
Antike Welt
Anz. Ger. Nmus.
Anzeiger des Germanischen
Nationalmuseums
Anz. Österreich. Akad. Wiss. Philos.-Hist. Kl.
Anzeiger der Österreichischen Akademie der
Wissenschaften, philosophisch–historische
Klasse
A. Orient.
Ars Orientalis
Arab. Archaeol. & Epig.
Arabian Archaeology and Epigraphy

Arab Hist. Rev. Ottoman Stud.
Arab Historical Review for Ottoman Studies/
Al-Majalla al-Tārīkhīya al-ʿArabīyali-l-Dirāsāt
al-ʿUthmānīya
Arab. Stud.
Arabian Studies
Archaeol. & Hist. Lebanon
Archaeology and History in Lebanon
Archaeol. Int.
Archaeology International
Archäol. Anz.
Archäologischer Anzeiger
Archäol. Ber. Yemen
Archäologische Berichte aus dem Yemen
Archäol. Mitt. Iran
Archäologische Mitteilungen aus Iran und
Turan
Archeól. Islam.
Archeólogie islamique
Archit. Assoc. Q.
Architectural Association Journal
Archit. Aujourd'hui
L'Architecture d'aujourd'hui
Archit. & Des.
Architecture and Design
Archit. Des.
Architectural Design
Archit. Forum
Architectural Forum
Archit. Hisp.
Architectura hispalense
Archit. Hist.
Architectural History
Archit. Rec.
Architectural Record
Archit. Rev. [London]
Architectural Review [London]
Archit. Sci. Rev.
Architectural Science Review
Archit. & Wohnen
Architektur und Wohnen
Archit.: Z. Gesch. Baukst
Architectura: Zeitschrift für Geschichte der
Baukunst
Archv Antropol. & Etnol.
Archivio per l'antropologia e l'etnologia
Archvs Asian A.
Archives of Asian Art
Archv Esp. A.
Archivo español de arte
Archv Esp. A. & Arqueol.
Archivo español de arte y arqueología

Archv Esp. Arqueol.
Archivo español de arqueología
Archvs Asian A.
Archives of Asian Art
Archvs Int. Hist. Sci.
Archives internationales d'histoire des sciences
Archv Vlkerknd.
Archiv für Völkerkunde
Argomenti Stor. A.
Argomenti di storia dell'arte
Arkheol. Raboty Tadzhikistane
Arkheologicheskiye raboty v Tadzhikstane
Arkhit. Nasledstvo
Arkhitekturnoye nasledstvo
Arqueol. & Territ. Med.
Arqueología y Territorio Medieval
Asian A.
Asian Art
Asian & Afr. Stud.
Asian and African Studies
Asiat. Stud.
Asiatische Studien
Atti & Mem. Accad. N. Lincei, Atti Cl. Sci. Morali
Atti e memorie dell'Accademia nazionale dei
Lincei, atti della classe di scienze morali
A+U
Architecture and Urbanism
Austral. & NZ J. A.
Australia and New Zealand Journal of Art
Azania
Azania: Journal of the British Institute in
Eastern Africa
Baghdad. Mitt.
Baghdader Mitteilungen
Balkan Stud.
Balkan Studies
B. A. Mag.
Beaux Arts Magazine
Bangladesh Hist. Stud.
Bangladesh Historical Studies
Ber. Forsch.-Inst. Osten & Orient
Berichte des Forschungs-Instituts für Osten
und Orient
Berlin. Mus.: Ber. Ehem. Preuss. Kstsamml.
Berliner Museen: Berichte aus den ehemaligen
preussischen Kunstsammlungen
Bibl. Archaeol. Rev.
Biblical Archaeology Review
Bijdr. Taal-, Land- & Vlkenknd.
Bijdragen tot de taal-, land- en volkenkunde
BLJ
British Library Journal

BM Q.
British Museum Quarterly

Boğaziçi Ü. Derg.: Human. Bilimler
Boğaziçi Üniversitesi dergisi: Hümaniter
bilimler

Bol. Arqueol. Med.
Boletín de arqueología medieval

Bol. Asoc. Esp. Orientalistas
Boletín de la Asociación española de orientalistas

Boll. A.: Min. Pub. Istruzione
Bollettino d'arte: Ministero della pubblica
istruzione

Bol. Mus. Arqueol. N. Madrid
Boletín del Museo arqueológico nacional de
Madrid

Bol. Real Acad. Córdoba Cienc., B. Let. & Nob. A.
Boletín de la Real academia de Córdoba de
ciencias, bellas letras y nobles artes

Bol. Real Acad. Hist.
Boletín de la Real academia de la historia

Bol. Soc. Esp. Excurs.
Boletín de la Sociedad española de
excursiones

Bonn. Jb.
Bonner Jahrbücher: Jahrbücher des Vereins
von Altertumsfreunden im Rheinlande

Brit. J. Aesth.
British Journal of Aesthetics

Brit. J. Mid. E. Stud.
British Journal of Middle Eastern Studies

Brit. Soc. Mid. E. Stud. Bull.
British Society for Middle Eastern Studies
Bulletin

Brit.–Yemen. Soc. J.
British–Yemeni Society Journal

Brunei Mus. J.
Brunei Museum Journal

Bull. Amer. Acad. Benares
Bulletin of the American Academy of
Benares

Bull. Amer. Inst. Iran. A. & Archaeol.
Bulletin of the American Institute for Iranian
Art and Archaeology

Bull. Amer. Sch. Orient. Res.
Bulletin of the American Schools of Oriental
Research

Bull. Archéol. Alg.
Bulletin d'archéologie algérienne

Bull. Archéol. Maroc.
Bulletin d'archéologie marocaine

Bull. Asia Inst.
Bulletin of the Asia Institute

Bull. Biblioph.
Bulletin du bibliophile

Bull. CIETA
Bulletin du CIETA (Centre international
d'étude des textiles anciens)

Bull. Cleveland Mus. A.
Bulletin of the Cleveland Museum of Art

Bull. Ecole Fr. Extrême-Orient
Bulletin de l'Ecole française d'Extrême-
Orient

Bull. Etud. Orient.
Bulletin d'études orientales

Bull. Fac. A. [Alexandria]
Bulletin of the Faculty of Arts [Alexandria]

Bull. Fac. A., Cairo U.
Bulletin of the Faculty of Arts,
Cairo University

Bull. Fac. A., Fouad I U.
Bulletin of the Faculty of Arts, Fouad I
University

Bull. Inst. Egyp.
Bulletin de l'Institut d'Egypte

Bull. Inst. Fondamental Afrique
Bulletin de l'Institut Fondamental d'Afrique
Noire Noire

Bull. Inst. Fr. Afrique Noire
Bulletin de l'Institut français d'Afrique noire

Bull. Inst. Fr. Archéol. Orient.
Bulletin de l'Institut français d'archéologie
orientale

Bull. Liaison Cent. Int. Etud. Textiles Anc.
Bulletin de liaison du Centre international
d'étude des textiles anciens

Bull. Met.
Bulletin of the Metropolitan Museum
of Art

Bull. Mnmtl
Bulletin monumental

Bull. Mus. Beyrouth
Bulletin du Musée de Beyrouth

Bull. Mus. F.A., Boston
Bulletin: Museum of Fine Arts, Boston

Bull. N. Early Amer. Glass Club
Bulletin of the National Early American Glass
Club

Bull. Needle & Bobbin Club
Bulletin of the Needle and Bobbin Club

Bull. Rijksmus.
Bulletin van het Rijksmuseum

Bull. SOAS
Bulletin of the School of Oriental and
African Studies

Bull. Soc. Archéol. Alexandrie
 Bulletin de la Société archéologique
 d'Alexandrie
Bull. Soc. Archéol. Copte
 Bulletin de la Société d'archéologie copte
Bull. Soc. Hist. Maroc
 Bulletin de la Société d'histoire du Maroc
Burl. Mag.
 Burlington Magazine
Byz. Forsch.
 Byzantinische Forschungen
Cah. Archéol.
 Cahiers archéologiques
Cah. Asie Cent.
 Cahiers d'Asie Centrale
Cah. A. & Tech. Afrique N.
 Cahiers des arts et techniques de l'Afrique du
 Nord
Cah. A. & Trad. Pop.
 Cahiers des arts et traditions populaires
Cah. Civilis. Méd.
 Cahiers de civilisation médiévale
Cah. Dél. Archéol. Fr. Iran
 Cahiers de la Délégation archéologique
 française en Iran
Cah. E.
 Cahiers de l'Est
Cah. Etud. Médit. Orient. Turco-Iranien
 Cahiers d'études sur la méditerranée orientale
 et le monde Turco-Iranien (CEMOTI)
Cah. Monde Rus. & Sov.
 Cahiers du monde russe et soviétique
Cah. St-Michel de Cuxa
 Cahiers de Saint-Michel de Cuxa
Cah. Tunisie
 Cahiers de Tunisie
Cent. Asiat. J.
 Central Asiatic Journal
Cer. Ant.
 Ceramic Antica
Chicago A. J.
 Chicago Art Journal
Chron. Mus. A. Dec. Cooper Un.
 Chronicle of the Museum of the Arts of
 Decoration of the Cooper Union
Cieta Bull.
 Cieta Bulletin
Coll. A. J.
 College Art Journal
Conn. A.
 Connaissance des arts

Contemp. A. Pakistan
 Contemporary Arts in Pakistan
Corsi Cult. A. Ravenn. & Biz.
 Corsi di cultura sull'arte ravennate e bizantina
C.-R. Acad .Inscr. & B.-Lett.
 Comptes-rendus de l'Académie des
 Inscriptions et Belles-Lettres (CRAI)
Crit. A.
 Critica d'arte
Cuad. Alhambra
 Cuadernos de la Alhambra
Cuad. A. U. Granada
 Cuadernos de arte de la Universidad de
 Granada
Current Anthropol.
 Current Anthropology
Current World Archaeol.
 Current World Archaeology
Damas. Mitt.
 Damaszener Mitteilungen
Dek. Isk. SSR
 Dekorativnoye iskusstvo SSSR
Des. Issues
 Design Issues
Doss. Archéol.
 Dossiers de l'archéologie
Dt. Bauz.
 Deutsche Bauzeitschrift
Dumbarton Oaks Pap.
 Dumbarton Oaks Papers
E. A.
 Eastern Art
E. A. Rep.
 Eastern Art Report
Edebiyat Fak. Araştırma Derg.
 Edebiyat Fakültesi Araştırma Dergisi
EJOS
 Electronic Journal of Oriental Studies
Environmntl Des.
 Environmental Design: Journal of the
 Islamic Environmental Design Research
 Centre
Epig. Vostoka
 Epigrafika vostoka
Estud. Patrm., Cult. & Cienc. Med.
 Estudios sobre Patrimonio, Cultura y Ciencias
 Medievales
Ethnol. Pol.
 Ethnologia polona
Etud. Balkan.
 Etudes balkaniques

E. & W.
East and West
Film Int.
Film International
F.M.R. Mag.
F.M.R. Magazine
Fol. Archaeol.
Folia archaeologica
Fol. Orient.
Folia orientalia
Fr. Hist. Stud.
French Historical Studies
Gac. Numi.
Gaceta Numismática
Gaz. B.-A.
Gazette des beaux-arts
Genava
Genava: Bulletin du Musée d'art et d'histoire
de Genève, du Musée Ariana et de la Société
auxiliaire du musée, la Bibliothèque publique
et universitaire
Geog. J.
Geographical Journal
Godishnik N. Arkheol. Muz. Plovdiv
Godishnik Narodni arkheologicheski muzea
Plovdiv
Gutenberg-Jb.
Gutenberg Jahrbuch
Harvard Ukrainian Stud.
Harvard Ukrainian Studies
Hist. Phot.
History of Photography
Hist. Religions
History of Religions
Human. Islam.
Humaniora Islamica
Ill. London News
Illustrated London News
Ind. Bouwknd. Tijdschr. Locale Tech.
Indisch bouwkundig tijdschrift locale techniek
Ind. Eco. & Soc. Hist. Rev.
Indian Economic and Social History Review
India Int. Cent. Q.
India International Centre Quarterly
Ind. Mus. Bull.
Indian Museum Bulletin
Inst. B.-Lett. Arab.
Institut des belles-lettres arabes (IBLA)
Int. Dev. Planning Rev.
International Development Planning Review
(IDPR)

Int. J. Hist. Archit.
International Journal of Historical Architecture
Int. J. Hist. Sport
International Journal of the History of Sport
Int. J. Housing Sci. & Applic.
International Journal for Housing Science and
its Applications
Int. J. Kurd. Stud.
International Journal of Kurdish Studies
Int. J. Mid. E. Stud.
International Journal of Middle East Studies
Int. J. Turk. Stud.
International Journal of Turkish Studies
Int. Labour Rev.
International Labour Review
Iran. Stud.
Iranian Studies
Isk. Tadz. Naroda
Iskusstvo tadzhikskogo naroda
Isk. Zodchikh Uzbekistana
Iskusstvo zodchikh Uzbekistana
Islam. A.
Islamic Art
Islam. Cult.
Islamic Culture
Islam. Q.
Islamic Quarterly
Islam. Rev.
Islamic Review
Islam. Stud.
Islamic Studies
İslâm Tetkikleri Enst. Derg.
İslâm Tetkikleri Enstitüsü Dergisi
Israel Explor. J.
Israel Exploration Journal
Istanbul. Forsch.
Istanbuler Forschungen
Istanbul. Mitt.
Istanbuler Mitteilungen
Istanbul Ü. Iktisat Fak. Mecmuası
İstanbul Üniversitesi: İktisat fakültesi
mecmuası
Istor. Mat. Kult. Uzbekistana
Istoriya material'noy kul'tury Uzbekistana
Izvestiya Akad. Nauk Kazakh. SSR
Izvestiya Akademii nauk kazakhskoy SSR
Izvestiya Akad. Nauk Tadzhik. SSR
Izvestiya Akademii nauk tadzhikskoy SSR
Izvestiya Balg. Arkheol. Inst.
Izvestiya na Balgarski arkheologicheski
institut

Izvestiya Imp. Rus. Geog. Obshchestva
Izvestiya imperatorskogo russkogo
geograficheskogo obshchestva

*Izvestiya Tavricheskogo Obshchestva Istor., Arkheol.
& Etnog.*
Izvestiya tavricheskogo obshchestva istorii,
arkheologii i etnografii

J. Aesth. & A. Crit.
Journal of Aesthetics and Art Criticism

J. Africanistes
Journal des africanistes

J. Afr. Soc.
Journal of the African Society

J. A. & Ideas
Journal of Arts and Ideas

J. Algerian Stud.
Journal of Algerian Studies

J. Amer. Orient. Soc.
Journal of the American Oriental Society

J. Amer. Res. Cent. Egypt
Journal of the American Research Center in Egypt

J. Anglo-Mongol. Soc.
Journal of the Anglo-Mongolian Society

J. Arab. Lit.
Journal of Arabic Literature

J. Arab. Stud.
Journal of Arabian Studies

J. Archit.
Journal of Architecture

J. Archit. Conserv.
Journal of Architectural Conservation

J. Archit. Educ.
Journal of Architectural Education

J. Archit. & Planning Res.
Journal of Architectural and Planning
Research

J. Arms & Armour Soc.
Journal of the Arms and Armour Society

J. Asian Civilis.
Journal of Asian Civilisations

J. Asian Hist.
Journal of Asian History

J. Asian Stud.
Journal of Asian Studies

J. Asiat.
Journal asiatique

J. Asiat. Soc. Bangladesh
Journal of the Asiatic Society of Bangladesh

J. Asiat. Soc. Mumbai
Journal of the Asiatic Society of Mumbai

J. Azerbaijan. Stud.
Journal of Azerbaijani Studies

Jb. Asiat. Kst
Jahrbuch für asiatische Kunst

Jb. Berlin. Mus.
Jahrbuch der Berliner Museen

Jb. Dt. Archäol. Inst.
Jahrbuch des Deutschen archäologischen
Instituts

Jb. Kön.-Preuss. Kstsamml.
Jahrbuch der Königlich-preussischen
Kunstsammlungen

Jb. Ksthist. Samml. Wien
Jahrbuch der kunsthistorischen Sammlungen
in Wien

Jb. Mus. Vlkerkund. Leipzig
Jahrbuch des Museums für Völkerkunde zu
Leipzig

J. Cent. Asia
Journal of Central Asia

J. Contemp. Hist.
Journal of Contemporary History

J. Cult. Geog.
Journal of Cultural Geography

J. David Col.
Journal of the David Collection

J. Econ. & Soc. Hist. Orient
Journal of the Economic and Social History of
the Orient

J. Egyp. Archaeol.
Journal of Egyptian Archaeology

Jerusalem Stud. Arab. & Islam
Jerusalem Studies in Arabic and Islam

Jewel. Stud.
Jewellery Studies

J. Gdn Hist.
Journal of Garden History

J. Gdn Stud.
Journal of Garden Studies

J. Gemmology
Journal of Gemmology

J. Glass Stud.
Journal of Glass Studies

J. Hist. Astron.
Journal for the History of
Astronomy

J. Hist. Geog.
Journal of Historical
Geography

J. Islam. Stud.
Journal of Islamic Studies

J. Lib. Hist., Philos. & Comp Librarianship.
Journal of Library History, Philosophy and
Comparative Librarianship

J. Malay. Branch Royal Asiat. Soc.
Journal of the Malayan Branch of the Royal
Asiatic Society
J. Mat. Cult.
Journal of Material Culture
J. N. Afr. Stud.
Journal of North African Studies
J. Nr E. Stud.
Journal of Near Eastern Studies
J. Oman Stud.
Journal of Oman Studies
J. Ottoman Stud.
Journal of Ottoman Studies
J. Pakistan Hist. Soc.
Journal of the Pakistan Historical Society
J. Palestine Stud.
Journal of Palestine Studies
J. Qur'anic Stud.
Journal Qur'anic Studies
J. Reg. Cult. Inst.
Journal of the Regional Cultural Institute
J. Res. Soc. Pakistan
Journal of the Research Society of Pakistan
J. Roman Archaeol.
Journal of Roman Archaeology
J. Royal Asiat. Soc. GB & Ireland
Journal of the Royal Asiatic Society of Great
Britain and Ireland
J. Semitic Stud.
Journal of Semitic Studies
J. Soc. Affairs
Journal of Social Affairs
J. Soc. Archit. Hist.
Journal of the Society of Architectural
Historians
J. Soc. S. Asian Stud.
Journal of the Society for South Asian Studies
J. Study Brit. Cult.
Journal for the Study of British Cultures
J. Turk. Stud.
Journal of Turkish Studies
J. Walters A.G.
Journal of the Walters Art Gallery
J. Warb. & Court. Inst.
Journal of the Warburg and Courtauld Institutes
J. World Hist.
Journal of World History
Keyhan Int.
Keyhan International
Kleine Beitr. Staatl. Mus. Vlkerknd. Dresden
Kleine Beiträge des Staatlichen Museums für
Völkerkunde Dresden

Kratkiye Soobshcheniya Inst. Arkheol. AN SSSR
Kratkiye soobshcheniya Instituta arkheologii
Akademii nauk SSSR
Kratkiye Soobshcheniya Inst. Istor. Mat. Kul't.
Kratkiye soobshcheniya Instituta istorii
material'noy kul'tury
Kst Orients
Kunst des Orients
Kült. Ve Sanat
Kültür ve sanat
Lahore Mus. Bull.
Lahore Museum Bulletin
Latv. U. Raksti
Latvijas Universitatis Raktsi
Lotus Int.
Lotus International
Madrid. Forsch.
Madrider Forschungen
Madrid. Mitt.
Madrider Mitteilungen
Mag. A.
Magazine of Art
Maghreb Rev.
Maghreb Revue
Malaysian Numi. Soc. Newslett.
Malaysian Numismatic Society Newsletter
Mamluk Stud. Rev.
Mamluk Studies Review
Mat. & Issledovaniya Arkheol. SSSR
Materialy i issledovaniya po arkheologii SSSR
Mat. Kult. Tadzhikistana
Material'naya kul'tura Tadzhikistana
Mat. Turcica
Materialia turcica
Med. Encounters
Medieval Encounters
Med. Hist. J.
Medieval History Journal
Med. Prosopography
Medieval Prosopography
Mél. Asiat.
Mélanges asiatiques
Mél. Casa Velázquez
Mélanges de la Casa Velázquez
Mél. Inst. Dominicain Etud. Orient. Caire
Mélanges de l'Institut dominicain d'études
orientales du Caire
Mél. Maspéro
Mélanges Maspero
Mém. Acad. Inscr. & B.-Lett.
Mémoires de l'Académie des inscriptions et
belles-lettres

Mém. Acad. Sci., B.-Lett. & A. Marseille
Mémoires de l'Académie des sciences, belles-lettres et arts de Marseille
Mém. Inst. Egypte
Mémoires de l'Institut d'Egypte
Met. Mus. J.
Metropolitan Museum Journal
Met. Mus. Stud.
Metropolitan Museum Studies
Mhft. Kstwiss.
Monatshefte für Kunstwissenschaft
Michigan Q. Rev.
Michigan Quarterly Review
Mid. E. J.
Middle East Journal
Mid. E. Rep.
Middle East Report
Mid. E. Stud.
Middle Eastern Studies
Mid. E. Stud. Assoc. Bull.
Middle Eastern Studies Association Bulletin
Mimar
Mimar: Architecture in Development
Misc. Estud. Arab. & Heb.
Miscelánea de estudios árabes y hebraicos
Mitt. Anthropol. Ges. Wien
Mitteilungen der Anthropologischen Gesellschaft Wien
Mitt. Dt. Archäol. Inst.: Abt. Kairo
Mitteilungen des Deutschen archäologischen Instituts: Abteilung Kairo
Mnmt Chart. Pap. Hist. Illus.
Monumenta chartae papyraceae historiam illustrantia
Mnmts Hist.
Monuments historiques
Mnmts Piot
Monuments Piot
Mod. Asian Stud.
Modern Asian Studies
Monde Iran. & Islam
Le Monde iranien et l'Islam
MSS Mid. E.
Manuscripts of the Middle East
Münster. Numi. Ztg
Münstersche numismatische Zeitung
Mus. Genève
Musées de Genève
Mus. Int.
Museum International
Muslim Educ. Q.
Muslim Education Quarterly
Mus.: Rev. Trimest.
Museum: Revue trimestrielle publiée par l'UNESCO
Narody Azii & Afriki
Narody Azii i Afriki
New Arab. Stud.
New Arabian Studies
Nexus Network J.
Nexus Network Journal
Niger. Field
Nigerian Field
19th-C. Fr. Stud.
Nineteenth-century French Studies
NKA: J. Contemp. Afr. A.
NKA: Journal of Contemporary African Art
Norsk Flkmus. Ab.
Norsk folkemuseums årbok
Nouv. Archvs Miss. Sci.
Nouvelles archives des missions scientifiques
Nouv. Mél. Orient.
Nouveaux mélanges orientaux
Nr E. Archaeol.
Near Eastern Archaeology
Numi. Chron.
Numismatic Chronicle
Numi. & Epig.
Numismatika i epigrafica
Numi. Meddel.
Numismatiska Meddelanden
Numi. Sborn.
Numizmaticheskii sbornik
Odu: U. Ife J. Afr. Stud.
Odu: University of Ife Journal of African Studies
Orient. A.
Oriental Art
Orient. Carpet & Textile Stud.
Oriental Carpet and Textile Studies
Orient. Coll. Mag.
Oriental College Magazine
Orient. Litztg
Orientalische Literaturzeitung
Orient. Mod.
Oriente Moderno
Orient. Num. Stud.
Oriental Numismatic Studies
Oxford A. J.
Oxford Art Journal
Oxford J. Archaeol.
Oxford Journal of Archaeology
Palestine Explor. Q.
Palestine Exploration Quarterly

Patrim. Mundial
Patrimonio Mundial
Persp. Médit.
Perspectives méditerranéennes
Proc. Amer. Philos. Soc.
Proceedings of the American Philosophical
Society
Proc. Brit. Acad.
Proceedings of the British Academy
Proche Orient Chrét.
Proche Orient chrétien
Proc. Ind. Hist. Congr.
Proceedings of the Indian History Congress
Proc. Semin. Arab. Stud.
Proceedings of the Seminar for Arabian Studies
Prog. Archit.
Progressive Architecture
Provence Hist.
Provence historique
Qajar Stud.
Qajar Studies
Q. Dept Ant. Palestine
Quarterly of the Department of Antiquities in
Palestine
Quad. Estud. Med.
Quaderns d'estudis medievals
Quad. Ist. It. Cult. R. A. E.
Quaderni dell'Istituto italiano di cultura per la
Repubblica Araba d'Egitto
Quad. Ist. Stud. Islam.
Quaderni dell'Istituto di studi islamici
Quad. Semin. Iran. U. Venezia
Quaderni del Seminario di iranistica
dell'Università di Venezia
Quad. Stud. Arab.
Quaderni di studi arabi
Rep. Dept Ant., Cyprus
Report of the Department of Antiquities,
Cyprus
Res. Afr. Lit.
Research in African Literatures
Réun. Soc. B.-A. Dépts
Réunion des Sociétés des beaux-arts des
départements
Rev. A. Asiat.
Revue des arts asiatiques
Rev. Afr.
Revue africaine
Rev. Alger
Revue d'Alger
Rev. Archéol.
Revue archéologique

Rev. Ethnog. & Sociol.
Review of Ethnography and Sociology
Rev. Etud. Islam.
Revue des études islamiques
Rev. Gén. Archit.
Revue générale de l'architecture
Rev. Géog. E.
Revue géographique de l'Est
Rev. Hist. A.
Revue de l'histoire de l'art
Rev. Hist. Maghréb.
Revue de l'Histoire Maghrébine
Rev. Ideas Estét.
Revista de ideas estéticas
Rev. Inst. B.-Lett. Arab.
Revue de l'Institut des belles-lettres arabes
Rev. Inst. Egipcio Estud. Islám. Madrid
Revista del Instituto Egipcio de Estudios
Islámicos en Madrid
Rev. Louvre
Revue du Louvre et des musées de France
Rev. Marseille
Revue Marseille
Rev. Monde Musul.
Revue du monde musulman
Rev. Monde Musul. & Médit.
Revue du monde musulman et de la
Méditerranée
Rev. Occident Musulman & Médit.
Revue de l'Occident musulman et de la
Méditerranée
Rev. Suisse Numi.
Revue suisse de numismatique
RIBA Trans.
Royal Institute of British Architects Transactions
Riv. Colon. It. ('Oltremare')
Rivista delle colonie italiane ('Oltremare')
Riv. Stud. Orient.
Rivista degli studi orientali
Sabah Soc. J.
Sabah Society Journal
Sarawak Gaz.
Sarawak Gazette
Sarawak Mus. J.
Sarawak Museum Journal
S. Asian Stud.
South Asian Studies
S. Asia Res.
South Asia Research
Sber. Phys. Mediz. Soz. Erlangen
Sitzungsberichte physikalischen-medizinischen
Sozietät zu Erlangen

Sborn. Geog. Top. Statisticheskikh Mat. Azii,
Izdaniya Voyenno-Uchyonnogo Komiteta
Glavnogo Shtaba Sbornik geograficheskikh,
topograficheskikh statisticheskikh materialov
po Azii: Izdaniya Voyenno-uchonnogo
komiteta glavnogo shtaba

Sborn. Muz. Antropol. & Etnog.
Sborník Muzea antropologii
i etnografii

Sci. Amer.
Scientific American

Soc. Etud. Iran. & A. Persan
Société des études iraniennes et de l'art
persan *Sosyal Antropol. & Etnol. Derg.*
Sosyal Antropoloji ve Etnoloji Dergisi

Sov. Arkheol.
Sovetskaya arkheologiya

Sov. Etnog. Sborn. Statey
Sovetskaya etnografiya: Sbornik statyey

Sov. Graf.
Sovetskaya grafika

Spazio & Soc.
Spazio e società

Spinks Numi. Circ.
Spinks Numismatic Circular

Stor. Città
Storia della città

Stroitel'stvo & Arkhit. Uzbekistana
Stroitel'stvo i arkhitektura Uzbekistana

Stud. Alb.
Studia Albanica

Stud. Conserv.
Studies in Conservation: The Journal of the
International Institute for Conservation of
Historic and Artistic Works

Stud. Dec. A.
Studies in the Decorative Arts

Stud. Hist. A.
Studies in the History of Art

Stud. Hist. Gdns & Des. Landscapes
Studies in the History of Gardens and
Designed Landscapes

Stud. Iran.
Studia iranica

Stud. Islam.
Studia islamica

Stud. Islam. A.
Studies in Islamic Art

Stud. Med.
Studi medievali

Sudan Notes & Rec.
Sudan Notes and Records

Svensk. Forskinst. Istanbul, Meddel.
Svenska forskningsinstitutet i Istanbul,
meddelanden

Svensk. Orientsällskapets Åb.
Svenska Orientsällskapets årsbok

Tanganyika Notes & Rec.
Tanganyika Notes and Records

Tech. & Cult.
Techniques and Culture

Tempora: An. Hist. & Archéol.
Tempora: Annales d'histoire et
d'archéologie

Textile Hist.
Textile History

Textile Mus. J.
Textile Museum Journal

Third World Q.
Third World Quarterly

Times India Annu.
Times of India Annual

Trad. Dwell. & Settmts Rev.
Traditional Dwellings and Settlements
Review

Transafr. J. Hist.
Transafrican Journal of History

Trans. Amer. Philos. Soc.
Transactions of the American Philosophical
Society

Trans. Orient. Cer. Soc.
Transactions of the Oriental Ceramic Society

Trudy Inst. Istor. A. Bakikhanova
Trudy Instituta istorii imeni A. Bakikhanova

Trudy Khorezm. Arkheol.-Etnog. Eksped.
Trudy Khorezmskoy arkheologo-etnogra
ficheskoy ekspeditsii

Trudy Kirgiz. Arkheol.–Etnog. Eksped.
Trudy Kirgizskoy arkheologo-etnograficheskoy
ekspeditsii

Trudy Sekt. Arkheol. Inst. Arkheol. Iskznaniya
Trudy Sektsii arkheologii instituta arkheologii i
iskusstvoznaniya

Trudy Sredneaziatskogo Gosudarstvennogo U.
Trudy Sredneaziatskogo gosudarstvennogo
universiteta

Trudy Yuzho-Turkmen. Arkheol. Kompleksnoi Eksped.
Trudy Yuzhno-turkmenistanskoy
arkheologicheskoy kompleksnoy ekspeditsii

Tues. Rev.
Tuesday Review

Turk. Area Stud.
Turkish Area Studies

Türk Arkeol. Derg.
 Türk arkeoloji dergisi
Turkoman Stud.
 Turkoman Studies
Turk. Rev.
 Turkish Review
Turk. Stud.
 Turkish Studies
Turk. Stud. Assoc. Bull.
 Turkish Studies Association Bulletin
Turquie Kemal.
 La Turquie kémaliste
U. Lect. Islam. Stud.
 University Lectures in Islamic Studies
Vakıflar Derg.
 Vakıflar dergisi
V&A Mus. Bull.
 Victoria and Albert Museum Bulletin
Verhand. Natforsch. Ges. Basel
 Verhandlungen der Naturforschenden
 Gesellschaft Basel
Vern. Archit.
 Vernacular Architecture
Visual Anthropol.
 Visual Anthropology
Voprosy Teor. Arkhit. Kompozitsii
 Voprosy teorii arkhiturnoy kompozitsii

Welt Islam.
 Die Welt des Islams
Welt Orients
 Die Welt des Orients
Winterthur Port.
 Winterthur Portfolio
World Archaeol.
 World Archaeology
World Herit. Rev.
 World Heritage Review
Zapiski Imp. Rus. Geog. Obshchestva
 Zapiski Imperatorskogo russkogo
 geograficheskogo obshchestva
Z. Bild. Kst
 Zeitschrift für bildende Kunst
Z. Dt. Mrgländ. Ges.
 Zeitschrift der deutschen
 morgenländischen Gesellschaft
Z. Dt. Ver. Bwsn & Schr.
 Zeitschrift des deutschen Vereins für
 Buchwesen und Schrifttum
Zentbl. Bibwsn
 Zentralblatt für Bibliothekswesen
Z. Gesch. Archit.
 Zeitschrift für Geschichte der Architektur
Z. Kstgesch.
 Zeitschrift für Kunstgeschichte

STANDARD REFERENCE BOOKS AND SERIES

ADB
 Allgemeine deutsche Biographie, 56 vols
 (Leipzig, 1875–1912)
A. Hisp.
 Ars Hispaniae
Archaeol. Surv. India, New Imp. Ser.
 Archaeological Survey of India, New Imperial
 Series
A. & Soc. Ser.
 Art and Society Series
Basl. Beitr. Ethnog.
 Basler Beiträge zur Ethnologie
BM Occas. Pap.
 British Museum, Occasional Papers
Brit. Archaeol. Rep. Int. Ser.
 British Archaeological Reports, International
 Series
Colloq. A. & Archaeol. Asia
 Colloquies on Art and Archaeology
 in Asia
Damas. Forsch.
 Damaszener Foschungen

Dict. Middle Ages
 J. R. Strayer, ed.: *Dictionary of the Middle Ages*,
 13 vols (New York, 1982–9)
Enc. Iran.
 E. Yar Shater, ed.: *Encyclopedia Iranica*
 (London, 1986)
Enc. Islam/1
 Encyclopaedia of Islam, 8 vols. and suppl.
 (Leiden, 1913–36/*R* 1987)
Enc. Islam/2
 Encyclopaedia of Islam (Leiden,
 1960–2005)
Enc. Islam/3
 Encyclopedia of Islam (Leiden, 2007–)
Enc. It.
 Enciclopedia italiana di scienze, lettere ed arti,
 39 vols. and suppls. (Milan, 1929–81)
Enc. Qur'an
 J. D. McAuliffe, ed.: *Encyclopedia of the
 Qur'an*, 5 vols. (Leiden, 2001–5)
EWA
 Encyclopedia of World Art

Forsch. Almohad. Moschee
 Forschungen zur almohadischen Moschee
Garland Lib. Hist. A.
 Garland Library of the History of Art
Mem. Archaeol. Surv. India
 Memoirs of the Archaeological Survey of India
Mém.: Dél. Archéol. Fr. Afghanistan
 Mémoires de la délégation archéologique
 française en Afghanistan
Mém.: Inst. Fr. Archéol. Orient. Caire
 Mémoires publiés par les membres de l'Institut
 français d'archéologie orientale du Caire
Mém.: Miss. Archéol. Fr. Caire
 Mémoires publiés par les membres de la
 Mission archéologique française du Caire

ODNB
 Oxford Dictionary of National
 Biography
Oxford Stud. Islam. A.
 Oxford Studies in Islamic Art
Pelican Hist. A.
 Pelican History of Art
Penguin Guide Mnmts India
 Penguin Guide to the Monuments of India
SBL
 Svenska biografiskt leksikon (Stockholm,
 1918–)
U. CA, Pubns Class. Archaeol.
 University of California, Publications in
 Classical Archaeology

The Grove Encyclopedia
of Islamic Art and Architecture

M

Mosul [Mawṣil]. City in northern Iraq. Located on the west bank of the Tigris River, opposite the ancient city of Nineveh, Mosul is surrounded by fertile plains. It replaced Nineveh under Byzantine rule and was conquered in 637 by Muslim Arabs, who used it as a base from which to conquer Azerbaijan and Armenia and as an important entrepôt for overland trade between Iran and Syria. It served as the capital of the Hamdanid (r. 905–91) and 'Uqaylid (r. 992–1096) dynasties, and, after a brief interregnum, became the capital of the ZANGID dynasty (r. 1127–1222). 'Imad al-Din Zangi (r. 1127–46) restored the fortifications and expanded the city. Under Nur al-Din Zangi (r. 1146–74) several important buildings were erected (see ARCHITECTURE, §V, B, 5), but most have been extensively rebuilt. The most important was the congregational mosque (1170–72; see ARCHITECTURE, fig. 23), of which the only medieval parts to remain are the brick minaret, some columns and the mihrab (1148), which came from another mosque. The Mujahidi (Khidr Ilyas) Mosque preserves a fine mihrab (1180). Power passed to the atabeg Badr al-Din Lu'lu' (r. 1222–59), whose palace had three iwans overlooking the Tigris. Several shrines to minor Shi'ite saints, such as those of Imam Yahya ibn al-Qasim (1239) and Imam 'Awn al-Din (1248), are square buildings containing tiled mihrabs and covered with *muqarnas* vaults under pyramidal roofs. The typical building material in the medieval period was rubble masonry revetted with stone and vaulted with brick. Zangid buildings were often decorated with a wide inscription band made of deep-blue marble inlaid with white alabaster. Following the Mongol attack in 1262 the city declined in importance. After a period of Mongol rule, the city passed to the AQQOYUNLU Turkmen in the 15th century, the Safavids of Iran in 1508 and the Ottomans in 1535. The opening of the Suez Canal in 1869 destroyed its trade position, but the discovery of oil in the region has made it the third-largest city in Iraq.

Mosul was known in medieval sources for fine textiles called *mawṣilīn*, from which the word muslin is derived, although these luxury fabrics with gold and silver threads were quite different from the cottons and silks usually associated with this term. Under the patronage of the Zangids and of Badr al-Din Lu'lu', fine illustrated manuscripts were produced at Mosul (see ILLUSTRATION, § IV, C). They continue the Classical tradition of technical and naturalistic illustration and often have frontispieces depicting the enthroned sovereign. A school of metalwork also flourished there in the 12th and 13th centuries (see METALWORK, §III, B), and the epithet *al-Mawṣili* came to be associated with the finest practitioners of the craft. Inlaid with gold and silver, vessels of copper alloy were decorated with scenes of the hunt, pleasures of the court and signs of the zodiac. The city was also known for its fine woodwork, such as a pair of wooden doors from the mosque of Nabi Jirjis and a minbar (1153) from the 'Amadiyya Mosque (both Baghdad, Iraq Mus.; see WOODWORK, §I, A, 2).

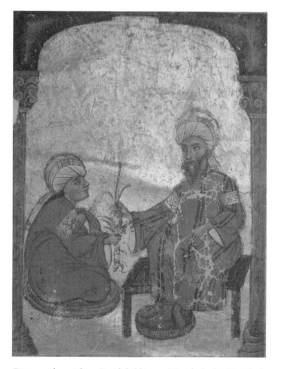

Diosocurides with a Pupil holding a Mandrake by Yusuf al-Mawsili, 192×140 mm; illustration from an Arabic translation of Dioscurides: *De materia medica*, from Mosul, 1228 (Istanbul, Topkapı Palace Museum, MS. Ahmet III 2127, fol. 2b); photo credit: Werner Formen/Art Source, NY

Enc. Islam/2: "Mawṣil"

F. Sarre and E. Herzfeld: *Archäologische Reise im Euphrat- und Tigris-Gebiet*, 4 vols. (Berlin, 1911–20), ii, pp. 203–305

S. al-Daywahji [Dewachi]: "Jāmiʿ al-nabī Jurjīs fī'l-Mawṣil" [The mosque of Nabi Jurjis in Mosul], *Sumer*, xvii (1960), pp. 100–12

S. al-Daywahji [Dewachi]: "Mashhad al-imām Yaḥyā b. al-Qāsim" [The shrine of the Imam Yahya ibn al-Qasim], *Sumer*, xxiv (1968), pp. 171–81

N. Y. al-Tutunji: "Jāmiʿ al-mujāhidi fī'l-Mawṣil" [The Mujahidi mosque in Mosul], *Sumer*, xxviii (1972), pp. 193–200

D. Patton: *Badr al-Din Lulu: Atabeg of Mosul, 1211–1259*, Occasional Papers of the Middle East Center of the Jackson School of International Studies, University of Washington, 3 (Seattle, 1991)

H. Al-Harithy: "The Ewer of Ibn Jaldak (623/1226) at the Metropolitan Museum of Art: The Inquiry into the Origin of the Mawsili School of Metalwork Revisited," *Bull. SOAS*, lxiv/3 (2001), pp. 355–68

Y. Tabbaa: "The Mosque of Nūr al-Din in Mosul 1170–1172," *An. Islam.*, xxxvi (2002), pp. 339–60

Moudarres, Fateh [Mudarris, Fātiḥ] (*b*. Aleppo, 1922; *d*. 1999). Syrian painter and sculptor. Initially a self-taught painter working in a realistic style, he was inspired by Surrealism in the 1940s and 1950s, and he explained his work in verse and prose to the public. After studying at the Accademia di Belle Arti, Rome (1954–60), he returned to Syria and developed a highly personal style that he described as "surrealistic and figurative with a strong element of abstraction" (see Ali, 1989, p. 131). Moudarres's work was influenced by the icons of the Eastern Orthodox Church and Syrian Classical art, which he studied in the National Museum of Damascus. His work became increasingly abstract in the 1960s, although after 1967 he expressed political themes. From 1969 to 1972 he studied at the Ecole des Beaux-Arts in Paris. His paintings have an accomplished sense of composition and balance of color. As one of the leaders of the modern art movement in Syria, Moudarres trained several generations of artists in his classes at the College of Fine Arts at the University of Damascus.

W. Ali: "Contemporary Art from the Islamic World," *Scorpion* (London, 1989)

W. Ali: *Modern Islamic Art: Development and Continuity* (Gainesville, 1997), pp. 91, 198

Mounting. Attachment of a work of art to a support or setting, or the application of accessories or decoration as embellishment. In many types of mount, these two distinct concepts may be combined, and the mount serves both a functional and decorative purpose.

In the early Islamic era the texts of manuscripts and their borders were one continuous sheet, but by the 11th century rulings often separated the text block from the margin in manuscripts of the Koran and other books (*see* ILLUMINATION). Perhaps as a result of the corrosive pigments (e.g. verdigris) used for marginal rulings, the paper often split, separating the text block from the borders. The necessity of repairing such damage seems to have led to the practice of setting the text, and later the illustrations, into new borders, thus providing mounts for manuscript pages. Separate margins are found in bound manuscripts and albums (Arab. *muraqqaʿ*; *see* ALBUM).

Carefully made mounts consist of two single sheets of paper with identical windows slightly smaller than the text or illustration that was affixed between them. On hastily crafted margins, four overlapping strips of paper surround the text or illustration on the *recto* of a folio, glued to four equivalent strips on the *verso*. The most celebrated Islamic and Indian mounts are borders from albums. The format of the standard album, established by the 15th century, consists of facing pages of calligraphy alternating with paintings or drawings mounted in borders with the same decorative patterns, even if the color of the paper varies.

A typical mounting for an Islamic or Indian album page comprises three zones. In the center is the text or picture. This then is surrounded by one or more narrow transitional borders, either plain or decorated with arabesques or cartouches of calligraphy: first comes a narrow border in strips pasted over the edges of the central zone, followed by two narrow colored borders; the inner one, overlapped by the first border, likewise overlaps the outer. The wide outer borders, the third stage, are made from a thick sheet of laminated paper with a window cut in the center or nearer the spine, overlapped on its inner edges by the outer transitional border. A folio-sized sheet would then be glued to the back, and the completed page would be joined to its *recto* or *verso*. Many albums, bound either in codex or concertina form, were intended to be expandable, and only the most expensive albums appear to have been planned as an entity.

Many album borders are made of colored paper sprinkled with gold and are separated from the paintings by narrow bands of arabesque. Elaborate examples of border decoration produced in the royal studio under the SAFAVID dynasty of Iran include a copy of Saʿdi's *Gulistān* ("Rose-garden"; *c.* 1525–30; dispersed) with fine border paintings of wild and mythical animals in a landscape painted in two shades of gold and silver on colored paper. Such borders apparently inspired a whole class of marginal decoration in Safavid Iran as well as the courts of their contemporaries to the west and east, the Ottoman and Mughal dynasties. Similarly, borders with geometric and floral arabesques, the most common of Iranian decorative mounts, found favor under the Ottomans and Mughals in the 16th century and were adapted to fit local styles.

In an album produced for the Ottoman sultan Murad III (*r.* 1574–95), the opulent variety of the floral arabesque and geometric borders rivals that of the finest Ottoman textiles and ceramics. These

borders are painted in gold and polychrome on colored or plain paper. Two other forms of mounting used under the Ottomans are marbled borders and those with cut-out decoration. Marbled borders, which also figure in 17th-century Mughal albums, appear in many Ottoman books, while cut-out decoration is found in the borders of the album compiled for the Englishman Peter Mundy (1618; London, BM, 1974 6–17 013).

Mughal artists adopted and maintained the various Persian styles of border decoration during most of the 16th century, but by 1599 leading artists under Prince Salim (later the emperor Jahangir, r. 1605–27) revolutionized the art of album mounts by creating border scenes ranging from European-inspired figures in landscapes to craftsmen producing a manuscript. Another distinctive feature associated with this workshop was the depiction of birds or flowers in polychrome on borders otherwise painted only in gold (see fig.). These borders are found in the Gulshan Album (Tehran, Gulistan Pal. Lib.), the Berlin Album (Berlin, Staatsbib.) and a third album (Tehran, priv. col.). Under Jahangir's successor, Shah Jahan (r. 1628–58), a new style of border decoration developed. Consisting of polychrome flowering plants with gold outlines and recalling the pietra dura inlay of contemporary buildings such as the Taj Mahal (see AGRA, §II, A), these borders can be found in the Kevorkian Album (Washington, DC, Freer, and New York, Met.), the Wantage Album (London, V&A) and the Minto Album (London, V&A, and Dublin, Chester Beatty Lib.). The decoration of Islamic Indian album mounts from the late 17th century onwards was rarely innovative and derived mostly from earlier geometric and floral arabesque patterns.

Enc. Islam/2: "Muraḳḳaʿ" [Album]

Wonders of the Age (exh. cat. by S. C. Welch, Cambridge, MA, Fogg, 1979–80)

M. C. Beach: *The Imperial Image: Paintings for the Mughal Court* (Washington, DC, 1981)

Y. Petsopoulos, ed.: *Tulips, Arabesques and Turbans: Decorative Arts from the Ottoman Empire* (London, 1982)

M. S. Simpson: "The Production and Patronage of the *Haft Aurang* by Jami in the Freer Gallery of Art," *A. Orient.*, xiii (1982), pp. 93–119

S. C. Welch and others: *The Emperors' Album* (New York, 1987)

M. S. Simpson: "Codicology in the Service of Chronology: The Case of Some Safavid Manuscripts," *Les Manuscrits du Moyen-Orient: Essais de codicologie et de paléographie*, ed. F. Déroche (Istanbul, 1989), pp. 133–7

M. S. Simpson: *Sultan Ibrahim Mirza's Haft Awrang, a Princely Manuscript from Sixteenth-Century Iran* (New Haven and Washington, 1997)

D. Roxburgh: *The Persian Album, 1400–1600: From Dispersal to Collection* (New Haven, 2005)

Mozarabic [Sp. *mozárabe*]. Term traditionally used to describe the art of Christians living in the areas of the Iberian peninsula ruled by Muslims in the 10th and 11th centuries. The Castilian word derives from the Arabic *mustaʿrib* ("Arabized") and is to be contrasted with MUDÉJAR, the term used to describe the art of Islamic inspiration produced for non-Muslim patrons in the areas of the Iberian peninsula reconquered by Christians between 1085 and the 16th century. Very few surviving works of art fit this strict definition of Mozarabic art, and it is difficult to characterize them. The only substantial building is the ruined three-aisled basilica at Mesas de Villaverde (Málaga; often identified as "Bobastro"), which preserves its rock-cut foundations and walls. The two illuminated manuscripts surviving from this period are quite different in style. The Biblia Hispalense (Madrid, Bib. N., Cod. Vit. 13–1), copied *c*. 900 at or near Seville by or for Bishop Servandus and completed

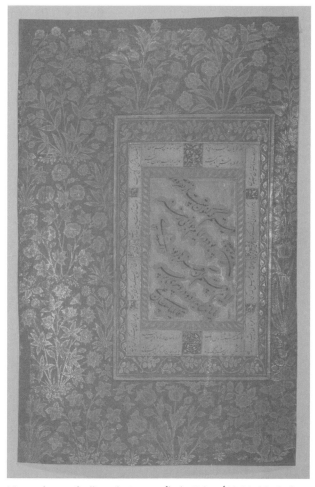

Mounted page of calligraphy in *nastaʿliq* by Sultan ʿAli Mashhadi, from an album belonging to the Mughal emperor Jahangir, gold on colored paper, poem from Iran, *c*. 1516, mount from India, *c*. 1625 (Copenhagen, Davids Samling, MS. 17/1987); photo credit: Davids Samling, Copenhagen

in 988 when figures of three prophets were added, shows some naturalism in the presentation of the symbols of the Evangelists. Ildefonsus's *Treatise on the Virginity of Mary* (Florence, Bib. Medicea-Laurenziana, MS. Ashb. 17), copied in Toledo by the archpriest Salomon in 1067, has distinctly Islamic-style foliage although the iconography is Hispanic.

The term Mozarabic has also been applied more generally to the art and culture of Christians who had emigrated in the 10th century from Muslim areas to resettle areas of northern Spain that had recently been reconquered. Because of this historical background, the term "resettlement" (Sp. *repoblación*) is more appropriate, although others have preferred *condal, fronterizo* or simply "10th-century." This art made use of the glorious monuments of old Visigothic towns and buildings and represents a reassertion of traditional Visigothic culture, primarily in architecture. The revival of forms was partly due to the desire by the Asturian kings (*r.* 718–1037) to see themselves as heirs to the ancient Visigothic kingdom destroyed by the Muslim conquest in the 8th century. The religious communities of the repopulated areas sought out buildings founded by the fathers of the Hispanic Church and settled there, venerating the sanctuaries and their ruins. This period, which began in the late 9th century, was prolonged variously in different Christian states of the peninsula: until *c.* 1000 in the Catalan counties and some parts of Aragon, and until the last third of the 11th century in the rest of Iberia. The distinctly Hispanic Mozarabic tradition was eventually integrated into the international Romanesque style.

I. Architecture. II. Decorative arts.

I. Architecture. When the Asturian kings established their court at Oviedo in 794, they chose the old Roman praetorium of the city. They restored defensive walls, churches and dwellings and used spolia for new construction. In the process the builders became familiar with old forms and techniques, contributing to the continuity of traditional building formulae. The survival of building traditions was assured in the east, where depopulation was less of a problem. Churches conform to the classical type for the Visigothic liturgy, which continued to be used until the adoption of the Roman rite and the introduction of the Romanesque style. The nave was divided by an iconostasis, a furnishing or fabric screen that separated the choir or presbytery near the altar from the area intended for the congregation. The only surviving example is at the monastery of San Miguel de Escalada (913; near León), where the triple arch would have been hung with curtains. Adjoining the presbytery were small sacristies or possibly penitential areas. Some churches may have had another apse on the west, a feature that had been introduced from North Africa

in the 6th century. Its funerary significance can be seen in such churches as that of Santiago de Peñalba (León).

The forms used were already known in the Visigothic period: cubic projections enclosing rectangular, semicircular or horseshoe apses; and a single nave or a nave flanked by aisles, generally with an area meant as a kind of transept and marked not by projections on the exterior but by a wider span on the main axis. The availability of materials and local building practices determined regional variants. Common features include the use of spolia columns, horseshoe arches, domes, barrel vaults with a horseshoe profile, and projecting cornices with brackets decorated with rosettes and trilobes. The inspiration of contemporary Islamic architecture in southern Spain (*see* ARCHITECTURE, §V, D, 1) is evident in the use of rectangular frames around arches (Sp. *alfiz*) and intersecting ribbed vaults. This type of vault, first used in the extension (961–6) of the mosque of Córdoba by al-Hakam II (*r.* 961–76; *see* UMAYYAD, §II, B, 2), was repeated at the end of the 10th century and in the 11th at such buildings as the church at San Millán de la Cogolla (Rioja) and the church of S. Baudelio, near Berlanga de Duero (Soria).

Buildings were painted on both the interior and exterior. Bright colors accented the architectural lines and details, such as arches, moldings, capitals and reliefs. At the church of S. María de Bamba (Valladolid), an attempt was made to reproduce the pattern of an Islamic textile: a lozenge border frames a crisscross pattern of roundels containing geometric and animal motifs. Geometric decoration survives at Santiago de Peñalba and S. Cebrián de Mazote (Valladolid), where there is also a small relief that gives some idea of monumental sculpture, although its iconography is unclear. Another example of pre-Romanesque monumental sculpture is a crude, chip-carved relief in Luesia (Saragossa) showing a king carrying a cross; the iconography is similar to that found in contemporary book illustration.

The architecture of León and Castile changed radically when the Asturian court moved to the city of León in the early 10th century. The Leonese (later Leonese–Castilian) court erected large buildings, chiefly in the Duero Valley. Documentary evidence and some archaeological remains indicate that palatine types, such as the royal pantheon of Oviedo, continued to be used, but most surviving architecture from the period is related to the activity of the monks of the resettlement, who erected buildings on old foundations and repeatedly enlarged them. The largest examples are such basilicas as S. Miguel de Escalada, S. Cebrián de Mazote, S. María de Bamba and, in Cantabria, S. María de Lebeña. In the mid-11th century the abbot of S. Domingo at Silos enlarged his monastic church from one to three aisles, following traditional models. The existence of ancient and venerated rock hermitages led to the construction of new sanctuaries

built around chambers cut out of the rock. This resulted in such curious solutions as the twin-naved church at San Millán de Cogolla, although its plan has also been explained as a provision for male and female monastic communities. Many small churches had a single nave and horseshoe-shaped apse within an orthogonal projection. The most important for their complex vaulting and religious and political significance are S. Miguel de Celanova (Orense), built by St. Rudesind, founder of Galician monasticism, and Santiago de Peñalba, built by St. Gennadius, restorer of Visigothic monastic rule and creator of the "Leonese Thebaid." The church of S. Baudelio, near Berlanga (second half of the 11th century), represents an unusual type with a square plan and an enormous central column supporting ribbed vaults and surmounted by a small vaulted aedicule. A tribune with a small altar–sanctuary occupies nearly half the interior. The original form of other buildings, such as S. María de Peñalba, indicates that this unusual type was more common than had previously been thought. S. Baudelio was probably built for a small religious community, although some scholars, relying on its extensive cycle of Romanesque murals, think it may have had some royal function.

All of the churches in Navarre and Aragon have been remodeled except for a group in Galicia. The pre-Romanesque church of the monastery of Leyre must have been remodeled like the one at Silos. The small church of S. Juan de la Peña, with two naves and partly cut into the cliff-side, is reminiscent of that at San Millán de la Cogolla. The churches in the Gállego Valley are later in date. Built in a popular and archaizing style, they use traditional Visigothic forms but also show early Romanesque features.

Most surviving buildings in the Catalan counties (including some in modern France) are simple structures based on pre-Islamic building practices. In the mid-10th century a modest type of church with a single nave and a rectangular apse, often with irregular sides, became popular throughout the region (e.g. S. Juan de Boada). S. Quirce de Pedret and S. María de Marquet have more complex plans. The former Benedictine abbey church of Saint-Michel-de-Cuxa in Roussillon, France (ded. 974; subsequently enlarged), has five apses along a large transept. Although the technique of construction is local and Mozarabic motifs such as the horseshoe arch are in evidence, the building was modeled on the chevet of the second monastic church ("Cluny II") of the Benedictine abbey at Cluny in France, for Cuxa pioneered the introduction of the Cluniac rite into Spain.

II. Decorative arts. Book illustrations produced in the Christian kingdoms are distinct from those attributed to Mozarabic artists, for the iconography seems to rely on Visigothic prototypes, although these are poorly known. The principal products were copies of the Bible and of the *Commentary on the Apocalypse* (8th century) by the monk Beatus of Liébana (now Lebeña). These manuscripts provide abundant information about scribes and artists, places of production and scriptoria. A fragment of a *Beatus* manuscript (Silos, Monastery of S. Domingo) is considered one of the earliest examples (late 9th century), but its venerable appearance may be due to the crude and clumsy workmanship rather than to its age. The early style is typified by a Bible of 920 (León Cathedral, MS. 6), supervised by the monk Vimara and executed by the scribe and painter Ioannes. Characteristic are the flat metallic figures executed with brilliant and intense colors without shading and backgrounds of bands of plain colors.

The apogee of the style was reached in such manuscripts as the Morgan *Beatus* (mid-10th century; New York, Pierpont Morgan Lib., MS. M. 644; see fig.), copied and illustrated by the monk Magius. The scribe Florentius, who transcribed and illustrated a copy of Pope Gregory I's commentary on the Book of Job, *Moralia in Job* (945; Madrid, Bib. N., Cod. 80) in the monastery of Valeránica, started a process of minimal naturalism, and some influence of Carolingian illumination can be seen. In the Girona *Beatus* (975; Girona Cathedral, MS. 7), there are

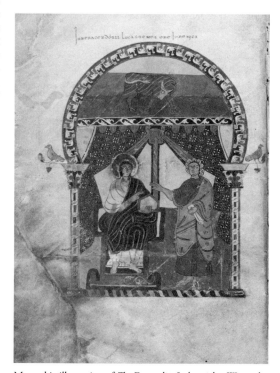

Mozarabic illustration of *The Evangelist Luke with a Witness* by Beatus of Liébana, from a *Commentary on the Apocalypse*, from León, Spain, mid-10th century (New York, Pierpont Morgan Library, MS. M.644, fol. 2v); photo credit: The Pierpont Morgan Library/Art Resource, New York

Carolingian influences not only in the decorative details but also in the large illustrations of *Christ in Majesty* (fol. *2r*) and the *Crucifixion* (fol. 16*v*). During the 11th century scriptoria continued to produce works of marked transitional character, but Romanesque formulae were gradually adopted. A magnificent *Beatus* (London, BL, Add. MS. 11695) with beautiful colored line drawing was produced at a monastery in Silos between 1091 and 1109, but there is disagreement as to whether it is traditional or Romanesque.

Other decorative arts include a few ivories produced at the monastery of San Millán de la Cogolla: a portable altar (Madrid, Mus. Arqueol. N.) and the arms of a cross (Paris, Louvre; Madrid, Mus. Arqueol. N.) are decorated with animal and floral motifs reminiscent of contemporary European ivories and Islamic ones (*see* IVORY, §II). Metalwares include a brass cross offered by Ramiro II (*r.* 931–51) to Santiago de Peñalba (León, Mus. Arqueol. Prov.), which continues the flat form of Asturian examples. A portable silver altar (Girona, Mus. Dioc.), probably originally commissioned for the abbey of S. Pere de Rodes and given by Josué and Elimburga to Girona Cathedral at the end of the 10th century, is decorated with crudely worked figures of Christ and angels. The great chalice of S. Domingo de Silos (late 11th century; Silos Abbey, Treasury) is of the conventional type with two semi-ovoids joined by a shaft with a central knob; it is entirely decorated with silver filigree forming little horseshoe arches.

See also CHRISTIAN ART IN THE ISLAMIC WORLD.

M. Gómez-Moreno: *Iglesias mozárabes* (Madrid, 1919)

M. Gómez-Moreno: *El arte árabe español hasta los almohades, arte mozárabe*, A. Hisp., iii (Madrid, 1951)

G. Menéndez Pidal: "Mozárabes y asturianos," *Bol. Real Acad. Hist.* (1954), pp. 137–291

J. Camón Aznar: "Arquitectura española del siglo X: Mozárabe y de la repoblación," *Goya*, lii (1963), pp. 206–19

E. Junyent: *L'arquitectura religiosa en la Catalunya carolingia* (Barcelona, 1963)

J. Camón Aznar: "El arte de la miniatura española en el siglo X," *Goya*, lxiv–lxv (1964), pp. 266–87

J. E. Uranga and F. Iñiguez Almech: *Arte medieval navarro* (Pamplona, 1971)

J. Fernández Arenas: *Arquitectura mozárabe* (Barcelona, 1972)

A. Durán Gudiol: *Arte altoaragonés de los siglos X–XI* (Sabiñánigo, 1973)

I. G. Bango Torviso: "Arquitectura de la décima centuria: ?Repoblación o mozárabe?," *Goya*, cxxii (1974), pp. 68–75

J. Ainaud de Lasarte: *Los templos visigótico-románicos de Tarrasa* (Madrid, 1976)

M. Mentré: *Contribución al estudio de la miniatura en León Castilla en la alta edad media* (León, 1976)

J. Fontaine: *L'art mozarabe* (Yonne, 1977)

J. Williams: *Early Spanish Manuscript Illumination* (New York, 1977)

Actas del simposio para el estudio de los Códices del "Comentario al Apocalipsis" de Beato de Liébana, 2 vols. (Madrid, 1978)

I. G. Bango Torviso: "El neovisigotismo artístico de los siglos IX–X: La restauración de ciudades y templos," *Rev. Ideas Estét.*, xxxvii (1979), pp. 319–38

J. Yarza: *Arte y arquitectura en España, 500/1250* (Madrid, 1979)

X. Barral y Altet: *L'art prerromanic a Catalunya (segles IX–X)* (Barcelona, 1981)

S. Silva y Verástegui: *Iconografía del siglo X en el reino de Pamplona–Nájera* (Pamplona, 1984)

J. Yarza-Luaces: *Arte asturiano, arte mozárabe* (Extremadura, 1985)

B. Cabañero and F. Galtier Marti: "'Tuis exercitibus crux Christi semper adsistat': El relieve real prerrománico de Luesia," *Artigrama*, lxxxix (1986), pp. 11–28

S. Noack: "En torno al arte 'mozárabe,'" *Actas del II congreso de arqueología medieval española: Madrid, 1987*, iii, pp. 581–8

R. Puertas Tricas: "Iglesias represtres de Málaga," *Actas del II congreso de arqueología medieval española: Madrid, 1987*, i, pp. 99–152

I. G. Bango Torviso: "La part oriental dels temples de l'abat-bisbe Oliba," *Quad. Estud. Med.*, iv (1988), pp. 51–66

A. Thiery: "A che punto è la questione mozarabica" ([Summary:] Mozarabic culture: the state of the art), *A. Med.*, (1988), pp. 29–64

I. G. Bango Torviso: *Alta edad media: De la tradición hispano-goda al románico* (Madrid, 1989)

J. A. Gutiérrez González: "Sistemas defensivos y de repoblación en el reino de León," *Actas del III congreso de arqueología medieval española: Oviedo, 1989*

M. Nuñez Rodriguez: *San Miguel de Celanova* (Santiago de Compostela, 1989)

F. Olaguer-Feliú: *El arte medieval hasta el año mil* (Madrid, 1989)

J. D. Dodds: *Architecture and Ideology in Early Medieval Spain* (University Park, PA, and London, 1990)

M. Mentré: *Illuminated Manuscripts of Medieval Spain* (London, 1996)

C. Hilsdale: "Towards a Social History of Art: Defining 'Mozarabic,'" *Med. Encounters*, v/3 (1999), pp. 272–88

O. Grabar: "About a Bronze Bird," *Reading Medieval Images: The Art Historian and the Object*, ed. E. Sears and T. K. Thomas (Ann Arbor, 2002), pp. 117–25

Mshatta [Mshattā; Mushatta; Qaṣr al-Mshattā]. Unfinished Islamic palace 25 km south of Amman, Jordan. The outer enclosure is a square (147 m externally) of fine ashlar masonry with regularly spaced half-round buttresses and, on the south, a gate flanked by two semi-octagonal towers. The interior is divided into three tracts, of which only the central one was laid out, again in three parts. The gate-block appears to have consisted of an enclosed hall, a small court and a mosque, but only the base courses were laid out. The second part comprised a large open court. The third block had a triple-arched façade in front of an audience hall containing two rows of gray–green marble columns terminating in a triconch. The hall, whose plan derives from a late Roman type, was flanked by four suites (Arab. *bayt*) of four vaulted rooms around a court. The walls, which rested on three courses of limestone masonry, were built of fired brick and

supported slightly pointed pitched-brick vaults of Mesopotamian style.

The most notable feature is the richly carved south façade (for illustration *see* MUSEUMS) presented by the Ottoman sultan Abdülhamid II (*r.* 1876–1909) to Emperor William II; at the urging of J. Strzygowski, Wilhelm Bode accepted it for Berlin (Pergamonmus.). The façade is divided by a zigzag molding into 40 triangles 2.95 m high, in various stages of completion. Each triangle has a central rosette in high relief, and the remainder of the field is sculpted in low relief with chalices, vines, lions, birds and griffins. Rediscovered by Europeans several times in the 19th century, the building was variously attributed to the Ghassanid and the Lakhmid dynasties in the 6th century or to the Sasanian occupation of Syria in the early 7th. An attribution to Islamic times, however, is certain because of the integral presence of the mosque and is supported by the find of two bricks fired with Arabic graffiti and one with an Arabic stamp impression. Mshatta may have been built by the caliph al-Walid II (*r.* 743–4) to welcome pilgrims returning from Mecca.

E. Herzfeld: "Die Genesis der islamischen Kunst und das Mshatta-Problem," *Der Islam*, i (1910), pp. 27–63, 115–44; Eng. tran. by F. Hillenbrand and J. M. Bloom as "The genesis of Islamic art and the problem of Mshattā," *Early Islamic Art and Architecture*, ed. J. Bloom, Formation of the Classical Islamic World, 23 (Aldershot and Burlington, VT, 2002), pp. 7–86

K. A. C. Creswell: *Early Muslim Architecture*, i (Oxford, 1932/*R* and enlarged 1969), pp. 578–606, 614–41

R. Hillenbrand: "Islamic Art at the Crossroads: East Versus West at Mshatta," *Essays in Honor of Katherine Dorn*, ed. A. Daneshvari (Costa Mesa, 1981), pp. 63–86

G. Bishei: "Qasr al-Mshatta in the Light of a Recently Found Inscription," *Studies in the Archaeology and History of Jordan*, iii, ed. A. Hadidi (Amman, 1986), pp. 193–7

O. Grabar: "The Date and Meaning of Mshatta," *Dumbarton Oaks Pap.*, xli (1987), pp. 243–7

V. Enderlein and M. Meinecke: *Mschatta-Fassade*, Sonderdruck aus dem Jahrbuch der Berliner Museen, 34 (Berlin, 1993)

V. Enderlein: "Bautechnische Beobachtungen an der Fassade von Mschatta," *Orient. Mod.*, xxiii (2004), pp. 417–26

T. Leisten: "Mshatta, Samarra, and al-Hira: Ernst Herzfeld's Theories Concerning the Development of the Hira-style Revisited," *Ernst Herzfeld and the Development of Near Eastern Studies, 1900–1950*, ed. A. C. Gunter and S. R. Hauser (Leiden, 2005), pp. 371–84

Mualla, Fikret (*b.* Istanbul, 1903; *d.* Nice, 20 July 1967). Turkish painter. After attending high school in Istanbul, he continued his education in Germany, where he became increasingly interested in painting, and in Paris, where he studied under André Lhote (1885–1962). On returning to Turkey, he designed costumes for operettas and worked on illustrations for books and magazines. His life, however, was severely affected by a childhood accident, and later by alcoholism; in the mid-1930s his health deteriorated, and he was committed to a mental hospital near Istanbul. Despite these adversities, his work began to be recognized in Turkey, and he painted up to 30 pictures of Istanbul for the Turkish Pavilion at the international exhibition in New York in 1939. From 1940 onwards he lived in Paris. The first exhibition there of his paintings was held at the Galerie Dina Vierny in 1954, after which his reputation as an artist increased. His subjects included Parisian cafés and bars, street scenes, places of entertainment, landscapes and a few portraits. He worked quickly in an Expressionist manner, using bright colors in gouache, usually on small sheets of paper (*see* TURKEY, color pl.). He painted fewer oil paintings; but they included *The Musicians* (*c.* 1940; Istanbul, Mimar Sinan U., Mus. Ptg & Sculp.).

A. Dino and A. Güler: *Fikret Mualla* (Istanbul, 1980) [Turk. text]

G. Renda and others: *A History of Turkish Painting* (Geneva, Seattle and London, 1988), pp. 223–7

Mudéjar. Spanish term used to describe the architecture and art of Islamic inspiration produced in the areas of the Iberian peninsula reconquered by Christians between 1085, when Alfonso VI of Castile-León (*r.* 1072–1109) seized Toledo from the Muslims, and the 16th century. The Castilian word derives from the Arabic *mudajjan* ("permitted to remain"), and it was initially thought that *Mudéjar* art was produced only by Muslims for Christian masters, but the term has come to be applied to a broader range of works produced by Muslims, Christians and Jews for Christian and Jewish patrons. *Mudéjar* may be contrasted to MOZARABIC, which, in its strictest sense, refers to the art of Christians living under Muslim rule in the peninsula in the 10th and 11th centuries. The distinctive and eclectic style of *Mudéjar* brick, stucco and timber architecture developed in many regions of Spain throughout the long Spanish Middle Ages. *Mudéjar* buildings are related to contemporary Islamic buildings in appearance and techniques of construction and decoration, but their structure is closer to Romanesque and Gothic architecture. The many long periods of peaceful co-existence during the lengthy wars of the Reconquest are attested not only in architectural borrowing but also in the paintings to the *Cantigas de Santa María* (Madrid, Escorial, Bib. Monasterio S. Lorenzo, MS. J.b.2), a collection of lyrics compiled for Alfonso X (*r.* 1252–84).

Mudéjar art lasted for so many centuries because the Islamic art from which it drew its inspiration was itself deeply rooted in the Iberian peninsula (*see* ARCHITECTURE, §§IV, D and V, D). The Christian monarchs, the Church and the populace admired mosques, palaces and mansions in the reconquered cities: mosques were consecrated and adapted to Christian worship without major architectural change, while palaces became the residences of

kings and aristocrats. New buildings, including churches, archiepiscopal palaces and even synagogues, were decorated in stucco carved with arabesques and geometric patterns and inscribed with Latin or Hebrew phrases juxtaposed to such Arabic ones as "happiness and prosperity" or the name Muhammad. Palaces were adorned with horseshoe arches, trefoil arches of exquisite design, gardens with two water channels crossing at the center, wide porticoed patios with a large central cistern, comfortable baths and central throne-rooms. This nucleus was decorated with fine ribbed cupolas, multicolored carved stucco, niches or cupboards for glazed ceramic jars, and with MUQARNAS and arabesques. Gradually this Islamic style of decoration gave way to a more naturalistic style inspired by Gothic art of the 13th and 14th centuries. Multicolored glazed tiles, which were already used on the exterior of the brick towers of Toledo and Aragón, adorned the floors and walls of many palaces and private houses. In this respect *Mudéjar* art went beyond the Islamic tradition, and the demand for glazed tiles became so great that manufacturing centers were established in Valencia, MÁLAGA, the Triana district of Seville, Toledo and El Puente del Arzobispo (Toledo), Teruel and Muel.

Mudéjar religious architecture developed in Toledo after the conquest of the city in 1085, when it became the residence of the kings of Castile and the ecclesiastical center of Spain. Brick and stone masonry between brick courses became popular, along with horseshoe and trefoil arches and façades similar to those found on mosques. The small mosque of Bab al-Mardum (999–1000) was transformed into the church of Cristo de la Luz in *c.* 1187 by the addition of a voluminous apse to its east side. Like the mosque, the apse was constructed of brick and articulated on the exterior with two stories of blind arcades, the upper one cusped. It differed from the mosque, however, in the extensive mural decoration on the interior. The church of S. Román, rebuilt in 1221 for Archbishop Jiménez de Rada in the same brickwork technique, had horseshoe arches with voussoirs alternately painted in red and white and extensive figural paintings surrounded by Arabic and Latin inscriptions. At the church of Santiago del Arrabal (before 1256), horseshoe arches were replaced by pointed ones, while a *Mudéjar* belfry was added to the tower, which had served as a minaret, as at S. Bartolomé (rest. early 14th century). These adapted minarets gave way to newly built monumental bell-towers decorated with friezes of arches, as at S. Román (late 13th century or early 14th) and S. Tomé (early 14th century).

The Jewish communities in Toledo and such other cities as Segovia, Córdoba, Seville and Granada erected synagogues in the *Mudéjar* style, although only a few have survived. The Ibn Shoshan synagogue of Toledo (13th century), later transformed into the church of S. María la Blanca, is a trapezoidal hypostyle brick building. Twenty-four octagonal brick piers support four arcades of horseshoe arches; the capitals, spandrels and upper walls are richly decorated with carved stucco. A similar and probably contemporary synagogue in Segovia was transformed into the church of Corpus Christi (destr. 1899). The small (6.95×6.37 m) synagogue of Córdoba (early 14th century; *see* CÓRDOBA, §III, B) has a patio and an entrance hall; the interior walls are decorated with carved Hebrew inscriptions and stucco panels surrounding cusped and lambrequin arches. A second Toledan synagogue (1366) built by Samuel Levi, finance minister to Peter the Cruel, and later consecrated as the church of Nuestra Señora del Tránsito, has a spacious hall (23×12 m) with magnificent carved plasterwork on the walls and a fine wooden roof (see fig. below). Hebrew and Arabic inscriptions are integrated into the extraordinarily complex ornament, which includes the arms of Castile among the *muqarnas*, arabesque and geometric patterns.

In Old Castile and León, *Mudéjar* architecture appeared during the reign of Alfonso VIII (*r.* 1158–1214), who won the battle of Navas de Tolosa (1212), effectively ending ALMOHAD rule in Spain. In 1187 he had founded the monastery of Las Huelgas and an adjoining palace; these were decorated in the purest Almohad style by master builders from Toledo and Seville. The Capilla de la Asunción, for example, has rich stucco of lambrequin arches supporting ribbed and *muqarnas* domes; the stucco-covered pointed barrel vaults over the cloister of S. Fernando (13th century) were decorated with a textile-like pattern of roundels enclosing birds and other animals. *Mudéjar* masters also built brick churches on Romanesque lines, such as those of S. Tirso (12th century) and S. Lorenzo (*c.* 1200), both at Sahagún. They have three semicylindrical apses and square towers above the transept and are decorated on the exterior with recessed arched panels in the Toledan style.

After the conquest of Córdoba in 1236, the famed vaults with interlaced ribs at the Great Mosque (*see* CÓRDOBA, §III, A) provided inspiration for vaults in churches in Toledo, Soria, Navarra and Saragossa, as well as at the hospital of San Blas, near Oloron, and Havarrens in southern France. With the conquest of Seville by Fernando III (*r.* 1217–52) in 1248, Christians had access to the great monuments of Almohad Andalucía, and *Mudéjar* architecture in this region retained a greater Islamic element, especially in SEVILLE where an old Almohad minaret, the Giralda, provided a model for *Mudéjar* towers, as at the churches of Omnium Sanctorum and S. Marcos. In such profoundly Arabized areas as the Aljarafe of Seville, Islamic-style domes were erected in many chapels and more complex churches, such as the chapel of the Magdalena, the Piedad de S. Marina and the narrow Quinta of S. Pablo. Alfonso XI (*r.* 1312–50), who defeated the Marinids at the Battle of Salado (1340), together with his son Peter the Cruel (*r.* 1350–69), had workers from Toledo, Seville and Granada build several lavish palaces in Tordesillas, Astudillo (Palencia), Córdoba and Seville. Façades exuberantly

decorated in stone or stucco surrounded patios and gardens with crossed water channels, an arrangement undoubtedly inspired by the Patio de los Leones in the Alhambra (*see* GRANADA, §III). The Alhambra, the greatest monument of the Nasrids (*r.* 1230–1492), was an inexhaustible source of exotic artistry that *Mudéjar* master builders adapted for new construction in Toledo and Aragón. Following the example of his friend and ally the Nasrid sultan V Muhammad (*r.* 1354–91 with interruption), Peter the Cruel had magnificent throne-rooms built in the midst of his gardens. The finest of his palaces was the Alcázar of Seville; its splendid Salón de Embajadores is one of the finest examples of the *Mudéjar* style. The Alhambra and the Alcázar of Seville were the inspiration for 14th-century renovations to the palaces of Toledo, where many large and lavish reception halls (Sp. *tarbea*) were built, such as the Taller del Moro, the Casa de Mesa and the hall of the Corral de Don Diego. All of these show the new, naturalistic decoration, with silhouettes of animals and animated scenes, first seen in the Sinagoga del Tránsito (Synagogue of Samuel ha-Levi; see fig.) in Toledo and the palace of Tordesillas.

In the province of Huelva, such churches as Villalba del Alcor and S. Clara de Moguer were built resembling the fortress–monasteries (Arab. *ribāṭ*) of the Arabs. Their robust appearance contrasted with their fragile interior patios, designed in the style of mosque courtyards. The cloister of the monastery of La Rábida at Huelva is a particularly attractive example. The Hieronymite monastery at Guadalupe (14–15th century) was built by emigrés from Seville and master builders from Toledo; its outstanding two-story cloister (1402–12) has arcades of horse-shoe arches and a *Mudéjar* pavilion (1405) in its center, surmounted by a spire in three stages built of brick, stucco and glazed tiles.

In Aragón during the 13th and 14th centuries, *Mudéjar* churches were built in brick with variegated exterior decoration, revealing that medieval Aragonese builders owed much to Andalusian models, such as the Giralda at Seville. The more archaic churches of S. Domingo and Santiago de Daroca (12th–13th century) and the bell-towers of Belmonte and S. María de Ateca gave way to the richly decorated churches of the Magdalena at Saragossa, S. Pedro and S. Salvador in Teruel. The style came to an end with the majestic towers of S. María at Calatayud (15th century) and the Torre Nueva at Saragossa (16th century; destr. 1892), a 55.6 m clock-tower built by Christian master builders together with one Jewish and two Muslim master builders.

At the beginning of the 15th century, *Mudéjar* architecture began to blend first into Late Gothic and then into the first manifestations of Renaissance or Plateresque styles associated with Queen Isabella I of Castile and León and Cardinal Francisco Jiménez de Cisneros. Among the finest examples are the palace of Peñaranda de Duero (Burgos), the chapel of S. Ildefonso (1510) and the Paraninfo (Great Hall; 1518–19) at the university in Alcalá de Henares, the

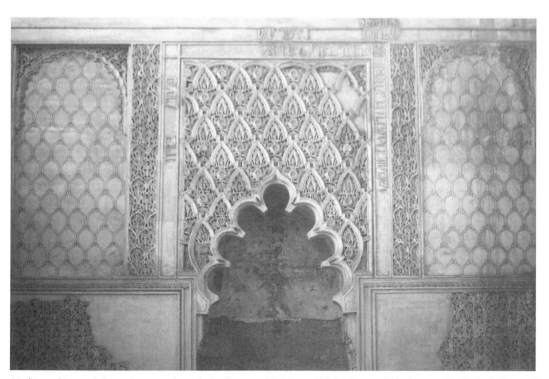

Mudéjar architectural decoration, carved panels, La Sinagoga del Tránsito, Toledo, Spain, 1366; photo credit: Sheila S. Blair and Jonathan M. Bloom

palace of Cárdenas de Ocaña (Toledo) and the Casa de Pilatos (Seville). In Andalucía the houses of the Moors who were baptized and remained in Granada after 1492 remained true to Islamic styles, with patios with two porticos and decoration resembling that of the Alhambra (e.g. Casa de Chapiz and the houses of Horno de Oro Street).

In addition to architectural decoration in carved, joined and painted wood (*see* ARTESONADO) and in brick, glazed ceramic tiles, plaster and paint, *Mudéjar* artists produced textiles, carpets, crockery, furniture, metalwares and arms and armor. *Mudéjar* textiles are closely related to those produced for Islamic patrons (*see* TEXTILES, §§II, C and III, A). Carpets were knotted for Christian and Jewish patrons, and many of the designs are Spanish versions of Turkish rugs (*see* CARPETS AND FLATWEAVES, §III, B). In addition to tiles, *Mudéjar* potters produced earthenwares overglaze-painted in luster. After production ceased at MÁLAGA, the major center under Muslim control, some time before the mid-15th century, the production of lusterwares continued elsewhere under Christian patronage, especially in Valencia.

D. Angulo Iñiguez: *Arquitectura mudéjar sevillana de los siglos XII, XIII, XIV y XV* (Seville, 1932)

L. Torres Balbas: *Arte almohade, arte nazarí, arte mudéjar, A. Hisp.*, iv (Madrid, 1949)

F. Chueca Goitia: *Historia de la arquitectura española: Edad antigua y edad media* (Madrid, 1965)

B. Pavón Maldonado: *Arte toledano: Islámico y mudéjar* (Madrid, 1973, rev. 2/1988)

B. Pavón Maldonado: *Arte mudéjar en Castilla la vieja y León* (Madrid, 1975)

M. Fraga: *Arquitectura mudéjar en la baja Andalucía* (Santa Cruz de Tenerife, 1977)

G. M. Borrás Gualis: *Arte mudéjar aragonés*, 3 vols. (Saragossa, 1978, rev. 1985)

M. Aguilar: *Málaga mudéjar: Arquitectura religiosa y civil* (Málaga, 1979)

B. Martínez Caviró: *Mudéjar toledano: Palacios y conventos* (Madrid, 1980)

M. Valdés Fernández: *Arquitectura mudéjar en León y Castilla* (León, 1981, rev. 2/1984)

Actas I–II y III de simposio internacional de mudéjarismo (Teruel, 1981–4)

P. Mogollón: *El mudéjar en Extremadura* (Extremadura, 1987)

P. Araguas: "Bene fundata est supra firmam petram: Mutations et interferences stylistiques à la cathedrale de Saragosse," *Rev. A.*, xcv (1992), pp. 11–24

J. Dodds: "The Mudejar Tradition in Architecture," *The Legacy of Muslim Spain*, ed. S. K. Jayyusi (Leiden, 1992), pp. 592–7

V. B. Mann, T. F. Glick and J. D. Dodds, eds.: *Convivencia: Jews, Muslims, and Christians in Medieval Spain* (New York, 1992)

M. A. Toajas Roger: *La techumbre del presbiterio de S. Clara de Tordesillas: Análisis histórico-artístico y algunas conclusiones de su estudio*, Homenaje al Profesor Hernández Perera (Madrid, 1992)

E. Nuere: "La armadura de lazo de la madrileña iglesia de San Pedro," *Academia (Madrid)*, lxxix (1994), pp. 175–94

J. M. Gomez-Moreno Calera: "Las iglesias del Valle de Lecrin: Estudio arquitectonico I," *Cuad. A. U. Granada*, xxvii (1996), pp. 23–37

A. Nicolini: "Sobre la insercion urbana mudejar de las iglesias en Andalucia e Hispanoamerica," *Cuad. A. U. Granada*, xxvii (1996), pp. 39–54

J. M. Gomez-Moreno Calera: "Las iglesias del Valle de Lecrin (Granada): Estudio arquitectonico II," *Cuad. A. U. Granada*, xxviii (1997), pp. 49–64

J. M. Rodriguez Domingo: "La Alhambra efimera: El pabellon de Espana en la Exposicion Universal de Bruselas (1910)," *Cuad. A. U. Granada*, xxviii (1997), pp. 125–39

D. F. Ruggles: "The Eye of Sovereignty: Poetry and Vision in the Alhambra's Lindaraja Mirador," *Gesta*, xxxvi/2 (1997), pp. 180–89

S. López Gómez: "Paños de cerámica emblemática imperial morisco-renacentista," *VIII simposio internacional de Mudejarismo. De mudéjares a moriscos: una conversión forzada, Teruel . . . 1999. Actas*, pp. 965–70

D. Raizman: "The Church of Santa Cruz and the Beginnings of Mudejar Architecture in Toledo," *Gesta*, xxxviii/2 (1999), pp. 128–41

R. López Guzmán: *Arquitectura mudéjar: Del sincretismo medieval a las alternativas hispanoamericanas* (Madrid, 2000)

P. J. Pradillo y Esteban: "Yeserias mudejares en el Alcazar Real de Guadalajara," *Goya*, cclxxvi (2000), pp. 131–9

G. Schneider: "Mudejarkuppeln mit geometrischen Ornamenten," *Architectura*, xxx/1 (2000), pp. 26–41

G. Taylor and G. Cooper: "Paradise Remade," *Garden Design*, xix/3 (2000), pp. 66–73

El arte mudéjar: La estética islámica en el arte cristiano (Madrid, 2000)

R. Camacho Martinez: "Intervenciones barrocas en la parroquia de Santiago de Malaga," *Cuad. A. U. Granada*, xxxii (2001), pp. 159–70

M. E. Diez Jorge: *El arte mudéjar: expresión estética de una convivencia* (Granada, 2001)

I. Henares Cuellar and R. J. López Guzmán: "Mestizo Geometry: Mudejar Architecture in New Spain," *A. México*, liv (2001), pp. 88–90

M. Toussaint: "Evocative Geometry: Mudejar Reminiscences," *A. México*, liv (2001), pp. 90–93

M. A. Jordano Barbudo: *El mudéjar en Córdoba* (Córdoba, 2002)

J. F. Moffitt: "Capable of Infinite Extension: From the Arabic Interlace to Alberti's Velo via Occam's Razor," *Source*, xxi/4 (2002), pp. 25–35

S. Montoya Belena: "La Ermita de la Santísima Trinidad, s. XVI, de Campillo de Altobuey, Cuenca: Historia, arte e iconografía," *Archivo de arte valenciano*, 83 (2002), pp. 5–23

A. R. Pacios Lozano: *Bibliografía de arte mudéjar: Addenda, 1992–2002* (Teruel, 2002)

Á. Ramírez Martínez and C. Usón Villalba: *Los 17 grupos de simetría en el arte mudéjar aragonés: La repetición como argumento, la infinitud como objetivo* (Tercuel, 2002)

F. Arnold: "Islamische Wohnburgen auf der Iberischen Halbinsel: Neue Ergebnisse einer Bauaufnahme in Almeria," *Architectura*, xxxiii/2 (2003), pp. 153–74

C. Robinson: "Mudéjar Revisited: A Prolegomena to the Reconstruction of Perception, Devotion, and Experience at the Mudéjar Convent of Clarisas, Tordesillas, Spain (Fourteenth Century A.D.)," *Res*, xliii (2003), pp. 51–77

J. M. Gomez-Moreno Calera: "Torres y puertas de la Alhambra: Ensayo morfológico-didáctico," *Cuad. A. U. Granada*, xxxv (2004), pp. 9–28

K. Kogman-Appel: *Jewish Book Art between Islam and Christianity: The Decoration of Hebrew Bibles in Medieval Spain*, The Medieval and Early Modern Iberian World, 19 (Leiden and Boston, 2004)

D. F. Ruggles: "The Alcazar of Seville and Mudéjar Architecture," *Gesta*, xliii/2 (2004), pp. 87–98

A. Franco: "Carpintería Mudéjar: Puertas de Sagrario Andaluzas," *Goya*, cccix (2005), pp. 354–67

J. M. Gomez-Moreno Calera: "La cerámica arquitectónica en el mudéjar granadino," *Cuad. A. U. Granada*, xxxvi (2005), pp. 9–27

Mughal [Moghul; Mogul]. Dynasty of Central Asian origin that ruled the northern part of the Indian subcontinent from 1526 to 1858.

I. Introduction. II. Family members.

I. Introduction. The dynasty's name Mughal derives from the word Mongol, as the founder (A) Babur ("tiger") was a Chaghatay prince in Central Asia who was descended on his father's side from the Mongol warlord Timur and on his mother's from Genghis Khan. After losing his Central Asian kingdom of FERGHANA, Babur conquered KABUL in 1504 and then defeated the LODI sultan at Panipat in 1526 and the Rajput chiefs at Kanwa near AGRA the following year. With these victories he gained a foothold in northern India and established a capital at Delhi (*see* DELHI, §I). Babur was succeeded by his son (B) Humayun ("auspicious"), who was dislodged within a decade by nobles of the old Lodi regime, particularly Farid Khan SUR, who defeated the Mughal ruler at Kannawj in 1540. Driven into exile, Humayun spent 15 years in Sind, Iran and Afghanistan, but was able to regain the throne in 1555 after squabbles for succession undermined the Sur regime. A year later, he tumbled down the stairs to his library and died, succeeded in turn by his son (C) Akbar ("great") who extended Mughal control over northern and central India during his 50-year reign (1556–1605). Akbar's son, (D) Jahangir ("world-seizer"), continued the policy of subduing outlying areas of India, and his son, (E) Shah Jahan ("king of the world"), undertook an ambitious program of uniting Central Asia and Iran in an empire of Sunni Islam designed to counter the Shi'ite Safavids in Iran. However, this grand plan ended in failure in 1647, and a conservative reaction ensued under his son, (F) Awrangzib ("ornament of the throne").

The rule of the later Mughals in the 18th and first half of the 19th century was marked by political disintegration. The Marathas gained control of Maharashtra and central India, the British slowly expanded their holdings in Bengal, and the Sikhs emerged as a militant force in Punjab. The Nizam of Hyderabad broke away in 1724, and autonomous emirs ruled Sind. The Nawabs of Murshidabad and Lucknow, while ostensibly vassals, were independent for all practical purposes. A devastating blow came in 1739 during the reign of Muhammad Shah (1719–48) when Nadir Shah of Iran sacked the Mughal capital. With relatively little territory or revenue, the Mughal court ceased to set the standard in the arts.

The Mughals were the greatest, longest-lasting and richest Muslim dynasty to rule India. Their enormous wealth, which derived from agriculture, dwarfed that of contemporary Muslim rulers, the OTTOMAN dynasty in the Mediterranean and the SAFAVID dynasty in Iran. Great builders, the Mughals consciously used architecture as a means of self-representation and an instrument of royalty. More monuments survive from the period of Mughal rule than from any other, and under Mughal patronage a distinctive and elegant style of architecture developed, characterized by ogee arches and bulbous domes executed in meticulously finished red sandstone and white marble (*see* ARCHITECTURE, §VII, D). The Mughal rulers were also major patrons of the arts, and the finest pieces were made in royal ateliers. The earlier emperors favored illustrated books (*see* ILLUSTRATION, §VI, E), but from the middle of the 17th century a taste developed for luxury wares such as jewelry (*see* JEWELRY, §II, F), weapons (*see* ARMS AND ARMOR, §II, C), textiles (*see* TEXTILES, §IV, E) and rugs (*see* CARPETS AND FLAT-WEAVES, §IV, E), lavishly crafted from precious metals, gems, hardstones and silk. The Mughals imported the finest wares, including spinels from Myanmar, Sri Lanka and Afghanistan and porcelains from China. They also collected the *objets d'art* made for their ancestors, the TIMURID dynasty of Central Asia, especially their luxury books (*see* ILLUSTRATION, §V, D) and jades (*see* JADE). These Timurid wares provided prototypes for Mughal wares, which were also inscribed with the names and titles of the emperors.

I. Habib: *The Agrarian System of Mughal India* (Bombay, 1963)

B. Gasgoigne: *The Great Moghuls* (London, 1971; *R* 1987)

A. J. Qaisar: *The Indian Response to European Technology and Culture, 1498–1707* (Delhi, 1982)

T. Raychaudhari and I. Habib, eds.: *The Cambridge Economic History of India*, i (Cambridge, 1982)

The Indian Heritage: Court Life & Arts under Mughal Rule (exh. cat., London, V&A, 1982)

E. Koch: *Mughal Architecture: An Outline of its History and Development (1526–1858)* (Munich, 1991/*R* New York, 2002)

C. B. Asher: *Architecture of Mughal India,* Cambridge History of India (Cambridge, 1992)

S. S. Blair and J. M. Bloom: *The Art and Architecture of Islam 1250–1800*, Pelican Hist. A. (New Haven and London, 1992), pp. 266–302 [chaps. 18 and 19 on architecture and the arts]

J. F. Richards: *The Mughal Empire* (Cambridge, 1993)

S. P. Verma: *Mughal Painters and their Work: A Biographical Survey and Catalogue* (Delhi, 1994)

T. Verma: *Karkhanas under the Mughals, from Akbar to Aurangzeb: A Study in Economic Development* (Delhi, 1994)

S. Swarup: *Mughal Art: A Study in Handicrafts* (Delhi, 1996)

Sultan, Shah, and Great Mughal: The History and Culture of the Islamic World (exh. cat., ed. K. von Folsach, T. Lundbæk and P. Mortensen; Copenhagen, Nmus., 1996)

M. Alam: "State Building under the Mughals: Religion, Culture and Politics," *Cah. Asie Cent.*, iii–iv (1997), pp. 105–28

Flowers Underfoot: Indian Carpets of the Mughal Era (exh. cat. by D. Walker; New York, Met., 1997)

R. Nath: *Mughal Sculpture: Study of Stone Sculptures of Birds, Beasts, Mythical Animals, Human Beings, and Deities in Mughal Architecture* (Delhi, 1997)

M. Zebrowski: *Gold, Silver & Bronze from Mughal India* (London, 1997)

M. Alam and S. Subrahmanyan, eds.: *The Mughal State 1526–1750* (Delhi, 1998)

A. S. Das: *Mughal Masters: Further Studies* (Bombay, 1998)

Dr. Daljeet: *Mughal and Deccani Paintings: From the Collection of the National Museum* (New Delhi, 1999)

S. P. Verma: *Flora and Fauna in Mughal Art* (Bombay, 1999)

H. Hattstein and P. Delius, eds.: *Islamic Art and Architecture* (Cologne, 2000), pp. 464–93 [good pictures]

J. Seyller: "A Mughal Code of Connoisseurship," *Muqarnas*, xvii (2000), pp. 176–202

E. Koch: *Mughal Art and Imperial Ideology: Collected Essays* (New Delhi, 2001)

C. van Ruymbeke: "Les souvenirs d'une princesse mogole: Gul-Badan Baygam, fille de Babur, sœur de Humayun, tante d'Akbar," *La femme: Dans les civilisations orientales et Miscellanea aegyptologica: Christiane Desroches Noblecourt in honorem*, ed. C. Cannuyer and others, Acta Orientalia Belgica, 15 (Brussels, 2001) pp. 191–204

R. Crill, S. Stronge and A. Topsfield, eds.: *Arts of Mughal India: Studies in Honour of Robert Skelton* (London, 2004)

P. Moura Carvalho: "What Happened to the Mughal Furniture? The Role of Imperial Workshops, the Decorative Motifs Used, and the Influence of Western Models," *Muqarnas*, xxi (2004), pp. 79–93

Goa and the Great Mughal (exh. cat., ed. J. Flores and N. Vassallo e Silva; Lisbon, Mus. Gulbenkian, 2004)

B. Schmitz and Z. A. Desai: *Mughal and Persian Paintings and Illustrated Manuscripts in the Raza Library, Rampur* (New Delhi, 2006)

P. Moura Carvalho: *Gems and Jewels of Mughal India* (2007), xviii of *The Nasser D. Khalili Collection of Islamic Art*, ed. J. Raby (London, 1992–)

E. Wright, S. Stronge and W. M. Thackston: *Muraqqa' Imperial Mughal Albums from the Chester Beatty Library*, Dublin (Alexandria, VA, 2008)

II. Family members.

A. Babur. B. Humayun. C. Akbar. D. Jahangir. E. Shah Jahan. F. Awrangzib.

A. BABUR [Zahīr al-Dīn Bābur] (*b.* Andijan, 14 Feb., 1483; *d.* Agra, 26 Sept., 1530; *r.* 1526–30). Babur's memoirs, the *Bāburnāma*, written in Chagatay Turkish, give some contradictory hints about the personality of the dynasty's founder: ambitious, casually violent, articulate, heavy drinking, personally engaging, highly cultured and interested in the arts. He was a collector of books, who transported his library on campaign. A copy of his autobiography transcribed at Agra in 1528 (Rampur, State Lib., no. 19) has his own annotations, and illustrated copies became popular under his grandson Akbar.

Babur's favorite type of artistic patronage was the garden, typically divided into four parts by watercourses (Ind.-Pers. *chār-bāgh*, a "four-plot" garden). He is said to have built ten in and around Kabul and many more in India. This type, which had been established under his ancestors, the Timurids, became the model for Mughal gardens (*see* GARDEN, §VI). Typically set outside the citadels or fortress palaces of pre-Mughal rulers, Babur's gardens symbolized his appropriation of the land and served as royal emblems of territorial control. They also provided the setting for symposia of pleasure, poetry, and government. After his death, he was buried at Agra, but in 1644 his remains were reburied in his favorite garden, an 11-hectare terraced garden south of KABUL.

WRITINGS

Bāburnāma (c. 1530) Eng. trans. and ed. by A. S. Beveridge, 2 vols. (London, 1922/R New Delhi, 1970); Eng. trans., ed. and annotations by W. M. Thackston as *The Baburnama: memoirs of Babur, prince and emperor* (Washington, D.C., 1996)

BIBLIOGRAPHY

M. Hasan: *Babur, the Founder of the Mughal Empire in India* (Delhi, 1986)

E. B. Moynihan: "The Lotus Garden Palace of Zahir al-Din Muhammad Babur," *Muqarnas*, v (1988), pp. 135–52

C. B. Asher: "Babur and the Timurid *Chahār-Bāgh*: Use and Meaning," *Environmntl Des.*, xi (1991), pp. 46–55

E. B. Moynihan: "But What a Happiness to Have Known Babur!," *Mughal Gardens: Sources, Places, Representations, and Prospects*, ed. J. L. Wescoat and J. Wolschke-Bulmahn, Dumbarton Oaks Colloquium on the History of Landscape Architecture, xvi (Washington, 1996), pp. 94–126

R. Nath: *India as Seen by Babur, AD 1504–1530* (Delhi, 1996)

E. Koch: "Mughal Palace Gardens from Babur to Shah Jahan (1526–1648)," *Muqarnas*, xiv (1997), pp. 143–65

S. Zajadacz-Hastenrath: "A Note on Babur's Lost Funerary Enclosure at Kabul," *Muqarnas*, xiv (1997), pp. 135–42

N. Azam: "Development of Mosque Architecture under Babur," *Proc. Ind. Hist. Congr.*, lxiv (2003), pp. 1406–13

B. Saggar: *Mongols in India: Babur and Humayun, the First Two Mughal Emperors* (Delhi, 2003)

S. Dale: *The Garden of the Eight Paradises: Babur and the Culture of Empire in Central Asia, Afghanistan and India (1483–1530)* (Leiden, 2004)

B. HUMAYUN [Naṣīr al-Dīn Humāyūn] (*b.* Kabul, 6 March, 1508; *d.* Delhi, 22 Feb., 1556; *r.* 1530–40, 1555–6). In typical Mongol fashion, Babur had divided his kingdom between his sons: Humayun received India, while his half-brother Kamran was sovereign of the more northerly parts of the empire including Kabul and Lahore. Somewhat inexperienced when he came to the throne at age 22, Humayun, like his father Babur, lost his kingdom early in his reign and was forced into exile during the SUR

interregnum and was received in Iran at the court of Shah Tahmasp (*see* Safavid, §II, A). When Humayun returned in 1545, he brought with him a number of Safavid court artists in his service. Humayun first captured Kabul in 1545, which became the center of his court until he took Delhi in 1555. Little is known of the Kabul period, but painters from Iran arrived there, and apparently some manuscripts were produced (see color pl. 2:VI). A year after his return to Delhi, Humayun died unexpectedly after tumbling down the stairs in his library.

The biographical, slightly hagiographical, account compiled by Humayun's sister at the request of his son Akbar portrayed the ruler as lenient. Like his father Babur, Humayun was interested in books. He inherited his father's library and returned from exile with Persian painters such as 'Abd al-Samad and Mir sayyid 'ali, who formed the core of the imperial atelier and introduced Persian idioms into the tradition of illustrated manuscripts produced for the Mughals. Humayun's greatest architectural creation was the foundation of Dinpanah, Delhi's sixth city (*see* Delhi, §I, F), in 1533, although it is unclear which parts date to his patronage or to that of Shir Shah. Similarly, much of the work in Purana Qil'a (*see* Delhi, §III, C) may be the work of his Sur rival. Humayun is best remembered today for his tomb at Delhi (*see* Delhi, §III, D), the first monumental Mughal mausoleum, but it was only begun six years after his death by his son Akbar.

Gulbandan Begum: *Humayūn-nāma*; Fr. trans. by P. Piffaretti; ed. J.-L. Bacqué-Grammont as *Le livre de Hûmayûn* (Paris, 1996)

G. D. Lowry: "Humayun's Tomb: Form, Function, and Meaning in Early Mughal Architecture," *Muqarnas*, iv (1987), pp. 133–48

P. Pal: *Humayun's Garden Party: Princes of the House of Timur and Early Mughal Painting* (Bombay, 1994)

D. F. Ruggles: "Humayun's Tomb and Garden: Typologies and Visual Order," *Gardens in the Time of the Great Muslim Empires: Theory and Design*, ed. A. Petruccioli, Studies in Islamic Art and Architecture, vii (Leiden, 1997), pp. 173–86

N. Misra and T. Misra: *The Garden Tomb of Humayun: An Abode in Paradise* (Delhi, 2003)

B. Saggar: *Mongols in India: Babur and Humayun, the First Two Mughal Emperors* (Delhi, 2003)

C. Akbar [Jalāl al-Dīn Muḥammad Akbar] (*b.* Umarkot, Sind, 15 Oct., 1542; *d.* Agra, 12 Oct., 1605; *r.* 1556–1605). Humayun's son Akbar, as his name suggests, was the most important ruler of the Mughal dynasty: he inherited a small and precarious kingdom, but by the time of his death fifty years later he had transformed it into a vast empire stretching from Kabul to the Deccan. An able ruler, Akbar established political, administrative and cultural institutions that endured until the 19th century. The history of his reign and the details of its institutions were recorded by his courtier Abu'l al-Fazl in the *Akbarnāma* and *Āyīn-i Akbarī*. Akbar introduced

active state patronage of craft manufacture and textile production. His interest in the imperial painting workshops encouraged the development of a new composite style fusing the work of such Persian émigrés as 'Abd al-samad and Mir sayyid 'ali with indigenous sultanate traditions (*see* Illustration, §VI, E, 2), in such manuscripts as the *Ṭūṭīnāma* ("Tales of a parrot"; Cleveland, OH, Mus. A., 62.279) and *Ḥamzanāma* ("Tales of Hamza"; *c.* 1562–77; dispersed). Many other manuscripts, mainly dynastic histories and works of Persian classical literature, were created for the imperial court, and their style was imitated in works produced for the nobility. Akbar was also interested in music and attracted outstanding musicians to his court, including the famous Tansen of Gwalior.

Akbar's contribution to architecture included an impressive series of forts and palaces that similarly blend Persian, Central Asia and Indian styles into a distinctive Mughal style unified by the ubiquitous building material, red sandstone, which was not only readily available, easily carved and attractive, but also the color reserved for imperial tents. The frenzy of building that occurred during Akbar's reign surpassed that under the Tughluq dynasty two centuries earlier. Buildings reflected the cosmopolitan nature of the empire, as craftsmen immigrated to the rich and powerful Mughal court. The most important buildings were constructed in the capitals at Agra, Lahore and especially the newly founded city of Fatehpur sikri. Akbar's tomb for his father Humayun at Delhi (*see* Delhi, §III, D) set the precedent for Mughal monumental tombs, in which domed buildings are set on a plinth in a fourfold garden. Akbar's own tomb at Sikandra, 8 km northwest of Agra, was likewise built under his son (see fig.).

Abu'l-Fazl:ʿĀyīn-i Akbarī [Annals of Akbar] (*c.* 1596–1602); Eng. trans. in 3 vols: vol. i, trans. H. Blochmann, ed. S. L. Gloomer ([Calcutta], 1871/*R* Delhi, 1965); vols. ii–iii, trans. H. S. Jarrett, ed. J. Sarkar (1948–9/*R* New Delhi, 1972–3)

Abu'l-Fazl: Akbarnāma (*c.* 1596–1602); Eng. trans. H. Beveridge, 3 vols. (Calcutta, 1907–39/*R* New Delhi, 1972–3)

S. A. A. Rizvi: *The Religious and Intellectual History of the Muslims in Akbar's Reign* (Delhi, 1975)

A. R. Khan: *The Chieftains in the Mughal Empire during the Reign of Akbar* (Simla, 1977)

Akbar's India: Art from the Mughal City of Victory (exh. cat. M. Brand and G. D. Lowry; New York, Asia Soc. Gals., 1985)

A. K. Das: "Akbar's Imperial Ramayana: A Mughal Persian Manuscript," *Marg*, xlv/3 (1994), pp. 61–72

S. P. Verma: *Painting under Akbar as Narrative Art* (Delhi, 1997)

The Adventures of Hamza (exh. cat. by J. Seyller; Washington, DC, Sackler Gal.; New York, Brooklyn Mus.; London, RA; Zurich, Mus. Rietberg; 2002–3)

D. Jahangir [Nūr al-Dīn Salim Jahāngīr] (*b.* Fatehpur Sikri, 31 Aug., 1569; *d.* 28 Oct., 1627; *r.* 1605–27). In 1568, the Sufi shaykh Mu'in al-Din Chishti is said to have presciently predicted that the

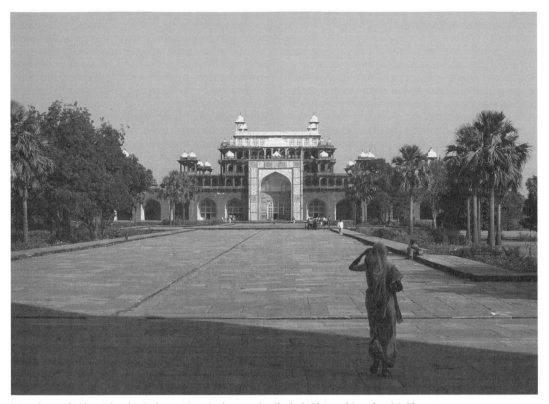

Mausoleum of Akbar, Sikandra, India, *c.* 1612–4; photo credit: Sheila S. Blair and Jonathan M. Bloom

childless Akbar would have three sons, and the following year Akbar's Rajput wife Maryam al-Zamani give birth to Prince Salim, the future Jahangir. As the fourth ruler of the dynasty, he continued the policies set in place by his father and, for the most part, did not interfere with the institutions of state. As a patron, he had an active interest in painting, architecture and gardens, as indicated by surviving pictures and monuments and his memoirs, the *Tūzuk-ī Jahāngīrī*. Like earlier emperors, he was an acute observer of the everyday world and took a special delight in curiosities from distant lands that were arriving in India. His connoisseur's eye for painting is revealed by the attributions, written in his own hand, that are found in many manuscripts (*see* ILLUSTRATION, §VI, E, 3). The ruler seems to have preferred small books with fewer but finer illustrations, often by a single artist, works intended for personal enjoyment, rather than state documents meant to impress. In addition to illustrated manuscripts, he also commissioned individual portraits, and many specimens of calligraphy and painting were collected in magnificent albums (*see* ALBUM). Works produced under his reign also show a growing interest in European motifs and techniques, as in the painting by BICHITR showing *Jahangir Preferring a Sufi to Kings* (Washington, DC., Freer; *see* ILLUSTRATION, color pl.).

Similarly, in architecture under Jahangir, attention shifted from public projects to work of a more private nature, such as hunting palaces, formal gardens and ornamental retreats, of which little survives. Buildings from this period of transition and experimentation are distinguished by highly decorated surfaces in a variety of materials, ranging from the familiar sandstone to white marble, stone intarsia, painting stucco and tile. A key example is the jewel-like tomb of his father-in-law and finance minister I'timad al-Dawla (*see* AGRA, §II, B). Splendid items of carved JADE and other precious objects made for Jahangir attest an impressive level of craftsmanship and the opulence of the emperor's material surroundings.

WRITINGS

Tūzuk-ī Jahāngīrī [Memoirs of Jahangir] (*c.* 1624); Eng. trans. A. Rogers, ed. H. Beveridge (London, 1904–14/*R* Delhi, 1968); ed., trans. and annotated by W. M. Thackston as *The Jahangirnama: memoirs of Jahangir, Emperor of India* (Washington, D.C., 1999)

BIBLIOGRAPHY

B. Prasad: *History of Jahangir* (London and Madras, 1922, rev. Allahabad, 5/1962)

K. Mahmud: "The Mausoleum of Emperor Jahangir," *A. Asia*, xiii (1983), pp. 57–66

M. Brand: "Mughal Ritual in Pre-Mughal Cities: The Case of Jahangir in Mandu," *Environmntl Des.*, xi (1991), pp. 8–17

C. B. Asher: "Appropriating the Past: Jahāngīr's Pillars," *Islam. Cult.*, vii/4 (1997), pp. 1–15

S. P. Verma: "Portraits of Birds and Animals under Jahangir," *Flora and Fauna in Mughal Art*, ed. S. P. Verma (Bombay, 1999), pp. 12–24

E. SHAH JAHAN [Shihāb al-Dīn Muḥammad Shāh Jahān] (*b.* Lahore, 5 Jan., 1592; *d.* Agra, 22 Jan., 1666; *r.* 1628–58). After revolting against his father Jahangir, as his father had done, Shah Jahan succeeded to the throne upon his father's death. During Shah Jahan's 30-year rule, the Mughal Empire attained its greatest prosperity. In 1636 he destroyed the kingdom of Ahmednegar and undertook a second war against the Deccan in 1655. In 1658 he fell ill, was imprisoned in the citadel of Agra by his son Awrangzib, and died there eight years later.

Under Shah Jahan's patronage, Mughal architecture achieved its classical moment, as centralized planning gave way to bilateral symmetry and the repertory of forms and materials was standardized. Cusped arches became ubiquitous, and white marble or fine stucco replaced red sandstone as the preferred facing material. These materials were highly polished and exquisitely finished with relief carving and colored inlay. The dynasty's greatest patron of architecture, Shah Jahan established an entirely new city at Delhi (*see* DELHI, §I, G) and undertook the wholesale reconstruction of the palaces at Agra and Lahore. His most famous project was the Taj Mahal at Agra (*see* AGRA, §II, A and color pl.), a stunning mausoleum of white marble built for his wife, but he was also an active builder of mosques and gardens.

The formality of Shah Jahan's architecture was paralleled in painting and the decorative arts. As artistic interest shifted to architecture, the royal painting atelier declined in size, and formal grandeur was achieved largely at the expense of the earlier naturalism (*see* ILLUSTRATION, §VI, E, 4). The finest paintings from his reign illustrate a copy of the *Pādshāhnāma* (Windsor Castle, Royal Lib.), an illustrated history of his rule. Although technically brilliant, with a complete assimilation of European perspective and landscape devices, these static and stylized images lack the warmth of portraits produced earlier under his father. Similarly, the many single-page portraits that were assembled in albums under Shah Jahan are somewhat stiff and formal. Of the many precious objects made for the court, perhaps the most impressive is the Emperor's white jade wine cup (London, V&A), but fine textiles were also made during his reign.

'Abd al-Hamid Lahauri: *Pādshāhnāma* [Emperor's book] (*c.* 1654–5); ed. K. Ahmad and A. Rahim, 2 vols. (Calcutta, 1865–8)

E. Koch: *Shah Jahan and Orpheus: The Pietre Dure Decoration and the Programme of the Throne in the Hall of Public Audiences at the Red Fort of Delhi* (Graz, 1988)

W. E. Begley, ed.: *Shah Jahan Nama of Inayat Khan: An Abridged History of the Mughal Emperor Shah Jahan* (New Delhi, 1990)

E. Koch: "Diwan-i 'Amm and Chihil Sutun: The Audience Halls of Shah Jahan," *Muqarnas*, xi (1994), pp. 143–65

M. Nanda: *European Travel Accounts During the Reigns of Shahjahan and Aurangzeb* (Kurukshetra, 1994)

King of the World: The Padishahnama: An Imperial Mughal Manuscript from the Royal Library, Windsor Castle (exh. cat. by M. C. Beach and E. Koch; New Delhi, N. Mus.; London, Queen's Gal.; and elsewhere; 1997–8)

K. S. Srivastava: *Two Great Mughals: Akbar and Aurangzeb* (Varanesi, 1998)

F. AWRANGZIB [Abū Muzaffar Muhiyy al-Dīn Muḥammad Awrangzīb] (*b.* Dahod, 3 Nov., 1618; *d.* Ahmednagar, 3 March, 1707; *r.* 1658–1707). After imprisoning his father and eliminating his brothers and nephews, Awrangzib ascended the throne in 1658. In the early part of his reign, patronage continued as before, with portraits of the Emperor following the conventions established in the time of Shah Jahan. Awrangzib was known for his piety and zeal, and his reign was marked by a gradual increase in Islamic orthodoxy. The latter part of his reign marks the end of the great age of imperial Mughal patronage. Painting and music were discouraged at court; artists began to rely on the nobility for patronage, some migrating to regional centers. Book illustration reached a stylistic plateau, as artists reverted to simplified, rather lifeless portraits and the floral naturalism characteristic of Shah Jahan's reign became stylized and objects became showy rather than practical. Awrangzib added little to the imperial palaces built by his forebears but commissioned the construction of a number of mosques. The best-known example is the Badshahi Mosque at Lahore, a building of extraordinary scale (for illustration *see* LAHORE). Much of Awrangzib's rule was occupied by wars in the Deccan against BIJAPUR and GOLCONDA, and portions of the empire in the northwest began to slip from Mughal hands.

J. Sarkar: *History of Aurangzeb*, 5 vols. (Calcutta, 1925–34)

M. Athar Ali: *The Mughal Nobility under Aurangzeb* (Bombay, 1968)

M. A. Nayeem, S. D. Ashraf, Sayyid Daul and others: *Mughal Documents: Catalogue of Aurangzeb's Reign* (Hyderabad, 1988–)

M. Nanda: *European Travel Accounts during the Reigns of Shahjahan and Aurangzeb* (Kurukshetra, 1994)

K. S. Srivastava: *Two Great Mughals: Akbar and Aurangzeb* (Varanesi, 1998)

I. Shah: "Major Architectural Remains of the Time of Awrangzib: Punjab and N.W.F.P.," *J. Pakistan Hist. Soc.*, xlix/1 (2001), pp. 45–53

Muhammad 'Ali (i) [Muḥammad 'Alī Muzahhib] (*fl. c.* 1600–10). Persian painter, active in India. He has been identified from three inscribed works bearing his name: a *Seated Poet* (Boston, MA, Mus. F.A.), a *Seated Youth* (Washington, DC, Freer) and the drawing of *A Girl* in the Binney Collection (San Diego, CA, Mus. A.). The latter, signed Muhammad 'Ali Jahangir Shahi with the presumed regnal date 5 (1610–11), shows that he worked for the Mughal emperor Jahangir (*r.* 1605–27) early in his reign. The painting of a *Young Prince Riding* (Geneva, Prince Sadruddin Aga Khan priv. col.) has also been

attributed to him. This is close in style to the painting in the Freer Gallery of Art, and the two share a competent but bland indebtedness to the work of FARRUKH BEG. The equestrian portrait of *Ibrahim 'Adil Shah II*, attributed to Muhammad 'Ali by S. C. Welch, is now known to be a signed work of Farrukh Beg. Muhammad 'Ali's small oeuvre, technical skill and dependence on another's artistic personality suggest that he was primarily an illuminator, namely the Muhammad 'Ali Muzahhib of Shiraz whose portrait was drawn by Reza 'Abbasi in AH 1020 (1611–12) following his return from India.

Indian Miniature Painting from the Collection of Edwin Binney, 3rd: The Mughal and Deccani Schools with Some Related Sultanate Material (exh. cat. by E. Binney; Portland, OR, A. Mus., 1973), no. 123

B. W. Robinson, ed.: *The Keir Collection: Islamic Painting and the Arts of the Book* (London, 1976), pt. III, no. 351

The Grand Mogul: Imperial Painting in India, 1600–1660 (exh. cat. by M. C. Beach; Williamstown, MA, Clark A. Inst.; Baltimore, MD, Walters A.G.; Boston, MA, Mus. F.A.; New York, Asia Soc. Gals.; 1978–9)

S. C. Welch: "Reflections on Muhammad 'Ali," *Gott ist schön und er liebt die Schönheit: Festschrift für Annemarie Schimmel*, ed. A. Giese and C. Bürgel (Berne, 1994), pp. 407–20

Prince, Poets & Paladins: Islamic and Indian Paintings from the Collection of Prince and Princess Sadruddin Aga Khan (exh. cat. by S. R. Canby; London, BM; Cambridge, MA, Sackler Mus.; Zurich, Mus. Rietberg; Geneva, Mus. A. & Hist.; 1998–2000), pp. 8, 138–9, 158

Muhammad 'Ali (ii) [Muḥammad 'Alī al-Mashhadī ibn Malik Ḥusayn al-Iṣfahānī] (*fl.* Isfahan, 1645–60). Persian illustrator. The son of a painter, Muhammad 'Ali became one of the most popular and prolific painters at the court of the Safavid monarch 'Abbas II (*r.* 1642–66; *see* SAFAVID, §II, B). Muhammad 'Ali was a skilled and competent artist who preferred rounded contours and simple forms. Although he was not as innovative in form and style as his contemporary MU'IN, Muhammad 'Ali's figures convey tremendous charm, animation and vitality. Eight of his paintings illustrate his own copy (Baltimore, MD, Walters A. Mus., MS 649) of Muhammad Riza Naw'i's *Sūz va gudāz* ("Burning and melting"). The largest number of the artist's ink drawings highlighted with color washes and gold illustrate a copy (Istanbul, Topkapı Pal. Lib., H. 1010) of Hafiz's *Dīvān* (collected poetry). His album pages include standard figures of youths, elderly men and lovers as well as more unusual group scenes, such as one of bears imitating a court.

T. Falk, ed.: *Treasures of Islam* (Geneva, 1985), no. 93

Prince, Poets & Paladins: Islamic and Indian Paintings from the Collection of Prince and Princess Sadruddin Aga Khan (exh. cat. by S. R. Canby; London, BM; Cambridge, MA, Sackler Mus.; Zurich, Mus. Rietberg; Geneva, Mus. A. & Hist.; 1998–2000), pp. 68, 78, 81

M. Farhad: "'Searching for the New': Later Safavid Painting and the Suz u Gawdaz (Burning and Melting) by Nau'i Khabushani," *J. Walters A. Mus.*, lix (2001), pp. 115–30

Muhammad Baqir (i) [Muḥammad Bāqir] (*fl.* 1750s–1760s). Persian painter. He is known for decorations in the margins of manuscripts, copies of European prints and 17th-century paintings, and wash drawings. His subjects range from floral sprays to nudes, such as the watercolor of a sleeping nymph (1765; Dublin, Chester Beatty Lib., cat. no. 282.VI). He contributed paintings and marginal decorations to a sumptuous album (1758–9; St. Petersburg, Hermitage), probably compiled for the Afsharid court historian Mirza Mahdi Khan Astarabadi. Muhammad Baqir's punning signature there suggests that he was a pupil of 'ALI ASHRAF. Muhammad Baqir signed one of the finest marginal paintings in a smaller but similar album (1764; dispersed; sold Hôtel Drouot, Paris, 23 June 1982) and may have been responsible for all of them, which include rose sprays and copies of *Susannah and the Elders*. Muhammad Baqir is sometimes said to have continued to work under the QAJAR ruler Fath 'Ali Shah (*r.* 1797–1834), for the impressive varnished covers that the ruler ordered to replace the original binding on the famous copy (London, BL, Or. MS. 2265) of Nizami's *Khamsa* ("Five poems") made for the Safavid shah Tahmasp I in 1539–43 are signed by Muhammad Baqir and SAYYID MIRZA. As the date of the binding (the late 1820s) would extend Muhammad Baqir's career beyond reasonable limits, it is more likely that the painter of the varnished covers should be identified with the enameler BAQIR.

B. W. Robinson: "Persian Painting in the Qajar Period," *Highlights of Persian Art*, ed. R. Ettinghausen and E. Yarshater (Boulder, CO, 1979), pp. 331–62

M. A. Karīmzāda Tabrīzī: *Aḥvāl u āthār-i naqqāshān-i qadīm-i īrān* [The lives and art of old painters of Iran] (London, 1985), no. 943

L. S. Diba: "Lacquerwork," *The Arts of Persia*, ed. R. W. Ferrier (New Haven and London, 1989), pp. 243–54

L. S. Diba: "Persian Painting in the Eighteenth Century: Tradition and Transmission," *Muqarnas*, vi (1989), pp. 147–60

B. W. Robinson: "Persian Painting under the Zand and Qājār Dynasties," *From Nadir Shah to the Islamic Republic* (1991), vii of *The Cambridge History of Iran* (Cambridge, 1968–91), pp. 870–90

Royal Persian Paintings: The Qajar Epoch 1785–1925 (exh. cat. by L. S. Diba with M. Ekhtiar; New York, Brooklyn Mus.; Los Angeles, CA, Armand Hammer Mus. A.; London; U. London, SOAS, Brunei Gal., 1998–9), pp. 121, 147, 180, 211–12

Prince, Poets & Paladins: Islamic and Indian Paintings from the Collection of Prince and Princess Sadruddin Aga Khan (exh. cat. by S. R. Canby; London, BM; Cambridge, MA, Sackler Mus.; Zurich, Mus. Rietberg; Geneva, Mus. A. & Hist.; 1998–2000), pp. 93, 94, 148–9

Muhammad Baqir (ii). *See* BAQIR.

Muhammad Hasan Afshar [Muḥammad Ḥasan Khān Afshār] (*fl. c.* 1835–*c.* 1865). Persian painter. A noted court painter and portraitist under the QAJAR rulers Muhammad Shah (*r.* 1834–48) and Nasir al-Din

(*r.* 1848–96), Muhammad Hasan Afshar was awarded the title Painter Laureate (Pers. *naqqāsh bāshī*). A portrait dated 1847 in the Churchill Album (London, BL, Or. MS. 4938) depicts Muhammad Shah seated in a red tunic with blue sash and flashing diamonds. The artist's most remarkable works are three life-size oil portraits of Nasir al-Din (Tehran, Gulistan Pal.; Tehran, Moghaddam priv. col. (see Robinson, 1991, fig. 30a); and Isfahan, Chihil Sutun Palace, dated 1860). The artist also painted small varnished objects, such as a penbox dated 1846 (priv. col., see Robinson, 1989, fig. 16a), which has a scene of the Last Judgment on the top and a Napoleonic battle scene on one side. The pen-box was only finished in 1861 by ISMAʿIL JALAYIR, who added a scene of the Qajar monarch Muhammad Shah in battle on the other side and a design and inscription on the base. Other members of the Afshar family also painted similar objects, such as another pen-box with a scene of the Last Judgment (Los Angeles, CA, Co. Mus. A., 73.5.159).

B. W. Robinson: *Persian Miniature Painting from Collections in the British Isles* (London, 1967)

M. A. Karīmzāda Tabrīzi: *Aḥvāl u āthār-i naqqāshān-i qadīm-i īrān* [The lives and art of old painters of Iran] (London, 1985), no. 988

B. W. Robinson: "Qajar Lacquer," *Muqarnas*, vi (1989), pp. 131–46

B. W. Robinson: "Persian Painting under the Zand and Qājār Dynasties," *From Nadir Shah to the Islamic Republic* (1991), vii of *The Cambridge History of Iran* (Cambridge, 1968–91), pp. 870–90

N. D. Khalili, B. W. Robinson and T. Stanley: *Lacquer of the Islamic Lands* (1997), xxii/2 of *The Nasser D. Khalili Collection of Islamic Art*, ed. J. Raby (London, 1992–), p. 149

Royal Persian Paintings: The Qajar Epoch 1785–1925 (exh. cat. by L. S. Diba with M. Ekhtiar; New York, Brooklyn Mus.; Los Angeles, CA, Armand Hammer Mus. A.; London; U. London, SOAS, Brunei Gal., 1998–9)

Qajar Portraits (exh. cat. by J. Raby; London, U. London, SOAS, Brunei Gal., 1999), nos. 104, 118

Muhammad Hasan Khan [Muḥammad Ḥasan Khān](*fl. c.* 1800–40). Persian painter. He signed a number of large oil paintings (Tehran, Nigaristan Mus.; ex-Amery priv. col.), including two life-size portraits of princes and a painting of *Shaykh Sanʿan and the Christian Maiden*. Other paintings that can be attributed to the artist on stylistic grounds include a third portrait of a prince in the same collection and two paintings of women (Tbilisi, Mus. A. Georg.). His style is characterized by a soft rendering of features, fondness for reddish brown and a hallmark vase of flowers. He also produced miniature paintings in the form of monochrome portraits. European travelers in Tehran in the 19th century erroneously attributed to him the large mural in the Nigaristan Palace depicting the court of the QAJAR monarch Fath ʿAli Shah (*r.* 1797–1834), but this painting is now considered the work of ʿABDALLAH KHAN.

S. Y. Amiranashvili: *Iranskaya stankovaya zhivopis'* [Iranian wall painting] (Tbilisi, 1940)

B. W. Robinson: "The Court Painters of Fatḥ ʿAlī Shāh," *Eretz-Israel*, vii (1964), pp. 94–105

S. J. Falk: *Qajar Paintings: Persian Oil Paintings of the 18th and 19th Centuries* (London, 1972)

B. W. Robinson: "Persian Painting in the Qajar Period," *Highlights of Persian Art*, ed. R. Ettinghausen and E. Yarshater (Boulder, CO, 1979), pp. 331–62

M. A. Karīmzāda Tabrīzī: *Aḥvāl u āthār-i naqqāshān-i qadīm-i īrān* [The lives and art of old painters of Iran] (London, 1985), no. 987

B. W. Robinson: "Persian Painting under the Zand and Qājār Dynasties," *From Nadir Shah to the Islamic Republic* (1991), vii of *The Cambridge History of Iran* (Cambridge, 1968–91), pp. 870–90

Royal Persian Paintings: The Qajar Epoch 1785–1925 (exh. cat. by L. S. Diba with M. Ekhtiar; New York, Brooklyn Mus.; Los Angeles, CA, Armand Hammer Mus. A.; London; U. London, SOAS, Brunei Gal., 1998–9)

Muhammadi [Muḥammadī Haravī] (*fl.* Qazvin, *c.* 1570–78; Herat, *c.* 1578–87). Persian draftsman and illustrator. Although the Ottoman historian Mustafa ʿAli identified Muhammadi as a son of SULTAN-MUHAMMAD (quoted in Armenag Bey Sakisian: *La Miniature Persane* (Paris and Brussels, 1929), p. 123), such a kinship is unlikely in light of Muhammadi's epithet *Haravī* (from Herat) used in an inscription on a painting after Muhammadi (Istanbul, Topkapı Pal. Lib., H. 2140, fol. 5*r*) of a seated youth with a falcon. As A. Welch has reconstructed Muhammadi's life, he worked at the studio of the SAFAVID ruler Ismaʿil II (*r.* 1576–8) at Qazvin but after the accession of Muhammad Khudabanda (*r.* 1578–88) left for Khurasan. Muhammadi's subsequent itinerary is suggested by his portrait (Istanbul, Topkapı Pal. Lib., H. 2155, fol. 20*v*) of ʿAliquli Khan dated 1584, while he was governor of HERAT (1581–7). B. W. Robinson places his *floruit* entirely in Herat from *c.* 1560 to *c.* 1590. Although Muhammadi worked on at least one manuscript, a copy (Istanbul, Topkapı Pal. Lib., H. 777) of Nizami's *Khamsa* ("Five poems"), he is best known for his portraits (e.g. London, BL, Orient. & India Office Lib., 28–14) and bucolic scenes (e.g. Paris, Mus. Guimet, no. 7111). His figural style conforms to that associated with Qazvin *c.* 1575, in which long-necked, round-cheeked youths and girls sway to music or toward one another. Often his figures appear off-balance, as if rocking on their heels. Although his hunting or encampment scenes are composed as a series of vignettes rather than as a unified whole, they and his slightly awkward portraits exerted a strong influence on the artists at the court of Shah ʿAbbas I (*see* ILLUSTRATION, §VI, A, 3).

A. Welch: "Painting and Patronage under Shah ʿAbbas I," *Iran. Stud.*, vii (1974), pp. 466–70

B. W. Robinson: "Muḥammadī and the Khurāsān Style," *Iran*, xxx (1992), pp. 17–30

Prince, Poets & Paladins: Islamic and Indian Paintings from the Collection of Prince and Princess Sadruddin Aga Khan (exh.

cat. by S. R. Canby; London, BM; Cambridge, MA, Sackler Mus.; Zurich, Mus. Rietberg; Geneva, Mus. A. & Hist.; 1998–2000), pp. 44, 133

S. R. Canby: *The Golden Age of Persian Art 1501–1722* (London, 1999), pp. 76, 89, 106–7 and figs. 60 and 95

S. Makariou: "Une nouvelle page attribuée à Muhammedi dans les collections islamiques du Louvre," *Rev. Louvre*, xlix/v (1999), pp. 46, 52, 111, 113

A. Soudavar: "The Age of Muhammadi," *Muqarnas*, xvii (2000), pp. 53–72

Muhammad ibn al-Zayn [Muḥammad ibn al-Zayn; Ibn al-Zayn] (*fl.* early 14th century). Arab metalworker. He is known from signatures on two undated inlaid wares, the Baptistère de St. Louis (Paris, Louvre, LP 16; *see* METALWORK, color pl., signed in six places) and the Vasselot Bowl (Paris, Louvre, MAO 331, signed once; see fig.). His style is characterized by bold compositions of large figures encrusted with silver plaques on which details are elaborately chased. His repertoire develops themes characteristic of later 13th-century metalwork from Mosul (*see* METALWORK, §III, B)—mounted or enthroned rulers, bands of running or prowling animals, an elaborate Nilotic composition, courtiers bearing insignia of office, and battle scenes on scroll grounds with strikingly naturalistic fauna. His work is marked by a realism of facial expression, in which Turco-Mongolian physiognomy, dress, headgear and even coiffure are prominent, and a vigor of movement, gesture or stance that enlivens and transforms even the running animals and rows of standing courtiers, some in Frankish costume. The technique and style of these pieces allow their attribution to the Bahri MAMLUK period in Egypt and Syria (*c.* 1250–*c.* 1350), but the absence of owners' inscriptions suggests that they were not made for a Mamluk sultan. The exceptional naturalism has encouraged scholars to date the Baptistère by identifying the figures depicted. Rice, for example, suggested that the basin was made for the amir Salar (*d.* 1310) on the basis of the emblems worn by one figure, but other scholars have suggested dates ranging from the mid-13th century to the mid-14th. Other works in the same distinctive style have been attributed to his workshop, such as a basin (Jerusalem, Mayer Mus. Islam. A.), a steel mirror inlaid with gold and silver and decorated with inscriptions and signs of the zodiac (Istanbul, Topkapı Pal. Mus.) and an incense burner found at Qus (Cairo, Mus. Islam. A.). A forged iron screen in the Isʿardiyya Madrasa (before 1345) in Jerusalem is inscribed with the name of Muhammad ibn al-Zayn, but the date of the screen and its relationship to the inlaid wares are uncertain.

D. S. Rice: "The Blazons of the 'Baptistère de Saint Louis,'" *Bull. SOAS*, xiii (1950), pp. 367–80

D. S. Rice: *Le Baptistère de Saint Louis* (Paris, 1951)

Renaissance of Islam: Art of the Mamluks (exh. cat. by E. Atıl; Washington, DC, N. Mus. Nat. Hist.; Minneapolis, MN, Inst. A.; New York, Met., and elsewhere; 1981), nos. 20, 21

J. M. Bloom: "A Mamluk Basin in the L. A. Mayer Memorial Institute," *Islam. A.*, ii (1987), pp. 19–26

D. Behrens-Abouseif: "The Baptistère de Saint Louis: A Reinterpretation," *Islam. A.*, iii (1988–9), pp. 3–9

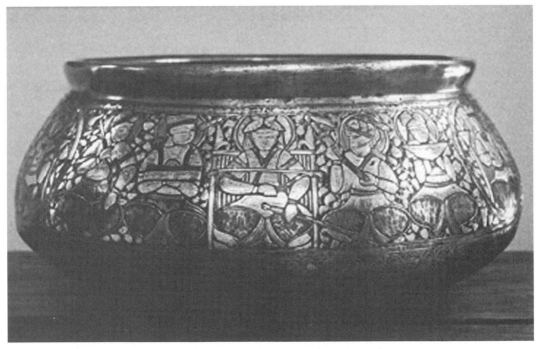

Vasselot Bowl by Muhammad ibn al-Zayn, copper alloy chased and inlaid with gold and silver, h. 103 mm, diam. 172 mm, early 14th century (Paris, Musée du Louvre); photo credit: Sheila S. Blair and Jonathan M. Bloom

J. W. Allen: "Muhammad ibn al-Zain: Craftsman in Cups, Thrones and Window Grilles?," *Levant*, xxviii (1996), pp. 199–208

R. Ward: "The 'Baptistère de Saint Louis'—A Mamluk Basin Made for Export to Europe," *Islam and the Italian Renaissance*, ed. C. Burnett and A. Contadini, Warburg Institute Colloquia, 5 (London, 1999), pp. 113–32

Muhammad Ja'far [Muḥammad Ja'far] (*fl. c.* 1800–30). Persian painter. He was the most prolific painter in enamels at the court of the QAJAR monarch Fath 'Ali Shah (*r.* 1797–1834), but unlike his contemporaries BAQIR and 'ALI, Muhammad Ja'far did not attach a title to his name when he signed his work. One of his earliest works is an inkpot for a penbox (1805; sold Paris, Hôtel Drouot, 25 May 1964, lot 2) decorated with busts of a young man and a girl. His most impressive pieces are large objects made for official presentation to foreign dignitaries. He enameled several large gold dishes that are decorated with a lion and sun in the center panel surrounded by alternating birds and floral swags. One (1813; ex-Kazrouni priv. col.; sold London, Sotheby's, March 1954, lot 867) was presented to Sir Gore Ouseley (1770–1844), the British ambassador to Iran, and another made of solid gold and weighing more than six pounds (1817–18; London, V&A, I.S.09406) was presented to the Court of Directors of the British East India Company on 18 June 1819. Muhammad Ja'far also painted a number of smaller objects such as the bowl and base of a waterpipe or hookah (Pers. *qaliyān*) and a jeweled snuff-box made in 1814 for the Crown Prince 'Abbas Mirza (all sold Paris, Hôtel Drouot, 25 May 1964, lots 29, 54 and 17 respectively). Muhammad Ja'far's painting is very fine, although his drawing is occasionally stiff and his shading harsh.

B. W. Robinson: "The Royal Gifts of Fath 'Ali Shah," *Apollo*, lii (1950), pp. 66–8

V. B. Meen and A. D. Tushingham: *The Crown Jewels of Iran* (Toronto, 1968)

B. W. Robinson: "Qājār Painted Enamels," *Paintings from Islamic Lands*, ed. R. Pinder-Wilson (Oxford, 1969), pp. 187–204

Royal Persian Paintings: The Qajar Epoch 1785–1925 (exh. cat. by L. S. Diba with M. Ekhtiar; New York, Brooklyn Mus.; Los Angeles, CA, Armand Hammer Mus. A.; London; U. London, SOAS, Brunei Gal., 1998–9), no. 53

Qajar Portraits (exh. cat. by J. Raby; London, U. London, SOAS, Brunei Gal., 1999), no. 55

Muhammad Qasim [Muḥammad Qāsim Tabrīzī] (*b.* ?Tabriz; *d.* 1659). Persian illustrator, painter and poet. He was the most important painter in mid-17th-century Isfahan after MU'IN. Muhammad Qasim contributed illustrations to several manuscripts, including many tinted drawings for two copies (1640; Istanbul, Topkapı Pal. Lib., H. 1010; and *c.* 1650; Dublin, Chester Beatty Lib., MS. 299) of Hafiz's *Dīvān* (collected poetry) and 42 paintings to a copy (1648; Windsor Castle, Royal Lib., MS. A/6, Holmes 151) of the *Shāhnāma* ("Book of

kings"). The artist also painted several murals of single figures and groups of picnickers in the side room (P4) adjoining the reception hall of the Chihil Sutun Palace (1647; *see* ISFAHAN, §III, G). He is best known for his album paintings of single figures or small groups; they often include short poems or letters that reflect his reputation as a celebrated poet. He was an accomplished draftsman and sensitive colorist who repeated a few carefully controlled hues to create overall balance and harmony, but his elegant figures are somewhat stiff and his landscapes mere backdrops.

I. Stchoukine: *Les Peintures des manuscrits de Shah 'Abbas 1er à la fin des Safavis* (Paris, 1964)

T. Falk, ed.: *Treasures of Islam* (Geneva, 1985), no. 89

B. Gray: "The Arts in the Safavid Period," *The Timurid and Safavid Periods*, ed. P. Jackson (1986), vi of *The Cambridge History of Iran* (Cambridge, 1968–91), pp. 903–4

Prince, Poets & Paladins: Islamic and Indian Paintings from the Collection of Prince and Princess Sadruddin Aga Khan (exh. cat. by S. R. Canby; London, BM; Cambridge, MA, Sackler Mus.; Zurich, Mus. Rietberg; Geneva, Mus. A. & Hist.; 1998–2000), pp. 78–9, 81

A. T. Adamova: "Muḥammad Qāsim and the Isfahan School of Painting," *Society and Culture in the Early Modern Middle East: Studies on Iran in the Safavid Period*, ed. A. J. Newman, Islamic History and Civilization: Studies and Texts, 46 (Leiden, 2003), pp. 193–212

Muhammad Sadiq [Muḥammad Ṣādiq; Mulla Sadiq; Sadiq] (*fl. c.* 1750–1800). Persian painter. The foremost painter at the court of Karim Khan (*r.* 1750–79), the ZAND ruler in Shiraz, he worked in a variety of media, from large oil paintings to miniatures, and painted and varnished objects (*see* LACQUER). His name has become synonymous with the Zand style. His reputation was so great that many works by different hands have been attributed to him. Works signed with his name range in date from the 1730s to the 1790s, an improbably long time, and it is likely that some are by other artists. Muhammad Sadiq was apparently a pupil of 'ALI ASHRAF, for one of his earliest works, a circular box depicting a young woman in early 18th-century dress on the interior (Tehran, Nigaristan Mus.), is painted on the exterior with birds and flowers in the style of his master and has a punning signature that invokes his master's name. Other early work includes several of the splendid marginal designs in a sumptuous album (1758–9; St. Petersburg, Hermitage). Muhammad Sadiq produced several oil paintings, including two signed works (ex-Amery priv. col.; Tehran, Nigaristan Mus.) depicting lovers drinking at a window and a prince on horseback attacked by a dragon. Several of the murals from Karim Khan's mausoleum (Shiraz, Pars Mus.) are signed by him. He also worked in miniature, for a mirror-case (1775–6; London, V&A, 763–1888) has a punning signature that invokes his namesake Ja'far al-Sadiq (*d.* 765), the sixth Shi'ite imam. The front covers are decorated with a hunting scene, and the

inside and back covers show amorous couples on a terrace.

After Karim Khan's death, Muhammad Sadiq continued to work for the QAJAR monarch Agha Muhammad (r. 1779–97), and, on the Shah's orders, Muhammad Sadiq repaired the mural in the Chihil Sutun Palace in Isfahan that depicts Nadir Shah's defeat of the Mughal armies at the Battle of Karnal in 1738. Several of the artist's painted objects, such as an octagonal mirror-case (1792–3; Tehran, Nigaristan Mus., 75.5.32), show that the Zand style continued into the early Qajar period. A signed mirror-case (1795–6; Berne, Hist. Mus., 72/13) has Christian scenes of the *Annunciation*, the *Presentation in the Temple* and the *Adoration of the Magi*, but another signed mirror-case dated the following year (Berne, Hist. Mus., 641) may be the work of his pupil. Figures play a predominant role in Muhammad Sadiq's style, which is notable for its fine detail, intimate atmosphere and poetic qualities. European features, such as shading, modeling, drapery and atmospheric perspective, remain superficial. His meticulous figural style made a great impression on his contemporaries, and his name was renowned many years after his death. His style was refined and developed by the miniature painter Najaf 'Ali Isfahani (*see* ISFAHANI, §I).

B. W. Robinson: "Persian Lacquer in the Bern Historical Museum," *Iran*, viii (1970), pp. 47–50

S. J. Falk: *Qajar Paintings: Persian Oil Paintings of the 18th and 19th Centuries* (London, 1972)

L. S. Diba: "Lacquerwork," *The Arts of Persia*, ed. R. W. Ferrier (New Haven and London, 1989), pp. 243–54

L. S. Diba: "Persian Painting in the Eighteenth Century: Tradition and Transmission," *Muqarnas*, vi (1989), pp. 147–60

B. W. Robinson: "Painting in the Post-Safavid Period," *The Arts of Persia*, ed. R. W. Ferrier (New Haven and London, 1989), pp. 225–31

B. W. Robinson: "Persian Painting under the Zand and Qājār Dynasties," *From Nadir Shah to the Islamic Republic* (1991), vii of *The Cambridge History of Iran* (Cambridge, 1968–91), pp. 870–90

N. D. Khalili, B. W. Robinson and T. Stanley: *Lacquer of the Islamic Lands* (1996), xxii/1 of *The Nasser D. Khalili Collection of Islamic Art*, ed. J. Raby (London, 1992–), pp. 74–5

Royal Persian Paintings: The Qajar Epoch 1785–1925 (exh. cat. by L. S. Diba with M. Ekhtiar; New York, Brooklyn Mus.; Los Angeles, CA, Armand Hammer Mus. A.; London, U. London, SOAS, Brunei Gal., 1998–9)

Muhammad Shafi' [Muḥammad Shafi' 'Abbāsī; Shafi' 'Abbāsī] (*fl.* Isfahan, 1628–c. 1674). Persian painter. The son of RIZA, Muhammad Shafi' developed and popularized bird-and-flower painting, a genre his father had introduced to the Isfahan school. *Youth Painting a Flower* (c. 1635; Washington, DC, Freer, 53.17) is probably a self-portrait; mounted beside a sketch of an elderly bespectacled man identified as Riza, it corroborates the claim of Muhammad Shafi''s kinship to Riza, also established by an inscribed drawing in Los Angeles (Co. Mus. A.). Muhammad Shafi' also completed at least one of his father's late drawings, *The Poet, the Robber and the Dogs* (Ham, Surrey, Keir priv. col., III.387). The quality of line in Muhammad Shafi''s drawings is somewhat dry, but paintings such as *Bird, Butterflies and Blossom* (1651–2; Cleveland, OH, Mus. A.) exhibit a sensitive palette and subtly modeled forms, which were derived from European sources, including English engravings. The botanical studies of Muhammad Shafi' are exemplified by a group of flower drawings, many signed and dated between 1640 and 1671, included in an album (London, BM, 1988, 4-23 01-056); they are the forerunners of a versatile new decorative genre which was continued by such late 17th-century painters as MUHAMMAD ZAMAN and 'ALIQULI JABBADAR and translated into intricate textile patterns. A velvet panel of pairs of standing females in a landscape of flowering plants (New York, Sotheby's, 11 Dec. 1994, lot 87) bears Shafi' 'Abbasi's signature, confirming his role as a textile designer.

B. Gray: "An Album of Designs for Persian Textiles," *Aus der Welt der islamischen Kunst, Festschrift Ernst Kühnel* (Berlin, 1959), pp. 219–25

B. W. Robinson, ed.: *Islamic Painting and the Arts of the Book* (London, 1976), pp. 208–10 [Keir col.]

E. Atıl: *The Brush of the Masters: Drawings from Iran and India* (Washington, DC, 1978), p. 83

Islamic Art and Design, 1500–1700 (exh. cat. by J. M. Rogers; London, BM, 1983), no. 58

S. R. Canby: *The Golden Age of Persian Art 1501–1722* (London, 1999), pp. 123–5, 136–7, 139. 141, 148, 150–51 and figs. 112, 113 and 126

Muhammad Sharif (*fl. c.*1580–1625). Indian miniature painter, son of 'ABD AL-SAMAD. Of noble descent and an accomplished courtier, he is not on the list of 17 highly prized artists compiled by Abu'l-Fazl, the biographer of the Mughal emperor Akbar (r. 1556–1605), in the *Āyīn-i Akbarī*, a contemporary account of court matters. The earliest manuscript with inscriptions naming Muhammad Sharif as a painter is the *Khamsa* ("Five poems") of Nizami (c. 1585; Ham, Surrey, Keir priv. col.). The style of miniatures assigned to him (fols. 73b, 157) suggests a painter at the beginning of his career. The work is mostly carefully contained within the margin, with rather primitive stylized animals, but where it breaks the margin more freedom of movement and greater realism appears. Muhammad Sharif acted as the designer/outliner in three miniatures in the *Razmnāma* ("Book of wars"; c. 1582–6; Jaipur, Maharaja Sawai Man Singh II Mus., MS. AG. 1683–1850): he collaborated with Bhanwari (fol. 122), Kesu Khurd (fol. 118) and Munir (fol. 68). Few other examples can be firmly assigned to him.

The Grand Mogul: Imperial Painting in India 1600–1660 (exh. cat. by M. C. Beach; Williamstown, MA, Clark A. Inst.; Baltimore, MD, Walters A.G.; Boston, MA, Mus. F.A.; New York, Asia Soc. Gals.; 1978–9)

The Imperial Image: Paintings for the Mughal Court (exh. cat. by M. C. Beach; Washington, DC, Freer, 1981)

Muhammad Shirin [Muḥammad, the "Shirin" Painter] (*fl. c.* 1825–50). Persian painter. He painted in a distinctive, bold style and is known for his depiction of plump moon-faced women. He has been assigned the name Muhammad on the basis of the punning signature, *yā muḥammad* ("O Muhammad") on a painting of a reclining woman (1842; Foroughi priv. col.). The artist is also known as the "Shirin" Painter, a name derived from a painting of a woman (Tehran, Nigaristan Mus., ex-Amery priv. col.) inscribed with the name Shirin. Several other paintings (Tehran, Nigaristan Mus.; Tbilisi, Mus. A. Georg.; London, V&A) can be assigned to him on stylistic grounds, and his output seems to have been quite large. He excelled in the depiction of women (e.g. a dancing woman with castanets; Tehran, Nigaristan Mus., ex-Amery priv. col.); his male figures are less successful.

S. Y. Amiranashvili: *Iranskaya stankovaya zhivopis'* [Iranian wall painting] (Tbilisi, 1940)

B. W. Robinson: "The Court Painters of Fatḥ ʿAlī Shāh," *Eretz-Israel*, vii (1964), pp. 94–105

S. J. Falk: *Qajar Paintings: Persian Oil Paintings of the 18th and 19th Centuries* (London, 1972)

B. W. Robinson: "Persian Painting in the Qajar Period," *Highlights of Persian Art*, ed. R. Ettinghausen and E. Yarshater (Boulder, CO, 1979), pp. 331–62

M. A. Karīmzāda Tabrīzī: *Aḥvāl u āthār-i naqqāshān-i qadīm-i īrān* [The lives and art of old painters of Iran] (London, 1985), no. 880

Treasures of Islam (exh. cat., ed. T. Falk; Geneva, Mus. A. & Hist., 1985), nos. 185–6

B. W. Robinson: "Painting in the Post-Safavid Period," *The Arts of Persia*, ed. R. W. Ferrier (New Haven and London, 1989), pp. 225–31

B. W. Robinson: "Persian Painting under the Zand and Qājār Dynasties," *From Nadir Shah to the Islamic Republic* (1991), vii of *The Cambridge History of Iran* (Cambridge, 1968–91), pp. 879–80 and fig. 21a

Muhammad Yusuf [Mir Muḥammad Yūsuf al-Ḥusaynī Muṣavvir] (*fl.* Isfahan, 1636–66). Persian painter. A prolific artist during the reigns of the Safavid shahs Safi (*r.* 1629–42) and ʿAbbas II (*r.* 1642–66), Muhammad Yusuf worked in a variety of styles. His earliest works, including the eight illustrations in a copy (1636; London, BL, Add. MS. 7922) of Baqi's *Dīvān* (collected poetry) and single-page drawings and paintings (e.g. *Youth Holding a Cane*; Boston, MA, Mus. F.A., 14.637), exhibit fine draftsmanship and a bright palette. In the 1640s he adopted a bolder calligraphic style for tinted drawings, such as the ones illustrating a copy of Hafiz's *Dīvān* (1640; Istanbul, Topkapı Pal. Lib., H. 1010) and several single-page compositions (e.g. Paris, Bib. N., MS. arabe 6074, fols. 3*r*, 4*v* and 5*r*). This change from the artistic ideals of the early 17th century to a new linear style may have resulted from exposure to the work of his contemporary MUHAMMAD QASIM, with whom he collaborated on several manuscripts, including the *Dīvān* of Hafiz in Istanbul.

I. Stchoukine: *Les Peintures des manuscrits de Shah ʿAbbas 1er à la fin des Safavis* (Paris, 1964)

B. Gray: "The Arts in the Safavid Period," *The Timurid and Safavid Periods*, ed. P. Jackson (1986), vi of *The Cambridge History of Iran* (Cambridge, 1968–91), p. 904 and pl. 65b

Prince, Poets & Paladins: Islamic and Indian Paintings from the Collection of Prince and Princess Sadruddin Aga Khan (exh. cat. by S. R. Canby; London, BM; Cambridge, MA, Sackler Mus.; Zurich, Mus. Rietberg; Geneva, Mus. A. & Hist.; 1998–2000), p. 78

S. R. Canby: *The Golden Age of Persian Art 1501–1722* (London, 1999), pp. 122, 138–9 and fig. 129

Muhammad Zaman [Muḥammad Zamān ibn Ḥājjī Yūsuf Qumī] (*fl.* 1649–1704; *d.* before 1720–21/AH 1133). Persian painter. He was the foremost practitioner of stylistic eclecticism in 17th-century SAFAVID painting (*see* ILLUSTRATION, §VI, A). In 20th-century writing on Persian painting he was confused with a Persian Christian called Muhammad-Paolo Zaman, who is mentioned in the *Storia do Mogor*, a history of Mughal India by the Venetian adventurer Niccolas Manucci (?1639–after 1712). According to Martin, for instance, Muhammad Zaman was sent by Shah ʿAbbas II to study painting in Rome in the 1640s; he returned a convert to Christianity and had to take refuge at the court of the Mughal emperor, Shah Jahan, who gave him an official post in Kashmir. This theory would account for the distinctive features in his painting, such as figures in European dress, an interest in atmosphere, night scenes and cast shadows, and an elusive but pervasive flavor of Mughal India. In 1962, however, this account was discredited by the publication of the Leningrad (now St. Petersburg) Album (St. Petersburg, Hermitage, E-14), and Muhammad Zaman's paintings remain the only source of information on his career.

Muhammad Zaman's spidery, black signature, usually referring to himself in one of the standard Persian formulae of self-deprecation, occurs on no fewer than 40 works. The most important include a *Night Scene* mounted in the Davis Album (New York, Met., 30.95.174.1), a series of penboxes and other papier-mâché objects dated between 1659 and 1674 (Tehran, priv. cols, see Zukāʾ, figs. 2–7 and 50–57) and six fine miniatures added to two unfinished royal manuscripts of the 16th century, five of which are dated AH 1086 (1675–6). Four of these were inserted in a copy of the *Khamsa* ("Five poems") of Nizami made for Shah Tahmasp between 1539 and 1543 (three in London, BL, Or. MS. 2265; the fourth, Soudavar priv. col.); the other two are in a fragmentary copy of the *Shāhnāma* ("Book of kings") of Firdawsi associated with Shah ʿAbbas I and datable to *c.* 1587 (Dublin, Chester Beatty Lib., Pers. MS. 277). Despite their traditional subject matter, the use of perspective, modeling with colors, landscape elements and other conventions drawn from

Western painting in these miniatures creates an unsettling contrast with the original 16th-century illustrations.

Other outstanding examples of Muhammad Zaman's work are the 16 miniatures of 1675–8 that he painted for an undedicated copy of Nizami's *Khamsa* (15 in New York, Pierpont Morgan Lib., MS. M. 469; one in a priv. col.) and six extraordinary and highly eclectic paintings based on Flemish and Italian prints, five of which bear dates between 1682 and 1689 (three mounted in the St. Petersburg Album, fols. 86, 89 and 94; one in Cambridge, MA, Fogg, inv. no. 1966.6; one Switzerland, priv. col.; the last untraced). All these are in a remarkably homogeneous, highly polished and finished style that does not need to be explained by a sojourn in Rome. Rather the artist's consistent mannerisms suggest that the European elements in his art were learnt in Iran from European prints, whose compositions were either selectively mined for details or copied in their entirety. Prints by Egbert van Panderen (*c.* 1581–?after 1628), Lucas Vorsterman I (1596–1675; reproducing a painting by Peter Paul Rubens (1577–1640)), Raphael Sadeler I (1560/61–1632) and others based on paintings by Italian masters, including one by Guido Reni (1575–1642), have been identified as the sources for some of Muhammad Zaman's paintings. The same Europeanizing style appears on papier-mâché objects painted by Muhammad Zaman and his brother Muhammad Ibrahim (ibn Hajji Yusuf) (*see* Lacquer). A son, Muhammad 'Ali (ibn Muhammad Zaman), also painted in his father's manner, as in a painting depicting the *New Year Audience of Shah Sultan Husayn* (1772; London, BM).

N. Manucci: *Storia do Mogor* (MS.; 1699–1709); Eng. trans. by W. Irvine as *Storia do Mogor, or Mogul India*, ii (London, 1907/*R* New Delhi, 1981), pp. 17–18

F. R. Martin: *The Miniature Painting and Painters of Persia, India and Turkey from the 8th to the 18th Century*, 2 vols. (London, 1912), i, pp. p. 76; ii, pl. 173

A. A. Ivanov: "Persidskiye miniatyury" [The Persian miniatures], *Al'bom indiyskikh i persidskikh miniatyur XVI–XVIII vv.* [An album of Indian and Persian miniatures of the 16th–18th centuries], ed. L. T. Guzal'yan (Moscow, 1962), pp. 44–55, pls. 83–90

Y. Zukā': "Muḥammad Zaman, nakhustīn nigārgar-i īrānī ki ba Urūpā firistāda shud" [Muhammad Zaman, the first Iranian artist to be sent to Europe], *Nigāh ba nigārgarī-i Īrān dar sadahā-yi davāzdahum va sīzdahum* [A look at painting in Iran in the 12th and 13th centuries AH] (Tehran, Iran. Solar 1353/1975), pp. 37–79

E. G. Sims: "Five Seventeenth-century Persian Oil Paintings," *Persian and Mughal Art*, ed. M. Goedhuis (London, 1976), pp. 228–30

E. G. Sims: "Late Safavid Painting: The Chetel Sutun, the Armenian Houses, the Oil Paintings," *Akten des VII. internationalen Kongresses für iranische Kunst und Archäologie*: München, 1976, pp. 408–18

A. A. Ivanov: "The Life of Muhammad Zaman: A Reconsideration," *Iran*, xvii (1979), pp. 65–70

E. G. Sims: "The European Print Sources of Paintings by the Seventeenth-century Persian Painter, Muhammad Zaman ibn Haji Yusuf of Qum," *Le stampe e la diffusione delle immagini e degli stili*, ed. H. Zerner (Bologna, 1983), pp. 73–83, pls. 76–83

Treasures of Islam/Trésors d'Islam (exh. cat., ed. T. Falk; Geneva, 1985), p. 129, no. 102 [ptg related to the works in the St. Petersburg Album]

A. Soudavar: *Art of the Persian Courts* (New York, 1992), pp. 374–5, fig. 151

O. Akimuškin and others: *Il Murakka' di San Pietroburgo: Album di miniature indiane e persiane del XVI–XVIII secolo* (St. Petersburg, Lugano and Milan, 1994) pp. 20, 69, 71, 73, 78, 83, 84, 109–114

N. D. Khalili, B. W. Robinson and T. Stanley: *Lacquer of the Islamic Lands* (1996), xxii/1 of *The Nasser D. Khalili Collection of Islamic Art*, ed. J. Raby (London, 1992–)

Royal Persian Paintings: The Qajar Epoch 1785–1925 (exh. cat. by L. S. Diba with M. Ekhtiar; New York, Brooklyn Mus.; Los Angeles, CA, Armand Hammer Mus. A.; London; U. London, SOAS, Brunei Gal., 1998–9)

Prince, Poets & Paladins: Islamic and Indian Paintings from the Collection of Prince and Princess Sadruddin Aga Khan (exh. cat. by S. R. Canby; London, BM; Cambridge, MA, Sackler Mus.; Zurich, Mus. Rietberg; Geneva, Mus. A. & Hist.; 1998–2000), pp. 68, 81, 90–92, 94

S. R. Canby: *The Golden Age of Persian Art 1501–1722* (London, 1999), pp. 105, 149, 150–51, 164, 166, 168 and figs. 140 and 156

E. Sims: "Towards a Monograph on the 17-century Iranian Painter Muḥammad Zamān ibn Ḥāji Yūsuf," *Islam. A.*, v (2001), pp. 183–99

Mu'in [Mu'īn Muṣavvir] (*b. c.* 1617; *fl.* Isfahan, 1635–97). Persian illustrator and painter. Numerous works clearly signed in black ink *mu'īn muṣavvir* ("Mu'in the painter") establish the dates of this artist's activity. He codified the style developed by his teacher Riza and remained impervious to the eclecticism of late 17th-century art (*see* Illustration, §VI, A). Mu'in often drew in magenta; his art had a firm ground in calligraphy and an equally firm colorism, but his palette is less intense than Riza's and less deep in tonality; his figures are also less mannered in form and less extravagant in line than Riza's and the males often sport the broad moustaches made fashionable by the Safavid shah 'Abbas I (*r.* 1588–1629). Signed works by Mu'in include copiously illustrated manuscripts, nearly 60 single-figure paintings and ink drawings, and painted and varnished bookbindings (*see* Lacquer). Many of the manuscripts (e.g. Dublin, Chester Beatty Lib., P. 270, dated 1656) are copies of Firdawsi's *Shāhnāma* ("Book of kings"). Such drawings as *A Lion Attacking a Youth* (1672; Boston, MA, Mus. F.A.) and *Portrait of Riza* (1635–73; Princeton U., NJ, Lib.), both of which have long, informative and highly personal inscriptions, convey the essence of the man. Mu'in's style is also evident in contemporary mural paintings, especially those in the Chihil Sutun pavilion (*see* Isfahan, §III, G). A prolific artist with many followers, he would have finished, and signed, many

pictures alone, while assistants such as Fazl'ali, whose signature appears together with Mu'in's on some illustrations in the Cochran *Shāhnāma* (New York, Met.), and others still anonymous, would have finished other pictures that bear Mu'in's signature or are in his distinctive style.

E. Kühnel: "Der Maler Mu'in," *Pantheon*, xxix (1942), pp. 108–14

I. Stchoukine: *Les Peintures des manuscrits de Shāh 'Abbās Ier à la fin des Safavis* (Paris, 1964), pp. 62–71 *ff*

B. W. Robinson: "The Shāhnāmeh Manuscript Cochran 4 in the Metropolitan Museum of Art," *Islamic Art in the Metropolitan Museum of Art*, ed. R. Ettinghausen (New York, 1972), pp. 73–86

E. J. Grube and E. G. Sims: "Wall Paintings in the Seventeenth-century Monuments of Isfahan," *Iran. Stud.*, vii (1974), pp. 511–42, figs. 1–5

M. Farhad: "The Art of Mu'in Musavvir: A Mirror of his Time," *Persian Masters: Five Centuries of Painting*, ed. S. R. Canby (Bombay, 1990), pp. 113–28

M. Farhad: "An Artist's Impression: Mu'in Musavvir's Tiger Attacking a Youth," *Muqarnas*, ix (1992), pp. 116 23

N. D. Khalili, B. W. Robinson and T. Stanley: *Lacquer of the Islamic lands* (1996), xxii/1 of *The Nasser D. Khalili Collection of Islamic Art*, ed. J. Raby (London, 1992–), pp. 38–43

Prince, Poets & Paladins: Islamic and Indian Paintings from the collection of Prince and Princess Sadruddin Aga Khan (exh. cat. by S. R. Canby; London, BM; Cambridge, MA, Sackler Mus.; Zurich, Mus. Rietberg; and Geneva, Mus. A. & Hist.; 1998–2000), pp. 16, 17, 82–9

S. R. Canby: *The Golden Age of Persian Art 1501–1722* (London, 1999), pp. 122–3, 125, 134, 136, 148, 151, 154 and figs. 123–4

E. Sims: *Peerless Images: Persian Painting and its Sources* (New Haven, 2002), pp. 71 and 73 and pl. 193

Mu'izzi. Name given to the line of Turkish sultans who conquered and ruled northern India from 1206 to 1290. The line is known as the Mu'izzi Mamluks of Delhi because the founder Qutb al-Din Aybak (*r.* 1206–10) was originally a slave (Arabic *mamlūk*) of the GHURID king Mu'izz al-Din Muhammad; two later sultans, Shams al-Din Iltutmish and Ghiyath al-Din Balban, were also manumitted slaves. As a trusted lieutenant, Qutb al-Din extended Ghurid power over the Ganges region. In Delhi he initiated the construction of the Quwwat al-Islam Mosque (*see* DELHI, §III, A) and in AJMER the Arhai Din ka Jhompra Mosque. These are the earliest and most important monuments of the Sultanate period. Iltutmish (*r.* 1211–36) consolidated Mamluk rule from the Indus to eastern India, building extensively at Delhi, Badaon and elsewhere. The most impressive buildings in Delhi are the extensions to the Quwwat al-Islam Mosque and his own tomb, situated near by. After the death of Iltutmish, a conflict ensued between his heirs and the nobles. Five rulers acceded to the throne within a decade. Finally, in the absence of a direct heir, Ghiyath al-Din Balban (*r.* 1266–87) came to power. Although he restored order to the sultanate, few building projects appear to have been undertaken. The most notable is Balban's tomb, now in ruins. Balban was succeeded by his grandson Mu'izz al-Din Kaiqubad (*r.* 1287–90). He shifted the capital to Kilokari, close to the present headworks of the Okhla Canal. The site is marked by a few ruins. Balban's line was abruptly ended in 1290 when the KHALJI dynasty seized power.

Enc. Islam/2: "Dilhi Sultanate"

Minhaj al-Din 'Uthman al-Juzjani: *Ṭabaqāt-i Nāṣirī* [An account of Nasir (al-Din Mahmud)] (*c.* 1259–60); Eng. trans. by H. G. Raverty, 2 vols. (London, 1881/R New Delhi, 1970)

Ziya al-Din Barani: *Tārīkh-i Fīrūz Shāhī* [History of Firuz Shah] (MS. 1357; Calcutta, 1860–62; Aligarh, 1957) [extracts trans. in Eng. in H. Elliot and J. Dowson: *History of India as Told by its Own Historians (The Muhammedan Period)*, iii (London, 1866–77/R Allahabad, 1964), pp. 93–268 and *J. Asiat. Soc. Bengal* (1869), pp. 181–220; (1870), pp. 1–51, 185–216; (1871), pp. 217–47]

R. C. Majumdar, ed.: *The Delhi Sultanate*, vi of *The History and Culture of the Indian People* (Bombay, 1960/R 1967)

S. J. Raza: "Nomenclature and Titulature of the Early Turkish Sultans of Delhi Found in Numismatic Legends," *Medieval Indian Coinages: A Historical and Economic Perspective*: February 17th–19th, 2001: 5th International Colloquium, pp. 85–96

Mukhtar, Mahmud [Mukhtār, Mahmūd; Moukhtar, Mahmoud] (*b.* Tanyra, 10 May 1891; *d.* Cairo, 27 March 1934). Egyptian sculptor. After graduating from the School of Fine Arts, Cairo in 1911, he was sent by the founder of the School, Prince Yusuf Kamal, to study sculpture at the Ecole des Beaux-Arts, Paris. Although Mukhtar was at ease in France and regularly exhibited at the Salon des Artistes Français, he increasingly looked for an Egyptian identity in art. In order to re-establish an Egyptian style in monumental sculpture he developed a "neo-pharaonic" style, and became the first Egyptian artist to use granite since ancient Egyptian times. *Egyptian Awakening* (1919–28), his massive pink granite statue depicting a sphinx about to rise and a woman unveiling, is set at the gateway to Cairo University.

During the 1920s Mukhtar became an influential figure in modern Egyptian art, prominent in the group La Chimère (founded 1927), which included the painters Raghib Ayyad (1892–1982), MOHAMMED NAGHI and MAHMUD SAID. In addition to his "neo-pharaonic" sculptures, he also produced works in other styles; for example *The Nile Bride* (Paris, Mus. Grévin), a marble figure of the late 1920s, was inspired by the Greco-Roman tradition. He also executed caricature sculptures and a series of cartoon drawings that appeared in the satirical paper *al-Kashkul*. He carved two statues of the nationalist leader Sa'd Zaghlul (1857–1927), one in Cairo and the other in Alexandria. In Cairo the Mukhtar Museum (opened 1964), in a building designed by the Egyptian architect Ramses Wissa Wassef (1911–74), contains a range of his sculptures, including *Khamsin Winds* (limestone, late 1920s), *The Blind*

(bronze, 1929), *Fellaha Lifting Jug* (limestone, 1929) and *Siesta* (red porphyry, early 1930s).

Badr El-Dine Abou Ghazi and G. Boctor: *Moukhtar, ou le réveil de l'Egypte* (Cairo, 1949)

M. S. al-Jabakhanji: *Tārīkh al-haraka al-fanniyya fī mis ilā ʿaynām 1945* [A history of the artistic movement in Egypt to 1945] (Cairo, 1986)

L. Karnouk: *Modern Egyptian Art: The Emergence of a National Style* (Cairo, 1988)

W. Ali, ed.: *Contemporary Art from the Islamic World* (London, 1989), pp. 24–9, 200

R. Ostle: "Modern Egyptian Renaissance Man," *Bull. SOAS*, lvii/1 (1994), pp. 184–92

L. Karnouk: *Modern Egyptian Art, 1910–2003* (Cairo, 2005), pp. 15–20

C. Williams: "Twentieth-century Egyptian Art: The Pioneers, 1920–52," *Re-envisioning Egypt 1919–1952*, ed. A. Gold-schmidt, A. J. Johnson, and B. A. Salmoni (Cairo, 2005), pp. 426–47

Mukund [Mukunda] (*fl. c.* 1570–1600). Indian miniature painter. All known works by Mukund were painted under the patronage of the MUGHAL emperor Akbar (*r.* 1556–1605). He must have joined the court atelier before the time of the *Razmnāma* ("Book of wars"; 1582–6; Jaipur, Maharaja Sawai Singh II Mus., MS. AG. 1683–1850), for the earliest works ascribed to him record the rare assignment of both the design and execution of six illustrations in that manuscript and another five in the *Khamsa* ("Five poems") of Nizami of *c.* 1585 (London, priv. col.). His prominence in the atelier is affirmed by ascriptions in all major manuscripts of the 1580s and 1590s and his inclusion among the 17 painters named in the *Āyīn-i Akbarī*, a contemporary account of Akbar's administration.

Like most Mughal painters, Mukund was capable of working in a variety of styles, from the relatively open composition, stocky figures, and *nīm qalam* (uncolored) style of the *Akbarnāma* ("History of Akbar"; 1596–7; Dublin, Chester Beatty Lib., MS. 3, fol. 202b; alternatively dated *c.* 1604) to the deep landscapes and nervous forms of the *Khamsa* of Nizami of 1595 (London, BL, Or. MS. 12208, fol. 19r). Nevertheless, his architectural settings and townscapes are consistently a flattened jumble of pastel walls and skewed pavilions. His figures often display a similar awkwardness, especially when incited to action or dramatic gestures. For example, Mukund's design for two paintings in an *Akbarnāma* (*c.* 1590; London, V&A, IS.2:1986, 70, 71/117) links a row of onlookers by means of interlocked arms, a formulaic solution whose tediousness is relieved in the latter work only by superior painting by MANOHAR. Mukund retained the facial conventions of the 1580s until the end of his career *c.* 1600, making his lightly modeled figures in three-quarter profile somewhat less expressive than those of his contemporaries.

The Imperial Image: Paintings for the Mughal Court (exh. cat. by M. C. Beach, Washington, DC, Freer, 1981)

D. Walker and E. Smart: *Pride of the Princes: Indian Art of the Mughal Era in the Cincinnati Art Museum* (Cincinnati, OH, 1985)

M. C. Beach: *Early Mughal Painting* (Cambridge, MA, 1987)

L. Y. Leach: *Mughal and Other Indian Paintings from the Chester Beatty Library* (Dublin, 1995), pp. 131, 133, 237, 256, 269, 276

Prince, Poets & Paladins: Islamic and Indian Paintings from the Collection of Prince and Princess Sadruddin Aga Khan (exh. cat. by S. R. Canby; London, BM; Cambridge, MA, Sackler Mus.; Zurich, Mus. Rietberg; Geneva, Mus. A. & Hist.; 1998–2000), no. 90

Mulla Sadiq. *See* MUHAMMAD SADIQ.

Multan. Town in Pakistan. An ancient stronghold of the Gandhara kingdom, the city was annexed to the Achaemenid Empire by Darius (*r.* 522–486 BCE) and, after Alexander the Great (*r.* 336–323 BCE), controlled successively by Bactrian, Indo-Parthian and Kushana dynasties. Traces of these cultures are buried beneath the core of the old citadel. The Buddhist remains in the region include the ruins of the town of Tulamba and a monastery and tower at the site of Sui Vihara. Ancient Multan probably had a concentric plan, with the citadel containing a stupa or temple in the center, similar in layout to Tulamba. With a revival of Hinduism in the 6th century CE, Multan fell under the sway of that faith, notably the worship of the sun god; in 641 the Chinese Buddhist pilgrim Xuanzang recorded that the worship of Buddha had almost disappeared. In the Arab invasion of Sind in 711 Multan was taken by Muhammad ibn Qasim, but in the 10th century the geographer al-Istakhri described the town as still predominantly Hindu, with the great temple known as Bayt al-dhahab (House of Gold) in the center of the town, while the Arab ruler lived 3 km away. Multan, however, was reconstructed and its plan adapted to that of an Islamic town, with the site of the old citadel incorporated in the ramparts of the Islamic fort at one side of the town. Together with Sind, Multan became a stronghold of the Shiʿites, who were later suppressed under the GHAZNAVID dynasty (*r.* 977–1186). Subsequently the town was under the KHALJI sultans of Delhi (*r.* 1290–1320) and the MUGHAL emperors (*r.* 1526–1857). After the annexation of the Punjab by the British in 1849, an obelisk and other memorials were erected, but the fort was demolished. The high mound of the citadel still dominates the city, however, and preserves within its core the original street layout.

Multan has a tradition of brick architecture with characteristic battered walls and corner towers, a style associated with Khurasan rather than India. The earliest Muslim building is the 12th-century ribat of Khalid Walid at nearby Kabirwala, a plain, ruinous building with an exceptionally fine mihrab of cut and molded brick decorated with Kufic inscriptions. Other pre-Mughal buildings are the shrine of Shah Yusuf Gardizi, which was built in 1152 and then

restored and covered with tiles in 1548, and the tombs of Shaikh Baha al-Haqq Zakariya (*d.* 1262), Shadna Shahid (*d.* 1270) and Shams al-din Tabrizi (*d.* 1276). These tombs, in the form of square, domed chambers, greatly influenced the later tomb architecture of India. The most celebrated tomb of Multan is that of Rukn-i 'Alam (1320–24). It consists of an octagonal tomb chamber with a hemispherical dome and tapering towers at each corner. Its finely carved wooden mihrab is unparalleled in Islamic India. The Mughal tombs of Multan are strongly influenced by earlier forms, particularly that of the tomb of Rukn-i 'Alam. Examples are the tombs of Sultan 'Ali Akbar, Sa'id Khan Quraishi and Ma'i Mihraban. The Sawi Mosque and the 'Idgah combine the Mughal style with the local architectural tradition of brick and ceramic tiles.

A. Cunningham: *The Ancient Geography of India* (London, 1871), pp. 230–41

A. Cunningham: *Archaeol. Surv. India Rep.*, v (1875), pp. 114–36

J. Marshall: "The Monuments of Muslim India," *The Cambridge History of India*, iii (Cambridge, 1928), pp. 597–9

A. Nabi Khan: *Multan: History and Architecture* (Islamabad, 1983)

B. B. Taylor: "Rebirth: Tile-making in Multan," *Mimar*, ix (1983), pp. 7–13

A. N. Khan: "Mausoleum of Shaikh Baha-u'd-din Zakariya at Multan and Introduction of Central Asian Art Tradition in South Asia," *J. Res. Soc. Pakistan*, xxiii/2 (1986), pp. 13–24

H. Edwards: "The Ribāṭ of 'Alī b. Karmākh," *Iran*, xxix (1991), pp. 85–94

R. Hillenbrand: "Turco-Iranian Element in the Medieval Architecture of Pakistan: The Case of the Tomb of Rukn-i'Alam at Multan," *Muqarnas*, ix (1992), pp. 148–74

H. Gaube: "Das Mausoleum des Yūsuf Gardīzī in Multan," *Oriens*, xxxiv (1994), pp. 330–47

R. Hillenbrand: "The Architecture of the Ghaznavids and Ghurids," *Sultan's Turret: Studies in Persian and Turkish Culture*, ii of *Studies in Honour of Clifford Edmund Bosworth*, ed. C. Hillenbrand (Leiden, 2000), pp. 124–206 [extensive bibliog.]

F. B. Flood: "Ghūrid Architecture in the Indus Valley: The Tomb of Shaykh Sādan Shahīd," *A. Orientalis*, xxxi (2001), pp. 129–66

K. Qadir: "Architectural Remains in Multan and its Environs: Local Precedents and Muslim Antecedent," *Lahore Mus. Bull.*, xiv/1 (2001), pp. 9–22

A. Patel: "Toward Alternative Receptions of Ghurid Architecture in North India (Late Twelfth–Early Thirteenth Century CE)," *Archvs Asian A.*, liv (2004), pp. 35–61

Muqarnas [Arab. *muqarnas*; *muqarnaṣ*; *muqarbaṣ*; Sp. *mocárabes*]. Three-dimensional decorative device used widely in Islamic architecture, in which tiers of individual elements, including niche-like cells, brackets and pendants, are projected over those below (for illustration *see* ABBASID). *Muqarnas* decoration, executed in stucco, brick, wood and stone, was consistently applied to cornices, squinches, pendentives, the inner surfaces of vaults and other parts of buildings throughout the Islamic world from the 12th century. Seen from below, the *muqarnas* presents a stunning visual effect as light plays over the deeply sculpted but regularly composed surface; this explains the comparison of *muqarnas* in European languages with "stalactite vaulting" (Ger. *Stalaktitengewölbe*) or "honeycombs" (Fr. *alvéoles*). The Arabic term *muqarnas* first appears in the 12th century, but a related verb had been used a century earlier to describe deeply carved and molded stucco ornament on Islamic architecture. It has been suggested and widely accepted that the word derives from the Greek *koronis* ("cornice"), although this derivation is not confirmed in any Arabic or Persian source. The Arabic lexicographer Firuzabadi (*d.* 1415) defined *muqarnas* as a form with stepped or serrated edges and the related word *qirnās* as a projecting rock on a mountain. These two definitions encompass the most salient features of all *muqarnas* decoration, namely fragmentation and seemingly unsupported projection. Scholars have focused their attention on the history and development of this most characteristic feature of Islamic architecture, and some have seen *muqarnas* as a manifestation of basic principles in the formation of an Islamic aesthetic.

I. Before *c.* 1100. II. After *c.* 1100.

I. Before c. 1100. The earliest ensembles of *muqarnas* decoration survive on 11th-century buildings in Iran and Central Asia, North Africa, Upper Egypt and Iraq, but the broad geographical distribution of these examples and their technical sophistication suggest that the form had evolved in one of these regions at least a century earlier and was then diffused to other Islamic lands. Such early scholars as Rosintal, Creswell and Marçais, however, interpreted the data as evidence of spontaneous and parallel developments in Iran, Egypt and North Africa.

The earliest known evidence for *muqarnas*-like decoration consists of concave triangular pieces of stucco excavated at NISHAPUR in northeast Iran, datable to the 9th or 10th century, and tentatively reassembled by the excavators to form a tripartite squinch. This reconstruction remains conjectural, and the earliest tripartite squinch *in situ* is found at the Arab-Ata Mausoleum at Tim (977–8) in the Zarafshan Valley of Uzbekistan, where niche-like elements, built of brick but similar in form to those found at Nishapur, have been combined within a trefoil arch. This type of tripartite squinch was successfully utilized in several 11th-century Iranian buildings, such as the GUNBAD-I QABUS (1006–7), where it appears over the portal, and the dome chamber of the Duvazdah Imam Mausoleum (1037–8) in YAZD. The tripartite squinch was fully exploited in the two dome chambers added in the late 11th century to the Friday Mosque at Isfahan (*see* ARCHITECTURE, fig. 12). At the Friday Mosque (1105–18) at Golpayegan, the squinches in the dome chamber enclose heptafoil arches formed by four tiers of

projecting elements, and five tiers, for example, are used over the portal to the Ghaffariyya tomb tower (14th century) at MARAGHA.

Niche-like elements were also combined in Iranian architecture to form cornices separating the roof from the shaft of a tomb tower and the stories of a minaret. At the Gunbad-i 'Ali (1056) in ABARQUH, for example, three tiers of niche-like elements project above the inscription band to form a highly sculpted cornice, which contrasts sharply with the smooth surfaces of the octagonal shaft and hemispheric dome. The cornice at Abarquh is constructed of mortared rubble, but most Iranian examples, such as the tomb tower at Risgit (c. 1100), are built of brick, as are the deeply sculpted cornices on Iranian minarets, although that of the Muhammad Mosque (1081–2) at BAKU in Azerbaijan is made of stone. The use of deeply sculpted cornices of niche-like elements to separate the parts of buildings may have developed from the local building tradition in which courses of shaped and angled bricks were corbelled to differentiate parts of buildings (e.g. DAMGHAN, Pir-i 'Alamdar tomb tower, 1026–7).

Excavations at the 11th-century site of QAL'AT BANI HAMMAD in Algeria yielded several, small, baked ceramic parallelepipeds (47×47×160 mm), fluted on three or four sides. Marçais reconstructed them in pendant clusters that would have hung from the juncture of a flat ceiling and a wall, but this reconstruction remains conjectural, and these elements stand outside the main development of *muqarnas*. Concave stucco cells grouped with brackets were also found at the site and dated to the mid-11th century. Golvin reconstructed them in corbelled tiers to show similarities to later *muqarnas* vaults in Iraq, North Africa and Sicily. It is quite unlikely, however, that such an important form originated in this remote North African site, and the technical sophistication of these fragmentary remains suggests that the form had an earlier history.

The earliest *muqarnas* cornice to survive in Egypt is found on the minaret of the Mashhad al-Juyushi (1085) in Cairo, where two (or perhaps three) tiers of niche-like elements separate the stories of the shaft. Painted plaster *muqarnas* elements were found in the ruins of the bath of Abu'l-Su'ud in Fustat (Old Cairo) and have been dated to the late 11th century. In several mausolea at Aswan in Upper Egypt and in Cairo, some of which date from the late 11th century, the zones of transition are variously elaborated, sometimes even approximating the appearance of *muqarnas*. They seem to reflect the now-lost architecture of the Hijaz, to which Upper Egypt was connected by the pilgrimage route across the Red Sea. The Hijaz, again, is an unlikely source for the origin of the form, and it was probably imported there as it was to central North Africa.

The earliest extant dome constructed entirely of *muqarnas* elements is the shrine of Imam Dur (1085–90), built by the 'Uqaylid prince Muslim ibn Quraysh in the tiny village of Dur, some 20 km north of Samarra in Iraq. An elongated square (h. 12 m)

topped by a vault of almost equal height, the chamber is transformed into an octagon by four squinches and four arches. The upper vault is composed of four eight-celled tiers of diminishing size, each rotated 45 degrees. The internal organization is reflected on the exterior by the tiered pyramid of alternating rounded and angular projections. The layering of increasingly small cells with multiple profiles makes the interior of the vault appear insubstantial, as the play of light on its intricate surfaces dissolves the mass. Such visual display is one of the novel characteristics of the *muqarnas* dome and distinguishes it from 11th-century Iranian domes, in which the use of *muqarnas* elements is restricted to the zone of transition. The sophisticated application of *muqarnas* in this small village shrine argues for the existence of earlier models elsewhere. The most likely place is the nearby capital of Baghdad, which underwent a cultural and political revival in the early 11th century under the stridently Sunni leadership of the Abbasid caliph al-Qadir (r. 991 1031), although none of its monuments from this period has survived. Tabbaa has suggested that during al-Qadir's reign *muqarnas* elements were first combined to form a dome, a fragmented and ephemeral structure that was a suitable metaphor for the atomistic theology propagated by the caliph's chief apologist, al-Baqillani. The relationship of the *muqarnas* dome to earlier elements, such as the tripartite squinch, the *muqarnas* cornice and the scattered fragments, is still unclear, but by the 12th century *muqarnas* had become a ubiquitous decorative device in Islamic architecture, used for a variety of purposes.

II. After c. 1100. The popularity of *muqarnas* from the 12th century on allows several distinct regional types to be delineated. The type used in southern Iraq follows the example of the shrine of Imam Dur and has tall conical brick vaults in which the inner articulation is reflected on the exterior, creating the appearance of a pine cone. In the shrine of Zumurrud Khatun at Baghdad, built by the Abbasid caliph al-Nasir (r. 1180–1225), the vault springs from an octagonal base. The type used in northern Iraq and northeast Syria consists of a brick or stucco *muqarnas* vault covered by a pyramidal brick roof, which is sometimes glazed. The finest example in MOSUL is the shrine of Imam 'Awn al-Din (1245), in which the central vault rests on four little *murqarnas* vaults at the corners. The individual cells of the central vault are made of small rectangular strips of glazed brick, a coloristic effect that enhances the sumptuousness of the interior. This vault, or one like it, may have provided the model for a technically related *muqarnas* vault over the tomb of Shaykh 'Abd al-Samad at Natanz (1307) in central Iran (*see* ARCHITECTURE, color pl.). The stucco vault at Natanz epitomizes the variety and complexity of form and richness of decoration of such structures erected in Iran under the Ilkhanid dynasty (r. 1256–1353). The earliest *muqarnas* portal vaults to survive in Iran date from the same time, and their high degree of

development presupposes the existence of earlier examples. An incised plaster plan for a *muqarnas* vault and stucco fragments were excavated from the ruins of the Ilkhanid palace (*c.* 1275) at Takht-i Sulayman in northwest Iran; they indicate that the precision and complexity of these vaults were achieved by sketching out the plan beforehand in order to facilitate construction. The popularity of the form in Iran is attested by the lyric poet Hafiz (*d.* 1389), who often used the expression *falak-i muqarnas* to refer to the dome of heaven.

Some spectacular *muqarnas* vaults were erected in the eastern Islamic world under the TIMURID dynasty (*r.* 1370–1506). At the shrine of Ahmad Yasavi at Turkestan, for example, the large central room, the mosque and the tomb have *muqarnas* vaults (for illustration *see* TURKESTAN), but the radial organization and emphasis on the ribbed crown differentiate them from earlier examples. Tiers of *muqarnas* cells were also used on exteriors to make the transition between the tall cylindrical drum and the base of the ribbed dome, creating the characteristic swelling profile of Timurid buildings. Tiers of cells continued to be used to separate the stages of minarets. Under the Timurids a new type of ribbed vault was developed, in which *muqarnas* cells were sometimes used to fill the interstitial surfaces. Although *muqarnas* vaulting seems to have lost some of its appeal in this period, the earliest treatise on the *muqarnas* vault to survive, the *Miftāḥ al-ḥisāb* ("Key to arithmetic"), was written by the Timurid mathematician Ghiyath al-Din al-Kashi in 1427. One chapter of his work presents a typology of *muqarnas* vaults known in his time and analyses them in terms of their individual elements and overall design.

Under the SAFAVID dynasty (*r.* 1501–1732) in Iran, *muqarnas* continued to be used for the vaults of large iwans, and the cells are often covered with tile mosaic, creating an unparalleled shimmering effect (e.g. Isfahan, Friday Mosque). *Muqarnas* vaults were, however, often eliminated from the interiors of religious buildings in favor of flat surfaces covered with brilliantly colored tile mosaic, as in the mosque of Shaykh Lutfallah (1603–19) (*see* ISFAHAN, §III, D). In the 18th century another stage in the evolution of *muqarnas* decoration in Iran began as the individual cells were covered with mirror glass (Pers. *ā'ina-kārī*). One of the earliest examples is the portal to the Chihil Sutun Palace (rest. 1706–7; *see* ISFAHAN, §III, G). Mirror-work *muqarnas* was often used for portals and vaults at the shrines of important Shi'ite martyrs, such as that for Husayn in Karbala in southern Iraq, where they create an oppressive, hypnotic effect.

In Syria the pine cone type of *muqarnas* vault used in Iraq was initially favored in such buildings as the hospital at Damascus built by the ZANGID ruler Nur al-Din (1154). The vestibule is covered by a *muqarnas* dome clearly modeled on Iraqi prototypes and is flanked by two niches covered with *muqarnas* vaults. Made of stucco and suspended from the load-bearing roof by a wooden framework, the vaults contain

pendants and terminate in eight-pointed stars. *Muqarnas* is also used to decorate the shallow hood of the portal, the earliest extant example of a feature that became extremely popular in later times. The translation of the brick and stucco *muqarnas* tradition into stone was concomitant with the development of the vigorous stereotomic tradition in ALEPPO that began in the last quarter of the 12th century, and stone *muqarnas* became one of the hallmarks of architecture in Syria and Egypt under the AYYUBID (*r.* 1169–1260) and MAMLUK (*r.* 1250–1517) dynasties. Herzfeld differentiated *muqarnas* domes of the Ayyubid period into Western and Iranian types, depending on the support system used. The vault of the Western type rises from *muqarnas* pendentives, whereas the vault of the Iranian type rests on squinches themselves made of *muqarnas* cells; both end with a scalloped semi-dome. Visually, the Western type presents a smooth transition from pendentive to staggered rows of cells and brackets to the little dome; the Iranian type, with a more abrupt beginning, looks more like a suspended vault. The Western type seems to be the earlier of the two—the first example being the portal vault of the Shadbakhtiyya Madrasa (1193) in Aleppo—but both types were used simultaneously in Damascus and Aleppo from the beginning of the 13th century. All of the fully developed examples in the 13th century, such as the Firdaws Madrasa (1235) in Aleppo and the Zahiriyya Madrasa in Damascus (1274), are of the Iranian type. *Muqarnas* was also applied to capitals of columns; some of the earliest are the enormous stone capitals (late 12th century) from the Great Mosque of Harran, now in southeast Turkey. The earliest evolved *muqarnas* capitals known adorn the Firdaws Madrasa in Aleppo (1235–7), whence the innovation may have spread north to Anatolia.

Muqarnas decoration was introduced to Anatolia following its conquest in the late 11th century, and examples were executed in wood, stucco and stone following precedents from neighboring Iran and Syria. The hoods of mihrabs were decorated with *muqarnas* in glazed tile (e.g. Konya, Sahib Ata Mosque, 1258); portals had *muqarnas* hoods sculpted in stone (e.g. Sivas, Çifte Minareli Madrasa, 1271; see fig. 1); several tiers of *muqarnas* were used to mark the transition between shaft and roof on tomb towers (e.g. Kayseri, Döner Künbed, *c.* 1275); the capitals of columns were decorated with *muqarnas* (e.g. Afyon, Ulu Cami, 1273); and *muqarnas* supported the balconies of minarets (e.g. Konya, Ince Minareli Madrasa, 1260–65). It was not normally used for pendentives or squinches, as the transition from base to dome was typically effected with a belt of prismatic consoles (*see* ARCHITECTURE, §VI, 2). *Muqarnas* continued to be used in buildings erected under the OTTOMAN dynasty (*r.* 1281–1924), but it was only one of many decorative devices used in classical Ottoman architecture of the 16th century (e.g. Istanbul, Süleymaniye Mosque, 1550–57). The use of *muqarnas* was gradually abandoned in the 18th century in favor of Europeanizing ornament.

In Egypt the first complete and sophisticated example of *muqarnas* is found on the Aqmar Mosque (1125) in Cairo, erected under the patronage of the Fatimid dynasty (*r.* 969–1171). A rectangular panel on the façade is carved with four tiers of *muqarnas*, and the chamfered corner of the building terminates in a hood with two tiers of inscribed *muqarnas*. This building was, however, exceptional, for *muqarnas* decoration became popular only in the mid-13th century. *Muqarnas* squinches in wood may have been used as early as 1211 for the original dome (rest.) over the tomb of Imam al-Shafi'i (*see* CAIRO, §III, F); they were indisputably used there for the dome over the tomb of the Ayyubid sultan al-Salih Najm al-Din Ayyub (*r.* 1240–49). Stone domes carried on pendentives decorated with *muqarnas* were typical of funerary architecture of the Mamluks, as in the mausoleum of Sultan Qa'itbay (1472–4; and CAIRO, §III, J). The Mamluk sultan Baybars I (*r.* 1260–77) is credited with introducing the fashion for a stone portal with a *muqarnas* hood from Syria into Egypt, where it quickly became a major feature of architectural decoration. Stunning *muqarnas* hoods and vaults carved in stone were used to embellish the portals of religious buildings (e.g. complex of Sultan Hasan, 1356–62; *see* CAIRO, §III, I) and palaces (e.g. palace of Yashbak, 1337).

By the mid-12th century complete *muqarnas* domes and vaults were used in North Africa and Sicily. The lobed dome of the Barudiyyin cupola (1107–43; *see* ARCHITECTURE, fig. 28) in Marrakesh, Morocco, rests on an octagon created by the intersecting ribs of two rotated squares. Little spaces in the corners are covered by *muqarnas* cupolas, and the transition to the central dome is so highly elaborated with lobed arches and vegetal ornament that the whole produces the insubstantial effect of a *muqarnas* dome. Although not a true *muqarnas* dome, it could not have been constructed without some knowledge of the type of *muqarnas* domes used in Iraq, such as that of Imam Dur. The filigree-stucco dome over the bay in front of the mihrab at the Great Mosque (1136) at TLEMCEN, Algeria, rests on *muqarnas* squinches and is capped by a *muqarnas* cupola. A series of superbly crafted and varied *muqarnas* vaults, all made of carved stucco, was added to the axial nave of the Qarawiyyin Mosque at FEZ, Morocco, when it was rebuilt in 1134–43. *Muqarnas* vaults are also found in 12th-century buildings erected under Norman patronage in Sicily, one of the few instances where *muqarnas* decoration was used in structures commissioned by non-Muslim patrons. Its use there confirms the continuing importance of North African models in Sicilian architecture of the period. The vault covering the nave of the Cappella Palatina (1131–53; *see* ARCHITECTURE, fig. 17) is the largest and most famous example. Made of wood and worked on seven levels, the scheme comprises three rows of eleven cupolas separated by two rows of ten stellate octagons. The individual elements are superbly painted with figural, vegetal and epigraphic motifs.

Other examples of *muqarnas* vaults at the Ziza Palace (*c.* 1165–7) in Palermo are executed in stucco or stone. The stone vault over the fountain there resembles a *muqarnas* vault of stucco, as it was not assembled from individually carved stone blocks but was carved after construction.

The tradition of *muqarnas* vaulting in the Muslim West attained its greatest sophistication in the vaults and domes of the Alhambra (*see* GRANADA, §III, A). The *muqarnas* domes in the Sala de los Abencerrajes (*see* fig. 2) and the Sala de Dos Hermanas (1354–9) expand the concepts of fragmentation and ephemerality, already evident in the earliest *muqarnas* dome, beyond the limits of logic. A great number of tiny cells in a variety of shapes, including a high proportion of pendants, and brightly colored in blue, ocher and gold, have been joined in intricate compositions. Carefully illuminated by modulated sources of lighting, these ever-changing domes appear to defy gravity, leading such scholars as Grabar to consider them architectural representations of the dome of heaven. The ubiquitous *muqarnas* passed into the architecture of Christian Spain (*see* MUDÉJAR), where it was used in such buildings as the Alcázar of Seville (1364–6), and it was occasionally imitated in European and North American Orientalist architecture (e.g. Columbus, OH, Ohio Theater, 1928). Modern architects in the Islamic world, such as Halim Abdelhalim, have experimented with new forms of the *muqarnas* (e.g. his 1981 entry for the 'Uthman ibn 'Affan Mosque competition in Doha, Qatar; *see* ARCHITECTURE, fig. 60).

Enc. Islam/2: "Muḳarbaṣ," "Muḳarnas"

Ghiyāth al-Dīn Jamshīd al-Kāshī (*d. 1429*): *Miftāh al-hisāb* ["Key to arithmetic"], ed. with Rus. trans. by B. A. Rosenfeld, V. S. Segal and A. P. Yushkevich (Moscow, 1951)

F. Sarre and E. Herzfeld: *Archäologische Reise im Euphrat- und Tigris- Gebiet*, ii (Berlin, 1920)

J. Rosintal: *Pendentifs, trompes et stalactites dans l'architecture orientale* (Paris, 1928)

E. Herzfeld: "Damascus: Studies in Architecture, I," *A. Islam.*, ix (1942), pp. 10–40

K. A. C. Creswell: *The Muslim Architecture of Egypt*, 2 vols. (Oxford, 1952–9)

G. Marçais: *L'Architecture musulmane d'Occident* (Paris, 1954)

L. Golvin: *Recherches archéologiques à la Qal'a des Banu Hammād* (Paris, 1965)

D. Jones: "The Cappella Palatina in Palermo: Problems of Attribution," *A. & Archaeol. Res. Pap.*, ii (1972), pp. 41–57

O. Grabar: *The Alhambra* (Cambridge, MA, 1978)

U. Harb: *Ilkhanidische Stalaktitengewölbe: Beiträge zu Entwurf und Bautechnik* (Berlin, 1978)

A. Paccard: *Le Maroc et l'artisanat traditionnel islamique dans l'architecture*, 2 vols. (St.-Jorioz, 1979)

Y. Tabbaa: "The Muqarnas Dome: Its Origin and Meaning," *Muqarnas*, iii (1985), pp. 61–74

C. K. Wilkinson: *Nishapur: Some Early Islamic Buildings and their Decoration* (New York, 1986)

J. M. Bloom: "The Introduction of the Muqarnas into Egypt," *Muqarnas*, v (1988), pp. 21–8

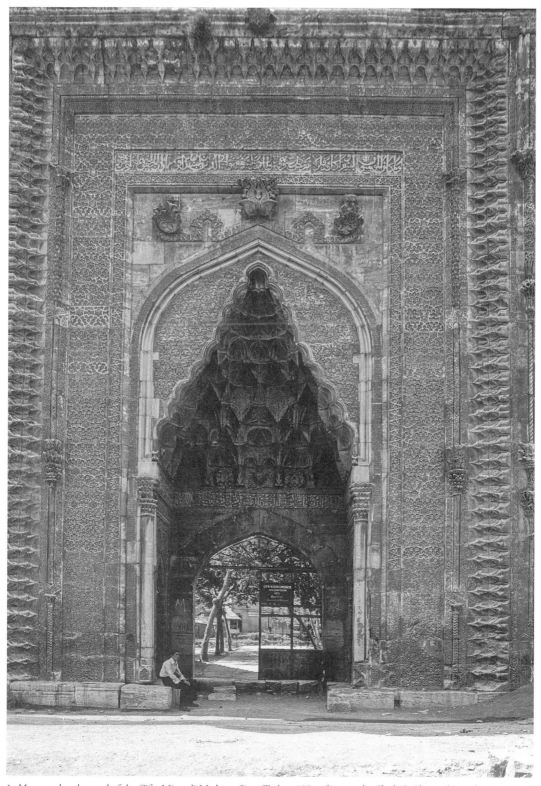

1. *Muqarnas* hood, portal of the Çifte Minareli Madrasa, Sivas, Turkey, 1271; photo credit: Sheila S. Blair and Jonathan M. Bloom

L. Golombek and D. Wilber: *The Timurid Architecture of Iran and Turan* (Princeton, 1988)

G. Necipoğlu: *The Topkapı Scroll–Geometry and Ornament in Islamic Architecture: Topkapı Palace Museum Library MS H.1956* (Santa Monica, 1995) [includes essay on the geometry of the muqarnas by Mohammad al-Asad]

Y. Tabbaa: *Constructions of Power and Piety in Medieval Aleppo* (University Park, PA, 1997)

H. Laleh: "Les muqarnas et leur réprensentation dans les panneaux à décor géometrique de brique de la mosquée de Haydariyya de Qazvin," *Mediaeval and Modern Persian Studies: 2 of Proceedings of the Third European Conference of Iranian Studies held in Cambridge, 11th to 15th September 1995*, Beiträge zur Iranistik, 17 (Wiesbaden, 1999), pp. 419–33

R. Hillenbrand: *Islamic Architecture: Form, Function and Meaning* (Edinburgh, 2000)

B. Pavón Maldonado: "El maʿlis del Taifa al-Muʾtaṣim en la alcazaba de Almería: Muqarnas = muqarbas = 'mucarnas' = almocárabes = mocárabes en el arte hispano-musulman," *Rev. Inst. Egipcio Estud. Islám. Madrid*, xxxii (2000), pp. 221–59

M. A. J. Yaghan: "Decoding the Two-dimensional Pattern Found at Takht-i Sulayman into Three-dimensional Muqarnas Forms," *Iran*, xxxviii (2000), pp. 77–95

A. Ghazarian and R. Ousterhout: "A *Muqarnas* Drawing from Thirteenth-century Armenia and the Use of Architectural Drawings during the Middle Ages," *Muqarnas*, xviii (2001), pp. 141–54

Y. Dold-Samplonius and S. L. Harmsen: "The Muqarnas Plate Found at Takht-i Sulayman: A New Interpretation," *Muqarnas*, xxii (2005), pp. 85–94

Murabitun, al-. *See* ALMORAVID.

Murdoch Smith, Sir Robert (*b*. Kilmarnock, 18 Aug. 1835; *d*. Edinburgh, 3 July 1900). Scottish soldier, archaeologist, diplomat and collector of Iranian art. He was educated at Glasgow University, and in 1855 he obtained a commission in the Royal Engineers. The following year he joined the expedition of Charles Newton to Halikarnassos, which resulted in the discovery of the Mausoleum and the acquisition of its sculptures for the British Museum. In 1860 with E. A. Porcher, Murdoch Smith formed at his own expense an expedition to Cyrene in Libya. From this expedition he returned with Greek sculptures and inscriptions (London, BM). In 1863 he was selected for service on the Iranian section of a proposed telegraph line from Britain to India, and in 1865 he became its director in Tehran, holding that post for the next 20 years. He initiated his collecting activities for the South Kensington (later Victoria and Albert) Museum in 1873 when he offered his services as an agent. From 1873 to 1885 he sent the museum 68 reports outlining his purchases and giving information about Iranian art. In 1875 he purchased for the museum the large collection of Jules Richard (1816–91) in Tehran, which consisted of approximately 2000 ceramics, metalwares, varnished objects, textiles, paintings and manuscripts. This collection and the other items Murdoch Smith had acquired formed an exhibition (1876) at the museum, accompanied by his handbook. In the years that followed he acquired many more items for the museum, aided in this task by his friendship with prominent Iranian ministers and Nasir al-Din (*r*. 1848–96; *see* QAJAR, §II, B). Murdoch Smith left Iran in 1885 to become director of the Science and Art (Royal Scottish) Museum, Edinburgh. In 1887 he retired from the army, became director-in-chief of the Indo-European telegraph department and went on a special diplomatic mission to Iran. He was also a member of the board of manufacturers in Scotland and chairman of the committee of the Scottish National Portrait Gallery.

WRITINGS

History of the Recent Discoveries at Cyrene, Made during an Expedition to the Cyrenaica in 1860–61 (London, 1864)
Persian Art (London, 1876)
Guide to the Persian Collection in the Museum (Edinburgh, 1896)

BIBLIOGRAPHY

W. K. Dickson: *The Life of Major-General Sir Robert Murdoch Smith* (Edinburgh and London, 1901)

J. Scarce: "Travels with Telegraph and Tiles in Persia: From the Private Papers of Major-General Sir Robert Murdoch Smith," *A. & Archaeol. Res. Pap.*, iii (1973), pp. 70–81

L. Helfgott: "Carpet Collecting in Iran, 1873–1883: Robert Murdoch Smith and the Formation of the Modern Persian Carpet Industry," *Muqarnas*, vii (1990), pp. 171–81

T. Masuya: "Persian Tiles on European Walls: Collecting Ilkhanid Tiles in Nineteenth-century Europe," *A. Orient.*, xxx (2000), pp. 39–54

Müridoğlu, Zühtü (*b*. Istanbul, 29 Jan. 1906; *d*. 1992). Turkish sculptor. He studied at the Fine Arts Academy, Istanbul, under the sculptor Ihsan Özsoy (1867–1944). From 1928 to 1932 he continued his studies in Paris, working in the studio of the sculptor Marcel Gimond (1894–1961) and at the Académie Colarossi. He also attended courses in aesthetics at the Sorbonne and art history at the Ecole du Louvre and exhibited at the Salon d'Automne (1931 and 1932). On returning to Turkey, he taught painting at Samsun High School (1932) and in 1933 was a founding member of the D Group in Istanbul. In 1936 Müridoğlu worked at the Arkeoloji Müzesi in Istanbul and in 1939 went to teach at the Gazi Teachers' College in Ankara. From 1940 he taught at the Fine Arts Academy in Istanbul. From 1947 to 1949 he stayed in Paris where he participated in the Salon des Indépendants in 1949 and 1950. After returning to Istanbul, he taught sculpture at the Fine Arts Academy with Ali Hadi Bara and exhibited his work at the Maya Gallery in 1952. His early sculptures were influenced by the work of Gimond and Charles Despiau (1874–1946), but he later developed his style in both statues and abstract works. With ALI HADI BARA he worked on the statue of the 16th-century Ottoman admiral *Barbarossa* in Beşiktaş, Istanbul, erected in 1946 on the 400th anniversary of

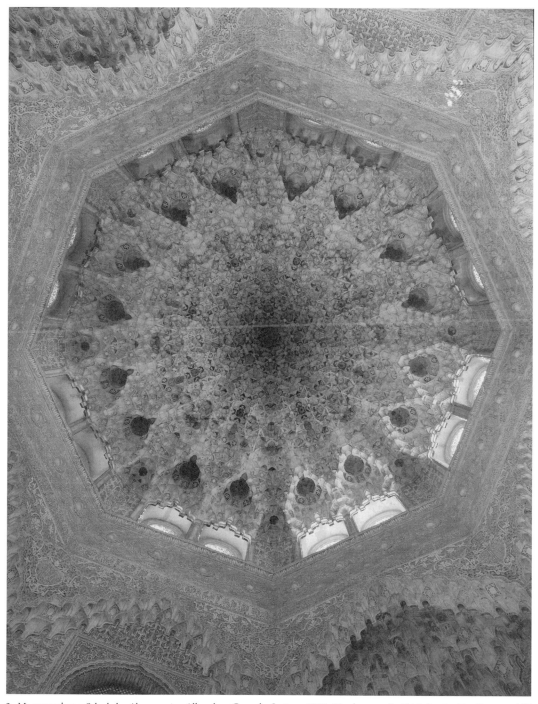

2. *Muqarnas* dome, Sala de los Abencerrajes, Alhambra, Granada, Spain, *c.* 1370–80; photo credit: Erich Lessing/Art Resource, NY

Barbarossa's death, and on the monument to *Atatürk and Ismet Inönü on Horseback* in Zonguldak. He also worked on the reliefs on the steps of the Atatürk Mausoleum (1953), and on the monuments to *Atatürk* at Büyükada, Istanbul, in Muş (1965), and in Eyüp (1966). Müridoğlu continued to exhibit sculpture in Europe, at such exhibitions as the Venice Biennale (1956) and the second Exposition Internationale de Sculpture Contemporaine at the Musée Rodin, Paris (1961).

WRITINGS

Zühtü Müridoglu kitabi (Istanbul, 1992) [autobiography]

BIBLIOGRAPHY

2e Exposition internationale de sculpture contemporaine (exh. cat., Paris, Mus. Rodin, 1961)

S. Tansuğ: *Çağdaş Türk sanatı* [Contemporary Turkish art] (Istanbul, 1986)

K. Giray: "Heykel Sanatımızın Müridi: Zühtü Müritoğlu," *Kült. Ve Sanat*, xvii (March 1993), pp. 32–5

W. Ali: *Modern Islamic Art* (Gainesville, 1997), p. 18

Karma heykel sergisi (exh. cat., Istanbul, Menkul Kıymetler Borsası Sanat Galerisi, 2000)

S. Bozdogan: *Modernism and Nation Building: Turkish Architectural Culture in the Early Republic* (Seattle, 2002), p. 290

C. Ileri: *Bellek ve ölçek: modern Türk heykelinin 15 sanatçisi/ Memory and Scale: 15 Artists of Modern Turkish Sculpture* (Istanbul, 2006)

Zühtü Müridoglu: resim, heykel: Bütün bir yasam/Zühtü Müridoglu: Drawing, Sculpture: A Complete Life (Istanbul, 2006) [text in Turk. & Eng.]

Musafa ʿIzzat. *See* MUSTAFA IZZET.

Musafa Raqim. *See* MUSTAFA RAQIM.

Musalla [Arab. *muṣallā*; Pers. *ʿīdgāh*]. Large open-air space where prayers are held on the occasion of the two major religious festivals in Islam, ʿId al-Fitr and ʿId al-Adha. In eastern Islamic lands, including Iran and the Indian subcontinent, the Arabic term *musalla* ("place of prayer") is often replaced by the Persian *ʿīdgāh* ("place of the festival"). A *musalla* must be large enough to contain all the males of a city who are old enough to engage in prayer; it may be walled and equipped with a freestanding mihrab and minbar constructed of durable materials, but it need have no other significant architectural form. Not every Islamic city has an architecturally formalized *musalla*. Normally located outside a city or town, a *musalla* may occasionally be found within the walls of a city; in any event, the site of a city's *musalla* generally reflected changes in urban development. *Musalla*s are often placed next to cemeteries (which are usually outside the walls, too); for this reason, or because prayers for the dead were performed at the *musalla* in Medina in Muhammad's day, funerary mosques are sometimes found at these sites. In some cities an open *musalla* was replaced with a mosque on the same site.

*Musalla*s are seldom accorded prominence in urban topographies, but many historical examples are known. Muhammad prayed at a *musalla* in Mecca and established another at Medina, outside the city wall to the southwest. Under the early Abbasid caliphs, Baghdad had a *musalla* outside the wall on the east side of the city, adjacent to the Malikiya cemetery. An *ʿīdgāh* was established at Delhi after its conquest by Muslims in the late 12th century. In the 12th century Damascus had a *musalla* outside the walls to the south of the city; Aleppo also had an extramural example. In the 15th century Cairo, then one of the largest Islamic cities, had no fewer than eight places of prayer called *musalla*s.

The case of HERAT in Afghanistan shows how the function of the *musalla* can be fulfilled in different ways at various times. An *ʿīdgāh* existed there in the 13th century, just north of the city walls. An iwan was constructed at the *ʿīdgāh* in the mid-15th century, when it is known to have been in a district of tombs and cemeteries, well to the northwest of the city. At this time it was also called a *musalla* and a *namāzgāh* (Pers.: "place of prayer"). In the 19th century the ʿId prayers were held at the ruins of the great Timurid religious monuments north of the city, and this area was then called the *musalla*, although it was without any architectural embellishment suited to the purpose. Finally, after the Great Mosque was renovated in the 1940s and the adjoining city wall was sliced through to create a large park, this new location proved large enough to accommodate the male population, and so the ʿId prayer services came to be held there.

Other *musalla*s with some substantial architectural features exist, or are known to have existed, at Bukhara, Isfahan, Mashhad, Shiraz, Samarkand and many other smaller towns in Iran and Central Asia. Freestanding iwans housing the mihrab, sometimes with open, flanking chambers, are common at these sites, but the minbar stands outside the structure.

Enc. Islam/2: "Muṣallā"

O. Caroe: "The Gauhar Shah Musalla (Mosque) in Herat," *Asian Affairs*, lx/N (1973), pp. 295–8

E. Galdieri: "A Hitherto Unreported Architectural Complex at Iṣfahān: The So-called 'Lesān al-ʿarż' Preliminary Report," *E. & W., n. s.*, xxiii (1973), pp. 249–64

Muscat and Oman. *See* OMAN.

Museums. Since the late 17th century when the museum first emerged in Europe as a public institution, various types have been created and some have developed collections of Islamic art. As a result Islamic objects, particularly in the West, have been placed in several contexts depending on the purpose of the institution and the nature of the artifact. Libraries, for example, house many Islamic books and works on paper. The museum devoted entirely to the presentation of Islamic art is a new phenomenon, and traditionally, the idea of the "national" museum, embracing a wide variety of items from many eras, has been more influential both in the West and in the Islamic lands. Few of these museums have comprehensive printed catalogues of their collections, and the most up-to-date information is usually available on-line or in catalogues of special exhibitions. As interest in Islam and Islamic art has surged in the recent decades, many permanent exhibitions of Islamic art are undergoing renovation and expansion, and despite—or perhaps because of—the growing interest in the subject, many are temporarily closed as of 2007.

I. Europe. II. North America. III. Islamic lands.

I. Europe. A few Islamic items were already present in 1759 when the British Museum in London

(http://www.thebritishmuseum.ac.uk) opened to the public as the first major "national" museum in Europe, and from the outset the museum contained a library, which accepted Oriental manuscripts. During the 19th century Islamic manuscripts began to enter the British Museum in greater numbers, and a Department of Oriental Manuscripts was formed in 1867. By 1913 a sub-Department of Oriental Prints and Drawings had also been established. Islamic objects entered the museum in increasing numbers from the late 19th century, especially after the Department of Oriental Antiquities was established in 1861. In 2003 it merged with Japanese Antiquities to become the Department of Asia. Its collection of Islamic art is one of the most comprehensive in the world, with particular emphasis on the arts of the book, metalwork and ceramics. From 1973 the Department of Oriental Manuscripts and Printed Books became part of the British Library (http://www.bl.uk).

In France, a "national" museum was established in Paris in 1793 to contain treasures confiscated in the Revolution. The collection of Islamic objects at the Musée du Louvre (http://www.louvre.fr) developed, in particular under the direction of Emile Molinier in the 1890s, and by 1906 a Department of Islamic Art had been created. The important collection of more than 1000 objects was, however, rarely displayed to the public until a new Islamic gallery was opened in 1993. In 2005 architects Rudy Ricciotti (b. 1952) and Mario Bellini (b. 1935) were chosen to design new Islamic galleries, to be opened in 2009 in the Visconti Court. The Bibliothèque Nationale (http://www.bnf.fr) in Paris also houses an important collection of manuscripts, coins and other Islamic objects.

During the course of the 19th century, other types of repositories for Islamic objects were established in Europe. These ranged from the museums of learned Orientalist societies to those connected with trade and colonial activities. In 1801, for example, the library and museum of the East India Company opened in London, and manuscripts, albums, paintings, penboxes and other Islamic items were purchased or bequeathed to the collection. Plunder also arrived, most notably from the 1799 campaign against Tipu Sultan (r. 1782–99) at Seringapatam, including his throne, weapons and a musical tiger. In 1880 the India Museum was incorporated in the South Kensington (now the Victoria and Albert or V&A) Museum in London (http://www.vam.ac.uk). Its Jameel Gallery for Islamic Arts, opened in 2006, houses 400 of the finest objects, including the Ardabil carpet. The library of the East India Company became the India Office Library, which is now administered by the British Library.

Museums of ethnography, particularly of "applied" or "industrial" art, are another type of museum established in Europe in the mid-19th century that developed collections of Islamic items. Following the Great Exhibition in 1851, the South Kensington Museum (1857) promoted education in "applied" art and design, and the museum is noted for its collections of Islamic textiles, ceramics, metalwork and other objects. Similar collections soon appeared throughout Europe: at Vienna (1863), and then at Berlin, Brno, Budapest, Dresden, Frankfurt, Hamburg, Kassel, Kiel and Leipzig. After a lottery yielded about six million francs to the Central Union of Decorative Arts, the collection of the Musée des Arts Décoratifs in Paris (http://www.lesartsdecoratifs.fr) developed in the 1880s. With this money objects were purchased and a temporary home for them was established at the Palais de l'Industrie. The first Islamic items for the museum were acquired in 1886 at the Paris sale of the collection of Albert Goupil (1840–84). Some 3000 of its Islamic objects are on deposit at the Louvre and displayed as part of their collection.

The Islamic department of the Staatliche Museen in Berlin (http://www.smb.spk-berlin.de) was, until World War II, at the forefront of enquiry into Islamic art. The cordial relationship between the German emperor William II (r. 1888–1918) and the Ottoman sultan Abdülhamid II (r. 1876–1909) led to the installation of the façade of the palace of MSHATTA (see fig.) in the Kaiser-Friedrich-Museum and, in 1904, the Islamische Kunstabteilung was founded on the initiative of Wilhelm Bode (1845–1929). FRIEDRICH SARRE, who gave 400 items from his private collection in 1921, was director of the department until 1931. In 1932 the considerably enlarged collection was transferred to the newly constructed Pergamonmuseum. ERNST KÜHNEL remained in charge during World War II, when many of the portable objects in the collection were dispersed for safekeeping in Germany. The Mshatta façade and many of the fine carpets, however, were severely damaged by bombs. In 1954 those objects that had been stored in West Germany were exhibited in the new museum complex at Dahlem (West Berlin), while those temporarily removed from East Germany to the Soviet Union were again displayed in the Pergamonmuseum. Under KURT ERDMANN, who became director of the museum in Dahlem in 1958, Islamic items were purchased for the first time since the war. After German reunification the two halves of the collection were reunited administratively in 1992, and since 1998 they have been displayed in the south wing of the Pergamonmuseum. The collection is extremely broad and is notable for its fine architectural fragments, many from German excavations in Iraq and Palestine, ceramics, woodwork, carpets, metalwares and ivories.

Other European museums with fine collections of Islamic art include the Hermitage Museum in St. Petersburg (http://www.hermitagemuseum.org), notable for many Iranian and Turkish objects from the Russian imperial collections. Islamic objects in the Habsburg collection passed to the Kunsthistorisches Museum in Vienna (http://www.khm.at). The Benaki Museum in Athens (http://www.benaki.gr) is distinguished for its collection of decorative arts, particularly from the Mediterranean Islamic lands. Since

1996 they have been displayed in a separate complex of Neo-classical buildings located in the historical center of the city. The Calouste Gulbenkian Museum in Lisbon (http://www.museu.gulbenkian.pt) has a particularly fine collection of Islamic ceramics as well as many splendid textiles, carpets, manuscripts and bindings. The Museo Nacional de Arte Hispano-musulmán was established by the scholar L. Torres Balbás in Granada. The Davids Samling in Copenhagen (http://www.davidmus.dk), housed in the residence of its founder C. L. David, continues to expand its encyclopedic collection of Islamic decorative arts. Closed for renovation, it will reopen in 2009 in expanded quarters on Kronprinsessegade. The Institut du Monde Arabe in Paris (http://www.imarabe.org), founded in 1980 to encourage the knowledge of Arab civilization and culture in France, has a museum in which objects from its own collection and other French public collections are exhibited. The Ashmolean Museum at Oxford (http://www.ashmolean.org), opened in 1683 with the collection of curiosities amassed by Elias Ashmole, has an important selection of Islamic ceramics within its Department of Eastern Art. The entire museum, except the grand façade, is being reconstructed and is scheduled to reopen in 2009. The Bodleian Library at Oxford (http://www.bodley.ox.ac.uk) has notable Islamic manuscripts, as does the John Rylands Library in Manchester (http://www.library.manchester.ac.uk).

II. North America. In the United States, the Freer Gallery of Art in Washington, DC, has had a collection of Islamic ceramics since its foundation in 1923, but particularly under the curatorship (1944–67) of RICHARD ETTINGHAUSEN the collections were expanded to include many fine examples of metalwork, ceramics and manuscripts. The superb collection was further enriched by the founding of the adjacent Sackler Gallery, which acquired some 500 Islamic manuscripts, paintings, albums, bindings and calligraphic specimens from the collection of HENRI VEVER in 1986. Both are part of the Smithsonian Institution (http://www.asia.si.edu) on the Mall near the Capitol. These collections are complemented by those of the Textile Museum (http://www.textilemuseum.org), which houses the incomparable collection of Oriental carpets assembled by GEORGE HEWITT MYERS. In New York City the Metropolitan Museum of Art (http://www.metmuseum.org), founded in 1870 on the inspiration of the South Kensington Museum, added a Near Eastern Department in 1932 with MAURICE S. DIMAND as curator. Under Ettinghausen's curatorship (1969–79), splendid new exhibition galleries were opened and the most comprehensive collection of Islamic art in the United States put on permanent display. The galleries are closed until early 2010 for expansion and renovation. The New York Public Library (http://www.nypl.org) has a fine collection of Islamic manuscripts, and the Brooklyn Museum (http://www.brooklynmuseum.org) has a good collection of objects, particularly ceramics.

Other significant collections in the United States include those in Boston (Mus. F.A.; http://www.mfa.org), Cambridge, MA (Fogg and Sackler museums; http://www.artmuseums.harvard.edu), Cleveland (Mus. A., http://www.clevelandart.org), Philadelphia (U. PA, Mus., http://www.museum.upenn.edu; Mus. A., http://www.philamuseum.org), and San Diego (Mus. A., http://www.sdmart.org). The most comprehensive is in Los Angeles (Co. Mus. A.; http://www.lacma.org/islamic_art), which houses a wide range of objects, including the mate to the ARDABIL carpet in the V&A. The nucleus of their 1700 objects belonged to the Nasli Heeramaneck Collection (1973), with several other private collections added in subsequent decades.

III. Islamic lands. The oldest museum in Asia is reputedly that of the Asiatic Society of Bengal (http://www.asiaticsocietycal.com), established in Calcutta in 1784. Now the Indian Museum, its scope was defined in 1814 as "the illustration of Oriental manner and history, and to elucidate the peculiarities of art and nature in the East." During the 19th century British administrators in India created many other museums, many with Islamic objects.

In Egypt, Khedive Isma'il (r. 1863–79) tried to curb the removal of architectural and artistic items to Europe by planning an Arab museum in 1869. His scheme was implemented by his successor Tawfiq (r. 1879–92), who in 1880 created a museum to preserve valuable items from mosques and private collections, and this enterprise formed the nucleus of the present Museum of Islamic Art in Cairo. Julius Franz (1831–1915) of the Ministry of Awqaf (pious foundations) was entrusted with the organization, and with the assistance of Ya'qub Artin (d. 1916) and Edward Rogers (1831–84), the rescued items were first deposited in the eastern arcades of the mosque of al-Hakim. To oversee the affairs of the museum and related projects, a khedival decree, issued in 1881, created the Comité de Conservation des Monuments de l'Art Arabe. The collection grew quickly and was moved to a building constructed in 1883 in the courtyard of the mosque of al-Hakim. In 1892 Max Herz (1856–1919) was appointed director. He wrote a catalogue and saw the opening of the collection in new premises in 1903 in a neo-Mamluk building on Port Said Street that is currently closed for renovation. From 1923 to 1951 Gaston Wiet served as director. This museum did not have a monopoly on all items: Islamic manuscripts continued to be housed in the khedival library in Cairo, directed by the German Orientalist Bernhard Moritz (1859–1939) from 1896 to 1911. Other important museums in Cairo include the Museum of Islamic Ceramics (opened in 1998 in the palace of Prince Amru Ibrahim in Zamalek). The collection consists of some 300 pieces of ceramics from different parts of the Islamic world.

In Turkey, Sultan Abdülhamid II established the Imperial Ottoman Museum at the Çinili Kiosk at the Topkapı Palace (see ISTANBUL, §III, E) in 1877. OSMAN HAMDI, director from 1881 to 1910, put into

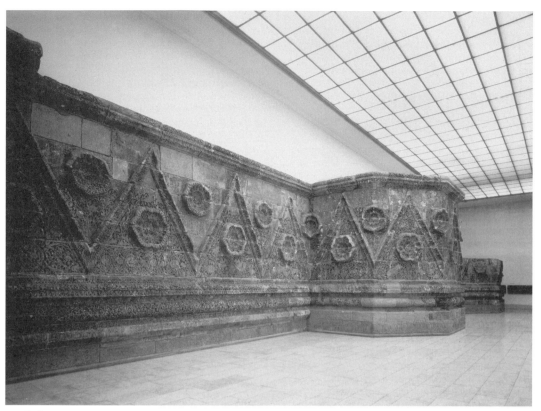

Façade from the palace of Mshatta, 8th century (Berlin, Pergamonmuseum); restored; photo credit: Bildarchiv Preussischer Kulturbesitz/Art Resource, NY

effect an order against the traffic in antiquities and organized excavations. In 1891 the archaeological collection was open to the public in a new building, and in later years annexes were built. After Abdülhamid was deposed in 1909, his collection at Yıldız Palace was moved back to the Topkapı Palace at the insistence of Hamdi's brother HALIL EDHEM ELDEM, who became director of the Imperial Ottoman Museum after Hamdi's death. Following the declaration of the Turkish Republic in 1923, museums were developed apace. In 1924 a decision was made to repair buildings at the Topkapı Palace and made them accessible to the general public. An extraordinary range of Islamic art collected by the sultans is displayed there, including manuscripts, textiles, metalwares and *objets d'art*. Çinili Kiosk has become a museum devoted to Islamic ceramics. The Islamic museum at the Süleymaniye complex, founded in 1914, reopened in 1927 as the Museum of Turkish and Islamic Art (Türk ve Islam Eserleri Müzesi), now housed in the palace of Ibrahim Pasha on the At Meydan. The ministry of pious endowments (Vakıflar) also founded the Carpet Museum (1979) and the Kilim and Flat-Woven Rug Museum (1982) in Istanbul. One of the important private museums in Istanbul is the Sadberk Hanim Museum (opened in 1980). Housed in 19th-century wooden villas overlooking the Bosporus, the collection ranges from

Turkish decorative arts to archaeological finds. The Sakıp Sabancı Museum (http://muze.sabanciuniv. edu/main/default.php) contains a fine collection of calligraphy. Museums were also established in many other centers in Turkey, particularly after 1925, when a law closing dervish tekkes came into effect and valuable items they contained were moved to local museums. The Mevlana Museum in KONYA, for example, was founded in 1926, while the Museum of Ethnography, noted for its woodwork, opened in ANKARA in 1928. These museums are under the administration of the Ministry of Culture (http:// www.kultur.gov.tr).

In Iran, museums were established from the 1930s onwards, along with exhibitions of Iranian art which proliferated in Europe and the United States. The Ethnographical Museum was founded in Tehran in 1938, and the Archaeological (Iran Bastan) Museum opened in 1946. The latter, now called the National Museum, contains a vast collection of both pre-Islamic and Islamic items. In the 1970s several other museums were established in the city, including the Nigaristan Museum, specializing in the art of the Qajar period, the Riza ʿAbbasi Museum (http://www. rezaabbasimuseum.ir) for decorative arts, the Carpet Museum, and the Museum of Glass and Ceramics (http://www.glasswaremuseum.ir). The Gulistan Palace Museum (http://www.golestanpalace.ir),

housed in one of the oldest buildings in the city, contains a fine collection of manuscripts. Other notable museums include the Imam Riza Shrine Museum (Astan-i Quds-i Razavi) in MASHHAD, which contains a wealth of material donated to the shrine over the centuries.

In most other Islamic countries, the creation of the nation state and the foundation of museums happened simultaneously. The National Museum in DAMASCUS, founded in 1919 when the Ottomans relinquished control over Syria, has a department of Arab–Islamic antiquities which exhibits finds from many sites, including the reconstructed façade from the palace at QASR AL-HAYR WEST. An archaeological museum was established in Baghdad in 1923, the same year that Turkey gave up its claim to rule there. Plans for an Iraqi national museum were developed in 1932, after the British mandate was terminated and Iraq became a sovereign state. The Iraq National Museum in BAGHDAD (http://www.baghdadmuseum.org), completed in 1963, contains material dating from the prehistoric period to the 19th century, including Islamic antiquities from sites such as SAMARRA and Wasit. The museum was looted in 2003, but some of the objects have been recovered. It is unclear when or whether it will reopen. In North Africa, the Musée National du Bardo in TUNIS, the Musée National des Antiquités in ALGIERS and the Musée des Antiquités in RABAT are the major depots for Islamic objects, although important items can be found in museums of ethnography, as well as smaller collections of provincial cities.

In Jerusalem, archaeological finds from excavations at sites, such as KHIRBAT AL-MAFJAR, are housed in the Rockefeller Museum, founded as the Palestine Archaeological Museum and now part of the Israel Museum (http://www.imj.org.il), which also houses other Islamic objects, particularly paintings and manuscripts. The Islamic Museum of the Aqsa Mosque (http://www.noblesanctuary.com/museum) houses an incomparable collection of objects and documents relating to the Haram al-Sharif (Temple Mount). The Mayer Museum for Islamic Art (http://www.islamicart.co.il) was founded by Mrs. V. B. Salomons (d. 1969) to honor the scholar LEO ARY MAYER, who had been professor of Islamic art and archaeology and rector of the Hebrew University. The collection, which was formed under the direction of Richard Ettinghausen, contains a broad range of objects from large parts of the Islamic world.

In the late 20th and early 21st centuries museums were founded in relatively young Muslim states. Kuwait led this movement in the early 1980s, when the Museum of Islamic Art or Dar al-Athar al-Islamiyya (http://www.darmuseum.org.kw), which contains the al-Sabah collection, was established in 1983 in Kuwait City. Its building was heavily damaged during the First Gulf War in 1991, and much of the collection was temporarily taken to Iraq. Although the collection was returned to Kuwait after the war, it will only be on display when the Kuwait National Museum and Library complex has been restored, scheduled for 2008. Meanwhile, the museum has organized traveling exhibitions of groups of objects such as Mughal jewelry and catalogues of individual media, including glass and ceramics. The Tareq Rajab Museum (http://www.trmkt.com), another important collection of Islamic art in Kuwait (opened in 1980; reopened in 1991), evaded war damage and continued to expand its galleries (Dar El Cid Exhibition Halls in 2001, Museum of Islamic Calligraphy in 2007). The oil and gas boom has fueled funding for the foundation of museums in other Gulf states. The Museum of Islamic Art in Doha was inaugurated in November 2008, and catalogues of masterpieces and of individual media such as silk and ivory show the extraordinary quality of this new collection. The museum's superstructure, evoking a multi-stepped ziggurat and built on an island in the Gulf, was designed by I. M. Pei (b. 1917) and Jean-Michel Wilmotte (b. 1948), architects of the Louvre pyramid. The United Arab Emirates have followed this museum race. Dubai is growing as a contemporary art center in the Middle East, and a number of art museums are due to open in the next few years.

Besides Islamic states in the Middle East, the establishment of the Islamic Arts Museum Malaysia (http://www.iamm.org.my), which opened in 1998, suggests a growing interest in the Islamic cultural heritage among Muslim communities in Southeast Asia. This museum is notable for its collection of Islamic objects from the region.

GENERAL

K. Ådahl and M. Ahlund, eds.: *Art Collections: An International Survey* (London, 2000)

A. Orient., xxx (2000) [entire issue ed. by L. Komaroff: *Exhibiting the Middle East: Collection and Perceptions of Islamic Art*]

S. Vernoit, ed.: *Discovering Islamic Art: Scholars, Collectors and Collections 1850–1950* (London, 2000)

S. Blair and J. Bloom: "The Mirage of Islamic Art: Reflections on the Study of an Unwieldy Field," *A. Bull.,* lxxxv (March 2003), pp. 152–84

EUROPE AND ASIA

M. Demaison: "Le Musée des Arts Décoratifs," *Les Arts* [Paris], xlviii (1905), pp. 1–45

A. F. Kendrick: *Catalogue of Muhammadan Textiles of the Medieval Period, Victoria and Albert Museum* (London, 1924)

L. Binyon: *L'Art asiatique au British Museum: Sculpture et peinture,* A. Asiat., vi (Paris and Brussels, 1925)

E. Blochet: *Les Enluminures des manuscrits orientaux—turcs, arabes, persans—de la Bibliothèque Nationale* (Paris, 1926)

E. Kühnel: "The Islamic Department of the Berlin Museum," *A. Islam.,* xv–xvi (1951), pp. 143–5

B. W. Robinson: *A Descriptive Catalogue of the Persian Paintings in the Bodleian Library* (Oxford, 1958)

A. J. Arberry and others: *The Chester Beatty Library: A Catalogue of the Persian Manuscripts and Miniatures,* 3 vols. (Dublin, 1959–62)

Museum für Islamische Kunst, Berlin: Katalog, 1971 (Berlin, 1971)

Persian Art: Calouste Gulbenkian Collection (Lisbon, 1972)

Museu Calouste Gulbenkian (Lisbon, 1975) [checklist]

B. W. Robinson: *Persian Paintings in the India Office Library: A Descriptive Catalogue* (London, 1976)

N. M. Titley: *Miniatures from Persian Manuscripts: A Catalogue and Subject Index of Paintings from Persia, India and Turkey in the British Library and the British Museum* (London, 1977)

L'Islam dans les collections nationales (exh. cat., Paris, Grand Pal., 1977)

B. W. Robinson: *Persian Paintings in the John Rylands Library: A Descriptive Catalogue* (London, 1980)

N. M. Titley: *Miniatures from Turkish Manuscripts: A Catalogue and Subject Index of Paintings in the British Library and the British Museum* (London, 1981)

R. Desmond: *The India Museum, 1801–1879* (London, 1982)

A. S. Melikian-Chirvani: *Islamic Metalwork from the Iranian World, 8th–18th Centuries,* London, V&A cat. (London, 1982)

F. Déroche: *Les Manuscrits du Coran,* 2 of i/1 of *Bibliothèque Nationale, Département des Manuscrits: Catalogue des manuscrits arabes,* 2 vols. (Paris, 1983–5)

D. Duda: *Die illuminierten Handschriften und Inkunabeln der österreichischen Nationalbibliothek: Islamische Handschriften I. Persiche Handschriften,* 2 vols. (Vienna, 1983)

D. Haldane: *Islamic Bookbindings in the Victoria and Albert Museum* (London, 1983)

K. Brisch, ed.: *Islamische Kunst: Löseblattkatalog unpublizierter Werke aus deutschen Museen* (Mainz, 1984–)

F. Spuhler: *Die Orientteppiche im Museum für Islamische Kunst Berlin* (Berlin, 1987)

E. Anglade: *Musée du Louvre: Catalogue des boiseries de la section islamique* (Paris, 1988)

K. von Folsach: *Islamic Art: The David Collection* (Copenhagen, 1990)

Masterpieces of Islamic Art in the Hermitage Museum (Kuwait, 1990)

N. Erzini: "'Moorish' Pottery in the Victoria and Albert Museum: The Contribution of George Maw of Maw and Co. to the Knowledge of Moroccan Ceramics in Britain," *Morocco,* iii (1993), pp. 57–72

L. Y. Leach: *Mughal and Other Indian Paintings from the Chester Beatty Library,* 2 vols. (Dublin, 1995)

Letters in Gold: Ottoman Calligraphy from the Sakıp Sabancı Collection, Istanbul (exh. cat. by M. U. Derman; New York, Met.; Los Angeles, CA, Co. Mus. A., 1998–9)

K. Ådahl: *Islamic Art Collections: An International Survey* (London, 2000)

K. von Folsach: *Art from the World of Islam in the David Collection* (Copenhagen, 2001)

S. Makariou: *Nouvelles acquisitions, arts de l'Islam, 1988–2001: Catalogue* (Paris, 2002)

V. Enderlein: *Museum of Islamic Art* (Mainz, 2003)

M. Q. Ribiero and M. F. Passos Leite, eds.: *Islamic Art in the Calouste Gulbenkian Collection* (Lisbon, 2003)

J. Gierlichs and A. Hagedorn, eds.: *Islamic Art in Germany* (Mainz am Rhein, 2004)

M. B. Piotrovsky and J. M. Rogers: *Heaven on Earth: Art from Islamic Lands: Works from the State Hermitage Museum and the Khalili Collection* (Munich, 2004)

Islamische Kunst in Berliner Sammlungen: 100 Jahre Museum für Islamische Kunst in Berlin (exh. cat. by J. Kröger with D. Heiden; Berlin, Mus. Islam. Kst; 2004–5)

Palace and Mosque: Islamic Art from the Middle East (exh. cat. by T. Stanley with M. Rosser-Owen and S. Vernoit; Washington, DC, N.G.A.; Fort Worth, TX, Kimbell A. Mus.; Tokyo, Setagaya A. Mus.; Sheffield, Millennium Gals.; 2005–6) [V&A collection]

Anna Ballian, ed.: *Benaki Museum: A Guide to the Museum of Islamic Art* (Athens, 2006)

M. B. Piotrovsky and A. D. Pritula: *Beyond the Palace Walls: Islamic Art from the State Hermitage Museum* (Edinburgh, 2006)

T. Stanley and R. Crill, eds.: *The Making of the Jameel Gallery of Islamic Art at the Victoria and Albert Museum* (London, 2006)

NORTH AMERICA

N. P. Britton: *A Study of Some Early Islamic Textiles in the Museum of Fine Arts, Boston* (Boston, 1938)

E. Schroeder: *Persian Miniatures in the Fogg Museum of Art* (Cambridge, MA, 1942)

E. Kühnel and L. Bellinger: *The Textile Museum: Catalogue of Dated Tiraz Fabrics: Umayyad, Abbasid, Fatimid* (Washington, DC, 1952)

R. Ettinghausen: "Almost One Hundred Years Ago," *Islamic Art in the Metropolitan Museum of Art,* ed. R. Ettinghausen (New York, 1972), pp. 1–8

M. S. Dimand and J. Mailey: *Oriental Rugs in the Metropolitan Museum of Art* (New York, 1973)

Ceramics from the World of Islam (exh. cat. by E. Atıl; Washington, DC, Freer, 1973)

P. Pal, ed.: *Islamic Art: The Nasli M. Heeramaneck Collection* (Los Angeles, 1974)

The Brush of the Masters: Drawings from Iran and India (exh. cat. by E. Atıl; Washington, DC, Freer, 1978)

M. S. Simpson: *Arab and Persian Painting in the Fogg Museum of Art* (Cambridge, MA, 1980)

E. Atıl, W. T. Chase and P. Jett: *Islamic Metalwork in the Freer Gallery of Art* (Washington, DC, 1985)

C. G. Ellis: *Oriental Carpets in the Philadelphia Museum of Art* (Philadelphia, 1988)

G. D. Lowry with S. Nemazee: *A Jeweler's Eye: Islamic Arts of the Book from the Vever Collection* (Washington, DC, 1988)

M. L. Swietochowski and S. Babaie: *Persian Drawings in the Metropolitan Museum of Art* (New York, 1989)

B. Schmitz: *Islamic Manuscripts in the New York Public Library* (New York and Oxford, 1992)

ISLAMIC LANDS

G. Wiet: *Catalogue général du Musée Arabe du Caire: Lampes et bouteilles en verre émaillé* (Cairo, 1929)

G. Wiet: *Album du Musée Arabe du Caire* (Cairo, 1930)

J. David-Weill: *Catalogue général du Musée Arabe du Caire: Les Bois à épigraphes jusqu'à l'époque mamlouke* (Cairo, 1931)

E. Pauty: *Catalogue général du Musée Arabe du Caire: Les Bois sculptés jusqu'à l'époque ayyoubide* (Cairo, 1931)

G. Wiet: *Catalogue général du Musée Arabe du Caire: Objets en cuivre* (Cairo, 1932)

J. David-Weill: *Catalogue général du Musée Arabe du Caire: Les Bois à épigraphes depuis l'époque mamlouke* (Cairo, 1936)

M. Bahrami: *Iranian Art: Treasures from the Imperial Collections and Museums of Iran* (New York, 1949)

Moslem Art in the Fouad I University Museum (Cairo, 1950)

R. O. Arık: *L'Histoire et l'organisation des musées turcs* (Istanbul, 1953)

M. A. al-ʿUsh: *Musée National de Damas: Département des antiquités arabes islamiques* (Damascus, 1976)

S. R. Dar: *Repositories of Our Cultural Heritage: A Handbook of Museums in Pakistan, 1851–1979* (Lahore, 1979)

B. Balpınar and U. Hirsch: *Flatweaves of the Vakıflar Museum Istanbul* (Wesel, 1982)

M. Jenkins, ed.: *Islamic Art in the Kuwait National Museum* (London, 1983)

R. Milstein: *Islamic Painting in the Israel Museum* (Jerusalem, 1984)

F. Çağman and Z. Tanındı: *The Topkapı Saray Museum: The Albums and Illustrated Manuscripts,* trans. and ed. by J. M. Rogers (London and Boston, 1986)

H. Tezcan and S. Delibaş: *The Topkapı Saray Museum: Costumes, Embroideries and Other Textiles,* trans. and ed. by J. M. Rogers (London and Boston, 1986)

C. Köseoğlu: *The Topkapı Saray Museum: The Treasury,* trans. and ed. by J. M. Rogers (London, 1987)

K. Çığ, S. Batur and C. Köseoğlu: *The Topkapı Saray Museum: Architecture: The Harem and Other Buildings,* trans. and ed. by J. M. Rogers (London and Boston, 1988)

D. M. Reid: "Cultural Imperialism and Nationalism: The Struggle to Define and Control the Heritage of Arab Art in Egypt," *Int. J. Mid. E. Stud.,* xxiv (1992), pp. 57–76

Tareq Rajab Museum (Kuwait, 1994/R 1998)

M. F. Abu Khalaf: *Islamic Art through the Ages: Masterpieces of the Islamic Museum of al-Haram al-Sharif in Jerusalem* (Jerusalem, 1998)

G. Fehervari: *Ceramics of the Islamic World in the Tareq Rajab Museum* (New York, 2000)

S. Carboni: *Glass from Islamic Lands: The Al-Sabah collection* (New York, 2001)

M. Keene and S. Kaoukji: *Treasury of the World: Jewelled Arts of India in the Age of the Mughals* (London, 2001)

Türk ve İslâm Eserleri Müzesi (Istanbul, 2002)

7000 ans d'art perse: Chefs-d'oeuvres du Musée national de Téhéran (exh. cat., Vienna, Ksthist. Mus.' Ghent, St-Pietersabdij, 2002–3)

P.-K. Fong, ed.: *Islamic Arts Museum Malaysia,* vol. 1 (Kuala Lumpur, 2002)

M. Rosser-Owen: *Ivory, 8th to 17th Centuries: Treasures from the Museum of Islamic Art, Qatar* (Doha, 2004)

J. Thompson: *Silk, 13th to 18th Centuries: Treasures from the Museum of Islamic Art, Qatar* (Doha, 2004)

O. Watson: *Ceramics from Islamic Lands* (London, 2004)

V. Porter and H. N. Barakat: *Mightier than the Sword: Arabic Script: Beauty and Meaning* (Kuala Lampur, 2005)

L. De Guise: *The Message and the Monsoon: Islamic Art of Southeast Asia: From the Collection of the Islamic Arts Musuem Malaysia* (Kuala Lampur, 2005)

P. Speiser: "Zur Entstehungsgeschichte des Museums für Arabische Kunst in Kairo," *Mitt. Dt Archäol. Inst.: Abt. Kairo,* lxi (2005), pp. 351–60

S. Al-Khemir, ed.: *From Cordova to Samarkand: Masterpieces from the Museum of Islamic Art in Doha* (Paris, 2006)

B. O'Kane, ed.: *The Treasures of Islamic Art in the Museum of Islamic Art of Cairo* (Cairo, 2006)

Islamic Art Collections: An International Survey. Art Ref. [N6260 .I85 2000]. Sponsored by UNESCO, a comprehensive guide to museums in 41 countries, and to libraries with illuminated manuscript collections. Includes scope of collection and number of objects, including "objects of unique interest" as well as brief bibliographies of print collection catalogues.

Mushatta. *See* MSHATTA.

Muslim [Muslim ibn al-Dahhān] (*fl.* Cairo, *c.* 1000). Arab potter. Twenty complete or fragmentary lusterware vessels signed by Muslim are known. A fragmentary plate with birds in a floral scroll (Athens, Benaki Mus., 11122) is inscribed on the rim "[the work of] Muslim ibn al-Dahhan to please … Hassan Iqbal al-Hakimi." Although the patron has not been identified, his epithet al-Hakimi suggests that he was a courtier of the FATIMID caliph al-Hakim (*r.* 996–1021). The other pieces, bowls or bases from them, are decorated with animals, birds, interlaced bands, inscriptions and floral motifs. One complete bowl (New York, Met., 63.178.1) shows a heraldic eagle, a second (Cairo, Mus. Islam. A., 14930) has a central griffin surrounded by palmettes, and a third (Cairo, Mus. Islam. A., 15958) has a design of four white leaves surrounded by an inscription in kufic offering good wishes. Muslim also countersigned objects made by other potters and may have been the master of an important workshop. His work represents the zenith in the animal, floral and abstract decoration of Egyptian lusterwares of the Fatimid period (969–1171), for after him Fatimid potters increasingly depicted figural subjects (*see* CERAMICS, §III, A).

A. A. Yusuf: "Khazzāfūn min al-ʿaṣr al-fāṭimī wa asālibuhum al-fanniya" [Ceramicists of the Fatimid period and their artistic styles], *Bull. Fac. A., Cairo U.,* xx (1958), pp. 173–279

M. Jenkins: "Muslim: An Early Fatimid Ceramicist," *Bull. Met.,* xxvi (1968), pp. 359–69

S. S. Blair: *Islamic Inscriptions* (Edinburgh, 1998), pp. 152–4 and fig. 11.66

J. M. Bloom: *Art of the City Victorious: The Art and Architecture of the Fatimids in North Africa and Egypt* (London, 2007)

Mustafa Ağa [Meremetçi: "the Mender"] (*d.* Istanbul, *c.* 1665). Ottoman architect. Known as "the Mender," owing to his early career as a repairer and restorer, he was appointed chief imperial architect on the removal of Kasım Ağa in 1644, although he reportedly spent so much on building stables at Üsküdar for Ibrahim (*r.* 1640–48) that he was dismissed the following year. Reappointed in 1651, he was charged with the rebuilding of the Dardanelles fortresses at Çanakkale (1659–61). His major commission, executed between 1660 and 1663, was to complete the Yeni Valide Mosque at Eminönü in Istanbul, begun by Davud Ağa in 1594. Mustafa Ağa added its associated pavilion, public fountains, primary school, Koran school, the tomb of its founder and the nearby Mısr Çarşı (Egyptian Bazaar).

He supervised construction of the pavilion (Turk. *kasr*) of Davud Pasha (1665) and was responsible for the construction of the fountain (Turk. *sebil*) of Mustafa Ağa (1664; destr.) in the courtyard of the mosque of Mahmud Pasha, and the Çamlıca Kiosk (1665; destr.). The single monument inscribed with the name of Mustafa Ağa is the Mustafa Ağa Çeşmesi (1660), a fountain in the Cibali district of Istanbul. The traveler Evliya Çelebi (1611–84) records the existence of a waterside residence (Turk. *yalı*) belonging to Mustafa Ağa on the Bosporus at Ortaköy.

Evliya Çelebi: *Seyāhatnāme* [Book of travels] (MS. *c.* 1684; Istanbul, 1928), i, p. 451; v, p. 17

İ. Kumbaracilar: *İstanbul Sebilleri* [Fountains of Istanbul] (Istanbul, 1936), p. 27

A. Refik: *Türk Mimarları* [Turkish architects] (Istanbul, 1936), pp. 49–56

İ. H. Tanışik: *İstanbul Çeşmeleri* [Fountains of Istanbul], i (Istanbul, 1943), p. 80

L. A. Mayer: *Islamic Architects and their Works* (Geneva, 1956), p. 111

G. Goodwin: *A History of Ottoman Architecture* (Baltimore and London, 1971), pp. 356–60

Z. Nayır: *Osmanlı Mimarlığında Sultan Ahmed Külliyesi ve sonrası, 1609–1690* [The Sultan Ahmed Complex and its successors in Ottoman architecture, 1609–1690] (Istanbul, 1975), pp. 140–41

Mustafa İzzet [İzzet Efendi; Kadıasker Mustafa İzzet; Muṣṭafā ʿIzzat] (*b.* Tosya, 1801; *d.* Istanbul, 1876). Ottoman calligrapher. He went to Istanbul at a young age and caught the attention of the Ottoman sultan Mahmud II (*r.* 1808–39), who, on hearing the youth's fine voice, took him into the Topkapı Palace to be trained and educated. He learned *thuluth* and *naskh* scripts from the calligrapher Mustafa Vasıf (*d.* 1852), from whom he received a diploma (Turk. *icazet*). Mustafa İzzet, who was a distinguished musician and became military judge (*kadıasker*) of Anatolia, tutored Sultan Abdülmecid (*r.* 1839–61) and granted him an *icazet* in *thuluth*. Mustafa İzzet produced 11 copies of the Koran, several books of Koranic quotations and prayers, some 200 calligraphic compositions describing the features and qualities of the Prophet Muhammad (*hilye*), and panels in a fine *naskh* in the style of Hafiz osman. He was also responsible for the large calligraphic roundels that adorn Hagia Sophia and he restored the inscription on the dome (*see* ISTANBUL, §III, A). Among his many pupils were MEHMED ʿŞEFIK, Muhsinzade Abdullah (1832–99), Abdullah Zühdü (*d.* 1879), Kayışzade Osman, Arif of Çarşamba (*d.* 1892) and Mehmed Hilmi. A follower of the Nakshbandi order of dervishes, Mustafa İzzet was buried in the graveyard of the Kadiri dervish convent in Tophane, Istanbul.

A. S. Ünver: *Hattat Kazasker Mustafa İzzet: Hayatı ve eserleri* [The calligrapher Kazasker Mustafa İzzet: his life and works] (Istanbul, 1953)

Ş. Rado: *Türk hattatları* [Turkish calligraphers] (Istanbul, n.d.), pp. 216–17

M. U. Derman: *The Art of Calligraphy in the Islamic Heritage* (Istanbul, 1998)

Letters in Gold: Ottoman Calligraphy from The Sakıp Sabancı Collection, Istanbul (exh. cat. by U. Derman; New York, Met.; Los Angeles, CA, Co. Mus. A.; Cambridge, MA, Sackler Mus.; 1999–2000)

S. S. Blair: *Islamic Calligraphy* (Edinburgh, 2006), p. 503 and fig. 11.12

Mustafa Raqim [Muṣṭafā Rāqim; Mustafa Rakım] (*b.* Ünye, 1757; *d.* Istanbul, 1826). Ottoman calligrapher. Together with his elder brother, the calligrapher Ismaʿil Zühdü Efendi (*d.* 1806), he went to Istanbul, where he studied with several masters and obtained his diploma at the age of 12. He rose through the Ottoman civil service and eventually held a number of high government offices. He and his brother are generally recognized as freeing Islamic calligraphy from the style canonized by HAFIZ OSMAN (*see* CALLIGRAPHY, §IV, A and V). His calligraphic works include a well-known picture of the invocation of the name of God (Arab. *basmala*; Turk. *besmele*) in the form of a crane and TUGHRAS for the sultans Mustafa IV (*r.* 1807–8) and Mahmud II (*r.* 1808–39). He also crafted the inscriptions on the tomb complex of Mahmud's mother, Nakşidil Sultan, in Istanbul.

Ş. Rado: *Türk hattatları* [Turkish calligraphers] (Istanbul, n.d.), pp. 196–9

A. Schimmel: *Calligraphy and Islamic Culture* (New York, 1984)

M. U. Derman: *The Art of Calligraphy in the Islamic Heritage* (Istanbul, 1998)

Letters in Gold: Ottoman Calligraphy from The Sakıp Sabancı Collection, Istanbul (exh. cat. by U. Derman; New York, Met.; Los Angeles, CA, Co. Mus. A.; Cambridge, MA, Sackler Mus.; 1999–2000)

S. S. Blair: *Islamic Calligraphy* (Edinburgh, 2006), pp. 501–3 and fig. 11.11

Muwahhidun, al-. *See* ALMOHAD.

Muzaffar ʿAli [Muẓaffar ʿAlī ibn Haydar ʿAlī al-Tabrīzī] (*fl.* late 1520s–70s; *d.* Qazvin, *c.* 1576). Persian calligrapher, illustrator, painter and poet. A versatile artist, he belonged to the second generation working for Tahmasp I (*r.* 1524–76) at the Safavid court in northwest Iran (*see* ILLUSTRATION, §VI, A). On the basis of brief notices by Safavid artists and historians, signed calligraphies and ascribed paintings, Dickson and Welch reconstructed his career. He studied calligraphy with the master Rustam ʿAli, and several folios in the album compiled for Bahram Mirza in 1544–5 (Istanbul, Topkapı Pal. Lib., H. 2154) are signed jointly by Rustam ʿAli for the writing and Muzaffar ʿAli for the *découpage* (Arab. *qatʿ*). He was a master of *nastaʿlıq* script, and two examples in the album prepared for Amir Ghayb Beg in 1564–5 (Istanbul, Topkapı Pal. Lib., H. 2161) are signed by him. In the introduction to this album, Malik Daylami wrote of his skill in calligraphic

decoration and gold illumination, and the chronicler Qazi Ahmad reported that he also excelled in gold-flecking, gilding and varnished painting. Muzaffar ʿAli reportedly studied painting with the renowned master BIHZAD, who was his great-uncle. Two paintings in London, one in a copy (BL, Or. MS. 2265, fol. 211r) of Nizami's *Khamsa* ("Five poems") dated 1539–43 and one in a copy (BL, Or. MS. 12985, fol. 5r) of Asadi's *Garshāspnāma* ("Book of Garshasp") of 1573–4, are ascribed to him. Welch attributed to him nine paintings (fols. 294r, 385v, 538r, 553r, 602v, 622r, 629r, 654r, 708v) from the monumental *Shāhnāma* ("Book of kings") made for Tahmasp (ex-Houghton priv. col., dispersed) and four (fols. 30r, 105r, 110v, 231r) in the splendid copy (Washington, DC, Freer, 46.12) of Jami's *Haft awrang* ("Seven thrones") of 1556–65. Welch identified the artist's work as lyrical and smooth, with loose compositions and thinly applied pigments. According to the historian Iskandar Munshi, the artist also designed the paintings for the Safavid royal palace in QAZVIN and the wall paintings for the Chihil Sutun Pavilion (both destr.), and personally executed much of the brushwork. He was the teacher of SADIQI and SIYAVUSH.

Malik Daylami: Preface to the Amir Husayn Beg Album (1560–61; Istanbul, Topkapı Pal. Lib., H. 2151), ed. and Eng. trans. by W. M. Thackston in *Album Prefaces and other Documents on the History of Calligraphers and Painters* (Leiden, 2001), pp. 18–21

Qazi Ahmad ibn Mir Munshi: *Gulistān-i hunar* [Garden of the arts] (*c.* 1606), ed. A. Suhayli (Tehran, Iran. Solar 1352/1974), p. 137; Eng. trans. by V. Minorsky as *Calligraphers and Painters* (Washington, DC, 1959), pp. 186, 191

Iskandar Munshi: *Tārīkh-i ʿālamārā-yi ʿabbāsī* [History of the world-conquering ʿAbbas] (1629); Eng. trans. by R. Savory as *History of Shah ʿAbbas the Great* (Boulder, 1978), pp. p. 271

M. B. Dickson and S. C. Welch: *The Houghton Shahnameh* (Cambridge, MA, 1981), pp. 154–64, pls. 168, 190, 221, 226, 237, 240, 241, 247, 255

M. Bayani: *Ahvāl va āthār-i khushnivisān* [Biographies and examples of calligraphers] (Tehran, Iran. Solar 1363/1985), pp. 209, 912

M. S. Simpson: *Sultan Ibrahim Mirza's Haft awrang: A Princely Manuscript from Sixteenth-century Iran* (London and New Haven, 1995), pp. 291–3

D. Roxburgh: *The Persian Album 1400–1600: From Dispersal to Collection* (New Haven, 2005)

Muzaffarid. Islamic dynasty that ruled in southern Iran and Kurdistan from 1314 to 1393. The founder, Sharaf al-Din Muzaffar, was a native of Khurasan and after holding several posts at the Ilkhanid court was appointed governor of Maybud near Isfahan. In 1314 his son Mubariz al-Din Muhammad (*r.* 1314–58; *d.* 1364) succeeded him in this post, and in turn added Yazd (1319), Kirman (1340), Shiraz (1354) and finally Isfahan (1356) to his domains, wresting much of southern Iran from the control of the Inju

governors and even briefly holding Tabriz. He was thus the major political figure in central and southern Iran until deposed and blinded by his son Shah Shujaʿ (*r.* 1364–84), whose reign was dominated by conflicts with his own brother (the governor of Isfahan) and the JALAYIRID rulers of western Iran. Shah Shujaʿ divided his territories between his son ʿAli (*r.* 1384–7) and his brother Ahmad (*r.* 1384–93 in Kirman), but other members of the family, Yahya (*r.* 1387–93 in Yazd) and Mansur (*r.* 1387–93 in Isfahan, Fars and Iraq), pressed their claims by force and thus weakened Muzaffarid power. Meanwhile, to the north, the TIMURID menace was growing, and although both ʿAli and Ahmad submitted to Timur, a local rebellion in Isfahan against Timur's tax collectors provoked an appalling massacre in which reputedly 200,000 people perished. Mansur fell in battle against Timur, who promptly executed the remaining 70 members of the royal house.

In the cultural sphere, the Muzaffarid rulers were notable patrons of architecture, and dozens of their buildings—including mud-brick tombs with fresco ornament, congregational mosques and madrasas—survive, especially in the areas of Isfahan (*see* ISFAHAN, §III, A), YAZD and ABARQUH (*see* ARCHITECTURE, §VI, A, 1). The great poet Hafiz (1325–90) lived at the court of Shah Shujaʿ, and in this period Ilkhanid modes of book painting gave way to those associated with the Timurids (*see* ILLUSTRATION, §V, C). Metalwork under the Muzaffarids (*see* METALWORK, §III, A) continued the tradition established under the Injus, featuring figural themes borrowed from book painting and etiolated inscriptions derived from Mamluk models.

Enc. Islam/2

S. Album: "Power and Legitimacy: The Coinage of the Mubāriz al-Dın Muḥammad ibn al-Muẓaffar at Yazd and Kirman," *Monde Iran. & Islam*, ii (1974), pp. 157–71

S. S. Blair: "Artists and Patronage in Late Fourteenth-century Iran in the Light of Two Catalogues of Islamic Metalwork," *Bull. SOAS*, xlviii (1985), pp. 53–9

L. Komaroff: "Paintings in Silver and Gold: The Decoration of Persian Metalwork and its Relationship to Manuscript Illumination," *Stud. Dec. A.*, ii/1 (1994), pp. 2–34

R. Schüttenhelm: "A Hoard of Muzaffarid Coins," *Numi. Chron.*, clxiii (2003), pp. 357–69

E. Wright: "The Calligraphers of Šīrāz and the Development of Nastaʿlīq Script," *Manuscripta Orientalia*, ix/3 (2003), pp. 16–26

Myers, George Hewitt (*b.* Cleveland, OH, 10 Sept. 1875; *d.* Washington, DC, 23 Dec. 1957). American collector. An heir to the Bristol–Myers pharmaceutical fortune, Myers began collecting Oriental carpets while an undergraduate at Yale University, New Haven, CT. He began to collect seriously from 1909, and in 1925 he founded the Textile Museum, housed in the residence that John Russell Pope (1873–1937) had designed for him in Washington, DC, and the adjacent structure. His collection then comprised

275 carpets, and he continued to enrich the museum until his death, when it included some five hundred carpets and thousands of textiles. Avoiding in large part the acquisition of then fashionable and costly showpieces, Myers built a collection of historical and traditional textiles from Asia and Central and South America that is virtually without parallel in its richness and quality.

S. P. Collins: "George Hewitt Myers, 1875–1957," *Halı*, xxvii (1985), pp. 6–7

W. B. Denny: "Connoisseur's Choice: The G.H. Myers Coupled-column Prayer Rug," *Halı*, xxxiii (1987), pp. 8–9 and 105

M. McWilliam: "One Man's Romance with Fiber Created the Textile Museum," *Smithsonian*, xvii/12 (March 1987), pp. 109–17

N

Naghi [Nagui; Nagy; Nājī], **Mohammed** (Muḥammad) (*b*. Alexandria, 1888; *d*. Cairo, 1956). Egyptian painter. He was educated at the Université de Lyon in France, where he studied law; at the School of Fine Arts, Cairo, and at Giverny under Claude Monet (1840–1926). During the 1920s he worked for the Egyptian diplomatic service at embassies abroad, but increasingly devoted himself to painting, developing an Impressionist style. In 1927 he became a member of a group of artists in Cairo called La Chimère, which included the sculptor MAHMUD MUKHTAR, and the painters MAHMUD SAID and Raghib Ayyad (1892–1982). His paintings of this period include the canvas mural *The Village* (1928; Alexandria, Mus. F.A. & Cult. Cent.). In 1930, not long after a diplomatic mission in Brazil, he left for Abyssinia (now Ethiopia), where he spent a year at the embassy in Addis Ababa. He studied the landscape of the country and painted portraits of Emperor Haile Selassie I (*r*. 1930–36, 1941–74) and other notable figures. Around this time also he studied indigenous Egyptian art. These and other experiences led to works such as the *Bread Bakers* (1934; Alexandria, Mus. F.A. & Cult. Cent.). After his Abyssinian expedition he became increasingly involved in painting murals for a number of public buildings, notably the *Renaissance of Egypt* (1935; Cairo, Senate), which depicts a slow colorful procession. In the early 1950s he formed the Atelier Group, which had branches in Cairo and Alexandria. He spent much of his life traveling and painting abroad, and in Egypt set up studios in Alexandria, Luxor, Memphis and in Cairo, where his old studio has become the Mohammed Naghi Museum.

E. J. Finbert: "Mohammed Naghi," *A. Vivant* (Jan. 1924)

Mohammed Naghi Retrospective Exhibition Catalogue (exh. cat., Prague, Higher Council F.A., 1958)

G. Boctor: "La Peinture en Egypte Moderne," *Afr. A.*, iii/1 (Autumn 1969), pp. 28–87

W. Ali, ed.: *Contemporary Art from the Islamic World* (London, 1989), pp. 24–30, 200–01

L. Karnouk: *Modern Egyptian Art, 1910–2003* (Cairo, 2005), pp. 24–31

C. Williams: "Twentieth-century Egyptian Art: The Pioneers, 1920–52," *Re-envisioning Egypt 1919–1952*, ed. A. Goldschmidt, A. J. Johnson, and B. A. Salmoni (Cairo, 2005), pp. 426–47

Na'in [Nā'īn; Nayin]. Town in central Iran. Na'in lies on the edge of the central desert to the east of Isfahan on the route from Qum to Yazd. The town has two buildings of architectural importance: the congregational mosque and a ruined palace. The mosque has been much rebuilt, but the original foundation can be dated *c*. 960 on the basis of its hypostyle plan and stucco decoration; it is one of the earliest congregational mosques to survive in Iran (*see* ARCHITECTURE, §V, A, 1). It has a small court surrounded by arcades and a roof supported by barrel vaults that are pointed with a noticeable stilt. A minaret with a square base and a tapering octagonal shaft is set in the southeast corner. The mihrab and the six bays around it are richly revetted with carved stucco. Motifs include vine scrolls, rosettes and acanthus typical of the Beveled style of carving associated with the Abbasid capital at Samarra and inscriptions in foliated kufic script framing the arches and bays. The piers on the qibla side of the court are decorated with small bricks laid in relief in diamond, zigzag and other geometric patterns. This style of brickwork is also found in the restorations to the congregational mosque at Isfahan done under the Buyids (*r*. 932–1062), and this suggests that, as at Isfahan, the court façade of the mosque at Na'in was redone soon after its construction. The three bays in front of the mihrab are covered by domical vaults, which may have been rebuilt later, perhaps at the same time that the fine wooden minbar was donated by a local merchant in 1311.

The two-story palace in Na'in has been dated *c*. 1560 on the style of the painted decoration, and it is one of the earliest examples of secular architecture built by the Safavids (*r*. 1501–1732) to survive (*see* ARCHITECTURE, §VII, B, 1). It has a sunken courtyard with two iwans on each of the longer façades. The largest iwan has intricate squinch-net vaulting rising from blind niches; both the stellate vaults and the niches are covered with figural designs of white stucco cut away to reveal a dark ground (see fig.). The traces of color that survive may be later. The scenes depicted, such as events from Persian poetry, enthroned royal couples, polo matches, banquets and the hunt, are typical of Safavid book painting (*see* ILLUSTRATION, §VI, A), while the vaults are decorated with chinoiserie themes of dragons, phoenixes and flying ducks.

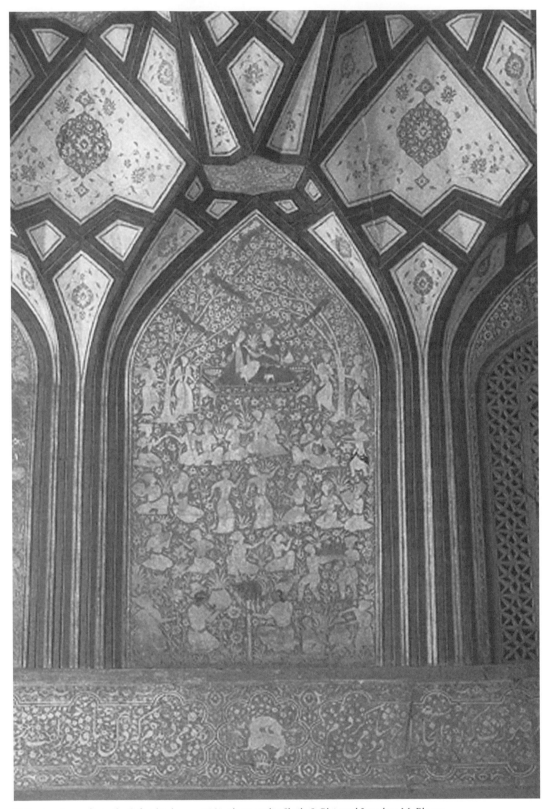

Na'in, interior vaults in the Safavid palace, *c.* 1560; photo credit: Sheila S. Blair and Jonathan M. Bloom

H. Viollet and S. Flury: "Un Monument des premiers siècles de l'hégire en Perse," *Syria*, ii (1921), pp. 226–34, 305–16

S. Flury: "La Mosquée de Nāin," *Syria*, xi (1930), pp. 43–58

M. B. Smith: "The Wood Mimbar in the Masḏid-i Ḏami', Nāīn," *A. Islam.*, v (1938), pp. 21–35

A. U. Pope and P. Ackerman, eds.: *Survey of Persian Art* (Oxford, 1938–9, rev. Shiraz, 2/1964–7), pp. 934–9

I. Luschey-Schmeisser: "Der Wand- und Deckenschmuck eines safavidischen Palastes in Nayin," *Archäol. Mitt. Iran*, n. s., ii (1969), pp. 183–92

I. Luschey-Schmeisser: "Ein neuer Raum in Nayin," *Archäol. Mitt. Iran*, v (1972), pp. 309–14

R. Hillenbrand: "Studi in Onore di Ugo Monneret de Villard (1881–1954), *Riv. Studi Orient.*, lix (1985), pp. 1–4

S. S. Blair: *The Monumental Inscriptions from Early Islamic Iran and Transoxiana* (Leiden, 1992), no. 9

B. Finster: *Frühe Iranische Moscheen* (Berlin, 1994), pp. 67–9, 209–22

T. Sabahi: "Flowers of the Desert: The Carpets of Nain," *Ghereh*, vi (1995), pp. xvii–xxii, Eng. trans. of "Fiori del deserto: I tappeti di Nain," pp. 17–22

S. R. Canby: *The Golden Age of Persian Art* (London, 1999), pp. 70–72

Nakhchyvan [Nakhchivan; Nakhčiwān; Nakhichevan]. Town and region in Azerbaijan. Set in a mountainous area known for good hunting and natural beauty, it is located in Transcaucasia northwest of the great southern bend of the Araxes River, which has formed the border with Iran since 1834. Archaeological excavations reveal that the town was founded in the 6th century BCE. It reached its apogee in the 12th century CE, when it became an important political and trading center between Transcaucasia, Iran and Anatolia and the capital of the Eldigüzid (Ildegizid) rulers of Azerbaijan (*r.* 1137–1225).

The medieval town developed within fortified walls (10th–14th century). The anonymous 13th-century author of *Ajā'ib al-dunyā* ("Wonders of the world") mentioned the construction near the town of a stone fortress with a madrasa and mosque and a source of water. In the town itself were the palace and government building. A local school of architecture, characterized by the use of engaged columns and glazed brick, developed for commemorative and religious buildings in the 12th century under 'Ajami ibn Abu Bakr, who designed the octagonal mausoleum of Yusuf ibn Kusayr (1162–3). The sides have reveals elaborately decorated with strapwork, and a frieze with a kufic inscription below the pyramidal roof and the three-line inscription over the door are done in terracotta. 'Ajami ibn Abu Bakr also designed the mausoleum (1186) for Mu'mina Khatun, wife of one of the Eldigüzids. The architect gave the decagonal tower (h. 25 m) monumental form by setting it on a socle faced with red diorite. He also used more elaborate decoration: the sides have pointed reveals with *muqarnas* hoods and several types of geometric patterns; the wide frieze below the *muqarnas* cornice is decorated with a kufic inscription composed of turquoise-glazed tiles. On the interior, a cylindrical chamber surmounts the crypt covered by a system of pointed arches. As part of the mausoleum for Mu'mina Khatun, 'Ajami ibn Abu Bakr also designed a mosque, now in ruins, which had a tall portal with a pointed arch flanked by tapering minarets.

Nakhchyvan was devastated by the Mongols in the 13th century. According to the 17th-century traveler Evliya Çelebi, it had 10,200 houses, 40 mosques, 20 caravanserais, 7 baths, some 1000 shops and 33 minarets, but the town plan (1827) drawn up by Russian military engineers shows only the remains of these buildings in the center of town, where there was a square with the mausoleum of Mu'mina Khatun, a palace and commercial structures (destr.). The Imamzada complex with three mausolea was begun in the 18th century. The first mausoleum comprises a cubic socle, an octagon shaft, a round drum and a helmet-shaped cupola. The drum is decorated with dark violet glazed brick in the *bannā'ī* technique. Two more mausolea were added in the 19th century. One, built of brick, is square with a cylindrical vault. The other, built of brick and stone, is a domed octagon with pointed reveals on the interior. A 19th-century mosque, now ruined, had a complex plan and façades articulated with pointed niches. The typical house in Nakhchyvan was a two-story square with passages leading from a central vestibule to corner rooms. The staircase leading to the first floor opened into a broad hall covered with a flat roof. The houses were set in courtyards, with the main façade looking on to the garden and an iwan-type gateway. In 1968 the architects U. Ibrahimov and N. Mamedbeyli drew up a town plan that determined all subsequent construction. The Musical Dramatic Theater, designed (1964) by I. Ismailov and G. Medjidov, has a portico with four paired columns topped with *muqarnas* capitals.

Enc. Islam/2: "Naḵčiwān"

V. M. Sysoyev: *Nakhchyvan' na Arakse i drevnosti Nakhchyvan-skoy avtonomnoy sotsialisticheskoy respubliki* [Nakhchyvan on the Araxes and the antiquities of the Nakhchyvan' autonomous socialist republic] (Baku, 1928)

A. V. Salamzade: *Adzhemi syn Abubekra Nakhchyvani* ['Ajami son of Abu Bakr Nakhchyvani] (Baku, 1976)

A. V. Salamzade and K. M. Mamedzade: *Pamyatniki nakhchy-vanskoy shkoly azerbaydzhanskogo zodchestva* [Monuments of the Nakhchyvan school of Azerbaijani architecture] (Baku, 1985)

M. S. Ne'mät: *Arabo-Perso-Tiurkoiazychne nadpisi nakhchivan-skoi autonomnoi respubliki (XII vek-nachalo XX veka)* [Arabic-Persian-Turkish inscriptions of the Nakhchyvan AR (XII–early XX centuries)], (Baku, 2001) [Eng. summary]

Nakkaş Osman. *See* OSMAN.

Nanha [Nānhā] (*fl. c.* 1582–1635). Indian miniature painter. His works epitomize the stylistic and typological changes that occurred in Mughal painting during the reigns of the three emperors who were his

patrons: Akbar (*r.* 1556–1605), Jahangir (*r.* 1605–27) and Shah Jahan (*r.* 1628–57). His earliest known works appear in the *Dārābnāma* ("Story of Darab"; *c.* 1580; London, BL, Or. MS. 4615); the *Razmnāma* ("Book of wars"; 1582–6; Jaipur, Maharaja Sawai Man Singh II Mus., MS. AG. 1683–1850), a translation of the Hindu epic the *Mahābhārata* commissioned by Akbar; and the *Tārīkh-i Khāndān-i Tīmūriyya* ("History of the house of Timur"; *c.* 1584; Bankipur, Patna, Khuda Bakhsh Lib.). Nanha is not among the 17 artists singled out for praise in the *Āyīn-i Akbarī*, a contemporary account of Akbar's reign, but his multiple roles as designer, painter and portraitist in the *Akbarnāma* of *c.* 1590 ("History of Akbar"; London, V&A, MS. IS.2:1896) suggest that he ranked high in the atelier's second tier of artists. He contributed more often to profusely illustrated manuscripts than to de luxe projects; however, one painting in Akbar's fine, small *Dīvān* (collected poems) of Anvari (1588; Cambridge, MA, Sackler Mus., MS. 1960.117.15) has been attributed to him and four paintings in the *Khamsa* ("Five poems") of Nizami (1595; London, BL, Or. MS. 12208, fols. 63*v*, 159*r*, and 305*v* (signed on a scroll held by a seated figure in yellow); and Baltimore, MD, Walters A.Mus., MS. W.613, fol. 16*v*) bear inscriptions naming him as the artist. Nanha's work displays two distinctive figure types: one whose thickset neck and shoulders impart a notable stockiness and another whose slender physique is accentuated by strong contours and a small but heavily modeled face.

Nanha is known particularly for his portraiture, which was well-suited to the taste of Jahangir. It has been suggested that he left the imperial workshop to join Jahangir when he rebelled and established a separate court at Allahabad. This theory is based on the paucity of works in imperial projects about 1600; an illustration in the *Dīvān* of Amir Hasan Dihlavi (1602; Baltimore, MD, Walters A.Mus., MS. W.650); and a single illustration (fol. 280*v*) late in the manuscript of the *Anvār-i Suhaylī* ("Lights of Canopus"; 1604–10/11, London, BL, Add. MS. 18579).

Unlike his more famous nephew, BISHAN DAS, also known for his portraiture, Nanha produced relatively few paintings for Jahangir and Shah Jahan. His self-portrait is included in an illustration for the *Jahāngīrnāma* ("History of Jahangir"; London, V&A, IS. 185-1984), which shows him as a middle-aged, dark-complexioned attendant kneeling among the figures surrounding Prince Khurram (the future Shah Jahan). A later work shows Shah Jahan with Prince Dara Shikoh (New York, Met., 55.121.10.36*v*). Portraits of nobles with inscriptions naming Nanha as the artist include those of *Zulfiqar Khan* from the Minto Album (*c.* 1635; London, V&A) and *Sayf Khan Barha* (New York, Met., 55.121.10.4*v*). Nanha also developed a minor specialty of scenes of lion attacks, one of his finest being *Perils of the Hunt* (Philadelphia, PA, Free Lib., M.36), painted uncharacteristically on silk.

Nanha's artistic identity has been somewhat obscured by his erroneous association with other artists with similar names. These include a lesser Akbar-period painter known from inscriptions as Nama or Naman. It has also been proposed (Losty, 1982) that Nanha is synonymous with the artist Kanha, explaining the orthographic difference as a variant Persian transliteration of regional pronunciations of the proper Hindu name Jnana. Although this view can be supported somewhat on stylistic grounds, its plausibility is undermined by the inscription on one painting (57/117) of the *Akbarnāma* of *c.* 1586–7 (or *c.* 1590) which lists Kanha and Nanha as the respective designer and painter, a formula never used when a single artist served both roles.

The Grand Mogul: Imperial Painting in India, 1600–1660 (exh. cat. by M. C. Beach; Williamstown, MA, Clark A. Inst.; Baltimore, MD, Walters A.G.; Boston, MA, Mus. F.A.; New York, Asia House Gals.; 1978–9)

The Imperial Image: Paintings for the Mughal Court (exh. cat. by M. C. Beach; Washington, DC, Freer, 1981)

The Art of the Book in India (exh. cat. by J. Losty; London, BL, 1982)

A. Schimmel and S. C. Welch: *Anvari's Divan: A Pocket Book for Akbar* (New York, 1983)

V&A Mus. Album, Occasional paper, 4 (1985), p. 16

S. C. Welch and others: *The Emperors' Album* (New York, 1987)

L. Y. Leach: *Mughal and Other Indian Paintings from the Chester Beatty Library* (London, 1995)

King of the World: The Padshahnama, an Imperial Mughal Manuscript from the Royal Library, Windsor Castle (exh. cat. by M. C. Beach and E. Koch; New Delhi, N. Mus.; London, Queen's Gal., and elsewhere; 1997–8)

S. Stronge: *Painting for the Mughal Emperor: The Art of the Book 1560–1660* (London, 2002)

Naqsh, Jamil (*b.* Kairana, India, 1937). Pakistani painter. His father, the painter Abdul Basit, introduced him to miniature painting. He devoted much of his two years at the National College of Arts, Lahore, to an internship with Mohammad Haji Sharif (1889–1978), the last of the old-guard miniature painters in Pakistan. Naqsh's first major exhibition was held in Lahore (1962); he then moved to Karachi.

Naqsh is among the most accomplished draftsmen in Pakistan, equally skilled in pencil, pen and ink, watercolor, oil and mixed media. His early figurative work is slightly abstract, reflecting the influence of another mentor, SHAKIR ALI. Naqsh's color schemes are often monochromatic or bichromatic in brilliant blues and reds. Other paintings in lighter, more neutral tones suggest the influence of Karachi painter 'Ali Imam (1924–2002).

Naqsh claims no symbolism for his ubiquitous rendering of women and pigeons (usually in combination), depicted both realistically and abstractly. While most painters returned to figurative art and realism in the late 1980s, Jamil embarked upon a colorful, lyrical series of non-objective paintings. In the 1990s, he introduced the image of the horse juxtaposed with nude female forms. A large retrospective

exhibition of his work was held in 2004 in the Mohatta Palace Museum in Karachi, and in 2006 his work was included in the New Delhi exhibition *Euphonic Palettes* showing the common heritage of Indian and Pakistani painters.

See also PAKISTAN, §III.

B. Ashraf: "An Inroduction to Jamil Naqsh," *The Sun* (2 May 1971), pp. 1–5

Nina: "Jamil Naqsh—Our Most Complete Artist," *Focus Pakistan*, iii/3 (1976), pp. 23–8

S. Ashraf: "Naqsh: Seeking Perfection," *The Herald* (Nov. 1979), pp. 34–6

Paintings from Pakistan (Islamabad, 1988)

M. Nesom-Sirhandi: *Contemporary Painting in Pakistan* (Lahore, 1992)

A. Naqvi: *Image and Identity: Painting and Sculpture in Pakistan 1947–1997* (Karachi, 1998)

Narrative art. Term used to describe art that provides a visual representation of some kind of story, usually based on a literary work. It is found throughout the world, and it appears not only as an art form in its own right in both two and three dimensions but also as decoration on a variety of objects. Narration, the relating of an event as it unfolds over time, is in principle a difficult task for the visual arts, since a work of art usually lacks an obvious beginning, middle and end, essential features of any story. Nevertheless, since ancient times many works of art have had as their subjects figures or tales from mythology, legend or history. The artists overcame the inherent limitations of visual narrative by representing stories that the viewer might be expected to know and would therefore retell in his or her mind while taking in the representation.

Narrative imagery in the Islamic lands continued an artistic tradition of the pictorialization of stories and historical events that had long prevailed throughout western Asia and the Mediterranean region. The earliest examples of recognizable narrative may be found among the frescoes in the bath complex at QUSAYR 'AMRA, an 8th-century site in the Jordanian desert. The diverse program of monumental decoration includes three hunting scenes, the first depicting a Bedouin round-up of onagers, and the other two depicting the killing (or perhaps branding) and butchering of the captured animals. Although the wall paintings are on different walls, they seem to represent a sequence or progression of related events that may well have taken place in the vicinity of the estate.

Virtually no examples of buildings decorated with narrative scenes survive from later periods, although some fragmentary remains and literary descriptions, such as those in the *Shāhnāma* ("Book of kings") compiled by the poet Firdawsi between *c.* 980 and *c.* 994 and revised *c.* 1010, may attest to the continuation of this imagery. In order to trace the history of narrative images through the medieval and later Islamic periods, it is necessary to turn to three-dimensional objects, particularly ceramics, metalwork and illustrated manuscripts. The vast corpus of Islamic objects includes various pieces decorated with identifiable narrative scenes, or at least with images that may be presumed to refer to some kind of story or actual event. A number of pieces of lusterware made in Egypt in the 11th and 12th centuries, for example, are said to represent genre scenes (*see* CERAMICS, §III, A), including cock fights and men wrestling, but these might just as easily represent fables or local legends. Scenes from the *Life of Christ* appear on a group of inlaid brasses from 13th-century Syria and Egypt, while the exploits of specific heroes figure on Iranian metalwork and enameled and luster-painted ceramics dating from the 12th century until the 14th (*see* METALWORK, §IV, A, 1). In these works the decoration comprises extracted, and occasionally conflated or epitomized, narratives rendered as discrete images. The emphasis on the single narrative moment, as opposed to serial narration, suggests that the iconography was sufficiently familiar, so that anyone looking at such works would be able to identify the complete narrative. The representation of a solitary figure riding a humped, horned cow, for instance, on the interior of a luster-painted bowl (e.g. bowl from Iran, 12th–13th century; Leipzig, Kstgewmus.) would have been enough to conjure up the entire story of how the legendary Iranian hero Faridun captured the evil usurper Zahhak with the help of the blacksmith Kawa. The depiction of a narrative sequence sometimes occurs, as in the famous enameled beaker from Iran (early 13th century; h. 120 mm, diam. 112 mm; Washington, DC, Freer) decorated with the tale of Bizhan and Manizha "told" in comic-strip style of three superimposed registers with small linked panels. Even here, however, only a few, select moments in the story, known from the *Shāhnāma*, are represented, and it is left to the viewer to fill in the narrative lacunae and reconstruct the entire heroic tale.

Pictorial narrative in Islamic illustrated manuscripts was also based on selection and extraction. Although Arab codices of the 13th century, such as a copy (Paris, Bib. N., MS. arabe 5847) of al-Hariri's *Maqāmāt* ("Assemblies"), contain narrative scenes, these generally were not required by the text and seem to derive from an interest in recording aspects of everyday life. Narrative painting as an artistic genre within the Islamic art of the book really developed and flourished in volumes of Persian and Turkish literature, including histories, epics, romances and mystical allegories, written in both prose and poetry. Illustrations in such texts not only depict the action of a story but also invoke mood, express emotion and interpret abstract themes.

The earliest known manuscript with narrative paintings is the well-known copy (Istanbul, Topkapı Pal. Lib., H841; *see* ILLUSTRATION, fig. 19) of *Varqa and Gulshah*, datable to the early 13th century. The Persian story of two star-crossed lovers contains 72 narrow illustrations set between lines of text. The majority of these compositions are in close proximity to the verses they illustrate and follow the content

and sequence of the text—a principle that obtained throughout the history of the pictorial narrative in Iran and neighboring regions. Another noteworthy feature of this manuscript is its high rate of illustration, with narrative scenes coming in rapid succession. This approach towards narrative illustration prevailed until the middle of the 14th century. Thereafter, illustrated manuscripts tended to have a much smaller selection of scenes, with greater emphasis placed on the landscape setting and other features of individual narrative compositions.

Manuscript painters evidently had considerable freedom in the choice of narrative episodes to be illustrated, and virtually no two volumes of the same text, be it the epic *Shāhnāma* by Firdawsi, Nizami's romances collected in the *Khamsa* ("Five poems"; *see* ILLUSTRATION, color pl. 2:VII, fig. 2) or Jami's mystical *Haft awrang* ("Seven thrones"), have the same set of illustrations. Invariably, certain favorite stories were illustrated again and again, leading to the formulation of standardized, and instantly recognizable, images. Such narrative topoi, however repetitive or iconographically formulaic, could evoke the entire progression of a story, including the overall plot, dramatic action and cast of characters. Narrative imagery in Islamic manuscripts goes beyond "mere" illustration. It also involves the use of visual metaphors, intended to enhance complex literary themes and mystical ideas. This is, perhaps, the most distinctive feature of Islamic narrative painting, through which it can rightly be acclaimed as one of the most imaginative narrative traditions in the history of art.

Muslim rulers of West and Central Asian origin introduced a secular and nationalist narrative tradition into India. The sultanate rulers (13th–16th century) of north India commissioned illustrations of Firdawsi's *Shāhnāma* ("Book of kings"), and books of fables and stories. The Mughal ruler Akbar (*r.* 1556–1605), once his Indian empire had been secured, commissioned illustrations to his grandfather Babur's biography, to the *Hamzanāma* (a Persian romance) and to the account of his own rule, the *Akbarnāma*, as well as to Hindu epics and other texts. Subsequent Mughal emperors and provincial Muslim rulers continued the practice of illustrating events in their reigns. Examples include the *Tūzuk-i Jahāngīrī* (*c.* 1620), the memoirs of Jahangir (*r.* 1605–27) and the *Pādshāhnāma* (*c.* 1646/50), an account of the reign (1628–58) of Shah Jahan.

A. S. Melikian-Chirvani: "Le Roman de Varqe et Golsah," *A. Asiatiques*, xxii (1970), pp. 1–262

A. S. Melikian-Chirvani: "Conceptual Art in Iranian Painting and Metalwork," *Akten des VII internationalen Kongresses für iranische Kunst und Archäologie*: Berlin, 1979, pp. 392–400

M. S. Simpson: "The Narrative Structure of a Medieval Iranian Beaker," *A. Orient.*, xii (1981), pp. 15–24

M. S. Simpson: "Narrative Allusion and Metaphor in the Decoration of Medieval Islamic Objects," *Pictorial Narrative in Antiquity and the Middle Ages*, ed. H. L. Kessler and M. S. Simpson, Stud. Hist. A., xvi (Washington, DC, 1985), pp. 131–49

A. S. Melikian-Chirvani: "Khwaje Mirak Naqqash," *J. Asiat.*, cclxxvi (1988), pp. 97–146

E. Baer: *Ayyubid Metalwork with Christian Images* (Leiden, 1989)

P. Chelkowski: "Narrative Painting and Painting Recitation in Qajar Iran," *Muqarnas*, vi (1989), pp. 98–111

S. P. Verma: *Painting under Akbar as Narrative Art* (Delhi, 1997)

N. N. Khoury: "Narratives of the Holy Land: Memory, Identity and Inverted Imagery in the Freer Basin and Canteen," *Orientations*, xxix/5 (1999), pp. 63–9

U. Marzolph: *Narrative Illustration in Persian Lithographed Books* (Leiden, 2001)

G. Fowden: *Qusayr 'Amra: Art and the Umayyad Elite in Late-Antique Syria* (Berkeley and Los Angeles, 2004)

Nasrid [Banū Naṣr; Banū'l-Aḥmar]. Islamic dynasty that ruled in southern Spain from 1230 to 1492. The Nasrids rose to power after the defeat of the Almohads (*r.* 1130–1269) at the battle of Las Navas de Tolosa (1212) and ruled over a kingdom that extended from the Straits of Gibraltar and Almería in the south to the mountains of the Serrania de Ronda and the Sierra d'Elvira in the north. In 1238 Granada (*see* GRANADA, §I, A) was captured and adopted as capital by the Nasrid ruler Muhammad I (*r.* 1232–72). As vassal to the Christian king Ferdinand III of Castile and León (*r.* 1217–52) and later to Alfonso X (*r.* 1252–84), Muhammad I witnessed their victories in Southern Spain, while many Spanish Muslim refugees were attracted to his kingdom. After the reign of Muhammad I the Nasrids alternated between submission to Castile and alliance with the Muslim MARINID dynasty of Fez, which resulted in four Marinid expeditions to the Iberian peninsula. The Nasrids became weakened by factional strife, and when Christian Spain was united by the marriage of Ferdinand II of Aragon to Isabella I of Castile in 1469, the Nasrid position grew precarious. After a series of defeats, the Nasrid kingdom dwindled, and under Abu'l-Hasan 'Ali (*r.* 1464–85 with interruption) there was a succession struggle. Nearly eight centuries of Muslim rule in Spain came to an end with the Christian conquest of Granada in 1492, and the last Nasrid ruler, Muhammad XI (*r.* 1482–92 with interruption), known to the West as Boabdil, became an exile in Morocco.

Architecture flourished under Nasrid rule, especially in Granada in the 14th century. The Nasrids are principally remembered for the construction of the citadel known as the Alhambra (*see* GRANADA, §III, A, 1), which comprised a palace–city; but there are remains of several other Nasrid buildings in Granada and elsewhere in the kingdom (*see* ARCHITECTURE, §VI, D, 1). Under Muhammad II (*r.* 1272–1302) the garden palace known as the Generalife was added and the palace known as the Dar al-Manjara al-Kubra (now the Cuarto Real de S. Domingo) built in the city. Muhammad III (*r.* 1302–8) built the Great Mosque (destr.) in Granada as well as the Partal Palace and the Torre de las Damas at the Alhambra, and Isma'il I (*r.* 1313–25)

rebuilt the Generalife and began work on the Mexuar. It was, however, during the reigns of Yusuf I (*r.* 1333–54) and Muhammad V (*r.* 1354–91 with interruption) that the most spectacular additions were made at the Alhambra, including the Palacio de Comares (*see* ARCHITECTURE, fig. 41) and the Palacio de los Leones. Yusuf also built a madrasa (rest.) in Granada.

Patronage of the decorative arts was equally important under the Nasrids, and splendid examples of ceramics, textiles, metalwork and jewelry survive, many inscribed with the Nasrid motto (*lā ghālib ilā'llah*: "There is no victor save God"). The Nasrids commissioned immense luster-painted objects, including earthenware jars known as Alhambra vases, and tile panels such as the Fortuny Tablet (1.08×0.63 m; Madrid, Inst. Valencia Don Juan), which bears an inscription dating it to the reign of Yusuf III (*r.* 1407–17; *see* CERAMICS, §IV, D). Nasrid silk textiles were among the finest produced and were prized by Muslims and Christians alike (*see* TEXTILES, §III, A), as were large knotted woolen carpets. Splendid swords, daggers, knives and shields richly decorated with cloisonné enamels exemplify the quality of Nasrid metalwork (*see* METALWORK, §III, D, and ARMS AND ARMOR, §I). Few manuscripts survived the Christian reconquest, but rare copies of the Koran (e.g. 1304; Paris, Bib. N., MS. arab. 385) give some idea of the richness of Nasrid decoration and the distinctive style of calligraphy.

Enc. Islam/2
L. Torres Balbás: *Arte almohade: Arte nazarí: Arte mudéjar,* A. Hisp., iv (Madrid, 1949)
L. Torres Balbás: *La Alhambra y el Generalife* (Madrid, 1950)
R. Arié: *L'Espagne musulmane au temps des Nasrides, 1232–1492* (Paris, 1973, 2/1990)
O. Grabar: *The Alhambra* (Cambridge, MA, and London, 1978)
S. S. Kenesson: "Nasrid Luster Pottery: The Alhambra Vases," *Muqarnas,* ix (1992), pp. 93–115
Al-Andalus: The Art of Islamic Spain (exh. cat., ed. J. D. Dodds; Granada, Alhambra; New York, Met.; 1992)
Schätze der Alhambra: Islamische Kunst aus Andalusien (exh. cat. by A. von Gladiss; Berlin, Kulturforum, 1995)
A. Fernández-Puertas: *The Alhambra, I: From the Ninth Century to Yusuf I (1354)* (London, 1997)
M. J. Viguera Molíns, ed.: *El reino nazarí de Granada (1232–1492),* 2 vols. (Madrid, 2000)
R. Arié: *Historia y cultura de la Granada nazarí* (Granada, 2004)
R. Irwin: *The Alhambra* (Cambridge, MA, 2004)

Nasuh Matrakçi [Naṣūḥ al-Silāḥī al-Matrāqī; Naṣūḥ ibn Qaragöz ibn 'Abdallāh al-Būsnawī] (*b.* Visoko, Bosnia; *fl.* 1517; *d.* 28 April 1564). Ottoman soldier, writer, copyist and illustrator. He initiated the topographical style of painting that became characteristic of the illustrated histories produced at the Ottoman court in the 1550s (*see* ILLUSTRATION, §VI, D, 1). As a youth he was recruited into the imperial service in a forced levy (*devşirme*) and was trained as a page in the household of Sultan Bayezid II (*r.* 1481–1512). He later served as an officer in the Ottoman army, where he was noted as a swordsman. He was also celebrated as the inventor of new forms of the game of *matrak*, played by throwing sticks or weapons as a form of military training.

Nasuh was a prolific writer on mathematics, swordsmanship and history. In 1520 he began the translation from Arabic into Turkish of al-Tabari's *Majuma' al-tawārīkh* ("Compendium of histories"), to which he added a section covering the history of the Ottomans to 1551. He transcribed and illustrated at least three volumes of this section on the Ottomans. Only one, an account of the campaigns of 1534–6 in Iraq and Iran with 128 illustrations, is signed, but a history of Sultan Bayezid II with 10 scenes and an account of the Hungarian campaign of 1543 and of operations by the Ottoman navy in the Mediterranean are identical in style. The latter has 32 illustrations. His paintings show views of cities devoid of figures, but with detailed, if schematic, representations of their major monuments and the surrounding countryside. They reflect influences of European maps but record Nasuh's own impressions of the sites.

UNPUBLISHED SOURCES

Istanbul, Topkapı Pal. Lib. [Tarih-i Sultan Bayezid ("History of Sultan Bayezid"); *c.* 1540; MS. R. 1272]

WRITINGS

Beyân-i menâzil-i sefer-i Irâkeyn-i Sultan Süleyman Han [Description of the stages on the campaign of Sultan Süleyman Khan in the two Iraqs] (1537; Istanbul, U. Lib., T. 5964); facs. edn. H. G. Yurdaydın (Ankara, 1976)
Tarih-i Feth-i Şiklôş, Estergon ve İstol(n)i Belgrad or Süleyman-name [History of the conquest of Siklos, Esztergom and Székesfehérvár or Book of Süleyman] (*c.* 1545; Istanbul, Topkapı Pal. Lib., H.1608); facs. edn. (Ankara, 1987) [pubd as work of Sinan Çavuş]

BIBLIOGRAPHY

Enc. Islam/2
H. G. Yurdaydın: *Matrakçı Nasuh* (Ankara, 1963)
Z. Akalay: "Tarihi konularda ilk Osmanlı minyatürleri" [The first Ottoman miniatures on historical subjects], *Sanat Tarihi Yıllığı,* ii (1966–8), pp. 102–15
W. B. Denny: "A Sixteenth-Century Architectural Plan of Istanbul," *A. Orient.,* viii (1970), pp. 49–63
E. Atıl: *The Age of Sultan Süleyman the Magnificent* (Washington and New York, 1987), pp. 82–6
H. G. Yurdaydın: "Matrakçi Nasuh: The Famous Knight, Scientist and Artist of the Period of Süleyman the Magnificent," *The Great Ottoman-Turkish Civilisation: 3. Philosophy, Science and Institutions,* ed. K. Çiçek (Ankara, 2000), pp. 348–56

Natanz [Naṭanz]. Town in central Iran, 130 km north of Isfahan. The antiquity of the town, situated on the eastern slopes of the Karkaz Mountains, is attested by the ruins of a fire temple of the Sasanian period (224–632 CE). A dependency of Isfahan in the Islamic period, the town preserves the oldest dated dome

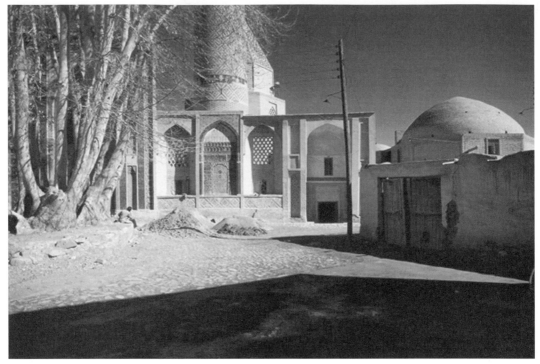

Natanz, façade of the shrine of ʿAbd al-Samad, early 14th century; photo credit: Sheila S. Blair and Jonathan M. Bloom

(999) in central Iran, probably built as an octagonal tomb for a local saint and later incorporated into the Friday mosque as the sanctuary dome. ʿAbd al-Samad (*d.* ?1299), a mystic of the Suhrawardi order, lived near the mosque, and after his death, an Ilkhanid vizier enlarged it (1304–9) and constructed the adjacent shrine complex (see fig.), comprising the mystic's tomb, with a superb *muqarnas* vault (1307–8; *see* ARCHITECTURE, color pl. 1:VI, fig. 3), and a *khanaqah* with a splendid tile mosaic façade (1307–8; *see* ARCHITECTURE, §VI, A, 1). A minaret was added in 1324–5. The complex was decorated with stucco inscriptions designed by the renowned calligrapher HAYDAR and luster tiles, including a mihrab hood (London, V&A, 71-1885), a cenotaph cover (New York, Met., 09.87) and a frieze (dispersed), identifiable by its headless birds, defaced by a later iconoclast.

Enc. Islam/2

A. Godard: "Naṭanz," *Āthār-ē-Īrān*, i (1936), pp. 75–106

H. Naraqi: *Āthār-i taʾrīkhī-yi shahristānhā-yi Kāshān u Naṭanz* [Historical monuments of Kashan and Natanz] (Tehran, Iran. Solar 1348/1970)

S. S. Blair: "The Octagonal Pavilion at Natanz," *Muqarnas*, i (1983), pp. 69–94

S. S. Blair: "A Medieval Persian Builder," *J. Soc. Archit. Historians*, xlv (1986), pp. 389–95

S. S. Blair: *The Ilkhanid Shrine Complex at Natanz, Iran* (Cambridge, MA, 1986)

S. S. Blair: "Sufi Saints and Shrine Architecture in the Early Fourteenth Century," *Muqarnas*, vii (1990), pp. 35–49

S. S. Blair: *The Monumental Inscriptions of Early Islamic Iran and Transoxiana* (Leiden, 1992), no. 58

R. Orazi: "Il caravanseraglio di Natanz," *L'Arco di Fango Che Rubò la Luce Alle Stelle: Studi in Onore di Eugenio Galdieri per Il Suo Settantesimo Compleanno*, ed. M. Bernardini et al. (Lugano, 1995), pp. 249–63

T. Masuya: "Persian Tiles on European Walls: Collecting Ilkhanid Tiles in Nineteenth-Century Europe," *A. Orient.*, xxx (2000), pp. 39–54

Nayin. *See* NAʾIN.

Nayshābūr [Nehshāpūr]. *See* NISHAPUR.

Neshat, Shirin (*b.* Qazvin, Iran, 26 March 1957). American photographer and video artist of Iranian birth. She earned a B.F.A. (1979) and an M.F.A. (1982) from the University of California at Berkeley. Unable to return to Iran for political reasons, she became involved in the Storefront for Art and Architecture in New York. Years later, having settled in New York, she began making art in response to the situation she found after a visit to the post-Shah religious state. Using the Islamic veil or chador, she made photographs that examined stereotypes of Muslim women as oppressed by the veil but also empowered by their refusal of the Western colonial gaze, as in *Women of Allah* (1993–7) and *Rebellious Silence* (1994). In these works Neshat is often posed with a gun, her image overlaid in Islamic script, as a way of confronting the Western view of Islam as both incomprehensible and dangerous. In 1998 she created a major video work, *Turbulent*, which took the form of a double projection: on one side a female singer in an

empty auditorium; on the other a man singing to a large and exclusively male audience. The work examines the constriction of tradition and the need for women to refute their invisibility in the eyes of the Iranian state through transgressive creative acts, as exemplified by Sussan Deyhim's extraordinary wordless singing. Neshat followed this with two more videos, *Rapture* (1999) and *Fever* (2000), both using double projection and examining the oppositions between male law and the female body in Islamic states. Her 2002 video *Tooba* ("Repentence"), inspired by the tree in the Koran, used the garden as a symbol for spiritual longing in Paradise. It was the first of her pieces to be shown in her native country, where she had been declared an enemy of the state in 1999. It marked a mythological turn in her work, continued in *Logic of the Birds* (2002), a full-length multimedia production made with singer Sussan Deyhim and produced by curator RoseLee Goldberg.

Women without Men (2004–8) is a five-part film based on the 1989 novel by Shahrnush Parsipur. Part one, *Mahdokht* ("Mother Earth"; 2004) and part two, *Zarin* ("Golden"; 2005) abandoned her earlier dualism of black/white and male/female for color and a style closer to Magic Realism. She is probably the best-known Persian artist working with the Western artistic world.

Shirin Neshat (exh. cat., essay by I. Zabel; Ljubljana, Gal. Mod. A., 1997)

Shirin Neshat: Rapture (exh. cat., essay by J. Rondeau; Paris, Gal. Jérôme de Noirmont, 1999)

J. Sorkin: "A Conversation with Shirin Neshat," *Make*, lxxxviii (2000), pp. 20–21

Shirin Neshat (essays by R. Noack, H. Naficy, and interview by G. Matt; Vienna, Ksthalle; London, Serpentine Gal., 2000)

I. Zabel: "Women in Black," *A. J.*, lx/4 (2001), pp. 16–25

C. Butler: "Ambivalence and Iranian Identity: The Work of Shirin Neshat," *E. A. Rep.*, iv/5 (2002), pp. 40–48

W. M. K. Shaw: "Ambiguity and Audience in the Films of Shirin Neshat," *Third Text*, lvii (2002), pp. 43–52

Outer & Inner Space: Pipilotti Rist, Shirin Neshat, Jane & Louise Wilson, and the History of Video Art (exh. cat. by J. B. Ravenal; Richmond, VA Mus. F.A., 2002)

Shirin Neshat (exh. cat., Milan, Castelle di Rivoli, 2002)

J. Jung and R. Jung: *Shirin Neshat [videorecording]: The Woman Moves* (Princeton, 2004)

A. Naeem: "Shirin Neshat's Women of Allah Series: The Differentiation and Degeneracy of Islam," *Chicago A. J.*, xiv (2004), pp. 2–17

Shirin Neshat: La última palabra/The Last Word (exh. cat., León, Mus. A. Contemp., 2005)

L. A. Zanganeh, ed.: *My Sister, Guard your Veil; My Brother, Guard your Eyes: Uncensored Iranian Voices* (Boston, 2006)

Word into Art: Artists of the Modern Middle East (exh. cat. by V. Porter; London, BM, 2006)

Nevşehirli Ibrahim Pasha. *See* IBRAHIM PASHA.

Nicaea. *See* IZNIK.

Niebuhr, Carsten (*b.* Lüdingworth, Hannover, 17 March 1733; *d.* Meldorf, 26 April 1815). German traveler and scholar. The son of a small farmer, in 1760 he was invited to join the Arabian expedition of Frederick V of Denmark (*r.* 1746–66) as surveyor and geographer, and in January 1761 a team set sail which included the philologist F. C. von Haven (1727–63), natural scientist Petrus Forskål (1732–63), physician Christian C. Cramer (1732–63) and artist Georg Wilhelm Baurenfeind (1728–63). The party visited the Nile, Mt. Sinai, Suez and Jiddah and then traveled overland to Mukha (Mocha) in southwest Arabia. In 1763 after the death of the philologist and the natural scientist, the others visited Sanʿa, capital of the Yemen, and returned to Mukha. They then set sail for Bombay (now Mumbai), the artist dying at sea and the physician in Bombay, leaving Niebuhr as sole survivor. He stayed in India for just over a year and then returned to Europe via Muscat in southeast Arabia, Iran, Mesopotamia, Cyprus and Asia Minor, reaching Copenhagen in November 1767. In the following years he compiled the results of the expedition in several volumes. Niebuhr's books, which sent a wave of excitement through the scientific world, brought travel writing to a new level of sophistication, especially with regard to archaeological investigation. The illustrations ranged from examples of kufic script to drawings of the reliefs at Persepolis. Niebuhr also made a list of 42 cuneiform characters from Persepolis, deducing that the script was based on letters, that vowels were included and that three different systems of writing were represented by the inscriptions (later named Old Persian I, Elamitic II and Babylonian III). His other achievements included accurately locating the ancient sites of Baghdad and Nineveh. His only son was the historian Barthold Georg Niebuhr (1776–1831), whose *Römische Geschichte* (Berlin, 1811–32; Eng. trans. as *Roman History*, London, 1828–42) had a profound impact on historical methods.

WRITINGS

Beschreibung von Arabien (Copenhagen, 1772); Fr. trans. as *Description de l'Arabie* (Amsterdam, 1774)

Reisebeschreibung nach Arabien und andern umliegenden Ländern, 3 vols. (Copenhagen, 1774–1837)

BIBLIOGRAPHY

ADB

Carsten Niebuhr und die arabische Reise, 1761–1767 (exh. cat. by S. T. Rasmussen, trans. and ed. D. Lohmeier; Copenhagen, Kon. Bib.; Kiel, Schleswig-Holsteinische Landesbib.; 1986–7)

S. T. Rasmussen, ed.: *Den arabiske rejse, 1761–1767: En dansk ekspedition set i videnskabshistorisk perspektiv* [The Arabian journey, 1761–67: a Danish expedition seen from a scientific-historical perspective] (Munksgaard, 1992)

Carsten Niebuhr (1733–1815) und seine Zeit: Beiträge eines interdisziplinären Symposiums von 7.–10. Oktober 1999 in Eutin

B. M. Fagan: *Return to Babylon: Travelers, Archaeologists and Monuments in Mesopotamia* (Boulder, CO, 2007)

Nigari. *See* HAYDAR RA'IS.

Niger, Republic of [République du Niger]. Country in West Africa bordered by Algeria and Libya to the north, by Chad to the east, by Nigeria and Benin to the south and by Burkina Faso and Mali to the west (*see* AFRICA, fig. 1). Niger is a landlocked country of *c.* 1,267,000 sq. km, of which two-thirds is Sahara Desert, the rest being savannah. The capital is Niamey. The five principal ethnic groups in the population of *c.* 13,957,000 (estimate, 2005) are the Hausa, the Djerma-Songhai, the Kanuri, the Tuareg and the Fulani. The official language is French. The predominant religion is Islam. While Niger has always been an important economic crossroads, contact with the West began only in the early 19th century, when explorers searched for the source of the River Niger. The French conquest of the area began in 1897, and Niger became a French colony in 1922. Niger became independent in 1960. This entry covers the art produced in Niger since colonial times. For architecture of the region in earlier periods, *see* AFRICA, §II, 3. *See also* FULANI, HAUSA and TUAREG.

Niger's continuing traditional art forms are representative of both its ethnic diversity and its geographic position between north and sub-Saharan Africa. Pottery items made for household use include jars, braziers and platters with pure forms and adorned with white, red or black geometrical motifs in continuous horizontal bands or with relief decorations. Djerma pottery is known for the intricate designs that cover the entire surface of the pot. Basketry is plaited, knotted or coiled and consists of mats, containers, fishing and hunting gear, and jar covers. Round Fulani jar covers have bright motifs on a natural ground. Calabashes are used throughout the country as household containers or as such smaller personal objects as snuffboxes. They are often heavily decorated with geometrical motifs and are principally made by the Hausa and the Fulani.

Long and elaborately decorated mats are often used as interior tent panels. Most designs include triangles, lozenges, zigzags and chevrons. Such leather items as cushions, bags, amulets, sandals and camel- and horse-trappings are characterized by the intricacy of their embroidered and appliqué designs and the profusion of their fringes. Although many woven cotton goods are imported from neighboring countries, the wedding blankets (*tera-tera*) of the Djerma and Songhai are greatly valued as prestige items. These are made of thin white bands of cloth joined and decorated with black and red geometrical motifs. Other blankets are decorated with polychrome designs, accentuated with embroidered motifs. Festive clothing is often embellished with Hausa embroidery, and Hausa hats are embroidered with brightly colored geometrical motifs.

Wooden items include domestic utensils, tent accessories, furniture and saddles. Although wooden Tuareg spoons and ladles have intricately decorated handles, metal tools and household utensils are simpler in form and shape. Such prestige pieces as knives and jewelry are more decorated, often with elaborate motifs. The Djerma and Songhai make cast copper anklets and bracelets displaying linear motifs. Fulani men and women place great importance on personal adornment. They wear large amounts of jewelry including amulets, bead necklaces and bracelets, all enhanced by elaborate make-up. Tuareg jewelry forms are characterized by simple shapes decorated with geometrical motifs and are almost always worn in multiples (Etienne-Nugue and Saley).

Traditional architectural structures in rural areas include round straw dwellings with conical roofs, square mud and wattle houses, and large, round jar-like granaries. Tents are made of mats attached to arched wooden beams. The façades of urban Hausa dwellings are decorated with colorful floral, geometrical or linear motifs that are maintained by specialists.

As well as the continuation of traditional practices, artistic activity in Niger has been influenced by colonial and post-colonial Western contact. While traditional housing is common in rural areas, cities have high-rise buildings that were built in the 1960s. Western-influenced graphic art is represented by billboards and sign-paintings. It is important to note, however, that even painters and sculptors who work in this style draw their inspiration from daily life and their cultural heritage. The paintings of Boubacar Boureima (*b. c.* 1964), for example, are abstract representations of Djerma-Songhai wedding blankets. While the manufacture of purely traditional items continues, the jewelry, leather goods, sculpture and pottery produced in urban centers are aimed at the tourist market. For example, potters at the national museum's craft center (*see* below) produce such "new" products as lamps and candelabra, while Tuareg manufacture leather cassette-holders and desk accessories. Table-linen, embellished with abstract embroidery, is made by Fulani women, and European designs are used to make purses and belts.

The Musée National du Niger, Niamey, was founded in 1958. Its permanent exhibitions include apparel, jewelry, leatherwork, weapons, musical instruments and dwellings, all illustrating the styles of the country's major ethnic groups. In 1962 the museum opened an artisans' cooperative and apprentice center—the Handicrafts Center and Cultural Activities Center—to ensure the continuity of traditional art forms and encourage innovation and change. A building for a regional museum in Zinder was constructed in 1987. Collecting of ethnographic material for it was in progress in the early 1990s. Most artists are either self-taught or receive their education abroad.

Y. F. M. A. Urvoy: *L'Art dans le territoire du Niger* (Niamey, 1955)

J. Anquetil: *Niger: L'Artisanat créateur* (Paris, 1977)

Catalogue des oeuvres artisanales, Niamey, Mus. N. Niger, cat. (Niamey, 1977)

J. Etienne-Nugue and M. Saley: *Artisanats traditionels en Afrique Noire: Niger* (Dakar, 1987)

Y. Poncet: "Mémoire d'image: La region d'Agadez (Niger) vue à travers les images satellitaires," *J. Africainistes*, lxii/2 (1992), pp. 91–103

A. Haour: *Ethnoarchaeology in the Zinder Region, Republic of Niger: The Site of Kufan Kanawa* (Oxford, 2003)

K. Loughran: "Jewelry, Fashion and Identity: The Tuareg Example," *Afr. A.*, xxxvi (2003), pp. 52–65, 93

Art of Being Tuareg: Sahara Nomads in a Modern World (exh. cat. ed. by T. K. Seligman; Palo Alto, Cantor Center and Los Angeles, UCLA Fowler Mus., 2006)

Nigeria, Federal Republic of. Country on the west coast of Africa, bordered by Niger to the north, Cameroon to the east and the Republic of Benin to the west (see fig.). It has a total area of 923,768 sq. km and a population of 140,000,000 (2006 census). The main ethnic groups are the Fulani, Hausa, Igbo and Yoruba. Since 1991 the capital has been the planned city of Abuja in the center of the country; the main city remains the coastal city of Lagos, the second-most populous in Africa, while Ibadan to its north is physically the largest. More than half the population is Muslim, but there is a substantial Christian minority, especially in the south. Nigeria has a long and complex history and an extremely rich art history. It attained independence from Britain in 1960. This article concerns the arts of Nigeria from the coming of Islam to the present day.

I. Introduction. II. Architecture. III. Painting and graphic arts. IV. Art education. V. Patronage, collectors and dealers. VI. Museums and exhibitions.

I. Introduction. Nigeria is a country perhaps of greater ecological and cultural diversity than any other in Africa. Although its boundaries were established in the rivalry between French and British colonizers, there is an awareness of a common Nigerian identity fostered before independence in 1960 and since, which, in spite of the civil war (1967–70), celebrates these diversities. This sense of identity is based on economic and other ties, often of considerable antiquity; trade networks across the Sahara linked communities in both forest and savannah to Mediterranean cities and ports, while from the late 15th century coastal trade developed to bring West Africa into an Atlantic world. The fishermen of coastal mangrove swamps, the Edo-, Yoruba-, Nupe- and Hausa-speaking states of forest and savannah, the egalitarian communities throughout the region, and the trading companies of the Niger Delta and Cross River all participated in networks that both sustained their very existence and engendered an interdependence, often bringing a sense of participation in a world far beyond the local community. The advent of Islam certainly enhanced such wider affiliations, while at the same time promoting the efficiency of long-distance trade. From the mid-19th century, and especially since independence, Christianity has provided an alternative to Islam, at least in the former respect. Local cult traditions, by contrast, have much more to do with a sense of local place, although in the late 20th century intellectuals such as the dramatist Wole Soyinka (*b.* 1934) have drawn on these traditions as sources of interpretive metaphors.

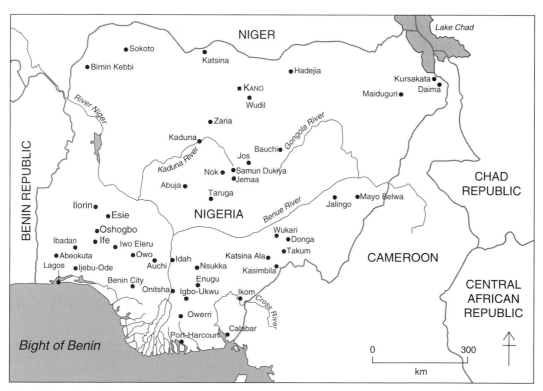

Map of Nigeria; Kano has a separate entry

More than 300 languages are spoken in Nigeria, and every African language family, other than Khoi-San, is represented. From the 10th century onwards (perhaps earlier) diverse state formations, in both forest and savannah–sahel, have generated their hierarchies, artisans, regalia and architectural forms. In both state and egalitarian cultural circumstances, masked performers play dramatic and political roles. Meanwhile, across these communities Fulani cattle herders have established transhumant patterns of movement determined by the needs of their herds. In the 20th century new forms of government and technology have developed, together with the museums and galleries necessary for the conservation and display of art, adding to the diversity of traditions inherited from the past. Moreover, Nigeria also provides the earliest known evidence of a developed sculptural tradition in sub-Saharan Africa in the pottery sculptures of the Nok culture (c. 500 BCE–c. 200 CE), and the earliest evidence for the working of copper and its alloys (and of textile manufacture) south of the Sahara is at the 9th-century CE forest site of Igbo-ukwu, to the east of the lower River Niger.

Islam provided the dominant ideology of the Kanuri and Hausa states since the 15th century, with the latter subject to the Islamic fundamentalist Fulani *jihād* of the early 19th century. The visual arts of this area are, most strikingly, the architectural and dress forms, although little is known of these before the 19th century establishment of new Fulani dynasties consequent upon the *jihād*.

The visual arts of Nigeria are invariably considered in three categories. The first is the pre- and proto-historic material (Nok, Igbo-Ukwu, Ife etc.), generally known through some coincidence of accidental discovery and/or archaeological excavation. Second, there are the art traditions of the more recent past, of social groups of pre-colonial temporal status (once referred to as "tribes," although their social realities and identities are now known to be more complex). The third is comprised of those art forms that persist or emerge in the context of the evolution of modern ethnic and national identity (*see* below). All these arts are claimed as Nigerian, although the interrelationship of forms from one group to another is only rarely obvious. The paradigm that, for example, brings together the antiquities of Ife, the sculptures in wood for shrines and palaces in the 19th and 20th century, and post-Independence developments in, say, textile design or painting, forms the notion of a Yoruba identity. Yet we know this to have evolved, in its present form, in the period from 1850 to 1950. Nevertheless, there are aspects of the Nigerian visual environment of the past that flourish in the late 20th century.

In spite of the ubiquity of a bland and undistinguished cement "International Style," architecture is perhaps the most obvious visual domain in which development within (rather than destruction of) local traditions is sometimes evident. Distinctive Hausa forms reach their high point in the mid-19th-century work of Baban Gwani, such as the Friday mosque in Zaria (now encased in an entirely modern exterior), which stands before the emir's palace, itself well known for an exterior decorative program. Buildings such as these continue to inform a local building tradition that is adaptable to renewal in cement. In the Yoruba region, in the mid-19th century, repatriated freed slaves from Brazil brought with them a distinctive style of architectural design, employed in houses and mosques in Lagos, and widely imitated throughout the Yoruba area for over a century; yet the older tradition of impluvium courtyards also persisted at least into the 1960s.

Development within hand-woven textiles has entailed the use of new yarns and colors, a willingness to experiment and perhaps to shift fashion demand, and vigorous patronage supported by past and present perceptions of ethnic and national identities. Women in the southern Igbo village of Akwete are widely known for their decorative weaving; yet it was only in the late 19th century that they reinvented weft-float patterning, on the basis of cloths previously imported into the Niger Delta from the Yoruba city of Ijebu-Ode. Then there is the continued flourishing of Yoruba hand-woven textiles using rayon and lurex. Perhaps the most unexpected element has been the resilience of masquerade, now sometimes incorporating television characters. Even in the Igbo-speaking part of Niger, for example, in the aftermath of the civil war of the late 1960s, and in other communities such as the Tiv, not formerly known for masking, what is effectively a completely novel tradition has been developed.

W. Fagg: *Nigerian Images* (Lagos and London, 1963/*R* 1990)

T. Shaw and J. Vandenburg: *A Bibliography of Nigerian Archaeology* (Ibadan, 1969)

E. Eyo: *Two Thousand Years of Nigerian Art* (Lagos, 1977)

T. Shaw: *Nigeria: Its Archaeology and History*, Ancient Peoples and Places, lxxxviii (London, 1978)

Treasures of Ancient Nigeria (exh. cat. by E. Eyo and F. Willett; Detroit, MI, Inst. A.; Oslo, N.G.; London, RA; and elsewhere; 1980–83)

J. Vansina: *Art History in Africa: An Introduction to Method* (London and New York, 1984)

O. Olapade: "Muslims in Contemporary Nigerian Art Culture," *Muslim Educ. Q.*, vi/3 (1989), pp. 52–8

J. Picton: "Islam, Artifact and Identity in South-Western Nigeria," *Islamic Art and Culture in Sub-Saharan Africa*, ed. K. Ådahl and B. Sahlström, *Acta Universitatis Upsaliensis*, 27 (Uppsala, 1995), pp. 71–98

R. O. R. Kalilu: "Bearded Figure with Leather Sandals: Islam, Historical Cognition, and the Visual Arts of the Yorùbá," *Africa* [Rome], lii (1997), pp. 579–91

II. Architecture. In his encyclopedic study Z. R. Dmochowski urged young Nigerian architects to "seek inspiration from the glorious past of their building art" (Moughtin, 1988; Dmochowski, 1990). Within Nigeria there are numerous culture groups each with its individual style. The styles range from Hausa and Kanuri in the dry northern savannah zones to those of the Igbo, Yoruba and Bini in

the wetter areas of the south; between is a multitude of smaller groups occupying the Middle Belt of Nigeria. There is, indeed, much to inspire the modern Nigerian architect, and the results can be clearly seen in such modern cities as Lagos and Ibadan.

Set well apart from the traditional cities of Nigeria, the colonial administration planned areas for British civil servants and business people. In these Government Reserved Areas (GRAs) the bungalow was the main architectural component, for example Port-Harcourt (1926–36). As a building type, this single-story building with a verandah, often on four sides, and set within large plots served its purpose well in climatic terms, while the appearance of the GRAs, with their spacious lawns and tree-lined streets, took on the form of the British garden suburb, providing a veritable home from home for the occupants.

Interesting examples of early colonial architecture are to be found at Wusasa near Zaria, where, in the early 1930s, a Christian mission was established. Local builders, structural techniques, architectural forms and decoration were employed in the service of a British architectural program. The houses are built of mud to form spaces of a size and disposition that accord with British ideas of comfort, suiting the life-style of the Western nuclear family. Such dwellings usually consist of a living-room, dining-room, study/bedroom, kitchen and bathroom downstairs, and two bedrooms and a dressing-room upstairs. At the same time the rooms have the usual delightful Hausa proportions, with high ceilings supported by arches, and are whitewashed and simply furnished. The center of the community is the church, a simple mud building of cruciform plan with the roof supported on horseshoe-shaped arches, and with pews, altar, lectern and priest's seat beautifully molded in mud. The interior surfaces are coated with small fragments of quartz set in gum arabic, so that the whole building glistens with a golden or silver sheen, depending upon the quality of light that filters through the narrow slit windows.

It is probably fair to say that E. Maxwell Fry (1899–1987) must be credited with the introduction of a fully developed modern style of architecture into West Africa, where he was working soon after the end of World War II. In addition to the wealth of his own extensive architectural traditions, Nigerian architecture thus received considerable impetus from the work of British architects. Particularly important was the group that included Maxwell Fry himself along with his partners Jane B. Drew (1911–96), Lindsay Drake (1909–80) and Denys Lasdun (1914–2001). Others were the architectural bureau of John Godwin (*b.* 1928) and Gillian Hopwood (*b.* 1927); the firm of J. E. K. Harrison and James Cubitt (1914–83); and the team of Architects' Co-partnership (Kultermann, 1963).

An important development by Fry and his partners is the first West African College at Ibadan, Nigeria, which is built on a site covering eight square kilometers of undulating farm- and forest-land with outcrops of granite. Though overtly modern in style and British in origin, those working on the university, while not copying African detail, nevertheless attempted to establish a link with local Yoruba traditions. In Jane Drew's words "the sunshine and moisture and heavy overcast sky and feeling of lethargy seem to call forth molded forms which are rhythmical and strong, not spiky and elegant, but bold and sculptural" (Hitchins, 1978). The group also took account of climatic conditions and incorporated natural controls into their designs. The long axis of the building, running east–west, was protected by a large overhanging monopitch roof, wall-to-wall and floor-to-ceiling open grilles were used for effective ventilation, and extensive shading devices were employed. The university has a number of fine buildings (e.g. faculty buildings, the central library, halls of residence and administrative buildings). Particularly elegant is the Arts Building, arranged around an airy courtyard, and the dining-hall, an open shallow dome supported on four points. There are many other buildings throughout Nigeria by Fry and his associates; they include office buildings, banks, schools and colleges, stadia and housing. Of particular interest is the head office (1961) of British Petroleum, Lagos. It comprises shops and a showroom at ground-level with offices above. The structure is a simple reinforced frame with external bays provided with adjustable sun control in the form of vertical louvres. The sculptural shapes of the small, open reinforced-concrete shell that is the delicate mosque (1958) of the Wudil Teacher Training Center and the circular domestic science classroom in the Women's Teacher Training College (1958), Kano, both exemplify the group's effort to come to terms with local culture.

The International Style is completely at one with the tropical climate of Nigeria, and there are many other fine buildings that employ it. John Godwin and Gillian Hopwood worked in Nigeria from 1955, spanning Independence, and designed office, residential, exhibition and school buildings. Their small mosque (1963) attached to the Police College, Kaduna, is a lovely interpretation of an ancient building type in a pure modern form—a refreshing contrast to the many pastiche mosques, complete with domes and sugary minarets, that appear throughout the Muslim world. Another work designed by this practice that is of interest is a private house in the Bauhaus style in Kano. Built of concrete and steel, despite its modernity the building is well adapted to the climate. James Cubitt and Partners, better known for their work in Ghana, were also employed in Nigeria. Of particular note is their severely classical and beautifully proportioned library at Port-Harcourt. Another British firm to have constructed numerous buildings is Architects' Co-Partnership. Their buildings include the port authority buildings at Port-Harcourt and some uncompromising living-quarters in Lagos, which display Miesian qualities of simplicity of form and detail (Kultermann, 1963).

Although Nigerian architects began to influence events in their country just before Independence, their real impact was increasingly felt afterwards,

with the growing confidence of self-reliance. Impressive early work was produced by Oluwole Olumuyiwa (*b*. 1929), with his Municipal Primary School, Lagos, and his Crusader House, Lagos. Alex Ekweme (*b*. 1932) designed a hospital for the Nigerian Railway Corporation, Ebute Metta, Lagos; the West African Airways Corporation building, Ikeja-Lagos; and the United Christian Commercial Secondary School, Apapa, Lagos. Hameed Balogun created the Liberian Ambassador's residence and Isola Kola-Bankole (*b*. 1928) was responsible for many buildings at the universities of Ife, Ibadan and Lagos. These are all part of a creative renaissance of a long and often unknown building tradition. The work frequently shows a new boldness in design, striking use of local materials and love of color.

Since Independence there has been a wealth of plans for cities, towns, hospitals and airports. Two early city plans, for Kano (Trevallion, 1963) and Kaduna (Lock), included suggestions for the development of areas of housing suitable for Muslim families. In Kano, on the Zaria road, such an area of housing was built by the Metropolitan Kano Planning and Development Board. The housing consisted of one- and two-story, low-cost, patio housing—a brave attempt to follow traditional house form (Moughtin, 1985). This contrasts with the plans provided by a British new town authority for use in Abuja, the new capital of Nigeria. There, in the middle of an African landscape, are British "new town," two-story terrace housing and four- and five-story blocks of flats. No attempt was made to suit the Nigerian climate or serve local housing needs (*Architects' J.*, 1985). Kenzō Tange (1913–2005) worked on a plan for the development of the capital, a huge undertaking for any country, at the same time as Nigeria was expanding its airport provision not only in Lagos but in many of its provinces (Egbor & Associates). In addition, there was a program for building new universities at Calabar, Ilorin, Jos, Kano, Maiduguri, Port-Harcourt and Sokoto, and for extending such existing universities as Zaria and Ibadan (Goss).

The first Nigerian architects were trained in Britain, with some (e.g. Olumuyiwa) able to travel, study and work in other European or North American countries. This small band of pioneers was soon joined by others educated in Nigeria's own schools of architecture at Zaria and Lagos. The early graduates from these schools were trained by British or other foreign expatriate academic staff but, in the last decades of the 20th century, the growing number of architects filling the ranks of the Nigerian Institute of Architects provided sufficient professionals for the development of a truly Nigerian school of architecture, based upon its own long and distinguished building traditions. Such architects owe much to the thorough historical documentation of Dmochowski and the important examples built by him with the help of local craftsmen at the Museum of Traditional Nigerian Architecture (MOTNA) in Jos. "Accepting tradition as the starting point of their creative, independent thinking, [present-day Nigerian architects]

should evolve in steel and concrete, glass and aluminium, a modern school of Nigerian Architecture" (Dmochowski).

U. Kultermann: *New Architecture in Africa* (London, 1963)

B. A. W. Trevallion: *Metropolitan Kano* (Oxford, 1963)

M. Lock: *Kaduna* (London, 1967)

U. Kultermann: *New Directions in African Architecture* (London, 1969)

S. Hitchins, ed.: *Fry, Drew, Knight, Creamer, Architecture* (London, 1978)

Egbor and Associates: "Lagos Murtala Muhammed Airport," *Airport Forum*, ix/4 (1979), pp. 57–68

A. Goss: "Nigerian Studies," *Building*, ccxliii/48 (1982), pp. 51–2

D. Toppin: "History of Working Abroad," *Architects' J.*, clxxvi/27 (1982), pp. 28–31

"Capital Folly of Nigeria," *Architects' J.*, clxxxii/47 (1985), pp. 69–78

J. C. Moughtin: *Hausa Architecture* (London, 1985)

J. C. Moughtin, ed.: *The Work of Z. R. Dmochowski: Nigerian Traditional Architecture* (London, 1988)

Z. R. Dmochowski: *An Introduction to Nigerian Architecture*, 3 vols. (London and Lagos, 1990)

V. Prévost: "Les mosquées 'Soudanaises,' expression de l'Islam Africain," *Les lieux de culte en Orient*, ed. C. Cannuyer, *Acta Orientalia Belgica*, xvii (Brussels, 2003), pp. 113–30

III. Painting and graphic arts. Painting using Western media and techniques was introduced to Nigeria at the end of the 19th century, with the establishment of Western education and colonial institutions. Though not specifically taught until well into the 20th century, Western-style art was present from the beginning of the colonial period in the form of cheap reproductions and illustrations in magazines, religious literature and trading catalogues. Around 1895 a pupil in one of the mission schools, Aina Onabolu (1882–1963), began to copy such illustrations and pictures, and he is regarded as the first Nigerian artist to use Western media. After school, Onabolu continued painting in watercolors and gouache, which he ordered from Britain. In 1905 he executed his portrait of Mrs. Spencer Savage, considered to be the earliest masterpiece of modern Nigerian painting. Determined to broaden the reach and appeal of the new art, he gave free lessons to enthusiasts and taught in schools without either official approval or pay. His "Neo-classical" Western style, emphasizing anatomical detail, chiaroscuro and strict linear perspective, earned him the nickname "Mr. Perspective." In 1920 he held the earliest Western-style exhibition in Lagos, after which he went to Britain and gained a teacher's diploma from St. John's Wood College in 1922. Although Onabolu's efforts produced the first modern Nigerian painters, an environment of fierce hostility and disregard from the religious establishment and the British colonial administration ensured that practice was difficult and patronage miserly. Consequently, this type of painting remained a curiosity restricted to Lagos.

In the 1930s Onabolu's academic style was overtaken when, on his own recommendation, the colonial administration invited Kenneth Murray (1903–72) to the country to teach art. Murray instructed his students to ignore the technique and verisimilitude emphasized by Onabolu and to concentrate on reproducing their environment. The result was a nativist tendency, which was used in commercial graphic art and school textbook illustration. The most successful product of the school was Ben Enwonwu (1921–94), who later produced his best work as a sculptor.

The 1940s and 1950s were dominated by Akinola Lasekan (1916–72), who, despite his lack of formal training, was an excellent draughtsman and painter. He gained prominence both as an artist and a teacher (*see* §VII below) and is credited with introducing genre painting into Nigerian art. Lasekan was Nigeria's foremost political cartoonist and received state recognition for his part in the anti-colonial movement.

In the late 1950s a group of young students at the Zaria College of Art and Science founded the Zaria Art Society. Under the painter Uche Okeke (*b*. 1933), the society initiated theoretical discourse around modernist tendencies and introduced the principle of "natural synthesis." This was the studied fusion of elements from old and new traditions, and members of the society combined original cultural themes, ideas and techniques with new media. The most prominent painters in the group were Okeke, and the painter and sculptor Demas Nwoko (*b*. 1935). They came to national attention with their mural for the Independence Pavilion, in 1960. Influenced by the philosophy of Negritude, Ben Enwonwu also began to use the principle of natural synthesis in his paintings, as he explored cultural tropes with improved technical ability.

In the mid-1960s a resurgence of nativism was encouraged by the emergence of such workshops as that in Oshogbo, set up by Suzanne Wenger (*b*. 1915) and run, from 1964, by British painter Georgina Betts. The Oshogbo experiment, described as a short cut to art, encouraged spontaneity, de-emphasized academy rules and antagonized academy-trained painters. Its methods were inspired by early 20th-century evolutionist anthropology and the rise of primitivism in Western art. An element of German Expressionism was also present, brought in through shows of Expressionist work in the Mbari Art Club, a center of cultural revival set up in the late 1950s in Ibadan by young Nigerian artists and writers in collaboration with the German critic Ulli Beier. The success of the first group led to the establishment of branches in Oshogbo (1962), Enugu, Lagos, Ife and Benin City. As well as arranging exhibitions and performances of music, dance and theater, the club published a series of paperback books, illustrating the works of contemporary artists. The Oshogbo school produced some painters of considerable merit, among them Jimoh Buraimoh (*b*. 1943), whose compositions are formed from paint and beads, and Muraina Oyelami (*b*. 1940).

The Mbari Art Club also ran the earliest printmaking workshops in Nigeria, one of the participants in which was Bruce Onobrakpeya (*b*. 1952). A major figure in Nigerian art, Onobrakpeya taught at St. Gregory's College, Lagos, before founding the Ovumaroro Studio, where he continued to offer instruction to young artists. His early prints are interpretations of oral traditions, distinguished by their drama and use of color. An avid experimentalist and innovator, in 1967 he developed a deep-etching technique referred to as Plastograph, using epoxy on linoleum rather than conventional masking media on metal plates. Prints taken from plaster casts of the original plates are then recycled into relief sculpture, as composite panels coated in bronze. As well as being an important educator and innovator, in the 1990s Onobrakpeya was regarded by many as the foremost printmaker in Africa, and his work was chosen to represent Nigeria at the Venice Biennale of 1990.

The civil war in 1967–70 brought about changes in painting and the graphic arts. Art for propaganda purposes required a blunt and direct style, and the work of many young artists was used, especially on the Biafra side. Foremost among these artists, Uche Okeke (*b*. 1933) added art of political commitment to the style of natural synthesis he had previously developed. This was taken up in the 1970s by Obiora Udechukwu (*b*. 1946) and other young artists of the Nsukka school, who worked during the war and afterwards studied under Okeke. In the 1970s three main tendencies emerged in Nigerian painting: the nativism of the Oshogbo school; genre painting, principally promoted by the Zaria art school and such other centers as the Yaba Technical Institute, Lagos, and the school at Auchi; and the social realism of the Nsukka school. Under Okeke and Udechukwu, the Nsukka school also pioneered the rediscovery of the body- and mural-painting traditions (uli) of the Igbo and their introduction into modern painting. Ulism, as the new tendency came to be known, combines such traditional aspects as a delicate linearity, emphasis on design, the use of symbolic and decorative motifs, the relegation of three-dimensionality and realist representation, and the primacy of negative space. These features are clearly seen in the highly colorful and decorative work of the painter and printmaker Uzo Egonu (1931–96), Nigeria's most renowned artist abroad. Ulism and the Nsukka school's social and political stance are, perhaps, the strongest influences on late 20th-century Nigerian painting.

A. Onabolu: *A Short Discourse on Art* (Lagos, 1922)

U. Beier: "Contemporary Nigerian Art," *Nigeria*, lxviii (1961), pp. 27–53

D. Onabolu: "Aina Onabolu," *Nigeria*, lxxix (1963), pp. 295–8

M. W. Mount: *African Art: The Years since 1920* (Bloomington, 1973)

P. Oyelola: *Everyman's Guide to Nigerian Art* (Lagos, 1976)

U. Okeke: "History of Modern Nigerian Art," *Nigeria*, cxxviii–cxxix (1979), pp. 100–18

The Nucleus: A Catalogue of Works in the National Collection of the National Gallery of Modern Art, Federal Department of Culture (Lagos, 1981)

U. Okeke: *Art in Development: A Nigerian Perspective* (Minneapolis, 1982)

B. Onobrakpeya: *Symbols of Ancestral Groves* (Lagos, 1985)

K. Fosu: *20th Century Art of Africa* (Zaria, 1986)

J. Kennedy: *New Currents, Ancient Rivers: Contemporary African Artists in a Generation of Change* (Washington, DC, and London, 1992)

IV. Art education. Nigeria has the highest number of art departments and colleges of all African countries. In the early 1990s there were over 32 degree- and certificate-awarding faculties in government institutions, with annual graduation figures of more than 1000 art and design students. Many of the art departments run long courses: at the University of Nigeria the B.A. course, headed for some time by the painter Akinola Lasekan (1916–72) at the invitation of the then president, despite Lasckan's own lack of formal training, lasts five years and has a strong emphasis on multi-disciplinary curricula, art history and philosophy. In addition to government colleges, several private and correspondence institutions offer courses in fine and applied arts. Many more artists are educated by direct apprenticeship. For example, after several years' teaching art at St. Gregory's College, Lagos, Bruce Onobrakpeya (*b.* 1952) retired to full practice in his Ovuomaroro Studio, where he continues to train apprentices and college students on compulsory internship. The New Culture Studio, run by the painter and sculptor Demas Nwoko (*b.* 1935), also trains apprentice artists and designers, and the Abayomi Barber school, Lagos, run by the Super Realist sculptor after whom it is named, is a popular training ground for artists in that style. The National Council for Arts and Culture provides funding for a studio and resident artists who offer tuition to trainees. Several prizes for study are endowed by the federal and state governments, private foundations and individuals. Some businesses, especially those with direct interests in the arts, such as manufacturers of textiles and artists' materials, also provide scholarships. At secondary-school level, art is generally a regular and often compulsory part of the curriculum.

U. Okeke: *Art in Development: A Nigerian Perspective* (Minneapolis, 1982)

O. Oloidi: "Growth and Development of Formal Art Education in Nigeria," *Transafr. J. Hist.*, xv (1986), pp. 108–26

V. Patronage, collectors and dealers. At the beginning of the 20th century patronage for modern Nigerian art came mainly from the emergent local élite, especially the Lagos civil service. With time they were overtaken by the upper classes of the colonial administration and, later, the churches. The involvement of expatriate art teachers and anthropologists increased foreign patronage. By the 1950s there was some local patronage, which was boosted by the emergence of a number of internationally acclaimed writers in the late 1950s. Writers such as Chinua Achebe (*b.* 1930) and the Nobel laureate Wole Soyinka (*b.* 1934) avidly collected their contemporaries' work. Local patronage increased after Independence with the emergence of a sense of national identity, and expatriate patronage also remained significant until the late 1960s. The oil economy of the 1970s created not only a class of wealthy Nigerian entrepreneurs, who indulged in art for personal commemoration, but also the self-confidence for a critical establishment. This grew in breadth and depth and encouraged greater local patronage and government involvement in the form of the establishment of the National Council for Arts and Culture as an organizing body, public commissions, acquisitions for the National Gallery and state ministries of culture, and prizes for outstanding art students. Business provided another significant source of patronage. In the late 1980s young entrepreneurs began collecting for investment. Earnings from this ran into several million naira annually, and many artists earned enough from their art to live on. In the 1990s art dealing remained unpopular, with collectors preferring to deal directly with the artists.

C. Ekwensi: "High Price of Nigerian Art," *Nigeria*, lxxxviii (1966)

U. Okeke: *Art in Development: A Nigerian Perspective* (Minneapolis, 1982), pp. 29–32

Nigerian and Foreign Patronage of the Arts, Goethe Institut (Lagos, 1987)

O. Oloidi: "Art Patronage and Professionalism: Towards a Golden Era in Nigeria," *Unity through Art: Catalogue of an Exhibition by a Galaxy of Nigerian Artists* (exh. cat., Lagos, N. Mus., 1990)

VI. Museums and exhibitions. As late as 1940 Nigeria had no museums at all. The discovery of ancient civilizations and such artifacts as the Igbo-Ukwu bronzes led to a campaign, pioneered by such figures as Kenneth Murray, to establish museums for the preservation of Nigeria's artistic heritage. Even in the 1990s, however, Nigeria's *c.* 100 million inhabitants and their rich cultural tradition have an inadequate provision of museums and galleries. The National Museum, Lagos (founded 1957), has a modest collection of artifacts from all the major centers of classical Nigerian art. In addition, museums now exist in such cities as Jos and such centers of ancient civilization as Oron, Benin, Ife and Nri. In the 1990s the museums were, however, grossly underfunded, being sustained solely by the government and, furthermore, the general socio-economic climate in the country made their collections vulnerable to the illicit international trade in antiquities. Unfortunately, the Museum Service has been unsuccessful in many battles to recover Nigerian pieces held in foreign collections, a celebrated case being the failure to obtain from Britain a Benin ivory mask for the World Black Festival of Arts and Culture in 1977.

The colonial administration was no more interested in galleries or centers of modern art than it was

in museums, and, until the 1960s, there were no galleries in the country. Instead, the Mbari Club (*see* §V above) was, for a while, the only proper display space available for modern art. The solution found was for artists to establish their own galleries. Examples (all in Lagos) include the Idubor Gallery founded by the sculptor Felix Idubor (1928–91), Afi Ekong's Bronze Gallery, and much later, Bruce Onobrakpeya's Ovuomaroro Gallery (*see also* §V above) and the painter and sculptor Uche Okeke's Asele Institute, which houses an impressive collection of early modern Nigerian art. In 1966 a group of young Nigerian artists and patrons founded the Federal Society for Arts and Humanities to prevent the export of important works of modern Nigerian art. Their collection, intended to form the nucleus of a never-realized national collection, is now housed by the University of Lagos. A National Gallery of Modern Art was eventually founded in 1981, with an initial collection of 301 works. Although the collection has since grown, in the early 1990s it had no works by such important figures as the painters and sculptors Uche Okeke (*b.* 1933) and Demas Nwoko (*b.* 1935). Other venues for contemporary art include the National Council for Arts and Culture's Gallery for Arts and Crafts, Lagos, and the National Museum's regular exhibitions of works by contemporary artists. A number of commercial galleries exist, especially in Lagos, and some, the Didi Museum for example, maintain tight schedules of contemporary art exhibitions. Hotels, businesses and individual patrons also organize regular, highly publicized exhibitions, as do state ministries of culture and foreign missions.

K. C. Murray: "A Museum for Nigeria," *Nigeria*, xx (1940), pp. 271–4

"Lagos Art Galleries," *Nigeria*, xcii (1967), pp. 2–18

S. Law: "Contemporary Works of Art Need a Home in Nigeria," *Nigeria*, c (1969), pp. 348–55

U. Okeke: *Art in Development: A Nigerian Perspective* (Minneapolis, 1982), p. 11

F. Aig-imoukhuede, ed.: *Tapping Nigeria's Limitless Cultural Treasures* (Lagos, 1987)

S. Peters and others, eds.: *Directory of Museums in Africa/Répertoire des musées en Afrique* (London and New York, 1990)

Nikaia. *See* Iznik.

Nishapur [Abarshahr; Nishāpūr; Nayshābūr; Nehshāpūr]. City in northeastern Iran. Situated in a fertile plain ringed by mountains, the city was founded by the Sasanian ruler Shapur I (*r.* 241–72) and known as Nehshāpūr ("New Shapur") or Abarshahr. It fell to the Arabs *c.* 651 and remained in Islamic hands, although a Nestorian Christian bishopric continued to function there. It became the principal city and entrepôt of Khurasan, a province that embraced much of present-day Turkmenistan, Uzbekistan and Afghanistan as well as northeastern Iran, and it was one of the three or four major cities in the Islamic world, with a population of over 100,000 and a surface area of some 17 sq. km. In 828 it became the capital of the Tahirid dynasty

(*r.* 821–73). A great artificial platform was built and a citadel erected upon it, as at Bukhara and Samarkand, and a palace and officers' quarters erected in the suburb of Shadyakh, several kilometers away. From 873 the Saffarid rulers (*r.* 867–*c.* 1495) settled their government at Nishapur, and 'Amr ibn Layth (*r.* 879–901) built an important mosque with an arcaded court and 11 gates. Around 900 the city became a capital of the Samanid dynasty (*r.* 819–1005) and a major center of the Saljuq dynasty (*r.* 1038–1194) after its occupation by Tughril (*r.* 1038–63) in 1038. It flourished most spectacularly from the 10th century to the 12th, when it comprised a citadel, the town proper and suburbs, all separately walled. Its sack by the Ghuzz Turks in 1153, a series of earthquakes in the 12th and 13th centuries and the calamitous Mongol invasion of 1221 reduced it to a provincial backwater. Much of Nishapur's role was taken over by Mashhad, and later buildings, such as the Friday Mosque (1494–5) and the tombs of the poet Farid al-Din 'Attar (15th century) and of the imam Muhammad Mahruq (17th century), are undistinguished. In the 20th century the ruins of medieval Nishapur attracted the attention of looters and antiquarians, and the site was excavated between 1935 and 1947 by an American team.

The excavations revealed houses of mud-brick with whitewashed walls and floors and windows of yellowish glass set in plaster. Painted dados constituted the principal decoration; some follow the styles of abstract carving associated with Samarra in Iraq, while others employ such figural themes as females and jinn associated with Central and East Asia. The highly developed *muqarnas* vaults are painted with vases and floral motifs (*see* Architecture, §V, A, 1). A bathhouse was splendidly painted with a hunting scene depicting many animals, birds and people (*see* Architecture, §X, C, 2). Multitudes of painted and glazed terracotta fragments of inscriptions were found, as well as 17 different terracotta and glazed shapes used in large brickwork panels. Other new features include inscribed window-frames and molded string courses, both in stucco.

The excavations produced a large quantity of pottery, including 12 types of ware, 11 of them glazed, allowing the ceramic production of an Iranian metropolis to be judged for the period *c.* 800 to *c.* 1200 (*see* Ceramics, §II, C and fig. 4). The most striking are decorated principally with inscriptions in black on white, reflecting contemporary Koranic calligraphy and composed with a rare intellectual rigor. Quite different in style is the buff ware, crammed with motifs from diverse sources. The excavation of several kilns showed that medieval stacking techniques were different from modern practice. Substantial quantities of Chinese wares and some Iraqi lusterwares were imported (*see* Ceramics, §II, B). The excavations also uncovered a wide range of small objects in iron, lead and bronze that functioned as weapons, furniture fittings, horse trappings, cosmetic implements and household utensils (*see* Metalwork, §II, A, 4).

C. K. Wilkinson: "Life in Early Nishapur," *Bull. Met.*, n.s., ix/2 (1950), pp. 60–72

R. W. Bulliet: *The Patricians of Nishapur: A Study in Medieval Islamic Social History* (Cambridge, MA, 1972)

C. K. Wilkinson: *Nishapur: Pottery of the Early Islamic Period* (New York, [1973])

R. W. Bulliet: "Medieval Nishapur: A Topographic and Demographic Reconstruction," *Stud. Iran.*, v (1976), pp. 67–89

J. W. Allan: *Nishapur: Metalwork of the Early Islamic Period* (New York, 1982)

P. E. Chevedden: "A Sāmānid Tombstone from Nīshāpūr," *A. Orient.*, xvi (1986), pp. 153–70

C. K. Wilkinson: *Nishapur: Some Early Islamic Buildings and their Decoration* (New York, 1986)

J. W. Allan: "The Nishapur Metalwork: Cultural Interaction in Early Islamic Iran," *Content and Context of Visual Arts in the Islamic World*, ed. P. P. Soucek (University Park, PA, and London, 1988), pp. 1–11

K. Rührdanz: "Zur Ikonographie der Wandmalereien in Tepe Madraseh (Nishāpūr)," *Proceedings of the Second European Conference of Iranian Studies held in Bamberg, 30th September to 4th October 1991 by the Societas Iranologica Europaea*, pp. 589–95

L. Golombek and R. B. Mason: "New Evidence for Safavid Ceramic Production at Nishapur," *Apollo* clxii, no. 401 (1995), pp. 33–6

J. Kröger: *Nishapur: Glass of the Early Islamic Period* (New York, 1995)

Nizam Shahi [Nizām Shāhī]. Dynasty that ruled portions of southern India from 1490 to 1636. It was one of five successor states that emerged in the Deccan with the collapse of the BAHMANI dynasty. Malik Hasan Bahri, a convert to Islam who became a powerful noble under the Bahmani rulers, was murdered following his involvement in a conspiracy in 1481 to kill Mahmud Gawan, the Bahmani minister. His son Malik Ahmad (*r.* 1490–1510) rebelled against the Bahmanis in 1490 and founded the Nizam Shahi dynasty, which ruled from Ahmadnagar. In the constant struggles for power in the Deccan, Burhan Nizam Shah (*r.* 1510–54) opposed the 'Imad Shahis of Berar and the 'ADIL SHAHI dynasty of Bijapur. Husayn Nizam Shah (*r.* 1554–65) joined the alliance that destroyed the Vijayanagara Empire in 1565. Husayn died shortly thereafter and was succeeded by Murtaza Nizam Shah (*r.* 1565–88). When the Mughals, having conquered Gujarat, Malwa and Khandesh, appeared on the northern frontier of the Nizam Shahi territory, the dynasty was already entering a state of decline. Six rulers succeeded to the throne between 1589 and 1610. The Mughal advance was thwarted by the military genius of Malik Ambar, an African slave under whom the Nizam Shahis were puppets. The end of the dynasty came soon after his death in 1626. Though constantly engaged in war, the Nizam Shahis built mosques, tombs and palaces at Ahmadnagar. A number of portrait paintings, drawings and manuscripts of great beauty were also prepared for them.

Enc. Islam/2: "Niẓām-shāhī"

W. Haig: *History of the Nizam-Shahi Dynasty of Ahmadnagar* (Bombay, 1923)

R. Shyam: *The Kingdom of Ahmadnagar* (New Delhi, 1966)

M. Zebrowski: *Deccani Painting* (London, 1983)

G. Michell and M. Zebrowski: *Architecture and Art of the Deccan Sultanate* (Cambridge, 1999)

Nubia. Region in the Nile Valley, immediately to the south of Egypt, in which several cultures flourished, from the Khartoum Mesolithic period (*c.* 10,000–*c.* 5000 BCE) to the establishment of the Islamic Funj sultanate *c.* 1505. Ancient Nubia corresponds essentially to the "Aethiopia" of Herodotus and other Classical writers and the "Kush" of the ancient Egyptians and Hebrews. It extends approximately from Aswan in southern Egypt to Khartoum in SUDAN. The most northerly part, Lower Nubia, has always been regarded as an Egyptian sphere of influence, and it is included within the borders of the modern Arab Republic of EGYPT. Egyptian control of the larger, southerly region, "Upper Nubia," was much more sporadic.

Apart from the seaports of Aydhab and Sawakin (Suakin), Islamic urban culture in Nubia was a relatively late phenomenon, developing after the establishment of the Funj sultanate in the early 16th century. During the late 11th century Aydhab developed into an international commercial and *hajj* (pilgrimage) center, both because of its proximity to Jiddah and Aden and because the crusaders in Palestine were obstructing the Sinai–Hijaz *hajj* route. Aydhab, which flourished until the 15th century, has not yet been excavated, but substantial coral-built enclosures for storage of merchandise and accommodation of pilgrims are visible on the surface. Early travelers describe its wealth and far-reaching links with the East.

From their capital at Sennar, on the Blue Nile, the Funj sultanate ruled a diverse tribal confederation in the Gezira and Nubia until the Turco-Egyptian conquest of 1821. At the core of Sennar was a walled complex of royal buildings, including a five-story palace, a *dīwān* for royal audiences and a mosque, none of which has survived, although they are recorded in 19th-century drawings. The most common form of domestic architecture during the Funj sultanate was the *tukl* hut, which had a conical grass roof. Permanent buildings were constructed only in such urban centers as Sennar, Shendi, Berber and Arbaji. Arches and arcuate roofing systems were not used until the late Funj period, despite their much earlier use in Upper Egypt. Fired mud-brick was also rare in Funj architecture, although it had been widely used in the Christian period. Along the Nile from Gezira to Dongola, numerous mud-brick tombs of local religious notables were built. These consisted of square, thick-walled buildings with dome-like roofs. Rough stone tombs of a similar type have been found in a series of desert cemeteries north of Kassala.

Sawakin, which had already replaced Aydhab as Nubia's main seaport in the 15th century, was

occupied by the Ottoman Turks, who expanded the port and erected houses and commercial facilities. The coral and stone buildings currently at the site date to the 19th and 20th centuries and follow the architectural style of the major Red Sea ports.

After the Turco-Egyptian conquest of Sudan in 1821, modern construction technologies were introduced into Nubia, including arches, fired brick and stone construction. For the first time since the Christian period, planned street systems began to be built. At Khartoum, the governor's palace, the Catholic mission and the mosque were monumental examples of the new colonial style. In 1885 the Mahdi, Muhammad Ahmad, seized Khartoum and subsequently founded a new capital at Omdurman. His successor, the Caliph 'Abdallah (r. 1885–98), demolished Khartoum and developed Omdurman into a sprawling metropolis. He also destroyed most of the larger towns in Nubia and the Gezira, eradicating provincial urban life in the region. The residential areas of Omdurman consisted of mud and grass houses, but several monumental structures were erected in the walled center, using materials salvaged from Khartoum. The most important buildings were the *khalifa's* palace, the domed tomb of the Mahdi and a vast open-air mosque. Only the palace and a few sections of the enclosure wall have survived. Britain's reconquest of the Sudan in 1898 reimposed a colonial administration on the region, and Khartoum was reconstructed by British engineers on a plan said to have been inspired by the Union Jack.

E. A. W. Budge: *The Egyptian Soudan: Its History and Monuments* (London, 1907)

O. G. S. Crawford: *The Funj Kingdom of Sennar* (Gloucester, 1951)

P. M. Holt: *A Modern History of the Sudan, from the Funj Sultanate to the Present Day* (London, 1961)

R. C. Stevenson: "Old Khartoum, 1821–1885," *Sudan Notes and Records*, xlvii (1966), pp. 1–38

Y. F. Hasan: *The Arabs in the Sudan from the Seventh to Early Sixteenth Century* (Edinburgh, 1967)

M. Abu Salim: *Tarikh al-Khartum* (Beirut, 1974)

R. S. O'Fahey and J. L. Spaulding: *Kingdoms of the Sudan* (London, 1974)

Y. Adams: "Islamic Archaeology in Nubia: An Introductory Survey," *Nubian Culture, Past and Present: Main Papers Presented at the Sixth International Conference for Nubian Studies in Uppsala, 11–16 August, 1986*, pp. 327–61

J. Alexander: "The Archaeology and History of the Ottoman Frontier in the Middle Nile Valley 910–1233 AH/1504–1820 AD," *Adumatu*, i (2000), pp. 46–71

I. S. el-Zein: "The Archaeology of the Early Islamic Period in the Republic of Sudan," *Sudan & Nubia*, iv (2000), pp. 32–6

D. A. Welsby: *The Medieval Kingdoms of Nubia: Pagans, Christians and Muslims on the Middle Nile* (London, 2002)

O

Oil painting. The traditional formats for painting in the Islamic world were book illustration (*see* ILLUSTRATION) and wall painting (*see* ARCHITECTURE, §X, C); oil paintings on canvas were a relatively late development. In Iran they began to be produced after the intensification of contacts with Europe in the 17th century, but the link with book production remained strong, so that the best examples give the impression of being enlarged miniatures. In Turkey an indigenous tradition of oil painting was established only in the 19th century, while it was introduced to India by British painters in the late 18th century.

I. Iran. II. Turkey. III. India.

I. Iran. The earliest examples of painting in oils to survive in Iran—the murals of the Chihil Sutun Palace (*see* ISFAHAN, §III, G; *see also* ARCHITECTURE, color pl. 1:VIII, fig. 1)—were done for Shah 'Abbas II (*r.* 1642–66) and were executed in pigment that was mixed with oil and painted directly on the plaster walls; the earliest examples of oil painting on canvas date from the second half of the 17th century. They show large, full-length figures, whose treatment resembles that of contemporary miniatures in the Westernizing style of SHAYKH 'ABBASI, MUHAMMAD ZAMAN and 'ALIQULI JABBADAR (*see also* ILLUSTRATION, §VI, A). The oil paintings were probably inspired by portraits of princes and ladies brought to the Safavid court by European envoys, but may also owe something to the Armenian community of the New Julfa quarter (*see* ISFAHAN, §III, I). Among the few oil paintings to survive from the early 18th century are two portraits of the Afsharid ruler Nadir Shah (*r.* 1736–47), one showing him half-length (London, Commonwealth Relations Trust), the other full-figure, seated (London, V&A, I.M. 20–1919). Both are in a thoroughly Europeanized style, perhaps modeled on English paintings seen during Nadir Shah's invasion of India. A contemporary but less sophisticated painting (untraced) shows a bridal pair, the bridegroom apparently one of Nadir Shah's sons.

A recognizably Persian style of painting developed in the work of MUHAMMAD SADIQ under the patronage of Muhammad Karim Khan (*r.* 1750–79), the Zand ruler at Shiraz. Muhammad Sadiq added still lifes and groups to the range of subjects. His figures are stiff, with modeled features very much in the European manner. Perspective is arbitrary, carpet-patterns are shown in ground plan, and landscapes rarely appear. A typical example of his work is *Girl Playing a Mandolin* (1769–70; Faroughi priv. col.). The other important artist of the time was Ja'far, who produced a large oil painting of *Muhammad Karim Khan and his Court* (Shiraz, Pars Mus.). In this work the contrast between the stiff and formal courtiers and the easily lounging figure of the sovereign, pulling at his waterpipe and winking knowingly at the spectator, is well shown.

Sadiq's style was developed under the patronage of the Qajar dynasty (*r.* 1779–1924). The inscription on a painting of *Shirin Visiting Farhad as he Carves Mt. Bisitun* (1793–4; 1.45×0.88 m, priv. col.; *see* Robinson, 1985, no. 184) shows that the artist Mirza Baba was already working for the Qajars at Astarabad before they established their capital at Tehran. The painting shows an often-illustrated scene from Nizami's *Khamsa* ("Five poems"), but the most characteristic works of the early 19th century are life-size portraits of Fath 'Ali Shah (*r.* 1797–1834). MIRZA BABA's best portrait of the Shah (1798–9; London, Commonwealth Relations Trust) was presented by the Shah to the East India Company in 1822. Mirza Baba's rival MIHR 'ALI also produced portraits of the Shah, of which the finest—perhaps the finest of all Persian oil paintings—shows the ruler full-length, wearing a robe of gold brocade embroidered with roses, the towering Qajar crown on his head, and the staff of Solomon, surmounted by a jeweled hoopoe, in his hand. The emphasis on the ruler's fine eyes, wasp-like waist and majestic beard alludes to his handsome appearance and personal vanity.

Other popular subjects were courtiers and princes. MUHAMMAD HASAN KHAN, for example, painted several fine portraits, such as *Prince Holding a Flintlock* (1.95×0.91 m; Tehran, Nigaristan Mus.), which emphasize the sitter's clothing and textiles. An enormous mural by 'ABDALLAH KHAN for the Nigaristan Palace in Tehran (1812–13; destr.) depicted Fath 'Ali Shah enthroned with 12 of his sons and flanked by serried rows of court officials and foreign ambassadors. The painting, known from several small-scale copies (e.g. London, India Office Lib., Add. Or. MS. 1239–42), contained in all 118 rather stiff life-size figures.

In the second half of Fath 'Ali Shah's reign, a younger generation of court painters came to the fore: SAYYID MIRZA, a painter of royal portraits who worked in a more impressionistic style; AHMAD, who probably trained under Mihr 'Ali and first imitated his style, but whose manner became more Westernized; and MUHAMMAD SHIRIN, who painted distinctive portraits of moon-faced beauties with huge eyes and tiny mouths.

In the mid-19th century all branches of painting were dominated by Abu'l-Hasan Ghaffari (*see* GHAFFARI, §II), known by the title Sani' al-Mulk ("Painter of the Kingdom"). His most celebrated work is a huge mural painted for the prime minister's palace (1856; now divided into seven panels, Tehran, Archaeol. Mus.). It depicts Nasir al-Din (*r.* 1848–96) enthroned between his sons and ministers and attended by courtiers and foreign envoys, in much the same way as 'Abdallah Khan had depicted the court of Fath 'Ali Shah. Sani' al-Mulk's forte was portraiture, uncompromising and sometimes merciless. His tradition was carried on by his nephew Muhammad (*see* GHAFFARI, §III), known as Kamal al-Mulk ("Perfection of the Kingdom"). He studied in Europe, and his mature work, including portraits, landscapes and genre scenes, is completely Europeanized in style. Two other oil painters enjoyed the patronage of Nasir al-Din. ISMA'IL JALAYIR, an early student in the Polytechnical School (Dar al-Funun) founded in Tehran in 1851, worked in the 1860s in an individual, though Westernized, style, sometimes entirely in grisaille. His paintings are infused with an atmosphere of gentle melancholy (see color pl. 3:I, fig. 1). The paintings of Mahmud Khan (1813–93), who was also Poet Laureate, consist mainly of landscapes and views of the royal palaces, executed with almost photographic realism, but he also produced several striking figural studies (e.g. *Two Men Reading by Candlelight*; exh. RA 1931; untraced).

B. W. Robinson: "The Court Painters of Fath 'Alī Shāh," *Eretz-Israel*, vii (1964), pp. 94–105

S. J. Falk: *Qajar Paintings: Persian Oil Paintings of the 18th and 19th Centuries* (London, 1972)

E. G. Sims: "Five Seventeenth-century Persian Oil Paintings," *Persian and Mughal Art* (exh. cat., London, Colnaghi's, 1976), pp. 223–51

J. Taboroff and L. S. Diba: "A Nineteenth-century Isfahan Painting," *Akten des VII. internationalen Kongresses für iranische Kunst und Archäeologie: München, 1976*, pp. 628–34

B. W. Robinson: "Persian Painting in the Qajar Period," *Highlights of Persian Art*, ed. R. Ettinghausen and E. Yarshater (Boulder, 1979), pp. 331–62

E. G. Sims: "The 17th century Safavid Sources for Qajar Oil Painting," *Islam in the Balkans: Persian Art and Culture of the 18th and 19th Centuries* (Edinburgh, 1979), pp. 99–102

B. W. Robinson: "Persian Royal Portraiture and the Qajars," *Qajar Iran*, ed. E. Bosworth and C. Hillenbrand (Edinburgh, 1983), pp. 291–310

M. A. Karimzada Tabrizi: *Aḥvāl u āthār-i naqqāshān-i qadīm-i īrān* [The lives and art of old painters of Iran] (London, 1985)

B. W. Robinson: "Lacquer, Oil-paintings and Later Arts of the Book," *Treasures of Islam* (exh. cat., ed. T. Falk; Geneva, Mus. A. & Hist., 1985), pp. 176–206

B. W. Robinson: "Painting in the Post-Safavid Period," *The Arts of Persia*, ed. R. W. Ferrier (New Haven and London, 1989), pp. 225–31

B. W. Robinson: "Persian Painting under the Zand and Qājār Dynasties," *From Nadir Shah to the Islamic Republic* (1991), vii of *The Cambridge History of Iran* (Cambridge, 1968–91), pp. 870–89

Royal Persian Paintings: The Qajar Epoch 1785–1925 (exh. cat. by L. S. Diba with M. Ekhtiar; New York, Brooklyn Mus.; Los Angeles, CA, Armand Hammer Mus. A.; London, U. London, SOAS, Brunei Gal.; 1998–9)

Qajar Portraits (exh. cat. by J. Raby; London, U. London, SOAS, Brunei Gal., 1999)

II. Turkey. Oil painting on canvas has been known since the Ottoman sultan Mehmed II (*r.* 1444–81 with interruption) invited Gentile Bellini (?1429–1507) to Istanbul in 1479, and oil portraits of the sultans were collected in the Topkapı Palace at various times (*see* DRESS, fig. 1). Until the 19th century, oil paintings were largely produced by traveling and émigré European artists for European patrons. Jean-Baptiste van Mour (1671–1737) and Jean-Etienne Liotard (1702–89) made their reputations with Orientalist works of Turkish subjects, and in the 19th century the European painters resident or traveling in the Ottoman Empire included such figures as Alexandre-Gabriel Decamps (1803–60) and Edward Lear (1812–88). European artists of lesser stature, such as the Italian count Amadeo Preziosi (1816–82), also settled in Turkey and appear to have sold their paintings to travelers and resident Europeans.

Although the European painting tradition had an impact on the traditional Turkish media of book illustration (*see* ILLUSTRATION, §VI, D) and mural painting (*see* ARCHITECTURE, §X, C, 2), at least from Bellini's time, an indigenous Turkish tradition of oil painting began only in the early 19th century. At that time the military academies of Istanbul started to teach linear perspective as an adjunct to producing images for military operations, and oil painting seems to have accompanied perspective, almost as an afterthought. A government-sponsored program of educating Ottoman artists in France ensued, and by the time of the Second Empire many Turkish painters were resident in Paris, studying at the studios of various painters. AHMET ALI and SÜLEYMAN SEYYIT, both painting instructors in military academies, were sent to Paris in the 1860s. After a preparatory course of language studies at the Ottoman School, they entered the Ecole des Beaux-Arts and worked with such academic painters as Gustave Boulanger (1824–88) and Jean-Léon Gérôme (1824–1904). OSMAN HAMDI, who was not a product of the military schools, also studied in Paris, before founding the Fine Arts Academy (Sanayi-i Nefise Mektebi) in Istanbul (*see* ISTANBUL, §II, B).

The early Turkish painters in oils followed the European genres of their masters. Still-life, landscape

and topographical painting were especially popular, as these genres did not conflict with traditional religious views against depicting humans (*see* Subject matter). Nevertheless, some of the most talented of the early generation of Turkish painters also painted portraits. Osman Hamdi, who became an influential figure, seems to have openly flouted traditional Islamic values, producing a prodigious number of canvases incorporating details from Istanbul monuments and works of art to lend authenticity to his work (see color pl. 3:I, fig. 2). Although Hamdi Bey, as he was known in the West, never seems to have produced nude studies or to have depicted the nude in his finished paintings, his work *Mihrab* shows a woman in a décolleté *entari* (traditional dress) sitting in a *rahle* (Koran-stand) in front of a tiled mihrab with copies of the Koran in disarray under her feet. This work seems almost calculated to offend religious sensibilities and contrasts remarkably with the gentle still lifes of Ahmet Ali and Süleyman Seyyit and the somewhat naive architectural landscapes of the military-trained Ahmet Ragıp (*fl.* 1890s), Hüseyin Zekaî Pasha (1860–1919) and Ahmet Ziya Akbulut (1869–1938).

By the end of the 19th century, Ottoman painters in oils were working in a wide variety of genres, producing not only Orientalist genre paintings but seascapes, portraits and Istanbul street scenes. The artists tended to be in the thrall of the academic painters, being for the most part untouched by the realism of Gustave Courbet (1819–77) and Edouard Manet (1832–83). Drawing on a variety of European sources, their work ranged from the meticulous architectural studies of Ahmet Ziya Akbulut to the elegant society portraits of Mihri Müşfik (1886–1954), one of Turkey's first significant women painters in oils, and to the popular Barbizon-inspired landscapes of Ali Riza (1858–1930), affectionately dubbed Hoca ("teacher") by his many students and friends. One of the most capable of the second generation of painters was the Ottoman prince Abdülmecid (1868–1944), who, after the deposition of the last sultan Mehmed VI Vahdettin, in 1922, became caliph until that office was abolished by Atatürk in 1924. Given the traditional Islamic injunctions against figural painting, it is ironic that this rather retiring figure excelled in portraiture and genre scenes; his best-known work, *Beethoven in the Saray* (Istanbul, Mus. F.A.), depicts a musical afternoon in the sultan's palace, with a piano trio performing for onlookers in front of a plaster bust of Beethoven, with the artist himself depicted listening at the right.

M. Cezar: *Sanatta batı'ya açılış ve Osman Hamdi* [Osman Hamdi and Western trends in art] (Istanbul, 1971)

T. Erol: "Painting in Turkey in XIX and Early XXth Century," *A History of Turkish Painting* (Seattle and London, 1988), pp. 87–234

S. Başkan: *Contemporary Turkish Painters* (Ankara, 1991)

III. India. Oil painting was introduced to India in the late 18th century by European, especially British, portrait painters. For example, Johan Zoffany (1733–1810), a German-born painter active in England, earned a fortune in Calcutta and Lucknow between 1783 and 1789 producing portraits of the colonial and local aristocracy. The Daniell brothers, Thomas (1749–1840) and William (1769–1837), cultivated the British market for oil paintings and drawings of the Mysore War. When they returned from India in 1794, they worked up their drawings of Indian landscapes into colored aquatints and oils, which were exhibited at the British Institution and the Royal Academy. These immigrant artists established Western-style oil painting as the medium to be preferred over indigenous pictorial conventions.

Johan Zoffany, 1733–1810 (exh. cat. by M. Webster; London, N.P.G., 1976)

M. Archer: *India and British Portraiture, 1770–1825* (London, 1979), pp. 130–77

M. Shellim: *India and the Daniells* (London, 1979)

M. Archer: *Early Views of India: The Picturesque Journeys of Thomas and William Daniell, 1786–1794* (London, 1980)

R. Chaterjee: "European Oil Painting and the Mughal Experience," *Indian Studies: Essays Presented in Memory of Prof. Nihar Rajan Ray* (Delhi, 1985), pp. 107–16

Okyay, Necmeddin [Efendi, Necmeddin; Üsküdari] (*b.* Istanbul, 29 Jan. 1883; *d.* Istanbul, 5 Jan. 1976). Turkish calligrapher. He attended the Ravzai Terakki school, where he received lessons in calligraphy from Mehmed Şevki and from Hasan Tal'at Bey. In 1905 he received permission to write in the *ta'liq* style from Sami (1838–1912) and in 1906 received permission for the *thuluth* and *naskh* styles from Bakkal Arif Efendi. Later, at the School of Calligraphers, he learnt to draw tughras and practiced *jālī-thuluth* (Turk. *celi-sülüs*) with Ismail Hakkı Altınbezer (1870–1946). He also learnt from Shaykh Ethem Efendi the art of marbled paper, at which he became very skilful. His use of the surname Okyay came from his proficiency at archery. He succeeded his father as preacher and imam at the Yenicami mosque at Üsküdar in Istanbul, where he remained for 40 years. He taught at the School of Calligraphers, the Oriental Decorative Arts School and finally at the Academy of Fine Arts in Istanbul, where he practiced the *ta'liq* style with his pupils. In addition to writing, he explored many crafts and skills related to calligraphy. From Baha Efendi he learnt the art of Turkish classical bookbinding and made fine sunburst bindings, and in turn trained Emin Barın (1913–87) and Islam Seçen in this art. He also learnt how to polish paper, developed formulae for preparing different varieties of ink and was skilled at identifying unsigned works of calligraphy. Among his pupils were the calligrapher Ali Alparslan (1925–2006) and mustafa u'ur Derman.

S. Rado, ed.: *Türk hattatlari* [Turkish calligraphers] (Istanbul, n.d.), p. 265 [Turk. text]

M. Ülker: *The Art of Turkish Calligraphy from the Beginning up to Present* (n.p., 1987), p. 89 [Eng. and Turk. texts]

S. S. Blair: *Islamic Calligraphy* (Edinburgh, 2006), pp. 597–8, 603

Oman, Sultanate of [Arab. Saltana 'Umān; formerly Muscat and Oman]. Independent state in the south-eastern corner of the Arabian peninsula, including several islands, with its capital at Muscat. It is bounded by the Gulf of Oman to the east, the Arabian Sea to the south, Yemen to the southwest, Saudi Arabia to the west and the United Arab Emirates, which separates the main portion of the country from the Musandam Peninsula, to the north. The country has an area of *c.* 212,380 sq. km and can be divided into four regions: the limestone massif of the Musandam Peninsula extending into the Strait of Hormuz; the arid Hajar Mountains, wadis, oasis towns and fertile coastal plain of northern Oman; the desert, which comprises two-thirds of the country and separates north from south; and southern Oman, Dhofar, a largely mountainous region with a tropical climate, which became more firmly part of Oman in the 19th century. The former name of Muscat and Oman (until 1970) underlined the traditional division between the coastal areas and the interior. The population of *c.* 2,200,000 (2005 estimate) consists largely of Arabs belonging to the Ibadi sect of Islam; there are also significant groups of Indian and Baluchi origin. From ancient times the Omanis were sea traders traveling to Mesopotamia, Africa, India and China. Northern Oman has been identified as the copper-rich land of Magan of the 3rd and 2nd millennia BCE, known from Mesopotamian cuneiform tablets. The frankincense trees of Dhofar brought the southern region prosperity and fame, particularly in the first centuries CE. The people converted to Islam *c.* 630. The Portuguese occupied the coastal towns in 1507, later making Muscat their base, until their expulsion in 1650. Treaties with Britain from the 17th century onwards marked the start of a close relationship. In the early 19th century Oman was at the height of its prosperity as a trading empire that extended into East Africa and parts of Iran and Baluchistan, but the separation of Zanzibar from the empire in 1856, and Muscat's weak control of the tribal interior, started a long period of decline. Oman's isolation and stagnation were reinforced in the mid-20th century, but in 1970 the new ruler, Sultan Qabus ibn Sa'id, began a process of modernization. The economy is based on oil exports (since 1967); agricultural produce such as dates, pomegranates, coconuts and bananas; fish exports and frankincense. This article discusses cultural history from the 19th and 20th centuries.

There are over 500 forts, castles, watch-towers and fortified walls throughout Oman, as well as historic mosques and markets or souks. Following the policy of the Ministry of National Heritage and Culture (established in 1976) a restoration program was launched, and some forts were restored (e.g. the 16th-century forts in Muscat, the 17th-century fort–palace at Jabrin and the fort at Rustaq, which dates from *c.* 600 CE). The mud-brick fort in Bahla, in origin probably also pre-Islamic, was placed on the UNESCO World Heritage list. Fine merchant houses dating from the 19th century, with narrow rooms grouped around a central courtyard, are still to be found in

Muscat (e.g. Bayt Nadir), although only a few remain along the corniche in nearby Muttra. Some also survive in Salala, capital of Dhofar, with ornate wooden shutters and crow-stepped crenellations. New, concrete, air-conditioned houses, widespread throughout Oman, and modern banks, offices, schools and hospitals were built after 1970, but the government attempted from the start to combine modern facilities with traditional Omani features (e.g. crenellations, arched forms, often whitewashed). Several buildings have successfully combined modern function with Omani form, such as the new ministries built in Greater Muscat, the capital area, in the early 1980s.

The fine arts movement began in the early 1980s with the establishment of the Atelier for Fine Arts in Muscat, which provided instructors, materials and studios. The government also began to send students on art scholarships to Egypt and Iraq. An important artist in those formative years was Anwar Khamis Sonia (*b.* 1948), who trained in Britain. Like the majority of Omani artists, he painted local landscapes and scenes of daily life in a naturalistic expressive manner (e.g. *Old Door*, 1988; Amman, N.G. F.A.). Other artists have produced abstract or calligraphic compositions, and there are also sculptors and ceramicists. In 1988 the Muscat Youth Biennale was founded for young artists from Asia and Europe, and in 1992 the Omani Society of Fine Arts was founded in Muscat.

The traditional arts and crafts continue to be practiced, though to a limited extent and sometimes with government support. In Muscat and Nizwa silversmiths make jewelry and *khanjar*s (curved daggers), the latter often worn by Omani men; the scabbard consists of embossed-silver designs, woven-silver thread and silver rings. In Bahla there are indigo-dyers and potters, the latter specializing in large water jars. Government-run centers for women throughout Oman include the teaching of old crafts. At a center near Khabura, housed in a *barasti* (a hut made of palm fronds), women work at traditional ground-loom weaving to produce animal trappings and narrow rugs. Typical red-and-black rugs and indigo-dyers are also found in 'Ibri.

By the late 1990s archaeological exploration in Oman was still in its infancy. In the north of the country there are numerous burial mounds, the earliest dating from the late 4th millennium BCE, ancient copper mines and rock art. In Dhofar there are sites dating to the height of the incense trade in the first centuries CE, such as the ancient city of Samhuram (at Khor Rori), excavated by an American team (1952–62). In 1992 archaeologists claimed to have discovered the ancient city of Iram (Ubar) near Salala, famous for its frankincense trade.

The Ministry of National Heritage and Culture assists the investigation of archaeological sites and the establishment of museums. Except for one in Sohar, the museums are all situated in Greater Muscat. The Oman Museum in Qurm (opened 1974) contains archaeological items and Islamic manuscripts and artifacts, while the National Museum in Ruwi (opened 1988) has a range of items, some relating to

Oman's maritime history. Various types of weapons are housed in the Armed Forces Museum (opened 1988), and in the Omani French Museum (opened 1992), located in the old French Consulate, traditional crafts and costumes are displayed, as well as exhibits showing the links between the two countries since the late 17th century. The Sohar Museum (opened 1992) in Sohar Fort contains weapons and local handicrafts. The Ministry also holds arts and crafts competitions and arranges exhibitions both in Oman and abroad.

J. Oman Stud. (1975–)

S. Abdulak: "Tradition and Continuity in Vernacular Omani Housing," *A. & Archaeol. Res. Pap.*, xii (1977), pp. 18–26

A. Hill and D. Hill: *The Sultanate of Oman: A Heritage* (London and New York, 1977)

R. Hawley: *Omani Silver* (London and New York, 1978)

W. D. Peyton: *Old Oman* (London, 1983) [good pls]

C. H. Allen: *Oman: The Modernization of the Sultanate* (Boulder, London and Sydney, 1987)

P. Ward: *Travels in Oman: On the Track of the Early Explorers* (Cambridge and New York, 1987)

M. Kervran: "La citadelle de Hawrat Bargha, dans le sultanat d'Oman," *A. Asiatiques*, xlii (1987), pp. 5–18

S. Kay: *Enchanting Oman*, Arabian Heritage (London and Dubai, 1988, rev. 1989)

Alliages et alliances: Des armes et des bijoux d'Oman (exh. cat., Paris, Inst. Monde Arabe, 1989)

P. M. Costa: *Musandam: Architecture and Material Culture of a Little Known Region of Oman* (London, 1991)

W. Dinteman: *Forts of Oman* (Dubai, 1993)

J. S. Rajab: "Silver Jewellery of the Sultanate of Oman," *A. Asia*, xxiv (1994), pp. 61–70

M. A. Bianciofori and S. Molton: *Bianciofori: Works of Architectural Restoration in Oman* (Rome, 1994)

X. B. Billecocq: *Oman vu par des artistes français du XVIIe au XXe siècle: Oman in the Work of French Artists from the XVIIth to the XXth Century* (Paris, 1995)

J. Parry: "Anglo-Omani Ties Pay Artistic Dividends," *A. & Islam. World*, xxix (1996), pp. 65–8

J. S. Rajab: *Silver Jewellery of Oman* (Kuwait, 1997)

M. Morris and P. Shelton: *Oman Adorned: A Portrait in Silver: Photography Based on the Collections of Rashid Abdullah Richmond and Ian McLeish* (Muscat, 1997)

S. S. Damluji: *The Architecture of Oman* (Reading, 1998)

S. Bandyopadhyay: "Deserted and Disregarded: The Architecture of Bilad Manh in Central Oman," *Archéol. Islam.*, x (2000), pp. 131–68

D. Willems: "Les mosquées anciennes dans l'Emirat de Fuja-ïrah: Un maillon entre les côtes méridionales de Golfe arabo-persique et le Sultanat d'Oman?," *Archéol. Islam.*, x (2000), pp. 169–94

P. M. Costa: *Historic Mosques and Shrines of Oman* (Oxford, 2001)

P. M. Costa: "The Palm-frond House of the Baṭinah," *Patterns of Everyday Life*, ed. D. Waines, Formation of the Classical Islamic World, 10 (Aldershot, 2002), pp. 67–78

G. Weisgerber: "Patterns of Early Islamic Metallurgy in Oman," *Production and the Exploitation of Resources*, ed. M. G. Morony, Formation of the Classical Islamic World, 11 (Aldershot, 2002), pp. 67–78

S. Bandyopadhyay and M. Sibley: "The Distinctive Typology of Central Omani Mosques: Its Nature and Antecedents," *Proc. Semin. Arab. Stud.*, xxxiii (2003), pp. 99–116

Y. S. al-Busaidi: "The Protection and Management of Historic Monuments in the Sultanate of Oman: The Historic Buildings of Oman," *Proc. Semin. Arab. Stud.*, xxxiv (2004), pp. 35–44

S. Bandyopadhyay: "Diversity in Unity: An Analysis of the Settlement Structure of Ḥārat al-ʿAqr, Nizwā (Oman)," *Proc. Semin. Arab. Stud.*, xxxv (2005), pp. 19–36

J. al-Zadjali: "An Omani Fashion Show," *Khilʿa: Journal for Dress and Textiles of the Islamic World*, i (2005), pp. 159–69

S. Bandyopadhyay: "The Deconstructed Courtyard: Dwellings of Central Oman," *Courtyard Housing: Past, Present and Future*, ed. B. Edwards and others (Abingdon, 2006), pp. 109–21

Onat, Emin (*b.* Istanbul, 1908; *d.* Istanbul, 1961). Turkish architect. Educated in Istanbul, he enrolled at the College of Engineering in 1926 and two years later went to Zurich, where he studied architecture under Otto Rudolf Salvisberg (1882–1940). On returning to Istanbul in 1934, he taught at the College of Engineering, later becoming the head of its architecture department. During the 1940s he worked in partnership with Sedad Hakkı Eldem, and together they formed the most prominent architectural practice in Turkey, designing the monumental building for the Faculties of Sciences and Letters (1942–4) at the University of Istanbul, the Faculty of Sciences (1945) at the University of Ankara and the Palace of Justice (1949) in Istanbul. However, for his most important work, the mausoleum of Kemal Atatürk (1944–53) in Ankara, Onat worked independently, assisted by Orhan Arda (1911–99). The mausoleum employed both modern and traditional building materials and construction methods, and its architecture referred to the Mausoleum of Halikarnassos. In 1946, when the College of Engineering became Istanbul Technical University, Onat was appointed dean of the Faculty of Architecture, and from 1951 to 1953 he was rector at the university. He then spent several years in politics, after which he continued teaching at the university. With Eldem and Paul Bonatz (1877–1956), Onat was an important figure in Turkey for his contribution to the Second National Architectural Movement, which promoted national and regional considerations in modern Turkish architecture.

D. Kuban: "Emin Onat ve cumhuriyet devri mimarisi" [The republican revolutionary architect], *Mimarlık*, iv–v (1961), pp. 142–53

R. Holod and A. Evin, eds.: *Modern Turkish Architecture* (Philadelphia, 1984)

Atatürk için düsünmek: Iki eser: Katafalk ve Anitkabir: Iki mimar, Bruno Taut ve Emin Onat/Für Atatürk gedacht: Zwei Werke: Katafalk und Anitkabir: Zwei Architekten, Bruno Taut und Emin Onat/Thinking for Atatürk: Two Works: The Catafalque and Anitkabir: Two Architects, Bruno Taut and Emin Onat (Istanbul, 1998)

Orfa. *See* Urfa.

Orientalism. Art-historical term applied to a category of subject matter referring to the depiction of

the Near East by Western artists, particularly in the 19th century.

I. Introduction. II. Subject matter. III. Conclusion.

I. Introduction. Orientalism was essentially a 19th-century phenomenon, a facet of Romanticism. However, before Napoleon invaded Egypt in 1798, there had been long, if sporadic European interest in the arts of the Islamic lands, particularly in Italy and especially in Venice, which had close commercial links with the East. Gentile Bellini (?1429–1507) painted Ottoman subjects, Paolo Veronese (1528–88) represented some figures in Turkish costume, Rembrandt van Rijn (1606–69) portrayed men in vaguely Orientalist garments and, most important for later developments, Rococo artists, including Jean-Baptiste Le Prince (1734–81) and Carle Vanloo (1705–65), painted opulent fantasies of harems and sultans. Jean-Étienne Liotard (1702–89) and Jean-Baptiste van Mour (1671–1737) lived in Turkey in the 18th century and provided a seemingly more authentic glimpse of the East. Yet it was only in the 19th century, when Europe became more involved politically in the Near East, and when means of travel improved, that Western artists began visiting the region in great numbers and paid closer attention to its distinctive features. In the 19th century Orientalism became a standard subject in which artists throughout Europe specialized.

Images of the life, history and topography of Turkey, Syria, Iraq, Iran, the Arabian Peninsula, Jordan, Israel, Lebanon, Egypt, Libya, Tunisia, Algeria, Morocco and sometimes modern Greece, the Crimea, Albania and the Sudan constitute the field of Orientalism. Although almost any biblical subject in Western art would rank as an Orientalist image by this definition, most such works dating before the 19th century fail to present any specifically Near Eastern details or atmosphere and are not Orientalist. Artists need not have journeyed to the Near East to be labeled Orientalist, but their works must have some suggestion of topographic or ethnographic accuracy.

Orientalism is notable in 19th-century architecture and decorative art but is most significant in painting, the graphic arts and photography. In sculpture only one major specialist arose: Charles Cordier (1827–1905). His busts of North African people in the 1850s introduced polychromy and semi-precious stones to sculpture in order to portray the opulence and patterning that were central to Western conceptions of a luxurious East.

The most important publication in the early development of Orientalism was the French government's *Description de l'Egypte* (Paris, 1809–22), the 24 volumes of which illustrate the monuments, people, flora, fauna and geography of Egypt. This project, initiated by Napoleon during his Egyptian campaign, provided information not only for the settings and costumes of paintings but also for Egyptian revival architecture, tombs and decoration. The Egyptian motifs that ornament Empire furniture, for example, stem from Napoleon's invasion; subsequent military events in the Near East, such as the Greek War of Independence, the conquest of Algeria, the Crimean War and the suppression of the Mahdi in the Sudan, also fostered Orientalist works.

Antoine-Jean Gros (1771–1835) executed the earliest grand history paintings that reflect an increased knowledge of the Near East. The French government provided him with detailed descriptions of commissioned subjects, and his *Battle of Aboukir* (1806; Versailles, Château) includes not only Islamic architecture and dress but also a strong impression of Eastern sunlight and terrain. Gros's paintings glorify Napoleon (e.g. *Bonaparte Visiting the Victims of the Plague at Jaffa, 11 March 1799*, 1804; Paris, Louvre), and there is a political current in much Orientalist art. French depictions of Algeria in the 1830s by Horace Vernet (1789–1863) and Eugène Delacroix (1798–1863; e.g. *Women of Algiers in their Apartment*, 1834; Paris, Louvre), even when they do not depict battles, are testaments of imperial possession. Exhibition reviews and imperialist publications indicate that images of nomads and harems, Romantic ruins of the ancient world, exotic marriage customs and primitive means of transport could all be pointedly interpreted as pictures of backwardness, decay and barbarism. The underlying assumption of much Orientalism is that colonialism was justified as a civilizing and modernizing force. Paintings such as *Massacre of the Janissaries* (1827; Rochefort, Mus. Mun.) by Charles-Emile de Champmartin (1797–1883) and *Execution without Judgement under the Moorish Kings of Granada* (1870; Paris, Mus. Orsay) by Henri Regnault (1843–71) more obviously speak of Near Eastern violence and misgovernment and imply the superiority of Western society. Not all Orientalist works, however, are primarily imperialist tracts, and many Orientalist artists deplored Westernization.

II. Subject matter. Orientalist painting can be grouped according to its subject matter, including secular history painting; religious works; depictions of harems, slaves and street markets; Bedouins and soldiers; and landscape and architecture. In the realm of history painting, Gros was followed by Vernet as the painter of French imperial power, and the *Capture of Abd-el-Kader's Train by the Duc d'Aumale* (1845; Versailles, Château) typifies the exaggerated movement, histrionics and dazzling light of Orientalist battle scenes. Paintings of Near Eastern history, both ancient and modern, display more violence and disorder than Western subjects, and this is particularly true of the works of Delacroix. *The Massacres at Chios* (1824) and the *Death of Sardanapalus* (1827; both Paris, Louvre) reflect not merely Romantic gusto for some un-Classical place beyond the restraints of Western culture, but also a conception of the Near East as wild and cruel. Delacroix's viewpoint was communicated to his friends and followers, including Jules-Robert Auguste (1789–1850; he traveled to the East before Delacroix), Richard Parkes Bonington (1802–28), Théodore Chassériau (1819–56) and Adolf Schreyer (1828–99). The association of the Near East with

turbulence and cruelty was ubiquitous, beyond the influence of one artist, and is found in such works of disparate style and date as *Revolt at Cairo* (1810; Versailles, Château) by Anne-Louis Girodet (1767–1824) and *Death of Cleopatra* (1875; Kassel, Schloss Wilhelmshöhe) by Hans Makart (1840–84). Near Eastern history paintings by English artists are rarer and more subdued. *Tartar Messenger Narrating the News of the Victory of St. Jean d'Acre* (1840; Sir James Hunter Blair priv. col., see K. Bendiner: "Wilkie in Turkey," *A. Bull.*, lxiii/2, 1981, p. 260) by David Wilkie (1785–1841), like the later works of Jean-Léon Gérôme, merges history painting with charming genre, and the lithographs of William Simpson (1823–99) published in his *Seat of War in the East* (London, 1856) present many quiet and domestic illustrations of the Crimean War.

Orientalist biblical pictures outnumber secular history paintings from the second half of the 19th century. The Near East was considered a land unchanged since ancient times, and Horace Vernet was the first artist to make use of Near Eastern costume, landscape and ethnic types in scriptural images. Alexandre-Gabriel Decamps also produced some examples, but this new field was taken up in the 1840s and 1850s most enthusiastically by English artists. They saw the presentation of biblical history in accurate Near Eastern garb and setting as Protestant, documentary and non-idolatrous. Wilkie traveled to Egypt and Palestine to produce such images and even thought of painting a *Last Supper* with Christ and the Apostles seated on the floor, Arab fashion. Wilkie died before carrying out his task, but William Holman Hunt (1827–1910) followed in the 1850s and produced the *Finding of the Saviour in the Temple* (1860; Birmingham, Mus. & A.G.), which set the new standard for Orientalized scriptural imagery. The biblical paintings of Ford Madox Brown (1821–93), Simeon Solomon (1840–1905), Edward John Poynter (1836–1919) and Vasily Vereshchagin (1842–1904) reflect Hunt's accomplishment, as do the illustrations in Protestant Bibles produced subsequently in Britain and America. The most influential Orientalized Bible was produced by James Tissot (1836–1902); his Old and New Testament illustrations were exhibited widely at the end of the 19th century and were published in lavish editions (e.g. Tours, 1896–7). They present Holy Writ in dramatic Near Eastern contexts and were the starting-point for the biblical epics of Hollywood.

Representations of faith and prayer constitute a different form of Orientalist religious art. The subjects are contemporary and the characters anonymous. Arabs and Turks are shown performing their devotions in the mosque and the desert and traveling to Mecca. Jewish services, Orthodox festivals and Roman Catholic worshippers in the Holy Land were also depicted. Although some works, such as Hunt's *Miracle of the Sacred Fire in the Church of the Sepulchre, Jerusalem* (1893–9; Cambridge, MA, Fogg) and Delacroix's *Fanatics of Tangiers* (1838; Minneapolis, MN, Inst. A.) portray religious mayhem, most of these genre paintings, whether by Gérôme, Léon

Belly (1827–77), John Frederick Lewis (1805–76), Frederick Goodall (1822–1904), Frederic Leighton (1830–96), Gustav Baurenfeind (1848–99), Ludwig Deutsch (1855–1935) or Rodolphe Ernst (1854–1932), are uncritical, non-sectarian tributes to those in the modern age who could still believe.

Genre painting was the most prevalent form of Orientalism in the 19th century, and harem scenes were particularly numerous. Despite greater accuracy in detail, the 18th-century libertine vision of Oriental domestic life persisted, and Western beauties continued to appear as odalisques. Male painters almost never saw a genuine harem, and their aim was to create an erotic ideal, not a sociological document. The nude odalisques by Jean-Auguste-Dominique Ingres (1780–1867), languid and sensual, were most influential. His imagery of voluptuous luxury, privacy and lethargy was echoed in works by Gérôme, Jean Lecomte de Noüy (1842–1929) and Edouard-Bernard Debat-Ponsan (1847–1913). The placement of the nude in a context neither classical nor allegorical heightened the figure's sexuality, and seraglio pictures, justified as ethnography, were among the most erotic public displays of the nude in the 19th century. As a personal troupe of pleasure-givers, the harem automatically possessed erotic meaning, even in more decorously dressed images such as Delacroix's *Women of Algiers in their Apartment* (1834; Paris, Louvre). This opulently robed seraglio tradition was carried on by Théodore Chassériau, Benjamin Constant (1845–1902) and Auguste Renoir (1841–1919) in France, and Lewis produced a minutely detailed version in England. The Orientalist harem chamber, closed-off, stuffed with patterned finery and dedicated to quiet pleasure, stimulated the construction of sumptuous Islamic lounges in residences throughout Europe and America, most notably the Arab Hall (1877–9) designed by George Aitchison (1825–1910) for Leighton House in London. Furthermore, the narcotic and decorative settings of Aesthetic paintings by Albert Joseph Moore (1841–93), Lawrence Alma-Tadema (1836–1912) and others reflect the same inspiration but are no longer tied to Muslim societies.

Slave market scenes, by Gérôme, Charles Gleyre (1806–74) and Regnault, are essentially outdoor harems and are equally erotic. Occasionally some negative portrayals were executed by William Allan (1782–1850) and others during the Greek War of Independence and by David Roberts (1796–1864) in his images of black slave traffic in his book *Egypt and Nubia* (London, 1846–9). Also related to harem imagery are Near Eastern market scenes, with a similarly complex array of colorful patterns and stuffs of many nations, which exhibit a 19th-century perception of Eastern street life as a marvelous jumble. Mariano Fortuny y Marsal (1838–74), Gérôme, William James Müller (1812–45), Lewis, Frank Brangwyn (1867–1956) and Leopold Carl Müller (1834–92) produced these views of splendid disorder.

In contrast to harems and city markets are pictures of Spartan Bedouin life. Eugène Fromentin (1820–76), Delacroix, Eugène-Alexandre Girardet, Adolf

Schreyer, Lewis, Frederick Goodall and Gustavo Simoni (1846–1926) depicted Bedouin men as noble herdsmen, hunters and warriors, and their women as gentle mothers. Western travelers often had themselves portrayed as these tough desert Arabs. Another aspect of this cowboy-like vision of the Near East is exemplified by the pictures of soldiers and seraglio guards by Gérôme, Decamps, Arthur Melville (1858–1904) and Lecomte de Noüy, but here a strong note of cruelty and savage violence is usually present.

From the publication of the *Description de l'Egypte* until the mid-19th century, the Orientalist landscape generally exhibited a scientific objectivity, documenting famous ancient and medieval sites in Turkey, Egypt and Palestine, although Prosper Marilhat (1811–47), Adrien Dauzats (1804–68) and later Edward Lear (1812–88) and Frederic Edwin Church (1826–1900) employed picturesque compositional devices. In desert landscapes, treeless and vast, however, standard formulae were impossible, and even architectural draftsmen such as Roberts created startlingly open landscapes (see fig.). Later painters played upon the emptiness of the East and produced such vistas of death as *The Sahara* (1867) by Gustave Guillaumet (1840–87) and Fromentin's *Land of Thirst* (*c.* 1869; both Paris, Mus. Orsay). A Romantic taste for ruins as symbols of degeneration and mortality was also widespread. Roberts's *The Holy Land, Syria, Idumea & Arabia* (London, 1842–5) and *Egypt and Nubia* remained the standard guides to Eastern archaeological and religious sites throughout the 19th century and were imitated in the photographs of Maxime Du Camp (1822–94), Francis Frith (1822–98) and Francis Bedford (1816–94). Roberts's scenes

of Palestine became acceptable Protestant icons, and his views of Islamic buildings inspired Victorian architects. Like many others, he saw Muslim architecture as the source of Gothic. Théodor Frère (1814–88) and Alberto Pasini (1826–99) continued this precise delineation of monuments into the 1880s, but in the later 19th century more evocative landscapes appeared. Luc Olivier Merson (1846–1920), Elihu Vedder (1836–1923), Lucien Lévy-Dhurmer (1865–1953) and other Symbolists imagined a dream-like East, filled with ancient mystery.

III. Conclusion. The increased authenticity of accessories and settings in 19th-century Orientalism did not prevent artists from indulging in fantasies of luxury, eroticism, violence or ancient history. Separate Eastern cultures were often mixed or generalized, and any evidence of modernity or rationality was usually ignored. Orientalism ultimately shored up Western myths more than it revealed Eastern realities, and in the 20th century only the stylistic approaches changed. Henri Matisse (1869–1954), Max Slevogt (1868–1932), Paul Klee (1879–1940), Vasily Kandinsky (1866–1944), August Macke (1887–1914), Oskar Kokoschka (1886–1980) and Bart van der Leck (1876–1958) merely reiterated the Orientalist subjects, themes and sentiments that had been established in the 19th century.

See also MOORISH STYLE.

J. Alazard: *L'Orient et la peinture française au XIXe siècle* (Paris, 1930)

R. Ettinghausen: "The Impact of Muslim Decorative Arts and Painting on the Arts of Europe," *The Legacy of Islam*, eds. J. Schacht and C. E. Bosworth (Oxford, 1974), pp. 292–320;

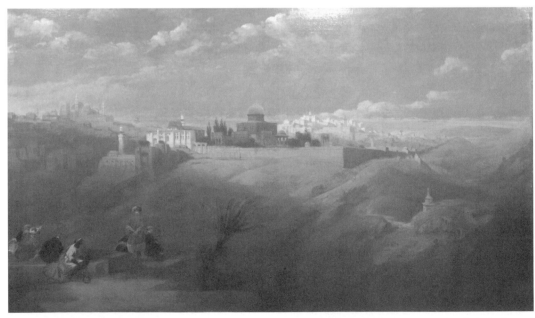

David Roberts: *View of Jerusalem,* oil on canvas, after 1838 (Doha, Museum of Orientalist Arts); photo credit: Sheila S. Blair and Jonathan M. Bloom

repr. as *Richard Ettinghausen, Islamic Art and Archaeology Collected Papers* (Berlin, 1984), pp. 1074–1119

P. Jullian: *The Orientalists: European Painters of Eastern Scenes* (Oxford, 1977)

E. Said: *Orientalism* (New York, 1978)

M. Verrier: *The Orientalists* (New York, 1979)

P. Hughes: *Eighteenth-century France and the East* (London, 1981)

Orientalism: The Near East in French Painting, 1800–1880 (exh. cat. by D. A. Rosenthal; Rochester, U. Rochester, NY, Mem. A.G., 1982)

L. Nochlin: "The Imaginary Orient," *A. America*, lxxi/5 (1983), pp. 118–31, 186, 189, 191

L. Thornton: *Les Orientalistes: Peintres voyageurs, 1828–1908* (Paris, 1983)

The Orientalists: Delacroix to Matisse (exh. cat. by M. A. Stevens; London, RA, 1984)

La Sculpture française au XIXe siècle (exh. cat., Paris, Grand Pal., 1986)

J. Sweetman: *The Oriental Obsession: Islamic Inspiration in British and American Art and Architecture 1500–1920* (Cambridge, 1987)

Matisse in Morocco (exh. cat., ed. J. Cowart and P. Schneider; Washington, DC, N.G.A.; New York, MOMA; Moscow, Pushkin Mus. F.A.; Leningrad, Hermitage, 1990)

Egyptomania: Egypt in Western Art 1730–1930 (exh. cat., Paris, Louvre; Ottawa, N.G.; Vienna, Ksthist. Mus.; 1994–5)

J. M. MacKenzie: *Orientalism: History, Theory, and the Arts* (Manchester, 1995)

J. Davis: *The Landscape of Belief: Encountering the Holy Land in Nineteenth-Century American Art and Culture* (Princeton, 1996)

D. Howard: *Venice and the East: The Impact of the Islamic World on Venetian Architecture 1100–1500* (New Haven, 2000)

Noble Dreams/Wicked Pleasures: Orientalism in America, 1870–1930 (exh. cat., ed. H. Edwards; Williamstown, MA, Clark A. Inst., 2000)

R. Mack: *Bazaar to Piazza: Islamic Trade and Italian Art, 1300–1600* (Berkeley, 2002)

R. Benjamin: *Orientalist Aesthetics: Art, Colonialism, and French North Africa 1880–1930* (Berkeley, 2003)

K. Davies: *The Orientalists: Western Artists in Arabia, the Sahara, Persia & India* (New York, 2005)

R. Irwin: *Dangerous Knowledge: Orientalism and its Discontents* (Woodstock, NY, 2006)

D. Fortenberry, ed.: *Who Travels Sees More: Artists, Architects and Archaeologists Discover Egypt and the Near East* (Oxford, 2007)

Venice and the Islamic World (exh. cat., ed. S. Carboni; Paris, Inst. Monde Arab.; New York, Met., 2007)

Ornament and pattern. Vegetal, geometric and other forms of ornament play an unusually important role in the architecture and visual arts of the Islamic lands, where virtually all surfaces are decorated (*see* SUBJECT MATTER). Indeed, a characteristic feature of Islamic ornament is *horror vacui*, the tendency to fill any empty space on a given surface. The ornamentation is neither essential to the underlying structure of an object or building, nor a necessary part of its serviceability, and this independence from the underlying body meant that ornament was widely applicable and easily transferable from one technique or medium to another. Most Islamic ornament can be classified either by the elements of which it is composed (e.g. vegetal, figural, geometric, epigraphic motifs or a combination of these) or the methods by which it is organized (e.g. linking, framing, expansion and subdivision).

I. Motifs and their transformation. II. Formation of order. III. Meaning. IV. Principles and concepts.

I. Motifs and their transformation. The motifs used in Islamic art can be classified under four common themes derived from the pre-Islamic, especially classical, repertory, but the balance is somewhat different in Islamic art and the motifs themselves were gradually abstracted and transformed over time.

A. Vegetal. B. Figural. C. Geometric. D. Epigraphic.

A. VEGETAL. The development of vegetal ornament falls into three periods. In the formative period of Islamic art (7th century–early 10th), Late Antique and pre-Islamic foliate and floral motifs were transformed into a distinctive Islamic style; these included naturalistic acanthus leaves, vines with or without tendrils, and clusters of grapes, palmettes, half palmettes and palmette-trees, pinecones, pomegranates, buds, rosettes and lotus flowers. Although vines, palmettes and rosettes predominate, most plant ornament comprises a combination of motifs. The palmette was particularly common in 9th-century Mesopotamian and Iranian architectural decoration and ceramics, and the same vegetal prototypes were the basis for the BEVELED STYLE first documented in the mid-9th century. Despite the abstract character of this type of ornament, it was derived from plant motifs—trefoils, three-petaled lotus blossoms and buds, vine leaves, palmettes, rosettes and undulating stems—arranged according to clearly defined principles. The most frequent arrangement is a reciprocating setting of identical flowers that form a frieze or border linked by curving lines or bands. Identical vegetal motifs are frequently arranged vertically in all-over patterns; typical examples show alternating rows of palmettes or stylized vine leaves linked by lotus blossoms that form calyx-like joints. The turning point in this style is exemplified by the art of SAMARRA, in which floral or other plant elements are transformed and integrated into compact complex patterns. This new style appeared nearly instantaneously in different media throughout most of the Islamic world. The area least affected was Spain, which maintained earlier traditions well into the early 11th century, as can be seen on architectural decoration (for illustration *see* ARABESQUE).

The most important development in the period of ornamental integration (10th–13th century), apart from the spread of Mesopotamian styles of ornament as far afield as Egypt and the eastern Islamic lands, was the appearance of fully-fledged ARABESQUE patterns, characterized by at least one axis of symmetry. A variety of fully developed arabesques appeared in different media in the late 10th century and the 11th, and by the 12th or 13th century the motif appeared

in nearly all media in varying degrees of elegance and sophistication. For example, stucco arabesques in the mosque (1158–60) at ARDISTAN in Iran are carved on two levels, and movement and depth are created by slender and gracefully winding half-palmettes that intersect and are held together along the central axis by alternating crescent-shaped loops. The infinite character of the arabesque created by constantly merging and separating stalks, palmettes and other plant elements is enhanced in patterns that combine vegetal motifs with arches, arcades or linked star medallions. These geometric motifs form a basic grid that interweaves with the arabesque, enriching its character and emphasizing its fluidity (e.g. moldings on the exterior of the Mosque of al-Hakim, c. 990–1013; see CAIRO, §III, D). Arabesques are the main theme of decoration on some Iranian luster and over-glaze-painted ceramics from the late 12th century to the mid-13th. Additional plasticity was achieved by modeling, as on a tile at Qum (c. 1206), where the delicate arabesques comprise feathery leaves, tulip blossoms and densely spaced stalks. The evolution of the arabesque culminated in late 13th-century Anatolia. The three-dimensional rendering of the arabesque on a spectacular gilt bronze lamp (Konya, 1280–81; Ankara, Mus. Ethnog.) is paralleled by that on contemporary woodwork, such as two splendid lecterns (1278–9; Konya, Mevlana Mus., and Berlin, Mus. Islam. Kst).

As a result of the Mongol invasions of the 13th century and new trade contacts with China, such East Asian floral motifs as lotus plants and leaves, peonies and composite flowers appeared increasingly in the vegetal repertory of the third period (late 13th century to 17th; see color pl. 3:II, fig. 1). The earliest Chinese-inspired floral motifs seem to occur on ceramics, such as the organically growing peony on a star tile from the Imamzada Ja'far at Damghan (1267; Paris, Louvre). Contemporary metalwares from Iran, Syria and Egypt, especially brasses inlaid with gold and silver (e.g. a basin made c. 1330 for the Mamluk sultan al-Nasir Muhammad; London, BM) display a decided preference for lotus blossoms, and a lotus-and-peony border decorates the frontispiece to a manuscript of the Koran (c. 1370; Cairo, N. Lib., 54). In the second half of the 14th century, artists in Iran and Central Asia came to favor more intricate, vivid and organic floral patterns, as on a splendid wooden lectern (1359; New York, Met.) where delicately carved stalks appear to grow naturally and carry a variety of richly carved and naturally conceived blossoms. In 15th-century Iran and Central Asia, two concomitant tendencies—continuous overall designs that spread symmetrically along the main axes, and real and fantastic sprays of flowers—can be seen, as on an illuminated page from a copy of Nizami's *Khamsa* ("Five poems"; 1431; St. Petersburg, Hermitage).

Trade relations between the Far East and the Mediterranean lands introduced a taste for more exotic vegetal motifs seen on Chinese porcelains and other imported goods. This new taste can be seen in tiles on the tomb of Ghars al-Din al-Tawrizi (c. 1420) in Damascus and the mosque of Murad II in Edirne (1435–6; see ARCHITECTURE, §X, B, 2). Nevertheless, Chinese flower and plant motifs never completely supplanted the arabesque. Known in Turkish as *rumi* ("Roman", i.e. Byzantine), arabesques with long pointed leaves from the curved side of which a second lobe often branches enjoyed much favor in the arts of the book and ceramics produced under the OTTOMAN dynasty in the 16th century. On many examples the arabesques are combined with flower heads, a cluster of volutes ultimately derived from the lotus, a style known in Turkish as *hatayi* ("Chinese"). By intertwining, intersecting and superposing different vegetal elements, artisans in 16th-century Ottoman workshops in Istanbul developed a distinctive new style of vegetal ornament known as SAZ (Turk.: "reed").

B. FIGURAL. Animals, imaginary creatures and birds were always part of the Islamic decorative repertory. These figures derived from the same artistic tradition as vegetal ornament, but the relatively naturalistic renderings of the earliest period were quickly transformed into semi-abstract designs. At first the general shape of the motif was retained, but the body was flattened, simplified and adapted to the form of the object. For example, a luster-painted bowl (New York, Brooklyn Mus.) shows a ?peacock, whose body has been transformed into a disc to fit the round base. This tendency towards abstraction brought about a nearly complete transformation of the motif, as on a polychrome luster-painted bowl excavated at Samarra (see color pl. 3:II, fig. 2), where palmettes form wings and spring from the bird's head, making the figure scarcely recognizable as a bird. The spread of the BEVELED STYLE to Egypt encouraged the tendency towards the complete transformation of the animal form, as on a wooden plaque (late 9th century or early 10th; Paris, Louvre, 6023) with the silhouette of a bird created from fully merged three-petaled lotus blossoms, half-palmettes and undulating stems. This abstract style of rendering was soon supplanted by a more naturalistic one; by the late 10th century Egyptian artists again depicted real animals from a large repertory.

In the eastern Islamic lands, however, stylization continued to be favored on ceramics associated with Nishapur and Samarkand in the period of SAMANID rule in the 10th century (see CERAMICS, §II, C, 3), where birds may serve concomitantly as central ornament and reduced in scale as background figures. In general, however, animal ornament followed the tendency towards naturalism. An increased variety of creatures, often shown in reserve and isolated, paired heraldically or aligned in narrow bands, figure on brass vessels, ceramics, ivories and silk textiles. The fascination with imaginary animals culminated between the 12th and 14th century. Human-headed creatures, such as sphinxes and harpies, figure prominently on ceramics and textiles produced in Egypt in the 11th and 12th centuries, and by the mid-12th century they were adopted in Iran by potters, metalworkers and weavers. Together with other fabulous beings, such as

winged lions and unicorns, they remained in vogue for the next two centuries in most of the eastern Islamic lands. Animals were presented heraldically in pairs, revolving around a central axis (sometimes with intertwined necks) and in friezes of quadrupeds chasing each other or aligned. In the early Islamic period, friezes were generally composed of animals of the same species, but from the 12th century friezes of different species were dominant. More often, however, animals were arranged in narrow bands, which decorate the rim of an object or form borders.

In the 14th century, representational motifs were replaced in the western and central Islamic lands by epigraphy, while in the eastern Islamic lands new species of birds and types of fabulous creatures from East Asia, such as the phoenix, dragon and *qilin* (a sort of unicorn), supplanted the fantastic fauna of former centuries. These fantastic animals were adopted not only in Iran but also under the Ottomans in Anatolia and the Mughals on the Indian subcontinent.

C. Geometric. Geometric patterns serve two artistic intentions in Islamic art: to form a closed design confined within its own border or to establish an open design with the possibility of infinite extension. Basic geometric motifs and even intricate interlacings are already present in architectural revetment produced under the Umayyads of Syria (*r.* 661–750). As it is difficult to discern a chronological or geographical development, geometric designs are better classified by the underlying units—squares and lozenges, circles, polygons and stars, as well as stalactites (*see* Muqarnas).

Some of the simplest and most commonplace units are squares, which can be divided diagonally or inscribed within each other. In Byzantine floor mosaics the effect came from the shapes of the squares, while in Islamic times the effect came from the structure of the lines enclosing the squares. Squares and lozenges lend themselves to perforation or piercing and were frequently used for wooden screens, window grilles, bronze lamps and incense burners. To avoid monotony, the empty areas could be filled with small flowers or buds. In the medieval period, diamond and cross patterns were retained, and artisans further subdivided the geometric units, combining squares and lozenges of different sizes, interlocking them in various ways or interlacing additional bands into the basic network. As a result, the lucidity of the pattern receded further, and new forms such as stars and hexagons appeared.

The same principles of pattern making were applied to circles. By making free use of the compass, craftsmen drew both simple and intricate repeat patterns and created interlacings adaptable to border designs and larger surfaces. They often omitted certain portions of the circles so that the patterns convey an inner tension, an illusion of expansion or rotation around a central axis and movement. From early Islamic times, circles and semicircles were used to define the composition, and such designs were particularly popular in metalware (*see* Metalwork, fig. 5).

Between the 10th century and the later 16th, stars and polygons were the most common basis for Islamic patterns. The basic elements were hexagons and octagons, but triangles, pentagons, decagons and other polygons added to the complexity of these patterns, which emphasized either the lines or the shapes enclosed by them (see fig.). Like other geometric ornament, polygonal and stellate patterns were used in most media of Islamic art, including the arts of the book, metalwork and woodwork, but they were explored foremost in architecture. The principle of interlacing can be seen in the brick decoration on the two tomb towers at Kharraqan (1067–8 and 1093–4). Patterns were also created by dividing the geometric unit into sub-units, and hexagons and octagons were divided by oblique and vertical lines into six or eight equilateral triangles. Another basic pattern was generated from hexagrams or octagrams. The decorative possibilities of these ornaments were exploited by architects in 15th-century Iran and Central Asia who used glazed and unglazed bricks, terracotta tiles and tile mosaic to differentiate various forms and highlight stellar elements (*see* Architecture, fig. 63).

D. Epigraphic. The importance of the written word in Islam brought about a widespread use of inscriptions on architecture (see color pl. 3:II, fig. 3; *see also* Architecture, §X, F) and other media. The earliest objects with epigraphic decoration, such as a mid-8th-century Mesopotamian bowl of unglazed clay (Damascus, N. Mus. 17261A) and an 8th-century Egyptian glass goblet with luster decoration (discovered 1965 at Fustat; Cairo, Mus. Islam. A.), show a casual, rather fortuitous use of inscriptions. By the 9th or 10th century, inscriptions were fully integrated into the rest of the decoration and enclosed in the same frames as other figural or vegetal decoration. Calligraphers invented a variety of scripts, both angular and flowing. At first unadorned letters were harmoniously spaced, but gradually the letters became more ornate, with added foliate and floral motifs (*see* Architecture, fig. 66), and the letters themselves were plaited and interlaced, particularly in the eastern Islamic lands.

One particular type of writing, found primarily on metalwork (*see* Metalwork, §I, E), is distinguished by the use of animal or human forms. Four varieties can be distinguished, according to the dominant figural feature. In ornithomorphic scripts, the entire letter is transformed into a bird or the vertical shafts or tails end in a bird's head. In human-headed scripts, heads are attached to the upper parts of the letters (e.g. inscription on the neck of a ewer, *c.* 1200; New York, Met.; *see* Metalwork, fig. 6). In zoomorphic scripts, heads of imaginary creatures, birds or quadrupeds are fused with the upper and lower ends of the letters. In the fourth script, almost the whole letter is transformed into a human being. The first three types occur in angular as well as round scripts, but the last is restricted to round scripts.

Inscriptions became the dominant feature in the early 14th century, often occupying large portions of

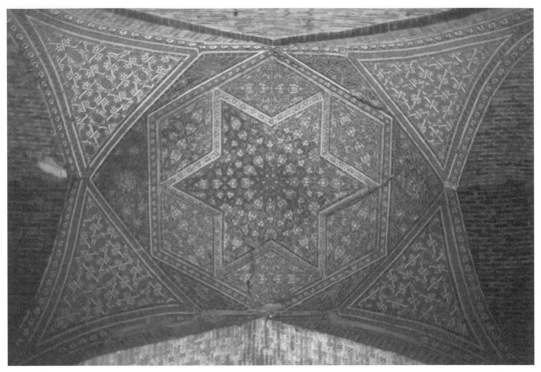

Star patterns on the vaults of the tomb of Uljaytu, Sultaniyya, Iran, 1305–15; photo credit: Sheila S. Blair and Jonathan M. Bloom

an object. Letters appear not only in continuous or intersecting bands, cartouches and roundels (*see* METALWORK, fig. 12), but also in a new circular arrangement in which the shafts of the letters point towards the center. Set in roundels or polylobed medallions, these radiating inscriptions were particularly favored on metalwares made for Mamluk dignitaries. The ornamental qualities of script were also exploited in epigraphic panels in which the words form a regular geometric design. Often termed square, squared or rectangular kufic, the script was frequently used for religious phrases or pious names.

II. Formation of order. Three principal methods were used to create overall patterns and avoid bare areas in Islamic art. By far the commonest was to use frames and borders, which outline the primary motifs and set them into medallions, panels and cartouches, link them together and give the design an inner cohesion. The structure of these frames and the resultant form of the panels or medallions were often closely related: the ultimate origin of round linked enclosures, for example, is a simple rope of two or three twisted strands or guilloche bands which, when loosened, created medallions that could be filled with other motifs. This transformation of guilloche bands can be found already in early Islamic ornament, as on a silver dish with a simurgh (9th century; Berlin, Mus. Islam. Kst). Further loosening of the twisted bands brought about larger enclosures, which, depending on the number of strands, became triangular or rhomboid in shape and

could be used to cover larger surfaces, as on the 13th-century Wade Cup (Cleveland, OH, Mus. A.).

In many instances the round enclosures have lobed or arched outlines, forming quatrefoils or polylobed medallions, which, like ordinary roundels, are linked and twisted into the upper and lower borders. Lobed frames, sometimes described as bracket-shaped, derive from lotus sepals in Chinese art and first appear in metalwork from eastern Iran, as on a 12th-century mortar (Herat Mus.). Linked bracketed arches often form friezes or continuous bands, as on a running band of ornament in the congregational mosque (1106–14) at Qazvin in Iran. Lobed and linked frames were further modified in Egyptian art, as on a carved stucco frieze above the entrance to the tomb of Qala'un (1284–5; *see* CAIRO, §III, H) in which the lobed outlines form a reciprocating frieze of identical arches. These arcaded compartments were developed into extremely refined border patterns in later Islamic art, particularly the arts of the book, where thin white lines form a frieze of reciprocating, often bracket-shaped lobed arches on a blue ground (*see* ILLUMINATION, fig. 3). Border designs of this type were also employed in Ottoman ceramics (*see* CERAMICS, §V, A), where they were transformed into a main decorative motif (e.g. a blue-and-white footed bowl, Paris, Louvre, 7880–92), and a similar development can be seen on 17th-century Iranian ceramics (*see* CERAMICS, §V, B, 1).

Other border patterns are formed by geometricized continuous scrolls derived from Hellenistic prototypes.

They consist of either half-palmettes or trefoils, of which one petal is extended to form an undulating stem. This ornamental frame, which was common in early Islamic art and architecture, was the source for a variety of foliate border patterns. Another category of frames and panels, already part of the common decorative vocabulary of Sasanian art, derived from niches and arcades in Late Antique architecture. Perhaps the earliest dated examples in Islamic art are two marble friezes at the Dome of the Rock (692) in Jerusalem, and variations are found throughout early Islamic art and architecture. Niches and frames remained particularly important in Egyptian Islamic art until the 15th century.

A second method of forming order was through the reciprocal repetition of basic designs, which brought about coherent patterns applicable to larger surfaces as well as to closed panels and frames. This method was already used extensively in the third style of wall decoration used at Samarra (see SAMARRA, fig. 2) in the 9th century. Either carved with slanting outlines (see BEVELED STYLE) or painted on flat surfaces, this type of ornament remained in vogue until the 14th century and should be regarded as one of the earliest expressions of an Islamic tendency to fill all the available space. In frames or borders formed by this method, the reciprocating or positive and negative shapes are frequently differentiated by color, be it in the form of dark and light stone, glazed tile or other material. Another coherent ornament that completely eliminates the background was created from rows of reciprocating ogee panels that, together with the interstices, form a close network of staggered ovoid shapes. These ogival panels were particularly favored for textile designs, beginning in the 13th and 14th centuries, as on a group of lampas weaves from the eastern Islamic lands (see TEXTILES, §III, C) and Ottoman velvets (see TEXTILES, §IV, A).

A third method of creating order was through geometric interlocking, of which three types are found. The first, tiling, derived from tile revetments in which forms with straight linear outlines were placed next to each other so that there was hardly any background left. In manuscripts and ceramics, patterns could be created with dovetailed hexagons or octagons, but in time the designs became more complex, including more composite polygons and star motifs and intricately structured compositions. This method is exemplified by illuminated pages from 14th- and 15th-century manuscripts of the Koran (e.g. one copied at Hamadan in 1313 for Uljaytu; Cairo, N. Lib.).

Similar geometric patterns were generated by strapwork, in which continuously crossing and overlapping bands determine the structure of the pattern. The size of the interstices varies, depending on the density of the network: more complex strapwork generates a greater variety of geometric enclosures. Particularly in more intricate patterns, the interstices are smaller than in the tile method. The visual effect differs: tiling draws more attention to the panels, while strapwork draws attention to the lines that generate the panels. These patterns were widely used in different techniques and media: carved wood, stucco, brick and stone; painted paper and clay; cast metal; and inlaid and encrusted ivory, ebony and mother-of-pearl. Strapwork is found already in the 10th century in the eastern Islamic lands, but it became particularly popular in the western lands, as on an early 12th-century Córdoban minbar formerly in the Kutubiyya Mosque, Marrakesh (see WOODWORK, color pl. 2:XVI, fig. 3). Like tiling, these complex strapwork schemes were used in later periods to decorate frontispieces, bookbindings, minbars, doors and shutters.

To create an illusion of depth and plasticity, artisans employed a stratigraphic method in which up to four decorative schemes and designs were arranged in layers set one on top of each other and in staggered lines. The three-dimensional effect was enhanced in various ways. In some cases the decorative schemes were interlaced; in the case of plaster, wood or ivory, the third dimension was emphasized by relief carving on different levels. In the case of painting or tile mosaic, color gives an illusion of depth, the darker colors seeming more distant than the light ones. Sometimes the outlines of the decorative schemes merge harmoniously, and no level is emphasized more than any other. At other times, one of the decorative schemes predominates: it is larger or painted in a lighter color so that it seems to overlay the other layers. In all cases, there is little if any void or undecorated ground. Rare before the 14th century, this method was used for carved stucco and stone in the 15th century (e.g. the arabesque and strapwork designs on the mausoleum of Qa'itbay; see ARCHITECTURE, color pl. 1:VI, fig. 1 and CAIRO, §III, J). More sophisticated designs were developed in Timurid architectural ornament, where the effect of structural intersections of the planes is heightened by a rich palette, as on much tilework, or deep relief-carving, as on a series of tombstones (e.g. Boston, Isabella Stewart Gardner Mus.). The three-dimensional manner culminated in carpets made in Iran in the late 16th century and early 17th (see CARPETS AND FLATWEAVES, §IV, C), where some designs show an interaction of four levels, with a fifth in the form of a large medallion overlaying them all.

III. Meaning. In order to understand whether these ornaments implicitly or explicitly communicated certain ideas, it is also necessary to consider the regional, social and religious variations of the people who created and beheld them. Some may have appreciated an ornament because it was aesthetically attractive or invited contemplation, while others may have interpreted the same design symbolically, as having religious, mystic or other connotations. According to al-Muqaddasi (d. 995) and al-Tha'alabi (d. 1037), one of the major attractions of ornament was its multiplicity of forms and colors, allowing the beholder constantly to detect new features that aroused his curiosity and invited contemplation. By contrast, for al-Ghazali (d. 1111), art and beauty—which undoubtedly would have included ornament—were closely tied to religion and to his concept of God.

Similarly, Muslim writers differed considerably in their interpretations of color and light. In 1184 Ibn Jubayr enthusiastically described the beauty of the mosaics on the qibla wall of the Great Mosque of Damascus under the brightness of the sun but did not, as one might have expected, refer to God as the source of light (Koran 24:35–6, the "Light Verse"). On the other hand, for al-Suhrawardi and other mystics, God alone is the essence of the Absolute Light that brings all things into existence, giving life to them by its rays (Ardalan and Bakhtiar, p. 47). In addition, since many motifs in Islamic art derive from earlier civilizations, it is difficult to determine whether or to what extent the medieval Muslim world was aware of the ideas originally attached to them. Modern scholars have also interpreted ornament in different ways. Ernst Kühnel (1949) stressed the decorative character of the arabesque in making the beholder's eyes wander, and insisted that it lacked any symbolic value. Ardalan and Bakhtiar, on the other hand, wrote that arabesques "recreate through Nature the cosmic process of the Creator" (p. 43), and they compared the infinity of the arabesque to the "manifold forms and patterns of the Creator" (p. 45).

One of the main functions of ornament, be it on buildings or portable objects, was to embellish a surface and to express contemporary ideas of beauty and aesthetic concepts, using forms, materials and techniques fashionable at the time. Nevertheless, some ornament was presumably meant to communicate a message, of which three types can be discerned.

A. Blessings. B. Metaphors. C. Emblems.

A. BLESSINGS. Ideas of wellbeing, whether in this world or the next, are often associated with vegetal motifs, such as blossoming or fruit-bearing trees occasionally flanked by real or imaginary animals or birds, palm trees, vases of flowers, blooming bushes etc. None of these designs was automatically invested with meaning, but under certain circumstances these configurations retained or were recharged with connotations close to those associated with the Tree of Life in ancient civilizations. Fruit-bearing trees or plant designs flanking the monumental portals on tombs and madrasas from late 13th-century Anatolia suggest similar iconographic concepts. In Iran and Central Asia the trees are planted in pots or beautiful vases and set in a niche. There was a clear preference for the cypress, a tree used in Persian literature as a metaphor for eternity. These and other decorations on shrines and religious artifacts attest to an increased interest in floral motifs in 15th-century Iran. Flowers also convey wellbeing in this world or the next, and it has been argued that since flowers constitute a vital part of any garden, they are the most common visual expressions not only for the earthly but also for the celestial Garden of Paradise. Such an explanation has been put forward particularly for Ottoman art, where tulips, narcissi, hyacinths and carnations dominate all artistic media, but it is impossible to know whether these flowers were always invested with paradisical symbolism.

Arched panels and arcades comprise another set of decorative motifs that may have invoked blessings. Because of formal resemblance to the MIHRAB, arched panels were occasionally charged with religious symbolism. This was certainly the case with decorative panels that carried one or more attributes marking them as a mihrab—an inscription such as the *shahāda* (profession of faith) or the Light Verse, a hanging lamp or a pair of candlesticks, as in the tile mosaic inscription on the Ulu Cami at Eski Malatya in Turkey. When these characteristic attributes of the mihrab are missing, however, it is more difficult to establish the connection between an arched panel and a prayer niche.

B. METAPHORS. Some ornaments visually transform a part of a building or object and give it new meaning, as in the ornament that transforms the interior of a hemispheric dome into a celestial sphere. Domed ceilings were imbued since Late Antiquity with cosmological attributes, and the idea of the dome as a reflection of heaven was continued into Islamic times. Celestial ornaments are attested on domed buildings and inscriptions in Anatolia and Iran from the 13th century. These ornaments convey two ideas, one related to the revolving light around the domed Domus Aurea ("Golden House") of the Roman emperor Nero. In the mosque of Eski Malatya, for example, the revolution of the dome is implied by radiating curvilinear lines of blue glazed tiles that emanate from a central hexagram spelling the name Muhammad. The other idea alludes to the stellar firmament. Over the interior surface of the dome are spread angular or round configurations that from below resemble luminary bodies; they transform the hemispheric cupola into the vault of heaven for the beholder. One of the most impressive examples of this decoration is the Karatay Madrasa (1251–2) at Konya, where the central dome is completely covered with geometric interlacing in light blue and purple tile mosaic, into which 24 radiating petaled roundels are interwoven.

In most domes stellar configurations are combined with ornament to give the illusion of a rotating firmament. In the dome of the congregational mosque (1322–6) at Varamin, for example, the revolving movement is suggested by two whorls of curved lines of brick rotating in opposite directions. The panels created by these intersecting lines enclose diamond-shaped panels in tile mosaic that spell out sacred names and resemble revolving stars. Similar ornament was employed for the decoration of pottery bowls, as on a 13th-century bowl with painted and gilded zigzag bands emanating from a central 13-pointed star enclosing a phoenix (Tehran, Archaeol. Mus.). Stellar themes painted or in tile mosaic seem to have reinforced the cosmic meaning of the dome in 15th-century Iranian architecture. One of the favorite designs was a sunburst motif, as on the mausoleum of Gawharshad (1432–3) at Herat (for illustration *see* HERAT).

A second category of metaphoric decoration comprises designs in which fish and imaginary water creatures encircle a sun or solar symbol. Unlike sunburst patterns, which were used in a variety of media, this motif was almost exclusively used for the interior decoration of metal, and less frequently on pottery, bowls and basins. From the late 12th century these fish-whorl patterns figure in several versions. Fish may revolve around a central device, and different types of aquatic figures swimming in different directions may encircle a solar symbol. On earlier examples the rotating fish swimming in the water clearly reflect the function of the vessel as a container for water: the fish represent water and transform the interior of the bowl into a pool. On later examples with imaginary creatures, such as the Baptistère de St. Louis (1290–1310; Paris, Louvre; *see* METALWORK, color pl. 2:XVI, fig. 3), this motif probably invoked dreams about distant foreign seas, the waters of which would bring wealth and good fortune to the person who drank it. Some beholders might even have viewed the whole design allegorically as the sun encircled by foreign seas and interpreted it as the source of life located in the land of darkness. However these designs were interpreted, they were for the beholder signs or symbols to inspire his imagination and make his mind wander into another world.

A third kind of metaphoric ornament imitated jewelry, giving a type of relatively cheap pottery vessels a precious appearance and transforming them almost into living beings. These transformations were first achieved by employing precious metal techniques, such as twisted wire and granulation, in barbotine and other cheap pottery techniques. The motifs imitated necklaces, pendants, brooches, earrings etc., and were applied to the neck, foot or shoulder of the inanimate objects as if they were humans. The earliest realization of this anthropomorphizing tendency appears in the mosaics of the Dome of the Rock, where artisans laid jeweled breastplates around the neck of an amphora and attached earrings with one or three suspended pearls to the S-shaped handles of vases. Analogous embellishment can be seen on pottery vessels made between the late 11th century and the early 14th in Iran and the central Islamic lands. One of the most striking examples (Jerusalem, Mayer Mus. Islam. A.) is an unglazed pilgrim flask from Gurgan in Iran; it is decorated with a ribbon carrying a three-petaled pendant suspended from the base of the spout, a location that must have suggested the human neck. Other types of jewelry, such as belt buckles, brooches and bracelets, seem to have been rarer, and their function on the body of the vessel was more arbitrary.

C. EMBLEMS. A third type of ornament has meaning as an emblem. For example, combatant animals appear frequently on medieval Islamic ceramics and metalwork, for their decorative qualities made them suitable as a central motif on dishes or bowls. Combatant animals were also a sign or symbol, the meaning of which changed over the centuries. The ancient Assyrian motif of the lion and bull in combat eventually became a decorative design in Islamic art. The use of emblems is first documented on 10th- and 11th-century Spanish stone-carvings, ivories and embroidered textiles. Combatant animals were particularly common on objects made for the vizier al-Mansur and his son 'Abd al-Malik (e.g. two marble troughs, one 987–8; Madrid, Mus. Arqueol. N.; the other 1002–7; Marrakesh, Ben Yusuf Madrasa). The frequency with which combatant animals appear on Hispano-Islamic objects, including the Mughira (968; Paris, Louvre) and Pamplona (1004–5; Pamplona, Mus. Navarra) caskets and the Suaire de St. Lazare (Autun Cathedral; Paris, Mus. Cluny; Lyon, Mus. Hist. Tissus), has been explained as talismanic (see Gomez-Moreno); but the motif of combatant animals on these objects had a more specific message as an emblem of political and military power.

Although it is more difficult to establish the emblematic character of combatant animals on other objects, inscriptions sometimes clarify the intended message by giving the ornament a concrete meaning. On a 13th century inkwell (New York, Met.) from Khurasan, the inscription invoking power, glory and success to the owner specifies the meaning of the emblem depicting an eagle seizing a duck, although other scholars have interpreted the same emblem on other inkwells (e.g. Nuhad al-Said priv. col.) as symbolizing the triumph of good over evil or royal power.

The ancient motif of animal heads joined in a swastika was adopted in the Islamic lands from the 10th century for the decoration of metal and ceramic wares. One of the earliest examples is a fragmentary bowl from Nishapur (Tehran, Archaeol. Mus.) with four horned and long-necked animals joined to make a swastika as its principal decoration. From the late 12th century to the early 13th, the motif of two, three or four hares with common ears seems to have enjoyed special favor among artists in the eastern Iranian world, as on a group of rectangular and round bronze trays (e.g. Jerusalem, Mayer Mus. Islam. A.). Revolving ducks with long necks forming a central knot or sphinxes with wings similarly entwined occur on the Wade Cup in Cleveland and several brasses ordered by BADR AL-DIN LU'LU' in the first half of the 13th century. A fish whorl composed of six or three fish drawn radially with their heads pointed together seems to have been used in the later 13th century and the 14th by metalworkers and ceramicists in Syria and Egypt.

It is easier to trace the development of these emblems than to explain their meaning. The ancient tradition of revolving animals, in which they are said to have held solar and lunar associations, does not imply that this meaning was still understood in Islamic times. Unlike combatant animals, which became symbolically charged by inscriptions or literary anecdotes, revolving designs are not explained by written sources and can only be understood by comparison with other types of revolving ornament,

such as whirling rosettes and stars. Like other wheel ornament, animal whorls became associated with stellar bodies by their revolving movement, and there was a recurring connection between wheel designs and birds. Animal wheels are therefore not an isolated phenomenon but part of an ornamental language that had general cosmic connotations. Whatever their specific meaning, animal whorls were extremely attractive ornaments that spread from eastern Iran westward and enjoyed relative popularity in the mid-12th century and the 13th.

IV. Principles and concepts. Although the basic motifs of Islamic ornament were inherited from pre-Islamic civilizations, and the individual motifs remained recognizable for a considerable time, a new approach to ornament, which gradually transformed its character and gave it its distinctive marks, was already apparent in early Islamic art. One feature of this new approach is the transformation of subsidiary motifs and designs into the main decorative theme. For example, the Late Antique acanthus scrolls, garlands and other vegetal designs became the major decorative motif in the mosaics of the Dome of the Rock in Jerusalem. Similarly, bands of reciprocal ogees and polylobed arches, ultimately derived from lotus petals, became a dominant design on ceramics of the 16th and 17th centuries.

Another feature associated with Islamic ornament is geometry, which Islamic artists employed not only for the development of spatial and linear decoration but also as an organizing principle of ornament. In this context geometry has three functions: as a matrix into which other forms were interwoven, as a means to create coherence and infinity and as a decisive factor in the creation of overall patterns. The richness and variability of geometric patterns in Islamic art stem from subdivisions and linear extensions of the geometric network as well as from the continuous interlocking and overlapping of forms that bring about new sub-units and shapes. These principles also applied to vegetal motifs, as in the arabesque. The principle of geometry and coherence is also followed in the composition of three-dimensional ornament and *muqarnas*.

Closely linked with these principles is *horror vacui*, described more positively by Gombrich as *amor infiniti*. Manifest already in the mosaics of the Dome of the Rock, it remained a dominant feature of Islamic art for centuries. It is not clear whether this inclination was brought about by religious or philosophic concepts or was determined by other factors. Ettinghausen (1979) hypothesized that closeness was associated with pleasantness and that richly planted gardens affected the taste and aesthetic attitude of Muslims; but his third suggestion—that sumptuousness means wealth and that beauty is expressed by plenty—is the most plausible explanation for the popularity of the concept.

Another feature of Islamic ornament is the integration of epigraphy into the overall decorative program; indeed, no other civilization exploited the decorative qualities of script as fully as did the Islamic world. Individual letters were adorned with ornament, shafts intertwined and interstices filled with scrolls and other decorative elements, and many scripts were invented to serve different functions. Inscriptions were not only a means of decoration but also a vehicle of information, and their transformation was often a function of legibility. The moral aphorisms calligraphed on 10th-century ceramics from the eastern Islamic lands, for example, could hardly have been read by most beholders, so the general message was presumably understood without being read.

Designs were frequently transmitted from one medium to another, a phenomenon rooted in Islamic aesthetics and connected with ideas concerning the function of ornament. As with *horror vacui*, several explanations have been proposed. The mobility of ornament can be explained by a yearning for embellishment, the character of which depended on contemporary taste and fashion. A second explanation was the impact of tradition and the availability of materials. This factor was valid primarily for architectural decoration, as when Iranian brick patterns were translated into stone in Anatolia. A third explanation was the obsession in Islamic civilization with textiles, an obsession expressed in the use of textile patterns to decorate objects and buildings. The textile metaphor also worked in the opposite direction when a textile pattern imitated revetment (e.g. a 15th-century silk curtain recalling the stucco revetment at the Alhambra; Cleveland, OH, Mus. A.). This last factor, characteristic of most Near Eastern civilizations, may have been the most characteristic of Islamic art, which has been characterized as a "draped universe."

GENERAL

Enc. Islam/2: "Zakhrafa" [Ornament]

A. Riegl: *Stilfragen* (Berlin, 1893); Eng. trans. by E. Kain as *Problems of Style* (Princeton, 1992)

E. Herzfeld: "Die Genesis der islamischen Kunst und das Mshatta-Problem," *Der Islam*, i (1910), pp. 27–63

E. Herzfeld: *Der Wandschmuck der Bauten von Samarra und seine Ornamentik* (1923), i of *Die Ausgrabungen von Samarra* (Berlin, 1923–48)

M. S. Dimand: "Studies in Islamic Ornament, I. Some Aspects of Omaiyad and Early Abbasid Ornaments," *A. Islam.*, iv (1937), pp. 293–337

B. P. Denike: *Arkhitekturnyy ornament Sredney Azii* [Architectural ornament of Central Asia] (Moscow, 1939)

A. U. Pope and P. Ackerman, eds.: *Survey of Persian Art* (London, 1939, 2/1964–7), pp. 1258–364, 2678–765

R. Ettinghausen: "Al-Ghazzālī on Beauty," *Art and Thought: Issued in Honour of Dr. Ananda K. Coomaraswamy on the Occasion of his 70th Birthday*, ed. K. Bharatna Iyer (London, 1947), pp. 160–65

M. Gómez-Moreno: *El arte árabe español hasta los almohades*, Ars Hispaniae, iii (Madrid, 1951)

M. S. Dimand: "Studies in Islamic Ornament, II," *Archaeologica Orientalia in Memoriam Ernst Herzfeld* (Locust Valley, NY, 1952), pp. 62–8

L. I. Rempel': *Arkhitekturnyy ornament Uzbekistana: Istoriya i teoriya postroyeniy* [Architectural ornament of Uzbekistan: a history and theory of its structures] (Tashkent, 1961)

D. Hill and O. Grabar: *Islamic Architecture and its Decoration, A.D. 800–1500: A Photographic Survey* (Chicago, 1964)

N. Ardalan and L. Bakhtiar: *The Sense of Unity* (Chicago, 1973)

E. H. Gombrich: *The Sense of Order: A Study in the Psychology of Decorative Art* (Ithaca, NY, 1979)

J. Rawson: *Chinese Ornament: The Lotus and the Dragon* (London, 1984), pp. 150–62

L. Golombek: "The Draped Universe of Islam," *Content and Context of Visual Arts in the Islamic World*, ed. P. P. Soucek (University Park, PA, and London, 1988), pp. 25–50

L. Golombek: "The Function of Decoration in Islamic Architecture," *Theories and Principles of Design in the Architecture of Islamic Societies*, ed. M. B. Ševčenko (Cambridge, MA, 1988), pp. 35–45

O. Grabar: *The Mediation of Ornament* (Princeton, 1992)

N. Simakoff: *Islamic Designs in Color*, Eng. trans. as Dover Pictorial archive series (New York, 1993) [Eng. trans. of N. Simakov, *Iskusstvo Srednei Azii*, portfolio published in St. Petersburg in 1883]

E. Baer: *Islamic Ornament* (Edinburgh, 1998)

D. Clévenot: *Ornament and Decoration in Islamic Architecture* (London, 2000)

G. Degeorge and Y. Porter: *The Art of the Islamic Tile*, Eng. trans. of *Art de la céramique dans l'architecture musulmane* (Paris, 2002)

J. Trilling: *Ornament: A Modern Perspective* (Seattle, 2003)

Cosmophilia: Islamic Art from the David Collection, Copenhagen (exh. cat. by S. S. Blair and J. M. Bloom; Chestnut Hill, MA, Boston Coll., McMullen Mus.; Chicago, U. Chicago, IL, Smart Mus. A.; 2006)

SPECIFIC MOTIFS AND TECHNIQUES

S. M. Flury: *Die Ornamente der Hakim- und Ashar-Moschee* (Heidelberg, 1912)

E. Kühnel: *Die Arabeske* (Wiesbaden, 1949); Eng. trans. by R. Ettinghausen as *The Arabesque: Meaning and Transformation of an Ornament* (Graz, 1976)

E. Kühnel: "Der mamlukische Kassettenstil," *Kst Orients*, i (1950), pp. 55–68

D. S. Rice: "The Brasses of Badr al-Din Lu'lu'," *Bull. SOAS*, xiii (1950), pp. 627–34

R. Ettinghausen: "The 'Beveled Style' in the Post-Samarra Period," *Archaeologica Orientalia in Memoriam Ernst Herzfeld* (Locust Valley, NY, 1952), pp. 72–83

D. S. Rice: *The Wade Cup in the Cleveland Museum of Art* (Paris, 1955)

R. Ettinghausen: "The 'Wade Cup' in the Cleveland Museum of Art, its Origins and Decorations," *A. Orient.*, ii (1957), pp. 327–66

A. Grohmann: "The Origin and Early Development of Floriated Kûfic," *A. Orient.*, ii (1957), pp. 183–214

W. Hartner and R. Ettinghausen: "The Conquering Lion, the Life Cycle of a Symbol," *Oriens*, xvii (1964), pp. 161–71

E. Baer: *Sphinxes and Harpies in Medieval Islamic Art* (Jerusalem, 1965)

E. Baer: "The Suaire de St Lazare: An Early Datable Hispano-Islamic Embroidery," *Orient. A.*, n. s. xiii (1967), pp. 36–49

E. Baer: "Fish-pond Ornaments on Persian and Mamluk Metal Vessels," *Bull. SOAS*, xxxi (1968), pp. 14–27

E. Baer: "The 'Pila' of Játiva: A Document of Secular Urban Art in Western Islam," *Kst Orients*, vii (1970–71), pp. 144–66

E. Baer: "An Islamic Inkwell in the Metropolitan Museum of Art," *Islamic Art in the Metropolitan Museum of Art*, ed. R. Ettinghausen (New York, 1972), pp. 199–212

E. Baer: "Notes on the Iconography of Inscriptions and Symbols in the Ulu Cami of Eski Malatya," *Ars Turcica: Akten des VI. internationalen Kongresses für türkische Kunst: München, 1979*, pp. 136–43

R. Ettinghausen: "The Taming of the Horror Vacui in Islamic Art," *Proc. Amer. Philos. Soc.*, cxxiii (1979), pp. 15–28

J. W. Allan: *Islamic Metalwork: The Nuhad Es-Said Collection* (London, 1982)

E. Baer: "Jeweled Ceramics from Medieval Islam: A Note on the Ambiguity of Islamic Ornament," *Muqarnas*, vi (1989), pp. 83–97

W. Denny: "Reflections of Paradise in Islamic Art," *Images of Paradise in Islamic Art*, ed. S. S. Blair and J. M. Bloom (Hanover, NH, 1991), pp. 33–44

N. N. N. Khoury: "The Mihrab Image: Commemorative Themes in Medieval Islamic Architecture," *Muqarnas*, ix (1992), pp. 11–28

L. Golombek: "The *Paysage* as Funerary Imagery in the Timurid Period," *Muqarnas*, x (1993), pp. 241–52

N. Kubisch: "Ein Marmorbecken aus Madinat al-Zahira im Archäologischen Nationalmuseum in Madrid," *Madrid. Mitt.*, xxxv (1994), pp. 398–417

G. Necipoğlu: *The Topkapı Scroll–Geometry and Ornament in Islamic Architecture: Topkapı Palace Museum Library Ms H.1956* (Santa Monica, 1995)

S. S. Blair: *Islamic Inscriptions* (Edinburgh, 1998)

E. Baer: "Ornament Versus Emblem: The Case of Combatant Animals," *Bamberger Symposium: Rezeption in der islamischen Kunst vom 26.6.–28.6.1992*, ed. B Finster, C. Fragner and H. Hafenrichter, Beiruter Texte und Studien, 61 (Beirut, 1999), pp. 13–18

J. M. Rogers: "Ornament Prints, Patterns and Designs East and West," *Islam and the Italian Renaissance*, ed. C. Burnett and A. Contadini, Warburg Institute Colloquia, 5 (London, 1999), pp. 133–65

E. Baer: *The Human Figure in Islamic Art: Inheritances and Islamic Transformations* (Costa Mesa, 2004)

B. O'Kane, ed.: *The Iconography of Islamic Art: Studies in Honour of Robert Hillenbrand* (Edinburgh, 2005) [contains several essays on ornament]

Ortukid. *See* ARTUQID.

Osman [Nakkaş Osman] (*fl. c.* 1560–*c.* 1581). Ottoman illustrator. Osman was the most renowned illustrator of historical manuscripts at the design atelier (Turk. *nakkaşhane*) of the Ottoman court during the sultanates of Selim II (*r.* 1566–74) and Murad III (*r.* 1574–95), although not one signed work of his is known. Contemporary records attest to his towering reputation at court and the respect in which his patrons and artist contemporaries held his work. The earliest works attributed to him are illustrations for a manuscript (Istanbul, Topkapı Pal. Lib., H. 1116) of the Turkish translation of Firdawsi's *Shāhnāma* ("Book of kings"), executed between 1560 and 1570. Osman's illustrations for Ahmed Feridun's *Nuzhat al-asrār al-akhbār dar safar-i Sigitvār* ("Chronicle of

the Szigetvár campaign"; 1568–9; Istanbul, Topkapı Pal. Lib., H. 1339), an account of the last European campaign and death of Süleyman, present the first fully mature examples of the Ottoman historical style of illustration (*see* ILLUSTRATION, §VI, D, 1). Osman was the premier exponent of this style, which characterized the greatest Ottoman historical manuscripts produced over the next half-century. His clear spatial sense and meticulous realism are manifest in his attention to details of costume, weaponry, architecture and objects of court ceremonial. His later work, such as the 44 paintings in Lokman's *Shāhnāma-yi Salīm Khān* ("*Shāhnāma* of Selim II"; Istanbul, Topkapı Pal. Lib., A. 3595), completed in January 1581, is documented by payroll registers from the Topkapı Palace, and Osman is praised as a painter without equal in Lokman's preface to the work. All the great Ottoman historical works of the reign of Murad III or Mehmed III (*r.* 1595–1603) bear the mark of his style, showing his critical success and the number of his disciples at the design atelier.

F. Çağman: "Şāhnāme-i Selīm Han ve minyatürleri" [The *Shāhnāma* of Selim II and its miniatures], *Sanat Tarihi Yıllığı*, v (1972–3), pp. 411–42

F. Çağman: "Nakkaş Osman in Sixteenth Century Documents and Literature," *Art Turc/Turkish Art: 10e Congrès international d'art turc: Genève, 17–23 Septembre, 1995*, pp. 197–206

S. Bağci: "From Translated Word to Translated Image: The Illustrated Şehnâme-i Türkî Copies," *Muqarnas*, xvii (2000), pp. 162–76

Osman Hamdi [Edhem, Osman Hamdi; Hamdi Bey] (*b.* Istanbul, 30 Dec. 1842; *d.* Eskihisar, Gebze, nr. Istanbul, 24 Feb. 1910). Turkish painter, museum director and archaeologist. In 1857 he was sent to Paris, where he stayed for 11 years, training as a painter under Gustave Boulanger (1824–88) and Jean-Léon Gérôme (1824–1904). On returning to Turkey he served in various official positions, including two years in Baghdad as chargé d'affaires, while at the same time continuing to paint. In 1873 he worked on a catalogue of costumes of the Ottoman Empire, with photographic illustrations, for the Weltausstellung in Vienna. In 1881 he was appointed director of the Archaeological Museum at the Çinili Köşk, Topkapı Palace, in Istanbul. He persuaded Sultan Abdülhamid II (*r.* 1876–1909) to issue an order against the traffic in antiquities, which was put into effect in 1883, and he began to direct excavations within the Ottoman Empire. As a result he brought together Classical and Islamic objects for the museum in Istanbul, including the Sarcophagus of Alexander, unearthed in Sidon in 1887. He also founded and was the first director of the Fine Arts Academy in Istanbul, which opened in 1883. As a painter he initiated figurative narrative and portrait painting in Turkey, inspired in particular by the Orientalism of some European painters (*see* OIL PAINTING, color pl. 3:I, fig. 2). His paintings were Realist in style with a great concern for detail, and Osman Hamdi often used photographs for

accuracy. Examples include the *Tortoise Breeder* (1906; Ankara, Mus. F.A.), the *Guardian of the Tombs* (1908; Istanbul, Mimar Sinan U., Mus. Ptg & Sculp.) and *The Lady with Mimozas* (1906; Istanbul, Mus. F.A.). His work was admired in Paris, and he regularly sent paintings to the Salon des Artistes Français. He was also a corresponding member of the Royal Academy in London and received an honorary doctorate from Oxford University. His younger brother HALIL EDHEM ELDEM, who was also educated in Europe, was appointed director of the Imperial Ottoman Museum after Hamdi's death and was a scholar of repute.

WRITINGS

with M. de Launay: *Les Costumes populaires de la Turquie en 1873* (Istanbul, 1873) [photographer: Pascal Sébah]

with T. Reinach: *Une Nécropole royale à Sidon* (Paris, 1892)

BIBLIOGRAPHY

Enc. Islam/2: "'Othmān Ḥamdī"

A. Thalasso: *L'Art ottoman: Les Peintres de Turquie* (Paris, 1910), pp. 8, 11, 13–6, 18–27, 39, 57

A. M. Mansel: "Osman Hamdi Bey," *Anatolia*, iv (1959), pp. 189–93

M. Cezar: *Sanatta Batı'ya Açılış ve Osman Hamdi* [Western trends in art and Osman Hamdi] (Istanbul, 1971)

G. Renda and others: *A History of Turkish Painting* (Geneva, Seattle and London, 1988), pp. 88, 90, 92–4, 104, 113, 115, 117, 134–5, 138, 143, 155, 160, 236

"Osman Hamdi Bey," *Turkish Rev.*, vii/34 (1993), pp. 63–8

Z. Celik: "Colonialism, Orientalism, and the Canon," *A. Bull.*, lxxviii (1996), pp. 202–5

W. M. K. Shaw: "The Paintings of Osman Hamdi and the Subversion of Orientalist Vision," *Aptullah Kuran için yazılar: Essays in honour of Aptullah Kuran*, ed. C. Kafescioğlu and L. Thys-Şenocak Shaw (Istanbul, 1999), pp. 423–34

W. M. K. Shaw: "Islamic Arts in the Ottoman Imperial Museum, 1889–1923," *A. Orient.*, xxx (2000), pp. 55–68

B. Tut: *Çizgi ve eller: Osman Hamdi Bey'den günümüze Türk resminde desen/Lines and Hands: Drawings in Turkish Painting from Osman Hamdi Bey to Present* (Istanbul, 2001)

K. Radt: "Carl Humann und Osman Hamdi Bey–zwei Gründerväter der Archäologie in der Türkei," *Istanbul. Mitt.*, liii (2003), pp. 491–507

W. M. K. Shaw: *Possessors and Possessed: Museums, Archaeology, and the Visualization of History in the Late Ottoman Empire* (Berkeley, 2003)

Osmanlı. *See* OTTOMAN.

Otrar. Site and region on the right bank of the Syr River 10 km west of Timur, Kazakhstan. Otrar has been identified with the region of Farab (Barab, Parab) mentioned by medieval Arabic and Persian historians and geographers. When the area was controlled by the Samanids (*r.* 819–1005) and Qarakhanids (*r.* 992–1211), Keder was the principal settlement and had a congregational mosque. Otrar, the first large fortress the Mongols encountered during their invasions, was destroyed; rebuilt in the mid-13th century, it became one of the largest centers on

the Syr River under the Chaghatayids (r. 1227–1370). It was then incoporated into the Timurid realm, and Timur (r. 1370–1405) died there. From the mid-15th century it was contested by the Uzbeks and the Kazakhs until the end of the 16th century, when it became a major political and economic center of the Kazakh khanate. It was abandoned in the mid-18th century.

The ruins of the city, inhabited since the first centuries CE, include a pentagonal central mound (20 ha; h. 18 m) enclosed by a wall, of which fallen ramparts and traces of a moat can be seen. Inside were the citadel and the city proper, which abutted the fortified suburbs (150 ha). The city had three gates, residential quarters and public buildings, and excavations revealed baths and dwellings dating from the 11th and 12th centuries. The main mosque, with a dome and internal piers, was built in the late 14th century or early 15th. Excavations in the suburbs revealed a potters' district (13th–15th century) with workshops and houses as well as a superb collection of fine ceramics. Excavations of the 16th- and 17th-century levels uncovered urban districts, streets and squares, and the potters' district in great detail. Several thousand coins (7th–17th century) have been discovered, as well as ceramics, metalwares, jewelry and everyday utensils.

Enc. Islam/2: "Fārāb"; "Otrār"

K. A. Akishev, K. M. Baypakov and L. B. Yerzakovich: Drevniy Otrar [Ancient Otrar] (Alma-Ata, 1972)

K. A. Akishev, K. M. Baypakov and L. B. Yerzakovich: Poznesrednekovyy Otrar [Late medieval Otrar] (Alma-Ata, 1981)

K. A. Akishev, K. M. Baypakov and L. B. Yerzakovich: Po sledam drevnich gorodov Kazakhstana [Along the ancient towns of Kazakhstan] (Alma-Ata, 1990)

K. Baipakov: "Les fouilles de la ville d'Otrar," Archéol. Islam., iii (1992), pp. 87–110

M. Kojaev, T. T. Ayazova and G. H. Sixdikova: "The Otrar State Archaeological Museum: The Arystanbab Mausoleum," Erdem, vii/21 (1995), pp. 957–63

K. Baipakov: "The Medieval Towns and Settlements of Kazakstan in the VI–XVIII cc," History of Kazakhstan: Essays (Almaty, 1998), pp. 20–30

Otto-Dorn, Katharina (b. Wiesbaden, 1908; d. Heidelberg, 4 April, 1999). Art historian of Viennese birth. She studied at Vienna University with Josef Strzygoswki, submitting her thesis on Sasanian silver in 1933. The following year she volunteered at the Islamic department of the State Museum in Berlin under ERNST KÜHNEL, who had succeeded FRIEDRICH SARRE as director three years earlier. In the spring of 1935 Otto-Dorn went to Turkey, working with the German Archaeological Institute on the ceramics of IZNIK and excavating at Kahta in southeast Anatolia. World War II forced her to return to Europe, and in 1948 she began teaching at Heidelberg University, while also excavating at RUSAFA in northeastern Syria and then at Kubadabad on Lake Beyşehir. In 1954 she returned to Turkey, where she established the chair of Islamic art and archaeology at Ankara and trained many Turkish students. In 1964 she returned to

Heidelberg, but unable to find a position in Germany, she took up the position of professor of Islamic Art at the University of California at Los Angeles, where she taught from 1967 until her retirement in 1978.

Otto-Dorn was a key figure in the transition between the scholars who founded the field of Islamic art in Germany, and its transmission to the Near East and America. Her reputation lies not in the number of her publications, but in their denseness and specificity. A specialist in archaeology and ceramics, she had a keen interest in iconography, notably figural and animal sculpture. The main thrust of her research was to emphasize the importance of the art and architecture of the Anatolian Saljuqs (see SALJUQ, §II), ranging from their wooden mosques and figural tombstones to their summer palace at Kubadabad. Many of her ideas are synthesized in her monograph on Islamic art.

WRITINGS

Das islamische Iznik (Berlin, 1941)

Türkische Keramik (Ankara, 1957)

Kunst des Islam (Baden-Baden, 1964/R 1980); trans. into Italian (1964), Spanish (1965), Dutch (1965), French (1967 and 1983) and Serbo-Croatian (1976)

"Das seldschukische Thronbild," Persica, x (1982), pp. 149–94

"The Griffin-sphinx Ensemble," The Art of the Saljuqs in Iran and Anatolia: Proceedings of a Symposium Held in Edinburgh in 1982, pp. 303–14

"Das Thronbild auf den spanisch-omayyadischen Elfenbeinkästen," Eröffnungs- und Plenarvorträge; Arbeitsgruppe "Neue Forschungsergebnisse und Arbeitsvorhaben," ed. E. Liskar, Akten des XXV. Internationalen Kongresses für Kunstgeschichte, Wien . . . 1983 (Vienna, 1985), pp. 101–4

"Das Drachenrelief vom Talismantor in Baghdad," Light on Top of the Black Hill: Studies Presented to Halet Çambel. Karatepe'deki ışık: Halet Çambel'e sunulan yazılar. Derleyenler, ed. G. Arsebük, M. J. Mellink and W. Schirmer (Istanbul, 1998), pp. 531–42

BIBLIOGRAPHY

A. Daneshvari, ed.: Essays in Islamic Art and Architecture in Honor of Katharina Otto-Dorn (Malibu, 1981) [contains complete bibliography to date]

J. Gierlichs: "In Memorian Katharina Otto-Dorn: A Life Dedicated to Turkish Islamic Art and Architecture," EJOS, iv (2001), pp. 1–14

J. Gierlichs: "Katharina Otto-Dorn (1908–1999)," Z. Dt. Mrgländ. Ges., clii/1 (2002), pp. 5–9

Ottoman [Osmanlı]. Islamic dynasty that began to rule in Anatolia in 1281; at its greatest extent in the 16th century the Ottoman Empire also included the Balkans, the Crimea, Iraq, Syria, the Hijaz, Egypt and North Africa. It lasted until the promulgation of the Constitution of the Turkish Republic in 1924.

I. Introduction. II. Family members.

I. Introduction. The Ottomans claimed descent from the eponymous Osman ('Uthman), a Turkish

ruler active in northwest Anatolia at the end of the 13th century and beginning of the 14th. His small emirate grew at the expense of the declining state of the Saljuqs of Anatolia (*see* SALJUQ, §II). Ideologically based on the concept of religious warfare (Turk. *gaza*, from Arab. *ghazw*), the state expanded rapidly to the west over Byzantine territory in Thrace and the Balkans, and to the east over the Turkish principalities of Anatolia (*see* BEYLIK). The first major expansion took place under Osman's son Orhan (r. c. 1324–60), and each succeeding sultan added further land and established firmer control over the state. In the mid-15th century the Ottomans developed a centralized ruling system; with the first standing army in Europe, the sultans became absolute rulers over their territory and subjects, with towns developing on important trade routes. BURSA was the capital from 1326 to 1402, followed by EDIRNE from 1402 to 1453, when, under (A) Mehmed II, the Ottomans conquered Constantinople and made it their capital ISTANBUL. As constant war to the west and east continued, the Ottoman state was transformed into a powerful empire with formalized administrative and religious principles. Expansion continued under (B) Bayezid II and Selim I (r. 1512–20), and during the reign of (C) Süleyman, the last of a series of powerful sultans, the Ottoman Empire reached its apogee, as a result of vast conquests in the Near East and central Europe. Known in the West as "the Magnificent," Süleyman proved his empire to be a world power and the foremost Islamic state. However, the failure of the Ottomans to capture Vienna, the onset of inflation during the reign of (D) Murad III and other difficulties led to the stagnation and decline that dominated Ottoman history from the 17th century. This phenomenon was paralleled by Westernization in the 18th century, when, starting with (E) Ahmed III, the Ottomans turned their eyes to Europe for solutions to their problems. The attempt to adapt European institutions, however, did not prevent the Ottomans from becoming politically and economically dependent on Europe throughout the 19th century (*see* (F) MAHMUD II and (G) ABDÜLAZIZ below).

Throughout their history the Ottomans remained supporters of art and artists. Under their patronage a distinctive architectural style developed that combined the Islamic traditions of Anatolia, Iran and Syria with those of the Classical world and Byzantium. The result was a rationalist monumentality that favored spatial unity and architectonic expression. Starting with Orhan, each sultan sponsored the building of at least one KÜLLIYE, a building complex combining religious, educational and charitable buildings and forming the nucleus for the developing quarters of the newly conquered towns. In addition to being social centers and an expression of the sultan's power, these complexes, which comprised a mosque, public kitchen (*imaret*), madrasa (*medrese*), as well as other public buildings such as a bath, hospital, library, caravanserai and the founder's tomb, record the development of Ottoman architecture (*see* ARCHITECTURE, §§VI, B, 2 and VII, A). As new public buildings were erected under the patronage of the sultans and high officials, Ottoman architecture developed the theme of the domed square unit, and new combinations of varying spatial and architectonic expression were sought. Among the buildings of a *külliye*, the mosque, or in some early cases the mosque–convent, was the crowning element. The capital cities of Bursa, Edirne and later Istanbul grew to house the numerous edifices that dominated the scene with their hemispheric domes and slender minarets. The decoration of these buildings with tiles, woodwork and carpets encouraged the development of the arts. Artists from all over the empire were employed in the production of pottery and tiles, illustrated manuscripts, textiles, carved wood and metalwares in a style that drew on the International Timurid style but became distinctly Ottoman.

With the conquest of Constantinople and the establishment of a new palace as the administrative center of the empire, the relationship between Ottoman patrons and the artists who worked under them was formalized and centralized. Two new institutions were established to organize artistic production. The corps of court architects (*hassa mimarları ocağı*) employed architects of differing ranks and controlled all building activity throughout the empire. The chief court architect (*ser mimaran-ı hassa*) directed the organization, planning and implementing of royal projects. The community of craftsmen (*ehl-i hiref*) brought together societies of artists and craftsmen who worked for the court, the most significant being the imperial design studio (*nakkaşhane*), where manuscripts were illuminated and illustrated and designs created for tiles, vessels, woodwork, carved stone and jade, metalwares, carpets and textiles. These institutions, by educating new architects and artists, helped the Ottomans form a uniform style, which flourished particularly in Istanbul but asserted its character everywhere in the empire.

After the conquest of Constantinople, the practice of building *külliye*s continued on a grand scale, and Ottoman architects followed the scheme of the great Byzantine church of Hagia Sophia (*see* ISTANBUL, §III, A), with its half-domes supporting the central dome, to unite worshippers in a mosque under a great centralized space. Beginning with the Fatih Mosque (*see* ISTANBUL, §III, B), the first royal mosque built after the conquest, the great domed space would characterize virtually all royal mosques built under the Ottomans. SINAN, the greatest Ottoman architect, became chief court architect and executed most of his work for Süleyman and his successor Selim II (r. 1566–74). As Sinan built for the sultans, the royal family and high officials, he extended the limits of spatial unity in domical architecture, and his work marks the classical age of Ottoman architecture. Among over 300 buildings that he designed throughout the empire, the mosques of the great imperial complexes of the Şehzade and Süleymaniye (*see* ISTANBUL, §III, C and ARCHITECTURE, fig. 43) and the Selimiye in Edirne (*see* ARCHITECTURE, fig. 44) are his masterpieces, each creating a great centralized space, the architectural expression of Ottoman power at its peak. The Topkapı Palace in Istanbul (*see* ISTANBUL,

§III, E) was the chief residence of the Ottoman sultans from the mid-15th century to the mid-19th. The Baghdad Kiosk (see fig. 1 and ARCHITECTURE, fig. 45), with its projecting eaves and domed central space, typifies Ottoman palace structures.

Later architects who worked for the court followed Sinan's path until the 18th century when, as part of the process of Westernization, the Baroque style of architecture was introduced, although it remained restricted mainly to decoration and minor architectural elements. In the 19th century the BALYAN family, an Armenian family of architects who worked for the last sultans, built numerous structures reflecting European Baroque, Empire and eclectic styles, and several European architects built barracks, government offices, banks and other structures required for the new Western institutions. In the final years of the empire Ottoman Neo-classicism emerged under the architects KEMALETTIN and VEDAT, who built several government buildings and mosques in a revivalist Ottoman style.

Artists in the imperial design studio illustrated histories of the Ottoman sultans and chronicles of important events (*see* ILLUSTRATION, §VI, D). Each sultan after Mehmed II had a *Shāhnāma* ("Book of kings") written to narrate the events of his reign and illustrated with paintings of them. Manuscripts such as the *Sulaymānnāma* ("Book of Süleyman"; Istanbul, Topkapı Pal. Lib., H. 1517) and the *Hunarnāma* ("Book of accomplishments"; Istanbul, Topkapı Pal. Lib., H. 1523) were created in this manner in the 16th century. The Iranian style used earlier gave way to a documentary realism for depicting important events in order to emphasize the imperial grandeur of the period. Artists in the imperial design studio used arabesques, split-leaf motifs (*rumi*), lotus-blossoms (*hayati*), cloud bands, triads (*çintimani*), spirals, bouquets, geometric and ogival designs and calligraphy as basic decorative themes. Many of the tiles and vessels decorating the interiors of mosques and palaces in the 16th and 17th centuries were produced under court patronage in the ceramic kilns in the town of IZNIK (see color pl. 3:III, fig. 1; *see also* CERAMICS, §V, A). High quality polychrome wares were produced here during the second half of the 16th century, particularly wares with a bright red among deep blue, green, turquoise and aubergine. Bursa was the primary textile-producing center of the Ottomans until the mid-17th century, the main products being silk, velvet, brocade and taffeta (*see* TEXTILES, §IV, A). Large palace carpets were produced in Bursa and Istanbul, as well as in Cairo with designs sent from the capital (*see* CARPETS AND FLATWEAVES, §III, B). Smaller carpets were produced in local Anatolian centers: for example, Holbein carpets, characterized by geometric designs, lozenges, medallions and stars, stylized floral and animal motifs, were produced in Uşak from the 15th century (*see* CARPETS AND FLATWEAVES, §III, A).

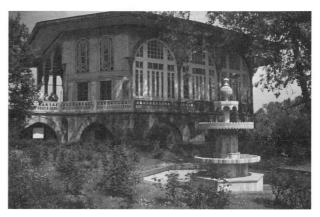

1. Bagdad Kiosk, Topkapı Palace, Istanbul, 1639; photo credit: Vanni/Art Resource, NY

Enc. Islam/2: "'Othmānlı"

Hafiz Huseyn Ayvanserayi: *The Garden of the Mosques: Hafiz Hüseyin al-Ayvansarayî's Guide to the Muslim Monuments of Ottoman Istanbul*, trans. and annotated by H. Crane (Leiden, 2000)

P. Wittek: *The Rise of the Ottoman Empire* (London, 1938)

A. Kuran: *The Mosque in Early Ottoman Architecture* (Chicago and London, 1968)

O. Aslanapa: *Turkish Art and Architecture* (London, 1971)

G. Goodwin: *A History of Ottoman Architecture* (Baltimore and London, 1971)

H. Inalcık: *The Ottoman Empire: The Classical Age, 1300–1600* (London, 1975)

S. Shaw and E. K. Shaw: *History of the Ottoman Empire and Turkey* (New York, 1977)

E. Akurgal, ed.: *The Art and Architecture of Turkey* (Oxford, 1980)

E. Atıl, ed.: *Turkish Art* (Washington, DC, 1980)

Y. Petsopoulos, ed.: *Tulips, Arabesques and Turbans: Decorative Arts from the Ottoman Empire* (London, 1982)

The Anatolian Civilisations III: Seljuk/Ottoman (exh. cat., 18th Council of Europe exh.; Istanbul, 1983)

S. Faroqhi: *Towns and Townsmen of Ottoman Anatolia* (Cambridge, 1984)

N. Atasoy and J. Raby: *Iznik: The Pottery of Ottoman Turkey* (London, 1989)

Art turc/Turkish Art: 10th International Congress of Turkish Art. 10e Congrès international d'art turc: Genève–Geneva. 17–23 September 1995

S. Ireland and W. Bechhoefer, eds.: *The Ottoman House: Papers from the Amasya Symposium, 24–27 September 1996*

Letters in Gold: Ottoman Calligraphy from the Sakip Sabanci Collection, Istanbul (exh. cat. by M. U. Derman; Los Angeles, CA, Co. Mus. A.; New York, Met.; Cambridge, MA, Sackler Mus.; 1998)

Topkapı à Versailles: Trésors de la Cour ottomane (exh. cat., Versailles, Trianon, 1999)

S. B. Krody: *Flowers of Silk & Gold: Four Centuries of Ottoman Embroidery* (Washington, DC, 2000)

N. Akin, A. Batur and S. Batur, eds.: *7 Centuries of Ottoman Architecture "A Supra-national Heritage"* (Istanbul, 2000)

I. Akşit: *The Mystery of the Ottoman Harem* (Istanbul, 2000)

S. Kangal and P. M. Işin: *The Sultan's Portrait: Picturing the House of Osman* (Istanbul, 2000)

K. Çiçek, ed.: *Culture and Arts, iv of The Great Ottoman-Turkish Civilization* (Ankara, 2000)

N. Atasoy and others: *Ipek: The Crescent & the Rose: Imperial Ottoman Silks and Velvets* (London, 2001)

P. Scott: *Turkish Delights* (London, 2001)

M. Ellis: *Ottoman Embroidery* (London, 2001)

W. B. Denny: *The Classical Tradition in Anatolian Carpets* (Washington, DC, 2002)

I. Keten: *Ottoman Monograms Tughra (Tuğra)* (Istanbul, 2002)

F. Hitzel: *Couleurs de la Corne d'Or: Peintres voyageurs à la Sublime Porte* (Courbevoie, 2002)

G. Öney: *Genèse de l'art ottoman: L'Héritage des emirs* (Aix-en-Provence, 2002)

G. Goodwin: *Life's Episodes: Discovering Ottoman Architecture* (Istanbul, 2002)

W. K. Shaw: *Possessors and Possessed: Museums, Archaeology, and the Visualization of History in the Late Ottoman Empire* (Berkeley, 2003)

From the Medicis to the Savoias: Ottoman Splendour in Florentine Collections (exh. cat. by D. Alexander and others; Istanbul, Sakip Sabanci Mus., 2003–4)

W. B. Denny: *Iznik: The Artistry of Ottoman Ceramics* (London, 2004)

G. Kürkman: *Armenian Painters in the Ottoman Empire: 1600–1923* (Istanbul, 2004)

G. Necipoğlu: *The Age of Sinan: Architectural Culture in the Ottoman Empire* (London, 2005)

Turks: A Journey of a Thousand Years, 600–1600 (exh. cat., ed. D. Roxburgh; London, RA, 2005)

K. Adahl, ed.: *The Sultan's Procession: The Swedish Embassy to Sultan Mehmed IV in 1657–1658 and the Rålamb Paintings* (Istanbul and London, 2006)

D. Kuban: *Osmanlı Mimarisi* [Ottoman architecture] (Istanbul, 2007)

II. Family members.

A. Mehmed II. B. Bayezid II. C. Süleyman. D. Murad III. E. Ahmed III. F. Mahmud II. G. Abdülaziz.

A. MEHMED II [Meḥemmed; Mehmet] (*b.* Edirne, 30 March 1432; *r.* 1444–6 and 1451–81; *d.* 3 May 1481). Known as Fatih ("Conqueror"), he succeeded his father Murad II (*r.* 1421–44 and 1446–51) first during the latter's temporary retirement and again after Murad's death in 1451. Mehmed expanded the Ottoman frontiers in all directions; he ended the thousand-year Byzantine Empire, conquering Constantinople in 1453 and the Morea and Trebizond in 1461. Upon capturing Constantinople, he declared the great city to be the new capital of his empire, and for almost three decades he sponsored major building projects to embellish the city and lay the foundations for the imperial court organization that was to characterize the Ottoman Empire in the 16th century.

Mehmed founded the Old Palace (Turk. *eski saray*; destr.) in the center of Istanbul on the site of the Byzantine Forum Tauri, an area now occupied by Istanbul University and the Süleymaniye Mosque complex. The Old Palace continued to serve as a residence for the harems of former sultans long after the seat of Ottoman power had been moved to the New Palace, now known as Topkapı Palace (*see* ISTANBUL, §III, E).

Mehmed was responsible for the layout of Topkapı in a series of courtyards, an arrangement partly predetermined by the Byzantine terraces and structures on the site at the tip of the Stamboul peninsula. In addition to building complexes within the palace, Mehmed ordered the building of the Çinili Kiosk, on the edge of a terrace in the park surrounding the palace; this curious building, of Iranian plan and decoration, was part of an ensemble of Turkish, Greek and European pavilions, the last planned to have decoration by the Venetian painter Gentile Bellini (?1429–1507). Mehmed also added to the great riverside palace in Edirne, the largest imperial residence during his reign.

Mehmed's great *külliye* or mosque complex, completed in 1470 on the highest hill of Istanbul on the ruins of the Byzantine church of the Holy Apostles (*see* ISTANBUL, §III, B), established a pattern of imperial patronage in the construction of complexes that asserted the dominance of the dynasty over the city. It also established a practical infrastructure in the form of schools, hospitals and other social-service buildings as part of the sultan's program of repopulating the former Byzantine capital. Chief among Mehmed's secular commissions were the two great covered markets (*bedesten*) that form the nucleus of the Grand Bazaar (*see* ISTANBUL, §III, F). His patronage of military architecture included the Rumeli Hisar fortress (*see* MILITARY ARCHITECTURE AND FORTIFICATION, fig. 3) on the Bosporus and the Yedi Kule ("Seven Towers") fortress by the Byzantine Golden Gate in the city walls, as well as the Tophane (cannon foundry), where the huge cannons that were the basis of his siege strategy were cast after the conquest.

Mehmed's patronage of artists, important in the establishment of patterns of Ottoman dynastic patronage, went far beyond his well-known invitation to the Signoria to send Gentile Bellini to his court. One of the greatest Renaissance patrons, he commissioned medals from Italian artists and amassed an unparalleled library of books in European and Islamic languages (*see* ILLUSTRATION, §V, F). During his reign, communities of craftsmen (*ehl-i hiref*) were established in many categories, including bookbinders and calligraphers, silk- and carpet-weavers, metalworkers and painters. Beginning with his reign, Turkoman artists migrated from Tabriz, bringing the International Timurid style to the Ottoman Empire, and this pattern provided a corner-stone for the imperial style of the 16th century.

Enc. Islam/2: "Meḥemmed II"

E. Atıl: "Ottoman Miniature Painting under Sultan Mehmed II," *A. Orient.*, ix (1973), pp. 103–20

E. H. Ayverdi: *Osmanlı mimârisinde Fâtih devri* [Ottoman architecture in the period of the Conqueror], 2 vols. (Istanbul, 1973–4)

J. Raby: "Cyriacus of Ancona and the Ottoman Sultan Mehmed II," *J. Warb. & Court. Inst.*, xliii (1980), pp. 242–6

J. Raby: "Mehmed II Fatih and the Fatih Album," *Islam A.*, i (1981), pp. 42–9

J. Raby: "A Sultan of Paradox: Mehmed the Conqueror as a Patron of the Arts," *Oxford A. J.*, v/1 (1982), pp. 3–8

J. Raby: "Mehmed the Conqueror's Greek Scriptorium," *Dumbarton Oaks Pap.*, xxxvii (1983), pp. 15–34

J. Raby: "Court and Export," *Orient. Carpet & Textile Stud.*, ii (1986), pp. 29–30, 177–88

J. Raby: "East and West in Mehmed the Conqueror's Library," *Bull. Biblioph.*, iii (1987), pp. 297–321

J. Raby: "Mehmed the Conqueror and the Byzantine Rider of the Augustaion," *Topkapı Sarayı Yıllığı*, ii (1987), pp. 141–52

J. Raby: "Pride and Prejudice: Mehmed the Conqueror and the Italian Portrait Medal," *Italian Medals*, ed. J. G. Pollard (Washington, DC, 1987), pp. 171–96

F. Richard: "Dīvānī ou taʿlīq: Un calligraphe au service de Mehmet II, Sayyidī Mohammad Monšī," *Les manuscrits du Moyen-Orient: Essais de codicologie et paléographie*, ed. F. Déroche, Varia Turcica, VIII (Istanbul, 1989), pp. 89–93

G. Necipoğlu: *Architecture, Ceremonial, and Power: The Topkapı Palace in the Fifteenth and Sixteenth Centuries* (Cambridge, MA and London, 1992)

J. Raby, Z. Tanındı and T. Stanley: *Turkish Bookbinding in the 15th Century* (London, 1993)

Art turc/Turkish Arts: 10th International Congress of Turkish Art. 10e Congrès international d'art turc: Genève–Geneva, 17–23 September 1995 [several articles on Mehmed's patronage of art and architecture]

P. Bádenas: "The Byzantine Intellectual Elite at the Court of Mehmet II: Adaptation and Identity," *International Congress on Learning and Education in the Ottoman World, Istanbul, 12–15 April 1999*, Studies and Sources on the Ottoman History Series, 6 (Istanbul, 2001), pp. 23–33

B. BAYEZID II [Bayezit; Bayazid] (*b.* Demotika, Thrace, Dec. 1447 or Jan. 1448, *r.* 1481–1512, *d.* nr. Demotika, 26 May 1512). Son of (A) Mehmed II. Compared to the reigns of his bellicose father and his son Selim I ("the Grim"; *r.* 1512–20), Bayezid's reign was relatively peaceful, but the building of the empire through conquest proceeded apace. Under his patronage the artistic establishments of the court (*ehl-i hiref*) continued to grow, and the Ottoman narrative painting style began to take form. In architecture Bayezid was one of the most liberal patrons the dynasty produced, and his large-scale building projects impress modern scholars by their relatively subdued political aspect and their concentration on Islamic philanthropy.

The two riverbank complexes built in provincial capitals at the sultan's order are among the most harmonious and attractive to be found in Ottoman architecture. The AMASYA complex, completed in 1486, is the largest and latest Ottoman structure built on the old two-dome plan of the Bursa mosques. The EDIRNE complex, probably completed by the architect HAYREDDIN in 1488, on the right bank of the Tunca River, with its simple geometric shapes and contrasts of golden building stone, red sandstone ornamentation and dark-gray lead roofs, presents one of the most effective statements of the Ottoman classical architectural aesthetic at an early stage in its development. The sultan's complex in the very center of Istanbul, at the northwest corner of the Grand Bazaar, was completed in 1504 by the architect Yaʿqub. The mosque, which is the centerpiece of a complex that included a madrasa, bath, library and other dependencies, was the first imperial Ottoman mosque to use two semi-domes in the fashion of Hagia Sophia (*see* ISTANBUL, §III, A) but is nevertheless both spatially and decoratively within the lineal tradition of Ottoman building, with its roots in Bursa and Edirne.

Bayezid's patronage of the *ehl-i hiref* and the arts of the book in particular continued the tradition of his father. Bayezid brought SEYH HAMDULLAH from Amasya to Istanbul, where the tradition of this great Ottoman calligrapher lasted well into the 18th century (*see* CALLIGRAPHY, §IV, A). The International Timurid style continued to be important in illumination and bookbinding, and its motifs were incorporated in the ceramics of Iznik (*see* CERAMICS, §IV, C) and in architectural decoration (e.g. the richly carved wooden shutters of the royal mosque at Amasya). The celebrated Fatih albums of calligraphy and painting (Istanbul, Topkapı Pal. Lib., H. 2153 and 2160), which served as a well-spring of later Ottoman court art, may have been compiled during Bayezid's reign. Several early illustrated manuscripts commissioned during Bayezid's reign show the germ of the classical Ottoman narrative style of painting; these include a manuscript of Hatifi's *Khusraw and Shirin* (1498–9; New York, Met., 69.27) with illustrations depicting contemporary Ottoman court officials and costumes and realistic architecture in the Ottoman style.

Enc. Islam/2: "Bāyazīd II"

C. J. Lamm: "Miniatures from the Reign of Bāyazīd II in a Manuscript Belonging to the Uppsala University Library," *Orient. Suecana*, i (1953), pp. 95–114

R. M. Meriç: "Bayezid camii mimarı" [The architect of the Bayezid Mosque], *Ankara Ü. Ilâhiyat Fak. Yıllık Araştırmalar Derg.*, ii (1958), pp. 4–77

R. M. Meriç: "L'Architecte de la mosquée Bayezit d'Istanbul," *Communications of the First International Congress of Turkish Art: Ankara, 1961*, pp. 262–5

A. Kuran: *The Mosque in Early Ottoman Architecture* (Chicago and London, 1968)

N. Atasoy and F. Çağman: *Turkish Miniature Painting* (Istanbul, 1974)

J. M. Rogers: "An Ottoman Palace Inventory of the Reign of Beyazid II," *Comité International d'Etudes Pré-Ottomanes et Ottomanes: VIth Symposium Cambridge, 1st–4th July 1984*, ed. J.-L. Bacqué-Grammont and E. van Donzel, Varia Turcica, 4 (Istanbul, 1987), pp. 39–53

C. SÜLEYMAN [Sulaymān II; Soliman] (*b.* Trabzon, 6 Nov. 1494; *r.* 1520–66; *d.* Szigetvár, 7 Sept. 1566). Grandson of (B) Bayezid II. He was the son of Selim I (*r.* 1512–20). Known in Turkey as Kanuni ("lawgiver") and in the West as "the Magnificent," Süleyman reigned for 46 years (*see* HISTORY, color pl. 2:VII, fig. 4), a period universally recognized as the apogee of Ottoman political, economic and cultural development. The sultan and high officials of his court were

major patrons of art and architecture, and the artistic institutions and systems of patronage established during his reign set the standard that Süleyman's two successors, his son Selim II (*r.* 1566–74) and grandson (D) Murad III, refined at the end of the 16th century.

Under Süleyman two major institutions involved in the production of art underwent unprecedented development. The office of the chief architect (Turk. *mi 'mar başı*) was held for most of Süleyman's reign (and for over two decades after) by the famous SINAN, and under his direction the office oversaw the building of vast numbers of religious, educational and commercial edifices in all quarters of the empire, so that the classical Ottoman architectural style was given definitive form (*see* ARCHITECTURE, §VII, A). Under Süleyman's patronage the two branches of the royal design studio (*nakkaşhane*)—the so-called *rumiyān*, literally "Romans" but actually artists from Anatolia, and the *ajemān*, literally "Persians" but actually émigré artists from Europe as well as from Iran—brought about the basic synthesis of the new Ottoman imperial style in decoration and book illustration and laid the groundwork for the even greater manuscript production that followed in the reigns of Selim II and Murad III (*see* ILLUSTRATION, §VI, D, 1). Working directly under court control, and completing major commissions for the sultan and his family, these artists were listed in periodic registers drawn up by the court accountants. Noteworthy among the painters were SHAHQULI, the *ajemi* émigré from Tabriz, and KARA MEMI, his *rumi* pupil, both instrumental in the foundation of the classical Ottoman decorative style. The sword-maker Ahmed Tekelü, the ivory-carver Gani and the calligrapher AHMAD KARAHISARI were among the many artistic luminaries of the court artistic establishment (*ehl-i hiref*), working under the patronage of Süleyman, his wife Hürrem (*d.* 1558), his daughter Mihrimah (1522–78), his son-in-law and chief minister Rüstem Pasha (1500–61) and other high officials and members of the sultan's family.

There is, however, little direct evidence of the sultan's personal involvement in artistic patronage, unlike the numerous documents and anecdotes detailing the interest in the arts taken by such sovereigns as the Safavid Tahmasp I or Murad III. Nevertheless, under Süleyman one particular genre of illustrated book—the Ottoman contemporary historical manuscript or political biography—took its basic form and substance, to be repeated in many other historical works in the following decades. 'Arifi's five-volume history of the Ottoman dynasty included a final volume, the *Sulaymānnāma* ("Book of Süleyman"; 1558; Istanbul, Topkapı Pal. Lib., H. 1517), with 65 illustrations of important events in the monarch's reign. It was finished around the same time as the great mosque complex that bears the ruler's name (*see* ISTANBUL, §III, C). The twin purposes of history and panegyric in the manuscript suggest a direct personal interest and involvement of the sultan, as do the surviving illuminated copies of the sultan's *Dīvān*

(collected poems; e.g. 1565–6; Istanbul, Topkapı Pal. Lib., R. 738 and 1566; Istanbul, U. Lib., T. 5467) written under the pen-name Muhibbi.

Documentation of Süleyman's patronage is immense: numerous official orders from the court to various production workshops, court registers listing artists and their salaries, construction account-books of the Süleymaniye Mosque and many deeds of endowment establishing various charitable foundations. In addition, the practice of collecting and preserving royal mementos in the Topkapı Palace itself has led to the survival of numerous items of clothing, weaponry, jewelry and precious objects that can be directly associated with Süleyman and his patronage.

Ö. L. Barkan: *Süleymaniye camii ve imareti insaatı, 1550–1557* [The construction of the Suleymaniye Mosque and its adjoining buildings, 1550–57], 2 vols. (Ankara, 1972–9)

J. M. Rogers: "The State and the Arts in Ottoman Turkey: I. The Stones of Süleymaniye and II. The Furniture and Decoration of Süleymaniye," *Int. J. Mid. E. Stud.*, xiv (1982), pp. 71–96, 283–313

G. Necipoğlu-Kafadar: "The Süleymaniye Complex in Istanbul: An Interpretation," *Muqarnas*, iii (1985), pp. 92–117

E. Atıl: *Süleymanname: The Illustrated History of Süleyman the Magnificent* (Washington, DC and New York, 1986)

The Age of Sultan Süleyman the Magnificent (exh. cat. by E. Atıl; Washington, DC, N.G.A.; Chicago, IL, A. Inst.; New York, Met.; 1987–8)

Süleyman the Magnificent (exh. cat. by J. M. Rogers and R. M. Ward; London, BM, 1988)

G. Necipoğlu: "Süleyman the Magnificent and the Representation of Power in the Context of Ottoman–Habsburg–Papal Rivalry," *A. Bull.*, lxxi (1989), pp. 401–27

G. Veinstein, ed.: *Soliman le Magnifique et son temps* (Paris, 1990)

G. Veinstein: "Patronage of Süleymân the Magnificent and the Organization of the Court Sponsored Arts and Crafts," *Eothen*, iv–vii (1993–6), pp. 165–75

S. Auld: "The Jewelled Surface: Architectural Decoration of Jerusalem in the Age of Süleyman the Magnificent," *The Real and Ideal Jerusalem in Jewish, Christian and Islamic Art: Studies in Honor of Bezalel Narkiss on the Occasion of his Seventieth Birthday*, ed. B. Kühnel, Jewish Art, 23/24 (Jerusalem, 1998), pp. 467–79

G. Necipoğlu: *The Age of Sinan: Architectural Culture in the Ottoman Empire* (London, 2005)

N. Vatin: "Un türbe sans maître: Note sur la fondation et la destination du türbe de Soliman-le-Magnifique à Szigetvár," *Turcica*, xxxvii (2005), pp. 9–42

D. MURAD III [Murat] (*b.* nr. Manisa, 4 July 1546; *r.* 1574–95; *d.* Istanbul, 16 Jan. 1595). Grandson of (C) Süleyman. He was the son of Selim II (*r.* 1566–74). After serving as governor of Manisa, Murad succeeded to the throne after the accidental death of his father. Murad commissioned a royal mosque in Manisa, the smallest of the 16th-century examples, and extensively rebuilt parts of the Topkapı Palace in Istanbul. His primary interest as a patron was in the arts of the book, and of all the Ottoman sultans he showed the most personal interest in the works of court painters, designers and calligraphers. A

manuscript of Jannabi's *Javāhir al-ghar'ib* ("Jewels of curiosities"; Cambridge, MA, Sackler Mus., ex-Binney priv. col.) completed for Murad in 1582 contains an illustration (fol. 217*r*) showing the sultan seated in the royal library in the presence of his court artists; Murad was the only Ottoman sultan to be so depicted, and under his patronage the work of the imperial design studio (*nakkaşhane*) reached its zenith.

Many major manuscripts were illustrated during his reign. Lokman's *Zubdat al-tawārīkh* ("Cream of histories"; 1583; Istanbul, Mus. Turk. & Islam. A., 1973) is a world history, while the *Nuṣratnāma* ("Book of victories"; 1584; Istanbul, Topkapı Pal. Lib., H. 1365) detailed the conquest of the Caucasus by the vizier Lala Mustafa. The *Sūrnāma* ("Book of festivals"; *c.* 1582–3; Istanbul, Topkapı Pal. Lib., H. 1344) depicts the festivals and guild processions surrounding the circumcision of his sons in 1584, and the *Hunarnāma* ("Book of accomplishments"; 1588; Istanbul, Topkapı Pal. Lib., H. 1523–4) is a two-volume historical work dealing with Ottoman dynastic accomplishments. The *Shāhanshāhnāma* ("Book of

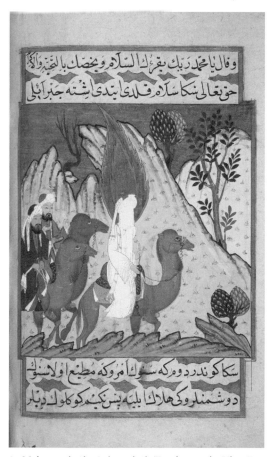

2. *Muhammad, Abu Bakr and Ali Traveling to the Ukaz Fair*, from the illustrated *Siyar-i Nabī* ("Life of the Prophet"), commissioned by Murad III, from Istanbul, 1594–5 (New York, Public Library, Spencer Collection, MS. IV. 2, fol. 132*v*); photo credit: New York Public Library/Art Resource, NY

the king of kings"; 1597; Istanbul, Topkapı Pal. Lib., B. 200), another two-volume history of the Ottoman dynasty, was commissioned by Murad but completed after his death under Mehmed III. In addition to these historical works, which were illustrated by teams of artists working under the head of the design studio, Murad also ordered the compilation of albums of single-leaf paintings, calligraphies and designs (e.g. Vienna, Österreich. Nbib., Cod. Mixt. 313). He also commissioned the six-volume *Siyār-i Nabī* ("Life of the Prophet"; 1594–5; dispersed, e.g. Istanbul, Topkapı Pal. Lib., H. 1221–3; New York, Pub. Lib., Spencer MS. 157, see fig. 2; Dublin, Chester Beatty Lib., Turk. MS. 419; *see also* ILLUSTRATION, fig. 23), illustrated with over 800 paintings and one of the most extensive Ottoman works on religious subjects.

Although Murad seems to have spared no expense in his prodigious patronage of the arts of the book, the court followed a fixed system of pricing for other artistic works, which was not adjusted to the serious inflation that began to afflict the empire in the 1580s, as gold and silver flooded in from the New World. Documents from Murad's reign attest to the difficulty the court had in forcing the tile-makers of IZNIK to make tiles for court commissions at an artificially low price, when ceramics sold in the bazaar brought higher profits. The sultan's interest in centralizing artistic production in the capital is attested in a famous order sent to the governor of Cairo in 1585, requiring the dispatch to Istanbul of 11 carpet-weavers and a substantial quantity of dyed wool; the movement of artisans from Cairo, Tabriz, the Balkans and Syria to the Ottoman capital, which had been going on since the 15th century, continued apace during Murad's reign. Despite adverse economic developments, the arts of court carpets and ceramics reached their technical and artistic apogee in Murad's reign; the finest Ottoman court prayer rugs (*see* CARPETS AND FLATWEAVES, §III, B) and the most daring and innovative Ottoman polychrome ceramic tiles and tablewares were made in the last quarter of the 16th century (*see* CERAMICS, §V, A, 3).

Enc. Islam/2

Turkish Miniature Paintings and Manuscripts from the Collection of Edwin Binney, 3rd (exh. cat. by E. Binney, New York, Met.; Los Angeles, CA, Co. Mus. A.; 1973)

N. Atasoy and F. Çağman: *Turkish Miniature Painting* (Istanbul, 1974)

W. B. Denny: "Dating Ottoman Turkish Works in the Saz Style," *Muqarnas*, i (1983), pp. 103–21

C. G. Fisher: "A Reconstruction of the Pictorial Cycle of the *Siyar-i Nabī* of Murad III," *A. Orient.*, xiv (1984), pp. 75–94

T. Reyhanlı: "The Portraits of Murad III," *Erdem*, iii/8 (1987), pp. 453–78

N. Atasoy and J. Raby: *Iznik: The Pottery of Ottoman Turkey* (London, 1989)

E. AHMED III [Ahmet] (*b.* 1673; *r.* 1703–30; *d.* 1736). He succeeded his brother Mustafa II

(*r.* 1695–1703) and reigned until he was forced to abdicate and was replaced by his nephew Mahmud I (*r.* 1730–54). Ahmed's reign forms the major part of what is known as the Tulip Period (Turk. *Lâle Devri*). Although his reign was a time of decline in Ottoman political fortunes, especially in the Balkans, there was also a marked revival in patronage of the arts in Istanbul, motivated by a self-conscious attempt to re-create the glories of the empire at its apogee in the 16th century. Fueled by the enthusiastic reports of Mehmed Yermisekiz Çelebi (*d.* 1732), ambassador plenipotentiary to the French court, the Ottomans avidly adopted European styles. In addition to the patronage of the sultan himself, this artistic revival was encouraged by the ambition and energy of his grand vizier IBRAHIM PASHA, who attempted to revive some of the old imperial manufactories, especially the tile industry.

Ahmed is perhaps best known for his patronage of the court painter LEVNI, the last of the great traditional Ottoman painters, who was in charge of the most famous of the later Ottoman historical manuscripts, the two-volume illustrated *Sūrnāma* ("Book of festivals"; *c.* 1720; Istanbul, Topkapı Pal. Lib., A. 3593). Written in meter by the court poet Vehbi, it was embellished by Levni and his assistants with 137 paintings. Commissioned to commemorate the circumcision of Ahmed's sons in 1720, the manuscript follows the tradition of the late 16th-century *Sūrnāma* of (D) Murad III, depicting not only festivities of various sorts on land and sea, but also a parade of the Istanbul guild corporations. Ahmed is also known for building fountains in the capital city. With their characteristic Tulip Period decoration of marble low reliefs carved with images of vases of flowers and spiraling *rinceaux*, and the delicate silhouettes of their wide eaves and tiny decorative domes, they include the large fountain building (1728–9) at the gate of Topkapı Palace (*see* ARCHITECTURE, fig. 46) and the four-trough fountain at the Üsküdar landing stage.

The Tulip Period was a period of extensive development of palace architecture in the Ottoman Empire, especially the wooden seaside palaces (Turk. *yalı*) built along the Bosporus and in the various river valleys around the capital, most notably at Kağıthane, where the sultan built a palace in the French style. Most of these ephemeral wooden structures later perished in fires or were destroyed when Ahmed was deposed. Among the more substantial palace structures he built were various parts of the harem in the Topkapı Palace and the small library in the Third Court of the palace. Although Ahmed built no imperial mosque in his own name, he commissioned the large and handsome mosque of Yeni Valide (*c.* 1710) in Üsküdar, dedicated to his mother. Lady Mary Wortley Montagu (1689–1762), whose famous letters from Turkey were written during Ahmed's reign, gives a vivid picture of the daily life, costumes and architecture of the upper Ottoman classes during this time. The expenditures on art and architecture during Ahmed's reign, coupled with his lavish support of festivals and pleasure-palaces, unfortunately contributed to the economic decline of the empire and were a major reason for the discontent that led to his overthrow.

Enc. Islam/2: "Aḥmad III"

R. Halsband, ed.: *The Complete Letters of Lady Mary Wortley Montagu* (Oxford, 1965)

E. Atıl: *Surname-Vehbi: An Eighteenth-century Ottoman Book of Festivals* (Ph.D. diss., Ann Arbor, U. MI, 1969)

G. A. Bailey: "The Synthesis of East and West in the Ottoman Architecture of the Tulip Period," *Oriental A.*, xlviii/4 (2002), pp. 2–13

F. MAHMUD II (*b.* 20 July 1785; *r.* 1808–39; *d.* 1 July 1839). Son of Abdülhamid I (*r.* 1774–89) and Nakşidil Sultan. His mother was born Aimée Dubucq de Rivery of French–Créole parentage, who was captured by pirates and sold to the Ottoman imperial harem, where she became Valide Sultan (Queen Mother). He succeeded his cousin Selim III (*r.* 1789–1807) and his brother Mustafa IV (*r.* 1807–8). Mahmud is chiefly known for breaking the power of the janissaries, whose reactionary views were in part responsible for the Ottoman military decline. In the realm of the arts, his patronage was a major force in Europeanizing Ottoman art and architecture and was closely identified with the *ampir* style, thought to reflect the Empire style of Napoleonic France.

The Nüsretiye (1826), his imperial mosque on the shores of the Bosporus near Tophane in Istanbul, was built in a late Baroque or even Rococo style that owed far more to Italy and south Germany than to the Neo-classicism of Napoleonic France. The architect was Krikor Balyan (*see* BALYAN, §I), the first of his family to serve the Ottoman sultans as chief architect. The choice of an Armenian for this important position reflected the "new" Ottoman Empire of technical modernization, secularism and Europeanization that Selim III, and then Mahmud II, tried to forge from their polyglot, multi-ethnic and geographically far-flung inheritance. The new Ottoman army required European-style uniforms, standard fire-arms and other types of equipment that demanded a large-scale, industrialized production in contrast to the traditional one-at-a-time artisanry of earlier times, and the establishment of early industrial concerns in Turkey to supply the army contributed to the gradual decline of traditional art forms. Under Mahmud II the printing press and movable type took increasing precedence over the calligrapher, the lithograph eclipsed even the few costume and view painters who had survived the death of royal patronage of illustrated manuscripts, and European perspective continued to supplant traditional methods of depicting space in painting. It was in 1835 under Mahmud that the first military school graduates from the empire were sent to France to learn "scientific" means of painting and drawing, by which is generally understood the rules of linear perspective.

G. Renda: *Batılılaşma döneminde Türk resim sanatı, 1700–1850* [Turkish painting in the period of westernization, 1700–1850] (Ankara, 1977)

G. Abdülaziz ['Abdul-'Aziz] (*b.* 9 Feb. 1830; *r.* 1861–76; *d.* April 1876). Son of (F) Mahmud II. He succeeded his brother Abdülmecid I (*r.* 1839–61). During Abdülaziz's reign royal and governmental patronage of the arts in the Ottoman Empire was profoundly changed by the system that had evolved in France under the Second Empire. In the midst of political and economic chaos caused by revolt in the Balkan provinces of the Ottoman Empire, Abdülaziz attempted major institutional reforms: the establishment of a lycée system and a university, the further development of classes for painting within the Ottoman military schools, the founding of the Istanbul Darüşşafaka (an institution that trained many Turkish painters until the emergence of the Academy of Fine Arts in 1883) and a continuation of the governmental practice established in 1835 of sending promising artists to Paris for study. Out of these beginnings eventually emerged some of the most prominent figures in Turkish artistic life at the end of the 19th century, including the painter Osman Hamdi of the Archaeological Museum in Istanbul, and others who were to staff the faculties of the Academy of Fine Arts.

Abdülaziz's interest in painting was partly due to the fact that he was himself an amateur painter in oils. During his reign Turkish and foreign painters frequently visited the court and received considerable attention from the sultan. He erected a royal mosque in Konya (1872) in a pronounced Europeanizing style, and several palace and educational buildings were erected at his command in Istanbul. The mosque (1871) of the sultan's mother, Pertevniyal Valide, at Aksaray in Istanbul, often attributed to the European architect Montani, is an Orientalist concoction of Ottoman, Gothic and various sorts of Moorish ornament.

M. Cezar: *Sanatta batı'ya açılış ve Osman Hamdi* [Western trends in art and Osman Hamdi] (Istanbul, 1971)

A. Turani: *Batı anlayışına dönük Türk resim sanatı* [Turkish painting developing the western concept] (Ankara, 1984)

F. Yenişehiroğlu: "Continuity and Change in Nineteenth-century Istanbul: Sultan Abdülaziz and the Beylerbeyi Palace," *Islamic Art in the 19th Century: Tradition, Innovation, and Eclecticism*, ed. D. Behrens-Abouseif and S. Vernoit, Islamic History and Civilization: Studies and Texts, 60 (Leiden, 2006), pp. 57–87

Özyazıcı, (Mustafa) Halim (*b.* Istanbul, 1898; *d.* Istanbul, 20 Sept. 1964). Turkish calligrapher. He was educated at the Gülşen junior high school in Istanbul, where he received lessons in calligraphy from Hamid Aytaç, with whom he practiced the *riqā'* style. He then studied drawing and sculpture at the Fine Arts Academy and calligraphy at the School of Calligraphers, both in Istanbul. He practiced the *thuluth* and *naskh* styles with the calligraphers Hasan Riza (1849–1920) and Kamil Akdik (1862–1941), and the *ta'līq* style with Mehmed Hulusi (1869–1940). Employed as an officer at the Imperial Chancery of State, he also received lessons in *dīvānī* from Ferit Bey, the director. During his military service he worked in the office of the military press and on returning to civilian life worked independently. When the Latin alphabet replaced Arabic script in Turkey in 1928, he abandoned calligraphy but in 1948 was appointed "old writing teacher" at the Fine Arts Academy, where he worked until 1962. He corrected many defective manuscripts of a variety of styles and periods, his work being hard to distinguish from the original. His own work was in various scripts, and he was in particular a master of *jalī-thuluth* (Turk. *celi-sülüs*). He also worked in mosques in Istanbul, Ankara and elsewhere in Turkey, as well as on public buildings, fountains and gravestones.

M. U. Derman: *Hattat Mustafa Halim Özyazıcı (1898–1964): Hayatı ve eserleri* [The calligrapher Mustafa Halim Özyazıcı (1898–1964): life and work] (Istanbul, 1964)

M. Ülker: *The Art of Turkish Calligraphy from the Beginning up to Present* (Istanbul, 1987), p. 92 [English and Turkish texts]

P

Pakistan, Islamic Republic of. Country in South Asia (see fig.) sharing its long eastern border with India and its western border with Afghanistan and Iran. The extreme north is dominated by the Himalayas and their offshoots, the Karakoram range in the northeast, which marks the border with China, and the Hindu Kush and Pamirs in the northwest. The Arabian Sea forms the southern border. Pakistan was created in 1947 when British India was partitioned on the eve of independence from colonial rule. It originally comprised two parts, West Pakistan and East Pakistan, separated by 1600 km of Indian territory. In 1971 East Pakistan became BANGLADESH. This survey focuses mainly on the arts produced since 1947.

I. Introduction. II. Architecture. III. Painting. IV. Sculpture. V. Carpets and textiles. VI. Other arts. VII. Art education. VIII. Museums and collections.

I. Introduction. Pakistan is a country of diverse geography and varied peoples. Some 97% of its population of 156.7 million (2007 estimate) are Muslim. Of its total area of some 800,000 sq. km, mountains and plateaux form about three-fifths, the remainder consisting of alluvial plain and desert. The country is divided into four provinces—Punjab, Sind, Baluchistan and the North West Frontier Province—plus the Northern Territories. Watered by the Indus and its five tributaries, the Punjab is Pakistan's most fertile and populous area. The capital, ISLAMABAD, and the historic cultural center, LAHORE, are the main cities in a predominantly agricultural region. Sind, the southernmost province, benefits economically from the fertile flood-plain of the Indus and the international commerce of the coastal city of Karachi. The Baluch tribes in the west are mostly nomadic, herding sheep, goats and camels in an area of barren mountains and plateaux with little rainfall. The Pathans populate the harsh, mountainous North West Frontier Province. Vast glaciers, deep blue lakes and lush valleys characterize the extreme north, home to the Kafirs and Kalash, two ethnically unique, non-Muslim nationalities, and to the people of Chitral, Gilgit and Hunza. The official language of Pakistan is Urdu; other important languages are Punjabi, Sindhi and Pushtu. Both languages and cultures have been influenced by numerous immigrant infusions from Iran, Afghanistan, India and Central Asia.

Muslim incursions began in 712 with the conquest of Sind by the Arab general Muhammad ibn Qasim. The remains of an early mosque were found at BANBHORE, a port town 65 km (40 miles) west of Karachi. After *c.* 1000, the GHAZNAVID ruler of present-day Afghanistan, Mahmud b. Sebüktigin (*r.* 998–1030), conducted nearly annual raids into the region; the Ghaznavids were succeeded in the late 12th century by the GHURIDS. With the establishment of a sultanate at Delhi at the end of the 12th century, the region came under the control of the Delhi sultans, of whom the TUGHLUQS were most involved in construction. Several mausoleums in Multan and Uchch date from these periods. In the 16th century much of the subcontinent was unified under the MUGHAL dynasty, and Akbar (*r.* 1556–1605) made LAHORE one of his capitals. European mercantile involvement in the affairs of the subcontinent began in earnest in the 16th century; by 1900 most of present-day Pakistan, apart from the tribal territories, had come under British rule.

R. E. M. Wheeler: *Five Thousand Years of Pakistan: An Archaeological Outline* (London, 1950)

5000 anni d'Arte in Pakistan (exh. cat., Naples, N. Mus., 1964)

S. Quraeshi: *Legacy of the Indus: A Discovery of Pakistan* (New York, 1974)

M. U. Malik and A. Schimmel: *Pakistan: Das Land und seine Menschen*

Geschichte, Kultur, Staat und Wirtschaft (Tübingen and Basel, 1976)

H. Jalal and others: *Pakistan Past and Present* (London, 1977)

K. U. Kureshy: *A Geography of Pakistan* (Karachi, 1977)

B. L. C. Johnson: *Pakistan* (London, 1979)

F. Robinson, ed.: *The Cambridge Encyclopedia of India, Pakistan, Bangladesh, Sri Lanka, Nepal, Bhutan and the Maldives* (Cambridge, 1989)

"50 Years of Art in Pakistan," *A. & Islam. World*, xxxii (1997) [entire issue]

II. Architecture. The traditional link between professional architects and building craftsmen on the Indian subcontinent was a casualty of British rule. Only professionals trained in the European system received official recognition; hereditary building craftsmen were legated to the service of regional notables and religious institutions or to activity on

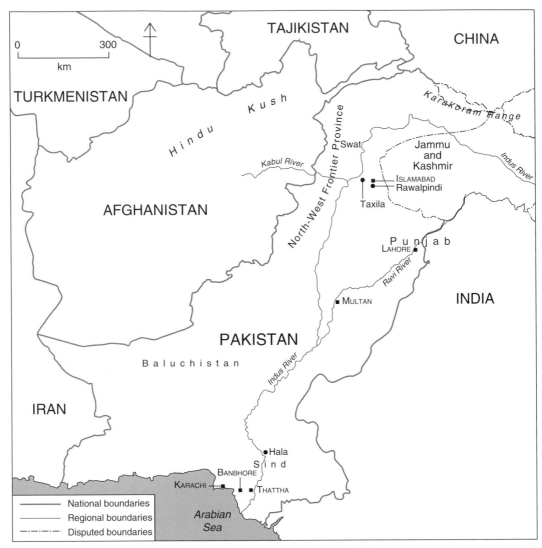

Map of Pakistan; those sites with separate entries in this encyclopedia are distinguished by Cross-reference type

the urban fringes, and they became the last guardians of indigenous architectural traditions.

Most local architects trained before 1947 studied abroad and were influenced by prevailing European fashions. More than any other Pakistani architect of his generation, Mehdi 'Ali Mirza absorbed and understood the philosophy of the Modern Movement. In his residences in Karachi and Lahore, the influence of Frank Lloyd Wright is easily recognized.

In 1958 the first regular courses in architecture became available in Pakistan at the National College of Arts (formerly Mayo School of Arts). In 1962 a department of architecture was created at the West Pakistan University of Engineering and Technology (formerly Moghulpura Engineering College). The first locally educated architects had begun to practice in Pakistan by the mid-1960s. Among them was Nayyar 'Ali Dada, who gained widespread recognition for his eclectic modernism. Yet in buildings such as the

Alhamra Arts Council and the Open Air Theater, Lahore, he displayed a concern for indigenous materials and forms.

A number of the most talented students of the National College of Arts were employed by the government-owned firm Pakistan Environmental Planning and Architectural Consultants since its establishment in the late 1960s. As a result this office has sustained a relatively high standard of design and has been responsible for some of the largest commissions undertaken by Pakistani architects. Among these are Frontier House; the National Film Development Corporation cinemas; and the Housing and House Building Finance Corporation buildings in Islamabad.

Depending on their training and interests, Pakistani architects have created varied buildings. Adhering to the tenets of the International style, Habib Fida 'Ali attained a degree of mature sophistication in the Burmah Shell Headquarters building in

Karachi. The slick commercialism employed by YASMEEN LARI in the Finance and Trade Center (1989) in the same city contrasts sharply with her earlier quest for a regional idiom manifested in the Anguri Bagh Housing, Lahore. While Fuad 'Ali Butt has exploited the structural logic of brick arches and shell concrete vaults in Lahore, in Islamabad Anwar Saeed has explored the permutations of elementary architectonic forms.

With less than one architect per million persons during the first two decades of its existence, Pakistan relied on foreign architects to carry out many large and prestigious projects. These included the Water and Power Development Authority House, Lahore; the Pakistan Institute for Nuclear Science and Technology; the Presidency, National Assembly and University, Islamabad, all by Edward Durrell Stone (1902–78); and the Secretariat and Sherazad Hotel, Islamabad, by Gio Ponti (1891–1979). Projects that are more responsive to local climate, materials and culture include the new campus for Punjab University (1959–73), Lahore, by Constantinos A. Doxiades (1913–75); William Perry's Institute of Business Administration and American School, Karachi; the Karachi University and museum at Mohenjo-daro by Michel Ecochard (1905–85); Tom Payette's Aga Khan Hospital, Karachi; and Ramesh Khosla's Serena Hotels in Faisalabad and Quetta. It has been suggested that works by hereditary craftsmen built in the modern period, such as the Bhong Mosque near Rahimyarkhan, represent the corruption of a grand tradition. However, there is evidence—in the work of certain architects in Lahore and that of the Architects Bureau in Peshawar—of a growing concern for a meaningful contemporary architecture nourished by indigenous roots.

ArchNet, http://archnet.org (accessed June 11, 2008)

K. K. Mumtaz: *Architecture in Pakistan* (Singapore, 1985)

K. B. Ahmad: "Architectural Education in Pakistan and the Problems of the Architectural Profession," *Architectural Education in the Islamic World*, ed. A. Evin (Singapore, 1986)

III. Painting. From 1947 young artists began to look to the West rather than to India for inspiration, though such pre-Partition painters as ABDUR RAHMAN CHUGHTAI and ALLAH BUX maintained their importance. ZUBEIDA AGHA introduced modern Western art in Karachi in 1949 with abstract "idea" paintings. SHAKIR ALI produced Cubist paintings in the early 1950s after his return from study in Europe. Cubism dominated the art scene for the next two decades until non-objective art became popular. In 1960 ISMAIL GULGEE, known for his portraiture, began experimenting with non-objective painting (in the manner of Jackson Pollock (1912–56)) after working with visiting American artist Elaine Hamilton (*b.* 1920).

In London Pakistani artist Kamil Khan Mumtaz (*b.* 1939) developed a style related to that of Adolph Gottlieb (1903–74) and Franz Kline (1910–62), and

the older artist 'Ali Imam (1924–2002) evolved an abstract, monochromatic, pointillist technique that was later taken up by some of his students in Karachi. East Pakistani painters such as ZAINUL ABEDIN, Murtaza Bashir (*b.* 1932), Abdul Baset (*b.* 1935) and Muhammad Kibria (*b.* ?1930) revitalized Cubism, introduced color field painting and created an Asian version of Abstract Expressionism.

Among young artists established in the 1960s, the dynamic AHMED PARVEZ and SADEQUAIN proved to be the most enduring. Their fiery personalities contributed to their reputations. Parvez's work is characterized by brilliantly colored, writhing forms and Sadequain's by elongated, knotty figures.

A majority of important painters of the 1980s and early 1990s graduated from the National College of Arts (formerly Mayo School of Arts) and Punjab University art department in the 1960s and 1970s. Some went to study abroad before returning as teachers. Realism and portraiture regained popularity under the tutelage of National College professor Khalid Iqbal (*b.* 1929); in the early 1990s Saeed Akhtar (*b.* 1938) became one of Pakistan's most prominent portrait painters. Iqbal Hussain (*b.* 1950), a controversial figure and portrait artist, is best known for his studies of prostitutes, musicians and children in the red-light district of old Lahore, where he was born and continues to reside. *Madam on a Charopy* (oil on board, 1.21×0.91 m, 1987; Washington, DC, priv. col.) captures both the intransigent personality of the subject and the emptiness of her life. Colin David (*b.* 1937) won fame as a painter of nudes, though these were not exhibited publicly. Mohammad Asif (*b.* 1945) painted still lifes.

With the proliferation of abstract art in the mid-1950s, two artists, Hanif Ramay (*b.* 1930) and ANWAR JALAL SHEMZA began to use calligraphy in a non-traditional manner, initiating the Calligraphic Movement. Shemza dissected and manipulated the script to form non-objective compositions, whereas Ramay created pictorial vignettes that maintained the integrity of the script. The allure of creative calligraphy was so compelling that nearly every artist in Pakistan had practiced this art form by the mid-1970s.

Calligraphy was patronized by government and business alike. Shakir 'Ali and Sadequain painted calligraphic murals for the Punjab Public Library and other public and private buildings. Sadequain calligraphed the Koran, Muslim literature and his own poetry in styles ranging from the abstract to traditional on leather, stone, panel, canvas and paper. Ismail Gulgee transformed his Jackson Pollock-inspired paintings into large, gracefully rendered calligraphic gestures with dabs and spatters of gold and silver. Ozzir Zubi (*b.* 1922), ZAHOOR UL-AKHLAQ, Rashid Ahmed Arshad (*b.* 1937), Sardar Mohammad (*b.* 1924), Aslam Kamal (*b.* 1935) and Rashid Butt also produced innovative works. Although the Calligraphic Movement began to decline in the 1980s, given the central role of calligraphy in Islamic culture a continued interaction with painting is likely.

In the 1980s the Lahore Landscape Movement gained momentum under the leadership of Khalid Iqbal. After retiring as principal and painting professor at the National College, he set out to capture the atmosphere and terrain of rural Lahore. Ghulam Rasul (*b*. 1942), one of the most talented members of this movement, is known for his village scenes near Islamabad, Iqbal Hussain for his attempts to capture morning mist on the Ravi River and Ijaz ul-Hassan (*b*. 1940) for clearly defined patterns and rich colors of ferns and tree-trunks. Misbahuddin Qazi (*b*. 1946), Zulqarnain Haider (*b*. 1939), Mohammad Nazir (*b*. 1952) and Shahid Jalal (*b*. 1948) are other proponents of the Movement. Pirzada Najam ul-Hasan (*b*. 1951) rejected the oil medium used by the others, preferring watercolor to depict monsoon skies. Several painters specialized in urban landscapes of old Lahore. Iqbal Ahmed (*b*. 1935) is known for panoramic views from rooftops; Ghulam Mustafa (*b*. 1952) for works depicting decaying monuments and congested gathering places; Ajaz Anwar (*b*. 1946) for scenes in watercolor of narrow streets with balconied façades; and Zubeda Javed (*b*. 1937), Khalid Mehmood (*b*. 1936) and Anna Molka Ahmed (1917–94) for depictions of historic places in the old city as well as landscapes in distinctive styles.

In addition to his calligraphic works Zahoor ul-Aklaq is known for "cerebral" paintings that integrate Occidental and Oriental, realistic and non-figurative imagery. Salima Hasmi (*b*. 1942) has interpreted themes from the poetry of her famous father, Faiz Ahmed Faiz, while Asad Salahuddin (*b*. 1950) has derived his subject matter from Sufism, mysticism and the occult. Askari Mian Irani (*b*. 1940) was one of the few Pakistani painters to treat religious themes with depth and sincerity, as in his innovative and attractive *tāvīz* paintings of the 1980s, which incorporate numerology and magic diagrams for good luck. His work in the early 1990s drew on MUGHAL themes. Mughal miniatures have been modernized by Bashir Ahmed (*b*. 1954) and Khalid Saeed Butt (*b*. 1950), who, along with Salahuddin (*b*. 1939), still practice the traditional style as well. Saira Wasim (*b*. Lahore, 1975) has transformed Mughal miniatures into exquisite political statements.

Karachi's artists include a number of outstanding women painters. Naheed Raza 'Ali (*b*. 1949) has produced abstract oil paintings treating historic and also feminist themes, as in the series *Eve and the Universe*. Meher Afroz (*b*. 1948), a printmaker and painter, has favored geometric forms in her oil paintings and landscapes in her watercolors. Qudsia Azmat Nisar (*b*. 1948) is best known for sprightly articulated watercolors. Deceptively childlike, her work skilfully balances linear symbols and vibrant washes. In the work of Najmi Sura (*b*. 1951) the lyrical Beloveds of Rajput miniatures are rendered as voluptuous women in mysterious and surreal environments.

By the early 1990s a number of Karachi's abstract and non-objective painters—Maqsood 'Ali (*b*. 1935), Tariq Javed (*b*. 1952), Mansur Aye (*b*. 1941), Mashkoor Raza (*b*. 1950)—had taken to figuration while JAMIL NAQSH, famous for his nudes, turned to non-figurative art. Shakeel Sidiqqi (*b*. 1951), Pakistan's only Photorealist, is best known for his middle-class domestic tableaux; M. A. Ahed (1919–2001), Eqbal Mehdi (*b*. 1946) and Ather Jamal (*b*. 1952) for their realistic watercolors of the people of Sind. Abdul Rahim Nagori (*b*. 1938) has endured censorship and discrimination for his colorful, daring socio-political narratives. Other noteworthy painters in Karachi are Wahab Jaffer (*b*. 1941), Zahin Ahmed (*b*. 1944), Mohammad 'Ali (*b*. 1951), Bashir Mirza (*b*. 1941), Laila Shahzada and Sardar Mohammad. Islamabad's painters include Zubaida Agha, Ghulam Rasul, Misbahuddin Qazi, Mansur Rahi and his wife Hajra Zuberi Mansur (*b*. 1941), and Jamila Masood (*b*. 1934).

Painting has begun to flourish in provincial capitals. In Quetta, the capital of Baluchistan, Mohammad Kaleem Khan (*b*. 1958) has painted portraits, landscapes, and still lifes in oil and watercolor. The art department at Peshawar University is an important training center. Among Peshawar's artists are Imtiaz Hussain, Mohammad Tasneem (*b*. 1951), Jahanzeb Malik (*b*. 1945), Tayyeba Ahmed (*b*. 1951), Nasiruddin Mohammad, Abbas 'Ali (*b*. 1958) and Arbab Mohammad Sardar (*b*. 1945). This fine art tradition is complemented by a vibrant tradition of popular painting, whether in religious posters or on decorated trucks, that is the focus of recent scholarly attention.

Calligraphy in Modern Art (Karachi, 1975)

A. & Islam. World, iv/2 (1986), pp. 50–77

M. Husain and G. Minissale: "The Big Picture," *The Herald* (Jan. 1990), pp. 166–74

I. ul-Hasan: *Painting in Pakistan* (Lahore, 1991)

M. Nesom-Sirhandi: *Contemporary Painting in Pakistan* (Lahore, 1992)

A. Naqvi: *Image and Identity: Fifty Years of Painting and Sculpture in Pakistan* (Karachi, 1998)

J. W. Frembgen: "An Imaginary Assembly of Sufi Saints: Notes on Some Devotional Pictures from Indo-Pakistan," *La Multiplication des images en pays d'Islam: De l'estampe à la télévision*, ed. B. Heyberger and S. Naef (Würzburg, 2003), pp. 81–102

J. J. Elias: "Truck Decoration and Religious Identity: Material Culture and Social Function in Pakistan," *Material Religion*, i/1 (2005), pp. 48–70

J. W. Frembgen: *The Friends of God: Sufi Saints in Islam, Popular Poster Art fromPakistan* (Karachi, 2006)

IV. Sculpture. As an Islamic nation Pakistan has not encouraged the production of three-dimensional art. Karachi artist SHAHID SAJJAD, the best-known sculptor in the country, developed his skills without any formal training. In the early 1960s Sajjad traveled to the remote forests of the Chittagong Hill Tracts of East Pakistan (modern Bangladesh), where he carved felled tree-trunks. In 1973 he learnt bronze-casting in Japan, and his heavy-bodied, earthy Chittagong tribal portraits in wood were transformed into contorted, agitated figures.

Painter and printmaker Zahoor ul-Akhlaq, who began making sculpture as a student at the National College of Art, Lahore, in the early 1960s, has produced geometric constructions usually in wood or steel. These vary from small personal objects to large public or corporate monuments. Arabic calligraphy and architectural forms and designs associated with both local traditions and Pakistan's Muslim heritage constitute a basis for his work. Ahmed Khan (*b.* 1938), a former National College of Art professor, also has used calligraphy as a sculptural form and as surface decoration for his civic and private commissions. In addition to large public site-specific sculptures in concrete, steel, bronze and stone, Ahmed Khan has created smaller works in clay and metal. Saleem Durrani, a graduate of the National College of Art, in the mid-1980s had specialized in welded metal constructions. He spent several years in the early 1990s learning advanced techniques in a foundry in Australia. Rabia Zuberi, principal and co-founder of the Central School of Art, Karachi, is best known for figurative and abstract work in wood; Ozzir Zubi (*b.* 1922) for small- and medium-sized calligraphic sculptures in a variety of media; Mohammad Asif, a National College of Art professor, for a series of over-life-size animal sculptures from complex steel-ribbed skeletons covered and shaped with home-made fiberglass; and Peshawar's Irshad Zamil for the realistic imagery of his work. Jamil Shah, founder of the art department of the University of Baluchistan, Quetta, is a sculptor as well as a painter and printmaker.

G. Minissale and F. Pastakia: "There is No Such Thing as Pakistani Art," *The Herald* (Nov./Dec. 1990), pp. 104–11 [interview with Shahid Sajjad]

V. Carpets and textiles. Pakistani knotted woolen carpets with their Islamic motifs belong to a tradition encompassing Turkey, China, Central Asia, Iran and north India (*see* CARPETS AND FLATWEAVES, §III, D). The Mughal emperor Akbar (*r.* 1556–1605) established an imperial carpet workshop at Lahore where artisans emulated Persian designs and evolved the more naturalistic Mughal style. The craft has since become a major industry, with Karachi and Lahore as the leading emporia. Influenced by overseas markets, rug merchants encourage the reproduction of acclaimed old patterns.

Pakistani craftsmen also produce fine plain or multicolored *namdās* (felted rugs) often with chain-stitch embroidery; *darīs* (flat woven cotton floor coverings); and *gābhās*, which feature scenes chain-stitched in wool on jute. Baluch *kilims* are flamboyant, colorful carpets woven of wool, goat-hair and mixed yarns.

Regional textile specialities include Multani bedcovers and shawls with repeating geometric or floral designs, woolen blankets and shawls from Swat, and Baluch and Kashmiri shawls with paisley and floral scrolls. Various decorative techniques for fabrics, such as tie-dyeing, wax resist, block-printing and embroidery have specific provincial characteristics. Sindhi and Baluch *rillis*, a Pakistani specialty combining printing, painting, appliqué and embroidery, are made into coverlets, clothing and saddle blankets. Baluchistan is famous for its mirror-work embroidery and Punjab for its embroidered *phūlkārī* shawls, the surfaces of which are often covered with stitches. Since the shawls are embroidered from the reverse side, their quality is judged from the back. Fine silk production as well as gold and silver wire embroidery further distinguish the Pakistani textile arts.

F. Yacopino: *Threadlines Pakistan* (Karachi, 1977)
I. A. Rehman: *Arts and Crafts of Pakistan* (Karachi, 1980)

VI. Other arts.

A. BASKETRY. Baskets and mats in varied sizes and colors often manifest regional characteristics. River communities, for example, produce rush and reed prayer-mats and floor runners. Thick reeds are twined to make stools and chairs, while thinner reeds are used for grain and date storage baskets, winnowing baskets, boxes, rattles and toys. Netted saddle-bags, chair seats and beds are woven of raffia. Date-palm, hemp and jute cords are woven into hangers and embellished with beads and tassels. Utility baskets are made from tree branches and cotton plant stems. Cane and bamboo, both imported, are also used for furniture and decorative items. Sindhi baskets are the most colorful and elaborate, while North West Frontier weavers prefer stately geometric patterns.

B. CERAMICS. While similar in some ways to those of neighboring countries, the popular arts of present-day Pakistan are often distinctly Pakistani. The most famous centers of glazed pottery at Hala, Multan and Peshawar represent regional traditions in the southern, central and northern parts of the country. The fertile alluvial soil of the lower Indus supplies the potters of Hala with excellent clay for glazed domestic wares. Floral and geometric designs in shades of brown are accented with yellow and green.

Blue-and-white floral patterns typify the glazed ware from Multan (produced in Hala as well). The cool, lively color scheme seems a logical reaction to the desert climate and burning sun. This ware is so popular that it is reproduced mechanically in Gujranwala and Gujrat, Punjab. Hand-made pottery in Gujrat is noted for embossed decoration on a brown body. Further north in the Peshawar valley and Swat-Chitral region, craftsmen decorate their earthenware with bold geometric patterns.

Unglazed ceramics proliferate in rural areas, as pots for water-wheels, for churning milk and for storing liquids, and as fodder troughs, musical instruments, bowls, pitchers and toys. Bahawalpur District in Punjab is known for its paper-thin (*kāgazī*) unglazed pottery, used as dishes and decorative items.

C. CEREMONIAL AND EPHEMERAL ARTS. Crafts are often part of religious and secular rituals in Pakistan. Decorated mausoleums (*tāziyās*) are an integral feature of the annual parade held to commemorate the

martyrdom of the two imams Husayn and Hasan, grandsons of the prophet Muhammad. These elaborate papier-mâché structures are taken through the streets along with a white horse that is saddled and garlanded with flowers and ribbons, and represents the white steed that returned to camp riderless on Imam Husayn's death. The *tāziyās* are destroyed at the end of the parade—in Karachi they are immersed in the sea.

Sāmiyānās, brightly colored canvas awnings under which large crowds partake of sumptuous meals while protected from the weather, are a common sight at weddings and other big celebrations. Intricate designs inscribed in henna on hands and feet are part of the wedding ritual for Pakistani brides. The wet mixture, cool to the skin, leaves behind attractive earth-colored ornamentation when removed after several hours of drying. Paper paraphernalia such as necklaces made from folded rupee notes or gold foil with fringe and ornamentation are worn by bridegrooms, graduates and public figures at appropriate ceremonies. Other notable works in paper are small, deft kites that inundate the skies, particularly in Punjab, on Basant, the spring festival that features fierce kite-cutting competitions.

D. METALWORK AND JEWELRY. During the Mughal periods, Wazirabad and Nizamabad in Punjab became centers for the production of daggers, knives and swords with engraved blades and handles inlaid with silver or gold (*see* ARMS AND ARMOR, §II, C). Carved and ornamented brass astrolabes, sundials and penboxes were also produced. Today silver tea services, dishes and decorative items are both handmade and die-cast. Plain, embossed, inlaid or enameled functional brass utensils (except for cooking vessels) and decorative objects are produced in large quantities.

Jewelry has always been a measure of status and wealth, a safe investment akin to a secure bank account. Gold and silver jewelry with precious or semi-precious stones and pearls emulating Mughal-period designs was the most popular by the end of the 20th century. In addition to anklets, bracelets, earrings and toe- and finger-rings, Pakistani women wear hair and forehead adornments and various types of nose ornaments. Tribal ornamentation is often unique. In the north, for example, Kalash women wear an abundance of silver and bead jewelry, as well as distinctive hats covered with cowrie shells and with a decorated flap at the back.

E. LEATHERWORK. Pakistan has had a flourishing leathercraft industry since ancient times. Each region produces its own style of wholly or partly handcrafted leather shoes. Multan and Bahawalpur are famous for a light-weight embroidered version (*khussā*). Those from Punjab are heavier and feature turned-up toes. The *triguli* from Sind, a slipper with broad toe and colorful pompom, resembles a traditional Greek slipper.

Camel-skin lamps molded over pottery and then lacquered are valued for their subtle glow as well as their beauty. Elaborate leather horse trappings, embroidered and studded with brass nails and cut-outs, are produced in Peshawar and Rawalpindi, where most of the horse carts (*tongas*) are painted and decorated.

F. STONE- AND WOODWORK. Stone artisans have worked their craft for centuries in Pakistan. Massive cemeteries in Sind and Baluchistan with richly carved stone tombs (8th–18th century) are among the country's artistic treasures. Pyramidal graves are carved with birds, animals and human figures, as well as Arabic calligraphy and floral and geometric designs. At Chaukandi in Sind, women's graves are distinguished by representations of jewelry, while men's tombs depict horsemen, camel riders, plowing scenes, weapons and, occasionally, just a turban. Relief-carved stone, *pietra dura* work and pierced marble screens (*jālīs*) produced in Lahore during the Mughal period are among the finest in the subcontinent. Contemporary craftsmen are inspired by these examples. Local onyx is used for decorative and functional items.

Carved wooden antiques from the north include furniture, doors, balconies and panels. Chiniot in Punjab is famous for its carved and inlaid wooden furniture made from the hardwood shisham.

Pakistan (London, 1977)
Folk Heritage of Pakistan (Islamabad, 1979)
I. A. Rehman: *Arts and Crafts of Pakistan* (Karachi, 1980)
S. Quraeshi: *Lahore: The City Within* (Lahore, 1988)
A. Riazuddin: *History of Handicrafts: Pakistan–India* (Islamabad, 1991)
J. W. Frembgen: "Religious Folk Art as an Expression of Identity: Muslim Tombstones in the Gangar Mountains of Pakistan," *Muqarnas*, xv (1998), pp. 200–10

VII. Art education. The National College of Arts (formerly Mayo School of Arts), Lahore, is the only nationally funded and accredited art institution in Pakistan. It offers a four-year degree in fine arts, crafts, commercial design and architecture. The Punjab University art department, also located in Lahore, grants an M.F.A. in painting and graphic design, as well as four-year degrees in fine arts, crafts, commercial design and art education.

Karachi has a variety of art schools. The most comprehensive is the Karachi School of Arts and Crafts. The Central School of Art (an arm of the National Council of Arts) offers drawing and painting classes. Private institutions such as Ozzir Zubi's School of Decor and Aftab Zafar's Pakistan Art Institute teach commercial and fine art.

A growing sophistication is evidenced by recently formed art departments at the University of Peshawar, Jamshoro University, Sind, and the University of Baluchistan, Quetta. A number of other colleges throughout Pakistan offer courses in art and art history; a few have art departments. For persons not enrolled in college, the National Council of Arts

provides art classes at its headquarters in Islamabad and in its regional offices.

VIII. Museums and collections.

A. MUSEUMS IN PAKISTAN. The first museum established in what is now Pakistan—the Victoria Museum, Karachi, of 1851—was abandoned in 1947. The oldest—and largest—present-day museum is the Lahore Museum, established in 1864; it is notable for collections of Gandharan sculpture, Islamic miniature paintings, manuscripts, textiles, arms, coins, Chinese porcelains and an ethnographic display. The Peshawar Museum (formerly Victoria Memorial Hall), built in 1905, possesses Gandharan sculpture, an ethnological section and a Muslim gallery.

The National Museum of Pakistan, founded in Karachi in 1950, contains artifacts from the Indus civilization, Gandharan stone sculpture, Hindu sculpture, Islamic arts, coins and an ethnological gallery. In Islamabad, the capital, the National Council for the Arts Heritage was founded in 1974; the Folk Heritage Museum emerged in the 1970s.

There are also site museums. The Lahore Fort, built by the Mughal emperor Akbar (r. 1556–1605) in the 1560s, now contains Mughal and Sikh galleries. The Archaeological Museum, Taxila, has a fine collection of Gandharan art and artifacts relating to the ancient site itself. The archaeological museums at Mohenjo-daro, founded in 1925, and at Harappa, founded in 1926, were further developed in the 1960s. The Swat Museum, Saidu Sharif, initiated in 1959 by the wali of Swat to house his private collection and established in 1963, likewise contains locally excavated material. Other types of museum include the Faqir Khana Museum, Lahore, a house containing a family collection that was the first private museum.

S. N. Das Gupta: *Catalogue of Paintings in the Central Museum, Lahore* (Lahore, 1922)

H. W. M. Hodges: *Major Museums in Pakistan: The State of Conservation* (Islamabad, 1970)

F. A. Aijazuddin: *Pahari Paintings and Sikh Portraits in the Lahore Museum* (London, 1977)

S. R. Dar: *Archaeology and Museums in Pakistan* (Lahore, 1977)

S. R. Dar: *Repositories of our Cultural Heritage: A Handbook of Museums in Pakistan (1851–1979)* (Lahore, 1979)

S. Niazi: *Directory of Cultural Institutions in Pakistan* (Islamabad, 1980)

S. Habeeb: "Museums in Pakistan: History, Scope, and their Role in the Society," *J. Pakistan Hist. Soc.*, xlviii/2 (2000), pp. 25–32

B. COLLECTIONS OF MODERN ART WORLDWIDE. The Pakistan National Council of Arts (Idāra-Saqafat-e-Pakistan), Islamabad, has the most comprehensive and up-to-date collection of post-1947 Pakistani art in the world. The National Art Gallery, designed by Naeem Pasha, opened in August 2007, after more than two decades of planning and a decade of construction. There are also significant repositories in the National Council branches at Lahore and Karachi. The Lahore Museum has a respectable collection of contemporary Pakistani art, as does the Alhamra Arts Council in the same city. Other fine collections in Lahore are housed at Packages Limited (diverse holdings), the Chughtai Museum Trust (art of Abdur Rahman Chughtai), Allah Bux Academy (art of Allah Bux, Abdul Aziz and Abdul Majid) and the Shakir Ali Museum (art of Shakir Ali). Shahid Jalal and Fazal Hyat, both of Lahore, maintain small, select collections.

In Karachi, Sultan Mahmood and ʿAli Imam have the largest, most comprehensive collections of contemporary Pakistani art. Mohammad Fayyaz and Wahab Jaffer, Karachi connoisseurs, collect ancient, contemporary and village art of Pakistan. Diverse, high-quality collections of contemporary art are held by Minoo Marker, Jamshed Marker and I. R. Siddiqi, all of Karachi.

In addition to the Pakistani National Council, Islamabad, the state supports a museum of paintings by Sadequain. While a sizeable percentage of contemporary Pakistani art resides elsewhere, significant collections are difficult to locate because so few exhibitions have been held outside the country. Dr. Aziz Khan has a small, excellent collection in Whittier, California, and Marcella and Khalid Sirhandi have a small collection in Kansas City, Missouri. Jalaluddin Ahmed, under the auspices of the Islamic Art Foundation, maintains a collection in London.

S. Irshad: "The Collectors," *The Herald* (May 1987), pp. 95–104

C. ART LEGISLATION. The history of legislation in regard to the protection and preservation of the cultural property of Pakistan covers a period of over one and one-half centuries, during which several government circulars, acts and statutes were issued and enacted. The first were the Bengal Regulation XIX of 1810 and the Madras Regulation VII of 1817. In 1863 an act was passed to enable the government to divest itself of the management of religious endowments. The Treasure Trove Act of 1878 was enacted to control and administer antiquities unearthed in the course of incidental excavations by private individuals. A major breakthrough was made in controlling such activities through passage of the Ancient Monuments Preservation Act VII of 1904. This act served as the main legal instrument for controlling and safeguarding all activities relating to archaeology in southern Asia until 1947. Immediately after the creation of Pakistan, however, the 1904 act was determined to be inadequate to control the export of antiquities. The Antiquities (Export Control) Act XXXI of 1947 was passed by the Parliament. In 1975 the Antiquities Act, 1975 (Act No. VII of 1976), was enacted, thus repealing all previous laws.

At present, archaeology is the concern of the federal government, which, under provisions of the

Constitution of 1973, takes care of the protection, preservation and presentation of the cultural heritage of Pakistan through the Department of Archaeology and Museums. The National Museum of Pakistan, Karachi, and archaeological museums at Saidu Sharif, Swat, Taxila, Lahore Fort, Harappa, Umerkot, Mohenjo-daro, Banbhore and Hyderabad are under its management and control, while the two other bigger museums at Lahore and Peshawar are controlled and managed by the provincial governments of Punjab and the NWFP respectively. No specimen of antiquity or ancient work of art could be legally exported out of the country. However, some ethnological material could be allowed for export, providing the federal government issued a written permit for the purpose through the Department of Archaeology and Museums.

S. R. Dar: *Repositories of Art Treasures* (Lahore, 1977)
A. N. Khan: *Archaeology in Pakistan: Administration, Legislation and Control* (Karachi, 1988)

Palace. Official residence of a ruler. The word derives from the Palatine Hill in Rome, where the residence of the Emperor Augustus (*r.* 27 BCE–14 CE) stood. This building was later developed as the Palace of the Caesars, covering the entire hill, and the name began to be applied to all other royal and imperial residences, including those of earlier eras. Although the Latin *palatium* eventually became the Arabic word *balāṭ*, in most Arabic-speaking lands the word *qaṣr*, which derives from the Greek *kastron*, is more commonly used to refer to a palace, although it often connotes merely the sense of a "fortified place." The Persian words *sarāy* and *kūshk*, commonly used to denote palaces in the eastern Islamic lands, have given European languages the words "seraglio" and "kiosk" respectively.

The first palaces built in North Africa, the Middle East and Central Asia under Islamic rule combined elements drawn from the earlier palatine traditions of pre-Islamic Arabia, Sasanian Iran and the Late Antique Mediterranean world. These forms were modified and transformed as Muslim rulers began to establish themselves in their new empire, but few distinctively Islamic palatial features emerged. The prestige of the capitals of the Abbasid caliphs (*r.* 749–1258) at Baghdad and Samarra established palace types that were initially imitated throughout the empire (*see* ABBASID). Later palaces in Morocco, Turkey, Iran and Central Asia retained some features of early Islamic palace design, but the impact of indigenous and particularly European traditions became increasingly apparent.

I. 7th–15th centuries. II. 16th–19th centuries.

I. 7th–15th centuries. The survival rate of Islamic secular architecture was generally lower than that of religious architecture, which was usually built of more durable materials and continuously repaired and restored despite the vagaries of political change.

Nevertheless, some luxurious palaces erected by princes of the Umayyad dynasty (*r.* 661–750) on the edges of the Syrian desert have been excavated. The simplest, such as Jabal Says and Khirbat al-Minya, were square, two-story structures with a central court, on to which opened apartments of several rooms (*see* ARCHITECTURE, §III, C). Such examples as QASR AL-ḤAYR WEST, KHIRBAT AL-MAFJAR, MSHATTA and UKHAYDIR (generally considered to be somewhat later) were important agricultural estates. They were larger and more elaborate structures, which combined the basic square enclosure with such features as a mosque, bath, music-room or caravanserai. The carved stucco and stone, floor mosaics, and wall and floor paintings at many of these sites show the extraordinary richness of Umayyad secular architecture and indicate the wide range of formal sources for construction techniques (e.g. brick barrel vaults) and decoration. It has been difficult to correlate particular patrons with individual palaces, but Hamilton convincingly identified Khirbat al-Mafjar as the private pleasure palace built by al-Walid II (*r.* 743–4) as heir apparent. The traditional interpretation of such "desert palaces" as places where the Umayyad élite could fulfill an atavistic longing for the desert has given way as many are discovered to have continued the Late Antique tradition of the *villa rustica*, having been centers of agricultural exploitation and private pleasure away from the prying eyes of the urban establishment.

Urban official palaces were simultaneously erected in Damascus, the imperial capital, and in newly founded provincial centers in Mesopotamia, Egypt and North Africa. Known almost exclusively through texts, the government house (Arab. *dār al-imāra*) was usually erected adjacent to the mosque, to allow the governor unhindered access to this center for the Muslim community. In Damascus, the palace of the first Umayyad caliph Mu'awiya (*r.* 661–80) was known as the *qubbat al-khaḍra'*. Although the name has usually been translated as "green dome" and was thought to indicate that the building was crowned with a copper cupola (subsequently oxidized to green), the correct translation as "the Dome of Heaven" shows that early Umayyad urban palaces continued not only the pre-Islamic Arabian tradition of tall palaces signifying the ruler's power but also the Mediterranean tradition of a heavenly dome over the ruler's throne. The name frequently reappears in early Islamic times, and the *qubbat al-khaḍra'* formed the visual and conceptual focus of the new Abbasid capital at Baghdad (founded 762). There, the palace built by al-Mansur (*r.* 754–75) idealized the traditional palace elements of a guarded entrance complex, a courtyard surrounded by living-quarters and a domed audience hall (*see* BAGHDAD). The palace became obsolete almost immediately as the Caliph's successors increasingly distanced themselves from their subjects, first in a series of suburban palaces near Baghdad and then in new capitals, for example RAQQA in Syria and SAMARRA, 125 km north of Baghdad.

The colossal palaces built by the caliphs at Samarra between 836 and 891 exemplify a major transformation in the Islamic palace: as the traditional expressions of power, height and domes were replaced by an emphasis on the horizontal expanse of the building. Such a palace as the Dar al-Khilafa (Jawsaq al-Khaqani; 836; *see* ARCHITECTURE, fig. 5) covered 175 ha, of which nearly half comprised a series of gardens along the Tigris. The visitor would have had to cross several immense courtyards before finally gaining access to the ruler, who, according to textual sources, remained stationary and was usually hidden behind curtains. The IWAN, a traditional Mesopotamian and Iranian vaulted hall open on one side to a court, increasingly accompanied or replaced the typical domed hall, and subterranean passages seem to have become an indispensable feature of the finest palaces. The Abbasid ideal was widely imitated throughout the medieval Islamic world, although regional variations can be detected already in the 9th century. Al-ʿAbbasiyya and Sabra–al-Mansuriyya, respectively the palaces of the Aghlabid (*r.* 800–909) and Fatimid (*r.* 909–1171) dynasties near Kairouan in Tunisia, are said to have copied the form of the palace at Baghdad, while the horizontal expanse of MADINAT AL-ZAHRA, the 10th-century palace–city of the Spanish Umayyad dynasty (*r.* 756–1031) outside Córdoba (*see* ARCHITECTURE, fig. 26), may have been inspired by the palaces of Samarra. Throughout the western Islamic lands the perpendicular juxtaposition of two rectangular halls was a characteristic unit that eventually evolved into the inverted T-plan reception room, evident for example at the Alhambra (*see* GRANADA, §III, 1). The most famous and best-preserved palace in the Islamic west, the Alhambra is actually a series of palaces built mostly in the 13th and 14th centuries by the Nasrid rulers of Granada (*r.* 1230–1492). The Palacio de Comares (*see* ARCHITECTURE, fig. 41), which included the audience hall, is an extremely elaborate version of the typical Granadine house, but the adjacent Palacio de los Leones is a more private structure, the origins of which go back to the Late Antique *villa rustica*.

From pre-Islamic times three types of palaces were known in Central Asia: the citadel (*arg*), the city palace and the garden palace. All had walls with gates, a reception or audience hall, an official area and living-quarters, including private areas for women. Various plans were used: Abu Muslim's palace (750) at Merv had a central domed chamber surrounded by four iwans opening on to four courts, while some of the palaces of the feudal aristocracy had central courts surrounded by living-quarters; others had a central domed hall. By the 11th century the four-iwan plan, in which iwans mark the four axes of an interior court, had become standard (e.g. LASHKARI BAZAR in Afghanistan and RIBAT-I SHARAF in Iran). Early palaces were often decorated with figural murals or elaborate stuccowork, as at the palace at Termez (11th–12th centuries). Glazed tile came into fashion in the 13th century: the Ilkhanid four-iwan palace at TAKHT-I SULAYMAN (*c.* 1275) was built on the site of a Sasanian sanctuary; its location and elaborate decoration with tiles depicting scenes from the Iranian national epic were intended to affirm the legitimate right of the Mongols to rule Iran.

Under the Timurid dynasty (*r.* 1370–1506) the citadel of SAMARKAND included not only the famous multi-story Goksaray ("Blue Palace") but also the Bustan Saray ("Garden Palace") and auxiliary buildings. The old citadel (Kunya Arg) in Khiva included the treasury, public audience hall (*dīvān-i ʿam*) and private audience hall (*dīvān-i khāss*). These palaces were constructed primarily for official purposes. The palace compound in Bukhara included a prison. Rulers also maintained strictly residential palaces in the principal cities. The magnificence of these palaces can be glimpsed in the ruins of Aq Saray ("White Palace," 1379–96) constructed by Timur (*r.* 1370–1405) in SHAHR-I SABZ, which preserve part of an enormous tiled portal, but the best remaining example of a Timurid-style palace is the Çinili ("tiled") Kiosk (1473) at Topkapı Palace in Istanbul (*see* ISTANBUL, fig. 4). Its cruciform domed central space is surrounded by four vaulted chambers, separated by iwans and porches or verandahs (known in Persian as *tālār*) opening to the exterior. The lavish decoration of the exterior and interior with tiles (Turk. *çini*) gave the palace its modern name. The palace of the Shirvanshahs at BAKU in Azerbaijan is a rare example of a stone palace.

Mongol and Timurid rulers often lived in tent palaces during the summer months. Constructed outside city walls and set within landscaped gardens, they included pavilions (cruciform or octagonal in plan) and/or ostentatious temporary structures, including tents as large as buildings. These tents have historical associations with nomadic traditions (*see* TENT, §II, 2). Garden palaces served as alternative royal residences. Timur built at least seven such palaces in Samarkand, and Khiva also had elaborate garden palaces. Although few examples of these early palaces survive, vivid descriptions by such travelers as the Spanish ambassador to Timur's court, Ruy Gonzalez de Clavijo (*d.* 1412), recall their sumptuous beauty. One such tent palace, set in a garden, measured 100 paces along one side and was crowned by an 11 m dome decorated with four eagles.

In India, the Delhi sultans ʿAla-al-din Khalji (*r.* 1296–1316) and Muhammad ibn Tughluq (*r.* 1325–51) had legendary "1000-pillared" halls (*hazār sutūn*)—perhaps derived from the *apadana* halls of the Persians—for public audience, but the earliest substantial remains of a palace from the Delhi Sultanate belong to the fifth city of Delhi, the Kotla Firuz Shah (Firuzabad) of Muhammad's successor (*r.* 1351–88). The palace occupied an extensive terrace beside the Yamuna River. Incorporating the constituent elements of the earliest Indian palaces derived from the Achaemenids—and providing for the royal daily round defined by Kautilya—the palace lacks the formality and the great vaulted structures of the Abbasid or Ghaznavid complexes. Instead, trabeated pillared pavilions seem to have

been distributed like the tent–palaces of Central Asia—for which the Tughluqs' Turkish ancestors must have felt at least as much affinity. The Bahmani sultans (*r.* 1347–1527) and their successors, heirs to the Delhi Sultanate's authority in the Deccan and great rivals of Vijayanagar, effected a synthesis between the imported and native traditions at Bidar and Bijapur in particular.

Further north, the early 15th-century sultans of Malwa were also effecting a synthesis of native and imported forms in their capital, Mandu. The main audience hall of Sultan Hushang Shah Ghuri (*r.* 1405–35)—the so-called Hindola Mahal (1425), with its roof carried on monumental arches—follows precedents stretching back through Baghdad to the Sasanians. Though incorporating an *apadana*, the ruler's private quarters (*daulat khana*) seem ultimately to descend from the Parthian tradition of courts, vaulted iwans and irregularly disposed chambers. It is hardly surprising to find this again across the gap of 1400 years since its introduction at Sirkap, especially as it was well adapted to the specific conditions of India. Generous courts, screened and canopied terraces and myriad small rooms respond to a climate in which much of life may seek the open air but also want cool, dark and varied retreats from sun and rain. On the other hand, indigenous elements are prominent in the women's quarters (*zenana*), summer palaces and pavilions of later Malwan rulers—the long, slender, arcaded Jahaz Mahal (late 15th century) in particular. The age-old *prasada* tradition is most persuasively recalled here in the kiosk-crowned pavilion, with its airy balconies, projecting into the Munja Talao, one of two reservoirs in Mandu. An even more fully integrated synthesis between native and imported forms was achieved at Malwa's northern outpost, Chanderi. Most significant is the late 15th-century multi-story Kushk Mahal. Square, it consists of four *prasadas* separated by cruciform halls, roofed over virile transverse arches that carried bridges linking the kiosked terraces at the fourth level of each block.

II. 16th–19th centuries.

Later Islamic palaces show the increasing impact of European ideas on traditional Islamic types. In Morocco royal palaces became royal cities. The huge al-Badi' Palace at MARRAKESH, built by the 'Alawi ruler Ahmad II al-Mansur (*r.* 1578–1603), had Italian marble columns and revetments. It was destroyed by Ahmad's successor, Mawlay Isma'il (*r.* 1672–1727), who salvaged the materials to erect his own royal city at MEKNÈS. Over 12 km of thick mud-brick walls with bastions enclosed three separate palaces, which comprised royal pavilions, mosques, barracks, prisons, stables, granaries, olive presses and huge pools with which to water the extensive gardens.

The first palaces of the Ottoman sultans (*r.* 1281–1924) in Bursa, Edirne and Istanbul have long disappeared, but Topkapı Palace at the tip of the Istanbul peninsula was used by the sultans until the 19th century (*see* ISTANBUL, §III, E). Four courts were arranged in order of increasing privacy: the first contained the armory, hospitals and barracks, the second contained the reception hall and the kitchens, the third was used by the palace school and the fourth consisted of gardens and pavilions. Continuously remodeled, the palace exhibits many styles of Ottoman architecture. In the 18th century European decorative motifs began to appear, but only in the 19th century were European palace types adopted extensively, as the Ottoman sultans built outside the city on the shores of the Bosporus. Dolmabahçe Palace (1853–5; *see* ISTANBUL, fig. 3), for example, designed by Garabed Balyan (*see* BALYAN, §II), includes an opulent double staircase with rock crystal balusters, the first grand staircase in Islamic architecture since the Abbasid palace at Samarra. Nevertheless, the traditional separation of men's and women's quarters was maintained.

The Safavid dynasty of Iran (*r.* 1501–1732) made Isfahan its capital when Tabriz was no longer safe from Ottoman incursions. 'Abbas I (*r.* 1588–1629) laid out his palace to the south of the old city between the new public square and a wide boulevard. The 'Ali Qapu (Sublime Gate; *see* ISFAHAN, §III, F) overlooked the square; its columnar portico (Pers. *talar*) served as a royal viewing stand; an elaborate music-room was decorated with ceramics in niches; and a gateway led to the gardens beyond. Pavilions within the park included the octagonal domed Hasht Bihisht ("Eight Paradises"; see fig.; *see also* ISFAHAN, §III, H) and the Chihil Sutun ("Forty Columns"; *see* ISFAHAN, §III, G), the columnar portico of which was reflected in a large pool and preceded a vaulted hall decorated with oil paintings of historical scenes. Many of these features, particularly the columnar portico, are also found in the palaces of Central Asia. The Tash Hawli ("Stone Courtyard") Palace at Khiva (1830–38; *see* ARCHITECTURE, fig. 54), for example, has 163 rooms and pillared porticos arranged around courtyards.

The Muslim rulers of India combined indigenous and Islamic palace traditions. At Bidar the courts of the *daulat khana* (ruler's private quarters; *c.* 1540) and the women's quarters are surrounded by varied chambers, but the dominant space seems usually to have been a colonnaded *talar*—as in Safavid Persia—rather than a vaulted iwan. The main court of the Gagan Mahal, however, was dominated by an iwan-like space, which may have been arcaded like its namesake at Bijapur. The *Diwan-i 'Am* (hall of public audience) was a huge *talar* with three rows of six wooden columns backed and flanked by rooms on several levels—again like its counterparts at Bijapur.

In the earliest surviving works of the Rajput rulers, the iwan or the *prasada* may usually be detected in the apparently random planning, which itself echoes the labyrinthine approach imported by the Parthians. For instance, at Chittaurgarh the *zenana* of Rana Khumba's early-15th century palace may be seen as a *prasada*, and it was recalled over a century later as the nucleus of the new palace (begun *c.* 1567) at Udaipur. At Gwalior the court and iwan of Man Singh Tomar's splendid late-15th century palace are given an indigenous

expression reiterated by the Mughal emperor Akbar in the Jahangiri Mahal at AGRA and developed in the so-called Jodh Bai Mahal at FATEHPUR SIKRI. The Bundela Rajputs anticipated the latter in their 16th-century works at Orchha and completed a series of experiments in the synthesis of imported and indigenous forms in the early-17th century Jahangiri Mahal there and the Govinda Mandir at Datia. The Datia work retains Orchha's regular court surrounded by apartments on two levels, partly arcaded, partly trabeated and surmounted by terraces with eight pavilions. However, rising from the center of the court and linked to the side pavilions by elegant bridges is a four-story *prāsāda* containing the royal apartments and darbar hall.

Perhaps inspired by the disconnected elements of the tent–palaces of their Central Asian ancestors, the Mughals preferred the *baradari* and *tālār*. Akbar's will to synthesize indigenous and imported traditions promoted the development of a prolix style that owed a great deal to Gujarat—and to the Rajputs. In the 17th century Shah Jahan further enriched the synthesis in motif and materials. Persian motifs, often in hardstone inlay, were given a conspicuous role, but the most characteristic features of the court style are cusped arches, long familiar in India, ribbed domes with *padmakosha*, especially popular in the Deccan, and the extravagantly bowed eaves and reed-bundle columns of the Bengali vernacular.

In the 18th century the Rajput rulers of Amer, Jodhpur, Bikaner, Jaisalmer, Udaipur and other states, long familiar with the imperial court, vied with one another in the embellishment of their courts. Working primarily in plaster or wood, they sustained the general inclination of the Mughals towards Gujarati floridity and specific appreciation of the decorative value of Bengali and Deccani forms. Persian motifs were still conspicuous in delicate inlay work of ivory and mirror or elegantly molded and painted stucco, as for instance in the entrance gateway known as the Ganesha Pol at Amer. Cusped arches were still predominant, but the post, bracket and beam, *chājjā* (projecting cornice), *chatrī* (kiosk), balcony and screen all played their part, and all were assembled with increasingly flagrant opulence as the 18th century progressed. Forms were repeated often with syncopated rhythm; there was a marked preference for the circular, the *banglā's* (roof) corners in-curved, the cupolas virtually spherical; the architectonic ceded to the vegetal—as in Rococo Europe. The fantasy, which is the charm of this palatial style, gave way to delirium as the 18th century gave way to the 19th, and the crossing of the debased court tradition with imported European forms generated a style of prodigal decadence. The cross-cultural influences that flowed between the Mughal and Rajput courts enriched both indigenous and imported traditions, but in the gardens of these residences, the contribution of the Mughals was crucial.

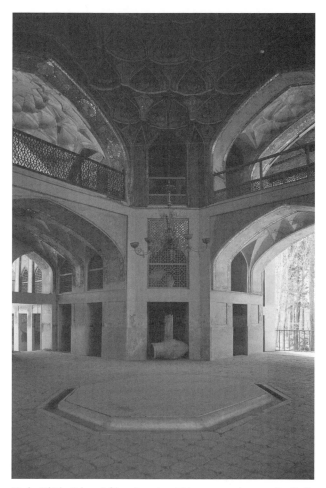

Hasht Bihisht Palace, Isfahan, Iran, late 17th century; photo credit: Sheila S. Blair and Jonathan M. Bloom

Enc. Islam/2: "Sarāy" [Palace]

K. A. C. Creswell: *Early Muslim Architecture*, 2 vols. (Oxford, 1932–40, rev. vol. 1, Oxford, 1969/*R* New York, 1979)

G. Marçais: "Salle: Antisalle: Recherches sur l'évolution d'un thème de l'architecture domestique en pays d'Islam," *An. Inst. Etud. Orient. U. Alger*, x (1952), pp. 274–301

O. Grabar: "Al-Mushatta, Baghdad and Wasit," *The World of Islam: Studies in Honour of P. K. Hitti* (London, 1965), pp. 132–46

J. Lassner: *The Topography of Baghdad in the Early Middle Ages* (Detroit, 1970)

O. Grabar: *The Formation of Islamic Art* (New Haven and London, 1973)

O. Grabar: *The Alhambra* (Cambridge, MA, 1978)

D. N. Wilber: "The Timurid Court: Life in Gardens and Tents," *Iran*, xvii (1979), pp. 127–34

R. Hillenbrand: "'La Dolce Vita' in Early Islamic Syria: The Evidence of Later Umayyad Palaces," *A. Hist.*, v (1982), pp. 1–35

M. Barrucand: *Urbanisme princier en Islam* (Paris, 1985)

R. Hamilton: *Al-Walid and his Friends* (Oxford, 1988)

J. Bloom: *Minaret: Symbol of Islam* (Oxford, 1989)

G. Necipoğlu: *Architecture, Ceremonial, and Power: The Topkapı Palace in the Fifteenth and Sixteenth Centuries* (Cambridge, MA, 1991)

A. Petruccioli and T. Dix: *Fatehpur Sikri* (Berlin, 1992)

A. Orient., xxiv (1994) [entire issue]

G. Michell and A. Martinelli: *The Royal Palaces of India* (London, 1994/*R* 1999)

R. Hillenbrand: *Islamic Architecture: Form, Function and Meaning* (Edinburgh, 1994), pp. 377–462

D. F. Ruggles: *Gardens, Landscape, and Vision in the Palaces of Islamic Spain* (University Park, 2000)

Y. Porter and A. Thévenart: *Palaces and Gardens of Persia* (Paris, 2003)

G. Fowden: *Qusayr 'Amra: Art and the Umayyad Elite in Late-Antique Syria* (Berkeley and Los Angeles, 2004)

Visualisierungen von Herrschaft: Frühmittelalterliche Resizenden: Gestalt und Zeremoniell: Internationales Kolloqium 3./4. Juni 2004 in Istanbul

F. Yenişehiroğlu: "Continuity and Change in Nineteenth-century Istanbul: Sultan Abdülaziz and the Beylerbeyi Palace," *Islamic Art in the 19th Century: Tradition, Innovation, and Eclecticism*, ed. D. Behrens-Abouseif and S. Vernoit, Islamic History and Civilization: Studies and Texts, 60 (Leiden, 2006), pp. 57–87

Palermo [anc. Gr. Panormos; Arab. Burlima]. Italian city, capital of Sicily. It is situated in a small plain at the foot of Mt. Pellegrino on the northwest coast and has served as a port since the 8th century BCE. Several magnificent buildings from the period of Norman domination (1072–1282) retain evidence of the period when Muslims ruled the island.

The city remained in Byzantine hands until the Arab conquest of 831, when it was renamed Burlima. As the capital of the Kalbid emirate (*r.* 917–1053) which ruled the island for the Fatimid caliphs of North Africa and Egypt, the city became a vital commercial, administrative and military center. Like Constantinople (now Istanbul) and Córdoba, it functioned as an emporium between various Mediterranean cities and between the Muslim and Christian worlds. With Palermo as capital, the western Mediterranean became the island's focus. The urban fabric was restructured to give its characteristic rectangular form. The old walled city, known as al-Qasr, became one of four quarters of the Muslim metropolis, with numerous side streets leading off its main east–west thoroughfare, the Via Cassaro (now the western half of Corso Vittorio Emanuele). The other quarters were the Kalsa (Arab. *khālisa*: "pure" or "chosen"); the southeast region, dominated by trade and industry; and the Schiavoni, the harbor district, which was given over to slaves imported for the Muslim navy and to foreign merchants. Almost nothing survives of some 300 mosques, warehouses, baths and markets described by medieval Arab authors. The most prominent and symbolic survival is the mosque column, inscribed with lines from the Koran, which was incorporated into the south portico of the cathedral. The Arabs introduced new cultivation techniques and crops, including rice, citrus fruits, cotton, sugar-cane and silk, transforming the environs of Palermo into a luxuriant area of orchards and gardens, lemon groves and mulberry trees.

In 1072 Palermo fell to the Normans, led by Roger de Hauteville (*r.* 1072–1101) and Robert Guiscard, Duke of Apulia (*r.* 1057–85). Under Norman rule, especially in the reign of Roger II in the first half of the 12th century, Palermo reached great prosperity and splendor, but paradoxically this was because the invaders were not strong enough to impose their own way of life, but allowed Arabic, north European, Roman and Greek traditions to subsist, creating a cultural richness in the city comparable to the agricultural fertility all around. The Normans did not expand beyond the walls of the old Muslim city, where, on the highest ground, they built a new royal palace on the remains of the Arab fortress, containing a silk factory and the Cappella Palatina (1134–40). The combination of artistic styles particularly evident in the Cappella Palatina encapsulates the Normans' political compromises. A noble quarter grew up around the palace, and an extensive park, with minor palaces and hunting lodges such as the Ziza, Cuba and Favara, was established on the city's western and southern outskirts. Many churches and monasteries were founded and the cathedral was begun in 1184 under Archbishop Gualtiero Offamilio (*r.* 1169–90). This building program reveals the Norman kings' determination to rival the Byzantine emperors: Roger II presided over one of the most brilliant courts in Europe. The autocratic character of Norman and Swabian rule, however, stunted the development of Palermo's autonomy and civic powers.

The dynastic crises that followed the death of William II (*r.* 1166–89) prompted the emigration of many Arabs and led to economic difficulties within the city. Although Emperor Frederick II revitalized the royal court, the subordination of Sicily to his empire required stronger links with north Europe than with Africa and the East. This undermined Palermo's supremacy, causing urban stagnation, marked by the transfer of the capital to Naples in 1282. In 1282 the rebellion known as the Sicilian Vespers deposed the oppressive papal vassal Charles I of Anjou (*r.* 1266–82), and Peter III of Aragon (*r.* 1276–85) was summoned to become King Peter I of Sicily.

The palace occupies the southwest side of the Piazza della Vittoria on the highest part of the old city. Roger II enlarged and converted the 10th-century Arab fortress on the site into a palace, now known as the Palazzo dei Normanni, of which the Cappella Palatina forms part. During the palace's reconstruction, Roger II added the Torre Rossa (destr. mid-16th century), the Torre Greca on the south side and the Torre Pisana on the north; between these stands the structure known as Gioaria, which contains the Sala degli Armigeri (hall of the squires) on the lower floor, the Sala di re Ruggero and the Sala dei Venti on the upper story, and the Cappella Palatina. According to a 14th-century Sicilian chronicle a fourth tower, known as the Chirimbi (destr.), was erected between the Gioaria and the Cappella Palatina by William I (*r.* 1154–66) and completed under William II. Since 1921 the palace has undergone much rebuilding and restoration. Of the towers, the square Torre Pisana (rest. after 1945) is the best preserved. Its ashlar walls are articulated by

such typical Arab–Norman features as pilasters and round-arched lintels, slightly inset. The central hall (h. *c.* 15 m) has a groin vault.

The Sala di re Ruggero is a small room with rich, but much restored, mosaic decoration in the vault and lunettes dating from the time of William I. The designs include motifs of Byzantine and Sasanian origin, such as deer, leopards, pairs of peacocks and circular motifs containing mythological animals, combined with lively hunting and landscape scenes and Islamic geometric ornament. The Royal Palace also housed a group of workshops for the manufacture of textiles, especially silks, which came under the direct control of the Norman kings and formed one of the main sectors of the Sicilian economy. Among the most illustrious products of the workshop is the so-called Mantle of King Roger (*c.* 1131; Vienna, Schatzkam.; *see* TEXTILES, color pl. 3:X, fig. 2).

The Cappella Palatina forms part of the Royal Palace and was built by Roger II from 1131 to replace the chapel of S. Maria di Gerusalemme (destr.), which had been erected in the palace grounds after 1072 by Robert Guiscard. The new chapel (elevated to a parish church in 1132) was consecrated in 1140, but it is probable that only the architectural structure was complete; its rich marble, mosaic and painted *muqarnas* decorations were not finished until some years later. Originally the chapel stood almost isolated at the center of the great palace complex, but much of its exterior is now hidden by later buildings. The ashlar walls are faced with pointed blind arches, as in the church of S. Maria dell'Ammiraglio. The campanile is lost. The chapel is flanked by a northern portico of seven columns and communicates with the palace via a narthex. Two carved portals with bronze doors made by a Sicilian craftsman (*c.* 1140–50) lead from the narthex into the basilica. The interior contains a rich mixture of decorative styles in different materials. The mosaic decoration mainly takes its character from two major campaigns in the Norman era. Between 1140 and 1143 the presbytery and dome were decorated with marble revetment and figural mosaics; an inscription at the base of the dome commemorates the work's completion in 1143, but the walls of the aisles were probably not completed until 1189.

At the west end of the nave is a Norman throne raised on five steps; its back is richly decorated with marble inlay. The chapel's interior decoration also includes a geometric marble pavement, ten antique granite and cipollino columns in the nave, and an Islamic-style *muqarnas* ceiling (*see* ARCHITECTURE, fig. 17) with elaborate painted decoration that has provoked much controversy about its meaning.

Enc. Islam/2: "Balarm"

F. Valenti: "Il Palazzo Reale di Palermo," *Boll. A.: Min. Pub. Istruzione*, iv (1924–5), pp. 512–28

M. Guiotto: *Palazzo ex reale di Palermo: Recenti restauri e ritrovamenti* (Palermo, 1957)

G. Giacomazzi: *Il palazzo che fu dei ré: Divagazione storico-artistica sul Palazzo dei Normanni* (Palermo, 1959)

R. Giuffrida, D. Malignaggi and S. Graditi: *Nel Palazzo dei Normanni di Palermo*, 2 vols. (Palermo, 1985–7)

G. Bellafiore: *Architettura in Sicilia nella età islamica e normanna (827–1194)* (Palermo, 1990)

E. Borsook: *Messages in Mosaic: The Royal Programmes of Norman Sicily (1130–1187)* (Oxford, 1990)

W. Tronzo: *The Cultures of his Kingdom: Roger II and the Cappella Palatina in Palermo* (Princeton, 1997)

J. Johns: *Arabic Administration in Norman Sicily: The Royal Dīwān* (Cambridge, 2002)

J. M. Bloom: "Almoravid Geometric Designs in the Pavement of the Cappella Palatina in Palermo," *The Iconography of Islamic Art: Studies in Honour of Robert Hillenbrand*, ed. B. O'Kane (Edinburgh, 2005), pp. 61–80

E. J. Grube and J. Johns: *The Painted Ceilings of the Cappella Palatina* (Genoa and New York, 2005)

Palestine [Arab. Filasṭīn]. Region between the eastern coast of the Mediterranean Sea and the Arabian desert, containing sites holy to Jews, Christians and Muslims. The exact borders have varied in different periods, but the term has come to be applied to the area now covered by ISRAEL and JORDAN as well as the Palestinian territories of the West Bank and the Gaza Strip. The first permanent agricultural settlements were established in 8000 BCE at Jericho. After *c.* 1200 BCE the coastal zone of Palestine was settled by the Peleset, later known as the Philistines, from whom the name of the region is derived. By 1000 BCE the area was dominated by Hebrew tribes, who made JERUSALEM their capital. The Kingdom of Palestine became divided into the Kingdom of Israel and the Kingdom of Judah, but these were destroyed, the former by Assyria in 721 BCE and the latter by Babylonia in 587 BCE. After a succession of various rulers, including Alexander the Great, the Romans occupied Jerusalem in 70 CE. As the place of Christ's life and passion, the region became a focus of Christian piety, and such sites as Bethlehem and the Holy Sepulcher were marked by monumental constructions from the 4th century, when the region came under Byzantine rule. After the Persians briefly occupied Jerusalem in the early 7th century, Muslims conquered the entire region by 641. Like others before them, they venerated sites associated with biblical patriarchs, and Jerusalem enjoyed special status, because it had been the first focus of prayer. By the 8th century, Muslims generally accepted Jerusalem as the third sanctuary of Islam after Mecca and Medina, and Islam began to replace Christianity as the dominant religion. The Crusaders held Jerusalem from 1099 to 1187 and maintained a presence in Palestine until they were expelled by the MAMLUK rulers of Egypt, under whose rule such cities as Jerusalem and Gaza were embellished with fine buildings (*see* ARCHITECTURE, §VI, C, 1).

Jerusalem continued to be a focus of patronage under the Ottomans, who controlled Palestine from 1516 to 1918, when the British invaded the area during World War I. The British Mandate over Palestine, covering the areas on both sides of the Jordan River, was approved by the League of Nations in July 1922.

Direct British administration was established in the region west of the Jordan; the emirate of Transjordan (later Jordan) was established to the east. Despite conflicting Arab and Jewish claims, Britain's support for Zionism in the Balfour Declaration and a huge rise in the Jewish population in the 1930s finally resulted in the foundation of the independent state of Israel in 1948. Territorial gains from Jordan, Egypt and Syria in 1963 and 1973 greatly increased the Palestinian population under Israeli control. The region of Sinai was returned to Egypt in 1978. It was not until 1993, however, that the Israeli government and the Palestine Liberation Organization signed a preliminary agreement for the eventual withdrawal of Israeli forces and the transfer of administrative responsiblities within the occupied areas.

Palestinian art can be understood historically to encompass not only the traditional Islamic "high" art of the region, such as the Dome of the Rock in Jerusalem, but also the folk arts and crafts traditionally practiced by Palestinians, such as pottery, jewelry and textiles. Ramallah ware is a thin-walled earthenware painted in red with simple geometric and plant designs. Palestinian folk jewelry includes bridal headdresses covered with coins, chokers, chains, bracelets and amulets, most of it made of silver, sometimes studded with coral, amber or agate. Textiles and embroidery have long played a major role in all walks of Palestinian life, from townsfolk and villagers to Bedouin. Dresses and wraps were traditionally embroidered, often in red and orange, with a variety of fine geometric patterns.

Modern Palestinian art can be understood to encompass not only the work of Palestinian artists practicing in Israel and the Palestinian territories, but also that of Palestinian refugees and émigrés working in the Arab world, Europe and America. In the early 20th century some Palestinian artists in Jerusalem painted religious works to sell to pilgrims as souvenirs. During the Mandate period the British had little interest in training artists. Some, such as Daoud Zalatino (*b.* 1906), who painted huge historical canvases, were largely self-taught, while others studied abroad. Jamal Badran (1909–99) was the first Palestinian to study at the School of the Arts and Decorations in Cairo, and after he returned to Jerusalem, he trained many young artists in his studio. After an Australian fanatic firebombed the Aqsa Mosque in Jerusalem in 1962, he recreated much of its architectural decoration. Hanna Musmar (1898–1988) was sent to Germany to study ceramics; he returned to Nazareth, where he made not only hand-painted vases, but also murals and sculptures dealing with larger issues. Ismail Shammout (1930–2006) was encouraged by Zalatino before he was forced to flee to Gaza in 1948. He eventually made his way to Cairo, where he trained under Egyptian artists at the College of Fine Arts. He held the first one-man show in Palestine at Gaza in 1953 and in the following year held the first group show of Palestinian artists in Cairo, including the work of Tamam Akhal (*b.* 1935). Shammout became the official painter of the Palestine Liberation Organization.

After the establishment of the State of Israel, some Palestinian artists trained in Israeli art schools and others joined with Israeli artists in projects and group shows. For example, in 1978 Abed Abidi (*b.* 1942) worked with the Israeli artist Gershon Knespel on a bas-relief monument in the village of Sakhneen commemorating six protesters shot dead during a demonstration. A 1985 exhibition entitled "Place Scape" included four Palestinians and ten Israelis all dealing with the landscape of Jerusalem.

Much Palestinian art of the late 20th century and early 21st reflects artists' reaction to the continued occupation. LEILA SHAWA was born in Gaza but educated in Italy and Austria; her work addresses issues ranging from the role of women to the plight of Palestinian children. Vera Tamari (*b.* Jerusalem, 1945) studied ceramics in Beirut and Florence as well as the history of Islamic art at Oxford; she now teaches at Ramallah. KAMAL BOULLATA trained in Italy and the USA; his silkscreen compositions often use the angular kufic script and involve Christian and Muslim texts. In 1996 the Khalil Kakakini Cultural Center Foundation was established in Ramallah to promote the arts and culture in Palestine.

Khalil Sakakini Cultural Centre, http://www.sakakini.org (accessed June 11, 2008)

S. Weir: *Palestinian Embroidery: A Village Arab Craft* (London, 1970)

J. Rejab: *Palestinian Costume* (London, 1989)

S. Weir: *Palestinian Costume* (Austin, 1989)

W. Ali: *Modern Islamic Art: Development and Continuity* (Gainesville, 1997)

L. el-Khalidi: *The Art of Palestinian Embroidery* (London, 1999)

G. Ankori: *Palestinian Art* (London, 2006)

S. Weir: *Embroidery from Palestine* (Seattle, 2006)

Word into Art: Artists of the Modern Middle East (exh. cat. by V. Porter; London, BM, 2006)

Panjikent [Panch]. *See* PENDZHIKENT.

Paper. The earliest books in the Islamic world were written on parchment and papyrus, the two flexible supports used in antiquity in the Mediterranean lands and West Asia, but paper, which was introduced from China, quickly replaced them both. In the medieval period the Islamic world became famous for its fine paper and was responsible for the introduction of papermaking technology to Europe. Paper transformed Islamic civilization as early as the 9th century by making books more accessible. It eventually transformed Islamic art by providing artists with a medium on which to work out and by which to transmit their ideas. By the 14th century, European papers began to replace those of the Islamic world and the Muslim contribution to the history of paper became largely forgotten, although Turkish, Persian, and Indian papermakers continued to produce papers for copying manuscripts.

I. History and development. II. Production and uses. III. Special papers.

I. History and development. Paper, a mat of cellulose fibers deposited with water on a screen and then dried, was invented in southeastern China, perhaps as early as the 2nd century BCE. The spread of Buddhism encouraged the spread of paper and papermaking throughout East Asia, and by the 7th century CE, paper was known from Central Asia to Korea and Japan. It was used not only for copying religious texts, but also for letters and documents of all types. When Muslim armies arrived in Central Asia in the late 7th and early 8th centuries they undoubtedly encountered paper for the first time. Paper (Arab. *kāghad* or *kāghid*) rapidly spread westward and progressively replaced papyrus and parchment. At the end of the 8th century the Abbasid caliph Harun al-Rashid (*r.* 786–809) is said to have encouraged the use of paper in the chancellery, and paper-mills may have been established at Baghdad. The earliest dated book written in Arabic on paper (866–7) is a fragmentary copy of Abu 'Ubayd's work on unusual terms in the Hadith (Leiden, Bib. Rijksuniv.), although the *Doctrina Patrum* (Rome, Vatican, Bib. Apostolica, Gr. 2200), a work on the teachings of the church fathers, was copied in Greek on paper at Damascus in the early 9th century. There must have been certain resistance among Muslims to the use of the new material, for parchment was retained for copying the Koran for some time, and the earliest known surviving Koran manuscripts on paper (e.g. Istanbul, U. Lib., A. 6778) date from the later part of the 10th century. Parchment, either on its own or combined with paper, continued to be used in the western Islamic lands when it had already been abandoned elsewhere.

The earliest centers of manufacture were located in the eastern part of the Muslim world at Samarkand and in the province of Khurasan in northeastern Iran. They retained their pre-eminent position for a considerable time and also maintained their reputation for a product of exceptional quality, much in demand by copyists. Production spread to all parts of the Islamic world, including such regions as Egypt where papyrus had traditionally been used. The technology of papermaking spread throughout the area between the Indian subcontinent and Spain (the importance of the Spanish town of Játiva (Shatiba in Arabic) for the manufacture of paper led to its being called *shābtī* in the west). In the 10th century paper-mills are known to have existed in Iraq, Syria and Palestine, although the exact date of their introduction to Baghdad and Cairo is still debated.

Muslim papermakers were responsible for the transmission of the technique to Europe via Spain and Sicily. In the Islamic world the introduction of paper was accompanied by the appearance of specific trades: the artisans who collaborated in the actual production of paper, and the *warrāq*, who became principally known as a paper merchant but whose role spread to encompass aspects of manuscript production such as bookbinding. The *Fihrist* ("Index") written in 987–8 by al-Nadim, a *warrāq* of Baghdad, is one of the most valuable sources for the early history of Islamic CALLIGRAPHY.

With the development of paper-mills in Europe and improvements in the manufacturing process, the favorable position of Islamic papermakers declined. The Islamic world became a net importer of paper, and, from the 14th century, an increasing number of manuscripts were copied on European paper, easily recognizable by the presence of watermarks, which had been invented at Fabriano in Italy in the 13th century. North Africa was the first to be affected by this change, but the rest of the Islamic world followed rapidly. Many individuals found the figural and Christian motifs in watermarks to be objectionable; European paper-mills, notably the Italian ones, were able to adapt to the taste of their clientele by using watermarks that were acceptable to Muslims. The most famous is the *trelune*: three crescent moons aligned. In the face of European competition local production declined, and when new paper-mills were established in the Ottoman Empire in the 18th century, European experts were sometimes employed in order to create a product similar to that from the West. This attempt to face competition was not seriously pursued in the 19th century, when technological advances, such as the introduction of wood-pulp, widened the gap between East and West. The lack of raw materials, notably timber and water, in the region increased the dependence on Western supplies of paper, although it is perfectly possible to make paper from grasses such as esparto, which flourish in the region.

II. Production and uses. Information about production methods is almost entirely based on literary sources: so far no physicochemical analysis of old paper has been carried out to check seriously the authenticity of these texts. The Chinese origin of papermaking makes it plausible that Islamic papermakers used linen (rags) and hemp (rope) as raw materials in the preparation of the pulp. Cotton was used only in rare instances: most traces that have been detected can be explained by an insufficiently careful selection of rags. Two other elements were also used to prepare the pulp: the North African ruler and author al-Mu'izz ibn Badis (*r.* 1016–62; *see* BOOKBINDING, §I) appears to have been aware of the use of unrefined (bast) flax, and examination of papers suggests that old paper was sometimes recycled. After having been cut up, the fibers were carefully softened, cleaned and then pounded, manually according to the traditional practice described by Ibn Badis, or mechanically with a hammermill, a machine that was invented in China for hulling rice and that seems to have spread across the Islamic lands with the cultivation of this plant. These operations continued until the pulp achieved a satisfactory degree of purity and texture.

The rectangular mold used in the production of sheets comprised a frame, inside which thin parallel strands were attached. These strands, which were of vegetable fiber (explaining the irregularities observed on the paper), left a number of parallel marks, known as laid-lines, on the sheet when extracted by the

papermaker from the tank of pulp. These are often the only marking that can be observed on Islamic papers. It is also reasonable to suppose that the configuration of these marks would vary according to local practice, relating to preference for one fiber over another and ways of arranging the strands within the mold. Western papers have two different types of markings in addition to the watermark: laid-lines in one direction and, perpendicular to these, chain-lines, which correspond to the strands that hold the laid-lines in place. In most Islamic papers only the laid-lines are visible; the chain-lines are not clearly visible except in a few papers with irregularly spaced groups of two or three chain-lines. The production of this kind of paper appears to have been concentrated in a zone stretching from Egypt to southeastern Turkey and lasted for several hundred years until the 15th century or the beginning of the 16th. A third type of Islamic paper bears no markings at all due to the interposition of a fine textile between the mold and the pulp.

Two types of mold seem to have been in use: a floating one, and a dipping one. The floating mold was floated in a shallow tank of water and filled with paper pulp; the mold was removed from the tank and the resulting sheet was left to dry in the mold. The dipping mold was immersed into a vat containing the paper-pulp. After having withdrawn the mold from the tank, the papermaker turned the sheet out from the mold onto felts, which were stacked and pressed. The damp sheets were then put out to dry, either hung on a line or applied to a flat surface. Although the dipping mold could make more sheets with fewer molds, the floating mold was particularly useful for making enormous sheets, such as those for a gargantuan copy of the Koran made for Timur c. 1400. Its disadvantage was that drying the sheet in the mold left one side rough and uneven.

Before it could be used as a writing support, the dried sheet of paper had to be subjected to sizing, an operation that rendered the surface smooth and nonporous. A starch-based product, in the form of a liquid, paste or powder, or albumin was spread over the paper to prevent it from absorbing ink. Each sheet was then laid on a completely smooth work surface and rubbed with a rounded tool, either egg-shaped of a very hard substance or a wooden pestle, the handle of which allowed great pressure to be exerted. When the paper reached a satisfactory degree of glazing, it only remained for the copyist to draw the lines required to guide his writing. For this purpose the copyist used a piece of card on which threads were strung at regular intervals. By pressing the sheet of paper with his nail against these lines, he obtained the necessary guide for his work.

The format of Islamic papers is still a subject of debate. Literary sources give an extensive list of various types of paper. Most of the names are geographic, such as *Baghdādī* (from Baghdad), *Shāmī* (from Syria) and *Dawlatābādī* (from Daulatabad in India). Occasionally the names refer to the appearance of the paper, for example *ḥarīrī*, a paper resembling silk rather than using silk as raw material. Some of these names undoubtedly indicated a format, even if terminology was loose, to judge from what is known from other media. The dimensions of these papers are never given in the sources, and the only line of investigation is empirical. Reconstructing the size of folios is further complicated by the copyists' distinctive way of making gatherings. Instead of using gatherings of four or eight pages, which derive from repeated folding of the full printed sheet of paper, they used, until the 19th century and the widespread adoption of printing, gatherings of ten pages, since there was no inherent advantage to copying out the text on large sheets before folding and cutting. Some clue to dimensions may be provided by Byzantine manuscripts copied on Islamic paper: Irigoin (1991) has established formats of 660/720×490/560 mm, 490/560×320/380 mm and 320/370×235/280 mm. A careful examination of the texts might provide additional information: for example, a beautiful copy of pamphlets on religion and philosophy by Rashid al-Din (1310; Paris, Bib. N., MS. arab. 2324) was copied, if one is to believe the preface, on sheets that each had a length of six sheets of the Baghdad format. Vertical scrolls, used for decrees and documents, were formed by gluing a succession of sheets or partial sheets end to end.

III. Special papers. Manuscripts were frequently copied on tinted papers, a practice that derives from an older tradition. Several examples are known of manuscripts on dyed parchment, notably the 10th-century Blue Koran (dispersed, e.g. Tunis, Mus. N. Bardo). A wide variety of colors was used, of which saffron yellow was the most common; according to textual sources the use of colors had a clear code of meaning. An early 15th-century manuscript of the Koran (Paris, Bib. N., MS. arab. 389–92) has pages tinted predominantly purple, although the paper shows marked differences in hue from one page to another. According to Ibn Badis, paper could be tinted in two ways: either the sheet was dipped in a colored bath, or a colorant (e.g. saffron) was added to the size during the process of smoothing the surface. Paper sprinkled with gold flecks (Pers. *zarafshānī*) was used as a support for calligraphy and for margins in such luxury manuscripts as the copy of the *Shāhnāma* ("Book of kings") prepared for the Safavid shah Tahmasp I (c. 1525–35; dispersed, ex-Houghton priv. col.; e.g. New York, Met.; see color pl. 3:IV).

Marbled paper (Pers. *kāghaz-i abrī*; Turk. *ebru*) may have reached the Indian subcontinent from the East at the end of the 15th century or, according to an Iranian source, around the middle of the 16th. From there the technique spread to Iran and Turkey. Drops of colorant were deposited with a brush or pipette on the surface of a bath, usually containing a mixture of gum tragacanth and water. Gall was also used to aid the dispersion of the colors on the surface. The drops of color were then worked with pointed instruments and combs to create shot patterns. When the desired pattern had been obtained,

the marbler delicately placed a sheet of unprepared paper on the surface of the bath, and, in a few seconds, this took up the design created. For each sheet it was necessary to recommence the operation, using the same bath.

Marbled paper became increasingly fashionable as a support for calligraphy (in which case pale colors were preferred), as a margin for pages of precious manuscripts, as endpapers (e.g. a *Dīvān* [collected poetry] of Anvari; 1515; London, V&A, 169–1923) or even for book covers. Marbled paper began to replace leather in Ottoman bindings of the 17th century, due to the economic crisis, and it continued to be used for centuries. The arts of calligraphy and marbling were closely associated; for example, MEHMED RESIM, known as Hatib, and NECMEDDIN OKYAY were skilled in both. Several types of marbled paper can be identified. The simplest (Turk. *battal ebrusu*) forms the basis for the more elaborate varieties, created either with a thin wire or a needle passed over the design in alternating directions (*tarama*) or turned around on itself (*bülbülyuvası*; literally "nightingale-nest"), or with a comb with narrow- or widely spaced teeth (*tarakh ebru*). Floral patterns were also made, a process perfected by Necmeddin Okyay, in varying degrees of stylization: pansies (the oldest), carnations, hyacinths, tulips and daisies.

Al-Mu'izz ibn Badis: *'Umdat al-kuttāb* [Staff of the scribes] (*c.* 1060); Eng. trans. by M. Levey as "Mediaeval Arabic Bookmaking and its Relation to Early Chemistry and Pharmacology," *Trans. Amer. Philos. Soc.*, n.s., lii/4 (1962), pp. 3–79

Qazi Ahmad ibn Mir Munshi: *Gulistān-i hunar* [Rose-garden of art] (1606); Eng. trans. by V. Minorsky as *Calligraphers and Painters* (Washington, DC, 1959), pp. 189–94

J. von Karabacek: *Das arabische Papier* (Vienna, 1887); Eng. trans. by D. Baker and S. Dittmar (London, 1991)

C. Huart: *Les Calligraphes et les miniaturistes de l'Orient musulman* (Paris, 1908/*R* Osnabrück, 1972)

F. Babinger: *Zur Geschichte der Papiererzeugung im osmanischen Reiche* (Berlin, 1931)

D. Hunter: *Papermaking: The History and Technique of an Ancient Craft* (New York, 1943)

J. Irigoin: "Les Premiers manuscrits grecs écrits sur papier et le problème du bombycin," *Scriptorium*, iv/1 (1950), pp. 194–204

C.-M. Briquet: "Le Papier arabe au Moyen Age et sa fabrication," *Mnmt Chart. Pap. Hist. Illus.*, iv (1955), pp. 162–70

C.-M. Briquet: "Recherches sur les premiers papiers employés en Occident et en Orient du Xe au XIVe siècle," *Mnmt Chart. Pap. Hist. Illus.*, iv (1955), pp. 129–61

J. Irigoin: "Les Types de formes utilisés dans l'Orient méditerranéen (Syrie, Egypte) du XIe au XIVe siècle," *Papiergeschichte*, xiii (1963), pp. 16–21

O. Ersoy: *XVIII ve XIX yüzyıllarda türkiye'de kâğıt* [Turkish paper of the 18th and 19th centuries] (Ankara, 1965)

A. Grohmann: *Arabische Paläographie*, i (Vienna, 1967), pp. 98–105

R. B. Loring: *Decorated Book Papers* (Cambridge, MA, 1973)

M. Beit-Arié: *Hebrew Codicology: Tentative Typology of Technical Practices Employed in Hebrew Dated Medieval Manuscripts* (Paris, 1976)

M. A. Kağıtçı: *Historique de l'industrie papetière en Turquie/ Historical Study of Paper Industry in Turkey* (Istanbul, 1976) [bilingual text]

U. Derman: *Türk sanatında ebru [Marbling in Turkish art]* (Istanbul, 1977)

Islamic Bindings and Bookmaking (exh. cat. by G. Bosch, J. Carswell and G. Petherbridge; Chicago, U. Chicago, IL, Orient. Inst. Mus., 1981)

M. A. Doizy and S. Ipert: *Le Papier marbré* ([Paris], 1985)

F. Richard: "Un Manuscrit méconnu: L'Anthologie poétique de la B.N. illustrée et signée par Behzâd," *Stud. Iran.*, xx/2 (1991), pp. 263–74

Y. Porter: *Peinture et arts du livre: Essai sur la littérature technique indo-persane* (Paris and Tehran, 1992)

J. Irigoin: "Les Papiers non filigranés: Etat présent des recherches et perspectives d'avenir," *Ancient and Medieval Book Materials and Techniques*, ed. M. Maniaci and P. F. Munafò, i (Vatican City, 1993)

M.-T. Le Léannec-Bavavéas: *Les papiers non filigranés médiévaux de la perse à l'Espagne, Bibliographie 1950–1995* (Paris, 1998)

J. M. Bloom: "The Introduction of Paper to the Islamic Lands and the Development of the Illustrated Manuscript," *Muqarnas*, xvii (2000), pp. 17–23

F. Déroche, ed.: *Manuel de codicologie des manuscrits en écriture arabe* (Paris, 2000)

J. M. Bloom: *Paper Before Print: The History and Impact of Paper in the Islamic World* (New Haven, 2001)

H. Loveday: *Islamic Paper: A Study of the Ancient Craft* (London, 2001)

I. Afshar: "Manuscript and Paper Sizes Cited in Persian and Arabic Texts," *Maqālāt wa-dirāsāt muhdāh ilā al-Duktūr Ṣalāḥ al-Dīn al-Munajjad/Essays in Honour of Ṣalāḥ al-Dīn al-Munajjid* (London, 2002)

H. Loveday: "A Comparative Study of Safavid Paper," *Safavid Art and Architecture*, ed. S. Canby (London, 2002), pp. 107–11

D. Roxburgh: "Persian Drawing *c.* 1400–1450: Materials and Creative Procedures," *Muqarnas*, xix (2002), pp. 44–77

A. Zohar: "The History of the Paper Industry in al-Sham in the Middle Ages," *Towns and Material Culture in the Medieval Middle East*, ed. Y. Lev (Leiden, 2002), pp. 119–33

S. S. Blair and J. M. Bloom: "Timur's Qur'an, a Reappraisal," *Shifting Sands, Reading Signs: Studies in Honour of Professor Géza Fehérvári*, ed. B. Brend and P. L. Baker (London, 2006) pp. 5–14

J. M. Bloom: "Paper: The Transformative Medium in Ilkhanid Art and Architecture," *Beyond the Legacy of Genghis Khan*, ed. L. Komaroff (Leiden, 2006), pp. 289–302

Papercuts. The two techniques of collage and *découpage* (Pers. *qiṭ'a*; Turk. *kaatı*) as a serious and refined art have their origins in Syria and Egypt. Several cut and pasted paper designs have been found in the rubbish-heaps of Fustat (Old Cairo) and attributed to the Fatimid period. Under the Mamluks (r. 1250–1517), openwork designs in leather were first used for the doublures (linings) of BOOKBINDINGS. The technique was extended to paper in Iraq and Iran during the rule of the Timurid dynasty (r. 1370–1506). Papercutting was first applied to ornamental calligraphy in *nasta'līq* script in

15th-century Herat, when so many of the crafts associated with fine Persian book production were perfected (*see* ILLUSTRATION, §V, D). Specimens of collage (cut-out letters pasted on to a background of contrasting color, usually light on dark) and, more rarely, *découpage* (a sheet of contrasting color mounted behind a sheet from which letters are cut out) survive from the 15th and 16th centuries. Perhaps the most famous example of collage is a copy of the *Dīvān* (collected poetry; dispersed, e.g. Istanbul, Mus. Turk. & Islam. A., MS. 1926) in Chaghatay Turkish by Husayn Bayqara, the last ruling Timurid prince of Herat (*r.* 1470–1506). The lines of *nastaʿlīq* script have been cut from sheets of light-blue, tan and beige paper and pasted on a dark-blue ground; the pages are enhanced with exquisite illumination and set within gold-flecked borders. The names of only a few practitioners of the art of cut-out calligraphy have been preserved. The best known is Shaykh ʿAbdallah of Herat, the son of Mir ʿAli Haravi; he is said to have been responsible for the *Dīvān* of Husayn Bayqara. The master papercutter (Pers. *qāṭiʿ*) Sangi ʿAli Badakhshi produced a *découpage* of some autograph verses of Mir ʿAli, and other examples of his work (e.g. New York, Met., 67.266.7.6) show that *découpage* continued to flourish in the Iranian world after 1500.

The arts of collage and *découpage* passed to Turkey under the Ottomans in the early 16th century when many Iranian craftsmen and artists emigrated there. Not only calligraphy (e.g. an illuminated frontispiece to a manuscript of Hadith prepared for the prince Mehmed; *c.* 1540; Istanbul, Topkapı Pal. Lib., E.H.

2851, fols. 1*v*–2*r*) but also miniature gardens replete with flowers, shrubs and trees were produced by Ottoman *découpeurs*, in collage (see fig.). The many surviving specimens by Fakhri of Bursa (*d.* 1617) such as a two-tiered garden scene in his style (Vienna, Österreich. Nbib., Cod. Mixt. 313, fol. 12*r*), attest his consummate skill with the paper-knife. Among the works of the artist Naqshi is a calligraphic specimen (Washington, DC, Sackler Gal., S86.0335) in which collage calligraphy in white is surrounded by an imitation of gold flecking (Pers. *zarafshānī*) composed of tiny gilt diamonds cut out and pasted on to the background in a floral design. Interest in papercuts continued in the 17th and 18th centuries (e.g. four pages glued in the back of an *Anthology*; London, BL, Or. MS. 13763 *a–d*) and may well have been the inspiration for European papercuts.

Mustafa Ali: *Manāqib-i hunarvarān* [Virtues of artists] (1587); ed. İ. M. Kemal (Istanbul, 1926), p. 63

Qazi Ahmad ibn Mir Munshi: *Gulistān-i hunar* [Rose-garden of art] (1606); Eng. trans. by V. Minorsky as *Calligraphers and Painters* (Washington, DC, 1959), p. 193

J. M. Rogers: *Islamic Art and Design, 1500–1700* (London, 1981), pp. 18–23

A. Schimmel: *Calligraphy and Islamic Culture* (New York, 1984), p. 55

M. Bayani: *Aḥvāl va āṣār-i khwushnavīsān* [Biographies and works of calligraphers], 2nd edn. in 4 vols. (Tehran, Iran, Solar 1363/1984–5), pp. 452–3

T. W. Lentz and G. D. Lowry: *Timur and the Princely Vision* (Washington, DC, 1989), pp. 268–70

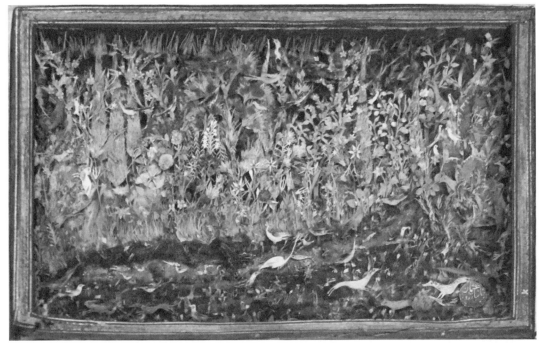

Three-dimensional papercut decorating the inside lid of a box, showing a landscape with birds and animals, from Turkey, 18th century Istanbul, Topkapı Palace Museum); photo credit: Sheila S. Blair and Jonathan M. Bloom

A. Froom: "Islamic Calligraphy and Papercuts by Fahri at the RISD Museum," *Glimpses of Grandeur: Courtly Arts of the Later Islamic Empires*, ed. S. Bonde and A. Froom (Providence, 1999), pp. 8–11

J. M. Rogers: "Ornament Prints, Patterns and Designs East and West," *Islam and the Italian Renaissance*, ed. C. Burnett and A. Contadini (London, 1999), pp. 133–65

Schätze der Kalifen: Islamische Kunst zur Fatimidenzeit (exh. cat. ed. by W. Seipel; Vienna, Ksthaus, 1998–9), nos. 33–5 [Egyptian papercuts]

Partav. *See* BARDA.

Parvez, Ahmed (*b.* Rawalpindi, 1926; *d.* Karachi, 5 Oct. 1979). Pakistani painter. Parvez started his career in Lahore, winning first prize in a 1952 exhibition at Punjab University. Most of his early works were still lifes. His Cubist style was transformed into a non-figurative one during a London sojourn (1955–65). Whether by accident or design, Parvez's paintings acquired a strong resemblance to the work of British painter Alan Davie (*b.* 1920); his 1968 exhibition at the Gallery International, New York, was billed (rightly or wrongly) as an homage to Davie.

Parvez's volatile personality was mirrored in his art, which is active, explosive and colorful. By the 1970s Parvez had transformed his colorful fragents, organic forms, circles and splashes into looser, more refined aggregates of squiggles, dots and dabs. These playful forms emerged as bouquets overflowing from an assortment of containers, most notably wine bottles and beer cans, a contentious imagery in Pakistan. Among the few Pakistani painters to be lauded in London and to earn a living by the sale of his art, Parvez was among the most productive and influential Pakistani painters of his generation. Many of his best works have been collected by the artist–collector Wahab Jaffer of Karachi and by Sultan Mahmood, one of Pakistan's first serious art collectors.

Parvez is considered one of the four cornerstones of modern Pakistani art. He was one of 10 painters honored posthumously with a 40-rial postage stamp issued on 14 August 2006.

See also PAKISTAN, §III.

"Ahmed Parvez: A Jewel of Pakistani Art," *Artistic Pakistan,* i/2 (April 1971), pp. 7–8

S. A. Imam: "A Dialogue with Ahmed Parvez," *Douaness*, iii/6 (Jan. 1982), pp. 37–41

S. A. Ali: "Forty Years of Art in Pakistan," *A. & Islam. World*, iv (1986), pp. 50–59

Paintings from Pakistan (Islamabad, 1988)

M. Nesom-Sirhandi: *Contemporary Painting in Pakistan* (Lahore, 1992)

A. Naqvi: "Transfers of Power and Perception: Four Pakistani Artists," *A. & Islam. World*, xxxii (1997), pp. 9–15 [special issue on 20th-century Pakistani art]

A. Naqvi: *Image and Identity: Painting and Sculpture in Pakistan 1947–1997* (Karachi, 1998)

P. Mittar: *Indian Art*, Oxford History of Art (Oxford, 2001)

Patronage. Works of Islamic art created under court patronage have long received primary attention from scholars, museum curators, collectors and the general public. This is because many major works of court patronage have been taken from their place of creation to Western museums, while the use of precious materials in court art or the relatively high degree of documentation have attracted interest. The patronage of the urban middle classes and the beautiful domestic works created in cities, villages and nomadic encampments have, by comparison, only recently come under a similar scrutiny. Despite some reassessment, the record of court patronage is, therefore, to a large extent still regarded as the most characteristic visual artistic tradition in Islam.

I. Court. II. Urban. III. Village and nomad.

I. Court. The existence of a sumptuous tradition of court art would seem to be at odds with the austere rules of personal conduct and the puritanical avoidance of luxury that characterized Muhammad's life and teachings, as described in the Hadith, the prophetic traditions. In fact, the imperatives of the institution of kingship exerted their independent influence on the civilization developed under his followers, often injecting into Islamic artistic culture pre-Islamic, non-Islamic or—from the strict religious perspective—even anti-Islamic elements. Despite this tension between theology and court art, patronage of the arts by the courts of Islamic states was central to the development of Islamic art and architecture over the centuries.

Court patronage in Islamic history began under the first Islamic dynasty, the Umayyads of Syria in the late 7th century (*see* UMAYYAD, §I). Their surviving architectural commissions show an assimilation of contemporary Helleno-Byzantine and Persian artistic traditions into a new and slowly developing Islamic synthesis under the umbrella of court patronage. Decoration of the Umayyad hunting-lodges in the Syrian desert, such as QUSAYR 'AMRA, often involved large-scale figural painting and sculpture, with depictions of the nude human form quite common, in stark (as it were) opposition to the puritanical and iconoclastic Semitic traditions of the Prophet.

Court artistic patronage over time resulted in the establishment of various institutions. The early emergence of the TIRAZ, a manufactory for the production of luxury textiles operated under close court control, shows the need in Islamic courts for a controlled and reliable supply of the robes of honor that formed such an important aspect of ritual gift-giving in Islam (*see* DRESS, §I). The various sorts of artistic media favored for court luxury objects in the formative period of Islamic art show a complete adoption of the tastes and in many cases the secular rites and rituals of earlier kingly traditions. Traditional luxury materials such as ivory, rock crystal, silk and precious metals formed the focus of much work by artists under court patronage. As various media came into

fashion, they found favor at particular courts. For example, the Umayyad court at Córdoba in the 10th century (*see* UMAYYAD, §II) was famous for ivories (*see* IVORY), many carved in the palace suburb of MADINAT AL-ZAHRA. Under the patronage of the FATIMID dynasty in 11th-century Cairo, the medium of carved ROCK CRYSTAL was popular. The OTTOMAN and SAFAVID courts of the 16th century commissioned great carpets and countless silk robes of honor as gifts to faithful retainers and foreign ambassadors. At the MUGHAL courts in the Indian subcontinent, specialists in JADE-carving found work for court patrons.

The building of large monuments by rulers and their high court officials, especially congregational mosques, shrines and works of urban infrastructure, answered a religious purpose. These monuments carried the additional message of the generosity and power of their royal or noble patrons and conveyed to the public the significance of dynastic patronage for the good not only of the faith but of the *res publica* as well. In early Islamic times the seat of urban power, the *dār al-imāra*, was often situated in the center of the city next to the congregational mosque, symbolically melding their functions and significance, and from early times the quintessential equality of Islamic believers before God was symbolically marred by the creation of the MAQSURA, a sumptuously decorated walled-off royal precinct within the prayer-hall, indicating the special status of the ruler–patron.

Court patronage served a variety of purposes in Islamic history, and often the aesthetic aspect was secondary. The great institutions for teaching (*see* MADRASA), built from the 11th century in many Islamic lands, exemplify royal patronage. Although their artistic and architectural aspects are important, the foundation of such buildings served the political and religious agenda of establishing Sunni Islam against the various heterodox Shi'ite sects. Throughout Islamic history the royal building and artistic embellishment of religious shrines often served a political end, as when the Umayyads erected the Dome of the Rock (691–2; *see* ARCHITECTURE, §III and JERUSALEM, §II, A) as a political, religious and artistic challenge to the dome over the Holy Sepulcher. In the 12th century the Ayyubids built a beautiful shrine for the remains of the great Sunni legalist al-Shafi'i in Cairo in order to have an orthodox shrine in their new capital, which they had just wrested from the Shi'ite Fatimids. The building (*see* CAIRO, §III, F), with all of its artistry, served as a symbol of Ayyubid political rule and religious piety. In a similar vein, the illustrated manuscripts of dynastic chronicles (see fig. 1) commissioned by the Ottoman and Mughal courts in later times served their very limited audiences as symbolic affirmations of the legitimacy of dynastic rule. The parade art of the Fatimids in Cairo, where processions through the streets, as in many Islamic lands, were the central projections of royal presence and power, seems to have been extremely elaborate, if physically somewhat ephemeral. Sometimes the sheer number and size of the staffs of court artistic establishments projected a political image, in the same way that the unusually large harems of some Islamic rulers served a symbolic rather than a practical purpose.

A view of court patronage in Islam is limited by the vagaries of survival of works of art—for example, the earliest Islamic palaces to have survived even partially intact date only from the 14th century (*see* PALACE)—and by the common practice by larger dynasties of attempting to erase the artistic record of their predecessors. By contrast, a wealth of historical texts and a limited but growing mass of archaeological data from earlier Islamic times give a reasonably clear picture of the practice of royal court patronage, if not of the art itself, even from such sites as BAGHDAD, virtually obliterated by the Mongols in 1258. From Spain and Morocco in the west to the Indian subcontinent and Central Asia in the east, the patterns of Islamic royal patronage show remarkable similarities over many centuries.

The court patronage of the three late Islamic empires—the Mughals, Safavids and Ottomans—is the best documented and most frequently studied by historians of art. Following models established in Timurid Iran, court artistic patronage (apart from the construction of buildings) focused around a centralized design studio staffed by artists specializing in the arts of the book—designers, calligraphers, painters, illuminators, binders—variously known as the *kitābkhāna/kutubkhāna* (literally, "house of the book(s)," often translated as "royal library") or the *naqqāshkhāna* ("house of design," the royal design studio). These royal studios developed various institutions, specialties and working methods. In the Indian subcontinent, for example, it was quite common for several specialist artists to collaborate on a single painting. The Ottoman design studio was divided into two groups: the "Anatolians" and the "Persians," each with its own director. In Iran, before Tahmasp (r. 1524–76; *see* SAFAVID, §II, B) turned away from painting, the shah himself was intimately involved in the day-to-day business of the painting studio in Tabriz (*see* ILLUSTRATION, §VI, A), in much the same way as the Timurid prince Baysunghur (*see* TIMURID, §II, G) had been in Herat a century earlier (*see* ILLUSTRATION, §V, D). In the Ottoman Empire, court patronage devolved on an elaborate structure of associations, known collectively as the *ehl-i hiref* ("people of talent"), based on individual artistic media from the association of rug-weavers to that of aigrette-makers.

Court artistic patronage in Islam had many different motivations, but one of the most interesting is the phenomenon of patronage as related to collecting works of art (*see* COLLECTORS AND COLLECTING). Islamic rulers collected various kinds of art. The passion of the Ottoman and especially the Safavid rulers for Chinese porcelains has been well documented. The dynastic collections of precious objects and works of art of all kinds amassed by the Safavids and Ottomans formed the basis of world-famous national MUSEUMS, and individual works from royal collections have been acquired for European, American

and Middle Eastern collections since the 19th century. The collecting passion among members of the court often sustained artists when large royal commissions were lacking, and the practice of compiling albums of calligraphy, paintings and even design sketches began in Iran in the 15th century (*see* ALBUM) and was practiced by such luminaries as the Ottoman sultan Murad III (*see* OTTOMAN, §II, D), the Mughal emperor Jahangir (*see* MUGHAL, §II, D) and the Safavid prince Bahram Mirza (1517–49).

Patronage of the arts was an accepted part of the royal role in Islamic civilization, and most Islamic sovereigns who had the time and the means became patrons of art and architecture whether or not they had any personal inclination towards the arts. Certain court patrons were prominently mentioned in chronicles as having a particular personal interest in the production of art and in the process of artistic creation, and these individuals were in some cases able to bring about almost single-handed great periods of production in the Islamic court art tradition. Concern with artistic patronage to the detriment of other affairs of state is as common a theme in Islamic history as it is in the European traditions, and it is always a temptation to equate the economic consequences of the profligate artistic patronage of the Ottoman sultans Murad III and Ahmed III (*see* OTTOMAN, §II, E) or the Safavid Tahmasp with the similar afflictions on the French body politic caused by the expense of the building and decoration of Versailles.

J. A. Pope: *Chinese Porcelains from the Ardebil Shrine* (Washington, DC, 1956)

O. Grabar: *The Formation of Islamic Art* (New Haven and London, 1973, rev. 1987)

R. Ettinghausen: "The Man-made Setting," *The World of Islam*, ed. B. Lewis (London, 1976), pp. 57–88

M. B. Dickson and S. C. Welch: *The Houghton Shahnameh* (Cambridge, MA, 1981)

R. Krahl: *Chinese Ceramics in the Topkapı Saray Museum, Istanbul*, ed. J. Ayers (London, 1986)

Islamic Art and Patronage: Treasures from Kuwait (exh. cat., ed. E. Atıl; Washington, DC, Trust Mus. Exh., 1990–91)

M. S. Simpson: "The Making of Manuscripts and the Workings of the *Kitab-khana* in Safavid Iran," *The Artist's Workshop*, ed. P. M. Lukehart, Studies in the History of Art, 38, Symposium Papers, XXII (Washington, DC, 1993), pp. 105–21

M. S. Simpson: *Sultan Ibrahim Mirza's Haft awrang: A Princely Manuscript from Sixteenth-century Iran* (New Haven, 1997)

H. al-Harithy: "The Patronage of al-Nāṣir Muḥammad ibn Qalāwūn, 1310–1341," *Mamluk Stud. Rev.*, iv (2000), pp. 219–44

S. Canby and J. Thompson, eds.: *Hunt for Paradise: Court Arts of Iran, 1501–1576* (Milan, 2003)

J. M. Bloom: *Arts of the City Victorious: Islamic Art and Architecture in Fatimid North Africa and Egypt* (New Haven, 2007)

II. Urban. The well-documented tradition of court patronage has often obscured the role of wealthy

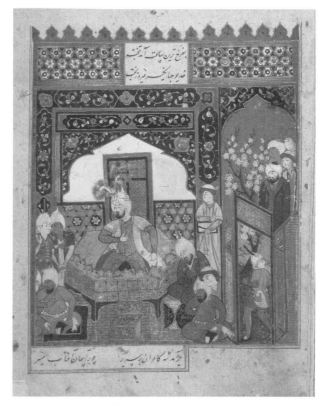

1. *Timur Enthroned at Balkh*; illustration from a copy of Hatifi's *Timūrnāma*, from Tabriz, Iran, *c.* 1538 (London, British Library, MS. Or. 2838, fol. 20*v*); photo credit: Erich Lessing/Art Resource, NY

city-dwellers as patrons in the artistic life of the Islamic lands. Discussions of such patronage tend to be concentrated on media or works of art that most art historians place in the second or third rank of artistic importance, significant for documentary rather than for aesthetic value. In fact, urban patronage of art in the Islamic lands is increasingly recognized for its own aesthetic value; the buildings, books, metalwares, ceramics, textiles and carpets of the urban middle classes, while in some cases following the fashion of the court and partaking of its imagery as well as its styles, in other cases may preserve far older and more elemental traditions out of which court art evolved. The lack of the written documentation, artists' names and institutional continuity often found in Islamic court art is more than compensated for by the sense of freshness, originality and social embeddedness of traditional urban art forms in the Islamic lands.

Islamic domestic architecture and patterns of neighborhood development have come under close scrutiny only recently; the urban dwellings of Fez and Tunis, Cairo and Damascus, Istanbul and Isfahan present some of the richest and most environmentally adaptive types of Islamic architecture, and the plans, forms, materials and decoration often show a remarkable degree of historical continuity in a given place (*see* VERNACULAR ARCHITECTURE). In the

Islamic lands, vernacular and domestic architecture often present the seeds from which the mosques, madrasas, palaces and urban commercial buildings eventually evolved, and the patterns of amenities and embellishments of the urban house, from the lathe-turned latticework window screen (Arab. *mashrabi-yya*) of the central Islamic lands to the WIND CATCHER of Iran and Iraq, present combinations of form and function of great beauty and significance in the history of Islamic architecture.

Early evidence of urban patronage survives mainly in the form of ceramics, which, unlike domestic architecture, metalware, textiles, carpets and jewelry, were both non-combustible and non-recyclable. For example, the epigraphic pottery produced in the 10th century under the SAMANID dynasty in eastern Iran and Central Asia (see fig. 2; *see also* CERAMICS, §II, C), with its elegant calligraphic decoration of moral aphorisms, gives evidence of a pious, discriminating and hard-working bourgeoisie accustomed to surrounding itself with beautiful things.

Urban patronage at times took the form of a direct command from a patron to an artist, but most commonly its nexus was the bazaar, where works of art were made to be sold to buyers by the artist himself or by an intermediary entrepreneur. The bazaar in turn reflected to a greater or lesser degree the tastes of the court itself, but also reflected interest in art forms that were distinctly middle-class or distinctly nomadic in their social and functional origins (*see* §III below).

Carpets made for middle-class urban Islamic patrons may at times have echoed the one-of-a-kind masterworks made in vast sizes from precious materials for the court, but just as often the carpets sold in the bazaar were of nomadic origins and genre. They served as storage containers, furniture or architectural decoration and displayed simple religious or tribal symbolism, reflecting the nomadic origin of the carpets and the nomadic ancestry of many Islamic city-dwellers. The same situation held for other media as well, from cotton, silk and wool textiles to the ubiquitous incised and tinned copper tableware.

The functional rituals of everyday life in Islam of necessity dictated that similar genres of art would be required by the urban merchant and his sovereign. The practice of eating food with three fingers of the right hand, for example, meant that washing ewers, basins, napkins and towels of great beauty were made for ruler and subject alike. Dictates of dress, sumptuary conventions and religious traditions about silk ("he who wears silk in this world will forgo it in the next"; *see* DRESS, §I) and JEWELRY (fine for women and horses but frowned on for men) all molded the patterns of urban patronage. CALLIGRAPHY, the universally approved Islamic art form—which conveyed to practitioner and purchaser alike the aura of prestige and piety—preoccupied middle-class collectors, whether it decorated an album page or a tile, a ceramic plate or a metal ewer.

On occasion, genres of art usually thought to be the sole province of high court notables made a significant impact on urban markets. Such is the case in the mid- to late 16th century with the illustrated and illuminated manuscripts from the workshops of Shiraz in Iran, which were produced for urban patrons outside the orbit of the Safavid court (*see* ILLUSTRATION, §VI, A). Dubbed "provincial schools" by scholars of painting, such centers of workshop production are more appropriately thought of as centers of production for urban patrons. Other examples of such patronage include the illustrated manuscripts of popular narrative poems such as al-Hariri's *Maqāmāt* ("Assemblies") made at Baghdad in the 13th century (*see* ILLUSTRATION, §IV, C), and the lavishly illuminated manuscripts of the Koran produced for middle-class patrons in all Islamic societies.

The often arcane and elevated symbolism, sometimes replete with poetic and epigraphic sophistication in inscriptions, found in such genres of Islamic art as the celebrated luster-painted or enameled pottery of 13th-century Iran (*see* CERAMICS, §III, C), should not obscure the fact that these pieces exemplify urban bourgeois art and survive in vast numbers when the prototypes made for the court in precious metals, enamels and book illustrations have all but vanished. The brightly colored Iznik tablewares of the 16th-century Ottoman Empire represent a technologically sophisticated and vastly appealing group of art objects that were avidly collected by Ottoman urban patrons, while the court was preoccupied to a great extent with collecting blue-and-white Chinese porcelains made for export to the courts of the Middle East (*see* CERAMICS, §V, A). Although scholars have sometimes been slow in recognizing the fact, the genres of Islamic art that have always been the most popular among collectors in the West—ceramics, carpets and textiles—and the ones that have found their way in vast numbers into Western collections

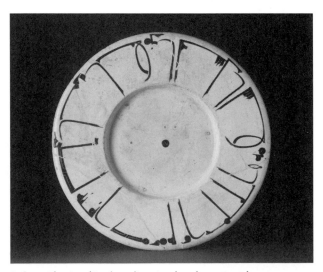

2. Samanid epigraphic plate, slip-painted earthenware under a transparent glaze, diam. 375 mm, h. 44 mm, from Samarkand, 10th century (Paris, Musée du Louvre, AA96); photo credit: Réunion des Musées Nationaux/Art Resource, NY

were for the most part first created for a wealthy, sophisticated and discriminating urban market in the Islamic lands.

L. Volov [Golombek]: "Plaited Kufic on Samanid Epigraphic Pottery," *A. Orient.*, vi (1966), pp. 107–33

O. Grabar: "Imperial and Urban Art in Islam: The Subject Matter of Fāṭimid Art," *Colloque international sur l'histoire du Caire: Cairo,* 1969, pp. 173–89

O. Grabar: *The Illustrations of the Maqamat* (Chicago and London, 1984)

S. Babaie and others: *Slaves of the Shah: New Elites of Safavid Iran* (London, 2004)

S. Faroqhi and R. Deguilhem: *Crafts and Craftsmen of the Middle East: Fashioning the Individual in the Muslim Mediterranean,* The Islamic Mediterranean, 4 (London, 2005)

III. Village and nomad.

The arid plateaux and mountains of the Middle East encouraged a mixed economy of irrigated agriculture and pastoral nomadism, while sea and land routes fostered trade and city life. Urban populations, peasants and nomads differed strongly in lifestyle and tradition while maintaining close economic and political connections.

The nomads of the Middle East had varied origins—they included North African Berbers (*see* BERBER), Arab Bedouins, Iranian Baluch and Turks from the steppe—but their pastoral economy imposed similar lifestyles. Nomads lived off their flocks of sheep and goats, using horses and camels primarily for transport and war. They dwelt in tents (*see* TENT, §I), moving as their flocks required new pasture, usually in a regular seasonal rotation (see fig. 3). This allowed the nomads to utilize desert and mountain areas unsuitable for agriculture. Although theoretically self-sufficient, pastoral nomads were interested in trade; while separate in consciousness, they usually lived in close contact with settled populations. This could be destructive, as nomads raided villages in times of need, but the different populations often lived in harmony—nomads buying village and city products and providing the important woolen industry with raw materials, while their livestock fertilized the agricultural fields they grazed in winter. Nor were nomad and settled populations entirely distinct. Most nomad groups had a hereditary ruling class, and nomad élites, like settled ones, often lived apart. Wealthy nomads often invested in land to secure their position, becoming part of the local settled élite, and poorer nomads who lost flocks through hunger or disease might take up a settled existence. Both groups could still retain ties to their tribes.

Migration inhibited the development of advanced technology, and nomad artistic production was limited largely to leatherwork and TEXTILES, which formed the major part of their material possessions. Many tents were embellished outside with decorative bands, door and chimney flaps and inside with wall and floor coverings. Both knotted carpets and embroidery were closely associated with nomads, and FELT was worked in appliqué designs. Textile

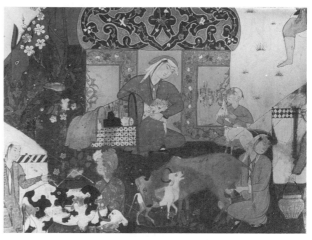

3. *Oasis Camp in the Desert* (detail); illustration from a copy of Nizami's *Layla and Majnun*, ?from Tabriz, 16th century (Tehran, Archaeological Museum); photo credit: Werner Forman/Art Resource, NY

products, used for individual status or produced for the nomad élite, could be of very fine quality. Another possession of artistic importance and status was JEWELRY, for which nomads were in part dependent on city or town craftsmen, who produced works specifically for the nomads' taste. Although it is impossible to say how many products were made for sale before the 18th century, it appears that the development of the commercial carpet industry in Anatolia (*see* CARPETS AND FLATWEAVES, §§II and III, A) began with nomad production.

Nomads also affected the artistic life of the Middle East as mercenaries, conquerors and rulers, since nomad life fostered horsemanship, archery and other military skills. From the 7th century to the 10th the Bedouins and Berbers were particularly active. From the 11th century to the 14th the Turks and Mongols of the Eurasian steppe repeatedly invaded the Middle East, and in the 14th and 15th centuries two partially nomadic Turkic powers, the OTTOMAN dynasty in the west and the TIMURID dynasty in the east, conquered the Middle East. This ended the nomad conquests, leaving the Turks as the ruling class until the 19th century. Destructive invasions from the steppe were followed by large-scale artistic patronage and the introduction of new ideas. The Saljuq dynasty (*see* SALJUQ, §I) who arrived through eastern Iran in the 11th century brought the artistic styles of that region to the central Islamic world. The ILKHANID and Timurid rulers, interested in world trade, introduced styles and techniques from the Inner Asian steppes and China. Chinese motifs and themes had a strong impact, encouraging, for example, the development of book painting (*see* ILLUSTRATION, §V, B) in Iran and in other areas.

Since historical sources and surviving artifacts derive largely from either court or urban milieux, the products of the medieval countryside are largely unknown. Historical accounts mention villages primarily as a source of revenue; they were usually taxed

collectively and more heavily than urban populations. Middle Eastern landowning and tax-farming systems encouraged absentee landlords, and most large landowners used their incomes to maintain themselves in the cities, leaving local affairs to the village headman. Scholars disagree on the level of connection between the city and the countryside; this clearly varied, probably decreasing in western Islamic lands under Ottoman rule. Most villages differed strongly in lifestyle from the city, and villagers were looked down on by the city populations. Many villagers, however, had close economic ties with the cities, which they provided with food. The organization of cities into quarters also tended to connect villages with the urban centers: people from one region lived in the same quarter and kept in touch with relatives within their village.

Small villages were underdeveloped and involved largely in subsistence agriculture; most profit went to the landlord, who provided seed and capital. Since the usual village building material was mud-brick or pisé, few examples of village architecture or other artifacts remain from the pre-modern period. Simple pottery and cloth production were widespread. Regional markets allowed some villages to specialize in producing specific textiles, pottery or metalwork for surrounding ones. Luxury arts were practiced primarily by city craftsmen, but neighboring villages often played a part in relatively sophisticated crafts. Villages might specialize in a cottage industry, selling through city merchants. Thus both textiles and pottery are often ascribed to a city and its surrounding region. The numerous trade routes through the Middle East allowed remote villages to produce fine crafts for export.

Certain areas far from major cities retained a local culture of tribe and village, sometimes expressed in regional artistic styles. These isolated populations, however, often participated in wider events as allies of a ruling power, mercenaries or bandits, and both artistic styles and techniques were open to new ideas. Western penetration in the 19th century brought greater commercialization of nomad and village production. This was particularly strong in the new cottage industry for the international carpet market (*see* CARPETS AND FLATWEAVES, §IV, C). Nevertheless, while economic ties were strengthened, the greater openness to Western ideas in the cities had the effect of widening the gulf between city and countryside in culture and consciousness.

A. K. S. Lambton: *Landlord and Peasant in Persia* (London, 1953)

I. M. Lapidus: "Muslim Cities and Islamic Societies," *Middle Eastern Cities*, ed. I. M. Lapidus (Berkeley and Los Angeles, 1969), pp. 47–79

C. Cahen: "Nomades et sédentaires dans le monde musulman du milieu du moyen âge," *Islamic Civilization, A.D. 950–1150*, ed. D. H. Richards (Oxford, 1973), pp. 93–104

M. Lombard: *Les Textiles dans le monde musulman du VIIe au XIIe siècle* (Paris, 1978)

G. Baer: *Fellah and Townsman in the Middle East: Studies in Social History* (London, 1981)

A. L. Udovitch, ed.: *The Islamic Middle East, 700–1900: Studies in Economic and Social History* (Princeton, 1981)

A. M. Khazanov: *Nomads and the Outside World* (Cambridge, 1983)

M. Brett: "The Way of the Peasant," *Bull. SOAS*, xlvii (1984), pp. 44–56

T. Barfield: *The Nomadic Alternative* (Englewood Cliffs, NJ, 1993)

R. Tapper and J. Thompson, eds.: *The Nomadic Peoples of Iran* (London, 2002)

R. Amitai and M. Biran, eds.: *Mongols, Turks and Others: Eurasian Nomads and the Sedentary World* (Leiden, 2005)

Pattern. *See* ORNAMENT AND PATTERN.

Payag [*Payāg; Prayāga*] (*fl. c.* 1595–1655). Indian miniature painter. He was the older brother of the well-known Mughal artist BALCHAND and possibly began his career in the imperial Mughal atelier late in the reign of Akbar (*r.* 1556–1605). A painter of this name worked on several minor manuscripts of the 1590s. There are no works attributable to Payag in the period of Jahangir (*r.* 1605–27), but some 20 known works were produced during the reign of Shah Jahan (*r.* 1628–58). These include four paintings in the lavishly illustrated court history of Shah Jahan's reign, the *Padshāhnāma* (Windsor Castle, Royal Lib., MS. HB.149, fols. 102*v*, 176*v*, 195*r* and 214*v*). These consist of two battle scenes and two darbar (court) scenes. The battle scenes are tightly structured, with figures arranged in small groups within landscapes leading to distant vistas. Payag's attention was often directed to such small details as the trim of the soldiers' attire. His dark and somber palette adds to the intensity of the scene.

Payag's primary skill was in portraiture, for which the darbar scenes provided excellent opportunities. The darbar was an official audience attended by the leading nobles of the court, who were required to stand before the emperor in a strict hierarchical proximity to the throne. Like his father Jahangir, Shah Jahan had court artists sketch the nobles arrayed in his darbars to provide historical verisimilitude. Payag excelled in the meticulous execution of facial characteristics of the distinct personalities arranged in typically symmetrical compositions.

His remarkable night scene, *Officers and Holy Men* (*c.* 1655; San Diego, CA, Mus. A., Binney Col.; see Binney, no. 59), reveals an obvious source in European chiaroscuro. (The painting has been erroneously ascribed to the artist Bichitr.) This painting is from late in Payag's career and demonstrates a relaxation of the strict rigidity of the artist's earlier works.

A. A. Ivanova and others: *Albom indiiskikh i persidskikh miniatur* (Moscow, 1962)

E. Binney III: *Indian Miniature Painting from the Collection of Edwin Binney, 3rd: The Mughal and Deccani Schools* (Portland, OR, 1973)

B. W. Robinson, ed.: *Islamic Painting and the Arts of the Book* (London, 1976)

The Grand Mogul: Imperial Painting in India, 1600–1660 (exh. cat. by M. C. Beach; Williamstown, MA, Clark A. Inst.;

Baltimore, MD, Walters A.G.; Boston, MA, Mus. F.A.; New York, Asia Soc. Gals; 1978–9)

E. S. Smart: "A Recently Discovered Mughal Hunting Picture by Payāg," *A.Hist.*, ii/4 (1979), pp. 396–400

W. Komala: *The Windsor Castle "Badshah-Nama" and its Place in the Development of Historical Painting during the Reign of Shah Jahan, 1628–58* (diss., Iowa City, U. IA, 1982)

P. Pal: *Master Artists of the Imperial Mughal Court* (Bombay, 1991)

L. Y. Leach: *Mughal and Other Indian Paintings from the Chester Beatty Library* (London, 1995)

King of the World: The Padshahnama, an Imperial Mughal Manuscript from the Royal Library, Windsor Castle (exh. cat. by M. C. Beach and E. Koch; New Delhi, N. Mus.; London, Queen's Gal., and elsewhere, 1997–8)

E. Smart: "The Death of Inayat Khan by the Mughal Artist Balchand," *Artibus Asiae*, lviii/3–4 (1999), pp. 273–9

Pendzhikent [Panjikent; formerly Panch]. Site in Tajikistan. Lying on the southern edge of the modern town of the same name in the middle reaches of the Zarafshan River, it flourished from the 5th to the 8th century CE as the easternmost town of Sogdiana. Excavation of the site began in 1946, carried out until 2006 by the late BORIS ILICH MARSHAK, who is buried there, have provided the fullest picture of pre-Islamic architecture, sculpture and particularly wall painting in Sogdiana. The settlement consisted of a citadel with three lines of fortifications, the fortified town, surburban estates and a necropolis. Although the citadel had a settlement on it from the first centuries CE, the town (*c.* 8 ha) dates from the 5th century. In the 6th century an additional 5.5 ha to the east and south of the original town was enclosed within a new wall. The internal wall was rebuilt on several occasions and then demolished at the beginning of the 8th century.

Pendzhikent was a principality from the 7th century, to judge from surviving coins, but reached its apogee in the first quarter of the 8th century when the Arabs had taken Sogdiana. Devastich, ruler of the principality, styled himself "King of Sogdiana and Lord of Samarkand," and during his rule Pendzhikent, like other parts of Sogdiana, alternately paid homage to the conquerors and resisted their dominance. The inhabitants abandoned the town after the insurrection of 722 when Devastich was captured and executed. Peace with the Arabs was concluded *c.* 740, and the Sogdians returned to restore many of the buildings, although barracks—probably for the Arab troops—occupied the site of Devastich's palace in the citadel. Pendzhikent was abandoned by its inhabitants *c.* 780 and later rebuilt on a new site.

Most of the population was Zoroastrian but with more pronounced pagan traditions than in Iran. There were also Christians and Buddhists, but the surviving works of art are linked with the local religion. From the beginning of the 5th century there was a rectangular sacred place with two very similar temples in the center of the city. Although they were rebuilt several times, the original plans were essentially preserved. One entered each temple through a portico on the east that led to a courtyard with pools and trees and was dominated on the west by another portico. This portico led into another courtyard with a narrow ramp providing access to the platform of the main building, which in turn had its own, third, portico, in front of a hall open to the east with four piers. A door at the back of the hall led into a rectangular naos, and the hall and naos were enclosed on three sides by a gallery. The temples, like all other structures at Pendzhikent, were built of pisé and mud-brick. The ceilings and columns in the temples were of wood, although those in the main rooms had stone bases. The open nature of the rooms, allowing the morning sun to stream in, was an unusual element, but some other peculiarities of plan seem to be derived from Hellenistic architecture in the east.

The temples at Pendzhikent were dedicated to the cult of the gods. At the end of the 5th century and beginning of the 6th there was in Temple I, the southern temple, a special place for the holy flame. Both temples provide evidence of the worship of water: reliefs of unfired clay in Temple I bear images of two tritons (5th century), and a frieze in Temple II bears figures of tritons and other aquatic creatures (6th century; St. Petersburg, Hermitage). Paintings in the main buildings of the western courtyards (5th–6th century) are of a ritual and mythological nature; those of the chapels are of a ritual nature.

Excavations in the town have revealed residential quarters with hundreds of two-story multi-room buildings, bazaars, shops and workshops along the streets. Although some of the buildings date from the 5th to the 7th century, those of the early 8th have been studied most fully. The houses pressed so closely together that streets resembled corridors. Vaulted ground-floor rooms had small windows under the vault, while the houses of the rich had high-ceilinged halls, often with four wooden columns, lit from above. The many members of the upper classes of Pendzhikent, landlords or merchants, lived in houses hardly inferior in size and luxury to the palace of Devastich himself. The palace, with four staterooms, burnt in 722. The main hall (18×12 m) was divided by two columns into square and rectangular parts; the raised rectangular part had a raised niche (4×4 m) along the axis. Burnt fragments of the wooden ceiling, including statues and panels with figures of seated gods in high relief, have been found in the room, as well as fragments of painted plaster murals depicting a besieged town and a coronation, probably contemporary events as some of the figures are clearly Arabs.

Paintings from the 6th century have been found in some residential buildings, but most date to the first half of the 8th century, when nearly a third of the houses had a stateroom decorated with paintings and carved wood. Charred carved panels and caryatids (St. Petersburg, Hermitage; Pendzhikent, Roudaki Abuabdullo Repub. Hist. & Reg. Mus.) have been found in the burnt ruins of several houses, while in others the wood has rotted, although the paintings have survived. The most varied scenes were found in

the Blue Hall (sector VI, room 41; *c.* 740; St. Petersburg, Hermitage), so called because of the ultramarine background to the paintings. Opposite the entrance was a depiction of a goddess enthroned on a reclining lion, on either side of which were two friezes (h. 1 m) illustrating some epic. One frieze depicts the hero Rustam attacking the demons. Along the base of the walls was a band (h. 500 mm) of rectangular panels with illustrations from magical tales, the *Tale of the Judge*, parables from the Indian *Pañcatantra* and Aesop's *Fables*.

Trudy Tadzhikskoy arkheologicheskoy ekspeditsii [Work of the Tadzhik archaeological expedition], i–iv; *Mat. & Issledovaniya Arkheol. SSSR*, xv (1950), xxxvii (1953), lxvi (1958), cxxiv (1966)

Arkheologicheskiye raboty v Tadzhikistane [Archaeological work in Tajikistan], i–xiv (1954–86)

Zhivopis' drevnego Pendzhikenta [Painting in ancient Pendzhikent] (Moscow, 1954)

Skul'ptura i zhivopis' drevnego Pendzhikenta [Sculpture and painting in ancient Pendzhikent] (Moscow, 1959)

A. M. Belenitsky, I. B. Bentovich and O. G. Bol'shakov: *Srednevekovyy gorod Sredney Azii* [The medieval town in Central Asia] (Leningrad, 1973)

A. I. Isakov: *Tsitadel' drevnego Pendzhikenta* [The citadel of ancient Pendzhikent] (Dushanbe, 1977)

A. M. Belenitsky: *Mittelasien: Kunst der Sogden* (Leipzig, 1980)

G. Azarpay: *Sogdian Painting* (Berkeley and Los Angeles, 1981)

A. M. Belenitsky, B. I. Marshak and V. I. Raspopova: "Sogdiyskiy gorod v nachale srednikh vekov: Itogi i metody issledovaniy drevnego Pendzhikenta" [A Sogdian town at the beginning of the middle ages: conclusions and methods of research in the study of ancient Pendzhikent], *Sov. Arkheol.*, ii (1981), pp. 94–110

V. I. Raspopova: *Zhilishcha Pendzhikenta* [Dwellings of Pendzhikent] (Leningrad, 1990)

Periodicals. *See* JOURNALS.

Perspective. Term used for any systematic technique that renders the illusion of recession behind a two-dimensional surface (including receding lines, gradients of color, tone and texture, degrees of clarity etc.). Until the late 13th century, such pictorial elements in the painting of the Islamic lands as figures, landscapes and buildings were used as mere space-fillers and did not depict depth or distance. The Mongol invasions brought from China to West Asia a new mode of depicting space, and painters began to suggest a sense of depth by means of different ground levels with indications of grass and pebbles (e.g. *Manafi'-i Hayavan* ["Usefulness of animals"] of Ibn Bakhtishu'; Maragha, *c.* 1290; New York, Pierpont Morgan Lib., M.500). This formula was developed by the painters of the Rashidiyya scriptorium (*see* ILLUSTRATION, §V, B, 3) in favor of a wider space, a convention which was visibly inspired by Chinese hand scroll painting in the large horizontal format. The use of shading also helped to enhance a sense of three-dimensionality. A new interest in space appears in the painting of the Jalayrid (*r.* 1336–1432) school (*see* ILLUSTRATION, §V, C, 1 and 2). Artists emphasized verticality by breaking the images into the text space and extending the picture into the margin (e.g. *Kalila and Dimna*; Istanbul, U. Lib., F.1422; the *Dīvān* [Collected poems] of Khwaju Kirman; 1396; London, BL, Add. MS.18113). In paintings produced under the Timurids (*r.* 1370–1506) artists developed remarkable conventions of depicting space as architecture became a major component in the spatial structure of the image. The layers of architectural frames emphasized verticality of the space, as can be seen in the works attributed to BIHZAD, but at the same time this reduced the visual effect of depth and distance.

While manuscript painting produced in the Safavid (*r.* 1501–1732), Ottoman (*r.* 1299–1922) and Mughal (*r.* 1526–1858) spheres (*see* ILLUSTRATION, §VI) did not thoroughly discard traditional two-dimensional flatness, painters began to experiment with European vanishing-point perspective, a technique that was introduced to the Islamic world through topographical prints and oil paintings. A growing interest in European concepts of depth and distance became evident, for instance, in the oil painting of the Isfahan school of the mid-17th century and early 18th. Artists adopted a variety of European techniques, such as repoussoir, cast shadows and modeling with color. In general, however, the depiction of space remained eclectic, combining indigenous two-dimensional styles and imported ideas of three-dimensionality.

B. Gray: *Persian Painting* (Geneva, 1961)

R. Ettinghausen: *Arab Painting* (Geneva, 1962)

R. Hillenbrand: "The Uses of Space in Timurid Painting," *Timurid Art and Culture: Iran and Central Asia in the Fifteenth Century*, ed. L. Golombek and M. Subtelny (Leiden, 1992), pp. 76–102

L. Bronstein: *Space in Persian Painting* (London, 1994)

E. Bahari: *Bihzad: Master of Persian Painting* (London, 1996)

Peul. *See* FULANI.

Philadelphia. *See* AMMAN.

Philippopolis. *See* PLOVDIV.

Photography [Arab. *taṣwīr, fūtūgrāfiyā*; Ottoman Turk. *taṣwīr*; Mod. Turk. *fotoğrafçilik*; Pers. *'akkāsī, fūtūghirāfī*]. Term used to describe the technique of producing an image by the action of light on a chemically prepared material. Although used privately in France and England as early as 1833, the process was announced publicly only in 1839.

I. Introduction. II. Foreign photographers. III. Local photographers.

I. Introduction. In January 1839 François Arago (1786–1853), a member of the Académie des Sciences, suggested that among the advantages the new

medium presented was that the millions of hiero-glyphs covering the monuments of Thebes, Memphis and Karnak could be copied by a single man rather than by scores of draftsmen, and in 1846 the English photographer and scientist William Henry Fox Talbot (1800–77) published a pamphlet with three prints of hieroglyphics for distribution among ar-chaeologists and Orientalists.

The Ottoman press reported the discovery of photography as early October 1839, and European colonial involvement in the Islamic lands of North Africa and West Asia ensured that photography was immediately brought there: for example, in 1839 Horace Vernet (1789–1863) and his travel companion Frédéric Goupil-Fesquet (1817–78) vis-ited Alexandria, where they took a daguerreotype of Ra's al-Tin Palace on 7 November. Although none of their original daguerreotypes have survived, litho-graphs were made from their plates. Joseph-Philibert Girault de Prangey (1804–92), who had written in the 1830s about the Islamic antiquities of Spain, embarked for Egypt in 1842 with daguerreotype equipment, which he used in 1843 and 1844 (e.g. *Cairo*, 1843; Austin, U. TX, Human Res. Cent., Gernsheim Col.).

Increasing curiosity about the East and the Euro-pean passion for Oriental themes in art, literature and music ensured that photographs of the "exotic" East would find a ready audience in the West (*see* ORIENTALISM). French and British visitors visited Egypt and Palestine, Syria, Lebanon, Iran and the Ottoman Empire, photographing Islamic architec-ture and city panoramas. Ethnologists and anthro-pologists soon followed, taking pictures of street scenes, festivals, craftsmen, tools and individuals. Most of the early photographers were European nationals from France and England, where the pro-cesses of photography were invented; they were fol-lowed by fewer numbers of Italians and Germans who traveled to the Near East recording cultural and physical phenomena. Some photographers experi-mented with the new technical discoveries without any particular mission, while others simply saw it as a means of earning a livelihood. Early photographs of the Middle East were not necessarily "natural" or "objective" representations but instead reproduced and reinforced many stereotypes.

II. Foreign photographers. Photographs by French nationals working in the Near East were meant to satisfy both mounting curiosity about archaeological matters and establish national hege-monies. Working with the calotype, Auguste Salz-mann (1824–72) in Jerusalem and Maxime Du Camp (1822–94) in Egypt set out to bring back proof of building methods and inscriptions, but beyond the informative value of these works, viewers were also accorded unusual visual experiences that stemmed from the photographer's acute sensitivity to the play of light on three-dimensional objects, as can be seen in Du Camp's *Colossus of Abu Simbel* (*c*. 1850; London, V&A). Du Camp had been sent in 1849 by

the Ministère de l'Instruction Publique on a mission to the Middle East to record the monuments and inscriptions. He undertook the trip (1849–51) with his friend the writer Gustave Flaubert (1821–80), and during his travels he used a modified calotype process imparted to him by Alexis de Lagrange (1825–1917). He brought back *c*. 200 pictures from Egypt and some from Jerusalem and Baalbek. The album *Egypte, Nubie, Palestine et Syrie: Dessins photo-graphiques recueillis pendant les années 1849, 1850, 1851, accompagnés d'un texte explicatif et précédés d'une introduction* was published by Gide and Baudry in 1852–4 (copy in Paris, Bib. Inst.; prints in Paris, Mus. Orsay; Paris, Bib. N.; Paris, Inst. Géog. N.). It contains 125 calotypes printed by Louis-Désiré Blan-quart-Evrard (1802–72), and it was the first printed work in France to be illustrated with photographs. It thus ushered in a new type of book and was a great success. The photographs are of various subjects: landscapes and ancient monuments (e.g. the *Temple of Philae*), details of inscriptions and modern cities (e.g., *Houses in Cairo with Flaubert in the Fore-ground*). Sometimes figures are included to give an indication of scale, as in *Colossus of Abu Simbel*, and introduce an element of the picturesque. With the clarity of his images and his direct approach to the monuments, Du Camp achieved the mission's objec-tives: exact reconstruction of sites and buildings.

The French photographer, archaeologist and painter Auguste Salzmann visited Italy and Algeria with his friend Eugène Fromentin (1820–76), and he was in Egypt at the time of the excavations of Auguste Mariette (1821–81). At the end of 1853, he set off for the Holy Land and brought back from his trip *c*. 200 calotypes. The album *Jérusalem* (pubd 1855–6; Paris, Mus. Orsay; Paris, Bib. N.; priv. col.) contained 174 of them. In 1863, he set off again with the archaeologist Louis Félicien Caignart de Saulcy (1807–80) to carry out more intensive research, and his photographs were used to illustrate the archaeo-gist's articles. The photographs Salzmann brought back from his first journey are the most moving images of Jerusalem taken during the 19th century, despite the desire for scientific accuracy that had given rise to them. His vision of the Holy City was one of the most profound and poetic of anyone who attempted the subject.

Between 1856 and 1860 the Englishman Francis Frith (1822–98) made three trips to Egypt and the Holy Land that established his pre-eminence among early travel photographers. On the first he sailed up the Nile to the Second Cataract, recording the main historic monuments between Cairo and Abu Simbel. On the second he struck eastwards to Palestine, visit-ing Jerusalem, Damascus and other sites associated with the life of Christ. The final expedition was the most ambitious, combining a second visit to the Holy Land with a deeper southward penetration of the Nile. Although Frith was not the first European photographer to visit Egypt, his work was wider in its geographical scope and more systematic in its cov-erage than that of, for example, Du Camp. Frith

photographed most of the key monuments several times, combining general views with close studies of their significant details and broader views of their landscape environment. The clarity of his images proved to be of immense value to archaeologists. The photographs are also often powerfully composed, revealing an understanding of the poetic qualities of light that gives them lasting aesthetic value. Frith's earlier experience as a printer proved useful in the commercial exploitation of his photographs. They were exhibited widely, sold through print dealers and issued in serial form to subscribers. In 1858–60 he published *Egypt and Palestine Photographed and Described by Francis Frith*, the first of a series of magnificent albums containing mounted albumen prints accompanied by letterpress commentaries. In 1862 he also produced a limited edition of *The Queen's Bible*, illustrated with his photographs of the Holy Land.

The German photographer Jakob August Lorent (1813–84), who received a doctorate at Heidelberg in 1837, became a naturalist, undertaking research trips in North Africa (1840), Asia Minor and Egypt (1842–5), on which he named eight new types of plants. He took up photography because of his deep admiration for the Egyptian and East Asian culture and architecture. On a longer trip to England, he learnt about William Henry Fox Talbot's negative–positive process on paper. He made extended photographic trips to southern Spain (Granada) and Algeria (1858–9), to Egypt and Nubia (1859–60) and to Greece (1860–61).

The French photographer Gustave Le Gray (1820–84) had studied painting with Paul Delaroche (1797–1856). He plunged into photography after 1847, and in May 1860 he boarded a yacht belonging to the writer Alexandre Dumas (1802–70). With Dumas and several young passengers Le Gray headed for Egypt, abandoning his family, and, most significantly, his creditors. For Le Gray the yacht was to be the perfect escape, a floating paradise moving toward a land of dreams. However, Dumas was detained in Sicily, where he met General Garibaldi. Dumas wanted to return to France to bring the General more arms, but Le Gray refused to return, wanting instead to get to Egypt to experience, as Dumas put it, "that voluptuous absence of will." Le Gray remained in Egypt for the last 24 years of his life. By 1869, he was teaching drawing and painting at the Ecole Polytechnique of the viceroy in Cairo and still photographing.

Antonio Beato (*c.* 1830–1903) and his brother Felice (*d.* after 1904) were British photographers of Italian origin, active from *c.* 1853 as assistants to their brother-in-law James Robertson (1813–after 1881) in Constantinople. From 1855 Felice and Robertson took photographs of the Crimean battlefields (now London, V&A, and Austin, U. TX, Ransom Human. Res. Cent.). Together with Robertson, both brothers traveled to Athens, Cairo, Jerusalem and finally India, where in 1858 Felice and Robertson documented the massacres carried out by the

British army following the Lucknow revolt. The pictures Felice took there are among the earliest known photographs of corpses. Antonio remained in the studio, probably taking photographs of the city, especially panoramas made from an assembly of a number of photographs. The brothers were both technically accomplished, achieving very high standards in clarity and composition, and Antonio's photographs are similar to others taken by Felice in different parts of the world (e.g. *River Scene, India*). While Felice was in China and Japan, Antonio moved from Calcutta to Egypt, finally settling in Luxor, where he had a studio at the Hotel Luxor until his death in 1903. Most of Antonio's photographs of the city of Cairo and the archaeological sites of the Nile are now preserved in the archives of the Egyptian Museum in Cairo.

In addition to Felice Beato, Samuel Bourne (1834–1912) moved to India in the 1860s and established a photographic firm with Charles Shepherd in Simla; he produced hundreds of legendary views of the Himalayas. The Russian photographer Sergei Mikhailovich Prokudin-Gorskii (1863–1944) took color photographs of the vast Russian empire between 1905 and 1915, including the Caucasus and Central Asia, for Tsar Nicholas II (*r.* 1894–1917). He made triple-frame glass negatives (Washington, DC, Lib. Congress) through blue, green and red filters, which could be printed or projected in color for magic lantern shows. His architectural views of Samarkand and Bukhara and their inhabitants are particularly striking.

III. Local photographers. Despite its distance from European centers, photography was introduced to Iran as early as 1844 by the Frenchman Jules Richard (1816–91), later known as Mirza Riza Khan. The Qajar ruler Nasir al-Din (*see* QAJAR, §II, A) became an enthusiastic amateur photographer, encouraging his courtiers to follow suit. The photograph became the image of Qajar dynastic power, and the monarch collected 20,000 covering all aspects of Persian life. Men were not allowed into the harem, and the photographs the monarch took there are the earliest portrait photographs of Iranian women. A department of photography was established at Tehran's *Dār al-funūn c.* 1860 and a court photographer appointed in 1863. The most prominent commercial photographer in Tehran was the Russian–Georgian ANTOIN SEVRUGUIN, who opened his studio in the 1870s and recorded his surroundings with an encyclopedic eye.

Elsewhere in the Near East the first local photographers appeared in 1850s, but religious taboos about making images tended to discourage Muslims and Jews from adopting the profession. From the 1860s commercial photographers supplied the local tourist trade, selling not only postcards and souvenir photographs but also chemicals and photographic equipment.

In such predominantly Sunni regions as Turkestan and India, opposition to photography continued even into the 20th century. Muftis issued fatwas

against photography in Egypt in 1908 and in Istanbul in 1920, but nevertheless the medium was increasingly accepted among all but the most traditionalist elements of society, since, enthusiasts argued, it did not actually "create" images but merely recorded shadows.

Initially, most local photographers were Armenians, Greek Christians or Jews. The first studio in Pera, the European district of Istanbul, was established by the Greek Vasilaki Kagopulo in 1850. The well-known photographic firm of Abdullah Frères was established in 1856 by a German chemist who visited Istanbul during the Crimean War. He returned to Germany in 1856 and handed the business to his employees, three Armenian brothers whose grandfather had changed his name from Hürmüzyan to 'Abdullah, although he had not converted to Islam. After taking a portrait of Sultan Abdülaziz in 1863, the firm was awarded the title of "Photographers of His Imperial Majesty the Sultan," and they earned additional international recognition at the Paris exhibition of 1867. After Sultan Abdülhamid II revoked their permit to display the imperial monogram in 1878, they opened a branch in Cairo in 1886. They returned to the sultan's favor in 1890 and were commissioned to contribute to the 51 photographic albums the sultan gave as gifts to the USA (Washington, DC, Lib. Congress) and other nations. Nevertheless, they were eventually forced to sell their business to the Greek J. Pascal Sebah (d. 1890) and his partner Joailler. Although one of the Abdullah brothers, Vincent (1820–1902), converted to Islam in 1899, the first Muslim to open a studio in Istanbul was Rahmizade Bahaüddin in 1910; the Ottoman Photographic Society was founded in 1914.

Very few Muslim photographers were active in Egypt and the Levant. Muhammed Sadiq Bey (1832–1902), a colonel in the Egyptian army, was the first photographer to take pictures in Mecca. He had probably learnt photography from one of the Europeans active in Egypt. In 1881 he accompanied the pilgrimage caravan bringing the *kiswa*, or covering, for the Ka'ba, and his remarkable photographs record the trip, the monuments and some of the individuals he met. He said that in the Ka'ba area he was forced to conceal his camera. Suleiman Hakim (perhaps a convert) worked in Damascus from the late 1870s, producing photographs for the tourist market. The first Jewish photographers began work in the 1880s in Jerusalem; they were probably Eastern European Jewish immigrants rather than locals. In India, one of the first local photographers was Raja Lala Deen Dayal, who took thousands of glass-plate negatives in the 1860s–70s (New Delhi, Indira Gandhi N. Cent. A.).

http://lcweb2.loc.gov/pp/ahiihtml/ahiiabt.html [Abdülhamid II Collection at the Library of Congress] (accessed June 11, 2008)

http://lcweb2.loc.gov/pp/prokhtml/prokabt.html [Prokudin-Gorskii Collection at the Library of Congress] (accessed June 11, 2008)

Enc. Islam/2: "Taṣwīr, §2. In the sense of photography"

A. M. Piemontese: "The Photography Album of the Italian Diplomatic Mission to Persia (Summer 1892)," *E. & W.*, n.s. xxii/3–4 (Sept.–Dec. 1972), pp. 249–311

E. Lucie-Smith: *The Invented Eye* (London, 1975)

M.-T. and A. Jammes: *En Egypte au temps de Flaubert 1839–1860: Les Premiers photographes* (Paris, 1976)

R. Thomas: "Some 19th-century Photographers in Syria, Palestine and Egypt," *Hist. Phot.*, iii/2 (1979), pp. 157–66

I. Afshar: "Some Remarks on the Early History of Photography in Iran," *Qajar Iran: Political, Social and Cultural Change 1800–1925*, ed. E. Bosworth and C. Hillenbrand (Edinburgh, 1982), pp. 261–90

C. Adle: "Notes et documents sur la photographie iranienne et son histoire: I. Les Premiers daguerrotypistes *c.* 1844–1854/1260–1270," *Stud. Iran.*, xii (1983), pp. 249–80

An den süssen Ufern Asiens, Ägypten, Palästina, osmanisches Reich: Reiseziele des 19. Jahrhunderts in frühen Photographien (exh. cat., Cologne, Röm.–Ger.-Mus., 1988)

N. N. Perez: *Focus East: Early Photography in the Near East 1839–1885* (New York, 1989)

F. N. Bohrer, ed.: *Sevruguin and the Persian Image, Photographs of Iran, 1870–1930* (Washington, DC, 1990)

D. Stein: "Three Photographic Traditions in Nineteenth-Century Iran," *Muqarnas*, vi (1990), pp. 112–30

A. A. Asani and C. E. S. Gavin: "Through the Lens of Mirza of Delhi: The Debbas Album of Early-Twentieth-Century Photographs of Pilgrimage Sites in Mecca and Medina," *Muqarnas*, xv (1998), pp. 178–99

L. A. F. Barjesteh van Waalwijk van Doorn and G. M. Volgelsang-Eastwood, eds.: *Sevruguin's Iran: Late Nineteenth Century Photographs of Iran from the National Museum of Ethnology in Leiden, the Netherlands* (Tehran, 1999)

V. Dehejia and C. Allen, eds.: *India Through the Lens: Photography 1840–1911* (Washington, DC, 2000)

A. Behdad: "The Powerful Art of Qajar Photography: Orientalism and (Self)-Orientalizing in Nineteenth-Century Iran," *Iran. Stud.*, xxxiv (2001), pp. 141–52

W.-D. Lemke: "Ottoman Photography: Recording and Contributing to Modernity," *The Empire in the City: Arab Provincial Capitals in the Late Ottoman Empire*, ed. J. Hanssen, T. Philipp and S. Weber (Würzburg, 2002), pp. 237–49

A. D. Navab: "To be or Not to be an Orientalist? The Ambivalent Art of Antoine Sevruguin," *Iran. Stud.*, xxxv/1 (2002), pp. 113–44

I. I. Nawwab and L. Werner: "Berlin to Makkah: Muhammad Asad's Journey into Islam," *Saudi Aramco World*, liii/1 (2002), pp. 6–32

J. B. Spurr: "Person and Place: The Construction of Ronald Graham's Persian Photo Album," *Muqarnas*, xix (2002), pp. 193–223

B. Öztuncay: *The Photographers of Constantinople, Fol. 1, Pioneers, Studios and Artists from 19th Century Istanbul* (Istanbul, 2003)

J.-S. Caillou: "Les graffiti de Baalbek: Mémoire des premiers historiens et photographes établis au Levant (1839–1898)," *Tempora: An. Hist. & Archéol.*, xiv–xv (2003–4), pp. 91–121

D. R. Nickel: *Francis Frith in Egypt and Palestine: A Victorian Photographer Abroad* (Princeton, 2004)

M. B. Dördöncü: *Mecca-Medina: The Yildiz Albums of Sultan Abdülhamid II* (New Jersey, 2006)

A. Gürsan-Salzmann: *Exploring Iran: The Photography of Erich F. Schmidt, 1930–1940* (Philadelphia, 2007)

Pinder-Wilson, Ralph (*b.* London, 17 Jan. 1919). British art historian and archaeologist. After serving in the Indian Army, Pinder-Wilson read Persian and Arabic at Oxford, taking an MA in 1947. He joined the Oriental Department of the British Museum as Assistant Keeper in 1949 and was appointed Deputy Keeper in 1969. In 1976 he was appointed Director of the British Institute of Afghan Studies in Kabul. There he supervised preservation work, excavations and fieldwork and made major contributions to the field of Afghan studies. He participated in archaeological excavations at HARRAN and SIRAF and was also an active member of the British Institute of Persian Studies for many years. After the British Institute in Kabul was closed in 1982 following the Soviet invasion, he returned to London and became involved in several research projects as a consultant. His expertise covers Islamic decorative arts from Persian painting to Islamic glass and rock crystal.

WRITINGS

Persian Painting of the Fifteenth Century (London, 1958)
ed.: *Paintings from Islamic Lands* (Oxford, 1969)
Studies in Islamic Art (London, 1985) [collected essays]
with G. T. Scanlon: *Fustat Glass of the Early Islamic Period: Finds Excavated by the American Research Center in Egypt, 1964–1980* (London, 2001)

BIBLIOGRAPHY

W. Ball and L. Harrow, eds.: *Cairo to Kabul: Afghan and Islamic Studies Presented to Ralph Pinder-Wilson* (London, 2002)

Pir Yahya ibn Nas al-Sufi al-Jamal. See YAHYA AL-SUFI.

Pishpek. See BISHKEK.

Pishtaq [Pīshṭāq; Pers.: "arch in front"]. Flat masonry or brick structure framing three sides of an arched opening (for illustration *see* IWAN and ISFAHAN, fig. 2). The *pishtaq*, one of the most distinctive forms of later Islamic architecture, became typical of major brick buildings in Iran, Iraq and Central Asia, where it was usually associated with the IWAN. The form is unknown in pre-Islamic architecture of the region, in which façades, whether on the court or the exterior, were uniform in height, and its origins and development in the early Islamic period are obscure. While the earliest Islamic religious buildings had simple portals, most 8th-century palaces had elaborate portals that projected from the façade, and the palaces at KUFA and UKHAYDIR in Iraq and MSHATTA in Jordan have been reconstructed with *pishtaqs*. The ruined structure at SARVISTAN, which has been reattributed to the early Islamic period, had a *pishtaq* in the middle of the triple-iwan façade and shallow porches framing the entrance arches of the two corner rooms, but the function of the building is controversial. By the 10th century elaborate portals had been introduced to Iranian mosques and mausolea (*see* ARCHITECTURE, §V, A, 1). The Jurjir or Hakim Mosque (late 10th century) in Isfahan has a projecting portal with intricate decoration, but, because of subsequent damage, its original height is uncertain. The façade of the Arab-Ata Mausoleum (978) at Tim near Samarkand is an elaborately framed arch, but, as it occupies the entire façade of the building, it differs from the typical *pishtaq* of later times, which projects above the roofline.

By the 12th century most important buildings in the eastern Islamic world—mosques, madrasas, mausolea, palaces and caravanserais—had portals that projected out from and above the main façade. Other notable examples from the eastern part of the region include the 11th-century caravanserai known as RIBAT-I MALIK, which has a pointed semi-dome enframed by a wide band of octograms in relief, and the 12th-century residence called RIBAT-I SHARAF, which is heavily decorated in the relief brickwork popular at the time of its construction. In a trio of 12th-century mausolea built by the Qarakhanid dynasty at UZGEND in the Ferghana Valley, squarish and shallow *pishtaqs* mask the tomb chambers behind them, as at the Arab-Ata Mausoleum. A portal added to one corner of the congregational mosque at Herat, Afghanistan, in 1200 and redecorated in the late 15th century has light blue tiles that form an inscription in knotted kufic script. These examples span the period when hypostyle congregational mosques in Iran and Central Asia were redeveloped by the insertion of tall axial iwans opening on their courtyards and large dome chambers in front of their mihrabs (*see* ARCHITECTURE, §V, A, 2 and 3). Although no contemporary example survives in its original state, the development of the *pishtaq* must have complemented these changes, so that the *pishtaq* matched the iwans in height and general form.

From the 13th to the 15th century, the *pishtaq*, now routinely centered in the main façade of the building, became proportionally taller and larger, as did the interior iwans to which it corresponds formally. The standard design, nascent already in the 10th century, was firmly established: the entry bay consists of a relatively small doorway below a tall, deep arch enclosing a pointed semi-dome, frequently filled with MUQARNAS; the lateral flanks of the entry bay are filled with decorative panels, epigraphic bands and modest niches; the frame of the arch is composed of tiers of flat niches and decorative and epigraphic bands running along the three sides of the *pishtaq*. The epigraphic bands of the *pishtaq* are the usual location for foundation inscriptions naming the building's patron and giving the date of construction or foundation. Koranic quotations are often included, and excerpts from endowment deeds for the structure are occasionally found. Tile decoration is mandatory; early examples include the *khanaqah* of 'Abd al-Samad (1307) at NATANZ in central Iran and the congregational mosque (1322–6) at VARAMIN. By the 15th century the entire *pishtaq* is covered with

tilework, as in the Blue Mosque (1465; *see* TABRIZ, §III, B). In a few cases, such as the Mosque of Bibi Khanum (1399–1405; *see* SAMARKAND, §III, B), twin minarets flank or surmount the *pishtaq*. In some cases, such as the mid-14th-century congregational mosque at YAZD, the *pishtaq* is fully twice as high as the façade to which it is attached, and it can occupy as much as half of the main façade, as in the madrasa of Ulugh Beg (1417–20) in Samarkand. The *pishtaq* of the Shah Mosque (1611–*c.* 1630; *see* ISFAHAN, §III, C), part of an entry complex that reorientates the visitor to the qibla, is one of the most familiar images of Persian architecture.

Beginning in the 12th century, the *pishtaq* was adopted in other areas of the Islamic world, such as India, Egypt and the Levant, where some aspects of the form were adapted for the indigenous tradition of building in stone. In these areas the vaulted portal was seldom taller than the rest of the building to which it was attached and often projected only marginally from the façade. Nevertheless, the idea of a striking vaulted portal is constant. In Anatolia the Iranian form of the *pishtaq* was translated into stone in such buildings as the caravanserai known as Sultan Han on the Konya–Aksaray road (1229), and the *pishtaq* became a standard feature in buildings erected under the patronage of the Saljuq dynasty of Anatolia (*r.* 1077–1307; *see* ARCHITECTURE, §V, C). Over time the decoration of the *pishtaq* was reduced; the portals of the great Ottoman mosques, such as the Süleymaniye (1552–9; *see* ISTANBUL, §III, C), are fairly plain and do not rise far above the bulk of the buildings to which they are attached.

K. A. C. Creswell: *Early Muslim Architecture* (Oxford, 1932–40), i, pp. 49, 585; ii, pp. 64–6

K. A. C. Creswell: *The Muslim Architecture of Egypt*, i (Oxford, 1952), p. 257

O. Grabar: "The Earliest Islamic Commemorative Structures," *A. Orient.*, vi (1966), p. 40

L. Bier: *Sarvistan: A Study in Early Iranian Architecture* (University Park, PA and London, 1986), pp. 21, 50–51

L. Golombek and D. Wilber: *The Timurid Architecture of Iran and Turan*, 2 vols. (Princeton, 1988)

R. Hillenbrand: *Islamic Architecture: Form, Function and Meaning* (Edinburgh, 1994)

Plasterwork. *See* STUCCO AND PLASTERWORK.

Plovdiv [Gk. Philippopolis; Turk. Filibe]. City in Bulgaria situated on both sides of the River Maritsa in the plain of Upper Thrace. The picturesque old town is built on and around five syenite hills, the only elevations in the surroundings. Until the first half of the 20th century, Plovdiv, with its many mosques, churches, synagogues and schools for its various ethnic, linguistic and religious groups, had a pronounced cosmopolitan character and, for Bulgaria, a sort of Mediterranean–Levantine flair.

The present city was founded by Philip II of Macedonia in 342 BCE on a site that had been inhabited since the Chalcolithic period and had acquired a more or less urban function in Thracian times. Philip's city was concentrated on the three hills that together form the so-called Trimontium. The Romans enlarged the city with a forum, aqueducts, houses, fortifications and an imposing marble stadium and theater. Plovdiv was repeatedly destroyed by barbarians, particularly in 444–7 CE by the Huns. Justinian I (*r.* 527–65) had it rebuilt in much smaller form. In the 7th century Slav tribes settled around the town. A Bulgarian prince, Malamir (*r.* 831–6), brought it within the borders of the First Bulgarian Empire, but between the end of the 10th century and the end of the 12th Plovdiv was again a Byzantine town. It was plundered and partly destroyed during the Third Crusade (1189–92), and the reconstructed town was conquered during the Fourth Crusade (1204); the chronicler Geoffroy de Villehardouin called it one of the most beautiful cities of eastern Europe. A year later the city rose in revolt against its Bulgarian "liberators" and was razed on the order of Tsar Kaloyan: the city walls were torn down, the palaces destroyed and the leading inhabitants killed. Between 1204 and submission to Ottoman rule in 1361 or 1364, the city changed hands 11 times between the Byzantines, Bulgarians and crusaders, reducing it to a small border town. During the Ottoman civil war between the sons of Bayezid I, Prince Musa captured the town and dismantled the walls (1412). The hitherto largely Greek civil population then settled in the nearby Greek town of Stanimaki (now Asenovgrad). In the first half of the 15th century, the Ottomans resettled the town with Turkish colonists from Anatolia, rebuilt the city and made it the seat of the governor-general of the Ottoman Empire in Europe.

The most important architectural monuments of Plovdiv, apart from the ancient remains, date from the Ottoman period, but of the dozens of mosques, baths, caravanserais and covered markets, only four survived the fury of 20th-century modernization. The great mosque (*c.* 1425; rest.) of Murad II (*r.* 1421–51 with interruption), a large rectangular hall with four piers carrying three domes flanked by three vaults, is one of the three examples of an Ottoman hypostyle (Ulu Cami) mosque in Europe; the others are at Edirne and Sofia. The original five-domed portico collapsed in the 18th century and was replaced in 1785 by an ungainly wooden porch. The minaret shows the rhombic brick decoration in two colors characteristic of early Ottoman architecture (*see* ARCHITECTURE, §VI, B, 2). The perfectly preserved decoration of the interior, painted in the late Ottoman Baroque style, was executed in 1818–19 by Seyyid Naskhbendi Mustafa from Edirne. The Imaret Mosque (1444; rest.), built by the governor-general Shihab al-Din Pasha, was modeled on the Yeşil (Green) Mosque at Bursa and is the largest example of a Bursa-type mosque in the Balkans. The Çifte Hamam ("double bath"; 1460s), with a profusion of stellate domes and *muqarnas* vaults, was probably founded by Isfandiyaroğlu Ismail Bey, the deposed ruler of Kastamonu, who resided in Plovdiv from 1461 to his death in 1479. The largest example of its

type in the Balkans, it is far more important than the 16th-century Orta Mezar Hamam in the town.

One of the largest cities of southeastern Europe, Plovdiv was by the 19th century the largest city of Turkish Bulgaria and a center of crafts and international trade. Many Plovdiv families had their counting-houses in Odessa, Vienna, Manchester and Calcutta, and one of the first textile factories in the Balkans was established in Plovdiv in 1847. The prosperity of the 19th century is reflected in the hundreds of bourgeois houses and mansions of the Trimontium quarter, built in a style that blends western Baroque decoration with Oriental elements, the most prominent being the four-iwan plan derived from Ottoman *konaks* (mansions) and palaces (e.g. Çinili Kiosk, Istanbul). Between 1830 and 1870 all 13 churches in the city, dating from Byzantine and later times, were replaced with larger three-naved pseudo-basilicas having stone walls but wood and plaster vaults. They all have rich interior decoration, notably the iconostasis, arch-hierarchal throne and ambo of carved wood. In the 19th century Ottoman Plovdiv abounded with bookshops, printing houses for five alphabets and literary societies, and an impression of the richness and beauty of the 19th-century city is given by the works of the 20th-century painter Tzanko Lavrenov. Nationalist doctrines in the 20th century led Turks, Greeks and Jews to leave, and Plovdiv became an almost entirely Bulgarian city, with many industries established in the environs after World War II. In the 1970s the historic old town on the Trimontium hills was restored in an exemplary manner, and much was done to excavate the Greco-Roman city and its Thracian precursor and integrate them into contemporary urban life.

S. Šiškov: *Plovdiv v svoeto minalo i nastoja šte* [Plovdiv in its past and present] (Plovdiv, 1927)

O. Rudlov and G. Rudlov-Hille: "Grad Plovdiv i negovite sgradi" [The town of Plovdiv and its buildings], *Izvestiya Balg. Arkheol. Inst.*, viii (1934) [fundamental and free from chauvinist distortions]

V. Peev: *Grad Plovdiv, minalo i nastojašte* [The town of Plovdiv, past and present] (Plovdiv, 1941)

C. Peev: *Alte Häuser in Plovdiv* (Berlin, 1943)

C. Peev: "*Golemijat Bezisten v Plovdiv*" [The market in Plovdiv], Godishnik N. Arkheol. Muz. Plovdiv, i (1948)

M. Bičev: *Bălgarski Barok* [Bulgarian Baroque] (Sofia, 1954)

C. Džambov, ed.: *Arkheologičeski proučvanija za istorijata na Plovdiv i Plovdivski Kraj* [Archaeological studies in the history of Plovdiv and the Plovdiv region] (Plovdiv, 1966)

C. Džambov, N. Abadžiev and I. Terziski: *Pametta na edin grad* [Memories of a town] (Plovdiv, 1972)

G. Kožuharov and R. Angelova: *Plovdivskata simetrička kăsti* [Plovdiv's symmetrical houses] (Sofia, 1974) [ignores Ottoman component]

S. Stojčev: *Plovdiv i okonostite mu: Pătelvoditel* [Plovdiv and its surroundings: a guide] (Sofia, 1974)

R. F. Hoddinoth: *Bulgaria in Antiquity: An Archeological Introduction* (London, 1975)

A. Fol: *Séminaires philippopolitaines de l'histoire et de la culture thrace* (Sofia, 1976)

Old Plovdiv (Sofia, 1977)

N. Genčev: *Văzro ždenskijat Plovdiv* [The revival of Plovdiv] (Plovdiv, 1981)

P. Berbenliev: *Arkhitekturnoto nasledstvo po Bălgarskite zemi* [Architectural heritage of Bulgarian lands] (Sofia, 1987) [good plans and photos]

M. Harbova: "L'Espace culturel de la ville balkanique entre l'Orient et l'Europe (d'après l'exemple de la ville de Plovdiv, XVIIIe–XIXe siècles," *Etud. Balkan.*, xxxviii/1 (2002), pp. 128–43

Poltoratsk. *See* ASHGABAT.

Pope, Arthur Upham (*b*. Phoenix, RI, 7 Feb. 1881; *d*. Warren, CT, 3 Sept. 1969). American art historian and archaeologist. He was educated at Brown and Cornell universities and taught at the University of California and Amherst College. In 1920 he married PHYLLIS ACKERMAN, who shared his scholarly interests in Persian art. By 1923 he had become director of the Legion of Honor Museum in San Francisco. In 1925 he began research in Iran and began acting as art adviser to the Iranian government. From 1930 he was director of the American Institute for Iranian Art and Archaeology (subsequently renamed the Iranian, then Asia, Institute and transferred to Pahlavi University in Shiraz). He lectured widely and organized international exhibitions and congresses of Persian art in Philadelphia (1926), London (1931), Leningrad (1935) and New York (1940) and helped many European refugee scholars get established in the USA, but his most durable achievement was editing the multi-volume *Survey of Persian Art*. In 1964 the shah of Iran invited Pope to move the Asia Institute to Shiraz. Almost single-handedly, Pope created popular interest in the art of Persia, which he believed to be the cradle of all civilization, just as the new shah, Reza Khan, was sweeping away the vestiges of the Qajar monarchy. Pope's reputation has been clouded, however, by his links to "the trade" and the suspicion that many works of art that passed through his hands were forgeries. He and his wife are buried in a lovely brick mausoleum near the Khwaju Bridge in Isfahan.

WRITINGS

An Introduction to Persian Art (London, 1930)

ed., with P. Ackerman: *A Survey of Persian Art from Prehistoric Times to the Present*, 6 vols. (London and New York, 1938–9); rev. 16 vols. (London, 2/1964–7/R Tokyo, 1977)

Masterpieces of Persian Art (New York, 1945)

Persian Architecture (London, 1965)

BIBLIOGRAPHY

Who Was Who, vi, pp. 1961–70

Who Was Who in America, v, pp. 1969–73

J. Gluck and N. Siver, eds.: *Surveyors of Persian Art: Arthur Upham Pope and Phyllis Ackerman, a Documentary Biography* (Ashiya, 1996) [with complete bibliography]

Portal. Ornamental entrance, gate or doorway to a building: from the Latin *porta*, meaning door or gate. *See also* DOOR and PISHTAQ.

A portal is normally used to emphasize the external part of the main entrance or entrances to a building or enclosure. This is frequently done with the intention of making those who approach feel overwhelmed by, or at least acutely aware of, the division between the ordinary space of the external world and the sacred, royal or otherwise significant space that lies beyond the portal. This effect can be achieved using various types of decoration, such as painted or carved designs, mosaic or inscriptions; monumental architectural elaborations are often incorporated. An early instance of a monumental entrance that could be classed as a portal is that of the prayer-hall of the Great Mosque of Damascus (*see* Damascus, §III). This entrance marks the transition between the courtyard of the mosque and the prayer-hall itself and is therefore not a true external entrance, but does display the monumentality and imposition of a portal. Three great arches and three arched windows are set within a larger blind arch, in turn set into a massive rectangular face topped with a portico and projecting far above the prayer-hall roof, a design with clear echoes of Classical architectural traditions. Spandrels and portico alike are decorated with mosaics representing trees and buildings on a gold ground, relating the external portal to the richly decorated mosaic interior of the building.

By the medieval period, it appears to have become standard for important buildings of the eastern Islamic world to have projecting portals, frequently taking the form of a decorated *pishtaq*—a form apparently unique to Islamic architecture—projecting above roof height. A nascent example of this is seen in the 10th-century fragment of the Jurjir Mosque at Isfahan: the portal has a semi-domed hood, into which a window and an arched entrance are set. A type of portal related to the Iranian *pishtaq* appears in the surviving 13th-century Saljuq monuments in Turkey, such as the mosque and hospital at Divriği or the Ince Minareli Madrasa in Konya. The latter, whose centerpiece is a virtuoso panel of carved Koranic inscription, is of a hooded type closely related to the Iranian *pishtaq*. The hospital portal at Divriği takes the form of an elaborately recessed arch; the mosque portal of the western façade is comprised of a shouldered arch containing a typically Anatolian Saljuq heavy *muqarnas* hood, set into a rectangular projection of the same height as the surrounding wall. Anatolian Saljuq portals were decorated within the portal area with extensive carved stonework and complex arrangements of monumental arches, engaged columns, voussoirs, bosses and so forth, but beyond the portals lie heavy, largely unpunctuated walls of solid stone which throw the magnificence and plasticity of the portals into even sharper relief.

The principle of the portal has never completely left Islamic architecture, although later developments in certain architectural traditions meant that the elaborately decorated portal was no longer necessarily the most significant marker of transition. For example, the sheer size of some Ottoman buildings such as the Sultan Ahmed Mosque or the Topkapı Palace (*see* Istanbul, §III, D and E), and the multiple gateways through which the visitor must pass to reach them, meant that Ottoman architects tended to favor plainer portal designs.

K. A. C. Creswell: *A Short Account of Early Muslim Architecture* (London, 1958/*R* Aldershot, 1989)

R. Hillenbrand: *Islamic Architecture: Form, Function and Meaning* (Edinburgh, 1994/*R* 2000)

Portrait. A work of art in any of a variety of media intentionally created by an artist depicting living or once living people. Current opinion considers the portrait to be a cultural construct linking the subject, the creator and the audience. Despite a widespread objection in Islamic societies against figural imagery in religious art, examples of portraiture can be found in the secular arts of the Islamic world almost from the very beginning. The portal of the palace at Khirbat al-Mafjar, for example, was decorated with a sculptured figure, presumably a portrait of the patron, the Umayyad ruler al-Walid II (*r.* 743–4). Although few other portraits are known to survive from early times, some remains of wall-painting from the Ghaznavid period (*r.* 977–1186) show realistic, albeit anonymous, figural representations as part of the palace decoration. Literary sources of this period also refer to life-like depictions of heroes, heroines and representations of royal personages in palace wall-painting, for instance the portraits of seven princesses in the palace of Bahram Gur in the *Khamsa* of Nizami Ganjavi (*c.* 1141–1217). Such elements can be viewed as the pre-Islamic heritage of life-size figural wall painting.

The survival of another pre-Islamic pictorial tradition—the Classical portrait—had a dramatic effect on early Arab painting, especially in the distinctive genre of the author portrait (e.g. *De Materia Medica* of Dioscurides; 1229; Topkapı Pal. Lib., Ahmet III, 2127). This iconographic subject was by degrees transferred from the Classical to the Islamic sphere, giving it a Muslim identity. This period also saw the fashion for the sovereign's portrait (e.g. Badr al-Din Lu'lu' (*r.* 1218–59) portrayed in five frontispieces of the *Kitab al-aghani* ("Book of songs"; 1217/18–19/20), now dispersed in Cairo, Istanbul and Copenhagen (N. Lib., Adab 579; Millet Lib., Feyzullah Ef.1565-6; Kon. Bib., Cod. arab. 168)). This tradition seems to have remained influential in the Islamic world during the early Ilkhanid period (*r.* 1256–1353; e.g. a frontispiece of the *Tarikh-i jahangusha* of Juvayni (1290; Paris, Bib. N., MS. supp. pers.205)).

Another important genre was the royal dynastic portrait. Early 14th-century copies of Rashid al-Din's *Jami' al-tawarikh* ("Compendium of Chronicles"; Topkapı Pal. Lib., H.1654; N. D. Khalili priv. col., MS727) contain portraits of Chinese emperors, along with Mongolicized images of legendary kings and actual historical rulers. Despite their anonymous quality, the royal images here may have acted as a political propaganda for the legitimacy of Mongol rule. Similarly idealized portraits of enthroned royal

personages, with the emphasis on their pedigree, can be seen in an early Timurid (*r.* 1370–1506) illustrated genealogical scroll (*c.* 1405–9; Topkapı Pal. Lib., H.2152). At the same time, more individualized portraits began to be made at the Timurid court (e.g. a portrait of Sultan Husayn Bayqara (*r.* 1470–1506) ascribed to Bihzad; Cambridge, MA, Sackler Mus., no.1958.59).

During the late 16th century, a distinctive genre of sultans' portraiture emerged in the Ottoman Empire (*r.* 1299–1924). Combining Iranian and Italian conventions and iconographic elements, detailed images of sultans served to enhance a dynastic identity (e.g. a portrait of Mehmet II (*r.* 1444–81), *c.* 1480; Topkapı Pal. Lib., H2153, fol.10). The Ottoman sultan Selim III (*r.* 1789–1807) was the first to have his portrait painted and printed for public distribution. His son Mahmud II (*r.* 1808–39) had his portraits hung on the walls of official buildings, publicly breaking the the taboo on human representation. In Iran, full-length figural murals (e.g. the wall painting of the audience hall, Chihil Sutun Palace; Isfahan, after 1647) and portraits painted in oil on canvas appeared in the 17th century. Not only indigenous pictorial conventions, but also styles inspired by the import of portraits of princes and ladies brought by European envoys and possibly the Armenian community, provided a source of inspiration for these unique styles of figural imagery. Under the Qajars (*r.* 1779–1924), life-size figural painting became an established medium and functioned as state portraiture. Examples of royal icons, such as those portraying Fath 'Ali Shah (*r.* 1797–1834), have a lifelike quality in facial representations yet remain somewhat lifeless in their depiction of physical appearances. In Mughal India (*r.* 1526–1858), portraits of royal personages were inserted into biographies of emperors, as a necessary component of contemporary visual documentation. Album drawings depicting single figures were also produced under the patronage of the Muslim sultans of the Deccan and the Rajput princes of Rajastan and Punjab.

G. C. Miles: "A Portrait of the Buyid Prince Rukn al-Dawlah," *Amer. Numi. Soc. Mus. Notes*, xi (1964), pp. 283–93

J. Raby: "Pride and Prejudice: Mehmed the Conqueror and the Italian Portrait Medal," *Italian Medals*, ed. G. Pollard, Stud. Hist. A (Washington, DC, 1987), pp. 171–94

E. R. Hoffman: "The Author's Portrait in Thirteenth-century Arabic Manuscripts: A New Islamic Context for a Late Antique Tradition," *Muqarnas*, x (1993), pp. 6–20

T. Fitzherbert: "Portrait of a Lost Leader: Jalal al-Din Kharazmshah and Juvaini," *The Court of the Il-khans 1290–1340*, ed. J. Raby and T. Fitzherbert (Oxford, 1996), pp. 63–77

L. Diva: "Invested with Life: Wall Painting and Imagery Before the Qajars," *Iran. Stud.*, xxxiv/1–4 (2001), pp. 5–16

K. Otto-Dorn: "Das islamische Herrscherbild im frühen Mittelalter (8.–11. Jh.)," *Das Bildnis in der Kunst des Orients*, ed. M. Kraatz, J. Meyer zur Cappellen and D. Seckel (Stuttgart, 1990), pp. 61–78

S. Kangal, ed.: *The Sultan's Portrait: Picturing the House of Osman* (Istanbul, 2000)

Postage stamps. *See* STAMPS.

Pozzi, Jean (Félix Anne) (*b.* 1884; *d.* Paris, 2 Oct. 1967). French diplomat and collector of art and historical documents. The son of the noted surgeon Samuel-Jean Pozzi (1846–1918), whose portrait was painted in 1881 by John Singer Sargent (1856–1925), the younger Pozzi was educated at the Lycée Condorcet, the Sorbonne and the Ecole des Sciences Politiques. He began a diplomatic career in 1908 and soon formed a collection of European and Islamic art. He was also interested in history, particularly Franco–Turkish relations from the 16th century, and wrote on the subject. From 1922 to 1925 he served as secretary to the French ambassador at Istanbul and Prague and was chargé-d'affaires at Munich. In 1926 he attended the international archaeological congress in Syria and was delegate (1926–34) to the Commission des Détroits at Istanbul. In 1934 he was appointed plenipotentiary minister in Iran, from 1937 he directed the archives of the French foreign ministry, and in 1939 he was appointed plenipotentiary minister in Egypt. Among other activities, he was president of the Société Française de Reproduction de Manuscrits. His collection of Islamic paintings and calligraphy, which by the 1920s was one of the foremost in Europe, consisted largely of Persian work, including paintings from the dismembered Great Mongol *Shāhnāma* ("Book of kings") of the early 14th century (*see* ILLUSTRATION, §IV, E, 2). Unlike many of his European contemporaries, Pozzi was equally interested in Islamic items from the 18th and 19th centuries and sensitive to the beauties of calligraphy. He left his collection to the city of Geneva: the Musée d'Art et d'Histoire received the Islamic items as well as the European paintings, drawings, engravings and artifacts, while the Bibliothèque Publique et Universitaire received his collection of 19th-century literary and historical documents.

WRITINGS

Le Khalifat et les revendications arabes (Paris, 1917)

BIBLIOGRAPHY

E. Blochet: *Les Peintures orientales de la collection Pozzi* (Paris, 1928)

M. Pianzola: "Le Legs de M. Jean Pozzi à la ville de Genève," *Mus. Genève* (Sept. 1972), pp. 17–18

P. M. Monnier: "Le Legs Pozzi à la Bibliothèque publique et universitaire," *Mus. Genève* (Oct. 1973), pp. 19–22

B. W. Robinson: "Miniatures persanes: Donation Pozzi," *Genava*, n. s., xxi (1973); as book (Geneva, 1974)

Prayaga. *See* ALLAHABAD.

Printing. Term used to embrace three distinct but related concepts. First, it denotes the multiplication of documents or similar items consisting of words, pictures or other signs by means of some controlling surface, image or set of codes; the assumption is that all the resulting copies of such documents are identical to one another, although there may sometimes be

appreciable differences between them. Secondly, it means the transfer of ink or some other substance by the impressing of one surface against another; such an action may lead to the above but does not necessarily lead to multiplication. Thirdly, an essential stage in some, but by no means all, printing is the assembly of prefabricated or otherwise predetermined characters (letters, numerals, and other signs) that relate to a particular written language or set of languages. Many printed items involve multiplication, impression and the assembly of prefabricated characters, but none of the three is essential to printing.

As Arabic script has joins between most letters, it presents problems quite unlike those of the Roman, Greek and Hebrew alphabets that preoccupied the first few generations of European typographers. Not only is a higher degree of punch-cutting skill required, especially if calligraphic norms are to be imitated, but matrices must be justified even more minutely if the breaks between adjacent sorts are to be disguised. The compositor likewise must constantly avoid using the wrong letter form. Moreover, as well as different initial, medial, final and free-standing sorts for most letters, an abundance of ligatures is also needed for pairs or groups of letters (*see* CALLIGRAPHY, fig. 1). If short-vowel marks (Arab. *ḥarakāt*) are required for Koranic and certain other texts, then even more sorts are needed, as well as huge quantities of quadrats and leads to be interspersed between the vowel marks. A full Arabic font can therefore contain over 600 sorts. Although some simplification was introduced in later periods, the Arabic script has never really acquired separate typographic norms, either aesthetic or practical, that could permit a decisive break with its scribal past. Since typography in its true sense has now been superseded, and modern methods of electronic "typesetting" permit a return to almost any variety of genuinely cursive script, this is unlikely to occur in the future.

I. Block-printing. II. Arabic printing in Europe. III. Printing in the Islamic lands.

I. Block-printing. Printing was practiced in the Islamic world probably as early as the 10th century. Block-prints on paper, found in Egypt, survive in several collections, notably Vienna (Nbib.), Cambridge (U. Lib.) and New York (Columbia U. Lib.), and further pieces have been excavated at Fustat (Old Cairo). At least one printed papyrus (Dublin, Chester Beatty Lib.) and two parchment pieces (see Arnold and Grohmann, 1929, pl. 15) are also preserved. The only literary and historical testimony to block-printing in the Arab world is two obscure references in Arabic poems in the 10th and 14th centuries to the production of amulets with *ṭarsh*, a non-classical Arabic term. It may refer to tin-plates with engraved or repoussé lettering used to produce multiple copies of Koranic and incantatory texts for sale to the illiterate poor: the style of the surviving pieces indicates that they were not intended to gratify any refined literary or artistic taste, since the script is far from calligraphic and there are even

errors in the Koranic texts. Some examples have headpieces with designs incorporating bolder lettering and ornamental motifs, sometimes white on black, which may have been printed with separate woodblocks. In 1294 the Ilkhanid sultan Gaykhatu (*r.* 1291–5) introduced paper money printed in Tabriz by Chinese artisans living there, but it was rejected by the Iranian people. Some block-printed patterns have also been found on the endpapers of manuscript codices (see Arnold and Grohmann, 1929, pl. 29A). The origin of the process used is unknown: while China or Central Asia has been suggested, the marked difference in techniques and the contrast with the luxury character of other Chinese imports and their imitations make this improbable, but a link with the printing of patterns on textiles, also practiced in medieval Egypt, cannot be ruled out. Islamic block-printing seems to have died out in the 14th or 15th century, and there is no evidence that it was ever used to produce books or substantial literary texts in any form. These remained the monopoly of scribes in the Islamic world until the 18th century, and the origins of Arabic typography and printed book production must be sought not in the Middle East but in Europe.

II. Arabic printing in Europe. Arabic printing with movable type originated in Italy in the early 16th century. The first book was the *Kitāb ṣalāt al-sawāʿī* ("book of hours") printed by the Venetian printer Gregorio de' Gregoriis (*fl. c.* 1480–1528) at Fano in 1514 and sponsored by Pope Julius II (*r.* 1503–13) for the use of Arab Melchite Christians in Lebanon and Syria. The type design is inelegant, and it was set in a clumsy, disjointed manner. Rather better was the typography of Paganino de' Paganini (1470–1541), who printed the whole text of the Koran at Venice in 1537–8, probably as a commercial export venture; but it was still so remote from calligraphic norms as to make it quite unacceptable to the Muslims for whom it was intended, especially as it also contained errors in the Koranic text. Italy remained the home of Arabic printing for the rest of the 16th century, and it was in Rome in the 1580s that Robert Granjon (*fl. c.* 1523–c. 1593) produced his elegant Arabic types, which for the first time achieved calligraphic quality, with their liberal use of ligatures and letter-forms derived from the best scribal models. They were used principally in the lavish editions of the Tipografia Medicea Orientale between 1590 and 1610, and they set the standard for nearly all subsequent work, especially that of the Dutch scholar–printer Franciscus Raphelengius (1539–97) and his successor Thomas Erpenius (1584–1624), who produced many Arabic texts with his more practical and workmanlike fonts in the early 17th century, and whose type-styles were much used or copied in Germany, England and elsewhere. Another elegant and beautiful font was commissioned by the French scholar–diplomat François Savary de Brèves (1560–1628) and evidently based on Arab or Turkish specimens of calligraphy acquired

while he was French ambassador in Istanbul between 1592 and 1604; it was executed in Rome before 1613 and later used both there and at the Imprimerie Royale in Paris in the mid-17th century, and again in the Napoleonic period. It subsequently provided a model for others, notably that of the Propaganda Fide, which had a monopoly of Arabic printing in Rome from 1662 onwards, and that of the monastic presses of 18th-century Romania.

There was a steady flow of Arabic printed books from most of the European centers of learning in the 17th, 18th and 19th centuries (see fig.). After Granjon, other leading typographers, such as William Caslon (1692–1766) and Giambattista Bodoni (1740–1813), were also involved in the design of Arabic fonts. As well as Orientalist editions, the European presses produced biblical and other Christian texts for use in the Middle East, and also some "secular" texts as a commercial export commodity aimed at Muslims, although these met with little success.

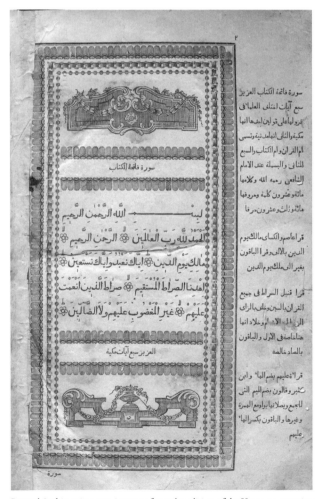

Printed Arabic script; opening page from the edition of the Koran manuscript printed in St. Petersburg by order of Catherine the Great, 1787 (private collection); photo credit: Sheila S. Blair and Jonathan M. Bloom

III. Printing in the Islamic lands. Arabic typography was not used in the Muslim world until the 18th century; all printed books in use had previously been imported from Europe. The reasons for this delay must be sought both in the nature of Islamic societies and in the supreme religious and aesthetic role accorded to the written word in the Islamic world. The segmentation and mechanization of the Arabic script by typesetting seemed tantamount to sacrilege; at the same time mass production of books challenged the entrenched monopoly of intellectual authority enjoyed by the learned class (Arab. *'ulamā'*) and threatened to upset the balance between that authority and the power of the State. This was one important reason why printing was eventually sponsored by modernizing rulers in the 18th and 19th centuries.

As in Europe, the earliest Arabic books printed in the Middle East were Christian texts. The earliest book printed in Arabic type is a Psalter, the *Kitāb al-zabūr al-sharīf*, printed at Aleppo in 1706 by the priest 'Abdallah Zakhir and published by the Melkite patriarch. Arabic printing in the Arab world remained in the hands of Syrian and Lebanese Christians for over a century. They used types cut and cast locally, modeled partly on local Christian book-hands and partly on the European tradition of Arabic type design, especially that of Orthodox Romania and of the Propaganda press in Rome.

Printing by Muslims was revived in Istanbul in the second decade of the 18th century, when Ibrahim Müteferrika (1674–1745), a Hungarian convert, began printing engraved maps using copperplates and probably techniques imported from Vienna; the earliest extant example is dated 1719–20. This was part of a program of westernizing innovations in the Ottoman capital that also led, less than ten years later, to the establishment of Müteferrika's famous book-printing establishment, complete with Arabic types cut and cast locally and modeled on the normal clear Ottoman *nesih* (Arab. *naskh*) script of the period (*see* CALLIGRAPHY, §IV, A). The first book, an Arabic–Turkish dictionary, was printed in 1728 and was followed by 16 others in Ottoman Turkish before the press was closed in 1742. Since the printing of the Koran and other religious texts was still forbidden, these books were all secular works, on history, geography, language, government (by Müteferrika himself), navigation and chronology. Several were illustrated with maps and engravings. Apart from a reprint in 1756, the press was not restarted until 1784, after which Ottoman Turkish printing had a continuous history until the adoption of the Latin alphabet in 1928.

Arabic printing in Egypt dates from 1822, apart from the relatively insignificant output of the presses of the French occupation in 1798–1801. The first book was printed at the state press of Muhammad 'Ali (r. 1805–48) at Bulaq near Cairo. This press was started by an Italian-trained typographer, Niqula Masabiki, and the first types were imported from Milan and are perceptibly European in style. They

were soon replaced by a succession of locally cut and cast founts based on indigenous *naskh* hands, which are somewhat cramped and utilitarian rather than calligraphic; they set the norm for Arabic typography in Egypt and at many other Muslim Arabic presses elsewhere for the rest of the 19th century. Types based on the more flowing *nasta'līq* script (*see* CALLIGRAPHY, §IV, B) were also employed, both for Persian texts and for headings in Arabic works, and a font in the distinctive *maghribī* script (*see* CALLIGRAPHY, §III, B) was also created but little used.

In the first half of the 19th century many Arabic books were imported into the Middle East by Christian missionaries. Most of these books were printed at a British-run press in Malta between 1825 and 1842; they included secular educational works as well as religious tracts. At first the types were brought from England, but in the 1830s a new font was cut and cast locally from calligraphic models, almost certainly prepared by the famous Lebanese writer Faris al-Shidyaq (1804–87), who had been a scribe in his youth and worked at the Malta press in this period. These books set new standards among the Arab (mainly Christian) pupils who used them, and the tradition was later continued by the American mission press in Beirut, which introduced a new typeface in the late 1840s, again based on calligraphic models. Known as American Arabic, it has a characteristic attenuated and forward-sloping appearance and was also used by several other presses in the Arab world. A more orthodox face, which was clear and workmanlike and based on Turkish models, was adopted by the press of the Jesuit mission in Beirut *c.* 1870 and became popular throughout the Levant.

Other Catholic mission presses inaugurated Arabic printing in Jerusalem in 1847 and in Mosul in 1856; in both cases their first fonts were brought from Europe (Vienna and Paris respectively). The first press in Iraq, however, had operated in Baghdad in 1830, using a font similar to those in Iran (presses had been established at Tabriz *c.* 1817 and Tehran *c.* 1823): an elegant Persian-style *naskh* with such curious idiosyncrasies as the shortened top stroke of the letter *kāf*. *Nasta'līq* typography was never favored in Iran, despite the prevalence of this style in the scribal tradition (including lithography). It was, however, used in the Indian subcontinent as early as 1778 and remained in use there, for both Persian and Urdu, until the mid-19th century; it was later revived in Hyderabad. Arabic typography burgeoned from the mid-19th century onwards, with presses starting in Damascus in 1855, Tunis in 1860, San'a in 1877, Khartoum in 1881, Mecca in 1883 and Medina in 1885. Most of these used local types in the Istanbul and Bulaq traditions, and many of them produced newspapers as well as books.

Since the late 1820s, however, many books, and some newspapers, had been printed not from type but by lithography (*see* ILLUSTRATION, §VI, B). This process was favored in many quarters, especially in Morocco, Iran, Central Asia and the Indian subcontinent, where it almost completely displaced typography for more than half a century. Its perceived advantages were that scribal calligraphy—including *nasta'līq*, which is difficult to reproduce typographically—could be directly reproduced and that it enabled many small publishers to avoid expensive investment in fonts. At best, lithographed texts can rival in beauty and clarity well-executed manuscripts of the period; at worst, they can degenerate into barely legible gray scrawls.

Arabic typography was revived in the Middle East in the late 19th century and early 20th, with considerable improvements in typefaces, especially in Egypt, where the new fonts of the Matba'at al-Ma'arif, and the Bulaq Press from 1902 onwards, set higher standards of clarity and elegance. In 1914 another new font at the Bulaq Press halved the number of sorts by eliminating many ligatures while retaining some of the calligraphic features of the older Bulaq types. The introduction of Linotype hot-metal machines further simplified the setting of Arabic-script texts, while inevitably moving further away from traditional calligraphy and book-hands. With the decline of metal types and the introduction of photo- and computer-generated typesetting, however, the way was opened for a return to calligraphic norms.

Apart from type styles, other aesthetic features of the Islamic printed book must be noted. As with early European incunabula, the tendency at first was to imitate manuscript styles and layouts. Words and lines were set closely, paragraphs and punctuation were lacking, the main type area was often surrounded by rules, and glosses or even complete commentaries appeared in the margins. Red ink was sometimes used for headings or keywords, following the scribal practice of rubrication. Traditional tapered colophons were common. Title-pages were often lacking, but the verso of the first leaf was commonly begun by a decorative headpiece (Arab. *'unwān*), often containing the title and/or the *basmala*, the invocation of the name of God. The earliest headpieces were engraved on wood; later, elaborate designs were constructed from fleurons and other single-type ornaments following a European printing practice, the aesthetic origins of which lay in the infinitely repeatable geometric and foliate patterns of Islamic art. In the late 19th century some elaborate pseudo-Islamic designs were used for headpieces and borders, especially in Ottoman Turkey, perhaps reflecting a European rather than an indigenous taste. Later, other European artistic styles such as *Jugendstil* can be detected in decoration and page design. By this time European norms of title-pages, paragraphing, punctuation, running heads and the like had begun to dominate book production in the Islamic world.

Illustrations in Islamic printed books, until the introduction of modern half-tone techniques at the end of the 19th century, can be divided into two categories. The first is woodcuts and engraved or lithographed plates used in typographic books, mainly for maps, diagrams and didactic or technical

illustrations. They often incorporate linear perspective, an innovation in many areas of the Islamic world. The second is pictures introduced into the texts of lithographed books; they are often copied from, or in the style of, paintings in manuscripts. They usually accompany literary texts from an earlier period, but sometimes modern elements intrude, as in the depiction of a gramophone in the illustration to an Uzbek lithographed text of 1913 (see Chabrov, 1984). By reproducing pictorial elements in a standard, repeatable form for a much wider readership than that of illustrated manuscripts, both kinds of illustration helped to transform artistic awareness among educated Muslims of the 19th and 20th centuries.

Enc. Islam/2: "Maṭbaʿa"

C. F. Schnurrer: *Bibliotheca arabica* (Halle, 1811, *R*/Amsterdam, 1970)

E. G. Browne: *The Press and Poetry of Modern Persia* (Cambridge, 1914)

F. Babinger: *Stambuler Buchwesen im 18. Jahrhundert* (Leipzig, 1919)

T. F. Carter: *The Invention of Printing in China and its Spread Westward* (New York, 1925, rev. 2/1955)

T. W. Arnold and A. Grohmann: *The Islamic Book: A Contribution to its Art and History from the VII–XVIII Century* (Leipzig and Paris, 1929)

C. A. Storey: "The Beginning of Persian Printing in India," *Oriental Studies in Honour of Cursetji Erachji Pavry* (London, 1933), pp. 457–61

S. N. Gerçek: *Müteferrika matbaası* [The Müteferrika press], i of *Türk matbaacılığı* [Turkish printing] (Istanbul, 1939)

J. Nasrallah: *L'Imprimerie au Liban* (Beirut, 1948)

A. Demeerseman: "La Lithographie arabe et tunisienne," *Rev. Inst. B.-Lett. Arab.*, xvi (1953), pp. 347–89; as booklet (Tunis, 1954)

Abu'l-Futuh Ridwan: *Ta'rīkh maṭbaʿat Būlāq* [History of the Bulaq press] (Cairo, 1953)

A. Demeerseman: "L'Imprimerie en Orient et au Maghreb: Une Etape décisive de la culture et de la psychologie islamiques," *Rev. Inst. B.-Lett. Arab.*, xvii (1954), pp. 1–48; as booklet (Tunis, 1954)

A. J. Arberry: *Arabic Printing Types: A Report Made to the Monotype Corporation Limited* (n. p., *c.* 1955)

Khalil Sabat: *Ta'rīkh al-ṭibāʿa fi'l-sharq al-ʿarabī* [History of printing in the Arab East] (Cairo, 1963, rev. 2/1966)

K. Jahn: "Paper Currency in Iran," *J. Asian Hist.*, iv (1970), pp. 101–35

M. Krek: *Typographia Arabica: The Development of Arabic Printing as Illustrated by Arabic Type Specimens* (Waltham, MA, 1971)

R. Meynet: "Les Difficultés de l'imprimerie," *L'Ecriture arabe en question: Les Projets de l'Académie de langue arabe du Caire de 1938 à 1968* (Beirut, 1971), pp. 30–35

G. Duverdier: "Les Caractères de Savary de Brèves, les débuts de la typographie orientale et la présence française au Levant au 17e siècle," *L'Art du livre à l'Imprimerie Nationale* (Paris, 1973)

R. Hamm: *Pour une typographie arabe: Contribution technique à la démocratisation de la culture arabe* (Paris, 1975)

M. Krek: *A Bibliography of Arabic Typography* (Weston, MA, 1976)

W. Henkel: *Die Druckerei der Propaganda Fide: Eine Dokumentation* (Munich, 1977)

M. Krek: *A Gazetteer of Arabic Printing* (Weston, MA, 1977)

Y. Safadi: "Arabic Printing and Book Production," *Arab Islamic Bibliography: The Middle East Library Committee Guide* (Hassocks, Sussex, 1977), pp. 221–34

H. A. Avakian: "Islam and the Art of Printing," *Uit bibliotheektuin en informatieveld* (Utrecht, 1978), pp. 256–69

M. Krek: "The Enigma of the First Arabic Book Printed from Movable Type," *J. Nr E. Stud.*, xxxviii (1979), pp. 203–12

M. W. Albin: "Iraq's First Printed Book," *Libri*, xxxi (1981), pp. 167–74

E. Krüger: "Vom Ende einer Kunst: Die Gestaltung des osmanischen Buchdruckes," *Gutenberg-Jb.*, lvi (1981), pp. 218–22

H. D. L. Vervliet: *Cyrillic and Oriental Typography in Rome at the End of the Sixteenth Century: An Inquiry into the Later Work of Robert Granjon (1578–90)* (Berkeley, 1981)

V. Cândea: "Dès 1701: Dialogue roumano-libanais par le livre et l'imprimerie," *Le Livre et le Liban jusqu'à 1900* (Paris, 1982), pp. 281–93

G. Duverdier: "Les Impressions orientales en Europe et le Liban," *Le Livre et le Liban jusqu'à 1900* (Paris, 1982), pp. 157–280

G. Endress: "Die Anfänge der arabischen Typographie und die Ablösung der Handschrift durch den Buchdruck," *Grundriss der arabischen Philologie*, ed. W. Fischer, i (Wiesbaden, 1982), pp. 291–6, 312–14

G. Roper: "Arabic Printing: Its History and Significance," *Ur* (1982), pp. 23–30

J. Balagna: *L'Imprimerie arabe en Occident: XVIe, XVIIe et XVIIIe siècles* (Paris, 1984)

G. N. Chabrov: "Illyustratsiya v turkestanskoy litografirovannoy knige, 1908–1916 gg." [Illustrations in the lithographed books of Turkestan, 1908–16], *Kniga*, xlix (1984), pp. 95–106

W. Gdoura: *Le Début de l'imprimerie arabe à Istanbul et en Syrie: Evolution de l'environnement culturel, 1706–1787* (Tunis, 1985)

M. Krek: "Arabic Block Printing as the Precursor of Printing in Europe: Preliminary Report," *Amer. Res. Cent. Egypt Newslett.*, cxxix (1985), pp. 12–16

G. Roper: "Arabic Printing and Publishing in England before 1820," *Brit. Soc. Mid. E. Stud. Bull.*, xii (1985), pp. 12–32

J. Nasrallah: "Les Imprimeries melchites au XVIIIe siècle," *Proche Orient Chrét.*, xxxvi (1986), pp. 230–59

R. W. Bulliet: "Medieval Arabic ṭarsh: A Forgotten Chapter in the History of Printing," *J. Amer. Orient. Soc.*, cvii (1987), pp. 427–38

G. Duverdier: "Savary de Brèves et Ibrahim Müteferrika: Deux drogmans culturels à l'origine de l'imprimerie turque," *Bull. Biblioph.* (1987), pp. 322–59

A. Nuovo: "Il Corano arabo ritrovato (Venezia, P. e A. Paganini, tra l'agosto 1537 e l'agosto 1538)," *La Bibliofilia*, lxxxix (1987), pp. 237–71

A. Tinto: *La tipografia medicea orientale* (Lucca, 1987)

M. W. Albin: "An Essay on Early Printing in the Islamic Lands with Special Relation to Egypt," *Institut Dominicain d'Etudes Orientales du Caire: Mélanges (MIDEO)*, xviii (1988), pp. 335–44

M. Borrmans: "Observations à propos de la première édition imprimée du Coran à Venise," *Quad. Stud. Arab.*, viii (1990), pp. 3–12

A. Nuovo: *Alessandro Paganino (1509–1538)* (Padua, 1990)

A. Nuovo: "A Lost Arabic Koran Rediscovered," *The Library*, 6th ser., xii (1990), pp. 273–92

K. K. Walther: "Die lithographische Vervielfältigung von Texten in den Ländern des Vorderen und Mittleren Orients," *Gutenberg-Jb.*, lxv (1990), pp. 223–36

M. Borrmans: "Présentation de la première édition imprimée du Coran à Venise," *Quad. Stud. Arab.*, ix (1991), pp. 93–126

R. Smitskamp: *Philologia Orientalis: A Description of Books Illustrating the Study and Printing of Oriental Languages in 16th and 17th-century Europe* (Leiden, 1992)

H. S. Abi Fares: *Arabic Typography: A Comprehensive Sourcebook* (London, 2001)

The Beginnings of Printing in the Near and Middle East: Jews, Christians, and Muslims (exh. cat. ed. K. Kreiser; Bamberg, Staatsbib., 2001)

U. Marzolph: *Narrative Illustration in Persian Lithographed Books* (Leiden, 2001)

Sprachen des Nahen Ostens und die Druckrevolution: eine interkulturelle Begegnung. Katalog und Begleitband zur Austellung/Middle Eastern Languages and the Print Revolution: A Cross-Cultural Encounter. A Catalogue and Companion to the Exhibition (exh. cat. ed. E. Hanebutt-Benz, D. Glass, G. Roper and T. Smets; Mainz, Gutenberg-Mus., 2002)

U. Marzolph, ed.: *Das gedruckte Buch im Vorderen Orient* (Dortmund, 2002)

P. Sadgrove, ed.: *History of Printing and Publishing in the Languages and Countries of the Middle East, J. Sem. Stud. Suppl., 15* (Oxford, 2004)

Exotische Typen: Buchdruck im Orient-Orient im Buchdruck (exh. cat. ed. M. Pehlivanian; Berlin, Staatsbib., 2006)

K. R. Schaefer: *Enigmatic Charms: Medieval Arabic Block Printed Amulets in American and European Libraries and Museums* (Leiden, 2006)

Prusa. *See* Bursa.

Q

Qahira, al-. *See* CAIRO.

Qairouan. *See* KAIROUAN.

Qajar [Qājār; Kadjar]. Turkmen dynasty of rulers and patrons who reigned in Iran from 1779 to 1924.

I. Introduction. II. Family members.

I. Introduction. After the fall of the SAFAVID dynasty and the campaigns of Nadir Shah (*d.* 1747), the Qajar tribe of Turkmen competed against the ZAND dynasty for power in Iran. Under Agha Muhammad Khan (*d.* 1797) the various branches of the Qajar tribe were united, and their authority expanded over the country. In 1785 Agha Muhammad took TEHRAN and adopted it as capital. In 1794 he captured the last Zand ruler Lutf 'Ali (*r.* 1789–94) at Kirman, and the following year he was formally crowned in Tehran. With the country pacified, subsequent Qajar rulers in the 19th century, particularly Agha Muhammad's nephew (A) Fath 'Ali Shah and the latter's great-grandson (B) Nasir al-Din, became important patrons of art and architecture at a time when Iran was increasingly exposed to European ideas. By the end of the 19th century, however, the country was deeply in foreign debt due to incessant warfare and royal extravagance. A demand for political liberalism arose, and in 1906 Muzaffar al-Din (*r.* 1896–1907) was forced to grant a constitution. Thereafter Qajar power and prestige faded rapidly. Russian, British and Ottoman troops occupied the country during World War I, and in 1924 the last Qajar ruler, Ahmad (*r.* 1909–24), was deposed, and the commander-in-chief of the army ascended the throne as Riza Shah Pahlavi.

The Qajars ruled as absolute monarchs and used architecture and art to project their power and awe their subjects. Congregational mosques were erected throughout the country; major shrines were restored; and *takya*s, arenas for the performance of the play lamenting the martyrdom of the imams Hasan and Husayn, were introduced. Traditional plans and forms were continued in religious buildings, but decoration in glazed tile was particularly colorful. The Qajar court migrated seasonally, and palaces were built in Tehran and the countryside. They are rambling, terraced structures set in elaborate gardens (*see* GARDEN, §IV). Palaces from the second half of the 19th century incorporated such European ideas as staircases, tall windows, engaged pilasters and landscape murals alongside traditional modes of decoration in glazed tile, carved stucco and mirrorwork (*see* ARCHITECTURE, §VII, B, 2).

The elaborate court life of the Qajars was recorded in OIL PAINTING, LACQUER, glass (*see* GLASS PAINTING) and ENAMEL, and such court painters as Sani 'al-Mulk ("Craftsman of the Kingdom") and Kamal al-Mulk ("Perfection of the Kingdom") (*see* GHAFFARI, §§II and III) worked on both a large and a small scale, producing life-size oil portraits and exquisitely decorated small objects for everyday use, such as penboxes, mirror-cases and caskets. Large paintings depicting Shi'ite martyrology, sometimes known as coffee-house paintings, were introduced in this period. Paintings from the period show a hybrid style, combining such European techniques as portraiture and perspective with the Iranian tradition of meticulous workmanship and rich color and pattern. Popular subjects from the traditional repertory include idealized youths of both sexes and flowers and birds. The warmth and sentimentality of Qajar painting distinguish it from the classical tradition of Persian book illustration (*see* ILLUSTRATION, §VI, B). Other techniques introduced from the West during the period include photography and lithography.

Enc. Islam/2: "Ḳādjār"

Qajar Studies: Journal of the International Qajar Studies Association (2001–)

Ḥasan-i Fasāʾī: *Fārsnāma-yi nāsirī* (Tehran, 1896); Eng. trans. by H. Busse as *History of Persia under Qājār Rule* (New York and London, 1972)

B. W. Robinson: "Qājār Painted Enamels," *Paintings from Islamic Lands*, ed. R. Pinder-Wilson (Oxford, 1969), pp. 187–204

S. J. Falk: *Qajar Paintings: Persian Oil Paintings of the 18th and 19th Centuries* (London, 1972)

B. W. Robinson: "Persian Painting in the Qajar Period," *Highlights of Persian Art*, ed. R. Ettinghausen and E. Yarshater (Boulder, 1979), pp. 331–62

E. Bosworth and C. Hillenbrand, eds.: *Qajar Iran: Political, Social and Cultural Change, 1800–1925* (Edinburgh, 1983), pp. 219–310

A. K. S. Lambton: *Qajar Persia* (London, 1987)

Woven from the Soul, Spun from the Heart: Textile Arts of Safavid and Qajar Iran, 16th–19th Centuries (exh. cat., ed. C. Bier; Washington, DC, Textile Mus., 1987)

Muqarnas, vi (1989) [four articles from a 1987 symp. on the art and cult. of Qajar Iran]

P. Avery, G. Hambly and C. Melville, eds.: *From Nadir Shah to the Islamic Republic* (1991), vii of *The Cambridge History of Iran* (Cambridge, 1968–91)

A. Seyf: "Carpet and Shawl Weavers in Nineteenth-century Iran," *Mid. E. Stud.*, xxix/4 (1993), pp. 679–89

Royal Persian Paintings: The Qajar Epoch 1785–1925 (exh. cat., ed. by L. S. Diba with M. Ekhtiar; New York, Brooklyn Mus.; Los Angeles, CA, Armand Hammer Mus. A.; London, U. London, SOAS, Brunei Gal.; 1998–9)

W. Floor: "Art (Naqqashi) and Artists (Naqqashan) in Qajar Persia," *Muqarnas*, xvi (1999), pp. 125–54

Qajar Portraits (exh. cat. by J. Raby; London, U. London, SOAS, Brunei Gal., 1999)

Iran. Stud., xxxiv/i (2001) [special issue devoted to Qajar art]

U. Marzolph: *Narrative Illustration in Persian Lithographed Books* (Leiden, 2001)

G. M. Vogelsang-Eastwood, L. A. Barjesteh van Waalwijk van Doorn and L. A. Ferydoun: *An Introduction to Qajar Era Dress* (Rotterdam, 2002)

W. Floor: *Traditional Crafts in Qajar Iran, 1800–1925* (Costa Mesa, 2003)

R. Hillenbrand, ed.: *Shahnama: The Visual Language of the Persian Book of Kings*, Varie Occasional Papers II (Aldershot, 2004) [several articles on manuscripts and metalwares]

W. Floor: *Wall Paintings and Other Figurative Mural Art in Qajar Iran* (Costa Mesa, 2005)

J. Scarce: "Some Interpretations of Religious and Popular Culture in Qajar Tilework," *Religion and Society in Qajar Iran*, ed. R. Gleave (London, 2005), pp. 429–48

D. Behrens-Abouseif and S. Vernoit, eds.: *Islamic Art in the 19th Century: Tradition, Innovation, and Eclecticism*, Islamic History and Civilization: Studies and Texts, 60 (Leiden: 2006) [several articles on Qajar art and patronage]

Iran. Stud., xl/4 (Sept 2007) [issue devoted to entertainment in Qajar Persia]

II. Family members.

A. Fath 'Ali Shah. B. Nasir al-Din.

A. FATH 'ALI SHAH [Fatḥ 'Alī Shāh] (*b.* 1771; *r.* 1797–1834; *d.* Isfahan, 23 Oct. 1834). Following his uncle, who had begun work on a palace in Tehran and had summer palaces (destr.) at Astarabad (now Gorgan) and Sari on the Caspian Sea, Fath 'Ali Shah enlarged the palace in the capital and established palaces elsewhere that catered to his peripatetic lifestyle. His main additions to the Gulistan Palace in Tehran are the Takht-i Marmar, a columnar audience hall, and the 'Imarat-i Badgir (rest.). His summer palaces in hillside villages subsequently incorporated in the northern suburbs of Tehran include the Qasr-i Qajar (destr.) and the Nigaristan Palace. He also built another summer palace, the Sulaymaniyya in the village of Karaj west of Tehran, and other palaces at Sultaniyya (destr.) and Chasma 'Ali near Damghan. He also renovated palaces and pavilions of the Safavid period, including the Hasht Bihisht (*see* ISFAHAN, §III, H) and the Bagh-i Fin at KASHAN, and constructed the Bagh-i Takht in SHIRAZ.

This spate of palatial building stimulated the patronage of other arts. Court painters produced large oil paintings portraying the king, his family, former rulers and singing and dancing girls. A large mural (1812–13; destr.) by 'ABDALLAH KHAN for the Nigaristan Palace depicted Fath 'Ali Shah enthroned in state with 118 life-size figures. The monarch was particularly proud of his appearance, especially his full beard and elaborate regalia, including a bejeweled crown, bracelets and belt with tassel and dagger. He adored fine jewelry and assembled the crown jewels of Iran (*see* JEWELRY, §II, A). He had many full-length portraits painted in oils; the finest (Tehran, Nigaristan Mus.) is by MIHR 'ALI. Fath 'Ali Shah revived the Achaemenid and Sasanian tradition of having himself portrayed in rock reliefs and had his portrait put on the coinage for the first time since the Arab conquest of Iran in the 7th century. He also commissioned illustrated manuscripts, including a magnificent copy (Windsor Castle, Royal Lib.) of his own *Dīvān* (collected poetry; he wrote under the name of Khaqan) with varnished covers, illumination and illustrations by MIRZA BABA, which was sent to London in 1812 as a present for the Prince Regent (later George IV, King of England). Single-page portraits and flower studies were also produced in some quantity during his reign, either for albums or for the tourist trade that flourished in the wake of the new diplomatic relations between the Persian court and various foreign powers, notably Eng-land. Two other forms of painting developed at this time: ENAMELS on gold, silver or copper and GLASS PAINTING.

Enc. Islam/2

B. W. Robinson: "The Royal Gifts of Fath 'Ali Shah," *Apollo*, lii (1950), pp. 60–68

B. W. Robinson: "The Court Painters of Fatḥ 'Alī Shāh," *Eretz-Israel*, vii (1964), pp. 94–105

V. B. Meen and A. D. Tushingham: *The Crown Jewels of Iran* (Toronto, 1968)

G. Hambly: "A Note on Sultaniyeh/Sultanabad in the Early 19th Century," *A. & Archaeol. Res. Pap.*, ii (1972), pp. 89–98

J. Lerner: "A Rock Relief of Fatḥ 'Alī Shāh in Shiraz," *A. Orient.*, xxi (1991), pp. 31–44

M. M. Eskandari-Qajar: "Qajar Imperial Attire: The Making of Persia's Lion and Sun King, Fath Ali Shah Qajar," *Qajar Stud.*, iii (2003), pp. 71–94

L. S. Diba: "An Encounter between Qajar Iran and the West: The Rashtrapati Bhavan Painting of Fath 'Ali Shah at the Hunt," *Islamic Art in the 19th Century: Tradition, Innovation, and Eclecticism*, ed. D. Behrens-Abouseif and S. Vernoit, Islamic History and Civilization: Studies and Texts, 60 (Leiden, 2006), pp. 281–304

B. NASIR AL-DIN [Nāṣir al-Dīn] (*b.* near Tabriz, 17 July 1831; *r.* 1848–96; *d.* Tehran, 1 May 1896). Great-grandson of (A) Fath 'Ali Shah. The first Iranian sovereign to visit Europe (he made trips in 1873, 1878 and 1889), Nasir al-Din returned with new ideas and artifacts that profoundly

Europeanized Iranian art. He built as extensively as his great-grandfather, but the new style of architecture introduced such European elements as pilasters and tall windows. Beginning in 1867, he reconstructed and expanded TEHRAN by demolishing congested areas and the remains of its 16th-century walls and constructing large squares and boulevards. He transformed the Gulistan Palace, adding the Shams al-ʿImarat, a multi-story building with two towers, on the east and other buildings (destr.). He built summer palaces in the hills to the north of Tehran; those at ʿIshratabad and Sultanatabad, both built in the 1880s, abandon the elegant symmetry found in Fath ʿAli Shah's work. Nevertheless, they retain many traditional aspects of taste, particularly colored tilework, ornately carved stucco and mirror mosaic.

The arts underwent similar Westernization during his reign (see color pl. 3:I, fig. 3). A more realistic style was introduced by the court painter Saniʿ al-Mulk (see GHAFFARI, §II), who had been sent to study in Italy in 1846 on the initiative of Nasir al-Din's father, Muhammad Shah. This realistic style is apparent in the most lavish illustrated manuscript of the period, a six-volume copy (1853–5; Tehran, Gulistan Pal. Lib., MSS 12367–72) of the Persian translation of the *Thousand and One Nights* prepared under his direction, and in mural paintings, including one depicting Nasir al-Din and his court (1857; now divided into seven panels, Tehran, Archaeol. Mus.)—a composition based on ʿAbdallah Khan's mural (1812–13; destr.) depicting the court of Fath ʿAli Shah—which Saniʿ al-Mulk painted for the Nizamiyya Palace. Photography had been introduced to Iran in 1844 by the Frenchman Jules Richard (1816–91), later known as Mirza Riza Khan, and Nasir al-Din became an enthusiastic amateur photographer, encouraging his courtiers to follow suit. Men were not allowed into the harem, and the photographs taken there by the monarch are the earliest portrait photographs of Iranian women. The most prominent commercial photographer was the Armenian Antoin Sevruguin, who recorded his surroundings with an encyclopedic eye. Religious painting also flourished, partly encouraged by the monarch's own activities. He built the Dawlat *takya* (destr.) in Tehran, which was decorated with large paintings on canvas depicting the martyrdom of the Shiʿite imams Hasan and Husayn.

Enc. Islam/2

C. Adle: "Notes et documents sur la photographie iranienne et son histoire," *Stud. Iran.*, xii (1983), pp. 249–80

I. Afshar: "Some Remarks on the Early History of Photography in Iran," *Qajar Iran: Political, Social and Cultural Change, 1800–1925*, ed. E. Bosworth and C. Hillenbrand (Edinburgh, 1983), pp. 261–90

P. Chelkowski: "Narrative Painting and Recitation in Qajar Iran," *Muqarnas*, vi (1989), pp. 98–111

D. Stein: "Three Photographic Traditions in Nineteenth-century Iran," *Muqarnas*, vi (1989), pp. 112–30

F. Bohrer, ed.: *Sevruguin and the Persian Image: Photographs of Iran, 1870–1930* (Seattle and Washington, DC, 1999)

Qalʿat Bani Hammad [Kalʿat Banī Ḥammād; Kalaa des Bani Hammed La Kalaa]. Site in central Algeria, 25 km northeast of M'Sila, that was the capital of the Hammadid branch of the ZIRID dynasty. In 1007 Hammad ibn Buluggin founded a *qalʿa* (Arab.: "fortress") in the Maadid Mountains; its strong ramparts (950×500 m) protected it several times against the attacks of the Zirids of Ifriqiyya (Tunisia). The site was rapidly populated by the forced transfer of neighboring inhabitants, who built the Manar Palace, several mosques, caravanserais and other public buildings. The Qalʿa reached its apogee during the reigns of al-Nasir (*r.* 1062–88) and al-Mansur (*r.* 1088–1105), thanks to the influx of refugees from Kairouan fleeing the invasions of Hilalian nomads. The city had four palaces, of which the largest (Qasr al-Bahr) had a vast central pool. One of the few extant remains is the elaborately decorated minaret (h. 20 m; see fig.) of the congregational mosque. The wealth of the city is attested by the range of glazed ceramics found there. Menaced in its turn by the advancing nomads, the town was abandoned by al-Mansur, who took refuge in Bejaïa (Bougie, now Annaba, N. Algeria). After the Hammadids were overthrown by the Almohads (*r.* 1130–1269) in 1152, the Qalʿa continued to decline, but Almohad presence there is shown by numerous ceramic shards of a distinctive type. The site was definitively abandoned by the end of the 12th century. It was identified by Méquesse in 1886, investigated by Blanchet and Robert and excavated by de Beylié in 1908, by Golvin from 1951 to 1962 and by Bourouiba after 1964. The excavations have produced numerous finds, including some of the earliest evidence for the use of *muqarnas* in the region.

Enc. Islam/2: "Kalʿat Banī Ḥammād"

R. Bourouiba: "Rapport préliminaire sur la campagne de fouilles de septembre 1964 à la Kalaa des Bani Hammed," *Bull. Archéol. Alg.*, i (1962–5), pp. 243–61

L. Golvin: *Recherches archéologiques à la Qalʿa des Banû Ḥammâd* (Paris, 1965)

A. Lezine: "Le Minaret de la Qalaʿa des Banu Hammad," *Bull. Archéol. Alg.* (1967), pp. 261–70

R. Bourouiba: *La Qalʿa des Bani Hammad* (Algiers, 1975)

D. F. Ruggles: "Vision and Power at the Qala Bani Hammad in Islamic North Africa," *J. Gdn Stud.*, xiv (1994), pp. 28–41

A. Khelifa: "La Qalʿa des Beni Hammad," *L'Algérie en héritage: Art et histoire* (exh. cat., ed. E. Delpont; Paris, Inst. Monde Arab., 2003), pp. 247–53

Qaraqoyunlu [Qarāqoyunlu; Karakoyunlu; Ḳarā-Ḳuyunlu]. Islamic dynasty of Turkmen rulers and patrons that reigned in eastern Anatolia, Iran and Iraq from 1380 to 1469. The Qaraqoyunlu (Turk.: "Black Sheep") arose in the region near Lake Van and expanded from TABRIZ, their capital from 1406. With the death of the Timurid ruler Shahrukh in 1447, Jahanshah (*r.* 1438–67), the last major Qaraqoyunlu ruler, expanded his empire to include Iraq, Oman and much of Iran. The empire collapsed when Jahanshah was defeated and killed by his AQQOYUNLU rival, Uzun Hasan. The Qaraqoyunlu

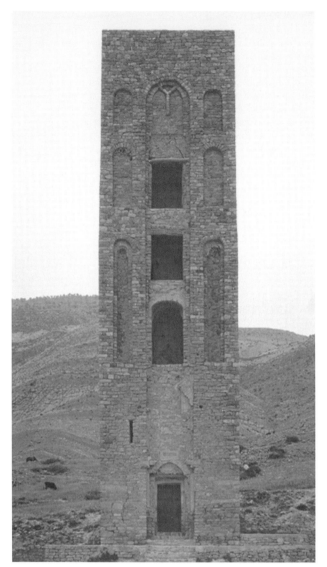

Qal'at Bani Hammad, minaret of the mosque, 11th century; photo credit: Sheila S. Blair and Jonathan M. Bloom

are known for their patronage of architecture and the arts of the book. Jahanshah built the small but finely tiled Darb-i Imam shrine in Isfahan in 1453–4, the year after he took the city. The greatest monument of his reign is the Blue Mosque in Tabriz, built by his wife Khatun Jan Begum as part of a complex (1465) which included a *khanaqah* and *zāwiya* (convent and dormitory; *see* Tabriz, §III, B and Architecture, fig. 32). The building is remarkable for its unusual plan and exquisite tile decoration, which is comparable to the finest Timurid work. Jahanshah's son Pir Budaq was a noted patron of manuscript painting while he was governor of Shiraz and then Baghdad for his father. In manuscripts illustrated for Pir Budaq the styles of Tabriz and Shiraz are assimilated to that of the Timurid capital, Herat. A copy (Istanbul,

Topkapı Pal. Lib., R. 1021) of the *Khamsa* ("Five poems") of Khusraw Dihlavi dated 1463 and a contemporary manuscript (Tehran, Gulistan Pal. Lib.) of *Kalila and Dimna* animal fables can be assigned to his patronage.

Enc. Iran.: "Darb-e Emām"; *Enc. Islam/2*: "Ḳarā-Ḳuyunlu"

I. Stchoukine: "La peinture à Baghdad sous Sultān Pīr Budāq Qāra-Qoyūnlū," *A. Asiatiques*, xxv (1972), pp. 3–18

B. W. Robinson: "The Turkman School to 1503," *The Arts of the Book in Central Asia, 14th–16th Centuries*, ed. B. Gray (London and Paris, 1979), pp. 215–47

L. Golombek and D. Wilber: *The Timurid Architecture of Iran and Turan*, 2 vols. (Princeton, 1988)

J. W. Allan: "Metalwork of the Turcoman Dynasties of Eastern Anatolia and Iran," *Iran*, xxix (1991), pp. 153–9

S. S. Blair and J. M. Bloom: *The Art and Architecture of Islam 1250–1800* (London and New Haven, 1992), chaps. 4 and 5

Timur and the Princely Vision (exh. cat by G. D. Lowry and T. Lentz; Washington, DC, Sackler Gal.; Los Angeles, CA, Co. Mus. A., 1992)

Qas al-Mshatta. *See* Mshatta.

Qashani. *See* Abu tahir.

Qasim ʿAli [Qāsim ibn ʿAlī Chihra-gushāy: "portrait painter"] (*fl.* Herat, *c.* 1475–*c.* 1526). Iranian illustrator. He was one of the most renowned painters at the court of the Timurid sultan Husayn Bayqara (*see* Timurid, §II, H) and his associate ʿAlishir nava'i (*see also* Illustration, §V, D). The chronicler Mirza Muhammad Haydar Dughlat (1500–51) described him as a portrait painter and pupil of Bihzad and said that Qasim ʿAli's works came close to Bihzad's but were rougher. The historian Khwandamir (*d.* 1535–6) noted that Qasim ʿAli worked in the library of ʿAlishir Nava'i, the poet, bibliophile and major patron, but that by the 1520s, having made the pilgrimage to Mecca and moved to Sistan, he apparently had ceased painting. His style is difficult to define because many works are falsely ascribed to him. The four paintings most convincingly attributed to him are in the style of Bihzad and illustrate a copy (divided, Oxford, Bodleian Lib., Elliott 287, 317, 339 and 408; Manchester, John Rylands U. Lib., Turk. MS. 3) of ʿAlishir's *Khamsa* ("Five poems") dedicated to Husayn Bayqara's son Badiʿ al-Zamann in 1485. *Mystics in a Garden* (Oxford, Bodleian Lib., Elliott 339, fol. 95*v*) bears an attribution to the slave Qasim ʿAli between the lines of text. The scene of bearded shaykhs in a lyrical landscape of blooming trees and flowers set against a night sky is a fine example of the calm, well-ordered, yet visually stunning oeuvre of the best artist from the school of Bihzad. An undated copy of the *Ahsān al-kibār* ("History of the faithful imams"; St. Petersburg, Saltykov-Shchedrin Pub. Lib., Dorn 312) contains a painting signed by Qasim ibn ʿAli in 1525 (*see* Safavid, §II, A), and a painting of *Bahram Gur in the Turquoise Pavilion* (Houston,

TX, A. & Hist. Trust col.; see Soudavar, no. 67) detached from a copy of Nizami's *Khamsa* is also signed by Qasim ibn ʿAli, but these two works show less reliance on Bihzadian models than the four earlier works assigned to Qasim ʿAli.

Ghiyāth al-Dīn Khwāndamīr: *Fadl-i az khulāsat al-akhbār* [Essences of the eminent] (1499–1500) ([Kabul], AH 1345/1926); Eng. trans. by T. W. Arnold as *Painting in Islam* (London, 1928/R 1965), pp. 139–40

Mīrzā Muḥammad Ḥaydar Dughlāt: "Iqtibas az *Tārīkh-i rashīdī*" [Selections from the *Tārīkh-i rashīdī*] (1541), ed. M. Shafiʿ, *Orient. Coll. Mag.*, x/3 (1934), pp. 150–72; Eng. trans., ed. W. M. Thackston in *A Century of Princes: Sources on Timurid History and Art* (Cambridge, MA, 1989), p. 361

B. W. Robinson: *A Descriptive Catalogue of the Persian Paintings in the Bodleian Library* (Oxford, 1958), pp. 65–7

I. Stchoukine: "Qasim ibn ʿAli et ses peintures dans les Ahsan al-Kibār," *A. Asiatiques*, xxviii (1973), pp. 45–54

B. Gray, ed.: *The Arts of the Book in Central Asia, 14th–16th Centuries* (London and Paris, 1979), p. 197; pl. lx

A. Soudavar: *Art of the Persian Courts: Selections from the Art and History Trust Collection* (New York, 1992)

E. Bahari: *Bihzad: Master of Persian Painting* (London, 1996), passim

E. Sims: *Peerless Images: Persian Painting and its Sources* (London, 2002), p. 58

Qasr al-Hayr East [Qasr al-Ḥayr al-Sharqī; Kasr el-Heir]. Early Islamic palace in the Syrian desert 97 km northeast of Palmyra. The remains, excavated between 1964 and 1972, consist of an outer enclosure (Arab. *hayr*) with sluice gates and surrounding an area of about 7 sq. km, two square fortified enclosures with regular half-round towers, as well as a bath, a minaret and a mud-brick settlement (unexcavated). The Lesser Enclosure (66 m sq.) is finely built of ashlar masonry and brick, with rooms on two stories around a court. It resembles the typical fortified residence (Arab. *qasr*) erected in the Syrian desert by the Umayyad caliphs (r. 661–750) but lacks the fine decoration typical of these buildings (see ARCHITECTURE, §III, C). The Greater Enclosure (160 m sq.) is built of ashlar masonry and mud-brick and comprises an arcaded court surrounded by seven courtyard houses, an industrial unit and a mosque. An inscription in the mosque (destr.) dates the construction of this "city" (Arab. *madīna*) to AH 110 (728–9). The bathhouse lies between the two enclosures and has a columned hall and a three-room suite similar to that at QUSAYR ʿAMRA. Grabar interpreted the Greater Enclosure as a "city" in the sense of a small artificial urban settlement and the Lesser Enclosure as a caravanserai. An alternative view would see both as part of a single settlement, the houses and mosque of the Greater Enclosure added at a later date to the princely residence of the Lesser Enclosure, to form a unit parallel to that found at ANJAR and the citadel at AMMAN. After abandonment in the 9th century both enclosures were reoccupied in the 12th and 13th centuries as a caravan stop on the route from central Syria to the Euphrates River. The square stone minaret dates from this reoccupation, as does a large quantity of fine pottery and other finds.

Enc. Islam/2: "Ḳaṣr al-Ḥayr al-Sharḳī"

O. Grabar and others: *City in the Desert: Qasr al-Hayr East* (Cambridge, MA, 1978)

G. Fowden: "Late-antique Art in Syria and its Umayyad Evolutions," *J. Roman Archaeol.*, xvii (2004), pp. 282–304

D. Genequand: "From 'Desert Castle' to Medieval Town: Qasr al-Hayr al-Sharqi," *Antiquity*, lxxix/304 (2005), pp. 350–62

D. Genequand: "The Early Islamic Settlement in the Syrian Steppe: A New Look at Umayyad and Medieval Qasr al-Hayr al-Sharqi (Syria)," *al-ʿUsur al-Wusta: The Bulletin of Middle East Medievalists*, xvii/2 (2005), pp. 20–24

Qasr al-Hayr West [Qasr al-Ḥayr al-Gharbī; Qasr el-Heir el-Gharbi; Kasr el-Heir]. Early Islamic palace in the Syrian desert 59 km southwest of Palmyra. The site was excavated between 1936 and 1938, and the palace façade and many carved and painted panels have been reconstructed in the Damascus Museum. The complex, built at the tail of a water-system deriving from the Roman dam at Karbaqa (16 km south), consists of a fortified residence (Arab. *qasr*), a bath, a courtyard building identified as a caravanserai, a rectangular irrigated enclosure (Arab. *hayr*), and a U-shaped structure thought to be a barrage for collecting water. This structure is decorated with stuccos including hunting scenes and may have been a trap for game, a type known locally since the Neolithic period. The residence, abutting an earlier rectangular stone tower thought to have been a monastery, is otherwise typical of those erected by the Umayyad caliphs (r. 661–750) in the Syrian desert (see ARCHITECTURE, §III, C). Measuring 71 m sq., it has half-round towers along the walls, which are built of stone for the first 2 m, with baked brick and mud-brick above. Two stories of rooms are arranged in suites (Arab. *bayt*) around a central court. The building was extensively decorated with carved stucco panels and statuary on the main gate, including the figure of a prince dressed in Persian clothing. Within, the door arches had stucco grilles and carved surrounds, and the upper story appears to have been decorated with stucco relief figures, including an almost life-size mounted knight. The walls of the ground floor were painted with simulated marble panels and large medallions. Two rooms identified as stairwells had floor frescoes, one in the Sasanian and one in the Byzantine style (see ARCHITECTURE, fig. 64). The bath is 30 m away, Roman-style and heated, with three rooms and a changing room. The caravanserai, built of mud-brick on a stone socle, is a porticoed courtyard building (55 m sq.) with six rooms on the entrance side and single long rooms on the other three sides. A small mosque projects from the southeast corner. The lintel retains holes for the pegs and grooves for metal letters, which stated that the work had been ordered by the caliph Hisham (r. 724–83) in Rajab AH 109 (November 727).

Enc. Islam./2: "Ḳaṣr al-Ḥayr al-Gharbī"

D. Schlumberger: "Les Fouilles de Qasr el Heir el-Gharbi," *Syria*, xx (1939), pp. 195–238, 324–73

D. Schlumberger: "Deux fresques omeyyades," *Syria*, xxv (1946–8), pp. 86–102

K. A. C. Cresswell: *A Short Account of Early Muslim Architecture* (London, 1958); rev. by J. W. Allan (Aldershot, 1989), pp. 135–46

D. Schlumberger: *Qasr el-Heir el-Gharbi* (Paris, 1986)

J. M. Bláquez: "La herencia clásica en el Islam: Qusayr ʿAmra y Qasr al-Hayr al-Gharbi," *Europa y el Islam*, ed. G. Anés y Álvarez de Castrillón (Madrid, 2003), pp. 44–142

G. Fowden: "Late-antique Art in Syria and its Umayyad Evolutions," *J. Roman Archaeol.*, xvii (2004), pp. 282–304

Qasr Kharana [Qaṣr Kharāna; Kharaneh; Haranee]. Early Islamic residence 65 km southeast of Amman, Jordan. Discovered in 1896, it is a rectangular structure some 35 m square with rounded towers at the corners and in the middle of each side. The entrance lies on the south. A vestibule leads to a central court (12 m sq.) surrounded by 61 rooms arranged in suites (Arab. *bayt*) on two stories. Almost all of the rooms are (or were) vaulted with transverse arches supporting shallow barrel vaults. Two phases of construction are visible, but the building was never completed. Most of the decoration, in molded stucco, is confined to the upper floor. An Arabic graffito of November 710 establishes that the building was standing at that time, but it has been debated whether it was a pre-Islamic or Islamic foundation, and it has been argued that it served as a fortress, palace, pilgrimage hostel or even a crusader castle. Survey of the site between 1979 and 1981 established its early Islamic date, although its intended function is still unclear. It is a fine, if small, example of the typical desert palace, built by the Umayyad caliphs in the Syrian desert during the late 7th and early 8th centuries (*see* ARCHITECTURE, §III, C and PALACE).

Enc. Islam/2: "Kharāna"

S. K. Urice: *Qasr Kharāna in the Transjordan* (Durham, NC, 1987)

G. Fowden: "Late-antique Art in Syria and its Umayyad Evolutions," *J. Roman Archaeol.*, xvii (2004), pp. 282–304

Qatar, State of [Arab. Dawlat Qaṭar]. Country in the Persian/Arabian Gulf comprising the Qatar peninsula and a few small islands, with its capital at Doha. The semi-desert, limestone peninsula extends *c.* 180 km north from mainland Arabia, with which it has long-standing links and rivalry, as it has with nearby Bahrain and Iran. The indigenous population (*c.* 850,000; 2007 estimate) is mainly Sunni Muslim, and includes many people originally from Iran and East Africa. There is also a large expatriate workforce. Evidence for occupation exists from about the 8th millennium BCE, and Qatar was probably involved in the flourishing Gulf trade in the 3rd millennium BCE and certainly in the medieval Islamic period, when the pearling industry flourished. European domination in the Gulf from the early 16th century led to the decline of the old trading centers, and the origins of the present state can be traced to the settlement of certain tribes in the 1730s. The Ottomans arrived in 1871 and maintained a presence in Doha until 1915, although Qatar managed to retain semi-autonomy. Under a treaty of 1916, Qatar established a protective relationship with Britain similar to that of the Trucial States (now United Arab Emirates). Oil was discovered in 1939 and first exported in 1949; there are also huge reserves of natural gas. In 1971 Qatar became fully independent as a hereditary monarchy.

The discovery of oil led to dramatic modernization from the 1950s and particularly in the 1970s. Old buildings were demolished, and new residential complexes and offices built; traditional villages were abandoned. Most buildings were in Western styles designed by foreign architects. However, an awareness of the need to preserve traditional buildings and to create an architecture that reflected Qatari heritage began to grow, especially among Qatari architects. Some buildings have been restored, such as the House of Muhammad Nasrullah (early 20th century), which has a wind-tower, and the Qatar National Museum, also in Doha (opened 1975), which is housed in the palace occupied in the early 20th century by the ruler of Qatar. The central majlis was built in 1918 by the Bahraini architect ʿAbdullah ibn ʿAli al-Mail. The Amiri palace, rebuilt in 1975 (architects: Michael Rice & Co.) as the National Museum, won an Aga Khan award for the restoration of Islamic architecture in 1980. In Wakra, 15 km south of Doha, fine examples of traditional architecture have been preserved, such as wind-towers and houses with stucco ornamentation. Many examples of carved wooden doors also survive.

The rapid building program has included adventurous designs (e.g. Halim ʿAbd al-Halim's entry for the ʿUthman ibn ʿAffan Mosque competition, Doha, 1981; *see* ARCHITECTURE, fig. 60). The flat-topped, pyramid-shaped Doha Sheraton Hotel (1982), built on reclaimed salt flats, was the first to dominate the West Bay urban area. It has since been joined by a handful of others. Qatar University (1983), built on a desert site, has a design based on traditional windtowers and is particularly striking. The Ministry of Information and Culture and National Theater complex (1982) and the Ministry of Foreign Affairs also combine modern functions with Islamic forms. Education City, a 2500-acre site on the outskirts of Doha founded by the Qatar Foundation in 1997, houses satellite campuses of a dozen American universities. The first was Virginia Commonwealth University School of the Arts, which contains offers degree programs in the arts and hosts an annual international design symposium, Tasmeem, and a gallery that presents exhibitions of modern art from the region. The new Museum of Islamic Art, designed by I. M. Pei (*b.* 1917) on an artificial island off the corniche, is scheduled to open in the spring of 2008. The pyramidal building will house a spectacular collection amassed over the last few decades.

Since the early 1980s the contemporary art movement in Qatar has been stimulated by the return of

trained local artists from Egypt, Iraq, France, Italy and the USA. Leading late 20th-century artists include Jassem Zeini (*b.* 1943), a graduate of the Baghdad Academy of Fine Arts in 1968 and a founder of the Free Atelier, and Sultan Alsileity (*b.* 1945). Like their counterparts in neighboring countries, most Qatari painters have depicted local scenes and customs. A few adopted a form of Surrealism, while two abstract painters, Ali Hassan Algabir (*b.* 1957) and Yussef Ahmad (*b.* 1955), employed calligraphy in their compositions. Algabir used both *nastaʿliq* and a free-hand script, while playing with the distribution of color and light. Yussef Ahmad transformed his letters into pure abstract signs within carefully structured compositions. Hassan al-Mulla (*b.* 1952), an Expressionist artist, executed paintings that often combine human figures and landscape with symbolic elements, for example in *Intersection* (1988; Amman, N.G. F.A.).

The Qatari Society for Fine Arts, established in 1980 in Doha, has been the main force behind the development of the modern art movement in Qatar. It arranges exhibitions in the country and abroad, publishes catalogues and books on art, awards prizes for artists, and collaborates with the Department of Arts and Culture in supporting local artists. The Free Atelier was opened by the government in 1980, on the same lines as the one in Kuwait. It offers art lessons and provides art materials free of charge for local artists. Traditional crafts are taught at school and in adult classes; leatherwork, brocade embroidery and weaving are still practiced, and some jewelry is made, as are traditional incense burners.

The discovery of Qatar's ancient past began in 1957 with a survey by a Danish team (see Bibby). Many of the archaeological finds are in the Qatar National Museum (1975) in Doha. The museum has two sections: the Old Palace with its stables was built around 1901 for Shaykh ʿAbdullah ibn Qasim al-Thani. It has been restored as an example of traditional Qatari architecture and has various ethnographic displays. The second section is the New Palace, which was constructed (1972–5) during restoration of the Old Palace; it contains various artistic, scientific and ethnographic exhibitions, and in the grounds there is a display of traditional native ships. In Zubara Fort, al-Khor and Wakra there are small museums of local artifacts.

Encl Islam/2: "Ḳaṭar"

G. Bibby: *Looking for Dilmun* (London, 1970)

B. de Cardi, ed.: *Qatar Archaeological Report: Excavations, 1973* (Oxford, 1978)

J. Raban: *Arabia through the Looking Glass* (London, 1979)

R. S. Zahlan: *The Creation of Qatar* (London, 1979)

J. Whelan, ed.: *Qatar: A MEED Practical Guide* (London, 1983)

M. El-Bassiouny: "Contemporary Art in Qatar," *A. & Islam. World*, iii/4 (1985–6), pp. 33–6, 126–7

W. Ali, ed.: *Contemporary Art from the Islamic World* (London, 1989)

P. Vine and P. Casey: *The Heritage of Qatar* (London, 1992)

S. Nagy: "Social Diversity and Changes in the Form and Appearance of the Qatari House," *Visual Anthropol.*, x/2 (1998), pp. 281–304

N. I. al-ʿIzzi al-Wahabi: *Qatari Costume* (London, 2003)

J. Thompson: *Silk: 13th to 18th Centuries. Treasures from the Museum of Islamic Art, Qatar* (Doha, 2004)

M. Rosser-Owen: *Ivory, 8th to 17th Centuries: Treasures from the Museum of Islamic Art, Qatar* (Doha, 2004)

S. al-Khemir: *De Cordoue à Samarcande: Chefs d'oeuvre du Musée d'art islamique de Doha* (Paris, 2006)

Qavam al-Din Shirazi [Qavām al-Dīn ibn Zayn al-Dīn Shīrāzī] (*b.* ?Shiraz; *fl.* 1410–38; *d.* 21 Feb. 1438). Iranian architect. Contemporary sources mention his first known work, the madrasa and *khanaqah* (1410–11; destr.) erected at Herat for the Timurid ruler Shahrukh (*see* TIMURID, §II, B). Epigraphic and literary evidence points to Qavam al-Din's authorship of the Friday Mosque (completed 1417–18) in the shrine at Mashhad, and the adjoining structures known as the Dar al-Huffaz and Dar al-Siyada are likely to be his work as well. The Friday Mosque (1417–38; mostly destr. 1885) and madrasa (completed 1432–3) built at Herat for Shahrukh's wife Gawharshad (*see* TIMURID, §II, C; for illustration *see* HERAT) are unanimously ascribed by contemporary sources to Qavam al-Din. Circumstantial evidence suggests that he was also responsible for the shrine of ʿAbdallah Ansari (completed 1428–9) at Gazurgah outside HERAT. This was the major building erected by Shahrukh in the second half of his reign and very likely caused the architect to take time from his project for Gawharshad, explaining the unusual length of time taken for the completion of the latter. The Ghiyathiyya Madrasa (completed 1444–5) at Khargird, ordered by Shahrukh's vizier Pir Ahmad Khwafi, is the best preserved of the architect's works (*see* ARCHITECTURE, fig. 33). He may also have been involved in the Buqʿa at Taybad, a shrine ordered by the same patron. Qavam al-Din's buildings are among the architectural masterpieces of the period of Timurid rule in eastern Iran and Transoxiana and display notable innovations in plan and, particularly, in vaulting. The use of intersecting vaults in cruciform dome chambers, first seen in mature form in the Dar al-Siyada at Mashhad, left a permanent mark on Iranian architecture.

L. Golombek: *The Timurid Shrine at Gazur Gah* (Toronto, 1969)

B. O'Kane: "The Madrasa al-Ghiyāṣīyya at Khargird," *Iran*, xiv (1976), pp. 79–92

T. Allen: *A Catalogue of the Toponyms and Monuments of Timurid Herat* (Cambridge, MA, 1981)

B. O'Kane: *Timurid Architecture in Khurasan* (Costa Mesa, 1987)

D. Wilber: "Qavam al-Din ibn Zayn al-Din Shirazi," *Archit. Hist.*, xxx (1987), pp. 31–44

L. Golombek and D. Wilber: *The Timurid Architecture of Iran and Turan*, 2 vols. (Princeton, 1988), pp. 189–93

Qayrawan, al-. *See* KAIROUAN.

Qazvin [Qazvīn; Qazwīn; Kazvin]. City in north central Iran, about 150 km northeast of Tehran. Qazvin occupies a favorable geographical position guarding the passes leading north through the Elburz Mountains to the Caspian Sea, but it never became

as important as such other medieval cities as RAYY, NISHAPUR and ISFAHAN, probably because of lack of water and vulnerability to earthquake. It stands on the site of an ancient city built by the Sasanian monarch Shapur II (r. 309–79), which allegedly replaced another city founded by Shapur I (r. 241–72). After the Arab conquest in 644, it continued to be a frontier town, and by the 10th century it consisted of an inner and outer city and had two congregational mosques. The Persian traveler Nasir-i Khusraw, who visited it in 1046, found a prosperous city surrounded by a strong wall and numerous gardens. In the 12th century it was threatened by the heretical sect known as the Assassins, whose headquarters at the castle of Alamut lay two days' march to the northeast of Qazvin.

Most of the medieval monuments of Qazvin have disappeared, including the mosque founded by the Abbasid caliph Harun al-Rashid (r. 786–809). The earliest surviving building is the dome chamber of the congregational mosque, which has a long endowment inscription giving the name of the patron, Khumartash, governor of the city under the Saljuqs (r. 1038–1194), and the date of foundation, 1106–15. The historian Hamdallah Mustawfi Qazvini (d. c. 1349), who was a native of the city, recorded that two iwans were added to the mosque in 1153, and the north iwan may well date from that period because its decoration is Saljuq in style. Most of the rest of the four-iwan mosque, which is remarkable for its extraordinary size, was rebuilt under the Safavid (r. 1501–1732) and Qajar (r. 1779–1924) dynasties. The south iwan, for example, is inscribed with the date 1658–9. The dome chamber in the Haydariyya Madrasa, which stands to the south of a court surrounded by Qajar structures, has close stylistic links to that in the congregational mosque and dates from a few years later. The decoration in brick and plaster is particularly fine and is notable for the masterful inscription in floriated kufic and the early use of glazed tile. The distinctive style of building developed in Qazvin in the Saljuq period can be seen in other monuments in the region, such as the mosques at Qurva and Sojas.

In 1220 Qazvin was captured by the Mongols, who razed its walls and many of its buildings, and it was some time before the city regained its former prosperity. The tomb of Hamdallah Mustawfi (rest. 1935) has a square base and a conical roof, the typical form for tomb towers along the Caspian littoral. Qazvin became particularly important in the Safavid period, and in 1555 under Tahmasp I (r. 1524–76) it was the capital, replacing TABRIZ, which was vulnerable to attack by the Ottomans. The only parts of Tahmasp's palace to survive are the portal known as the 'Ali Qapu ("Lofty gate") and a two-story pavilion (rest.) with faded wall paintings known as the Chihil Sutun ("Forty columns") or the Kulangi Farangi ("European chapel"), which now serves as the city's museum. The shrine for Shahzada Husayn, a son of the eighth Shi'ite imam Riza (1568 and later), consists of a monumental portal, a spacious court surrounded by an arcade, and an iwan leading to the large octagonal tomb chamber; it is notable for the elaborate decoration in tile mosaic and mirrorwork and the fine grillework around the cenotaph.

In 1598 'Abbas I (r. 1588–1629) transferred the capital to Isfahan, but Qazvin remained an important center, partly because of the attempt to increase trade with Europe through southern Russia. Writing in 1607, Father Paul Simon, the first superior of the Discalced Carmelites in Persia, noted an abundance of silks, carpets and brocades. Qazvin's prosperity declined during the upheavals at the end of the Safavid period, but it became strategically and commercially important again under the Qajars due to the increased importance of the trade routes through Trebizond and over the Caspian Sea. Velvets, brocades and cotton cloth were manufactured there, and it had a rich network of caravanserais and vaulted bazaars. The Shah Mosque, another vast mosque with four iwans around a central court, was erected in the middle of the bazaar at the beginning of the 19th century and is decorated with glazed tiles with floral motifs. Two gateways, the Darvaza-yi Kushk ("Gateway of the palace") and the Darvaza-yi Qadim-i Tehran ("Old gateway to Tehran"), are other fine examples of Qajar decoration in glazed tile. The Husayniyya Amini, built by Muhammad Riza Amini in 1878 as an arena for the performance of the play lamenting the martyrdom of the imams Hasan and Husayn, consists of several halls and underground chambers and preserves good examples of Qajar decoration in mirrorwork, glazed tile and wooden windows with colored glass.

Enc. Islam/2: "Ḳazvīn"

P. Varjavand: *Sarzamīn-i Qazvīn* [The region of Qazvin] (Tehran, Iran. Solar 1349/1971)

D. N. Wilber: "Le Masğid-i ğāmī' de Qazwīn," *Rev. Etud. Islam.*, xli (1973), pp. 199–229

J. Sourdel-Thomine: "Inscriptions seldjoukides et salles à coupoles de Qazwin en Iran," *Rev. Etud. Islam.*, xlii (1974), pp. 3–43

W. Kleiss: "Der safavidische Pavillion in Qazvin," *Archäol. Mitt. Iran*, ix (1976), pp. 253–62

E. Escharaghi: "Description contemporaine des peintures murales disparues des palais de Šâh Ṭahmâsp à Qazvin," *Art et société dans le monde iranien*, ed. C. Adle (Paris, 1982), pp. 117–26

J. Bergeret and L. Kalus: "Analyse de décors épigraphiques et floraux à Qazwin au début du VIe/XIIe siècle," *Rev. Etud. Islam.*, xlv (1977), pp. 89–130

A. Schafiyeh: "Das Grab des Šeyu'l-Islām Maǧdu 'd-Dīn Abū'l-Futūḥ Aḥmad as shown Ǧazzālī in Qazwin," *Oriens*, xxxiv (1994), pp. 348–53

M. Szuppe: "Palais et jardins: Le complexe royal des premières Safavides à Qazvin, milieu XVIe–début du XIIe siécles," *Sites et monuments disparus d'après les témoignages de voyageurs*, ed. R. Gyselen, Res Orientalis VIII (Leuven, 1996), pp. 143–77

E. Wirth: "Qazvin—Safavidische Stadtplanung und Qadjarischer Bazar," *Archäol. Mitt. Iran*, xxix (1997), pp. 461–504

S. R. Canby: *The Golden Age of Persian Art, 1501–1722* (London, 1999)

H. Laleh: "La maqsūra monumentale de la mosquée du vendredi de Qazvin à l'époque saljuqide," *Bamberger Symposium: Rezeption in der islamischen Kunst vom 26.6.–28.6.1992*, ed. B. Finster, C. Fragner and H. Hafenrichter, Beiruter Texte und Studien, 61 (Beirut, 1999), pp. 217–30

H. Laleh: "Les muqarnas et leur réprésentation dans les panneaux à décor géometrique de brique de la mosquée de Haydariyya de Qazvin," *Proceedings of the Third European Conference of Iranian Studies held in Cambridge, 11th to 15th September 1995. Part 2: Mediaeval and Modern Persian Studies*, ed. C. Melville, Beiträge zur Iranistik, 17 (Wiesbaden, 1999), pp. 419–33

Quba (i). *See* KUVA.

Quba (ii) [Cuba; Kubba]. Town, regional center and district in Azerbaijan. The town was founded in the 15th century on the right bank of the Kudial River as a small fortress in the foothills of the Caucasus, and by the 16th century a system of fortifications had developed. The town reached its apogee in the 18th century under the *khans* of Kuba who made it the capital of their kingdom (1744–89). The city walls enclosed a higgledy-piggledy mass of streets and buildings stretched out along the river. The palace (destr.) was situated on the river bank, with its façade turned toward the Djuma (Friday) Mosque. From the 1840s the town developed on a more regular plan. The main street, with the district council building, the apothecary and the houses of the nobility, ran east–west from Baku Gate to Gamsar Gate. Bazaar Square near the palace had a caravanserai on the north, the house of Major-General Bakikhanov opposite, and small shops and booths along the east and west sides. The architect Kasym-bek Gadzhibababekov (*fl.* late 1850s) contributed to the development of the grid plan. Traditional houses in Kuba are multi-story buildings of stuccoed brick with rooms grouped around an iwan. In newer houses, façades open to the street and balconies replace the iwans. Roofs are flat or pitched and tiled. Buildings from the 19th century include the mausoleum of a holy man in the cemetery, a bathhouse, the Sakine Khanum Mosque and the octagonal Djuma Mosque. Kuba has become one of the main centers of carpet-weaving in Azerbaijan (*see* CARPETS AND FLATWEAVES, §IV, B), although the 18th-century carpets known as Kuba carpets were probably not woven there. The town has a local history museum.

Enc. Islam./2: "Ḳuba"

M. Useynov, L. Bretanitsky and A. Salamzade: *Istoriya arkhitektury Azerbaydzhana* [The history of the architecture of Azerbaijan] (Moscow, 1963)

G. Mekhmandarova: *Dzhuma mechet' v Kube* [The Djuma Mosque in Kuba] (Baku, 1986)

Quds, al-. *See* JERUSALEM.

Qum [Qumm; Qom; Kum]. Major shrine center in central Iran. Sasanian remains in the vicinity suggest that the site may have been occupied in pre-Islamic times, but most medieval geographers and historians

claimed that it was founded after the Muslim conquest in the 7th century. By 712–13 it had become a bastion for persecuted Shi'ites, and throughout the medieval period it attracted members of the more extreme Shi'ite sects. Under the Saljuqs (*r.* 1038–1194) Qum was celebrated for its madrasas, and it is still the most important center of Shi'ite theological studies in Iran.

Its reputation as a holy city is linked to the presence of the tomb of Fatima al-Ma'suma, the sister of the eighth Shi'ite imam, Riza. In 816–17, while *en route* to visit her brother at Tus in northeastern Iran, she fell ill at Saveh, a Sunni town, and asked to be taken to nearby Qum, where she died and was buried. Her tomb acquired particular importance under the SAFAVID dynasty (*r.* 1501–1732), which adopted Shi'ism as the state religion. The site was expanded and renovated by 'Abbas I (*r.* 1588–1629), who wanted to attract pilgrims to the Shi'ite shrines of Iran rather than those of Iraq, which was in the hands of the rival Ottomans. Qum became a major shrine, second only to Mashhad, site of Riza's tomb, and the shrine of Fatima is the only major shrine in Iran dedicated to a woman. The holy precinct (Pers. *āstāna-yi muqqadasa*) is reached through the New Court (*sahn-i jadīd*), built by a vizier of the Qajar ruler Nasir al-Din (*r.* 1848–96; *see* QAJAR, §II, B) in 1883. On the west a mirrored hall (*eyvān-i ā'ina*) flanked by two tall minarets opens into the tomb chamber. The oldest extant part is the interior north façade (1519); the dome was covered with gold-plated tiles in 1803–4, and the rest was modified in the late 19th century. A second older court (*sahn-i 'atīq*), dating from the 15th century, lies to the north of the tomb. Its southern iwan (*eyvān-i talā*; "Iwan of gold") was embellished with gilded *muqarnas* by Nasir al-Din in the 19th century. To the west of the tomb stands the Masjid-i Bala-sar ("Mosque at the top of the head") and to the south lies the Women's Court (*sahn-i zanāna*; 1666).

Because of its religious importance, Qum became a favorite burial place for religious and political dignitaries and members of the royal family. Some 28 tomb towers mark the graves of scholars, saints and descendants of the imams. Most are sophisticated structures with octagonal or dodecagonal plans, well-defined stories, battered walls and carved plaster revetment on the interior. The last four Safavid rulers and 32 other Safavid princes are interred within the sanctuary. Among these, the tomb of 'Abbas II (*r.* 1642–66), located in the southwest corner of the shrine between the Masjid-i Bala-sar and the Women's Court, stands out for its fine tile revetment. The tombs of the Qajar monarchs Fath 'Ali Shah (*r.* 1797–1834; *see* QAJAR, §II, A) and Muhammad (*r.* 1834–48) are also in Qum.

Enc. Islam/2: "Ḳum"

M. Bazin: "Qom, ville de pélerinage et centre régionale," *Rev. Géog. E.*, i–ii (1973), pp. 78–136

M. Tabataba'i: *Turbat-i Pākān* [Monuments and buildings of Qum], 2 vols. (Qum, 1976)

L. Golombek and D. Wilber: *The Timurid Architecture of Iran and Turan* (Princeton, 1988), i, pp. 196–7, 399–405

Qusantiniya. *See* ISTANBUL.

Qusayr ʿAmra [Quṣayr ʿAmra]. Early Islamic site 61 km east of Amman. Set on the banks of the Wadi Butum in an open steppe, the complex is built of roughly shaped flint and limestone and roofed with small barrel vaults. It consists of a basilical audience hall (11.5×14 m), terminating in a central square apse flanked by small rooms and an attached hypocaust bath of three rooms (the cold bath is placed in the main hall; *see* ARCHITECTURE, fig. 2). In addition to a well and raised water-tank, there is a subsidiary building 200 m away. First discovered by Alois Musil in 1898, the building is notable for its well-preserved fresco paintings, cleaned in 1974. At the head of the apse a prince is depicted in Late Roman style, seated in a niche with two attendants, while six female figures are depicted on its sides. On the west wall of the main hall is a panel depicting six kings, four of whom can be identified by Greek and Arabic inscriptions as the Byzantine emperor, Roderic (the last Visigothic king of Spain), the Sasanian king and the Negus of Abyssinia. A sequence of four major frescoes depicts a hunt of onagers, and ceiling panels reminiscent of Early Christian floor mosaics present scenes of daily life. The soffits of the transverse arches preserve two dancers. The paintings in the bath were executed by a different hand. The first room has animals and birds in a diaper pattern, the cool room has scenes of bathing, and the cupola of the hot room preserves a zodiac (see fig.). The Hellenistic Syrian style of the frescoes and the superior execution of the Arabic inscriptions suggest that the paintings represent the tradition of the pre-Islamic Arab tribes of Syria. The building can be attributed to the Umayyad dynasty (*r.* 661–750), as it must post-date the little-known Roderic (*r.* 710–11). While Grabar and others attributed it to the libertine caliph al-Walid II (*r.* 743–4) before his accession, the small barrel vaults and round arches suggest an earlier date, perhaps in the reign of al-Walid I (*r.* 705–15).

A. Musil: *Kusejr Amra* (Vienna, 1907)

K. A. C. Creswell: *Early Muslim Architecture*, i (Oxford, 1932/*R* and enlarged 1969), pp. 390–449

O. Grabar: "The Painting of the Six Kings at Quṣayr ʿAmrah," *A. Orient.*, i (1954), pp. 185–7

M. Almagro and others: *Qusayr ʿAmra, residencia y baños omeyas en el deserto de Jordania* (Madrid, 1975)

A. Almagro Gorbea: *Tres monumentos islámicos restaurados por España en el mundo árabe: Qusayr ʿAmra, el Palacio Omeya de Amman, la zauiya de Sidi Qasim en Túnez* (Madrid, 1981)

J. M. Blázquez: "La pintura helenística de Qusayr ʿAmra. II," *Archv Esp. Arqueol.*, lvi (1983), pp. 169–212

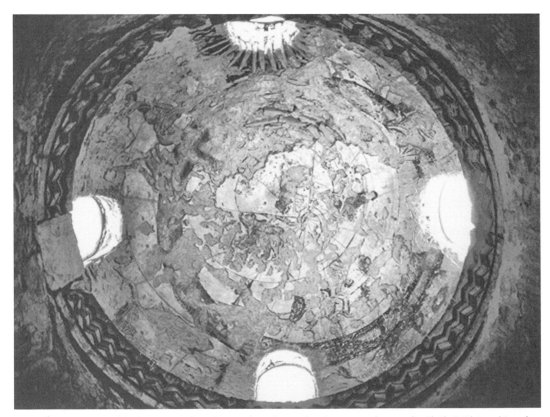

Qusayr ʿAmra, interior of the hot room ceiling showing the zodiac, early 8th century; photo credit: Sheila S. Blair and Jonathan M. Bloom

J.-P. Brunet, R. Nadal and C. Vibert-Guigue: "The Fresco of the Cupola of Qusayr 'Amra," *Centaurus: International Magazine of the History of Mathematics, Science, and Technology*, xl (1998), pp. 97–123

H. Aigner: "Athletic Images in the Umayyid Palace of Qasr 'Amra in Jordan: Examples of Body Culture or Byzantine Representation in Early Islam?," *Int. J. Hist. Sport*, xvii/1 (2000), pp. 159–64

C. Vibert-Guigue: "Qusayr 'Amra et le Répertoire de peintures grecques et romaines paru à Paris en 1922," *Cah. Archéol.*, l (2002), pp. 75–92

J. M. Bláquez: "La herencia clásica en el Islam: Qusayr 'Amra y Qasr al-Hayr al-Gharbi," *Europa y el Islam*, ed. G. Anés y Álvarez de Castrillón (Madrid, 2003), pp. 44–142

G. Fowden: "Late-antique Art in Syria and its Umayyad Evolutions," *J. Roman Archaeol.*, xvii (2004), pp. 282–304

G. Fowden: *Qusayr 'Amra: Art and the Umayyad Elite in Late Antique Syria* (Berkeley, 2004)

Quseir [Quṣayr al-Qadīm; al-Quṣayr al-Qadīm; Quseir al-Qadim; el-Kusair el-Kadim; Qusayr; Kuseir; Kusayr]. Port on the Egyptian coast of the Red Sea east of Luxor. Located at the mouth of the Wadi Hammamat, the shortest overland route between the Nile Valley and the Red Sea, the port was known in the 1st and 2nd centuries as Leukos Limen and in the 13th and 14th centuries as Qusayr. Despite its proximity to the Nile, the port was never as important as Berenice or Aydhab, probably because it was difficult for ships to sail there against the prevailing north wind. Excavations begun in 1978 have revealed the remains of a Roman port, an industrial area, a Roman villa, houses from the Islamic period, glass, ceramics and a wealth of organic remains due to the dryness of the climate.

Enc. Islam/2: "Ḳuṣayr"

D. S. Whitcomb and J. H. Johnson: *Quseir al-Qadim 1980, Preliminary Report* (Malibu, CA, 1982)

G. Vogelsang-Eastwood: *Resist Dyed Textiles from Quseir al-Qadim, Egypt* (Paris, 1990)

F. T. Hiebert: "Commerical Organization of the Egyptian Port of Quseir al-Qadim: Evidence from the Analysis of the Wooden Objects," *Archéol. Islam.*, ii (1991), pp. 127–59

C. Meyer: *Glass from Quseir al-Qadim and the Indian Ocean Trade* (Chicago, 1992)

J. M. Thayer: "In Testimony to a Market Economy in Mamlūk Egypt: The Qusayr Documents," *al-Machriq*, viii (1995), pp. 45–55

D. Whitcomb: "Quseir al-Qadim, Egypt: Text and Context in the Indian Ocean Spice Trade," *Al-'Usur al-Wusta*, vii/2 (1995), pp. 25–7

L. Guo: "Arabic Documents from the Red Sea Port in Quseir in the Seventh/Thirteenth Century, Part 1: Business Letters," *J. Nr E. Stud.*, lviii/3 (1999), pp. 161–90 and lx/2 (2001), pp. 81–116

S. Moser and others: "Transforming Archaeology through Practice: Strategies for Collaborative Archaeology and the Community Archaeology Project at Quseir, Egypt," *World Archeol.*, xxxiv/3 (2002), pp. 220–48; repr. in *Museums and Source Communities: A Routledge Reader*, ed. L. L. Peers and A. K. Brown (London, 2003)

L. Guo: *Commerce, Culture, and Community in a Red Sea Port in the Thirteenth Century: The Arabic Documents from Quseir* (Leiden, 2004)

D. P. S. Peacock and L. K. Blue: *Myos Hormos—Quseir al-Qadim: Roman and Islamic Ports on the Red Sea* (Oxford, 2006)

Qutb Shahi [Qutb Shāhī; Ḳutbshāhī]. Dynasty that ruled portions of southern India from 1512 to 1687. It was founded by Quli Qutb Shah (*r.* 1512–43), a QARAQOYUNLU Turkmen prince who emigrated to Bidar, capital of the BAHMANI rulers, in 1478 and became the governor of the Telanga or Telingana region of the eastern Deccan. After the murder of the minister Mahmud Gawan in 1481, Quli Qutb Shah made GOLCONDA his main center and in 1512 declared his independence. Like the rulers of the other Bahmani successor states, he engaged in constant wars with his neighbors, chiefly Orissa and Vijayanagara. Such conflicts continued in the long reign of Ibrahim Qutb Shah (*r.* 1550–80), who joined the alliance that destroyed Vijayanagara in 1565. Muhammad Quli Qutb Shah (*r.* 1580–1612) was, like his contemporary the Mughal emperor Akbar (*r.* 1556–1605), devoted to creative ventures. He founded the city of HYDERABAD on the Musi River in 1590–91 and adorned it with gardens, palaces, mosques and other buildings, including the famous Char Minar (Four Minarets), a gateway at the crossing leading to the four quarters of the old city. He was also a notable patron of the book arts (*see* ILLUSTRATION, §VI, E, 7). Decline set in as the Mughal rulers pursued their expansionist policy in the Deccan. 'Abdullah Qutb Shah (*r.* 1626–72) signed a "Deed of Submission" to the Mughals but maintained considerable independence. 'Abdullah's mausoleum is regarded as the most characteristic dynastic tomb at Golconda. Abu'l Hasan Qutb Shah (*r.* 1672–87) struggled against the forces of the Mughals and the Marathas under Shivaji. The Mughal emperor Awrangzib (*r.* 1658–1707) finally besieged and captured Golconda in 1687.

Qutbshahi art and architecture are marked by a distinct Persianate style, due in part to the Iranian antecedents of the dynasty and to the close contacts they maintained with their contemporary Shi'ite rulers in Iran, the Safavids. Like them, the Qutbshahis patronized poets and painters. Muhammad Quli was himself a poet, and his collection of Urdu poetry in the Salar Jung Museum is one of the most richly illustrated Indian books. Rather than the Mughal interest in realism, Qutbshahi painting is idealized, marked by fantastic color and distorted forms that produce an atmosphere of languor and lyricism. Their stronghold at Golconda, which was expanded under successive rulers, notably Ibrahim in the second half of the 16th century, and the new city of Hyderabad, are similarly indebted to Persianate models in the symmetrical layout of bazaar streets, arched portals, open squares, gardens and fountains. Their religious architecture shows a distinct sculptural aspect, with deeply modeled plasterwork, pierced plaster screens, fluted brackets and cornices, and petals surrounding the base of bulbous domes.

A. M. Siddiqui: *History of Golconda* (Hyderabad, 1956)

H. K. Sherwani: *Muhammad Quli Qutb Shah* (London, 1967)

H. K. Sherwani: *History of the Qutb-Shahi Dynasty* (New Delhi, 1974)

J. F. Richards: *Mughal Administration at Golconda* (Oxford, 1975)

H. K. Sherwani: "Town Planning and Architecture of Haidarabad under the Qutb Shahis," *Islam. Cult.*, l (1976), pp. 61–80

M. Zebrowski: *Deccani Painting* (London, 1983), pp. 153–207

D. N. Varma: "Qutbshahi Miniatures in the Salar Jung Museum," *Salar Jung Museum Bi-annual Research Journal*, xix–xx (1984), pp. 55–68

G. Michell: "Golconda and Hyderabad," *Islamic Heritage of the Deccan*, ed. G. Michell (Bombay, 1986), pp. 77–85

D. James: "The 'Millennial' Album of Muhammad-Quli Qutb Shah," *Islam. A.*, ii (1987), pp. 243–54

S. H. Safrani: *Golconda and Hyderabad* (Bombay, 1992)

A. A. Hussain: "Qutb Shahi Garden Sites in Golconda and Hyderabad," *The Mughal Garden: Interpretation, Conservation and Implications*, ed. M. Hussain, A. Rehman and J. L. Wescoat (Rawalpindi, Lahore and Karachi, 1996), pp. 93–104

G. Michell and M. Zebrowski: *Architecture and Art of the Deccan Sultanates*, New Cambridge History of India, 1.7 (Cambridge, 1999), pp. 17–18, 47–53, 98–106, 191–226, 269–70

V. K. Bawa: The Politics of Architecture in Qutb Shahi Hyderabad: A Preliminary Analysis," *Studies in History of the Deccan: Medieval and Modern: Professor A. R. Kulkarni Felicitation Volume*, ed. M. A. Nayeem, A. Ray and K. S. Mathew (Delhi, 2002), pp. 329–41

M. A. Nayeem: *The Heritage of the Qutb Shahis of Golconda and Hyderabad* (Hyderabad, 2006)

R

Rabat [Rabāt]. Capital of Morocco, located on the Atlantic coast at the mouth of the Bou Regreg River. Rabat is composed of four distinct parts: the medina, the walled royal city (Arab. *al-maswār*), a French quarter between them and a zone of new quarters erected around this core since 1956. Rabat became the Moroccan capital in 1912, when most of the country came under French control. The earliest urban foundation in the area was the Roman outpost of Sala Colonia, to the south of the present city, and excavations there have revealed the remains of several buildings from the time of Trajan (*r.* 98–117), including a forum, a nymphaeum and a triumphal arch. The modern city owes its existence and name to a small fort (Arab. *ribāt*, a fortress for warriors for the faith), founded in the 10th century on the west bank of the Bou Regreg River during the struggle against the heretical Barghwata Berbers; an army camp was perhaps established on the ruins of Sala Colonia. The fort and the camp were enlarged by members of the Almohad dynasty (*r.* 1130–1269) as a base in the war against the Christian kings of Spain; at the end of the 12th century Abu Yusuf Yaʿqub al-Mansur (*r.* 1184–99) founded a large city there, which he named *ribāt al-fath* ("fortress of victory") in commemoration of his defeat of the Christians at al-Arak (now Santa Maria de Alarcos) in 1195. The most important monuments of Rabat date from this period, including the city's extensive network of pisé walls and the Bab al-Ruwah ("Gate of wind") and the Udayas Gate (*see* MILITARY ARCHITECTURE AND FORTIFICATION, fig. 2). The most impressive monument is the minaret of an immense mosque (180×140 m), planned as the largest in the western Islamic world but left unfinished at Yaʿqub's death. The 44 m tower, which was intended to be nearly 90 m high, would have resembled the Giralda in Seville (*see* ARCHITECTURE, §V, D, 4). After Yaʿqub's death, the enormous city was abandoned in favor of the more prosperous Salé (Salā), its sister city on the north bank of the Bou Regreg. The congregational mosque of Salé had been rebuilt in 1196, and a madrasa was established there by the Marinid sovereign Abu'l-Hasan ʿAli (*r.* 1331–48) in 1341.

Between 1284 and 1348 several members of the Marinid family were buried in the ruins of Sala Colonia, which may have benefited from some special religious prestige, and in 1336 the ensemble, comprising their tombs, a mosque, a hospice for Sufis, two minarets and the remains of several unidentified buildings amid gardens, was surrounded by a wall with a monumental entrance. Known as Chella, the site is one of the most charming in Morocco. Rabat had a miserable existence from the 13th century until the 16th, but from 1609 Muslim exiles from Spain settled in and around its ancient fortress, and, as the Sallee Rovers, gained political and economic autonomy, primarily from piracy. The medina in the northern part of Almohad Rabat dates from this period, and many of its houses preserve portals recalling Spanish architecture of the early 17th century. Rabat again lost importance with the transfer of the capital to Meknès during the reign of Ismaʿil (*r.* 1672–1727), but a royal residence was created for the ʿAlawi dynasty (*r.* 1631–) in the southwestern portion of the Almohad enclosure. The Udaya tribe was then installed in the ancient fortress, which came to be known as the kasba of the Udaya (Oudaia). By 1900 Rabat was a small town in a large enclosure, with several important remains, and its revival in the 20th century offers an instructive example of different models of colonial and postcolonial urbanism (*see* MOROCCO).

Rabat has an important archaeological museum housing many of the antiquities found in Morocco, including some splendid Hellenistic bronzes, as well as the Musée des Oudaias, a museum of Hispano-Moresque culture. A national craft museum displays modern items. The city has been known since the 18th century for the manufacture of pile carpets that resemble, and were probably modeled on, those of Anatolia. The typical carpet has 1875 symmetrical knots per sq. dm and is distinguished from Anatolian models by its unusual length, designed to fit the typical interiors of Moroccan houses (*see* CARPETS AND FLATWEAVES, §IV, F).

J. Caillé: *La Ville de Rabat jusqu'au Protectorat français*, 3 vols. (Paris, 1946)

J. Caillé: *La Petite histoire de Rabat* (Casablanca, 1950)

J. Caillé: *La Mosquée de Hassan à Rabat* (Paris, 1954)

J. L. Abu-Lughod: *Rabat: Urban Apartheid in Morocco* (Princeton, 1980)

From the Far West: Carpets and Textiles of Morocco (exh. cat. by P. L. Fiske, W. R. Pickering and R. S. Yohe; Washington, DC, Textile Mus., 1980)

M. el-Mghari: "Réflexions sur les matériaux de construction des monuments almohades de Rabat," *L'Architecture de terre en Méditerranée*, ed. M. Hammam (Rabat, 1999), pp. 155–67

Rabbath Ammon. *See* AMMAN.

Ramdas [Rāmadāsa] (*fl. c.* 1590–1650). Indian miniature painter. This technically talented artist contributed to several of the major productions of the royal workshop during the final two decades of the Mughal emperor Akbar's reign (*r.* 1556–1605). He worked on one of the major productions of the imperial workshop, the illustration of the autobiography of the first Mughal emperor, Babur (*r.* 1526–30), the *Bāburnāma*; the manuscript was presented to Akbar on 24 November 1589. Ramdas was responsible for the important scene depicting Babur in a garden at Agra, celebrating his victory over Ibrahim Lodi (London, V&A, IM.275–1913; see Das, pl. vi, pp. 20–21). According to a note on the margin, the painting was completed in 50 days.

The same or another Ramdas was later responsible for at least two paintings in the lavishly illustrated official court history of Shah Jahan (*r.* 1628–58), the *Padshāhnāma* (Windsor Castle, Royal Lib., MS. HB.149, fols. 48*v* and 51*r*). The *Padshāhnāma* paintings demonstrate extreme variations in the artist's style. His eclectic approach ranges from the rigid symmetry and courtly elegance typically associated with the Shah Jahan period to unusually animated facial expressions and intense color contrasts.

A. K. Das: *Dawn of Mughal Painting* (Bombay, [n.d.])

E. Smart: "Six Folios from a Dispersed Manuscript of the Babur Nama," *Indian Painting* (exh. cat., London, Colnaghi's, 1978), pp. 109–32

The Grand Mogul: Imperial Painting in India, 1600–1660 (exh. cat. by M. C. Beach; Williamstown, MA, Clark A. Inst.; Baltimore, MD, Walters A.G.; Boston, MA, Mus. F.A.; New York, Asia Soc. Gals.; 1978–9)

King of the World: The Padshahnama, an Imperial Mughal Manuscript from the Royal Library, Windsor Castle (exh. cat. by M. C. Beach and E. Koch; New Delhi, N. Mus.; London, Queen's Gal., and elsewhere, 1997–8)

Raqqa [al-Rafiqa]. City in northern Syria on the east bank of the Euphrates River, 250 km east of Aleppo. The site has long been occupied: the antique city of Kallinikos was succeeded by al-Rafiqa, a new settlement founded by the Abbasid caliph al-Mansur next to it in 772, which later took the name of Raqqa. Harun al-Rashid (*r.* 786–809), disliking Baghdad, made Raqqa his capital for part of his reign. It declined in importance in the following centuries, despite a brief revival under the Zangid dynasty (*r.* 1127–1222). Although the city was virtually deserted by the early 20th century, it has been reborn, and the modern town is fast enveloping the medieval site. Nearly all of Raqqa was built in brick. Substantial parts of the original congregational mosque, rebuilt by the Zangid ruler Nur al-Din in 1165–6, and the city walls remain, along with the 12th-century

Baghdad Gate, long attributed to the city's founding. An extramural congregational mosque and cemetery outside the Baghdad Gate survived until the 1980s. Excavations since the 1950s in the area outside the walled city uncovered mansions of the late 8th century. Like the residences at Samarra (*see* SAMARRA, §II), they are decorated with carved stucco, but they do not show the BEVELED STYLE identified with Samarra. A 12th-century palace (rest.) has a basilical reception hall facing a courtyard with three iwans, and *muqarnas* brackets and squinch fillings. Excavations have revealed evidence for the production of early Abbasid glazed wares, as well as the medieval lusterwares traditionally attributed to the site (*see* CERAMICS, §III, B).

Enc. Islam/2: "al-Raḳḳa"

K. A. C. Creswell: *Early Muslim Architecture*, ii (Oxford, 1940)

K. A. C. Creswell: *A Short Account of Early Muslim Architecture* (London, 1958); rev. by J. W. Allan (Aldershot, 1989), pp. 243–8, 270–75

M. al-Khalaf: "Die 'abbāsidische Stadtmauer von ar-Raqqa/ar-Rāfiqa," *Damas. Mitt.*, ii (1985), pp. 123–31

M. al-Khalaf and K. Kohlmeyer: "Untersuchungen zu ar-Raqqa-Nikephorion/Callinicum," *Damas. Mitt.*, ii (1985), pp. 134–62

K. Toueir: "Der Qaṣr al-Banāt in ar-Raqqa," *Damas. Mitt.*, ii (1985), pp. 297–319

M. Meinecke: "The Architecture of ar-Raqqa and its Decoration," *Colloque international d'archéologie islamique: IFAO, le Caire, 3–7 février 1993*, pp. 140–48

S. Heidemann: *Die Renaissance der Städte in Nordsyrien und Nordmesopotamien: Städtische Entwicklung und wirtschaftliche Bedingungen in ar-Raqqa und Harran von der Zeit der beduinischen Vorherrschaft bis zu den Seldschuken* (Leiden, 2002)

S. Heidemann: "The History of the Industrial and Commercial Area of 'Abbasid Al-Raqqa, called Al-Raqqa Al-Muhtariqa," *Bull. SOAS*, lxix/1 (2006), pp. 33–52

M. Jenkins-Madina: *Raqqa Revisited: Ceramics of Ayyubid Syria* (New Haven, 2006)

Ra's al-Khayma. *See under* UNITED ARAB EMIRATES.

Rashid al-Din [Rashīd al-Dīn Faḍl Allāh] (*b.* Hamadan, ?1247; *d.* Tabriz, 18 July 1318). Persian bureaucrat, historian and patron. Physician to the Ilkhanid ruler Abaqa (*r.* 1265–82), vizier to Ghazan (*r.* 1295–1304) and Uljaytu (*r.* 1304–16), and author of administrative reforms aimed at promoting a centralized tax-based government, Rashid al-Din probably played a major role in the transformation of Ilkhanid government from a nomadic Central Asian regime into a sedentary Islamic polity. He attained great power and wealth, possessing extensive agricultural and economic interests across the Ilkhanid dominions, and his varied intellectual interests reflected the cosmopolitan nature of Ilkhanid society. He contributed to the flowering of Persian historical writing, and his greatest work, the *Jāmi' al-tawārīkh* ("Compendium of histories," or "World history"), is the first universal history with sections on the Mongols, Chinese, Franks, Jews, Indians and the Islamic dynasties. He also wrote books on Islamic theology and practical science including

agriculture, mineralogy, civil and naval architecture, and translated works on Mongol and Chinese medicine, pharmacology and government.

Like other members of the court, Rashid al-Din used his wealth to finance architectural projects in the form of pious tax-shelter foundations (Arab. *waqf*). The largest was the Rabʿ-i Rashidi, a complex centered on his tomb (*see* TABRIZ, §III, A). He also built extensively in Sultaniyya and Hamadan. None of his buildings survives, but details of their planning and administration can be gleaned from the endowment deed for the Rabʿ-i Rashidi and from the *Jāmiʿ al-tawārīkh*. Rashid al-Din ordered splendid manuscripts of the Koran (e.g. 1310–11; London, BL, Or. MS. 4945) to furnish his endowments as well as magnificent copies of his own works in imperial style, specifying the use of large Baghdadi paper (*see* CALLIGRAPHY, §V, B). His endowment deed provided 60,000 dinars for assembly, translation, copying, gilding, binding and distribution. Two fragments of the *Jāmiʿ al-tawārīkh* that were probably copied and illustrated under his supervision (Edinburgh, U. Lib., MS. Arab 20 and London, Nour priv. col., ex-Royal Asiat. Soc.) show how Far Eastern pictorial conventions were adopted in their strip-like illustrations, colored washes, style and motifs. Other contemporary copies in Istanbul (Topkapı Pal. Lib., H. 1653 and H. 1654) had some illustrations added later in the 14th century, and the Diez Albums (Berlin, Staatsbib. Preuss. Kultbes., Orientabt., Diez A fol. 70–72) contain detached miniatures that may have come from contemporary or slightly later copies. The Rabʿ-i Rashidi was plundered after the vizier's execution, but it was revived as a center of manuscript production in the 1320s under his son Ghiyath al-Din.

Enc. Islam/2: "Rashid al-Din Tabib"

Cent. Asiat. J., xiv (1970) [whole issue]

G. Inal: "Artistic Relationship between the Far and the Near East as Reflected in the Miniatures of the *Ǧāmiʿ at-tawārīh*," *Kst Orients*, x (1975), pp. 108–43

D. T. Rice: *The Illustrations to the "World History" of Rashīd al-Dīn* (Edinburgh, 1976)

B. Gray: *The World History of Rashīd al-Dīn: A Study of the Royal Asiatic Society Manuscript* (London, 1978)

B. W. Robinson: "Rashīd al-Dīn's World History: The Significance of the Miniatures," *J. Royal Asiat. Soc. GB & Ireland* (1980), pp. 212–22

S. S. Blair: "Ilkhanid Architecture and Society: An Analysis of the Endowment Deed of the Rabʿ-i Rashīdī," *Iran*, xxii (1984), pp. 67–90

T. Allen: "Byzantine Sources for the *Jāmiʿ al-tawārīkh* of Rashīd al-Dīn," *A. Orient.*, xv (1985), pp. 121–36

S. R. Canby: "Depictions of Budda Sakyamuni in the Jamiʿ al-tavarikh and the Majmaʿ al-tavarikh," *Muqarnas*, x (1993), pp. 299–310

S. S. Blair: *Compendium of Chronicles: Rashid al-Din's Illustrated History of the World* (London, 1995)

S. S. Blair: "Patterns of Patronage and Production in Ilkhanid Iran: The Case of Rashid Al-Din," *The Court of the Il-Khans 1290–1340*, ed. J. Raby and T. Fitzherbert, Oxford Stud. Islam. A., xii (Oxford, 1996), pp. 39–59

B. Hoffmann: "The Gates of Piety and Charity: Rašīd al-Dīn Faḍl Allāh as Founder of Pious Endowments," *L'Iran face à la domination mongole*, ed. D. Aigle (Tehran, 1997), pp. 189–202

F. Richard: "Un des peintres du manuscrit Supplément persan 1113 de l'histoire des Mongols de Rašīd al-Dīn identifié," *L'Iran face à la domination mongole*, ed. D. Aigle (Tehran, 1997), pp. 307–20

K. Rührdanz: "Illustrationen zu Rašīd al-Dīns Taʾrīḫ-i mubārak-i Ġāzānī," *L'Iran face à la domination mongole*, ed. D. Aigle (Tehran, 1997), pp. 295–306

W. M. Thackston, ed. and trans.: *Jamiʿ ut-Tawarikh: Compendium of Chronicles: A History of the Mongols*, 3 vols. (Cambridge, MA, 1998–9)

A. Ivanov: "The Name of a Painter Who Illustrated the World History of Rashid al-Din," *Persian Painting, from the Mongols to the Qajars: Studies in Honour of Basil W. Robinson*, ed. R. Hillenbrand (London, 2000), pp. 147–9

S. S. Blair: "Writing and Illustrating History: Rashīd al-Dīn's Jāmiʿ al-tavārīkh," *Theoretical Approaches to the Transmission and Edition of Oriental Manuscripts: Proceedings of a Symposium Held in Istanbul, March 28–30, 2001*, pp. 57–65

A. Soudavar: "In Defense of Rašīd-Od-Din and His Letters," *Stud. Iran.*, xxxii/1 (2003), pp 77–120

Rasulid. Islamic dynasty that ruled in the Yemen from 1229 to 1454. The long period of Rasulid control of Tihama—the Red Sea coastal plain—and the southern highlands of the Yemen was the most brilliant in the early and medieval history of the country. Nur al-Din ʿUmar (*r.* 1229–50), the founder of the dynasty, was descended from a Turkmen ambassador (Arab. *rasūl*) who had entered the Yemen in 1183 with the AYYUBID conquerors. Nur al-Din ʿUmar declared his independence from them, but the Rasulid debt to the Ayyubids was enormous: the Rasulids built on the Ayyubid conquests and their efficient administration but expanded their territories north as far as the Holy Cities of Mecca and Medina and east into Hadramawt and Oman. The major commercial port was Aden, through which all manner of commodities passed in unprecedented quantities. The Rasulids frequently vied for control of SANʿA, the chief highland city, with the Shiʿite ZAYDI imams in the north of the country. After al-Nasir Ahmad (*r.* 1400–24), the dynasty crumbled because of constant slave revolts and internecine squabbles, and in 1454 the Rasulids lost Aden and control of Tihama and lower Yemen.

The Rasulids were great champions of literature, and scholars composed important works on history, biography, genealogy, agriculture, medicine and farriery. The Rasulids were also patrons of fine architecture; the outstanding buildings are the Muzaffariyya Mosque (1249–95) and the Ashrafiyya Madrasa (1397–1401) in Taʿizz, the Rasulid capital in the southern highlands (*see* ARCHITECTURE, §VI, C, 2 and fig. 40), in which Syrian, Egyptian and Anatolian features were introduced. Other Rasulid monuments are in ZABID, an important winter center in Tihama with a strong intellectual tradition, al-Janad near Taʿizz, and Ibb. The Rasulid emblem was a five-petaled

rosette, and examples of it are seen on inlaid metal-wares and enameled glass produced under the Mamluks (r. 1250–1517) for export to the Rasulids, as well as on the painted ceilings of the Taʿizz mosques.

M. van Berchem: "Notes d'archéologie arabe, III," *J. Asiat.*, 10th ser., iii (1904), pp. 5–96 [includes objects with the Rasulid emblem]

R. B. Lewcock and G. R. Smith: "Three Medieval Mosques in the Yemen," *Orient. A.*, xx (1974), pp. 75–86, 192–203

G. R. Smith: *The Ayyūbids and Early Rasūlids in the Yemen*, 2 vols. (London, 1974–8)

N. Sadek: "Rasulid Women: Power and Patronage," *Proc. Semin. Arab. Stud.*, xix (1989), pp. 121–6

N. Sadek: "In the Queen of Sheba's Footsteps: Women Patrons in Rasulid Yemen," *Asian A.*, vi/2 (1993), pp. 15–27

R. Giunta: *The Rasūlid Architectural Patronage in Yemen: A Catalogue* (Naples, 1997)

V. Porter: "Enamelled Glass Made for the Rasulid Sultans of the Yemen," *Gilded and Enamelled Glass from the Middle East*, ed. R. Ward (London, 1998), pp. 91–5

N. Sadek: "Taʿizz, Capital of the Rasulid Dynasty in Yemen," *Proc. Semin. Arab. Stud.*, xxxiii (2003), pp. xiii, xiv, 309–13

E. Lambourn: "Carving and Recarving: Three Rasulid Gravestones Revisited," *New Arab. Stud.*, vi (2004), pp. 10–29

Rayy [Rāyy, Shahr-i Rayy, Shahr Rey, Rai, Rey; anc. Ragha; Gr. Rhages]. Medieval city in Iran, the ruins of which extend over a wide area just south of Tehran. Ancient Ragha was one of the earliest cities in Iran: a settlement existed in the 3rd millennium BCE, it was mentioned in Darius' inscription at Bisutun (5th century BCE), and the city is mentioned in the Zoroastrian *Avesta* and in the Apocryphal *Book of Tobit* (iv, 1). It was a royal residence under the Parthian dynasty (r. c. 250 BCE–224 CE) and a bishopric of the Nestorian Christians under the Sasanians (r. 224–651). It was captured by Muslim Arabs c. 640 and later served as the residence of the governors in charge of eastern Iran, including the province of Khurasan. One such governor, the future Abbasid caliph al-Mahdi (r. 775–85), who was stationed there during the caliphate of his father al-Mansur (r. 754–75), built a congregational mosque and had the city named al-Muhammadiyya after himself. By the 10th century Rayy had become one of the most prominent cities in western Asia and, despite incursions by the Ghuzz in the 11th century, it flourished under the Saljuqs (r. 1038–1194). In the late 12th century factional strife between Shiʿites and Sunnis in the city led to its depopulation. It was wrecked by the Mongols in 1221 and further devastated by Timur (Tamerlane) in 1384, after which it remained in ruins. The tomb of "Shah" ʿAbd al-ʿAzim (d. c. 864), a descendant of the Prophet, which was restored under the Saljuq and later dynasties, remains a major shrine center.

Excavations in the 20th century have unearthed elements of the city plan and a range of pre-Islamic and Islamic artifacts. The medieval city consisted of several loosely related sites to the south and west of a high ridge. The major architectural monument to survive is a large flanged tomb tower (1139), apocryphally known as the Tower of Tughril after the founder of the Saljuq dynasty (d. 1063), who was buried at Rayy. Built of brick, the walls are surmounted by a high *muqarnas* cornice, but the conical roof is missing. A large circular tomb tower (1073–4; destr. c. 1895) stood further east on the plain, and there are two groups of ruined tomb towers at the edge of the Bibi Shahr Banu mountain range at Aminabad and the Naqqara Khana outcrop. Several fragments of wall paintings with figures were allegedly discovered at Rayy (see ARCHITECTURE, §X, C, 1). The city was a famous center for silk production, and excavations in the 1920s uncovered fragments of spectacular silk textiles that have been attributed to the Buyid (r. 932–1062) and Saljuq periods. Many other textiles, including large palls and tomb covers woven in a variety of complicated techniques such as triple weaves and lampas, have also been attributed to the site, but their provenance is uncertain and their authenticity has been questioned (see TEXTILES, §II, B). Rayy was also a center of ceramic production, and both lustered and enameled wares have been attributed there, although no kilns for them have been found (see CERAMICS, §III, C). Several large figural stucco sculptures and relief panels are also attributed to the city.

Enc. Islam/2

B. Kariman: *Rayy-i bāstān* [Ancient Rayy], 2 vols. (Tehran, Iran. Solar 1345–9/1966–70) [theoretical reconstruction of the history of Rayy based on hist. texts]

B. Kariman: *Barkhī az āthār-i bāmānda az rayy-i qadīm* [A few of the remaining monuments from ancient Rayy] (Tehran, Iran. Solar 1350/1971)

C. Adle: "Notes préliminaires sur la tour disparue de Rey (466/1073–4)," *Memorial Volume of the VIth International Congress of Iranian Art and Archaeology: Oxford, 1972*, pp. 1–12

C. Adle: "Constructions funéraires à Ray circa Xe–XIIe siècle," *Akten des VII. internationalen Kongresses für iranische Kunst und Archäologie: München, 1976*, pp. 511–15

E. J. Keall: "The Topography and Architecture of Medieval Rayy," *Akten des VII. internationalen Kongresses für iranische Kunst und Archäologie: München, 1976*, pp. 537–44

D. King: "The Textiles Found near Rayy about 1925," *Bull. Liaison Cent. Int. Etud. Textiles Anc.*, lxv (1987), pp. 34–59

S. S. Blair: *The Monumental Inscriptions from Early Islamic Iran and Transoxiana* (Leiden, 1992), pp. 185–6

J. L. Merritt: "Archaeological Textiles Excavated at Rayy," *Tech. & Cult.*, xxxiv (1999), pp. 7–15, 197

Raza, Sayed Haider (*b.* Babaria, Madhya Pradesh, 22 Feb. 1922). Indian painter, active in France. The son of a forest warden, he was educated at the Government High School in Damoh. In 1939 he entered the School of Art in Nagpur, after which he studied at the Sir Jamshetjee Jeejebhoy School of Art, Bombay (now Mumbai), receiving a diploma in 1947. While in Bombay his work came to the notice of the critic Rudolf von Leyden, who became his champion. In 1947 he was a founding member of the Progressive Artists' Group in Bombay and in 1948 won the Gold Medal of the Bombay Art Society. In 1950, with a study grant from the French government, he left India

for the Ecole des Beaux-Arts, Paris, where he studied from 1950 to 1953. He traveled widely in Europe at this time and after his studies continued to live in France, where he exhibited his work. From 1955 he had a permanent show at the Galerie Lara Vincy in Paris and in 1956 was the first non-French artist to be awarded the Prix de la Critique. In 1962 he was a visiting lecturer at the University of California, Berkeley, CA, and had his first solo exhibition in the USA in Palo Alto, CA. He visited India in 1959 and 1968 but otherwise continued to work in France in the milieu of the Ecole de Paris. He held solo exhibitions in India, Europe and the United States and participated in group exhibitions such as those at the Salon de Mai, Paris (1951), Venice Biennale (1956, 1958), Paris Biennale (1957), Bruges Biennale (1958), São Paulo Biennale (1959), Rabat Biennale (1963), Menton Biennale (1964, 1966, and 1972 where he received the Prix de la Biennale), the India triennales from 1968, Museum of Modern Art, Oxford (1982), Royal Academy of Arts, London (1982), and the Centre National des Arts Plastiques, Paris (1985).

His early paintings in Bombay consisted mainly of cityscapes and landscapes in watercolor; he painted similar subjects when he arrived in France but later turned to work in oils. During the 1950s his colors became less subdued, while underlying his work was a sense of geometry and color harmony. Influenced by the art of Paul Cézanne (1839–1906) and also by Rajput miniatures, the main theme of his paintings has been transfigured nature in varying degrees of abstraction. Such works include *Nuit Provençal* (oil on canvas, 1.44×1.11 m, *c.* 1964; C. and D. Herwitz Col.) and *Paysage* (acrylic on canvas, 1.19×1.19 m, 1983; C. and D. Herwitz Col.). During the 1960s he was also influenced by the movement known as Neo-Tantric art—arrangements of traditional symbols of circles, squares and triangles.

His paintings are in a number of private and public collections: these include the Musée d'Art Moderne de la Ville de Paris; the Bibliothèque Nationale, Paris; the Musée de Grenoble; the Asia Society Galleries, New York; the National Gallery of Modern Art, New Delhi; the Central Museum, Nagpur; and the Museum and Picture Gallery, Vadodara. In 1981, he was awarded the Padma Shri and in 1983 he was elected a Fellow of the Lalit Kala Akademi. In 1997 Raza was awarded the Madhya Pradesh Government's prestigious Kalidas Samman.

WRITINGS

Raza (New Delhi, 2002) [transcript of an interview, poem by him in Hindi with English translation and reproduction of his paintings]

With A. Vajapeyi: *Passion: Life and art of Raza* (New Delhi, 2005)

BIBLIOGRAPHY

R. von Leyden: "Sayed Haider Raza," *Sadanga* (April 1954), pp. 3–20

P. Gauthier: *Raza* (Bombay, 1956)

W. George: "Raza and the Orient of the Spirit," *Lalit Kala Contemp.*, xvi (1973), pp. 29–36

India: Myth and Reality, Aspects of Modern Indian Art (exh. cat. by D. Elliot, V. Musgrave and E. Alkazi; Oxford, MOMA, 1982)

Indian Art Today: Four Artists from the Chester and Davida Herwitz Family Collection (exh. cat. by P. Mitter and D. A. Herwitz; Washington, DC, Phillips Col., 1986)

U. Bickelmann and N. Ezekiel, eds.: *Artists Today, East–West Visual Arts Encounter* (Bombay, 1987)

G. Sen: *Bindu: Space and Time in Raza's Vision* (New Delhi, 1997)

Timeless Visions: Contemporary Art of India from the Chester and Davida Herwitz Collection (exh. cat. by S. S. Bean; Salem, MA, Peabody Essex Mus., 1999)

A. Vajapeyi: *Seven: Raza, Dhawan, Viswanadhan, Akhilesh, Sujata, Seema, Manish = Saptaka* (Paris, 2003)

M. Imbert: *Raza, an Introduction to his Painting* (Noida, 2003)

F. Mennekes: *S. H. Raza: Bilder von 1966 bis 2003* (Berlin, 2003)

O. Germain-Thomas: *Mandalas* (Paris, 2004)

Palette Quota Group Show for Charity (exh. cat., New Delhi, Palette A. Gal., 2007)

Regalia. As successors to the Prophet Muhammad, the caliphs often used objects associated with him, such as his mantle (Arab. *burda*), sword and staff (*qaḍīb*), as insignia of office, but contact with Byzantium and the revival of the royal traditions of Sasanian Iran led to the introduction and adoption of more elaborate regalia, including crowns and thrones (*see* Throne), particularly in the eastern Islamic lands where Sasanian traditions were the strongest.

I. Crowns. II. Other regalia.

I. Crowns. The traditional headgear in the Islamic lands is the turban (Arab. *'imāma*; Pers. *dūl band*; Turk. *tülbend*); and indeed it is commonly said that the turban is the crown of the Arabs. Following the example of the Prophet Muhammad, Muslim rulers traditionally wore the turban or its variants. Crowns of the defeated Sasanian and Byzantine enemies of Islam are pictured on several buildings erected by the Umayyad dynasty (*r.* 661–750) in Syria and Palestine. Several crowns are depicted on the interior mosaics at the Dome of the Rock (692; *see* Jerusalem, §II, A). The most elaborate has prominent wings and a central crescent moon on the top; it is similar to the headgear on the Sasanian king depicted in a mural at Qusayr 'Amra. Diadems depicted in the Dome of the Rock are composed of jeweled plaques with pendent pearl chains or have pointed triangular pieces or pinnacles above the plaques and longer chains. These can be identified as crowns of the Byzantine emperor and empress, as similar ones are worn by Justinian and Theodora in the mosaics of S. Vitale (547) at Ravenna in Italy. By the 10th century the Byzantine imperial diadem was worn over a silk skullcap, and this feature was also copied in Islamic representations.

As examples of crowns survive only from the late periods, the early history of crowns must be studied from their depiction in other arts. Crowns were worn by three types of figures in Islamic art. The first group

of crowned figures include portraits of early Islamic rulers in stucco sculptures and coins and medallions. Fragments of a large figure wearing a winged crown were excavated at QASR AL-HAYR WEST (*c.* 730). The prominent location on the main gate and large size of the statue suggest that it represents an Islamic prince, perhaps the Umayyad caliph Hisham (*r.* 724–43), to whom the structure is attributed. A comparable statue was excavated from a similar location at KHIRBAT AL-MAFJAR, but the top of the head is missing. Several coins and medallions made for the Abbasid caliphs (*r.* 749–1258) show crowned figures. A gold presentation piece (971; Paris, Bib. N., Cab. Médailles) depicts a crowned figure holding a wine-cup on one side and a falcon on the other, and an inscription identifies the figure as the Abbasid caliph al-Mutiʿ (*r.* 946–74). This identification suggests that the crown worn by figures on a series of presentation coins minted between the 9th and the 12th centuries may be the crown of the caliphate (Arab. *tāj al-khalīfa*), one of the insignia of sovereignty (*ālāt al-mulūkiyya*) worn by the caliph for ceremonial occasions and festivals. A less sumptuous series of pictorial coins issued by several dynasties in northern Mesopotamia shows enthroned crowned figures at royal ease.

A second group of crowned figures in Islamic art pertains to celestial imagery and includes zodiacal figures, angels, harpies, sphinxes and other fabulous animals. The largest cycle is found on the ceiling of the Cappella Palatina in Palermo (1132–53) and was executed by painters familiar with traditions of pictorial representation in the Islamic lands. Zodiacal figures represented in copies of al-Sufi's popular treatise, *Kitāb ṣuwar al-kawākib al-thābita* ("Book of the fixed stars"; e.g. 1009–10; Oxford, Bodleian Lib., MS. Marsh 144), are sometimes crowned. A crowned figure, thought to be Alexander and seated on a platform borne to heaven by large birds, appears on an enameled bronze dish made for the Artuqid ruler of northern Mesopotamia, Daʾud (*r.* 1114–44; Innsbruck, Tirol. Landesmus.). Crowned harpies and sphinxes are depicted on pottery and manuscripts made in the medieval Islamic period. Most of the crowns have two or three peaks decorated with palmettes. Buraq, the Prophet's steed on the *miʿrāj*, his miraculous night journey to heaven, is always shown crowned (see fig.), and angels are often shown crowned, as in a drawing by the Ottoman court painter SHAHQULI (Washington, DC, Freer, 37.7).

The third group of crowned figures consists of representations of historical kings. Although the Arab historian al-Masʿudi wrote in the 10th century that he had seen a copy of a book with pictures of the Sasanian monarchs depicted in their regalia, the earliest surviving representations of this type date from the 12th century to the early 14th, when manuscripts and overglaze-painted ceramics show figures wearing crowns loosely based on the Sasanian winged type, with crescent omitted and the wings patterned with large palmettes. These crowns become common in illustrations to Firdawsi's *Shāhnāma* ("Book of kings")

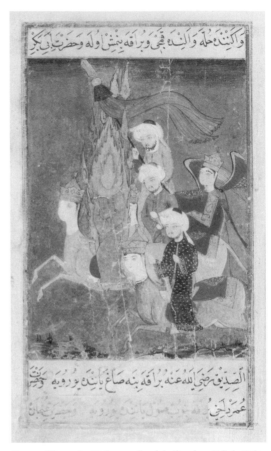

Crowned figures in *Muhammad and the first three Caliphs Riding on Buraq with an Archangel*, manuscript illumination, Turkey, early 17th century (Berlin, Staatsbibliothek zu Berlin Preussischer Kulturbesitz, MS. Oriental Division, or.oct. 1596); photo credit: Bildarchiv Preussischer Kulturbesitz/Art Resource, NY

and other Persian epics and romances. A new type of crown, featuring crenellated headband, high dome with top finial surrounded by a cloud collar, and jewels studding the band, points and topknot, appeared in the mid-14th century, as seen, for example, in illustrations to the Great Mongol ("Demotte") *Shāhnāma*. This new crown, probably derived from those of the Middle Byzantine period, remained standard for crowns depicted in Persian manuscripts over the next four centuries.

A distinctive new type of headgear was introduced to Iran in the early 16th century under the SAFAVID rulers (*r.* 1501–1732). Comprising a crimson cap with 12 gores wrapped in a white turban, it is said to commemorate the 12 Shiʿite imams. It was supposedly devised by the Aqqoyunlu ruler Haydar in 1487 after receiving instruction in a dream from imam ʿAli himself, but it may derive from the headgear worn by the Bektashi dervishes of Anatolia as early as the 13th century. The first depictions of this headgear appear in a manuscript of Muhammad ʿAsafi's *Dastān-i Jamāl-ū Jalāl* ("Story of Jamal and Jalal"; 1503–5;

Uppsala, U. Lib., MS. O Nova 2). During the reign of Tahmasp I (r. 1524–76), the red cap became so elongated that it resembled a baton, and the hat was worn by everyone from prince to stable-boy, to judge from manuscript illustrations. Under ʿAbbas I (r. 1588–1629) the symbolic crown of the Safavids was revived in a new shape: a short knobbed baton was wrapped in a horizontal, wheel-like fashion. Although not usually worn by the shah himself, this hat was worn by men with immediate allegiance to him, such as governors, generals, envoys and personal guards. The symbolic Safavid headgear was apparently transformed into an actual crown of state, possibly in the late 17th century. According to the Huguenot jeweler John Chardin (1643–1713), Sulayman I (r. 1666–94) wore a crown at his coronation, and engravings illustrating Chardin's travels show a crown similar to the one worn by courtiers to ʿAbbas II (r. 1642–66), although the jeweled plumes are more elaborate.

A new form of Persian crown was introduced by the Afsharid ruler Nadir Shah (r. 1736–47), who reportedly wore a gold crown shaped like the tall bulbous headdress of an Armenian bishop and adorned with gems and pearls. Portraits of the Shah show him wearing a four-pointed, red felt hat adorned with jeweled plumes and gems, and it is likely that the crown was a gilded version of a contemporary felt hat. The Qajar ruler Agha Muhammad (r. 1779–97) is credited with introducing a new type of crown of high ovoid form, the lower two-thirds studded with pearls and the plain upper part terminating in a large jeweled finial. It is depicted in several portraits by Mirza baba (Windsor Castle, Royal Lib., MS. A/4), and a copper crown of this type with poor quality enamel inlays (Tehran, Gulistan Pal.) may have been made as a replica. Fath ʿAli Shah (r. 1797–1834) commissioned a new imperial crown, a c. 300 mm-high confection of diamonds, pearls, emeralds and rubies, with a giant red spinel topping the red velvet skullcap (Tehran, Bank Markazi, Crown Jewels Col.). Known as the Kayani crown, it was used by all successive Qajar monarchs and refashioned under Nasir al-Din (r. 1848–96), who also commissioned a tiara in Paris. The Pahlavi ruler Riza Shah (r. 1926–41) commissioned several Iranian jewelers to make a new imperial crown inspired by Sasanian models, and Muhammad Riza Shah (r. 1941–79) commissioned the Parisian jeweler Pierre Arpels to make a crown of emeralds, pearls, rubies and spinels for the coronation of Empress Farah in 1967.

Under the Ottomans (r. 1281–1924), the turban—often decorated with a jeweled aigrette—remained the standard royal headgear until the 19th century, except under Süleyman (r. 1520–66), who ordered a spectacular gold helmet from Venetian goldsmiths in 1532. The helmet comprised four crowns with enormous pearls, a headband with diamonds, and a neck guard with straps, as well as a plumed aigrette. The ensemble, valued at 144,400 ducats, featured 50 diamonds, 47 rubies, 27 emeralds, 49 pearls and a large turquoise. It apparently symbolized Süleyman's political aspirations in western Europe by alluding to the papal tiara and the Habsburg crown, but its meaning was soon lost and it was melted down.

II. Other regalia. The early caliphs used only a few objects as regalia, but by the Abbasid period a tall cap (*qalansuwa*) wrapped with a turban was an additional mark of sovereignty (*see* Dress, §III). The Fatimid caliphs of Egypt (r. 969–1171) had the most elaborate ceremonial in the medieval Islamic world, perhaps imitating Byzantine court ceremonial. Fatimid ceremonial included the use of the parasol (*mizalla*), and many relics of the early Shiʾite martyrs, such as ʾAli's twin-bladed sword known as Dhuʾl-fiqar, were miraculously discovered and used as regalia. Lesser but powerful princes adopted elaborate regalia and ceremonial. The Hamdanid amir of Aleppo, Sayf al-Dawla (r. 945–67), for example, was invested with a diadem set with precious stones, neck chain and two gold arm buckles also set with precious stones. The Saljuq Turks (r. 1038–1194) regarded the bow and arrow as regal attributes but also adopted various Islamic insignia. The *ghāshiyya*, a saddle-cover probably studded with precious stones, was carried in processions before the Saljuq ruler as a mark of sovereignty. Many of these items were adopted by the Mamluk sultans of Egypt and Syria (r. 1250–1517), who regularized and codified the systematic usage of weapons and implements, such as the mace, bow, sword and pen-box, to symbolize the power of the state. Indeed, much of the information about medieval Islamic regalia is derived from Mamluk historians, particularly Ibn Khaldun (1332–82) and al-Qalqashandi (1355–1418).

Although some regalia is depicted in medieval Islamic imagery, few examples survive from before c. 1500. The few medieval pieces include carved rock crystals (e.g. a spherical knop of a silver chalice carved in low relief with a lion and griffin; Leuven, St. Jacob) thought to have been ceremonial mace- or scepter-heads. After the Ottomans conquered the Mamluks in 1517, many relics of the Prophet Muhammad, including his mantle, bow and standard, and of the early caliphs were brought to Istanbul (Topkapı Pal. Mus., Holy Mantle Pavilion), where they became regalia of the Ottoman sultans in their role as caliphs. Other Ottoman *objets d'art* such as a golden water canteen encrusted with jewels (Istanbul, Topkapı Pal. Mus.) also seem to have served as royal insignia. The Ottoman investiture ceremony included the girding on of the sword of ʿUthman [Osman], founder of the dynasty, in the mosque of Eyüp, although this symbolic rite was largely invented in the 19th century.

The regalia of the Safavid rulers of Iran included a throne, sword and dagger. In addition to a jewel-encrusted shield and saber (Tehran, Bank Markazi, Crown Jewels Col.), the peripatetic ruler Nadir Shah had four sets of horse furniture set with pearls, rubies, emeralds and diamonds that may have served as thrones. Muhammad Karim Khan (r. 1750–79), the Zand ruler of Shiraz, is depicted in an oil painting (Shiraz, Pars Mus.) with a large water-pipe, possibly

of Venetian glass, in an elaborate jeweled mount; a jeweled water-pipe became a usual part of the regalia of the later Iranian monarchs, such as Agha Muhammad. The jeweled epaulets, swordbelt and decorations adopted by the Qajar monarch Muhammad (r. 1834–48) imitated the attire of contemporary European monarchs, and his successor, Nasir al-Din, ordered other imperial regalia inspired by what he had seen in Europe, including a golden globe (Tehran, Bank Markazi, Crown Jewels Col.) weighing some 34 kg and set with 51,000 gems, the land masses indicated in rubies and the seas in emeralds.

Enc. Iran.: "Crown," "Crown Jewels"; *Enc. Islam/2*: "Marāsim" [Official court ceremonies], "Mawākib" [Processions], "Miẓalla" [Parasol], "Taḏj" [Crown]

J. Chardin: *Travels of Sir John Chardin into Persia and the East Indies*, ii (London, 1686), pp. 38–45

M. Canard: "Le Cérémonial fatimide et le cérémonial byzantin: Essai de comparaison," *Byzantion*, xxi (1951), pp. 355–420

M. Bahrami: "A Gold Medal in the Freer Gallery of Art," *Archaeologica Orientalia in Memoriam Ernst Herzfeld*, ed. G. C. Miles (Locust Valley, NY, 1952), pp. 5–20

G. C. Miles: " Miḥrāb and 'Anazah: A Study in Early Islamic Iconography," *Archaeologica Orientalia in Memoriam Ernst Herzfeld*, ed. G. C. Miles (Locust Valley, NY, 1952), pp. 156–71

V. B. Meen and A. D. Tushingham: *Crown Jewels of Iran* (Toronto, 1968)

O. Kurz: "A Gold Helmet Made in Venice for Sultan Sulayman the Magnificent," *Gaz. B.-A.*, lxxiv (1969), pp. 249–58

C. Köseoğlu: *Topkapı Sarayı Müzesi* (Tokyo, 1980), Eng. trans. and ed. by J. M. Rogers as *Topkapı Saray Museum: The Treasury* (London and Boston, 1987)

B. Schmitz: "On a Special Hat Introduced during the Reign of Shāh 'Abbās the Great," *Iran*, xxii (1984), pp. 103–12

L. Ilich: "Münzgeschenks und Geschenkmünzen in der mittelalterlichen islamischen Welt," *Münster. Numi. Ztg*, xv (1985), p. 11, no. 39

E. Whelan: "Representations of the *Khāssakīyah* and the Origins of Mamluk Emblems," *Content and Context of Visual Arts in the Islamic World*, ed. P. P. Soucek (New York, 1988), pp. 219–53

G. Necipoğlu: "Süleyman the Magnificent and the Representation of Power in the Context of Ottoman–Hapsburg–Papal Rivalry," *A. Bull.*, lxxi (1989), pp. 401–27

A. Amanat: "The Kayanid Crown and Qajar Reclaiming of Royal Authority," *Iran. Stud.*, xxxiv (2001), pp. 17–30

Z. Indırkas: "The Survival of Central Asian and Sassanian Influences in Saljûq Crowns," *Islam. Cult.*, lxxvii (2003), pp. 63–89

L. Jones: " 'Abbasid Suzerainty in the Medieval Caucasus: Appropriation and Adaptation of Iconography and Ideology," *Gesta*, xliii (2004), pp. 143–50

H. Aydın: *The Sacred Trusts: Pavilion of the Sacred Relics, Topkapı Palace Museum, Istanbul* (Somerset, NJ, 2005)

Reis Haydar. *See* HAYDAR RA'IS.

Reitlinger, Gerald (*b.* London, 2 March 1900; *d.* Beckley, 8 March 1978). English collector, archaeologist and writer. Trained as an artist, Reitlinger traveled widely, taking part in two Oxford University archaeological expeditions to Iraq in the 1930s. After World War II he wrote three studies on the history of the Nazi period in Germany and many articles on art, both as a scholar and a journalist. His best-known work is the seminal three-volume study of the art market from 1750 to the 1960s. His residence at Woodgate House at Beckley, E. Sussex, was the site of almost legendary social gatherings and housed the major passion in his life, his art collection, which comprised some 2000 pieces, mainly Far Eastern and Islamic ceramics. Although a fire ravaged Woodgate House in February 1978, the collection was spared, and after Reitlinger's death a few weeks later, it came to the Ashmolean Museum in Oxford. Some of the most important pieces in the collection were published in the catalogue accompanying a memorial exhibition.

WRITINGS

The Economics of Taste, 3 vols. (London, 1961–70)

BIBLIOGRAPHY

ODNB

Rt Hon. Lord Bullock: "Gerald Reitlinger: A Portrait," *Eastern Ceramics and Other Works of Art from the Collection of Gerald Reitlinger* (exh. cat., Oxford, Ashmolean, 1981), pp. 9–12

J. W. Allan: "Prunus Sprays and Pepper Pots," *Orient. A.*, lxii (1996), pp. 18–23

Resafa. *See* RUSAFA.

Ribat-i Malik. Caravanserai on the Malik steppe near Kermine in Uzbekistan. Built at the beginning of the 11th century to service the road between Bukhara and Samarkand, it is one of the largest secular buildings from the medieval period in Central Asia. Ribat-i Malik is famous for its majestic main façade with powerful walls decorated with corner towers and closely set cylindrical buttresses (destr.) and a monumental portal richly decorated with brickwork patterns, carved terracotta and plaster (*see* CENTRAL ASIA, fig. 3). First described and drawn in 1840, the building was studied in detail in the 1970s when the plan was uncovered. The walls (91×89 m externally) were built of mud-brick with fired brick for the portal and main façade, columns, arches and domes. The portal opened on to the southern half, which had one large and two small yards lined with service quarters, stables, kitchens and store-rooms. A portal at the rear of the central yard gave access to the northern half, which originally had a central courtyard (22.5 m sq.) surrounded by an arcade of plaster-faced brick columns in front of four large and nine small rooms. Passages on either side led to further yards. The central courtyard was transformed by the addition of an octagonal domed rotunda (diam. 18 m), the grandest room in the caravanserai, supported by paired double columns and containing an octagonal platform in the center. The interior was completely covered by plaster carved with geometrical and epigraphic motifs, and painted, like all the carved plaster at the site, in yellow, blue and red. The building was renovated in the late 11th century or early 12th, possibly by the Qarakhanid governor Shams al-Mulk Nasr.

N. B. Nemtseva: *Rabat-i Malik: Khudozhestvennaya kul'tura sredney Azii, IX–XIII vv.* [Ribat-i Malik: the artistic culture of Central Asia, 9th–13th century] (Tashkent, 1983)

S. S. Blair: *The Monumental Inscriptions of Early Islamic Iran and Transoxiana* (Leiden, 1992), pp. 153–4

Ribat-i Sharaf [Ribāṭ-i Sharaf; Robat Sharaf]. Ruined building in northeast Iran on the road from Nishapur to Merv (now Mary, Turkmenistan). It was built as a caravanserai in 1114–15 probably by Sharaf al-Din Qummi, the governor of Khurasan (for illustration *see* CARAVANSERAI). After its sack by the Ghuzz Turks, it was extensively remodeled in 1154 as a residence for the Qarakhanid princess Turkan Khatun, wife of the Saljuq sultan Sanjar (*r.* 1118–57). It is a rectangular building (4863 sq. m) with a fortified exterior and a single projecting entrance on the southeast. The monumental entrance leads to a first court (32.4×16.5 m), the sides of which have iwans and dome chambers flanked by smaller rooms. The iwan opposite the entrance leads to a larger court (31.8×31.3 m) with a similar but more elaborate plan. To the left of the first and second portals are mosques with mihrabs inserted into their southwest walls. Another small mihrab was inserted on the exterior right of the outer portal for travelers who arrived after the gates were closed, and a large underground cistern in front of the entrance provided water throughout the year. At the far end of the complex two extensive suites of rooms flank the central iwan and dome. The massive baked-brick construction and numerous staircases indicate that there was at least one upper story.

The building is a rare example of a royal and secular building to survive from the period and is remarkable for the variety and richness of its brick vaulting and decoration in brick and stucco. The two campaigns document a change of taste in architectural decoration. Five different types of squinches were used to support the domes, and arch profiles include pointed, keel-shaped, trilobed and flat. These were filled with an extraordinary variety of geometric patterns (Pers. *hazārbaf*) worked in the brick bonds, where the recessed joints create a sense of texture and movement. In the restoration of the site in the 1970s the brick patterns of the original structure were often obscured by a thick layer of plaster, which was itself carved in a bewildering array of vegetal, epigraphic and geometric patterns, including some that imitate brick. The projecting rectangular frames (*see* PISHTAQ) around the monumental portal and the far iwan were enlivened by superb inscriptions in an attenuated angular script worked in cut brick, but only fragments of names, titles and dates are legible. The redecoration was commemorated in a new foundation inscription carved in stucco around the walls of the iwan in a cursive script against a scroll ground. During the restoration several objects were discovered under the floors. They include the only known example of true LACQUER in the Islamic world, 57 pieces of metalware (11th–14th century), a royal decree of the Safavid ruler Ismaʿil (1511–12), as well as glazed and unglazed ceramics, coins and glass fragments from the period when the building was constructed.

A. Godard: "Khorāsān," *Athar-é Iran*, iv (1949), pp. 7–68

M. Y. Kiani, ed.: *Robāt-e Sharaf* (Tehran, 1981) [Persian with English summary]

Rice, David Storm [Reich, Sigismund (Susya)] (*b.* Schönbrunn, 28 March 1913; *d.* London, 19 April 1962). British art historian of Austrian birth. In 1923 he emigrated with his parents to Palestine but returned to Europe in 1931 to attend the Accademia Reale di Belle Arti in Florence for a year. From 1932 to 1935 he studied Arabic, philology, social anthropology and the history of religion in Paris, graduating from the Ecole Pratique des Hautes Etudes. After receiving a doctorate from the Université de Paris in 1937 for a thesis on the Aramaic-speaking communities of the Anti-Lebanon, he began to take an interest in Islamic art under the influence of LEO ARY MAYER, Ralph Harari and GASTON WIET. From 1939 to 1947 he served in the British Army, changing his name and nationality. In 1947 he was appointed to a lectureship in Near and Middle Eastern history at the School of Oriental and African Studies of the University of London, where he became reader (1950) and professor (1959) in Islamic art and archaeology. He excavated at Alanya and Harran in Turkey, but the results of his campaigns at Harran from 1951 to 1959—his major contribution in this field—remain mostly unpublished. He also devoted much of his time to the study of medieval artifacts, especially metalwork. His monographs on individual objects and his six "Studies in Islamic Metal Work" are artistic and scholarly masterpieces (he always illustrated his studies with his own drawings and detailed photographs) that remain substantial contributions to a previously neglected field.

UNPUBLISHED SOURCES

Jerusalem, Mayer Mus. Islam. A. [pap., drgs and phot.]

WRITINGS

Etude sur les villages araméens de l'Anti-Liban (Damascus, 1937)

Le Baptistère de Saint Louis (Paris, 1951)

"Studies in Islamic Metal Work," *Bull. SOAS*, xiv (1952), pp. 564–78; xv (1953), pp. 61–79, 229–38, 489–503; xvii (1955), pp. 206–31; xxi (1958), pp. 225–53

The Unique Ibn al-Bawwāb Manuscript in the Chester Beatty Library (Dublin, 1955)

The Wade Cup in the Cleveland Museum of Art (Paris, 1955)

With S. Lloyd: *Alanya (ʿAlāʾiyya)* (London, 1958)

BIBLIOGRAPHY

J. B. Segal: Obituary, *Bull. SOAS*, xxv (1962), pp. 666–71 [with full list of writings]

Riyadh [al-Riyādh; Riadh; Riyad]. Capital city of Saudi Arabia. Located in the center of the Arabian peninsula, the mud-brick village of Riyadh became important with the rise of SAUDI rule, and in 1824 it was adopted as the capital when Imam Turki (*r.* 1823–34) expelled the last of the Ottoman forces from the town. Turki rebuilt the walls of Riyadh and

constructed a palace and congregational mosque (both destr.) of mud-brick and stone covered with mud plaster. The oldest building of importance in Riyadh is the Masmak Palace (19th century; rest.), located in the commercial center of the city. The palace, which was also built of mud-brick covered with mud plaster, is a rectangular fort with a large gate and four corner towers with triangulated battlements; it contains courtyards and numerous rooms. The Murabba and Shamsiya palaces were also built of mud-brick and gypsum around interior courtyards. In the early 20th century Riyadh was still a small town with two principal streets dividing it into quarters. Surrounded by a thick mud wall (h. 7 m; destr. 1944) with circular guard towers and four large gates, Riyadh consisted of a maze of twisting streets with mud-brick courtyard houses of one or two stories.

After the discovery of immense oil deposits in Saudi Arabia in the 1930s, Riyadh expanded rapidly, growing from less than 1 sq. km to 45 sq. km by 1960 and over 1500 sq. km in 2000. The population stands at 4.5 million (2007 estimate). The old city walls have been demolished, and the old congregational mosque on al-Dira, the main square of the city, was replaced by the concrete Masjid al-Jami' al-Kabir. By the 1950s the government ministries had been transferred from Jiddah, and in 1953 a railway connected Riyadh with Ad Dammam on the Gulf coast. In 1984 the airport 10 km north of the city was superseded by King Khalid International Airport, designed by Hellmuth, Obata and Kassabaum. Many buildings in a range of modern architectural styles utilizing modern construction techniques have been erected, ranging from high-rise blocks to garden villas.

The King Faisal Center for Research and Islamic Studies houses one of the largest collections of Arabic manuscripts in the Arab world, and the city's two university libraries and public libraries house many thousands more. Exhibitions highlight the history of manuscripts of the Koran and the Islamic Heritage Museum is the first public museum in the city to display Islamic art.

L. M. Weiss: "Riadh, die Stadt des Königs ibn Sa'ud," *Atlantis* (1930), pp. 522–30

M. S. Mousalli, F. A. Shaker and O. A. Mandily: *An Introduction to the Urban Patterns in Saudi Arabia: The Central Region* (London, 1977)

G. R. D. King: *The Historical Mosques of Saudi Arabia* (London and New York, 1986), pp. 156–9

W. Facey: *Riyadh: The Old City* (London, 1992)

S. al-Hathloul: *Tradition, Continuity, and Change in the Urban Environment: The Arab-Muslim City* (Riyadh, 1996)

P. Harrigan: "Riyadh: Arab Cultural Capital 2000," *Saudi Aramco World*, li/4 (2000), pp. 50–60

S. al-Hathloul: "Riyadh," *Encyclopedia of 20th-Century Architecture*, ed. R. S. Sennott (New York, 2003), pp. 1113–15

Riza [Riżā; Reza; Āqā Riza; Āqā Riżā Kāshānī; Riżāyi 'Abbāsī] (*b.* ?Kashan, *c.* 1565; *d.* ?Isfahan, 1635). Persian painter and draughtsman. The leading artist under the Safavid shah 'Abbas I (*r.* 1588–1629) is

known by three names, Riza, Aqa Riza and Riza-yi 'Abbasi, and the study of this figure has been complicated by contemporary references, variations in signature and inscriptions by other artists. The Safavid chroniclers Qazi Ahmad (1606) and Iskandar Munshi (1629) refer to the artist as Aqa Riza. A drawing (Ham, Surrey, Keir priv. col., III.387) illustrating *The Poet, the Robber and the Dogs*, a story from Sa'di's *Gulistān* ("Rose-garden"), contains one inscription dated 1619 stating that it was executed by "Riza the painter of 'A[bbas]" and another inscription dated 1654 stating that Riza's son MUHAMMAD SHAFI' colored the drawing of "the deceased Aqa Riza." The two forms of the artist's name on one work confirm his single identity, although some scholars have believed that work attributed to him was actually done by two different people: Aqa Riza, active in the late 16th century, and Riza-yi 'Abbasi, active from *c.* 1600 to 1635. Stchoukine's landmark study outlined Riza's stylistic development and demonstrated the unity of his work despite the various signatures and changes of style.

Qazi Ahmad identified Riza's father as 'Ali Asghar, an artist active at the Safavid court from *c.* 1525 to 1577, and stated that Riza lived in Mashhad for nearly a decade in the 1560s and 1570s. During the troubled reign of Muhammad Khudabanda (*r.* 1578–88), artists had to adapt their work to non-royal tastes and purses, so when Riza became active in the mid- to late 1580s, single-page portraits and genre scenes made for albums had replaced manuscript illustration as the main source of income for court artists (*see* ILLUSTRATION, §VI, A). The *Young Man in a Blue Coat* (Cambridge, MA, Sackler Mus., 1936.27) characterizes Riza's earliest work in which the single standing figure, fine line, closed contours and palette of primary colors derive from the court style of the 1570s and 1580s. Riza's treatment of drapery, however, diverges from the example of his predecessors, and the young man's skirt, instead of hanging straight, billows to the side as if blown in the wind. The turban and sash ends, ever a source of fascination for Riza, resemble frayed cloth fluttering in the breeze. The portrait embodies the technical finesse, sensitivity and charm of Riza's drawing.

From 1591, the year of Riza's first dated drawing, *A Man Holding a Cup* (Istanbul, Topkapı Pal. Lib., H. 2166, fol. 18*r*), until 1603, the year when he first signed his name Riza-yi 'Abbasi on the pivotal *Kneeling Woman* (St. Petersburg, Hermitage), he primarily drew in a fine calligraphic style, delineating curves with a line of varying thickness and depicting drapery folds with slashes of ink. In addition to portraits of courtly youths, Riza increasingly portrayed working men and dervishes. The portraits of youths display a certain sharpness, whereas those of working men and dervishes exhibit honesty and pensiveness (e.g. *Youth and an Old Man*; Washington, DC, Sackler Gal., S86.0292 and *Young Man Handing a Bowl to an Old Man*; Paris, Louvre, MS. MAO152; see color pl. 3:VIII, fig. 3). It is thought that the young Riza

participated in the illustration of a copy (Dublin, Chester Beatty Lib., Pers. MS. 277) of the *Shāhnāma* ("Book of kings") prepared for 'Abbas I, and the painting *Faridun Spurns the Ambassador from Salm and Tur* and three others are generally ascribed to him.

Following the move of the Safavid court to Isfahan in 1598, 'Abbas I conferred the title *'Abbāsī* on Riza. Shortly afterwards, Riza appears to have undergone a midlife crisis: he ceased to depict court figures, and his biographers complained that he had taken up with wrestlers and low-life types. A series of portrait-drawings of solitary shaykhs standing or dancing wildly in confining desert landscapes (e.g. *Shaykh in the Wasteland*, *c.* 1605; Istanbul, Topkapı Pal. Lib., H. 2145, fol. 11*r*) attests to the artist's disaffection in this period. Riza apparently ran out of money and returned to portraying courtiers *c.* 1610. The disillusionment of his middle years had an enormous effect on his artistic style. The primary colors and virtuoso technique of his early portraits give way in the 1620s to darker, earthier colors and a coarser, heavier line. New subjects only partly compensate for this disappointing stylistic development. Bird studies and a series of works after designs by Bihzad and Muhammadi augment Riza's single-figure portraits of shaykhs, hunters, shepherds and courtiers. In his last decade Riza increasingly satirized his sitters, as demonstrated in his 1634 portrait of a European feeding wine to his dog (Detroit, MI, Inst. A.). Throughout the 17th century Persian artists, such as Riza's pupil Mu'in, Muhammad Yusuf and Muhammad Qasim, looked to Riza's late style, although none of them could equal the complexity and incisiveness of his portrayal of later Safavid society.

Qazi Ahmad ibn Mir Munshı: *Gulistān-i hunar* [Garden of the arts] (*c.* 1606); Eng. trans. by V. Minorsky as *Calligraphers and Painters* (Washington, DC, 1959), pp. 192–3

Iskandar Munshi: *Tārīkh-i 'ālamārā-yi 'abbāsī* [History of the world-conquering 'Abbas] (1629); Eng. trans. by R. Savory as *History of Shah 'Abbas the Great* (Boulder, 1978), pp. 270–74

F. Sarre and E. Mittwoch: *Die Zeichnungen von Riza 'Abbasi* (Munich, 1914)

P. W. Schulz: *Die persisch-islamische Miniaturmalerei: Ein Beitrag zur Kulturgeschichte Irans* (Leipzig, 1914), pp. 184–92

B. W. Robinson: *A Descriptive Catalogue of the Persian Paintings in the Bodleian Library* (Oxford, 1958), pp. 153–7

I. Stchoukine: *Les Peintures des manuscrits de Shah Abbas I à la fin des Safavis* (Paris, 1964), pp. 84–133

B. W. Robinson and others: *Islamic Painting and the Arts of the Book* [The Keir Col.] (London, 1976), pp. 208–10

A. Welch: *Artists for the Shah* (New Haven and London, 1976), pp. 100–49

S. R. Canby: "Age and Time in the Work of Riza," *Persian Masters: Five Centuries of Painting*, ed. S. R. Canby (Bombay, 1990), pp. 71–84

S. R. Canby: *The Rebellious Reformer: The Drawings and Paintings of Riza-yi Abbasi of Isfahan* (London, 1996)

E. Atıl: "Reza Abbasi and his Recumbent Nude by Water's Edge," *P : Art and Culture Magazine*, ix (2003), pp. 76–9

Robat Sharaf. *See* RIBAT-I SHARAF.

Robinson, Basil W (*b.* London, 20 June 1912; *d.* London, 29 Dec. 2005). British historian of Persian painting. Robinson came to love Persian painting as a boy and in 1931, while still at school, he visited the great International Exhibition of Persian Art held at Burlington House in London several times, including once with the traveler and historian Brigadier General Sir Percy Sykes (1867–1945). After taking a degree at Oxford, he read for a post-graduate year cataloguing the Bodleian collection of Persian miniatures. In 1939 he joined the Victoria and Albert Museum, where he worked briefly in the library before being transferred to the Department of Metalwork, where he remained, becoming Keeper in 1966 until his retirement in 1972. He was an expert not only in Oriental metalwork, but also in Japanese swords and sword-mounts, Japanese prints and especially Persian miniatures. Along with organizing major exhibitions, such as the *Loan Exhibition of Persian Miniature Paintings from British Collections* (1951), the Kuniyoshi exhibition of 1961, and *Persian Miniature Painting from Collections in the British Isles* (1967), he prepared catalogues of Persian paintings in the foremost libraries of Britain and other Western countries, as well as the Kevorkian Collection in New York and the Pozzi Collection in Geneva. Widely known by the affectionate nickname "Robbie," he was a warm and generous colleague. His enduring contribution to the field of Oriental art lies not only in his discerning catalogues but also in his championship of such unfashionable topics as Qajar painting in enamel and lacquer.

WRITINGS

A Descriptive Catalogue of the Persian Paintings in the Bodleian Library (Oxford, 1958)

Persian Miniature Painting from Collections in the British Isles, (London, 1976)

Islamic Painting and the Arts of the Book: The Keir Collection (London, 1976)

Persian Paintings in the Indian Office Library: A Descriptive Catalogue (London, 1976)

Persian Paintings in the John Rylands Library: A Descriptive Catalogue (London, 1980)

Persian Paintings in the Collection of the Royal Asiatic Society (London, 1998)

Fifteenth-Century Persian Painting: Problems and Issues (New York, 1991)

Studies in Persian Art, 2 vols. (London, 1993) [collected essays]

BIBLIOGRAPHY

R. Hillenbrand, ed.: *Persian Painting from the Mongols to the Qajars: Studies in Honour of Basil W. Robinson* (London and New York, 2000)

"B W Robinson: Obituary," *Daily Telegraph* (3 Jan. 2006)

Rock crystal. Clear colorless quartz in hexagonal crystals was imported from East Africa, the Laccadive and Maldive Islands in the Indian Ocean, and North Africa; it was carved in the central Islamic lands (Iran, Iraq, Syria and Egypt) from the 8th to the 11th century.

The most common forms are containers, such as phials, flasks, ewers, cups and dishes, but maceheads, sword-pommels, chessmen, small pendants, beads, seals and amulets are also known. Carving was the primary means of decoration. Most of the 180 objects known are preserved in European royal and church treasuries, but a few pieces have been excavated, notably at Fustat (Old Cairo) and Susa in Iran. Five centuries later the technique was revived in Turkey under the Ottoman dynasty (r. 1281–1924), in Iran under the Safavids (r. 1501–1732) and in India under the Mughals (r. 1526–1857), when crystals were often combined with gold and set with gems.

I. 7th–11th centuries. Rock crystal had been carved in the Late Antique Mediterranean lands and in Sasanian Iran, but by the Islamic conquests in the 7th century, the industry is believed to have died out in Egypt and Syria, leaving Mediterranean production concentrated at Constantinople and other centers in Europe. The industry flourished continuously in the Sasanian lands, as exemplified by the Cup of Solomon (late 5th century or 6th; Paris, Bib. N., Cab. Médailles; see fig.), a dish formed of a lattice of gold with inset roundels of garnet, green glass and rock crystal. A large central medallion of rock crystal depicts the Sasanian emperor seated on a throne supported by winged horses. The continuation of this tradition can be seen in one of the earliest Islamic pieces known, a small shallow dish mounted in gold and once set with precious stones that was excavated at Susa (l. 95 mm; Paris, Louvre). Carved in relief with fan palmettes issuing from a central area, the dish can be attributed to the early 9th century.

Other pieces can also be attributed broadly to the eastern Islamic world in the 9th and 10th centuries. Each of a group of small crescent-shaped pendants, all found in Iran, represents a small leather bag with grooved lines indicating straps and imitates a well-known type of amulet-case. A goblet found at Qazvin (h. 97 mm; London, BM) has a flanged rim and collar at the base of the bowl, features that characterize contemporary Persian relief-cut glass. Nishapur in northeastern Iran has been suggested as the place of production because it is thought to have produced superb relief-cut glass goblets of this form, and the split-leaf palmettes on the Qazvin goblet are similar to those found on fragments of frescoes excavated there. An oil lamp in St. Petersburg (Hermitage) has been attributed to Mesopotamia on the basis of its acanthus leaves and pearl borders. According to the great polymath al-Biruni (d. 1048), Mesopotamia was the center of the Islamic rock crystal industry, for unworked crystal was imported to Basra where it was carved.

Many pieces were carved in the BEVELED STYLE current in Iraq, the capital province of the Abbasid empire in the 9th century. This style of carving may also have been introduced into Egypt under the Tulunid dynasty (r. 868–905) and into the eastern Islamic world. Thus the style is a broad indication of date but is less useful in establishing provenance. The finest examples, carved with great assurance and a clearly defined decorative composition, are now mounted in a pair of 16th-century Venetian candlesticks. The Beveled style is also found on a group of small cylindrical flasks with a band of carved ornament around the mid-section. One example (Baghdad, Iraq Mus.) was excavated at Wasit in Iraq; others have been found in Egypt.

A dozen small flasks or ampullae carved in the form of fish have been attributed to Egypt on iconographic grounds, since the fish was a common motif there. At least two were found in Egypt, but one was found at Samarkand and another was acquired in Iran. Some (e.g. Cologne, Cathedral of St. Severin) reproduce only the forked tail and fins of fish, while others (e.g. London, BM) are decorated with foliage in the Beveled style. A group of small flasks in the shape of molars are attributed to Egypt in the Tulunid period. They are octagonal in section and rest on four pointed feet. Each of the four alternate sides is decorated with a lentiloid shield. One was excavated at Fustat; an identical example was preserved in the church at Burscheid, Germany. They are attributed to Egypt because it is thought that the glass houses there had sufficiently mastered the glasscutting technique necessary to shape these small flasks. A group of objects in which the sole decoration is an inscription carved in relief can also be attributed to Egypt in the mid-10th century because of the style of the simple or foliate kufic inscriptions, which invoke blessings and good wishes on the owner. One of these, a phial (h. 91 mm, diam. 35 mm; Cairo, Mus. Islam. A.), has a flaring neck and cylindrical body, but the splayed foot has been broken.

The Beveled and relief styles were often used side by side for small pieces beginning in the 10th century in Egypt, perhaps because relief carving was more difficult. A set of 15 chessmen (Kuwait City, Mus. Islam. A.) includes a king and queen decorated with palmettes in the Beveled style and a knight, bishop and rook carved with trefoil leaves in relief on a garlanded stem. A group of 14 relief-carved flasks in the shape of a crouching lion (e.g. London, BM) should also be attributed to this period. Most have a cylindrical boring (diam. 13 mm) from the animal's chest to near the hindquarters, and the haunches and shoulders are decorated with lentiloid leaves and paired interlocking half-palmettes. Several spherical crystals are thought to have been ceremonial mace or sceptre heads. The finest (Leuven, St. Jacob), reused as the knop of a silver chalice, is decorated with a lion and griffin carved in low relief and set within raised circular frame bands.

After the Fatimid dynasty (r. 909–1171) conquered Egypt in 969, larger and finer objects in rock crystal began to be produced, as artisans from Basra brought new expertise to the Fatimid capital. Three bear the names of prominent individuals. One ewer (h. 180 mm, diam. 125 mm; Venice, S. Marco) bears the name of the caliph al-'Aziz (r. 975–96); the inscription on another ewer (ex-Medici col.; Florence, Pitti) indicates that it was made personally for the Commander of Commanders, a title borne by Husayn ibn Jawhar between 1000 and 1008; and a rock crystal crescent (Nuremberg, Ger. Nmus.) is inscribed with

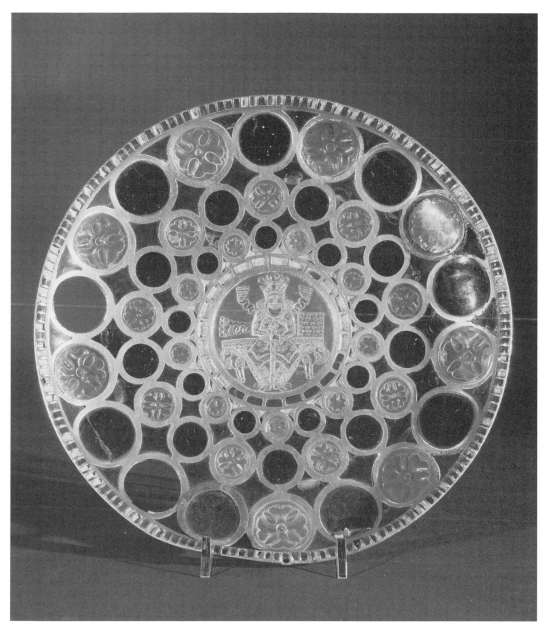

Sasanian rock crystal dish with garnet, green glass and gold, also known as the Cup of Solomon, late 5th– early 6th century (Paris, Bibliothèque Nationale, Cabinet des Médailles); photo credit: Erich Lessing/Art Resource, NY

the name of the caliph al-Zahir (*r.* 1021–36). The two inscribed ewers belong to a group of six of similar shape and size (ex-Saint-Denis Abbey; Paris, Louvre; Fermo Cathedral; Venice, S. Marco; London, V&A; for illustration *see* FATIMID). Made of flawless crystal, they have pear-shaped bodies, thin walls, mouths with prominent lips, necks with two or three sharp moldings, another molding (except on the London piece) below a flared footring, and a handle cut from the same piece of crystal as the body, pierced and surmounted by an animal. The bodies have a central stylized foliate motif, flanked by animals decorated with

intaglio discs. The animals vary: paired birds (Paris, Florence and Fermo), confronted seated lions (the 'Aziz ewer), running moufflon (the second Venice ewer) and falcons attacking gazelles (London). The Paris and Fermo ewers are inscribed with an anonymous supplication. The six ewers can be placed in chronological order on the basis of style: the 'Aziz ewer, Florence, Paris, Fermo, the second Venice ewer and London. The last two represent the pinnacle in the development of Egyptian rock crystal carving: they are characterized by a smoothly polished ground, low relief and an even secondary plane, and their

decoration is denser than on the other pieces. Their vegetal arabesques have notched stems and are more three-dimensional than the others.

Other large pieces can be attributed to the same period in Egypt. Notable examples include a handled cup and saucer given by Henry II (r. 1002–24) in 1014 to the cathedral at Aachen, where it is mounted in the golden ambo, and a similar cup in the Residenz, Munich, said to have been given by Henry II to the chapel at Regensburg. All three objects are decorated in relief with looping stems from which full and half-palmettes emerge. The decoration is restrained and controlled; the surface is smoothly polished. Related examples include a heart-shaped flask (h. 170 mm; Kuwait, Mus. Islam. A.) decorated with half-palmettes disposed symmetrically on a vertical stem.

The production of rock crystal objects continued at least to the mid-11th century, because the Persian traveler Nasir-i Khusraw, who visited Egypt between 1046 and 1050, mentioned that fine rock crystal vessels were produced and sold in the Lamp Market of the Cairo bazaar. He also said that fine-quality unworked crystal from Qulzum on the Red Sea began to replace the poorer-quality material from northwest Africa. Other accounts state that the treasury of the Fatimid caliphs contained 18,000 (or 36,000) items of rock crystal, including large basins, carafes and jars that could hold up to 16 litres. None of these enormous pieces is known to have survived the looting of the Fatimid treasuries in the 1060s, when it is thought that the craft died out in Egypt.

II. 12th–19th centuries.

A group of vertically faceted crystal cups or jugs has traditionally been attributed to the Near East or Egypt between the 12th and the 14th centuries, but they bear datable European metal mounts and are more likely to be of European, possibly Burgundian, workmanship. In the early 15th century, the Egyptian historian al-Maqrizi, who knew the accounts of the dispersal of the Fatimid treasury, lamented that crystal was no longer available in Egypt.

Crystal was fashioned elsewhere in the Islamic lands. The 17th-century French visitors to the Safavid court, Jean-Baptiste Tavernier (1605–89) and the Huguenot Sir John Chardin (1643–1713), mentioned hardstone-cutting among the crafts practiced in the Isfahan bazaar, and the technique may well have included the fashioning of rock crystal. A dagger (Istanbul, Topkapı Pal. Mus.) made for the Ottoman sultan Selim I (r. 1512–20) has a rock crystal handle and a gold-encrusted blade with a chronogram equivalent to 1514–15; the piece probably commemorates his victory over the Safavids at Chaldiran, and the handle may well have been a trophy taken from the Safavid palace at Tabriz.

Rock crystal soon became popular at the Ottoman court (see color pl. 3:III, fig. 2). A pot-bellied jug with a cylindrical neck (second quarter of the 16th century; Istanbul, Topkapı Pal. Mus.) is decorated only with vertical oblong panels with trefoil heads that allow the beauty of the material to shine through. All other examples of rock crystal in the Topkapı Palace Treasury are elaborately embellished. They include imported European vessels with chip-carving or wheel-cut foliate sprays to disguise natural flaws, as well as vessels sheathed in gold or encrusted with precious stones, both cabuchon and cut, in gold collar-mounts with scroll traceries. Masterpieces include an octagonal canteen carved from a single piece of rock crystal with a gold head and foot and encrusted with rubies and emeralds, and a round-ended pen-box made of panels of rock crystal framed with gold bands, set with emeralds and rubies, and lined with white paper illuminated with fine blue and gilt foliate sprays. These pieces represent the high point of Ottoman rock crystal and incrustation workmanship; the technique of encrustation became increasingly repetitive in the 17th century. In contrast, pieces from Mughal India (e.g. a dish; London, BM, 1964 4-19 1) are closer to the European taste that lets the material stand alone, although European motifs such as acanthus scrolls are transmuted into Eastern ones such as lotuses and chrysanthemums.

Enc. Islam/2: "Billawr" [Rock crystal]

C. J. Lamm: *Mittelalterliche Gläser und Steinschnittarbeiten aus dem nahen Osten* (Berlin, 1929–30)

R. Pinder-Wilson: "Some Rock Crystals of the Islamic Period," *BM Q.*, xix (1954), pp. 84–7; also in *Studies in Islamic Art* (London, 1985), pp. 145–50

D. S. Rice: "A Datable Islamic Rock Crystal," *Orient. A.*, n. s., ii/3 (Autumn 1956), pp. 85–93

H. R. Hahnloser and others: *Il tesoro di San Marco* (Florence, 1971)

The Arts of Islam (exh. cat., London, Hayward Gal., 1976), pp. 119–28

Islamic Art and Design, 1500–1700 (exh. cat. by J. M. Rogers; London, BM, 1983), pp. 150–51

E. Atıl: *The Age of Sultan Süleyman the Magnificent* (Washington, DC and New York, 1987), pp. 127–31

A. Contadini: *Fatimid Art at the Victoria and Albert Museum* (London, 1988), pp. 16–38

R. Pinder-Wilson: "Islamic Rock Crystals," *Dar al-Athar al-Islamiyyah Newslett.*, xx (1989), pp. 16–21

A. Shalem: "Fountains of Light: The Meaning of Medieval Islamic Rock Crystal Lamps," *Muqarnas*, xi (1994), pp. 1–11

S. S. Blair: "An Inscribed Rock Crystal from 10th-century Iran or Iraq," *Entlang der Seidenstrasse: Frühmittelalterliche Kunst zwischen Persien und China in der Abegg-Stiftung*, ed. K. Otavsky, *Riggisberger Berichte*, vi (1998), pp. 345–53

M. Casamar Pérez and F. Valdés Fernández: "Les objets égyptiens en cristal de roche dans al-Andalus, éléments pour une reflexion archéologique," *L'Egypte fatimide: Son art et son histoire. Actes du colloque organisé à Paris …mai 1998*, pp. 367–82

A. Shalem: "The Rock-Crystal Lionhead in the Badisches Landesmuseum in Karlsruhe," *L'Egypte fatimide: Son art et son histoire. Actes du colloque organisé à Paris …mai 1998*, pp. 359–66

A. Shalem: "Islamic Rock Crystal Vessels—Scent or Ampullae?," *Bamberger Symposium: Rezeption in der islamischen Kunst vom 26.6.–28.6.1992*, ed. B. Finster, C. Fragner and H. Hafenrichter, Beiruter Texte und Studien, lxi (1999), pp. 289–99

J. M. Bloom: *Arts of the City Victorious: The Art and Architecture of the Fatimids in North Africa and Egypt* (New Haven and London, 2007)

Rogers, J. M(ichael) (*b.* Barrow-in Furness, 1935). British historian of Islamic art. After studying philosophy, politics and economics at Oxford and teaching philosophy there, his interests gradually shifted to Islamic art, particularly the art and architecture of Seljuq Anatolia, about which he eventually wrote his Ph.D. He taught at the American University of Cairo from 1965 until 1977, when he joined the Department of Oriental Antiquities at the British Museum. From 1991 to 2000 he was the Nasser D. Khalili Professor at the School of Oriental and African Studies, University of London and has been Honorary Curator of the Khalili Collection of Islamic Art since 1992. His extensive and meticulous scholarship, largely found in hundreds of learned articles, chapters, and reviews, is marked by his fluency in many languages and vast knowledge of primary sources.

WRITINGS

The Spread of Islam (Oxford, 1976)

Islamic Art and Design 1500–1700 (exh. cat., London, BM, 1983)

ed. and rev.: *The Topkapı Saray Museum and Its Collections*, 5 vols. (London, 1985–8)

Süleyman the Magnificent (exh. cat. with R. M. Ward; London, BM, 1988)

Mughal Painting: An Introduction (London, 1993)

Empire of the Sultans: Ottoman Art from the Collection of Nasser D. Khalili (Geneva, 1995)

BIBLIOGRAPHY

D. Behrens-Abouseif and A. Contadini, eds.: *Essays in Honor of J. M. Rogers, Muqarnas*, xxi (2004) [entire issue, with bibliography 1965–2004]

Ruhā', al-. *See* URFA.

Rupbas [Rūpbās]. Site of a 17th-century palace in Bharatpur District, Rajasthan, India. The village of Rupbas is situated at the end of a long range of red sandstone hills in the Chambal Valley, which had strategic military and commercial importance for the MUGHAL rulers. The area was one of numerous hunting locations visited by the emperors during their annual tours and was frequently visited by Jahangir (*r.* 1605–27). However, contemporary historical sources suggest that no permanent palace existed prior to 1635. One of the priorities of Shah Jahan (*r.* 1628–58) on his accession was to remodel several existing structures, culminating in a vast building program, one facet of which was the creation of the palace at Rupbas.

The palace façade overlooks a tank and is aligned almost exactly to the northeast, probably in consideration of the position of the sun in the final weeks of winter (the period of the most intense hunting activity). The red sandstone façade (w. about 180 m) has seven octagonal towers (Pers. *buruj*) that project 3.25 m beyond the outer wall. These towers are decorated with delicate tracery windows carved with a recurring hexagonal motif that is seen on numerous monuments, notably at the secondary tombs within the complex of the Taj Mahal at Agra. The primary

western entrance to the palace leads directly into the main courtyard. The arched portal iwan is carved with an elaborate relief pattern, a recurring eight-lobed motif with central floral devices involving simple reiterations of an inverted lotus followed by an upturned lotus and, finally, a round and fully opened blossom.

'Abd al-Hamid Lahauri: *Padshahnama* [Emperor's book] (*c.* 1654–5), 2 vols. (Calcutta, 1865–8)

Muhammad Salih Kanbu: *'Amal-i-Salih* [Work of Salih] (1659–60), 3 vols. (Calcutta, 1912–39 and Lahore, 1967)

A. C. L. Carlleyle: "4—Rûp-Bâs, or Rûp-Vâs," *Archaeol. Surv. India, Annu. Rep.*, vi (Calcutta, 1878)

J. A. Hughes: *Shah Jahan's Lal-mahal at Bari and the Tradition of Mughal Hunting Palaces* (diss., Iowa City, U. IA, 1988)

C. Asher: *Architecture of Mughal India* (Cambridge, 1992), p. 205

R. Nath: *History of Mughal Architecture, vol. 3: The Transitional Phase of Colour and Design, Jehangir, 1605–1627 A.D.* (New Delhi, 1994), pp. 279–81

Rusafa [al-Ruṣāfa; Assyrian Rasappa; Bibl. Rezeph; Gr. Rhesafa; Lat. Risafa, Rosafa; Byz. Sergiopolis; Arab. Ruṣāfat Hisham, Ruṣafa]. Site of an ancient city in northern Syria *c.* 200 km east of Aleppo and 30 km south of the Euphrates River, with both Byzantine and Islamic remains. Although it was known from earlier travelers' reports, full descriptions of the monuments were not published until the early 20th century. Excavations were undertaken by the Deutsches Archäologisches Institut from 1952, directed first by Kollwitz and from 1976 by Ulbert.

Although the city is attested in both Assyrian and biblical sources (2 Kings 19:12; Isaiah 37:12), the earliest known architectural information is from the 3rd century CE, when Diocletian (*r.* 283–305) established it as a frontier fortress. Around 300 a high-ranking officer in the eastern Roman army, Sergius, was executed there. The martyr's remains were originally buried outside the walls and became the focus of a cult. From the late 5th century onwards Rusafa was one of the most important pilgrimage centers in the eastern Mediterranean and was already an episcopal see. By the late 6th century it had become known as Sergiopolis and assumed metropolitan status, which it retained until the 13th century. The wealth brought by pilgrim traffic made it the target of repeated Persian attacks and, as a result, massive city walls were built during the 6th century, as well as other public buildings and cisterns. The latter, vaulted and divided by massive piers, were designed for a population of about 6000. After the Arab conquest under the caliph Hisham (*r.* 724–43) Rusafa was for a time the seat of the Syrian Umayyad empire and renamed Rusafat Hisham, although the city was not to lose its Christian character in the Middle Ages. It was destroyed by the Mongols in 1259, but even then some people continued living among the ruins.

The city walls with 50 towers have survived intact, forming an irregular rectangle with an area of *c.* 20 ha. There are four main gates, all decorated with sculpture. The north gate (early 6th century) is the most richly decorated; its three entrances are framed

by a false façade with richly sculptured archivolts above column shafts surmounted by capitals. The closest parallels to its architectural sculpture are in the contemporary buildings of northern Mesopotamia at Nisibis (now Nusaybin) and Dayr Zafaran (both now in Turkey). The varied decorative elements, for example in the archivolts, can also be found in the centrally planned building (42×21.7 m) that forms the most splendid and elegant church in the city. Here much of the architectural sculpture has remained *in situ*, some retaining traces of coloring. The discovery of a synthronus and a font has led to the suggestion that this building was the cathedral in the 6th century. This tetraconch has parallels in the region (Aleppo, Apameia, Bosra) and testifies to the considerable ability of early 6th-century Syrian architects.

Basilica B, the earliest to have been examined, was partly excavated by Kollwitz, who identified it as the martyrium of St. Sergius. In 1989 and 1990 excavations uncovered the foundation inscription of 518 and also the walls of an earlier martyrium of unfired brick beneath the floor of the 6th-century basilica. The church is a columned basilica (48.5×25.7 m) with five asymmetrical spaces at its east end. The room flanking the north side of the main apse is a triconch that, judging by arrangements known in other Syrian churches, probably contained the sarcophagus holding the saint's relics. The base of an ambo remains in place in the nave. The church was destroyed by an earthquake in the early Middle Ages.

The focus of the largest Christian complex is the church known as Basilica A (6th century), dedicated by inscription to the Holy Cross. This three-aisled basilica (54.4×28.6 m), with its widely spaced arcade, underwent numerous alterations and restorations and remained in use for Christian worship until the 13th century. Excavation has revealed many alterations in the arrangements of the bema, the sanctuary and the synthronus, such as an increase or decrease in the number of seats for priests, traces of devices for hanging curtains on the templon, and the later addition of an altar ciborium. By the early Middle Ages this basilica had probably already taken over the role of the cathedral and also became the pilgrimage center of the city after the relics of St. Sergius had been translated to the room flanking the north side of the apse. A monumental peristyle courtyard and a complex that probably contained a large baptistry were provided for pilgrims. This area also contained a 6th-century floor mosaic representing animals in a paradisaical landscape; it is in the tradition of the mosaics in the martyrium of Antioch-Seleucia (now Samandağ). The church known as Basilica C, a columnar basilica (37×20 m), is also of the 6th century. The base of the ambo and the screen to the sanctuary have survived *in situ*.

In the second half of the 6th century the audience hall of the nomad Ghassanid chieftain al-Mundhir (*r.* 569–82) was built outside the city walls, probably by local craftsmen. It was a quincunx supported on four massive cruciform piers. All its architectural sculpture survives *in situ*, some of it painted. One of

the many ruins of early Islamic buildings in the area to the south of the walled city was investigated by Otto-Dorn in 1952 and identified as a palace of the Umayyad caliph Hisham. In 1990 a square pavilion was excavated, which has a columnar porch surrounding an inner room decorated with wall paintings and colored stucco. Its situation, in the middle of a field enclosed by a brick wall, can be seen as an early example of the so-called paradise garden, of pre-Islamic Persian inspiration. Also of the Umayyad period is the large three-aisled court mosque, built largely of reused materials, which occupied part of the Christian pilgrimage courtyard of Basilica A within the walls. The qibla wall, with minbar and two mihrabs, stands to its full height. The side walls and the rest of the articulation of the interior were excavated in 1985–6. Archaeological evidence confirms that the cathedral and the principal mosque functioned side by side in the Middle Ages.

Excavations have produced quantities of Raqqa pottery (*see* CERAMICS, §III, B) of the 12th and 13th centuries. From the same period a treasure consisting of Christian liturgical silver vessels (Damascus, Mus. N.) was found in the pilgrimage courtyard of Basilica A. This find, of which some pieces were made in Syria and others were Western imports of the Crusader period, demonstrates the continuing importance of Rusafa in the Middle Ages.

Enc. Islam

F. Sarre: "Rusafa-Sergiopolis," *Mhft. Kstwiss.*, ii (1909), pp. 95–107

F. Sarre and E. Herzfeld: *Archäologische Reise im Euphrat- und Tigrisgebiet*, ii (Berlin, 1920), pp. 1–45

H. Spanner and S. Guyer: *Ruṣāfa: Die Wallfahrtsstadt des Heiligen Sergios* (Berlin, 1926)

A. Musil: *Palmyrena: A Topographical Itinerary* (New York, 1928), pp. 260–72

Archäol. Anz., lxix (1954), pp. cols. 119–38; lxxii (1957), pp. 64–109; lxxviii (1963), pp. 328–60; lxxxiii (1968), pp. 307–43 [preliminary excavation reports on Rusafa by J. Kollwitz]

K. Otto-Dorn: "Bericht über die Grabung im islamischen Rusafa," *Archäol. Anz.*, lxix (1954), pp. cols. 138–59

K. Otto-Dorn: "Grabung im umayyadischen Ruṣāfah," *A. Orient.*, ii (1957), pp. 119–34

J. Kollwitz: "Die Grabungen in Resafa," *Neue deutsche Ausgrabungen im Mittelmeergebiet und im Vorderen Orient* (Berlin, 1959), pp. 45–70

W. Karnapp: *Die Stadtmauer von Resafa in Syrien* (Berlin, 1976)

T. Ulbert: "Eine neuentdeckte Inschrift aus Resafa," *Archäol. Anz.*, xcii (1977), pp. 563–9

M. Mackensen, T. Ulbert and D. Sack: *Resafa* (Mainz, 1984–)

Damas. Mitt., v (1991), pp. 119–82 [articles by W. Brinker, N. Logar, P.-L. Gatier and T. Ulbert]; vi (1992), pp. 403–78 [articles by T. Ulbert, N. Logar]

J. L. Bacharach: "Marwanid Umayyad Building Activities: Speculations on Patronage," *Muqarnas*, xiii (1996), pp. 27–44

D. Sack and others: *Die grosse Moschee von Resafa, Rusafat Hisham*, Resafa, 4 (Mainz, 1996)

S

Sadequain (*b*. Amroha, 1930); (*d*. Karachi, 10 Feb. 1987). Pakistani painter. Sadequain was one of Pakistan's most dynamic and influential artists. Born into a family of Koran scribes, Sadequain learned the power of verse and the aesthetic of calligraphy. As a youth in Delhi, he worked as a copyist for All India Radio, in his free time roaming the streets painting anti-British, pro-Pakistani slogans on walls and walkways. He earned extra money drawing maps and illustrating textbooks.

Shortly after going to Pakistan in the early 1950s, Sadequain attracted the attention of Karachi entrepreneur Hasan Habib. About 1956 he was taken under the wing of Pakistan's prime minister, Hussain Shaheed Suhrawardy. Sadequain's abstract or Cubist-like figures, seascapes and still-lifes from this period lack conviction. A self-imposed period of seclusion on Karachi's barren seacoast transformed his art. Cacti became his alter ego—a symbol of life enduring in a hostile environment.

Sadequain's career soared in the 1960s. He traveled to and exhibited in Europe and the USA. In 1961 he was laureate winner of the French Biennale for artists under 35. He received state patronage for his calligraphic and figurative murals while continuing to produce satiric works. A 1965 exhibition featured paintings critical of what he saw as demoralizing national repression. These paintings depict artists (including Sadequain himself) and intellectuals caught in cobwebs, their decapitated heads balanced aloft or carried by others, while worms crawl up their knotty bodies. Conservatives and religious groups led violent protests against a 1976 exhibition, reacting against the nudity in his art and its social and political content. Bombs exploded, and paintings were destroyed. The Punjab Assembly grappled with the incident for a month. Works from this period include *Fasting Sadequain*, modeled on Gandharan sculptures of the emaciated Buddha.

During the next year martial law was imposed. Sadequain returned to poetry and calligraphy. He continued to travel and paint murals and in 1981 was provided with a house (now the Sadequain Museum) in Islamabad. A ceiling mural and some of Sadequain's calligraphy are in the permanent collection of the Central Museum, Lahore. Other works are in Frere Hall, Karachi, and private collections throughout Pakistan. Sadequain was lauded in India on his first and only return in 1981, and in 2006 he was one of 10 Pakistani painters honored posthumously with a 40-rial postage stamp.

See also PAKISTAN, §III.

S. A. Ali: "Sadequain, 1968–69," *Artistic Pakistan*, ii/3 (June 1969), pp. 7–11

A. Iqbal: "Sadequain's Sketch of an Indian Visit," *The Muslim* (25 Jan. 1983)

Sadequain Biodata and World Opinion, Pakistan National Council of Arts (Islamabad, 1983)

R. Hakim: "Sadequain is a Showman Because He Has Something to Show," *The Herald* (July 1985), pp. 110–17

S. A. Ali: "Forty Years of Art in Pakistan," *A. & Islam. World*, iv (1986), pp. 50–59

S. Mir: "A Thinker through Images," *Dawn* (20 Feb. 1987), pp. 1–2

Paintings from Pakistan, UNESCO and the Pakistan National Council of Arts (Islamabad, 1988)

I. ul-Hasan: *Painting in Pakistan* (Lahore, 1991)

M. Nesom-Sirhandi: *Contemporary Painting in Pakistan* (Lahore, 1992)

M. C. Sirhindi: "Painting in Pakistan: 1947–1997," *A. & Islam. World*, xxxii (1997), pp. 17–32

A. Naqvi: "Transfers of Power and Perception: Four Pakistani Artists," *A. & Islam. World*, xxxii (1997), pp. 9–15 [special issue on 20th-century Pakistani art]

A. Naqvi: *Image and Identity: Painting and Sculpture in Pakistan 1947–1997* (Karachi, 1998)

N. Ali: "Ṣādiqayn, Pakistani Calligrapher & Artist," *Lahore Mus. Bull.*, xv (2000), pp. 13–15

P. Mittar: *Indian Art*, Oxford History of Art (Oxford, 2001)

S. K. Nizai: *Love Sonnets of Ghālib: Translations and Explications* (Delhi, 2002) [illustrations by Sadequain]

Saʿdi [Saʿdī, Saʿdian]. Islamic dynasty that ruled Morocco between 1511 and 1659. Like their ʿAlawi successors, the Saʿdis were *sharīfs* (descendants of the prophet Muhammad) and both dynasties are sometimes classed together as the "Sharifs of Morocco." The Saʿdis came from Arabia and settled in the Sus region of southern Morocco in the late 14th century. Taking advantage of the political chaos in Morocco at the beginning of the 16th century, they seized power and established their capital in Marrakesh. Their most brilliant sovereign, Ahmad al-Dhahabi ("the Golden"; *r*. 1578–1603), repulsed a Portuguese invasion and contained Ottoman attempts at

domination, while his armies took Moroccan rule as far south as Timbuktu and the Niger. After Ahmad's death the dynasty's authority declined rapidly until it was recognized only in Marrakesh, which was taken by the 'Alawis in 1659.

Sa'di architectural patronage (*see* ARCHITECTURE, §VII, E, 1) was concentrated in Marrakesh, where they built numerous mosques, madrasas and shrines, as well as the royal city within the Almohad walls. The most noteworthy religious buildings to have survived are those forming the dynastic necropolis set against the southern wall of the Kasba Mosque (*see* ARCHITECTURE, fig. 58). Outside Marrakesh the only remarkable works are the pavilions added to the courtyard of the Qarawiyyin Mosque in Fez. In general, Sa'di religious architecture kept to the tradition established under the Almohad dynasty but was adapted to the more limited needs of the time. Of Sa'di secular architecture only the bare walls of beaten earth and baked brick of the royal city in Marrakesh remain. Its layout followed Andalusian models in its combination of pools, fountains, gardens, open pavilions and massive walls and its once splendid decoration in carved stucco and tile. This Andalusian influence is also seen in the two pavilions in the Qarawiyyin Mosque, which were modeled on those in Granada at the Alhambra's Patio de los Leones (Court of the Lions; *see* GRANADA, color pl.). Apart from richly decorated Koran manuscripts, for example that copied for Sultan 'Abd Allah in AH 975 (1568; London, BL, Or. MS. 1405; *see* SUBJECT MATTER, color pl.), little is known about Sa'di patronage of other arts.

E. Lévi-Provençal: *Les Historiens des Chorfa: Essai sur la littérature historique et biographique au Maroc du XVIe au XXe siècle* (Paris, 1922)

G. Rousseau and F. Arin: *Le Mausolée des princes saadiens à Marrakech*, 2 vols. (Paris, 1925)

G. Deverdun: *Marrakech: Des origines à 1912*, 2 vols. (Rabat, 1959–66)

Sadiq. *See* MUHAMMAD SADIQ.

Sadiqi [Ṣādiqī; Ṣādiqī Beg; Ṣādiqī Beg Afshār] (*b.* Tabriz, 1533–4; *d.* Isfahan, 1609–10). Persian calligrapher, painter, poet and chronicler. He came from a notable family of the Khudabandalu Turkoman tribe. At the age of 32 he turned to art, studying under the poet–calligrapher Mir San'i at Tabriz; in 1568 Sadiqi moved to the Safavid capital at Qazvin, where he studied painting with MUZAFFAR 'ALI. Sadiqi rose quickly in the royal atelier. The last major manuscript produced for the Safavid ruler Tahmasp (*r.* 1524–76), a copy (London, BL, Or. MS. 12985) of Asadi's *Garshāspnāma* ("Book of Garshasp"), dated 1573–4, has one painting (fol. 85*v*) attributed to Sadiqi, and he played a leading role in illustrating the incomplete copy (dispersed) of the *Shāhnāma* ("Book of kings") made for Isma'il II (*r.* 1576–8). The seven paintings ascribed to Sadiqi show such characteristics of his early style as distinct coloring, hard contours, flat

architecture and rigid figure drawing. During the reign of Muhammad Khudabanda (*r.* 1578–88) Sadiqi drifted from the court and turned from manuscript illustration to single-page studies (e.g. Paris, Bib. N., Supp. Pers. 1171, and Boston, MA, Mus. F.A., 14.636). After the assassination of the Shah's wife in 1579, the artist left for Gilan and Mazanderan, and two years later fought daringly at the Battle of Astarabad. Upon the accession of 'Abbas I (*r.* 1588–1629), Sadiqi was appointed head of the royal library at Qazvin. He supervised at least one royal project, a monumental copy (Dublin, Chester Beatty Lib., Pers. MS. 277) of the *Shāhnāma* prepared for the Shah during the first decade of his reign, and the three surviving paintings attributed to Sadiqi show his debt to the work of RIZA. Sadiqi had the personal wealth to commission and illustrate a copy (Dumfries House, Strathclyde) of Kashifi's *Anvār-i Suhaylī* ("Lights of Canopus") in 1593. Its 107 illustrations, all attributed to Sadiqi, are remarkable depictions of daily life. Sadiqi was dismissed from the office of librarian *c.* 1596–7, but retained his title and salary. He devoted his later years to writing, and his works are informative sources about Safavid artists, techniques of painting and his own life.

WRITINGS

Qanun al-Suvar [Canons of painting] (*c.* 1576–1602), Azeri Turk. edn. and trans. by A. Yu. Kaziev as *Ganun ös-sövär* (Baku, 1963); Eng. trans. by M. B. Dickson and S. C. Welch as *The Houghton Shahnameh* (Cambridge, MA, 1981), app.I, pp. 259–69

Majma' al-Khwass [Concourse of the élite] (early 1590s), ed. 'Abd al-Rasūl Khayyāmpūr (Tabriz, Iran. Solar 1327/1948)

Kulliyat [Collected works] (1601–2; Tabriz, Pub. Lib., MS. 3616 [possibly the holograph copy]; Tehran, Malik Lib., MS. 6325 [a contemp. copy])

BIBLIOGRAPHY

Qazi Ahmad ibn Mir Munshi: *Gulistān-i hunar* [Garden of the arts] (*c.* 1606), ed. A. Suhayli (Tehran, Iran. Solar 1352/1974); Eng. trans. by V. Minorsky as *Calligraphers and Painters* (Washington, DC, 1959), p. 191

Iskandar Munshi: *Tārīkh-i 'ālamārā-yi 'abbāsī* [History of the world-conquering 'Abbas] (1629); Eng. trans. by R. Savory as *History of Shah 'Abbas the Great* (Boulder, 1978), pp. 271–2

B. W. Robinson: "Two Persian Manuscripts in the Library of the Marquess of Bute. Part II," *Orient. A.*, xviii (1972), pp. 50–56

A. Welch: *Artists for the Shah* (New Haven, 1973), pp. 41–99

T. Gandjei: "Notes on the Life and Works of Ṣādiqī: A Poet and Painter of Ṣafavi Times," *Der Islam*, lii (1975), pp. 112–18

B. W. Robinson: "Ismā'il II's Copy of the *Shāhnāma*," *Iran*, xiv (1976), pp. 1–8

M. B. Dickson and S. C. Welch: *The Houghton Shahnameh* (Cambridge, MA, 1981)

G. A. Bailey: "In the Manner of the Frankish Masters: A Safavid Drawing and its Flemish Inspiration," *Orient. A.*, xl/4 (Winter 1994–5), pp. 29–34

G. A. Bailey: "The Sins of Sadiqi's Old Age," *Persian Painting, from the Mongols to the Qajars: Studies in Honour of Basil W. Robinson*, ed. R. Hillenbrand (London, 2000), pp. 264–5

R. Skelton: "Ghiyath al-Din 'Ali-yi Naqshband and an Episode in the Life of Sadiqi Beg," *Persian Painting, from the Mongols to the Qajars: Studies in Honour of Basil W. Robinson*, ed. R. Hillenbrand (London, 2000), pp. 249–63

Safavid. Dynasty that ruled in Iran from 1501 to 1732.

I. Introduction. II. Family members.

I. Introduction. The dynasty took its name from its ancestor Shaykh Safi al-Din (*d.* 1334), the much-venerated head of a sectarian Sufi order based at ARDABIL in northwest Iran. The Safavids rose to power after almost 200 years in which, after the fall of the Ilkhanids and apart from the meteoric career of Timur, Iran had lacked cohesiveness and relatively fixed boundaries. This period was also one of religious ferment during which folk Islam, Sufism and extreme Shi'ism flowered. The Safavids combined these three elements, turning the order at Ardabil into a revolutionary Shi'ite movement originally dominated by Turkmen tribesmen (the *qizilbash*, "red-heads") from eastern Anatolia and Azerbaijan, and creating a successful political system that they quickly imposed on the country as a whole. The Safavids taught that their legitimacy depended on the teachers of religious law who exercised their personal judgment (Pers. *ijtihād*) in that domain until the ultimate return of the Mahdi, the Hidden Imam. By making Shi'ism the official religion, the Safavids forged an ideology that not only strengthened the State but also helped to create a new sense of national identity and thus enabled Iran to escape absorption into the empires of the neighboring Ottoman and Mughal superpowers—although its frontiers were frequently contested. The Safavids made Iran (with the old Shi'ite centers of Iraq) the spiritual bastion of the Shi'a against the onslaughts of orthodox Sunni Islam and the repository of Persian cultural traditions and self-awareness.

Yet for the indigenous population Twelver Shi'ism (*see* ISLAM, §I) was at first alien. This was the age of the Islamic superpowers, all of whom shared the same Turco-Persian rather than Arab culture. Thus Islam, like Europe, emancipated itself from its medieval heritage by creating larger political groupings. The rulers of these superpowers were keenly competitive, alert to match claims (e.g. to the caliphate) with counter-claims. Their horizons were wide: Isma'il (*r.* 1501–24), the first Safavid shah, bore the title Emperor of Iran (*pādshāh-i Īrān*) with its implicit notion of an Iranian state stretching from Afghanistan to the Euphrates, from the Oxus to the Persian Gulf. The long reign of Isma'il's son (A) Tahmasp helped establish the role of Iran *vis-à-vis* its neighbors, but it fell to Tahmasp's grandson, (B) 'Abbas I, to set the country on the road to greatness by creating an efficient standing army and a centralized administration, thereby laying the foundations of the modern Iranian state.

The Safavids continued the Ilkhanids' attempts to foster closer diplomatic ties with European powers, as evidenced by the frequent exchange of embassies with the various courts of Europe to cement alliances against the Ottomans. Similarly, the Safavids were alert to the political and economic implications of the opening of the sea route from Europe to the Far East in 1498, which diverted Ottoman pressure away from Iran to the Red Sea and the Indian Ocean: the Dutch, the English and the Portuguese were permitted to establish trading posts on the Persian Gulf, where Indian merchants also settled. For the Iranians this meant revenue from customs dues, while for the European powers such posts were essential if they were to control the increasingly lucrative East Indian trade. The inevitable clash of interests resulted in frequent hostilities, especially with the Portuguese. Attempts were also made to avoid Ottoman customs dues by relocating the silk and spice routes to the north across Russia. Much Safavid silk reached Europe, especially the Habsburg domains and Scandinavia (e.g. the Silk Room at Rosenberg Castle, Denmark), in this way. Indeed, some textiles and carpets were made specifically for the West and bear (not always accurately) the arms of royal and noble houses. Conversely, Europe exported muskets, mail shirts, clocks, Italian paintings, Chinese porcelains, Japanese screens and even plants, fruits and vegetables (such as the turnip) unknown in Iran, and 'Abbas had several Europeans in his permanent service. The dramatic increase in commercial and diplomatic relations with the European powers was fostered by a tolerance rarely encountered in Iran and reflected in a multi-racial society. Colonies of Armenians, Georgians and Hindus were settled in villages or key towns, while Western religious orders, such as the Augustinians, Carmelites and Capuchins, founded convents in Isfahan and other major centers as part of a worldwide missionary campaign, which also embraced China, Japan and the Americas.

The principal achievements of the Safavids were architectural (*see* ARCHITECTURE, §VII, B, 1). Pride of place goes to the expansion of Isfahan (*see* ISFAHAN, §I) masterminded by 'Abbas from 1598. This resulted in the famous maidan, perhaps the largest piazza in the world; the Chahar Bagh (Four Gardens) esplanade and royal quarter linking the maidan with the Zaindeh River; and the huge covered bazaar. The Shah Mosque, the mosque of Shaykh Lutfallah and the Madar-i Shah, an interdependent complex of madrasa, caravanserai and bazaar built by Husayn I (*r.* 1694–1722), are the finest public buildings of the time. The royal palaces, such as the 'Ali Qapu, Chihil Sutun (see color pl. 3:V, fig. 1; *see also* ISFAHAN, fig. 4) and Hasht Bihisht, embowered in gardens and embellished with verandahs, frescoes and fanciful *muqarnas* vaults, expressed to perfection the luxurious lifestyle of the court. The major shrines of MASHHAD, ARDABIL and MAHAN (see color pl. 3:V, fig. 2), too, were all transformed in this period. In secular architecture the network of caravanserais erected across the country by 'Abbas deserves special note.

The fall of Herat in 1507 to the Shaybanids and the flight of the last Timurid ruler to Safavid protection meant that some of the Timurid library and craftsmen, including Bihzad, went to Tabriz (*see* Illustration, §VI, A, 2). Early Safavid painting combined the traditions of Timurid Herat and Turkmen Tabriz to reach a peak of technical excellence and emotional expressiveness that for many is the finest hour of Persian painting. But the loss of royal patronage by *c.* 1550 meant that after the *Shāhnāma* ("Book of kings"; dispersed, ex-Houghton priv. col.), made for Tahmasp, himself a painter, and justly termed "a portable art gallery" because all the most illustrious painters of the time contributed to it, and the copy of Jami's *Haft awrang* ("Seven thrones"; 1556–65; Washington, DC, Freer, 46.12), the day of the luxury royal book was effectively over. There developed in its stead the custom of artists producing single leaves of painting or drawing for eventual incorporation with pages of calligraphy and ornament into an album. This sea-change brought artists out of the court and into the public market, a process that accelerated the break with traditional anonymity and the rise of the artist as a personality (*see* Sadiqi, Riza and Siyavush) and fostered a new searching realism and emphasis on genre scenes. While many painters continued to exercise their skills in paintings of idealized youths and maidens whose high gloss recalls the pin-up, others experimented with book covers and "lacquerwork" (*see* lacquer) or (under European influence) with full-length oil paintings (*see* Oil painting, §I).

In the field of carpets the Safavids turned a cottage industry into a national one (*see* Carpets and flatweaves, §III, C). 'Abbas founded carpet factories at Isfahan and Kashan. The pair of Ardabil carpets (1539–40; London, V&A, and Los Angeles, CA, Co. Mus. A.; *see* Carpets and flatweaves, color pl.), with their sublime evocation of Paradise, and the Hunt Carpet (1522–3 or 1542–3; Milan, Mus. Poldi Pezzoli), all signed, mark the apogee of the art. Similarly, textile factories were established by royal command all over the realm, from Shirvan to Mashhad and Kirman, each with orders to "weave in its own manner" (*see* Textiles, §IV, C). Here also much of the production was for export, and such notable painters as Riza were co-opted to provide designs. Velvets, brocades and block-printed cottons were made in huge quantities. Safavid potters, especially at Mashhad and Kirman, developed new types of Chinese-inspired blue-and-white wares, due perhaps to the influence of the 300 Chinese potters and their families settled in Iran by 'Abbas. Other Safavid specialities included lusterware, celadon, polychrome tiles, the white pseudo-porcelain Gombroon wares and Kubachi pottery, with its engaging portrait busts in bright colors (*see* Ceramics, §V, B, 1). Safavid metalwork continues the traditions of Timurid Khurasan, and its main centers in Khurasan and Azerbaijan specialized in wares with a pronounced Sufi and Shi'ite character. Persian poetry—for example by Hafiz and Sa'di—and sometimes even Armenian texts ousted Arabic inscriptions, while new shapes include lampstands and ewers of Chinese inspiration (*see* Metalwork, §IV, C). Safavid arms and armor were distinguished for damascened swords and helmets of watered steel (*see* Arms and Armor, §II, B).

E. Galdieri and R. Orazi: *Progretto di sistemazione del Maydan-i Šāh* (Rome, 1969)

R. Orazi: *Wooden Gratings in Safavid Architecture* (Rome, 1976)

S. C. Welch: *Persian Painting: Five Royal Safavid Manuscripts of the 16th Century* (New York, 1976)

E. Galdieri: *Esfahân: 'Ali Qapu: An Architectural Survey* (Rome, 1979)

Wonders of the Age: Masterpieces of Early Safavid Painting, 1501–1576 (exh. cat. by S. C. Welch; London, BL; Washington, DC, N.G.A.; Cambridge, MA, Fogg; 1979–80)

R. Savory: *Iran under the Safavids* (Cambridge, 1980)

M. B. Dickson and S. C. Welch: *The Houghton Shahnameh* (Cambridge, MA, 1981)

P. Jackson, ed.: *The Timurid and Safavid Periods (1986),* vi of *The Cambridge History of Iran* (Cambridge and London, 1968–)

C. Bier, ed.: *Woven from the Soul, Spun from the Heart: Textile Arts of Safavid and Qajar Iran, 16th–19th Centuries* (Washington, DC, 1987)

J. Calmard, ed.: *Etudes safavies* (Paris and Tehran, 1993)

M. Farhad and M. S. Simpson: "Sources for the Study of Safavid Painting and Patronage, or Méfiez-vous de Qazi Ahmad," *Muqarnas,* x (1993), pp. 286–91

W. Kleiss: "Safavid Palaces," *A. Orient.,* xxiii (1993), pp. 269–280

C. Melville, ed.: *Safavid Persia: The History and Politics of an Islamic Society,* Pembroke Persian Papers, 4 (London, 1996)

A. Soudavar: "The Early Safavids and their Cultural Interactions with Surrounding States," *Iran and the Surrounding World: Interactions in Culture and Cultural Politics,* ed. N. R. Keddie and R. Mathee (Seattle, 2002), pp. 89–120

Hunt for Paradise: Court Arts of Safavid Iran 1501–1576 (exh. cat., ed. J. Thompson and S. R. Canby; New York, Asia Soc. Gals. and Milan, Mus. Poldi Pezzoli, 2002–3)

S. R. Canby, ed.: *Safavid Art and Architecture* (London, 2002)

Y. Crowe: *Persia and China: Safavid Blue and White Ceramics in the Victoria & Albert Museum 1501–1738* ([Great Britain], 2002)

A. J. Newman, ed.: *Society and Culture in the Early Modern Middle East: Studies on Iran in the Safavid Period* (Leiden, 2003)

S. Babaie and others: *Slaves of the Shah: New Elites of Safavid Iran* (London, 2004)

A. J. Newman: *Safavid Iran: Rebirth of a Persian Empire* (London, 2006)

II. Family members.

A. Tahmasp [Tahmāsp] I (*b.* 1514; *r.* 1524–76; *d.* Qazvin, 14 May 1576). Only ten years old when he came to the throne, Tahmasp was immediately put under the thumb of a Turkmen regent, and opposing Turkmen factions wrought havoc and civil war for nearly a decade until the Shah reasserted royal authority in 1533. During his 52-year reign, longer than any other Safavid, Tahmasp managed to stave off invasions from the Uzbeks to the east and Ottomans to the west. Between 1540 and 1553 he carried out four campaigns in the Caucasus, probably to train his troops and gain booty, and the large numbers of

Circassian and Armenian prisoners he brought back radically changed Safavid society, upsetting the old balance between Iranians and Turks.

A bigot and a miser, Tahmasp was not a great patron of architecture. He commissioned a large domed octagon, perhaps as his own tomb for the shrine of Shaykh Safi at ARDABIL. A magnificent pair of enormous matched carpets traditionally associated with the site (1539–40; London, V&A, and Los Angeles, CA, Co. Mus. A.) must have been royal commissions (*see* CARPETS AND FLATWEAVES, §IV, C and color pl. 1:XIV, fig. 1). Of the royal palace, mosque, baths, bazaar and maidan that he built in his capital QAZVIN, only a gatehouse and the small kiosk known as Chihil Sutun remain. Tahmasp himself reportedly painted murals there (destr.), as did MUZAFFAR 'ALI and SADIQI. These wall paintings reflect Tahmasp's interest in the arts of the book, for he had studied painting in Herat under BIHZAD from 1516 to 1522, then in Tabriz under SULTAN-MUHAMMAD, head of the library workshop there (*see* ILLUSTRATION, §VI, A, 2). While still a youth, the Shah copied a pocket sized manuscript of 'Arifi's *Gūy ū Chawgān* ("Ball and bandy"; 1524–5; St. Petersburg, Rus. N. Lib., Dorn 441) ornamented with fine illumination and 16 unsigned paintings. Other artists worked at Tabriz under his patronage: Muhammad al-Haravi signed another copy of 'Arifi's text in the same year (St. Petersburg, Acad. Sci. Inst. Orient. Stud., D. 184), and an undated copy of *Ahsān al-Kibār* ("History of the faithful imams"; St. Petersburg, Saltykov-Shchedrin Pub. Lib., Dorn 312) contains a painting signed by Qasim ibn 'Ali in 1525 and dedicated to the Shah.

At this time the Shah was mainly concerned with the largest of his manuscript commissions, one of the most sumptuous books ever produced in Iran, a magnificent copy of the *Shāhnāma* ("Book of kings"; dispersed, ex-Houghton priv. col.; *see* PAPER, color pl. 3:IV). The manuscript lacks a colophon but opens with an illuminated dedication to Tahmasp, and a painting on fol. 60*v* is dated 1527. Its 759 folios were illustrated by 258 full-page miniatures by the leading artists of the day, of whom Welch and Dickson identified nine major painters and five assistants. Tahmasp's next major commission was a copy of Nizami's *Khamsa* ("Five poems"; 1539–43; London, BL, Or. 2265) calligraphed by Shah Mahmud Nishapuri and adorned with paintings attributed to such artists as MIR MUSAVVIR, AQA MIRAK, Sultan-Muhammad and MIR SAYYID 'ALI. Tahmasp himself continued to paint, and his portrait of his brother Bahram Mirza (1517–49) is preserved in the album that the librarian DUST MUHAMMAD prepared for the prince in 1544 (Istanbul, Topkapı Pal. Lib., H 2154). In 1556 Tahmasp moved his capital from Tabriz to Qazvin and soon thereafter his interest in painting waned, and his nephew Ibrahim Mirza at Mashhad became the leading patron of the arts of the book.

Enc. Islam/2

I. Stchoukine: *Les Peintures des manuscrits Safavis de 1502 à 1587* (Paris, 1959)

S. C. Welch: *A King's Book of Kings* (New York, 1972)

A. H. Morton: "The Ardabil Shrine in the Reign of Tahmasp I," *Iran*, xii (1974), pp. 31–64; xiii (1975), pp. 39–58

Wonders of the Age: Masterpieces of Early Safavid Painting, 1501–1576 (exh. cat. by S. C. Welch; London, BL; Washington, DC, N.G.A.; Cambridge, MA, Fogg; 1979–80)

E. Echraghi: "Description contemporaine des peintures murales disparues des palais de Šāh Tahmāsp à Qazvin," *Art et société dans le monde iranien*, ed. C. Adle (Paris, 1982), pp. 117–26

S. C. Welch and M. Dickson: *The Houghton Shahnameh*, 2 vols. (Cambridge, MA, 1983)

R. Hillenbrand: "The Iconography of the Shāh-Nāma-yi Shāhī," *Safavid Persia: The History and Politics of an Islamic Society*, ed. C. Melville, Pembroke Papers, 4 (London, 1996), pp. 53–78

Hunt for Paradise: Court Arts of Safavid Iran 1501–1576 (exh. cat. ed. J. Thompson and S. R. Canby; New York, Asia Soc. Gals. and Milan, Mus. Poldi Pezzoli, 2002–3)

S. S. Blair: "The Ardabil Carpets in Context," *Society and Culture in the Early Modern Middle East: Studies on Iran in the Safavid Period*, ed. A. J. Newman (Leiden, 2003), p. 125–43

B. 'ABBAS I ['Abbās] (*b.* 27 Jan. 1571; *r.* 1588–1629; *d.* Mazandaran, 19 Jan. 1629). Grandson of (A) Tahmasp. On ascending the throne, 'Abbas was immediately assailed by internal and external threats to his authority. To overcome resurgent Turkmen factionalism, he recruited the new third force that his grandfather Tahmasp had introduced—Circassian, Georgian and Armenian slaves (Pers. *ghulām*). To pay for the new standing army he reorganized the fiscal administration, converting state lands under Turkmen governors into crown provinces, the revenues of which were collected by the Shah's bailiffs. Establishing internal security allowed him to turn to his outside enemies: in 1598 he moved against the Uzbeks, recapturing Herat and stabilizing the northeast frontier, and in 1602 he took on the Ottomans, expelling them from Iranian territory and concluding an advantageous peace treaty in 1618.

'Abbas's reign marks the cultural florescence of Iran under the Safavids. Much of his patronage involved his reorganization of state administration. He made the manufacture and sale of silk a state monopoly and established royal workshops for textiles and carpets in such cities as Kashan, Kirman, Isfahan, Mashhad, Astarabad and Tabriz (*see* TEXTILES, §IV, C). To improve communication and trade, he had caravanserais and bridges built through his empire (*see* ARCHITECTURE, §VII, B, 1). A mixture of political, economic, pious and personal motives probably engendered his restorations to major shrines at Mashhad, Ardabil, Qum, Mahan and Turbat-i Jam. The most lavish were his numerous additions to the shrine of Imam Riza at Mashhad, especially the 200 m esplanade that traversed the north end of the shrine through the Old Court and its associated iwans and chambers, such as the dome chamber of his general Allahvardi Khan. At ARDABIL he had the hall for Koran reciters (Arab. *dār al-huffāz*) redecorated in 1627–8 and the Porcelain Room (Pers. *chīnī khāna*) prepared to receive his fine collection, which he deposited there between 1607 and 1611.

His greatest architectural project was the new capital at ISFAHAN in place of Qazvin, established in the spring of 1598 just before he launched his campaign against the Uzbeks. To the south of the old Saljuq maidan and Friday mosque and connected by a long bazaar, 'Abbas ordered a new 8 ha maidan with the bazaar portal on the north. A small oratory, the mosque of Shaykh Lutfallah, was erected on the east (*see* ARCHITECTURE, color pl.), and a new Friday mosque, the Shah Mosque, was built on the south (*see* ISFAHAN, fig. 3). On the west, the 'Ali Qapu ("Sublime Porte") served as a royal viewing stand and gave access to a large palace and garden precinct, which stretched as far as the Chahar Bagh, a royal esplanade running 4 km north–south to the Allahvardi Bridge (1602) over the Zaindeh River to New Julfa, where 'Abbas had settled his Armenian workers.

The art of book painting flourished under 'Abbas's patronage (*see* ILLUSTRATION, §VI, A, 5). SADIQI served as head of the royal workshop in Qazvin, which continued to produce manuscripts in the grand imperial tradition, such as a copy of the *Shāhnāma* ("Book of kings"; Dublin, Chester Beatty Lib., Pers. MS. 277), of which only 12 large paintings survive. 'Abbas had another copy of the *Shāhnāma* transcribed at Isfahan in 1614 (New York, Pub. Lib., Spencer col. MS. 2), but its 44 paintings are modern works in an archaizing style typical of the great *Shāhnāma* (Tehran, Gulistan Pal. Lib.) made for the Timurid prince Baysunghur at Herat in 1430. Four paintings by Habiballah, an illuminated frontispiece by Zayn al-'Abidin and a tooled and gilded binding were added to the splendid 15th-century copy of Farid al-Din 'Attar's *Mantiq al-Tayr* ("Conference of the birds"; New York, Met., 63.210), which the Shah endowed in 1609 to the shrine of Shaykh Safi at Ardabil. Nevertheless, the manuscript tradition was on the wane as single-page paintings and drawings became more popular. The Shah commissioned album paintings from RIZA, who became the leading painter of the reign. His calligraphic style of drawing and numerous figure subjects, not only pretty youths and girls but also old dervishes (e.g. Washington, DC, Freer, 53.17), agreed with the Shah's taste in popular culture.

Enc. Iran.; Enc. Islam/2

Iskandar Munshī (1629): *Tārīkh-i 'ālamārā-yi 'Abbāsī* [History of the world-conquering 'Abbas], Eng. trans. by R. Savory as *History of Shah 'Abbas the Great* (Boulder, 1978)
I. Stchoukine: *Les Peintures des manuscrits de Shah 'Abbas Ier à la fin des Safavis* (Paris, 1964)
E. Galdieri: "Two Building Phases of the Time of Sāh 'Abbas I in the Maydān-i Sāh of Isfahan: Preliminary Note," *E. & W.*, n. s., xx (1970), pp. 60–69 *Shah 'Abbas and the Arts of Isfahan* (exh. cat. by A. Welch; New York, Asia Soc. Gals.; Cambridge, MA, Fogg; 1973–4)
Iran. Stud., vii (1974) [whole issue]
A. Welch: *Artists for the Shah* (New Haven, 1976)
R. D. McChesney: "Four Sources on Shah 'Abbas's Building of Isfahan," *Muqarnas*, v (1988), pp. 103–34; and "Postscript," *Muqarnas*, viii (1991), pp. 137–8
B. Schmitz: *Islamic Manuscripts in the New York Public Library* (New York and Oxford, 1992), pp. 105–10
E. J. Grube and E. Sims: "The Representations of Shāh 'Abbās I," *L'Arco Di Fango Che Rubò La Luce Alle Stelle: Studi in Onore Di Eugenio Galdieri Peril Suo Settantesimo Compleanno*, ed. M. Bernardini and others (Lugano, 1995), pp. 177–208
K. Rizvi: "The Imperial Setting: Shah 'Abbās at the Safavid Shrine of Shaykh Safi in Ardabil," *Safavid Art and Architecture*, ed. S. R. Canby (London, 2002), pp. 9–15
S. P. Blake: "Shah 'Abbās and the Transfer of the Safavid Capital from Qazvin to Isfahan," *Society and Culture in the Early Modern Middle East: Studies on Iran in the Safavid Period*, ed. A. J. Newman (Leiden, 2003), pp. 145–64
J. Golmohammadi: "The Cenotaph in Imāmzāda Ḥabīb b. Mūsā, Kashan: Does it Mark the Grave of Shāh 'Abbās I?," *Sifting Sands, Reading Signs. Studies in Honour of Professor Géza Fehérvári*, ed. B. Brend and P. L. Baker (London, 2006), pp. 61–9

Ṣahkulu. *See* SHAHQULI.

Said, Issam (Sabah) el- [Sa'id, 'Isam Sabah al-] (*b.* Baghdad, 7 Sept. 1938; *d.* London, 26 Dec. 1988). Iraqi architect, painter and designer. The grandson of the Iraqi prime minister Nuri el-Said (*d.* 1958), he studied architecture in England at Corpus Christi College, Cambridge (1958–61), and attended Hammersmith College of Art and Design, London (1962–4). From the early 1960s he incorporated sentences and words in kufic and other scripts into his paintings. He designed the interior of the Central Mosque and the Islamic Cultural Center in London (1976–7), and he was consultant to PPA Ltd. of Canada for the Abdul Aziz University master plan in Jiddah (1977–8) and to TYPSA Ltd. of Spain for the Imam Saud Islamic University master plan in Riyadh (1978–9). In Baghdad he designed the Aloussi Mosque (1982–8) and al-Aboud Mosque (1984). In addition to his paintings in oil and watercolor he worked with such materials as paleocrystal (a transparent material made of polyester resin) and enamel on aluminum. His *Geometric Multiples* (enamel on aluminum, 1979; Amman, N.G. F.A.) is made of 16 magnetic squares, each with an identical calligraphic and geometric design, which can be arranged in various combinations. He also designed carpets and furniture. At the time of his death he was working on a doctoral thesis entitled *The Methodology of Geometric Proportioning in Islamic Architecture* at Newcastle University.

WRITINGS

with A. Parman: *Geometric Concepts in Islamic Art* (London, 1976)
T. el-Bouri and K. Critchlow, eds.: *Islamic Art and Architecture: The System of Geometric Design* (Reading, 1993) [extracts from Issam el-Said's doctoral thesis]

BIBLIOGRAPHY

Issam el-Said website, http://issam-el-said.co.uk (accessed June 11, 2008)
E. el-Said and others: *Issam el-Said: Artist and Scholar* (London, 1989)
W. Ali: *Modern Islamic Art: Development and Continuity* (Gainesville, FL, 1997), pp. 179–82

Said, Shaker Hassan al- [Saʿīd, Shākir Ḥasan al-]. (*b.* Samawa, 1925; *d.* 2004). Iraqi painter and writer. Said graduated in 1948 from the Higher Institute of Teachers, Baghdad, where he studied social sciences, and in 1954 from the Institute of Fine Arts in Baghdad, where he was taught by Jawad Salim, with whom he founded the "Baghdad Modern Art" group. In 1955 he was sent on a government scholarship to Paris, where he attended the Académie Julian, the Ecole des Arts Décoratifs and also trained as a special student under Raymond Legueult (1898–1978). In 1959 he returned to Baghdad and was inspired by Arab painting of the 13th century, notably the work of al-Wasiti (*see* ILLUSTRATION, §IV, C); he also read the works of the mystic philosopher al-Hallaj (*d.* 922) and was drawn to Sufism. He gave up figural depiction in his paintings and turned to Arabic calligraphy, the spiritual and physical qualities of the letters becoming the central subject of his compositions. In 1971 he formed the "One-dimension" group in Baghdad, which promoted the modern calligraphic school in Arab art, and in the same year the group held its only exhibition. His preoccupation with the spiritual element in art continued in his later work (e.g. *Objective Contemplations*, oil on wood, 1984; Paris, Inst. Monde Arab.).

WRITINGS

Fuṣūl min tārīkh al-ḥaraka al-tashkīliyya fiʾl-ʿIrāq [Chapters from the history of modern art in Iraq] (Baghdad, 1983)

Al-Uṣūl al-ḥaḍārīyah wa-al-jamālīyah li'l-khaṭṭ al-ʿArabī [Cultural and aesthetic principles in Arabic script] (Baghdad, 1988)

al-Ḥurrīyah fī al-fann wa-dirāsāt ukhrā [Freedom in art and other studies] (Beirut, 1994)

Maqālāt fī al-tanẓīr wa-al-naqd al-fannī [Essays on artistic comparison and criticism] (Baghdad, 1994)

Ḥiwār al-fann al-tashkīl li [Conversation on the art of creation] (Amman, 1995)

BIBLIOGRAPHY

Croisement des signes (exh. cat. Paris, Inst. Monde Arab., 1989)

W. Ali: *Modern Islamic Art: Development and Continuity* (Gainesville, FL, 1997), pp. 48, 168–9

Word into Art (exh. cat. by V. Porter; London, BM, 2006), no. 41 and p. 139

Sajjad, Shahid (*b.* Muzaffarnagar, India, 1937). Pakistani sculptor. The most prominent sculptor in Pakistan in the late 20th century, Sajjad pioneered the art form and gave it credibility. He had neither tradition to follow nor models to emulate since Pakistan, created in 1947 as a Muslim country, did not encourage three-dimensional art. At a young age Sajjad became interested in calligraphy and soon mastered the skill. He practiced drawing and carefully observed signboard painters at work. He became a successful commercial artist, dabbling in film making and painting. A restless soul, he spent three years traveling in Europe and Asia on a motorcycle. Sajjad was particularly fascinated by the wood-carvings of Bali, the Philippines and Japan, and by reliefs in wood by Paul Gauguin (1848–1903) in the Musée du Louvre, Paris.

Sajjad took up sculpture in 1963. Thereafter his development fell into three phases. In the first phase his work was two-dimensional, consisting of figurative wood reliefs, often painted. In the second phase, especially from 1968 to 1970 while living in the Chittagong Hill Tracts, a remote forest area in what is now Bangladesh, Sajjad carved figures in the round from tree trunks. In the third phase (1973), after a trip to China and Japan, he added bronze to his repertory.

Sajjad's imagery has always been figurative. The cast bronze images of his third phase—twisting, struggling, abstract human forms—contrast markedly with the serene and primitive images of the previous phase. The influence of the sculptor Auguste Rodin (1840–1917) is apparent. A confirmation of Sajjad's prominence, and a breakthrough for the official recognition of sculpture in Pakistan, was the 1981 commission by the Armoured Corps Centre Mess, Nowshera, a large bronze relief completed in 1984. Other work in wood and smaller bronze sculptures are in private collections in Karachi and Lahore. His work continues to attract. a retrospective exhibition of 68 sculptures and prints was held at the National College of Arts, Lahore in 2007.

See also PAKISTAN, §IV.

F. Mirandale: "Expressionism in Sculpture," *Art* (n.d.), pp. 10–11

A. Naqvi: "Images in Wood and Bronze," *Focus Pakistan*, iv/1 (1977), pp. 23–5

H. Zaman: "Contours of a New Sensibility," *A. & Islam. World*, iv/2 (1986), pp. 66–9

G. Minissale and F. Pastakia: "There Is No Such Thing as Pakistani Art," *The Herald* (Nov.–Dec. 1990), pp. 104–11

A. Naqvi: *Image and Identity: Painting and Sculpture in Pakistan 1947–1997* (Karachi, 1998)

P. Mittar: *Indian Art,* Oxford History of Art (Oxford, 2001)

A. Naqvi: *Shahid Sajjad's Sculptures: Collected Essays* (Lahore, 2007)

Salahi, Ibrahim el- [Ṣalaḥī, Ibrāhīm al-] (*b.* Omdurman, 1930). Sudanese painter. After studying at the School of Design at Gordon Memorial College in Khartoum (1948–51), he worked as an art teacher at Wadi Seidna Secondary School near Omdurman. In 1954 he was sent on a scholarship to the Slade School of Fine Art in London, and while in Europe he visited Florence to enhance his knowledge of Renaissance art. In 1957 he returned to Sudan and became head of the Painting Department at the College of Fine and Applied Art in Khartoum. In 1962 he was sent by UNESCO on a tour to the USA, South America, Paris and London. After returning to Sudan, he searched for a Sudanese artistic identity by traveling throughout the country recording local architecture and designs used in the decoration of such items as utensils and prayer rugs. He also explored Coptic manuscripts, trying to discover the arts of African Sudan through them. During this same period he became fascinated by the ingenuity of Islamic art. His previous knowledge of Coptic manuscripts led him to experiment with Arabic calligraphy, which he saw

as both a means of communication and a pure aesthetic form. In the 1950s he was one of the first Arab artists to include Arabic calligraphy and signs in his paintings. After political imprisonment in his country he lived in exile in England and Qatar, where he was an adviser on communications to the Emir. Working in all media, he defined his Arab–African heritage by synthesizing Arabic calligraphy with African forms. His work is in collections in New York (Met.; MOMA), Melbourne (N.G. Victoria), Newcastle, NSW (Reg. A.G.) and Berlin (Neue N.G.).

WRITINGS

Drawings (Evanston, IL, 1962)
Ibrahim el Salahi: *Identity and Exile: Conversation with Ulli Beier* ([Bayreuth], 1990)
with N. Aas: *Painting in Shades of Blackness: Ibrahim Salahi* (Bayreuth, 1991)

BIBLIOGRAPHY

Ibrahim el-Salahi: Images in Black and White (exh. cat., London, Savannah Gal. Mod. Afr. A., 1992)
W. Ali: *Modern Islamic Art: Development and Continuity* (Gainesville, FL, 1997)

Salim, Jawad (*b.* Ankara, 1920; *d.* Baghdad, 22 Jan. 1961). Iraqi sculptor and painter. He came from a family of painters, including his father Hajj Muhammad Salim al-Mosuli, his brother Nizar Salim, and his sister Naziha Salim. After a short period on government scholarships in Paris from 1938 to 1939 and in Rome from 1939 to 1940, he worked during World War II at the Archaeological Museum in Baghdad, where he became acquainted with Mesopotamian sculpture. From 1946 to 1949 he studied in London at the Slade School of Fine Art. He experimented with modern art and was inspired by ancient Iraqi culture, drawing on local forms, symbols and folklore. On returning to Iraq, he directed and taught at the sculpture department of the Institute of Fine Arts, Baghdad, until his death. In 1951 he founded the Baghdad Group of Modern Art; this group became concerned with establishing the identity of an Iraqi artistic tradition. After Iraq was declared a republic in 1958, he was commissioned to make the *Monument of Liberty*, located at the intersection of six major roads at the entrance of the National Park in the center of Baghdad, and one of the largest modern sculptures in the Arab world. It is a frieze 50 m long and 8 m high, consisting of a number of groups of figures in low-relief bronze on travertine. Besides his sculptures and paintings he also worked on designs for book covers and for metalwork.

J. I. Jabra: *Iraqi Art Today* (Baghdad, 1972) [Eng. and Arab. texts]
J. Hamudi: *Dalīl al-fannānīn al-ʾirāqiyyīn* [A catalogue of Iraqi artists] (Baghdad, 1973) [Arab. text]
J. I. Jabra: *Jawād Salīm wa nasab al-hurriyya* [Jawad Salim and the Monument of Liberty] (Baghdad, 1974) [Arab. text]
J. I. Jabra: "An Artist of his Country," *Ur* (1981), pp. 82–5 [special issue on Iraqi art]
B. al-Haidari: "Jawad Salim and Faiq Hassan and the Birth of Modern Art in Iraq," *Ur*, iv (1985), pp. 10–20
W. Ali, ed.: *Contemporary Art from the Islamic World* (London, 1989), pp. 159–65
S. al-Khalil: *The Monument: Art, Vulgarity and Responsibility in Iraq* (London, 1991), pp. 78–95
W. Ali: *Modern Islamic Art: Development and Continuity* (Gainesville, 1997), pp. 47–52, 145–6, 158, 186, 190–91, 206
U. al-Khamis: "Lorna Selim Remembers," *Strokes of Genius: Contemporary Iraqi Art*, ed. M. Faraj (London, 2001), pp. 41–6

Saljuq [Seljuk; Selçuk]. Turkish Islamic dynasty with branches that ruled in Iran, Iraq and Syria from 1038 to 1194 and in Anatolia from 1077 to 1307.

I. Great Saljuqs. II. Saljuqs of Anatolia.

I. Great Saljuqs. Arab dominion of the eastern Islamic world came to an end in 945 when the caliphs were forced to surrender their temporal authority to their army commanders, who belonged to the Persian BUYID family. Henceforth the caliphs preserved only the forms and not the substance of power. For the next century political control of this huge area passed to various dynasties, principally of Persian origin, among which the Buyid family was pre-eminent. One dynasty alone broke this mold: the GHAZNAVIDS, who controlled Afghanistan, much of the Punjab and parts of eastern Iran. They had begun as Turkish military slaves but had assimilated Perso-Islamic ways. This Turkish hegemony became definitive under the Saljuqs, who dispossessed the Ghaznavids and Buyids alike, took over Baghdad in 1055 and thereafter began a fundamental reshaping of the body politic. For the first time since the 7th century, nomads ruled the Middle East—for the Saljuq Turks expanded westward toward the shores of the Mediterranean, controlling Anatolia, Iraq and parts of Syria as well as the Iranian world. From obscure pagan beginnings in their Central Asian homeland on the fringes of the Islamic world, they rose in three generations to become the greatest contemporary Muslim power. No contemporary written Turkish sources describe this process, which can therefore be studied only through the medium of much later historians whose perception of events is essentially Muslim. It is clear, however, that in their rise to power the Saljuqs had preserved intact their ethnic and tribal identity, and with it their military strength. Henceforth many traditions of steppe society infiltrated the Muslim world. Among these was the principle of clan ownership, with no clearly defined hereditary succession. Territory was often partitioned among a ruler's male relations—an extreme example is the Anatolian Saljuq sultan Qilij Arslan, who divided his lands among his 11 sons. Another custom decreed the appointment of a guardian or atabeg for a prince in his minority, and such atabegs often supplanted the lawful ruler. Turkish traditions such as these clashed with Muslim norms and destabilized Islamic society.

Yet this Turkish element was counterbalanced by more ancient ones. Guides to good government ("Mirrors for princes") were written for the Saljuq rulers, in which the Sasanian tradition of the divine right of kings was modified by the principle that the monarch must obey the law as defined by Muslim jurists. Like the Ghaznavids, the Saljuqs acknowledged the caliph's sphere of influence and generally operated within the existing political framework, for example by having their names mentioned alongside the caliph's in the Friday sermon at Baghdad and on the coins. Even their regnal titles stressed the Arabic word *dīn* ("religion"). These various strands were symbolized in the name of the greatest Saljuq ruler, Sultan Malikshah (*r.* 1072–92), which blends the royal titles of Arab, Persian and Turk. Saljuq administration struck a similar balance between Turkish and Islamic ways. A tripartite system developed in which the Turkish military aristocracy was supported by Persian high officials and a Persian or Arab religious class. Moreover, the Saljuqs consolidated the revival of orthodoxy, which had begun in Baghdad as a politico-religious response to the Shi'ism of the Buyids. Through their high officials, the Saljuqs gained vigorous impetus to the building of madrasas—colleges where the orthodox Islamic sciences were taught and the administrators of the regime trained. They favored Sufism—indeed some of the sultans and their officials adopted such notable Sufis as Jalal al-Din Rumi (1207–73) as their private mentors and encouraged the movement to become part of official orthodox Islam, with organized fraternities. It was under the Saljuqs that the pivotal figure of al-Ghazali (1058–1111), the leading Muslim intellectual and theologian of the Middle Ages, formulated his synthesis of Sufism and Sunnism, thereby introducing a moderate mystical element into orthodoxy. The Saljuqs also took vigorous measures against the extreme Shi'a. The greatest of Saljuq viziers, Nizam al-Mulk, in his work *The Book of Government* (*Siyāsatnāma*), advised his master the sultan not to employ them, and they were cursed from the pulpits. Shi'i mosques, madrasas and libraries were pillaged. This repression was in part prompted by a powerful resurgence of the extreme branch of the Shi'a, the Isma'ilis, who terrorized the Saljuq State by the weapon of assassination—indeed, they are better known in the West as the Assassins.

Yet the apogee of the Saljuq State was short-lived. A corrupt system of tax farming led to a loss of central control as the military class gained power at the expense of the State. Indeed, after the death of Sultan Muhammad in 1118, the Saljuq Empire split; the long reign of Sanjar (*d.* 1157) ensured stability in the east, but the western territories were riven with discord. By degrees landed property became so devalued that the entire landowning class, the *dihqans*, who had survived nearly five centuries of Islamic rule in Iran, were wiped out by the early 13th century. The bureaucracy was top-heavy; offices were bought and sold, nepotism flourished (the 12 sons of Nizam al-Mulk were honored as if they were religious leaders)

and officials shared the fate of their disgraced masters. The fissiparous system of family and clan ownership, the institution of the atabeg and the uncertain succession all combined to create periodic crises in the ruling house. At a lower level, the nomadic element in Saljuq society was profoundly destructive. The Turkmen were resentful of the Persianization of their chiefs; their prime aim was plunder and they resisted settlement. New waves of nomads, notably the Ghuzz tribe, which in the 1150s captured Sultan Sanjar himself and his consort, created further havoc. The last Saljuq sultans followed each other in quick succession and ruled steadily diminishing territories until Tughril III (*r.* 1176–94), the last of the line, was killed in battle.

While remarkably little in the way of the visual arts has survived from pre-Saljuq Iran, under the Saljuqs the situation is dramatically reversed, and for the first time in Islamic Iran the flavor of a period can be captured adequately by studying a mass of its artifacts. An unprecedented expansion in the forms, techniques and ideas of the visual arts occurred.

The heritage of the Saljuqs—political, religious and cultural—can scarcely be exaggerated and is highlighted by the contrast between the pre-Saljuq and the post-Saljuq periods. In the 10th and 11th centuries minor Persian and Arab dynasties had flourished throughout eastern Islam at the expense of the enfeebled caliphate. The unity of the faith had disintegrated, although Arabic was still the predominant language. By the late 12th century the situation had changed decisively: orthodox Islam was now much stronger, having absorbed some heterodoxies and defeated others. This was principally due to the Turkish dynasties of the Ghaznavids and the Saljuqs. The caliph had regained his theoretical power by allying himself with the sultan and was about to recover actual political strength too. The Turks now dominated the Middle East; some of the territories that they now controlled, such as Anatolia, northwest Iran and Central Asia, have remained Turkish-speaking ever since. Theirs was in some senses a disruptive influence; they represented a pastoral economy immemorially opposed to architecture. One contemporary historian remarked wryly that tax farming was the only way to interest Turks in agriculture. They constituted a recurrent political threat because certain tribes could flout the authority of the sultan. Plunder was the only aim of many of the tribesmen, and this could not always be channeled into holy war. But the Saljuq leaders quickly adapted themselves to the Persian way of life. Under their aegis Persian became widespread throughout the empire, and Iran itself became an artistic center of the first importance, enjoying a role comparable to that of Italy in late medieval Europe. Above all the center of gravity in the Islamic world had shifted from the Arab territories to Anatolia and Iran. The traditional centers of Islamic power in the Middle East, Damascus and Baghdad, had now to some extent been supplanted by such Saljuq capitals as Merv, Nishapur, Rayy and Isfahan—every one of them in the Iranian

world. This dominance of eastern Islam, together with the rule of the Shi'i Fatimids in Egypt and sometimes Syria, made final that break between the eastern and western parts of the Islamic Near East that has endured virtually ever since.

The area within which Saljuq art flourished is often loosely taken to be that of modern Iran, but more of it was outside these political boundaries than within them. Modern scholarship has not progressed far enough to identify the various local schools inside the Iranian world with confidence, though it is clear that the arts of Syria and Anatolia had their own distinctive character. Similarly the chronology of Saljuq art is hard to correlate with political events. The rhythms of stylistic development are not those of dynasties. Typically Saljuq work is found in the early 11th century as in the early 13th, and thus outside the timespan of Saljuq political power. Most Saljuq art in fact dates from the period of Saljuq decline, and extremely similar work in various fields, but notably architecture, was practiced under the Ghaznavids, GHURIDS, Qarakhanids and Khwarazmshahs, all dynasties that co-existed with or succeeded the Saljuqs proper.

J. Boyle, ed.: *The Saljuq and Mongol Periods* (1968), v of *The Cambridge History of Iran* (Cambridge, 1968–91)

R. Ettinghausen: "The Flowering of Saljuq Art," *Met. Mus. J.*, iii (1970), pp. 113–31

J. Sourdel-Thomine: "La Mosquée et la madrasa," *Cah. Civilis. Méd.*, xiii (1970), pp. 97–115

J. Raby, ed.: *The Art of Syria and the Jazira, 1100–1250* (Oxford, 1985)

S. S. Blair: *The Monumental Inscriptions of Early Islamic Iran and Transoxiana* (Leiden, 1992)

R. Hillenbrand, ed.: *The Art of the Saljūqs in Iran and Anatolia, Proceedings of a Symposium held in Edinburgh in 1982* (Costa Mesa, CA, 1994)

M. Hattstein and P. Delius, eds.: *Islam: Art and Architecture* (Cologne, 2000)

Y. Tabbaa: *The Transformation of Islamic Art during the Sunni Revival* (Seattle, 2001)

Turks: A Journey of a Thousand Years 600–1600 (exh. cat. ed. D. J. Roxburgh; London, RA, 2005)

II. Saljuqs of Anatolia [Selçuks of Rum]. The founder of the dynasty, Sulayman ibn Qutalmish (*r.* 1077–86), was a distant cousin of the Saljuq sultan Alp Arslan (*r.* 1063–72), who entered Anatolia with groups of nomadic Turkmen in the wake of the Saljuq victory at the Battle of Manzikert (now Malazgirt) in 1071. Although Sulayman was able to penetrate deeply into Byzantine territory, seizing Nicaea (later Iznik) in 1081, his real territorial aspirations lay further east, and in 1086, having taken Cilicia and Antioch, he was killed while attacking Aleppo. His son Kiliç Arslan I (*r.* 1086–1107) tried to create a more extensive power base for himself; despite advantageous alliances, he too was unable to hold western Anatolian territory against the rising Komnenian dynasty (*r.* 1081–1185), and the Byzantines retook Nicaea. Kiliç Arslan's successors

concentrated their power in central Anatolia with their capital at KONYA, whence they threatened the rival Turkmen Danishmendids (*r. c.* 1071–1177), the Armenian rulers of Cilicia and the crusaders at Edessa (Urfa). Kiliç Arslan II (*r.* 1156–92) forced the Danishmendids to submit and won a great victory over the Byzantine emperor Manuel I (*r.* 1143–80) at Myriocephalon (now Çardak) in the Phrygian passes in 1176, an event that ended Byzantine hopes of recovery in the east. In his later years Kiliç Arslan's territories were divided among his sons, seriously delaying political unification.

The Latin conquest of Constantinople (1204) allowed the Saljuqs of Anatolia to re-establish their power and indeed to reach their political zenith (1204–37), thus preventing the crusaders in the Levant from finding an outlet northwards in the 13th century. The Saljuqs seized Antalya and Sinop and built a new Mediterranean port (*c.* 1225) at Alanya. Saljuq territory was an important transit stage for the slave trade from southern Russia, which provided the manpower for the armies of the Mamluks of Egypt and Syria (*see* MAMLUK), the eventual conquerors of the crusaders. Commercial relations were also established with the Italian maritime republics. With the crushing defeat of the Saljuqs by the Mongols at Kös Daği (1243), Anatolia became a Mongol protectorate, eventually breaking up into independent emirates (*see* BEYLIK), among which the OTTOMAN rulers were to emerge supreme.

As with many successors to the Great Saljuqs, the Saljuqs of Anatolia modeled themselves closely on Perso-Islamic traditions, whence they drew their political, religious and cultural heritage. Located on the very periphery of the Islamic world and perennially aware of the proximity of Christian states (Byzantium, Armenian Cilicia and the Crusader kingdoms), the Saljuqs of Anatolia formed a staunchly Sunni marcher state, which survived considerably longer than its more famous namesake further east. The Saljuqs of Anatolia did not abandon the traditional Turkmen concept of power, and their history was punctuated by periods of internal weakness caused by the division of land among the sultan's sons (e.g. in 1192 after the death of Kiliç Arslan II). There was undoubtedly considerable tension between the aspirations of the nomads who constituted the major military strength of the dynasty (especially their mounted archers) and those of the Perso-Islamic urban élite, which emerged in the Anatolian cities and with which the Saljuq sultans became closely identified.

The distinctive character of Anatolian Saljuq art owes much to the geographical compactness of the state and to the strong Christian presence in the land. The artistic heritages of Iran, Syria and the Jazira were also strong. Royal and official patronage was dispensed on a lavish scale by the sultan himself, queens and princesses, viziers, doctors and numerous emirs. Scores of theological colleges (*see* MADRASA), the largest number to survive in any single part of the medieval Muslim world, and some 100 caravanserais (*see* CARAVANSERAI), which underpinned the

slave trade and fostered commercial links with Iran, Mesopotamia and Syria, testify to the strong control exercised by the central authorities (*see* ARCHITECTURE, §V, C). Numerous mausolea survive, often of the Iranian tomb tower type, both free-standing and attached to pious foundations. This architecture was usually executed in high-quality stonework, richly ornamented with geometric patterns and floral motifs and—a rarity in medieval Islamic art—figural sculpture (*see* ARCHITECTURE, §X, A, 2). The signatures of many Iranian craftsmen account for the frequent appearance of brick buildings embellished with glazed tilework, a field that developed faster in Anatolia than in Iran (*see* ARCHITECTURE, §X, B, 2). Excavations at Kubadabad, Kaykubadiye and Konya have revealed Saljuq palaces with lavish displays of luster and enameled tiles with a varied figural iconography including courtly, mythical, astrological and animal themes. Saljuq woodwork (notably mihrabs, minbars and Koran stands) constitutes the fullest body of such work in the contemporary Islamic world (*see* WOODWORK, §II, C). A group of early carpets found in the mosques of Konya, Beyşehir and Divriği are often associated with the Saljuqs, although they may more probably date to the early 14th century (*see* CARPETS AND FLATWEAVES, §II). Saljuq metalwork (*see* METALWORK, §III, A, 1) and the arts of the book (*see* ILLUSTRATION, §V, F), however, were very much in the shadow of Iranian and Mesopotamian traditions. In addition, scattered throughout Anatolian Saljuq art are persistent visual evocations of the nomadic arts of the Eurasian steppe, with an accompanying undertow of magical and shamanistic beliefs that owed nothing to Islam.

T. T. Rice: *The Seljuks in Asia Minor* (London, 1961)

K. Erdmann: *Ibn Bibi als kunsthistorische Quelle* (Istanbul, 1962)

C. Cahen: *Pre-Ottoman Turkey* (London, 1968); Fr. trans. as *La Turquie pré-ottomane* (Istanbul and Paris, 1988)

K. Otto-Dorn: *L'Art de l'Islam* (Paris, 1968), pp. 154–82

C. Cahen: "The Turks in Iran and Anatolia before the Mongol Invasions," *The Later Crusades, 1189–1311*, ii of *A History of the Crusades*, ed. K. M. Setton, R. L. Wolff and H. W. Hazard (Madison, Milwaukee and London, 1969–89), ii, pp. 661–92

O. Aslanapa: *Turkish Art and Architecture* (New York, 1971)

M. Sozen: *Anadolu medreseleri: Selcuklu ve beylikler devri* [Anatolian madrasas: the Saljuq and Beylik periods], 2 vols. (Istanbul, 1972)

M. Meinecke: "Fayencedekorationen seldschukischer Sakralbauten in Kleinasien," *Istanbul Mitt.* (1976) [suppl. 13]

The Art of the Saljūqs in Iran and Anatolia, Proceedings of a Symposium held in Edinburgh in 1982 S. Redford: "The Seljuqs of Rum and the Antique," *Muqarnas*, xi (1994), pp. 31–4

M. Hattstein and P. Delius, eds.: *Islam: Art and Architecture* (Cologne, 2000)

S. Redford, T. P. Beach and S. Luzzadder-Beach: *Landscape and the State in Medieval Anatolia: Seljuk Gardens and Pavilions of Alanya, Turkey* (Oxford, 2000)

Turks: A Journey of a Thousand Years 600–1600 (exh. cat. ed. D. J. Roxburgh; London, RA, 2005)

Samanid. Islamic dynasty that ruled in northeastern Iran and western Central Asia from 819 to 1005. The dynasty takes its name from Saman, a converted Zoroastrian noble from Balkh, whose four grandsons served the Abbasid caliph al-Ma'mun (*r.* 813–33) and were rewarded *c.* 819 with governorships in Transoxiana. By 875 they controlled the entire province. Isma'il ibn Ahmad (*r.* 892–907) was the most astute and successful of these rulers—at his death his empire extended from the borders of India to near Baghdad—but he continued to acknowledge caliphal suzerainty. His successors, also staunch Sunnis, who were weakened by constant rebellions and the growing power of the Shi'i BUYID dynasty, found their territories reduced to Transoxiana and part of Khurasan and yielded real power to their Turkish military slaves. One of these, Alptigin, founded the GHAZNAVID dynasty, which in 994 took over Samanid territory south of the Amu (Oxus) River, while the Qarakhanids (*r.* 992–1211) united the nomadic Turkish tribes to the north and east, invaded Transoxiana and in 992 took Bukhara, the Samanid capital. The last fugitive Samanid was killed in 1005.

Under the Samanids the Iranian world regained its political autonomy and its cultural identity. BUKHARA and SAMARKAND became major centers of learning and civilization where Persian culture flourished, as represented by such poets as Rudaki (*d.* 940), Daqiqi (*d. c.* 980) and Firdawsi (*d.* 1020), who continued the *Shāhnāma* ("Book of kings") under Samanid patronage. Samanid frontiers were protected against the pagan Turks by fortress–monasteries (Arab. *ribāṭ*). The huge hoards of Samanid silver coins unearthed in Sweden reflect the busy trade in amber, furs and especially slaves conducted with the Vikings through southern Russia. Samanid architecture, represented by the mausoleum of the Samanids (920s; *see* BUKHARA, §II, A; CENTRAL ASIA, §II, A and ARCHITECTURE, fig. 9), used decorative brickwork with consummate mastery, while Samanid potters at NISHAPUR and Afrasiab (Old Samarkand) produced reasonable imitations of Chinese porcelain decorated with stylish calligraphy. Strong echoes of Sasanian figural iconography pervade Samanid metalwork and in ceramics the Nishapur buff wares (*see* CERAMICS, §II, C).

L. Volov [Golombek]: "Plated Kufic on Samanid Epigraphic Pottery," *A. Orient.*, vi (1966), pp. 107–33

C. K. Wilkinson: *Nishapur: Pottery of the Early Islamic Period* (New York, 1973)

M. S. Bulatov: *Mavzoley Samanidov: Zhemchuzhina arckhitektury sredney Azii* [The mausoleum of the Samanids: a pearl of Central Asian architecture] (Tashkent, 1976)

B. Marschak: *Silberschätze des Orients: Metallkunst des 3.–13. Jahrhunderts und ihre Kontinuität* (Leipzig, 1986)

S. S. Blair: *The Monumental Inscriptions of Early Islamic Iran and Transoxiana* (Leiden, 1992), pp. 25–9

P. Morgan: "Samanid Pottery: Types and Techniques," *Cobalt and Lustre: The First Centuries of Islamic Pottery*, ed. E. J. Grube (1994), ix of *The Nasser D. Khalili Collection of Islamic Art*, ed. J. Raby (London, 1992–), pp. 55–114

A. Naymark: "The Size of Samanid Bukhara: A Note on Settlement Patterns in Early Islamic Mawarannahr," *Bukhara: The Myth and the Architecture*, ed. A. Petruccioli (Cambridge, MA, 1999), pp. 39–60

Samarkand [Samarqand; formerly Afrasiab]. City in Uzbekistan. Located on the south bank of the Zarafshan River, the city was the economic and administrative center of Sogdiana and Transoxiana, the land between the Amu and Syr rivers, and an active participant in international trade along the Silk Route. To the northeast of the modern city lie the ruins of ancient and medieval Samarkand, a hilly triangular plateau (219 ha) known since the 17th century as Afrasiab (see fig. 1).

I. History and urban development. II. Art life and organization. III. Buildings.

I. History and urban development.

A. Before 1220. The first settlement (mid-1st millennium BCE) on the site of Samarkand may have been an outpost of the Achaemenid Empire of Iran. The settlement was fortified with pisé ramparts and then with walls of oblong mud-bricks with corridors running at right angles and pierced with ventilation slits and embrasures. The northern part had additional bastions and a citadel (1b). The irregular terrain and the four gates in the walls determined the network of streets, along which craftsmen had their workshops. A canal and open reservoirs supplied the town with water. Samarkand is first mentioned in relation to the campaigns of Alexander the Great in Sogdiana (329–327 BCE) when he took the large fortified town of Maracanda without force and restored

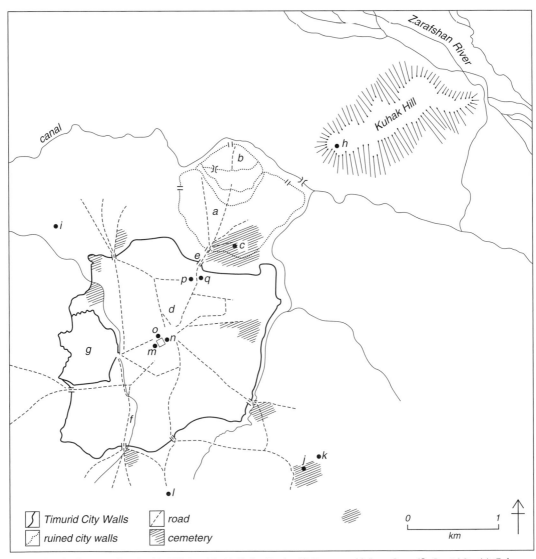

1. Samarkand, plan: (a) Afrasiab; (b) Old Citadel; (c) Shah-i Zinda; (d) Registan; (e) Iron Gate; (f) Gur-i Mir; (g) Goksaray; (h) observatory; (i) *namāzgāh*; (j) shrine of ʿAbdi Darun; (k) Ishrat Khana; (l) 17th-century *namāzgāh*; (m) madrasa of Ulughbeg; (n) madrasa of Shir Dar; (o) madrasa of Tilla Kar; (p) mosque of Bibi Khanum; (q) mausoleum of Bibi Khanum

its fortifications. The new internal corridor was lined with square bricks and had lancet-shaped embrasures. The walls incorporated layers of reed to protect against salt and damp as well as anti-seismic beams. The corridors, more than 5 km long, were paved throughout.

Fragmentary stone foundations of monumental structures (3rd–2nd century BCE) have been found at Afrasiab (1a). Water reservoirs planted with trees, including the gold and silver peaches for which the city was famed, have also been found. The thin and red polished ceramics reveal in their form and quality the strong Hellenization of culture; terracotta figurines based on Hellenistic models were replaced by stylized large-headed images. During the Kushana period (1st century BCE–4th century CE) merchants founded new trading stations and expanded Sogdian colonies, and the range of finds at the site, including blue paste objects from Egypt, reflects the wide network of trade. Workshops of metalworkers and potters have been excavated. A new leaden aqueduct supplied the city with water.

The city shrank during the troubled period in the 4th and 5th centuries CE. New defenses, with two rows of walls and two moats enclosing only one-third of the former town, were built in the 5th century. The abandoned quarters were transformed into a necropolis with burials in ossuaries. The quality of the pottery declined, the shapes of vessels altered and many were hand-modeled. In the 6th and 7th centuries, when Samarkand was the capital of Sogdiana under the local Ikhshid dynasty, the abandoned areas were reclaimed, the necropolis destroyed and new multi-room houses constructed and decorated with wall paintings, wood-carving and sculpture. Excavation of the main hall of the Ikhshid palace brought to light monumental wall paintings, including a depiction of envoys bringing tribute to the ruler of Samarkand (see CENTRAL ASIA, §IV, A). Sources record the presence of a pagan temple, as well as buildings for the Buddhist and Nestorian communities.

In 712 Samarkand was conquered by the Arabs. A congregational mosque was constructed on the ruins of the main Sogdian temple, the walls were partly destroyed and the population declined. The situation improved markedly in the 9th and 10th centuries when the city was incorporated into the Samanid domain. The area was again walled with four gates, and a citadel erected in the north with two gates, the ruler's palace and the prison. A commercial and artisanal suburb arose to the south and west of Afrasiab. Several parts of the ruined site show streets paved with stone and fired brick, water-conduits and sewers. Excavation has revealed a palace with a vast audience hall and a large residence with an iwan and square domed reception room. Decoration was in stucco carved in vegetal and geometric motifs reminiscent of the style found at Samarra, the 9th-century Abbasid capital in Iraq. A potters' quarter of some 15 households in an area of 4000 sq. m yielded many ceramics; a complete ivory chess set (Samarkand, Ikramov Mus. Hist. Cult. & A. Uzbekistan) was also found.

By the 11th century the town had grown beyond its defensive walls and new suburbs were built. Under the Qarakhanids (r. 992–1211) the old town was transformed into an administrative and defensive center, the congregational mosque was enlarged and rebuilt, and the area around the tomb of Qutham ibn 'Abbas (see §III, A below) developed. In 1220 Samarkand was seized by the Mongol army of Genghiz Khan and the city and its water supply destroyed.

Enc. Iran.: "Afrāsiāb"

V. A. Shishkin: *Afrasiab: Sokrovishchnitsa drevney kul'tury* [Afrasiab: treasury of ancient culture] (Tashkent, 1966) *Afrasiab*, i–iv (1969–75)

I. Ahrarov and L. Rempel': *Reznoy shtuk Afrasiaba* [The carved stucco of Afrasiab] (Tashkent, 1971)

L. I. Al'baum: *Zhivopis' Afrasiaba* [The paintings of Afrasiab] (Tashkent, 1975)

G. V. Schischkina: "Les Remparts de Samarcânde à l'époque hellénistique," *La Fortification dans l'histoire du monde grec* (Paris, 1986)

B. I. Marshak: "Le programme iconographique des peintures de la Salle des ambassadeurs à Afrasiab (Samarkand)," *A. Asiat.*, xlix (1994), pp. 5–20

N. Y. Vishnevskaya: "Pre-Mongol Glazed Pottery of Afrasiab (Late VIIth to Early XIIIth Century)," *A. & Islam. World*, xxxiii (1998), pp. 12–17

Y. Karev: "Un palais islamique vu VIIIe siècle à Samarkand," *Stud. Iran.*, xxix (2000), pp. 273–96

Y. Karev: "Qarakhanid Wall Paintings in the Citadel of Samarqand: First Report and Preliminary Observations," *Muqarnas*, xxii (2005), pp. 45–84

B. 1220 AND AFTER. With the destruction of the water system, Afrasiab was abandoned and the population moved south to an area that had been surrounded by a ring of defensive walls with six gates (see fig. 1). The new settlement quickly grew, so that by the second half of the 13th century Samarkand was once more a renowned commercial center. A congregational mosque and madrasa were built, and several tombs added to the Shah-i Zinda (see §III, A and fig. 2 below), the complex surrounding the tomb of Qutham ibn 'Abbas.

Under the Timurids (r. 1370–1506) the city entered its most outstanding period, which lasted until the middle of the 15th century. During the reign of Timur (r. 1370–1405), the city was capital of a vast and powerful empire, a political and commercial center of global importance and one of the richest towns in Asia, where the best craftsmen from all the conquered lands were brought. Vast construction works were undertaken: the city walls (7 km) were rebuilt with six gates, and roads led from the gates to the center near the Registan Square (1d). The road from the Iron Gate (1e) on the north was lined at the beginning of the 15th century with two-story shops and galleries. A new congregational mosque (see III, B below) was built near the market square by the Iron Gate with a madrasa–mausoleum for Timur's wife opposite. Another ensemble was constructed in the southern part of the city, the Gur-i Mir (1f), the

tomb where Timur and some of his descendants were buried (*see* III, C below). The necropolis to the northeast of the city walls, the Shah-i Zinda (see figs. 1c and 2), was transformed as new tombs for Timur's relatives and court notables replaced ruined structures. Most building activity in Timurid Samarkand took place in the new citadel in the western part of the town. It was enclosed by a high wall with two gates and contained Timur's four-story palace, Goksaray (1g), armorers' workshops, store-rooms, a mint and a prison. According to the Spanish ambassador Ruy Gonzalez de Clavijo (*d.* 1412), Samarkand was surrounded by earthen ramparts, deep ditches, gardens and vineyards. The city produced a wealth of different goods and had a sophisticated system of water distribution. The palaces with fourfold gardens (Pers. *chahār bāgh*) along the main axis were particularly luxurious, having lawns, glades, allées, pools and pavilions. More than a dozen imperial country gardens are known (*see also* ARCHITECTURE, §VI, A, 2).

Although Shahrukh (*r.* 1405–47) moved the capital to Herat, Timur's grandson Ulughbeg, governor of Transoxiana (1409–47 and *r.* 1447–9), erected new buildings. He transformed the Registan Square into an impressive ensemble (*see* III, D below; see also fig. 1m) and had a large observatory (1h; see also III, E below) built in the suburbs northeast of Afrasiab beyond the irrigation canal. Other construction undertaken during his reign included the rebuilding of the *namāzgāh* (an open-air praying place (1i)) to the west of the Shaykhzada Gate, the erection of an elegant pavilion on the Chupan-ata hill and the addition of a *khanaqah* to the shrine of 'Abdi Darun (1j) to the southeast of the city beyond the Firuza Gate. The wife of Abu Sa'id (*r.* 1459–69) erected Ishrat Khana (*c.* 1464; 1k), a mausoleum in memory of her daughter that became the burial place of female members of the dynasty. Rectangular in plan, the building has a cruciform tomb chamber at the center and an octagonal crypt. It is remarkable for its varied vaulting and fine decoration (*see* CENTRAL ASIA, §II, B). The Aksaray mausoleum (*c.* 1470) was built near the Gur-i Mir for the male members of the dynasty. Hardly visible among the surrounding vegetation, this small incomplete building is notable for its fine interiors with tile mosaic and carved and painted plaster. Khwaja Ahrar (Khodzha Akhrar), the head of the Nakshbandi order of Sufis and the most powerful religious figure in Central Asia in the second half of the 15th century, was also a major patron of architecture in the city: he (or his sons) built a funerary complex in the Suzangaran area. It comprised a tomb on a platform surrounded by a wall, a *khanaqah* (later replaced by a madrasa) and a large octagonal pool.

Under the Shaybanids (*r.* 1500–98), who often transferred the capital to Bukhara, interest in building in Samarkand slackened, and the several major structures erected around the middle of the century did not change the topography of the city. Construction was revived in the 17th century when Samarkand became the center of the domain of the Alchin family. To please the clergy there was a concentration on religious building: a new *namāzgāh* was built to the south of the city (1l) and a *khanaqah* (1633) was added to the shrine of 'Abdi Birun. Nadr Divan Begi erected a madrasa near the Khwaja Ahrar Cemetery. The effective ruler of the city, Yalangtush Bi Alchin remodeled the Registan Square during the first half of the century (*see* ARCHITECTURE, fig. 52), adding the Shir Dar ("lion-possessing"; 1616–36) and Tilla Kar ("goldwork"; *c.* 1646–60) madrasas (see figs. 1n and 1o). All the 17th century buildings were on a vast scale and were luxuriously decorated but repeated traditional structures and decoration.

The 18th-century economic crisis in Central Asia was reflected in the decrease of building in major cities including Samarkand, although at the end of the century a recovery is attested in the rebuilding of the Khwaja Ahrar madrasa and repairs to the madrasas of Shaybani Khan and Ulughbeg (1m) in the Registan. A hexagonal retail market building was built next to the Shir Dar madrasa and served as the central market for the sale of headgear. At the beginning of the 19th century a small madrasa was erected in the Shah-i Zinda, alongside a summer mosque with wooden columns supporting a ceiling, with polychrome decoration in oil paint (1c). Such small mosques surrounded by greenery and forming a complex with a reservoir or canal were typical of the region. By the early 19th century Samarkand was surrounded by high walls with towers and six gates; the citadel housed barracks and the khan's palace, the town comprised many houses, shops and workshops. After the Russian annexation of Turkestan in 1868 a new town grew in the southwest. Built along European lines, it had straight streets, a radial layout and areas of greenery.

R. Gonzalez de Clavijo: *Vida y hazañas del gran Tamorlan con la descripción de las tierras de su imperio y señoría* (St. Petersburg, 1881/*R* 1971); Eng. trans. by G. LeStrange as *Embassy to Tamerlane, 1403–1406* (London, 1928)

G. A. Pugachenkova and L. I. Rempel': *Vydayushchiesya pamyatniki arkhitektury Uzbekistana* [Outstanding architectural monuments of Uzbekistan] (Tashkent, 1958)

D. Brandenburg: *Samarkand* (Berlin, 1972)

G. A. Pugachenkova: *Zodchestva tsentral'noy Azii, XV vek* [The architecture of Central Asia, 15th century] (Tashkent, 1976)

G. A. Pugachenkova: *Chefs d'oeuvre d'architecture de l'Asie centrale, XIV–XV siècles* (Paris, 1981)

L. Golombek and D. Wilber: *The Timurid Architecture of Iran and Turan*, 2 vols. (Princeton, 1988)

S. Bianca: *Planning for the Historic City of Samarkand* (Geneva, 1996)

R. Hillenbrand: "The Timurid Achievement in Architecture," *Islamic Period: From the Fall of the Sasanian Empire to the Present*, ed. A. Daneshvari (2005), xviii of *A Survey of Persian Art from Prehistoric Times to the Present* (Costa Mesa, CA, 1973–2005), pp. 83–125

II. Art life and organization. Chinese prisoners captured in the battle of Talas (751) are reputed to have introduced the art of papermaking to Samarkand, and the city was renowned for its paper throughout the medieval Islamic world (*see* PAPER). Under the Timurids and Shaybanids, Samarkand became an important center for the production of fine illustrated manuscripts (*see* CENTRAL ASIA, §IV, A and ILLUSTRATION, §§V, D, and VI, C). Fine ceramics were also produced there, particularly under the Samanids in the 10th century. Many examples of these earthenwares with thick slip decoration have been excavated at Afrasiab (see fig. 1a above) and are often known after the site; they are similar to earthenwares excavated at Nishapur in northeast Iran (*see* CERAMICS, §II, C). Under the Timurids Samarkand was also a major center of ceramic production. A large quantity of pottery was excavated at the Timurid citadel (1g), including some *lājvardīna* tiles (deep blue glaze with overglaze enamel and gold) and many blue-and-white shards. Some copied Yuan originals, but others resemble Syrian imitations of Yuan porcelains and bear out contemporary accounts that Timur brought potters from Damascus to Transoxiana in 1402. The Samarkand workshops apparently declined after 1411 when Ulughbeg, governor of Samarkand for his father Shahrukh, issued an edict freeing those forcibly brought to Samarkand to return home. Ulughbeg also erected a special pavilion to house his porcelain collection (Pers. *chīnī-khāna*). Excavation at this site revealed several blue-and-white porcelain tiles and local imitations.

Tenth-century geographers mentioned Samarkand as a center for the production of copper or copper alloys, and a distinctive type of bronze ewer with an upwardly pointing spout recalling an animal or bird head is associated with the city in the late 10th century and early 11th. Another type of ewer with a pear-shaped body and flat lip is attributed to the region in the 12th and 13th centuries on the basis of an example (St. Petersburg, Hermitage, CA 12745) acquired in Samarkand in 1885. As the main town in a region of cotton and silk production, Samarkand has always been an important textile center. Many of the archaeological finds are housed in the Ikramov Museum of the History of Culture and Art of Uzbekistan, the Afrasiab Museum and the Ulughbeg Memorial Museum at the Observatory.

N. B. Nemtseva: "Stratigrafiya yuzhnoy okrainy gorodishcha Afrasiab" [Stratigraphy of the southern borders of the city of Afrasiab], *Afrasiab*, i (1969), pp. 153–205

B. I. Marshak: "Bronzovyiy kuvshin iz Samarkanda" [A bronze ewer from Samarkand], *Srednyaya Aziya i Iran* [Central Asia and Iran], ed. A. A. Ivanov and S. S. Sorokin (Leningrad, 1972), pp. 61–90

Timur and the Princely Vision (exh. cat. by T. W. Lentz and G. D. Lowry; Washington, DC, Sackler Gal.; Los Angeles, CA, Co. Mus. A.; 1989)

L. Golombek, R. B. Mason and G. Bailey: *Tamerlane's Tableware: A New Approach to the Chinoiserie Ceramics of Fifteenth- and Sixteenth-century Iran* (Costa Mesa, CA, 1996)

III. Buildings.

A. Shah-i Zinda. B. Mosque of Bibi Khanum. C. Gur-i Mir. D. Registan. E. Observatory.

A. SHAH-I ZINDA. Necropolis on the south slope of the Afrasiab hill (see figs. 2 and 3). The site has been excavated systematically since 1957. It took shape between the 11th and 19th century around the tomb of Qutham ibn 'Abbas (2a), the "living king" (Pers.

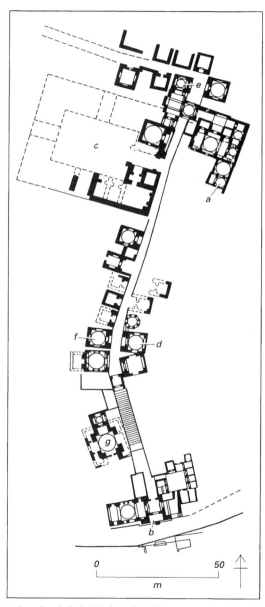

2. Samarkand, Shah-i Zinda, 11th–19th centuries, plan: (a) tomb of Qutham ibn 'Abbas; (b) domed portal; (c) madrasa of Tamgach Khan; (d) mausoleum of Shirinbeg Aga; (e) mausoleum of Tuman Aga; (f) mausoleum of Shad-i Mulk Aga; (g) mausoleum of 'Ulugh Sultan Begum'

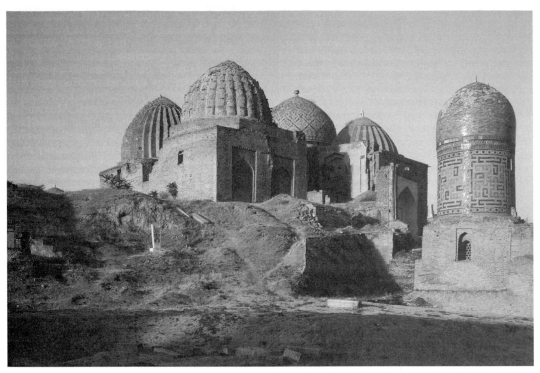

3. Samarkand, Shah-i Zinda, view from the west, 11th–19th centuries; photo credit: Sheila S. Blair and Jonathan M. Bloom

shāh-i zinda), a cousin and companion of the Prophet Muhammad who reportedly died during the first Arab siege of Samarkand in 677. A domed portal (2b) on the south leads up a flight of steps to a narrow north–south lane lined by domed square tombs, roughly divided into lower, middle and upper groups. The axis of development was determined by the terrain and earlier construction on the site, which included a road, street and canal. In the 11th century the grave, located in the center of the upper group on the east side of the street, was marked with a two-story multi-chambered mausoleum, a semi-subterranean room with wooden consoles (perhaps a mosque) and a small minaret (destr.). On the west side of the corridor, opposite the entrance to the tomb complex, excavations revealed a large four-iwan structure (44×55 m; 2c) that has been identified as the first madrasa in Samarkand, erected in 1066 by the Qarakhanid ruler Tamgach Khan (r. 1052–66). The portal and main façade were faced with polished brick and glazed tile, while interior surfaces were decorated with polychrome painting on stucco, carved plaster and terracotta.

After Samarkand was sacked in 1220, the Shah-i Zinda was abandoned and the madrasa gradually transformed into a hospice (*khanaqah*), although Qutham's grave retained its status as the most revered holy site in the town. Under the Timurids construction was resumed as 11th- and 12th-century buildings were replaced by several mosques and single-chamber domed mausolea for members of the Timurid family, nobility and clerics. At the end of the 14th century and beginning of the 15th, the middle and upper group with its internal courtyard took shape and a western corridor developed, also lined with domed mausolea. The monochrome facings of the earlier buildings were replaced with luxurious polychrome revetments of glazed tile, tile mosaic and glazed terracotta in a palette dominated by bluish tones with a great deal of gilding. The portals facing the narrow street are particularly striking, and the ribbed domes are covered with glazed tile. Elegant epigraphic, vegetal and geometric motifs are interwoven on the façades, and interiors are also decorated luxuriously with delicately painted plaster (e.g. mausolea of Shirinbeg Aga, 1385–6, and Tuman Aga, 1405–6; 2d and 2e) or bold tiles (e.g. mausoleum of Shad-i Mulk Aga, *c.* 1371–83; 2f; *see also* CENTRAL ASIA, §II, B).

The lower group was developed under Ulughbeg (1409–49). To the west on the slope of the hill was the most majestic building, the two-domed mausoleum erroneously known as that of "Ulugh Sultan Begum" (2g). To complete the ensemble, a monumental portal and winter mosque (1435–6) was added by Ulughbeg in the name of his son 'Abd al-'Aziz. No significant changes were made after this date, although several undistinguished buildings, including a mosque and madrasa, were built on the site. Almost all the buildings have been restored to

make the site one of the most memorable architectural ensembles in Central Asia.

Enc. Islam/2: "Kuṭham b. al-'Abbās"

N. B. Nemtseva: "Istoki kompozitsii i etapy formirovaniya ansamblya Shakhi-Zinda" [The origins and architectural development of the Shah-i Zinda], trans. with additions by J. M. Rogers and A. Yasin, *Iran*, xv (1977), pp. 51–74

N. B. Nemtseva and Yu. Z. Shvab: *Ansambl' Shakh-i Zinda: Istoriko-arkhitekturnyy ocherk* [The Shah-i Zinda ensemble: a historical and architectural outline] (Tashkent, 1979)

L. Golombek and D. Wilber: *The Timurid Architecture of Iran and Turan*, 2 vols. (Princeton, 1988), pp. 233–52, nos. 11–24

J. Soustiel and Y. Porter: *Tombeaux de paradis: Le Shāh-e Zende de Samarcande et la céramique architecturale d'Asie centrale* (Saint-Remy-en-l'Eau, 2003)

B. MOSQUE OF BIBI KHANUM. Congregational mosque by the Iron Gate. Construction was begun 11 May 1399 after Timur's triumphant campaign in India, and craftsmen brought from India, Azerbaijan, Khurasan, Iran and Syria completed the building in 1404–5. The huge structure (132×99 m; for illustration *see* TIMURID, §II, A), known as the mosque of Bibi Khanum after Timur's wife whose mausoleum and madrasa lie opposite, comprised an interior court (76×64 m) surrounded by hypostyle domed halls with carved stone columns (see fig. 4). Four main units were set on the axes of the court. An enormous portal, its arch spanning 18.8 m and flanked by round towers, gave access to the interior. Another portal opposite flanked by octagonal towers led to a large domed chamber which served as the prayer-hall, while two smaller domed chambers lay behind shallow iwans on either side of the court. Four slender minarets stood at the corners of the building. The ablution pavilion in the center of the court has been replaced by a stone lectern to support an elephantine copy of the Koran.

A wide range of techniques was used to decorate the building, including marble panels for the dado, brick mosaic on the walls, tile mosaic and glazed tile for facing, and painting on plaster and papier-mâché relief with gilding on interior surfaces. The building was a legend in its own time, and its construction is shown in a double-page painting (fols. 359*b*–360*a*) in a manuscript (Baltimore, MD, Johns Hopkins U., Garrett Lib.) of Sharaf al-Din 'Ali Yazdi's *Zafarnāma* ("Book of Victory") copied in 1467–8 for the Timurid ruler Husayn Bayqara. By the 19th century most of the mosque lay in ruins, and the earthquake of 1897 destroyed all but the northwest minaret and the four main units on the axes. Since the 1960s the building has been restored and rebuilt; despite the

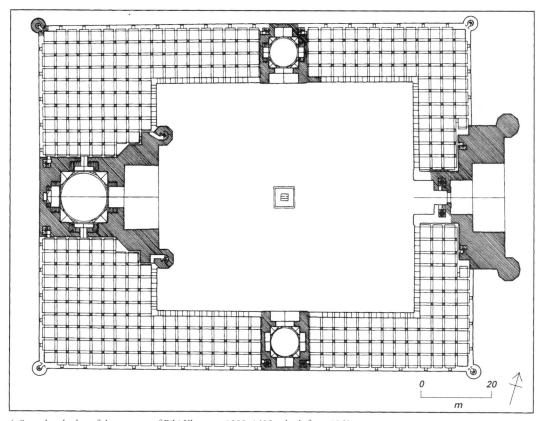

4. Samarkand, plan of the mosque of Bibi Khanum, 1399–1405; rebuilt from 1960

ravages of time, the architectural massing, spacious interiors and glitter and intensity of the tiled and painted decoration are still impressive.

Sh. Ye. Ratiya: *Mechet' Bibi-khanym* [The mosque of Bibi Khanum] (Moscow, 1950)

L. Yu. Man'kovskaya: *Bibi-khanym* [Bibi Khanum] (Tashkent, 1963, rev. 1965)

L. Golombek and D. Wilber: *The Timurid Architecture of Iran and Turan*, 2 vols. (Princeton, 1988), pp. 255–60, no. 28

C. GUR-I MIR [Pers.: "grave of the prince"]. Majestic religious and funerary complex in the southern part of the city (see fig. 1f above; *see also* ARCHITECTURE, color pl.), which contains the tombs of Timur and his descendants. It is the earliest example of ensemble planning typical of architecture under the Timurids, and the richest surviving example of Timurid architectural decoration. At the end of the 14th century Muhammad Sultan, Timur's grandson and heir-presumptive, built a small madrasa and *khanaqah* on either side of a rectangular court with a minaret at each corner and a portal in the middle of the north side. In 1404–5 a burial vault was built on the south side of the court to contain the remains of Muhammad Sultan, who died on campaign. In February 1405 the Gur-i Mir became the burial place of Timur himself. The cruciform chamber is housed within an octagonal structure surmounted by a high cylindrical drum supporting two tiers of muqarnas and an ovoid ribbed dome. On the interior, arched pendentives support a low hemispheric vault; the two shells are connected by invisible spur walls. The cruciform burial vault has a small flat quadripartite dome. The exterior of the building is decorated with glazed and matt bricks in tile mosaic and *banna'ī* technique (*see* ARCHITECTURE, §X, B, 2) while the impressive interior has an onyx dado with a jasper inscription band accented in gold, and walls and ceiling embellished with pressed and molded papier-mâché painted in light blue and gold. The cenotaphs of several Timurid princes, made of light gray marble or dark green jade, are set in the floor and surrounded with carved marble grilles. Their marble tombstones are in the crypt below. In 1424 Ulughbeg added a gallery along the south (destr.) and east sides of the octagonal mausoleum. A large square hall, of which only the iwan survives, was later built to the west.

Le Gour-Emir (1905), i of *Les Mosquées de Samarcand* (St. Petersburg, 1905–)

I. Ye. Pletnyov: *Gur-Emir* (Tashkent, 1963, rev. 1965)

L. Golombek and D. Wilber: *The Timurid Architecture of Iran and Turan*, 2 vols. (Princeton, 1988), pp. 260–63, no. 29

D. REGISTAN [Pers. rīgistan: "sandy region"] Square at the center of Samarkand (see fig. 1d above). It began to take shape in the 14th century, when it was embellished with a congregational mosque and commercial structures. Under Ulughbeg new buildings were added and the square began to take on its present aspect. The madrasa of Ulughbeg (1417–20) was erected on the west, and his *khanaqah* (c. 1420;

destr.) on the east replaced the Tuman Aga warehouse. To the north the square was bounded by the Mirzoi Caravanserai; to the south the Kukeldash and Mukatta mosques were built in the 1430s along with public baths. The only one of these buildings to survive is the madrasa, a rectangle (81×56 m) with a square court surrounded by two stories of cells with four iwans on the axes. Domed cruciform rooms at the corners were used for teaching and a large vaulted hall opposite the entrance served as the mosque. The main façade on the Registan has a huge *pishtaq* (portal, span 16.5 m) flanked by corner towers. The decoration of the building is rich and varied. With marble panels around the bottom of the walls, brick mosaic facing the large surfaces, fine mosaic and maiolica panels in the tympana of the arcade in the court and the iwans, and polygons and stars in terracotta and marble background, the building incorporates an endless variety of geometric, epigraphic and vegetal designs in a range of predominantly blue tiles.

Alterations in the 16th century included a large double madrasa (1501–10; destr.) built by Shibani Khan on the east of the square, and another madrasa (destr.) built by Abu Sa'id ibn Kuchkunji (d. 1533), a leading political figure, on the south. In the early 17th century the effective ruler of the city, Yalangtush Bi Alchin, remodeled the Registan with two new madrasas. The Shir Dar ("lion-possessing"; 1616–36), which replaced Ulughbeg's *khanaqah* and mirrored his madrasa in plan and composition of the façade, is decorated on the exterior with brick and tile mosaic dominated by yellowish-green tiles. The depiction in the spandrels of lions with human-faced suns rising behind them has given the building its name. The Tilla Kar ("gold-work"; c. 1646–60) madrasa, the largest building on the Registan, combined the function of madrasa and congregational mosque. Behind the entrance on the south, the symmetrical courtyard plan has been adjusted so that the entire west side is occupied by a domed prayer-hall flanked by hypostyle halls carried on octagonal piers. The dado is paneled in marble while the walls and dome are covered with pressed and molded paper, richly painted and gilded. The main façade generally follows the others, although the walls are articulated by two stories of arched recesses. Despite the different dates of construction, the three buildings facing the Registan (*see* ARCHITECTURE, fig. 52) present a unified appearance, and the strict harmony of proportion, majestic volumes and intense colors of the façades create an impressive city center.

K. S. Kryukov: *Registan* (Tashkent, 1975)

L. Golombek and D. Wilber: *The Timurid Architecture of Iran and Turan*, 2 vols. (Princeton, 1988), pp. 263–5, no. 30

E. OBSERVATORY. Built in 1420 by Ulughbeg on the Kuhak Hill northeast of Samarkand (see fig. 1h above), it is one of the few civic structures of the Timurid period to survive in part. Only the foundations and underground part of the marble sectant with its gradations have been preserved, but excavations

between 1908 and 1967 revealed the original appearance of the cylindrical three-story building (diam. 46.6 m; h. 30 m). The main entrance lay in the center of the north side and service quarters were reached from the south. The exterior, with an open arched gallery, was faced with glazed brick and tile mosaic typical of the 15th century. The observatory housed three giant astronomical instruments: the sextant, a sundial and quadrant sector. Nearby were the Bagh-i Maydan gardens and the Chihil-sutun summer palace. There is now a museum in memory of Ulughbeg on the site.

M. Ye. Masson: *Observatoriya Ulugbeka* [Ulughbeg's Observatory] (Tashkent, 1941)

G. A. Pugachenkova: "Arkhitektura observatorii Ulugbeka" [The architecture of Ulughbeg's Observatory], *Isk. Zodchikh Uzbekistana*, iv (1969), pp. 107–31

V. A. Nil'sen: *Observatoriya Ulugbeka v Samarkande* [Ulughbeg's Observatory in Samarkand] (Tashkent, 1986)

L. Golombek and D. Wilber: *The Timurid Architecture of Iran and Turan*, 2 vols. (Princeton, 1988), pp. 265–7, no. 31

Samarra [Sāmarrāʾ]. Town in Iraq. It lies 125 km north of Baghdad on the east bank of the River Tigris, immediately above the northern tip of the Mesopotamian alluvium, where the flood-plain of the river cuts into a rolling bare steppe of gravel and conglomerate probably laid down in the Pleistocene. A prehistoric cemetery yielded pottery of the 6th millennium BCE. In the 9th century CE Samarra was made the capital of the ABBASID caliphs (r. 749–1258), and later the city became an important Shiʿite shrine center.

In antiquity a post road to the north was served by several towns on the east bank of the Tigris. Samarra itself was known for a fort, near which the Roman emperor Julian the Apostate was killed in battle against the Sasanians in 363 CE, and a monastery. The town of Karkh Fairuz, founded in the 4th or 5th century, stood to the north. The Nahrawan, the great irrigation canal dug by the Sasanian king Khusraw Anushirvan (r. 531–79), which watered the east bank of the Tigris to the region below Baghdad, had two inlets north and south of Samarra. The Qatul al-Kisrawi on the north had a palace at its entrance; the Nahr al-Qaʾim on the south had a monumental tower there, the Burj al-Qaʾim. The Abbasid caliph Harun al-Rashid (r. 786–809) added the Qatul Abuʾl-Jund, the inlet of which lay south of Samarra, and began to build a palace; but construction was abandoned in 796. This has been identified as the Husn al-Qadisiyya (see fig. 1a), an octagon measuring 1500 m across. The outer walls were built of mud-brick, and the lines were laid out for a mosque, a palace, a central square and three avenues. The layout copies that of the Round City at BAGHDAD (see ARCHITECTURE, fig. 3).

In the wake of disturbances between the population of Baghdad and the newly recruited regiments of Turkish slaves and other Central Asians, the caliph al-Muʿtasim (r. 833–42) reportedly decided to found a new military and administrative capital. After trying a number of sites and beginning to build at the site of Harun al-Rashid's palace on the Qatul, he settled in 836 at Samarra, called in the Arabic sources *surra man raʾā* ("he who sees it is delighted") and known as a resort area. The contemporary description of the city by the Arab geographer al-Yaʿqubi (d. 892) can be largely reconciled with the evidence of the remains, a strip of mounds stretching 50 km along the bank of the Tigris and scattered over an area of 150 sq. km. Air photographs reveal the lines of avenues and plans of buildings, some 5700 of which have been identified. Construction at Samarra was of fired brick, mud-brick and pisé, as well as the unusual technique of gypsum bricks. The most frequent form of decoration was the stucco dado, and three styles were identified by Herzfeld (and revised by K.A.C. CRESWELL): Style A, a carved technique derived from earlier styles; Style B, a simplified cross-hatched style; and Style C, the BEVELED STYLE, a molded technique suitable for covering extensive wall surfaces (see fig. 2). Marble paneling and wall paintings are found in the finer buildings, glass tiles are known from al-Mutawakkil's congregational mosque and luster-painted ceramic tiles from the Dar al-Khilafa, and remains of glass mosaic have also been found (see ARCHITECTURE, §X, D). The site has also yielded an abundance and variety of Islamic and Far Eastern ceramics from the period of its heyday (see CERAMICS, §II, B).

Al-Muʿtasim's main palace, the Dar al-Khilafa ("house of the caliphate"; 1b), which became a vast complex of 125 ha, was laid out in the north of the central area (see ARCHITECTURE, fig. 5). It included a block of reception halls, excavated by Herzfeld from 1911 to 1913, fronted by the only standing section, a triple iwan known in modern times as the Bab al-ʿAmma ("gate of the people"). Behind it was a large rectangular court, two sunken pools (Arab. *birka*), a polo ground, and a second residential palace to the north. The pools, excavated in recent years, were cut into the conglomerate: one was square and the other circular; each was surrounded by an underground complex (*sirdab*) of four iwans connected by rooms for occupation in the summer. Herzfeld identified the main palace as the Jawsaq al-Khaqani, but this is more likely to have been al-Muʿtasim's official palace, the Dar al-ʿAmma, while the Jawsaq was the residence.

Several lesser palaces, including the Waziri and the ʿUmari palaces, lay adjacent to the Dar al-Khilafa. To the south were five avenues, along which stood the government ministries (*diwan*), markets and residential areas for less important military groups. The original congregational mosque was built on a site somewhere under the modern town. Some grand houses from this area have been excavated, revealing complexes of courtyards and rooms with reception halls in the form of T-shaped iwans and decorated with stucco dados. On the west bank of the Tigris the remains of palaces and gardens can be seen. One square palace at Huwaisilat (1c) and part of another have been excavated and identified as al-Muʿtasim's

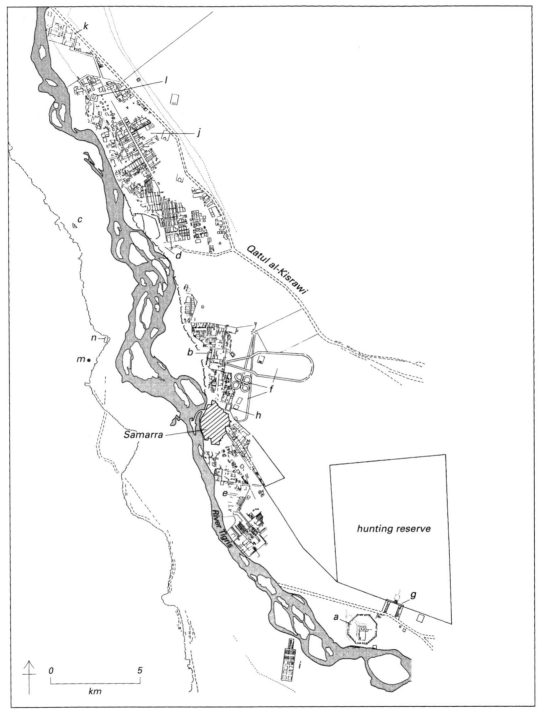

1. Samarra, late 8th century CE– late 9th, plan: (a) Husn al-Qadisiyya; (b) Dar al-Khilafa; (c) al-Huwaisilat; (d) Sur Ashnas; (e) Matira; (f) race-courses; (g) al-Musharrahat; (h) Great Mosque of al-Mutawakkil; (i) al-Istabulat; (j) al-Mutawakkiliyya; (k) Qasr al-Jaʿfari; (l) mosque of Abu Dulaf; (m) Qubbat al-Sulaibiyya; (n) Qasr al-ʿAshiq

Qasr al-Juss ("palace of plaster"). Al-Mu'tasim's successor, al-Wathiq (r. 842–7), built the Haruni Palace, which has been identified with the site of al-Quwair in the flood-plain of the Tigris, partially flooded since the construction of a barrage in the 1950s.

The military cantonments (qaṭīʿa) outside the central area all follow a similar pattern: a palace, several lesser residences, a ceremonial avenue and a grid of streets. Most were not walled. The troops were quartered in houses rather than barracks, and al-Mu'tasim arranged for the purchase of Turkish slave-girls for wives, in order to avoid the mixing of Turks with the indigenous population. The cantonment of the Turkish general Ashnas was outside the walls of Karkh Fairuz, separated from the main city. The palace, now called Sur Ashnas (1d), is a quadrilateral with a mosque in the center. The cantonment of Khaqan Urtuj is adjacent to the Dar al-Khilafa; it has a palace facing on to the steppe. The cantonment of Afshin, a Central Asian prince, was built at Matira (1e), south of Samarra and at first separated from it. The palace, called Sur Jubairiyya (destr.), was square and overlooked the river.

In the steppe to the east of the city are three race-courses for horse racing (1f). Two are out-and-back courses, 80 m wide and 10.42 km long. One has a rest house for the caliph and a viewing mound, Tell al-'Aliq, on which Herzfeld found a small pavilion. The third course is a closed cloverleaf, 5.31 km long, and has a central viewing pavilion. A fourth linear course, 104 m wide and 9.78 km long, lies adjacent to the cantonments at Karkh. A quadrilateral enclosure (9×6 km) to the southeast appears to be a hunting reserve (ḥayr). On its south side at al-Musharrahat (1g) there is a palace facing on to a basin.

Ja'far al-Mutawakkil (r. 847–61) was the greatest builder at Samarra, doubling the size of the city. He built a new congregational mosque, known as the Great Mosque (848–52; 1h; see also ARCHITECTURE, fig. 4). Measuring 239×156 m, it was for many centuries the largest mosque in the world. Its minaret (original h. 52 m) has an external spiral ramp and is known as the Malwiyya ("spiral"; see MINARET, fig. 1). The unusual form of the minaret has often been linked to the Mesopotamian ziggurat, but it may have been a circular variation of later ancient brick towers. It seems to have inspired European depictions of the Tower of Babel as a spiral. In the 850s al-Mutawakkil had a new cantonment built for his son al-Mu'tazz in the south at Balkuwara. It had a rectangular palace, set inside a square enclosure (1171×1171 m) and facing the river. The reception halls form a square block with a central dome chamber and four iwans arranged in a cross. The iwan, excavated by Herzfeld in 1911, has walls adorned with tall niches and Style C stuccos. The cantonment known as al-Istabulat (1i) lies on the west bank. It has a rectangular palace on the Tigris and a second walled rectangle (2.5×0.5 km) containing a partly finished cantonment. Identified probably as al-'Arus ("the Bride"), it is certainly one of the 19 palaces al-Mutawakkil is credited with building. In 859

2. Samarra, detail showing Style C stuccowork, c. mid-9th century (Berlin, Museum für Islamische Kunst); photo credit: Sheila S. Blair and Jonathan M. Bloom

al-Mutawakkil began to lay out al-Mutawakkiliyya (1j), a new city to the north of Samarra bordering the cantonment of Ashnas at Karkh. The main palace, the Qasr al-Ja'fari (1k), had reception halls at the junction of the Tigris and the Qatul al-Kisrawi, while accommodation blocks spread for 1.7 km to the east. A grand avenue (w. 98 m) leading south to Sur Ashnas was flanked by palaces and houses. The congregational mosque for the new city is known as the mosque of Abu Dulaf (1l). Measuring 213×135 m and having arcades of fired brick supported on piers and a spiral minaret (h. 16 m), it is a smaller replica of al-Mutawakkil's congregational mosque at Samarra. To the north of al-Ja'fariyya, there is another hunting reserve with a double enclosure wall, four gates and a viewing mound at Tell al-Banat. In 861, only two years after the city was begun and six months after al-Mutawakkil took up residence there, he was murdered and his new city abandoned.

In the decade following al-Mutawakkil's murder, the Turkish corps made and unmade four caliphs; the Turkish corps declined in importance only in the 870s, when drafted to fight the Zanj revolt in southern Iraq. Al-Mu'tamid (r. 870–92) continued to live at Samarra; his nephew al-Mu'tadid (r. 892–902) re-established residence in Baghdad. The Qubbat al-Sulaibiyya (1m), on the west bank opposite the Dar al-Khilafa, is an octagonal domed building (diam. 19 m) with an ambulatory, raised on an open platform with four ramps. Herzfeld identified it as the mausoleum of al-Muntasir (r. 861–2), which would make it the first monumental mausoleum in Islam. However, it is now certain that al-Muntasir was buried in al-Sawsaq. Its formal similarity to the Dome of the Rock (see JERUSALEM, §II, A) has also suggested an identification with a "Ka'ba" reported to have been built by the caliph to allow his amirs to perform the pilgrimage ceremonies locally. The Qasr al-'Ashiq (rest. 1983; 1n), the best-preserved of the palaces, stands on a hill overlooking the right bank. It is a rectangle (140×90 m) with bastioned walls and can be identified with al-Ma'shuq ("the Beloved"; 878–82) built

by al-Muʿtamid. The building, mounted on a platform of barrel vaults, is constructed of fired brick and gypsum blocks. The interior has a cruciform arrangement of halls facing on to an interior court. It is notable for the earliest known use of a pointed arch struck from four centers.

Parts of the city were plundered by Bedouins and other brigands in the 880s, and, despite an attempt by al-Muktafi (r. 902–8) to resettle at Samarra, the city declined rapidly, contracting into the walled town of Karkh, the village of Matira (1e) and the market area of Samarra itself. Post-Abbasid Samarra contains the tomb of the 10th and 11th imams of the Shiʿa, al-Hasan al-ʿAskari and al-Hadi (d. 874), and the site where the 12th imam disappeared in 878. The imams were buried in a house near the original congregational mosque of al-Muʿtasim, and the site was first developed as a shrine by the Hamdanid (r. 905–1004) and Buyid (r. 932–1062) dynasties, who were both Twelver Shiʿis and venerated the imams. The shrine complex was rebuilt several times, most recently in the 19th century, although a "cave" (Arab. sirdāb) still bears an inscription of the caliph al-Nasir li-Din Allah (r. 1180–1225).

Samarra remained a small town supported by the pilgrimage trade to the shrines of the imams until the 20th century. The site was first excavated under the direction of Henri Viollet in 1907 and 1909 and ERNST HERZFELD in 1911 and 1913. German excavations were curtailed by the outbreak of World War I. Archaeological fieldwork recommenced in the 1930s, and in the 1980s Northedge began a systematic survey which was hampered by political developments in the 1990s. The construction of a dam to prevent flooding downstream in the first half of the 20th century ultimately led to a sharp increase in the town's population, particularly of Sunnis, despite the presence there of major Shiʿi shrines. Following the 2003 invasion of Iraq, tensions erupted between various factions. In April 2005 a bomb destroyed the top tier of the Malwiya minaret, and in February 2006 bombs destroyed the golden dome over the tomb of Hasan al-ʿAskari. In June 2007 the twin minarets flanking the ruined dome were also destroyed.

Aḥmad ibn Abī Yaʿqūb ibn Wādiḥ al-Yaʿqūbī: *Kitāb al-buldān* [Book of lands] (AD 889); ed. M. J. de Goeje, Bibliotheca Geographorum Arabicorum, vii (Leiden, 1892/*R* 1967); Fr. trans. by G. Wiet as *Les Pays* (Cairo, 1937)

F. Sarre and E. Herzfeld: *Archäologische Reise im Euphrat- und Tigris-gebiet*, i (Berlin, 1911)

E. Herzfeld: *Der Wandschmuck der Bauten von Samarra und seine Ornamentik* (1923), i of *Die Ausgrabungen von Samarra* (Berlin and Hamburg, 1923–48)

E. Herzfeld: *Die Malereien von Samarra* (1927), iii of *Die Ausgrabungen von Samarra* (Berlin and Hamburg, 1923–48)

K. A. C. Creswell: *Early Muslim Architecture*, ii (Oxford, 1940) *Ḥafriyyāt Sāmarrāʾ, 1936–1939* [Excavations at Samarra, 1936–9], 2 vols. (Baghdad, 1940)

E. Herzfeld: *Geschichte der Stadt Samarra* (1948), vi of *Die Ausgrabungen von Samarra* (Berlin and Hamburg, 1923–48)

A. Susa: *Rayy Sāmarrāʾ fī ʿahd al'khilāfa al-ʿabbāsiyya* [The irrigation of Samarra during the Abbasid caliphate], 2 vols. (Baghdad, 1948)

J. M. Rogers: "Samarraʾ: A Study in Medieval Town Planning," *The Islamic City*, ed. A. H. Hourani and S. M. Stern (Oxford, 1970), pp. 119–55

A. Northedge: "Planning Samarraʾ: A Report for 1983–4," *Iraq*, xlvii (1985), pp. 109–28

A. Northedge and R. Falkner: "The 1986 Survey Season at Samarraʾ," *Iraq*, xlix (1987), pp. 143–73

A. Northedge: "The Racecourses at Sāmarrāʾ," *Bull.* SOAS, liii (1990), pp. 31–56

A. Northedge: "An Interpretation of the Palace of the Caliph at Samarra (Dar al-Khilafa or Jawsaq al-Khaqani)," *A. Orient.*, xxiii (1993), pp. 143–70

C. F. Robinson, ed.: *A Medieval Islamic City Reconsidered: An Interdisciplinary Approach to Samarra,* Oxford Stud. Islam. A., xiv (Oxford, 2001)

T. Leisten: *Excavation of Samarra: Volume 1: Final Report of the First Campaign, 1910–1912*, Baghdader Forschungen, xx (Mainz am Rhein, 2003)

A. Northedge: *The Historical Topography of Samarra,* Samarra Studies, i (London, 2005)

A. Northedge: "Remarks on Samarra and the Archaeology of Large Cities," *Antiquity*, lxxix (2005), pp. 119–29

Sami [Sami Efendi; Mehmed Sami] (*b.* Istanbul, 13 March 1838; *d.* Istanbul, 1 July 1912). Ottoman calligrapher. He was the son of Mahmud Efendi, the head of the quilt-makers guild. Sami learned *taʿlīq* script from the calligraphers Kibriszade Ismail Hakkı Efendi and Ali Haydar Bey (1802–70) and *thuluth* script from Boşnak Osman Efendi. He was also inspired by the work of MUSTAFA RAQIM. Sami's fine inscriptions and calligraphic compositions adorn several mosques and fountains in Istanbul. He trained such calligraphers as NECMEDDIN OKYAY and Ahmed Kamil Akdik (1862–1941) and was buried in the cemetery of the Fatih Mosque, Istanbul.

Ş. Rado: *Türk hattatları* [Turkish calligraphers] (Istanbul, n.d.), pp. 239–41

U. Derman: *Hattat Sami Efendi (1838–1912): Hayatı ve eserleri* [The calligrapher Sami Efendi (1838–1912): his life and works] (Istanbul, 1962)

Letters in Gold: Ottoman Calligraphy from the Sakip Sabanci Collection, Istanbul (exh. cat. by M. U. Derman; New York, Met.; Los Angeles, CA, Co. Mus. A.; Cambridge, MA, Harvard U. A. Mus., 1998–2000)

Sanʿa [Ṣanʿāʾ]. Capital city of the Republic of Yemen, with a population of 1.7 million (2004 census). The largest city in South Arabia for much of the last two millennia, Sanʿa is strategically situated at the point where the central highland plain narrows: it controls the movement of people and goods north from the important spice-growing areas and the Indian Ocean to the Mediterranean and west from the ancient Sabaean capital at Maʾrib to the Red Sea ports. By the 2nd century CE it had become the second capital of Sabaʾ (Heb. Sheba). In the 3rd century a splendid fortified palace known as Ghumdan was erected to

the west of the town. It is said to have been a square building of seven (or ten, or twenty) stories, guarded at its corners by bronze lions' heads that roared when the wind blew. The windowed room at the top was roofed with a slab of marble or alabaster. In the 4th century, when Judaism and Christianity began to replace the old polytheistic cult, churches were built. The cathedral was erected, reputedly by two builders sent by Justinian, after the Abyssinian conquest in 525. According to the historian al-Azraqi (d. 837), a steep flight of alabaster steps on the west led to a podium (h. 5 m). The nave had colored marble paving, alabaster windows and columns of precious wood, which were painted and decorated with gold and silver. Beyond lay an iwan and an unusually large domed chamber decorated with mosaics, which were stripped in 684 to decorate the Ka'ba in Mecca.

In the early 7th century, when Yemen converted to Islam, a congregational mosque was erected in the governor's garden to the west of Ghumdan. The architectural history of this mosque is exceedingly complex. According to some sources, the Prophet Muhammad specified its plan and construction, but the building was enlarged and reconstructed on the orders of the Umayyad caliph al-Walid I (r. 705–15) and again in 753–4 with materials removed from the cathedral. In 875–6 it was ruined in a great flood, but was soon rebuilt in stone and gypsum and roofed with teak, although this structure too was repeatedly restored and repaired. The hypostyle plan and individual elements may go back to the earliest centuries of Islam, but the rich decoration in carved and painted wood, carved stone and stucco epitomizes the finest of Yemeni craftsmanship over the centuries (see ARCHITECTURE, §V, B, 4). In 1965, after severe damage by a storm, an extraordinary cache of fragments of early manuscripts of the Koran was discovered in the ceiling.

The city is graced with many other religious structures, including the Jabbana, an enclosure for open-air prayer outside the walls (see MUSALLA), and the mosque of Farwah ibn Musayk, one of the Companions of the Prophet. Although both buildings were founded in the 7th century, they have been extensively restored. Several mosques (e.g. the Madrasa and Filayhi mosques) were built or restored under the Rasulids (r. 1229–1454); they use the stilted keel arch, which remained characteristic until Ottoman styles were introduced in the 16th century. The Ottoman governor Hasan Pasha began the great domed mosque of al-Bakiriyya in 1597; the design is so completely Ottoman that it may well be the work of a Turkish architect. Despite the acceptance of other Ottoman mosque elements, patterned brick minarets were characteristic of all mosques after the early 16th century, e.g. the Madrasa and Salah al-Din mosques.

Many multi-story houses typical of traditional Yemeni cities survive in San'a (see color pl. 3:VI, fig. 1 and VERNACULAR ARCHITECTURE, fig. 7). Stone was used for the lower stories and lighter materials for the upper levels, where the principal room for entertaining and finest part of the building was found. As early as the 9th century, San'a was described as a city of mansions and tall towers adorned with gypsum, brick and dressed stones. The oldest surviving house is thought to be one built of stone and earth in Harat al-'Alami; its existence is attested in legal documents from the 14th century. Stylistic features, such as stepped masonry and massive timbers embedded in walls, suggest that the lowest stone levels of several houses are more than 500 years old, and oral tradition suggests that the lower stories, including fine reception rooms, of some of the large houses in the Zabara quarter date to the late 14th century.

Since pre-Islamic times palaces have been traditionally built on the western side of the city. The Ayyubid rulers in the late 12th century built a palace to the west of the wadi that bisects the city in an area subsequently known as the "Sultan's Garden." In the 17th century a ruler built his palace further west on the site of the present Mutawakkil Palace. Other large buildings in the old city are the great caravanserais (Arab. samsara) that surround the market. They belong to a peculiar south Arabian type in which high stables and storerooms on the lower levels support upper levels with raised courtyards surrounded by lodgings for merchants and drovers. The Samsarat al-Baw'ani is said to be the oldest caravanserai close to its original state, although the Samsarat al-Majjah, reputedly more than 300 years old, is more typical. On the exterior, the stone walls of the lower three levels are surmounted by elaborate blind arcades concealing the upper three stories of brick. Seventeen public baths survive in the city, of which the oldest is believed to be Hammam Yasir and one of the largest is Hammam al-Maydan (c. 1600), built by Hasan Pasha. Since the revolution in 1962 San'a has undergone extraordinary development, not all of it beneficial. A law promulgated in 1974 requires that new building be executed in traditional styles in order to maintain visual harmony in this unique assemblage of traditional Yemeni urban form. In 1986 the Old City was inscribed on the Unesco World Heritage List.

City of San'ā' (exh. cat., ed. J. Kirkman; London, BM, 1976)

G. Bonnenfant and P. Bonnenfant: Les Vitraux de Sana'a (Paris, 1981)

R. B. Serjeant and R. Lewcock, eds.: San'ā': An Arabian Islamic City (London, 1983)

Masāhif San'ā' [Manuscripts of the Koran from San'ā'] (exh. cat., Kuwait City, Mus. Islam. A., 1985)

B. Finster: "Die Grosse Moschee von San'ā': 4. vorläufiger Bericht," Archäol. Ber. Yemen, iii (1986), pp. 185–93

R. B. Lewcock: The Old Walled City of San'ā' (Paris, 1986)

H. Kopp and others: Sanaa: Développement et organization de l'espace d'une ville arabe (Aix-en-Provence, 1993)

K. A. Al-Sallal: "Sana'a: Transformation of the Old City and the Impact of the Modern Era," Planning Middle Eastern Cities: An Urban Kaleidoscope, ed. Y. Elsheshtawy (London, 2004), pp. 85–113

Saqqakhana [Saqqakhaneh; Pers. saqqākhāna]. Iranian art movement of the 1960s. The artists of the Saqqakhana movement introduced in their work a new vocabulary of motifs derived from Iranian

folklore and the folk art of the Shi'a. The term was first used by the Iranian art critic Karim Emami to describe the paintings of HUSSEIN ZENDEROUDI at the third Tehran Biennale in 1962. For Emami, Zenderoudi's paintings captured the mood of Shi'i folk art, and he used the term *saqqākhāna*, the Persian name for public drinking fountains traditionally found on street corners, to describe it. These votive fountains comprise a niche with a water tank, metal bowl and other items and usually contain the portrait of one of the Shi'a imams, metal trays with candle-holders and small locks or pieces of rag fastened to symbolize pious wishes. Zenderoudi had been influenced by Shi'i folk art as early as 1959, when he visited Rayy, a Shi'i center south of Tehran, with PARVIZ TANAVOLI and saw posters that employed simple forms, repeated motifs and bright colors. The sketches he made on the basis of these posters were the first Saqqakhana works. He continued to paint works inspired by Shi'i folk art in the 1960s, while Tanavoli experimented with religious subject matter in sculpture.

The movement spread in particular among artists who attended the College of Decorative Arts in Tehran. Hussein Zenderoudi was a student at the College for a few months, Parviz Tanavoli taught sculpture there in the early 1960s, and the Saqqakhana artists Faramarz Pilaram (1937–83), Sadeq Tabrizi (*b.* 1938), MASSOUD ARABSHAHI and Mansur Qandriz (1935–65) also studied there. Karim Emami's friendship with these artists also began at the College. The public success of the movement can be attributed to the use of Iranian motifs and the publicity brought about by the Tehran Biennales, which lasted until 1966. While the movement relied at the outset on Shi'i folk art, it later broadened its base to include motifs from other sources. Massoud Arabshahi in particular was notable for employing pre-Islamic motifs in the same spirit.

Saqqakhaneh (exh. cat. by K. Emami and P. L. Wilson; Tehran, Mus. Contemp. A., 1977)

E. Yarshater: "Contemporary Persian Painting," *Highlights of Persian Art*, ed. R. Ettinghausen and E. Yarshater (Boulder, 1979), pp. 363–78

H. Keshmirshekan: "Neo-traditionalism and Modern Iranian Painting: The Saqqa-khaneh School in the 1960s," *Iran. Stud.*, xxxviii (2005), pp. 607–30

Sarajevo. Capital city of BOSNIA AND HERZEGOVINA on the River Miljacka. Already settled in the Neolithic period, the site was was colonized in the 1st century CE by the Romans, and in the early Middle Ages a settlement called Vrhbosna ("peak of Bosnia") was established on the ruins of the Roman town. Bosnia was at that time under the jurisdiction of the Roman Catholic Church, and fragments of Romanesque capitals and columns dating to the 11th and 12th centuries have been discovered in several locations. Medieval Vrhbosna is mentioned in the charter (1244) of King Bela IV of Hungary (*r.* 1235–70), and the town flourished in the early 15th century under the rule of the Bosnian kings. It fell to the Ottoman Turks in 1435

and remained under Ottoman domination for 400 years. The name Sarajevo dates from this period. The urban development of the city was financed mainly by Bosnian grandees who had converted to Islam. Gazi Ishakbey Ishaković-Hranušić built a mosque (1462), baths and caravanserai, shops, mills and the first European fresh-water supply system, which, together with an elegant bridge, formed the nucleus of modern Sarajevo. Gazi Husrefbey erected one of the most romantic mosques in the Balkans (1521–31; damaged 1992–4). He also built a madrasa (1537; damaged 1992); steam baths (hammam), which were in use until World War II; a library of 25,000 volumes (1537; destr. 1992); and a covered market (1551), among other projects. Further public buildings were added in the course of the 16th century: the Ali Pasha Mosque (1560–61; damaged 1992), the Ferhadija Mosque (1561; damaged 1992), the Sultan's Mosque (1566; damaged 1992) and the Old Synagogue (now the Jewish Museum; damaged 1992).

The most important additions of the 17th century were the clock tower and a stone bridge, while in 1727 fortifications, including several city gates, were erected around the old town. In 1797 the Latin Bridge was built. At this time the city had *c.* 4500 houses; trade and crafts flourished, governed by *c.* 30 guilds. The residential districts were on the slopes of the hills surrounding the business center in the valley. Each residential district of 40 houses was served by a mosque, school and shops. Houses were detached and set in lush gardens. The principle of the vertical and horizontal layout allowed each house uninterrupted views over the town. Typically, around each house's solidly built core was a lightweight timber tracery of projecting loggias and verandahs. The interiors were almost minimalist, with built-in ornamented cupboards, settees around the walls and basic showers (the water was heated in large earthenware stoves). There were up to 5 miles of water pipes, 70 schools, 50 hotels (hans) and 7 public baths, as well as numerous cafés.

The Austro-Hungarian occupation in 1878 made an ambivalent impact on the urban character of the city. On the one hand, its effect was regressive as the heavy hand of the European planners lacked the sophistication and sensitivity of the Bosnians. On the other hand, electrification and the railway network brought Bosnia into the modern world. The first urban plan was drawn up in 1891. Planning intervention consisted mainly in straightening out the irregular pattern of medieval streets and the banks of the River Miljacka. Massive public buildings altered the scale of the lower city but disproved theories about the need for urban homogeneity. The differences between the two planning and architectural approaches came later to be recognized as Enriching and dynamic. The break-up of the Austro-Hungarian Empire in 1918 was a retrograde step in terms of urban planning. The "Europeanization" by Austria-Hungary had been carried out with characteristic thoroughness and seriousness, while the Yugoslav regime was culturally inferior and gave free rein to provincial speculators and small-scale developers. This led to an obvious decline in the

city, which swung after World War II to another damaging extreme: the building explosion of massive "socialist" projects, which proved equally dismal. The Americanization of the city in 1984 in honor of the Winter Olympic Games of that year further distorted the image of the town. In the three-year civil war that followed Bosnia's secession from Yugoslavia in 1992, the city was besieged, and many of its buildings destroyed or severely damaged.

Since then, however, the economy has been subject to reconstruction and rehabilitation. The Central Bank opened in 1997 and the Stock Exchange began trading in 2002. Tourism recovered and the city underwent a building boom, as new commercial, industrial, and residential structures were built and old buildings damaged in 1992 were restored. The Holiday Inn (1983; architect Ivan Straus), for example, reopened in 2008 as part of the Grand Media Complex.

The National Museum of Bosnia and Herzegovina (established 1888) is home to the Sarajevo Haggadah, one of the oldest surviving copies of the text, made in Barcelona c. 1350 and brought by Jews fleeing the Spanish Inquisition. Contemporary art flourished after the civil war, but has been somewhat restricted by lack of funding. The Sarajevo Center for Contemporary Art, founded in 1996 as part of George Soroš's Open Society Project, is run on a project-by-project basis, mounting outdoor shows investigating the effects of war. The Ars Aevi Museum of Contemporary Art has a permanent collection of some 130 works, and a new building, designed by Renzo Piano (b. 1937), is scheduled to open by 2009. The rich collection of manuscripts in the Oriental Institute and much of the National Library were badly damaged by bombing in 1992.

See also BOSNIA AND HERZEGOVINA.

Enc. Islam/3

D. Grabrijan and J. Neidhardt: *Arhitektura Bosne i put u savremeno* [The architecture of Bosnia and towards the Modern Movement] (Sarajevo, 1953)

Enciklopedija likovnih umjetnosti [Encyclopedia of fine arts], iv (Zagreb, 1966), pp. 163–4

A. Riedlmayer: "Convivencia under Fire: Genocide and Book Burning in Bosnia," *The Holocaust and the Book: Destruction and Preservation*, ed. J. Rose (Amherst, MA, 2001), pp. 266–91

A. Riedlmayer: "The Bosnian Manuscript in Gathering Project," *Int. J. Turk. Stud.*, x/1–2 (2004), pp. 27–33

Sarkhej. Site about 8 km west of Ahmedabad, India. The extensive complex was begun by the second ruler of the Gujarat Sultanate, Muhammad Shah (r. 1442–51), who constructed a mausoleum and mosque in honor of his adviser, the famous saint Shaykh Ahmad Khattu (d. 1446). Completed by Muhammad Shah's successor Qutb al-Din Shah (r. c. 1452–8), this sacred place became a retreat for the sultans of Gujarat. Mahmud Bigara (r. c. 1458–c. 1511), the most famous and powerful of them, added a large tank surrounded by broad steps and separate palaces for himself and his female household; later, he erected a mausoleum

opposite that of the saint, in which he, his son Muzaffar II and his queen Rajbai were buried. Both mausolea were built in the Gujarati Sultanate style that flourished in the 15th and 16th centuries and comprise pillared halls with central tombs enclosed by perforated stone screens carved with a variety of geometric and floral motifs. In 1584 the military commander of the Mughal emperor Akbar's army celebrated his victory over the Gujarati sultans by creating a pleasure-garden, the Fateh Bagh ("Garden of Victory").

G. Michell and S. Shah, eds.: "Mediaeval Ahmadabad," *Marg*, xxxix/3 (1988) [whole issue]

C. E. B. Asher: *The Architecture of Mughal India* (Cambridge, 1994), p. 10

Sarre, Friedrich (*b.* Berlin, 22 June 1865; *d.* Neubabelsberg, 1 June 1945). German archaeologist, art historian and collector. He traveled to the Middle East and met Carl Humann (1836–96), who was excavating Pergamon and advised Sarre to study the monuments of medieval Anatolia. In 1895 he visited Phrygia, Lycaonia and Pisidia and in 1896 went on a longer journey in Asia Minor. His principal aim was to discover architectural monuments and archaeological sites; he always traveled with a trained architect and became a talented photographer. He also collected epigraphic material which he sent to such Arabists as Bernhard Moritz, Eugen Mittwoch and MAX VAN BERCHEM. In the years 1897 to 1900 Sarre traveled to Iran. Objects from his collection were exhibited in Berlin (1899) and at the *Exposition des arts musulmans* (Paris, 1903). In 1905 he met the young ERNST HERZFELD, and in 1907–8 they traveled together from Istanbul via Aleppo and Baghdad to the Gulf to find an Islamic site suitable for excavation. Their choice, which Herzfeld later described as Sarre's, fell upon SAMARRA, the capital of the Abbasid dynasty in the 9th century CE, and their travels were published as *Archäologische Reise im Euphrat- und Tigris-Gebiet*. Sarre's wide range of interests also led him to write on other topics, such as the Persian painter RIZA and on carpets in the catalogue to the Munich exhibition of Islamic art (1910). Most of his private collection was eventually given to the Kaiser-Friedrich Museum in Berlin; he also collected on behalf of the Museum with Wilhelm Bode. Many of the items were destroyed during World War II, and the looting and burning of his house shortly after his death led to the destruction of other works of art, his library, photographs and papers.

WRITINGS

Denkmäler persischer Baukunst, 2 vols. (Berlin, 1901–10)

with E. Herzfeld: *Iranische Felsreliefs* (Berlin, 1910)

with E. Herzfeld: *Archäologische Reise im Euphrat- und Tigris-Gebiet*, 4 vols. (Berlin, 1911–20)

with F. R. Martin: *Die Ausstellung von Meisterwerken muhammedanischer Kunst*, 4 vols. (Munich, 1911–12/R London, 1985)

with E. Mittwoch: *Die Zeichnungen von Riza ʿAbbasi* (Munich, 1914)

Konia: Seldschukische Baudenkmäler (Berlin, 1921)
Die Kunst des alten Persien (Berlin, 1922)
Islamic Bookbindings, trans. F. D. O'Byrne (Berlin, 1923)
Die Keramik von Samarra (1925), ii of *Die Ausgrabungen von Samarra* (Berlin and Hamburg, 1923–48)
"Die Keramik der islamischer Zeit," *Das islamische Milet*, ed. K. Wulzinger and P. Wittek (Berlin, 1935)
Der Kiosk von Konia (Berlin, 1936)

BIBLIOGRAPHY

Friedrich Sarre Schriften (Berlin, 1935)
W. Cohn: Obituary, *Burl. Mag.*, lxxxviii/515 (Feb. 1946), p. 46
R. Ettinghausen: Obituary, *Coll. A. J.*, v/4 (May, 1946), pp. 359–60
E. Herzfeld: Obituary, *A. Islam.*, xi–xii (1946), pp. 210–12
A. Northedge: "Friedrich Sarre's *Die Keramik von Samarra* in Perspective," *Continuity and Change in Northern Mesopotamia from the Hellenistic to the Early Islamic Period*, ed. K. Bartl and S. R. Hauser (Berlin, 1996), pp. 229–58
D. J. Roxburgh: "Au bonheur des Amateurs: Collecting and Exhibiting Islamic Art, ca. 1880–1910," *A. Orient.*, xxx (2000), pp. 9–38

Sarvistan [Sarvistān; Sarvestān]. Iranian site near the town of the same name in the province of Fars, *c.* 100 km southeast of Shiraz. It consists of a large ruined building that stands isolated in a valley, once famous for its cypress trees but now desolate. The site remains unexcavated. "Discovered" in 1810 by William Ouseley (1767–1842), it was visited in 1840 by Flandin and Coste, who recorded the building in some detail and attributed it to the Sasanian period (224–632 CE). Dieulafoy, however, believed that the building belonged to the Achaemenian period (538–331 BCE), but Flandin's and Coste's dating has been more generally accepted and was refined by Herzfeld, who identified the "palace" as that said to have been built in Fars by Mihr Narseh, the minister of the Sasanian king Bahram V (*r.* 420–38), in a garden planted with 12,000 cypresses. Bier showed that a date in the early Islamic period seems likely on the basis of a comparison with such monuments as the Abbasid palace at Ukhaydir in Iraq (*c.* 778).

The building at Sarvistan (*c.* 45×37 m) contains some 13 interconnected rooms and columned halls grouped around a central court. Its walls are constructed of mortar and rubble faced with roughly shaped stones. The brick vaulting has mostly fallen, but enough remains to permit the reconstruction of domes and semi-domes on squinches, barrel vaults, and transverse vaults on diaphragm arches. The building's original appearance must have been severe, as its only decoration consists of wall niches in some rooms and stucco "sawtooth" friezes marking the springing of vaults. The walls do not seem to have been plastered, and it is unlikely that they ever bore the painted scenes envisioned by earlier writers. The similarity of its general layout to that of the Zoroastrian sanctuary at Takht-i Sulayman in northwest Iran led Bier to suggest that the building was a fire temple rather than a palace or garden pavilion.

In the town of Sarvistan itself is the mausoleum of Shaykh Yusuf Sarvistani, dated by inscriptions to between 1281 and 1350. Built of dressed stone, it is an open-sided, square structure, the dome of which is supported by four groups of three columns.

W. Ouseley: *Travels in Various Countries of the East; More Precisely, Persia*, ii (London, 1821), pp. 73–7
E. Flandin and P. Coste: *Voyage en Perse: Perse ancienne*, i (Paris, 1843), pp. 23–7, pls. 28–9
M. Dieulafoy: *L'Art antique de la Perse: Achéménides, parthes, sassanides*, iv (Paris, 1885)
F. Sarre and E. Herzfeld: *Archäologische Reise im Euphrat- und Tigris-Gebiet*, ii (Berlin, 1920), pp. 332–3
O. Reuther: "Sasanian Architecture," *Survey of Persian Art*, ed. A. U. Pope and P. Ackerman (Oxford, 1938, 2/1964–7), ii, pp. 493–578, figs. 133–4, 151–2; iv, pls. 148A–C
M. Siroux: "Le palais de Sarvistān et ses voûtes," *Stud. Iran.*, ii (1973), pp. 49–65
E. Galdieri: "Un Exemple curieux de restauration ancienne: La Xodâ-Xâne de Chiraz," *Art et société dans le monde iranien*, ed. C. Adle (Paris, 1982), pp. 297–309
L. Bier: *Sarvistan: A Study in Early Iranian Architecture* (University Park, PA, 1986)

Sasaram [Pers. Sahsarām]. Town in Rohtas District, Bihar, India. It is the site of an Ashokan inscription from the 3rd century BCE and several fine tombs from the 16th century CE. Sasaram was probably situated on an important early trade route. The edict issued by the emperor Ashoka (*r. c.* 269–232 BCE) is inscribed on the wall of a rock-cut cave located near the summit of Chandan Shahid Hill, about 4 km south of the town center. Its eight-line text in Brahmi script calls on all subjects to commit themselves to the goal of piety. The single-chambered enclosure is probably contemporary with the edict; its entrance of plaster-covered bricks suggests later additions were made to the rock-cut core.

A second rock-cut cave at Tara Chandi Hill, 1.5 km away, has a 12th-century inscription naming the site as Sasaram. At the entrance to the cave are the remains of a structural porch. A nearby rock-cut sculpture possibly depicts the Hindu deities Shiva and Parvati. Pre-Islamic period remains found at Sasaram also include a life-size image of the Hindu god Vishnu and coins.

Islam became an important force in the area in the 14th century, probably the period when the Muslim saint Pir Chandan Shahid lived in the vicinity. His grave is situated about 9 m from the cave with the Ashokan edict, known locally as "the lamp house of the martyred saint, Pir Chandan" (Pers. *chirāqdān-i Pīr Chandan Shahīd*). The grave is marked by a stepped cenotaph (h. approx. 1.2 m). To the west is a small rectangular wall mosque, which has a simple mihrab and is surmounted by battlements. Austere structures of this type are characteristic of the 14th century, although an inscription associated with the tomb indicates 19th-century repair work. Near the tomb is a rubble-built mosque with access to the roof, where a single wall on the qibla side is faced by

an open-air prayer area. The mosque is undated and may have been built in several stages.

During the rule of the Delhi sultans of the Lodi dynasty (1451–1526), Sasaram, situated in their easternmost territories, was given as a landholding (*jāgīr*) to Hasan Sur, a petty Afghan noble. On Hasan Sur's death *c.* 1526, the landholding was passed to his son, Farid Sur, the future ruler Sher Shah Sur (*r.* 1538–45), who ousted the Mughal emperor Humayun. Sher Shah and his successors (1545–55) ruled from Delhi but maintained Sasaram as their dynastic burial ground. The two most impressive tombs are those Sher Shah constructed for his father, Hasan Sur, and for himself.

Hasan Sur's tomb is a larger (diam. 34.5 m) and more elaborate version of the octagonal tombs built for such Delhi sultans as Sikandar Lodi (*r.* 1489–*c.* 1517). While the Delhi tombs viewed from the exterior rise in two stages, Hasan Sur's is built in three. The central domed chamber is surrounded by a verandah that forms the lowest level. It has three arched entrances on each of its eight sides, and each is roofed with three low domes. The second level, also octagonal in plan, has a *chatri* (domed pavilion) at each angle. The third level is formed by the great dome. The tomb's central chamber contains the graves of Hasan Sur and other family members. The structure is enclosed in a walled rectangular compound (106×91 m). Integrated in the western wall is a multi-bay, three-aisled mosque. Outside the enclosure are a serai and a large stepped tank with a pillared gallery at water-level for religious meditation.

A Persian inscription in the tomb building indicates it was constructed after Sher Shah assumed the title sultan in 1538. The construction of such a monumental tomb for a low-ranking, long-deceased relative was unprecedented in the Islamic tradition. In building this tomb (and one for his grandfather in Narnaul) and by using structural types associated with royalty and/or saints, Sher Shah seemingly enhanced his undistinguished genealogy.

Sher Shah's own octagonal tomb (diam. 41.5 m), completed three months after his death by his son and successor Islam Sur (*r.* 1545–54), was at that time the largest mausoleum in the subcontinent. A more refined version of Hasan Sur's tomb, it is also built in three stages; *chatris* have been used to embellish the roofs of the first and second octagonal levels. The central dome was also originally surmounted by a *chatri*, but in the 19th century it was replaced by a finial type found commonly on Hindu temples and Muslim tombs. The mausoleum is situated in the center of a large rectangular artificial tank (370×292 m). The tomb sits askew on its stepped plinth so that the west wall containing the mihrab is aligned with the qibla axis, suggesting that the tank and its central island were pre-existing works reused by Sher Shah. Koranic verses carved on the tomb's mihrab indicate that, for the purpose of this tomb, the pool represents the waters of paradise—the just reward for devout Muslims.

Planned as a larger version of Sher Shah's tomb, the mausoleum of his son and successor, Islam Shah Sur, was never completed beyond the ground floor. It is situated in the middle of an even larger tank (385 sq. m). All three tombs are constructed of rubble faced with a local, dressed buff sandstone. Traces of glazed and painted decoration can still be seen.

A non-royal tomb is said to be that of 'Alawal Khan, reputedly the architect of Sher Shah's tomb. Probably built by 'Alawal Khan himself in the mid-16th century, it consists of a high-walled enclosure (34.4 m sq.) surrounding three simple tombstones. Some 100 m northeast of Sher Shah's tomb is a small square tomb within a rectangular enclosure. Constructed of rough stone and covered with a stucco veneer, it resembles early to mid-16th-century buildings in the Delhi region.

In the early 17th century Safdar Khan, a major landholder in the Mughal province (Pers. *sūba*) of Bihar, made Sasaram his administrative center. A ruined mansion is said to be Safdar Khan's; its plan and style suggest an early 17th-century date. The main structure of this complex is a multi-story building with a large central reception room (*dīwān khāna*), the vaulted ceiling of which extends the entire height of the building. Surrounding this chamber on various levels are smaller rooms reached by stairs. The deeply recessed vaulting of the exterior façades is covered with finely cut and polychromed stuccowork. The complex also has pillared galleries and a bath (*ḥammām*).

During the time of Safdar Khan's tenure in Sasaram, one 'Ali Akbar constructed a mosque dated AH 1022 (1613–14) at the foot of Pir Chandan Hill. Although his identity is disputed, 'Ali Akbar was clearly a man of considerable wealth, for he subsequently constructed an entire new township about 20 km west of Sasaram. When the mosque was renovated in the late 19th century, stone slabs from the original structure, beautifully carved with calligraphy intertwined with floral arabesques, were embedded in the newer construction.

During 1633–6 a mosque (destr.) and an *'īdgāh*, where the male Muslim population of the town gathered for 'Id prayers, were constructed near Sher Shah's tomb. They were provided by Majahid Khan, the *faujdār* (officer in charge of law and order) of Sasaram. The *'īdgāh* consists of a wall marked by mihrabs facing a large open courtyard. Sasaram declined as an administrative center in the late 17th century and no further notable monuments were constructed after this date.

'Abbas Khan Sarwani: *Tārīkh-i Sher Shāhī* [The history of Sher Shāhī] (*c.* 1579); Eng. trans., ed. S. M. Imam al-Din, 2 vols. (Dhaka, 1964)

Abu Muhammad Muslih: *Tārīkh-i Sahsarām Nāṣir al-Hukkām* (R Sasaram, 1925)

M. H. Quraishi: *List of Ancient Monuments Protected under Act VII of 1904 in the Province of Bihar and Orissa* (Calcutta, 1931)

F. Buchanan-Hamilton: *The History, Antiquities, Topography, and Statistics of Eastern India: Comprising the Districts of*

Behar, Shahabad, Bagalpoor, Goruckpoor, Dinajepoor, Puri-aniya, Ronggopoor, and Assam, 3 vols, ed. M. Martin (London, 1938)

D. R. Patil: *The Antiquarian Remains of Bihar* (Patna, 1963)

K. Qanungo: *Sher Shah and his Times* (Bombay, 1965)

Q. Ahmad: *Corpus of Arabic and Persian Inscriptions of Bihar* (Patna, 1973)

C. B. Asher: "The Mausoleum of Sher Shāh Sūrī," *Artibus Asiae*, xxxix (1977), pp. 273–98

C. B. Asher: "Legacy and Legitimacy: Sher Shah's Patronage of Imperial Mausolea," *Sharī'at and Ambiguity in Southern Asian Islam*, ed. K. P. Ewing (Berkeley, 1988), pp. 79–97

G. H. R. Tillotson: "The Paths of Glory: Representations of Sher Shah's Tomb," *Orient. A.*, xxxvii (1991), pp. 4–16

Saudi [Āl Saʿūd]. Dynasty that has ruled most of the Arabian Peninsula since 1746. The foundations of Saudi rule were laid when Muhammad ibn Saʿud (*r.* 1746–65) formed an alliance with the theologian Muhammad ibn ʿAbd al-Wahhab (*d.* 1791), who wanted to purify Islam in Arabia. Under ʿAbd al-ʿAziz I (*r.* 1765–1803) RIYADH and most of the Najd region came under Saudi rule, and the Hijaz region, including Mecca and Medina, soon followed. Saudi expansion was countered when the Ottoman sultan Mahmud II (*r.* 1808–39) commissioned his viceroy in Egypt, Muhammad ʿAli (*r.* 1805–48), to reconquer the Hijaz and Najd. After the withdrawal of Turco-Egyptian forces, Riyadh was recaptured by Turki (*r.* 1823–34) and became the new capital of a reduced "second" Saudi state. After the death of Faysal I (*r.* 1834–65 with interruption), Saudi fortunes began to wane, and by 1891 the "second" Saudi state had come to an end. ʿAbd al-ʿAziz II (*r.* 1902–53), known in the West as Ibn Saʿud, reconquered the Arabian Peninsula and established the "third" Saudi state. His successes were achieved by alliances with Bedouin tribesmen, who were settled in farming communities and educated. By 1932 the Kingdom of SAUDI ARABIA had been recognized internationally as an independent nation, and from the 1930s the economy was transformed by the discovery of oil.

All three Saudi states constructed and restored many mosques as part of their program to standardize the practice of Islam. Each of the farming settlements established by the "third" state had a new mosque, but the enormous increase of wealth in the 20th century led to major building programs and the rapid expansion of towns and cities. As guardians of MECCA and MEDINA, the Saudi dynasty has also seen to the maintenance and expansion of facilities at the holiest sites of Islam, visited annually by millions of pilgrims.

Enc. Islam/2: "Suʿūd, Āl"

A. Assah: *Miracle of the Desert Kingdom* (London, 1969)

G. R. D. King: *The Historical Mosques of Saudi Arabia* (London, 1986)

J. Kostiner: *The Making of Saudi Arabia 1916–1936: From Chieftaincy to Monarchical State* (Oxford, 1993)

L. McLoughlin: *Ibn Saud: Founder of a Kingdom* (Basingstoke, 1993)

Saudi Arabia, Kingdom of [Arab. Al-Mamlaka al-ʿArabiyya al-Saʿūdiyya]. Country occupying the greater part of the Arabian Peninsula, with its capital at Riyadh. It has an area of *c.* 2,250,000 sq. km, extending from the Red Sea to the Gulf, and has borders in the north with Jordan, Iraq and Kuwait; in the east with Qatar, the United Arab Emirates and Oman; and in the south with Yemen (*see* GEOGRAPHY AND TRADE, fig. 1). In the west of the country is the Hijaz, a narrow coastal plain rising to an escarpment that extends the length of the Red Sea and contains the cities of Mecca, Medina and Jiddah; it is bordered in the south by the hilly plateau of the ʿAsir. East of the Hijaz, desert encircles the Tuwayq escarpment and the plateau of the Najd where the capital is situated; in the north lies the Nafud Desert; in the south the sand dunes of the Dahna extend into the Rubʿ al-Khali, a sand desert that covers a quarter of the kingdom. The indigenous population of *c.* 27,500,000 (2007 estimate), a small percentage of which is Bedouin, consists largely of Sunni Muslims, the majority of whom follow the Wahhabi puritan creed that originated in the 18th century. A small minority of the population is Shiʿa, mainly in the Eastern Province, and there is a large expatriate workforce.

The origins of the modern state date to the first years of the 20th century. ʿAbd al-ʿAziz II (Ibn Saʿud; *r.* 1902–53) left Kuwait, where part of the SAUDI family lived in exile, recaptured Riyadh from the Rashidis (1902) and gradually extended his rule. In the 1920s the Hijaz was taken from Sharif Husayn of Mecca, and ʿAbd al-ʿAziz adopted the title of King of the Hijaz and Najd. In 1932 his territories were renamed the Kingdom of Saudi Arabia. Maladministration under his son Saʿud (*r.* 1953–64) brought internal tensions and near bankruptcy. Saʿud was deposed in favor of his brother Faysal (*r.* 1964–75), who sought to modernize the country and yet retain its traditional values, a sometimes difficult policy that created opponents at both extremes, and was followed, after Faysal's assassination, by his brothers Khalid (*r.* 1975–82) and Fahd (*r.* 1982–2005). After Fahd suffered a stroke in 1995, his half-brother Abdullah served as regent until he succeeded to the throne in August 2005. The country is ruled by the king and senior members of the Saudi family. Repeated calls for some form of representative government led in 1993 to the establishment of a consultative assembly, the *majlis al-shūra*. Men and women are segregated in open society, though education for girls rapidly expanded after the 1960s. Oil, discovered in 1938, changed the country from being one of the world's poorest to one of its richest. Modern development was at its most intensive in the 1970s and early 1980s. Agriculture made dramatic progress in the 1980s, while recession in the 1990s caused the pace of development to slow. Increased oil revenues in the first decade of the 21st century led to huge budget surpluses, which have been spent on reducing national debt and paying for education, development and security measures.

I. Architecture. II. Other arts. III. Archaeology and museums.

I. Architecture. Traditional architecture in Saudi Arabia can be divided into a number of regional styles, reflecting climate and local traditions. In the Najd, buildings have thick walls of unfired mud-brick covered by mud-plaster on stone foundations, with roofing of wooden beams, palm matting or twigs spread with a layer of mud. They are usually attached to neighboring houses to reduce the number of walls exposed to the sun. Courtyard houses of one or two stories are typical, with blank walls and tiny windows. Large wooden doors at the few entrances have geometrical decorations made by painting, carving or burning. The outer walls often have parapets topped by mud crenellations. A few traditional houses survive in RIYADH, and the city's master-plan of 1971 included the preservation of parts of the old city. From the 1970s several Saudi architects urged that lessons should be learned from traditional house designs and urban patterns (e.g. narrow, irregular streets that give protection from the sun). Modern villas are often based on the courtyard pattern but are made of concrete rather than mud-brick.

In the central Hijaz and Red Sea coast, typical buildings are of coral rag and wood, covered with plaster, with roofing of palm thatch and wooden beams. Ottoman influences in this former province are notable. In al-Balad district of Jiddah the Ottoman- and Egyptian-style houses mostly date from the mid-18th century to the early 20th. Usually four stories high, they have windows screened by carved wooden balconies or casements known as *rawāshin* (e.g. Bayt Nassif, restored from the mid-1970s as a museum and library). Heavy wooden doors are often decorated with relief carvings of leaves, flowers and fruit, which can be found elsewhere in the Hijaz (e.g. at Mecca, Ta'if and Yanbu'). A policy of conservation has been particularly notable in Jiddah. Mohamed Said Farsi, mayor of Jiddah (1972–86) and its urban planner from 1968, imposed a system of listed buildings of the old town, which ensured that many of the traditional buildings survived (*see* VERNACULAR ARCHITECTURE, fig. 5). The walls and old gates were demolished in 1947, but the latter were reconstructed. The architect Sami Angawi, based in Jiddah, has been concerned with restoring old buildings, reconstructing missing details and adapting the houses to modern living; he has built up a photographic record of traditional features from the whole of the country, from which he designs new buildings or appropriate restoration for old ones.

In the Ahsa' Oasis and along the Gulf the traditional architecture shows similarities with buildings in Bahrain, Dubai, Qatar and Oman. In Al-Hufuf and at Qatif on the coast are houses of two or three stories built around a central courtyard. They are made of rough stone embedded in mortar with walls finished in plaster. The outer walls are often whitewashed, and

pointed arches are a frequent feature. Rooms are sometimes arranged for winter or summer use.

In the 'Asir the traditional architecture is similar to the building styles of Yemen. Rough-cut stone houses are typical north of Abha; around Abha, houses are of stone or mud or a combination, sometimes with heavy painted wooden or cast-iron doors. Mud houses are similar to those at Najran, where mud is rammed on in layers and left to dry, creating houses of five to eight stories high. Horizontal rows of stone slabs are added between each layer to delay the impact of rainwater. The finest town houses in Najran have colored glass windows, and whitewash is sometimes applied to door and window surrounds and parapets on roof terraces, features typical of Yemen.

From the 1970s new construction has taken place on a massive scale in Saudi Arabia, including the building of the vast new industrial cities of Jubayl and Yanbu', modern urban centers, airports (e.g. Jiddah and Riyadh and over 20 others) and housing, and the introduction of new building techniques and materials. Numerous old buildings were demolished in the desire to modernize, and architects and designers were commissioned from all over the world, with Saudi architects taking an increasing role by the 1990s. In the early 1970s the major cities had master-plans for their physical development. This article selects a few examples from the rich variety of modern architecture.

In Riyadh, high-rise buildings, often with glass frontages, mix with modern interpretations of austere Najdi architecture (e.g. the United Nations building) and the most avant-garde designs. King Khalid International Airport (1983–4) combines Islamic forms and technical innovation. The four terminals are triangular in plan, with roofs made up of 72 triangular-shaped, spherically arched sections. The Television Center (1982) contains a transmission tower (h. 170 m) standing in an open plaza. It consists of a concrete shaft topped by a multi-faceted, tinted-glass globe containing a restaurant. The base of the shaft is encircled by marble forms suggesting desert tents. The King Fahd International Stadium (1988) has a seating bowl derived from a four-center ellipse. The fabric roof is in the form of a ring that rises into 24 tent-shaped peaks. The commercial and residential complex of al-Khairia (1982), northwest Riyadh, was designed by Kenzō Tange as a city within a city and contains the King Faysal Center for Research and Study on Islamic Culture. Other major projects included the Diplomatic Quarter, to accommodate embassies that moved from Jiddah in the 1980s, and King Sa'ud University on a campus site northwest of the city. The Iraqi architect Basil al-Bayati (*b.* 1946), based in London, who has designed several buildings in Saudi Arabia, won a competition to design the mosque for the university. Palm Mosque (1984) has a traditional design but is distinctive in its use of symbols, in particular buttresses in the shape of palm trunks, which deliberately echo the original palm trunks of the mosque of the Prophet in Medina.

King Fahd University of Petroleum and Minerals at Dhahran (from 1963), the center of the oil empire, is a much-noted example of modern architecture that blends with its surroundings, with long arcades, fountains and a stone water-tower, and contains a mosque, conference hall and library. The Dhahran Air Terminal (1961) was designed by the American architect Minoru Yamasaki (1912–86).

In response to the increasing numbers of worshippers, expansion and renovation at the Holy Mosque of MECCA and the Prophet's Mosque at MEDINA were undertaken by King 'Abd al-'Aziz and his successors, while under King Fahd a huge program was initiated to extend the mosques. In Mecca the size of the Holy Haram was increased, a new main entrance and eighteen other gates were built and two new minarets added. In Medina after 1985 six new minarets were added, each crowned with a gold-plated crescent, and twenty-seven main plazas, each capped by a remote-controlled sliding dome and paved with geometrically patterned marble. A major project for the transformation of Mecca is due for completion c. 2013, entailing the building of ultra-modern residential quarters and commercial centers.

The modern transformation of Jiddah was guided by Mohamed Said Farsi. He was determined to create a modern city that was harmonious in design, where details were as important as individual buildings. The Hajj Terminal at King Abdul Aziz International Airport, 64 km northwest of Jiddah, designed by Gordon Bunshaft (1909–90) of the architectural firm Skidmore, Owings & Merrill, pushed building technology to new limits and at the same time utilized the traditional form of the tent. The roof consists of fiberglass "tent" units, 20 m above the ground, each rising conically a further 13 m. The entire structure is supported by steel radial cables and pylons. It won the 1983 AGA KHAN AWARD FOR ARCHITECTURE. Of a different style is Bunshaft's award-winning National Commercial Bank of Jiddah (1982). It is a triangular, stone-faced prism with a series of internal courts stacked one above the other. Also in the 1980s, the Egyptian architect ABDEL WAHED EL-WAKIL designed the Sulaiman Palace and several mosques in Jiddah (see fig.). Rejecting the simple application of Islamic elements on a modern concrete structure, he was concerned to develop a modern interpretation of traditional styles. His pure white Municipality Mosque (El-Wakil Mosque) won the Aga Khan Award for Architecture in 1989 and was praised for its formal elements, which spoke of both the past and the present.

II. Other arts. Until the early 1960s there were no trained modern artists in Saudi Arabia. Nevertheless, after Kuwait, Saudi Arabia was one of the first countries in the region to understand the importance of art education. The Institute of Art Education was founded in Riyadh in 1965, followed by the colleges of art education at Umm al-Qura University in Mecca and Abdulaziz University in Jiddah. The General Directorate of Youth (1973), responsible for cultural and artistic activities, sponsors all artistic societies. These include the Saudi Arabian Society for Culture and Arts (1973), which has branches in Jiddah, Dammam and al-Ahsa' and held its first exhibition in 1975, and the House of Saudi Arts (1980; *Dār al-funūn al-sa'ūdiyya*), which in 1981 invited other resident Arab and foreign artists to participate in an exhibition.

The first Saudi artist to be sent abroad was the painter and sculptor Abdul Halim Radwi (*b.* 1939), who trained at the Accademia di Belle Arti in Rome and later obtained a Ph.D. in Spain. Another pioneer painter was Muhammad Mossa al-Saleem (*b.* 1939), who did not have a formal art training. Apart from a few calligraphic paintings, his work mainly depicts desert landscapes. The most prominent Saudi painter of the next generation is Faisal Samra (*b.* 1955), a graduate of the Ecole des Beaux-Arts in Paris. Samra developed an individual style, producing works in oil on wood or unframed canvas with thread and bamboo sticks.

From 1972 Mayor Farsi aimed to make Jiddah into a city that emphasized art on the street rather than in a museum. He and his team commissioned or acquired sculptures, fountains and monuments to reflect Saudi culture, as well as to delight and stimulate. They obtained works based on such traditional shapes as coffeepots and censers, and on Arabic calligraphy, as well as works by such international artists as Henry Moore (1898–1986), Joan Miró (1893–1983), the Spanish artist and architect Julio Lafuente (*b.* 1921) and the German artist Ottmar Hollmann (*b.* 1915). The Saudi artists who participated included Radwi (the first to contribute), Shafiq Mazloum (*c.* 1951–86; of Palestinian origin) and Darwish Salamah (*b.* 1933), who created model houses of traditional Saudi architecture. The Egyptian artists Salah Abdulkarim (1928–89) and Mustafa Senbel (*b.* 1946) were also involved. Various materials were used, including marble, bronze and scrap metal; some sculptures used obsolete aircraft, cars and ships. All were carefully sited in Jiddah, the largest grouping of sculptures being displayed along the Corniche and in al-Hamra Open Air Museum.

The traditional nomadic life in Saudi Arabia encouraged such portable art forms as textiles, metalware, jewelry, pottery and leatherwork (usually camel leather and goat hide), and every permanent settlement had resident skilled craftsmen. During the 20th century many of these crafts declined in the face of mass-produced goods, but weavers, leatherworkers, wood-carvers, silversmiths and coppersmiths are still found. Decorated brass-bound chests are a speciality of the Gulf area. Weaving is traditionally done by Bedouin women, who make brightly colored striped rugs, camel trappings and tents; the latter are traditionally black and made of goat-hair, sometimes mixed with sheep's wool and camel-hair. Rifles decorated by metalsmiths were made from the late 18th century into the 20th. The hilts and sheaths of daggers and swords also have a variety of designs, often in silver, some of them influenced by Omani and

Turkish styles. Jewelry continues to be an important craft; for centuries it has formed part of the personal wealth of a woman and some designs have remained the same for thousands of years. Silverware is often studded with such hardstones as amber, turquoise, garnets, agate, lapis lazuli, coral and cornelian; decoration may consist of granulation, filigree, repoussé and niello details.

III. Archaeology and museums. In the 19th century the English explorers Charles Doughty (1843–1926) and Sir Richard Burton (1821–90) traveled in northwestern Arabia: Doughty was the first European to investigate the Nabataean site at Mada'in Salih (1876–7), and Burton explored Midian (1877–8) on the Red Sea coast and noted the sites of several ruined cities. The French traveler Charles Huber and the archaeologist Julius Euting (1839–1913) copied inscriptions between Ha'il and Tayma' and secured the Tayma' Stone (6th century BCE) for the Musée du Louvre in 1884. Other regional surveys followed in the first half of the 20th century. After World War II Saudi Arabia was inaccessible to foreign archaeologists, but in 1962 Geoffrey Bibby (1917–2001), part of a Danish team based in Bahrain and Kuwait, and assisted by the Arabian–American Oil Company, was allowed to make a reconnaissance of sites around Dhahran and in 1964 conducted a brief survey of Tarut Island. The impetus of the excavations in Bahrain and other Gulf states led to the creation in 1964 of the Saudi Arabian Department of Antiquities and Museums in Riyadh, a branch of the Ministry of Education, which drew up a set of antiquities regulations. In 1968 a Danish team under Bibby made the first sondages at the Hellenistic site of Thaj and on Tarut Island. In 1976–80 the Department of Antiquities carried out a detailed archaeological survey of the whole country with the help of survey teams from the USA, Britain and France.

Under the first and second development plans (1970–80), greater attention was directed toward antiquities and museums. The Museum of Archaeology and Ethnography in Riyadh, the first modern museum in the country, was founded in 1978; the Folklore Museum in Riyadh has costumes and traditional handicrafts, as has the Museum of Yousif Najjar in Yanbu', reflecting the importance given to traditional Saudi values. Regional museums were set up near the main archaeological sites. A project for implementation by 1990 was the Murabba cultural complex in Riyadh, with museums and exhibition halls.

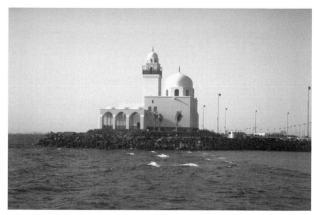

Abdel Wahed el-Wakil: Island Mosque (Al Jazirah Mosque), view from across the harbor, Jiddah, Saudi Arabia, 1980s; photo © Christopher Abel/Aga Khan Trust for Culture

Enc. Islam/2: "[al-]Su'ūdiyya, al-Mamlaka al-'Arabiyya"

ArchNet, http://archnet.org (accessed June 11, 2008)

G. R. D. King: "Some Observations on the Architecture of South-west Saudi Arabia," *Archit. Assoc. Q.*, viii (1976), pp. 20–29

N. Anderson and others: *The Kingdom of Saudi Arabia* (London, 1977, rev. 9/1993)

G. R. D. King: "Traditional Architecture in Najd, Saudi Arabia," *Proc. Semin. Arab. Stud.*, vii (1977), pp. 90–100

M. S. Mousalli, F. A. Shaker and O. A. Mandily: *An Introduction to Urban Patterns in Saudi Arabia: The Central Region* (London, 1977)

T. Prochazha jr: "The Architecture of the Saudi Arabian Southwest," *Proc. Semin. Arab. Stud.*, vii (1977), pp. 120–33

S. Binzagr: *Saudi Arabia: An Artist's View of the Past* (Lausanne, 1979)

S. Kay and M. Basil: *Saudi Arabia: Past and Present* (London, 1979)

J. Buchan and others: *Jeddah: Old and New* (London, 1980)

H. Colyer Ross: *Bedouin Jewellery in Saudi Arabia* (Fribourg, 1981, rev. Clarens-Montreux, 1989)

M. A. al-Mani and A. S. al-Sbit: *Cultural Policy in the Kingdom of Saudi Arabia* (Paris, 1981)

G. R. D. King: "Some Examples of the Secular Architecture of Najd," *Arab. Stud.*, vi (1982), pp. 113–42

T. Minosa: *Najran: Desert Garden of Arabia* (Paris, 1983)

A. Salman: *Al-tashkīl al-mu'āṣir fī duwal majlis al-ta'āwun al-khalījī* [Contemporary art in the countries of the Gulf Cooperation Council] (Kuwait, 1984)

K. Talib: *Shelter in Saudi Arabia* (London and New York, 1984)

A.-M. I. Daghistani: *Ar-Riyadh: Urban Development and Planning* (Riyadh, 1985)

J. Grant: "Saudi Art: A Fledgling about to Take Off," *A. & Islam. World*, iv/1 (1986), pp. 28–32

G. R. D. King: *The Historical Mosques of Saudi Arabia* (London and New York, 1986) *'Asir: Heritage and Civilization* (Riyadh, 1987) [bilingual text]

B. al-Bayati: *Basil al-Bayati: Architect* (London, 1988)

Z. H. Fayez: *Saudi Arabia: A Cultural Perspective* (Jiddah, 1988)

A. Guise and others: *Riyadh* (London, 1988)

N. al-Saud, J. al-Anqari and M. al-'Ajroush: *Abha: Bilad Asir: South-western Region of the Kingdom of Saudi Arabia* (Riyadh, 1989)

I. Bongard: "Profile: Faisal Samra," *A. & Islam. World*, v/2 (1990), pp. 53–6

H. M. S. Farsi: *Jeddah: City of Art: The Sculptures and Monuments* (London, 1991)

The Two Holy Mosques, Saudi Arabian Information Centre (London, 1993) *A. & Islam. W.*, xxv (1994) [entire issue]

G. R. D. King: *The Traditional Architecture of Saudi Arabia* (London, 1998)

G. R. D. King: "The Tower-house in Saudi Arabia and its Pre-Islamic Antecedents," *Bamberger Symposium: Rezeption in der islamischen Kunst vom 26.6—28.6.1992*, ed. B. Finster, C. Fragner, H. Hafenrichter, Beiruter Texte und Studien, lxi (Beirut, 1999), pp. 175–81

A Land Transformed: The Arabian Peninsula, Saudi Arabia and Saudi Aramco (Dhahran, 2006)

Sauvaget, Jean (*b*. Niort, 26 Jan. 1901; *d*. Cambo, 5 March 1950). French art historian, archaeologist and epigrapher. He was educated at the lycée of Niort and then went to Paris, where he studied Arabic at the Ecole des Langues Orientales and at the Sorbonne. In 1924 he joined the Institut Français at Damascus as a research fellow and in 1929 became its secretary general. He returned to Paris in 1937 as the director of Islamic history at the Ecole Pratique des Hautes Etudes. He also taught the history of Islamic art at the Ecole du Louvre, Arabic at the Sorbonne and, from 1942 to 1944, Syrian Arabic and the geography and history of the Middle East at the Ecole des Langues Orientales. In 1946 he was elected to the Collège de France. His doctoral thesis on the urban history of Aleppo, which was published in 1941, was one of his major works. It established his method of revealing the "silent web of Islamic history" by combining a close study of such physical remains as buildings and inscriptions with a careful reading of historical sources. Although he regarded himself as an archaeologist, he never excavated, considering archaeology more a type of evidence than a methodological procedure. Following the Swiss epigrapher MAX VAN BERCHEM, Sauvaget championed the importance of Islamic inscriptions as historical documents to illustrate the perennial themes of divine power and political authority. His best-known works concern the mosques and palaces of the Umayyad period. In all his writings, which include books on the monuments of Damascus and the Umayyad mosque at Medina, and articles on Classical and Islamic archaeological sites in Syria, Jordan, Lebanon, Palestine and Iran, he attempted to show how deeply medieval Islam was rooted in Classical antiquity. He edited the *Journal asiatique* and the *Répertoire chronologique d'épigraphie arabe* and also translated medieval Arabic texts.

WRITINGS

Les Monuments historiques de Damas (Beirut, 1932)

Alep: Essai sur le développement d'une grande ville syrienne, des origines au milieu du XIXe siècle (Paris, 1941)

Introduction à l'histoire de l'Orient musulman (Paris, 1943, rev. 1961) [Eng. trans. as C. Cahen, ed., *Jean Sauvaget's Introduction to the History of the Muslim East, a Bibliographical Guide* (Berkeley, 1965; R Westport, CT, 1982)]

La Mosquée omeyyade de Médine: Etude sur les origines architecturales de la mosquée et de la basilique (Paris, 1947) [Eng. trans. of Chapter 6, "The Mosque and the Palace," in J. M. Bloom, ed., *Early Islamic Art and Architecture* (Aldershot, 2002), pp. 122–57]

BIBLIOGRAPHY

R. Blachère: Obituary, *J. Asiat.*, ccxxxix (1951), pp. 1–4

Mémorial Jean Sauvaget, 2 vols. (Damascus, 1954–61)

A. Raymond: "Reflections on Research in the History of the Arab City during the Ottoman Period (Sixteenth–Eighteenth Centuries) or Jean Sauvaget Revisited," *Text and Context in Islamic Societies*, ed. I. A. Bierman (Reading, 2004), pp. 23–68

Sawākin. *See* SUAKIN.

Sayyed. Medieval site on the Pyandzh River, 18 km southwest of the village of Moskovsky in Kulyab district, Tajikistan. Excavations since 1970 under Erkinoy Gulyamova have brought to light individual buildings from the 10th–11th century, although the citadel has not been excavated. One of the buildings was a palace, to judge from the magnificent decoration in carved and painted stucco. It measures 50×50 m and had a central courtyard (25×25 m) surrounded by 40 rooms and luxurious living-quarters in the south, with an attached bathhouse. In Room 19, which has stucco paneling preserved to a height of 1.5 m, there was an elaborate mihrab in the west wall and a ceiling supported by squinches resembling compressed acanthus leaves. The stucco decoration is comparable to the work partly preserved at Kurbanshaid (*see* HULBUK) and similar to that found at Ghaznavid monuments in Afghanistan (*see* ARCHITECTURE, §V, A, 3). It is characterized by a mastery of ornamental composition suited to the location in the building and rich stucco decor with animal motifs including lions, birds and fish, and skillful use of color. As at Kurbanshaid, only fragments of the wall paintings have survived. Other buildings, such as another square building with a central courtyard, were more sparsely decorated. Many ceramic, glass and bronze objects (examples in Dushanbe, Tajikistan Acad. Sci., Donish Inst. Hist., Archaeol. & Ethnog.) found at Sayyed are similar to those found at Kurbanshaid.

E. Gulyamova: "Raskopi na gorodishche Sayyed v 1975 g." [Excavations at the site of Sayyed in 1975], *Arkheol. Raboty Tadzhikistane*, xv (1975 [1980]), pp. 182–9

E. Gulyamova: "O rabotakh Kul'bukskogo i Moskovskogo otryadov v 1979 g." [On the work of the Hulbuk and Moskovsky teams in 1979], *Arkheol. Raboty Tadzhikistane*, xix (1979 [1986]), pp. 264–77

E. Gulyamova: "Raskopi gorodishcha Sayyed v 1980 g." [Excavations at the site of Sayyed in 1980], *Arkheol. Raboty Tadzhikistane*, xx (1980 [1987]), pp. 202–10

E. Gulyamova: "Raskopi na gorodishche Sayyed i Manzara v 1981 g." [Excavations at the sites of Sayyed and Manzara in 1981], *Arkheol. Raboty Tadzhikistane*, xxi (1981 [1988]), pp. 395–403

Drevnosti Tadzhikistana [Antiquities of Tajikistan] (exh. cat., ed. Ye. V. Zeymal'; Leningrad, Hermitage, 1985), pp. 182–9

Sayyid. Dynasty that ruled portions of northern India from 1414 to 1451. Khidr Khan (*r.* 1414–21), the governor of Punjab, attacked Delhi after the

death of Mahmud, the last Tughluq king, legitimizing his coup by paying formal allegiance to Shahrukh, a son of Timur. Khidr Khan's son, Mu'izz al-Din Mubarak Shah (r. 1421–34), is said to have founded a center in Delhi called Mubarakabad. This has disappeared, but the site is perhaps indicated by Mubarak Shah's octagonal tomb, which is located in the area called Kotla Mubarakpur. The reign of Muhammad Shah (r. 1434–45), the next Sayyid king, was marked by a decline in the authority of the sultanate. In particular, Buhlul Lodi, the Afghan governor of Sirhind, emerged as an autonomous power. Muhammad Shah's tomb, also of the octagonal type, is located in the Lodi Gardens, Delhi. In the face of a disintegrating sultanate, 'Ala al-Din 'Alam Shah (r. 1445–51), Muhammad Shah's son and successor, retired to Budaun and left the supervision of the capital to his relatives. Buhlul Lodi took advantage of the situation and captured Delhi. He first professed to rule on behalf of 'Alam Shah but eventually founded the Lodi dynasty.

Enc. Islam/2: "Dilhi Sultanate," "Sayyids"

Yahya ibn Ahmad al-Sirhindi: *Tārīkh-i Mubārakshāhī* [History of Mubarak Shah] (1434–5) (Calcutta, 1931; Eng. trans. by K. K. Basu, Baroda, 1932)

R. C. Majumdar, ed.: *The Delhi Sultanate*, vi of *The History and Culture of the Indian People* (Bombay, 1960/R 1967)

Sayyid Aqa Jalal al-Din Mirak al-Hasani al-Isfahani. *See* Aqa mirak.

Sayyid Haydar ibn ?Asl al-Din. *See* Haydar.

Sayyid Mirza [Sayyid Mīrzā] (*fl. c.* 1810–40). Persian painter. He specialized in oil portraits of the Qajar monarch Fath 'Ali Shah (r. 1797–1834) and his family, and he also produced fine examples of painted and varnished ("lacquered") pieces. One of the artist's earliest works is a mirror-case (1815–16; Dublin, Chester Beatty Lib.) with depictions of the *Virgin and Child* and the *Annunciation*. Sayyid Mirza, together with Baqir, signed the impressive varnished covers that Fath 'Ali Shah ordered to replace the original binding on the famous copy (London, BL, Or. MS. 2265) of Nizami's *Khamsa* ("Five poems") made for the Safavid shah Tahmasp I in 1539–43. Sayyid Mirza's signature appears on the front cover, on which Fath 'Ali Shah is depicted hunting with his sons. The artist's most impressive work (1828–9; Firuz priv. col.), a large painting of the Shah enthroned with his sons and courtiers, was in the Hasht Bihisht Palace in Isfahan during the 19th century. In 1829–30 Sayyid Mirza painted two rather stiff portraits of Fath 'Ali Shah's sons (see Schulz, ii, pl. 185); they were probably part of a series of portraits that flanked a portrait of the Shah. Sayyid Mirza's skill and charm are evident in his less formal paintings. A portrait of Yusuf (*c.* 1830; ex-Amery priv. col.; Tehran, Nigaristan Mus.) depicts the biblical Joseph as a young Qajar noble standing in a garden with gazelles. A painting of a woman dancing with castanets (London, V&A, P.21–1933) and another of a young falconer (priv. col., see Robinson, "Painting in the Post-Safavid Period," 1989, pl. 4) have been attributed to him on stylistic grounds. His son, Mirza Hasan of Isfahan, did lithographs.

P. W. Schulz: *Die persisch-islamische Miniaturmalerei* (Leipzig, 1914)

B. W. Robinson: "The Court Painters of Fatḥ 'Alī Shāh," *Eretz-Israel*, vii (1964), pp. 94–105

B. W. Robinson: "A Pair of Royal Book Covers," *Orient. A.*, x/1 (Spring, 1964), pp. 32–6

S. J. Falk: *Qajar Paintings: Persian Oil Paintings of the 18th and 19th Centuries* (London, 1972)

B. W. Robinson: "Persian Painting in the Qajar Period," *Highlights of Persian Art*, ed. R. Ettinghausen and E. Yarshater (Boulder, 1979), pp. 331–62

D. James: "Lacquer Items in the Chester Beatty Library," *Lacquerwork in Asia and Beyond*, ed. W. Watson (London, 1981), pp. 178–254

M. A. Karimzada Tabrizi: *Ahvāl u āthār-i naqqāshān-i qadīm-i īrān* [The lives and art of old painters of Iran] (London, 1985), no. 448

B. W. Robinson: "Painting in the Post-Safavid Period," *The Arts of Persia*, ed. R. W. Ferrier (New Haven and London, 1989), pp. 225–31

B. W. Robinson: "Qajar Lacquer," *Muqarnas*, vii (1989), pp. 131–46

B. W. Robinson: "Persian Painting under the Zand and Qājār Dynasties," *From Nadir Shah to the Islamic Republic* (1991) vii of *The Cambridge History of Iran* (Cambridge, 1968–91), pp. 870–89 and fig. 21b

W. Floor: "Art (*Naqqash*) and Artists (*Naqqashan*) in Qajar Persia," *Muqarnas*, xvi (1999), pp. 125–54

E. Sims, B. I. Marshak and E. J. Grube: *Peerless Images: Persian Painting and Its Sources* (New Haven, 2002), p. 112

Saz [Turk.: "reed"]. Style of vegetal ornament popular in Ottoman decorative arts of the 16th century. Characterized by the use of long, feathery sawtoothed leaves and composite blossoms, it was developed in the court workshops by such artists as Shahquli and applied to manuscript illumination, textiles, crockery (*see* Ceramics, fig. 14) and tiles, among other arts.

Seals. Islamic seals follow pre-Islamic, particularly Sasanian traditions, especially in the choice of materials. Engraved gemstones were used throughout the Islamic period as seals, and also possibly as talismans or ornaments. Seal gemstones are carved in intaglio, in contrast to talismanic and ornamental gemstones, which are usually carved in relief. Gemstones were an ideal material for seals, but occasionally they were replaced by precious or base metals or even glass. Their decoration is almost exclusively epigraphic, especially from the 7th to the 14th or 15th century, and most surviving examples come from the eastern Islamic world.

Seals from the 7th to the 12th century have inscriptions in the angular script often known as kufic. The inscriptions are brief, sober and pious and contain three kinds of text. Some are religious in content, bearing Koranic quotations, prayers to God,

Muhammad or 'Ali, or moral aphorisms. Texts of the second type contain the name of the owner accompanied by a set religious expression indicating his relationship to God and his humility and resignation (see fig.). Texts of the third type contain only the owner's proper name, usually in the traditional Islamic pattern of "A son of B." In many cases it is impossible to identify the individual concerned.

The oldest seals use a simple kufic script characterized by a straight horizontal base line. This simple kufic script is typical of seals made from the 7th to the 9th century, but was also used in later periods, when owners wished to imitate the earlier style in order to add magical power to the usual, signatory function of the seals. During the 10th century some letters became more rounded. This evolution can be seen most easily in inscriptions containing the name of the owner and his father, because the loop of the letter *nūn* in the word *ibn* ("son") developed decoratively. At first it became deeper and rounded, but later, probably during the 10th or 11th century, it was transformed into a long oblique stroke that descends below the base line. At roughly the same time, certain tails and loops climb toward the top of the engraved space, a distinctive feature for dating these objects. Summary decorative elements, such as schematized small leaves, were added occasionally to the lower end of the letter *nūn* or rarely to other characters extending below the base line or to the tips of the long upstrokes that reach the top of the engraved space. As other letters gradually lost their rigidity, a cursive script developed, either in the 12th century or possibly earlier in the eastern Islamic world, as suggested by coins from the late 10th century.

From the 13th century and especially after the 15th, new tendencies developed in seal carving. Inscriptions became considerably longer. Their decoration, hitherto limited to a few schematized motifs such as a six-pointed star formed by three short crossed strokes, became more naturalistic and filled the area more completely, including the space between the characters. The variety of gemstones became more limited, by far the most popular being cornelian. In addition to texts in Arabic, there are inscriptions in Persian, usually short poems, and later in Turkish. From the 16th century many inscriptions include the year in which the seal was made. These dates are sometimes difficult to read, as the figures are executed summarily and can be confused with the overall decoration. The word for thousand is often omitted as obvious and has to be supplied where appropriate.

Rulers' seals were impressed on documents to authenticate them and to prevent the interpolation of substitute texts. Seal impressions are often found on the opening or closing pages of manuscripts and can sometimes be used to trace ownership. Seal impressions could also be engraved on ceramics, as on the Chinese porcelains that the Safavid shah 'Abbas endowed to the shrine at Ardabil.

Enc. Islam/2: "Khātam"

J. T. Reinaud: *Monumens arabes, persans et turcs, du cabinet de M. le Duc de Blacas et d'autres cabinets*, 2 vols. (Paris, 1828)

J. Hammer-Purgstall: *Abhandlung über die Siegel der Araber, Perser und Türken* (Vienna, 1849)

H. L. Rabino: *Coins, Medals and Seals of the Shāhs of Iran (1500–1941)* (Cambridge, 1945)

H. L. Rabino: "La Sigillographie iranienne moderne," *J. Asiat.*, ccxxxix (1951), pp. 193–207

I. H. Uzunçarşılı: *Topkapı Sarayı Müzesi mühürler seksiyonı rehberi* [Topkapı Palace Museum: guide to the seals section] (Istanbul, 1959)

'U. N. al-Naqshabandi and H. 'A. 'A. al-Hurri: *Al-akhtām al-islāmiyya fī'l-mathaf al-'irāqī* [Islamic seals in the Iraq Museum] (Baghdad, 1975)

A. G. Mu'ini: "Muhr-u naqsh-i muhr" [Seals and their inscriptions], *Hunar va Mardum*, xvi (Iranian solar 1357/1978), pp. 42–63

L. Kalus: *Catalogue des cachets, bulles et talismans islamiques*, Paris, Bib. N., Cab. Médailles cat. (Paris, 1981)

P. Gignoux and L. Kalus: "Les Formules des sceaux sasanides et islamiques: Continuité ou mutation?," *Stud. Iran.*, xi (1982), pp. 123–53

G. Kut and N. Bayraktar: *Yazma eserlerde vakıf mühürleri* [Endowment seals on manuscripts] (Ankara, 1984)

L. Kalus: *Catalogue of Islamic Seals and Talismans*, Oxford, Ashmolean cat. (Oxford, 1986)

D. J. Content, ed.: *Islamic Rings and Gems: The Benjamin Zucker Collection* (London, 1987)

A. Gacek: "Ownership Statements and Seals in Arabic Manuscripts," *Manuscripts of the Middle East*, ii (1987), pp. 88–95

M. Bayani: "Maker's Seals, Qajar Pen Box Makers and their 'Brand Marks,'" *Lacquer of the Islamic Lands*, ed. N. D. Khalili, B. W. Robinson and T. Stanley (1997), xxii of *The Nasser D. Khalili Collection of Islamic Art*, ed. J. Raby (London, 1992–), pp. 256–9

Cornelian seal inscribed with the profession of faith, with the names Muhammad and 'Ali and the date 1261, Iran, 1845 (Copenhagen, Davids Samling); photo credit: Davids Samling, Copenhagen

V. Porter and J. M. Rogers: "Islamic Seals," *7000 Years of Seals*, ed. D. Collon (London, 1997), pp. 176–204

L. Kalus and J. M. Rogers, eds.: *Seals and Talismans* (1998) xiii of *The Nasser D. Khalili Collection of Islamic Art*, ed. J. Raby (London, 1992–)

V. Porter: "Islamic Seals: Magical or Practical?," *U. Lect. Islam. Stud.*, ii (1998), pp. 135–49 (repr. in E. Savage-Smith, ed. *Magic and Diviniation in Early Islam* (Aldershot, 2004), pp. 179–200)

A. T. Adamova: "On the Attribution of Persian Paintings and Drawings of the Time of Shah 'Abbas I: Seals and Attributory Inscriptions," *Persian Painting, from the Mongols to the Qajars: Studies in Honour of Basil W. Robinson*. ed. R. Hillenbrand (London, 2000), pp. 19–38

S. S. Blair: "Coins and Seals," *The Splendour of Iran*, ed. N. Pourjavady (London, 2001), iii, pp. 236–43

Sedrata. Site of a settlement in the Sahara in the early Islamic period, near the modern-day Algerian city of Ouargla. Sedrata was briefly the capital of the Khariji sect in North Africa until it was destroyed in the 11th century.

In the 7th century, the Kharijites, a highly conservative opposition party that rejected both the succession of 'Ali b. Abu Talib as well as that of his rivals, fled from persecution to the Maghrib. The Rustamid dynasty of Kharijites established their capital at Tahart (now in western Algeria), but fled from there to Sedrata in 909 when the Fatimids invaded. The Kharijites remained at Sedrata until it was destroyed in 1077; leaving Sedrata they took refuge in the oasis towns of the Mzab Valley in Central Algeria, where the Kharijite tradition has survived to the present day. The austere architectural tradition of these towns is rather hard to reconcile with the sophisticated and intricate stucco decoration found at Sedrata.

After the Kharijites left, the city of Sedrata effectively disappeared into the desert, only to be excavated by Marguerite Van Berchem and others in the 20th century. Several attractive stucco panels were recovered from the remains of various buildings at the site. Carved deeply and evenly, they are notably flat and dense when compared to the stucco traditions of Samarra, although they also work within an abstracting geometric mode. Some of them are reminiscent of textile designs in their repetitive decoration, covering large surfaces with flat, bold patterns. Pieces of the stucco from Sedrata are preserved in the museum at Ouargla; a stunning arch from a niche, decorated with heavily carved bands of lattice, scrollwork and geometric designs, is held in the Musée National des Antiquités in Algiers. In 1995 a set of Algerian postage stamps printed with images of the Sedrata stucco panels were produced.

Enc. Islam/2: "Khārijis," "Mzab"

M. van Berchem: "Le Palais de Sedrata dans le desert Saharien," *Studies in Islamic Art and Architecture in Honour of Professor K. A. C. Creswell* (Cairo, 1965), pp. 8–29

R. Bourouiba: *Cités disparues: Tahert, Sedrata, Achir, Kalaâ des Béni-Hammad* (Algiers, 1981)

A. Hamlaoui: "Les stucs de Sedrata," *L'Algérie en heritage: Art et histoire* (exh. cat., ed. E. Delpont; Paris, Inst. Monde Arab., 2003), pp. 301–6

Şeker Ahmet Pasha. *See* AHMET ALI.

Selçuk [Ephesos]. Site and city on the west coast of Turkey, *c.* 2 km northeast of the ancient site of Ephesos. The region was occupied since perhaps the 10th century BCE, and has important remains of the Greek, Roman, early Christian and Byzantine periods. In 1304 the town that had grown up around the church of St. John on Ayasuluk Hill was taken by the Turks. It became known as Ayasuluk, and it reached the height of its prosperity in the 14th century as part of the principality of Aydın. The Moroccan traveler Ibn Battuta, who visited the town in 1333, noted that it had 15 gates. The church of St. John was used as a mosque until the mid-14th century, after which it fell into ruin. The most important monument of the Islamic period is the mosque of Isa Bey (1374; *see* ARCHITECTURE, fig. 36), built just below the church of St. John for 'Isa ibn Muhammad ibn Aydın (*r.* 1360–90), the amir of Aydın, by 'Ali ibn al-Dimishqi ('Ali the son of the Damascene). A rectangular stone building (53×57 m), it has a central court bordered on three sides by two-story arcades. The prayer-hall on the fourth (south) side has two aisles—parallel to the qibla wall—that are intersected by a transept of two domed bays leading to the mihrab. The walls are constructed of ashlar; the minarets are of brick, and the magnificent western façade is faced with marble. Much of the material was taken from the ruins of ancient Ephesos, although such elements as the *muqarnas* and joggled voussoirs were obviously made specifically for the mosque. Many of its features, including its spacious plan, elevation and decoration with marble inlay, are foreign to Anatolian architecture and derive from earlier buildings in Syria, notably the Umayyad mosque of Damascus. The integral court of the mosque is a feature adopted by Ottoman architects for imperial mosques. In the 15th century the Aydinid amirate was annexed by the Ottomans (*r.* 1281–1924), and the town gradually fell into decline.

Enc. Islam/2: "Aya Soluk"

K. Otto-Dorn: "Die Isa Bey Moschee in Ephesus," *Istanbul. Mitt.*, xvii (1950), pp. 115–31

A. Ogan: "Aydın ogullarından Isa Bey camii" [The Aydinid mosque of 'Isa Bey], *Vakıflar Derg.*, iii (1956), pp. 73–81

M. Meinecke: "The Great Mosques of Southeastern Anatolia: A Genetic Approach," *9. Milletlerası Türk Sanatları Kongresi, 23–27 Eylül, Atatürk Kültür Merkezi-Istanbul: Bildriler/9th International Congress of Turkish Art, 23–27 September 1991, Atatürk Cultural Center*, pp. 467–84

M. Meinecke: *Patterns of Stylistic Changes in Islamic Architecture: Local Traditions versus Migrating Artists* (New York, 1996)

Seljuk. *See* SALJUQ.

Semnan. *See* SIMNAN.

Senegal, Republic of [République du Sénégal]. Country on the west coast of Africa, bordered by Mauritania to the north, Mali to the east and Guinea and Guinea-Bissau to the south. The Gambia protrudes from the Atlantic coast into the interior of

Senegal. The capital is Dakar. Under French influence from the mid-17th century, Senegal gained full independence in 1960.

I. Geography and cultural history. II. Continuing traditions. III. Architecture. IV. Painting, textiles and graphic arts. V. Glass painting. VI. Sculpture. VII. Patronage and art institutions.

I. Geography and cultural history. Senegal occupies a geographically intermediate position, ranging climatically from the desert of the Sahel belt, through savannah, to rain forest in the south. The population (11,658,000; 2005 estimate) comprises a number of peoples, including Wolof, Serer, Tukolor and Fulani. Senegal is noted for its religious and racial tolerance. The majority of the population (80%) is Muslim, while 10% are Christian and 10% follow traditional religions. The national language is French. Except for a small group of nomadic Fulani, most of the population are settled agriculturalists, although Senegal also has a relatively developed manufacturing sector, some mining and, from the early 1990s, an expanding tourist industry.

The area now occupied by Senegal was the location of the 9th-century kingdom of Takrur, one of the first African kingdoms to adopt Islam, and then of the 13th-century Wolof Empire. In 1638 a French trading station was established at the mouth of the Senegal River, marking the start of a French influence that culminated in full colonization in the 19th century. The colonial government ostensibly practiced a policy of full integration of the indigenous people into the French nation (*assimilation*).

Léopold Sédar Senghor, Senegal's first president (1960–80), actively promoted the philosophy of negritude, which encouraged a recognition of the culturally destructive consequences of colonialism and a revival of black African traditions, one result of which was the development of a specifically Senegalese style in art. This entry covers the art produced in the area since colonial times.

II. Continuing traditions. Colonization affected mainly the country's urban areas, and many cultural traditions continued, relatively unchanged, in the rural areas. For example Bassari women continued to bind small wooden figures on to their backs as a public announcement of pregnancy. Similarly, the decoration and painting of cloth using vegetable and mineral colors and traditional dyeing methods have been very important for centuries. Body decoration, including scarification, continued to be done in traditional styles in rural areas, especially for dances during community feasts. The mud walls of houses and granaries continued to be painted in the area near the Mali border. Among the Wolof elaborately decorated mats were woven from millet stalks. Strictly organized castes practiced the crafts of leatherwork and metalwork.

III. Architecture. One-story houses and commercial premises dating from the 18th and 19th centuries survive on the island of Gorée, off Dakar, and in St. Louis. The Great Mosque was built there between 1825 and 1847. Architectural building thrived between 1920 and 1939. Imposing administrative buildings in the colonial neo-Sudanese style and built in white cement were erected in Dakar. Examples include the Cathédrale du Souvenir Africain (1923–9) and the Institut Français d'Afrique Noire (1936). The Palais du Président de la République (1953) and the Palais de Justice (1954–8) are good examples of buildings in Dakar constructed during the late colonial period. After independence new government buildings were built in the capital, and the university campuses at Dakar and St. Louis were extended. A fine example of a building dating from Senghor's presidency was the Musée Dynamique (1966; from 1988 the Département de Justice) overlooking the bay of Soumbedioune, Dakar. This cement building is a box shape with a surrounding colonnade. Dakar's business center has hotels and offices, such as the BCEAO Bank Tower (1977) built in the International Style, but with a number of "Africanizing" decorative elements on the façades. The large mosque (1967) in Dakar was built in a traditional, North African style with Moroccan collaboration.

IV. Painting, textiles and graphic arts. During Senghor's presidency the visual arts were characterized by large, brilliantly colored, often bizarre representations of mythological scenes with wild, dynamically rhythmed accents. Such works dealt less with contemporary themes than with traditional motifs and legends and picturesque everyday scenes. The most important representative of this "neo-African" style, or Ecole de Dakar as it became known, was Papa Ibra Tall (*b.* 1935), who played an important role in the cultural life of Senegal. Both his paintings and his designs for the state carpet factory attracted worldwide acclaim. Other well-known artists of this period are the illustrator Amadou Bâ (*b.* 1945) and the painter and tapestry designer Ousmane Faye (*b.* 1940). Though technically of an earlier generation, the latter's father, Mbor Faye (1900–84), also came to prominence at this time. His most important paintings are small, appealing portraits on canvas, reminiscent in their simple clear composition and luminous colors of Senegalese glass-painting tradition (*see* V below). Among those who followed their own path, rather than official artistic direction, were the painter and graphic artist Iba N'Diaye (*b.* 1928), who spent much of his time in France, and his pupil Mor Faye (1947–85). The painter Alpha Woualid Diallo (*b.* 1927) was well known for his historical scenes; he also illustrated books. The paintings of Pape Mamadou Samb (*b.* 1951), also known as Papisto Boy, attracted great interest abroad, despite lack of appreciation by the official Senegalese art institutions. His interest in both gallery and street art is expressed in large, multi-scene wall paintings, full of mystical symbols and cryptic references to Serer traditions, Islam and Christianity.

After Senghor's retirement, Senegalese artists received less state encouragement, but they were also much less restricted, and a new generation began to

develop. Unburdened by experiences from the colonial era but constantly confronted with the serious problems of contemporary Senegalese society, they found little relevance in the concept of negritude. The legacy of the neo-African style of the Ecole de Dakar artists, however, can be seen in both the form and content of the younger generation's work. This is hardly surprising, as many of the younger artists had been trained by the older ones. In the paintings of Senegalese artists in the early 1990s the human being generally stood at the center of traditional motifs and themes. Motifs and subjects relating to everyday reality were less common. As elsewhere in Africa, in the poorer residential areas painted signs advertising tailors, hairdressers and other businesses, as well as the wall paintings decorating restaurants and bars comprise a popular art tradition.

V. Glass painting. By *c.* 1900 a popular form of glass painting or *verre églomisé* (Wolof *souweres*) had developed in Thiès and Kaolack. Popular Arab oleographs with such Islamic motifs as Muhammad's winged horse were used as patterns. Representations of popular Islamic holy men, historical scenes, legends, myths or beautiful young women in clear, simple colored compositions were very common. Such works went out of fashion with the advent of colored prints and illustrated magazines in the 1960s, gaining a new clientele a little later among tourists. The art, however, grew trite with little artistic merit, being reduced, finally, to "airport art." Even so, the most important representative of this genre, Gora M'Bengue (1931–88), succeeded in preserving the tradition. His pictures have an intense clarity and may be taken to provide an insight into the essential nature of Senegalese life, which is characterized not only by *joie de vivre* and sensuality but also by a deep religious sense. M'Bengue's themes include Islamic leaders, children studying the Koran, family scenes, picture stories, and portraits of beautiful women, famous sportsmen and musicians. Among the younger practitioners Alexis N'Gom stands out for imaginative subject matter (e.g. a hare driving a car). In the 1990s Serigne N'Diaye (*b.* 1953) sought new forms, tones and expressions, and was one of a number of artists working in this medium, which experienced a renaissance.

VI. Sculpture. The early Islamicization of Senegal restrained the development of sculptural art forms up to and including the colonial period. Since independence, however, a few artists have worked as sculptors. Encouraged by Senghor, the metal-caster Sheikh Marône Diop (1918–81) restored the popularity of traditional bronze-casting. Of younger sculptors Babacar Sadikh Traoré (*b.* 1956) has won wide acclaim for his contemplative, deeply religious sculptures made from a wide variety of materials.

VII. Patronage and art institutions. Under Senghor's presidency the Senegalese state did much to promote cultural institutions, devoting over 25% of its budget to education and culture. The Ecole Nationale des Beaux-Arts was founded in 1961, and in its early days was run by Iba N'Diaye and Pierre Lods, a Belgian art teacher who had earlier founded the Poto-Poto school in the Belgian Congo (now the Democratic Republic of Congo; formerly Zaïre). The Manufactures Sénégalaises des Arts Décoratives was opened in Thiès in 1966. Contemporary Senegalese art has been bought by the state as well as by both Senegalese and Western private collectors. The Musée d'Art Africain, Dakar, was established in 1961, from the collections of the Institut Fondamental d'Afrique Noire (formerly Institut Français d'Afrique Noire). It exhibits traditional West African art. The Musée Dynamique was opened on the occasion of the First World Festival of Negro Arts. It showed contemporary art, except when it was closed between 1977 and 1984, until it was closed permanently in 1988. The Galerie Nationale d'Art, Dakar, also showing temporary exhibitions, was founded by the Senegalese business community in 1983. The Théâtre Daniel Sorano, Dakar, foreign cultural institutes and international hotels also mounted temporary exhibitions. The Salon des Artistes Sénégalaises has mounted large exhibitions from time to time. Among other Senegalese museums, both the Musée Historique d'Afrique Occidentale, Gorée, and the Musée de Saint-Louis du Sénégal also have art collections. The Ecole Normale Supérieure d'Education Artistique, Dakar, was founded in 1979 by presidential decree, taking the place of the Ecole des Beaux-Arts (1964–74) where only primary school art teachers had been trained.

Enc. Islam/2

ArchNet, http://archnet.org [articles and photographs of contemporary Senegal architecture] (accessed June 11, 2008)

P. Fougeyrollas and L. V. Thomas: *L'Art africain et la société sénégalaise* (Dakar, 1967)

"Tapisseries de Thiès," *Afr. A.*, iii/2 (1970), pp. 61–3 [Fr. & Eng. text]

M. W. Mount: *African Art: The Years since 1920* (Bloomington, 1973)

B. Pataux: "Senegalese Art Today," *Afr. A.*, viii/1 (1974), pp. 26–31, 56–9, 87

Art sénégalais d'aujourd'hui (exh. cat., Paris, Grand Pal., 1974)

Contemporary Art of Senegal/Art contemporain du Sénégal (exh. cat., Hamilton, Ont., A.G., 1979)

H. Fichte and L. Mau: *Ich bitte dringend um Häusermauern, dass Pape Samb sie bemalen kann* (Frankfurt am Main, 1980)

Contemporary Art of Senegal (exh. cat., Washington, DC, Corcoran Gal. A., 1980)

J. Oledzki: "L'Art non officiel au Sénégal," *Ethnol. Pol.*, vii (1981), pp. 81–97

Hinterglasmalerei aus Dakar und Bayreuth (exh. cat., Bayreuth U., Iwalewa-Haus, 1982)

J. Rejholec: *Zur Umstrukturierung kolonialer Kulturinstitutionen: Probleme und Perspektiven der Museen in Senegal, Veröffentlichungen aus dem Übersee-Museum,* Bremen, Reihe F, Bremer Afrika Archiv, 18 (Bremen, 1984)

M. Renaudeau and M. Strobel: *Peinture sous verre du Sénégal* (Paris and Dakar, 1984)

Kunst im Senegal heute (exh. cat., Bonn, Inst. Auslandsbezieh. Gal., 1984)

Senegal bis Zambia: Neue Kunst aus Afrika (exh. cat. by W. Bender and J. Ströter-Bender; Bayreuth U., Iwalewa-Haus, 1984)

Ansätze: Senegalesische Kunst der Gegenwart (exh. cat., ed. R. Ruprecht; Bayreuth U., Iwalewa-Haus, 1985)

Senegal: Narrative Paintings—The Collection of Maurice Dedieu (exh. cat., Lafayette, U. SWLA, A. Mus., 1985)

Treasures of a Popular Art: Paintings on Glass from Senegal (exh. cat., ed. M.-T. Brincard and M. Dedieu; New York, Afr.-Amer. Inst., 1986)

Iba N'Diaye: Gemälde, Lavierungen, Zeichnungen (exh. cat., Munich, Staatl. Mus. Vlkerknd., 1987)

"Souweres": Peintures populaire du Sénégal, Cahiers de l'Association pour le Développement des Echanges Interculturels au Musées des Arts d'Afrique et d'Océanie, 4 (Paris, 1987)

La Peinture nègre: Die neue Malerei im Senegal (exh. cat., ed. R. Ruprecht; Bayreuth U., Iwalewa-Haus, 1988)

C. Gouard: *Fodé Camara ou l'oeuvre ouverte: Essai d'approche anthropologique d'une jeune peinture sénégalaise* (diss., U. Paris I, 1989)

Bildende Kunst der Gegenwart im Senegal/Anthologie des arts plastiques contemporains au Sénégal/Anthology of Contemporary Fine Art in Senegal (exh. cat., ed. F. Axt and El Hadji Moussa Babacar Sy; Frankfurt am Main, Mus. Vlkerknd., 1989)

I. Ebong: "Negritude: Between Mask and Flag—Senegalese Cultural Ideology and the 'Ecole de Dakar,'" *Africa Explores* (exh. cat. by S. Vogel; New York, Cent. Afr. A., 1991), pp. 198–209

"Yala Yana": Kunst der Gegenwart aus dem Senegal (exh. cat., Stuttgart, Inst. Auslandsbeziehungen, 1991)

J. Kennedy: *New Currents, Ancient Rivers: Contemporary African Artists in a Generation of Change* (Washington, DC and London, 1992), pp. 97–107

A. F. Roberts and M. N. Roberts: "A Saint in the City: Sufi Arts of Urban Senegal," *Afr. A.*, xxxv/4 (2002), pp. 52–73, 93–6

A Saint in the City: Sufi Arts of Urban Senegal (exh. cat. by A. F. Roberts and others; Los Angeles, UCLA Fowler Mus. Cult. Hist., 2003)

J. L. Grabski: "Dakar's Urban Landscapes: Locating Modern Art and Artists in the City," *Afr. A.*, xxxvi/4 (2003), pp. 28–39, 93

J. Nevadomsky: "A Saint in the City: Sufi Arts of Urban Senegal," *Amer. Anthropol.*, cv/4 (2003), pp. 844–7

E. Harney: *In Senghor's Shadow: Art, Politics, and the Avant-Garde in Senegal, 1960–1995 (Objects/Histories)* (Chapel Hill, NC, 2005)

Sepahan. *See* ISFAHAN.

Serbia [Srbija]. Republic of former Yugoslavia in southeastern Europe. It is bordered to the west by Croatia, Bosnia and Herzegovina, Montenegro and Albania, to the south by Macedonia, to the east by Bulgaria and Romania, and to the north by Hungary. The territory of Serbia covers an area of *c.* 88,360 sq. km and includes the autonomous provinces of Vojvodina in the north and Kosovo in the south. Vojvodina occupies the country's only extensive lowland, which is watered by the Danube and its tributaries the Tisa and Sava rivers. The rest of Serbia is mostly mountainous or hilly, lying within the Kopaonik, Tara, Zlatibor, Zlatar, Sara and Prokletije ranges, and is traversed by numerous rivers such as the Drina, Lim, Ibar, Vlasina and Morava, the last draining much of the region northwards to the Danube. The capital is Belgrade.

During the 13th and 14th centuries the borders of Serbia expanded to include other Slav-populated areas formerly under Byzantine administration. The greatest territorial gains were achieved by King Stephen Uroš II Milutin (*r.* 1282–1321) and his grandson Stephen Uroš IV Dušan (*r.* 1331–46; emperor 1346–55). Dušan's statesmanship and power provided him with the opportunity to establish an effective defense of the Serbian Empire against the growing threat of Ottoman invasion. His enterprise, however, was interrupted by his premature death, and despite their efforts, the brothers Vukašin (*r.* 1365–71) and Uglješa Mrnjavčević were unable to organize a Christian coalition against the Ottomans, who defeated the brothers' forces in 1371 on the River Marica. Then in 1389, the Ottoman army under Sultan Murad (*r.* 1359–89) routed the Serbs led by Prince Lazar (*r. c.* 1370–89) at the Battle of Kosovo, during which both leaders lost their lives. Despite the fact that the Serbian state, albeit reduced in size, survived until 1459 under Lazar's successors, its defeat at Kosovo assumed an extraordinary importance in the historical tradition of the Serbs. Fought in the heart of Serbian lands, the battle and its outcome were interpreted as a choice between the kingdom of this world and the kingdom of heaven.

Belgrade eventually fell to the Ottomans in 1521 along with much of the Kingdom of Hungary. Serbian uprisings in the early 19th century led to increasing autonomy from Istanbul, culminating in the expulsion of the Ottomans in 1867 and the formal recognition of sovereignty in 1878. Following World War I, Serbia became part of the Kingdom of Yugoslavia; following World War II it was one of the federal republics of Socialist Yugoslavia, which lasted until the 1980s. Religious and ethnic tensions led to the Yugoslav Wars of the 1990s, the independence of the federal republics and the emergence of the Republic of Serbia. Much cultural heritage, particularly of the Muslim population, suffered damage and willful destruction, especially in the southern province of Kosovo, which continues to be populated by an Albanian Muslim majority governed under UN administration.

Building activity did not cease after the Ottoman conquest, as Serbia's Muslim overlords were soon active in the construction of new fortresses (e.g. Priština) and the refurbishment or enlargement of existing ones (e.g. the addition in 1480 of three outer polygonal towers to the Smederevo Fortress). The Ottomans built numerous other public monuments, including baths (e.g. at Prizren and Priština, 16th century), bridges (e.g. over the Bistrica River, Prizren, 15th–16th century) and mosques. Some of the most important examples in this last category are the

Hadim Mosque at Djakovica, the Imperial Mosque at Priština, the Altun-alem Mosque at Novi Pazar (all 16th century) and Sinan Pasha's mosque (1615) at Prizren. Traditional Ottoman domestic architecture also became widespread, with its characteristic use of post-and-pane construction and the division of the interior of the house into a women's and a men's section. Examples of the more luxurious type of town house (Turk. *konak*) survive in Vranje, Priština, Prizren, Peć and Djakovica. The style of housing that developed under the Ottomans and continued to be built even after Serbia gained full independence in 1830 is similar to that found in the towns and villages throughout the Balkans.

Evliya Çelebi in Albania and adjacent regions: Kossovo, Montenegro, Ohrid [Evliya Çelebi's book of travels, v] ed. R. Dankoff and R. Elsie (Leiden and Boston, 1999)

A. Andrejević: *Islamska monumentalna umetnost XVI veka u Jugoslaviji* [Islamic monumental art of the 16th century in Yugoslavia] (Belgrade, 1984)

S. Petković: "Art and Patronage in Serbia during the Early Period of Ottoman Rule (1450–1600)," *Byz. Forsch.*, xvi (1991), pp. 401–14

B. Pantelić: "Nationalism and Architecture: The Creation of a National Style in Serbian Architecture and its Political Implications," *J. Soc. Archit. Hist.*, lvi (1997), pp. 16–41

A. Herscher and A. J. Riedlmayer: "Monument and Crime: The Destruction of Historic Architecture in Kosovo," *Grey Room*, i (2000), pp. 108–22

A. Riedlmayer: "Convivencia under Fire: Genocide and Book Burning in Bosnia," *The Holocaust and the Book: Destruction and Preservation* (Amherst, 2001), pp. 266–91

Sergiopolis. *See* Rusafa.

Seville [Sp. Sevilla; formerly Arab. Ishbīliya; Lat. Hispalis]. Spanish port city on the Guadalquivir River and capital of Andalusia, with a population of 704,000 (2006 estimate). In 1248, after over five centuries of Islamic rule, the city came under Christian rule. In the 16th century it reached its peak of prosperity as a result of the first Spanish contact with America in 1492.

The prehistoric settlement occupied by ancient Iberians, Phoenicians, Greeks and Carthaginians became a Roman settlement after the 2nd Punic War (206 BCE). Called Hispalis, it was the capital of the most important Roman province, Hispania Ulterior (later Baetica). It was subsequently invaded by the Vandals (411–29 CE), Suevi (441–56) and Visigoths (486–712), whose rule lasted, with only a brief interruption, until shortly after the Muslim invasion of Spain in 711. Although its people rebelled frequently against the central government of the Umayyad rulers of Córdoba (r. 756–1009), Islamic Ishbiliya was important as a strategically placed inland port on the only navigable river in Spain. After the fall of the Umayyad dynasty in the 11th century, Seville became the predominant *taifa* (Arab. "party kingdom") capital when the former governor, Abu'l-Qasim Muhammad ibn 'Abbad, declared independence.

The ambitious Abbadid rulers al-Mu'tadid (r. 1042–69) and al-Mu'tamid (r. 1069–91) expanded the territorial possessions of the kingdom, and the capital enjoyed economic prosperity as a cultural and commercial center. The fall of Toledo to the Christians in 1085 prompted the Berber ALMORAVIDS of Morocco to intervene in 1086, temporarily saving Seville and the rest of Spain from the Christian threat, and in 1091 Yusuf ibn Tashfin (r. 1061–1106/7) made Seville the Almoravid capital in Spain, second in prestige only to Marrakesh. When the Almoravid grip weakened, the austere ALMOHADS, another Berber dynasty from Morocco, entered Spain in the name of Caliph 'Abd al-Mu'min (r. 1130–63) and in 1147 made the city their regional capital. On 23 November 1248 Ferdinand III of Castile and León (r. 1217–52) conquered the city and consecrated the Congregational Mosque as the cathedral.

Roman remains near Seville include the city of Italica. Two great granite columns with Corinthian capitals from Italica were re-erected at the Alameda de Hércules in Seville. Other Roman remains include the Caños de Carmona aqueduct which was repaired and extended from Alcalá de Guadaira to the Buhayra palaces, and the Alcázar (see fig. 1a) by the Almohads in 1172. Visigothic remains—largely architectural fragments, stone capitals and carved stone crosses—survive (Seville, Mus. Arqueol. Prov.). The extraordinarily strong city walls (c. 1st century BCE) were repaired by 'Abd al-Rahman II of Córdoba (r. 822–52) following a Viking attack in 844, repaired again by the Almoravids and extended by the Almohads; the wall was made of mortar and rubble and was 7 km long. It had curtain walls and towers protected by a barbican. Near the river another section of curtain wall joined the enclosure to the Torre del Oro. All but the section between the Puertas de Córdoba and Macarena (rebuilt 1795; 1b and 1c), together

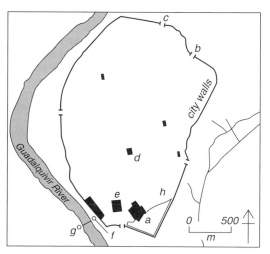

1. Seville, plan of the city before 1248; (a) Alcázar; (b) Puerta de Córdoba; (c) Puerta de la Macarena; (d) first congregational mosque, 829; (e) congregational mosque, 1172; (f) Torre del Oro; (g) Torre de la Plata; (h) Santa Cruz quarter

with seven Almohad towers, was destroyed in the 19th century. Aljarafe, the agricultural district on the west bank of the river, was particularly famed in Islamic times for its fertile orchards and abundant olive groves, as was the Jannat al-Musalla (garden of the prayer ground) to the south for its sugar cane. In addition to his other palaces, al-Mu'tamid built a pavilion surrounded by gardens and orchards east of the city walls in the area known as al-Buhayra, to which the Almohad ruler Abu Ya'qub Yusuf (r. 1163–84) added handsome palaces, gardens and pools in 1171, employing as his architect Ahmad ibn Basu. To supply both the old city and new palace district with water, he ordered the renovation of the Roman aqueduct outside the Bals Qarmuna (Carmona Gate). A verdant suburb grew up around the palace complex but the entire Buhayra area was destroyed following the Christian conquest. The area was known to the Christians as the Huerta del Rey and was excavated in 1972 by J. Zozaya and F. Collantes de Terán.

The old city retains much of the Islamic character and a few of its monuments from the *taifa* and Almohad periods. The first congregational mosque (1d; mostly destr. 1671; now S. Salvador) in Seville was constructed by the qadi Ibn 'Adabbas in 829. With a width of 48.5 m, it contained 11 aisles perpendicular to the qibla wall, separated by brick arches resting on stone pillars. In 1079 the upper part of the minaret was restored by al-Mu'tamid. The mosque was restored in 1195 by the Almohad ruler Abu Yusuf Ya'qub al-Mansur (r. 1184–99); it toppled in 1335 and was rebuilt. As with many of the city's former mosques, the minaret now serves as the base of a church tower. Abu Ya'qub Yusuf ordered a new and larger (150×100 m) congregational mosque (1172–6; now the cathedral; 1e) in another district next to the Alcázar comprising a rectangular court preceding a rectangular prayer-hall, with an enormous minaret on the left side at the juncture between the two. The prayer-hall had 17 aisles of 14 bays arranged in the T-plan typical of Almohad mosques (see ARCHITECTURE, §V, D, 4), with five domed bays along the qibla wall. The only surviving parts of the congregational mosque are the Puerta del Perdón, the Puerta de Oriente and the minaret (h. 50.85 m; see fig. 2), known as the Giralda, which dominates the town. Its cut-stone foundations and base were begun in 1184 by Ahmad ibn Basu on the orders of Abu Ya'qub Yusuf, and work was resumed by the architect 'Ali of Gomara on the orders of Abu Yusuf Ya'qub al-Mansur. The lantern, the work of Abu Layth al-Siqilli, was completed in 1198. The body of the minaret has a central block of seven superposed chambers with vaults of varying design, surrounded by a spiral ramp. Built of brick and decorated with panels of interlacing arches applied as surface ornament in the upper half, the minaret attests to an increasing awareness of the tower's possibilities as an imposing visual element of the urban skyline.

Although outside the Roman walls, the site of the Alcázar (Arab. *al-qasr*) had been an important

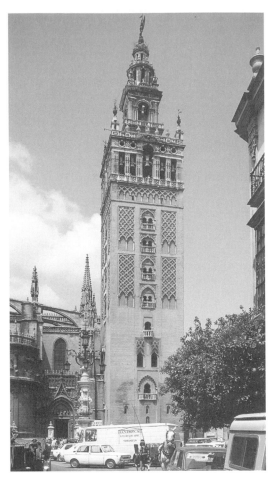

2. Seville, minaret (also known as the Giralda) of the Congregational mosque, begun 1184; transformed into a bell tower for the cathedral by Hernán Ruiz II in 1558–68; photo credit: Sheila S. Blair and Jonathan M. Bloom

stronghold from an early date. A Palaeo-Christian basilica was built there, probably encircled by a walled precinct (destr. 844). The Dar al-Imara (913–14), the original nucleus of the Alcázar, was built over the old basilica by the Umayyad ruler Abd al-Rahman III (r. 912–61) and was enlarged in the 11th century by a series of fortified walls extending toward the west, which resulted in a new palace complex called al-Qasr al-Mubarak, or El Bendito. Part of this building was called al-Turayya, or the throne room (the present Salón de Embajadores). In the 12th century a military precinct was constructed toward the south, marking the boundary of an area that became the orchards and inner gardens of the Alcázar. One portion of the 9th-century stone wall restored by the Almohads, the Puerta de León, and three gardens, including the excavated El Yeso and Patio de Crucero, survive. After the Reconquista the Alcázar became the favorite residence of the monarchs of Castile. In the second half of the 13th century Alfonso X (r. 1252–84) built a Gothic palace (Cuarto

del Caracol) that transformed the Almohad building and incorporated a garden into it. About 1340 Alfonso XI of Castile and León (*r.* 1312–50) built the Sala de la Justicia, the first example of Andalusian *Mudéjar* art. It was, however, Peter the Cruel (*r.* 1350–66; 1367–9) who substantially rebuilt (1364–6) the Alcázar using artists from Toledo and Granada and Sevillian *Mudéjar* craftsmen. Notable surviving features include the portal at the back of the Patio de la Montería, with a magnificent wall hanging protected by the sumptuous projecting wooden eaves; the main Patio de las Doncellas, an arcade of cusped and lobed arches on coupled marble columns, surmounted by open arabesque work, influenced by the art of Córdoba and Granada; the Salón de Embajadores, crowned by a fine cupola with pendentives, and walls, arches and doorways covered with elaborate, intricate Moresque decoration in delicate polychrome; the smaller Patio de las Muñecas, influenced by the art of Granada; and a 15th-century *artesonado* ceiling (*see* ARTESONADO, color pl.).

The Almohads built two three-story duodecagonal towers (1220–21) as part of the city ramparts; a chain could be stretched across the river between them to prevent the passage of enemy ships. The Torre de la Plata (destr. 1821; see fig. 1g) stood on the west bank and the Torre del Oro (1f) on the east; the latter (now a naval museum) survives, although without its original golden tiles. The city was made up of two residential areas of unequal size separated by the river: the walled enclosure to the east, and the suburb of Triana to the west. The two were connected by a pontoon bridge (1170; destr. 1852) built by the Almohads. In 1383 a breakwater, the future Patín de las Damas, was built to the west between the river and the wall. The site of the port was a sand-bank until the 15th century, when the first wharves were built next to the Torre del Oro, which protected the port. The 14 main gates in the walls were mostly walled in after the Christian conquest; the names of the gates, several of which survive (e.g. Puerta del Sol), are still used to refer to certain areas. The wall defended the city not only against possible enemies but also against floods until the third quarter of the 20th century. In moments of danger the gates were blocked with large planks and other materials.

The few Muslims (*c.* 300 in 1430) who remained in Seville after 1248 took refuge in morerías ("Moorish quarters") until their expulsion in 1502. The Jews, on the other hand, arrived with Ferdinand III and formed an important judería ("Jewish quarter"; now the Santa Cruz district) under royal protection. They numbered *c.* 2000 in 1391 and were driven out in 1483. Twenty-four mosques were converted into parish churches; at the end of the 13th century S. Ana de Triana (altered) was added to them, and in 1391 three synagogues in the Jewish quarter became churches, for example S. María la Blanca (rebuilt 1595 by Vermondo Resta). The cathedral was also weakened by the earthquake of 1356, and in 1401 work began on the enormous Gothic building that stands on the site of the former mosque.

Seville kept the essential characteristics of the Islamic city until the 16th century. In 1248 it was a fortified town covering 287 ha and it remained this size until the 19th century. Despite the destruction, rebuilding or conversion of Seville's mosques, baths, palaces and markets after the Reconquista, the narrow streets, blind alleys and overhanging balconies of the Santa Cruz quarter (1h) still reflect the dense urban pattern of the Islamic city.

Enc. Islam/2: "Ishbiliya"

R. Caro: *Antigüedades y principado de la ilustrísima ciudad de Sevilla y corografía de su convento jurídico* (Seville, 1634)

F. Arana y de Varflora: *Compendio histórico y descriptivo de la muy noble y muy leal ciudad de Sevilla*, i (Seville, 1789)

R. Amador de los Ríos: *Inscripciones árabes de Sevilla* (Madrid, 1875/*R* Seville, 1998)

J. Gestoso y Pérez: *Sevilla monumental y artística*, 3 vols. (Seville, 1889–92)

H. Terrasse: "La Grande Mosquée almohade de Séville," *Mémorial Henri Basset*, ii (Paris, 1928), pp. 249–66

M. M. Antuña: *Sevilla y sus monumentos árabes* (El Escorial, 1930)

J. Hernández Díaz, A. Sancho Corbacho and F. Collantes de Terán: *Catálogo arqueológico y artístico de la provincia de Sevilla*, 4 vols. (Seville, 1939–55)

L. Torres Balbás: "Notas sobre Sevilla en la época musulmana," *Al-Andalus*, x (1945), pp. 177–96

L. Torres Balbás: "La primitiva mezquita mayor de Sevilla," *Al-Andalus*, xi (1946), pp. 425–39

Séville musulmane au début du XIIe siècle: Le traité d'Ibn 'Abdun sur la vie urbaine et les corps de métiers, trans. and ed. E. Lévi-Provençal. (Paris, 1947/*R* 2001)

J. de Mata Carriazo: "Las murallas de Sevilla," *Archit. Hisp.*, xv (1951), pp. 9–39

J. de M. Carriazo: *La boda del emperador* (Seville, 1959)

V. Lléo Cañal: *Nueva Roma: Mitología y humanismo en el renacimiento sevillano* (Seville, 1979)

J. Bosch Vilá: *Historia de Sevilla: La Sevilla islámica, 712–1248* (Seville, 1984)

R. Lledó Carrascosa: "Risala sobre los palacios Abbadies de Sevilla de Abū Ŷa'far Ibn Aḥmad de Denia: Traducción y estudio," *Sharq al-Andalus*, iii (1986), pp. 191–200

A. Marín Fidalgo: *El Alcázar de Sevilla bajo los Austrias*, 2 vols. (Seville, 1990)

H. Ecker: "'Arab Stones' Rodrigo Caro's Translations of Arabic Inscriptions in Seville (1634), Revisited," *Al-Qantara*, xxiii/2 (2002), pp. 347–401

M. A. Tabales Rodríguez: *El Alcázar de Seville: Primeros estudios sobre estratigrafía y evolución constructive* (Seville, 2002)

A. Wunder: "Classical, Christian, and Muslim Remains in the Construction of Imperial Seville (1520–1635)," *J. Hist. Ideas*, lxiv/2 (2003), pp. 195–212

D. F. Ruggles: "The Alcazar of Seville and Mudejar Architecture," *Gesta*, xliii/2 (2004), pp. 87–98

Sevruguin, Antoin (*b.* Tehran, late 1830s; *d.* 1933). Russian photographer active in Iran. The son of Vassil de Sevruguin, an Orientalist who served as a diplomat with the Russian embassy in Tehran, and Achin Khanoum. After his father's death, Sevruguin followed his Georgian mother to Tblisi, where he met the Russian

photographer Dmitri Ivanovitch Jermakov (1845–1916), who had opened a studio there. In 1870 Sevruguin traveled to Iran with his brothers, photographing the landscape, archaeological sites and the people of Azerbaijan, Kurdistan and Luristan. He eventually settled in Tehran and established a studio, becoming an official court photographer to Nasir al-Din Shah (r. 1848–96), and was sought as a portraitist by members of the élite. Sevruguin made annual trips to Vienna to keep abreast of modern photographic developments. The art historian FRIEDRICH SARRE commissioned Sevruguin to photograph Achaemenid and Sasanian monuments in southern Iran for *Iranische Felsreliefs*, which he published with ERNST HERZFELD (although Sevruguin's contribution went unmentioned). Sevruguin's business was damaged during the Constitutional Revolution of 1908 and again during the rule of Riza Shah (r. 1925–41), who confiscated his glass plates because they were "old fashioned." Nearly 700, however, were bequeathed to the American Presbyterian Mission in Tehran and are now in the Smithsonian Institution, Washington, DC.

http://www.asia.si.edu/visitor/archivesFindingAids.htm [Sevruguin archive at the Smithsonian] (accessed June 11, 2008)

F. N. Bohrer, ed.: *Sevruguin and the Persian Image, Photographs of Iran, 1870–1930* (Washington, DC 1990)

L. A. F. Barjesteh van Waalwijk van Doorn and G. M. Volgelsang-Eastwood, eds.: *Sevruguin's Iran: Late Nineteenth Century Photographs of Iran from the National Museum of Ethnology in Leiden, the Netherlands* (Tehran, 1999)

Seyyit, Süleyman (*b.* Istanbul, 1842; *d.* Istanbul, 1913). Turkish painter. After studying at the Military Academy in Istanbul, he was sent by Sultan Abdülaziz (r. 1861–76) to Paris, where he underwent a preparatory education at a special Ottoman school and later studied at the Ecole des Beaux-Arts. In Paris, under Alexandre Cabanel (1823–89), he developed his talent for meticulous workmanship. On returning to Turkey he was appointed assistant to the painter Osman Nuri Pasha (1839–1906) at the Military Academy, and he taught there for many years. Disappointed at his failure to rise above the rank of major, he also worked as a French teacher at several schools. He contributed articles to newspapers and wrote an unpublished work on perspective. His paintings, which were influenced by European art, included still-lifes, such as *Still-life with Hyacinths* (1900; Istanbul, Mimar Sinan U., Mus. Ptg & Sculp.), and landscapes, for example *Inside the Woods* (1900s; Istanbul, Mimar Sinan U., Mus. Ptg & Sculp.). Like the painter Ahmet Ali, he generally avoided figural narrative subjects. Unfortunately many of his paintings, sold posthumously as part of his estate, later deteriorated in private collections.

Z. Güvemli: *The Sabancı Collection of Paintings* (Istanbul, 1984) [Eng. and Turk. texts]

S. Tansuğ: *Çağdaş türk sanatı* [Contemporary Turkish art] (Istanbul, 1986), pp. 54–8, 64, 85, 93–4, 131, 177, 366–8

G. Renda and others: *A History of Turkish Painting* (Geneva, Seattle and London, 1988), pp. 88, 92–4, 96, 105–6, 111, 113, 115, 119, 134, 143, 236

Shadow-puppets. Shadow theater was much appreciated in the Islamic lands by all social levels, from the court to the poor, until the beginning of the 20th century. The term *khayāl al-zill* ("shadow fantasy") is of Arabic origin, but shadow-puppets are known primarily from the lands of the former Ottoman Empire, where shadow theater developed from the 16th century and reached its apogee in the 17th, and from Southeast Asia. Earlier traditions elsewhere are known only through literary sources.

Karagöz, the name of the principal hero of Turkish shadow theater, has often come to designate the entire genre, even in non-Turkish speaking countries, such as Tunisia, Algeria or Greece. Nearly all surviving shadow-puppets, except for a few Egyptian examples, correspond to the Turkish type. Shadow-puppets were not considered worthy of collecting until the beginning of the 20th century, and no preserved puppet seems more than one or two centuries old. Although there may have been professional puppet-makers, the puppeteer usually made his own puppets, copying older puppets that had to be replaced. Some costume details help to date certain models, while more recent puppets may be distinguished by their realistic style and less elaborate workmanship; puppets with filigree work, in contrast, seem to date from the 19th century. Despite its widespread popularity, shadow theater could not survive against cinema and television, and it has been preserved only by organized endeavors to revive popular art forms.

In the shadow theater a substantial curtain separates the operator from the public. A rectangle (formerly 2×2.5 m; more recently *c.* 1×0.6 m) cut in the curtain some 1.5 m above ground level is covered by a thinner white fabric: the puppeteer sits behind this screen and holds the puppets (which stand *c.* 200–400 mm high) against it. Two lamps illuminate the puppets from behind; the light shining through their translucent bodies makes them glow like stained glass. The puppeteer moves the puppets by means of sticks and speaks the dialogue, adapting his voice to each character, as he recites or improvises the text. It is essentially a one-man show, although he is often accompanied by a singer and tambourine player.

The puppets, cut from thin but stiff pieces of translucent leather, are flat and colored. Their joints are fixed simply by strings. They have a round hole with a socket, where the manipulating stick (*c.* 500 mm) is fixed. Some puppets, including Karagöz, have two sticks. Nearly all puppets are caricatures of standard characters. The two main characters are Karagöz (Turk.: "black" + "eye"), a rough, poor, lazy and clownish gypsy, and his neighbor Hacivat, who is more bourgeois, polite, cunning and opportunistic. The numerous female roles are always gossips and intriguers. There are also many heavily caricatured stock figures based on professionals, provincials and foreigners, as well as dwarfs, opium-addicts, idiots etc. Certain characters, such as Farhad and Shirin, were made for specific plays. Some types, such as Nile boatmen, are peculiar to Egyptian plays. Animals, real or fantastic, appear quite often

(see fig.). Props are scarcely used, but a wide range of decorative showpieces are employed to fill the empty stage before the beginning of the play.

All plays follow the same four-part program. The play opens with the "Poem of the curtain" explaining the mystical and didactic character of shadow plays. This is followed by blessings, then Hacivat calls for Karagöz, who appears and fights him. The second part, the "Dialogue," is a humorous improvisation between Hacivat and Karagöz, which ends with another fight between the protagonists. The third part, the "Performance," is the play proper. It is not necessarily related to the "Dialogue," and its contents can be inspired by classic literary romances (e.g. Farhad and Shirin), by popular narratives or by sketches from daily life. This last form was used by political satirists from the end of the 19th century. The concluding element, the "Epilogue," resembles the "Dialogue" and announces the next performance. All plays, even those of the literary type, have farcical elements. The traditional plays have been written down only in the later 20th century; 47 have been recorded, but some were taken from the same prototype. As a new play was usually presented every night but one during the month of Ramadan, one could expect a repertory of some 28 or 29 plays.

The origins of Islamic shadow theater are controversial. Popular tradition suggests an origin in the Anatolian city of Bursa in early Ottoman times, as Şeyh Kuşteri, the legendary inventor of shadow theater, and the two protagonists are supposed to have lived in Bursa during the days of the Sultan Orhan (r. c. 1324–60). Although this theory was accepted by the 17th-century Ottoman historian Evliya Çelebi, it is not very reliable. Two other theories suggest that shadow theater originated in China or India respectively, then spread to Central Asia, whence it was brought by the Turks to Anatolia. However, these two hypotheses, based on the mediation of Central Asian tribes, confuse puppets and shadow-puppets, as it seems that there were only three-dimensional puppets in Central Asia. A fourth theory, which proposes an Indian origin and subsequent transmission to the Near East by gypsies, relies on the fact that Karagöz himself is a gypsy. A fifth hypothesis posits an Egyptian origin and introduction to Anatolia by the Ottoman sultan Selim I (r. 1512–20) after the conquest of Egypt in 1517. This theory goes back to the 16th-century Egyptian chronicler Ibn Iyas, a usually reliable source.

Islamic shadow theater seems closer to the Chinese than to the Indian or Indonesian types, and may have come to the Near East from China and reached Egypt before Anatolia. In any event, shadow theater is known to have existed in China and Egypt from the 13th century. Three shadow plays by the 13th-century Egyptian ophthalmologist Ibn Daniyal anticipate later Karagöz plays. Shadow theater is known only through literary references in Iran, Syria and Spain, but they are too allusive to allow the reconstruction of the ways shadow-puppets were used, the kinds of plays or the form of the puppets. Major collections of shadow-puppets are held in Hamburg, Museum für

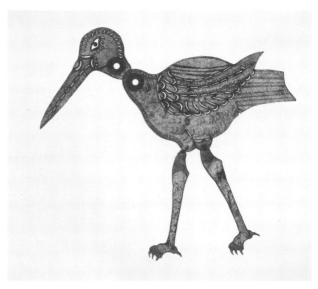

Shadow-puppet of a stork, translucent leather, Turkish, h. 240 mm, late 19th–early 20th century (London, British Museum); photo © British Museum/Art Resource, NY

Kunst und Gewerbe, and Jerusalem, L. A. Mayer Memorial Institute for Islamic Art.

Enc. Islam/2: "Karagöz"; "Khayāl al-ẓill" [Shadow fantasy]
G. Jakob: *Geschichte des Schattentheaters* (Hannover, 1925)
J. M. Landau: *Shadow Plays in the Near East* (Jerusalem, 1948)
M. And: *A History of Theatre and Popular Entertainment in Turkey* (Ankara, 1963–4)
A. Tietze: *The Turkish Shadow Theatre and the Puppet Collection of the L. A. Mayer Memorial Foundation* (Berlin, 1975)
A. Gökalp: "Les Indigènes de la capitale et le kaleïdoscope culturel ottoman: Les "figures ethniques" sur la scène du Karagöz turc," *Théâtre d'Ombres: Tradition et modernité* (Paris, 1986)
S. Moreh: "The Shadow Play (Khayâl al-Zill) in the Light of Arabic Literature," *J. Arab. Lit.*, xviii (1987), pp. 46–61
J. Mrázek: "More than a Picture: The Instrumental Quality of the Shadow Puppet," *Studies in Southeast Asian Art: Essays in Honor of Stanley J. O'Connor*, ed. N. A. Taylor (Ithaca, NY, 2000), pp. 49–73
A. Buturović: "The Shadow Play in Mamluk Egypt: The Genre and its Cultural Implications," *Mamluk Stud. Rev.*, vii (2003), pp. 149–76
J. T. Monroe and M. F. Pettigrew: "The Decline of Courtly Patronage and the Appearance of New Genres in Arabic Literature: The Case of the Zajal, the Maqama, and the Shadow Play," *J. Arab. Lit.*, xxxiv/1–2 (2003), pp. 138–77

Shafi' 'Abbasi. *See* MUHAMMAD SHAFI'.

Shahquli [Shāhqulī-i Baghdādī; Şah Kulu; Şahkulu; Shah Kulu] (*fl.* 1520/21; *d.* ?Istanbul, ?1555–6). Ottoman artist. A master in the imperial Ottoman painting studio, he played a leading role in formulating the *saz* style that characterized the high court art produced under sultan Süleyman (r. 1520–66; *see* ILLUSTRATION, §VI, D, 1). This style, in which mythical creatures

derived from Chinese or Islamic sources move through an enchanted forest made up of oversized composite blossoms and feathery leaves, has parallels in the art of the Aqqoyunlu and Safavid courts at Tabriz, where Shahquli trained under a master named Aqa Mirak. He was later exiled from the city, going to Amasya in central Anatolia. From there he moved to Istanbul, where he joined the imperial painting studio in December 1520 or January 1521; by 1526 he was receiving a daily wage of 22 silver coins (akçe). According to the historian Mustafa ʿAli, writing in 1586, Shahquli was given an independent studio where the sultan liked to watch him work. By 1545 Shahquli was head of the "Anatolian" (Rūmī) section of the studio. About the same time he presented the sultan with several items, including a representation of a peri on paper. A note in a list of gifts made by the sultan to his court artists in 1555–6 states that Shahquli had died before the gift could be presented to him.

Shahquli's signature is found on two ink drawings: one (damaged; Istanbul, Topkapı Pal. Lib., H. 2154, fol. 2r) represents a dragon and was incorporated into an album, the preface of which was written in 1544–5; the other (Washington, DC, Freer, 37.7) depicts a flying peri holding a bottle and stemmed cup. A third drawing (New York, Met., 57.51.26), also representing a dragon, bears his name, but this appears to be a later copy. His refined brushwork and strong sense of design and dramatic movement are also seen in several unsigned drawings of dragons and peris and studies of blossoms and leaves.

W. B. Denny: "Dating Ottoman Turkish Works in the Saz Style," Muqarnas, i (1983), pp. 103–21

B. Mahir: "Saray nakkaşhanesinin ünlü ressami Şah Kulu ve eserleri" [Shahquli, the famous artist of the palace painting studio, and his works], Topkapı Sarayı Müzesi Yıllığı, i (1986), pp. 113–30

Turks: A Journey of a Thousand Years 600–1600 (exh. cat. ed. D. J. Roxburgh; London, RA, 2005)

Shahr-i Rayy. See RAYY.

Shahr-i Sabz [Shakhrisyabz]. Town in Uzbekistan. Located south of the Aq Sai range (Zeravshanskiy Khrebet) in the Kashka River basin, the town was part of southern Sogdiana in ancient times. In early medieval times the main town in the region was known as Kish, but, after it was destroyed by the Mongols, a new town grew up around the remains of the abandoned settlement at the end of the 13th century. In the 14th century the small unfortified town was renamed Shahr-i Sabz (Pers. "green town"). The Timurid ruler Timur was born in the nearby village of Khwaja-i Ghar, and in the 1360s and 1370s Shahr-i Sabz became his winter quarters and during his reign the second royal residence after Samarkand. In 1378–9 the center of the town was surrounded with walls 4 km long, articulated with half-towers and four gates; beyond the walls lay a moat with drawbridges. Two axial streets divided the town into quadrants. The northeast quarter contained a park

with Timur's palace, Aq Saray ("White Palace"; 1379–96); the ruins of its elephantine portal bear splendid tile decoration (see CENTRAL ASIA, fig. 4). Nobles and religious figures lived in the northwest, the bazaar and commercial area were in the center and craftsmen lived in the southwest. The Barlas Cemetery, with two ensembles around the graves of the Barlas tribe, lay in the southeast quarter. The Dar al-Siyada (also known as the Hazrat Imam; 1375–1404) on the east has a mausoleum for Timur's son Jahangir (d. 1372) covered with a conical vault and a magnificent stone crypt, perhaps intended for Timur. The Dar al-Tilava on the west consists of two square mausolea with portals opposite a domed mosque. The northern tomb (1373–4) was built by Timur for shaykh Kulal, the spiritual adviser of Timur's father Taraghay, who was also buried there. The Gok Gumbad Mosque (Rus. Kok Gumbaz: "blue dome"; 1435–6) was built by Timur's grandson Ulughbeg, who also erected the southern mausoleum, the Gumbad-i Sayyidan (1437–8), for his descendants. In the 16th and 17th centuries Shahr-i Sabz belonged to the khanate of Bukhara. In the 20th century it became a regional center for carpets and silk embroideries and a major tourist attraction.

G. A. Pugachenkova: Termez, Shakhrisyabz, Khiva (Moscow, 1976)

M. E. Masson and G. A Pugachenkova: "Shahr-i Sabz from Timur to Ulūgh Bek, Transl. by J. M. Rogers," Anatolia, vi (1978), pp. 1–115 and Iran, xvii (1980), pp. 121–43

L. Golombek and D. Wilber: The Timurid Architecture of Iran and Turan, 2 vols. (Princeton, 1988), pp. 271–81, nos. 39–44

Sham, al-. See DAMASCUS.

Sharjah. See under UNITED ARAB EMIRATES.

Shāsh. See CHACH.

Shaubak [Shawbak]. See KRAK DE MONERAL.

Shavgar. See TURKESTAN.

Shawa, Leila (Rashad) [Shawwa, Layla Rashād] (b. Gaza, 4 April 1940). Palestinian painter and jewelry designer. She was trained in Cairo at the Leonardo da Vinci School of Art (1957–8), and in Rome at the Accademia di Belle Arti (1958–64) and the Accademia di S. Giacomo (1960–64); she also attended summer courses at the School of Seeing in Salzburg, where she worked under Oskar Kokoschka (1886–1980). On returning to Gaza she was appointed supervisor for arts and crafts education in UNRWA schools (1965–7) and a UNESCO lecturer in child education at training courses for UNRWA teachers (1966–7). From 1967 to 1975 she worked in Beirut as a full-time painter and children's book illustrator. In 1977 she collaborated with a team of architects on the construction of the Cultural Center in Gaza, executing large stained-glass windows for the project. In 1987 she settled in London. Her

paintings are distinguished by their bold style and subject matter. After a period early in her career when she depicted fictional Oriental cities and horses, she dealt with contemporary issues, such as the role and aspirations of women (e.g. *Impossible Dream*, 1988, oil on canvas; Amman, N.G. F.A.). She also derived inspiration from the graffiti-covered walls of Gaza, transferring her photographs of the walls to large screenprints on canvas, overdrawn with her own abstract signs (e.g. *Walls of Gaza*, 1992; Amman, Abdul Hamid Shoman Found.).

W. Ali, ed.: *Contemporary Art from the Islamic World* (London, 1989), pp. 239, 244

F. Lloyd, ed.: *Contemporary Arab Women's Art: Dialogues of the Present* (London, 1999)

Word into Art (exh. cat. by V. Porter; London, BM, 2006)

Shaybanid [Shibanid]. Dynasty of Uzbek Turks that ruled Transoxiana from 1500 to 1598. Descended from Shayban (Shiban), youngest son of Jochi, the oldest son of Genghis Khan, they are sometimes known as the Abu'l-Khayrids, after Muhammad Shaybani's grandfather, Abu'l-Khayr, who seized Khwarazm from the Timurids in 1447. As orthodox Sunni Muslims, the Shaybanids were continuously at war with the Safavid dynasty of Iran, who had made Shi'ism the state religion in 1501. Samarkand was initially the center of the Shaybanid state, but in the second half of the 16th century Bukhara was made the political center and focus of significant architectural patronage. In 1598 the Shaybanids were replaced by the Janids, who also claimed descent from Jochi and who were connected to the Shaybanids by marriage, ruling in Bukhara until 1785. Khwarazm and its capital Khiva remained under the Arabshahids, a collateral branch of the Shaybanids, until the end of the 17th century, when they were replaced by various khans descended from Genghis Khan.

The Shaybanid court in Bukhara assumed the cultural mantle of the Timurids. In 1507 when Muhammad Shaybani (*r.* 1500–10) expelled the last TIMURID ruler from Herat he took as booty many Timurid *objets d'art* and hired or abducted poets, musicians and artists who had flourished under Timurid patronage at Herat. The painter BIHZAD may have gone to Bukhara, and he is known to have gone to Tabriz after Shaybani's death in 1510, but the legacy of Herat lived on in the painters of Bukhara. Throughout the 16th century there was a slowly ossifying continuation of the Timurid style in poetry, manuscript painting and other arts. 'Abd al-'Aziz (*r.* 1540–49) was noted as a patron of the arts of the book, as seen in an illustrated copy of Sa'di's *Gulistan* ("Rose-garden," 1543; Paris, Bib. N., MS. supp. pers. 1958). Bukhara paintings of this period show a highly finished though uninventive post-Timurid style, which was restricted in palette but favored strong colors, and in which peculiarities of costume and landscape composition are common. By the end of the 16th century, book painting had declined in quality, though illumination, still based on Timurid models, remained fine.

The Shaybanids built extensively at Bukhara, where many of their public works, constructed of baked brick and decorated with tilework, survive, albeit with much restoration. These include a new congregational mosque (1514) and several madrasas arranged in ensembles around open tanks. Plans and decoration were derived from Timurid models, although the tilework displays a narrower repertory of techniques and colors (*see* ARCHITECTURE, §VII, C, BUKHARA and CENTRAL ASIA, §II, A, 3 and 4). Under the Shaybanids Sufi establishments were expanded. For example, 'Abd al-'Aziz built a mausoleum with attached hospice (1545) over the grave of Baha' al-Din Naqshbandi (1318–89), founder of the Naqshbandiyya order; the complex became a major pilgrimage center. International contacts, particularly with Muscovy, encouraged the construction of commercial facilities, such as markets and caravanserais.

A. M. Pribitkova: *Masterpieces of Architecture in Central Asia* (Moscow, 1971)

M. M. Ashrafi-Aini: "The School of Bukhara to *c.* 1550," *The Arts of the Book in Central Asia, 14th–16th Centuries,* ed. B. Gray (London and Paris, 1979), pp. 248–72

M. E. Subtelny: "Art and Politics in Early 16th Century Central Asia," *Cent. Asiat. J.,* xxvii (1983), pp. 121–48

M. M. Ashrafi: *Bekhzad i razvitiye bukharskoy shkoly miniatyury XVI v.* [Bihzad and the development of the Bukhara school of miniatures in the 16th century] (Dushanbe, 1987)

R. D. McChesney: "Economic and Social Aspects of the Public Architecture of Bukhara in the 1560s and 1570s," *Islam. A.,* ii (1987), pp. 217–42

B. Brend: "A Sixteenth-century Manuscript from Transoxiana: Evidence for a Continuing Tradition in Illustration," *Muqarnas,* xi (1994), pp. 103–16

B. Babajanov: "Datation de la mosquée Vâlida-ye 'Abd al-'Azîz Khân à Boukhara d'après les données épigraphiques et historiographiques," *Stud. Iran.,* xxviii/2 (1999), pp. 227–35

M. Hattstein and P. Delius, eds.: *Islam: Art and Architecture* (Cologne, 2000/*R* 2004), pp. 436–47

A. S. Melikian-Chirvani: "The Anthology of a Sufi Prince from Bokhara," *Persian Painting, from the Mongols to the Qajars: Studies in Honour of Basil W. Robinson,* ed. R. Hillenbrand (London, 2000), pp. 151–85

Shaykh 'Abbasi [Shaykh 'Abbāsī] (*fl.* 1650–84). Persian painter. He was one of a small group of artists working in Iran in the second half of the 17th century who painted in an eclectic manner that drew on European images and Mughal Indian styles (*see* ILLUSTRATION, §VI, A, 6). He appears to have been the earliest of this group, which included Muhammad Zaman and 'Aliquli Jabbadar, to integrate these "exotic" elements into his work. He invariably inscribed his work with the punning Persian phrase *Bahā girift chū gardīd Shaykh 'Abbāsī* ("It [He] acquired worth when he became Shaykh 'Abbasi"). The honorific it contains ('Abbasi; also a type of coin, whence the pun) suggests that he was in the service of Shah 'Abbas II (*r.* 1642–66). He also signed paintings during the reign of Shah Sulayman (*r.* 1666–94).

Shaykh 'Abbasi illustrated manuscripts and painted miniatures on single leaves of paper and, almost certainly, on lacquered papier-mâché objects, such as pen-boxes and mirror-cases. More than 15 of his known paintings are signed, 8 in one manuscript (Baltimore, MD, Walters A. Mus., MS. W.668), and 25 can be attributed to him. His subjects include portraits of Safavid and Mughal rulers and of the Virgin and Child copied from European prints. His style is unmistakable, combining sure draughtsmanship with pale, transparent color washes. Unlike Muhammad Zaman, he had a minimal interest in illusionism, restricting himself to darkening the edges of trees and buildings along one side (usually the right). His figures, especially heads and faces, are Indian in appearance as well as in the stippled manner in which they are drawn. His later pictures seem more Indian than his earlier work; Zebrowski proposed a connection with Golconda painting (see ILLUSTRATION, §VI, E, 7) based on the evidence of influence both given and received.

Shaykh 'Abbasi had two sons whose styles of painting were so similar to that of their father that only the signature distinguishes the hand: 'Ali Naqi (New York, Pierpont Morgan Lib., MS. M. 458, fol. 23v) and Muhammad Taqi, who signed a painting dated AH 1056 (1646; sold London, Sotheby's, 7 April 1975, lot 46); both signed themselves "son of Shaykh 'Abbasi."

Enc. Iran.: "'Abbāsī, Šayḵ," "'Alī-Naqī"

M. Zebrowski: *Deccani Painting* (London, 1983), pp. 195–201, figs. 164–6

A. Soudavar: *Art of the Persian Courts* (New York, 1992), pp. 367–8, fig. 146

E. Sims: *Peerless Images: Persian Painting and its Sources* (New Haven, 2002)

S. Babaie and others: *Slaves of the Shah: New Elites of Safavid Iran* (London, 2004)

Shaykh Hamdullah ibn Musafā Dede. *See* HAMDULLAH, ṢEYH.

Shaykhi [Shaykhī] (*fl.* Tabriz, 1475–82). Illustrator. The name Shaykhi is recorded in a single manuscript, a copy of Nizami's *Khamsa* ("Five poems"; Istanbul, Topkapı Pal. Lib., H. 762), which contains the finest surviving examples of Turkmen painting (see ILLUSTRATION, §V, E). A note on fols. 316v–317r recounts the complicated history of the manuscript and states that the Aqqoyunlu ruler Khalil (*r.* 1478) commissioned Shaykhi, along with DARVISH MUHAMMAD, to illustrate the work. None of the ten Turkmen-period paintings remaining in the volume is signed, but most of those illustrating the poem *Haft paykar* ("Seven portraits") are considered the work of Shaykhi. His style is characterized by squat figures, vibrant color and exuberant vegetation, which bursts from the frame. The two Ya'qub Beg albums in Istanbul (Topkapı Pal. Lib., H. 2153 and H. 2160) contain 71 works attributed to Shaykhi. The attributions are written in black ink beside illustrations of Turkmen and Chinese figures, Central Asian nomads,

fantastic monsters, demons and chinoiserie. Many of the drawings are similar in style to the paintings from the *Khamsa*, but the careless writing and the varying phrases cast doubt on the authenticity of the attributions, which some scholars consider contemporary but others date to the early 18th century.

Colophon to a copy (Istanbul, Topkapı Pal. Lib., H. 762, fols. 316v–317r) of Nizami's *Khamsa* ("Five poems"); Eng. trans., ed. W. M. Thackston, *Album Prefaces and Other Documents on the History of Calligraphers and Painters* (Leiden, 2001), p. 50

I. Stchoukine: "Les Peintures turcomanes et ṣafavies d'une Khamseh de Niẓâmî, achevée à Tabrîz en 886/1481," *A. Asiatiques*, xiv (1966), pp. 3–16

I. Stchoukine: *Les Peintures des manuscrits de la "Khamseh" de Niẓâmî au Topkapı Sarayı Müzesi d'Istanbul* (Paris, 1977), pp. 71–81

B. W. Robinson: "The Turkman School to 1503," *The Arts of the Book in Central Asia, 14th–16th Centuries*, ed. B. Gray (London and Paris, 1979), pp. 242–3

Islam. A., i (1981) [issue ded. to the Istanbul albums], pp. 27–30, 32–6, 62–4, 66–8

F. Çağman and Z. Tanındı: *The Topkapı Saray Museum: The Albums and Illustrated Manuscripts*, trans. and ed. J. M. Rogers (London and Boston, MA, 1986), pl. 72

E. Sims: *Peerless Images: Persian Painting and its Sources* (New Haven, 2002)

Turks: A Journey of a Thousand Years 600–1600 (exh. cat. ed. D. J. Roxburgh; London, RA, 2005)

Shaykh Muhammad [Shaykh Muḥammad ibn Shaykh Kamāl al-Sabzavārī] (*d.* Qazvin, *c.* 1588). Persian calligrapher and illustrator. Son of a master calligrapher who specialized in religious manuscripts, he studied with the painter and chronicler DUST MUHAMMAD, who mentioned Shaykh Muhammad as one of the calligraphers working in the royal library of the Safavid monarch Tahmasp I (*r.* 1524–76). The chroniclers Qazi Ahmad and Iskandar Munshi wrote that Shaykh Muhammad had a good *nasta'līq* hand and could produce replicas of earlier masters. They also cited his skill in portraiture and reported that he was in service to Tahmasp's nephew Ibrahim Mirza, first when he was governor at Mashhad in 1556, then during his exile at Sabzevar (1567–74), and finally when the prince moved to western Iran; most of Shaykh Muhammad's signed and dated works are from this period. They include two calligraphic pieces dated 1562–3 and 1568–9 (Istanbul, Topkapı Pal. Lib., H. 2137, fol. 18v, and H. 2151, fol. 39r) and a painting (Washington, DC, Freer, 37.21) of a *Camel and Keeper* surrounded by verses in *nasta'līq* and the date 964 (1556–7). Two drawings (Paris, Louvre, and Washington, DC, Freer, 37.23) of kneeling youths with partial or indistinct signatures have the same heavy eyelids and projecting eyes as the Freer painting and are probably contemporary. On the basis of the figures, animals and clearly defined landscape in the Freer painting, other paintings in the magnificent copy (Washington, DC, Freer, 46.12) of Jami's *Haft awrang* ("Seven thrones") made for Ibrahim Mirza between 1556 and 1565, and one painting added to

the monumental *Shāhnāma* ("Book of kings") made for Shah Tahmasp (ex-Houghton priv. col., fol. 341*v*), have been attributed to Shaykh Muhammad. Other signed works include paintings (Istanbul, Topkapı Pal. Lib., H. 2166, fol. 24*v*, and H. 2156, fol. 45*r*) and drawings of male figures (e.g. Paris, Louvre, K3427, and Dublin, Chester Beatty Lib., MS. 242), which show the hand of a mature master. According to Iskandar Munshi, Shaykh Muhammad briefly joined the royal library of Shah Isma'il II (*r.* 1576–8) but soon returned to Khurasan, where he entered the service of prince 'Abbas. Shaykh Muhammad died while working on a new royal palace, presumably painting the murals for the palace 'Abbas (*r.* 1588–1629) built at Qazvin after his accession.

Dust Muhammad: "The Bahram Mirza Album (1544)," *Album Prefaces and Other Documents on the History of Calligraphers and Painters* ed. and trans. W. M. Thackston (Leiden, 2001), pp. 4–17

Qāżī Aḥmad ibn Mīr Munshī: *Gulistān-i hunar* [Rose-garden of art] (c. 1606); Eng. trans. by V. Minorsky as *Calligraphers and Painters* (Washington, DC, 1959), pp. 75, 187–8

Iskandar Munshī: *Tārīkh i 'Ālamārā yi 'Abbāsī [History of the world-adorning 'Abbas] (1629); Eng. trans. by R. Savory as History of Shah 'Abbas the Great* (Boulder, CO, 1978), p. 273

M. B. Dickson and S. C. Welch: *The Houghton Shahnameh* (Cambridge, MA, 1981), pp. 165–77, p. 177

M. Bayani: *Ahvāl u āthār-i khūshnivīsān* [Biographies and works of calligraphers] (Tehran, 2/Iran. Solar 1363/1984), pp. 741–2, 837–8

M. S. Simpson: "Shaykh-Muhammad," *Persian Masters: Five Centuries of Painting*, ed. S. R. Canby (Bombay, 1990), pp. 99–112

M. S. Simpson and M. Farhad: *Sultan Ibrahim Mirza's Haft Awrang: A Princely Manuscript from Sixteenth-Century Iran* (New Haven, 1997)

M. S. Simpson: "Discovering Shaykh-Muhammad in the Freer Jami'," *A. Orient.*, xxviii (1998), pp. 104–14

M. S. Simpson: *Persian Poetry, Painting & Patronage : Illustrations in a Sixteenth-century Masterpiece* (Washington, DC and New Haven, 1998)

E. S. Ettinghausen: "Hidden Messages and Meanings: The Case of the Infant Witness Testifies to Yusuf's Innocence," *A. Orient.*, xxix (1999), pp. 141–5

D. J. Roxburgh: *The Persian Album, 1400–1600: From Dispersal to Collection* (New Haven, 2005)

Shaykhzada [Shaykhzāda] (*fl.* Herat, *c.* 1520–30, Bukhara, *c.* 1530–40). Persian painter. The Ottoman chronicler Mustafa 'Ali, the only 16th-century source to mention Shaykhzada, said he was a pupil of BIHZAD and came from Khurasan. One painting, *Episode in a Mosque* (priv. col., *see* Welch, 1976, pl. 16) from a copy of Hafiz's *Dīvān* ("Collected poems"; *c.* 1526–7; divided, Cambridge, MA, Sackler Mus., and New York, Met.), is ascribed to Shaykhzada at the bottom. Based on this ascription, Dickson and Welch have posited a first phase of the artist's career at Herat in the mid-1520s and attributed to him another painting from the same manuscript, *Polo Scene* (destr., *see* Welch, 1976, fig. C), 14 of the 15 paintings in a copy

of Nizami's *Khamsa* ("Five poems"; 1524–5; New York, Met., 13.28.7) and four of the five illustrations in a copy of 'Alishir Nava'i's *Dīvān* (1526–7; Paris, Bib. N., MS. supp. turc 316–17; *see* ILLUSTRATION, §VI, A). Shaykhzada's crisp, rational treatment of architecture, exquisite ornament and certain stock figures owe a clear debt to his presumed teacher. Dickson and Welch suggested that because the artist's traditional style went unappreciated he moved to the Uzbek court at Bukhara, where he was instrumental in founding a new school of painting (*see* ILLUSTRATION, §VI, C). The rubrics around a double-page composition opening a copy of Hatifi's *Haft manzar* ("Seven countenances"; 1537–8; Washington, DC, Freer, 56.14) name the Uzbek ruler 'Abd al-'Aziz (*r.* 1540–49) and the artist Shaykhzada. The paintings contain the puffy-faced, heavy-browed figures typical of the Bukharan style that continued under his pupils Mahmud and 'Abdullah.

Mustafa 'Alī: *Manāqib-i hunarvarān* [Exploits of artists] (1587); ed. I. M. Kemal (Istanbul, 1926), p. 64

S. C. Welch: *Persian Painting: Five Royal Safavid Manuscripts of the 16th Century* (New York, 1976), pp. 18–20; pls. 11, 12, 14, 16

M. M. Ashrafi-Aini: "The School of Bukhara to *c.* 1550," *The Arts of the Book in Central Asia, 14th to 16th Centuries*, ed. B. Gray (London and Paris, 1979), p. 268; pl. lxxiii

Wonders of the Age: Masterpieces of Early Safavid Painting, 1501–1576 (exh. cat. by S. C. Welch; London, BM; Washington, DC, N.G.A.; Cambridge, MA, Fogg; 1979–80)

M. B. Dickson and S. C. Welch: *The Houghton Shahnameh* (Cambridge, MA, 1981), pp. 36–8; pls. 34, 35, 39, 40, 44

E. Bahari: *Bihzad: Master of Persian Painting* (London, 1996)

B. Brend: *Perspectives on Persian Painting: Illustrations to Amīr Khusrau's* Khamsah (London, 2003), pp. 190–91

M. Barry: *Figurative Art in Medieval Islam and the Riddle of Bihzâd of Herât (1465–1535)* (Paris, 2004)

Shemza, Anwar Jalal (*b.* Simla, India, 1929; *d.* Stafford, England, 18 Jan. 1985). Pakistani painter, printmaker, writer and teacher, active in England. Born into a Kashmiri family of carpetmakers, he grew up in Lahore and received a diploma in fine arts in 1947 from the Mayo School of Arts there and also studied at the Slade School of Fine Art, London (1959–60). He was active in the literary circles of Lahore as a poet and short-story writer throughout the 1950s. Although trained in traditional miniature techniques, calligraphy and formal tessellated pattern making, in his early work he propagated a modernist, iconoclastic approach to painting, creating cubistic cityscapes and still lifes in oil on canvas. Strongly influenced by Paul Klee (1879–1940), Shemza later drew on Arabic and Persian calligraphy in strongly linear works. In his ink-and-watercolor *Untitled Drawing* (1959; Lahore, A. Council Col.) the structure is geometric yet the forms remain fluid and rhythmic. He participated in the International Print Biennial, Tokyo (1962), and the International Biennale of Young Artists, Paris (1965). In 1960 he married the English artist Mary Katrina and returned to

Pakistan several times during the 1960s before settling in Stafford, England, to teach art. Exhibitions of Shemza's work were held at Gallery One, London (1960), the Gulbenkian Museum of Oriental Art and Archaeology, Durham (1963), the Commonwealth Institute, London (1966), the Arts Council galleries of Lahore (1967) and Karachi (1967), and the Ashmolean Museum, Oxford (1972). A posthumous exhibition toured several cities in Pakistan during the late 1980s; its theme, "Roots," reflected Shemza's nostalgia for his origins. Works shown were in a variety of media, including silk-screen prints as well as paintings in gouache and acrylic, all small in size (the largest 300×400 mm). The chief subject matter, jewel-like plant forms that blended calligraphic curves and linear pattern, were suggestive of Islamic architectural façades or the ornate designs of Eastern carpets and textiles. His fusion of Western abstraction and Islamic motifs continues to attract attention: a retrospective exhibition of his abstract paintings was held at the Birmingham Museum and Art Gallery in 1997–8.

See also PAKISTAN, §III.

S. A. Ali: "Forty Years of Art in Pakistan," *A. & Islam. World*, iv/2 (1986), pp. 50–59

K. S. Butt, ed.: *Paintings from Pakistan* (Islamabad, 1988), pp. 84–9

I. Hassan: *Painting in Pakistan* (Lahore, 1991), pp. 68–9

A. Naqvi: *Image and Identity: Painting and Sculpture in Pakistan 1947–1997* (Karachi, 1998)

Shepherd, Dorothy (*b.* Welland, Ont., 15 Aug. 1916; *d.* Ashville, NY, 13 Aug. 1992). American art historian, specializing in medieval Islamic textiles. Having studied at the University of Michigan under Mehmet Aga-Oglu and R. Ettinghausen (B.A. 1939; M.A. 1940), Shepherd enrolled at the Institute of Fine Arts of New York University to conduct further research on Hispano-Islamic textiles. In 1942 she joined the Cooper Union Museum for the Arts of Decoration where she was in charge of its textile collection. After an interruption of her scholarly career during World War II when she served for the Office of War Information in London and Luxembourg and the Monuments, Fine Arts and Archives Division of the United States Military Government in Frankfurt and Berlin, she joined the Cleveland Museum of Art as Associate Curator of Textiles in 1947 and became Curator of Textiles in 1952. In 1955 she was appointed as Curator of Near Eastern Art and Adjunct Professor of Near Eastern Art at Case Western Reserve University, also in Cleveland. She became Chief Curator of Textiles and Islamic Art in 1979 and was associated with the museum until her retirement in 1981. She made a significant contribution to the development of the collection of Islamic art at Cleveland, and she published many acquisitions in the Museum's *Bulletin*. She is best known for her studies of a type of textile made in the region of Bukhara, known as *zandaniji* (1959, 1981) and for her interest in iconography. She steadfastly believed in the authenticity of the so-called "Buyid" textiles that began to appear on the market in the 1930s, despite growing doubts about their genuineness (*see* TEXTILES, §II, B).

WRITINGS

D. Shepherd and W. Henning: "Zandaniji Identified?" *Aus der Welt der islamischen Kunst: Festschrift für Ernst Kühnel zum 75 Geburtstag am 26.10.1957*, ed. R. Ettinghausen (Berlin, 1959), pp. 15–40

"Banquet and Hunt in Medieval Islamic Iconography," *Gatherings in Honor of Dorothy E. Miner* (Baltimore, 1974), pp. 79–92

"Medieval Persian Silks in Fact and Fancy (A Refutation of the Riggisberg Report)," *Bull. Liaison Cent. Int. Etud. Textiles Anc.*, xxxix–xl (1974), pp. 1–239

"Zandaniji Revisited," *Documenta textilia: Festschrift für Sigrid Müller-Christensen*, ed. M. Flury-Lemberg (Munich, 1981), pp. 105–22

Shi. *See* CHACH.

Shibanid. *See* SHAYBANID.

Shiraz [Shīrāz]. City in the province of Fars in southwest Iran.

I. History and urban development. Set in the heart of the Zagros Mountains, Shiraz enjoys a superb natural site in the basin of the Iranian plateau. Arabs sent in the early 7th century to conquer the Sasanian capital of Istakhr, one day's journey to the north, selected the site as a military encampment, and the city became the seat of the caliph's power in southern Iran. With the appearance of various local dynasties under Abbasid suzerainty, Shiraz developed into a regional center. The Saffarid ruler Ya'qub ibn al-Layth (*r.* 867–79) made it his capital, and his brother 'Amr (*r.* 879–901) founded the old congregational mosque (Arab. *al-jami' al-'atiq*), which still survives, albeit in a much restored form. Buyid rulers (*r.* 932–1062) fortified the city walls, added palaces, public facilities and gardens, and extended the city toward the south with the major suburb of Kard-fannakhusraw.

Shiraz escaped the ravages of the Turco-Mongolian invasions and remained a prosperous but provincial enclave. Saljuq, Ilkhanid, Timurid and Safavid rulers from the 11th century to the 18th appointed local families, such as the Salghurids (*r.* 1148–1270) or the Injuids (*r.* 1303–57), as hereditary governors (*see* ARCHITECTURE, §VI, A, 1). The Salghurid Sa'd ibn Zangi (*r.* 1203–31) endowed another congregational mosque. Destroyed by earthquake and subsequently rebuilt, the "new mosque" (Pers. *masjid-i naw*) is the largest congregational mosque in Iran (150×75 m). The city reached its apogee under the Zand ruler Muhammad Karim Khan (*r.* 1750–79), who wished to do for Shiraz what 'Abbas I (*see* SAFAVID, §II, B) had done for Isfahan. Muhammad Karim Khan glorified his capital with broad avenues, a great public square, mosque, bazaar and palace. The buildings he

ordered, such as the Masjid-i Vakil ("Regent's mosque"; *see* ARCHITECTURE, fig. 51), are traditional in form, but their decoration in glazed tile is notable for the strong colors, especially bright pink and yellow, and naturalistic blossoms and flowers.

Nicknamed the city of roses and nightingales, Shiraz is famous for its fragrant gardens. Many of these, such as Naranjistan ("Orangery") or Bagh-i Iram ("Garden of Paradise"), were palatial residences for important Qajar families in the 19th century. Set in large gardens bisected by water-channels and planted with cypress trees and flowering shrubs, the houses are decorated with glittering mirror, plaster and tile (see color pl. 3:VI, fig. 2).

II. Art life and organization. Shiraz was also the home of poets, such as the witty Saʿdi (*d.* 1292) and the lyric Hafiz (*d.* 1390), and the literary circle that gathered around the authors made the city a center for manuscript production. One of the first identifiable schools of Persian book painting flourished there in the first half of the 14th century under the Injuid governors (*see* ILLUSTRATION, fig. 9). The earliest manuscript that can be attributed to Shiraz is a small copy (London, BL, Or. MS. 13506) of *Kalila and Dimna*. It is linked to earlier "Mesopotamian style" painting (*see* ILLUSTRATION, §IV, C) by its witty animal drawing, but its red background heralds the mature Injuid style that can be seen in a group of four dated copies (Istanbul, Topkapı Pal. Lib., H. 1479, 1330; St. Petersburg, Saltykov-Shchedrin Pub. Lib., Dorn 329, 1333; two dispersed MSS, one dated 1341 and another, ex-Stephens priv. col., datable before 1352) of the *Shāhnāma* ("Book of kings"). The style is linear in character, with rough but lively drawing and a vibrant palette against a red or ocher ground. Figures are stiff, buildings feature zigzag brickwork, and hills are often triangular. The painters did not strictly follow the Chinese motifs and conventions introduced in the Ilkhanid capitals in the north; instead, their simple planar compositions are reminiscent of wall painting, perhaps because of the city's proximity to the major Achaemenid and Sasanian reliefs (538–331 BCE and 226–645 CE). The Injuid style of painting is so distinctive that it can be used to attribute other undated or unsigned manuscripts, such as a copy (Oxford, Bodleian Lib., Ouseley MS. 379–81) of the *Kitāb-i samak-i ʿayyār* ("Book of Samak the Paladin").

A distinctive style of provincial painting continued in the second half of the 14th century, when Shiraz was under the control of the Muzaffarid dynasty. The palette includes a fine blue, line is less pronounced, hills are more rounded and landscape is more romantic. The most typical feature is the egg-like human head that projects from the neck like a mask and is topped by a dandified, drooping turban. The high horizon that becomes standard in all later Persian painting is already visible in the copy (Istanbul, Topkapı Pal. Lib., H. 1511) of the *Shāhnāma* dated 1371 (*see* ILLUSTRATION, §V, C). Shiraz remained a haven during the Timurid struggle for

power at the end of the 14th century, and painters from Baghdad seem to have emigrated there and infused the provincial style with a new technical brilliance and theatricality.

A collection of *Epics* copied in 1397 (divided, London, BL, Or. MS. 2780, and Dublin, Chester Beatty Lib., MS. P.114) maintains a few features typical of Shiraz painting under the Muzaffarids, such as oval faces and illumination of gold sprays on blue ground, but is of a much higher quality, with lavish applications of gold and lapis on polished, ivory-colored paper. Figures are larger and more robust, and landscape is highly developed, with flowering plants and pastel rocks textured to resemble coral or pumice. The high style of the *Epics* with rich pigments and fine illumination was in turn continued in manuscripts produced for Iskandar Sultan (*see* TIMURID, §II, D), who governed Shiraz from 1409 to 1414, particularly in an *Anthology* copied in 1410 (Lisbon, Fund. Gulbenkian, LA 161) and a *Miscellany* copied the following year (London, BL, Add. MS. 27261; *see* ILLUSTRATION, fig. 13). Shirazi manuscripts can often be distinguished by their paper, calligraphy and layout; one text is written diagonally in the margins of a folio with another text or illustration.

The Timurid court in Khurasan, with great wealth and the patronage of Prince Baysunghur, soon acquired the best talent available for the production of luxury illustrated books, but Shiraz remained a center of production for manuscripts in a provincial Timurid style. A copy (Oxford, Bodleian Lib., Ouseley Add. MS. 176) of the *Shāhnāma* produced for Baysunghur's brother Ibrahim Sultan (*see* TIMURID, §II, F), governor of Shiraz from 1414 to 1435, retains such motifs from earlier Shiraz painting as rounded rocky horizons but consolidates the new provincial style. Compositions are simple, with tall figures, horses with protruding chests and pricked ears, and women's kerchiefs tied in "cocks' combs." Color is subdued, and pigments are poorer than those used in contemporary HERAT (particularly a pale green, which corrodes paper). Two styles of book painting for the market flourished in Shiraz during the later 15th century (*see* ILLUSTRATION, §V, E). The Turkmen Commercial style with stocky figures and stylized landscape is seen in the copy (Tehran, Riza ʿAbbasi Mus. and dispersed) of the *Khavarānnāma*, celebrating the virtues and exploits of ʿAli, the son-in-law of the Prophet Muhammad, which had paintings signed by Farhad between 1476 and 1487. The Brownish (Turk. *kumral*) style with its more subdued colors can be seen in such manuscripts as a copy (London, BL, Or. MS. 2931) of Nizami's *Khamsa* ("Five poems") dated 1474.

Under the Safavids (*r.* 1501–1732), artists in Shiraz continued to turn out numerous manuscripts in simplified versions of the metropolitan styles practiced in the capitals of Tabriz, Qazvin and Isfahan (*see* ILLUSTRATION, §VI, A, 4). A copy (London, BL, Add. MS. 24944) of the *Kulliyāt* ("Collected works") of Saʿdi dated 1566 shows the finest-quality work. Manuscripts are generally larger (the *Kulliyāt* copy

measures 216×135 mm) and have full-page illustrations. Compositions are crowded, with many figures portrayed against a high horizon. Illumination and binding are often superior to illustrations, which are decoratively painted, particularly in yellow. In lesser-quality works, freshness is lost and the conventions become stylized.

Other portable arts were also produced in Shiraz. A local school of metalwork that flourished under Injuid patronage in the first half of the 14th century has been identified by Melikian-Chirvani on the basis of specific titulature containing the phrase "kingdom of Solomon," a metaphorical reference to the nearby ruins at Persepolis. Book illustration continued, as did the late 15th-century tradition of varnished painting on book covers. From the 18th and 19th centuries varnished paintings on papier-mâché objects (see LACQUER) and large oil paintings appeared (see OIL PAINTING, §I). Such local artists as MUHAMMAD SADIQ favored a predominantly red palette and yellowish varnish for European-inspired nudes and flower-pieces.

G. D. Guest: *Shiraz Painting in the Sixteenth Century* (Washington, DC, 1949)

A. J. Arberry: *Shiraz, Persian City of Saints and Poets* (Norman, 1960) B. Gray: *Persian Painting* (Geneva, 1961)

'Ali Naqi Bihruzi: *Bannāhā-yi tārīkhī va āthār-i hunarī-yi julga-yi Shīrāz* [The historical buildings and artistic monuments of the Shiraz plain] (Shiraz, Iran. Solar 1349/1971)

D. Wilber: *The Masjid-i 'Atiq of Shiraz* (Shiraz, 1972)

B. Gray, ed.: *The Art of the Book in Central Asia* (Boulder, 1979), pp. 121–46, 215–48

E. Galdieri: "Un exemple curieux de restauration ancienne: La Xodâ-Xâne de Chiraz," *Art et société dans le monde iranien*, ed. C. Adle (Paris, 1982), pp. 297–309

A. S. Melikian-Chirvani: *Islamic Metalwork from the Iranian World, 8th–18th Centuries* (London, 1982), chap. III

N. Titley: *Persian Miniature Painting* (Austin, 1984), pp. chaps. 4, 6 and 8

A. T. Adamova and L. T. Guizalian: *Miniatury Rukopisi Poemy "Shaxname" 1333 goda* [Miniatures of the 1333 manuscript of the poem "Shāhnāma"] (Leningrad, 1985)

D. S. Whitcomb: *Before the Roses and Nightingales: Excavations at Qasr-i Nasr, Old Shiraz* (New York, 1985)

D. Wilber: "Shiraz 1935," *Iran*, xxvii (1989), pp. 125–8

L. Marlow: "The Peck Shahnameh: Manuscript Production in Late Sixteenth-Century Shiraz," *Intellectual Studies on Islam: Essays Written in Honor of Martin B. Dickson, Professor of Persian Studies, Princeton University*, ed. M. M. Mazzaoui and V. B. Moreen (Salt Lake City, 1990), pp. 229–43

J. Lerner: "A Rock Relief of Fath 'Ali Shah in Shiraz," *A. Orient.* xxi (1991), pp. 31–43

L. Uluç: "A Persian Epic, Perhaps for the Ottoman Sultan," *Met. Mus. J.*, xxix (1994), pp. 57–69

B. O'Kane: "The Bibhani Anthology and its Antecedents," *Orient. A.* xlv/4 (Winter 1999), pp. 9–18

L. Uluç: "Selling to the Court: Late Sixteenth-Century Manuscript Production in Shiraz," *Muqarnas*, xvii (2000), pp. 73–96

F. Çağman and Z. Tanındı: "Manuscript Production at the Kāzarūnī Orders in Safavid Shiraz," *Safavid Art and Architecture*, ed. S. R. Canby (London, 2002), pp. 43–8

J. W. Limbert: "City Administration in Hafez's Shiraz," *Views from the Edge: Essays in Honor of Richard W. Bulliet*, ed. N. Yavari, L. G. Potter, J.-M. R. Oppenheim (New York, 2004), pp. 116–40

J. W. Limbert: *Shiraz in the Age of Hafez: The Glory of a Medieval Persian City* (Seattle, 2004)

T. Stanley: "The Kevorkian-Kraus-Khalili Shahnama: The History, Codicology and Illustrations of a Sixteenth-Century Shiraz Manuscript," *Shahnama: The Visual Language of the Persian Book of Kings*, ed. R. Hillenbrand (Aldershot, 2004), pp. 85–98

M. Ekhtiar: "Innovation and Revivalism in Later Persian Calligraphy: The Visal Family of Shiraz," *Islamic Art in the 19th Century: Tradition, Innovation, and Eclecticsm*, ed. D. Behrens-Abouseif and S. Vernoit (Leiden, 2006), pp. 257–79

Shrine. Shrines—a structure or place where worship or devotions are offered to a deity, spirit or sanctified person—are one of the major features of Islamic architecture. The principal Islamic shrine is the Ka'ba in MECCA, which Muslims believe is the House of God erected by the prophet Abraham and rebuilt several times. The Koran enjoins all believers to direct their five daily prayers in the direction of the Ka'ba (Arab. *qibla*), and to make a pilgrimage (*ḥajj*) to Mecca and the nearby sites of Arafat and Mina. The Ka'ba was already venerated in pre-Islamic times, when it stood at the center of a sacred enclosure (*haram*) in which arms were laid down and the shedding of blood prohibited. Although the form of the Ka'ba, a simple cubic structure of stone, had little impact on later building, the central role of pilgrimage in Islam led to the development of other shrines throughout Islamic lands, none of which is sanctioned in the Koran or prophetic traditions.

I. Focus of veneration. II. Shrine forms.

I. Focus of veneration. Jerusalem, which had been the Muslims' qibla before Mecca, was soon identified with the "furthest mosque" (*al-masjid al-aqsā*) of the Koran 17:1, from which Muhammad took his mystical night journey and ascended to Heaven. Its major Islamic monument, the Dome of the Rock (691–2; *see* JERUSALEM, §II, 1 and ARCHITECTURE, color pl.), is an annular structure that follows traditional Byzantine models. The rock on which it stands was later identified as the site from which the Prophet ascended, but it remains a matter of debate whether it was constructed to commemorate the spot on which Abraham was believed to have offered up Isaac or to symbolize Islam's triumph over Christianity. Jerusalem's special role in Islam led to the development of other shrines there by the 10th century, including stations (*maqām*) and domes (*qubba*) commemorating events in Muhammad's life, and gates and mihrabs dedicated to ancient prophets.

When Muhammad died at MEDINA in 632, he was buried in a room of his house, which also had served the nascent Muslim community as its first mosque; this building, the house of the Prophet, became an important shrine for Muslims (*see* ARCHITECTURE,

§II and fig. 1). Because of its proximity to Mecca, a visit there is often included in the Pilgrimage. The Prophet disapproved of any construction over gravesites, but the example of his own grave, which came to be surrounded by a pentagonal screen and eventually covered with a green dome, along with the persistence of pre-Islamic practices, inspired a tradition of monumental funerary architecture over the graves of revered Islamic figures (*see* CEMETERY and TOMB). These tombs were often the focus of veneration and pilgrimage, and relics of the Prophet were often venerated. The pavilion in the Topkapı Palace, Istanbul, known as the Hırka-i Saadet Dairesi (pavilion of the Holy Mantle), contains the largest collection, including hairs from his beard, his teeth, footprint, seal and mantle, all acquired by the Ottoman sultans (*r.* 1281–1924) after they took control of Mecca and Medina in the early 16th century.

The most important shrines were built over the gravesites of descendants of the Prophet, particularly those early ones venerated by the Shi'a as his rightful heirs (*imām*). 'Ali, the Prophet's son-in-law, fourth caliph and first imam, was martyred at Najaf near Kufa in Iraq in 661; his son Husayn, the second imam, was martyred at nearby Karbala in 680. These sites already attracted pilgrims in the 7th century and had custodians in the 8th, but the first monumental constructions there seem to have been erected only at the end of the 9th century. These shrines were continuously embellished and enlarged and became the centers of cities that eclipsed others nearby. Similarly, the burial site of the eighth imam, 'Ali Riza, who died at Tus in northeast Iran in 818, was the nucleus for the city of MASHHAD ("place of martyrdom," "martyrium"). His sister Fatima died the year before at QUM in central Iran and was buried there. All of these cities became major pilgrimage centers for Iranian Shi'is, particularly when the holy cities of Arabia were inaccessible. The tomb of Idris I (*d. c.* 791), a descendant of the Prophet and founder of the Idrisid dynasty (*r.* 789–926) of Morocco, was also venerated (see fig. 1), and the city that grew up around it eclipsed the Roman and Byzantine site of Volubilis.

Places where the imams had passed were often venerated in Iran with shrines called *qadam-gāh* ("place of the footstep"), such as the octagonal shrine erected in Khurasan by the Safavid shah Sulayman in 1680 to mark the place where imam 'Ali Riza had passed. Bodies (or parts thereof) of the Shi'i imams were sometimes miraculously discovered in remote locations. In the 10th century it was claimed that the head of Husayn, which the Shi'a believed had been severed from his body after his martyrdom at Karbala, was in such diverse localities as Damascus, Homs, Aleppo and Raqqa in Syria, Medina in Arabia and Merv in Central Asia. In 1091 Husayn's head was again discovered at Ascalon (now Ashqelon), the last stronghold in Palestine of the Fatimid caliphs of Egypt (*r.* 969–1171), who transferred it in 1153 to Cairo, where it became the focus of a major shrine, the mosque of Sayyidna al-Husayn. The appearance

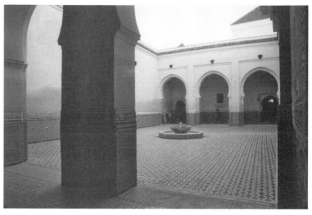

1. Shrine and tomb of Idris I, Moulay Idris, Morocco, late 8th century; rebuilt 18th century; photo credit: Sheila S. Blair and Jonathan M. Bloom

of Husayn's head in so many different locations can be explained by the persistence of head cults from pre-Islamic times. The grave of 'Ali was "discovered" in 1135 in the village of Khwaja Khayran, east of Balkh, Afghanistan, and rediscovered in 1480–81, when the rulers of the Timurid dynasty (*r.* 1370–1506) began to transform the site into a major shrine. The site, Mazar-i Sharif ("the noble place that one visits"), has eclipsed Balkh in importance and was repeatedly restored and enlarged in the 16th and 17th centuries. Biblical figures were also commemorated with shrines of varying importance. Hebron houses a major shrine to Abraham (Ibrahim), and Mosul in Iraq has smaller shrines to Seth (Shith), Jonah (Yunus) and St. George (Nabi Jirjis), who was martyred there. A shrine for the prophet Daniel at Susa in southwest Iran was attested by the 14th century.

Other shrines commemorated the gravesites of the companions of the Prophet, such as the mausoleum of Sidi 'Uqba in Biskra, Algeria, which commemorates 'Uqba ibn Nafi', the conqueror of North Africa, or the mausoleum of Eyüp Ensari, who participated in the first siege of Constantinople, outside the walls of that city. At Samarkand the tomb of Qutham ibn al-'Abbas, who had had a very undistinguished career, was the nucleus for the necropolis known as the Shah-i Zinda (*see* SAMARKAND, §III, A). The cult of Qutham may have been encouraged by his family, the Abbasids; it was a synthesis of various Islamic, Iranian and Sogdian traditions. Other shrines commemorated jurists and learned men, such as Abu Hanifa (*d.* 767), whose tomb in Baghdad was erected in 1066, and the imam al-Shafi'i (*d.* 820), whose tomb in Cairo was monumentalized by the Ayyubid sultans in the late 12th century and early 13th (*see* CAIRO, §III, F). A shrine over the grave of the 9th-century mystic al-Hakim al-Tirmidhi was erected by the Qarakhanid ruler Ahmad I (*r.* 1081–9) and later embellished and expanded by rulers into the Timurid period (*see* TERMEZ). The shrine known as Char Bakr (The Four Bakrs), honoring four early religious scholars from Bukhara named Abu Bakr, developed a few

kilometers west of Bukhara; in the 16th century it was enlarged under the care of the Jubayri family. The enormous shrine (1399; see fig. 2, Architecture, fig. 31 and Ornament and pattern, color pl.) over the grave of Ahmad Yasavi (*d.* 1166), the Sufi shaykh responsible for converting the Turks to Islam, was largely the work of a single campaign under Timur (*r.* 1370–1405).

As Islam has no established authority to judge the status of sainthood, it is bestowed solely by public opinion, and saints are thus very numerous, though their cults are localized. Some shrines commemorated groups of people, such as the Ten Promised Paradise (*'Ashira Mubashira*) honored in the mosque of Kucha-Mir (*c.* 1050–1100) at Muhammadiyya outside Nayin or the Twelve Imams honored at the Duvazdah Imam (1037–8) at Yazd. The graves of Sufi saints, sometimes known in the western Islamic lands as marabouts (Arab. *murābiṭ*), became particularly important as shrines throughout the Islamic lands in later times. The modest tomb of the mystic Abu Yazid (Bayazid) al-Bistami (*d.* 874) at Bistam in Iran was marked in 1120–21 with a minaret and a mosque and substantially enlarged in the late 13th century and early 14th, when several other constructions were added. The tomb of Abu Madyan (*d.* 1197) at al-'Ubbad near Tlemcen, Algeria, was transformed into a major shrine by the Marinid sultan Abu'l-Hasan 'Ali (*r.* 1331–48). Finally, the purpose of some shrines has been lost. The Mashhad al-Juyushi in Cairo, for example, is known to have

been erected by the Fatimid vizier Badr al-Jamali in 1085 as a martyrium, but the reason for it is unclear.

Shrines were visited to ask the saint for intercession and to seek God's blessing. The saint's birthday according to the Muslim lunar calendar was traditionally the day of honor, but a seasonal veneration of one to three days was also practiced, often reflecting the continuation of a pre-Islamic nature festival. In popular Islam, local shrines were often visited to seek help in such daily problems as infertility and sickness. Women played an unusually important role in the veneration of saints and the development of shrines, perhaps because they were not required to be present at Friday prayers in the congregational mosque and in some cases were even excluded. Cemeteries, which had been the site of lamentation by women in pre-Islamic times, provided a ready focus for their piety. The female members from the family of the Fatimid caliphs, for example, were buried in the Qarafa cemetery outside Cairo, which already contained many shrines to male and female descendants of the Prophet. Many female members of the Timurid line had tombs built in the Shah-i Zinda necropolis at Samarkand.

II. Shrine forms. The remarkable range of people and events commemorated in shrines throughout the Islamic lands is matched by an equal variety of architectural forms. Graves were often marked with head- and footstones (*see* Stele) or cenotaphs (*see* Cenotaph), which were often enclosed with wooden or metal

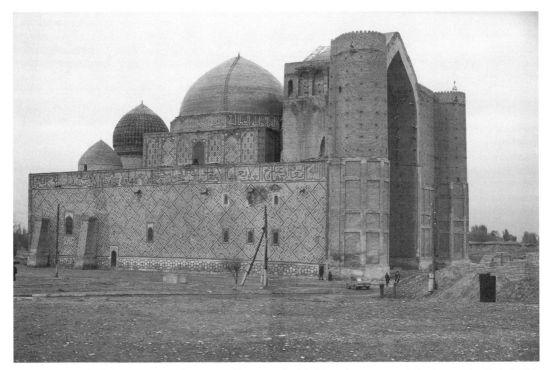

2. Shrine and tomb of Ahmad Yasavi, Turkestan, Kazakhstan, as rebuilt by Timur beginning in 1399; photo credit: Sheila S. Blair and Jonathan M. Bloom

grilles, probably inspired by that around the Prophet's tomb. The Prophet's disapproval of monumentalizing graves inspired the development of the *hazīra*, a roofless enclosure around the gravesite, such as is found around the tomb of the mystic 'Abdallah Ansari at Gazurgah (begun 1425) near Herat, Afghanistan. The most widespread form of shrine is undoubtedly the domed cube, and small examples of this type are found in baked and unbaked brick from Morocco to Central Asia. Domes could be covered simply in plaster or more elaborately with *muqarnas* vaults or tiled roofs, usually green or blue. The domes over the graves at major Shi'i shrines at Najaf, Karbala, Mashhad and Qum are marked by golden domes to distinguish them from the tombs of lesser figures. Simple domed cubes were sometimes monumentalized by the addition of grander structures such as iwans, portals, minarets and courts. The simple cell, for example, at Linjan near Isfahan, Iran, where the Sufi shaykh Pir-i Bakran lived and taught, was transformed after his death in 1303 into a shrine by the addition of an entrance corridor and an iwan.

Gravesites were transformed into elaborate shrine complexes, particularly in later centuries. They often comprised several types of charitable institution, such as mosques, schools, hospitals, soup-kitchens and hospices for resident Sufis and itinerants (*see* KÜLLIYE). The tomb of 'Ali Riza at Mashhad, for example, had an impressive domed tomb chamber decorated with luster tiles by the early 13th century. In the 14th century the shrine was restored several times, and in the 15th century it was transformed into the centerpiece of an elaborate complex with the addition of a large congregational mosque, a room for descendants of the Prophet and one for reciters of the Koran, and three madrasas. The "Little Cities of God," such as ARDABIL and Natanz in Iran, evolved in the 14th century around shrines to such Sufi saints as Safi al-Din, the eponym of the Safavid dynasty (*r.* 1501–1732) and 'Abd al-Samad, a follower of the mystic al-Suhrawardi (1145–1234; for illustration *see* NATANZ). The complexes have small domed tombs, lodgings for residents and visitors, and communal spaces for prayer, teaching and Sufi rituals of recitation and dancing. They are notable for their lavish decoration, often in glazed and luster tiles and carved stucco (*see* ARCHITECTURE, color pl.). The ensembles of luster tiles surviving on the walls of many shrines in Iran, such as those of Fatima at Qum and 'Ali Riza at Mashhad, have led some scholars to propose that luster tiles had special significance for the Shi'a. The association of luster tiles with Shi'i shrines, however, may be an accident of survival and the continued veneration of these shrines.

Shrines were endowed in perpetuity by such wealthy individuals as sultans and government officials. The Marinid sultan Abu'l-Hasan 'Ali, for example, endowed the revenues from gardens, houses, orchards, windmills, baths and arable land to support the shrine of Abu Madyan near Tlemcen. These endowments were so generous and so widespread that they enabled the 14th-century Moroccan traveler Ibn Battuta to survive for 25 years without paying for a night's lodging. The Safavid shah 'Abbas I (*r.* 1588–1629) endowed the dynastic shrine at Ardabil with an extraordinary collection of manuscripts and Chinese porcelains, along with a building to house them.

Enc. Islam/2: "Ḥadjdj" [Pilgrimage], "Ḳuds" [Jerusalem]

M. van Berchem: "La Chaire de la mosquée d'Hébron," *Festschrift Eduard Sachau* (Berlin, 1915), pp. 298–310

F. W. Hasluck: *Christianity and Islam under the Sultans* (Oxford, 1929)

U. Monneret de Villard: *La Necropoli musulmana di Aswan* (Cairo, 1930)

G. E. von Grunebaum: *Muhammadan Festivals* (London, 1951)

O. Grabar: "The Umayyad Dome of the Rock in Jerusalem," *A. Orient.*, iii (1959), pp. 33–62

O. Grabar: "The Earliest Islamic Commemorative Structures," *A. Orient.*, vi (1966), pp. 7–46

L. Golombek: *The Timurid Shrine at Gazur Gah* (Toronto, 1969)

L. Golombek: "The Cult of Saints and Shrine Architecture in the Fourteenth Century," *Near Eastern Numismatics, Iconography, Epigraphy and History: Studies in Honor of George C. Miles*, ed. D. Kouymjian (Beirut, 1974), pp. 419–30

L. Golombek: "Mazar-i Sharif—A Case of Mistaken Identity?," *Studies in Memory of Gaston Wiet*, ed. M. Rosen-Ayalon (Jerusalem, 1977), pp. 335–44

J. M. Bloom: "The Mosque of the Qarafa in Cairo," *Muqarnas*, iv (1987), pp. 7–20

S. S. Blair: "Sufi Saints and Shrine Architecture in the Early Fourteenth Century," *Muqarnas*, vii (1990), pp. 35–49

R. D. McChesney: *Waqf in Central Asia: Four Hundred Years in the History of a Muslim Shrine, 1480–1889* (Princeton, 1991)

A. Welch: "The Shrine of the Holy Footprint in Delhi," *Muqarnas*, xiv (1997), pp. 166–78

D. DeWeese: "Sacred Places and 'Public' Narratives: The Shrine of Aḥmad Yasavī in Hagiographical Traditions of the Yasavī Ṣūfī Order, 16th–17th Centuries," *Muslim World*, xc/3 (2000), pp. 353–76

R. D. McChesney: "Architecture and Narrative: The Khwaja Abu Nasr Parsa Shrine," *Muqarnas*, xviii (2001), pp. 94–119 and xix (2002), pp. 78–108

K. Rizvi: "The Imperial Setting: Shah 'Abbās at the Safavid Shrine of Shaykh Ṣafi in Ardabil," *Safavid Art and Architecture*, ed. S. R. Canby (London, 2002), pp. 9–15

Shufu [Shule]. *See* KASHGAR.

Shusha. Regional center in the Nagorno-Karabakh region of Azerbaijan. The town was founded in 1756–7 when the Karabakh potentate Panah 'Ali Khan built a fortress on a rocky area surrounded by the mountain streams Dashalty and Khalfali-chay. The eponymous fortress Panakhabad was later renamed Kala or Shusha-qalasy and finally Shusha. Situated in the strategic and economic center of Karabakh, it became the capital of the Karabakh khanate. The town was surrounded by stone walls with round towers protecting the gates. The *khān* and his court lived in a rectangular citadel surrounded by bazaars, a Friday Mosque and residential quarters. The first nine residential quarters, known as Ashagy

Mekhelle, were built in the 1760s. Another eight were added under Khan Ibrahim Khalil (r. 1759–1806), and another twelve after the khanate was absorbed into the Russian empire in 1805. Each quarter was centered around a mosque surrounded by small squares containing a source of drinking water set in a stone façade sometimes decorated with blind arches. Town estates incorporating a garden and vegetable plot were separated from the street by stone walls. A typical example is the Mehmandarov House (19th century). The blind lower story houses service quarters and arched gates; the upper story, with a row of semicircular windows, is residential. In 1883 the Djuma (Friday) Mosque was built on the site of several earlier mosques. Designed by the local architect Kerbalai Sefi Khan Karabagi, the rectangular building has six octagonal columns creating a three-aisled interior with two domes. The façade is decorated with three semicircular arches, and the building is flanked by two minarets with shafts in glazed brick.

Modern buildings in Shusha include the mausoleum of the Azerbaijani poet Mulla Panakh Vaqif, designed by the architects A. V. Salamzade and E. I. Kanukov. Reminiscent of the type of tomb tower found at NAKHICHEVAN, BARDA and other sites in Azerbaijan, the mausoleum has a pyramidal base supporting a stone prism with faceted columns and an openwork lattice. Shusha was known as a center for the production of carpets (see CARPETS AND FLATWEAVES, §IV, B). The Museum of the History of Shusha contains a collection of local finds.

E. Avalov: *Arkhitektura goroda Shusha* [Architecture of the town of Shusha] (Baku, 1977)

S. S. Fatullayev: *Gradostroitel'stvo i arkhitektura Azerbaydzhana XIX–nachala XX vekov* [Urban planning and architecture in Azerbaijan in the 19th century and the early 20th] (Leningrad, 1986)

K. M. Mamedzade and N. A. Sarkisov: *Shusha: Mavzoley Vagifa* [Shusha: the mausoleum of Vaqif] (Baku, 1986)

R. E. Wright: "An Inscribed Shusha Carpet," *Hali*, cxxviii (2003), p. 81

Sikandra [Sikandara]. Site 8 km from Agra in Uttar Pradesh, India. It was apparently first developed in the reign of Sultan Sikandar LODI (r. 1489–1527), after whom it was named. Although a number of ruined structures from the Lodi period are reputed to survive in the area, the site is known principally for the tomb of the Mughal emperor Akbar (r. 1556–1605; see MUGHAL, §II, C). Akbar apparently selected Sikandra as the site for a garden, which was named Bihistabad (Pers.: "Abode of Paradise"), and it was here that he was buried. Construction of his tomb may have been in progress when he died; it was completed between 1612 and 1614 by his son, the emperor Jahangir (r. 1605–27). The contribution of each has been debated: the form of the building seems characteristic of Akbar's reign, while some of the decoration is typical of Jahangir (for illustration see MUGHAL).

The main tomb or mausoleum, square in plan, is built in five receding stories. The unusual design is reminiscent of the so-called Panch Mahal at FATEHPUR SIKRI. The lowest level (103.94×103.94×9.14 m), which functions as a high plinth, has arcades on all four sides. These are divided into square bays by massive piers and arches. The original decoration in the arcades has been destroyed. In the center of each side of the plinth there is a projecting portal, set within a rectangular frame. The frame carries panels with bold geometric inlay in colored marble. The entrance, through the southern portal, leads to a vestibule profusely ornamented with floral and calligraphic designs in incised stucco and paint (some have been restored; see STUCCO AND PLASTERWORK, color pl.). An inclined passage runs down to the square tomb chamber (12.19×12.19×18.29 m), now stripped of any original decoration. Akbar's simple brick-and-mortar tombstone is placed in the center. Four ventilators from the chamber open on the third story above. The superstructure of the tomb consists of four stories resting on the plinth, the lower three of which are open halls with square pillars and ornamental arches. The fifth story, entirely in white marble, has a court open to the sky surrounded by arcades closed by carved screens. Akbar's marble cenotaph and an octagonal marble pedestal are placed on the platform. A mystical poem in Persian runs around the interior of the upper arcade under a stone projection (Hindi *chajjā*).

The tomb has a variety of marble-faced *chatrīs* (domed pavilions) on each level. Engaged towers at the corner of the plinth are crowned by massive octagonal pavilions; slender square *chatrīs* stand at the corners of the highest level; *chaparkhats* (*chatrīs* that are oblong in form) rise above the main recessed arch of each façade. It has been suggested (by the English traveler William Finch, who visited Agra in 1608–11, and by others since) that the upper story was to have been crowned by a dome.

The mausoleum is set in a vast square garden that was enclosed by high walls. The main gateway is on the south; symmetry was maintained by ornamental false gateways on the other three sides. The garden is divided into quarters by red sandstone causeways (w. 22.86 m), which connect the tomb with the gates. A water channel runs down the middle of each causeway, and the causeways are expanded at intervals into square terraces with fountains and ponds. Stairs leading down to the garden have chutes for water in the middle, the water flowing eventually into the garden's irrigation courses. Four ponds with fountains grace the main platform of the mausoleum. These fountains were fed by underground glazed clay pipes running from overhead tanks situated in the four quarters of the garden.

The monumental gate on the south side (41.88×30.48×22.86 m) is also constructed of red sandstone with exquisite geometric and floral patterns in inlay and mosaic. The north and south faces are identical with a recessed arch (h. 18.59 m) set in a rectangular frame. The double-story wings on either

side have alcoves one above the other. The interior takes the form of an octagonal hall with suites of rooms on the east and west side in two stories. The gate is dominated by four tapering white-marble minarets that rise from the corners (rebuilt in Lord Curzon's time). Each is divided into three stories by balconies and crowned by a domed pavilion. The lowest story is fluted and has stalactites supporting the balconies while the other balconies have bracket supports. The decorative scheme of the gate is varied yet harmonious. The spandrels of the arches have arabesque scrolls of white, black and green marble. Neighboring panels have geometric patterns in tessellated mosaic. Calligraphic designs outline the entrance portal.

The gateways on the east and west (h. 24.38 m) are identical sandstone structures (the northern gate is in ruins). Each has a high central arch flanked by two-story wings with alcoves and *chatrī*s above. These gates have a complex of square, semi-octagonal and rectangular rooms and diagonal rooms and diagonal passages. Both are profusely decorated with painting, stucco, inlay, mosaic and carved relief. Motifs such as the elephant with upturned trunk supporting a fringe of lotus buds and the peacock with outspread tail are typical of the Akbar period.

Southwest of Akbar's mausoleum complex is the tomb of Maryam Zamani, so-called because Akbar's queen was interred there. The tomb is a square structure of red sandstone with massive octagonal *chatrī*s on the corners and *chaparkhat*s at the mid-point of each of the sides, forming an impressive superstructure even without a dome. The building conforms to the imperial type of domeless tomb favored in the time of Jahangir. One of the mileage markers (*kos minār*) built by the Mughals at regular intervals between Delhi and Agra stands on the highway to the east of Maryam's tomb.

E. W. Smith: *Mogul Colour Decoration at Agra*, pt. 1, Archaeol. Surv. India New Imp. Ser., xxx (Allahabad, 1901)

E. W. Smith: *Akbar's Tomb at Sikandara*, Archaeol. Surv. India New Imp. Ser., xxxv (Allahabad, 1909)

R. Nath: *Agra and its Monumental Glory* (Bombay, 1976)

R. Nath: *Akbar: The Age of Personality Architecture (1985), ii of History of Mughal Architecture* (New Delhi, 1982–5)

E. Koch: *Mughal Architecture* (New York, 1991)

C. Asher: *Architecture of Mughal India (The New Cambridge History of India)* (Cambridge, 1995)

B. M. Alfieri: *Islamic Architecture of the Indian Subcontinent* (London, 2000)

Silk Route. System of trade routes linking East Asia with Europe that operated from *c*. the 2nd century BCE to the 15th century.

I. Introduction. II. Routes. III. Art.

I. Introduction. The Silk Route, originally called the "Silk Road" (*Seidenstrasse*) by the German explorer and geographer Ferdinand von Richtofen (1833–1905), was not a single "road" but a network of routes—both terrestrial and maritime—and silk was only one of the many commodities traded along it. Trade along the eastern part of what was later to become the Silk Route began several millennia before the Christian era. Archaeologists found silks from the 2nd millennium BCE at Sapalli-tepa, near Termez, Uzbekistan. In addition to local sources, China obtained jade from Central Asia during the Shang (*c*. 1600–*c*. 1050 BCE) and Zhou (*c*. 1050–256 BCE) periods. Chinese silk was traded with the West during the later part of the Zhou period, and Western glassware reached China during the Qin period (221–206 BCE). Trade between East and West was facilitated by Alexander the Great's conquest of Central Asia in the late 4th century BCE and the establishment of the Greco-Bactrian kingdoms, under which Bactria became the hub for trade between China, India and Iran. However, the traditional date given for the opening of the eastern portion of the Silk Route from China to Central Asia by the traveler and diplomat, Zhang Qian (*d*. 114 BCE), is 115 BCE or 105 BCE. He was sent by the Han (206 BCE–220 CE) emperor Wudi (*r*. 141–87 BCE) to obtain "heavenly" horses from the Central Asian kingdom of Ferghana (Kyrgyzstan) and to find allies against the nomadic Xiongnu, who blocked China's access to Central Asia. The route was finally opened after the Chinese succeeded in expelling the Xiongnu from the Gansu corridor and gained control of the area that is now the Xinjiang Uygur Autonomous Region. In the 1st century BCE the Chinese engaged in trade through Parthian intermediaries with the Roman Empire. This process of indirect trade between the ruling Western and Central Asian powers, via the Eurasian steppes and using the most northern branch of the Silk Route, continued until the 13th century when, for the first time in history, a single political entity, the Mongol Khanate, controlled the entire length of the Silk Route. During its 1500-year history the influence of the Silk Route reached far beyond the great trading and political centers of China and the Mediterranean, extending to the Atlantic shores of Europe in the west and to Japan in the east.

The Silk Route was subject to several periods of prosperity and decline depending on the political situation in China and the West. It thrived during the stability of the Han and Tang (618–907) periods, and again during Mongol rule (the Yuan dynasty, 1279–1368, in China and the ILKHANID period, 1256–1353, in Iran), when much of the traffic went along the more northerly "Steppe route." The route through Central Asia was disrupted by the expansion of Islam and civil war in China in the 8th century and again towards the end of the Tang period, when the Tibetans gained control of the route and succeeded in blocking China's communications with the West. Trade along the southern route (*see* II, A below) diminished during the Song period (960–1279) and had virtually ceased by the 12th century. The Western part of the route was disrupted by the fall of the Sasanian Empire to the Arabs in 651 and by the gradual decline of Byzantine power. The Portuguese opening of direct maritime trade between Europe and China

in the mid-16th century effectively closed the long-distance overland routes.

Although primarily a commercial (and often a military) highway, the Silk Route was also a conduit for ideas, technologies and artistic forms and styles. In addition to the secret of silk, several other important technologies were exchanged between East Asia and Europe along the Silk Route, notably paper and printing and glassmaking (*see* PAPER). The route was also used to propagate the great religious faiths of the world—Christianity, Islam and, most notably, Buddhism—which shaped much of the social, political and artistic development of Central and East Asia.

II. Routes.

A. Land. B. Sea.

A. LAND. The roads and cities along the 8000-km Silk Route changed with the rise and fall of empires in both East and West. However, for most of its history the starting-point of the route in China was the Han- and Tang-period capital Chang'an (now Xi'an, Shaanxi Province; see fig.). The old provincial highway ran through western Shaanxi Province to Taizhou (now Tianshui, Gansu Province). Some 25 km south of the town are the Buddhist cave temples of Mt. Maiji. Going further west the route led to Lanzhou, Gansu Province, on the Yellow River. Lanzhou was the provincial capital of successive periods and an important trading center. Set in the cliffs to the south of the city is the Bingling Temple, a large cave sanctuary containing some of the oldest Buddhist sculptures and wall paintings in Gansu Province, which show distinct Gandharan influence (Northern Liang period, 4th century). Continuing northwest on the highway, the route passed Liangzhou (now Wuwei) in the neck of the Gansu corridor. Liangzhou was a major communications center and military garrison in the Western Han period (206 BCE–9 CE). During the Six Dynasties period (222–589) Wuwei was the capital of lesser states, until it was occupied by the forces of the Northern Wei (386–534) in 420. During the Sui (581–618) and Tang periods Wuwei was an important trading center with a large population. Going further west the route reached Ganzhou (now Zhangye), which became an important town in the Tang period. The frontier town of Jiayuguan is located at the Western end of the Great Wall of China in the foothills of the Jiayu Mountains and was one of the main Chinese military outposts on the Central Asian frontier. From Jiayuguan the town of Anxi was reached, situated at the far western end of the Great Wall; this was a major strategic town during the Han period, and in the 11th and 12th centuries, when the Tanguts controlled Gansu Province, it flourished, with a large international population and rich cultural life. Some 100 km further west is Dunhuang, the last Chinese town in Gansu Province before the route left areas dominated by Chinese culture. During the Tang period, when it was

known as Shazhou, the town was an important trading and religious center.

At Dunhuang the route branched into northern and southern routes. The northern route went to Hami in the foothills of the Tianshan range. Hami was built in the 7th–6th centuries BCE and was famous for its orchards; watch-towers guarding the trading route still survive. Proceeding west the route entered the Turfan depression. Since the Han period Turfan had been under Chinese control for long periods of time, and the culture that had developed in this fertile oasis was strongly influenced by Chinese civilization. The city of Khocho (Chin. Gaochang) was the capital during most of the period, when the area was known as Xizhou. The cave temple at Bezeklik was built north of the city and flourished in the 8th–9th centuries. Later the city of Jiaohe, to the west of modern Turfan, became the cultural center of the region, until it was sacked by the Mongols in the 13th century. From the Turfan depression the northern route reached the oasis of Karashahr, which has two important Buddhist sites, Schorchuck and Ming-oi. Finally it reached the region of Kucha, which experienced its greatest period of prosperity during the 4th–7th centuries. The mainly Buddhist population carved several cave temples in the mountains north of the route, including those at Kizil, Kumtura, Subashi and Shikshin. Leaving Kucha, the road went to Aksu, another oasis town with Buddhist cave temples. From there it reached Kashgar, in modern Xinjiang Uygur Autonomous Region, where it joined the southern route.

Although the southern route declined during the Tang period, there is evidence that it was much used under the Six Dynasties. From Dunhuang the route skirted the Lopnor salt marsh. A branch of the route circled the northern edge of the Lopnor and passed through Loulan, which connected with the northern route in the Karashahr area. Miran was the first major Buddhist center on the southern route, flourishing from the 3rd to the 6th century. From Miran the road continued to Charklik, once a major town in the Shanshan kingdom. Proceeding further south, the route passed through Niya, Keriya and Domoko, important Buddhist centers between the 5th and 7th centuries, before reaching Khotan, a thriving town during the Tang period. Buddhism was particularly strong here, and there were several important Buddhist temples in the area, including Rawak, Khadalik and Dandan-oilik. As late as the 10th century Khotan was the capital of a small kingdom, the ruler of which was a vassal of the Song. Before the 12th century, however, the city had been abandoned for lack of water. After Khotan travelers passed through Kargilik and Yarkand before the southern and northern routes converged at Kashgar. Buddhism reached Kashgar in the 1st century. Descriptions of the town from the 4th and 7th centuries were written by the monks Faxian (*c.* 337–*c.* 422) and Xuanzang (600–64); the latter wrote that the town was an important Buddhist center and that its inhabitants made fine woolen carpets. Kashgar was under Chinese control from

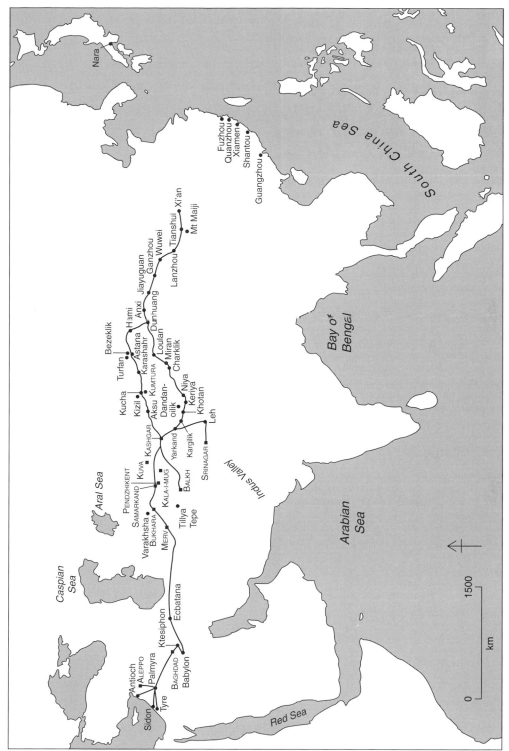

Map showing major Silk Route trade routes; those sites with separate entries in this encyclopedia are distinguished by CROSS-REFERENCE TYPE

685 until the late 8th century. From the mid-10th century the town came under the influence of Islam, and during the Yuan period it supported a strong Mongol garrison.

Another route led from Yarkand to India over the Karakorum passes in the high Pamirs to Leh, capital of Ladakh; from there it went west to Srinagar in Kashmir and south into the Indus Valley. According to the geographer Ptolemy (*fl.* 2nd century CE) there was a stone tower in the Pamir Mountains where merchants from China and the Mediterranean lands exchanged goods. From Kashgar the route crossed the Pamirs to reach the city of Balkh (ancient Bactria, Afghanistan). Another way went to one of the most important cities on the route, SAMARKAND (ancient Maracanda, now in Uzbekistan). The town was destroyed by the Mongols in 1220 and was rebuilt by Timur (*r.* 1370–1405) as the capital of his empire. From Samarkand the route went through BUKHARA (Uzbekistan) or further south through Bactria before reaching MERV (ancient Antiochia-in-Margiana; now Mary, Turkmenistan), an important trading center and Islamic city until its destruction by the Mongols in 1221. The route crossed the Iranian plateau to Ectabana (now Hamadan, Iran), whence it led to a succession of great Mesopotamian cities, including Babylon, Ctesiphon and Baghdad. From there the route crossed the Syrian desert, where the city of Palmyra was an important trading center in Roman times, and terminated at the Mediterranean ports of Aleppo, Tyre, Sidon and Antioch.

B. SEA. The main port for the sea route in Guangdong Province was Guangzhou (Canton); during the Tang period ships also used Xiamen and Shantou. In Fujian Province the main ports were Quanzhou and Fuzhou. From these ports Chinese junks set out for ports in Java (Indonesia), Vietnam, Cambodia and the Malaccan Peninsula, whence they eventually reached India. As early as the Eastern Han period (25–220 CE) Chinese ships traded with Southeast Asian kingdoms. During the 4th century, when Faxian was returning to China from India by sea, his ship left the kingdom of Champa (Bengal) and stopped in Sri Lanka and Java, which were then dominated by Hindus. Although Chinese ships sailed all the way to India and Persia, the sea route was controlled by Arab seafarers. By the middle of the Tang period there were large communities of Arab seamen and merchants in Fujian Province. Western and Central Asian artifacts were transported by sea from China to Japan during the Nara (710–94) and Heian (794–1185) periods, and a large collection of these objects, including textiles, ceramics, metalwork, musical instruments and masks, is preserved in the Shōsōin repository in Nara.

III. Art.

A. Textiles. B. Metalwork, ceramics and glass.

A. TEXTILES. Although direct contact between the Chinese and Roman empires was never established, Rome (and later the Byzantine Empire) was a major consumer of Chinese silk from the 1st century BCE, although there is evidence for trade in Chinese silk with the West from the later Zhou period. Even after silk began to be cultivated outside of China in the 2nd–3rd centuries CE, the demand for high-quality Chinese products did not diminish. Silk production in Western Asia was based on imported raw silk from China in the 3rd–5th centuries. There is some indirect evidence concerning the cultivation of silkworms in Iran from the 4th century. The Byzantine Empire had its own raw silk from the 6th century. In a reverse trade from west to east, Byzantine and Sasanian polychrome silks became common in China in the 6th and 8th centuries, when they were imitated by Chinese craftsmen. Silks from the Byzantine Empire and Sasanian Iran show almost no Chinese designs, but Sasanian motifs—birds, animals and mythical beasts—became popular in the Byzantine Empire from the 8th century and in Islamic lands from the 8th or 9th century, where they were produced in several regions, from Iraq to Spain (*see* TEXTILES, §§II, B and C).

Another group of Central Asian silks, characterized by patterns of medallions containing heraldic animals and known as *zandanījī* ("from Zandana," a village near Bukhara; *see* CENTRAL ASIA, §VI, A, 1 and TEXTILES, §II, B), has been found over a large area from western Europe to western China. It has been supposed to be Sogdian, however the style of this group is not Sogdian at all. The Sogdians, who came from the Zarafashan Valley in the 3rd century BCE, established a number of colonies along the Silk Route. Sogdian paintings from Samarkand, Pendzhikent and Varakhsha show the fabrics used for clothing during the 5th–8th centuries; monochrome fabrics with simple designs were used until the beginning of the 7th century. Finds in Turfan show that fabrics decorated with medallions bordered by rows of pearls and other Iranian motifs became popular in China during the late 6th century. The use of two types of silk, one monochrome patterned, the other polychrome with complicated rosettes, which was characteristic of Tang-period China, became widespread at the end of the 7th century (examples in the Shōsōin repository, Nara). Both types of silk were found at the Sogdian fortress of KALA-I MUG (before 722–3). A silk found in Astana (Tokyo, Otani priv. col.) bears a design of a crescent enclosing an Arabic inscription, a Koranic quotation, invoking victory. The piece was probably woven in Iran and must postdate the Islamic conquest of Iran in the mid-7th century, making it an early example of Islamic silk. A woven silk fragment, dating from the 7th–8th centuries, belongs to the *zandanījī* group, it shows two confronted lions. Chinese silk designs were widely imitated by Western Asian and Italian weavers in the 13th and 14th centuries.

B. METALWORK, CERAMICS AND GLASS. Precious metalware makes it possible to establish the link between the sedentary and nomadic cultures of the Silk Route. The nomads acquired great wealth from

the tolls they levied on caravans. In addition, they often attacked and subjugated towns along the route and received tributes from the rulers of Byzantium, China and Iran. They frequently adopted the customs and religions of their settled neighbors: the Khazars adopted Judaism, the Uighurs, Manichaeism, and the Karluks, Nestorian Christianity. A gold vessel found in southern Siberia (St. Petersburg, Hermitage) dating from the Hellenistic period (323–31 BCE) has Greek, Scythian, Iranian and Chinese motifs. Chinese Han-period gold diadems have been found in Kargala (Kazakhstan) and Tillya Tepe (Afghanistan); Chinese mirrors from the same period have been found in Ferghana and Sogdiana. The Sogdians, who were among the leading traders along the Silk Route from the 6th to the 9th century, were skilled metalworkers, whose work was influenced by Byzantium, Iran and China. Western silverware has also been found in northern China dating to the 5th–7th centuries. The links weakened toward the end of the 8th century and particularly in the 9th and 10th centuries, although they were never completely severed. Byzantine silverware of the 9th and 10th centuries is similar to 8th-century Sogdian silverware. Byzantine vessels were decorated with Chinese leaf patterns and phoenixes, motifs that also appear on Byzantine manuscript illustration and ivory-carvings. The metalworkers of the various nomadic peoples used Sogdian, Iranian or Chinese motifs, and the same influence can be seen in silverware from Tibet, a state that emerged as a dominant power on the Silk Route in the 7th and 9th centuries. Between the 9th and 10th centuries, the Magyars, who migrated to the area of modern Hungary in the 9th century, developed an individual metalwork style based on Sogdian and early Islamic designs.

After the Mongol conquests in the 13th century, metalwork techniques became standardized throughout their dominions. The Mongol filigree style was probably the result of collaboration between Europeans at the Mongol court, such as the Parisian goldsmith Guillaume Bouchier during the first half of the 13th century, and Chinese craftsmen. The style was widely imitated in Syria and Egypt from the 13th to the 15th century.

Chinese ceramics, the styles of which often imitated first Parthian then Sogdian designs, became widespread throughout West Asia in the 9th–10th centuries, being highly valued and extensively copied (see CERAMICS, §II, B). They were exported primarily by sea from China to the Persian Gulf. Chinese 12th-century celadons, found in Samarkand and Fustat (Old Cairo), are evidence that both the land and sea routes to China were still in operation during the Song period (960–1279). West Asian and Islamic glassware dating from the 5th to the 9th century has been found in burial sites and temples in East Asia, imported first along the overland route, and later also by sea to the southern Chinese ports.

S. Beal and Si-Yu-Ki: *Buddhist Records of the Western World*, 2 vols. (London, 1884)

Y. I. Smirnov: *Vostochnoye serebro: Atlas drevney i serebryannoy posudy vostochnogo proiskhozhdeniya, naydennoy preimushchestvenno v predelakh Rossiyskoy imperii* [Oriental silver: an atlas of ancient silver products of oriental origin found mainly in the Russian empire] (St. Petersburg, 1909)

H. A. Giles, trans.: *The Travels of Fa-Hsien (AD 339–414)* (London, 1923, rev. 1956/*R* 1981)

Sizhou zhi lu [The silk road], Urumqi Museum of the Xinjiang Uygur Autonomous Region (Beijing, 1973)

Along the Ancient Silk Routes: Central Asian Art from the West Berlin State Museums (exh. cat. by H. Hartel and M. Yaldiz, New York, Met., 1982)

J. E. Vollmer, E. J. Keall and E. Nagai-Berthrong: *Silk Roads—China Ships* (Toronto, 1983)

Xinjiang kaogu sanshi nian [Thirty years of archaeology in Xinjiang] (Urumqi, 1983)

Yang Han-Sung and others, trans.: *The Hye-Ch'o Diary: Memoir of the Pilgrimage to the Five Regions of India,* Religions of Asia, ii (Berkeley and Seoul, 1984)

Faxian: *Faxian zhuan (jiaozhu)* [The Faxian account, annotated] (Shanghai, 1985)

Xuanzang: *Da Tang xiyou ji (jiaozhu)* [The great Tang record of the journey to the West, annotated], ed. Li Xianlin (Beijing, 1985)

B. Marschak: *Silberschätze des Orients: Metallkunst des 3.–13. Jahrhunderts und ihre Kontinuität* (Leipzig, 1986)

H. G. Franz, ed.: *Kunst und Kultur entlang der Seidenstrasse* (Graz, 1987)

H. Hartel and M. Yaldiz: *Die Seidenstrasse: Malereien und Plastiken aus buddhistischen Hohentempeln* (Berlin, 1987)

Liang Xinmin: *Lishi wenhua mingcheng Wuwei* [The history and culture of the famous city of Wuwei] (Wuwei, 1987)

H.-J. Klimkeit: *Japanische Studien zur Kunst der Seidenstrasse,* Studien in Oriental Religionen (Weisbaden, 1988)

H.-J. Klimkeit: *Die Seidenstrasse: Handelsweg und Kulturbrücke zwischen Morgen- und Abendland* (Cologne, 1988)

Shi Jinbo, Bai Bin and Wu Fengyun, eds.: *Xixia wenwu* [Xixia artefacts] (Beijing, 1988)

Xinru Liu: *Ancient India and Ancient China: Trade and Religious Exchanges, 1–600* (Oxford, 1988)

J. L. Abu-Lughod: *Before European Hegemony: The World System, 1250–1350* (New York and Oxford, 1989)

A. Eggebrecht, ed.: *Die Mongolen und ihr Weltreich* (Mainz, 1989)

Caves of the Thousand Buddhas: Chinese Art from the Silk Route (exh. cat. by R. Whitfield and A. Farrer; London, BM, 1990)

Silk Road A. & Archaeol., i– (1990–)

J. Giès and others: *Les Arts de l'Asie centrale: La Collection Paul Pelliot du Musée national des arts asiatiques, 2 vols.* (Paris, *c.* 1993; Eng. trans., London, 1996–; Jap. trans., Tokyo, 1994–5)

J. Harmatta and others, eds.: *History of Civilizations of Central Asia,* ii (Paris, 1994)

E. I. Lubo-Lesnichenko: *Kitai na Shelkovom puti* [China on the Silk Route] (Moscow, 1994)

La seta e la sua via (exh. cat., ed. M. T. Lucidi; Rome, Pal. Espos., 1994)

Silk Roadology, i– (1995–)

Usbekistan: Erben der Seidenstrasse (exh. cat. by J. Kalter, M. Pavaloi; Stuttgart, Linden-Mus. and Berlin, Mus. Vlkerknd., 1995), Eng. trans. as *Uzbekistan: Heirs of the Silk Road* (London, 1997)

A. H. Dani, V. M. Masson, B. A. Litvinsky and others, eds.: *History of Civilizations of Central Asia,* iii (Paris, 1996)

Land Routes of the Silk Roads and the Cultural Exchanges between the East and West before the 10th Century: Urumqi, 1990 (Beijing, 1996)

Sérinde, Terre de Bouddha: Dix siècles d'art sur la Route de la Soie (exh. cat., Paris, Grand Pal.; Tokyo, Met. A. Mus.; 1996)

Weihrauch und Seide: Alte Kulturen an der Seidenstrasse (exh. cat., ed. W. Seipel; Vienna, Ksthist. Mus., 1996)

T. T. Allsen: *Commodity and exchange in the Mongol Empire: A Cultural History of Islamic Textiles* (Cambridge, 1997)

Xinjiang weiwuer zizhiqu silu kaogu zhenpin [Archaeological treasures on the Silk Route in Xinxiang Uygur Autonomous Region] (Shanghai, 1998)

Sekai bijutsu dai zenshu: Toyohen, New History of World Art, 15 (Tokyo, 1999)

S. Whitfield: *Life along the Silk Road* (London, 1999)

Monks and Merchants: Silk Road Treasures from Northwest China, Gansu and Ninxia, 4–7th Century (exh. cat. by A. L. Juliano and J. A. Lerner; New York, Asia Soc. Gals., 2001)

R. Mack: *Bazaar to Piazza: Islamic Trade and Italian Art, 1300–1600* (Berkeley, 2002)

F. Wood: *The Silk Road: Two Thousand Years in the Heart of Asia* (London and Berkeley, 2002)

J. Tucker and A. Tozer: *The Silk Road: Art and History* (London, 2003)

K. Nebenzahl: *Mapping the Silk Road and Beyond: 2,000 Years of Exploring the East* (London, 2004)

The Silk Road: Trade, Travel, War, Faith (exh. cat. ed. by S. Whitfield; London, BM, 2004)

Simnan [Simnān; Semnan]. Small town in northeastern Iran. Simnan lies *c.* 180 km east of Tehran on the main route to Mashhad. Its antiquities include a fortress, a medieval bath, a congregational mosque in the center of town, and another mosque (1827–8) built by the Qajar ruler Fath ʿAli Shah (*r.* 1797–1834), but the best-known monument is the minaret (1030–34) of the congregational mosque. Built of baked brick, the minaret (h. 28.5 m) tapers sharply toward a *muqarnas* cornice and a balcony, both of which are later replacements for the original top of the tower. It is decorated in relief brickwork with broad bands of geometric designs and two inscriptions in a rough style of kufic script, furnished with serifs. The upper inscription is Koran 41:33, while the lower one states that the minaret was ordered by the governor, Abu Harb Bakhtiyar ibn Muhammad. The patron of the Persian poet Minuchihri, Abu Harb also commissioned a mausoleum and minaret in the nearby town of DAMGHAN. Like most Iranian minarets of its period, the minaret at Simnan was originally separate from the mosque it served. The mosque itself contains remnants of its 11th-century structure: it has a large dome in front of the mihrab and an adjacent iwan set in a much modified hypostyle plan.

Enc. Islam/1: "Semnān"

C. Adle: "Le Minaret du Masjet-i Jâmeʿ de Semnân *circa* 421–25/1030–34," *Stud. Iran.,* iv (1975), pp. 177–86

S. S. Blair: *The Monumental Inscriptions from Early Islamic Iran and Transoxiana* (Leiden, 1992), pp. 99–100

W. Kleiss: "Befestigungen in den Provinzen Semnan und Khorasan," *Archäol. Mitteil. Iran,* xxviii (1995), pp. 369–92

P. Willey: "The Ismaili Fortresses in Semnan and Khorasan 1100–1250," *U. Lect. Islam. Stud.,* ii (1998), pp. 167–81

A. Anisi: "The Friday Mosque at Simnan," *Iran,* lxiv (2006), pp. 207–28

Sinan [Koca Sinan; Sinan Abdülmennan Ağa] (*b.* Ağirnas village, Kayseri, *c.* 1500; *d.* Istanbul, 1588). Ottoman architect. As chief architect (Turk. *mimarbaşi*) for the Ottoman court from 1538 to 1588, he formulated the principles of classical Ottoman architecture and is credited with designing 476 buildings throughout the Ottoman Empire during its greatest years. His 196 surviving buildings, particularly the domed imperial mosques of Istanbul and Edirne, reveal the development of his architectural style and his mastery of siting, structure and space; account-books for his imperial commissions give corollary information about contemporary building practices. He was particularly interested in proportional systems and in constructing foundations and large domes, feats for which he was celebrated as a master builder in his own time. The main facts of his life and works are known through three so-called autobiographical manuscripts and his deed of trust, but they are not always reliable and present him as a documented legend.

I. Life and work. II. Working methods and style.

I. Life and work. Sinan was probably born in central Anatolia to a Christian family. He was recruited in the *devşirme,* the periodic levy of the Christian population of the Ottoman Empire, soon after the accession of Selim I (*r.* 1512–20) and entered the Janissaries, the Ottoman crack infantry troops, in 1521. Promotions came steadily and quickly as he participated in all the major campaigns of Süleyman (*r.* 1520–66), eventually being made a *haseki* officer, the most prestigious and lucrative rank in the Janissary corps. Sinan probably gained engineering experience building temporary bridges for the army and studied in depth the architectural monuments of the conquered cities of Europe and the Middle East. During his military career, Sinan's biographers credit him with restoring a mosque and shrine in Baghdad and erecting several small mosques in Istanbul. His military career also brought him to the attention of the sultan and the viziers who would later become his patrons.

On the death of Ali Acemi, in 1538 Sinan was appointed chief court architect, a position in which he supervised all public works. He designed religious complexes and civil structures and controlled construction throughout the empire and the market in building materials. With all these responsibilities, Sinan could not have designed and supervised all the buildings commonly ascribed to him. His primary responsibility was to the sultans; in his spare time he designed buildings for the chief officials, leaving his assistants to design less important buildings in the provinces. As head of the Corps of Court Architects, however, he took credit for all work the office

produced. The works in the eastern provinces exhibited metropolitan designs but were often realized in local techniques, such as striped masonry. Even the Süleymaniyya complex in Damascus (1552–9; *see* ARCHITECTURE, fig. 47), an imperial commission, was constructed in this traditional Syrian technique, although the dome, slender minarets and broad double portico of the building are typical of the classical Ottoman style, as is the axial and symmetrical composition of the subsidiary buildings surrounding the courtyard in front of the mosque.

Sinan's extant work, primarily domed mosque complexes, can be divided into three periods, but few of his purely civil commissions survive, so the study may present a somewhat distorted view of his architectural career. Buildings of the first period, such as the Şehzade Mehmed Mosque (1543–8) in Istanbul, explore the possibilities of the Ottoman style as inherited from his predecessors; buildings from the mid-1550s to 1570, of which the greatest is the Süleymaniye complex (1557; *see* ARCHITECTURE, fig. 43 and ISTANBUL, §III, C) in Istanbul, fully realize the potential of the classical Ottoman style; those from the 1570s to his death, such as the Selimiye Mosque in EDIRNE (1569–75), transcend the limits of classical Ottoman architecture to transform space and the play of light on masonry into an eloquent and poetic medium of expression.

Sinan's first major commission came from Süleyman's wife Hürrem Sultan (Roxelane) to build a modest complex near Aksaray in Istanbul. The buildings, which include a single-domed mosque and U-shaped madrasa, follow plans Sinan's predecessors had already developed during the reigns of Bayezid II (r. 1481–1512) and Selim I. Mihrimah Sultan, Süleyman's only daughter and the wife of the Grand Vizier Rüstem Pasha, then commissioned Sinan to build a complex at Üsküdar in Istanbul. Known as the Iskele (Jetty) Mosque (completed 1548), the building exhibits many of the hallmarks of Sinan's mature style. He responded creatively to the exigencies of the site by raising the mosque on a high vaulted basement. Slender pencil-point minarets frame the hierarchical composition of a single domed baldacchino girdled by a multi-windowed band on an angular base, flanked by semi-domes on three of its four sides and preceded by a broad double portico. Soon after Sinan started to work on the Iskele Mosque the sultan himself commissioned a mosque in memory of his favorite son, Şehzade Mehmed (see fig. 1). Although sharing some of the design features of Mihrimah Sultan's Mosque, this is larger and more ambitious. Sinan refined the scheme of the mosque of Bayezid II in Istanbul (1501–6) by removing the lateral hospice buildings, integrating the minarets into the structure to produce a totally centralized scheme, and flanking the large domed baldacchino with four semi-domes to produce a symmetrical quadriform superstructure supported on four freestanding piers and four piers in each wall. The conceptually coherent interior based on a modular plan differs markedly from the additive ones typical of

early Ottoman buildings. Although the progression from the courtyard to the mosque to the tomb suggests a longitudinal axis, the elevation belies this orientation, for Sinan introduced arcades on the side façades of the building and made them more elaborate than the main one. Both the interior wall piers and the exterior arcades replaced the massive walls of early Ottoman architecture with more interesting chiaroscuro effects.

For the huge Süleymaniye complex (1550–57; for plan *see* KÜLLIYE) Sinan prepared the gently sloping hillside site that dominates the Golden Horn with an elaborate system of foundations and retaining walls. The mosque, its courtyard and a cemetery garden were placed at the center and apex of the complex, which included over a dozen educational, charitable and commercial structures. Sinan exploited the slope by arranging the subsidiary buildings along three longitudinal axes at different levels within a framework of subtle geometric relationships. The superstructure of the mosque (*see* ARCHITECTURE, §VII, A, 2) consists of a dome (diam. 26.2 m) buttressed on the north and south by half-domes, but the lateral setting of the rectangular forecourt and prayer-hall contrasts subtly with the longitudinal tendency in the baldacchino. The disposition has often been compared to that of Hagia Sophia, and Sinan was undoubtedly inspired by the great Byzantine church, but he replaced its screened and hierarchical interior with a virtually undivided space that is immediately comprehensible in its entirety and exchanged the neglected exterior for meticulously realized and detailed façades.

Even in his smaller commissions Sinan showed the same concern with effective siting and use of varied dome plans. He elevated the Rüstem Pasha Mosque in Istanbul (1562–3; see fig. 2) on a terrace of shops to separate it from a busy commercial district, and the effect of an idyllic garden retreat is strengthened by the interior revetment of exquisite Iznik tiles. The octagonal system of squinches supported by piers was probably inspired by the Byzantine church of SS. Sergios and Bakchos, but Sinan made the central space more appropriate for a mosque by extending it laterally beyond the piers. In the Mihrimah Sultan Mosque at Edirnekapi in Istanbul (c. 1565), he likewise raised the building on a vaulted platform to accentuate its hilltop site and used pendentives rather than squinches to support the dome. By using pendentives, in contrast to squinches which transmit the dome's load on to the walls, the architect could pierce the walls with tiers of large windows and flood the interior with light.

In his earlier domed mosques Sinan had occasionally experimented with hexagonal systems of support (e.g. Sinan Pasha at Besiktaş in Istanbul, 1554–5, and Kara Ahmed Pasha at Topkapı in Istanbul, c. 1560, both ultimately derived from the Uç Şerefeli Mosque in Edirne), but in the mosques for SOKOLLU MEHMED PASHA in Istanbul (1571–2; see fig. 3) and Selim II in Edirne (1569–75) he eliminated the unnecessary subsidiary spaces beyond the supporting

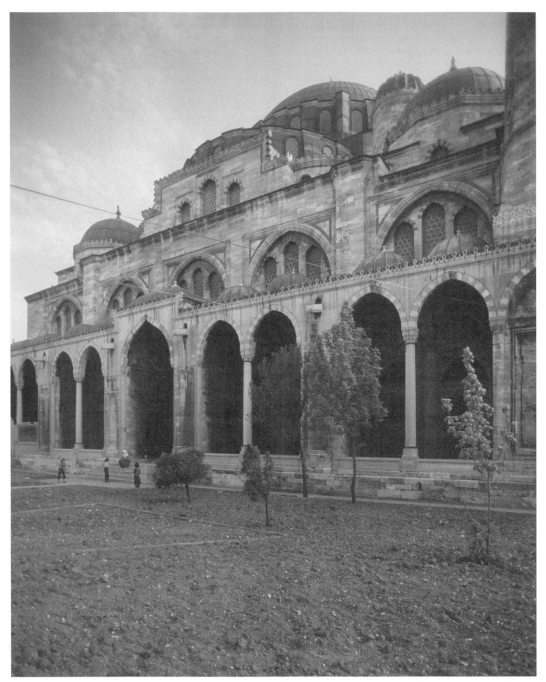

1. Sinan: Şehzade Mehmed Mosque, Istanbul, 1543–8; photo credit: Vanni/Art Resource, NY

piers of the baldacchino to create unified and extraordinarily elegant interiors. In other buildings of his late period he experimented with spatial and mural treatments unknown in the classical Ottoman canon, but his successors such as Sedefkâr Mehmed Ağa ignored these ideas and returned to his earlier and more traditional schemes for inspiration. At the Sokollu Mehmed Pasha Mosque Sinan gave the hexagonal baldacchino scheme of earlier mosques its simplest treatment by surmounting the prayer-hall with a central dome shouldered on either side by a pair of half-domes placed at 60° angles to the longitudinal axis and creating a laterally set rectangular hall free of any independent vertical supports. Wrapping the madrasa around the three sides of the courtyard in front of the mosque broke sharply with tradition but circumvented the

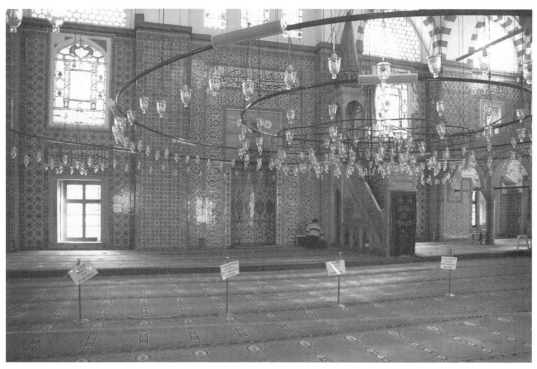

2. Sinan: Rüstem Pasha Mosque, interior, Istanbul, 1562–3; photo credit: Sheila S. Blair and Jonathan M. Bloom

imperial prerogative that forbade commoners to build a mosque preceded by a courtyard. Here, as in Rüstem Pasha's mosque, Sinan used wall tiles from Iznik to superb effect on the interior.

The Selimiye in Edirne (for illustration *see* EDIRNE and ARCHITECTURE, fig. 44) is more striking than Sinan's earlier imperial mosques and summarizes earlier formal experiments to create the optimum domed space by using an octagonal baldacchino on eight elephantine piers enclosed by screen walls that flood the interior with light. Semi-domes over the four corners transform the octagonal zone into a laterally set rectangular prayer-hall. Under the crown of the dome, a tribune for muezzins emphasizes the centralized character of the interior. Its 31.28 m dome deliberately surpasses that of Hagia Sophia. Four tall (70.89 m) minarets at the corners of the prayer-hall accentuate the vertical posture of the structure, which sits on a hilltop dominating the city and can be seen miles away from any direction.

Toward the end of his life Sinan experimented with innovative double-domed tombs, enveloping a Greek-cross chamber within an octagonal body (e.g. the tombs of Zal Mahmud Pasha at Eyüp in Istanbul, *c.* 1580, and of the Şehzadeler at Ayasofya in Istanbul, *c.* 1580), or using three arms for the interior and the fourth as an inverted portico (tomb of Kiliç Ali Pasha at Tophane in Istanbul, 1580–81). The last major work attributed to Sinan is the Atik Valide Mosque (1583), built for Nurbanu Valide Sultan, the mother of Murad III (*r.* 1574–95), on terraces cut into the gentle slopes of a hillside at Üsküdar

overlooking the Bosporus. Here, however, the disposition is more sophisticated than at the Süleymaniye complex: the terracing of the hillside not only binds the architecture to the site but displays the hierarchical order among the several buildings of the complex.

II. Working methods and style. Sinan's practical training as an engineer gave him an empirical rather than a theoretical approach to building that is consistent with the training and expectations of his

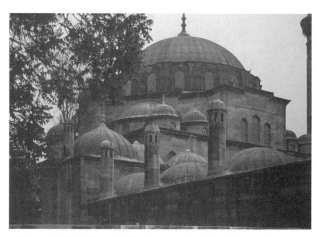

3. Sinan: Sokollu Mehmed Pasha Mosque, Istanbul, 1571–2; photo credit: Vanni/Art Resource, NY

contemporaries in the Ottoman Empire as well as those in the West, such as Filippo Brunelleschi (1377–1446). This approach is evident in his concern for elaborate foundations, great piers and massive arches that support the enormous domes of his mosques as well as in the numerous civil works, such as aqueducts and bridges, which he designed and erected. His office provided plans and models for buildings throughout the empire, which deputies and pupils from his office, such as Mehmed Ağa and AHMED DALGIÇ, might realize in brick and stone with the assistance of local master builders. Although provincial buildings are similar in plan to metropolitan examples and some of them are of fine quality, others contrast sharply in elevation with those Sinan or his close associates supervised. This suggests that his office did not prepare elevation drawings, leaving the on-site supervisor to extemporize the elevation. Over Sinan's career, his systems of proportion became increasingly sophisticated: the innocent mathematics of the Şehzade Mehmed Mosque give way to the complex geometries of the Süleymaniye and Selimiye.

Sinan used forms that were traditional in Ottoman architecture and his interest in architectural decoration was limited, but he introduced a new geometric purity, structural rationality and spatial integrity to the design of Ottoman mosques. The single-domed baldacchino generated both exterior and interior configurations. On the exterior a pyramidal composition of small domes and semi-domes culminates in a drumless dome framed by slender minarets; on the interior the drumless dome vertically integrates the interior space into a unified whole. Sinan's style may lie in the coherent way he realized this concept, but his genius as a master of the classical Ottoman style lies in the way he created and resolved tension within this limited formal vocabulary. The roofs of his buildings and the arches that support them are consistently curved, but he scrupulously avoided curvilinear elements in his plans, where he relied on rectangular, hexagonal and octagonal systems. The squinches or pendentives became zones of transition and resolution between angles and curves. Although the liturgical requirements of a mosque demand no such focus, Sinan's domed mosques strongly accentuate the center beneath the main dome. This baldacchino system allowed Sinan to break open the walls with windows to flood the interior with light and show how harmonious space was rationally created. While the lower casements became a major element of design and provided easy and direct visual communication with the exterior, Sinan often screened the upper windows with stucco and marble to manipulate the play of light, accentuate the wall surface and increase tension and visual ambiguity.

Sinan was more interested in spatial qualities than in decoration, and the decoration of his interiors, with some notable exceptions such as the splendid tiled interiors of his mosques for Rüstem Pasha and Sokollu Mehmed Pasha, is of minor interest. The delicate moldings consistently found on interior surfaces correspond to the more substantial horizontal cornices on the exterior that separate the tectonic layers—walls, transition zone and dome—of his mosques, underscore the continuity of contours in each register between its various parts (e.g. domes, minarets and outbuildings) and tie his buildings together.

Enc. Islam/2; *Macmillan Enc. Architects*

Mustafa Sai Çelebi (*d.* 1595): *Tezkiretül-Bünyan* [Record of construction] (1583–4) (Istanbul, 1315/1897)

Mustafa Sai Çelebi (*d.* 1595): *Tezkiret ül-Ebniye* [Record of edifices] (*c.* 1586) (Istanbul, n.d.)

Tuhfet ül-Mi'marin [Works of architecture] (1590s)

Sinan's works are given variously in three near-contemporary sources, two published in a critical edition by R. M. Meriç: *Mimar Sinan. Hayatı, Eseri I: Mimar Sinan'ın hayatına eserlerine dair metinler* [Mimar Sinan. His life and work I: texts concerning his life and works] (Ankara, 1965)

H. Crane and E. Akin, ed. and trans.: *Sinan's Autobiographies: Five Sixteenth-Century Texts* (Leiden, 2006)

A. Gabriel: "Les Mosquées de Constantinople," *Syria*, vii (1926), pp. 359–419

A. M. Charles: "Haghia Sophia and the Great Imperial Mosques," *A. Bull.*, xii (1930), pp. 321–44

A. Gabriel: "Le Maître architecte Sinan," *Turquie Kemal.*, xvi (1936), pp. 2–13

E. Akurgal: "Sanat Tarihi Bakimindan Sinan" [Sinan from the viewpoint of art history] *Ankara Ü. Dil Ve Tarih Coğrafya Fakültesi Derg.*, no. 2 (1944), pp. 375–84

H. Konyali: *Mimar Koca Sinan'ın Eserleri* [The works of the master Sinan] (Istanbul, 1950)

O. Bozkurt: *Koca Sinan'ın Köprüleri* [Sinan's bridges] (Istanbul, 1952)

S. Corbett: "Sinan the Architect-in-Chief to Suleiman the Magnificent," *Archit. Rev.* [London], cxiii (1953), pp. 290–97

E. Egli: *Sinan der Baumeister osmanischer Glanzzeit* (Zurich, 1954/R 1976)

C. Bektaş, ed.: *Koca Sinan. Sinan Komitesince 380. Ölüm yildönümü dolayisiyle yayinlanmiştir* [A collection by various authors to commemorate the 380th anniversary of the death of the architect Sinan] (Istanbul, 1968)

A. Inan: *Mimar Koca Sinan* (Ankara, 1968)

D. Kuban: "An Ottoman Building Complex of the Sixteenth Century: The Sokollu Mosque and its Dependencies in Istanbul," *A. Orient.*, vii (1968), pp. 19–39

O. Aslanapa: *Turkish Art and Architecture* (London, 1971)

G. Goodwin: *A History of Ottoman Architecture* (Baltimore and London, 1971)

A. Stratton: *Sinan* (New York, 1972)

Ö. L. Barkan: *Süleymaniye Camii ve Imareti Insaatı: 1550–1557* [The construction of the Süleymaniye Mosque and its adjoining buildings, 1550–57], 2 vols. (Ankara, 1972–1979)

M. Sözen, ed.: *Türk mimarisinin gelişimi ve mimar Sinan* [The development of Turkish architecture and the architect Sinan] (Istanbul, 1975); Eng. trans. by Z. Nayir as *Turkish Architecture and Architect Sinan* (Istanbul, 1976)

D. Kuban: "Selimiye at Edirne: Its Genesis and an Evaluation of its Style," *IVème Congrès international d'arts turcs* (Aix-en-Provence, 1976), pp. 105–11

J. M. Rogers: "The State and the Arts in Ottoman Turkey: The Stones of Süleymaniye," *Int. J. Mid. E. Stud.*, xiv, no. 1 (1982), pp. 71–86

G. Necipoğlu-Kafadar: "The Süleymaniye Complex in Istanbul: An Interpretation," *Muqarnas*, iii (1985), pp. 92–117

D. Kuban: "The Style of Sinan's Domed Structures," *Mugarnas*, iv (1987), pp. 72–97

A. Kuran: *Sinan: The Grand Old Master of Ottoman Architecture* (Washington, DC and Istanbul, 1987)

J. Erzen: "Sinan as Anti-classicist," *Muqarnas*, v (1988), pp. 70–86

G. Necipoğlu: "Challenging the Past: Sinan and the Competitive Discourse of Early-modern Islamic Architecture," *Muqarnas*, x (1993), pp. 169–80

A. Aktaş-Yasa, ed.: *Ulusararasi Mimar Sinan Sempozyumu Bildirleri, Ankara 24–27 Ekim 1988* [Proceedings of the 1988 international symposium on Sinan] (Ankara, 1996)

D. Kuban: *Sinan's Art and Selimiye* (Istanbul, 1997)

D. Kuban: *Sinan: An Architectural Genius* (Berne, 1999)

G. Necipoğlu: *The Age of Sinan: Architectural Culture in the Ottoman Empire* (Princeton, 2005)

J. M. Rogers: *Sinan* (London, 2006)

D. Kuban: *Osmanlı Mimarisi* (Istanbul, 2007); Eng. trans. as *Ottoman Architecture* (London, in preparation)

Siraf [Sīrāf; now Tāherī]. Medieval city on the Gulf coast of Iran, 240 km southeast of Bushire. From the 9th century to the 11th, Siraf was the largest and finest port in Iran, but the city declined when maritime trade shifted to other ports in the 12th century, despite a brief revival in the 14th and 15th centuries. Siraf prospered because of the expansion of Islamic rule in the east, the revival of the economies of Iraq and Iran after the Abbasid dynasty (*r.* 749–1258) came to power and increased sea trade between Gulf ports and those of Arabia, East Africa, India and China. Despite torrid summers, poor soil and low rainfall, the city enjoyed two natural advantages over nearby coastal settlements: a sheltered bay to protect ships from storms and a relatively easy caravan route to the Iranian plateau.

The site already existed in the Sasanian period (226–645 CE). Pre-Islamic remains include a cliff-top citadel, a fort with features that recall Roman frontier fortifications of the 4th century and more than 100 rock-cut chamber tombs that appear to be Zoroastrian ossuaries. The presence of Red Polished ware from Gujarat or Sind shows that Siraf already participated in long-distance trade at this time. The early Islamic city developed around the bay and occupied an area defined by the sea, a precipitous ridge on the landward side and two seasonal watercourses that cross the coastal plain. The heart of the city consisted of 110 ha of houses, bazaars, mosques and workshops built of stone and mortar. A larger area contained gardens and the huts of the poorer members of the community.

Excavations and surveys carried out between 1966 and 1973 documented the congregational mosque and other mosques, houses, a palace, part of the bazaar, part of the potters' quarter and a monumental cemetery. The congregational mosque was founded in the early 9th century, soon enlarged and then repaired in the 12th century, as attested by a fragmentary inscription in stone. The original mosque

(51×44 m) consisted of a courtyard surrounded on three sides by a single arcade and on the fourth by a prayer-hall three bays deep. A square minaret stood opposite the mihrab. At least ten small mosques were also found. Most of them were rectangular buildings divided by an arcade and entered through a yard; three of them had a staircase minaret. Houses were square in plan and had six to fourteen rooms disposed around a central courtyard. Wooden stairs led to the upper stories, which had balconies overlooking the court. Built of rubble, they were all decorated with friezes and panels of carved and molded stucco. The palace, which stood in the coolest part of the city, was one of five large residences incorporating several such units within a wall. The bazaar extended some 600 m along the shore and had rows of small, self-contained shops. A pottery factory, which occupied an entire city block, comprised a group of walled yards containing workshops and kilns. Most of the wares produced were unglazed jars, bowls and cooking pots. The potters' quarter supplied much of the earthenware used at Siraf in the 10th century, and these wares have been found in East Africa and Pakistan. The cemetery contained more than 30 mausolea, some of them two stories high and all designed for collective disposal of the dead. They are unlike any other early Islamic mausolea in the region, and the identity of the sect that built them is unknown.

A wide range of artifacts was uncovered, including coins from the city's mint, which operated from 934 to 993, stone grave covers dating from 975 to 1335 and small alabaster containers. The most common imported object was glazed pottery from Iraq. Other imported goods included Chinese and Southeast Asian ceramics such as stoneware jars with green glaze, which arrived as containers for perishable goods, several varieties of stoneware dishes, bowls and ewers, and white porcelain.

Enc. Islam/2

Iran, vi–xii (1968–74) [interim excav. reps from Siraf by D. Whitehouse]

D. Whitehouse: "Islamic Glazed Pottery in Iraq and the Persian Gulf," *AION*, xxix (1979), pp. 45–61

D. Whitehouse: *Siraf III: The Congregational Mosque and Other Mosques from the Ninth to the Twelfth Centuries* (London, [1980])

N. M. Lowick: *Siraf XV: The Coins and Monumental Inscriptions* (London, 1985)

M. Tampoe: *Maritime Trade between China and the West: An Archaeological Study of the Ceramics from Siraf (Persian Gulf), 8th to 15th century A.D.* (Oxford, 1989)

E. J. Keall and R. B. Mason: "The 'Abbasid Glazed Wares of Sīrāf and the Baṣra Connection: Petrographic Analysis," *Iran*, xxix (1991), pp. 51–66

J. M. Scarce: "Bandar-i Tahiri —A Late Outpost of the Shahnama," *Shahnama: The Visual Language of the Persian Book of Kings*, ed. R. Hillenbrand (Aldershot, 2004), pp. 143–54

Sivas. City in central Anatolia (Turkey). Following the defeat of the Byzantines by the Saljuqs of Rum at Manzikert in 1071, the Byzantine city of Sebastea

became the capital of a Danishmend Turkoman principality in northern Cappadocia and Pontus. Now known as Sivas, it was absorbed by the Saljuqs in the 12th century and by the Ilkhanids of Iran in the 13th. Sivas was the capital of the Uighur chief Eretna from 1326 to 1352; at the end of the 14th century it was taken by the Ottomans. Several buildings surviving from the pre-Ottoman period are distinguished by an inventive combination of decorated stone and brick (*see* ARCHITECTURE, §V, C).

The Ulu Cami (1197), or congregational mosque, is a hypostyle stone structure, with an open court and ten rows of rectangular piers supporting arcades perpendicular to the qibla wall on which the flat timber and earthen roof rest. The brick minaret (?1213) in the southeast corner has tile-mosaic decoration on the base and two religious inscriptions on the shaft. The Darüşşifa (1217–18), or hospital of the Saljuq sultan 'Izz al-Din Kayka'us I (*r*. 1210–19), comprises an elaborate portal leading to an arcaded court with four iwans. The iwan on the south has been replaced by the founder's mausoleum, which rises above the stone structure as an octagonal prism of brick. Its façade on the court is elaborately decorated with glazed bricks and tile.

Three madrasas were erected in 1271–2 by patrons in apparent competition with each other. The Buruciye Madrasa, built by Muzaffar ibn Hibatallah al-Mufaddal al-Burujirdi, has a splendid portal of carved stone leading to the typical rectangular court with lateral porticos, axial iwans and cells for students. The square tomb of the founder, to the left of the entrance, has fine tiles glazed in turquoise blue and manganese purple. The Gök ("Blue") Madrasa (1271–2) was constructed for Fahr al-Din 'Ali ibn al-Husayn, known as Sahib Ata, by the architect Kaluyan from Konya. It has a spectacular carved stone façade with a fountain (Turk. *çeşme*) on the left and an elaborate marble portal in the center, surmounted by two brick minarets. The details on this portal repeat those of the Çifte Minareli ("Twin minaret") Madrasa at ERZURUM. The building is also remarkable for the tile mosaic decoration of its mosque and the lateral iwans, although the main iwan and adjacent cells have been completely destroyed; the madrasa is used as the Sivas Museum. Only the façade of the Çifte Minareli Madrasa in Sivas has been preserved (*see* MUQARNAS, fig. 1). Erected opposite the Darüşşifa by the Ilkhanid grand vizier Shams al-Din Muhammad (Juvayni), the building has a portal surmounted by two brick minarets with tile decoration. Summary excavation has revealed that it had a court with four iwans and that buildings flanked it on the north and south.

The mausoleum for Hasan Beg, the son of Eretna (1348), which is also known as the Güdük Minare Türbesi ("Truncated minaret tomb"), has a cubic base of finely laid stone surmounted by a faceted zone of transition and cylindrical drum, both of brick. Tiles of turquoise-glazed ceramic have been placed between the bricks, and a band of blue-and-white tiles has been inserted under the cornice. The original conical roof has been replaced by a timber framework of similar shape (*see* ARCHITECTURE, §VI, B).

H. Denizli: *Sivas Tarihi ve Anitlari* [History and Monuments of Sivas] (n.d.)

M. van Berchem and H. Edhem: *Matériaux pour un Corpus Inscriptionum Arabicarum, 3ème partie: Asie Mineure* (Cairo, 1917), pp. 1–54

İ. Hakkı and R. Nafiz: *Sīvās Şehrī* [The city of Sivas] (Istanbul, 1346/1928)

A. Gabriel: *Monuments turcs d'Anatolie* (Paris, 1934), ii, pp. 143–64

K. Endil: *Sivas Rehberi* [Guidebook of Sivas] (Sivas, 1953)

J. M. Rogers: "The Cifte Minare Medrese at Erzurum and the Gök Medrese at Sivas," *Anatol. Stud.*, xv (1965), pp. 63–85

J. M. Rogers: " Seljuk Architectural Decoration at Sivas," *The Art of Iran and Anatolia from the 11th to the 13th century A.D.*, ed. W. Watson (London, 1975), pp. 13–27

M. Meinecke: *Fayencedekorationen seldschukischer Sakralbauten in Kleinasien*, 2 vols. (Tübingen, 1976)

I. Yasak and A. Kaleli: *Dünden Bugüne Sivas Ili* [Sivas District from Yesterday to Today] (Sivas, 1986)

T. A. Sinclair: *Eastern Turkey: An Architectural and Archaeological Survey*, 3 vols. (London, 1987–9), ii, pp. 296–310

N. B. Bilget: *Gök Medrese* (Ankara, 1989)

N. B. Bilget: *I. İzzeddin Keykâvus Darüşşifasi* [Hospital of İzzeddin Keykâvus] (Ankara, 1990)

N. B. Bilget: *Sivas'ta Buruciye Medresesi* [Buruciye Madrasa at Sivas] (Ankara, 1991)

E. S. Wolper: "The Politics of Patronage: Political Change and the Construction of Dervish Lodges in Sivas," *Muqarnas*, xii (1995), pp. 39–47

E. S. Wolper: *Cities and Saints: Sufism and the Transformation of Urban Space in Medieval Anatolia* (University Park, PA, 2003)

R.G. Hovannisian, ed.: *Armenian Sebastia/Sivas and Lesser Armenia* (Costa Mesa, CA, 2004)

Siyah Qalam [Ustād Muḥammad Siyāh Qalam] (*fl.* late 14th century or 15th). Name associated with a Persian, Turkmen or Central Asian painter or painters. The full name, which translates as "Master Muhammad Black Pen," refers in the narrowest sense to the inscriptions on 65 paintings and drawings, mostly of demons, nomads and workers, in two albums (Istanbul, Topkapı Pal. Lib., H. 2153 and H. 2160). Whether the inscriptions are signatures, attributions to a specific artist or references to a type of painting is debatable; no consensus of opinion has been reached as to when, where and why the works were produced. The two albums contain no introduction, patron's name or date of compilation. They are known as the Ya'qub Beg Albums on the basis of the number of calligraphies signed by scribes with the epithet Ya'qubi, referring to the Aqqoyunlu Turkmen Ya'qub Beg (*r*. 1478–90). The latest calligraphy in one album (H. 2160) is dated 1511–12 and the first and last folios are stamped with the seal of the Ottoman sultan Selim I (*r*. 1512–20), so the album was probably complete by 1512 and had entered Ottoman possession by 1520 (*see also* ILLUSTRATION, §V, F). The other album (H. 2153) is contemporary, since it also contains the seal of Selim I and several

calligraphies produced after the death of Ya'qub, including one dated 1496. In addition to the Siyah Qalam group, the 546 paintings and drawings in H. 2153 and the 131 in H. 2160 include 14th- and 15th-century works attributed to artists working in Tabriz, Baghdad, Herat and Samarkand, as well as European prints, Chinese paintings and Ottoman paintings, presumably added during the reign of Selim I or later.

Of the artists named in inscriptions in the two albums, SHAYKHI (named on 71 works) and Muhammad Siyah Qalam (named on 65 works) are the most frequent. Shaykhi is identifiable as the artist who, with DARVISH MUHAMMAD, illustrated a copy (Istanbul, Topkapı Pal. Lib., H. 762) of Nizami's *Khamsa* ("Five poems") made for Ya'qub in 1491. In the albums, however, the credibility of the inscriptions is undermined by the clumsiness of the hand in which most of them are written and its resemblance to that of the Ottoman sultan Ahmed I (*r.* 1603–17). So many varieties of style are attributed to the same artist that most scholars believe the inscriptions are apocryphal. Nevertheless Togan (1953–4) identified Siyah Qalam with the painter Mawlana Muhammad, mentioned by the Timurid historian Khwandamir (*d.* 1535–6) and polymath 'Alishir Nava'i (*d.* 1501) as a painter of strange figures who worked first at the Timurid court at Herat, then traveled to Iraq, where he worked at the Turkmen court, before returning to Herat in 1491. Togan then (1963) changed his identification of Muhammad Siyah Qalam to Hajji Muhammad Bakhshi Uyghur, a late 15th-century calligrapher and painter at the court of Husayn Bayqara (*r.* 1470–1506) at Herat. Robinson proposed that Darvish Muhammad and Muhammad Siyah Qalam were the same man, arguing that an artist of Darvish Muhammad's stature in Ya'qub's workshop would have been too important to have a mere three works included in the Ya'qub Beg Albums, and that Darvish Muhammad's teacher, Shah Muzaffar, was also known as Siyah Qalam.

Although the works attributed to Siyah Qalam include those in an intensely colored, sinicizing style, the bulk of the Siyah Qalam group consists of representations of demons, scantily clothed seated or dancing figures, heavily draped travelers, and horses depicted in somber tones against a blank ground. In addition to the large scale of the figures and their ferocious faces, the group is characterized by a rendering of drapery and skin in which fat, rippling and parallel folds emphasize the weight and movement of flesh and clothing. The style could not be further from the metropolitan idioms practiced at the Jalayirid, Timurid or Turkmen courts (*see* ILLUSTRATION, §V, C, D, and E). Dates and provenance assigned to the group range from the 12th to the 16th century, from Central Asia to Tabriz. The most common attributions are to the mid- to late 14th century at Samarkand or Herat and to the mid- to late 15th century at Tabriz under the Turkmen rulers. From historical descriptions and artistic prototypes, scholars have concluded variously that the figures are shamans,

Qalandar dervishes, Russian boyars or copies after European prints. Much of the evidence concerning the identity of the figures is convincing yet conflicting, and conclusive information about the authorship, provenance and meaning of the Siyah Qalam group remains elusive.

Z. V. Togan: "Topkapı Sarayında dört cönk"/"Four Albums in the Topkapı Museum," *Islâm Tetkikleri Enst. Derg.*, i (1953–4), pp. 73–89 [Eng. summary, pp. 87–9]

Z. V. Togan: *On the Miniatures in Istanbul Libraries* (Istanbul, 1963)

M. S. Ipşiroğlu: *Siyah Qalam* (Graz, 1976)

E. J. Grube and E. Sims, eds.: *Between China and Iran: Paintings from Four Istanbul Albums* (London, 1985), also as *Islam. A.*, i (1985, dated 1981) [with extensive bibliog. and illus.; see esp. papers by F. Çağman, E. Esin, E. J. Grube, A. A. Ivanov, B. Karamağaralı, J. Raby, B. W. Robinson and Z. Tanındı]

F. Çağman and Z. Tanındı: *The Topkapı Saray Museum: The Albums and Illustrated Manuscripts*, ed. and trans. J. M. Rogers (Boston, 1986), pp. 114–56

N. S. Steinhardt: "Siyah Qalem and Gong Kai: An Istanbul Album Painter and a Chinese Painter of the Mongolian Period," *Muqarnas*, iv (1987), pp. 59–71

J. M. Rogers: "Siyah Qalam," *Persian Masters: Five Centuries of Painting*, ed. S. Canby (Bombay, 1990), pp. 21–38

L. Gillard: "Siyah Qalam, New Perspectives," *Persica*, xv (1993–5), pp. 95–141

B. O'Kane: "Siyah Qalam: The Jalayirid Connections," *Orient. A.* xlix/2 (2003), pp. 2–18

F. Çağman: "Glimpses into the Fourteenth-Century Turkic World of Central Asia: The Paintings of Muhammad Siyah Qalam," *Turks: A Journey of a Thousand Years 600–1600* (exh. cat. ed. D. J. Roxburgh; London, RA, 2005), pp. 148–89

Siyavush [Siyāvush, Siyāvush Beg] (*b.* Georgia, *c.* 1536; *d.* before 1616). Persian illustrator. According to the Safavid chronicler Qazi Ahmad, Siyavush was a Georgian slave brought to Tabriz as a child and assigned to the royal studio. He studied under *Muzaffar 'ali*, artist and boon companion to the Safavid ruler Tahmasp I (*r.* 1524–76). The earliest extant works attributed to Siyavush are 19 paintings from the incomplete copy (dispersed) of the *Shāhnāma* ("Book of kings") made for Isma'il II (*r.* 1576–8). Exemplifying the artist's mature style, these paintings reveal a penchant for dramatic landscape elements and well-organized compositions. The variety of human types expresses a range of emotions but lacks a certain psychological depth, in the opinion of A. Welch. According to the Safavid chronicler Iskandar Munshi, after the accession of Muhammad Khudabanda (*r.* 1578–88), Siyavush and his brother Farrukh Beg became companions of Hamza Mirza (*d.* 1586), heir to the throne. A battle scene in a copy (ex-O. Homberg priv. col., see Welch, fig. 4) of Khwandamir's *Habīb al Siyār* ("Beloved of careers"), produced in 1579 for a Tajik official at the Safavid court in Qazvin, is attributed to Siyavush. Iskandar Munshi praised the artist as an excellent miniaturist, unequalled in pen and ink sketches and in mountain scenes. This description is borne out in three of his four known

drawings: *Two Youths under a Tree* (Istanbul, Topkapı Pal. Lib., H. 2135, fol. 11*v*), *Archer Attacking a Dragon* (Paris, Louvre) and *Two Men Asleep in a Landscape* (see Welch, fig. 10). They depict figures in landscapes in which the mountain formations, more vegetal than mineral, set the mood for the scene. Siyavush reportedly gave up painting in the late 1590s, but by 1606 was working again in Shiraz (*see* ILLUSTRATION, §VI, A, 4). Among his students was VELI CAN.

Qazi Ahmad ibn Mir Munshi: *Gulistān-i hunar* [Garden of the arts] (*c*. 1606); Eng. trans. by V. Minorsky as *Calligraphers and Painters* (Washington, DC, 1959), p. 191

Iskandar Munshi: *Tārīkh-i 'ālamārā-yi 'abbāsī* [History of the world-conquering 'Abbas] (1629); Eng. trans. by R. Savory as *History of Shah 'Abbas the Great* (Boulder, 1978), pp. 272–3

A. Welch: *Artists for the Shah* (New Haven, 1973), pp. 17–40

B. W. Robinson: "Isma'il II's Copy of the *Shāhnāma*," *Iran*, xiv (1976), pp. 1–8

S. R. Canby: *The Golden Age of Persian Art* (London, 2002)

Smith, Robert Murdoch. *See* MURDOCH SMITH, ROBERT.

Sokollu Mehmed Pasha [Paşa] (*b.* Sokol, Bosnia, 1505; *d.* Istanbul, 1579). Ottoman vizier and patron. Born of noble Slav ancestry, he rose through the Ottoman slave bureaucracy to become Chief Admiral (1546) and Third Vizier (1559) and served as Grand Vizier to sultans Süleyman, Selim II and Murad III until his assassination. An individual of vast capabilities, Sokollu Mehmed Pasha was one of the greatest patrons of architecture in the golden age of the Ottoman Empire (*see* ARCHITECTURE, §VII, A). He established charitable foundations throughout the empire, many of them designed by the renowned architect SINAN. Over a dozen were established in Bosnia: in addition to the eponymous bridge (1577) over the Drina at Višegrad and two other bridges at Lin and Rudo, he founded mosques, schools and caravanserais, contributing greatly to the prosperity and infrastructure of the region. At the other end of the empire, near Payas (Yakacık) in the province of Antakya (Antioch), Sokollu had Sinan construct a large complex of buildings including a small mosque, alms-kitchen, caravanserai, market and double bath. Other important complexes were founded at Luleburgaz and Havsa in Thrace.

The best-known examples of his patronage are found among the 14 buildings he erected in Istanbul. Sinan's complex (1571) at Kadırga establishes Mehmed Pasha's rank among great architectural patrons. Considered to be the pre-eminent foundation by an Ottoman vizier, the complex is set in a walled garden on a steep hillside overlooking the Sea of Marmara and consists of a mosque with a madrasa wrapped around its forecourt. The complex must have been enormously expensive for its small size, for it contains some of the richest and most highly planned and perfectly executed tile revetments ever to have been produced by the IZNIK manufactories.

With its great calligraphic panels by the calligrapher Hasan in the tradition of AHMAD KARAHISARI, its interior division into two discrete stylistic levels and its masterful stone-carving and architectural painting, the Sokollu complex occupies a place at the apogee of Ottoman artistic accomplishment. As a token of his piety, Sokollu arranged for three tiny fragments of the Black Stone from Mecca to be placed in his building above the mihrab, the minbar and the interior of the main door. The other complex (1579) at Azap Kapı was also supported by his wife, Esmahan Gevher Sultan, daughter of Selim II and a patron in her own right, who may have had the building completed after her husband's death.

Enc. Islam/2

D. Kuban: "An Ottoman Building Complex of the Sixteenth Century: The Sokollu Mosque and its Dependencies in Istanbul," *A. Orient.*, vii (1968), pp. 19–39

G. Goodwin: *A History of Ottoman Architecture* (Baltimore and London, 1971)

E. H. Ayverdi: *Avrupa'da osmanlı mi'mari eserleri: Yugoslavya* [Ottoman architecture in Europe: Yugoslavia] (Istanbul, 1981)

M. Begić: *Mehmed Sokolovitch, le destin du'un grand vizir* (Lausanne, 1994)

M. A. Lala Commeno: "Notes upon the Architectural Patronage of Sokollu Mehmed Pasha in the Ottoman Bosnia," *9th International Congress of Turkish Art, 23–27 September 1991* (Ankara, 1995), vol. 2, pp. 417–23

R. H. W. Stichel: "Der Istanbuler Palast des osmanischen Grossvezirs Sokollu Mehmet Pascha (gest. 1579) in zeitgenossischen Abbildungen," *Architectura*, xxvi/2 (1996), pp. 197–214

Z. Yürekli: "A Building Between the Public and Private Realms of the Ottoman Elite: The Sufi Convent of Sokollu Mehmed Pasha in Istanbul," *Muqarnas*, xx (2003), pp. 159–85

Solkhat-Krym [Solgaht]. *See* STARYY KRYM.

Soltaniye. *See* SULTANIYYA.

Somalia [Somali Republic; Arab.: Jamhūriyat al-Ṣūmāl; formerly Somali Democratic Republic, British Somaliland Protectorate]. Country in northeast Africa bordered by Djibouti and Ethiopia to the west, Kenya to the south and the Gulf of Aden and the Indian Ocean to the north and east. The capital is Mogadishu. The Somali people, who also live in Djibouti, Ethiopia and Kenya, comprise *c.* 98% of the population of 9,118,000 (2007 estimate). Most of the population are nomadic pastoralists, though there is some sedentary agriculture in the south, as well as a number of mercantile centers, especially on the coast. Most Somali are Sunni Muslims. The official language is Somali, though Arabic, Italian and English are also spoken.

Somalia is mountainous to the north, though most of the land is low plateau. The climate is hot with monsoon winds and irregular rainfall. The area has long had external trade links, for example with Egypt since at least the 4th millennium BCE. Arab and Persian traders set up commercial centers on the

coast in the mid-1st millennium CE. The Islamicization of the area began in the 7th century. The Somalis began arriving in the area c. 1000. No political unity was established, however, and in the late 19th century Somali lands were divided up by the British, Italian and French colonial powers. Modern Somalia was divided between British Somaliland (established from 1884) and Italian Somaliland (from 1889). From 1941 these were united as the British Somaliland Protectorate, though part of this was returned to Italy in 1950 by the United Nations. British and Italian Somalia joined together in 1960 as the newly independent Somali Republic. From the 1960s the country has faced great problems of drought and famine, as well as economic and political instability.

Traditional skills continue to be important, their existence being maintained both by the demands of Somali custom and by the presence of clans of artisans. A major form of Somali artistic expression is wood-carving and wood-engraving, which is applied to architectural elements and to such everyday objects as headrests (a standard item of furniture among nomads), spoons, combs, bowls, vases, boxes and chests. Ornamental motifs include chevrons, crosshatching and the dot and circle. Metalworking techniques include appliqué, filigree, repoussé work and engraving. Somali jewelry includes necklaces, bracelets, earrings, armlets and cosmetic containers. Regional specialities include the working of gold and silver in Mogadishu and pottery manufacture in the south and along the coast. The domestic utensils of the pastoral nomads include items made from plant fibers and animal skins. Other Somali crafts include the weaving of carpets, clothes and prayer-mats, leatherworking, basketry and ivory-carving. Masking traditions have been reported in the south (Clark).

Traditional forms of architecture also continued to be used. The women of the nomadic pastoralists build a small, portable, dome-shaped hut (*aqal*) that consists of a framework of branches covered by mats, skins or other materials and has an interior height ranging from c. 1 to 2 m. Although usually one room, in some northern areas there is a separate room for women. For the sedentary agriculturalists of southern Somalia, where wood and grass are more plentiful, the traditional dwelling (*mundul*) comprises a cylindrical framework of poles sealed with mud and dung and covered with a conical thatched roof. The central post, beams, doors and lintels may be carved, and these elements are reused. In the coastal region there are cities containing a third, distinct architectural tradition of Arab-style stone houses. These are usually one or two stories high and often have carved wooden lintels, doors and windows. Decoration includes plait and leaf motifs, eight-petal rosettes, four-petal asters and half circles.

From the early 20th century European ideas and technology influenced traditional Somali architecture. Italian influences were visible first in domestic architecture but by the 1930s also in a number of public buildings; the Italians also initiated urban planning in the capital. From World War II there was a growth of towns accompanied by the construction of a variety of modern buildings designed by Western architects, and these changes have affected indigenous vernacular architecture. The most common house-type in Mogadishu, the *arish*, has a rectangular plan inspired by Arab and European buildings, with walls of branches sealed with mud and dung and a sloping roof of thatch or metal. Windows are sometimes included, and the exterior may be whitewashed. The *baraca* is identical in plan but has walls made of board, usually supported by a foundation of stone and concrete. When a *baraca* has masonry walls it is known as a *casa matoni*.

Western-style painting, graphics and sculpture are little practiced in Somalia, although some Western-style sculptural monuments to the nationalist struggle have been created. The National Museum of Somalia (formerly the Garesa), Mogadishu, was founded in 1934 in a 19th-century palace of the sultan of Zanzibar. It was revitalized after being placed under the control of the Ministry of Education in 1964 and houses a collection of such ethnographic items as pottery remains, gravestones, coins, arms and a range of everyday items from throughout the country. A cultural center incorporating a provincial museum with a wide range of Somali material culture opened in Hargeïsa in the late 1970s. By the late 1980s the University of Somalia had no school of art, and no separate art college existed.

B. Francolini: "Arte indigena Somalia," *Riv. Colon. It. ("Oltremare")*, xi (1933), pp. 891–4

J. D. Clark: "Dancing Masks from Somaliland," *Man*, lxiii/4 (1953), pp. 49–51; pl. D

I. M. Lewis: *A Modern History of Somaliland: From Nation to State* (London, 1965); rev. as *A Modern History of Somalia: Nation and State in the Horn of Africa* (London, 1980, rev. Boulder and London, 1988)

H. Stöber: "Zu den Eigentumsverhältnissen bei einigen nordostafrikanischen Viehzüchtervölkern," *Abh. & Ber. Staatl. Mus. Vlkerknd., Dresden*, xxv (1965), pp. 209–23

V. L. Grotanelli: "Somali Wood Engravings," *Afr. A.*, i/3 (1968), pp. 8–13, 72–3, 96

M. J. Arnoldi: "The Artistic Heritage of Somalia," *Afr. A.*, xvii/4 (1984), pp. 24–33, 93

A. Medri: "Riflessioni sull'origine, gli usi e le tecniche di lavorazione delle terrecotte in Somalia meridionale," *Faenza*, lxxi/1–3 (1985), pp. 82–90 [with Eng., Fr. & Ger. summaries]

Somalia in Word and Image (exh. cat., ed. K. S. Loughran and others; Washington, DC, Found. Cross-Cult. Understanding, 1986)

S. Ciruzzi: "Le collezioni etnografiche somale del Museo nazionale di antropologia ed etnologia di Firenze," *Archv Antropol. & Etnol.*, cxviii (1988), pp. 291–6 [with Eng. summary]

K. McMahon: "The Hargeisa Provincial Museum," *Afr. A.*, xxi/3 (1988), pp. 64–8, 87–8

Somalia: Monili ed ornamenti tradizionali (exh. cat. by C. Manca; Rome, Ist. It.-Afr.; Mogadishu, It. Embassy; 1989)

E. Lambourn: "The Decoration of Fakhr al-Dīn Mosque in Mogadishu and Other Pieces of Gujarati Marble

Carving on the East African Coast," *Azania*, xxxiv (1999), pp. 61–86

A. I. Samatar: "Social Transformation and Islamic Reinterpretation in Northern Somalia: The Women's Mosque in Gabiley," *Geographies of Muslim Women: Gender, Religion, and Space*, ed. G.-W. Falah and C. Nagel (New York, 2005), pp. 226–48

Sourdel-Thomine, Janine (*b.* Rochefort-sur-Mer, 15 Nov 1923). French scholar of Islamic art. After earning degrees in classical Arabic (1946) and Islamic art (1948) in Paris, she was associated with the French institute in Damascus from 1949 to 1954, and traveled to Turkey, Egypt and Afghanistan. She returned to Paris, where she wrote her thesis at the Ecole Practique des Hautes Etudes (1957) and taught there and at the Sorbonne, where she became vice-president (1982–9). She married to Dominique Sourdel, the eminent French historian of Islam, with whom she often collaborated on synthetic studies of Islamic civilization. Her own specialty is the study of Arabic epigraphy, a field that she studied with JEAN SAUVAGET, and she meticulously analyzed the inscriptions on many major monuments from Syria to Afghanistan.

Epitaphe coufiques de Bab Saghir, iv of *Les monuments Ayyoubides de Damas* (Paris, 1950)

"Deux minarets d'époque seljoukide en Afghanistan," *Syria*, xxx (1953), pp. 103–36

Guide des lieux de pèlerinage, 2 vols. text and trans. of 'Alī ibn Abī Bakr al-Harawī's *Kitāb al-ishārat ilā ma'rifat al-ziyārat* (*d.* 1215) (Damascus, 1953–7)

with D. Schlumberger: *Lashkari Bazar: Une résidence royale ghaznévide et ghoride*, Délégation archéologique française en Afghanistan, 18; 2 vols. (Paris, 1963–78)

with D. Sourdel: *La Civilisation de l'Islam classique* (Paris, 1968)

with B. Spuler: *Die Kunst des Islam, Propyläen Kunstgeschichte*, 4 (Berlin, 1973)

Le Minaret Ghouride de Jam: Un chef d'oeuvre du XIIe siècle (Paris, 2004)

with D. Sourdel: *Dictonnaire Historique de l'Islam* (Paris, 1996); Eng. trans. by C. Higgitt as *A Glossary of Islam* (Edinburgh, 2007)

Sousse [Sūsa; anc. Hadrumetum]. Port city in Tunisia, *c.* 150 km southeast of Tunis. Founded as a Phoenician colony in the 9th century BCE, the city of Hadrumetum came under Carthaginian control in the 6th century but allied itself with Rome in the Third Punic War, for which it received the status of *civitas libera*. It became the capital of the province of Byzacena and—after Carthage—the most important city of Roman Africa. By the 3rd century CE it had become seat of a bishopric. After the Arab invasions of the late 7th century, the city regained importance as the port for KAIROUAN and staging-point for the conquest of Sicily undertaken under the Aghlabids (*r.* 800–909). The city was briefly occupied by the Normans of Sicily in the 12th century and attacked by the Spanish (16th century), French and Venetians (18th century), although it had long been superseded

by Tunis. It was heavily damaged during the North African campaign of 1942–3.

In addition to many splendid mosaic pavements (Tunis, Mus. N. Bardo and Sousse, Mus. Archéol.), the remains of Roman Hadrumetum include over 5 km of catacombs (2nd–4th century CE). Buildings of the Aghlabid period include the *ribāṭ* (796), a fortress–monastery constructed to the west of the ancient harbor. A fortified square building with a central courtyard surrounded by a portico and chambers arranged on two stories, it has a mosque on the second story; a lighthouse tower was added to the southeast corner in 821. The congregational mosque (850–57; rest.) is notable for its stone vaulting and staircase minaret. The small nine-bay oratory known as the mosque of Bu Fatata (838–41) is an early example of a type widespread in Islamic architecture. The ramparts (859; rest.) may follow the trace of the Byzantine fortifications; the Khalef Tower (859), a lighthouse and watch-tower at the highest point of the walls, forms the core of the kasba (11th–15th century).

K. A. C. Creswell: *Early Muslim Architecture*, ii (Oxford, 1940/*R* New York, 1979)

A. Lézine: *Le Ribat de Sousse* (Tunis, 1956)

L. Foucher: *Hadrumetum* (Tunis, 1964)

A. Lézine: *Sousse: Les Monuments musulmans* (Tunis, 1968)

A. Lézine: *Deux villes d'Ifriqiya: Sousse, Tunis: Etudes d'archéologie, d'urbanisme, de démographie* (Paris, 1971)

S. Kouraïchi: "Analyse du décor d'une collection de pierres tombales conserves au ribāṭ de Sousse," *Archéol. Islam.*, viii–ix (1999), pp. 177–206

Spolia. From the Latin for "spoils [of war]," the term is used within the history of art and architecture to mean the re-use of earlier building materials and sculpture in later monuments. In Islamic architecture, the term spolia is most commonly, although by no means exclusively, used to refer to the re-use of Classical architectural elements, particularly stone columns and capitals, in medieval settings, but the term is equally applicable to Indian Muslims' reuse of temple elements for their mosques. In most cases spolia were used only in the first periods of a region's Islamization, where they may be regarded as not only a practical recycling of readily available building materials but also a representation of the triumph of Islam over earlier faiths.

The use of Classical and Byzantine spolia is seen in many of the great buildings of the early Islamic Mediterranean area. The two great monuments of the Umayyads, the Dome of the Rock (begun 692; *see* JERUSALEM, §II, A) and the Great Mosque of Damascus (706–15; *see* DAMASCUS, §III), both incorporate spolia in the form of marble columns with Classical capitals (*see* CAPITAL). The Great Mosque of Córdoba (begun 785; *see* CÓRDOBA, §III, A) is a forest of Classical spolia columns, which were too short for the space and needed to be built up by the device of double arches. The mosques of 'Amr in Fustat (rebuilt 827) and of Sidi 'Uqba in Kairouan (rebuilt 836) also had roofs supported by arcades of spolia columns

and capitals, as did the 10th-century mosque of al-Azhar in Cairo. In Iran stone was scarce, but a few monuments made use of pre-Islamic spolia, such as the Achaemenid bull-headed capitals of the now-destroyed mosque at Istakhr, Iran.

Spolia columns and capitals also feature in the somewhat later Islamic buildings of Anatolia, and can be seen in the Saljuq Alaeddin Mosque in Konya (*c.* 1150–1220), the Great Mosque of Diyarbakır (rebuilt 12th century) and later in the great columns supposedly from Baalbek used in the interior of the Süleymaniye Mosque in Istanbul (1550–57; *see* ISTANBUL, §III, C). As the supply of spolia dwindled in the Mediterranean Islamic world, new elements were sometimes made following Classical and Byzantine models, so that distinctly Islamic variations of Corinthian and Composite capitals began to appear. Occasionally, however, spolia were taken from later buildings: the complex of Qala'un in Cairo, for example, has a magnificent portal taken from the Crusader church at Acre.

Muslim builders in India also made extensive use of spolia, particularly columns, from temples. Major mosques, such as the Quwwat al-Islam Mosque complex in Delhi (founded 1193) and the Atala Mosque in Jaunpur (1377–1404) use temple spolia on a monumental scale, sometimes defacing figurative sculpture in accordance with Muslim requirements for religious buildings. Spolia was also used for more modest religious buildings such as the vernacular mosques of Nagar in Fatehpur Sikri.

K. A. C. Creswell: *Early Muslim Architecture* (Oxford, 1932–40, rev. and enlarged ed. of v. 1, 1969)

C. Ewert and J. P. Wisshak: *Forschungen zur almohadischen Moschee*, i (Mainz, 1981)

J. M. Rogers: "The State and the Arts in Ottoman Turkey: The Stones of Süleymaniye," *Int. J. Mid. E. Stud.*, xiv/1 (1982), pp. 71–86

K. A. C. Creswell: *A Short Account of Early Muslim Architecture*, (rev. and ed. J. W. Allan, Aldershot 1989)

M. Barrucand: "Les chapiteaux de remploi de la mosquée al-Azhar et l'émergence d'un type de chapiteau médiévale en Egypte," *An. Islam.*, xxxvi (2002), pp. 37–75

F. B. Flood: "Pillars, Palimpsests, and Princely Practices: Translating the Past in Sultanate Delhi," *Res*, xliii (2003), pp. 95–116

D. Behrens-Abouseif: "European Arts and Crafts at the Mamluk Court," *Muqarnas*, xxi (2004), pp. 45–54

F. B. Flood: "Image against Nature: Spolia as Apotropaia in Byzantium and the *Dār al-Islām*," *Med. Hist. J.*, ix/1 (2006), pp. 143–66

P. Plagnieux: "Le portail d'Acre transporte au Caire: Sources et diffusion des modeles rayonnants en Terre sainte au milieu du XIIIe siècle," *Bull. Mnmtl*, clxiv/1 (2006), pp. 61–6

Squinch. An arch or similar structure built diagonally across the corner of a square building to support and act as a transition to a polygonal or round superstructure, normally a dome. Islamic architecture makes great use of squinch forms and a complex vocabulary of types evolved over the centuries.

Scholars have not reached an agreement on the origins of the squinch but it may well have originated in Sasanian Persia and been quickly assimilated by Late Imperial Rome: arched squinches are used in Sasanian palaces at Firuzabad at Qasr-i Shirin, and later become a characteristic of Byzantine buildings. A predilection for domed monuments, particularly funerary monuments, is notable in Islamic countries and led to the further development of the squinch as decorative element. Such monuments are divided internally into three horizontal zones: base, zone of transition, and dome. The zone of transition in the architecture of Iran and Central Asia from the 10th century to the 14th, where great innovations in squinch construction were made, typically comprised four blind arches alternating with four squinches. In many cases the zone of transition was a major focus of internal decoration, as in the Samanid mausoleum at Bukhara (*see* BUKHARA, §II, A) and Tim (977–8). In the Bukhara tomb, the squinch areas are subdivided into two parallel arches buttressed by a half arch to create two concave segments per squinch corner, while the trilobed squinch makes its first dated appearance at Tim.

The trilobed squinch, with the profile of a shouldered or trilobed arch and interior subdivided into further concave arches, rose to prominence in the architecture of Iran in the Buyid and Saljuq periods, as at the Duvazdah Imam mausoleum in Yazd (1036–7) and the Friday Mosque at Isfahan (founded 771). It is a forerunner of the MUQARNAS squinch, first seen in northeastern Iran, as subdivision of the squinch space into smaller and smaller concave arched components gave rise to the cascading tiers of *muqarnas* (see fig.). *Muqarnas* squinches, varying in complexity from the smoothly arching stone cells of the Firdaws Mosque at Aleppo (1235–6) to the extraordinary stucco honeycombs of the Alhambra Palacio de los Leones (*c.* 1370–91), appear to be uniquely Islamic.

Squinch-net vaulting is another form of decoration used to make the transition from base to vault.

Squinch in the dome chamber of the congregational mosque, Gulpayagan, Iran, 1105–18; photo credit: Sheila S. Blair and Jonathan M. Bloom

The dome is supported by a network of squinches or pendentives of various shapes, divided by intersecting bands. This scheme was employed to great effect by Timurid architects at the Mausoleum of Gawharshad at Herat (1417–38), where the dome appears to be lifted upwards by the supports, an effect that is enhanced by the brightly painted fan-like forms on the squinches, pointing toward the dome itself. Closely related to the squinch-net vault are so-called "Turkish triangles," which simplify the squinch into a vertical fan of triangular facets, as can be seen in the Karatay Madrasa in Konya (1251–2).

K. A. C. Creswell: "The Squinch Before AD 700," *Early Muslim Architecture*, ii (Oxford, 1940/*R* 1979), pp. 101–18

Y. Tabbaa: "The Muqarnas Dome: Its Origin and Meaning," *Muqarnas*, iii (1985), pp. 61–74

L. Bier: *Sarvistan: A Study in Early Iranian Architecture* (University Park, PA, 1986)

J. Bloom: "The Introduction of the Muqarnas into Egypt," *Muqarnas*, v (1988), pp. 21–8

L. Golombek and D. Wilber: *The Timurid Architecture of Iran and Turan* (Princeton, 1988)

R. Hillenbrand: *Islamic Architecture: Form, Function and Meaning* (Edinburgh, 1994)

Srinagar [Śrīnagara; anc. Srinagari]. Principal city of Kashmir and now capital of the state of Jammu and Kashmir, India. Set at an altitude of 1593 m beside Dal Lake, on the Jhelum River, the city stands at the head of passes leading from the plains of India into Central Asia. It was always an important commercial and strategic center, while the natural beauty of its lakes and surrounding hills was a great attraction to both Mughal and British rulers.

Srinagar is best known for its Islamic monuments. Its most important mosque, the Jamiʿ Masjid or congregational mosque, lies at the heart of the city. Inside, over 370 columns, each made from a single deodar trunk, support a series of pyramidal roofs and pagoda-shaped minarets. The 117 m-long sidewalls are pierced by arched entrances. The first mosque, completed in 1385 at the time of Sultan Sikander (r. c. 1340–49; c. 1414–15), has been rebuilt three times; the present structure, dating from the time of the Mughal emperor Awrangzib (r. 1658–1707), replaced the one destroyed by fire in 1674. The Shah Hamadan Mosque (1395) is typical of the wooden architecture of Kashmir. It, too, was prone to fire and was destroyed in 1479 and 1731; however, the masonry plinth, composed of ancient temple fragments, remained intact. Standing alongside the Jhelum, the cuboid base of the mosque is rendered elegant by the addition of a pyramidal roof and a 38 m-high spire; in spring, flowers blossom in the roof's turf covering. The tomb of the mother of Zayn al-ʿAbidin (1421–72), the son of Sultan Sikander, was built c. 1430 on the foundations of an old Hindu temple; its dome and glazed tiles indicate Persian influence. Almost directly opposite the Shah Hamadan Mosque is the Pather Masjid, a fine stone mosque built in 1623 for Empress Nur Jahan (d. 1645).

Another stone edifice, the mosque of Akhund Mulla Shah (1649), has an unusual ground plan; it contains the only surviving example in Kashmir of a stone lotus finial over the pulpit.

Srinagar's Hindu monuments include the Shiva Temple at Pandrethan and the Shankaracharya Temple on Takht-i-Sulaiman Hill whose square plan, recessed sides and circular inner sanctum indicate that it could be the oldest surviving Hindu shrine in Kashmir. The Hari Parbat Fort overlooking the town was built between 1592 and 1598 by the Pathan governor Azim Khan (d. 1744), as shown by a Persian inscription commemorating the completion of the work, with additions made in the 18th century. Srinagar also boasts a number of fine old timber houses with distinctive earth roofs and nine ancient wooden bridges used to cross the city's many waterways. The nearby lakes accommodate hundreds of wooden houseboats, many of which preserve the interior décor favored during the British period. The Sri Pratap Singh Museum contains artifacts from Harwan and Ushkur, as well as a large collection of sophisticated Kashmiri metal and stone sculptures.

The best-known of Srinagar's monuments, the Shalimar Bagh (garden), was built by the Mughal emperor Jahangir (r. 1605–27) for his wife Nur Jahan c. 1620 (see GARDEN, §V). Situated in the most secluded part of Dal Lake, it comprises three terraces watered by a series of elegantly designed canals and pools. The uppermost level features a black marble pavilion surrounded by fountains. Added by Shah Jahan (r. 1628–58) in 1630, the pavilion has a three-tiered pyramidal roof derived from traditional Kashmiri wooden mosques. Other Mughal gardens in Srinagar include the Nishat Bagh (c. 1625) and the Nazim Bagh.

R. C. Kak: *Ancient Monuments of Kashmir* (London, 1933/*R* New Delhi, 1971)

J. C. Harle: *The Art and Architecture of the Indian Subcontinent* (Harmondsworth, 1986)

P. Davies: *Islamic, Rajput, European,* ii of Penguin Guide Mnmts India (London, 1989)

G. Mitchell: *Buddhist, Jain, Hindu,* i of Penguin Guide Mnmts India (London, 1989)

C. A. Asher: *Architecture of Mughal India* (Cambridge, 1992)

S. K. Sharma and S. R. Bakshi: *Kashmir Art, Architecture and Tourism* (New Delhi, 1995)

J. L. Wescoat and J. Wolschke-Bulmahn, eds.: *Mughal Gardens: Sources, Places, Representations, and Prospects* (Washington, DC, 1997)

Staircase. Flight of steps or ramps providing vertical communication between different levels of a building. From the time of the earliest stone buildings, staircases have also played an important role in guiding and controlling access and providing an entrance in keeping with the status of the building. For the set of steps mounted by the Imam in a mosque, *see* MINBAR.

The pre-Islamic Middle East contains several notable examples of monumental staircases: the massive

staircase at the Kushana cult center of Surkh Kotal in Afghanistan (*c.* 1st–4th century CE), that at Wadi Hadhramaut in southern Arabia, and above all the famous double stairway at Persepolis (*c.* 515 BCE) with its relief sculpture decoration of ranked courtiers and guards. All are clearly designed to enhance the magnificence of the associated buildings. But this monumental approach was not generally carried over to Islamic secular or religious architecture. Some mosques were raised a little off the ground and entered by steps, whether for symbolic or practical reasons. For example, the mosque depicted in a frontispiece to an early parchment manuscript of the Koran discovered in Sanaʿa is clearly approached by steps. The raised mosque in the court of the Sultan Han (13th century) in Anatolia is one floor off the ground and entered by a double stairway, keeping it above the dust and the animals of a working caravanserai. The double mausoleum of Salar and Sanjar al-Jawli in Cairo (begun 1303) is approached by a flight of steps, principally because of the uneven topography of the site. The attractive staircase of the south porch of the Amiriya Madrasa, at Radaʿ, Yemen (1504; rest. 1982–2004) flanks the entrance with two sets of stairs parallel to the building's outer wall, enhanced by a stepped wall rising alongside each of them. In secular architecture the only example of a monumental staircase is at the 9th-century Dar al-Khilafa palace at the Abbasid capital of Samarra.

In India, pre-Islamic traditions of elevating religious structures carried over into the Islamic period. In Islamic structures the impressiveness of the entry steps was dictated by the height of the podium. In front of the entrance to the tomb of Iʿtimad al-Dawla (1628) in Agra is a series of only three steps, while the Jamiʿ Masjid (1650–56) of Shah Jahan (*r.* 1628–58) in Delhi required more monumental points of access, its plinth being about 21.3 m high. Placed before the mosque's three gateways, its sweeping and majestic staircases rather resemble truncated stepped pyramids. for the most part, however, grand sweeping staircases were not developed within the Indian tradition. Even within the palaces of the Rajputs and Mughals, access to upper stories was generally through narrow stairwells rather than open staircases, perhaps part of a defensive strategy.

There are of course many less remarkable staircases within Islamic architecture, such as the rarely seen internal staircases of minarets, and those which are used for roof access and other practical concerns. Before the adoption of the tower minaret, some early mosques had an external stair, like the narrow, unwalled external staircase on the Umayyad mosque in Bosra, Syria (8th century). Within vernacular architecture too the staircase is extensively employed, particularly in such countries as Iran where roofs can be used for sleeping, and areas in the Arabian Peninsula such as Yemen where houses are traditionally built several stories high; however these staircases are rarely spectacular. The adoption of European fashions in the late Ottoman period led to grand staircases in the European palatial style, such as the one with rock-crystal balusters at the Dolmabahçe Palace in Istanbul (1853).

K. A. C. Creswell: *Early Muslim Architecture* (Oxford, 1932–1940/*R* 1979)

J. Schacht: "Ein archäischer Minaret-Typ in Ägypten und Anatolien," *A. Islam.*, v (1938), pp. 46–54

J. Schacht: "Further Notes on the Staircase Minaret," *A. Orient.*, ii (1957), pp. 149–73

F. Varanda: *Art of Building in Yemen* (Cambridge, MA and London, 1982)

H. C. G. von Bothmer: "Architekturbilder im Koran: Eine Prachthandschrift der Umayyadenzeit aus dem Yemen," *Bruckmanns Pantheon,* xlv (1987), pp. 4–20

J. M. Bloom: *Minaret: Symbol of Islam* (Oxford, 1989)

B. M. Alfieri: *Islamic Architecture of the Indian Subcontinent* (London, 2000)

D. Kuban: *Osmanlı Mimarisi* (Istanbul, 2007); Eng. trans. as *Ottoman Architecture* (London, in preparation)

Stalinabad. *See* DUSHANBE.

Stamps. Although various forms of courier service had existed in medieval times, a postal system was introduced in North Africa, West and South Asia as early as the mid-19th century in response to European political hegemony. Consequently postage stamps were issued in several Islamic states under the auspices of European sponsors (India in 1854; Ottoman Turkey in 1863; Egypt in 1866, Iran in 1868 and Afghanistan in 1871). It was, however, during the second half of the 20th century that the themes and designs of postage stamps issued in the Islamic world became diversified and worthy of observation as a primary historical, cultural and political document. The stamp began to be viewed as an instrument of propaganda among newly independent countries, and small yet graphically and realistically depicted national flags, symbols of nations, cultural heritage, historical events, as well as the portraits of political leaders and local heroes, were considered as an effective visual tool in conveying a political and cultural message. Propagandistic stamps, for example with the theme of independence from foreign forces in most Islamic countries and martyrdom in post-revolution Iran, continue to be issued as a reminder of national events. The architectural heritage of both pre-modern and modern times was also one of the popular iconographic themes used in Islamic stamps, and this was due not only to the glow of national pride but recently to the promotion of the tourism industry. In addition to the frequent appearance of the Dome of the Rock in Jerusalem, each state made a deliberate choice of iconic buildings for its stamp design so as to reinforce its contribution to Islamic civilization: in Turkey, Ottoman mosques and minarets, for example the Hagia Sofia and the Blue Mosque, were frequently used in the postage design; the Kaʿba in Mecca and the Mosque of the Prophet in Medina, two of the most important Islamic monuments, appeared on the stamps of Saudi Arabia. The use of portraits in stamp design was long discouraged

in some countries due to orthodox Islamic beliefs, while countries with rich pictorial traditions, such as Iran, did not hesitate to portray human figures on postal stamps.

Enc. Islam/2: "Posta"

H. W. Hazard: "Islamic Philately as an Ancillary Discipline," *The Word of Islam: Studies in Honour of Philip K. Hitti,* ed. J. Kritzeck and R. B. Winder (London, 1959), pp. 199–232

R. Obojski: "Mosques, Minarets and Stamps," *Saudi Aramco World,* xxxii/2 (1981), pp. 8–11

D. M. Reid: "The Symbolism of Postage Stamps: A Source for the Historian," *J. Contemp. Hist.,* xix/2 (1984), pp. 223–49

P. Chelkowski and H. Dabashi: *Staging a Revolution: The Art of Persuasion in the Islamic Republic of Iran* (London, 2000)

Staryy Krym [Solkhat-Krym; Solghat; Eski Krym]. Site in the Crimea 85 km east of Symferopol'. Lying at the foot of Mt. Agarmysh, which marks the northeast end of the second Crimean Ridge, the town was the administrative center of the Mongols in the Crimean peninsula (Taurica). It reached its apogee in the late 13th century and first half of the 14th and until the 16th century controlled the steppe route from the east coast of the Crimea into the heart of the continent. Its convenient geographical position, combined with its function as a regional capital that minted its own coinage from the 1260s to the 1420s, made the town part of the extensive trade carried on by the Golden Horde with southern Europe, the Levant, Anatolia, Central Asia, Iran and the Delhi sultanate.

The total area of Staryy Krym within the defensive enceinte measured 220 ha. The multinational population lived in colonies organized along confessional lines. Thus, the Christian colony, embracing Orthodox, Catholic and Georgian communities, comprised Alans, Polovtsians, Russians, Armenians and Latins. In the 14th century there were one Franciscan and several Georgian monasteries. The Jewish colony comprised Rabbinists and Karaites, but the Muslim community set the tone of town life. To build the Friday Mosque (destr.) in 1287, 2000 dinars were sent from Cairo along with a master stone-carver to embellish the doorway. Many madrasas were built in the 1330s. The mosque built on the north wall in the 15th century incorporates elements from an earlier mosque (1314) and is related to buildings in Anatolia. The names of two builders, Mahmud ibn 'Uthman al-Irbili and 'Abd at-'Aziz al-Irbili, point to other links between the Crimea and Irbil in northern Mesopotamia. A school of *sgraffito* ceramics developed in the 14th century, and the scribe and miniaturist Nater, along with his sons and pupils, worked in one of the scriptoria in the Armenian quarter in the second half of the 14th century. In 1454 Hajji Giray, founder of the Giray dynasty (*r. c.* 1426–1792), transferred his capital from Staryy Krym to the mountain stronghold of Kirk-er, also known as CHUFUTKALE. The first rulers of the new dynasty maintained a palace in Staryy Krym and minted coins there until 1517. The town was destroyed in the second half of the 16th century.

I. N. Borozdin: "Solkhat," *Novyy Vostok,* xiii–xiv (1929)

V. V. Bartol'd: *Krym: Raboty po istoricheskoy geografii* [Crimea: studies in historical geography], iii of *Sochineniya* [Collected works] (Moscow, 1971), pp. 467–9

Z. M. Korkhmazyan: *Armanskaya miniatyura Kryma (XIV–XVII vv.)* [Armenian miniatures of the Crimea (14th–17th century)] (Erevan, 1978)

M. G. Kramarovsky: "Solkhat-Krym: K voprosu o naselenii i topografii goroda v XIII–XIV vv." [Solkhat-Krym: on the problem of the population and topography of this town in the 13th–14th centuries], *Itogi rabot arkheologicheskikh ekspeditsii Gosudarstvennogo Ermitazha* [About excavation results of the State Hermitage archaeological expeditions] (Leningrad, 1989), pp. 141–57

M. Kramarovsky: "The 'Sky of Wine' of Abu Nuwas and Three Glazed Bowls from the Golden Horde, Crimea," *Muqarnas,* xxi (2004), pp. 231–38

Stchoukine, Ivan (Sergeyevich) (*b.* 1885; *d.* Beirut, Oct. 1975). French art historian of Russian descent, son of the textile merchant and collector Sergey Shchukin (1854–1936). His father traveled extensively and was fascinated by Asia, and in 1905–6 he took his family on a long trip to India, where Ivan encountered the Orient that was to become his life passion. He began his own collection of Chinese painting, the studied and precise perfection of which he found preferable to the powerful brilliance of the huge canvases by Henri Matisse (1869–1954) and Pablo Picasso (1881–1973) that his father collected. Through his father and their acquaintances in Paris, he also observed instances of forgeries being uncovered after careful observation of details. His youthful artistic surroundings sharpened his visual sensibility, leading him to an uncanny ability to see the smallest details of a painting. He had a masterful eye, and even indirect involvement with forgeries made him realize that visual experiences must be stored and organized. The development of a method to organize Persian painting became his essential aim. He spent most of his life in Paris and then in Syria and Lebanon, where he held minor posts in the French educational system, retiring from the French Institute in Beirut. He was the first to present the manuscript treasures of the Topkapı Palace in Istanbul in some order, but his success and reputation came late.

In addition to many articles dealing with individual manuscripts, collections or (rarely) problems and issues, Stchoukine's opus consists of a series of books on the history of Islamic painting from the late 13th century to the 17th. The method of presentation is the same throughout. Following an introduction identifying the period and the texts that deal with painters, single pages or whole manuscripts are identified and described with an almost obsessive search for oddities or incoherences that would indicate a repair or an addition; only then is the work attributed to an individual or a school. Stchoukine applied this method so rigorously and systematically that for the first time in the study of Islamic painting it was possible to see the rationale for an attribution, and in most cases his attributions have stood the test of time.

Stchoukine was conscious of the need to go beyond connoisseurship into broader and more synthetic approaches, and in the second half of his books there are elaborate discussions of categories of visual information (e.g. landscape, composition, people, animals) that tie together groups of paintings. Although not always inspiring, these pages show that he was seeking to identify the stylistic and aesthetic or judgmental categories appropriate for Islamic painting.

WRITINGS

La Peinture indienne à l'époque des Grands Moghols (Paris, 1929)

with F. Edhem: *Les Manuscrits orientaux illustrés de la Bibliothèque de l'Université de Stamboul* (Paris, 1933)

La Peinture iranienne sous les derniers 'Abbâsides et les Il-Khâns (Bruges, 1936)

Les Peintures des manuscrits tîmurîdes (Paris, 1954)

Les Peintures des manuscrits safavis de 1502 à 1587 (Paris, 1959)

Les Peintures des manuscrits de Shâh 'Abbâs Ier à la fin des Safavis (Paris, 1964)

La Peinture turque d'après les manuscrits illustrés: Ire partie: de Sulaymân Ier à 'Osmân II, 1520–1622 (Paris, 1966)

"Les Peintures turcomanes et safavies d'une Khamseh de Nizâmî, achevée à Tabrîz en 886/1481," *A. Asiatiques*, xiv (1966), pp. 3–16

La Peinture turque d'après les manuscrits illustrés: IIme partie: De Murâd IV à Mustafâ III, 1623–1773 (Paris, 1971)

with B. Fleming, P. Luft and H. Sohrweide: *Illuminierte islamische Handschriften* (Wiesbaden, 1971)

Les Peintures des manuscrits de la "Khamseh" de Nizâmî au Topkapı Sarayı Müzesi d'Istanbul (Paris, 1977)

BIBLIOGRAPHY

J. Auboyer: Obituary, *A. Asiatiques*, xxxiii (1977), pp. 213–14

Stele [Gr.; pl. stelai; Lat. stela, pl. stelae]. Stone or pillar set upright in commemoration of some event or as a marker for a grave. Stelae are frequently carved or inscribed. Most areas of the world at most periods have produced such objects, but they are often called by other names and the word stele is used chiefly in the Mediterranean world.

Islamic law prescribes that bodies be inhumed in a vault so that the dead can sit up and face Mecca on Judgment Day, and orthodox tradition forbids veneration of the dead, including the erection of upright stones. Nevertheless, graves in the Muslim world were marked by monoliths, larger multi-piece constructions (*see* CENOTAPH) and tombs (*see* TOMB). Whereas stelae from other traditions such as Coptic Egypt were decorated with figures, architectural façades and crosses, Muslim stelae are almost exclusively epigraphic. Their inscriptions provide social and historical information about conversion, classes, titulature and sectarianism, but are particularly important as dated evidence for the development of writing, the most characteristic feature of Islamic art (*see* CALLIGRAPHY).

The speed with which tombstones were introduced in a particular area seems to have depended on the strength of indigenous traditions of honoring dead ancestors, heroes and benefactors. The Copts in Egypt, for example, had a long tradition of erecting headstones, and the first evidence for Muslim tombstones comes from there: a continuous series of more than 4000 stelae dating from the year 790 (see fig.). The tradition quickly spread to other areas in the western Islamic world (the first surviving example from Kairouan in Tunisia is dated 850; that from Spain, 854). In Syria, while texts mention cemeteries, the first surviving tombstones date from the 11th century. In contrast, there was no tradition of erecting tombstones in pre-Islamic Iran, and a series of stelae from Yazd in central Iran suggests that they only became popular there in the 11th century.

Stelae were carved from any stone available, including marble, limestone, sandstone and basalt. When stone was unavailable, less durable materials were used. Small bricks (average size 280×280×50 mm), for example, were used as grave markers in the Merv Oasis in Central Asia. Wood was also used in North Africa, but it obviously decayed faster than stone.

The most common and the earliest known shape of stele is the upright rectangle, which is generally twice as tall as it is wide and is embedded in the ground on one short end. A single stele serves as a headstone; pairs mark the head and foot of the grave. The stele stands as a testimonial to the grave, and hence is often called "witness" (Arab. *shāhid*). Decoration, either incised or carved in relief, became more

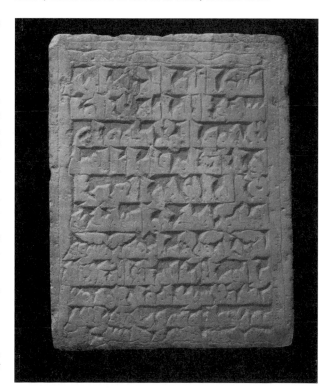

Marble tombstone with foliated kufic inscription, 585×440 mm, ?from Egypt, 869 (Copenhagen, Davids Samling); photo credit: Davids Samling, Copenhagen

elaborate over time. One of the most common motifs was an arch resembling a MIHRAB, and sometimes it is not clear whether the stele was intended as a grave marker or an indicator of the direction of prayer. Certain styles of arches were characteristic of specific sites and periods. Marble stelae (0.4–0.5×0.8–1.0 m) decorated with a rectangular inscription band framing a horseshoe arch set on two columns were popular in the Spanish city of Almería in the first half of the 12th century. Contemporary examples from Iran are usually of ceramic, decorated either in blue- or black-underglaze or luster painting; they have inscription bands framing pointed or polylobed arches, often decorated with a hanging lamp, probably a reference to the Koranic verse from the *Sūrat al-Nūr* ("Light") 24:35, in which God is described as the Light of the Heavens, a lustrous niche containing a lamp.

Sometimes the upright shape was varied. The rectangular end could be curved. Stelae made in Syria in the late 12th century are ogival with rounded tops; some examples from Morocco end in disc-shaped roundels, often surmounting two bilateral arms in the shape of a Latin cross, and were probably intended to be anthropomorphic. At other times the thin slab and tabular form was abandoned so that the tombstone resembles a column shaft. Columnar shafts with octagonal tops predominated in the cemeteries of Toledo in Spain and Kairouan in the 10th and 11th centuries. In Anatolia and the eastern Mediterranean lands under the Ottomans, the top blossomed into a turban, a style particularly popular for graves of dervishes. A small group of tombstones from Central Asia, Iran and Turkey were carved in the shape of animals; these pieces probably represent the survival of pre-Islamic nomadic customs.

A second type of stele is the elongated low block laid along the top of the grave like a small sarcophagus. It may well represent a schematic imitation of the mound of earth. These box-shaped grave covers are not coffins, but large blocks of stone, usually roughly hollowed out and placed over the grave with the hollow side down. Like the upright stele, this rectangular type also varied in shape, from simple parallelepipeds to more complex prismatic, gabled, stepped or crested shapes. Some 60 sandstone ones dating from the late 10th century to the 12th were excavated at SIRAF on the Persian Gulf. They varied in size, from 1.50×0.41×0.42 m to 0.54×0.21×0.16 m, the smallest probably for a child's grave, and over half of them had a stepped crest. Sometimes the rectangular box was combined with the upright slab. The typical grave marker from northern Syria, for example, is an uncovered box with two upright stones at either end, and many Moroccan examples are rectangular boxes with upright slabs at both ends.

These stelae are usually inscribed in Arabic, but in later periods Arabic was replaced by, or mixed with, indigenous languages. In the 19th century, for example, stelae from Central Asia were bilingual, Russian and Arabic. The text was usually in prose, but Arabic poetry occurs on a group of 9th-century stelae from Sicily, and cartouches with Persian or Turkish verses are characteristic of later examples from Iran, India

and Turkey. The text, first carved in lines in a rectangular frame, was later written in panels, cartouches and bands. The earliest inscriptions were done in a simple angular script, but in the 8th and 9th centuries the script was embellished with such decorative devices as the barb, hook, arc and palmette. The beveled stems of the letters evolved into floral ornament, often set on an undulating scroll ground. Cursive scripts were introduced slowly from the 10th century, and bands of angular and cursive were often juxtaposed. In the 14th century, when the Mongols ruled Iran, inscriptions in square kufic, resembling Chinese seal script, became popular. The inscription sometimes took on such a decorative shape that it was virtually illegible, as when a verse from *Sūrat al-Baqara* ("Cow"; 2.131), containing the longest word in the Koran, was sculpted in the shape of a polylobed arch.

The inscription had a dual purpose—to record the name of the deceased and to bear witness to his faith. The basic formula included the invocation to God (Arab. *basmala*); introductory phrases about judgment, resurrection or the juxtaposition of life's transience with God's permanence; the deceased's name, genealogy, titles and the date of his death; and eulogies. The basic statement of testimony was often supplemented by the profession of faith (*shahāda*) or popular Koranic verses, such as *Sūrat al-Ikhlāṣ* ("Purity"; 112) or the Throne Verse from *Sūrat al-Baqara* (2:255). Other Koranic verses were popular in specific areas: a verse from *Sūrat Fāṭir* ("The Originator of Creation"; 35:5) about the vanity of earthly life, for example, is typical of Andalusian tombstones.

Enc. Islam/2: "Kabr" [grave]

J. Bourrilly and E. Laoust: *Stèles funéraires marocaines* (Paris, 1927)

E. Levi-Provençal: *Inscriptions arabes d'Espagne* (Leiden and Paris, 1931)

H. Hawary and H. Rached: *Les Stèles funéraires,* Cairo, Musée Arabe, i and iii (Cairo, 1932–9)

G. Wiet: *Les Stèles funéraires,* Cairo, Musée Arabe, ii and iv–x (Cairo, 1936–9)

J. Sourdel-Thomine: *Epitaphes coufiques de Bāb Ṣaghīr* (1950), iv of *Les Monuments ayyoubides de Damas* (Paris, 1938–50)

B. Roy and P. Poinssot: *Inscriptions arabes de Kairouan* (Paris, 1950–58)

G. Wiet: "Stèles coufiques d'Egypte et du Soudan," *J. Asiat.,* ccxl (1952), pp. 273–97

S. M. Zbiss: *Corpus des inscriptions arabes de Tunisie* (Tunis, 1955)

G. Deverdun: *Inscriptions arabes de Marrakech* (Rabat, 1956)

J. Sourdel-Thomine: "Stèles arabes anciennes de Syrie du Nord," *An. Archéol. Syrie,* vi (1956), pp. 11–38

M. O. Jimenez: *Repertorio de inscripciones arabes de Almería* (Madrid and Granada, 1964)

M. Amari: *Le epigrafi arabische di Sicilia,* ed. F. Gabriele (Palermo, 1971)

G. Fehérvári: "Tombstone or Miḥrāb? A Speculation," *Islamic Art in the Metropolitan Museum of Art,* ed. R. Ettinghausen (New York, 1972), pp. 241–54

B. Karamağaralı: *Ahlat mezartaşları* [Tombstones of Ahlat] (Ankara, 1972)

J. Sourdel-Thomine: "Quelques réflexions sur l'écriture des premières stèles arabes du Caire," *An. Islam.*, xi (1972), pp. 23–35

I. Afshar: "Two 12th Century Gravestones of Yazd in Mašhad and Washington," *Stud. Iran.*, ii (1973), pp. 203–11

A. M. 'Abd al-Tawab and S. Ory: *Stèles islamiques de la nécropole d'Assouan* (Cairo, 1977–86)

K. Moaz and S. Ory: *Inscriptions arabes de Damas: Les Stèles funéraires. I. Cimetière d'al-Bâb al-Ṣaġîr* (Damascus, 1977)

N. M. Lowick: *Siraf XV: The Coins and Monumental Inscriptions* (London, 1985)

M. Schneider: *Mubārak al-Makkī: An Arabic Lapicide of the Third/Ninth Century* (Manchester, 1986)

I. D. Mortensen: "Nomadic Cemeteries and Tombstones from Luristan, Iran," *Cimetières et traditions funéraires dans le monde islamique*, ed. J. -L. Bacqué-Grammont and A. Tibet (Ankara, 1996), pp. 175–83

L. Kalus and C. Guillot: "La stele funéraire de Hamzah Fansuri," *Archipel*, lx (2000), pp. 3–24

R. Giunta: "Some Brief Remarks on a Funerary Stele Located in the Ġaznī Area (Afghanistan)," *E. & W.*, li/1 (2001), pp. 159–65

M. Schneider: "La stele funéraire en arabe de Qudam b. Qādim (Yémen)," *Le Muséon*, cxiv/3 (2001), pp. 107–36

L. Kalus and C. Guillot: "Réinterpretation des plus anciennes steles funéraires islamiques nousantariennes: II. La stele de Leran (Java) datée de 475/1082 et les steles associées," *Archipel*, lxvii (2004), pp. 17–36, 247

Stucco and plasterwork. General terms for a decorative art that, at its simplest, is a render of mortar designed to decorate a smooth wall or ceiling and, in its more sophisticated form, is a combination of high-relief, sculptural and surface decoration. The words stucco and plaster are used virtually interchangeably and, most flexibly, can be applied to mixtures of mud or clay; more precisely, however, stucco usually means a hard, slow-setting substance based on lime as opposed to quick-setting plaster based on gypsum.

Revetments of carved, molded and sometimes painted gypsum plaster (Arab. *jiss*) were extraordinarily important in the decoration of Islamic architecture. The relatively dry climate throughout the region permitted the use of this cheap, flexible and versatile medium for decoration on exterior and interior surfaces. Stucco was most commonly applied to walls constructed of mud-brick, pisé or rubble and was also used for window and balcony grilles and to construct MUQARNAS ("stalactite") vaults. At first, builders continued Late Antique, Early Byzantine and Near Eastern traditions. Stuccos from the site of Chal-Tarqan/Eshqabad near Rayy in northern Iran, for example, were once thought to be Sasanian but were later ascertained to date from the late 7th century or the early 8th, well after the region was conquered by Muslim forces. A distinctively Islamic style of stucco decoration emerged only in the 9th century, and the extensive use of stucco persisted in western Islamic lands and the Iranian world (*see* ARCHITECTURE, §X, A, 1).

Gypsum was freely available throughout the region. The 10th-century geographer Ibn Hawqal mentioned that deposits of superb quality were found near Nishapur in Khurasan, and the material was widely exported. Stucco was made of pure gypsum and dissolved glue or of a mixture of lime and powdered marble or eggshell. In Iran, gypsum is stirred continuously until it loses its rapid setting power; this "killed" plaster is applied in several coats and does not finally set for 48 hours. Throughout the Islamic lands, stucco was carefully smoothed and painted, marked with designs with a pointed instrument before being carved with iron tools while still slightly wet—this is evident from unfinished work, such as at KHIRBAT AL-MAFJAR (724–43) near Jericho or in the interior of the Kutubiyya minaret in Marrakesh (*c.* 1157)—or molded.

Until the mid-8th century the major center of Islamic architectural patronage was Syria, where the primary media of architectural decoration were carved stone and applied mosaic (*see* ARCHITECTURE, §III). The expansion of the Islamic empire into Mesopotamia, Iran and Central Asia, where carved and/or painted stucco had long been the principal technique of architectural decoration, led to the increased prominence of stucco in architectural revetment and sculpture. At QASR AL-HAYR WEST (724–7), a palace in the desert between Damascus and Palmyra, for example, the two-towered gateway was transformed into a surface carved with carpet-like panels filled with vegetal and geometric motifs. The tympanum of the entrance contained a life-size stucco statue, probably of the caliph. Pierced stucco panels were used for a parapet in the intercolumnation of the upper-floor gallery around the court, and stucco also decorated the arches and tympana of the doorways. The use of stucco was even more extensive at the ruined palace at KHIRBAT AL-MAFJAR. The light, porous sandstone of the bathhouse porch was covered with exuberant stucco decoration, including another life-size statue set within a more architectonic frame. The brick dome of the vestibule was supported by athletes in loincloths, couchant rams and bare-breasted beauties. The finest stuccos were found in the private audience chamber within the bath-hall, where the walls were covered with carpet-like panels of exquisite beauty and the dome was decorated with birds, winged horses and a striking arrangement of six human heads emerging from acanthus leaves (see fig. 1). Stucco grilles and tracery, which had been unknown in the pre-Islamic architecture of the Mediterranean region, also became common in this period and continued to be produced for centuries, often inset with pieces of colored glass.

The emergence of Iraq as the central province of the Islamic empire in the 8th and 9th centuries led to the further development of stucco techniques (*see* ARCHITECTURE, §IV, A). The palaces erected by the Abbasid caliphs at SAMARRA in the mid-9th century were expansive structures of mud-brick, and stucco was the ideal medium to disguise this humble material quickly and effectively. Three increasingly abstract styles (A–C) of carved and molded ornament have been delineated. Styles A and B preserve recognizable

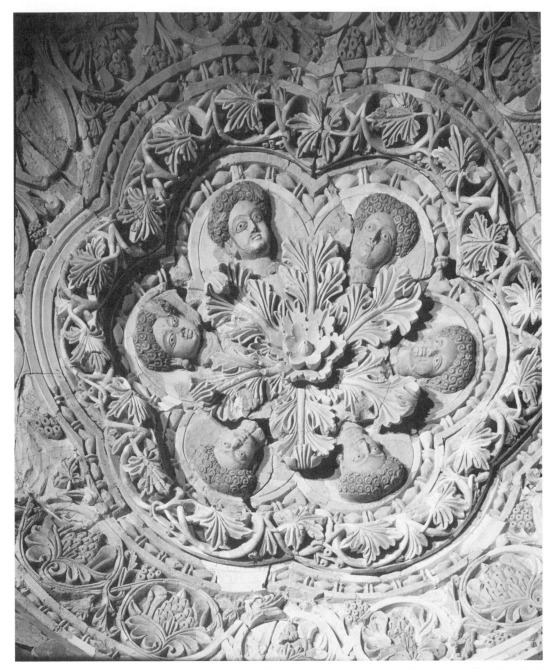

1. Stuccoed dome from the audience chamber of the bath-hall at Khirbat al-Mafjar, Jordan, early 8th century (Jerusalem, Israel Museum); Scala/Art Resource, NY

vegetal forms, but Style C, the BEVELED STYLE, is characterized by a distinctive slanted cut (Ger. *Schrägeschnitt*) and consists of endless rhythmic and symmetrical repetitions of curved lines with spiral terminals (*see* SAMARRA, fig. 2). Stucco carved in the Samarra styles quickly became popular throughout the Abbasid realm. At the nine-domed mosque (mid-9th century) at BALKH in Afghanistan, carved stucco ornament covers most of the superstructure; at the

Friday Mosque (10th century) at NA'IN in central Iran, such decoration distinguishes the mihrab and the six bays in front of it; at the congregational mosque (876–9) of Ibn Tulun in Cairo (*see* CAIRO, §III, B), restrained bands of carved stucco outline the arcades and soffits.

In Egypt the Samarra styles of carving stucco were replaced by increasingly naturalistic themes. This development can be traced in the buildings of Cairo,

where even the letters of inscriptions begin to sprout leaves and flowers, as at the mosques of al-Azhar (970–72), and al-Hakim (completed 1013). Perhaps the finest example of this restrained and elegant style is the stucco decoration surrounding the mihrab in the *mashhad* of al-Juyushi (1085; *see* ARCHITECTURE, fig. 20), where inscriptions, arabesques and floral motifs executed in shallow relief are superbly balanced within a composition fitted to the lines of the structure. Carved stucco played a minor role in subsequent Egyptian architecture, although isolated examples, such as the decoration surrounding the mihrab in the madrasa of al-Nasir Muhammad (1304), are of exceptional quality.

Elaborate decoration with carved stucco seems to have been introduced to North Africa from Mesopotamia in the early 9th century, to judge from excavations of several palaces near KAIROUAN in Tunisia. Extensive revetments of plaster carved in geometric patterns, preserved at the site of SEDRATA (10th or 11th century), the capital of the schismatic Kharijites in the Algerian Sahara, show that the Abbasid style of elaborate stucco revetment was not tied to political affiliations. Samarra styles of decoration had little impact on the development of stucco in Spain, where carved plaster began to replace carved marble in the second half of the 10th century and became the most common medium of decoration in the 11th century. In North Africa stucco also became the major medium of decoration under the Almoravid dynasty (r. 1046–1147). The bay in front of the mihrab (c. 1136) at the congregational mosque at Tlemcen in Algeria (for illustration *see* ALMORAVID) is covered with a stunning dome of intricately carved stucco tracery supported by transverse ribs. Elsewhere, serried tiers of molded niche-like elements were assembled in *muqarnas* vaults, which became increasingly popular in the western Islamic lands. The lavish style favored by the Almoravids became more restrained under the Almohad dynasty (r. 1130–1269), as, for example, at the mosque at Tinmal in Morocco (1153–4), where chaste and elegant carving contrasts with expanses of plain plaster and *muqarnas* vaults. In later times the role of carved plaster was increasingly limited to vaults and the upper wall surface between a tiled dado and wooden cornice. Restraint gave way to exuberance in such masterpieces as the ʿAttarin Madrasa in Fez (1323–5; *see* ARCHITECTURE, color pl.).

Carved stucco was also used extensively in the eastern Islamic lands (*see* ARCHITECTURE, §VI, A) where it was known as *gach* (Pers.; cf. Tajik *ganch*). While the Samarra styles and techniques of shallow relief were continued, as in the large panel beside the mihrab at the 14th-century shrine of Pir-i Bakran at Linjan in central Iran (*see* ARCHITECTURE, fig. 61), a tradition of increasingly high relief can be traced in the decoration of other mihrabs. In the finest examples, such as those at the congregational mosque at Ardistan (1158–60), arabesques of stems and leaves on intersecting levels create a sense of movement and depth. This style continued into the 14th century, as shown by the superb mihrab added to the winter prayer-hall of the Friday Mosque at Isfahan in 1310 (see fig. 2). Decoration was largely epigraphic and

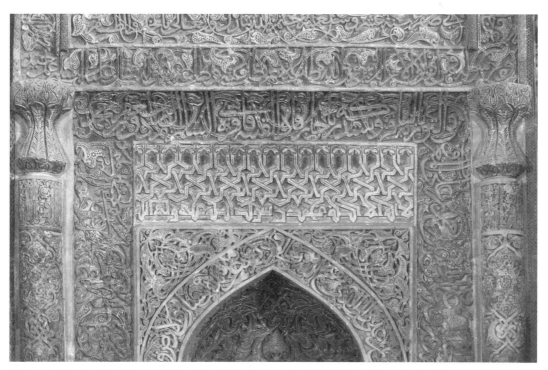

2. Stuccoed mihrab, Friday Mosque, Isfahan, Iran, 1310; photo credit: Sheila S. Blair and Jonathan M. Bloom

vegetal, but secular buildings, such as the Regents' Palace (12th century; *see* TERMEZ), show that animal themes were used as well. Stucco was also used for *muqarnas* vaults. The earliest surviving example is the shrine of Imam al-Dawr (Imam Dur; 1085–90) in Iraq, but its sophisticated level of construction presupposes an earlier tradition. This Mesopotamian tradition of *muqarnas* domes passed to Iran (e.g. tomb of ʿAbd al-Samad at NATANZ, 1307–8; *see* ARCHITECTURE, color pl.) and Central Asia (e.g. tomb of Ahmad Yasavi, 1397–9; for illustration *see* TURKESTAN). The taste for stucco-carving in high relief seems to have waned in the 15th century, except along the Caspian coast of Iran, where a provincial tradition persisted. Elaborate stucco revetments became popular again at the start of the 17th century, when palace interiors were decorated with *muqarnas* and niches intended for the display of porcelain (e.g. the Music Room at the ʿAli Qapu Palace, begun 1597; *see* ISFAHAN, §III, F and ARCHITECTURE, fig. 50).

In the decoration of Islamic architecture in the Indian subcontinent, stucco was widely used as wall plaster (either smooth or with applied decoration) or for carved medallions and geometrical patterns (see color pl. 3:VII). Noteworthy Islamic monuments using stucco include the mausolea of Khan-i Jihan Tilangani (1368–9) and the Chotte Khan-ka Gumbad (15th century) in Delhi; the Jahaz Mahal (1460) at Mandu in Madhya Pradesh; the mid-15th-century mausolea of Aʿzam Khan Khayr Khan at GOLCONDA in Andhra Pradesh; the mausolea of ʿAla al-Din Ahmad Bahmani (1458) and Khan Jahad Barid (1553) at BIDAR in Karnataka; and the mausoleum of Firuz Shah Bahmani (1442) at GULBARGA, also in Karnataka. In the Deccan, stucco was commonly used to produce round architectural medallions bearing plant designs and (from the 15th century onwards) "elephant trunk" patterns. From the mid-6th century onwards, the use of stucco, especially as plaster in interiors, declined.

Enc. Iran.: "Gačborí" [plasterwork], *Enc. Islam/2*: "Djiss" [plaster]

S. M. Flury: *Die Ornamente der Hakim- und Ashar-Moschee* (Heidelberg, 1912)

R. M. Riefstahl: "Persian Islamic Stucco Sculpture," *A. Bull.*, xiii (1931), pp. 439–63

K. A. C. Creswell: *Early Muslim Architecture*, 2 vols. (Oxford, 1932–40), 2nd edn. of vol. 1 in 2 pts. (Oxford, 1969)

B. P. Denike: "Reznaya dekorovka zdaniya, raskopannogo v Termeze" [The carved decoration of the building excavated in Termez], III *Mezhdunarodnyy kongress po iranskomu iskusstvu i arkheologii. Doklady: Leningrad, sentyabr' 1935* [3rd International Congress on Iranian Art and Archaeology. Papers: Leningrad, September 1935], pp. 39–44 [Fr. summary]

G. I. Kotov: "Mekhrab Meshed-i Misriana" [The mihrab from Mashhad-i Misriyan], *III Mezhdunarodnyy kongress po iranskomu iskusstvu i arkheologii. Doklady: Leningrad, sentyabr' 1935* [3rd International Congress on Iranian Art and Archaeology. Papers: Leningrad, September 1935], pp. 104–8 [Fr. summary]

R. Ettinghausen: "The 'Beveled Style' in the Post-Samarra Period," *Archaeologica Orientalia in Memoriam Ernst Herzfeld* (Locust Valley, 1952), pp. 72–83

K. A. C. Creswell: *The Muslim Architecture of Egypt*, 2 vols. (Oxford, 1952–9)

G. Marçais: *L'Architecture musulmane d'occident* (Paris, 1954)

L. I. Rempel': *Pandzhara: Arkhitekturnyye reshotki i ikh postroyeniye* [Panjara: architectural grilles and their construction] (Tashkent, 1957)

D. Hill and O. Grabar: *Islamic Architecture and its Decoration A.D. 1500–1900* (London, 1964)

A. M. Pribytkova: "O 'krasivoy' mecheti Dandenakana" [On the "handsome" mosque at Dandanqan], *Arkhit. Nasledstvo*, xvii (1964), pp. 185–94

H. Wulff: *The Traditional Crafts of Persia* (Cambridge, MA, 1966), pp. 133–5

I. Akhrarov and L. I. Rempel': *Reznoy shtuk Afrasiaba* [The carved stucco of Afrasiab] (Tashkent, 1971)

C. Ewert: "Islamische Funde in Balaguer und die Aljafería in Zaragoza," *Madrid. Forsch.*, xvii (1971) [whole issue]

D. Hill and L. Golvin: *Islamic Architecture in North Africa* (London, 1976)

D. Thompson: *Stucco from Chal Tarkhan-Eshqabad near Rayy* (Warminster, 1976)

U. Harb: "Ilkhanidische Stalaktitengewölbe," *Archäol. Mitt. Iran* (1978) [suppl. iv]

S. R. Peterson: "The Masjid-i Pa Minar in Zavareh: A Redating and Analysis of Early Islamic Iranian Stucco," *Artibus Asiae*, v (1978), pp. 60–90

E. Galdieri: *Esfahân: ʿAli Qapu: An Architectural Survey* (Rome, 1979)

B. O'Kane: "Timurid Stucco Decoration," *An. Islam.*, xx (1984), pp. 61–84

R. Shani: "On the Stylistic Idiosyncrasies of a Saljūq Stucco Workshop from the Region of Kāshān," *Iran*, xxvii (1989), pp. 67–74

G. Curatola and G. Scarcia: *Le arti nell'Islam* (Rome, 1990)

S. S. Blair: *The Monumental Inscriptions of Early Islamic Iran and Transoxiana* (Leiden, 1992)

S. R. Peterson: "The Masjid-i Pā Minār at Zavāra: A Redating and an Analysis of Early Islamic Iranian Stucco—II," *The Art of the Saljūqs in Iran and Anatolia*, ed. R. Hillenbrand (Costa Mesa, 1994), pp. 59–66

R. Shani: "Stucco Decoration in the Gunbad-i ʿAlawiyyān at Hamadan," *The Art of the Saljūqs in Iran and Anatolia*, ed. R. Hillenbrand (Costa Mesa, 1994), pp. 71–8

M. Kervran and V. Bernard: "Miḥrābs omanais du 16e siècle: Un curieux exemple de conservatisme de l'art du stuc iranien des époques seldjouqide et mongole," *Archéol. Islam.*, vi (1996), pp. 109–56

S. al-Radi, ed.: *The ʿAmiriya in Radaʿ: The History and Restoration of a Sixteenth-Century Madrasa in the Yemen* (Oxford, 1997)

M. Meinecke: "Abbsidische Stuckdekorationen aus ar-Raqqa," *Bamberger Symposium: Rezeption in der islamischen Kunst*, ed. B. Finster, C. Fragner and H. Hafenrichter (Beirut, 1999), pp. 247–67

F. B. Flood: "The Ottoman Windows in the Dome of the Rock and the Aqsa Mosque," *Ottoman Jerusalem, the Living City: 1517–1917*, ed. S. Auld and R. Hillenbrand (London, 2000), pp. 431–63

M. Riazi: "Stucco," *The Splendour of Iran*, ed. N. Pourjavadi, (London, 2001), ii, pp. 474–97

J. M. Scarce: "Princes and Heroes of Bandar-i Taheri—A Late Qajar Fort and the Shahnama," *Cairo to Kabul: Afghan and Islamic Studies Presented to Ralph Pinder-Wilson,* ed. W. Ball and L. Harrow (London, 2002), pp. 181–93

A. Hamlaoui: "Les stucs de Sedrata," *L'Algérie en héritage: Art et histoire,* ed. E. Delpont (Paris, 2003), pp. 301–6

L.-A. Hunt: "Stuccowork at the Monastery of the Syrians in the Wādī Naṭrūn: Iraqi-Egyptian Artistic Contact in the 'Abbasid Period," *Christians at the Heart of Islamic Rule: Church Life and Scholarship in 'Abbasid Iraq,* ed. D. Thomas (2003), i of *History of Christian–Muslim Relations* (Leiden, 2003–8), pp. 93–127

L. Korn: "Iranian Style 'Out of Place'? Some Egyptian and Syrian Stuccos of the 5–6th/11–12th Centuries," *An. Islam.,* xxxvii (2003), pp. 237–60

J. M. Scarce: "Bandar-i Tahiri—A Late Outpost of the Shahnama," *Shahnama: The Visual Language of the Persian Book of Kings,* ed. R. Hillenbrand (Aldershot, 2004), pp. 143–54

Y. Dold-Samplonius and S. L. Harmsen: "The Muqarnas Plate Found at Takht-i Sulayman: A New Interpretation," *Muqarnas,* xxii (2005), pp. 85–94

C. Cardell-Fernandez and C. Navarrete-Aguilera: "Pigment and Plasterwork Analyses of Nasrid Polychromed Lacework Stucco in the Alhambra (Granada, Spain)," *Stud. Conserv.,* li/3 (2006), pp. 161 76

Suakin [Sawākin; Suakim]. Port in northeast Sudan on the coast of the Red Sea. A small village in the 13th century, by the 15th century Suakin had replaced Aydhab as the chief African port on the Red Sea. Suakin consisted of a settlement on an island about a mile in circumference in the center of a deep bay and a mainland suburb known as El Geyf. From the early 16th century to the 19th, the town was a major mercantile center of the Ottoman Empire. A causeway to the island was built by General C. G. Gordon in 1877, and El Geyf was encircled by fortifications, including an impressive gateway known as Kitchener's Gate, in the 1880s and 1890s. By the 1920s the port had silted up, and Suakin was abandoned in favor of Port Sudan, to the north. In the 1980s Suakin began to be redeveloped as the second port of Sudan.

The buildings of Suakin were largely constructed of madrepore, or rock-coral, taken from the seabed. The vernacular style of construction under the Ottomans was akin to that of Jiddah in Arabia and Mitsiwa in Ethiopia. The houses, which had a white plaster finish, were up to four stories in height and often built in blocks or terraces of three or more, separated by narrow streets. They had large casement windows (Arab. *rushān*) and doors of Java teak surmounted by carved stone door-hoods and denticulated parapets. From the 1860s an Egyptian style of architecture began to incorporate features from Egypt and Europe. As the buildings had no plaster covering, they decayed quickly and the town fell into ruin.

Enc. Islam/2: "Sawākin"

D. Roden: *The Twentieth Century Decline of Suakin* (Khartoum, 1970)

J. P. Greenlaw: *The Coral Buildings of Suakin: Islamic Architecture, Planning, Design and Domestic Arrangements in a Red Sea Port* (London, 1976/*R* 1995)

M. Calia: "Suakin, Memory of a City," *Environmntl Des.,* xviii/1 (1997), pp. 192–201

Subject matter. For all its rich variety, the subject matter of Islamic art has always been studied piecemeal, and the lack of a comprehensive survey has vitiated popular understanding of the artistic tradition. Among common misconceptions—usually of Western origin—are that Islamic art does not evolve significantly, that it is almost exclusively a religious art, and that it avoids depicting living creatures. Even the perception that Islamic art is essentially ornamental is wide of the mark, though no one could deny the strength of the so-called *horror vacui*—the desire to leave no space void—as a basic generative principle in all media, periods and types of decoration (*see* ORNAMENT AND PATTERN). Whether more can be read into it than an affinity for ornamented surfaces is doubtful. Leitmotifs in Islamic art include the continuity of ideas over many centuries and across most of the Islamic lands, the dominating influence of the first century of Islam on what was to follow, and the pervasive impact of the religion on all art. The overarching unity created by such leitmotifs makes the concept of "Islamic art" meaningful.

I. Introduction. II. Religious themes. III. Royal themes. IV. Secular themes. V. Vegetal themes. VI. Geometry. VII. Writing. VIII. Natural world. IX. Magic. X. Heavenly bodies.

I. Introduction. The distinctive character of Islamic art was due to imaginative changes applied to material borrowed from Late Antiquity, the Ancient Near East, Central Asia, India and the Far East. This astonishing range of sources is largely explained by the geographical position of the Islamic lands, the natural bridge between the Mediterranean world and eastern Asia. Yet the formidable unity of Islamic art transcended not only these borrowings but also regional substyles and chronological evolution. Powerful unifying factors were the annual pilgrimage to Mecca, the land and sea trade routes that crisscrossed these lands, and a shared religion whose language— Arabic—was the lingua franca of the entire culture. Although the major ethnic divisions of Arab, Persian and Turk were strongly marked, each race at times ruled the others, guaranteeing continuous cross-fertilization between artistic traditions. In such contexts designs and motifs migrated frequently from one medium or area to another. Similarly, the various categories proposed for the subject matter of Islamic art (e.g. geometry, vegetal ornament, writing etc.) overlap so much that they merge and challenge the validity of such categories. Yet they are necessary, if only as a convenient means of imposing order on the potentially inchoate mass of material.

The "gaps"—what is not found in Islamic art— have played a crucial role in its typecasting in the West. Three-dimensional sculpture of substantial scale is rare, perhaps as a result of the religious taboo on devotional images. The virtual absence of easel and OIL PAINTING until modern times is more difficult to

explain on religious grounds. For the Westerner, accustomed to regarding painting as the principal expression of art, it requires an effort of imagination and will to adjust expectations when looking at Islamic art and to encounter it on its own terms. These include a more profound and sophisticated approach to ornament than in Western art and, conversely, little interest in the pursuit of naturalism for its own sake, a pursuit that Western art inherited from the Classical world and that engendered a fascination with the human body, portraiture, genre, still-life and landscape. Islamic art also had little time for myth or figural religious images. Equally, there is little trace of the personality cult that came to surround Western artists, with the concomitant notion that the artist was inspired and that he could attain privileged social status. Although the names of thousands of Muslim artists, architects and craftsmen are known, their biographies, with few exceptions, are not.

II. Religious themes. Much of the subject matter of Islamic art is religious. For all the theological discussion about the prohibition of images, the prohibition was effective only insofar as devotional images were never produced (*see* ICONOCLASM). The iconoclastic controversy in Byzantium may have sharpened Islamic awareness of the issue, but it was not responsible for the particular Islamic stance, and Muslim artists were not dependent on theological approval of their work.

Pride of place goes to architecture, especially the MOSQUE, its furnishings and accessories—the MINARET, MIHRAB, MINBAR and prayer rugs (*see* CARPETS AND FLATWEAVES). Other popular building types with religious associations are the MADRASA or theological college and the mausoleum (*see* TOMB), often used as a place for prayer as well as burial. Indeed, some of the principal Islamic shrines have grown up around saints' tombs, expanding to become huge multi-functional complexes (*see* SHRINE). The Ka'ba in MECCA became a popular symbol of sanctity, depicted in poetic manuscripts, pilgrimage guides and certificates, and glazed tiles; textile coverings and keys for the Ka'ba served as pious gifts from rulers and high officials.

Special veneration was accorded to manuscripts of the KORAN, and the text was copied by calligraphers on parchment and later on paper in special scripts developed by noted masters (*see* CALLIGRAPHY). Illumination was concentrated on frontispieces and finispieces forming carpet pages of complex geometric interlace (see color pl. 3:XVI, fig. 2), and chapter headings, marginal palmettes and roundels marking verse counts were frequently illuminated, particularly in gold and ultramarine (*see* ILLUMINATION). Tooled leather bindings for each volume—often 30 in a single copy of the Koran—echo in monochrome the carpet pages within. Folding wooden stools allow the book to be displayed open (*see* WOODWORK, fig. 6); like the wooden or inlaid metal boxes used to store multi-volume manuscripts of the Koran (*see* METALWORK, color pl.), they bear Koranic inscriptions.

These occur so frequently throughout Islamic art—on buildings, clothing, pottery, metalwork, glass—that they constitute one of its principal subjects, sanctifying even the most everyday objects.

Another religious theme is Paradise. Sometimes it is explicit, as in the depictions of Muhammad's journey to the Seven Heavens (Arab. *mi'rāj*; *see* ILLUSTRATION, color pl.). The trees of Paradise—gigantic and bejeweled—are described at length in the Koran and its commentaries. The trees are represented carefully in the *Mi'rājnāma* ("Book of the [Prophet's] Ascension"; 1436; Paris, Bib. N., MS. suppl. turc 190) and probably in the mosaics of the Dome of the Rock (*see* JERUSALEM, color pl.) and the Aqsa Mosque (*see* MOSQUE, fig. 1), and the Great Mosque of Damascus (*see* ARCHITECTURE, color pl.), as well as the stucco carvings of the Gunbad-i 'Alaviyyan at Hamadan, Iran (?12th century) and the Ardabil Carpet (*see* CARPETS AND FLATWEAVES, color pl.). The houris who await true believers are occasionally depicted, as are the chalices from which the blessed will drink, the buildings in which they will recline and the fruit they will eat. The hybrid birds on the tiled portal of the Shah Mosque (*see* ISFAHAN, fig. 3) may also refer to Paradise, particularly as the inscriptions on the portals of religious buildings and the steel plaques on their gates sometimes play on the concept of such buildings as gates to Paradise. Most references to Paradise, however, are coded or even subliminal. The numerous Koranic verses that describe water as an attribute of Paradise allow the ablution fountains in mosques or the water dispensaries erected for the public good in many Islamic cities (*see* ARCHITECTURE, fig. 46 and CAIRO, fig. 4) to allude gracefully to this connection, and sometimes the choice of Koranic quotations makes it explicit. The most powerful earthly foretaste of Paradise is the GARDEN. Thus depictions of supernally blossoming gardens in book illustrations, glazed tiles (*see* ARCHITECTURE, color pl.) or carpets (*see* GARDEN, color pl.) lend themselves to double meanings. So do actual gardens, from the Generalife (*see* GRANADA, §III, B) to those of the Taj Mahal (*see* AGRA, §II, A). Many gardens are walled and thus inaccessible, quartered with water-channels and given a funerary context by their association with a mausoleum.

Hagiography began to affect Islamic art after *c.* 1300, probably when many Muslim taboos were broken following the Mongol invasions. Initially images of the Prophet Muhammad derived from Christian prototypes, but gradually a fuller iconography developed, culminating in the Ottoman period. Illustrated manuscripts of the *Mi'rājnāma* depicted Muhammad in a heavenly setting, and in time this event was treated ecstatically, making Muhammad a more than earthly figure wrapped in flame and escorted by angels. The Prophet, 'Ali and his family were particularly exalted by Shi'ites, with depictions of the lion (*haydar*, a name of 'Ali), 'Ali's martial exploits and Muharram ceremonies (when 'Ali's martyrdom was commemorated) and associated architecture, figural

tilework and furnishings. Countless shrines in Iran testify to this devotion. Jewish and Christian sources provided the basis for the *Qiṣāṣ al-anbiyāʾ* ("Tales of the Prophets"), whose popularity explains the frequent depiction of Nuh (Noah), Sulayman (Solomon), Daʾud (David), Ibrahim (Abraham), Musa (Moses), Yunus (Jonah) and ʿIsa (Jesus) in Islamic painting. The favorite figure was unquestionably Yusuf (Joseph), whose story, as interpreted by poets with Sufi leanings, is widely depicted in manuscripts (*see* BIHZAD, color pl.), tilework, carpets and murals.

Christian scenes, usually from the lives of Jesus and Mary, appear sporadically on pottery, murals and ceiling paintings, but principally on inlaid metalwork made under the Ayyubids of Syria (for illustration *see* ISLAMIC ART; *see also* METALWORK, §III, B). The superlative quality of these images shows that Muslim craftsmen were prepared to work on a substantial scale for Christian patrons. Conversely, Muslim objects were used in a Christian context in medieval Europe, as in the rock crystal vessels popularly supposed to hold Christ's blood, silks and ivory boxes used as reliquaries, episcopal thrones made from heterogeneous fragments of Muslim carvings and Abbasid coins overstruck with the names of Western rulers.

Mystical themes permeated later Persian book painting (*see* ILLUSTRATION, §§V, D and VI, A). Sometimes, as in Nizami's *Khamsa* ("Five poems") or ʿAttar's *Manṭiq al-ṭayr* ("Conference of the birds"), the text is crammed with references to mystical experience and teaching, and some protagonists are clearly allegorical. In other cases, however, the artist emphasized or even introduced the Sufi element, as in the illustrations to a copy (Washington, DC, Freer, 32.29–37) of the *Dīvān* (collected poetry) of Ahmad Jalayir. These themes may be tied to a given narrative (e.g. the story of Yusuf and Zulaykha) or may illustrate familiar Sufi practices or symbols. Sufi poets were held in high esteem at court, and important officials manifested Sufi leanings and erected many Sufi foundations (*see* KHANAQAH).

Religious symbols in Islamic art, while not fully understood, include the crescent, often used with a star to denote Islam; the color green, which can connote sanctity or descent from the Prophet; banners, flags and orbs, often inscribed with some religious motto; the white veil, principally associated with Muhammad; haloes, whether circular on the European model or flaming as in Buddhist art; the various types of turban (e.g. those furnished with a red baton to indicate Safavid allegiance); and a group of images relating to light—pierced domes, hanging lamps, rayed designs etc.—that play on the association between God and light (Koran 24:35).

Distinctive renderings of supernatural beings established themselves from the 13th century onwards, almost exclusively in book painting. Angels figure in cosmological manuscripts, texts dealing with the life of the Prophet and individual album leaves intended as a test of draftsmanship. No clear difference can be discerned between the *jinn*s who attend Sulayman in manuscript frontispieces and the *div*s with whom the heroes of Firdawsi's *Shāhnāma* ("Book of kings") fight or the demons who torment the guilty in hell in the *Miʿrājnāma*.

III. Royal themes. Much of the finest Islamic art was produced under royal patronage, and royal themes are a central concern (*see* PATRONAGE, §I). As with religious art, architecture played a crucial role. Palaces were the most visible embodiment of royal luxury (*see* PALACE), and they transmitted this idea in many forms—entire cities; huge complexes, tightly or loosely organized medieval machines for living; country estates focused on a single royal residence; hunting-lodges; and pavilions. Nor was the element of naked power forgotten. In most major Islamic cities the citadel, often at the city center, contained the ruler's residence, treasury and a substantial garrison (*see* MILITARY ARCHITECTURE AND FORTIFICATION, fig. 1). Gates and portals drove home the same message by their royal symbols (lions, eagles, dragons) and inscriptions.

The congregational mosque also had a significant political role (*see* ARCHITECTURE, §II), as the caliph, or his accredited representative, led the people in prayer, and his sermon delivered from the throne-like minbar served as a declaration of political allegiance. The architectural forms employed had a long political history in other cultures: the mihrab can be linked with the niche or apse in which the emperor or bishop sat, the minbar is a type of throne, the MAQSURA or royal box recalls the Byzantine *kathisma* (imperial box at the hippodrome), and the dome and axial nave had honorific associations already ancient at the coming of Islam. In time the minaret was also put to use as a symbol of power. Thus the mosque as a whole embodied the theoretical doctrine that religious and secular authority were one. Mausolea too served to glorify secular power, though somewhat less in the western Islamic lands. Sometimes a religious gloss was given by the titulature of the inscriptions, which might vaunt the piety of the tenant; by the location near the tomb of a holy man; or by the addition of a mihrab. But while major mausolea for religious figures are known (*see* CAIRO, fig. 6), the masterpieces of the genre were erected for secular princes (*see* ARCHITECTURE, figs. 9, 10, 30, 38, 39 and color pl. 1:VI, fig. 1). Tents (*see* TENT, §III), despite their impermanence, epitomized courtly luxury by their sheer size and the sumptuousness of their fabrics.

The most original Islamic contribution was the so-called princely cycle, a series of interrelated scenes depicting the pleasures and ceremonies of the royal court: the music of harp, tambourine, flute, trumpet, drum and lute; dancing girls; wrestling, stick fights, jousts and gladiatorial combats with animals; hunting with dogs and falcons, including the retrieval of game; drinking and banqueting; homage and audience scenes; board games; riding on elephants—the range is remarkably wide. Cup-bearers, grooms and

servants, chamberlains and various other office-bearers with appropriate attributes are often included. Scenes of country life and agricultural pursuits, such as vintaging or digging, are sometimes incorporated. The cycle is flexible: it is as easily extended as contracted and may have drawn partially on Byzantine and Sasanian sources. It is found as readily in the portable arts, for example in metalwork or ivory (see IVORY, color pl.), as in stone sculpture (e.g. the Pila of Játiva; Játiva, Mus. Mun.) or murals (see ARCHITECTURE, fig. 64). Usually the component images are placed side by side in a single band or roundels to reinforce and intensify each other. Apart from a straightforward description of court life, these images could be intended to evoke graphically the conspicuous consumption expected of royalty. This cycle may also be related to the benedictory inscriptions that so often accompany it. Both say the same thing—one visually, the other in words: this is the Good Life. The epigraphic references to such things as perpetual happiness and lasting security evoke the hereafter, when the Good Life will continue in Paradise for all eternity.

Images of the ruler in majesty were as common in Islamic as in medieval Western or Byzantine art and derived from the same sources. Formal enthronements were most popular, occurring from Umayyad times onwards in three-dimensional sculpture, medals and frescoes, but above all as frontispieces in manuscripts from the 13th century onwards (see PATRONAGE, fig. 1). Frequently the ruler is shown surrounded by his courtiers, amirs and bodyguards. Apart from a few starkly symbolic images, actual portraits are relatively late, beginning c. 1420 with frontispieces depicting Baysunghur (see TIMURID, §II, G) and thereafter including depictions of the rulers of the Ottoman, Safavid and Mughal superpowers. The standard method of referring to a ruler was epigraphic. COINS provide the perfect laboratory for tracing this evolution, with the ruler's name moving from border to field and gradually taking on titles. Silks and other stuffs made in royal workshops emblazoned the royal name and titles on robes, headgear, armbands and hangings (see TIRAZ). Thus inscriptions became a kind of livery, with length and content determined according to a strict hierarchy.

Artists were best able to integrate royal titulature with the shape and design of objects in metal and glass, particularly under MAMLUK patronage. Serried ranks of letters, their uprights forming a bristling phalanx, parade around dishes and bowls proclaiming amiral or royal titles and taking up most of the surface (see GLASS, fig. 2 and METALWORK, fig. 12). Emblems punctuate the epigraphy and identify the owner by office rather than by name. In architecture, too, inscription bands and panels, often carefully proportioned and located for maximum legibility, identify the patron, whose name is often accompanied by a list of titles. In tiled inscriptions the ruler's name stands out from the rest of the inscription by the different color employed—amber (for gold, the royal color), blue or dark green.

Apart from the ownership of the building, perhaps the most common royal theme expressed by such inscriptions was victory, although the notion of erecting a monument solely to commemorate a victory was foreign to Islamic taste. Thus victory monuments, often identified as such not only by historical circumstances but also by the presence of the Koranic chapter "Victory" (48) in their inscriptions, may be mosques, minarets or other commemorative buildings. A more coded reference to victory may be made by the use of spolia, usually taken from the religious edifices of other faiths—Christian, ancient Egyptian and Hindu or Jain. Battles were a favorite theme of murals in royal palaces. Few examples survive (see ARCHITECTURE, §X, C), but they are plentiful in book painting. The victory theme is also expressed in representations of submission or symbolic conquest of an enemy depicted as an animal (see ARCHITECTURE, fig. 62 and TEXTILES, color pl.) or in epigraphic mottoes. Inscriptions of prophylactic character or claiming victory decorate armor (see ARMS AND ARMOR), banners and standards.

The symbols employed in Islamic royal iconography still await the comprehensive study long accorded to their Western counterparts. Many types of crown (see REGALIA), THRONE, parasol, honorific arch and canopy are depicted. Seated rulers are often shown holding a cup, which can be related either to the magical cup of Jamshid in the Persian tradition or to a complicated range of ceremonies among the Turks. Rulers often hold a leafy branch in their other hand, but its significance is still elusive. Some elements of royal costume served symbolic as well as practical ends (see DRESS, §I), and some textile designs functioned as dynastic or personal symbols, while others were borrowed from foreign cultures. Color symbolism in royal costume requires further study. An elaborate system of emblems developed under the Mamluks: emblems set in cartouches comprised simplified symbols (such as napkin, cup, sword, polo-stick) that identified the patron's office. Used on architecture, woodwork, metalware, ceramics, glass, coins and costume, these emblems evoke to perfection the rigid hierarchy of the Mamluk military caste.

Finally, royal life is transfigured and rendered exemplary in the world of myth. In the *Shāhnāma*, the roll-call of monarchs reaches back to the beginning of time and continues until the coming of Islam, so that myth gives way almost imperceptibly to history. But myth and history alike are interpreted through the prism of national sentiment, and Firdawsi's version of Iranian kingship has become part of the heritage of every Iranian. A few Iranian rulers who are historical figures, including Alexander the Great, Ardashir, Bahram V, Khusraw I and Khusraw II, Sultan Mahmud of Ghazna, Sultan Malikshah and Sultan Sanjar, have taken on a mythic identity in Iranian literature. Royal themes from Firdawsi and Nizami, far from being confined to book painting, infiltrated many other media, notably ceramics and tilework, but also carpets, carved stuccos, lacquer and metalwork. Moreover, the popularity of Firdawsi and

Nizami spread to Ottoman Turkey and to India. The Indian poet Amir Khusraw Dihlavi (1253–1325) took up the themes of Nizami, and both Arabic versions of the *Shāhnāma* and Ottoman pastiches of it are also known (*see* ILLUSTRATION, §II, B, C, and D).

IV. Secular themes. Secular themes play a distinguished role in Islamic art, whether in the field of folk art, science, literature or daily life. Genre images, although underrated, are ubiquitous and include occupations such as building, metalworking, handicrafts, the labors of the months (a popular theme in metalwork) and, above all, agricultural work (a subplot in so much of later Persian painting).

The theme of popular entertainment crops up in varied guises. Egyptian luster pottery under the Fatimids (*see* CERAMICS, §III, A), for example, depicts scenes of stick-wielding men in combat, wrestling and cock-fighting. Depictions of dances with zoomorphic masks occur sporadically in Islamic art, from murals on Umayyad hunting-lodges to depictions of Ottoman guild processions. These processions, to judge from contemporary book illustrations, encompassed several kinds of public spectacle, such as bands, tumblers and acrobats, stilt-walkers and dwarfs. The Ottoman painter LEVNI specialized in such themes, which were closely connected with the celebration of such major festivals as the Prophet's birthday or the end of Ramadan. These subjects constitute a separate genre in Ottoman painting, while under the Mughals the repertory extended to Hindu festivals and spectacles. Other non-Islamic festivals are depicted because of their strangeness, as in the illustrations to al-Biruni's *Āthār al-bāqiya* ("Chronology of ancient nations"; 1307–8; Edinburgh, U. Lib., Arab. MS. 161), which feature "outlandish" Zoroastrian, Indian and Babylonian customs.

A far more common theme was genre—the humdrum activities of daily life. Such topics enjoyed a pervasive popularity in Islamic art from the 12th century onwards, whether in Iraq or Spain—where the Pila of Játiva is carved with vignettes of rustic life, or the illustrated romance of *Bayad and Riyad* (*see* ILLUSTRATION, color pl.) is abuzz with swooning lovers, intriguing duennas and literary salons dominated by imperious *précieuses*. A secular bias can be seen in the earliest body of Islamic book painting to survive (*see* ILLUSTRATION, §§III and IV): breech-clouted laborers toil in the fields, assistants mix potions in apothecaries' booths, scholars dispute with each other or lecture their students. Teeming low life abounds in the paintings of numerous manuscripts of al-Hariri's *Maqāmāt* ("Assemblies") produced in 13th-century Iraq and Syria (*see* ILLUSTRATION, fig. 5). The smells and squalor, the bustle and noise of contemporary city life are conjured up with uncanny realism in these pages. The hubbub of tavern and slave-market, the ceremonious ritual of mosque and law-court, the fanfares and gala celebrations that announce military processions or the departure of the pilgrim caravan to Mecca—all are captured with the utmost economy, flair and conviction. An entire panorama of 13th-century Arab life

unfolds before our eyes. And then, as suddenly as it had appeared, this world vanishes forever for reasons that cannot easily be fathomed.

Henceforth book painting catered principally to aristocratic taste, and the texts of choice were epics and lyrics, except for an enigmatic corpus of paintings associated with SIYAH QALAM depicting the grinding routine of nomadic life—tending animals, shouldering crushing burdens, pitching camp, plodding blindly on. No body of genre scenes in Islamic painting can match these for *gravitas* and emotional depth. A more muted realism characterizes the school of BIHZAD, where the emphasis is on the tableau rather than the individual. The formal set-pieces of court life are offset by lively vignettes of woodcutters and melon-sellers, herdsmen, ploughmen and fishermen, and occasionally by an entire *mise-en-scène* drawn from everyday life: a nomadic encampment, a school, a cluttered building site, a busy hammam. This exaltation of ordinary people is quietly revolutionary, but the overriding emphasis on technique seems to prevent anything more than a surface engagement with the appearance of things. Nature methodized seems to have been the watchword of those later Persian painters who toyed with realism, such as MUHAMMADI with his pastel landscapes and al fresco picnics; RIZA, whose sketches from low life and louche pageboys, executed with a dazzling calligraphic line, took Safavid taste by storm; and MUʿIN, who produced some notable portraits.

Secular themes in book painting covered subjects as varied as adventures, seafaring, hunting, carousing, battle, banqueting, wrestling and other sports and—above all—romance. In the book of animal fables known as *Kalila and Dimna*, stories of animals sugared a bitter pill of political expediency and worldly wisdom, spiced with moral homilies. Illustrated versions of this text were popular throughout Syria, Iraq, Egypt and Iran in the 13th and 14th centuries. Artists had free rein in the lively if stereotyped depiction of animals, often shown devoid of habitat and in anthropomorphic contexts (e.g. the king of the birds wears a crown).

In scientific works (*see* ILLUSTRATION, §II, A) illustrations were perceived as diagrams explaining the all-important texts, which covered astronomy, military techniques and maneuvres, automata and especially pharmacology. The plants depicted are schematic, but their ornamental qualities are patent, and thus sheer entertainment steals a march on science. Books on animals also added much Islamic material to a Classical substratum; their interest was as much pharmacological as zoological. Geography and the wonders of creation caught the imaginations of medieval Muslim painters, with depictions of angels and *jinn*, exotic and even fabulous animals (see color pl. 3:VIII, fig. 2) and plants, and weird humanoid creatures believed to lie over some distant horizon.

V. Vegetal themes. Vegetal ornament from various sources was taken to new heights of intensity and sophistication in Islamic art. The Classical world, for

example, provided the motifs of the acanthus and the inhabited scroll and familiarized the Islamic world with openwork carving, from which the entire tradition of *mashrabiyya* (spoolwork) may spring, and the Corinthian capital, which served as the point of departure for a series of variations that left the Classical original unrecognizable. Sasanian Iran and Mesopotamia contributed the palmette and the winged palmette, the rosette and, above all, the notion of repeat designs whereby vegetal forms took on a geometric character. The preference for stucco (*see* STUCCO AND PLASTERWORK), whose innate flexibility allowed it to accommodate any quirk of design, encouraged this type of even surface patterning. Such trends culminated at SAMARRA, the Abbasid capital, where molded and colored vegetal motifs running the gamut from naturalism to abstraction were employed like wallpaper (*see* SAMARRA, fig. 2).

The principal achievement of Islamic art in the field of vegetal ornament was the invention of the ARABESQUE, whose very name encapsulates its origin. A key characteristic of this geometricized vegetal ornament is its protean variety, which allows it to be adapted to any number of contexts—tightly coiled or loosely undulating, confined to a few leaves or loaded with fruit and blossoms, grand or tiny, background or foreground.

Chinese motifs, which had infiltrated Islamic art at least from the early Abbasid period onwards, came to the fore in the wake of the Mongol invasions in the 13th century. Motifs included the peony, lotus and chrysanthemum, and the combination of these foreign blossoms changed familiar floral designs. Although increasingly schematized, these flowers may have triggered an interest in observing nature more closely, and by the 15th century accurately rendered, botanically distinguishable flowers had entered the repertory of Islamic art: among them the dianthus, hyacinth and above all the tulip. Under OTTOMAN patronage, the SAZ style, an overall surface decoration loosely based on some of these plant forms, developed, and tulipomania reached such a height at the capital in the early 18th century that the period was dubbed *lale devri* ("tulip age").

Vegetal motifs are put to manifold uses. They may be a discreet background for more important decoration, such as epigraphic bands, or they may claim an equal role as foil, as for example the vegetal interlace that constitutes the infill for polygonal patterning on carved woodwork. In both cases, artists exploited the differences between vegetal and other ornament. Vegetal motifs also lend themselves to borders, demarcating one field of ornament from another. The internal logic of a vegetal scroll, helped by colorcoding, makes it ideal for palimpsest compositions in which successive designs are superimposed without loss of coherence.

The pervasiveness of vegetal ornament in Islamic art is shown by the transformation of architecture into an organic entity. The process began with window grilles of the Umayyad period, continued in the lambrequin arches of western Islamic architecture

(*see* ARCHITECTURE, fig. 26) and culminated in panels from the Aljafería Palace (11th century) in Saragossa, where columns, capitals and arches dissolve in a jungle of rank vegetation. Squinches, too, were apt to take on foliate character, as were mihrabs and arches, where the underlying architectural framework is often swamped by the abundance of plant life (*see* ARCHITECTURE, fig. 61). The scale, type and location of vegetal ornament may vary from one context to another. It may fill a huge window, dominate the dado or cover a dome; it is found in manuscript carpet pages and frontispieces. Along with geometry, it provides the basic repertory for carpet design and is equally dominant in carved ivories, pottery and metalwork.

With increasing abstraction, vegetal ornament became fantastic as botanical accuracy was left behind. Geometry is apt to take over, so that vegetal scrolls are disciplined into regular repeating or even concentric circles. Calligraphy assumes organic forms, so that the shafts of letters sprout leaves or even blossoms, as in foliated and then floriated kufic (*see* ARCHITECTURE, fig. 66). Similarly, figures of people, animals and birds often take on vegetal character (*see* ORNAMENT AND PATTERN, color pl.). And only fantasy of the most luxuriant kind can account for the vast supernal trees of Paradise. That same paradisiacal significance can often be sensed in Islamic vegetal decoration, for example in mihrabs or prayer rugs, but it is rarely made explicit. Perhaps artists used vegetal motifs to suggest in general terms the abundance of God's creation. The celebration of fertility would come naturally to people reared in a harsh desert environment; indeed, the image of an oasis is evoked in mosque courtyards with trees and a pool or fountain. A popular motif found in mosaics, silk textiles, architecture and ivories is a monumental tree flanked by animals. The context of some examples points to a close connection with the immemorially ancient theme of the Tree of Life.

VI. Geometry. Like vegetal themes, geometry pervades Islamic art at all levels. Its importance in art owes much to the Arab fascination with mathematics seen in scientific instruments and devices—celestial globes, astrolabes, automata—and in treatises on them or on the minutiae of architectural construction and decoration by Abu'l-Wafa' al-Buzajani (940–98) and Ghiyath al-Din Jamshid al-Kashi (*d.* 1429). The many Arabic scientific and mathematical terms that have found their way into English (zenith, nadir, algorithm, algebra), along with "Arabic" numerals and the very concept of zero, tell the same story. But the translation of such concepts into practice is of prime interest in the visual arts. The construction of Islamic buildings was achieved by squaring the circle, the practical equivalent of calculations involving the square root of two; measurements were achieved by means of ropes and pegs. A system of rotated squares underlies some of the most complex designs in Islamic architecture, for example MUQARNAS vaults. Much practical knowledge was

handed on verbally from master to apprentice, but simplified graphic designs served as an aide-mémoire for those with the expertise to decode them. Examples requiring such extrapolation are the rolls that contain only a fraction of the entire plan, the grids that seem to have served as a skeletal framework for the huge religious buildings erected by the Shaybanids in Central Asia, or the incised plan of a *muqarnas* vault found at Takht-i Sulayman. A grid of equilateral triangles underlies not only window grilles and mosaic floors of the Umayyad period but also mosques and madrasas of the later periods, and the importance of the diagonal as the key generative measurement has been demonstrated in Umayyad palaces and in Persian painting. Proportional relationships help to explain the innate harmony and symmetry of many Islamic buildings; the use of modular elements such as arches and windows has the same effect. And the Islamic predilection for ornament did not exclude a delight in plain statement by means of solid geometry: cubes, hemispherical domes, cylindrical minarets and conical roofs. Their bare surfaces increased the direct impact of such simple forms.

Geometry makes its principal impact in the patterned surfaces that characterize so much of Islamic art. These patterns can be finite—as in dados, doors, book covers and carpets—or infinite—as in the designs used for borders and curved spaces such as domes and many metalwork shapes. But there are no hard-and-fast distinctions governing the way these two categories operate, or their contexts. Often the framework echoes the nature of the pattern within, so that square panels encase square kufic, or stars enclose stellate designs. Geometrical ornament, like vegetal, lends itself to palimpsest compositions, notably in carpets but also in tile mosaic schemes, for example those with raised polygons. The nomenclature used for geometric patterns, whether in medieval Iraq or in modern Iran and Morocco, reveals that patterns were perceived not in terms of line but as solids. An oval, for example, was called an almond. The craftsman would thus have at his disposal a repertory of named shapes from which to create his pattern.

Geometry finds endlessly varied expression in Islamic art. A given shape, for example, can undergo successive color changes within a pattern, so that the same lines do double or triple duty simply by reappearing in different colors. Geometry can control the apparently organic exuberance of foliate ornament, as in the case of tightly coiled concentric vegetal scrolls. In the case of calligraphy, a precise set of rules based on the modular diamond shape created by a pen drawn across a surface determined the form of each individual letter. Thus at a fundamental level geometry controls the whole art of writing, although this, like many another use of geometry in Islamic art, is hidden. An instinctive feel for geometry may explain such pervasive features as balance (the preference for mirror symmetry and hierarchies), rotation and repetition. Repetition is most effective within a

geometric framework that can control and modulate monotony, infinity, rhythm, mystery and unity—to name only a few associations that it triggers. The repetition of columns and arcades in hypostyle mosques or of domes and vaults can create effects of crescendo and diminuendo, suggest unity in diversity or define a vanishing point.

Medieval Islamic literary sources do not discuss the meanings of geometry in the visual arts, but this has not dampened modern speculation about the meaning of geometry. Muslims occasionally attached symbolic value to numbers, as attested by the various systems of *abjad*, in which each letter of the alphabet was allotted a specific numerical value. And geometry was used to define the concept of the Perfect Man in the writings of the 10th-century group known as the *Ikhwān al-safā'* ("Sincere brethren"). This intriguing evidence, however, cannot begin to account for the dominant role geometry plays in Islamic art. Some expressions could be interpreted as meditations on nature—flowers, stars, crystals, snowflakes, seashells, spiders' webs—and this would be particularly apt for certain *muqarnas* vaults, carpets or Koran frontispieces. More generally, the ubiquity of geometric themes may suggest that they express the unity (Arab. *tawhīd*) that is a prime attribute of God. In Christian thought, too, geometry was an archetypal expression of God's thought, but it remains dubious whether the Muslim artist was motivated by such beliefs when he devised a geometric composition.

VII. Writing. The many references in the Koran to writing contribute to the high regard for CALLIGRAPHY embedded in Islam from the beginning, and the custom of making copies of the KORAN clinched the prestige of calligraphy in the Muslim world. Many thousands of manuscripts of the sacred text, most of them now incomplete, show that the text was copied on a much greater scale than was the Bible in the medieval West, although the reasons for this have yet to be explored in appropriate detail. The status of the Koranic scripts was enhanced by the moral dimension of calligraphy, whereby fine writing was regarded as an expression of virtue, and calligraphers copying Korans took care to put themselves in a state of ritual purity before beginning their task.

From almost the beginning of Islam, writing was a major artistic theme. COINS bore religious messages— the *basmala* (invocation), the *shahāda* (profession of faith) and quotations from the Koran. Most inscriptions in the Muslim world were written in Arabic, even when that was not the local language: the fact that the Koran was in Arabic gave that language undisputed premier status to Muslims. The longest building inscriptions (*see* ARCHITECTURE, §IX, F) are Koranic, and thus the building itself serves as the sacred book of Islam. In much the same way, minarets were apt to bear the profession of faith at their summits. Mosque domes were often inscribed on the interior with the 99 Beautiful Names of God, each in a separate cartouche and orbiting like stars in the firmament. In mystical circles, certain letters of the

alphabet were assigned special significance, notably *wāw* (which was associated with *tawḥīd*) and the *lām–alif* ligature, which was held to mirror the relationship between the soul and the Beloved. The names of God, Muhammad and 'Ali, reduced to the very limits of legibility in the highly abstracted "square kufic," were often used as a mantle over an entire building. Kufic inscriptions were used to sanctify everyday objects, often by means of the word *baraka* ("blessing"), but also by the associations that the script had with the Koran and with Koranic inscriptions, associations that lent it a proclamatory air.

In a largely illiterate society, much of the impact of calligraphy and epigraphy was symbolic. Inscriptions are frequently rendered illegible by their complex script or lofty placement. Writing could be used to connote the faith, as in the case of minarets covered with inscriptions or buildings converted to Islamic use. The stereotyped formulae on so much medieval metalwork had an all-embracing symbolic function, at once prophylactic and benedictory, and were probably understood in general terms, even by those who could not decipher them in detail. Other types of epigraphy, such as the closely serried inscriptions so popular in Mamluk art, or the numerous versions of the Ottoman Tughra, had unmistakably royal associations. The special colors used for royal names in monumental inscriptions had symbolic impact. The alphabet took on specific symbolism when *abjad* was used in poetic chronograms or combination locks. Also important are calligraphic pictures, in which letters are coaxed into the shapes of animals, birds, mosques, mihrabs, boats, faces and figures. Sometimes the letters that form the design contain a pun on what is depicted—e.g. the word *haydar* ("lion," a name of 'Ali) written in the form of a lion. Mirror images, necessarily involving writing executed back to front, are also a popular category. The entire genre had a riddling, almost perverse quality about it, inviting the viewer to uncover double meanings and hidden symbolism.

Writing was ornamented in many ways. Perhaps the commonest, so far as kufic was concerned, was for letters to acquire extra decorative devices—foliations, floriations, plaited or bifurcated shafts, rosettes etc. Almost equally popular were various kinds of distortion, whereby the calligrapher would alternate thick and thin strokes or elongate certain letters while cramming others close together. In the 12th and 13th centuries there was a short-lived vogue in inlaid metalwork for animated inscriptions, in which first the terminations of the shafts, then the shafts themselves and finally the entire inscription would be made up of human faces, then human figures and eventually animals too. Presumably the near-illegibility of such inscriptions was part of the fun. Other tricks included *boustrophedon*, in which alternate lines of text would be written directly above the previous line, but upside down; palimpsests, where as many as three inscriptions, each in a different color or hand, are superimposed on each other; inscriptions written so as to form part of larger geometric patterns or inscriptions; square kufic, in which the letters are forced into interlocking rectilinear shapes; and exercises in virtuosity, some of astounding skill. Entire chapters of the Koran are written on a leaf or even a grain of rice, or a Koran copied on such a tiny scale that it fits into a walnut shell.

A separate category, found most often in metalwork and carpets, comprises pseudo-inscriptions in which real letters formed nonsense words or sequences. Closely linked to this is "Kufesque," in which the letters not only fail to spell out rational messages but are no longer Arabic letters, even though they have a generic resemblance to them. Kufesque is typically used in a Christian rather than a Muslim context (e.g. the doors of the cathedral of Le Puy in France, the exterior brickwork of Hosios Loukas in Greece, or on textiles in paintings by Gentile da Fabriano (*c.* 1385–1427) and other late medieval Italian masters). Such "inscriptions" were prized because of their exotic aura. Many inscription bands, whether on a monumental or small scale, develop their own rhythms by means of massed uprights or descenders, by giving letters serpentine tails and by manipulating spacing.

VIII. The natural world. Nature plays a major role in Islamic art, though more as an inspiration than as a model to be carefully copied. Animals and birds are the principal focus, as shown by early carpets, pottery and stucco decoration. The popularity of the hunt as a theme for decoration ensured that the relevant animals—dog, hare, deer, lion etc.—were depicted frequently. Animals and birds were suitable for background or secondary ornament, as in the margins of illustrated books, as infill or as borders. Occasionally they are depicted with the most meticulous naturalism, as in the illustrated copies of the *Kalila and Dimna* animal fables (e.g. Istanbul, U. Lib., F. 1422).

Fantasy is more evident than realism. Egyptian woodwork and pottery from Samarra or Nishapur delight in creatures that have botanical, anthropomorphic and epigraphic elements. A deep-rooted fear of idolatry may help to explain the bizarre lengths to which metalworkers went to avoid creating readily identifiable creatures when they fashioned zoomorphic ewers or incense burners; the Pisa griffin (see fig. 1), which partakes of three distinct species as well as having its surface decorated with panels and bands of vegetal, geometric and epigraphic ornament, exemplifies this paradoxical flouting of reality. Scrolls ending in human or animal heads decorate metalwork, *doublures* and carpets. Strangest of all, though, are certain Safavid and Mughal drawings, composite images created out of a plethora of twisted, struggling individual vignettes of living beings enmeshed in the manner of the 16th-century Milanese painter Giuseppe Arcimboldo (?1527–93), and their dating suggests that they were inspired by European models. Another aspect of fantasy is the prevalence of fabulous creatures including double-headed eagles, lions with one

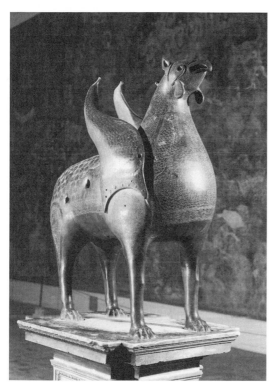

1. Bronze griffin, h. 1.07 m, from the western Mediterranean, 11th century (Pisa, Museo dell'Opera del Duomo); photo credit: Scala/Art Resource, NY

face but multiple bodies, the simurgh, winged horses, griffins, sphinxes and harpies. Exotic creatures of Far Eastern derivation—the dragon, *qilin*, unicorn and phoenix—appear in Islamic pottery, textiles and especially book painting following the Mongol invasions. Dragons also guard portals.

Greater importance is accorded to royal creatures, principally the lion, the eagle or falcon, and the elephant. All are the stock-in-trade of costly textiles, on which they are often depicted in heraldic modes in roundels, rampant, passant, regardant, addorsed or confronted or attacking weaker creatures. Lions act as pedestals for rulers, guard thrones or balustrades and decorate royal mausolea and caravanserais. Rulers such as Bahram Gur are often shown fighting and overcoming them. Eagles decorate ivories, royal buildings and city walls. The words for "lion" (Arab. *asad*, Pers. *shīr*, Turk. *arslān*) and "eagle" or "falcon" (*tughril*, *toğrul*) figure as royal cognomens or titles. Elephants are depicted carrying monarchs in battle and as chess pieces. These and other creatures often discharge a symbolic role. Examples include such popular themes as apotheosis, the lion-strangler and the peacock or "birds of paradise" that guard the entrances of sacred buildings. Research is gradually revealing the symbolic associations of creatures such as the rabbit, the cat, the camel, the cockerel and others, especially in a literary context in which they represent emotions or states of mind. The fish is

a popular theme, often representing the sea, especially in scenes where the ruler is presented as cosmocrator, but also with zodiacal or cosmological associations. In much the same way, the snake represented the earth. The bull—apart from its obvious zodiacal connections, and the lion–bull combat, an ancient Near Eastern theme of royal, apotropaic and calendrical significance—connoted ritual feasting, drinking and sacrifice and was also a symbol of strength in a Turkish milieu. Some animals took on extra importance when the Turco-Mongol animal calendar, which had close links with that of China, came into use alongside the Islamic lunar calendar.

Animals frequently served didactic purposes. The utility of the *Kitāb al-bayṭara*, a treatise on farriery, needed images of horses to accompany the text. The very title of al-Jahiz's *Kitāb al-ḥayawān* ("Book of animals"; Milan, Bib. Ambrosiana, Ar. A. F. D. 140 Inf.) explains why the text is lavishly illustrated with images of animals—stereotyped but recognizable—and often brought vividly to life by a telling detail, such as the ostrich watchfully hatching her eggs. Arabic and Persian books on the usefulness of animals have illustrations depicting animals in their medicinal and pharmacological contexts. Al-Sufi's treatise on the fixed stars includes depictions of animals alongside humans under the appropriate constellation. Animals are a central theme in the principal medieval Islamic encyclopedia of the natural world, al-Qazwini's *'Ajā'ib al-makhlūqāt* ("Wonders of creation"), which exists in many copies, some with hundreds of illustrations.

Landscape was the other major theme from the natural world. It can be found in many media, but its fullest development was reserved for book painting, especially in Iran. It occasionally takes center stage as a theme, although it mostly provides a background for the ostensible action. Such landscapes were composed by combining a limited number of components, though these are capable of almost infinite variation in color, tone, size, shape and texture. Rocks are a case in point; in some manuscripts they are treated with Baroque technicolor exuberance, a visual feast in their own right while also serving as a subtle commentary on the action. Many representational conventions, for example those governing fire, smoke, dust and clouds, derived from Chinese prototypes. China also provided, perhaps via woodblock maps, the conventions for water, whether still or in spate, clumps of grass, rocks, mountains, multiple receding planes and trees. Painters often misunderstood the subtleties of these conventions and used them carelessly or with unbecoming brashness. The decorative potential of such landscape symbols became paramount, and their capacity to suggest endless space was destroyed by substituting sharp for blurred outlines and bright colors for the original monochrome. Painters used landscape not as a bearer of meaning, nor as an objective correlative to the themes of the poetry that accompanied it in its original Chinese setting, but as a gorgeous backdrop to the action. For a time, especially when the influence

of Chinese art was at its height, landscape played a decisive part in the creation of mood, thereby deepening and enriching the meaning of the painting (*see* ILLUSTRATION, fig. 11). Later 14th-century painters simplified, toned down and tamed such expressionist landscapes (e.g. ILLUSTRATION, fig. 12). To the extent that the Persian text was hyperbolic, the landscape was its appropriate equivalent, but its role was reduced and less profound than it had been in Chinese painting.

IX. Magic. Apotropaic images were common. City or citadel gates bear depictions of dragons (*see* ARCHITECTURE, fig. 62), serpents, lions and other fearsome beasts; doorknockers feature lions or intertwined serpents, the latter providing doubly effective protection because knots were widely held to have magical efficacy. Doors might bear serpents and, more frequently, knotted designs. Frontispieces and finispieces to books sometimes had images of apotropaic intent; so too did *ex libris* compositions. Knotted devices occur frequently in Islamic pottery, but their meaning is still unexplained, as are those attached to certain types of star (e.g. the hexagram, Solomon's seal). Thresholds were apt places for knotted motifs and for spolia; the message here was one of perpetual victory. In the Umayyad mosque of Damascus, a gold vine (perhaps knotted), the *karma*, marked—and protected—the perimeter of the mosque. When going into battle, Ottoman sultans wore talismanic shirts over their armor; these bore lengthy religious inscriptions, mainly from the Koran. Apotropaic powers were attributed to certain automata, for instance the roaring lions that guarded caliphal thrones or the rider placed above the palace at Baghdad; his lance was popularly held to point in the direction from which the city was threatened. Similarly, the winged female figures that flank figures of authority in the frontispieces of medieval Mesopotamian book painting probably have a protective function—hence the way they look alertly to the left and right of the figure they flank like bodyguards.

Talismanic images are closely related to apotropaic ones and often reflect folk beliefs, for example the *panjah* or *khams*, the "Hand of Fatima." People wore amulets with inscriptions that were held to bring good luck, and many vehicles in Afghanistan and Pakistan, for example, still bear inscriptions reading *mashallah* ("What God wills"). Divination bowls have detailed inscriptions invoking blessings and curses in specific circumstances (see fig. 2), and mirrors were also used for divination, to judge from the invocatory and magical inscriptions on their reverse sides. The medieval equivalent of registered post was to inscribe an object with the word *budūh*, the *abjad* value of whose letters (2:4:6:8) was held to give a greater degree of security. Muslims attributed talismanic powers to celadon, for it was believed to crack if poison were put into it. Large unglazed water jars bear reliefs perpetuating ancient Mesopotamian iconography, whose talismanic power had apparently survived the coming of Islam. Illustrated texts such as the *Fālnāma* ("Book of divination") detail magical episodes and practices involving talismans.

Mythical beasts often have something magical about them. Griffins transport Alexander the Great into the empyrean, and Pegasus appears on silks and in manuscripts. A weird array of mythical creatures, deriving partly from Chinese sources but largely from a shamanistic milieu, can be found in the corpus of paintings associated with SIYAH QALAM. Some are creatures of nightmare, having human form but with the heads and appendages of demons, equipped with ravening fangs and claws.

The Islamic world, like the medieval West, tended to place marvels in the East. Thus al-Wasiti, the painter of the Schefer *Maqāmāt* ("Assemblies"; 1237; Paris, Bib. N., MS. arabe 5847), depicted sphinxes and harpies in the wondrous Eastern Isles, where marvels such as the talking or *waqwaq* tree abound. The text and hence the illustrations of al-Qazwini's cosmology teem with outrageous hybrid creatures. Another fruitful source of marvels was poetry, especially in Iran: the bestial tribes of Gog and Magog, Amazons and lion-men, the quest for the Water of Life, the impious ascension of Kay Ka'us into the heavens, such monsters as dragons, lion-apes, unicorns, horned wolves or the Great Worm of Kirman, kings with snakes sprouting from their shoulders, stone warriors, witches and warlocks, demons, fairies and sirens—artists were spoilt for choice. But these texts also struck a more elevated chord as treasure-houses of myth, interpreting the past in heroic terms and providing models for conduct as well as material for entertainment. Hence the emphasis was on the great kings and heroes of Iranian legend—Gayumars, Tahmuras, Jamshid, Kaykhusraw and Faridun, Zal, Suhrab and Rustam—and actual historical figures too, such as Iskandar (Alexander the Great) and the Sasanian monarchs. History and myth mingle, and facts are mythologized (e.g. the Khusraw and Shirin story). Finally, outright thaumaturgy is occasionally depicted. The principal figure here is Solomon; references to him as a wonder-worker, lord of the *jinn*s and master of the speech of animals and birds, are widespread. The popularity of the *Qiṣāṣ al-anbiyāʾ* helped to spread this iconography and embraced the miracles of the other prophets too, for example Moses, besides influencing the detailed cycle of the life of the Prophet.

X. Heavenly bodies. For Muslims the lore of the stars embraced astronomy and astrology and was of absorbing interest because the heavenly bodies were widely believed to affect human life. Hence the widespread use of zodiacal imagery in Islamic art. Solar references are particularly numerous and build on foundations laid in the Classical world (e.g. the nimbus) and in the Ancient Near East (e.g. the rosette). The lion is the creature with solar associations *par excellence*, through the zodiacal sign of Leo (often shown overcoming Taurus, the bull), and since the lion was also a popular symbol for the monarch, rulers could also lay claim to solar associations, as in the

Fountain of the Lions in the Alhambra (for illustration *see* FOUNTAIN). The connection is plainest in the Iranian royal emblem of the lion and sun, whose origins date to Parthian times, though the motif seems to have attained popularity only in the 13th century. Thereafter it was commonly encountered in coins, pottery, architecture and even—in the 19th century—postage stamps and banknotes. Eagles too could embody solar references. More abstract expressions of the solar theme occur in unmistakably royal contexts, such as the rayed vaulting and mosaics and numerous rosettes at KHIRBAT AL-MAFJAR or the rayed vault mosaics at the Great Mosque of Córdoba (*see* CÓRDOBA, §III, A). The interiors of domes often display radiating designs, which are replicated on a smaller scale in the *shamsa* motifs in manuscripts. But domes, which by ancient tradition were equated with the vault of heaven—hence the description of so many early Islamic domes as *qubbat al-khaḍrāʾ* ("dome of the sky")—could have an oculus or star-shaped opening to link with the sky. The poetic quotations on bowls show that they were widely understood to parallel the dome of Heaven. The radiating theme also found expression in epigraphy, especially in the Mamluk period, when radiating inscriptions, with the shafts mimicking the rays of the sun, were popular. The solar parallel was emphasized by the use of gold inlay. The image of rotation, once again with heavenly associations, was taken up by sphinxes processing in a circle and by the fishpond theme. Textiles employ a wide range of heavenly images, but the sun is paramount in most of them (*see* CARPETS AND FLATWEAVES, color pl).

The moon had only peripheral importance in Islamic iconography. Lunar eclipses are alluded to in painting and metalwork, and the lunar crescent, which appeared in the Umayyad period, became a major astrological theme on 12th- and 13th-century Mesopotamian coins. Only thereafter did the crescent, often in association with a star, become a symbol of the Islamic faith itself, but the evolution of the process remains obscure. The most obvious example of lunar imagery in Islamic art is the Aqmar Mosque in Cairo (*see* ARCHITECTURE, fig. 19); its name ("moonlit") proclaims the connection, and its façade is festooned with radiating epigraphic and Shiʿite images, linking lunar and religious themes.

Solar and lunar references are merely facets of the broader category of ʿilm al-nujūm, star lore. Knowledge of this branch of science was expected of any educated Muslim, and this may explain the frequency of celestial references in Islamic art. The planets—which in Muslim belief included the sun and moon—and their symbols are the stock-in-trade of hundreds of medieval metalwares and, to a lesser extent, pottery. The so-called planet children, too, are a familiar theme in metalwork and manuscripts right up to Ottoman times. The role of astrology in Islamic art is still unclear, even in familiar stories such as Nizami's *Haft paykar* ("Seven portraits"), one of the most popular cycles in Iranian painting, which is shot through with astrological references. The zodiac infiltrates the

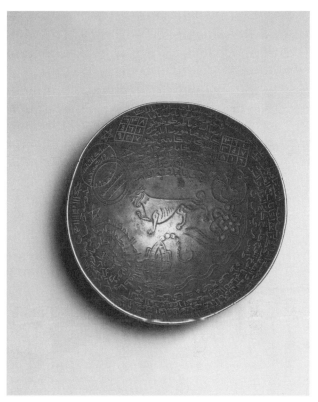

2. Divination bowl with magical inscriptions, from Syria or Jazira, 13th century (Berlin, Museum für Islamische Kunst); photo credit: Bildarchiv Preussischer Kulturbesitz/Art Resource, NY

Turco-Mongol animal calendar, religious imagery, city and bazaar gates, bridges, coinage, manuscripts and above all metalwork, where the popularity of zodiacal themes may have had something to do with the choice of metals used in these objects—though why metalwork in particular featured astrological images remains an open question.

Light is a more pervasive theme. Frequent use is made of the celebrated Sura of Light in the Koran (chapter 24), especially verse 35, a favorite inscription for mihrabs since it is often understood to refer to a lamp in a niche; many mihrabs contain depictions of hanging lamps. Minbars are often inscribed with the following verse so that they are thematically linked with the mihrab; indeed they often bear other references to light, for example stellar polygons (*see* MINBAR, color pl. 2:XVI, fig. 3), stars or God's name, executed in ivory or bone and therefore standing out as if highlighted from the predominantly dark background of the minbar. Lamps make the same obvious pun by bearing all or part of Sura 24:35, as well as rosettes and similar solar motifs. Since they tend to be made of glass or of pierced metal, the letters of the inscriptions stand out like neon signs when the lamp is lit. The transparency of windows is used to the same effect, with pierced grilles, lunettes and spoolwork creating patterns of light, while in the case of stained glass (*see* ARCHITECTURE, §IX, B) polychromy

is added. MUQARNAS vaults become metaphors for light in that they mimic the rotating heavens, with expert fenestration creating shafts of light that seem to shoot downwards in several directions. Inscriptions link these ceilings with the Milky Way and the Pleiades, thus proving that the cosmic implications of these light effects were deliberate. The same is true of entire palaces conceived as receptacles of light with alabaster ceilings and glass walls. Some palaces with these features were intended to emulate the legendary palaces of Ghumdan, Sadir and Khwarnaq in pre-Islamic Arabia. The MINARET, which is etymologically linked to notions of fire and/or light, served as a vehicle for actual and spiritual illumination. Minarets were illumined on special occasions (even today they bear neon religious inscriptions) and were used as lighthouses for ships or nocturnal caravans.

Haloes of various kinds—circular, rayed and flame or mandorla—are encountered in Islamic painting. Billowing clouds around inscriptions in manuscripts may be intended to sanctify them and thus act as yet another kind of halo. Various types of metalwork, too, exploited the multiple associations of light, for example by allegorical inscriptions of Sufi intent: candlesticks, incense burners, torchstands, candelabra and polykandela. Finally, many titles used by Muslim potentates employ the concept of light: sun (*shams*), moon (*qamr, badr*), light (*nūr*), star (*najm*), celestial sphere (*falak*) and lamp (*sirāj*), in such combinations as "Light of Religion" (*nūr al-dīn*) or "Sun of the State" (*shams al-dawla*). Thus the powerful implications of light in a moral and religious context would be made to serve political ends.

GENERAL

E. Herzfeld: "Die Genesis der islamischen Kunst und das Mshatta-Prolem," *Der Islam*, i (1910), pp. 27–63

R. Ettinghausen: "Interaction and Integration in Islamic Art," *Unity and Variety in Muslim Civilization*, ed. G. von Grunebaum (Chicago, 1955), pp. 107–31

F. Rosenthal: *Four Essays on Art and Literature in Islam* (Leiden, 1971)

O. Grabar: *The Formation of Islamic Art* (New Haven, 1973/*R* and enlarged 1987)

R. Ettinghausen: "The Man-made Setting: Islamic Art and Architecture," *Islam and the Arab World*, ed. B. Lewis (London, 1976), pp. 57–88

R. Ettinghausen: "Originality and Conformity in Islamic Art," *Individualism and Conformity in Classical Islam*, ed. A. Banani and S. Vyronis jr (Wiesbaden, 1977), pp. 83–114

T. Allen: *Five Essays on Islamic Art* (Sebastopol, CA, 1988)

J. M. Bloom: *Minaret: Symbol of Islam,* Oxford Studies in Islamic Art, 7 (Oxford, 1989)

Image and Meaning in Islamic Art: Selected Papers from a Symposium on Islamic Iconography Held in Edinburgh on Oct. 26–27, 1990

O. Grabar: *Mediation of Ornament* (Princeton, 1992)

B. Finster, C. Fragner, and H. Hafenrichter, eds.: *Bamberger Symposium: Rezeption in der islamischen Kunst vom 26.6.–28.6.1992,* Beiruter Texte und Studien, 61 (Beirut, 1999)

R. Hillenbrand: "Richard Ettinghausen and the Iconography of Islamic Art," *Discovering Islamic Art: Scholars, Collectors*

and Collections, 1850–1950, ed. S. Vernoit (London, 2000), pp. 171–81

W. Ball and L. Harrow, eds.: *Cairo to Kabul: Afghan and Islamic Studies Presented to Ralph Pinder-Wilson* (London, 2002)

B. Heyberger and S. Naef, eds.: *La multiplication des images en pays d'Islam: De l'estampe à la télévision (17e–21e siècle),* Istanbuler Texte und Studien, 2 (Würzburg, 2003)

B. O'Kane, ed.: *The Iconography of Islamic Art: Studies in Honour of Robert Hillenbrand* (Edinburgh, 2005)

P. L. Baker and B. Brend, eds.: *Sifting Sands, Reading Signs: Studies in Honour of Professor Géza Fehévári* (London, 2006)

E. J. Whelan: *The Public Figure: Political Iconography in Medieval Mesopotamia* (London, 2006)

Cosmophilia: Islamic Art from the David Collection, Copenhagen (exh. cat. by S. S. Blair and J. M. Bloom; Chestnut Hill, MA, Boston Coll., McMullen Mus.; Chicago, U. Chicago, IL, Smart Mus. A.; 2006–7)

RELIGIOUS AND ROYAL

Enc. Islam/2: "Hilāl" [Crescent]; "Rank" [Emblem]

L. A. Mayer: *Saracenic Heraldry* (Oxford, 1933)

R. Ettinghausen: "Die bildliche Darstellung der Ka'ba im islamischen Kulturkreis," *Z. Dt. Mrgländ. Ges.,* n. s. xii (1934), pp. 111–37

J. Sauvaget: *La Mosquée omeyyade de Médine* (Paris, 1947)

R. Ettinghausen: "Persian Ascension Miniatures of the Fourteenth Century," *Accademia nazionale dei lincei, atti del XII convegno "volta" promosso dalla classe di scienze morali, storiche e filologiche, tema: Oriente e occidente nel medioevo*: *Roma*, 1957, pp. 360–83

W. Hartner and R. Ettinghausen: "The Conquering Lion: The Life-cycle of a Symbol," *Oriens*, xvii (1964), pp. 161–71

J. Sourdel-Thomine: "Clefs et serrures de la Ka'ba: Notes d'épigraphie arabe," *Rev. Etud. Islam.*, xxxix (1971), pp. 29–86

R. Ettinghausen: *From Byzantium to Sasanian Iran and the Islamic World* (Leiden, 1972)

D. Shepherd: "Banquet and Hunt in Medieval Islamic Iconography," *Gathering in Honor of Dorothy E. Miner*, ed. U. E. McCracken (Baltimore, 1974), pp. 79–92

D. E. Klimburg-Salter: "A Sufi Theme in Persian Painting," *Kst Orients*, xi (1977), pp. 43–84

R. Milstein: "Sufi Elements in Late Fifteenth Century Herāt Painting," *Studies in Memory of Gaston Wiet*, ed. M. Rosen-Ayalon (Jerusalem, 1977), pp. 357–70

E. Baer: "The Ruler in Cosmic Setting: A Note on Medieval Islamic Iconography," *Essays in Islamic Art and Architecture in Honor of Katharina Otto-Dorn*, ed. A. Daneshvari (Malibu, 1981), pp. 13–20

R. Etitnghausen: *Islamic Art and Archaeology: Collected Papers,* ed. M. Rosen-Ayalon (Berlin, 1984)

C. Williams: "The Cult of 'Alid Saints in the Fatimid Monuments of Cairo," *Muqarnas*, i (1983), pp. 37–52; iii (1985), pp. 39–60

A. Daneshvari: *Medieval Tomb Towers of Iran: An Iconographical Study* (Lexington, KY, 1986)

M. V. Fontana: *La Leggenda di Bahrām Gūr e Āzāda: Materiale per la storie di una tipologia figurative dale origini al XIV secolo* (Naples, 1986)

K. Brisch: "Observations on the Iconography of the Mosaics in the Great Mosque of Damascus," *Content and Context of*

Visual Arts in the Islamic World, ed. P. P. Soucek (University Park, PA, and London, 1988), pp. 13–24

E. Whelan: "Representations of the *Khāssakīyah* and the Origins of Mamluk Emblems," *Content and Context of Visual Arts in the Islamic World*, ed. P. P. Soucek (University Park, PA, and London, 1988), pp. 219–53

E. Baer: *Ayyubid Metalwork with Christian Images* (Leiden, 1989)

Images of Paradise in Islamic Art (exh. cat., ed. S. S. Blair and J. M. Bloom; Hanover, NH, Dartmouth Coll., Hood Mus. A.; New York, Asia Soc. Gals.; Brunswick, ME, Bowdoin Coll. Mus. A.; and elsewhere; 1991–2)

A. Orient., xxiii (1993) [whole issue devoted to Islamic palaces]

M. V. Fontana: *Iconografia dell'Ahl al-Bayt: Immagini di arte persiana dal XII al XX secolo, AION,* liv, suppl. 78 (Naples, 1994)

R. Hillenbrand: *Islamic Architecture: Form, Function and Meaning* (Edinburgh, 1994)

T. Allen: *Imagining Paradise in Islamic Art* (Sebastopol, CA, 1995)

J. Scarce: "Yusuf and Zulaika: Tilework Images of Passion," *Islamic Art in the Ashmolean Museum*, ed. J. Allen, Oxford Studies in Islamic Art, 10 (Oxford, 1995), pt. 2, pp. 63–84

R. Hillenbrand: "The Iconography of the Shāh-nāma-yi Shāhī," *Safavid Persia: The History and Politics of an Islamic Society*, ed. C. Melville, Pembroke Persian Papers, 4 (London, 1996), pp. 53–78

I. Demant Mortensen: "Nomad Iconography on Tombstones from Luristan, Iran," *Dance, Music, Art, and Religion: Based on Papers Read at the Symposium on Dance, Music, and Art in Religions Held at Åbo, Finland ... 1994*, ed. T. Ahlbäck, Scripta Instituti Donneriani Aboensis, 16 (Stockholm, 1996), pp. 219–27

R. Shani: *A Monumental Manifestation of the Shīʿite Faith in late Twelfth-Century Iran: The Case of the Ganbad-I ʿAlawiyān, Hamadān,* Oxford Studies in Islamic Art, 11 (Oxford, 1996)

E. Baer: "Female Images in Early Islam," *Damas. Mitt.,* xi (1999), pp. 13–24

E. Baer: "The Human Figure in Early Islamic Art: Some Preliminary Remarks," *Muqarnas*, xvi (1999), pp. 32–41

E. Koch: "The Just Hunter: Renaissance Calendar Illustrations and the Representation of the Mughal Hunt," *Islam and the Italian Renaissance*, ed. C. Burnett and A. Contadini, Warburg Institute Colloquia, 5 (London, 1999), pp. 167–83

R. Milstein: "The Iconography and the Ideological Program," *Stories of the Prophets: Illustrated Manuscripts of Qiṣaṣ al-Anbiyāʾ*, Islamic Art and Architecture, 8 (Costa Mesa, 1999), pp. 25–40

L. Treadwell: "The 'Orans' Drachms of Bishr ibn Marwān and the Figural Coinage of the Early Marwanid Period," *Bayt al-Maqdis: Jerusalem and Early Islam*, ed. J. Johns, Oxford Studies in Islamic Art, ix/2 (Oxford, 1999), pp. 223–69

R. Hillenbrand, ed.: *Persian Painting, from the Mongols to the Qajars: Studies in Honour of Basil W. Robinson*, Pembroke Persian Papers, 3 (London, 2000)

O. Pancaroğlu: "Socializing Medicine: Illustrations of the Kitāb al-diryāq," *Muqarnas,* xviii (2001), pp. 155–72

G. C. Miles: "Miḥrāb and ʿAnazah: A Study in Islamic Iconography," *Early Islamic Art and Architecture*, ed. J. M. Bloom, The Formation of the Classical Islamic World, 23 (Aldershot, 2002), pp. 149–65

E. Sims: *Peerless Images: Persian Painting and its Sources* (London, 2002)

K. Rizvi: "Religious Icon and National Symbol: The Tomb of Ayatollah Khomeini in Iran," *Muqarnas,* xx (2003), pp. 209–24

E. Baer: *The Human Figure in Islamic Art: Inheritances and Islamic Transformations* (Costa Mesa, 2004)

M. Barry: *Figurative Art in Medieval Islam and the Riddle of Bihzâd of Herât (1465–1535)* (Paris, 2004)

R. Hillenbrand, ed.: *The Visual Language of the Persian Book of Kings,* Varie Occasional Papers, 2 (Aldershot, 2004)

R. Milstein: *La Bible dans l'art islamique* (Paris, 2005)

NATURE, LANDSCAPE AND ANIMALS

A. Riegl: *Stilfragen* (Berlin, 1893); Eng. trans. by E. Kain as *Problems of Style* (Princeton, 1992)

E. Kühnel: *Die Arabeske* (Wiesbaden, 1949); Eng. trans. by R. Ettinghausen as *The Arabesque: Meaning and Transformation of an Ornament* (Graz, 1976)

R. Ettinghausen: *Studies in Muslim Iconography I: The Unicorn* (Washington, DC, 1950)

R. Ettinghausen: "Early Realism in Islamic Art," *Studi orientalistici in onore di Giorgio Levi della Vida* (Rome, 1956), i, pp. 250–73

E. Baer: *Sphinxes and Harpies in Medieval Islamic Art* (Jerusalem, 1965)

R. Ettinghausen: "The Dance with Zoomorphic Masks and Other Forms of Entertainment Seen in Islamic Art," *Arabic and Islamic Studies in Honor of Hamilton A. R. Gibb*, ed. G. Makdisi (Leiden, 1965), pp. 211–24

E. Baer: "Fish-pond Ornaments on Persian and Mamluk Metal Vessels," *Bull. SOAS*, xxxi (1968), pp. 14–27

G. Azarpay: "The Eclipse Dragon on an Arabic Frontispiece Miniature," *J. Amer. Orient. Soc.*, xcviii (1977–8), pp. 363–74

B. Brend: "Rocks in Persian Miniature Painting," *Landscape Style in Asia*, ed. W. Watson, Colloq. A. & Archaeol. Asia, ix (London, 1979), pp. 111–37

P. P. Soucek: "The Role of Landscape in Iranian Painting to the 15th Century," *Landscape Style in Asia*, ed. W. Watson, Colloq. A. & Archaeol. Asia, ix (London, 1979), pp. 86–110

J. Rawson: *Chinese Ornament: The Lotus and the Dragon* (London, 1984)

A. Daneshvari: *Animal Symbolism in Warqa wa Gulsha* (Oxford, 1986)

J. S. Cowen: *Kalila wa Dimna: An Animal Allegory of the Mongol Court: The Istanbul University Album* (New York, 1989)

R. Hillenbrand: "Mamlūk and Īlkhānid Bestiaries: Convention and Experiment," *A. Orient.*, xx (1990), pp. 149–87

E. J. Grube: "Prolegomena for a Corpus Publication of Illustrated Kalīlah wa Dimnah Manuscripts," *Islam. A.*, iii (1990–91), pp. 301–481

B. O'Kane: "Rock Faces and Rock Figures in Persian Painting," *Islam. A.*, iv (1990–91), pp. 219–46

L. Golombek: "The *Paysage* as Funerary Imagery in the Timurid Period," *Muqarnas*, x (1993), pp. 241–52

Y. Özbek: "The Peacock Figure and its Iconography in Medieval Anatolian Turkish Art," *Art turc/Turkish Art, 10th International Congress of Turkish Art, 17–23 September 1995: Geneva*, pp. 537–46

L. S. Diba: "The Rose and the Nightingale in Persian Art," *A. Asia,* xxvi/6 (1996), pp. 100–12

A. S. Melikian-Chirvani: "The Iranian Wine Horn from Pre-Achaemenid Antiquity to the Safavid Age," *Bull. Asia Inst.*, n. s. x (1996), pp. 85–139

S. Carboni: *Following the Stars: Images of the Zodiac in Islamic Art* (New York, 1997)

M. V. Fontana: "A Blue-and-white Timurid Jug with Two Confronting Dragons," *Orient. Mod.*, xv/76 (1997), pp. 587–600

E. J. Grube: "Notes on the Decorative Arts of the Timurid Period. III: On a Type of Timurid Pottery Design: The Flying-bird-pattern," *Orient. Mod.*, xv/76 (1997), pp. 601–9

R. Nath: *Mughal Sculpture: Study of Stone Sculptures of Birds, Beasts, Mythical Animals, Human Beings, and Deities in Mughal Architecture* (Delhi, 1997)

A. Khatchatrian: "Towards the Interpretation of Eagle Relief Carvings on Seljuq and Armenian Monuments," *Iran & Caucasus*, ii (1998), pp. 25–38

K. Otto-Dorn: "Das Drachenrelief vom Talismantor in Baghdad," *Light on Top of the Black Hill: Studies Presented to Halet Çambel*, ed. G. Arsebük, M. J. Mellink, and W. Schirmer (Istanbul, 1998), pp. 531–42

Y. Kadoi: "Cloud Patterns: The Exchange of Ideas between China and Iran under the Mongols," *Orient. A.*, xlviii/2 (2002), pp. 25–36

A. Contadini: "A Bestiary Tale: Text and Image of the Unicorn in the Kitāb naʿt al-ḥayawān (British Library Or. 2784)," *Muqarnas*, xx (2003), pp. 17–33

F. W. Bunce: *Islamic Tombs in India: The Iconography and Genesis of their Design* (Delhi, 2004)

M. Guardia: "A propos de la cuve de Xàtiva: Un exemple de synthèse des substrats classique et Islamique," *Cah. St-Michel de Cuxa*, xxxv (2004), pp. 95–113

L. J. Oh: "Islamicised Pseudo-Buddhist Iconography in Ilkhanid Royal Manuscripts," *Persica*, xx (2004), pp. 91–154

O. Pancaroğlu: "The Itinerant Dragon-slayer: Forging Paths of Image and Identity in Medieval Anatolia," *Gesta*, xliii/2 (2004), pp. 151–64

GEOMETRY AND SECULAR THEMES

R. Ettinghausen: "The Bobrinski Kettle: Patron and Style of an Islamic Bronze," *Gaz. B.-A.*, xxiv (1943), pp. 193–208

D. S. Rice: "The Seasons and the Labors of the Months in Islamic Art," *A. Orient.*, i (1954), pp. 1–39

O. Grabar: "Imperial and Urban Art in Islam: The Subject Matter of Fāṭimid Art," *Colloque international sur l'histoire du Caire: Caire, 1969*, pp. 173–89

O. Grabar: "The Illustrated Maqāmāt of the Thirteenth Century: The Bourgeoisie and the Arts," *The Islamic City*, ed. A. Hourani and S. M. Stern (Oxford, 1970), pp. 207–22

E. Baer: "The 'Pila' of Játiva: A Document of Secular Urban Art in Western Islam," *Kst Orients*, vii (1970–71), pp. 144–66

C. Adle: "Recherches sur le module et le tracé correcteur dans la miniature orientale," *Monde Iran. & Islam*, iii (1975), pp. 81–105

P. Soucek: "An Illustrated Manuscript of al-Biruni's *Chronology of Ancient Nations*," *The Scholar and the Saint*, ed. P. Chelkowski (New York, 1975), pp. 103–65

K. Critchlow: *Islamic Patterns* (London, 1976)

U. Harb: *Ilkhanidische Stalaktitengewölbe: Beiträge zu Entwurf und Bautechnik* (Berlin, 1978)

R. Ettinghausen: "The Taming of the Horror Vacui in Islamic Art," *Proc. Amer. Philos. Soc.*, cxxiii (1979), pp. 15–28

A. Paccard: *Le Maroc et l'artisanat traditionnel islamique dans l'architecture*, 2 vols. (Saint-Jorioz, 1979)

L. Golombek: "The Draped Universe of Islam," *Content and Context of Visual Arts in the Islamic World*, ed. P. P. Soucek (University Park, PA, and London, 1988), pp. 25–50

S. Carboni: "The London Qazwīnī: An Early 14th-century Copy of the *Ajāʾib al-Makhlūqāt*," *Islam. A.*, iii (1988–9), pp. 15–32

E. Baer: "Jeweled Ceramics from Medieval Islam: A Note on the Ambiguity of Islamic Ornament," *Muqarnas*, vi (1989), pp. 83–97

G. Necipoğlu: "Geometric Design in Timurid/Turkmen Architectural Practice: Thoughts on a Recently Discovered Scroll and its Late Gothic Parallels," *Timurid Art and Culture: Iran and Central Asia in the Fifteenth Century*, ed. L. Golombek and M. Subtelny (Leiden, 1992), pp. 48–66

I. el-Said: *Islamic Art and Architecture: The System of Geometric Design*, ed. T. el-Bouri and K. Critchlow (Reading, 1993)

G. Necipoğlu: *The Topkapı Scroll: Geometry and Ornament in Islamic Architecture: Topkapı Palace Museum Library MS H. 1956* (Malibu, 1995)

J. M. Rogers: "Ornament Prints, Patterns and Designs East and West," *Islam and the Italian Renaissance*, ed. C. Burnett and Contadini, Warburg Institute Colloquia, (London, 1999), pp. 133–65

WRITINGS

D. S. Rice: *The Unique Ibn al-Bawwab Manuscript in the Chester Beatty Library* (Dublin, 1955)

L. Volov [Golombek]: "Plaited Kufic on Samanid Epigraphic Pottery," *A. Orient.*, vi (1966), pp. 107–33

A. Schimmel: *Islamic Calligraphy* (Leiden, 1970)

R. Ettinghausen: "Arabic Epigraphy: Communication or Symbolic Affirmation," *Near Eastern Numismatics … Studies in Honor of G. C. Miles*, ed. D. Kouymjian (Beirut, 1974), pp. 297–317

R. Ettinghausen: "Kufesque in Byzantine Greece, the Latin West and the Muslim World," *A Colloquium in Memory of G. C. Miles, 1904–1975* (New York, 1976), pp. 28–47

E. C. Dodd and S. Khairallah: *The Image of the Word*, 2 vols. (Beirut, 1981)

A. Schimmel: *Calligraphy and Islamic Culture* (New York, 1984)

S. Auld: "Kuficising Inscriptions in the Work of Gentile da Fabriano," *Orient. A.*, n. s., xxxii (1986), pp. 246–65

R. Hillenbrand: "Qur'anic Epigraphy in Medieval Islamic Architecture," *Rev. Etud. Islam.*, xiv (1986), pp. 173–90

D. James: *Qurʾāns of the Mamluks* (London, 1988)

S. S. Blair: *The Monumental Inscriptions of Early Islamic Iran and Transoxiana* (Leiden, 1992)

A. Khatibi and M. Sijelmassi: *The Splendour of Islamic Calligraphy* (New York, 1996)

I. Bierman: *Writing Signs: The Fatimid Public Text* (Berkeley, 1998)

S. S. Blair: *Islamic Inscriptions* (Edinburgh, 1998)

Mightier than the Sword: Arabic Script: Beauty and Meaning (exh. cat. by V. Porter and H. B. Barakat; Kuala Lumpur, Islam. A. Mus., 2004)

S. S. Blair: *Islamic Calligraphy* (Edinburgh, 2006)

Word into Art: Artists of the Modern Middle East (exh. cat. by V. Porter; London, BM, 2006)

MAGIC AND HEAVENLY BODIES

W. Hartner: "The Pseudoplanetary Nodes of the Moon's Orbit in Hindu and Islamic Iconographies," *A. Islam*, v (1938), pp. 113–54

D. S. Rice: *The Wade Cup in the Cleveland Museum of Art* (Paris, 1955)

R. Ettinghausen: "The 'Wade Cup' in the Cleveland Museum of Art: Its Origins and Decorations," *A. Orient.*, ii (1957), pp. 327–66

W. Hartner: "Zur astrologischen Symbolik des 'Wade Cup,'" *Aus der Welt der islamischen Kunst: Festschrift für Ernst Kühnel* (Berlin, 1959), pp. 234–43

E. Wellesz: "An Early Al-Ṣūfī Manuscript in the Bodleian Library in Oxford," *A. Orient.*, iii (1959), pp. 1–26

E. Baer: "Representations of 'Planet-children' in Turkish Manuscripts," *Bull. SOAS*, xxxi (1968), pp. 526–33

W. Hartner: "The Vaso Vescovali in the British Museum: A Study in Islamic Astrological Iconography," *Kst Orients*, ix (1973–4), pp. 99–130

R. Ettinghausen: "Abrī Painting," *Studies in Memory of Gaston Wiet*, ed. M. Rosen-Ayalon (Jerusalem, 1977), pp. 345–56

J. W. Allan: *Islamic Metalwork: The Nuhad Es-Said Collection* (London, 1982)

R. Hillenbrand: "The Symbolism of the Rayed Nimbus in Early Islamic Art," *Cosmos*, ii (1986), pp. 1–52

R. Milstein: "Light, Fire and the Sun in Islamic Painting," *Studies in Islamic History and Civilization in Honour of Professor David Ayalon*, ed. M. Sharon (Jerusalem, 1986), pp. 533–52

A. S. Melikian-Chirvani: "The Lights of Sufi Shrines," *Islam. A.*, ii (1987), pp. 117–36

J. C. Bürgel: *The Feather of the Simurgh: The "Licit Magic" of the Arts in Medieval Islam* (New York, 1988)

D. Behrens-Abouseif: "The Façade of the Aqmar Mosque in the Context of Fatimid Ceremonial," *Muqarnas*, ix (1992), pp. 29–38

N. N. N. Khoury: "The Mihrab Image: Commemorative Themes in Medieval Islamic Architecture," *Muqarnas*, ix (1992), pp. 11–28

J. M. Bloom: "The Qubbat al-Khaḍrā' in Early Islamic Palaces," *A. Orient.*, xxiii (1994), pp. 131–7

P. P. Soucek: "Solomon's Throne/Solomon's Bath: Model or Metaphor?," *A. Orient.*, xxiii (1994), pp. 109–34

A. Caiozzo: "Quatre signes d'un zodiaque caché: Les porteurs du trône divin dans les cosmographies en arabe et en persan d'époque médiévale," *An. Islam.*, xxxiii (1999), pp. 1–29

A. Malecka: "Solar Symbolism of the Mughal Thrones: A Preliminary Note," *A. Asiatiques*, liv (1999), pp. 24–32

A. Caiozzo: "Les talismans des planètes dans les cosmographies en persan d'époque médievale," *Der Islam*, lxxii/2 (2000), pp. 221–62

L'Etrange et le Merveillleux en terres d'Islam (exh. cat., Paris, Louvre, 2001)

J. W. Allan: "'My Father is a Sun, and I am the Star': Fatimid Symbols in Ayyubid and Mamluk Metalwork," *J. David Col.*, i (2003), pp. 25–48

Sudan, Democratic Republic of the [Arab. Al-Jamhuryat es-Sudan Al-Democratica]. Country in northeast Africa bordered by Libya and Egypt to the north, by the Red Sea and Ethiopia to the east, by Kenya, Uganda and the Democratic Republic of Congo (formerly Zaïre) to the south and by the Central African Republic and Chad to the west (*see* Africa, fig. 1). The capital is Khartoum.

I. Geography and cultural history. II. Continuing traditions. III. Architecture. IV. Painting, graphic arts and sculpture. V. Patronage and art institutions.

I. Geography and cultural history. Sudan has a uniform relief, most of its 2,505,913 sq. km lying 1000 m below sea level. The terrain ranges from desert in the north to swamp, savannah grasslands and equatorial rain forest in the south. Arabic is the official language and Islam the state religion, although about 4% of the population are Christians and many more follow traditional African religions. The population of *c.* 40 million (2007 estimate) comprises more than 50 ethnic groups (with *c.* 600 subgroups), and some 115 languages are spoken. Although most Sudanese are subsistence farmers, nomadic and semi-nomadic pastoralists occupy large areas. Only 15% live in urban areas. Geographically and culturally, Sudan links North Africa, Asia and sub-Saharan Africa. Its diverse cultures are a complex mix of African and Islamic traditions, showing patterns of continuity from such ancient cultures as Kush (*c.* 860–650 bce), Christian Nubia (*c.* 1323–1504) and the Funj Sultanate of Central Sudan (*c.* 1504–1820). Islam began to be adopted from the 14th century. Turco-Egyptian rule (1820–81) was followed by the Mahdist state (1881–98), until the country was brought under a form of colonial rule by the British through the Anglo-Egyptian Condominium (1898–1955). Independence was declared in 1956 and has been followed by alternating periods of parliamentary democracy and military rule. Since the early 1990s Sudan has suffered from an economy affected by drought, famine and a poor transport system, civil war and political instability, with the Sudan People's Liberation army, based in southern Sudan, pitted against the Islamic government in the north.

II. Continuing traditions. Sudan's rich Kushitic and Nubian heritage is continued in the ceramic traditions of various parts of the country, for example in Darfur, where women are the main pottery producer. Other continuing craft traditions include basketwork with bright geometric patterns, rugs woven by Sudan's nomadic peoples, cotton cloth woven by the riparian peoples, gold and silver jewelry, leatherwork and bead- and needlework. Sudanese body arts are particularly well known, especially the ornate body painting and complex patterns of cicatrization and hair styling among some Nuba. Less complex traditions are found among other ethnic groups. Sculpture is limited mainly to the Zande of southwest Sudan and related peoples such as the Bongo, although carving of ivory ornaments, wooden utensils, calabashes, musical instruments and furniture is widespread. For the cattle-keepers of southern Sudan, their livestock, in particular the color-configurations of their hides and the shape of their horns, provides both the inspiration and focus for aesthetic contemplation and activity. Arabic calligraphy is also practiced and has had a marked influence on the work of a number of Sudanese artists (*see* §IV below), while verses from the Koran, sometimes accompanied by geometric or floral designs, are also used as ornamentation in both secular and religious buildings. By the 1990s many of Sudan's traditional arts were under

threat from modernization and the importation of mass-produced goods.

III. Architecture. The traditional, rectangular or square box-house (*bayt jalus*) with a flat roof, made of pure dried clay, sun-dried mud, brick or cow-dung plaster (*zibala*), continues to be the dominant architectural type in Sudan. In its pure form, wooden frames are used only for the roof, windows and doors. It is widespread everywhere, except in the south where the heavy rains make sloping grass roofs essential. The traditional box-house style was seen at its most complete in Omdurman, the city built by the Caliph 'Abdallah (*r.* 1885–98) in 1885, which was the country's capital for 13 years. Omdurman fully retained its character until the 1960s. The pure form underwent ornate development in Nubia (an area flooded during the 1960s by the Aswan High Dam), where white, blue and yellow painted motifs, as well as plates and saucers, were used to decorate the mud walls.

Khartoum, the capital and largest, most modern city, was rebuilt by Lord Kitchener in the early 1900s after its devastation by the Mahdi's army in 1885. The city center was laid out in a series of Union Jack patterns for purposes of defense. The main buildings, including the Palace, Governor's House, Gordon Memorial College, Grand Hotel, banks and offices (all completed between 1900 and 1912), were built in a variety of foreign styles, thus reflecting colonial power. Unrelated to Sudanese life and culture, imported architectural styles continue to be used in Khartoum to the detriment of the development of an indigenous architecture. It has been only since independence that the Sudanese have begun to take seriously the profession of architecture, and a modern Sudanese style has yet to emerge.

IV. Painting, graphic arts and sculpture. Painting and sculpture in Western terms were unknown in Sudan until the Anglo-Egyptian Condominium. In 1945 the British established a design school in Khartoum (*see* §V below), which became a nucleus for the development of modern art in Sudan. The activities generated by individual artists associated with the art school became known both locally and abroad and their achievements are considered an important aspect of contemporary developments in African art. After graduating in Khartoum, many of the students studied in London, where they were introduced to the products of different cultures, including African and Islamic arts exhibited in British museums and galleries. This opportunity to study their own artistic traditions came at a time when Sudanese nationalism was at its peak (1950s–1960s). On returning to Sudan they were highly conscious of their artistic heritage and of the value of indigenous crafts. They began to define themselves as Sudanese artists and developed styles based in their own cultures, utilizing the motifs and patterns of Sudanese Arabic calligraphy and craft works. The absence of a tradition in painting and sculpture left room for exploring

indigenous cultures with a fresh vision and gave rise to new trends in contemporary Sudanese art.

One of the best known of these artists is the graphic artist and painter Ahmed Mohammed Shibrain (*b.* 1932), who has been associated with the Khartoum Technical Institute since 1956. Shibrain also studied at the Central School of Art and Design, London, from 1957 to 1960. His work is primarily calligraphic. Working with pen and ink, he abstracts in a complex manner the Islamic calligraphy of Koranic verses into powerful visual images (e.g. *Calligraphy*). Shibrain's contemporary IBRAHIM EL-SALAHI studied at the Gordon Memorial College, Khartoum, and at the Slade School of Fine Art, London. Working in all media, El Salahi also draws on calligraphy as well as on a vast range of other sources, including Sudanese craft objects, African sculpture and Tantric art. El Salahi has exhibited widely in Africa, Europe and the USA, and examples of his work are held in several public collections. Osman Waqialla (1925–2007) similarly makes calligraphic compositions of Koranic verses. After moving to England in 1967, he became a consultant to the firm of banknote makers, De La Rue.

A number of other Sudanese painters and graphic artists have received international attention. The painter, printmaker and interior designer Tag el Sir Ahmed (*b.* 1933) became known while studying at the Royal College of Art, London. His work is highly acclaimed for its individual style, delicate lines and coloring. Many of his works can be seen as romantic reminiscences concerning religious, personal and historic events. Shaigi Rahim (*b.* 1935) studied at the Khartoum Technical Institute in 1951 and at the Slade School of Fine Art, London, from 1959 to 1962, returning to teach at the Khartoum Technical Institute. He also worked for a time as a stage designer at the Royal Opera House, Covent Garden, London. Rahim's work is characterized by delicate and colorful interlocking geometric patterns.

Sudan's first- and best-known woman artist is Kamala Ibrahim Ishaq (*b.* 1939). As well as studying at the Khartoum Technical Institute from 1959 to 1963, she studied painting, illustration and lithography at the Royal College of Art, London, in the late 1960s, before returning to teach at the Khartoum Technical Institute. Her paintings are carefully composed, their imagery being drawn in large part from her experiences of the Zar possession cult of Khartoum and Omdurman. Mohammad Omer Khalil (*b.* 1936) is a graphic artist whose work in many different techniques has been widely exhibited (e.g. Ithaca, NY, Cornell U., Johnson Mus. A., 1993; Washington, DC, N. Mus. Afr. A., 1994–5). Another student of the College of Fine and Applied Art, Khartoum, where he taught from 1959 to 1962, Khalil also studied in Florence. He has taught at the Pratt Institute of Fine Art and the New School for Social Research, both New York, where he has been based since 1969. His etchings have the intricacy and precision of Islamic calligraphy, though he also juxtaposes forms and images to a collage-like effect.

Musa Khalifa (*b.* 1941) was a student of Shibrain's at the College of Fine and Applied Art, Khartoum, from 1965 to 1969. A member of Breeding Desert, a Sudanese artists' organization, Khalifa combined inherited and foreign elements in his own synthesized visual vocabulary. His works are halfway between painting and calligraphy. Mohamed Omer Bushara (*b.* 1946) was refused entry to the College of Fine and Applied Art, Khartoum, but he later studied at the Slade School of Fine Art, London. While line is of great importance in his work, creating delicate detail, his compositions are often more angular than those of most other Sudanese artists. Many of his drawings are concerned with anger, fear and the dilemmas of life. Bushara has had a number of important exhibitions (e.g. New York, Afr.-Amer. Inst., 1981). Salih Abdou Mashamoun (*b.* 1946) was educated in Egypt and received only informal art training. Like Bushara, much of Mashamoun's work deals with alienation and tragedy. Though his paintings feature figures and faces, vestiges of the Sudanese calligraphic tradition remain. Among artists from southern Sudan, Severino M. Matti (*b.* 1938) is perhaps the best known. His works include lively and evocative paintings of the Lokoya people of southeast Sudan.

Pastoral and nomadic lifestyles are not conducive to the development of sculptural traditions, and Islam does not encourage the three-dimensional representation of living creatures. Moreover, there has been little public patronage, and even Khartoum remains almost bare of sculpture. One of the very few government-commissioned public sculptures is a marble cross, its surface incised with stylized portraits representing Sudan's different ethnic groups. The work of an Italian artist, it was erected in front of the presidential palace as a symbol of unity. Although Sudan's antique sculptural remains have had little impact on the country's modern art, it has been claimed that the work of ceramicist Mohammed Ahmed Abdulla (*b.* 1933) has architectural qualities, drawn from traditional domes and arches, as well as from calabash and basketry forms (Kennedy, 1992). One of the few Sudanese artists to work in three dimensions, Abdulla studied at the Khartoum Technical Institute, as well as at the Central School of Art and Design, London. An internationally known Sudanese sculptor is Amir I. M. Nour (*b.* 1936), who studied at the School of Fine and Applied Art, Khartoum, and in London at the Slade School of Fine Art and the Royal College of Art, as well as at Yale University, New Haven, CT. Working in a variety of modern materials, including bronze, wood, steel, iron and cast polymer, Nour drew on the forms of utilitarian and everyday objects and architecture. In his work he often united stark geometrical volumes in bold three-dimensional complexes (e.g. *Grazing at Shendi,* 1969; artist's col.). Nour has had a number of one-man shows in the USA (e.g. New York, Afr.-Amer. Inst., 1974; Pittsburgh, PA, Carnegie Mus. A., 1976), where he was based from the early 1970s.

V. Patronage and art institutions. Patronage of the arts in Sudan has been limited. There are some opportunities in the graphic arts for such work as designing postage stamps, signs and labels. In general, however, artists depend mainly on the patronage of foreign visitors and on exhibitions abroad for the sale and exposure of their work. The country as a whole lacks both public and private galleries. Even Khartoum has neither art galleries nor a museum for the exhibition of contemporary art, although artists occasionally exhibit in the city's major hotels. The National Museum, Khartoum, has a collection of Nubian antiquities with temples, sculptures and columns on permanent display in a spacious garden, as well as collections of Nubian and Meroitic decorative arts. The Ethnographic Museum, Khartoum, houses a collection of artifacts from various parts of Sudan. There are also small museums with archaeological collections at Marawi and Sheikan.

The British established a school of design in 1945 in the then Gordon Memorial College (later the University of Khartoum). This was expanded, renamed the School of Fine and Applied Art (later College of Fine and Applied Art) and transferred to Khartoum Technical Institute (later the University of Sudan for Science and Technology) when the latter was founded in 1951. The original school was modeled on British art colleges, except for the use of nude models, which Islamic tradition does not permit. Its aim was to produce teachers for secondary schools. Until at least the early 1970s the curriculum comprised a practical training in Western techniques with little reference to indigenous culture. Neither African nor Islamic arts were part of the syllabus, nor were the ancient traditions of Sudan.

Enc. Islam/2: "Sūdān"

C. E. J. Walkley: "The Story of Khartoum," *Sudan Notes & Rec.,* xviii/2 (1935), pp. 221–41; xix/1 (1936), pp. 71–92

A. J. Arkell: "Darfur Pottery," *Sudan Notes & Rec.,* xxii/1 (1939), pp. 79–88

A. Kronenberg and W. Kronenberg: "Wooden Carvings in the South-western Sudan," *Kush,* viii (1960), pp. 274–81

"Tag Ahmed and Amir Nour," *Arab World,* i (July 1962), pp. 14, 17, 18, 23, 25

E. S. Brown: *Africa's Contemporary Art and Artists* (New York, 1966), pp. 96–109

U. Beier: *Contemporary Art in Africa* (London, 1968), pp. 28–34

D. R. Lee: "Mud Mansions of Northern Sudan," *Afr. A.,* vi (1971), pp. 60–62, 84

"New Sculpture from Amir I. M. Nour," *Afr. A.,* iv/4 (1971), pp. 54–7

M. Wenzel: *House Decoration in Nubia,* Art and Society (London, 1972)

M. Wahlman: *Contemporary African Arts* (Chicago, 1974)

African Art Today: Four Major Artists (exh. cat., ed. R. R. Jeffries; New York, Afr.-Amer. Inst., 1974)

African Artists in America (exh. cat., New York, Afr.-Amer. Inst., 1977), pp. 3–4, 6–7, 9–10

S. Denyer: *African Traditional Architecture: An Historical and Geographical Perspective* (London, 1978)

Africa: Emergent Artists, Tribal Roots and Influence (exh. cat., ed. R. H. Browning; New York, Altern. Cent. Int. A., 1978)

Art et cultures d'Afrique noire (exh. cat., Reims, Maison Cult. André Malraux, 1978)

S. M. Matti: "Lokoya Village Life: Hunters and the Hunted," *Heritage*, i/1 (1982), pp. 63–5

A. Fisher: *Africa Adorned* (London, 1984)

K. Fosu: *20th-century Art of Africa*, (Zaria, 1986)

W. Ali and S. Bisharat, eds.: *Contemporary Art from the Islamic World* (London, 1989), pp. 125–9

J. Coote: "'Marvels of Everyday Vision': The Anthropology of Aesthetics and the Cattle-keeping Nilotes," *Anthropology, Art and Aesthetics*, ed. J. Coote and A. Shelton, Oxford Studies in the Anthropology of Cultural Forms (Oxford, 1992), pp. 245–73

R. Fegley: "Beauty from Mud: House Decoration Among the Danagla of Sudan," *The World & I: A Chronicle of our Changing Era* (Washington, DC, 1992), pp. 638–51

J. Kennedy: *New Currents, Ancient Rivers: Contemporary African Artists in a Generation of Change* (Washington, DC and London, 1992), pp. 108–22, 190–91, 197–8 [useful bibliog.]

Creative Impulses—Modern Expressions: Four African Artists (exh. cat. by S. M. Hassan; Ithaca, NY, Cornell U., Johnson Mus. A., 1993)

Mohammed Omar Khalil: Etchings—Amir I. M. Nour: Sculpture (exh. cat. by S. Williams; Washington, DC, N. Mus. Afr. A., 1994–5)

M. A. Abusabib: "The Impact of Islam on African Art: The Case of the Sudan," *Islamic Art and Culture in Sub-Saharan Africa*, ed. K. Ådahl and B. Sahlstrong (Uppsala, 1995), pp. 139–48

W. Ali: *Modern Islamic Art: Development and Continuity* (Gainesville, 1997), pp. 114–18

E. A. Farah: *House Form and Social Norms: Spatial Analysis of Domestic Architecture in Wab-Nubbawi, Sudan* (Gothenburg, 2000)

N. Levtzion and R. L. Pouwels, eds.: *The History of Islam in Africa* (Athens, OH, 2000)

M. B. Visonà: *Lands of the Nile: Egypt, Nubia and Ethiopia* (New York, 2001)

M. A. Abusabib: *Art Politics and Cultural Identification in Sudan* (Uppsala, 2004)

M. A. Abusabib: *"Islamization" of the Arts: The Sudanese Experience* (Uppsala, 2004)

S. O. Elsadig: "The Domed Tombs of the Eastern Sudan," *Sudan & Nubia*, iv (2004), pp. 37–43

Word into Art: Artists of the Modern Middle East (exh. cat. by V. Porter; London, BM, 2006)

S. Adams: "In My Garment There is Nothing but God: Recent Work by Ibrahim el Salahi," *Afr. A.*, xxxix/2 (2006), pp. 26–35

L. Werner: "The Decorated Houses of Nubia," *Saudi Aramco World*, lvii/4 (2006), pp. 2–7

Sulayhid [Arab. Ṣulayḥid]. Ismaʿili dynasty that ruled the *Yemen* from 1047 to 1138. The Sulayhids, who ruled as representatives of the Fatimid caliphs of Egypt, were responsible for restoring Ismaʿili Shiʿism to the Yemen. The dynasty was founded by ʿAli ibn Muhammad al-Sulayhi (*r.* 1047–67), who had come under the influence of a Fatimid missionary; after the missionary's death, the Fatimid caliph al-Mustansir (*r.* 1036–94) named ʿAli as Fatimid agent in south Arabia. In 1046 ʿAli and 60 men from his tribe began to set up the rule of the Fatimids in the Yemen, and in 1047 they fortified the mountain village of Masar to the west of Sanʿa. In the early 1060s ʿAli obtained sovereignty over Zabid and Sanʿa, which he made his capital in 1063, and asserted himself over the Maʿnids of Aden. From 1063 he sent the annual covering (Arab. *kiswa*) for the Kaʿba at Mecca, a sign of his power and prestige. In 1067 ʿAli was murdered and his army massacred by the Najahid prince of Abyssinia in revenge for ʿAli's murder of the prince's father. ʿAli's son al-Mukarram Ahmad (*r.* 1067–84) reconquered the Tihama and stormed Zabid, and under him the Sulayhid domain reached its maximum extent. Al-Mukarram's wife al-Sayyida al-Hurra Arwa bint Ahmad became increasingly prominent in the affairs of state, and, after the death of her husband, she reigned with the backing of the Fatimid caliph, first as regent for her sons and then independently. She made Dhu Jibla in the southern mountains the new Sulayhid capital, where she erected a palace and mosque (1088–9). The mosque (*see* ARCHITECTURE, §V, B, 4) introduced several features characteristic of Fatimid mosques in Egypt. Her authority gradually declined, and the Sulayhids lost Sanʿa in 1097. In 1110–11 the tribe of Khawlan briefly took the castle of Taʿkar, where Arwa had her summer residence and kept the Sulayhid treasures. She died in 1138 and was buried in her mosque at Dhu Jibla. The effective power of the Sulayhid dynasty came to an end with her death, although a few Sulayhid princes continued to hold fortresses to the end of the century.

Enc. Islam/2

R. W. Stookey: *Yemen: The Politics of the Yemen Arab Republic* (Boulder, 1978), pp. 58–77

W. Daum, ed.: *Yemen: 3000 Years of Art and Civilization in Arabia Felix* (Innsbruck, 1987)

S. Travoulsi: "The Queen was Actually a Man: Arwā bint Ahmad and the Politics of Religion," *Arabica*, l/1 (2003), pp. 96–108

Sultan ʿAli Mashhadi [Sulṭān ʿAlī ibn Muḥammad ibn al-Mashhadī] (*b.* Mashhad; *fl.* 1453–1519; *d.* Mashhad, 1520). Persian calligrapher. Orphaned at an early age, he was an autodidact and was later trained by Azhar (*fl.* 1421–72), one of the students of Jaʿfar, or by one of Azhar's students. From 1470 to 1506 Sultan ʿAli worked at the Timurid court in Herat for the major bibliophiles of the time, Husayn Bayqara (*see* TIMURID, §II, H) and ʿALISHIR NAVAʾI. Sultan ʿAli designed architectural inscriptions, such as the one (1477–8) on the marble platform for the tombstones of Husayn Bayqara's ancestors erected in the shrine complex at Gazurgah outside Herat. He also calligraphed some of the finest Persian and Turkish manuscripts produced for the Timurid court, such as a copy of ʿAttar's *Manṭiq al-ṭayr* ("Conference of the birds"; 1483; New York, Met., MS. 63.210) and a copy of Saʿdi's *Būstān* ("Orchard"; 1488; Cairo, N. Lib., Adab Farsi 908). Sultan ʿAli's calligraphy,

which is more fluid and spacious than that of Ja'far, is the classic statement of the eastern, or Khurasani, style of *nasta'līq* (*see* CALLIGRAPHY, § IV, B). In 1514, having retired to Mashhad after the overthrow of the Timurid dynasty, Sultan 'Ali wrote a verse treatise in Persian on writing and teaching calligraphy. This work, which was later incorporated in Qazi Ahmad's biography of calligraphers and painters, contains both practical and autobiographical information and shows the close association between religious discipline and the practice of calligraphy. Sultan 'Ali's calligraphy was praised by such connoisseurs as the Mughal emperor Babur (*r.* 1526–30) and the chronicler Mirza Muhammad Haydar Dughlat. Many great calligraphers of the 16th century, such as Sultan-Muhammad Nur and Sultan Muhammad Khandan, were trained by him.

WRITINGS

Risāla [Epistle] (1514); Rus. trans., facs. ed. G. I. Kostygova as "Traktat po kalligrafii Sultan-'Ali Meshkhedi," *Trudy Gosudarstvennoy Pub. Bib. M. E. Saltykova-Shchedrina*, ii/5 (1957), pp. 103–63; Eng. trans. by V. Minorsky in *Calligraphers and Painters* (Washington, 1959), pp. 106–25

BIBLIOGRAPHY

Zahir al-Din Muhammad Babur: *Bāburnāma* [History of Babur] (*c.* 1530); Eng. trans., abridged, ed. W. M. Thackston as "Babur Mirza's *Baburnama*: A Visit to Herat," *A Century of Princes: Sources on Timurid History and Art* (Cambridge, MA, 1989), p. 267
Mirza Muhammad Haydar Dughlat: *Tārīkh-i Rashīdī* [Rashidian history] (1541–7); Eng. trans., abridged, ed. W. M. Thackston in *A Century of Princes: Sources on Timurid History and Art* (Cambridge, MA, 1989), p. 360
Qazi Ahmad ibn Mir Munshi: *Gulistān-i hunar* [Rose-garden of art] (1606); Eng. trans. by V. Minorsky as *Calligraphers and Painters* (Washington, 1959), pp. 101–25
L. Golombek: *The Timurid Shrine at Gazur Gah* (Toronto, 1969), p. 85
M. Bayani: *Ahvāl va āsār-i khwushnavīsān* [Biographies and works of calligraphers], 2nd edn in 4 vols. (Tehran, Iran. Solar 1363/1984–5), pp. 241–66
D. J. Roxburgh: *The Persian Album 1400–1600: from Dispersal to Collection* (New Haven, 2005)
S. S. Blair: *Islamic Calligraphy* (Edinburgh, 2006), pp. 55, 60, 277, 280–81, 285–6, 430, 432, 434, 537, 540, 590 and fig. 7.17

Sultaniyya [Sulṭāniyya; Soltaniye]. Village in northwest Iran and one of the capitals of the Ilkhanid dynasty (*r.* 1256–1353). Set in a pastured plain 120 km northwest of QAZVIN en route to TABRIZ, the site was selected by Arghun (*r.* 1284–91) as his summer capital. His son Uljaytu (*r.* 1304–17) enlarged the site so that the city created by royal edict surpassed Tabriz, the principal urban center of the realm. Beginning in 1305, a citadel with towers, mosques, madrasas, *khanaqah*s, markets, baths, hospitals, palaces, residences and gardens was built, but most had been destroyed by the mid-17th century. Standing remains include a tower (1310; diam. 12 m) known as the tomb of Çelebi Oğlu, the ruins of an adjacent

khanaqah, and the massive mausoleum that Uljaytu erected for himself (*see* ARCHITECTURE, fig. 30), which has become virtually synonymous with the name Sultaniyya (Pers. "the imperial [city]").

The tomb of Uljaytu was the centerpiece of one of the largest charitable foundations of its time, which included places for prayer, Koran reading, residence and meditation contained within an ensemble of four iwans connected by arcades around a court. Built of baked brick above a foundation of local pale-green stone, the mausoleum is cardinally orientated and has a large central domed chamber (h. 50 m, diam. 25 m) supported by heavy walls (w. 7 m) and ringed by eight towers. The walls are pierced on the interior by eight tall and deep bays; set into a rectangular frame, each bay is divided in two, the upper stories linked by a passage. A gallery, reached by staircases in the northeast and northwest corners, rings the building on the exterior below the base of the dome. To the south or qibla is a rectangular room (15×20 m). The building is remarkable for its ornamentation: its interior walls are covered by seemingly unlimited and inventive patterns worked in tile mosaic and carved and painted plaster (for illustration *see* ORNAMENT AND PATTERN). The interior also bears two contemporary decorative schemes, one applied on top of the other and obliterating it: the first is executed in glazed brick and tile combined with carved stucco and terracotta, the second consists largely of painted plaster, with smaller areas of *cuerda seca* glazed tiles, appliqué plaster and plaster-stiffened cloth ornaments. The first is almost anepigraphic, while epigraphy is the primary element of the painted decoration. The first scheme emphasizes the axes of the building, while the second emphasizes its circular quality and accents only the qibla bay.

Up to 1982 the redecoration had been explained by a change in Uljaytu's religious orientation, causing him to abandon a plan to re-inter the bodies of 'Ali and Husayn, the two great Shi'ite martyrs. Blair (1987) translated the inscriptions, confirming that the building was dedicated in 1313–14 but redecorated in painted plaster shortly before Uljaytu's death in 1317; she also suggested that the change responded to Uljaytu's aspirations as protector of the Holy Cities and leader of the Islamic world. Sims (1988) further proposed that the materials of the original anepigraphic decoration were "iconographically" inappropriate for the interior of a royal mausoleum.

Enc. Islam/2
D. Wilber: *The Architecture of Islamic Iran: The Il-Khanid Period* (Princeton, 1955/ *R* New York, 1969), pp. 64–7
A. U. Pope and P. Ackerman, eds.: *Survey of Persian Art* (2/1964–7), pp. 1103–18, 1339–45
E. G. Sims: "The Internal Decoration of the Mausoleum of Oljeitu Khudabanda: A Preliminary Re-examination," *Quad. Semin. Iran. U. Venezia*, ix (1982), pp. 89–123
S. S. Blair: "The Mongol Capital of Sultaniyya 'The Imperial,'" *Iran*, xxiv (1986), pp. 139–51

S. S. Blair: "The Epigraphic Program of the Tomb of Uljaytu at Sultaniyya: Meaning in Mongol Architecture," *Islam. A.*, ii (1987), pp. 43–96

M. Mihryar, A. Kabiri and F. Tawhidi: "Burj va bārū-yi arg-i shahr-i qadīm-i Sulṭāniyya" [Towers and walls of the citadel of the old city of Sultaniyya], *Āthār*, xii–xiv (Iran. Solar 1365/1988), pp. 209–64

E. G. Sims: "The 'Iconography' of the Internal Decoration in the Mausoleum of Uljaytu at Sultaniyya," *Content and Context of Visual Arts in the Islamic World*, ed. P. P. Soucek (University Park, 1988), pp. 139–76

F. A. Tavakoli: *Kitābshināsī-yi sulṭāniya/A Bibliography of Sultanyeh* (Tehran, 2002)

The Legacy of Genghis Khan: Courtly Art and Culture in Western Asia, 1256–1353 (exh. cat., ed. L. Komaroff and S. Carboni; New York, Met.; Los Angeles, CA, Co. Mus. A.; 2002–3)

Sultan-Muhammad [Sulṭān-Muḥammad Tabrīzī; Sultan-Muhammad 'Irāqī] (*fl. c.* 1505–50). Persian illustrator. He was apparently a native of Tabriz and spent most of his life there. Contemporary sources suggest that he was at the height of his creative powers in the 1520s and 1530s when he was one of the leading painters in the employ of the Safavid shah Tahmasp (*see* SAFAVID, §II, A). Sultan-Muhammad's documented paintings include contributions to a monumental copy (dispersed, ex-Houghton priv. col.; *see* PAPER, color pl. 3:IV) of Firdawsi's *Shāhnāma* ("Book of kings") made for Tahmasp between *c.* 1524 and *c.* 1529 and paintings from a copy (divided, New York, Met. and Cambridge, MA, Sackler Mus.) of Hafiz's *Dīvān* (collected poems), probably executed between 1531 and 1533. Sultan-Muhammad's paintings for these manuscripts demonstrate how the tradition of western Iranian painting was practiced in Tabriz, Shiraz and other centers during the 15th century (*see* ILLUSTRATION, §V, D) continued to be significant at the Safavid court (*see* ILLUSTRATION, §VI, A, 2). His paintings for the *Shāhnāma* also suggest that he was familiar with a group of paintings now in Istanbul (e.g. Topkapı Pal. Lib., H. 762, H. 2153) and Berlin (e.g. Staatsbib. Preuss. Kultbes., Orientabt., Diez A 70–73), many of which contain themes of Chinese origin. In Sultan-Muhammad's illustrations, however, these exotic elements are subordinated to the narrative content of the images. His paintings are also unusual for their psychological and compositional cohesion. The outstanding example of these qualities is the *Court of Gayumars*. Sultan-Muhammad's signed paintings from the *Dīvān* have compositional analogies with paintings in other Safavid court manuscripts, particularly the use of architecture to structure a figural composition. They are unusual, however, for the variety of figures portrayed and the regular distribution of colors, particularly red, yellow, blue and green. Like his predecessor BIHZAD, Sultan-Muhammad was buried in Tabriz near the tomb of the poet Kamal Khujandi (*d.* 1400). His son MIRZA 'ALI also worked in Tahmasp's workshop.

Wonders of the Age: Masterpieces of Early Safavid Painting, 1501–1576 (exh. cat. by S. C. Welch, London, BL; Washington, DC, N.G.A.; Cambridge, MA, Fogg; 1979–80), pp. 118–29

M. B. Dickson and S. C. Welch: *The Houghton Shāhnāmeh* (Cambridge, MA, 1981), pp. 57–86

P. Soucek: "Sultan Muhammad Tabrizi: Painter at the Safavid Court," *Persian Masters: Five Centuries of Painting*, ed. S. R. Canby (Bombay, 1990), pp. 55–70

S. R. Canby: *The Golden Age of Persian Art, 1501–1722* (London, 1999), pp. 31, 34, 50–52, 58, 65, 72 and figs. 20, 33 and 42

Z. A. Desai: "An Album with Miniatures by the Persian Safavid Painter Sultan Muhammad," *Marg*, liii/4 (2005), pp. 74–81

Sur [Arab. Sūr]. Afghan dynasty that ruled much of northern India from 1538 to 1555. Sher Shah, the first Sur ruler, rose to prominence in Bihar during the 1530s by uniting various Afghan tribes and crippling the authority of the MUGHAL emperor Humayun (*r.* 1530–40, 1555–6) at the Battle of Chausa in 1539. Although Sher Shah assumed the title of Sultan and minted coins in his own name as early as 1538, it was not until 1540 that he ousted Humayun from India. He then briefly ruled from his capital at Delhi (*see* DELHI, §F) renaming it Shergarh. Although much of his seven-year reign was spent consolidating Sur territories, Sher Shah was a notable patron of architecture. He erected a tomb for his grandfather at Narnaul and large octagonal mausolea for his father and himself at SASARAM, his former estate in Bihar. In addition, he is often credited with completing the Purana Qila in Delhi (*see* DELHI, §III, C), which served as his citadel, and the Qil'a-i Kuhna Mosque. Contemporary texts state that he built numerous forts across northern India for the safety of his subjects and provided caravanserais for the welfare of travelers and tree-lined highways linking Bengal to Punjab; the Grand Trunk Highway continues to be known as Sher Shah Suri Marg. Sher Shah died in 1545 and was succeeded by his son Islam Sur (*r.* 1545–53), who built fewer structures. The last Sur, 'Adil Shah, was defeated by Humayun's forces in 1555, allowing the resurgence of Mughal power.

Enc. Islam/2: "Shīr Shāh Sūr"

'Abbas Khan Sarwani: *Tārīkh-i Sher Shāhī* [The history of Sher Shahi] (*c.* 1579); Eng. trans. by S. M. Imam al-Din, 2 vols. (Dhaka, 1964)

K. Qanungo: *Sher Shah and his Times* (Bombay, 1965)

I. H. Siddiqui: *History of Sher Shah Sur* (Aligarh, 1971)

C. B. Asher: "Legacy and Legitimacy: Sher Shah's Patronage of Imperial Mausolea," *Sharī'at and Ambiguity in Southern Asian Islam*, ed. K. P. Ewing (Berkeley, 1988), pp. 79–97

G. H. R. Tillotson: "The Paths of Glory: Representations of Sher Shah's Tomb," *Orient. A.*, xxxvii/1 (1991), pp. 4–16

C. B. Asher: "Building a Legacy: Sher Shah Sur's Architecture and the Politics of Propaganda," *Marg*, lviii/1 (2006), pp. 24–35

Sūsa. *See* SOUSSE.

Swahili. People living on the coast and islands of East Africa from Mogadishu in SOMALIA to the southern borders of TANZANIA. Swahili culture is Islamicized and urban. Its visual arts serve mostly religious or local political purposes. Art and architecture can be best viewed *in situ*: in the towns themselves, at such

architectural ruins as those at Gedi and Kilwa, as well as in local museums such as those at Lamu and ZANZIBAR, where outstanding examples of Swahili crafts are displayed. Outside East Africa, Swahili arts are not very easily accessible. Most museum material is kept in storage. There are, however, important collections in museums in the USA (e.g. Washington, DC, N. Mus. Nat. Hist.) and Europe (e.g. London, BM; Berlin, Mus. Vlkerknd.). See the works listed in the bibliography for illustrations, especially Bravmann's *African Islam* for a broad range of Swahili crafts.

The origins of the Swahili have long been debated, but current research indicates that they are clearly African, although contact with outside influences, particularly Islam, has resulted in a culture distinct from that of the rest of East Africa. Elements of Swahili culture have also diffused into many parts of the hinterland, often blurring simple distinctions between coastal and hinterland peoples. In addition, through trade in particular, such pockets of Swahili culture as the town of Ujiji in Tanzania have been created far into the interior. The Swahili language has spread even more widely, being the national language of Kenya and Tanzania and spoken also in areas of Uganda, the Democratic Republic of Congo (formerly Zaïre), Mozambique and Zimbabwe.

In the past, the Swahili were traders, above all, and served as an important link between the peoples of the interior and the wider world. As early as the 7th century, ships following the seasonal monsoon winds traveled between the Arabian Peninsula and the East African coast. By the 12th century Swahili traders were part of a network that included the Middle East, India, China and the Mediterranean world. During the 10th century, for example, they played a key role in the transport of gold, ivory and rock crystal that figured prominently in the arts of the Mediterranean. By the time the Portuguese arrived on the coast in the late 15th century, there were more than 400 Swahili sites along the East African coast, although some had already fallen into decline.

Larger Swahili towns were characterized by elaborate mosques and multi-story houses for the élite, built of coral blocks and with mangrove pole ceilings. Both secular and religious buildings evoked a sense of intimate, compartmentalized space, the former through a plan of sequentially arranged rooms, the latter with rows of pillars that supported the roof beams in the prayer-hall. Although the older buildings are in ruin, later mosques offer a clear picture of the Swahili sense of ornament. Decorative plasterwork, handcarved *in situ*, embellishes the walls of 18th- and 19th-century buildings. The non-figural motifs include rosettes, curves and spirals, chains, zigzags and geometric shapes. Similar motifs are found at the entrances to some of the contemporary houses of the élite. Here, double-panel doors are framed by intricately carved jambs, lintels and centerposts, all set on a heavy raised sill. They are often

called "Zanzibar doors" after the island where their quantity and complexity was unsurpassed, though they were also made in such other places as Lamu, Malindi and Mombasa in Kenya and Bagamoyo in Tanzania. In general, doors with rectangular lintels and more geometric carving represent an earlier style, while those with arched lintels and more curvilinear motifs represent a later Indian influence dating from the 19th century.

The stone tombs and mausolea of the Swahili have been said to be the most imaginative and experimental of their art forms. They were built from the late 14th century until the 16th in the so-called "golden age" of Swahili culture. Apparently erected for only those of great wealth and status, they were made from the same type of plastered coral rag that was used for houses and mosques. The tombs are characterized by two features: a surrounding wall, sometimes decorated with panels and niches similar to those found in Swahili houses; and a superstructure, sometimes decorated with finials and imported Chinese and Persian ceramic bowls. Within those parameters, however, one finds great variation, ranging from domed tombs to those with step or wing forms rising from the walls. Particularly noteworthy are pillar tombs, a distinctively Swahili form, with a superstructure consisting of a tall, usually round pillar that may reach more than 5 m in height. While an origin outside Africa cannot be discounted, such tombs may in fact relate to pre-Islamic religious customs, common in East Africa, involving the erection of posts, tusks or piles of rocks to commemorate the deceased.

The Swahili have used a variety of techniques both to make objects and to decorate imported ones. Large chests and small boxes for keeping personal possessions, often imported from India or the Persian Gulf, were decorated with brass fittings and carved with some of the same motifs used in plasterwork and at house entrances. Such household objects as mortars and coconut graters as well as Koran stands were also embellished with decorative carving. From the 18th or 19th century, craftsmen at Siyu, Pate Island, Kenya, produced small, lidded wooden containers, turned on lathes and stained with mangrove dyes, for spices and cosmetics. Siyu craftsmen used the same technique to make beds with brightly striped frames and similarly striped spindles on the headboard and footboard. Such beds were symbols of status and power, as were the distinctive chairs that Swahili woodworkers also produced. The chair of power (*kita cha enzi*) was a large, angular construction with an attached footrest and removable back. Made of ebony, the chair was decorated with inlaid designs of ivory and bone and inset string or fiber panels. While some of these woodworking techniques and forms were introduced from Persia, Arabia, India and elsewhere, and the chair of power may have been derived from an Egyptian prototype, craftsmen used them to make objects that were uniquely Swahili.

The Swahili also excelled in metalwork. Copper and brass kettles and containers were once made, but

they were replaced by imported ware. Silver and gold were used to inlay ivory and other materials. Jewelry-making has a long history among the Swahili, encouraged by the custom of making lavish displays of personal adornments at weddings and on other important occasions. Particularly notable are amulet necklaces of small silver or gold cases or boxes made to contain pieces of paper inscribed with passages from the Koran.

Most Swahili crafts were practiced by men. Islam encourages the seclusion of women where this is financially possible, but many women became accomplished mat-makers, as the art could easily be pursued in the privacy of the home. Finely worked mats for sitting, sleeping and prayer were still being made in the 1990s from fronds of the wild date palm. The fronds were plaited into narrow strips and then sewn together; by dyeing some of the fronds before plaiting, intricate patterns were created, sometimes even including phrases in Arabic script. Swahili-style mats provide a prime example of how elements of Swahili culture have spread, since by the late 20th century they were made by women from many different ethnic groups.

Other crafts may have been important at one time, but by the 1990s they had assumed minor roles or disappeared altogether. Weaving is not generally practiced. The embroidery on the traditional man's cap, or *kofia*, is often done by machine. Pottery was not highly developed, imported ware having been available for many years. Swahili leatherworkers made sandals primarily, though their repertory once included shields, whips, scabbards and bags. Although no longer worked for local consumption, ivory was once carved into ceremonial horns and handles for daggers and other weapons.

Enc. Islam/2

P. S. Garlake: *The Early Islamic Architecture of the East African Coast*, British Institute of History and Archaeology in East Africa, Memoir, i (London and Nairobi, 1966)

F. J. Berg and B. J. Walter: *Mosques, Population and Urban Development in Mombasa* (1968)

U. I. Ghaidan: "Swahili Art of Lamu," *Afr. A.*, v/1 (1971), pp. 54–7, 84

U. I. Ghaidan: "Swahili Plasterwork," *Afr. A.*, vi/2 (1973), pp. 46–9

J. de Vere Allen: "Swahili Architecture in the Later Middle Ages," *Afr. A.*, vii/2 (1974), pp. 42–7, 66–8, 83–4

U. Ghaidan: *Lamu: A Study of the Swahili Town* (Nairobi, Kampala and Dar es Salaam, 1975)

J. de Vere Allen and T. H. Wilson: *Swahili Houses and Tombs of the Coast of Kenya*, Art and Archaeology Research Papers (London, 1979)

J. S. Kirkman: "The Friday Mosque at Kilindini, Mombasa," *Azania*, xvii (1982)

R. A. Bravmann: *African Islam* (Washington, DC, 1983)

N. I. Nooter: "Zanzibar Doors," *Afr. A.*, xvii/4 (1984), pp. 34–9, 96

L. W. Donley: "Life in the Swahili Town House Reveals the Symbolic Meaning of Spaces and Artefact Assemblages," *Afr. Archaeol. Rev.*, v (1987), pp. 181–92

M. C. Horton: "The Swahili Corridor," *Sci. Amer.*, cclvii/3 (1987), pp. 86–93

L. Pouwels: *Horn and Crescent: Cultural Change and Traditional Islam on the East African Coast, 800–1900*, African Studies Series, 53 (Cambridge, 1987/R 2002)

H. Brown: "Siyu: Town of the Craftsmen—A Swahili Cultural Centre in the Eighteenth and Nineteenth Centuries," *Azania*, xxiii (1988), pp. 101–13

J. de Vere Allen: "*The kita cha enzi* and Other Swahili Chairs," *Afr. A.*, xxii/3 (1989), pp. 54–63, 88

J. Knappert: "Swahili Arts and Crafts," *Kenya Past & Present*, xxi (1989), pp. 20–28

M. Horton: "Swahili Architecture, Space and Social Structure," *Architecture and Order: Approaches to Social Space*, ed. M. P. Pearson and C. Richards (New York, 1994), pp. 147–69

E. Linnebuhr: *Sprechende Tücher: Frauenkleidung der Swahili (Ostafrika). Katalog* (Stuttgart, 1994)

D. Parkin, ed.: *Continuity and Autonomy in Swahili Communities: Inland Influences and Strategies of Self-determination*, Veröffentlichungen der Institute für Afrikanistik und Ägyptologie der Universität Wien, 65 (Vienna, 1994)

M. A. Muombwa: "Kofia in Zanzibar," *Swahili Forum II/Afrikanistische Arbeitspapiere*, xlii (1995), pp. 132–7

A. H. Athman: "Styles of Swahili Carving," *Swahili Forum III/Afrikanistische Arbeitspapiere*, xlvii (1996), pp. 11–29

J. Fleisher and A. LaViolette: "The Recovery of Swahili Settlements in the Absence of Stone Architecture: Two Preliminary Surveys from Pemba Island, Tanzania," *Nyame Akuma: Bulletin of the Society of Africanist Archaeologists*, lii (1998), pp. 64–73

S. Pradines: "L'Influence indienne dans l'architecture swahili," *Afrikanistische Arbeitspapiere*, lx (1999), pp. 103–20

R. M. Beck: "Aesthetics of Communication: Texts on Textiles (Leso) from the East African Coast (Swahili)," *Res. Afr. Lit.*, xxxi/4 (2000), pp. 104–24

J. E. G. Sjutton: *Kilwa: A History of the Ancient Swahili Town with a Guide to the Monuments of Kilwa Kisiwani and Adjacent Islands* (Nairobi, 2000)

F. Chami, ed.: *Southern Africa and the Swahili World* (Dar es Salaam, 2002)

S. Pradines: "La maison wa-ungwana, du XVe au XVIe siècle: Mission archéologique française de Gedi, 2002," *Nyame Akuma: Bulletin of the Society of Africanist Archaeologists*, lvii (2002), pp. 13–18

S. Pradines: "L'Art de la guerre chez les Swahili: Les premiers forts d'Afrique orientale," *J. Africanistes*, lxxii/2 (2002), pp. 71–87

S. Pradines: "Au cœur de l'islam médiéval, Gedi, une cité Swahili," *Archeologia*, cccxcvi (2003), pp. 28–39

S. Pradines: "Le mihrâb swahili: L'Evolution d'une architecture islamique en Afrique subsaharienne," *An. Islam.*, xxxvii (2003), pp. 355–81

R. L. Pouwels: *African and Middle Eastern World, 600–1500* (Oxford, 2005)

Syria [Syrian Arab Republic; Arab. Al-Jumhūriyya al-ʿArabiyya al-Sūriyya]. Country in the Middle East with its capital at DAMASCUS. Syria has an area *c.* 185,000 sq. km, extending east from the Mediterranean Sea, and has borders, established in the 20th century, with Turkey, Iraq, Jordan, Israel and Lebanon (*see* GEOGRAPHY AND TRADE, fig. 2). Its pivotal

position at the meeting-place of three continents made it a battleground and prize for both the ancient Egyptians and for the French in the 20th century. Modern Syria has a population of *c.* 20,315,000 (2007 estimate). Most speak Arabic as their first language, with Kurds forming the largest linguistic minority (*c.* 9%), followed by Armenians, Turkmen and Circassians. About 70% are Sunni Muslim; 15% belong to splinter Shi'a sects—'Alawi, Druze and Isma'ili—and 15% are Christian, the majority being Greek Orthodox. Formerly a mainly agricultural country, Syria experienced industrialization in the 1970s that led to the dominance of the manufacturing, commercial and mining sectors, with oil replacing cotton as the main export. The potential for agriculture, however, is great; the Furat Dam on the River Euphrates was completed in 1978. However, military expenditure has been a heavy economic burden. This article covers artistic developments in the country mainly from the mid-19th century.

Syria was a province of the Ottoman Empire until October 1918, when Allied forces and British-backed Arab troops led by Amir Faysal (*d.* 1933), son of the Grand Sharif of Mecca, took Damascus and Aleppo, and Turkey capitulated on 30 October. Syrian hope for independence was crushed when the League of Nations at San Remo in 1920 announced that Greater Syria was to be partitioned into the French mandates of Lebanon and Syria, and the British mandate of Palestine. Lebanon was made an independent country, enlarged with Syrian territory, including the Beqa'a Valley and the port of Tripoli. In 1939 the region of Alexandretta, including Syria's ancient capital of Antioch, was given to Turkey. In 1941 British and Free French forces expelled the Vichy French authorities, and full independence was achieved in April 1946. The post-war years were characterized by wars with Israel from 1948 onwards, Syrian intervention in Lebanon, support for the Palestinian liberation movement and political instability with numerous coups. In 1958 Syria united with Egypt as the United Arab Republic, but the union collapsed in 1961. Under General Hafiz al-Assad, an 'Alawite Muslim who became President in 1971, Syria sided with the West against Iraq in the Gulf War of 1990–91, and relations with the West were restored. After his death in 2000, he was succeeded by his son Bashar al-Assad.

Under the French mandate steps were taken to preserve and restore the architectural past (e.g. KRAK DES CHEVALIERS). Some successful restoration work has also been done since 1946, for example the reconstruction of the 18th-century 'Azm Palace in DAMASCUS, which won an AGA KHAN ARCHITECTURAL AWARD in 1983. Rapid urbanization occurred after World War I, especially in Damascus, ALEPPO, HAMA and Homs, due to the rising birth rate and migration from rural areas. With urban development came some destruction of traditional buildings, poorly regulated construction and the decline of such traditional skills as carpentry. UNESCO has been concerned to safeguard the historic quarters of Aleppo

and Damascus (*see also* URBAN DEVELOPMENT, §I) which were seen in the 1980s as in need of urgent attention. Syrian towns have also been damaged by armed conflict; in 1982, for example, an uprising in Hama resulted in large sections of the city being demolished. Traditional houses are generally modest structures. There are three typical house types: the iwan or living-room house, which consists of a covered space open on the fourth side; the *riwāq* or gallery house; and combination types. Domed mud houses are built in northern Syria (see fig.), but modern concrete-block houses are becoming increasingly widespread.

In the mid-19th century Syrian artists adopted European styles and subject matter in emulation of the artists working at the Ottoman court. Among the pioneers of modern Syrian painting were Tawfiq Tariq (1875–1945) in Damascus and Munib al-Naqshabandi (1890–1960) in Aleppo, who depicted contemporary and historical Arab events, which remained a popular subject under the French mandate. After 1920 some artists received scholarships to study in Cairo, Paris or Rome, and French artists visited Syria. Impressionism became influential, particularly in the work of Michel Kirsheh (1900–73), who depicted everyday life in Damascus. Artists also began to organize themselves into groups and hold exhibitions; in 1943, for example, the Arab Society of Fine Arts was established and the following year held an exhibition in Damascus of work by Syrian and foreign artists.

After independence, government agencies began to collect works of art and to set up fine-art centers throughout Syria. Artistic activities, including official exhibitions, are supervised by the Ministry of Culture, which took over from the Directorate of Fine Arts in 1958. A year later a College of Fine Arts was established in Damascus, based on the College of Fine Arts in Cairo. In 1972 the college became part of Damascus University. The Union of Fine Arts was established in 1969 and mediates between artist and patron. In 1971 the first Congress of Plastic Arts in the Arab

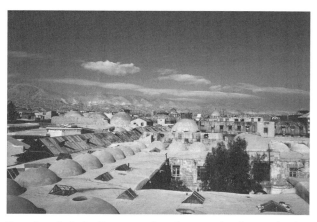

Domed roofs, Syria, Ottoman and modern periods; photograph taken 1975; photo credit: Sheila S. Blair and Jonathan M. Bloom

World took place in Damascus and resulted in the establishment of a pan-Arab association of artists.

Various trends developed from the mid-1950s as artists such as Adham Ismaʿil (1922–63), who used calligraphic forms in a modern context, became less inclined to imitate Western schools and more aware of their Arab–Islamic heritage (e.g. Arabic calligraphy, arabesque patterns, folk art, handicraft designs). Political and social themes have been a significant element in modern Syrian art, as in the work of FATEH MOUDARRES, who studied in Rome and Paris and was Professor of Fine Arts at Damascus. In his paintings figures and landscape are blended in a surreal, abstract style, such as his *Christ the Child of Palestine* (1989; Amman, N.G.F.A.). Mahmud Hammad (1922–88) also studied in Rome and founded the school of calligraphic painting in Syria. His abstract paintings were inspired by the shapes and movement of Arabic calligraphy (e.g. *Calligraphy*, 1985; Amman, N.G.F.A.). Impressionistic works depicting the Syrian countryside were painted by Nasir Shoura (1920–92). Traditional dress, folktales and decorated porcelain were some of the sources in the work of Nazir Nabaʿa (*b.* 1938), who studied in Cairo and Paris and became Professor of Fine Arts at Damascus University; his detailed, realistic style is charged with symbolism, as in his *Damascus* (1986; Paris, Inst. Monde Arab.). Several important expatriate artists lived in Europe and the USA, such as the painter and sculptor Sami Burhan (*b.* 1929), resident in Italy.

The most important centers of craft production are Damascus and ALEPPO. At Damascus in the early 20th century Koran boxes, Koran tables, trays, vases and other objects were made in the Mamluk Revival style of metalwork (see color pl. 3:IX, fig. 1; *see also* METALWORK, §IV, B), which alluded to metalworking traditions under the Mamluks (*r.* 1250–1517). After World War I the production of luxury goods declined, although after the oil boom in the 1970s craftsmen found new markets in the Gulf states and in tourism. In the late 20th century such crafts as inlaid woodwork, textiles and jewelry continued to be practiced.

From the late 17th century European travelers began to explore Syria and to record such sites as Palmyra, but it was not until the early 20th century that systematic exploration began, and under the French mandate laws were passed to prevent unauthorized excavations. In the 1920s and 1930s important sites such as Apameia, Dura Europos, Mari, Qalʿat Simʿan, Tell Brak and Ugarit were investigated. The building of the Furat Dam in the 1970s led to the loss of such sites as Habuba Kabira, but with aid from UNESCO these were largely investigated and documented before they were lost.

Through the Service des Antiquités the French established the first museums in Syria—at Damascus and Aleppo—and an important collection at Suwayda. In 1947 the Directorate General of Antiquities and Museums was established to conserve Syrian antiquities and supervise archaeological museums and excavations. The major archaeological collections are at the National Museum in Damascus (which also contains manuscripts) and Aleppo; there are also museums at Tartus, Latakia—which also houses an exhibition of contemporary art—and Suwayda (opened in 1991); for information on other archaeological museums *see* individual site articles. There are museums of popular arts and traditions in Damascus (in the ʿAzm Palace), Aleppo and BOSRA.

Enc. Islam/2: "al-Shām"

C. Imam: *Musée des arts et des traditions populaires: Palais Azem, Damas* (Damascus, 1964)

A. al-Rihawi: *Al-mabānī al-tārīkhiyya: Ḥimāyatuhā wa ṭuruq ṣiyānatuhā* [Historic buildings: their protection and methods of conservation] (Damascus, 1972)

A. Bahnassi: "Taṭawwur al-fann al-sūrī khilāl miʾat ʿām" [Development of Syrian art over one hundred years], *Al-ḥawlīyāt al-āthāriyya al-sūriyya*, xxiii (1973)

D. Chevallier: *Villes et travail en Syrie du XIXe au XXe siècle* (Paris, 1982)

G. Degeorge: *Syrie: Art, histoire, architecture* (Paris, 1983)

A. Bahnassi: *Ruwwād al-fann al-ḥadīth fī'L-bilād al-ʿarabiyya* [Pioneers of modern art in the Arab countries] (Beirut, 1985)

Art contemporain arabe, Paris, Inst. Monde Arab. (Paris, [1988])

Quatre Peintres arabes: Première (exh. cat., Paris, Inst. Monde Arab., 1988)

W. Ali, ed.: *Contemporary Art from the Islamic World* (London, 1989), pp. 253–60

R. Antoun and D. Quataert: *Syria: Society, Culture and Policy* (New York, 1991)

J. Kalter, M. Pavaloi and M. Zerrnickel: *Syrien, Mosaik eines Kulturraumes* (Stuttgart, 1991)

R. Burns: *Monuments of Syria: An Historical Guide* (London and New York, 1992)

J. Kalter and others: *The Arts and Crafts of Syria: Collection Antoine Touma and Linden-Museum, Stuttgart* (London and New York, 1992)

M. B. Behsh: *Towards Housing in Harmony with Place: Constancy and Change in the Traditional Syrian House from the Standpoint of Environmental Adaptation* (Lund, 1993)

A. Gangler: *Ein traditionelles Wohnviertel im Nordosten der Altstadt von Aleppo in Nordsyrien* (Tübingen, 1993)

Syrie: Mémoire et civilization (exh. cat.; Paris, Inst. Monde Arabe; 1993)

W. Ball: *Syria: A Historical and Architectural Guide* (Essex, 1994)

B. Bollmann: *Damaskus–Aleppo: 5000 Jahre Stadtentwicklung in Syrien*, Beiheft der Archäologischen Mitteilungen aus Nordwestdeutschland, 28 (Mainz am Rhein, 2000)

B. Keenan: *Damascus: Hidden Treasures of the Old City* (London, 2000)

D. B. Monk: An Aesthetic Occupation: *The Immediacy of Architecture and the Palestine Conflict* (Durham, NC 2002)

P. Mortensen, ed.: *Bayt al-ʾAqqad: The History and Restoration of a House in Old Damascus*, Proceedings of the Danish Institute in Damascus, 4 (Aarhus and Oakville, CT 2005)

H. Kennedy, ed.: *Muslim Military Architecture in Greater Syria: From the Coming of Islam to the Ottoman Period* (Leiden, 2006)

T

Tabriz [Tabrīz]. Capital city of the province of Azerbaijan in northwest Iran.

I. History and urban development. II. Art life and organization. III. Buildings.

I. History and urban development. Located on the banks of the Mihran River, the site owes its importance to its strategic location on the only negotiable pass linking the east–west trade route between Trebizond and the Caspian Sea and the northern route into the Caucasus. In the early Islamic period it was a small center less than half a mile square and was known for its brisk trade and manufacture of textiles. In 1299 under Ghazan, seventh ruler of the ILKHANID dynasty (*r.* 1256–1353), it was raised to the status of imperial capital. The urban core lay on the south bank of the river: at the center was the congregational mosque, surrounded by bazaars that connected to gates in the city walls. Ghazan tripled this area to a perimeter of 25,000 paces, the size of the city until the 19th century. The Ilkhanid capital had two suburbs, that of Ghazan on the west and that of his vizier RASHID AL-DIN on the east (*see* §III, A below). The western suburb, Shanb-i Ghazan, included institutions of learning, a library, a hospital, a mosque and the sultan's own magnificent tomb.

The only monument surviving from the Ilkhanid period is the Arg (see fig. 1), originally a huge barrel-vaulted hall (30×65 m; walls 10.4 m thick). The vault,

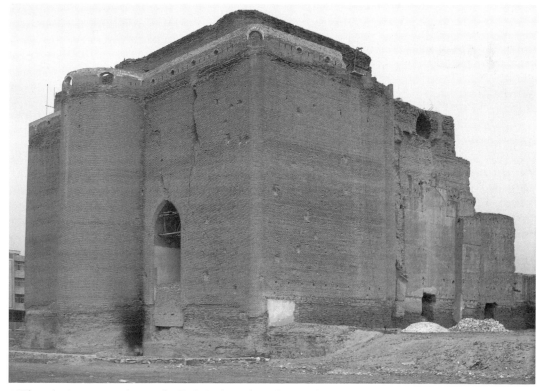

1. Tabriz, the Arg, *c.* 1310; photo credit: Sheila S. Blair and Jonathan M. Bloom

intended to surpass the fabled Sasanian iwan at Ctesiphon, fell soon after its construction. Located just outside the city gate on the south, the hall formed the principal component of the new congregational mosque ordered by the vizier ʿAlishah, which also had a large, richly decorated forecourt with a pool and several outbuildings (*see* ARCHITECTURE, §VI, A, 1).

Tabriz continued as an artistic center after the fall of the Ilkhanids. The Jalayirid sultan Uways I (*r.* 1356–74) built the Dawlatkhana, a palace said to have had 20,000 rooms decorated with paintings; it continued to be used into the following century. The city was taken repeatedly by TIMURID rulers (*r.* 1370–1506) and many of its public monuments were destroyed and its artisans carried off to Central Asia, but building was resumed and manuscript production re-established under the Turkoman confederacies of the Qaraqoyunlu (*r.* 1380–1468) and the Aqqoyunlu (*r.* 1468–1508). The garden suburbs north of the river were developed for palatial estates and religious complexes such as the mosque, hospital and Hasht Bihisht, the palace of Uzun Hasan (*r.* 1453–78). The Blue Mosque (*see* §III, B below) is the only surviving example of the rich architectural patronage of the Turkmen (*see* ARCHITECTURE, §VI, A, 2).

In 1500 control of Azerbaijan passed to the SAFAVID dynasty, but in 1514 Tabriz was taken by the Ottoman sultan Selim I (*r.* 1512–20), who carried away many of the city's treasures, including 1000 artisans. Ottoman armies continued to harass the city throughout the 16th century, and the Ottoman threat caused the Safavid shah Tahmasp (*r.* 1524–76) to move the capital to QAZVIN. With the growing importance of the Russian frontier, Azerbaijan became of special interest to the Qajar dynasty (*r.* 1779–1924). New avenues were cut through the city core, and new mosques and caravanserais were built after the devastating earthquake of 7 January 1780. Large gardens, such as the Bagh-i Shimal on the south, were the stage for intrigues among foreigners.

Enc. Islam/2
M. J. Mashkur: *Tārīkh-i Tabrīz tā pāyān-i qarn-i nuhum-i hijrī* [History of Tabriz to the end of the 9th century AH] (Tehran, Iran. Solar 1352/1973)
C. Melville: "Historical Monuments and Earthquakes in Tabriz," *Iran*, xix (1981), pp. 159–77
C. Adle: "Le prétendu effondrement de la coupole du mausolée de Qâzân Xân à Tabriz en 705/1305 et son exploitation politique," *Stud. Iran.*, xv (1986), pp. 267–71
H. Sultanzadeh: *Tabriz: Khishti ustuvar dar miʿmari-i Iran* [Tabriz, a solid cornerstone of Iranian architecture] (Tehran, 1997)
I. P. H. Khuniq: *Tabriz bih rivayat-i tasvir* [Tabriz in pictures] (Tabriz, 2005) [chiefly illustrations; captions in Persian and English]

II. Art life and organization. From the 14th century to the mid-16th, Tabriz was a major artistic and intellectual center in Iran known for its production of illustrated manuscripts. A school of painting flourished there under the Ilkhanids, as attested by several copies (Edinburgh, U. Lib., Arab. MS. 20; London, Nour priv. col.; Istanbul, Topkapı Pal. Lib., H. 1653, 1654) of Rashid al-Din's *Jāmiʿ al-tawārīkh* ("Compendium of histories") produced there in the early 14th century, probably at the Rabʿ-i Rashidi (*see* §III, A below; *see also* ILLUSTRATION, fig. 8). The city's cosmopolitan nature meant that artists drew on a variety of ideas and sources to create a highly innovative and sophisticated pictorial style. This new artistic idiom is best reflected in a copy (ex-Demotte priv. col.; dispersed) of the *Shāhnāma* ("Book of kings"), one of the most celebrated Persian illustrated manuscripts (*see* ILLUSTRATION, fig. 9). Internal evidence suggests that the codex was executed *c.* 1335 for Rashid al-Din's son Ghiyath al-Din, who served as minister to the Ilkhanid court from 1328 to 1335. Tabriz was an administrative seat of the Jalayirids (*r.* 1336–1432), and such fine illustrated manuscripts as a copy (*c.* 1405–10; Washington, DC, Freer, 31.32–31.37) of Nizami's *Khusraw and Shirin* continued to be produced there despite repeated seizure by the Timurids.

The arts flourished at Tabriz under the Turkmen confederations in the later 15th century. The AQQOYUNLU rulers Uzun Hasan (*r.* 1453–78), Khalil (*r.* 1478) and Yaʿqub (*r.* 1478–90) were all major patrons of the illustrated book, and the brilliant color and exuberant drawing of the Turkmen court style can best be seen in a copy (Istanbul, Topkapı Pal. Lib., H. 762) of Nizami's *Khamsa* ("Five poems"), begun in the mid-15th century. The city was also a center for the production of ceramics and glazed tiles, as attested by the Blue Mosque (*see* §III, B below). In the first half of the 16th century under the Safavids, Tabriz was associated with one of the most remarkable schools of book production in Iran (*see* PATRONAGE, fig. 1). Artists from all over the empire joined forces to forge a new pictorial style, which culminated in the monumental copy (ex-Houghton priv. col.; dispersed; *see* PAPER, color pl. 3:IV) of the *Shāhnāma* prepared for Tahmasp (*r.* 1524–76). With its 258 illustrations, the manuscript rivaled the earlier Ilkhanid copy in scope and splendor. The Safavids also established a state manufactory for carpets at Tabriz and several fine examples, including the Ardabil carpets (London, V&A, and Los Angeles, CA, Co. Mus. A.), are often attributed there (*see* CARPETS AND FLATWEAVES, §III, C). With Tahmasp's transfer of the capital to Qazvin in 1548–9, Tabriz ceased to play a leading role in the administrative and artistic life of Iran. A commercial carpet industry was revived in the 19th century, and carpets were also produced in such surrounding villages as Heriz, a name that has become synonymous with a distinctive angular design (*see* CARPETS AND FLATWEAVES, §IV, C).

K. Jahn: "Täbris, ein mittelalterliches Kulturzentrum zwischen Ost und West," *Anz. Österreich. Akad. Wiss. Philos.-Hist. Kl.*, cv/16 (1968), pp. 201–13

O. Grabar and S. Blair: *Epic Images and Contemporary History: The Illustrations of the Great Mongol Shahnama* (Chicago, 1980)

M. B. Dickson and S. C. Welch: *The Houghton Shāhnāmeh*, 2 vols. (Cambridge, MA, 1981)

J. T. Wertime and R. E. Wright: "The Tabriz Hypothesis: The Dragon & Related Floral Carpets," *Halι Annual*, ii (1995), pp. 31–53; 188–9

M. D. Nazarli: "Funktsional'noe prednaznachenie knizhnoĭ miniatyury Tebrizskogo dvora XVI v." [Functional peculiarities of the Tabriz court XVI century book miniatures], *Vostok*, ii (1996), pp. 89–97; 208

J. T. Wertime: "The Tabriz Hypothesis Revisited," *Halι*, cix (2000), pp. 91–3

S. R. Canby: *The Golden Age of Persian Art: 1501–1722* (London, 2000), chap. 3, pp. 40–62

Hunt for Paradise: Court Arts of Safavid Iran, 1501–1576 (exh. cat., ed. J. Thompson and S. R. Canby; London, BM; Milan, Mus. Poldi Pezzoli; New York, Asia Soc. Gals.; 2003)

III. Buildings.

A. Rabʿ-i Rashidi. B. Blue Mosque.

A. RABʿ-I RASHIDI [Rabʾ-i Rashīdī]. Eastern suburb of Tabriz founded by the Ilkhanid vizier Rashid al-Din in 1309. Although almost totally destroyed, the quarter can be reconstructed from the text of its endowment deed. Surrounded by ramparts, it had a monumental entrance complex leading to the main section, which included the founder's tomb complex, a hospice, a *khanaqah*, a hospital and service buildings. The prodigious endowment, second only to those established by Ilkhanid sultans, was clearly designed to keep the income in the patron's family: half went to the overseers (Rashid al-Din and, after his death, his sons); the other half provided support for more than 300 employees and slaves and upkeep for the buildings, which were meant to commemorate the family. The focus of the complex was the tomb where the Koran was recited around the clock and feasts and special readings were held on holidays. The endowment also provided for the annual copying of a 30-volume manuscript of the Koran and a collection of traditions of the Prophet, and an addendum dated 1314 directed the overseer to commission annually two copies (one in Arabic, the other in Persian) of Rashid al-Din's own works. The form of all these manuscripts was carefully specified (good Baghdadi paper, neat script, careful collation with the original and leather binding), and the few that have survived, such as a copy (1314–15; divided, Edinburgh, U. Lib., Arab. MS. 20, and London, Nour priv. col.) of the *Jāmiʿ al-tawārīkh* ("Compendium of histories") show that the patron's instructions were faithfully executed.

D. Wilber and M. Minovi: "Notes on the Rabʿ-i Rashidi," *Bull. Amer. Inst. Iran. A. & Archaeol.*, v (1938), pp. 247–59

D. Wilber: *The Architecture of Islamic Iran: The Il-Khanid Period* (Princeton, 1955), pp. 129–31

S. S. Blair: "Ilkhanid Architecture and Society: An Analysis of the Endowment Deed of the Rabʿ-i Rashidi," *Iran*, xxii (1984), pp. 67–90

S. S. Blair: *A Compendium of Chronicles: Rashid al-Din's Illustrated History of the World* (1995), xxvii of *The Nasser D. Khalili Collection of Islamic Art*, ed. J. Raby (London, 1992–)

B. Hoffmann: "Rašīduddīn Faʿdlallāh as the Perfect Organizer: The Case of the Endowment Slaves and Gardens of the Rabʿ-i Rašīdī," *Proceedings of the Second European Conference of Iranian Studies held in Bamberg, 30th September to 4th October 1991*, ed. B. G. Fragner and others, Serie Orientale Roma, 73 (Rome, 1995), pp. 287–96

B. Hoffmann: *Waqf im mongolischen Iran: Rašīduddīns Sorge um Nachruhm und Seelenheil* (Stuttgart, 2000)

B. BLUE MOSQUE [Masjid-i kabūd; Muẓaffariyya]. One of a large complex of buildings erected in 1465 by Khatun Jan, wife of the Qaraqoyunlu sultan Jahanshah (*r.* 1438–67), outside the southeast entrance to the city. According to an endowment deed dating from the previous year, it was intended as a mausoleum for the queen and her family but may have been for the sultan himself. The complex also included a hospice for mystics, with two pools fed by a canal (destr.). The mosque is known for its unusual plan and brilliant tile mosaic revetments that are unmatched for their variety and technical virtuosity (see fig. 2). The central square hall, once covered by a large dome (diam. 16 m), is enclosed on three sides by a U-shaped corridor covered with seven domes. Behind the square hall on the axis of the main entrance is a smaller domed hall containing a mihrab. The plan, also used in the Shah Mosque in Mashhad (1451), built by an architect from Tabriz, has been connected to that used for Bursa-type mosques built under the early Ottomans in Anatolia (*see* ARCHITECTURE, §VI, B, 2). Ottoman mosques are not known to have been used for funerary purposes, but the Timurids, the contemporary rulers of Central Asia, did build funerary mosques, such as the Ishrat Khana and Aksaray in Samarkand, although with a different arrangement. Both the interior and exterior of the Blue Mosque were covered with tile mosaic, predominantly in blue (*see* ARCHITECTURE, fig. 32). In addition to the dense floral and arabesque designs characteristic of Timurid architecture, there are medallion-shaped panels set against a background of unglazed brick tiles. The most lavish decoration was concentrated on the hall with the mihrab: it had a white marble dado with Koranic verses elegantly carved along the upper border, and its walls and zone of transition were clad in a purple mantle of small hexagonal tiles accented with designs in gold leaf.

F. Sarre: *Denkmäler persischer Baukunst* (Berlin, 1901–10), pp. 27–32, pls. XX–XXVIII, figs. 23–9

A. U. Pope and P. Ackerman, eds.: *Survey of Persian Art* (2/1964–7), pp. 1130–31 and pls. 452–6

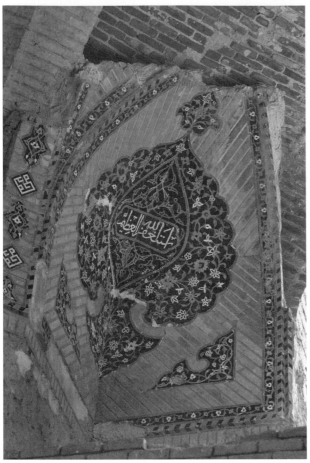

2. Tilework, interior of the Blue Mosque, Tabriz, 1465; photo credit: Sheila S. Blair and Jonathan M. Bloom

J. T. Tabataba'i: *Naqshhā va nigāshtihā-yi masjid-i kabūd-i tabrīz* [Paintings and drawings of the Blue Mosque of Tabriz] (Tabriz, 1969)

L. Golombek and D. Wilber: *Timurid Architecture of Iran and Turan* (Princeton, 1988), pp. 407–9, pls. 415–26, color pl. XVb, fig. 140

Tāherī. *See* Sīraf.

Tajikistan. Republic in Central Asia bounded by Uzbekistan to the west, Kyrgyzstan to the north, China to the east and Afghanistan to the south (see fig.). The capital Dushanbe in the west was transformed from a village after 1929 when it was connected to the Transcaspian Railway.

The history of the territory reflects its position as a gateway to the Transoxiana plains. From the 6th century bce it was part of the Achaemenid Empire until taken by Alexander the Great *c.* 334 bce. Thereafter it fell within the Greco-Bactrian orbit (mid-3rd century–2nd bce) until overrun by Yueh-chih and possibly also Saka (Scythian) nomads *c.* 145 bce.

Subsequently the Yueh-chih/Tokharians and one of the Yueh-chih tribes, the Kushanas, held sway: the Kushanas were powerful from the 1st to the 3rd century ce when Ardashir I (*r.* 224–41) incorporated the region into the Sasanian Empire. The Sasanians were overwhelmed by the Huns in 425. Significant Turkic invasions followed, and in the 6–8th centuries the Turkic Khaqanate was dominant. Major pre-Islamic sites have been excavated at Pendzhikent and Khodzhent. The Arab conquest was succeeded by the Tahirids, Saffarids, Samanids and then by the Qarakhanids in the 10th century, the Saljuqs in the 11th and 12th and the Mongols in the 13th and 14th. Despite a sequence of Turkic overlords, the Tajiks themselves remained Iranian, not Turkic, a distinction preserved by their sedentary rather than nomadic existence. For the rest of their history the Tajiks were closely tied to the Uzbeks but maintained a de facto independence on the edge of Uzbek territory. Russian interest in the area in the 18th and 19th centuries led to the taking of Ura tyube and Khodzhent, while the emirate of Bukhara took Karategin and Darwen in the 1870s, so that the area was effectively divided into two parts, north and south, both in the hands of external rulers. After the 1917 Revolution the Russian lands were included in the Turkestan SSR. The nominally independent Bukhara was taken by the Red Army in 1921, and in 1924 the Tajik ASSR, comprising both Russian and Bukharan lands, was created within the Uzbek SSR. In 1929 the area was renamed the Tajik SSR and gained Khodzhent, then part of the Uzbek SSR. As a result of the break-up of the USSR Tajikistan declared independence on 9 September 1991.

I. Architecture. II. Painting and sculpture. III. Decorative arts.

I. Architecture. Fortified structures in Tajikistan, such as the citadels in Hissar, Khodzhent and Isfara, incorporate medieval traditions. Religious buildings (two madrasas in Hissar, dating from the turn of the 18th/19th century and from the mid-19th century respectively) repeat the forms of earlier periods. Tajik architects concentrated on the construction and decoration of town buildings and rural mosques and housing. The widespread and varied use of wood (beamed roofs resting on columns with figured bases and capitals; plank ceilings with lofty cornices) encouraged the development of such kinds of architectural detail as deep relief carving and polychrome tempera painting on wood. Walls were decorated with carved and painted *ganch*, a local type of stucco distinguished by its white color, and an impression of great richness was created by patterns done in the *kundal* technique (painting in bright colors, including gilt and silver, on relief *ganch* ground). Local schools of architectural ornamentation were formed in Ura Tyube, Khodzhent and Isfara, as well as in Samarkand and Bukhara, with their sizeable Tajik populations.

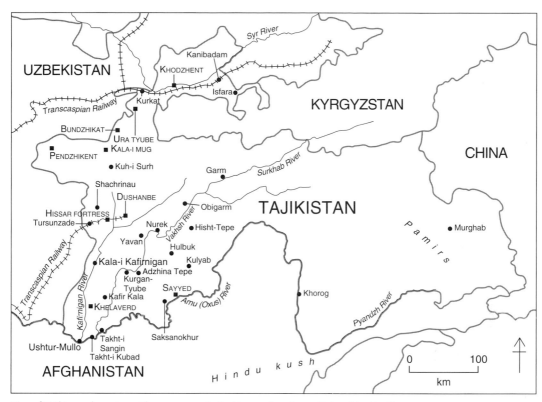

Map of Tajikistan; those sites with separate entries in this encyclopedia are distinguished by CROSS-REFERENCE TYPE

In Soviet times the patriarchal life of dilapidated old towns and villages was destroyed by the rapid construction of factories, power stations, railways and planned towns. The capital of Soviet Tajikistan, Dushanbe, was built from scratch on the site of a small village. In the 1930s and 1940s, and again in the 1960s, uniform plans formed the basis for the reconstruction of old towns such as Khodzhent, Kurgan-Tyube, Kanibadam, Isfara, Ura Tyube and Kulyab, while the new industrial towns of Nurek, Tursunzade (Regar) and Yavan were founded in the 1950s and 1960s. Until the late 1960s the architecture of Tajikistan, despite attempts to use traditional local architectural elements, remained a provincial version of general Soviet styles, and projects were usually designed by foreign architects. In the 1970s, given the complex mountainous terrain, high seismicity and hot climate, construction projects tended increasingly to accord with the national heritage (e.g. a school in the resort of Obigarm, 95 km from Dushanbe, 1200–1300 m above sea-level; by M. Bobosaidov, 1980–82; 500-bed sanatorium in a high mountainous gorge at the resort of Khodja obi Garm, 48 km from Dushanbe, 1800–2000 m above sea-level; by Eduard Vladimirovich Ersovsky (*b.* 1938) and others, 1984).

II. Painting and sculpture. The figural arts of Soviet Tajikistan were initially (in the 1920s) bound up with Samarkand, then the capital of the Uzbek SSR, which included the autonomous republic of Tajikistan. After the formation of the Tajik SSR (1929), its purpose-built capital, Dushanbe, became the artistic center, and the painters Eremey Grigorievich Burtsev (1894–1942) and Porphiriy Ivanovich Fal'bov (1906–67), together with the Moscow artists Piotr Nicholaevich Staronosov (1893–1942), Igor Alexandrovich Ershov (1907–74) and others, moved there. In the 1930s the Tajik artist and portrait painter Abdullo Ashurov (1904–77) and the landscape painter M. Khoshmukhamedov began to work. Most artists followed the tradition of Russian Realism, but a few (e.g. P. I. Fal'bov) turned to Expressionism and Revolutionary art. During World War II a series of propaganda posters (e.g. for the Okna Tadzhik TA ("Windows of Tajikistan"), the Tajik telegraphic agency, modeled on the Okna TASS)—colored posters designed by famous Soviet artists and poets—were printed in Dushanbe. In post-war years and in the 1950s the increased number of professional artists, including many who had studied in Leningrad (now St. Petersburg), led to a strengthening of the links between Tajik art and the Russian SFSR and prepared the ground for a more intensive artistic growth in Tajikistan itself. In the 1960s and 1970s many individual talents emerged, including those of the painter Zuhun Nurdjanovich Khabiboulayev (*b.* 1932); the sculptors Orif Abdur-raufovich

Akhunov (*b.* 1936) and Valimad Odinayev (*b.* 1945); the monumental artists Asror Tashpulatovich Amindzhanov (*b.* 1930), Sukhrob Usmanovich Kurbanov (*b.* 1946), Savzali Negmatovich Sharipov (*b.* 1946), Murirat Dambunayevich Beknazarov (*b.* 1943) and Zieratsho Davutov (*b.* 1946); and the tapestry artist Dot Abdusamatov (*b.* 1941). Their work, using contemporary forms and methods, but preserving national aesthetic traits, is evidence of the formation of an independent school of contemporary Tajik art. Work of the 1980s shows a wide variety of styles, techniques and subjects, together with heightened interest in the national heritage and a free use of the repertory of world art. The main collections of Tajik art are housed in the Republican, Historical, Regional and Fine Arts Museum in Dushanbe.

III. Decorative arts. The Tajiks, who from the earliest times had practiced various kinds of urban crafts, had developed many types of decorative art throughout their territories by the late feudal period. Tajik potters, carvers, gilders, weavers, embroiderers, gold embroiderers, engravers and jewelers worked in Bukhara and Samarkand. In Khodzhent, Isfara, Kanibadam and Ura Tyube, they made ceramics with greenish-blue and brownish-yellow underglaze painting with the portrayal of flowers and *Chini-safol* ("Chinese motifs"). The expertise of jewelers is shown in the abundance of small lively details and cascades of elegant design, distinguishing women's ornaments (for foreheads, tresses, chests, shoulders, heads etc.) using silver and electroplating, with insets of cabochons of precious stones and hardstones, and fish, bird, half-moon, palm and arch motifs (*see also* CENTRAL ASIA, §VIII, F). Fabrics exhibited diversity: in Khodzhent more than 60 types of silk and cotton fabrics—striped, patterned and with a bright picture of *abr* ("cloud")—were made, while in Ura Tyube a firm and light material (*tibit*), from sheep's wool and goat and camel hair, was produced. Printed fabrics were widely popular, with images printed in terracotta and black with wooden rollers. In the mountain villages and the valleys the main decoration for the national costume was embroidery with satinstitch, tambour stitch and a dense small cross-stitch. Many other items were embroidered: bedspreads, towels, personal veils, room friezes, prayer-mats and wall panel-hangings.

After Central Asia had become part of Russia (*c.* 1860–80), the flow of imported machine-made articles appreciably reduced the local production of fabrics and embroidery by hand. Acquaintance with the output of Russian centers resulted in the appearance in Tajik ornament of foreign decorative motifs, and the introduction of aniline dyes led to coarser, harder coloring. However, these changes did not affect all aspects of art: some branches of traditional handicrafts continued to develop and flourish in the 20th century. In the Soviet period, national artistic traditions took on a new life in the creative works of the masters of ornamental painting (Mirzorahmat Alimov (1891–1971), Yuldashbek Baratekov

(1890–1967)), wood-carving (Sirodzhiddin Nuritdinov (*b.* 1919)), *ganch*—a type of stucco work, hand embroidery (Zulfiya Bakhretdinova (*b.* 1922)) and painted ceramics (Ashurbay Mavlyanov (1908–69), Safar Sakhibov (*b.* 1926), R. Khodzhiev (*b.* 1914)). In addition to traditional national industries, various decorative arts that were new to Tajikistan developed: tapestry weaving, artistic working of stone and metal and the making of porcelain and contemporary ceramics.

Enc. Islam/2: "Tādjīkistān"

L. Aini: *Iskusstvo Tadzhikskoi SSR* [Art of the Tajik SSR] (Leningrad, 1972) [in Tajik, Rus. and Eng.]

N. Yunusova: *Tadzhikskaya vyshivka* [Tajik embroidery] (Moscow, 1979)

N. Bellinskaya, M. Ruziev and N. Yunusova: *Po zakonam krasoty* [According to the law of beauty] (Dushanbe, 1981)

V. G. Vecelovskiy, R. S. Mukimov and M. Kh. Mamadnuzarov: *Arkhitektura Sovetskogo Tadzhikistana* [Architecture of Soviet Tajikistan] (Moscow, 1987)

L. S. Aini: *Izobrazitelnoye iskusstvo Tadzhikskoi* (Moscow, 1990) [album]

A. I. Maniakhina and N. N. Negmatov: *Katalog fondov Severo-Tadzhikistanskoi arkheologicheskoi kompleksnoi ekspeditsii* (Dushanbe, 1997) [Catalogue of the finds of the Northern Tajik archaeological expedition]

N. Z. Yunusova: "Tajik Skullcap," *J. Cent. Asia*, xx/1 (1997), pp. 1–27

N. Nekrasova, P. Clark and A. J. Ahmed: *Treasures from Central Asia: Islamic Art Objects in the State Museum of Oriental Art, Moscow* (London, 1998)

A. Rajabov, P. Dzhamshedov and M. Mamadnazarov: *Ancient Cilivization [sic] and its Role in Formation and Developing of Central Asian Culture of Samanides Epoch* (Dushanbe, 1999)

B. I. Marshak and V. A. Livshitz: *Legends, Tales, and Fables in the Art of Sogdiana* (New York, 2002)

G. Maitdinova and N. N. Negmatov: *Istoriia tadzhikskogo kostiuma* (Dushanbe, 2003) [History of Tajik costume]

R. M. Masov, S. G. Bobomulloev and M. A. Bubnova: *Osorkhonai millii bostonii Tojikiston/Natsional'nyi muzei drevnostei Tadzhikistana/Musée National des Antiquités du Tadjikistan/National Museum of Antiquities of Tajikistan* (Dushanbe(?), 2005)

M. Dinorshoev: "Tajikistan," *Towards the Contemporary Period: From the Mid-nineteenth to the End of the Twentieth Century*, ed. M. K. Palat and A. Tabyshalieva, vi of *History of Civilizations of Central Asia* (Paris, 2005), pp. 289–303

R. S. Mukimov and S. M. Mamadzhanova: *Arkhitekturno-khudozhestvennoe nasledie TSentral'noi Azii* [Architectural and artistic heritage of Central Asia] (Dushanbe, 2006) [Russian; Summary and table of contents in English]

A. Rajabov and R. S. Mukimov: *Ocherki istorii i teorii kul'tury tadzhikskogo naroda* (Dushanbe, 2006) [Notes on the history and theory of the culture of the Tajik people]

Talas. *See* ZHAMBYL.

Tanavoli, Parviz (*b.* Tehran, 1937). Iranian sculptor, painter, art historian and collector. He studied sculpture at the College of Fine Arts at Tehran University,

graduating in 1956, and then attended the Accademia di Belle Arti in Carrara (1956–7) and the Accademia di Belle Arti in Milan (1958–9), where he worked under Marino Marini. In 1960 he began to teach at the College of Decorative Arts in Tehran, and in 1961 he was invited to the Minneapolis College of Arts and Design as a visiting artist, where he taught sculpture until 1963. In 1964 he returned to Tehran to teach sculpture at the College of Fine Arts. Primarily a sculptor, he has worked with a range of materials, including bronze, copper, brass, scrap metal and clay. In the 1960s he contributed to the art movement in Iran known as SAQQAKHANA, and he made sculptures that were reminiscent of religious shrines and objects. Pairs of figures and fantastic birds were also common subjects. Themes from classical Persian literature also influenced him. He frequently rendered the word *hich* (nothing) as a sculpture in calligraphic form (*see* IRAN, color pl. 2:XI, fig. 1), using the word on a small scale for a ring and on a large scale for a sculpture in stainless steel (h. 3.35 m) on the campus of Hamline University, St. Paul, MN, where he was visiting artist in 1971. The same year he made bronze gates for the tomb of Riza Shah in Rayy. He exhibited his work widely and received commissions from all over the world. He taught at art colleges and universities in Iran and the USA, retiring from his position of professor of sculpture at Tehran University in 1981. As an art historian he wrote books and articles on Iranian art, especially rugs and textiles. His writings, like his sculptures, demonstrate an awareness of the traditions of Iranian life gained from extensive travel to villages and tribal areas. He also formed collections of Islamic rugs, textiles, tools, locks and naive stonework.

WRITINGS

Locks from Iran: Pre-Islamic to Twentieth Century (exh. cat., Washington, DC, Smithsonian Traveling Exhibition; 1987)

Lion Rugs: The Lion in the Art and Culture of Iran (Basle, 1985)

with I. A. Firouz: *Shahsavan Iranian Rugs and Textiles* (New York, 1985)

Kings, Heroes and Lovers: Pictorial Rugs from the Tribes and Villages of Iran (London, 1994)

Horse and Camel Trappings from Tribal Iran (Tehran, 1998)

with A. Neshati: *Persian Flatweaves: A Survey of Flatwoven Floor Covers and Hangings and Royal Masnads* (Woodbridge, 2002)

Sormehdan: Kohl Containers of Iran from Prehistory to the 19th Century, trans. C. Ferguson (Tehran, 2007)

BIBLIOGRAPHY

K. Emami: "Tanavoli Turns Popper," *Keyhan Int.* (8 Nov. 1965)

Parviz Tanavoli: Fifteen Years of Bronze Sculpture (exh. cat. by A. W. Grey and others; New York U., Grey A.G., 1976–7)

J. Allan and B. Gilmour: *Persian Steel: The Tanavoli Collection*, Oxford Stud. Islam. A., xv (Oxford, 2000)

D. Galloway, ed.: *Parviz Tanavoli: Sculptor, Writer and Collector* (Tehran, 2000)

Parviz Tanavoli: Recent Bronzes (exh. cat., Vancouver, Elliott Louis Gal., 2006)

Word into Art: Artists of the Modern Middle East (exh. cat. by V. Porter; London, BM, 2006), no. 52 and p. 141

Tanzania, United Republic of [Swahili Jamhuri ya Mwungano wa Tanzania]. Country in East Africa comprising the mainland area of Tanganyika and the major island of ZANZIBAR, as well as a number of smaller islands, which joined to form the United Republic in 1964. Tanganyika is bordered by Uganda and Kenya to the north, by the Indian Ocean to the west, by Mozambique, Lake Malawi, Malawi and Zambia to the south, and by the Democratic Republic of Congo (formerly Zaïre), Rwanda and Burundi to the west (*see* AFRICA, fig. 1). The capital is Dodoma, though the economic and administrative center and the largest city by far is Dar es Salaam.

I. Geography and history. II. Painting, sculpture and graphic arts. III. Museums, galleries and art education.

I. Geography and history. Much of mainland Tanzania is a vast savannah plateau, intersected by an arm of the Great Rift Valley, rising westwards and southwards to higher, more fertile areas, and sloping eastwards to the Indian Ocean coast. The islands, Zanzibar and Pemba especially, are fertile, spice-growing islands famous for their cloves. The total land area of Tanzania is 945,087 sq. km. The majority of the population of 38 million (November 2006 estimate) are Bantu-speakers, though there are also Nilotic-speaking groups, including Maasai, as well as a number of Europeans and Asians. The national and official language is Swahili, spoken by 95% of the population, though English is also used in education and government. A third of the population is Muslim, a further third Christian, while others follow traditional religions.

The area has been subject to many external influences: Zanzibar has ancient links with Arabia as well as with the African mainland. Long-distance trade developed markedly during the 19th century, when traders from the coast brought with them Arab culture and the Swahili language. Contacts with the external world increased after the sultan of Muscat moved his capital to Zanzibar in 1840. French, American, British and German interests began to compete for trade, and from the 1860s Christian missionaries and Western explorers began to infiltrate the mainland. The mainland area was annexed by Germany in 1884 as part of German East Africa, while Zanzibar came under a British Protectorate in 1890. Tanganyika became a British mandated territory under the League of Nations in 1919 (later a UN trusteeship), becoming independent in 1961 and a republic in 1962. Zanzibar became independent in 1963. Throughout its colonial history the area's economic development was slow and uneven. Since independence Tanzania has pursued a policy of African socialism.

Traditional beliefs have continued to exert an influence on modern Tanzanian life and to inspire

music, dance and sculpture into the 1990s. Daily lives largely follow the customs and practices that developed over thousands of years, and, although Tanzanian culture has been affected by foreign contact, the struggle to preserve and promote the country's cultural heritage without creating cultural isolation has been considered to be of great importance. One area in which traditional practices have continued vigorously is house building. The Chagga, for example, still construct the round buildings typical of East Africa, where the grasslands provide materials for the distinctive thatches that are built down to ground-level. These houses follow traditional arrangements, with each family homestead surrounded by banana groves and a dry stone wall or low hedge, and the larger clan area being demarcated by a larger hedge or an earth bank. Modifications introduced in the 20th century include the introduction of cement blocks and corrugated metal roofing to replace traditional materials.

In the 1980s the Conservation of Historical Monuments Authority, with financial assistance obtained locally and internationally, embarked on the conservation of the ancient, stone town of Zanzibar, using local original building materials and techniques. Once restored, buildings were used for accommodation and shops or as historical tourist attractions. Large private investment, as well as being used for the construction of new houses, has also been directed into the rehabilitation of the old houses. Typically several stories high, they have elaborate wooden, carved balconies and brass-studded doors. Door-carvings include representations of natural objects and of such pre-Islamic motifs as lotuses, fish and date palms. There are over 500 such carved doors in Zanzibar town.

The restoration of the stone town has encouraged the revival of cottage industries and medium-scale business producing chests, silver and brass trays and paintings. From 1972 Nyumba ya Sanaa (the House of Arts), Dar es Salaam, which sponsors the production of traditional arts, expanded from two art and craft centers to fifteen different workshops. Focusing on employing handicapped youths, Nyumba ya Sanaa encourages the production of such items as jewelry, hand screen- and other textile prints, tie-and-dye fabrics, woven and embroidered goods, basketry and pottery.

Following independence in 1961, cultural ministries were assigned to find and revive the best traditional customs. Specific bodies offering patronage include the National Art Council of Tanzania, responsible for the development and promotion of traditional arts, and the National Cottage Industries Corporation (NCIC), established in 1965 by the government's National Development Corporation. In the early 1990s the NCIC continued to offer both training in craft production and business management and also practical assistance in setting up cottage industries. In addition, the state-run Tanzanian Handicrafts Marketing Corporation (HANDICO) bought such locally produced arts and crafts as sculptures, leather goods, batik fabrics, basketry and Tingatinga paintings (*see* §II, below), selling them through its own shops or overseas.

II. Painting, sculpture and graphic arts. Several groups of artists with little formal art education were established in Dar es Salaam in the 1980s and 1990s, including the Kinodoni Art Group of graphic artists, and a group founded by Edward Saidi Tingatinga (1937–72), who developed a style of painting using household paints and emulsion on hardboard, which he taught at the Msasani Workshop, Dar es Salaam. The paintings of Tingatinga artists, as they are known, have distinctive designs portraying animals, trees and other natural objects and evoke a mood of tranquility. Their work has been popular with visitors to Tanzania and is frequently sold abroad. Other artists of the same generation as Tingatinga include Fatima Shaaban Abdullah (*b.* 1939), who trained at the Women's Teacher Training College, Zanzibar (1959), and the Makerere School of Fine Arts, Kampala, Uganda (1959–64), before going on to teach at the Nkrumah Teacher Training College, Zanzibar (from 1964). Her works, characterized by rich colors, boldly applied, have been widely exhibited in Africa, America and Europe. The painter and printmaker Francis Msangi (*b.* 1937) also trained at the Makerere School of Fine Arts (1959–64). From 1973 to 1985 he was in the USA, where he received a B.F.A. degree from the California College of Arts and Crafts, Oakland, and a Ph.D. in education from Stanford University. Msangi has taught widely in the USA and East Africa, where from 1985 he was a lecturer at Kenyatta University, Nairobi, Kenya. Msangi's work is often explicitly political, dealing with apartheid and other forms of oppression as well as political assassinations and other such events. Even in such non-political works as *Women Working in the Field* (*c.* 1970; Frankfurt am Main, Mus. Vlkerknd.), his colors are often brilliant and his shapes bold and violent. Sam Ntiro (*b.* 1923) became well known for his interpretations of Tanzanian rural scenes. His realistic representations of everyday life include murals on public buildings. Educated at the Slade School of Fine Art, London, he was acting head of the Makerere School of Fine Arts, Kampala, Uganda (1956–8, 1960–61) before being appointed to various diplomatic and ministerial posts. He has had many international exhibitions, and examples of his work are in the permanent collections of a number of institutions (e.g. London, Commonwealth Inst.; New York, MOMA).

A younger generation of painters emerged in Tanzania during the 1980s. Their work is characterized by a move away from abstract and non-objective designs towards an academic and realistic manner of conveying subjects of social concern. This generation includes such artists as Raza Mohamed, Peter Paul Ndembo, Louis Mbughuni and John Masanja. In Zanzibar, Abdallah Farahani and his son Iddi Abdallah Farahani have produced watercolor landscapes and seascapes, while Dr. Ali Hussein Darwish started

with figurative painting before moving to designs based on Arabic calligraphy.

Tanzania can also boast a thriving modern school of sculpture produced, in the main, by Makonde and related peoples. One of Tanzania's leading academic sculptors, Abbas Kihago, received many official commissions to produce monumental cement sculptures for public sites in celebration of Tanzania's victory over the army of Idi Amin. Another, Job Andrew Madeghe, created large clay sculptures that can be seen at the University of Dar es Salaam, where he was educated. George Lilanga (1934–2005) produced brightly-colored sculptures and paintings animated by a keen sense of social critique and caricature. On a smaller scale, the ceramicist Edwin Kihururu established a center specializing in ceramic works in his home town of Same.

III. Museums, galleries and art education. The King George V Memorial Museum (now National Museum of Tanzania), Dar es Salaam, was established in 1899 as a geological museum, to which an ethnographical collection was added in 1934. Subsequent expansion included the establishment (1966) of the Village Museum, with its examples of different traditional housing units: typical Wagogo, Wazaramo and Wanyamwezi houses, built using local materials and traditional techniques, are intended to provide an understanding of indigenous architecture and crafts. Specialized and local museums include those at the archaeological sites of Isimila, Tanga, Kilwa and the Old Fort, Zanzibar. The Sukuma Museum, Mwanza, was opened in 1968 to preserve all aspects of Tanzanian culture. In addition to permanent displays, these museums frequently host exhibitions by local artists.

Tanzania has had a number of private art galleries, including the Kibo Art Gallery, Kibo (founded 1962), with a permanent collection and space for temporary exhibitions, and Sanaa Zetu, Moshi, with displays of handicrafts. The first art gallery in Dar es Salaam, the National Arts of Tanzania Gallery, opened in 1970, though art exhibitions were held at the National Museum. Apart from its temporary shows, the work of the gallery also included organizing exhibitions of Tanzanian art for foreign galleries, monitoring standards of Makonde sculpture and encouraging the purchase of wood-carvings by hotels and visitor centers. Local and international exhibitions were also organized by such societies in Tanzania as the Society of East African Artists, the Tanzania Arts Society, the Tanzanian Crafts Council and the Tanzania Society of African Culture. These bodies often used temporary exhibition spaces provided by hotels and foreign embassies.

In contrast to training in the non-academic popular and traditional arts provided by state-organized bodies (*see* §I above), aspiring academic artists in Tanzania have continued to be poorly served. The art department of the College of National Education, Chang'ome, was established in 1972. At about the same time the Institute of Education, Dar es Salaam, began to offer classes organized on an irregular basis, according to the availability of volunteer teachers. The University of Dar es Salaam offers a Masters Degree in Fine Art. Such institutions as the College of Arts, Bagamoyo, and art centers in Zanzibar and Dar es Salaam have offered some training, while the National Archives, Dar es Salaam, contains documents of value to ethnographical and artistic research projects. In general, postgraduate education has been received in the schools of neighboring African states, especially Uganda, or in art schools in the West.

Enc. Islam/2

F. R. Barton: "Zanzibar Doors," *Man*, xiv/6 (1924), pp. 81–3, pl. F

S. Ntiro: "East African Art," *Tanganyika Notes & Rec.*, lxi (Sept. 1963), pp. 121–34

J. Kariara: "Kibo Art Gallery," *Tanganyika Notes & Rec.*, lxiv (March 1965), pp. 147–9

F. Msangi: "I Opened my Eyes to the World," *Afr. A.*, iii/4 (1970), pp. 28–31 [*see also* iv/1 (1970), pp. 62–3]

J. A. R. Wembah-Rashid: "Tingatinga of Tanzania," *Afr. A.*, v/4 (1972), pp. 20–21

J. A. R. Wembah-Rashid: "Edward Saidi Tingatinga: In Memoriam," *Afr. A.*, vii/2 (1974), pp. 56–7

J. A. R. Wembah-Rashid: *Introducing Tanzania through the National Museum* (Dar es Salaam, 1974)

J. von D. Miller: *Art in East Africa: A Guide to Contemporary Art* (London and Nairobi, 1975)

R. de Z. Hall: "A Tribal Museum at Bweranyange, Bukoba District," *Tanganyika Notes & Rec.*, v (1983), pp. 1–4

N. I. Nooter: "Zanzibar Doors," *Afr. A.*, xvii/4 (1984), pp. 34–9, 96

U. Malasins: *The Stone Town of Zanzibar* (Zanzibar, 1985)

P. O. Mlama: "Tanzania's Cultural Policy and its Implications for the Contributions of the Arts to Socialist Development," *Utafiti*, vii/1 (1985), pp. 9–19

K. F. Msangi: *Proposal for a Comprehensive Arts and Crafts Education Programme for Tanzania and Structure for its Implementation* (diss., Stanford U., CA, 1987)

F. Y. Masao: "Museum Architecture in the United Republic of Tanzania: Living with a Mixed Legacy," *Museum* [Paris], xli/4 (1989), pp. 204–9

A Tanzanian Tradition: Doei, Iraku, Kerewe, Makonde, Nyamwezi, Pare, Zaramo, Zigua and Other Groups (exh. cat. by C. Bordogna and L. Kahan; Tenafly, NJ, Afr. A. Mus., 1989)

J. Agthe: *Wegzeichen: Kunst aus Ostafrika, 1974–89/Signs: Art from East Africa, 1974–89*, Frankfurt am Main, Mus. Vlkrknd. cat. (Frankfurt am Main, 1990)

Art from the Frontline: Contemporary Art from Southern Africa (exh. cat., Glasgow, A.G. & Mus.; Salford, Mus. & A.G.; Dublin, City Cent.; London, Commonwealth Inst.; 1990)

J. Kennedy: *New Currents, Ancient Rivers: Contemporary African Artists in a Generation of Change* (Washington, DC and London, 1992), pp. 144–50

J. Mack: "Eastern Africa," *Africa: The Art of a Continent*, ed. T. Phillips; London, RA; Munich; New York, 1995), pp. 116–77

J. Fleisher and A. LaViolette: "The Recovery of Swahili Settlements in the Absence of Stone Architecture: Two Preliminary Surveys from Pemba Island, Tanzania," *Nyame Akuma:*

Bulletin of the Society of Africanist Archaeologists (SAFA), lii (1998), pp. 64–73

H. Said: "The History and Current Situation of Cultural Heritage Care in Sub-Saharan Africa," *Asian & Afr. Stud.* [Bratislava], viii/1 (1999), pp. 91–100

D. M. K. Kamamba: "Kilwa Kisiwani y Songo Mnara," *Patrim. Mundial*, xix (2000), pp. 66–79

S. Clark: "The Politics of Pattern: Interpreting Political and National Iconography on Kanga Cloth," *East African Contours: Reviewing Creativity and Visual Culture*, ed. H. Arero (London, 2005), pp. 85–97

S. Mascelloni and E. Mascelloni: *George Lilanga* (New York, 2006)

Tara [Tara Kalan] (*fl. c.* 1560–1600). Indian miniature painter. His work conformed to the conventions of the period of patronage of the emperor Akbar (*r.* 1556–1605; *see* MUGHAL, §II, C), when Tara contributed to at least six manuscripts. His work is characterized by a love of bright primary colors and a lively sense of movement and realism. His figures often have ample, unruly mustaches and beards, large glaring eyes, and bared teeth. By 1590 his work shows an experienced hand and a firm handling of the brush, with a clear grasp of the techniques of stippling and feathered shading. Possibly a Hindu, Tara appears fairly low on the list of 17 prized artists compiled by Abu'l-Fazl, Akbar's court biographer, in the *Āyīn-i Akbarī*. In a detailed study of the *Tūtīnāma* ("Tales of a parrot"; *c.* 1560–70; Cleveland, OH, Mus. A., MS. 62.279), two folios are assigned to this artist. On the basis of this ascription, he has seems to have worked on the figures in several paintings in the dispersed *Hamzanāma* ("Book of Hamza"; 1557–77). This would place Tara on the level of the more senior artists in the workshop in the early years of Akbar's patronage.

Tara's name appears in the *Razmnāma* ("Book of wars"; *c.* 1582–6; Jaipur, Maharaja Sawai Man Singh II Mus.), where Tara had sole responsibility for fols. 37 and 56 and acted as a designer in fol. 135, collaborating with Tulsi Khurd ("the younger"). Tara also was the colorist for DASWANTH in three folios of this manuscript. In the *Tīmūrnāma* ("History of Timur"; 1584; Bankipur, Patna, Khuda Bakhsh Lib.) he acted as painter/colorist for BASAWAN. Tara's hand is visible in fol. 130b in the *Khamsa* ("Five poems") of Nizami (*c.* 1585; Ham, Surrey, Keir priv. col.), where he had sole responsibility; in fol. 182*v* he collaborated with Kesu Khurd ("the younger"). One folio is assigned to Tara in the *Dārābnāma* ("Story of Darab"; *c.* 1583–6; London, BL, Or 4615). In the first *Akbarnāma* ("History of Akbar"; *c.* 1587–90; London, V&A, MS. IS.2:1896) he was assigned fols. 17 and 61 as a painter/colorist; in both he worked for Basawan (for illustration *see* BASAWAN).

P. Chandra: *The Tūtī-nāma of the Cleveland Museum of Art and the Origins of Mughal Painting* (Graz, 1976)

The Imperial Image: Paintings for the Mughal Court (exh. cat. by M. C. Beach; Washington, DC, Freer, 1981)

The Adventures of Hamza (exh. cat. by J. Seyller; Washington, DC, Sackler Gal.; New York, Brooklyn Mus.; London, RA; Zurich, Mus. Rietberg; 2002–3), pp. 244–53

Tarabulus. *See* TRIPOLI.

Taraz. *See* ZHAMBYL.

Tashkent [formerly Binket]. Capital city of Uzbekistan. The city belonged to the region of CHACH in the Chirchik Valley in the middle reaches of the Syr River. In the course of its long history, the town has moved somewhat, and the earliest remains have been covered by later layers. The oldest archaeological monument is the Ming-Uryuk Hill on the Salar channel in the center of the city, which was the site of ancient and early medieval Tashkent. By the 8th century the town occupied some 30 ha and had a fortress with a citadel, defensive walls enclosing the city proper and a suburban quarter for artisans. The Arab conquest in the early 8th century destroyed the irrigation system, but the city flourished again in the 9th century when Binket, located on a branch of the Chirchik 4.5 km southwest of Ming-Uryuk, became a large economic and cultural center for Transoxiana. Now known as the "old city," Binket had a citadel, a square city proper covering 16 ha and quartered by two main roads, and inner and outer suburbs, the whole enclosed by walls. The walls of the inner suburb had ten gates; those of the outer had seven. The city proper had three gates; a fourth led to the citadel. In the 10th century the city and its suburbs covered 400 ha. At the end of the 10th century the city was taken by the Qarakhanids (*r.* 992–1211), and in the early 13th century it fell to the Khwarazmshahs. Although some of the town, especially its western part, was heavily developed, the city lost its economic and political role.

The town was severely damaged during the Mongol conquest of 1219 and only regained its importance under the Timurids (*r.* 1370–1506). The center of the city took form in the area of the Charsu maidan, where a madrasa (destr.) and Friday Mosque (1451; rest. 1888) were founded by Khwaja Ahrar (1404–92), leader of the Naqshbandi order of Sufis. The Charsu, the intersection of the two main roads, was lined with bazaars. Many mausolea were built, such as the Zengi Ata shrine (*c.* 1390) for Shaykh Ay Khwaja, the mausoleum of Kaldirgach Bey (first half of the 15th century) and the mausoleum of Yunus Khan (1487–1502). Tashkent reached its peak in the 16th and 17th centuries, and the courts of the local sultans became gathering places for poets, scholars, musicians, theologians, calligraphers and architects. The Baraq Khan Madrasa (first half of the 16th century) has an entrance portal leading to a court with two mausolea and many small cells. The larger mausoleum is crowned by a blue tile dome and the drum is ornamented with tile mosaic. The interior, supported on intersecting arches, is decorated with painted and gilded carved stucco. To the north is the tomb of Abu Bakr Muhammad Qaffal Shashi (16th

century), with a pointed dome and portal decorated with glazed bricks and tile. It probably replaced an earlier shrine over the site revered since the 10th century. Designed by the court architect Ghulam Husayn, the building is monumental despite its small size.

Tashkent remained a bustling commercial and craft center during the 18th century when Central Asia underwent an economic crisis. In the 19th century when the city was incorporated into the Kokand khanate, economic links with Russia were developed. The city flourished and was divided into four large sectors—Sheykhantaur, Sibzar, Kukcha and Beshagach. A new fortress for the Kokand khan was built on the banks of the Ankhor Canal. After the region was annexed by the Russians in the 19th century, Tashkent became the main town of Uzbekistan. Alongside the old town, a confused mass of narrow streets, a new town (1865) was erected following European design principles of radial and grid planning. In the 20th century Tashkent became the largest city in Central Asia. Vast housing estates were built after World War II, when Tashkent became a major industrial center and haven for refugees.

After much of the city was devastated by an earthquake on 26 April 1966, it was decided to demolish virtually all the old buildings except for a few designated historical monuments. New buildings were designed to resist earthquakes and were often decorated with traditional materials. For example, the Institute for Oriental Studies of the Uzbekistan Academy of Sciences (1960s) has murals recalling the style of book painting that flourished in the region in the 16th century (see ILLUSTRATION, §VI, C and CENTRAL ASIA, §IV, B). The House of Knowledge (1968; architects I. Demchinskaya, Yu. Miroshnichenko and S. Shuvayeva) is decorated with polychrome mosaic panels by L. Polishchyk and S. Shcherbinina, and the Uzbekistan Hotel (1974; architects L. Yershova, I. Merport and V. Rachchupkin) has *brises-soleil* in imitation of traditional window grilles.

As the capital of Uzbekistan, Tashkent is home to many major museums. The Fine Arts Museum of Uzbekistan has Sogdian murals, Buddhist statues and Zoroastrian art along with a more modern collection of 19th and 20th century decorative arts, such as embroidered hangings (*suzani*). The Museum of Applied Arts is housed in a traditional Uzbek house originally commissioned for a wealthy tsarist diplomat. Tashkent's largest museum, the History Museum, housed in the ex-Lenin Museum, contains some notable finds from the Islamic period such as the foundation plaque dated 401/1010–11 from the destroyed minaret at Gurganj. The Amir Timur Museum is a modern recreation dedicated to the life of the Turco-Mongolian warlord.

Enc. Islam/2

A. A. Abdurazakov: "Medieval Glass from the Tashkent Oasis," *J. Glass Stud.*, xi (1969), pp. 31–6

M. Bulatov and T. Kadyrova: *Tashkent* (Leningrad, 1977)

M. I. Filanovich: *Tashkent: Zarozhdeniye i razvitiye goroda i gorodsky kul'tury* [Tashkent: the birth and development of the city and urban culture] (Tashkent, 1983)

L. Golombek and D. Wilber: *The Timurid Architecture of Iran and Turan*, 2 vols. (Princeton, 1988), pp. 281–3

R. D. Crews: "Civilization in the City: Architecture, Urbanism, and the Colonization of Tashkent," *Architectures of Russian Identity: 1500 to the Present*, ed. J. Cracraft and D. B. Rowland (Ithaca, 2003), pp. 117–34

Tehran [Teheran; Tihrān]. Capital city of Iran since 1785.

I. History and urban development. II. Art life and organization.

I. History and urban development. Located on the southern foothills of the Alburz Mountains, Tehran was a small agricultural enclave in medieval times with the typical shape of a walled rectangle with gates in the middle of the four sides and two additional gates and a citadel (500×800 m) on the north. As other important centers in the area declined, the city developed to become particularly prominent under the patronage of the QAJAR dynasty (r. 1779–1924; see ARCHITECTURE, §VII, B, 2). Agha Muhammad (r. 1779–97) selected the citadel for his palace and administrative center, and Fath 'Ali Shah (r. 1797–1834; see QAJAR, §II, A) completed the Gulistan Palace. The only buildings that remain from this sprawling complex with luxuriant gardens set with pools and pavilions are the Takht-i Marmar (see color pl. 3:VIII, fig. 1), a columnar audience hall, and the 'Imarat-i Badgir on the north and south sides. In the surrounding bazaar quarter Fath 'Ali Shah had several mosques built, including the Shah Mosque (completed 1824), with the traditional layout of four iwans grouped around a central courtyard containing an ablution tank.

In 1870–72 the city was enlarged and rebuilt by Nasir al-Din (r. 1848–96; see QAJAR, §II, B). Congested areas were demolished and large squares and broad boulevards laid out. The city was quadrupled in size and encircled with new walls embellished with towers, 12 tiled gates and a moat. The work was modeled on that ordered by Napoleon III (r. 1852–70) in Paris, and the walls were designed by General Buhler to a plan based on the fortifications built there by Sébastien Leprestre de Vauban (1633–1707). At the center of the new city stood the Gulistan Palace, which was also rebuilt (1867–92), maintaining the traditional segregation of public and private areas. On the east side Nasir al-Din ordered the Shams al-'Imarat, a private residence comprising a multi-story tower with two turrets as balconies. The work was supervised by Dust 'Ali Khan Nizam al-Dawla. Fath 'Ali Shah's taste for painted decoration was replaced by Nasir al-Din's for polychrome tilework, ornately carved stucco and mirror-glass. Nasir al-Din then turned to the north side of the palace, replacing Fath 'Ali Shah's buildings with a spacious series of rooms (1873–82), including a stair decorated with mirrors, a tiled vestibule, an

audience hall and other reception areas. The rooms were linked behind an impressive double-story façade that combined such European features as tall windows and semi-engaged Classical columns with tilework decoration. The Naranjistan (Orangery) Palace was built and the retaining walls of the compound tiled. New women's quarters (Pers. *andarūn*; destr.) were built behind the audience hall, and the small Kakh-i Abyad (White palace), a two-story rectangular building that has been converted into the Ethnographic Museum, added on the south side near the entrance to the palace gardens.

Work on the palaces by later Qajar monarchs was on a much reduced scale. Muzaffar al-Din (*r.* 1896–1907) added tilework friezes (1899) to the hall leading from the entrance vestibule of Nasir al-Din's building on the north side. In techniques and subject matter the old and modern are blended: the friezes are worked in a stippled and hatched sepia and white color scheme inspired by contemporary lithographs and photographs and show rulers of Persia from the Parthians to the Safavids and views of Persian and European monuments. The Qajar court summered in the Shimiranat (Shemran), villages in the foothills that have become northern suburbs of the capital. One of Fath ʿAli Shah's favorite palaces there, the Nigaristan (completed 1810), comprised a 300-acre garden set with a domed pavilion, an octagonal audience hall decorated with paintings of the royal family receiving foreign ambassadors and a closed rectangular structure built around an inner courtyard serving as the women's quarters. Only a vaulted pavilion decorated in mauve and white stucco survives; it now serves as the Museum of National Arts. The most splendid of Fath ʿAli Shah's summer palaces was the Qasr-i Qajar (destr. 1950s), a series of symmetrically ascending terraces, each contained within an arcaded brick wall. At the summit were the royal apartments decorated with portraits of the royal family. A columnar gatehouse at the base gave access to an enormous formal garden bisected by water channels and a central pool. Nasir al-Din's two summer palaces, ʿIshratabad and Sultanatabad, built in 1888 above and below the Qasr-i Qajar, continue the tradition of separate buildings set within a garden precinct but are more irregular in plan and decoration. At ʿIshratabad the monarch's private apartments are contained in a four-story brick tower; the three bottom stories are decorated with polychrome tiles and the upper story has an open colonnade. The women's quarters included 17 chalets grouped around a lake. At Sultanatabad the private apartments are contained in a five-story polygonal tower and the public audience hall is a rectangular building with a deep colonnaded porch. Its reception room has a superbly painted ceiling and dado of polychrome tiles, whose subjects range from traditional Persian themes to whimsical copies of European subjects.

Enc. Islam/2: "Tihrān"

P. Coste: *Monuments modernes de la Perse* (Paris, 1867), p. 42; pls. LVIII–LXI

Y. Dhikaʿ: *Tārīkhchi-yi sākhtimānhā-yi arg-i salṭanatī-yi Tihrān va rāhnamā-yi kākh-i gulistān* [A short history of the construction of the royal fortress of Tehran and guide to the Gulistan Palace] (Tehran, Iran. Solar 1349/1970–71)

H. Kariman: *Tihrān dar guzāshta va hāl* [Tehran in the past and today] (Tehran, n.d.)

J. Scarce: "The Royal Palaces of the Qajar Dynasty: A Survey," *Qajar Iran*, ed. E. Bosworth and C. Hillenbrand (Edinburgh, 1983), pp. 329–51

W. Barthold: *An Historical Geography of Iran*, trans. S. Soucek (Princeton, 1984), pp. 125–8

II. Art life and organization. Since 1785, when the Qajar ruler Agha Muhammad made Tehran the capital of Iran, it has been an important center of art and architecture, mainly because of royal policies and patronage, first under the Qajars and then under the Pahlavis (*r.* 1925–79). Many painters were employed at the Qajar court (*see* ILLUSTRATION, § VI, B). ʿABDALLAH KHAN, MIHR ʿALI and MIRZA BABA, for example, produced large oil portraits of Fath ʿAli Shah as well as murals and book illustrations. The Dar al-Funun (Polytechnic) was opened in 1851 with painting included in the curriculum. By 1911 the painter Kamal al-Mulk (*see* GHAFFARI, §III) had established a school of art that promoted Western-style work. PHOTOGRAPHY, which was introduced to Iran in the 1840s, was encouraged at Nasir al-Din's court and also developed commercially; the most successful photographer was the Armenian ANTOIN SEVRUGUIN. In the late 19th century Nasir al-Din established a museum in the Gulistan Palace.

Art life was further enriched under Riza Shah Pahlavi (*r.* 1925–41). In 1928 the French scholar ANDRÉ GODARD was invited to establish an archaeological service. In 1938 the Ethnographical Museum was founded, and the College of Fine Arts was opened at Tehran University; it became an important training ground for contemporary artists. In the same year the Crown Jewels were declared a national resource rather than the private property of the shah, thereby leading to the creation of the Crown Jewels Museum in the Bank Melli. Under Muhammad Riza (*r.* 1941–79) an increasing number of Western-style buildings were constructed in Tehran, and art inspired by contemporary Western styles received government support. In 1946 the Archaeological (Iran Bastan) Museum was founded. Commercial art galleries began to open in the 1950s, and five Tehran Biennale exhibitions were held between 1958 and 1966, the first four at the Abyad Palace in the Gulistan compound, the fifth at the Ethnographical Museum. An indigenous art movement known as SAQQAKHANA flourished, and many of the artists associated with it studied at the College of Decorative Arts, established in 1960. Such architects as NADER ARDALAN and KAMRAN DIBA were active in the 1960s and 1970s; their buildings, such as the Center for Management Studies (1972) and the Museum of Contemporary Art (1976), combined traditional Iranian and modern Western forms. In the 1970s several other museums were opened,

including the Nigaristan Museum, which specialized in the art of the Qajar period, the Riza 'Abbasi Museum, with a large collection of fine arts, the Carpet Museum and the Museum of Glass and Ceramics. Queen Farah formed a large collection of contemporary Iranian art, which she donated to various museums, and local works were commissioned by public institutions. With the establishment of the Islamic Republic of Iran in 1979, the nature of government patronage changed and art commemorating the ideals of the Revolution has been supported.

For additional information and bibliography *see* IRAN.

Enc. Islam/2: "Tihrān"

Royal Persian Paintings: The Qajar Epoch 1785–1925 (exh. cat. by L. S. Diba with M. Ekhtiar; New York, Brooklyn Mus.; Los Angeles, CA, Armand Hammer Mus. A.; London, U. London, SOAS, Brunei Gal.; 1998–9)

Qajar Portraits (exh. cat. by J. Raby; London, U. London, SOAS, Brunei Gal., 1999)

S. Balaghi and L. Gumpert, eds.: *Picturing Iran: Art, Society and Revolution* (London 2002)

H. Keshmirshekan: "Discourses on Postrevolutionary Iranian Art: Neotraditionalism during the 1990s," *Muqarnas*, xxiii (2006), pp. 131–58

Tent. Portable structure with a fabric covering sustained by or interacting with rigid supports. Because of their mobility, tents have been essential in providing shelter for the nomads of the Middle East and Central Asia, and have been attested since the earliest written and pictorial records. The same constructional principles have been adapted for court and army life by the rulers of these and neighboring regions, including India and Europe. At times they were realized with a magnificence and sense of display hard to imagine today. Cloth also came to be used for tepees after the destruction of the American buffalo herds deprived the Plains Indians of the traditional material used for covering.

I. Introduction. II. Nomadic. III. Court and ceremonial.

I. Introduction. Three distinct traditions of tent construction are already recognizable in the earliest records. Two of these are nomadic, representing Middle Eastern and Central Asian practice. The third can best be described as urban, being concerned with military and court use. Each is characterized by the use of a different type of fabric: the Middle Eastern form by woven goat hair; the Central Asian by felted sheep's wool; and the urban by woven vegetable fiber in canvas or calico, extended in court contexts to a range of much richer materials, including satin, brocade or velvet. A further fundamental distinction separates the Central Asian tradition from the other two: the Central Asian tent is a compression structure in which the felt covering rests on a self-supporting frame that can be set up independently, while the other two types are tension structures in which the supports (which are generally separate from each

other and cannot be regarded as a frame) both carry and are held in place by the covering, with which they are therefore interdependent. In all three types the fabric used came in characteristic widths, resulting from the method of manufacture, and had to be made up with seams. In the urban tradition, however, there was a tendency for practical considerations to be subjected to geometrical order, which included adjustment of the form to exploit particular patterns woven into cloth. The design of nomads' tents is empirical, based on centuries of experience, its fitness for purpose being closely linked to the exploitation of materials available in particular ecological settings and the need to replace worn parts regularly. The tent is in a continuous state of renewal, and parts of the cloth may be deliberately moved to different positions so as to distribute wear: so long as this process is continued, the tent is in a sense everlasting. Urban tents, conversely, tended to be used intact until they wore out, since the supplies of materials and labor were more immediately available to the court or military than to a nomadic pastoralist dependent on the seasons. The integration of empirical design within a rigorously constrained life-style and carefully regulated economy thus achieved aesthetic appeal through the simple fitness of form to given conditions. The closeness of this fit has ensured the survival of the forms in a given context, so that the idea of the design outlives the material in which it takes shape. By contrast, the urban tradition, with its potential for lavish display, gave rise to exceptionally fine but usually unique tents that were essentially ephemeral through the perishability of the material. Their survival has, in practice, been confined to mention in court records. The more ordinary aspect of the urban tradition acquired an undistinguished continuity through practical, primarily military tentage; in parallel with urban building, this represented a fund of basic skills that could be drawn on from time to time to produce outstanding effects.

As urban tents co-existed with those of Middle Eastern and Central Asian nomads, the traditions interpenetrated at several levels. Nomads, rather than living an entirely isolated pastoral life, exist in symbiosis with neighboring settled populations, exchanging goods and skills or obtaining them by raiding. On a simple level, materials typical of the urban tradition are sometimes borrowed by nomads. Thus the Kurds of Khurasan incorporate a width of white calico in the front curtains of their tents (to keep their milk clean of smuts), and the Arabs of Syria may use canvas instead of goat hair for their summer-weight tents. Such substitution has become more common in the late 20th century as the economic self-sufficiency of pastoral life has broken down. In general, however, no attempt is made to transfer the decorative techniques typical of the finer urban tents to a nomadic setting: such decoration as does appear on hair tents is usually well integrated with the weaving technique. It is doubtful whether large urban pavilions were ever adopted by nomads of the Middle Eastern tradition to the extent that they were in

Central Asia, since the design of their own tents allowed them to be greatly extended, as demonstrated by the huge tents used by the *khān*s of the Qashqa'i confederation in southwest Iran or by the kings of Saudi Arabia. Nevertheless, it may be noted that the "Bedouin" tent used by Colonel Qaddafi of Libya in the late 20th century was, in fact, an urban tent. The persistence of the urban tradition throughout the Near and Middle East, despite the supremacy of one nomadic dynasty after another, illustrates the thesis on the softening of the nomadic spirit in contact with urban ways (Ibn Khaldun: *Muqaddima*; Eng. trans. by F. Rosenthal as *The Muqaddimah*, London, 1993). At court, the nomad tradition was irrelevant.

The use of fine urban tents by nomad rulers is documented from the 13th century when such objects were evidently a recognized and welcome form of tribute: rivals contending for the governorship of the Iranian provinces of Khurasan and Mazandaran *c.* 1240 each sent a tent to the Mongol *khān* Chaghatay (Ögedey); in 1248 Louis IX of France sent a chapel of red cloth to Güyük Khan; and in 1256 the Ilkhanid prince Arghun presented his grandfather Hülegü, founder of the dynasty, with a tent at Shafurqan near Balkh. Other urban tents were acquired through capture, for example the "large and very beautiful tents of linen" seen by Piano Carpini in 1246, which Batu (*r.* 1227–55), leader of the Horde of Jochi, seized from Bela IV (*r.* 1235–70) of Hungary. What is significant here is that such tentage was accepted for the status it conferred and taken into the very heart of the nomad world as the ruler's audience tent. A practical reason for this adoption is provided by Willem van Rubruck, who noted in 1253 that the Mongols' own tents could not hold so large an assembly.

Conversely, the Central Asian framed tent was accepted in the court milieux of the Middle East, where it acquired the Persian name *khargāh*. It was introduced as early as the 11th century by the Ghaznavid and Saljuq dynasties, both of Turkish stock, and at this time the combination of tent types became standard for royal camps in Iran, to judge from the juxtaposition of the words *khargāh* and *pardasarāy* ("enclosure screen") throughout Firdawsi's epic *Shāhnāma* ("Book of kings"), completed in 1010. Within a few centuries the *khargāh* became common enough in Mamluk Egypt to acquire an Arabic plural, *kharkāwāt*. The interpenetration of tent types resulted in the transfer of characteristic covering materials: both in the Middle East and in its home territory, the Central Asian tent was often given a royal covering of brocade or velvet. By the 15th century such rich materials were accepted as fitting for rulers' tents, as shown clearly by the Timurid illustrations to a manuscript (*c.* 1430; Paris, Bib. N., MS. supp. pers. 1113, fols. 16*v*, 65*r*, 66*v*, 85*v* etc.) of Rashid al-Din's *Jāmi' al-Tawārīkh* ("Compendium of histories"). If the illustration showing the *altan ordo* ("Golden headquarters") of Genghis Khan (*d.* 1227) covered with gold brocade (fol. 44*v*) is accurate, this practice may be two centuries older.

Tent structure was also modified by interaction. The apical roof wheel characteristic of the Central Asian type, but supported on a central pole, was used in the 15th century, particularly by the Aqqoyunlu Turkmen, to raise a conical canvas canopy extended by guy ropes, as seen in a manuscript painting (*c.* 1480; Istanbul, Topkapı Pal. Lib., H. 2153, fols. 90*v*–91*r*) attributed to the court of Ya'qub Beg at Tabriz. This type of tent was subsequently adopted by the Safavid dynasty, which used it frequently, to judge from illustrations for the *Shāhnāma* (*c.* 1530; ex-Houghton priv. col.; dispersed) made for Tahmasp I. Another spectacular example of such interaction is the adaptation by the Mughal emperor Akbar (*r.* 1556–1605) of the Central Asian tent trellis to form the rectangular *gulal bar* enclosure fence around his camp center in the late 16th century, adding much to its dignity and impressiveness.

Seasonal movement motivating the use of tents was common to nomads and townspeople alike; it was only the scale of the movement that varied. Many courtiers in India of the 16th and 17th centuries preferred to live in tents rather than within palace walls, and as late as the 19th century townsmen in Iran used tents for brief changes of climate. The regular progress of a monarch with his substantial administrative entourage was essential to his maintenance of control over a large territory, and the camp became an extension of the palace (see fig. 1), compete with council chambers, halls of audience, royal workshops, stables and even bazaars on a scale that astonished European visitors. Rapid movement of the principal tents was achieved by sending in advance a duplicate set to the next stage. The appointment of officers in charge of the choice of site and the quartermasters was correspondingly important.

II. Nomadic.

A. Near and Middle East and North Africa. B. Anatolia, Central Asia and Mongolia.

A. NEAR AND MIDDLE EAST AND NORTH AFRICA. The goats whose hair forms the primary material for tent cloth are usually black throughout this region. Since an important characteristic of the hair is its oiliness, it is generally spun without being washed, and the resulting cloth, when new, fully justifies the term "black tent" as a generic one. Some variation in the weave occurs regionally and according to the weight required for the climate or even season, but it is most frequently a warp-faced ribbed plain weave, in which the main strength lies along the tightly spun warps in the length of the cloth. The relatively open weave allows the material to transpire in the heat, so that the velum (roof) gives shade while allowing heated air to escape; in this respect it is much more comfortable than canvas. During rain, the water forms menisci in the pores, sealing them, and the surplus slides off the oily surface, provided it lies at an angle. After exposure to strong sunlight, the color gradually fades to shades of brown and the oil

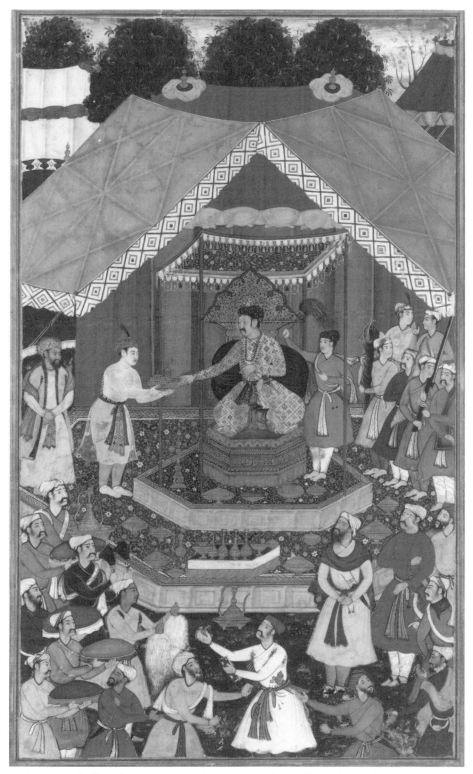

1. Court tent of Akbar, showing symmetrical setting, Mughal, probably northern India, 1592–4; from an *Akbarnāma* manuscript (London, Victoria and Albert Museum, MS. IS. 2:94-1896); photo credit: Victoria and Albert Museum, London/Art Resource, NY

disappears. The regular replacement of sections of the velum therefore allows the restoration of this quality as well as the repair of the worn parts. The cloth, which when woven by nomads themselves is usually made on a simple ground loom, is in widths of 450–600 mm, 700 mm being the most a weaver can conveniently manage. Since the tension of the guy ropes must be taken down the length, other means may be used to resist the tension across the width of the velum.

Assyrian and Hebrew sources associated these tents with Semitic peoples, including the Israelites, as early as the 8th century BCE, and the descriptions of the goat-hair tent roof of the tabernacle (Exodus 26, 36) may be evidence for their use as early as the 13th century BCE. Details of the inner, framed structure corresponded to sacred Egyptian structures, so the tabernacle may represent the first example of the interpenetration of nomadic and urban traditions. Pre-Islamic Arabic poetry confirms the use of hair cloth, although black goat hide and red tents are also mentioned. The latter may relate to an early tradition of domed leather tents (Arab. *qubba*), which had a cultic significance by the time of the Prophet (*c.* 600 CE) and were later treated as tribal emblems. One of the earliest representations of a nomadic encampment in a copy of al-Hariri's *Maqāmāt* ("Assemblies," *c.* 1225–35; St. Petersburg, Acad. Sci., S. 23, p. 288) is impressionistic, although the coarse black texture of the velum and its multiple peaks diminishing in height towards the ends are still characteristic of Bedouin tents.

The present form of tents in Arabia is uniform except for small details. The rectangular velum is made up of six or eight cloths (*shuqqah* or *filij*), so that the central seam can form the ridge along the middle. The size is determined by the number of poles (*ʿamūd*) set upright under this center line: those at the extreme ends are not included. The number of central poles (and therefore the ridge profile) varies from region to region. Among the Al Murrah in southern Saudi Arabia, one is used for a tent 6.0×2.8 m, two for one 11.0×3.3 m, and four for one of 20.0×4.3 m. Important sheikhs may have tents with five, seven or even nine main poles: von Oppenheim cites a Shammar example of 35×15 paces (*c.* 28×12 m), with poles of *c.* 3.5 m.

The more actively nomadic tribes regard very large tents as an impediment. The normal height of the central poles is *c.* 2 m. Props with forked tops, about 500 mm shorter, are ranged along the front and back edges opposite the poles, at each end and at the corners, all at an angle that can be regulated to suit the weather. The guys (*toneb*) of Arab tents typically extend at a low angle, up to 15 m from the edge, to maximize the hold on the pegs (*wuted*) in the sand. Those at either end are passed through V-shaped purchases (*khorb*) attached by a batten to a short leash of webbing sewn directly to the velum on the ridge and corners. The strain from the transverse guys is transferred by similar purchase to a girth of webbing (*tarīje*) *c.* 200 mm wide, passing across the velum on the underside, and sewn to it, on the line of each of the main poles: front and rear guys thus compensate each other. This webbing is woven in contrasting warp patterns of checks or ladder bars, including camel-hair, cotton or dyed wool for decorative effect; decoration of the tent is usually limited to this girth of webbing.

Once the tent is pitched, with its back to the wind, a rear wall woven in broad stripes of black, white and sometimes brown along the length is pinned along the velum edge. A similarly banded curtain hung from the front to the rear of the tent separates the men's and reception quarters from the women's end and kitchen. Here the natural tones are enhanced by brilliantly colored cross-stripes, displayed by a projection in front of the tent; in east Jordan the patterns form striking compositions of triangles and lozenges in black and white.

The spread of this model through the Islamic world is most clearly traced in North Africa, where it has been modified progressively to suit local conditions, although almost all of the basic terminology, whether Arab or Berber, is of Arabian origin and the essential form of the velum remains unchanged. The form of Moroccan tents from the Middle Atlas exploits the more plentiful timber to help deflect the heavier rainfall. There, a ridge bar some 2 m long is supported on two tall poles set on the short axis, with the velum cloths running across it. This is most fully developed, in a long cantilevered curve, often finely carved, among Berbers such as the Zaine. The end walls are heavily decorated in colored brocading, and more lightly woven cloths draped on the girths close the long sides. Yellow matting woven from dwarf palm leaves may replace some or all of the cloths. In more desert areas, the ridge bar is reduced to a small carved cap on the top of the pole.

In eastern Morocco and Algeria the velum is woven of wool and camel hair (see fig. 2); dyes are used to produce warp stripes specific to the tribe: red and brownish black for the Oulad Naïl, or cream and coffee for the Zoua, set off with brightly colored girths and tassels inside (*see* CARPETS AND FLATWEAVES, §IV, F).

The black Yörük tent of Turkey is plainly derived from Arab models, even to such details as the incised patterns on the pole cap, although the streamlined profile and long guy ropes, no longer required in Anatolia, have been eliminated. The Turks apparently adopted the tent because it withstood the damp climate better than their own felt ones (*see* §B below) and obviated the heavy investment in wool for coverings. Kurdish tents also seem to reflect Arab influence despite a distinct terminology, but the velum is hung from the poles which protrude through slits in it. The Ghilzai Pashtun in East Afghanistan have a tent whose poles pierce the velum, as among the Kurds: the similarity remains unexplained. As in all Iranic tents, the weave and construction of the velum is similar, though there are no transverse girths, and cane screens are used consistently for side walls. Among the Lur and Lak in the Zagros range, the

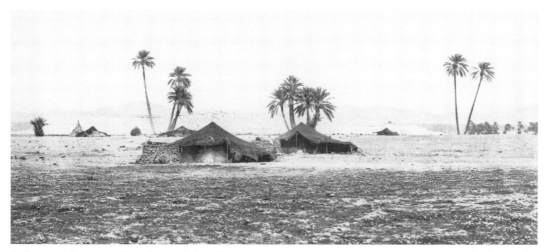

2. Gustave de Beaucorps: *Nomad Camp, Biskra, Algeria*, waxed paper negative, *c.* 1857–9 (Paris, Musée d'Orsay); photo credit: Réunion des Musées Nationaux/Art Resource, NY

velum is made in two halves toggled together, for ease of transport in difficult terrain. This recalls the description of the Israelite tabernacle. The Baluch of Turkmenistan and the Taranchi (now Uighur) of Turkestan show that the use of black tents extended into Central Asia.

Tibet has a somewhat independent black tent tradition, in which the eaves are extended by guy ropes running over props set outside the walls, giving the tent a spider-like appearance: this leaves the interior largely free of supports. In southern Baluchistan, the velum is spread like a tunnel over parallel arches of bent withies, and tunnel-form tents are widespread in western and southern Turkey, Azerbaijan, northern Afghanistan and Tajikistan, almost certainly indicating a still earlier, once-common tent type. In some regions the withies are bent on both axes to form an armature. These may have affected the design of Durrani Pashtun tents in West Afghanistan, as these make use of a single, jointed wooden arch on the transverse axis in winter.

B. ANATOLIA, CENTRAL ASIA AND MONGOLIA. At the beginning of the 20th century the felt tent was used from extreme western Anatolia across a territory some 8500 km long to the Greater Khingan mountains of western Manchuria, and from about 35° N in northern Afghanistan to 55° N in the Urals or the Altay and Baykal mountains. Throughout this area the structure was surprisingly uniform, differing locally in detail rather than in principle.

The felt tent was the primary dwelling of the major Turkic and Mongolian pastoral peoples of the region but was also adopted by the Persian-speaking Tajik and Chahar Aymaq of northwest Afghanistan. Following the expansion of the Turks and the Mongols in medieval times, the felt tent was used in the Crimea and the plains to the north of the Black Sea, and it probably reached Hungary with the Cumans

in the 12th–13th century. It came to be used widely in both Turkey and Iran from the 11th century and was transformed into an item of court tentage, with the use of fine materials for the covering. The felt tent reached a peak of development in the 16th century; it continued to be used until the early 18th century when, for reasons as yet unexplained, it was replaced by canvas tentage. A similar transition occurred at the Mughal court in India, to which the felt tent had been brought by the Chaghatay Turks (*see* §III, B, 3 below).

Although the felt tent is generally known in the West as a yurt (Fr. *yourte*, Ger. *Jurte*, Rus. *yurta*), the word is a misnomer, referring, in the Turkic languages, to territory, campsite or tent-site, but never to the tent itself. The Turkic word for the felt tent is simply *ev* ("dwelling") and its cognates *öy*, *üy* etc. The Mongol equivalent is *ger* ("dwelling"), and since the 10th century Persian has used *khargāh*. For this reason the type will here be called the trellis tent, after its most characteristic feature, the collapsible wall of diagonally crisscrossed laths. The independent wooden frame consists of this cylindrical trellis wall, which for a family tent is *c.* 5.5 m in diameter and stands 1.5 m high, with a framed doorway for access; a set of radial struts 2.5 m long inclines inwards from the crossings at the top of the trellis to form a roof; the upper tips of the struts are inserted into slots around the rim of a horizontal lightly domed roof wheel (maximum diam. 2 m) at the summit, some 3 m above the ground. The trellis is made up of four or more sections, each light enough to be handled by one individual.

The sections, assembled from laths pierced and pinned together with raw camel hide, can be extended and fitted together neatly at the vertical junctions to provide structural continuity. They can also be folded together on the lazy-tongs principle to form compact units for transport, usually nested together in pairs,

two on each side of the pack animal. Their stability when erected depends on the use of one or more girths passed horizontally around the upper part of the completed wall and around the doorposts, restraining the thrust of the struts and allowing the frame to stand without further support. The structural viability of the frame depended on the invention of the girth principle.

Since the number of roof struts corresponds to the number of crossings or "heads" on the top of the trellis and this to the circumference, the size of the tent frame is usually given in terms of the number of heads. To secure the interlock between the trellis sections, the number of laths in each layer, and thence the number of heads in each section, has been standardized in combinations corresponding to a range of sizes. This led in turn to prefabrication of the parts, with the advantage that these could easily be replaced when needed. A typical size was of 64 heads for a family tent, and the maximum known was 360. The pattern is modified regionally through variations in the heaviness of the frame, the number of sections and struts, the size of trellis mesh and the profile of the roof. The frame is often made of willow, the curved parts being bent by specialist tribal craftsmen by heating, but other timbers, such as Caucasian elm and birch, are also used. In both Kazakh and Kirgiz frames, the lower part of the roof struts and the top of the trellis laths are fluted on the interior, and Kazakh frames are painted red. Besides the main types there were subsidiary, lighter and less expensive structures used by poorer shepherds or for traveling and campaigns.

The set of wool felts comprises one rectangular wall felt for each trellis section, two semicircular roof felts with an excision to fit the rim of the roof wheel, a rectangular door flap and a round or square top felt over the wheel, which can be partially folded back to admit light or let out smoke in winter. The thickness of the felt varies from 5 mm for the wall to 10 mm for the roof and 15 mm for the top, and the edges of the felts are trimmed with wool rope. The felts are made from rectangular blanks with gussets for the corners. The ideal propitious color, used for wedding and guest tents, is white, but in practice less prosperous tribesmen often use brown wool, at least on the inner surface, and the felt gradually darkens from exposure to smoke. In areas where karakul wool is used, the felt can be faced with white cotton sheeting. The walls are further sheathed by a screen of vertical stems connected by horizontal binding lines of hair. Among the Turkmen this is of plain split canes placed outside the felts. The Kazakh and Kirgiz use slender steppe grass set between trellis and felts. They use similar screens, in which the individual stems are wrapped in colored wools to build elaborate patterns, for backing door flaps and fencing kitchen and dairy areas inside. The high degree of thermal insulation provided by the overlapping felts suggests that they were initially needed for warmth in winter, but the climatic control is equally effective in summer heat, when the wall felts can be raised and the top felt

opened to create an involuting air current, with the cane screens filtering the dust. The hemispherical form combines minimum surface area with minimal weight for transport (*see also* KAZAKHSTAN, §II).

In the Turkmen tent the felts are plain except for the door flap, which is laid in a diagonally branching pattern. Decoration is concentrated in a set of two or three girths around the trellis, woven in a sophisticated yet standardized variety of techniques, with another girth around the base of the struts and one encircling the screen outside. The Kazakh, Kirgiz and Uzbek also use multiple girths, in a more restricted range of techniques, but augmented by networks of similarly woven ties for the felts. Those for the front roof felt, crossing over the rear half of the dome inside, are colored, while those for the rear felt, crossing over the front half of the dome outside, are white. Kazakh and Kirgiz roof felts are embellished around the periphery outside with ornamental rectangular patches, serving originally as loops to hold a girth, and with trefoils or retroflexed horn motifs in appliqué-work. Perhaps the most decorative of all Turkic tribal tents is the Karakalpak, in which, though the wall felts are absent, the cane screen is set off outside with elaborate panels of felt or pile-work flanking the matching door flap. In all these tents a tasseled rope or band hangs from the roof wheel inside to anchor the dome during storms. In principle the door faces south. Internally the tent is centered on a hearth surrounded by a square or circular fender below the smoke hole. The reception area is behind this along the rear, with the women's half usually to the right (looking in) and men's to the left. The floor at the back and sides is covered with felts.

The Mongolian *ger* is different in detail: the roof struts are straight and taper downward; they are looped instead of lashed to the trellis heads. The doorframe cannot be dismantled, and the retroflexed trellis is often of five sections. The cordage is of ropes only, and the girths are limited to a rope at the trellis heads and two or more securing the covering outside. The roof wheel is typically cut and jointed work (in elm), rather than bent. In the Mongolian Republic itself, no screens are used, although they do occur among the Kalmak and in Manchuria. The tent has a low conical roof, in which the roof wheel is often supported by a pair of center poles bearing against the rim on either side. In a type found in Inner Mongolia and the east, the edge of the roof wheel, consisting of a set of adjacent radial "fingers" secured to bent hoops, is hinged permanently to the tops of the struts, and divided diametrically for transport on a cart. The exposed woodwork is painted poppy red, with the struts, roof wheel, poles and doorway often ornamented with colored scrollwork and gilded carving. The inside of the trellis is often masked by colored cotton hangings with contrasting borders, and, since the middle of the 20th century, the outside has been sheathed in white canvas over the felts. Extra layers of felts can be added in winter. Door and floor felts are typically quilted in complex fret patterns or whorls. Princes' tents were formerly denoted by a red

collar fitted around the outside of the roof wheel with four or more radiating arms extending to the eaves.

Both Turkic and Mongolian tents share the same structural organization, besides shared details such as the pinning pattern of the trellis, which denote a common origin. Round felt tents are mentioned in Chinese dynastic histories from the 3rd century BCE among the Hsiung-nu and the High Cart confederation. Since the Turkic type, with its dependence on wood bending techniques, can be related to bent wooden wheels (c. 350 BCE) found in barrow No. V at Pazyryk in Siberia, deriving from a tradition a millennium older, the connection with these cart-dwelling nomads is significant. The first clear evidence for the trellis tent, however, is given in a 9th-century text, where a set of early Turkish tent terms corresponds unmistakably to modern Turkmen ones. In two poems datable to 829–46, the Chinese poet Po Chü-i (d. 846) described a round blue felt tent he owned at a time when it was fashionable to copy Uighur customs. It was plainly a well-made structure, comfortable in winter, suggesting the product of a long tradition. The trellis appears to be derived from the crossed and bound arches used in the bender tent found in many parts of Asia, but in this case the invention of the girth principle and the subsequent separation of the walled structure from the dome represent a crucial phase. An ivory pyxis (5th century; Schatzkammer der Probsteikirche St. Ludgerus, Werden) depicts a Near Eastern pastoral scene with a tent combining just this bender structure and girth with a wall forming a prototypical trellis. As a related form was still found in huts in Turkmenistan in the last decade of the 20th century, this type seems formerly to have been widespread. It may even be compared with a depiction on a Chinese lacquer bowl (before 756) from the Shōsōin in Japan, which also shows the same door arch. It seems that the structure was originally thatched and later adapted to portable use with a cloth cover, as indicated by Uighur murals in Bezeklik temple No. 9 at Khocho.

The earliest known paintings that incontestably show felt trellis tents are scenes from the story of Lady Wenji on fragments from a scroll (Boston, MA, Mus. F.A., 28.62–65) from the Southern Song court of Gaozong (r. 1127–62). These and later copies depict Khitan (proto-Mongol) tents of the time. Not only are they fully developed but they represent both known types, one domed with a salient roof wheel and the other smaller with apparently straight struts. Both have bluish felts in summer and brown in winter, with cane screens, but no cordage is shown. Illustrations in a copy of al-Hariri's *Maqāmāt* ("Assemblies," c. 1225–35; St. Petersburg, Acad. Sci., S.23) show that the hemispherical dome was known early in the Middle East. Until the 13th century the Mongols associated trellis tents only with the neighboring Tangut and Kereyit peoples. The tents are, however, mentioned regularly in histories of the Ilkhanid dynasty (r. 1256–1353) of Iran as tribal

Mongol dwellings, at best of white felt or at worst of black, with roof wheel, door flap and storm rope. Those used as reception tents at court were covered in brocade and were sometimes of vast size, as confirmed by a tent plinth 28 m in diameter discovered at Karakorum, the Mongol capital. Two illustrations (Berlin, Staatsbib. Preuss. Kultbes., Orientabt., MS. Diez A 70, fols. 8 top and 18 top), probably detached from an early 14th-century manuscript of Rashid al-Din's *Jāmiʿ al-tawārīkh* ("Compendium of histories"), show glimpses of trellis tents with external girths and cordage; one has a rounded dome and a salient, domed roof wheel of cross-arched spokes, the other an apparently retroflexed roof profile like that used by the Chahar Aymaq in the 20th century. The historian al-Mazandarani records trellis tents of 60, 80 and 100 heads during the reign of Abu Saʿid (r. 1316–35). Therefore it seems that the dominant early form was the domed, bent-wood Turkic type and that the straight-strutted Mongol type only became prevalent later, perhaps adapted to the fingered roof wheel.

Two types of domed felt tents used by the Mongol–Turkic hordes are distinguished by the *Hei-Ta Shih Lüeh* ("A short report on the Black Tatars," 1237) and Piano Carpini's account (c. 1250): trellis tents that could be taken apart, made in Yantsin, and those that could not, made in the steppe. The latter were carried on carts for use in flattish terrain and were then the usual Mongol dwelling; they were still used by the Kazakh in c. 1510. Willem van Rubruck noted c. 1254 that in the largest cart tents (diam. 9 m) the wheels were set 1.5 m within the wall frame, and this arrangement was preserved on a smaller scale (diam. 3 m) in the only cart tents surviving in the first decades of the 20th century, those of the Nogay in the northern Caucasus. Rubruck emphasized the colored felt appliqué-work representing vines, trees, birds and beasts around the smoke hole and on the door flap. Immense trellis tents (h. 10 m) were used at Timur's great assembly at Samarkand in 1404, according to the Castilian ambassador Ruy Gonzalez de Clavijo. They were all sheathed in red cloth, one with appliqué-work and another lined with sable inside the trellis. The tents had networks of white bands around the exterior, doors of steppe grass and a flounce of white cotton at the eaves, a feature already recognizable in the Lady Wenji paintings. Great height and red coverings remained characteristics of royal tents (see §III below). The use of furs had already been noted by Marco Polo in the tent of Qubilay (Kublai Khan; r. 1260–94), with tiger skins outside and a mosaic of sable and ermine within. The continuation of this tradition can still be seen in the tent of Bogdo Han (r. 1911–24) at Ulan Bator, entirely sheathed in snow leopard pelts. Towards 1410 the domes of Timurid tents assumed a bulbous profile, achieved by allowing the struts to bow out from the trellis top, probably under Özbek influence. The form became usual for royal tents under the Safavids of Iran and Mughals of India, although the Ottomans continued to use the hemispherical dome:

in all of these the roof wheel, often gilded, formed a secondary dome above.

Trellis tents were also adopted at the Manchu court. A handbook of 1755 instructs that the emperor's tent should be 34 feet (10.34 m) across and 20 feet (6.08 m) high, with walls 5 feet 6 inches (1.67 m) high, doors at the front and rear, and 160 roof struts. A plan (London, India Office Lib.) drawn by Capt. Parish, an engineer during Lord Macartney's embassy to Jehol (Chengde) in 1793, shows the throne tent as *c.* 23 yards (21 m) in diameter, with two supporting poles astride the center, eight at half span and twelve at the wall. Outside, the roof ring was surrounded by a cloud collar in blue and the white hemispherical dome set off with a network of bands with golden studs. Comparison with the permanent temple-tents at Ulan Bator, such as Züün Aymag, suggests that the poles must have supported three concentric ring beams, with two tiers of roof struts, and trellis sections between the peripheral poles. This may well have been the structure of such giant tents as the *sira ordo* of Ögödey Khan at Karakorum in the 13th century.

In shamanistic terms, the tent represented a microcosm, with access to the heavenly world of the spirits through the smoke hole, and earth, wood, fire, water and metal all incorporated in the active hearth, within a system of four cardinal directions. The hearth could be considered as a gate to the underworld, and the column of smoke rising up through the smoke hole as a connection able to carry offerings to God.

III. Court and ceremonial.

A. Before *c.* 1500. B. After *c.* 1500.

A. BEFORE C. 1500. Three aspects of the princely tent tradition were already established in Achaemenid times, probably following Assyrian prototypes (Xenophon: *Cyropaedia* V. v. 2). The tent of the Achaemenid ruler Xerxes, captured by the Greeks at Plataia in 479 BCE, represents these: it was of immense size, displayed costly materials and was round. Both roundness and extent were intended as a model of the heavens, as a setting for the "cosmic" ruler; according to Hesychius, a later source, such tents were even called "heavens" (Gr. *ouranos*). A fourth aspect of the tradition has been inferred (Broneer) from the probable derivation of the rear wall (*skene*) of the Odeon from this tent: that it reproduced the form of palace architecture at Susa, Xerxes' capital in Iran. (A parallel precedent in Egypt can be seen in the festival tent of Ptolemy II (*r.* 285–246 BCE), which imitated masonry architecture in minute detail (Athenaeus: *Deiphosophists* V. 196–7)). Persian tents remained famous in the Classical world: Artaxerxes I's (*r.* 465–424 BCE) gift of one to Timagoras, illustrates a further characteristic: that they were treated as worthy gifts for men of rank.

These qualities were exploited throughout the Islamic world until the 18th century and were seen as the appropriate setting for God's representative on earth ("the shade of the Shadow of God"). The dimension of height, above all, was seen as expressive of majesty, although the symbolism of ample skirts that literally sheltered the court and thence the people was also recognized. Thus the tent "of wonderful size and beauty" sent by the Abbasid caliph Harun al-Rashid (*r.* 786–809) to Charlemagne in 806 had so many apartments that it resembled a palace; it was so high "that no archer could shoot an arrow to its roof" and its curtains were of byssus dyed in many colors. The Frankish response, even to the exaggeration of height, was just that expected in Baghdad. A tent made for the caliph al-Mutawakkil (*r.* 847–61) was of red Armenian stuff woven with gold: red became the color for royal tents alone. The Ghaznavid ruler Mahmud (*r.* 998–1030) used an enclosure screen (Pers. *saray-parda*) of red Shustari brocade with a canopy and ridged tent of gilded silk brocade. He also had a great tent (*khayma*) of silk brocade figured with gold; these were used deliberately to impress the khan of Turkistan. Mahmud's main enclosure screen, probably about 2.5 m high and stiffened with vertical battens at 1 m intervals, could house 10,000 horsemen.

Reports of the tents dispersed from the stores of the Fatimid caliphs of Egypt in 1067 give an impression of the range of material at this time. Fabrics included "royal" and gold brocade, stuffs from Armenia, Aleppo, Bahnasa, Karduvan, Tustar and even silk from China; some were plain, others were embroidered or woven with designs of animals, birds and men. The tents were lined and the guy ropes covered with silk or cotton; poles were silver-plated, a tradition that still survived in Morocco in the last quarter of the 20th century. A tent of the *fustat* type had a round roof 20 cubits in diameter supported on a pole 65 cubits high and a wall in 64 panels; this was also available in velvets and Dabiqi brocade. There were flat-roofed tents (*musattah*) with four walls and six poles, tents with one side only, fortress- and castle-tents, large tents (*midrab*), tents with two poles (*fazah*) and trellis tents (*khargah/kharkawat*) as used already in the 10th century by the Khazar Turks (*see* §II, B above).

The earliest Islamic paintings of trellis tents appear in a manuscript of al-Hariri's *Maqāmāt* ("Assemblies," *c.* 1225–35; St. Petersburg, Acad. Sci., S. 23, pp. 12a, 37a, 43b; see fig. 3), probably painted at Baghdad, where the typically hemispherical Turkic dome has a gilded roof wheel and various types of brocade coverings figured with arabesques and scrolls around leaves and palmettes. Other tents in these scenes have conical roofs supported on a single pole by what is probably a gilded leather cap; the raking walls are brailed back for an opening, and the covers are also brocade. A ridged tent has gabled ends, an arched door and ornaments in indigo on a white ground, perhaps representing appliqué-work. Similar tents, apparently decorated with appliqué-work, illustrate the word *khayma* in the Persian text of the romance of *Warqa and Gulshah* (Istanbul, Topkapı

Pal. Lib., H 841), a manuscript probably produced
c. 1250 in Anatolia. In these tents, however, the
emphasis on arabesques and bird or animal figures on
the walls or conical roof is much stronger; gilded
valances and finials are shown. A manuscript of the
Shāhnāma produced at Shiraz (1331; Istanbul,
Topkapı Pal. Lib., H 1479) shows the same tech-
nique on white ridged tents with strongly-raking
walls and two poles engaged in reinforced peak-caps.
A marquee with vertical walls and forceful appliqué-
work arabesques is illustrated in a page from the
Great Mongol *Shāhnāma* (*c.* 1335; Kansas City, MO,
Nelson–Atkins Mus. A., 55–103). A tent with a sin-
gle pole supporting a rounded roof with raking skirts
is depicted in two manuscripts from Shiraz, the
Kitāb-i Samak ʿAyyar ("Book of Samak the Paladin,"
1330–40; Oxford, Bodleian Lib., Ouseley MS. 380,
fol. 238*v*) and the Stephens *Shāhnāma* (1352; New
York, Met., fol. 149*r*). The flattened roof shape sug-
gests an internal frame that must presage the later
combination of roof wheel, pole and canvas, seen for
example in a Timurid copy of Rashid al-Din's *Jāmiʿ
al-tawārīkh* (*c.* 1430; Paris, Bib. N., Supp. pers.
1113, fol. 187).

The Ilkhanid Mongol ruler Hülegü had already
been presented with a *bārgāh* with a thousand pegs
by Arghan in 1255. A painting (Cambridge, MA,
Sackler Mus., 1960 186) from a dispersed copy of
Ibn Jajarmi's poetic anthology *Mūʿnis al-aʾhrar* (Isfa-
han, 1341) is useful in identifying types named in
the text: the *bārgāh* can be seen as a canvas tent with
raking walls, the *khargāh* as a trellis tent complete
with trellis frame, roof wheel and struts in the tradi-
tional red. *Bārgāh* had come to be the usual term for
a ruler's tent of state, which was used in combination
with the trellis tent as a private chamber. A famous
example of this combination can be seen in the tents
of the Ilkhanid Ghazan Khan (*r.* 1295–1304) erected
for the festivities of Ujan in 1302 illustrated in the
Timurid *Jāmiʿ al-tawārīkh* (fol. 239*r*): a yellow mar-
quee with vertical walls and a frieze of white Kufic
script on blue stands behind a trellis tent of vine
green with golden phoenixes, and a rectangular
flounced awning. The Ilkhanid original (*c.* 1310) of
this picture appears to be a scene in the Diez albums
(Berlin, Staatsbib. Preuss. Kulturbes. Orientabt., MS
Diez A 70, fol. 8 top), where the two-poled mar-
quee, this time with raking walls, has an arched
porch projecting at right angles. There is again a bold
arabesque on the roof and cloud-bands in the span-
drels; the inscription is that in the Timurid adapta-
tion. Behind it stands a tall bell tent with a disc at the
peak and repeated arabesques in the panels, all prob-
ably depicting appliqué-work in blue on a plain
white ground: the effect is far less sumptuous than
the Timurid one, but bold. A red tent to the left
shows the combination of roof wheel and guyed
conical roof. (For comments on the trellis tent, *see*
§II, B above).

The sumptuous tentage set up by Timur at Kan-i
Gil near Samarkand in 1404 included both trellis
and guyed tents, but their use in linked series is a new

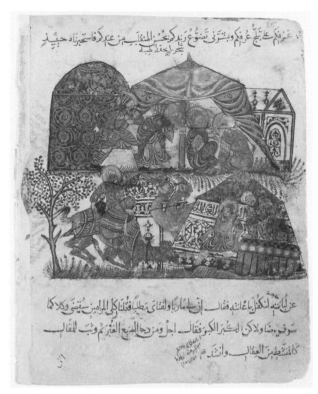

3. *Old Man and Adolescent Boy before the Tents of the Rich Pilgrims,* 265×215
mm, illustration from al-Hariri: *Māqamāt* ("Assemblies"), from Iraq,
c. 1225–35 (St. Petersburg, Academy of Sciences, Institute of Oriental
Studies, MS. C-23, fol. 43b); photo credit: Giraudon/Art Resource, NY

feature. A huge castellated pavilion 30 m square was
supported by guys on twelve poles 10 m high, with
verandahs all round: innovation was also characteris-
tic of the royal tradition. Trellis tents depicted in Per-
sian paintings from the period *c.* 1400–20 show a
bulbous profile (easily obtained by slight adjust-
ment): it may have stimulated the development of
the Islamic bulbous dome. The high status accorded
royal tents is indicated by an account of a *khargāh*
that belonged to the Aqqoyunlu ruler Uzun Hasan
(*r.* 1453–78). Its woodwork was painted in rose and
azure and depicted fighting beasts; it was covered
with blue cloth trimmed in red silk and had a painted
wooden door. It first passed to the Safavid shah
Ismaʿil I (*r.* 1501–24); he sent it to ʿAli Dawlat who
offered it to the Mamluk sultan Qansuh al-Ghawri
(*r.* 1501–16). The Arab tradition has continued in
Cairo where appliqué-work tents (Arab. *sīwān*) with
geometric patterns and inscriptions were still used in
the late 20th century for weddings, funerals and
other gatherings.

Tents for military staff drew on this royal reper-
tory, and bell tents were used by soldiers from the
14th century. The essential aspect of the camp was to
protect the ruler on whose agency depended the
security of all: the order and defenses of the camp
had a symbolic as well as a practical function.

B. AFTER c. 1500. Tents were used extensively at the courts of the Ottomans, Safavids and Mughals.

1. Ottoman Empire. 2. Iran. 3. India.

1. Ottoman Empire. The trellis tent tradition of Central Asian nomads and the guyed tradition of the Middle East had both been introduced to Anatolia after the Saljuq conquest at the end of the 11th century, and they continued in use as the region came under the control of the Ottomans. Trellis tents covered with felt are attested at Birgi in the early 14th century, at least among princes, and the presence of such tents may be inferred further east. A century later Turkmen tribesmen were seen using felt tents at Iskenderun, Tarsus and along the Toros Range as far as Sultan Dağ. European travelers were consistently impressed by the quality of both these and the urban tents made of cotton with cotton guy ropes, compared to their own equivalents of linen and hemp. In the mid-15th century the Ottoman sultan and his following lived largely in tents, and a corps of 60 men was responsible for pitching the royal tents alone. These consisted of 12 trellis tents (*otak*) surrounded by 12 large pavilions and a very large pavilion top serving as a council chamber and refectory between these and the thousand tents of the janissaries; each pavilion was shaded by an awning decorated in gold, silk and brilliant colors and the entire set was duplicated for an advance camp.

Bell tents (*çadır*), just large enough to shelter 25–35 janissaries each, remained dominant in Ottoman armies until the mid-19th century; a broad apical wooden disk (*kümac*) supported the conical roof on a central pole and the wall, at least shoulder high, spread from the eaves. Diagonally striped valances around the disc and the eaves set off the plain white cotton exterior; the tent was always lined. Large versions (*c.* 1555), as drawn by Melchior Lorck (1526/7–after 1588), were fitted with a rectangular porch canopy; long guys were rigged to both eaves and pole top. A book illustration of *c.* 1450 (Cambridge, MA, Sackler Mus.) shows disked bells next to a trellis tent with a superimposed conical fly sheet, later elaborated to a distinct type. Following the Ottoman victory at Chaldiran in 1514, when a complete Safavid camp was captured, the Ottomans appear to have modified Iranian tent types. A painting in a copy of the *Mantiq al-tayr* ("Conference of the birds," 1515; Istanbul, Topkapı Pal. Lib., EH 1512) shows a trellis tent in late Timurid style with a bulbous dome worked in brocade and an eaves flounce. A page from Hamdi's *Yūsuf and Zulaykhā* (1515; Munich, Bayer. Staatsbib. cod. turc. 183, fol. 132*v*) displays similar influence in a bell top tent cleft at the front to reveal the throned occupant.

The range of royal tentage developed its own character during the reign of Süleyman (*r.* 1520–66; see fig. 4). A painting (*c.* 1560; ex-Kraus priv. col., New York, fol. 9*r*) from 'Arifi's *Shāhnāma-yi āl-i 'uthmān*, puts Osman, the eponymous Ottoman ruler, in a trellis tent surmounted by a cleft bell top. 'Arifi's *Sulaymānnāma* (1558; Istanbul, Topkapı Pal. Lib., H 1517, fols. 346*r*, 441*r*, and 550*r*) shows the bulbous type repeatedly in a subsidiary role as a retiring tent, while tall domed tents of various profiles supported on a central pole take the role of audience tents (fols. 98*r*, 109*r*, 346*r*, 441*r*, 506*r*, 550*r* and 570*r*). The trellis of the prototype had apparently been dispensed with although the roof wheel must have been retained, and the cloud-collar ornament at the top still recalls the original. A variant of this type (fols. 374*r*, 588*r*) has two peaks close together. Both rectangular and round awnings are used. The decoration shown reflects the painter's taste but indicates a contrast of gilt lobed medallions and a ground of fine arabesques or lightly flowered brocade. The royal precinct is defined by a tall crenellated white enclosure screen, in straight runs, sometimes with blue appliqué arabesques.

Nevertheless, tall but otherwise orthodox trellis tents were still used for audiences in 1584, as in the *Nuṣratnāma* ("Book of victories"; Tokapı Pal. Lib., 1365, fol. 43*v*). By this date the audience tent was shown consistently with a conical upper canopy immediately above the main roof (cf. Mughal practice at this time) and flaring skirts (*Nuṣratnāma*, fols. 73*v*, 81*v*, 102*r* and 106*r*). Lokman's *Hunarnāma* ("Book of achievements," 1584–8; Istanbul, Topkapı Pal. Lib., H 1523, fol. 153*v* and H 1524, fol. 257*v*) emphasizes the continued importance of trellis tents so tall that they needed guys for extra support. Their symbolic relation to the tomb-tower form is suggested by their use at burials, such as that of Süleyman (Dublin, Chester Beatty Lib., MS 413, fol. 115*v*). The *Shāhnāma-yi Mehmed Khan* (*c.* 1598; Istanbul, Topkapı Pal. Lib., H 1609, fol. 26*v*) shows a comparable range of tents, with the addition of a square belvedere with steps and a flat baldachin, but with a marked change towards restrained decoration: the bell top of the audience tent is of a plain paneled green and the trellis tent is of red figured material.

The failure of the first siege of Vienna in 1529 and the Habsburg reproduction of the captured campcenter in built form led Evliya Çelebi to list its elements, still used in his day (1665), as having a merloned enclosure (*sokak*) 4000 paces in circumference with 16 angle turrets (*kule*), housing a privy chamber (*has oda*), the treasury (*hazine*), pantry (*kiler*), large and small chambers (*büyük ve küçük odaları*), pages' quarters (*seferli oda*), guard rooms (*doğancılar odaları*), an audience tent (*arz odası*), a pavilion of justice (*adalet köşki*), the execution tent (*leylak*) and the sublime council chamber (*divanhane-yi-ali*: "overlooking the world"), large tents (*çerge*) and small ones (*hurde cadırları*). *Otak* or *otağ* was a comprehensive term for the royal quarters, qualified as, for example, *otak-i bargah-i hassa* (the privy court tent) or *otağ-i humayun* (the imperial tent). Other sources identify *oba* as a felt trellis tent and *çerge* as ridged marquees in sizes varying from two poles to the seven used for audience tents (*divanhane çerge*) or eight for the royal stables (*istabl*). The usual janissaries' tents were the disk-topped *cadır*.

Awnings were *sayeban* (in baldachin form) or *günlük*. The sizes of tents were given in *hazine*, apparently the number of cloth widths. By 1615 the Italian traveler Pietro della Valle (1586–1652) could record that the pasha's enclosure for the Iranian campaign was half a mile in circuit. It and almost all its tents were green externally, for camouflage, he assumed, and this was to remain the custom. Inside they were red worked in an arcaded design with a lamp depicted in each panel. A large round antechamber, with a design of foliage inside, opened to a broad covered street, made to match and carpeted throughout, leading to the round audience tent, the further half of which was curtained off; it was spread and furnished with brocaded silk. This in turn led to the pasha's private quarters of at least ten interconnected pavilions lined with silk or gold. The poles too were painted and gilded with gilt finials. The value was given as 16,000 *zecchini*.

These arrangements, except for the street, were confirmed by the English traveler John Covel in 1674–5 for the tents of the sultan and his vizier. The sultan's crenellated enclosure, 400 by 100 feet (122.0×3.5 m), with red on green canvas, was divided into three courts: the first contained a raised, flat-roofed belvedere 8 feet (2.44 m) square, a rectangular flat-topped antechamber 15 paces by 12 (Covel's stride was evidently 700mm or less), a round single-poled audience tent with a cap 15 or 17 paces across and a three-posted marquee 35 or 37 paces long. The second held the sultan's private quarters, a ridged, latticed *oda* 12–13 feet (3.2–3.9 m) square, which had apparently replaced the trellis tent (as in India; see fig. 1 above), and tents for pages. The third court contained the smaller kitchen and store tents. The marquee was of green canvas outside, with floral appliqué-work on satin inside, including some birds and animal figures and a matching curtain. The belvedere was of reddish-purple cloth, and the *oda* was hung with red cloth lined with flowered damask. Before six horsetail standards at the main gate lay the round executioner's tent; this was the first to be pitched, and from it the quartermasters laid out the camp. Sir Paul Rycault added that the sultan's tents then cost 180,000 dollars and had poles plated in gold; like other foreigners, he remarked that the tentage showed if anything more splendor than the palace buildings. The paintings from Vehbi's *Sūrnāma* ("Book of festivals," *c.* 1720; Istanbul, Topkapı Pal. Lib., A. 3593) illustrate similar tents, with an emphasis on red chevron ornament externally.

Of the 6500 Ottoman tents captured at Vienna in 1683, the several that survive conform to these details. That at Stockholm (Kun. Armémus.) is a ridge tent with polygonal ends, 30 m in perimeter and 5.5 m high; the outside is of green cotton and the inside of appliqué-work in warp-satin on red cotton, reinforced with webbing. Its roof is decorated with two tiers of engrailed panels, the upper containing fine floral sprays, the lower bolder pole medallions between swelling colonnettes, echoed below a floral valance by an elongated version in the wall. The use of engrailed arches is similar, though on a blue

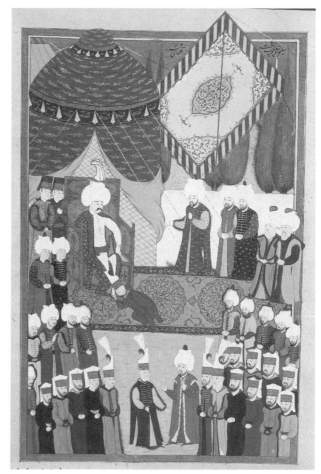

4. Trellis tent of Selim I, with gilded roof wheel and awning; miniature, from the *Hunarnāma* ("Book of accomplishments"), 1588 (Istanbul, Topkapı Palace Library, MS. H. 1523–4); photo credit: Giraudon/Art Resource, NY

ground, in a tent of the same two-poled form at the Wawel in Kraków (N. A. Cols., no. 896; 13.5×3.2 m), but the upper roof panels are replaced by a broad band of floral ornament in a reticulated ogival framework; the appliqué-work is in gold, white, rust and olive, with inscriptions worked in gilded leather. A tent wall dated AH 1120 or 1129 (1708 or 1716; Istanbul, Mil. Mus.) shows that this ornamental scheme survived until the 18th century. The effect is highly rhythmical and resembles ceramic tilework of the same period. Similar paneling could also be woven in brocade with metallic thread, as in a tent (Vienna, Ksthist. Mus., Wagenburg S. 220) where green and gold decorate cherry-colored silk. By the end of the 18th century a Europeanized Rococo style was introduced, with oval windows, Classical vases and sinuous leafy frames in the same paneled scheme (e.g. dated AH 1208 or 1218/1793 or 1803; Istanbul, Mil. Mus., no. 23615). The Signore Conte di Marsigli, however, noted that the extravagance in military tentage had already been abolished in the last

decades of the 17th century. The high status of tentage can be judged from the fact that it continued to form a significant part of royal gifts to foreign powers until the 1740s. The Ottoman tent at the Wagenburg (Ksthist. Mus.), Vienna, is a case in point: it is listed in Ottoman records as having two poles and 20 *hazine*.

2. Iran. The range of tentage depicted in paintings (e.g. Mir Sayyid ʿAli: *Nomad Encampment, c.* 1540) from the early years of the Safavid dynasty is essentially unchanged from that of the 15th century but shows refinement in the use of appliqué-work for medallions set in lining panels and for valances on the otherwise plain exteriors of guyed tents. The outer covers of trellis tents, by contrast, show elaborate and carefully tailored designs of strapwork, cartouches and bird or animal figures. A felt tent (Turk. *şirvanlı*) erected for the guests of ʿAbbas I and seen by the traveler Pietro della Valle in 1619 was "long and rounded in the ceiling, as though like a gallery." It was a bowshot in length and contained two banqueting tables and a service table. It was striped lengthwise, open at the middle below and guyed. It apparently derived from the tunnel tents of Azerbaijan but was of far greater size. Wooden plinths (*yurt*) for tents were part of the tent stores in the 18th century.

The innovative Iranian urban tradition culminated in the jeweled tent of the Afsharid ruler Nadir Shah (*r.* 1736–47), finished in 1740 and designed expressly to use up the jewels he found in the treasury at Delhi. These were mounted on golden plaques sewn onto the satin lining so as to form part of a larger composition. Here Persian *shīrvanī* was used for a tent with separate roof and walls; it had cast golden poles and pegs. It was packed into long boxes and transported with difficulty by eight elephants. Under the Qajars (*r.* 1779–1924) tents were decorated with panels of block-printed cotton depicting legendary scenes, in parallel with rug design; a late 19th-century example (sold New York, Sotheby's, 10 Dec. 1981, lot 209) measures 4 m sq. and has a pyramidal roof. As in earlier examples, the panels are divided by a stiffening batten within a vertical pocket.

3. India. Free-standing tents are well documented in India during the Islamic period. By the 11th century they belonged within the urban and military tradition of the Middle East, including the Central Asian trellis tent and much of the terminology used was Persian, but the type most elaborately developed in India was the camp and its royal precinct, being essential in a vast territory for both military and administrative control. Such tents also served in the transferal of the court to a cooler region each summer. Palace buildings, too, were shaded by large, often ostentatiously expensive awnings and other tentage.

From the Ghaznavid period the main types were the *khayma* and *dihlīz*, or vestibule used for public audience; both were of canvas stretched by guy ropes, like the great enclosure screen, *sarāy-parde*, around

them. The trellis tent, *khargāh*, was also present. By the 13th century a marquee-like *bārgāh* was used as a tent of state. Royal tents distinguished by size, majesty, richness of materials and their red color, a royal privilege, were thus established as a topos. Ibn Battuta records that a suite of tents sent to Muhammad Tughluq (*r.* 1325–51) consisted of an enclosure, an awning to shade its interior, a guyed tent with an annex and a retiring tent, all in appliqué work decorated with gold leaf. Tents other than royal ones at this time were white embroidered with blue. Firuz Shah (*r.* 1351–88) prohibited the depiction of people or animals on tents, an indication that at least some of this decoration was figurative.

Such types continued to be used by the Mughals. Babur (*r.* 1526–30) undoubtedly preferred a trellis tent of the domed Central Asian type as a retiring room. Mughal book paintings depict such tents with a bulbous dome in Timurid style and coverings of rich textiles in lieu of felt. A guyed audience tent was often set a little in front. Under Humayun (*r.* 1530–40, 1555–6) the *dihlīz* appeared for the last time. The military camp included tents of state, *bārgāh*, as well as a treasury, a bedding store, kitchens, buttery, stables, tents for ablutions and latrine tents. Another *bārgāh* served the royal harem. In 1534 Humayun developed for his own presence chamber a zodiac tent (*khargāh-i davāzdah burj*), with 12 towers through which the stars could shine. A demountable three-story pavilion, the Qasr-i Ravan (Moving Palace), open on six sides with multicolored hangings, was used for palace festivities.

Under Akbar (*r.* 1556–1605) tents reached a new level of eclectic magnificence, but the reorganization of the imperial camp was his most notable innovation. The entire camp precinct was laid out as a series of rectangular spaces of successively greater privacy from west to east (adumbrating the layout used later for the Red Fort at Delhi), 1275 m long. The women's quarters at the eastern end were protected by a wooden trellis adapted from the Central Asian tradition, enclosing a tent of state, trellis tents and wooden pavilions. Fronting the public audience courtyard at the west end was a larger tent of state for the élite, surrounded by 50 awnings. A courtyard at the center was used for relaxation and for private audience in the evening. The imperial complex was made in duplicate so that an advance camp could be sent ahead to the next site. The tents of officers and men extended in a 30-km circuit around the royal center. Book paintings of the period show that most royal tents were a plain red externally, with eaves valances in yellow or diapered white; the principal tent of state might have elaborate appliquéwork medallions. Gold brocade seems to have been reserved for trellis tents and awnings. Double-nap velvet, already used in 1535, Portuguese broadcloth and various brocades were probably imported from Europe or Turkey. In 1605 the tent department was valued at ten million rupees.

Developments under Jahangir (*r.* 1605–27) and Shah Jahan (*r.* 1628–58) mainly affected palace tents.

The tent of state, now devoid of its walls, was rigged as two distinct roofs, one above the other, on two tall main poles, with a throne canopy on four slender poles below making a third stage. Its awnings were arranged in a continuous series around the eaves, and a pair of trellis tents, their woodwork sheathed in silver, were set symmetrically behind (see fig. 1). The eaves assumed a bowed line, probably under Bengali influence. The most famous new tent of this type, known as *aspak*, of gold-brocaded velvet on silver and gold-sheathed poles, was first pitched at Agra in 1628. An even finer example was pitched at Agra in 1635 to house the new Peacock Throne. Comparable tents were used in front of the audience halls of the Red Fort at Delhi; at its inauguration in 1648 the tent for public audience matched the building in length (57 m) and, with a width of 37 m, could accommodate 10,000 courtiers. These tents were planned as part of the building from its inception, as must also have been true in earlier settings. More indigenous materials, notably chintz from Machilipatnam (Masulipatam), were used in the mid-17th century, especially under Awrangzib (*r.* 1658–1707), as material excesses were reduced. In his reign the trellis tent finally went out of fashion, but the trellis enclosure was extended to fence off the entire royal precinct.

Among the few surviving tents from the 17th century are the roof of a small tent of state of silk brocade woven in arched panels (Ahmedabad, Calico Mus. Textiles), a tent of crimson silk velvet set off with gilt embroidery, which is surrounded by cusped arcades (Jodhpur Fort; see Welch), and a small ridged tent of crimson velvet ornamented with gold leaf and lined with a delicate pattern of pink silk flowers against a golden ground (Jaipur Palace). Examples from the 18th and 19th centuries show extensive use of colored embroidery, such as floral designs in pink and turquoise on quilted white cotton (e.g. Jodhpur Fort). Animal and human figures were sometimes used in non-Muslim contexts, as in an example in cherry-colored silk from Dhrangadhra (on loan to Ahmedabad, Calico Mus. Textiles). Tents remain in use in modern times to house public meetings, often with geometric appliqué in bright colors. Block printing is also used, especially for temple canopies.

GENERAL

Enc. Islam/2: "Khayma" [Tent]
C. G. Feilberg: *La Tente noire: Contribution ethnographique à l'histoire culturelle des nomades* (Copenhagen, 1944)
J. Bidault and P. Giraud: *L'Homme et la tente* (Paris, 1946)
A. U. Pope: "Tents and Pavilions," *Survey of Persian Art*, ed. A. U. Pope and P. Ackerman (2/1964–7), iii, pp. 1411–26
P. Drew: *Tensile Architecture* (London, 1979)
T. Faegre: *Tents: Architecture of the Nomads* (London, 1979)
B. Rasch: *Tent Cities of the Hajj*, Mitteilungen des Instituts für Leichte Flächentragwerke, 29 (Stuttgart, 1980)
P. A. Andrews: "From Tent Screens to Kilims," *Orient. Carpet & Textile Stud.*, iii/2 (1990), pp. 61–4
P. A. Andrews: *Felt Tents and Pavilions: The Nomadic Tradition and its Interaction with Princely Tentage*, 2 vols. (Cologne, 1996)

P. A. Andrews: *Felt Tents and Pavilions: The Nomadic Tradition and its Interpenetration with Princely Tentage*, 2 vols. (London and Cologne, 1999)

NOMADIC

N. Kharuzin: *Istoriya razvitiya zhilishcha u kochevuikh' i polu-kochevuikh' tyurkskikh' i mongol'skikh' narodnostey Rossii* [History of the development of the dwellings of the nomadic and semi-nomadic Turkic and Mongolian peoples of Russia] (Moscow, 1896)
G. A. Bonch-Osmolovsky: *Svadebnye zhilishcha turetskikh narodnostey* [The nuptial dwellings of the Turkish peoples], Materialy po etnografii etnograficheskogo otdela Gosudarstvennogo Russkogo Muzeya, iii/1 (Leningrad, 1926), pp. 101–10
E. Laoust: "L'Habitation chez les transhumants du Maroc Central: i. La Tente et le douar," *Hespéris*, x (1930), pp. 151–253
A. de Boucheman: *Matériel de la vie bédouine recueilli dans le désert de Syrie (tribus des Arabes Sba'a)*, Documents d'études orientales de l'Institut Français de Damas, iii (Paris, 1934), pp. 97–115
M. F. von Oppenheim: *Die Beduinen*, i–iii (Leipzig, 1939–52)
E. Rackow and W. Caskel: "Das Beduinenzelt," *Baessler-Archiv*, xxi (1938), pp. 151–84 [a collation of existing inf. and terminology]
Z. V. Togan, ed.: *Ibn Faḍlans Reisebericht* (Leipzig, 1939/R 1966), excurs. no. 14a, pp. 118–19
G. M. Crowfoot: "The Tent Beautiful: A Study of Pattern Weaving in Trans-Jordan," *Palestine Explor. Q.* (Jan.–April 1945), pp. 34–47
H. R. P. Dickson: *The Arab of the Desert: A Glimpse into the Bedawin Life in Kuwait and Saudi Arabia* (London, 1949, 1951)
Cahiers des arts et techniques de l'Afrique du Nord, iv (1955) [eight articles on tents in Morocco, Algeria and Tunisia]
K. Ferdinand: "The Baluchistan Barrel-vaulted Tent and its Affinities," *Folk*, i (1959), pp. 27–50; ii (1960), pp. 33–50
L. Golvin: *L'Art de la tente* (Algiers, 1960)
K. A. Kitchen: "Some Egyptian Background to the Old Testament," *Tyndale House Bull.*, v–vi (1960), pp. 7–13 [the Tabernacle]
A. Róna-Tas: "Notes on the Kazak Yurt of West Mongolia," *Acta Orient.* [Budapest], xii (1961), pp. 79–102
A. Róna-Tas: "A Preliminary Report on a Study of the Dwellings of the Altaic Peoples," *Aspects of Altaic Civilization*, ed. D. Sinor (The Hague, 1962), pp. 47–56
S. Cammann: "Mongol Dwellings—with Special Reference to Inner Mongolia," *Aspects of Altaic Civilization*, ed. D. Sinor, Uralic and Altaic Series, 23 (The Hague, 1963), pp. 17–22 [symbolism]
J. Nicolaisen: *Ecology and Culture of the Pastoral Tuareg*, Nationalmuseets Skrifter Etnografisk Roekke, ix (Copenhagen, 1963), pp. 350–91
K. Ferdinand: "Ethnographical Notes on Chābār Aimāq Hazāra and Moghol," review article, *Acta Orient.* [Copenhagen], xxviii (1964), pp. 187–200
U. Johansen: "Die Nomadenzelte Südost-Anatoliens," *Bustan*, ii (1965), pp. 33–7
E. Esin: "Al-Qubbah al-turkiyyah: An Essay on the Origins of the Architectonic Form of the Islamic Turkic Funerary

Monument," *Atti del III congresso di studi arabi ed islamici: Ravello, 1966*, pp. 281–313

L. Edelberg: "Seasonal Dwellings of Farmers in North-western Luristan," *Folk*, viii–ix (1966–7), pp. 373–401

M. F. von Oppenheim: *Die Beduinen*, iv (Wiesbaden, 1967)

O. du Puigaudeau: "Arts et coutumes des Maures, i.," *Hespéris-Tamuda*, viii (Rabat, 1967), pp. 145–63

R. Loffler and E. Loffler: "Eine ethnographische Sammlung von den Boir Ahmad, Südiran," *Archv Vlkerknd.*, xxi (1967–8), pp. 104ff

A. K. Margoulan: "The Kazakh Yourta and its Furniture," *Trudy VII mezhdonarodnogo kongressa antropologicheskikh i etnograficheskikh nauk* [Works from the 7th international congress of anthropological and ethnographical sciences], vii (Moscow, 1970), pp. 98–104

P. A. Andrews: "Tents of the Tekna, Southwest Morocco," *Shelter in Africa*, ed. P. Oliver (London, 1971), pp. 124–42

P. A. Andrews: "The White House of Khurasan: The Felt Tents of the Iranian Yomut and Gökleń," *Iran*, xi (1973), pp. 93–110

O. Kademoğlu: "Yörüklerde üç direkli karaçadır" [The three-poled black tent among the Yörük], *1. Uluslararası Türk folklore semineri bildirileri* [First international Turkish folklore meeting] (Ankara, 1974), pp. 296–304

R. Dor: *Contribution à l'étude des Kirghiz du Pamir Afghan*, Cah. Turc., i (Paris, 1975), pp. 171–231

D. Maydar and L. Dar'süren: *Ger oron suutsnui tüükhen toym* [An historical survey of Mongol dwellings] (Ulaan Baatar, 1976)

S. I. Vaynshteyn: "Problemy istorii zhilishcha stepnykh kochevnikov Evrazii" [Problems concerning the history of the dwelling of Eurasian steppe-nomads], *Sovetskaya etnografiya* (Paris, 1976), no. 4, pp. 42–62

P. A. Andrews: "Alačix and Küme: The Felt Tents of Azarbaijan," *Mardomshenāsī va farhang-e ʿāmme-ye Īrān*, iii (Winter 1977–8), pp. 19–45

M. Centlivres-Demont: "Yourtes et huttes des turcophones du Nord-Afghan (Qataghan et Turkestan)," *Quand le crible était dans la paille: Hommage à P. Boratav* (Paris, 1978), pp. 125–32

P. A. Andrews: "The Felt Tents of Central Asia: The Turkish Contribution to a Tradition," *Akten des VI. internationalen Kongresses für türkische Kunst: München, 1979*, pp. 403–18

P. A. Andrews: "The Mongolian Trellis Tent," *Mongolia, Land of the Five Animals* (exh. cat., London, Horniman Mus. & Lib., 1979), pp. 10–22

C. Humphrey: "Inside a Mongolian Tent," *Mongolia, Land of the Five Animals* (exh. cat., London, Horniman Mus. & Lib., 1979), pp. 23–35

P. A. Andrews: "The Tents of Chinggis Qan at Ejen Qoriy-a," *J. Anglo-Mongol. Soc.*, vii/2 (1981), pp. 1–49

M. S. Mukanov: *Kazakhskaya yurta* [The Kazakh yurt] (Alma Ata, 1981)

J.-P. Digard: *Techniques des nomades baxtyâri d'Iran* (Cambridge and Paris, 1982), pp. 153–60

W. Herberg and A. Janata: "Die Firuzkuhi-Jurte des Museums für Völkerkunde in Wien," *Afghanistan J.*, ix (1982), pp. 95–103

S. U. Azadi: "The Turkoman Kaplyk (Tent Entrance Decoration)," *Orient.Carpet & Textile Stud.*, i (1985), pp. 131–9

P. A. Andrews: "Felt Tents in Anatolia," *Sosyal Antropol. & Etnol. Derg.*, iv (1986), pp. 33–63

P. A. Andrews: *Nomad Tent Types in the Middle East*, 2 vols, Tübinger Atlas des Vorderen Orients, map no. A IX 5 (Wiesbaden, 1990) and accompanying book with same title, suppl. B. 74, i–ii (Wiesbaden, 1996)

P. A. Andrews: "The Evolution of the Trellis Tent: A Middle Eastern Development?," *L'Asie centrale et ses voisins: Influences réciproques*, ed. R. Dor (Paris, 1990), pp. 141–64

D. Balland: "Tents, Yurts, Huts and Caves: On the Cultural Geography of Temporary Dwellings in Afghanistan," *Folk*, xxxiii (1991), pp. 107–15

L. Prussin: "The Tent in African History," *African Nomadic Architecture: Space, Place, and Gender*, ed. L. Prussin (Washington, DC, 1995), pp. 1–19

S. Rasmussen: "The Tent as Cultural Symbol and Field Rite: Social and Symbolic Spaces, 'Topos,' and Authority in a Tuareg Community," *Anthropol. Q.*, lxix/1 (1996), pp. 14–26

R. Tapper and J. Thompson, ed.: *The Nomadic Peoples of Iran* (London, 2002)

COURT AND CEREMONIAL

Ibn Battuta: *The Travels of Ibn Battūta*; Eng. trans. H. A. R. Gibb (Cambridge, 1958–71), iii, pp. 672–6, 752–5

Iacopo de Promontorio: ed. F. Babinger as *Die Aufzeichnungen des Genuesen Iacopo de Promontorio de Campis über den Osmanenstaat um 1475* (Munich, 1957), pp. 46–8

R. Gonzalez de Clavijo: *Historia del Gran Tamorlan e itinerario y enarracion del viage …* (Seville, 1582); Eng. trans. by G. Le Strange as *Narrative of the Spanish Embassy to the court of Timur at Samarkand in the years 1403–1406* (London, 1928)

Abu'l-Fazl: *Āyīn-i Akbarī* [Annals of Akbar], (*c.* 1596–1602); Eng. trans. in 3 vols: i, trans. H. Blochmann, ed. S. L. Gloomer ([Calcutta], 1871/R Delhi, 1965), *āyīn*s 16, 17 and 21; ii and iii, trans. H. S. Jarrett, ed. J. Sarkar (Calcutta, 1948–9/R Delhi, 1972–3)

F. Gladwin: *The Persian Moonshee* (Calcutta, 1801), pp. 69–74 [incl. extracts transl. into Eng. from Ray Chandar Bhan Brahman's *Qavāʿid al Saltanat* ("Rules of the sultanate") on tents at the time of Shah Jahan]

P. della Valle: *Viaggi di Pietro della Valle il Pelegrino* (Rome, 1662), iii, pp. 238–43

P. Rycaut: *The History of the Turkish Empire* (London, 1687), pp. 132, 303

L. F. de Marsigli: *Stato militare dell'Imperio Ottomano* (The Hague and Amsterdam, 1732), ii, pp. 56ff [the first systematic analysis of the Ottoman camp and tentage]

J. Covel: *Diary*, ii of *Early Travels and Voyages in the Levant*, ed. T. Bent (London, 1893), pp. 163–8, 208 [MS., London, BL, Add. 22, 912]

W. Irvine: *The Army of the Indian Moghuls, its Organization and Administration* (London, 1903)

E. Çelebi: *Seyahatnâme*, ed. Kilisli Rifʿat Bilgä (Istanbul, 1928), vii, pp. 223–4

O. Broneer: "The Tent of Xerxes and the Greek Theater," *U. CA, Pubns Class. Archaeol.*, i (1929), pp. 305–11

Abdul Aziz: *Thrones, Tents and their Furniture Used by the Indian Mughuls* (Lahore, 1946)

P. A. Andrews: "The Tents of Timur: An Examination of Reports on the Quriltay at Samarqand, 1404," *Arts of the Eurasian Steppelands*, Percival David Foundation Colloquies on Art and Archaeology in Asia, 7, ed. P. Denwood (London, 1977), pp. 143–79

P. Högl: "Ein bucharisches Zelt," *Baessler-Archv*, n. s. xxviii (1980), pp. 61–71

M. Piwocka: *Namioty wschodnie: Panstwowe zbiory sztuki na Wawelu* [Oriental tents: the state collections of arts in Wawel Castle] (Warsaw, 1982)

B. M. Wass: "The Tentmakers of Cairo," *Islamic Art from Michigan Collections* (exh. cat., ed. C. G. Fisher and A. W. Fisher; East Lansing, MI State U., Kresge A. Mus., 1982), pp. 17–26

C. Çürük and E. Çiçekçiler: *Örnekleriyle Türk çadırları* [Examples of Turkish tents] (Istanbul, 1983) [catalogue of tents in the Military Museum] *India: Art and Culture, 1300–1900* (exh. cat. by S. C. Welch; New York, Met., 1985)

G. Klingberg, A. Andersson and I. Wallenborg: "Ett blommande turkist 1600-talstält," *Svensk. Forskinst. Istanbul, Meddel.*, xi (1986), pp. 77–83

P. A. Andrews: "The Generous Heart or the Mass of Clouds: The Court Tents of Shah Jahan," *Muqarnas*, iv (1987), pp. 149–65

N. Atasoy: *Otag-i Humayun: The Ottoman Imperial Tent Complex* (Istanbul, 2000)

INDIVIDUAL EXAMPLES

M. L. Chodkiewicz: "Une Tente persane du XVIe siècle," *Journal Zasiatique*, 8th ser., i (1883), pp. 275–80

T. Mankowski: "Les Tentes orientales et les tentes polonaises," *Rocznik orientalistyczny*, xxii/1 (1957) pp. 77–109

S. J. Gąsiorowski: "La Tente orientale du Musée Czartoryski à Cracovie," *Fol. Orient.*, i (1959), pp. 303–21

S. J. Gąsiorowski: "Historie des formes decoratives de quelques tissus orientaux de Cracovie," *Fol. Orient.*, ii (1960), pp. 103–52

G. Feher jr: "La Tente turque du Musée National Hongrois," *Fol. Archaeol.*, xiii (1961), pp. 214–23

Z. Zygulski jr: "Turkish Trophies in Poland and the Imperial Ottoman Style," *6o Congresso dell'Associazione internationale dei musei d'armi e di storia militaria: Zurigo, 1972*, pp. 25–66

T. Majda: "Die Blumendekoration der orientalischen Zelte in den Staatlichen Kunstsammlungen im Wawel in Krakau," *Akten des VII. internationalen Kongresses für iranische Kunst und Archaeologie: München, 1976*, pp. 463–6

Die Türken von Wien: Europa und die Entscheidung an der Donau 1683 (exh. cat., ed. R. Waissenberger; Vienna, Hist. Mus., 1983), nos. 11/21–28, 12/1–9, 25

B. Biedronska-Slota: "A Turkish Tent in the Kraków National Museum," *Art turc/Turkish Art: 10e Congrès international d'art turc: Genève, 17–23 Septembre, 1995*, pp. 183–190

N. Atasoy: *Otag-i Humayun: The Ottoman Imperial Tent Complex* (Istanbul, 2000)

A. Fernández-Puertas: *La tienda turca otomana de la Real Armería (c.1650–1697)* (Madrid, 2003)

Termez [Tirmidh]. City in Uzbekistan. Located on the right bank of the Amu River near its confluence with the Surkhan, the remains of Old Termez (Stary Termez) lie 12 km west of the modern city, founded in the late 19th century as a Russian military settlement on the border between the khanate of Bukhara and Afghanistan. Noted by many travelers in the 19th century, Old Termez was investigated by the first expedition (1926–8) of Soviet scholars led into Central Asia by Prof. B. P. Denike. The site was excavated by the Termez Archaeological Expedition (TAKE; 1936–8) under M. Ye. Masson, and by others after World War II.

Excavations show that there was some sort of settlement on the site of the citadel of Old Termez in the Greco-Bactrian period (3rd–2nd centuries BCE). During the Kushana period (1st century BCE–4th century CE) the site, known as Tarmita, was a large city covering at least 300 ha. Its outer mud-brick wall enclosed not only the heavily populated citadel and riverbank but also extensive suburbs, including the Buddhist religious center on Kara Tepe, a three-crested hill in the northwest part of the city, and the mud-brick burial vaults from the Kushana period further west near the banks of the Amu River. Other contemporary remains include the suburban monastery on Fayaz Tepe 1 km north of Kara Tepe, the Zurmala Tower—a large stupa on a rectangular platform (20×15 m) in the form of a domed cylindrical tower originally faced with tiles and stone—to the southeast of the town, and remains of another complex outside the northern wall, whose cellars contained fragments of stone and ceramic vessels with Buddhist inscriptions. The remains of monumental religious and secular buildings, stone, clay and plaster sculptures, wall paintings, terracottas, ceramic vessels and hundreds of copper coins all show that the town flourished as an entrepôt and center of artistic production. Between the 4th and the 7th century when Bactria was repeatedly invaded by the army of Sasanian Iran, Chionites, Hephthalites, Turkish tribesmen and finally the Arabs, Termez declined. Monumental buildings, such as the monasteries at Kara Tepe and Fayaz Tepe, were abandoned and used as burial sites. The Chinese pilgrim Xuanzang, who visited Bactria c. 630, described Ta-mi (Termez) as a relatively small town in the small, semi-independent country of Tu-kh-lo (Tokharistan).

In 689 Termez fell to the Arab military commander Musa ibn 'Abdallah, who maintained a personal fiefdom there until 704, when the city was incorporated into the caliphate. For several centuries Termez, the main settlement on the Amu River, flourished as the center of a semi-autonomous administrative region. The town consisted of a citadel with the ruler's palace, city proper with the Friday mosque and suburbs with the outdoor praying place (Pers. *namāzgāh*), all enclosed by walls. According to 10th-century geographers, the bazaars were built of pisé, but most of the streets and squares were paved with fired brick. Excavations show that the system of fortifications from the 10th to the 12th century encompassed 550 ha. The walls and towers of the citadel, unlike those of the town and suburbs, were faced with fired brick. In the northern suburb, remains of the palace of the local rulers (11th–12th century) have been found. It comprised several buildings around a courtyard, and the iwan opposite the entrance was decorated with three registers of carved plaster panels showing geometric patterns and

zoomorphic motifs. Another room had carved panels and paintings along the top of the walls (*see* ARCHITECTURE, §X, A, 2). The small (10×10 m) Chorsutun (Pers. *chahār-sutūn*: "four-column") Mosque in the western suburb had a mihrab, floors, walls and nine columns of brick supporting the roof, presumably domed. Adjacent to the mosque was a minaret (1032; destr.). The ruins of a monumental public building near the city walls bore traces of colored murals. Craftsmen's houses and wells have been found in the suburbs.

The Qarakhanid ruler Ahmad I (*r.* 1081–9) erected a domed square mausoleum near the citadel over the grave of the 9th-century mystic Abu ʿAbdallah Muhammad, known as al-Hakim al-Tirmidhi (Khakimi at-Termezi), the philosopher of Termez. The interior is covered with elegant carved stucco inscriptions set against a field of geometric and floral ornament. In the 12th century a memorial mosque, comprising a portico with three domes on simple *muqarnas*, was constructed on the north, with facings of fired brick and carved stucco. In 1220 Termez was devastated by the Mongols under Genghis Khan, although the shrine continued to be venerated. The Timurid ruler Khalil (*r.* 1405–9) constructed a domed chamber (10×10 m) with axial niches and simple squinches to serve as a *khanaqah* for Sufis and ordered a magnificent carved marble cenotaph. The strategic importance of the ford led to the rebuilding of the city in the 15th century to the east near the Surkhan River on land that had been the cemetery of the Sayyids of Termez. The funerary ensemble there known as Sultan-Saʿdat (11th–17th century) comprises four groups of structures arranged around a long rectangular space.

There are several medieval architectural monuments in the environs of Termez, such as Kyr-Kyz (9th–10th century), the large mud-brick country estate that possibly belonged to the Samanids. The square (54×55 m) building with corner towers has vaulted rooms on two stories grouped around a small central yard. Iwans in the exterior walls lead to four vaulted corridors. The minaret at Yar Kurgan (1108–9) has a shaft formed of closely set half columns linked by an arcade and surmounted by an inscription band; the columns are decorated with bricks laid in basketweave patterns. The Zul-Kifl Mosque (Dhu'l-Kifl; 11th–12th century), on Aral-Paygambar Island in the Amu River, has a tall portal and broad dome on squinches. The *khanaqah* of Koklidor (16th century) consists of a deep iwan leading to a main domed room flanked by lateral rooms linked by corridors. The plaster vaulting is especially fine.

Enc. Islam/2: "Tirmidh"

S. Flury: *Islamische Schriftbänder Amida-Diarbekr, XI. Jahrhundert; Anhang: Kairuan, Mayyâfâriqîn, Tirmidh* (Basel, 1920)

M. Ye. Masson: "Gorodishcha Starogo Termeza i ikh izucheniye" [The sites of Old Termez and the study of them], *Trudy Uzbek. Filiala Akad. Nauk SSSR*, i/3 (1940–41), pp. 5–122

G. A. Pugachenkova: "Bronzovoe zerkalo iz Termeza" [A bronze mirror from Termez], *Sovetskaya Etnografiya* (1961), pp. 153–5

G. A. Pugachenkova: *Termez, Shakhrisyabz, Khiva* (Moscow, 1976); Germ. trans. as *Termes, Schahr-I Sabz, Chiwa* (Berlin, 1981)

Z. A. Arshavskaya, E. V. Rtveladze and Z. A. Khakimov: *Srednevekovyye pamyatniki Surkhandar'i* [Medieval monuments of the Surkhan River] (Tashkent, 1982)

Z. A. Khakimov: "Pamyatniki arkhitektury v yuzhnom Uzbekistane" [Architectural monuments in southern Uzbekistan], *Khudozhestvennaya kul'tura sredney Azii, IX–XIII vv.* [The artistic culture of Central Asia in the 9th–13th century] (Tashkent, 1983), pp. 149–60

L. Golombek and D. Wilber: *The Timurid Architecture of Iran and Turan*, 2 vols. (Princeton, 1988), nos. 50 and 51

S. S. Blair: *The Monumental Inscriptions of Early Islamic Iran and Transoxiana* (Leiden, 1992), nos. 38 and 63

M. Bernardini: "Note sur la 'Porte de fer' près de Termez (Darband/Qahalgha)," *Environmntl Des.*, xviii/1 (1997), pp. 160–63

P. Leriche and S. Pidaev: "Termez," *Doss. Archéol.*, ccxlvii (1999), pp. 43–9

E. G. Nekrasova: *Termez i ego arkhitekturnye pamiatniki* [Termez and its architectural monuments] (Tashkent, 2001)

S. Pidaev: "Mosquées de quartier dans l'ancienne Tirmidh (Ouzbékistan)," *Archéol. Islam.*, xi (2001), pp. 61–74

M. Fedorov: "Qarakhanid Coins of Tirmidh and Balkh as a Historical Source: New Numismatic Data on the History of the Qarakhanid Dominions of Tirmidh and Balkh," *Numi. Chron.*, clxiii (2003), pp. 261–85

Terrasse, Henri (*b.* Vrigny-aux-Bois, 8 Aug. 1895; *d.* Grenoble, 11 Oct. 1971). French archaeologist, art historian and historian. After active service in World War I, he studied history and geography at the Ecole Normale Supérieure in Paris, where one of his teachers was Emile Mâle. In 1921 Terrasse emigrated to the French protectorate of Morocco, where he taught first at the Collège Moulay Yusuf and later at the influential Institut des Hautes Etudes Marocaines in Rabat, lecturing on Islamic history and art. In 1932 he published his doctoral thesis for the Sorbonne, and in 1935 he was appointed inspector of historic monuments in Morocco. He became director of the Institut des Hautes Etudes Marocaines in 1941 and professor of Muslim archaeology at the University of Algiers in 1945. After Moroccan independence in 1956, he was director of the Casa de Velázquez in Madrid until his retirement in 1965. In addition to founding the *Mélanges de la Casa de Velázquez*, he published prolifically on western Islamic history, architecture, ceramics, metalwork, woodwork and jewelry, and wrote the first general history of Morocco. His interests also extended to Islamic art in the Middle East and the relationship between Christian and Islamic art. His work is sometimes characterized by misconceptions typical of the French colonial school of scholarship, such as the dichotomous interpretation of Moroccan history into Arab and Berber cultures. Nonetheless, his pioneering studies of the archaeology and architectural

history of 11th- to 14th-century Morocco remain the foundation for most later art history of the region.

WRITINGS

La Mosquée des Andalous a Fès (Paris, n.d.)

L'Art hispano–mauresque des origines au XIIIe siècle (Paris, 1932)

with H. Basset: "Sanctuaires et forteresses almohades," *Hespéris*, iv (1924), pp. 9–91 and 181–203; v (1925), pp. 311–76; vi (1926), pp. 102–270; vii (1927), pp. 117–71 and 287–345; also as *Sanctuaires et forteresses almohades* (Paris, 1932/R Paris, 2001)

with J. Hainaut: *Les Arts décoratifs au Maroc* (Paris, 1923)

La Grande Mosquée de Taza (Paris, 1943)

L'Histoire du Maroc depuis les origines jusqu'au protectorat français (Casablanca, 1949–50)

with J. Meunié: *Recherches archéologiques à Marrakech* (Paris, 1952)

with J. Meunié: *Nouvelles Recherches archéologiques à Marrakech* (Paris, 1957)

La Mosquée al-Qaraouiyin à Fès (Paris, 1968)

BIBLIOGRAPHY

J. Célérier: "L'Histoire du Maroc de Henri Terrasse," *Hespéris*, xxxix (1952), pp. 222–38

J. Hubert: "M. Henri Terrasse," *Acad. Inscr. & B.-Lett.: C. R. Séances* (1971), pp. 592–96

L. Golvin: "Henri Terrasse (1895–1971): Publications d'Henri Terrasse," *Rev. Occident Musulman & Médit.*, xii (1972), pp. 7–21

H. Laoust: "Henri Terrasse (1895–1971)," *Rev. Etud. Islam.*, xl (1972), pp. 3–6

H. Laoust: "Notice sur la vie et les travaux de Henri Terrasse," *Acad. Inscr. & B.-Lett.: C. R. Séances* (1981), pp. 133–50

Textiles. Textiles have been an especially important art form in the Islamic lands. In addition to their use in Dress, textiles were also the major form of furnishing, particularly as carpets (*see* Carpets and flatweaves), at all levels of traditional Islamic culture, from the nomadic encampment to the royal court. Textiles were the primary indicators of social status and, at times, of ethnic and occupational status, and they formed the major item of commerce, fueling long-distance trade, the financial systems to support it and consequently wars of conquest. Furthermore, textiles were often the means by which artistic styles and motifs spread, particularly before the widespread adoption of paper and cartoons.

Fine fabrics of wool, linen, silk and cotton were produced in the Islamic lands, continuing the textile traditions of earlier times. Before *c.* 1250 embroidered and tapestry woven linens and cottons made in state factories were particularly important. Patterned silks, which had been made in some regions during the early period, became significant throughout the Islamic lands after *c.* 1250. Court production of luxury fabrics, such as figured silk velvets and brocades, was encouraged by many of the great powers that arose in the Islamic lands after *c.* 1500.

I. Introduction. II. Before *c.* 1250. III. *c.* 1250 to *c.* 1500. IV. After *c.* 1500.

I. Introduction. In Islamic civilization, as in other traditional societies, most textiles were simple, inexpensive and plain, made from humble materials by uncomplicated processes and intended to serve the basic needs of clothing, shelter and everyday utility. Nevertheless, many different types of fine textiles were produced in the Islamic lands, and these were among the most prized in the medieval world. In addition to their utilitarian functions, fine textiles were used as flags and banners (*see* Flag), carpets and canopies, places of prayer or devotion, robes or gifts of state, adornment for rites of power or passage, and even as necessary parts of ceremonies associated with death. Most traditional Islamic societies were, and still are, weaving cultures; custom and the temperate dry environment militated against the use of furs, leather and felts as clothing, while climate, religion and social custom supported the covering of the body with woven fabrics. Long-distance trade in textiles formed a basis of the pre-Islamic economy into which the Prophet Muhammad was born in the late 6th century, and early Islamic civilization inherited a long and rich tradition of fine weaving from the Sasanian and Byzantine empires.

A. Fibers and manufacture. B. Textiles in religious, royal and nomadic life. C. Trade.

A. Fibers and manufacture. Of all fibers used in Islamic textiles, wool has the most complex lineage and importance to the social order as it is the major economic product of nomadic herding societies. Wool has been used on all levels of textile production, from the coarsest felts and woven stuffs used for tents (*see* Tent, §I) to the finest carpets and court textiles. The raising of sheep was prevalent in the semi-arid region extending from the Iberian Peninsula across northwest Africa to Central Asia long before the birth of the Prophet. Sheep herding was closely linked with nomadism in the semi-mountainous areas where there was less competition between the depredations of grazing flocks and the restriction on grazing necessary for agriculture to survive. With the coming of Islam, the trade in both raw wool and wools increased across this region, and numerous documents attest to a thriving production in virtually all Islamic lands capable of sustaining grazing. In certain cases, such as the invasion of Anatolia by Turkish tribes after 1071, the arrival of Central Asian nomads and their flocks appears to have increased wool production dramatically.

Flax is another fiber with a long tradition of use in the Islamic world. The main centers of production were in Egypt, Syria and lower Mesopotamia, where rivers provided large quantities of fresh water for processing the raw material into linen threads. Although some significant early Islamic textiles (e.g. the Veil of Ste. Anne, from Damietta, Egypt,

1096–7; Apt Cathedral) are linen, the importance of this fiber for luxury fabrics waned in the face of increased production of cotton and silk. Cotton, which requires a subtropical climate and irrigated fields, was gradually introduced into the Middle East and North Africa from India in the 1st millennium, and became well established from early Islamic times in Transoxiana, Khurasan, Mesopotamia and Syria, areas that have continued to be important centers of production. Despite the prominence of Egyptian cotton in modern times, cotton does not seem to have been a major product there in medieval times.

Silk, introduced to the Middle East from China and a major medium of artistic expression from the early days of Islam, rapidly became the pre-eminent fiber for luxury textiles. Sericulture, which requires a temperate climate and adequate rainfall for the cultivation of mulberry trees on which the silkworms feed, had been introduced into Central Asia from China along the Silk route in the 4th century. By early Islamic times, major centers of cocoon production included Transoxiana, the Caspian littoral and Syria. Iran, in particular, inherited from the Sasanian era a complex drawloom technology, and Islamic silks of immense complexity were produced in the medieval period (see §II, B below). Silk weaving spread as far as Spain in the west where equally magnificent fabrics, often copying eastern prototypes, were made (see §II, C below). In later Islamic times silk was produced throughout the Islamic lands, with monarchs establishing royal manufactories to produce silks for the court. Typically the taste for silk began with the importation of Chinese fabrics and then led to the importation of cocoons or threads for local looms and finally to the cultivation of mulberry trees. The city of Bursa in western Anatolia, for example, reached prominence first as a market for the transshipment of cocoons across the Mediterranean and then as a major center for the cultivation of mulberry trees, which covered the surrounding plain by the mid-17th century (see §IV, A below). Northern Syria was another major area of production, and by the 15th century commerce in silk was a mainstay of the economy of the Ottoman Empire (1281–1924) and as a result of trading contacts with European purchasers fueled the development of European banking.

The making of textiles has long been a basic element of socialization in many Islamic lands. Young urban women were taught the domestic art of embroidery, which not only served to indicate their neatness and industriousness but also contributed to the value of their dowries. In villages and encampments very young girls were taught the craft of spinning, while weaving, especially of carpets, was often the exclusive province of women. Men generally controlled large-scale and commercial operations, such as dyeing and marketing. Further, in nomadic and village societies the designs of fabrics and carpets often serve as visual symbols of tribal and family groups.

Certain genres of textiles are closely allied to daily life in the Islamic lands. In Central Asia, for example, elaborate animal trappings were used to decorate the bridal procession. In Morocco, intricately woven silk wedding-sashes constituted a major element of artistic weaving and perpetuated a wide repertory of traditional patterns. In many parts of the Middle East a wide range of textiles was developed for common social rituals: the protocol of the formal meal required tablecloths, napkins (Arab. *mandīl*) and other textiles; towels and coverings were used in the bathhouse; embroidered kerchiefs featured as prizes in athletic contests; and elaborate embroidered textiles depicting flowers carried an entire glossary of iconographic messages.

B. Textiles in religious, royal and nomadic life. Costly and ostentatious personal adornment with elaborate textiles is generally frowned on in Islam, especially for men; but at the same time the Koran (e.g. 55:35–78) promises silken garments, cushions and carpets in Paradise as a reward to believers who submit to God's will on earth. The Hadith include numerous references to clothing and textiles; one of the most famous is the saying attributed to the Prophet that he who wears silk in this world will forgo it in the next. This prophetic tradition meant that religious figures rarely, if ever, wore silk, although court officials and others of high status and great wealth often did. Traditions and stories of the Prophet's life mention his cloak and banner, both conserved as relics in Istanbul (probably wool; Topkapı Pal. Mus.). Colored textiles, such as the black banners of the Abbasid dynasty (r. 749–1258), were major political symbols in early Islamic religious struggles, and in later Islamic times the green banner became a symbol of religious revolt.

Textiles figure strongly in various religious rituals. A seamless white cloth is required for a burial shroud (see Islam, §II, E), while for many people the turban in its various forms is the primary outward indication of the wearer's adherence to Islam. Textile coverings for women, from the chadar worn in Iran to the *ehram* in Anatolia, developed as a response to the religious demand that women's bodies be covered in public. Many Islamic sumptuary conventions, such as the wearing of green turbans by some religious figures, are based directly on religious custom or legislation. The use of textiles is so pervasive in the Islamic world that Golombek has described it as a "draped universe." Its central shrine, the Ka'ba in Mecca, is adorned annually with a new woven veil (Arab. *kiswa*), and numerous works of art and architecture are covered with patterns reminiscent of textile designs.

Throughout most of Islamic history there has been an implicit conflict between the concepts of religious duty and kingship, and this conflict is particularly clear in the area of fine textiles. They had served prominently in the ritual giving of royal gifts that characterized many Near Eastern monarchies long before the rise of Islam. In early Islamic times, a

state-controlled system of manufactories producing textiles for such gifts and other royal purposes came into being (*see* Tiraz). Likewise, the preference for silk for royal garments meant that from early times Islamic courts participated directly in developing the commerce and weaving of silk.

The prototypes for the textiles produced for early Islamic rulers may be found in the complex brocaded silks produced for the Byzantine and Sasanian courts. Hieratic designs of roundels with confronted animals, both real and imaginary, and images of royal symbols and pastimes passed into the Islamic repertory with ease, continuing to be found on Islamic textiles from Central Asia to Spain at least until the 13th century (see color pl. 3:X, fig. 2). The production of elaborate silks, especially with figural designs, seems to be associated with periods of relative religious tolerance. The inscriptions on a Nasrid silk from Granada proclaim "I exist for pleasure, for pleasure am I" (dispersed; Washington, DC, Textile Mus.; Copenhagen, David Saml; see *Cosmophilia*, no. 109), while the production of figural silks in Iran under the Safavid ruler Tahmasp I (*r.* 1524–76) apparently went into decline when the shah turned to religion in his old age (*see* Safavid, §II, A).

Textiles, especially those made from wool, were the major artistic form among nomads, from the Arab Bedouins and Berbers in the West to the Turks and Mongols in the East. Since these peoples often came to assume political leadership in the Islamic world, the art of the knotted carpet and other textiles associated with nomadic society, economy and culture gained a more general importance and continued to be practiced long after nomads had adopted sedentary lifestyles based on agriculture, trade and artisanry in the cities. Examples of the widespread persistence of textiles of nomadic origin include the large tents and canopies used for royal ceremonies, which sometimes attained enormous scale and size (*see* Tent, §III); the cushions that line the walls of traditional Islamic houses; the quilt that covers the charcoal brazier; and the various bags and wrappers that serve for storage and display.

C. Trade. Trade in textiles and fibers created and supported many commercial arteries in the Islamic lands. Throughout the Middle Ages silk reached the West through the Islamic lands, and by the 15th century the transshipment of cocoons and silk thread accounted for a major part of the economies of such prominent Islamic dynasties as the Mamluks (*r.* 1250–1517) in Egypt and Syria, the Timurids (*r.* 1370–1506) in Iran and Central Asia, and the Ottomans in the eastern Mediterranean. Fabrics made of linen, cotton, wool and animal hair were also important at various times, along with the more glamorous silks. The impact of this trade on European cultures is demonstrated by such words entering European languages as cashmere (the fine underhair of Kashmir goats), pashm (a fine wool or goat hair, from Pers. *pashm*: "wool"), camlet (camels' hair), mohair (the fine hair of the Angora goat, from Arab. *mukhayyar*:

"by choice, deliberately", referring to watered mohair), damask (from Damascus), muslin (from Mosul) and organdy (from Urgench). From the 9th century silks woven in Iran with historical inscriptions were taken by trade or conquest to Europe, where they acquired legends linking them with Christian events and personalities and became relics, such as the "Shroud of St. Josse" (see fig. 2 below). Islamic silks of this kind were virtually synonymous with power and authority, both secular and ecclesiastical, in western and northern Europe. From the 10th century the records of the Cairo Geniza, a trove of medieval Jewish documents, attest to a brisk Mediterranean trade in textiles. The stupendous coronation robe of the Holy Roman emperors (Vienna, Schatzkam.; see color pl. 3:X, fig. 2) was made in Palermo for the Norman king of Sicily Roger II Hauteville (*r.* 1130–54) in 1133–4 (*see* §II, C below). In later times Turkish silks were used extensively for ecclesiastical vestments in Russia and Poland, and Bursa amassed incredible wealth not only as an entrepôt for textiles, but also as a major manufacturing center for velvets.

The role of textiles as vectors for designs can be seen in one of the celebrated 14th-century Konya carpets (*see* Carpets and flatweaves, §II), which features a design of lotus blossoms adapted from a Chinese silk made under the Yuan dynasty (*r.* 1279–1368). Turkish carpets with Chinese silk designs then entered the Mediterranean commerce and were copied by Spanish weavers. A *Mudéjar* carpet with a unique pattern of hooked motifs in staggered rows (Washington, DC, Textile Mus.) clearly shows that designs of Chinese origin were carried as far as the western limits of the Islamic world.

Many bazaars in the Islamic world were built around the cloth market (Turk. *bezzāzistān*), a building that bears a striking analogy to the cloth-hall of medieval Europe. The role of the market supervisor (Arab. *muhtasib*; Turk. *mühtesib*) included keeping track of the quality of fibers, weaving and dyestuffs used in textile production, as well as assuring a fair market price for such textiles. Regulation and taxation of textile production were central to the economies of many Muslim states, and expansion of markets coupled with access to raw materials influenced state policy in many Islamic realms.

Enc. Islam/2: "Harīr" [silk], "Kattan" [linen], "Kutn" [cotton], "Sūf" [wool], "al-Nassāj" and "al-Ḥaʾik" [weaver]

Hali: Carpet, Textile and Islamic Art (1981–)

Khilʿa: Journal for Dress and Textiles of the Islamic World (2005–)

P. Ackerman: "Islamic Textiles: History," *Survey of Persian Art*, ed. A. U. Pope and P. Ackerman (London, 1938–9; 2/1964–7), pp. 1995–2162

R. B. Serjeant: "Islamic Textiles: Material for a History up to the Mongol Conquest," *A. Islam*, ix (1942), pp. 54–92; x (1943), pp. 71–104; xi–xii (1946), pp. 98–145; xiii–xiv (1948), pp. 75–117; xv–xvi (1951), pp. 29–85; as book (Beirut, 1972)

E. Kühnel and L. Bellinger: *Catalogue of Dated Tiraz Fabrics* (Washington, DC, 1952)

F. May: *Silk Textiles of Spain* (New York, 1957)

F. Dalsar: *Bursa'da ipekçilik* [The Bursa silk industry] (Istanbul, 1960)

H. Inalcik: "Bursa and the Commerce of the Levant," *J. Econ. & Soc. Hist. Orient*, iii (1960), pp. 131–47

E. H. Schafer: *The Golden Peaches of Samarkand* (Berkeley and Los Angeles, 1962)

S. D. Goitein: *Economic Foundations* (1967), i of *A Mediterranean Society* (Berkeley and Los Angeles, 1967–88)

F. Rosenthal: "A Note on the *Mandīl*," *Four Essays on Art and Literature in Islam* (Leiden, 1971), pp. 63–99

M. Lombard: *Les Textiles dans le monde musulman* (Paris, 1978)

L. Golombek: "The Draped Universe of Islam," *Content and Context of Visual Arts in the Islamic World*, ed. P. P. Soucek (University Park, PA, and London, 1988), pp. 25–50

Images of Paradise in Islamic Art (exh. cat., ed. S. S. Blair and J. M. Bloom; Hanover, NH, Dartmouth Coll., Hood Mus. A.; New York, Asia Soc. Gals.; Brunswick, ME, Bowdoin Coll. Mus. A.; and elsewhere; 1991–2)

K. von Folsach and A.-M. K. Bernsted: *Woven Treasures: Textiles from the World of Islam* (Copenhagen, 1993)

P. L. Baker: *Islamic Textiles* (London, 1995)

Islamische Textilkunst des Mittelalters: Aktuelle Probleme = Riggisberger Berichte, 5 (1997) [special issue on medieval Islamic textiles]

J. Balfour-Paul: *Indigo* (London, 1998)

J. Thompson: *Silk: 13th to 18th Centuries: Treasures from the Museum of Islamic Art, Qatar* (Doha, 2004)

Cosmophilia: Islamic Art from the David Collection, Copenhagen (exh. cat. by S. S. Blair and J. M. Bloom; Chestnut Hill, MA, Boston Coll., McMullen Mus.; Chicago, Smart, Mus., 2006–7)

II. Before c. 1250. The textile traditions of the Byzantine and Sasanian empires continued and developed under the rule of the Umayyad (*r.* 661–750) and Abbasid (*r.* 749–1258) dynasties. Manufactories were established throughout the Islamic lands for weaving cotton and linen fabrics and decorating them with wool and silk for official presentation and use. Extraordinarily elaborate drawloom silks were also produced, particularly in Iran and in Spain, whereas a distinct group of ikats was made in the Yemen.

A. Egypt. B. Iran and the eastern Islamic lands. C. Spain and North Africa. D. Yemen.

A. EGYPT. The Egyptian textile industry that flourished in antiquity continued after the Arab conquest in 640–41, when Egypt became one of the main centers for the production of fine textiles in the Islamic world. Flax remained the major fiber and was spun with a characteristic S-twist and Z-plied before being woven into fine linens, which were often embellished with tapestry bands or embroidery. This decoration, which often included figural representations as well as inscriptions, was worked in wool or silk, both imported fibers, although wool and silk textiles were also produced locally. Because of Egypt's unusually dry climate, many textiles have been preserved, particularly in graves. Some fabrics were undoubtedly imported, but those made in Egypt can often be distinguished by fiber, spinning and decoration. The large number of examples inscribed with dates and names of individuals and places of manufacture allows them to be sequenced to a degree impossible for fabrics from other areas of the Islamic world. Even so, the surviving fragments hardly reflect the wealth of textiles mentioned in medieval sources.

The prevalence of linen in Egypt allowed the production of a tightly woven fabric, in contrast to the loosely woven fabrics—cotton, silk and *mulḥam* ("half-silk"; *see* §B below)—of the eastern Islamic lands. The tight weave allowed fabrics to be embroidered with stitches that created uneven tension on the face and reverse, giving a puckered effect, and a great variety of stitches including stem stitch, flat stitch and couching was used. Furthermore, in contrast to cotton, linen did not need to be glazed, though the absence of glaze made it difficult if not impossible to draw a preliminary design on the fabric before embroidering the decoration. As a result, other methods of planning the design, such as couching and counting threads, were generally employed in Egypt, and these serve to distinguish Egyptian work from other early Islamic textiles.

Textile production in Egypt was concentrated in three areas: Upper Egypt, the Faiyum and Lower Egypt. Production sites in Upper Egypt known from inscriptions and texts include Asyut, Taha, al-Qais and Bahnasa. Those in Lower Egypt include Misr (Fustat or Old Cairo) at the head of the Nile Delta, Damietta and Tinnis at the eastern edge of the Delta, and Alexandria at the western edge of the Delta. Upper Egypt was known for its wool tapestry work, while wool, silk and linen were woven in the Faiyum. Lower Egypt, dominated by the Delta with its abundance of fresh water for retting flax, was naturally the center of linen manufacture.

The tapestry technique and pictorial representation that had been characteristic of Egyptian textiles produced before the Arab conquest continued in Islamic times, although there was a change in the organization and execution of the design on the loom. Coptic robes were usually unshaped linen garments decorated in wool or linen with narrow vertical bands on the front and back and tapestry medallions on the shoulders, front, back and sleeves. The warp ran vertically on the finished garment. The typical Arab dress was similarly a loose linen robe, but the warp ran horizontally in the finished garment, so that the tapestry stripes on either side of the neck and across the top of the sleeves follow the weft. These garments were often woven in the form of a cross and finished without cutting. This fashion continued until the 11th century, when it was superseded by a cut and tailored garment of the Persian type.

Coptic textiles (Arab. *qubāṭī*) are reported to have been used by the caliphs 'Umar (*r.* 634–44) and 'Uthman (*r.* 644–56) for the covering (*kiswa*) annually draped over the Ka'ba in Mecca. *Qubāṭī*

continued to be used for this purpose for several centuries, although it is likely that the term eventually took on the more general meaning of a white linen cloth. Such fabrics are generally associated with the Tinnis–Damietta group of factories, which is also known to have produced fine napkins, cloaks and shirts. Egypt was a center for the production and trade in alum, natron and indigo, used in the dyeing and preparation of cloth, and the inclusion of Egypt in the Islamic Empire provided new sources for dyestuffs and materials: madder and kermes, for example, were increasingly supplanted by lac from India, which produced a stronger and clearer red dye, and silk from Syria began to replace wool.

A considerable number of two-colored silk textiles, woven as trimmings for tunics, have been found in Egyptian graves, especially at Akhmim. Woven in a pictorial style derived from late Hellenistic art, they have been attributed to Egypt or Syria in the 8th and 9th centuries. Some bear Greek or Coptic names, indicating that they were made for the Christian market; others in an identical style bear inscriptions in Arabic, which are often indecipherable (e.g. London, V&A, 2150-1900, a compound twill of undyed silk warp and two colors of silk weft showing stylized figures under a tree).

The major innovation of the coming of Islam was the introduction of state manufactories for textiles. The fabrics they produced, known in Arabic as Tiraz from their inscriptions containing good wishes and the name and titles of the ruling caliph, were made up into robes of honor worn by the caliph or bestowed by him as official gifts. Inscriptions and texts mention both public ('āmma) and private (khāṣṣa) factories, but the distinction between the two types is unclear. Although the institution was probably introduced to Egypt under the Umayyad dynasty (r. 661–750), the production of tiraz can be clearly documented there only from the 9th to the 13th century: one tapestry fragment (Cairo, Mus. Islam. A., 3084) was woven in the public factory at Misr under the Abbasid caliph al-Amin (r. 809–13), and the earliest embroidered tiraz (Cairo, Mus. Islam. A., 9439) was made in a private factory for his successor al-Ma'mun (r. 813–33) in 831–2. Over time, both the titles and the style used in the inscriptions became more elaborate. Egyptian tiraz are distinguished by such features of calligraphy as horizontal bars across tall letters and the use of peculiar locutions.

Although tapestry weaving had a very long history in Egypt, embroidery was apparently introduced from Iraq in the Islamic period. Tapestry weaving continued to be used for non-caliphal pieces, but throughout the 9th century and into the first decades of the 10th, tiraz fabrics ordered by caliphs in Egypt almost always had embroidered texts. With the establishment of the Tulunid dynasty (r. 868–905), whose leader was initially sent from Iraq as governor for the Abbasids, Z-spinning was introduced to Egypt, probably by craftsmen brought from Iraq. Z-spinning continued to be used along with traditional S-spinning until c. 940, when, presumably, the

last of the foreign workers died. A characteristic group of tapestry weaves, often with large-scale animal and figural compositions (e.g. Washington, DC, Textile Mus.), is attributed to the Faiyum and Upper Egypt and dated to the late 9th century because of similarities with other arts assigned to the Tulunid period.

Because weaving linen was a very old craft in Egypt, it is difficult to distinguish the product of one factory from another, but by the 10th century technical and stylistic features of the embroidery make it possible to distinguish the work of individual factories, such as those at Alexandria, Tinnis, Misr and Tuna. Although the vast majority of pieces in the name of the caliph al-Muqtadir (r. 908–32) were embroidered, a few individual examples of tiraz were tapestry woven (e.g. 920–21; Ann Arbor, U. MI, Kelsey Mus., 22509). The new technique seems to have determined the style of the inscription, for the short letters, many without descending tails, indicate a lack of refinement in comparison to earlier embroidered texts. By the middle of the 10th century, tapestry weaving seems to have become the norm, for under al-Muti' (r. 946–74) embroidery was rare.

The arrival of the Fatimid caliphs (r. 909–1171) in Egypt in 972 brought about an increased demand for luxury textiles, since Cairo became the capital of a caliphate with an elaborate court ceremonial. The Fatimids had already shown a taste for luxury textiles before their conquest of Egypt in 969, for several Egyptian tiraz fabrics made before that date are inscribed with their names and titles. New robes of honor with inscriptions naming the caliph were distributed to courtiers in summer and winter, and medieval sources describe the extraordinary contents of the Dār al-kiswāt, a treasury of textiles in the caliphs' palace. The Persian traveler and spy Nasir-i Khusraw, who visited Egypt from 1047 to 1050, gives an impressive list of shot silks and fine muslins or linens produced in various Egyptian towns. Silk brocade (dībāj) is known to have been woven at the Dār al-dībāj in Cairo.

Fatimid tiraz production can be divided into four periods on the basis of its decoration. In the first period (969–1021), foliate designs and animals or birds appear confronted or addorsed within hexagonal or oval medallions between kufic borders (e.g. Cairo, Mus. Islam. A., 9444). The decorative bands are few and narrow at first but eventually increase in number and breadth. Under al-Hakim (r. 996–1021) a more subtle type of decoration became fashionable. The miniature designs, with small and elegant birds and palmettes, are well drawn and clearly defined with simple inscriptions. In the second period (1021–94) the technique became finer and a greater variety of decorative motifs was used, although the general disposition of medallion bands between kufic borders was maintained. Textiles from the mid-11th century are marked by graceful calligraphy with symmetrical and clear small letters, a tall curve in the final letters and elaborate interlacing with vines and palmettes (e.g. Boston, MA, Mus. F.A., 30.675).

1. Fragment of a decorated linen textile, with *tiraz* band, 243×460 mm, from Egypt, 11th century (London, British Museum); photo © British Museum/Art Resource, NY

In the third period (1094–1130), the finest in Fatimid Egypt for the production of *tiraz*, the decorative style was developed with broad bands of plaited ribbons containing animal or arabesque motifs in the interstices (see fig. 1). Some epigraphic borders show an early use of cursive script. The most famous example, the Veil of Ste. Anne (from Damietta, Egypt, 1096–7; Apt Cathedral), made of bleached linen tabby, has three parallel bands of tapestry-woven ornament in colored silk and some gold filé (thread). The central band has interlacing circles joining three medallions containing pairs of addorsed sphinxes. Kufic inscriptions around the medallions name the Fatimid caliph al-Musta'li (*r.* 1094–1101) and his vizier al-Afdal, the supervisor of the work. Lateral bands decorated with birds and animals contain another inscription stating that the textile was woven in the royal factory at Damietta in 1096–7. The piece was probably intended as an over-garment or mantle, the central band containing the medallions falling down the back; it was probably acquired either by the bishop or lord of Apt, both of whom participated in the First Crusade in 1099.

In the fourth period (1130–64), the plaited decoration became increasingly elaborate, and the bands are so wide that they cover the entire fabric. The ground color is generally bright yellow, probably in imitation of even finer luxury fabrics that were embroidered with gold thread. Other types of luxury textiles appear in this period, including fabrics printed with gold and outlined in red or black (e.g. Cairo, Mus. Islam. A., 10836). Inscriptions, in a debased cursive script, became increasingly stylized. A silk fabric assigned to the period of Ayyubid rule in Egypt (1169–1252) has continuous undulating bands forming lozenge-shaped medallions containing paired birds and griffins flanking a tree (dispersed, e.g. New York, Met.).

Nāṣir-i Khusraw: (d. *c.* 1075): Safarnāma [Book of travels], Eng. trans. by W. M. Thackston as *Nāser-e Khosrāw's Book of Travels* (Albany, 1986)

Aḥmad ibn 'Alī al-Maqrīzī (1364–1442): *Al-Mawā'iz wa'l-i'tibār bi-dhikr al-khitat wa'l-āthār* [On the districts and monuments of Cairo], 2 vols. (Cairo, 1853), ii, pp. 409–13

O. von Falke: *Kunstgeschichte der Seidenweberei* (Berlin, 1913); Eng. trans. as *Decorative Silks* (New York, 1922, London, 3/1936)

A. F. Kendrick: *Catalogue of Textiles from Burying Grounds in Egypt* (London, 1921)

E. Kühnel: *Islamische Stoffe aus ägyptischen Gräbern* (Berlin, 1927)

E. Combe and others: *Répertoire chronologique d'épigraphie arabe*, 19 vols. (Cairo, 1931–)

G. Marçais and G. Wiet: "Le 'Voile de Sainte Anne' d'Apt," *Mnmts Piot*, xxxiv (1934), pp. 177–94

H. A. Elsburg and R. Guest: "The Veil of Saint Anne," *Burl. Mag.*, lxviii (1936), pp. 140–45

R. Pfister: "Matériaux pour servir au classement des textiles égyptiens postérieurs à la conquête arabe," *Rev. A. Asiat.*, x (1936), pp. 1–16 and 73–85

N. P. Britton: *A Study of Some Early Islamic Textiles in the Museum of Fine Arts Boston* (Boston, 1938)

E. Kühnel: "La Tradition copte dans les tissus musulmans," *Bull. Soc. Archéol. Copte*, iv (1938), pp. 79–89

R. Pfister: "Toiles à inscriptions abbasides et fatimides," *Bull. Etud. Orient.*, xi (1945–6), pp. 47–90

E. Kühnel and L. Bellinger: *Catalogue of Dated Ṭirāz Fabrics: Umayyad, Abbasid, Fatimid, The Textile Museum, Washington, D.C.* (Washington, DC, 1952)

R. B. Serjeant: *Islamic Textiles: Material for a History up to the Mongol Conquest* (Beirut, 1972), pp. 135–64

Y. Stillman: "New Data on Islamic Textiles from the Geniza," *Textile Hist.*, x (1979), pp. 184–95; repr. in *Patterns of Everyday Life*, ed. D. Waines, The Formation of the Classical Islamic World, 10 (Aldershot, 2002), pp. 197–208

C. Rogers, ed.: *Early Islamic Textiles* (Brighton, 1983)

G. Vogelsang-Eastwood: "Two Children's Galabiyehs from Quseir al-Qadim, Egypt," *Textile Hist.*, viii/2 (1987), pp. 133–42

H. Glidden and D. Thompson: "Ṭirāz Fabrics in the Byzantine Collection, Dumbarton Oaks, Part One: Ṭirāz from Egypt," *Bull. Asia Inst.*, ii (1988), pp. 119–39

G. Vogelsang-Eastwood: *Resist Dyed Textiles from Quseir al-Qadim, Egypt* (Paris, 1990)

G. Cornu, O. Valansot and H. Meyer: *Tissus islamiques de la collection Pfister* (Vatican City, 1992)

Tissues d'Egypte: Témoins du monde arabe VIIIe–XVe siècles (exh. cat., Geneva, Mus. A. & Hist.; Paris, Inst. Monde Arab.; 1993–4)

L'Egypte Fatimide: Son art et son histoire, ed. M. Barrucand (Paris, 1999) [Papers from a 1998 colloquium in Paris, several on Egyptian textiles]

N. A. Hoskins: "Textiles," *Fustat Finds: Beads, Coins, Medical Instruments, Textiles, and Other Artifacts from the Awad Collection*, ed. J. L. Bacharach (Cairo, 2002)

G. Frantz-Murphy: "A New Interpretation of the Economic History of Medieval Egypt: The Role of the Textile Industry 254–567/868–1171," *Manufacturing and Labor*, ed. M. G. Morony, The Formation of the Classical Islamic World, 12 (Aldershot, 2003), pp. 119–42

Textiles in Situ: Their Find Spots in Egypt and Neighbouring Countries in the First Millennium CE, Riggisberger Berichte, 13 (2006)

J. M. Bloom: *Arts of the City Victorious: The Art and Architecture of the Fatimids in North Africa and Egypt* (London, 2007)

B. Iraq and the eastern Islamic lands. Of the enormous quantities of textiles known from contemporary sources to have been produced in the lands of the eastern caliphate, only a relatively small number of embroideries, printed and/or painted textiles and fabrics with woven decoration have survived.

The earliest embroideries belong to a well-defined technical group: all are chain-stitched in polychrome wools and usually white cotton yarns on a cotton ground that was originally embroidered with red wool. The most important of these, showing the fragmentary figure of a mounted Sasanian king with soldiers (Athens, Benaki Mus.), probably dates from the end of the period of Sasanian rule (226–637). Others continue the Sasanian tradition but can be attributed to the period of Umayyad rule (661–750) after the Islamic conquest of the region. One example in Cairo (Mus. Islam. A.) shows an Iranian soldier killing a horseman within a field bordered by double rows of pearls, while other fragments in Swedish collections (see Lamm) are worked with floral motifs, rosettes or a frieze of birds between single rows of pearls.

The largest number of surviving embroideries comprise Tiraz textiles, which feature a band of inscription embroidered on a ground of *mulham* ("half-silk": silk warps and cotton wefts) or cotton. The fabric was often glazed—probably with wheat starch—to stiffen and polish it, and pressed. The most common embroidery stitches are chain, double-chain and split stitches, although blanket, coiled double-running, couching and back stitches are also found. Dated or datable pieces fall between the caliphate of al-Muʿtazz (*r.* 866–9) and the fall of Baghdad to the Saljuqs in 1055. The only weaving centers named in the inscriptions are Merv, Bishapur and Baghdad; a very rare *mulham* fragment (Cairo, Mus. Islam. A.) has an embroidered inscription naming Merv as the place of manufacture, and a tapestry-woven border.

A small group of sumptuous embroideries are worked with polychrome silks and gold thread on a *mulham* ground; for stylistic and epigraphic reasons they have been assigned to the 11th and 12th centuries. The silk floss was embroidered primarily in split stitch, although running, self-couching and outline stitches were also used; the gold threads were couched, in some cases over a layer of ivory silk floss. The largest piece (Boston, MA, Mus. F.A. and Cleveland, OH, Mus. A.) is a fragmentary hanging with a design of large linked roundels enclosing single birds or animals, bordered by animal friezes and with small roundels in the interstices. A kufic inscription at the bottom is surmounted by a border composed of a vine forming tangent roundels, of which the only complete one encloses a large bird. Small fragments with lions aligned in rows (Washington, DC, Textile Mus.) may also be from a hanging. Many other embroidered pieces consist of borders, in one instance with inscription bands beside friezes of winged horses

(Washington, DC, Textile Mus.), and in another with an alternating design of paired peacocks within a roundel and a star that encloses a bird (Cleveland, OH, Mus. A.). Further types of border, although in more fragmentary condition, show a bird amid scrolling vines below a frieze of geometric ornament (Cleveland, OH, Mus. A.), or cartouches enclosing inscriptions or harpies within framing bands of scrolling vines (Athens, Benaki Mus.; Boston, MA, Mus. F.A.), while one rare embroidery (New York, Met.) is ornamented with a frieze of Christian saints under an arcade. Yet other fragments (e.g. Cleveland, OH, Mus. A.; Washington, DC, Textile Mus.) have designs based on *tiraz* bands, or merely display inscriptions in foliated kufic.

A number of examples of printed and painted textiles survive (Cairo, Mus. Islam. A.; Athens, Benaki Mus.; Lyon, Mus. Hist. Tissus; New York, Met.; New York, Cooper-Hewitt Mus.; Washington, DC, Textile Mus.; Cleveland, OH, Mus. A.; Boston, MA, Mus. F.A.; Toronto, Royal Ont. Mus.; former Lamm priv. col., now divided between Göteborg, Röhsska Kstslöjdmus.; Lund, Kulthist. Mus.; Stockholm, Medelhavsmus.; Stockholm, Nmus.). On a cotton or *mulham* ground, designs were printed with wooden blocks and gold and polychrome pigments, or drawn with dark brown or red ink, with other colors, particularly gold, often applied as well. Both techniques were occasionally used together. One painted cotton attributed to the 9th century (see Lamm, pl. XVIIA) is decorated in bands: a bird enclosed in a pearl roundel, a pearl border and a fragmentary section with a female head and a Sasanian flag. Fragments attributed to the 11th and 12th centuries show animals and/or birds enclosed in roundels or arranged in rows, squares and bands, together with tripartite bands similar to *tiraz* textiles, or simple inscriptions. Many designs resemble those of embroidered and woven pieces, suggesting that they may have been less expensive alternatives.

Textiles with woven decoration from the 8th and 9th centuries include tapestry fragments with warps of wool and wefts of wool and cotton; their designs are strongly based on Sasanian models. Some (Krefeld, Dt. Textilmus.; Cairo, Mus. Islam. A.) have bands of rosettes within tangent diamonds, birds enclosed by medallions of pearls and cabochons, or geometric designs. Some dozen fragments (Cairo, Mus. Islam. A.; New York, Met.; Athens, Benaki Mus.; Cleveland, OH, Mus. A.; former Lamm priv. col.) show rams, framed singly or standing in a frieze, as well as small palmette trees flanked by birds and borders of debased rosettes. Additional isolated fragments include one with rosettes within a geometric floral design and another (Cleveland, OH, Mus. A.) with a female head. A final group woven entirely of wool (Cairo, Mus. Islam. A.; Washington, DC, Textile Mus.) was found in Egypt but have been attributed to Iran or Iraq. Usually displaying birds or animals within roundels that are arbitrarily cut by ornamental borders, they typically have red grounds and designs in pastel colors. Five have a rare twill

tapestry weave, and several have Arabic inscriptions datable on epigraphic grounds to the 8th century, including one (Washington, DC, Textile Mus.) bearing the name of Marwan, presumably the Umayyad caliph Marwan II (r. 744–50).

Compound weaves from this early period include fragments woven of wool and cotton showing Sasanian-inspired motifs such as birds in pearl roundels, or geometric patterns (Cleveland, OH, Mus. A.; Washington, DC, Textile Mus.; Paris, Mus. Cluny). A few silks show Sasanian-inspired birds or simurghs in roundels or polygonal compartments (e.g. Wolfenbüttel, Herzog August Bib.; Aachen, Domschatzkam.; St. Petersburg, Hermitage; London, V&A; Reims, Mus. St-Remi). Another group attributed to 9th-century Baghdad (Washington, DC, Textile Mus.; Athens, Benaki Mus.) is brocaded in silk and gold and silver. The pieces are woven with lozenges, often enclosing cocks within octagons or stars, or with a dense mesh of geometric figures, within which are many motifs from the earlier Sasanian tradition. One (Berlin, Mus. Islam. Kst) is inscribed with the title of the Abbasid caliph al-Muntasir (r. 861–2).

A number of silks can be dated from the 10th to the 12th century. One, a compound silk (Berlin, Mus. Islam. Kst), is woven with an inscription band with a title typical of the Buyid rulers of Iran and Iraq (r. 934–1062). A second (Bamberg, Diözmus.), brocaded with gold, has an inscription band followed by aligned roundels enclosing pairs of birds. Four others, of which three are lampas or variations of lampas weaves (Berlin, Tiergarten, Kstgewmus.; Maastricht, St. Servaasbasiliek; ex-Uwaroff priv. col., Moscow; Boston, MA, Mus. F.A.), have designs of paired animals or birds flanking a floral element and often enclosed by a roundel bordered by animals, birds or inscription bands. Another small group of silks (Bamberg, Diözmus.) with a tabby foundation weave and twill binding of supplementary wefts is ornamented with diverse designs incorporating animals and birds; these appear to date from the late 12th century or early 13th. Several silk-and-gold textiles can be attributed to the end of the period: one from a reliquary at Siegburg (Berlin, Tiergarten, Kstgewmus.) is woven with double-headed eagles within shields; another, a lampas textile (Augsburg, Maximilianmus.) woven with dodecagons depicting the well-known tale of Bahram Gur and Azada riding on camelback, was retrieved from the tomb of Bishop Hartmann (d. 1286) in Augsburg Cathedral. A third, from a grave in Bamberg Cathedral, is a lampas weave with a design of animals in linked roundels and an inscription at the top.

Eleven pieces, scattered around the world, are documented in the archives of the Victoria and Albert Museum, London, as having been found between 1925 and 1930 south of Tehran at the necropolis at Rayy. They include two with inscription bands naming Buyid rulers: a linen *tiraz* brocaded in silk with the name of Fakhr al-Dawla (r. 977–97; Washington, DC, Dumbarton Oaks); and a compound twill silk tomb-cover with the name of Baha' al-Dawla (r. 998–1012; Washington, DC, Textile Mus.). Another large compound twill silk (dispersed; see *Survey of Persian Art*, pl. 992A and figs. 644a and b) has a pattern of birds flanking a tree, while fragments of a compound tabby silk (London, V&A) show paired lions in roundels with octagonal figures in the interstices. Four of the Rayy pieces are silk doublecloths: one (Riggisberg, Abegg-Stift.) is adorned with linked octagons enclosing paired falconers on horseback, and the interstices are filled with ovals enclosing paired birds on a diapered ground; two more (London, V&A; Washington, DC, Dumbarton Oaks) show aligned roundels, bordered with animals and birds, enclosing paired animals and birds, while smaller roundels or octagons fill the interstices; the fourth (London, V&A; Washington, DC, Textile Mus.; Paris, Mus. Cluny) features paired sphinxes flanking a palmette tree within an inscribed octagon, and the interstices are filled with a geometric grid. Two more of the Rayy discoveries are tabby weaves with supplementary pattern wefts: one, the Ganymede Silk (divided), has crowned figures supported by double-headed eagles within a rectangular grid of kufic inscriptions; the other (Paris, Mus. Cluny; Paris, Mus. A. Déc.; New Haven, CT, Yale U. A.G.) has alternating bands of kufic inscriptions and scrolling vines. Another piece is a lampas weave with a design of polygons enclosing four pairs of sphinxes and foliate ornament.

Many other silks attributed to this period are said to have come from Rayy, but have no documentation (principal collections: Cleveland, OH, Mus. A.; Washington, DC, Textile Mus.; Riggisberg, Abegg-Stift.; New Haven, CT, Yale U. A.G.). They are woven with a wide range of patterns, often similar to those on the documented pieces, and in addition to the structures known from the documented pieces they include triplecloths and lampas weaves that are brocaded or have twill grounds. Their authenticity has been the subject of intense debate. A study using epigraphic and radiocarbon analysis of 17 textiles has revealed inconsistencies between the texts inscribed on many of the textiles and their purported dates; the results indicated that textiles in this group may range in date from the medieval period to post-1950, when new isotopes of carbon were introduced into the atmosphere.

Silks also survive from the eastern boundaries of Iran and Transoxiana. An early group, all compound weaves, has been assigned to Sogdiana, the region between Bukhara and Samarkand (principal collections: St. Petersburg, Hermitage; Sens Cathedral; Liège, Mus. A. Relig. A. Mosan; Berlin, Mus. Islam. Kst; London, BM; London, V&A). The reverse side of one (Huy, Collegiate Church of Notre Dame) has an ink inscription penned in Sogdian identifying the textile as *zandanījī*, that is, derived from the town of Zandana near Bukhara. Although the Sogdian school of weaving is recorded in documents as early as the 6th century, from archaeological, documentary and epigraphic evidence the existing silks appear to have been produced from the late 7th century to the 9th.

They can be divided into three broad categories on technical grounds, two of which—Zandaniji II and III—have been assigned to the Islamic period in the 8th and 9th centuries. Designs typically consist of rows of geometric compartments enclosing paired animals or birds, rosettes, geometric figures or scenes repeated in mirror reverse. Many motifs are derived from Byzantine sources, Sasanian and post-Sasanian Iran and the Far East, yet they have been transformed into a distinctly Sogdian style within which various degrees of stylization and geometricization can be observed. The Lion Silk (10th–11th century) at Maastricht (Schatkamer St.-Servaasbasiliek) is related technically and stylistically to this group, but is later in date. Another silk attributed to the province of Khurasan in eastern Iran is the "Shroud of St. Josse" (Paris, Louvre; see fig. 2). The fragments show a highly stylized design of confronted elephants above a kufic inscription inside a wide border with a procession of Bactrian camels, a cock in the corner and framing bands of geometric ornament. According to its inscription, this compound twill silk was made for the Turkish commander of Khurasan, Abu Mansur Bakhtakin (d. 961).

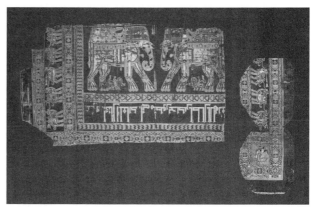

2. Eastern Iranian silk textile known as the "Shroud of St. Josse," fragments 520×940 mm and 620×245 mm, from Khurasan, 10th century (Paris, Musée du Louvre); photo credit: Réunion des Musées Nationaux/Art Resource, NY

O. van Falke: *Kunstgeschichte des Seidenweberei* (Berlin, 1913); Eng. trans. as *Decorative Silks* (New York, 1922, London, 3/1936)

F. E. Day: "Dated Tirāz in the Collection of the University of Michigan," *A. Islam.*, iv (1937), pp. 420–47

C. J. Lamm: *Cotton in Medieval Textiles of the Near East* (Paris, 1937)

R. Pfister: "L'Introduction de coton en Egypte musulmane," *Rev. A. Asiat.*, xi/3 (Sept. 1937), pp. 167–72

G. Wiet: "Tissus brodés mésopotamiens," *A. Islam.*, iv (1937), pp. 54–62

N. P. Britton: *A Study of Some Early Islamic Textiles in the Museum of Fine Arts, Boston* (Boston, 1938), pp. 23–35, 70, 76–7

P. Ackerman: "Islamic Textiles: History," *Survey of Persian Art*, ed. A. U. Pope and P. Ackerman (London, 1938–9, 2/1964–7), pp. 1995–2162

G. Wiet: *Soieries persanes* (Cairo, 1948)

E. Kühnel and L. Bellinger: *Catalogue of Dated Tiraz Fabrics in the Textile Museum* (Washington, DC, 1952)

E. Kühnel: "Abbasid Silks of the Ninth Century," *A. Orient.*, ii (1957), pp. 367–71

D. G. Shepherd and W. Henning: "Zandaniji Identified?," *Aus der Welt der islamischen Kunst: Festschrift für Ernst Kühnel* (Berlin, 1959), pp. 15–40; repr. in *Early Islamic Art and Architecture*, ed. J. Bloom, The Formation of the Classical Islamic World, 23 (Aldershot, 2002), pp. 257–82

A. Mordini: "Une Soierie abbasside du IXe siècle," *Bull. Liaison Cent. Int. Etud. Textiles Anc.*, xxxi (1970), pp. 50–64

M. Bernus, H. Marchal and G. Vial: "Le Suaire de Saint Josse," *Bull. Liaison Cent. Int. Etud. Textiles Anc.*, xxxiii (1971), pp. 22–5

A. A. Jerusalimskaya: "K slozheniiu shkoly khudozhestven-nogo sholkotkachestva v Sogde" [On the formation of the Sogdian school of silk weaving], *Sredniaya Aziya i Iran* [Central Asia and Iran], ed. A. A. Ivanov and S. S. Sorokin (Leningrad, 1972), pp. 5–46

R. B. Serjeant: *Islamic Textiles: Material for a History up to the Mongol Conquest* (Beirut, 1972) [repr. of *A. Islam.*, ix–xvi (1942–51)]

Bull. Liaison Cent. Int. Etud. Textiles Anc., xxxvii (1973) and xxxviii (1973) [two issues devoted to the "Buyid" silks in the Abegg-Stiftung, Riggisberg]

D. G. Shepherd: "Medieval Persian Silks in Fact and Fancy (A Refutation of the Riggisberg Report)," *Bull. Liaison Cent. Int. Etud. Textiles Anc.*, xxxix/xl (1974) [whole issue]

L. von Wilckens: "Sieben Seidengewebe und ein Stickereifragment," *Anz. Ger. Nmus.* (1975), pp. 140–46

K. Riboud: "A Newly Excavated Caftan from the Northern Caucasus," *Textile Mus. J.*, iv (1976), pp. 21–42

L. Golombek and V. Gervers: "Tiraz Fabrics in the Royal Ontario Museum," *Studies in Textile History, in Memory of Harold B. Burnham*, ed. V. Gervers (Toronto, 1977), pp. 82–125

S. Müller-Christensen: "En persisk brokade fra Domkirken i Augsburg," *By og Bygd [Town and country], Festskrift til Marta Hoffmann, Norsk Flkmus. Ab.*, xxx (1983–4), pp. 185–94

Internationales Kolloquium: Textile Grabfunde aus der Sepultur des Bamberger Domkapitals: Schloss Seehof, 1985

D. King: "The Textiles Found near Rayy about 1925," *Bull. Liaison Cent. Int. Etud. Textiles Anc.*, lxv (1987), pp. 34–58

A. S. Melikian-Chirvani: "*Parand* and *Parniyan* Identified: The Royal Silks of Iran from Sasanian to Islamic Times," *Bull. Asia Inst.*, v (1991)

S. S. Blair, J. M. Bloom and A. E. Wardwell: "Reevaluating the Date of the 'Buyid' Silks," *A. Orient.*, xxii (1993), pp. 1–41

Entlang der Seidenstrasse: Frühmittelalterliche Kunst zwischen Persien und China in der Abegg-Stiftung, Riggisberger Berichte, 6 (1998)

J. L. Merritt: "Archaeological Textiles Excavated at Rayy," *Tech. & Cult.*, xxxiv (1999), pp. 7–15; 197

L. Wooley: "Textiles," *Excavations at Ghubayrā, Iran*, ed. M. Shokoohy (London, 2000), pp. 278–86

Central Asian Textiles and Their Contexts in the Early Middle Ages, ed. R. Schorta, *Riggisberger Berichte*, 9 (2006)

S. A. Yatsenko: "The Late Sogdian Costume (the 5th–8th cc. AD)," *Ērān ud Anērān: Studies Presented to Boris Ilich*

Marshak on the Occasion of His 70th Birthday, ed. M. Compareti, P. Raffetta and. G. Scarcia (Venice, 2006); on-line at http://www.transoxiana.org/ (accessed June 11, 2008)

M. Comparetti: "The Role of the Sogdian Colonies in the Diffusion of the Pearl Roundels Pattern," *Ēran ud Anērān: Studies Presented to Boris Ilich Marshak on the Occasion of His 70th Birthday*, eds. M. Compareti, P. Raffetta and. G. Scarcia (Venice, 2006); on-line at http://www.transoxiana.org/ (accessed June 11, 2008)

C. Spain and North Africa. Textiles produced in the western Islamic world before the 13th century show a wide variety of styles and techniques and a high level of artistic achievement. The cultivation of the silkworm, the weaving of silk textiles and the institution of the Tiraz, or official factories, were all introduced to the Iberian peninsula under the Umayyads of Spain (*r.* 756–1031). Documents mention official factories at Córdoba, Almería, Fiñana, Seville and Málaga; weaving was also an important industry at Valencia, Lleida and Toledo. Because most of the surviving textiles were preserved in churches, the vast majority were adapted to serve Christian liturgical functions and therefore no longer preserve their original form. No examples have been preserved in North Africa, although a fragmentary silk twill with an inscription embroidered in yellow thread (divided: London, V&A, 1314–1888, T.13-1960; New York, Brooklyn Mus.; and Brussels, Musées Royaux A. & Hist.) was probably made for the Umayyad caliph of Syria Marwan II (*r.* 744–50) in the official workshop of Ifriqiyya, presumably located at Kairouan. Other official factories were located at Sousse in Tunisia, the Qal'at Bani Hamad in Algeria and Fez in Morocco; in Tunisia weaving was an important industry at Mahdia, while Gabès, famous for its sericulture, was the site from which silk production was introduced to Sicily by the Aghlabid dynasty (*r.* 800–909), when they took control of the island.

The earliest dated Spanish textile is the celebrated *tiraz* of the Spanish Umayyad ruler Hisham II (*r.* 976–1013 with interruption), which was preserved in the church of S. María del Rivero, San Esteban de Gormaz Soria Province (Madrid, Real Acad. Hist.). Both its design and technique—silk and gold tapestry inwoven in a silk tabby ground—can be traced to Egypt. The gold wefts are typical of those found in Spanish Islamic textiles: silvered and gilded strips of membrane Z-wrapped around a silk core. Another 11th-century textile in the form of a *tiraz* and woven in the same inwoven-tapestry technique is preserved in Huesca (Mus. Episc. & Capitular Arqueol. Sagrada). Several related but smaller inwoven tapestries datable to the 9th to 11th centuries include borders from San Pedro de Montes and San Pedro Arlanza (Madrid, Inst. Valencia Don Juan; Covarrubias, Mus. Parroq.); parts of the shrouds of St. Froilan and St. Columba (León and Sens cathedrals); a fragment from a reliquary in Oviedo Cathedral (untraced); and a band from the mitre of St. Valerius (Roda de Isábena Cathedral). A further example, a 10th-century band (Madrid, Inst. Valencia Don Juan), is woven in the same technique, but its pattern of linked roundels, the most complete enclosing a peacock, reflects Near Eastern designs. Fragments from a reliquary in the cathedral of El Burgo de Osma, and from the alb of Abbot Biure (Barcelona, Mus. Dioc.), are additional examples of Spanish textiles attributable to the 11th century.

The earliest drawloom textiles include three 11th-century compound-twill silks in the church of S. Isidoro, León. Two, with designs of aligned roundels enclosing either floral motifs or paired animals, and stars or four-directional palmettes in the interstices, are based on Near Eastern models; that with animals has inscriptions around the roundels stating that it was made in Baghdad, but the epigraphy betrays its Spanish origin. The third silk has wide and narrow bands ornamented with inscriptions, opposing rows of paired animals and birds, and inhabited vines. Two important compound-twill silks, the Witches Pallium (Vic, Mus. Episc.) and the lining of the reliquary of St. Millán (Logroño, Monasterio de Yuso-PP Agustinos Recoletos), are woven in red, with friezes of paired animals or birds and Trees of Life in dark green and yellow. A slightly later (11th–12th century) compound-twill silk from the tomb of St. Bernard Calvó at Vic (dispersed, e.g. Cleveland, OH, Mus. A.) has rows of double-headed eagles grasping lions, a motif borrowed from the Near East. Contemporary with this textile is a group of compound-twill silks modeled after Byzantine textiles. Their Spanish origin is indicated by the Arabic inscription on one (Vic, Mus. Episc.) woven with ogival inscription bands framing paired griffins. This fragment is related stylistically both to a silk in Amsterdam (Rijksmus.) and to another reportedly from the monastery of Santa Maria de l'Estavy (New York, Cooper-Hewitt Mus.).

Another group of drawloom silks unified by design and technique can be attributed to the 12th century (Boston, MA, Mus. F.A.; Cleveland, OH, Mus. A.; New York, Cooper-Hewitt Mus.; New York, Met.; Quedlinburg, Schlossmus.; Burgos, S. Juan de Ortega; Riggisberg, Abegg-Stift.; Salamanca, Mus. Dioc.; Vic, Mus. Episc.). They are sometimes known as the Baghdad Group because the inscription on one of them, from the church of El Burgo de Osma (Boston, MA, Mus. F.A.), states that it was made in Baghdad. However, both the epigraphy and the technique are Spanish. Another, the chasuble of San Juan de Ortega at Quintanaortuña (Burgos), has an inscription naming the Almoravid ruler 'Ali ibn Yusuf (*r.* 1106–42). The design of this group of textiles consists of aligned, slightly elliptical roundels framed by friezes of animals or birds and enclosing paired animals or birds. The exception is the Lion Strangler Silk (dispersed, e.g. Cleveland, OH, Mus. A., see color pl. 3:XI, fig. 1; New York, Cooper-Hewitt Mus.), found in the tomb of St. Bernard Calvó at Vic, which presents a bearded and turbaned central figure strangling confronted lions. The whole group has four-directional palmettes that fill the

interstices, and horizontal inscription bands sometimes interrupt the roundels. The ground is typically ivory-colored, and the pattern predominantly red and green with details in yellow or brocaded with gold. The weave is lampas, except for the horizontal inscription bands, which are a compound weave; the warps are typically arranged in groups of two and four, and the gold wefts are bound in a honeycomb pattern.

Another group of 12th-century lampas silks brocaded with gold is characterized by double-headed eagles, grasping gazelles or birds, which flank concentric bulb palmettes. Examples from the tombs of Alfonso VII of Castile (*d.* 1157) and the infante Don García (*d.* 1145 or 1146) are now in Toledo Cathedral and the parochial church at Oña (Burgos); others are in the cathedrals of Bremen and Bamberg. Closely related in design but from the 13th century is a fragment (Bamberg Cathedral) with gazelles and bulb palmettes. Additional silk-and-gold lampas textiles depicting animals and birds in roundels (e.g. Provins Cathedral; Berlin, Staatl. Museen Preuss. Kultbes.; Madrid, Inst. Valencia Don Juan, 2059) are distinguishable from the Baghdad Group by technical details. A large (2.25×1.75 m) and nearly complete compound twill panel (Burgos, Real Monasterio de las Huelgas, Mus. Telas & Preseas) woven *c.* 1200, with inscribed roundels enclosing paired lions, borders and an inscription across the top, served as a pall for Maria de Almenar (*d.* 1234). One of the most accomplished compound-twill silks is the Cope of King Robert, a chasuble used in 1258 to wrap the relics of St. Exupère at St. Sernin, Toulouse. Pairs of large peacocks and small animals flanking Trees of Life are arranged in horizontal rows; beneath each is a kufic inscription repeating the word *baraka* ("blessing"). Palmette trees separate the units.

Sicily under Islamic rule was renowned for its silk textiles, and the industry continued there under the Normans (*r.* 1061–1194). Textiles formerly thought to originate from Sicily are now attributed to Spain; the only group of textiles clearly attributable to Sicily is part of the set of coronation robes of the Holy Roman Emperor and Empress (Vienna, Schatzkam.). The most famous is the stupendous mantle (see color pl. 3:X, fig. 2) of Roger II Hauteville, which bears an Arabic inscription along the hem stating that it was made in the royal workshop at Palermo in 1133–4. A semicircle (diam. 3.42 m) of red silk, it is embroidered in gold thread and pearls and features a central tree separating addorsed lions attacking camels. It is partially lined with a sumptuous silk and gold tapestry-woven fabric with figural scenes. The Holy Roman set also includes an alb made for William II Hauteville on which a bilingual Latin and Arabic inscription embroidered in pearls and gold states that it was made in 1181 at Palermo.

R. B. Serjeant: *Islamic Textiles: Material for a History up to the Mongol Conquest* (Beirut, 1972) [repr. of *A. Islam.*, ix–xvi (1942–51)]

D. G. Shepherd: "The Hispano-Islamic Textiles in the Cooper Union Collection," *Chron. Mus. A. Dec. Cooper Un.*, i (1943), pp. 357–401

M. Gómez-Moreno: *El Panteón real de las Huelgas de Burgos* (Madrid, 1946)

M. Gómez-Moreno: "Tapicería, bordados y tejidos," *El Arte árabe español hasta los Almohades,* A. Hisp., iii (Madrid, 1951), pp. 344–51

D. G. Shepherd: "The Textiles from Las Huelgas de Burgos," *Bull. Needle & Bobbin Club*, xxxv (1951), pp. 3–26

F. Day: "The Ṭirāz Silk of Marwān," *Archaeologica Orientalia in Memoriam Ernst Herzfeld*, ed. G. C. Miles (Locust Valley, NY, 1952), pp. 39–61

D. G. Shepherd: "The Third Silk from the Tomb of Saint Bernard Calvo," *Bull. Cleveland Mus. A.*, xxix (1952), pp. 13–14

C. Bernis: "Tapicería hispano-musulmana (siglos IX–XI)," *Archv Esp. A.*, xxvii (1954), pp. 189–212

F. E. Day: "The Inscription of the Boston 'Baghdad' Silk," *A. Orient.*, i (1954), pp. 191–4

E. Grohne: "Mittelalterliche Seidengewebe aus Erzbischofsgräbern im Bremer Dom," *Alte Kostbarkeiten aus dem bremischen Kulturbereich* (Bremen, 1956), pp. 107–67

E. Kühnel: "Die Kunst Persiens unter den Buyiden," *Z. Dt. Mrgländ. Ges.*, cvi/1 (1956), pp. 78–92 (90 and fig. 26)

F. L. May: *Silk Textiles of Spain: Eighth to Fifteenth Century* (New York, 1957)

D. G. Shepherd: "A Dated Hispano-Islamic Silk," *A. Orient.*, ii (1957), pp. 373–82

D. G. Shepherd: "Two Medieval Silks from Spain," *Bull. Cleveland Mus. A.*, xlv (1958), pp. 3–7

D. G. Shepherd and G. Vial: "La Chasuble de St-Sernin," *Bull. Liaison Cent. Int. Etud. Textiles Anc.*, xxi (1965), pp. 20–31

R. A. Lazaro Lopez: "Découverte de deux riches étoffes dans l'église paroissiale d'Oña," *Bull. Liaison Cent. Int. Etud. Textiles Anc.*, xxxi (1970), pp. 21–5

D. G. Shepherd: "A Treasure from a Thirteenth-century Spanish Tomb," *Bull. Cleveland Mus. A.*, lxv (1978), pp. 111–34

C. Partearroyo: *Historia de las artes aplicadas e industriales en España* (Madrid, 1982)

Internationales Kolloquium: Textile Grabfunde aus der Sepultur des Bamberger Domkapitals: Schloss Seehof, 1985

R. M. Martín i Ros: "Tomba de Sant Bernat Calbó: Teixit dit de Gilgamés," *Osona II* (1986), iii of *Catalunya romànica* (Barcelona, 1975–), pp. 728–31

R. M. Martín i Ros: "San Joan de las Abadesses: Teixit anomenat *Palli de les Bruixes*," *El Ripollès* (1987), x of *Catalunya romànica* (Barcelona, 1975–), pp. 399–402

C. Partearroyo Lacaba: *La seda en España: Leyenda, poder y realidad* (Tarrasa, 1991)

J. D. Dodds, ed.: *Al-Andalus: The Art of Islamic Spain* (New York, 1992)

R. M. Martín i Ros: "Les vêtements liturgiques dits de Saint Valère: Leur place parmi les tissues hispano-mauresques du XIIIe siècle," *Tech. & Cult.*, xxxiv (1999), pp. 49–66; 194; 196

D. Martinez San Pedro: "La seda en Almería: Notas para su estudio," *Actas del III Congreso de Historia de Andalucía: Córdoba 2001:2. Andalucía Medieval*, pp. 245–57

M. J. Feliciano: "Muslim Shrouds for Christian Kings?: A Reassessment of Andalusi Textiles in Thirteenth-century Castilian Life and Ritual," *Under the Influence: Questioning the Comparative in Medieval Castile*, ed. C. Robinson and L. Rouhi (Leiden, 2005)

D. YEMEN. The manufacture and trade in textiles were already important to the highly developed civilization of South Arabia in pre-Islamic times. Textiles may have been exported to Egypt soon after 3000 BCE, textile merchants of Sheba are mentioned in a biblical reference from the 6th century BCE, and Yemeni textiles were esteemed outside the Arabian peninsula from the 4th century. They were used to confer status and to pay taxes and tribute in the Hijaz and Sasanian Iran. Finely striped Yemeni cloth was used to cover the Kaʿba in Mecca, a tradition maintained by the Prophet Muhammad (whose body was also wrapped in Yemeni shrouds) and continued until the mid-7th century when Coptic cloth was substituted.

Yemeni textiles maintained their fine reputation in the Islamic period and were exported for use by the caliphs and the élite. The Umayyad (r. 661–750) and early Abbasid (r. 749–1258) caliphs favored Yemeni tie-dyed and brocaded cotton cloth with bands of inscriptions (see TIRAZ), specially woven in Sanʿa. Yemeni textiles, in particular cloaks with borders and striped cloth manufactured in Sanʿa and Aden, were in great demand in the Levant, Egypt, Baghdad and China, although after 1000 there was increased competition from other sources. From the 11th to the 13th century, as Yemeni exports declined, Jewish and Muslim merchants based in Aden dominated the east–west textile trade.

Cotton (probably indigenous) was cultivated in antiquity, and silk was introduced by the 4th century. In Islamic times, Yemen was also known for its dyes: its specialities were madder, indigo and *wars* (*Flemingia grahamiana*, an unusual yellow/orange dye, derived from a plant), cultivated for both local use and export. The most important centers of textile production were Aden, renowned for its fine linen stuffs, and Sanʿa, with its cotton, silk and wool decorated stuffs, most notably the famous ikat cloths. Indeed, the Malaysian word *ikat* may derive from the Arabic ʿ*aqada*, to tie or knot, and some experts regard South Arabia as the original home of ikat. These cotton ikats, called ʿ*aṣb* (referring to the technique of binding the warp threads for resist dyeing), *washī* (decorated), *burd* or *ridāʾ* (referring to the cloaks and gowns made of ikat), were of exceptionally fine quality and were imitated by weavers in Egypt, Spain and Iran, who had probably learnt the techniques from Yemeni craftsmen. The tie-dyed warps were usually dyed in shades of blue and yellow prior to weaving, and this patterned yarn was woven in wide stripes alternating with narrower ones in plain colors (see fig. 3). As these textiles were woven in tabby weave, often warp-faced, the fabric had pronounced stripes, although sometimes a tartan effect was achieved when the wefts were dyed as well. The most common decoration was an inscription embroidered in undyed cotton or painted, gilded and outlined in black ink (e.g. Cleveland, OH, Mus. A., 50.353, cotton tabby with painted inscription naming the Yemeni imam Yusuf ibn Yahya (r. 955–1003)). Ornaments in silk or cotton tapestry weave or brocaded cotton were less frequent.

C. J. Lamm: *Cotton in Medieval Textiles of the Near East* (Paris, 1937)

A. Bühler: *Ikat Batik Plangi* (Basle, 1972)

R. B. Serjeant: *Islamic Textiles: Material for a History up to the Mongol Conquest* (Beirut, 1972)

L. Golombek and V. Gervers: "Tirāz Fabrics in the Royal Ontario Museum," *Studies in Textile History in Memory of H. B. Burnham*, ed. V. Gervers (Toronto, 1977), pp. 82–125

J. Baldry: *Textiles in Yemen: Historical References to Trade and Commerce in Textiles in Yemen from Antiquity to Modern Times* (London, 1982)

S. S. Blair: "Legibility Versus Decoration in Islamic Epigraphy: The Case of Interlacing," *World Art: Themes of Unity in Diversity: Acts of the XXVIth International Congress of the History of Art: Washington, DC, 1986*, ii, pp. 229–31

H. W. Glidden and D. Thompson: "Ṭirāz in the Byzantine Collection, Dumbarton Oaks: Parts Two and Three: Ṭirāz from the Yemen, Iraq, Iran, and an Unknown Place," *Bull. Asia Inst.*, iii (1989), pp. 89–105

J. Balfour-Paul: "The Indigo Industry of the Yemen," *Arab. Stud.*, ed. R. B. Serjeant and R. L. Bidwell, University of Cambridge Oriental Publication, 42 (Cambridge, 1990), pp. 39–62

G. Cornu and O. Valansot: "Wašī yéménite des IXe-Xe siècles au Musée historique des tissus de Lyon," *Archéol. Islam.*, ii (1991), pp. 47–70

A. Maurières, P. Chambon and E. Ossart: *Reines de Saba, itinéraires textiles au Yémen* (Aix-en-Provence, 2003)

III. c. 1250–c. 1500. The end of the Abbasid caliphate brought about the decline of official manufactories for textiles in the Islamic lands, but exquisite silks continued to be woven on drawlooms. Three regional groups can be identified.

A. Spain and North Africa. B. Egypt and Syria. C. Eastern Islamic lands.

A. SPAIN AND NORTH AFRICA. The major innovation in 13th-century textiles was the gradual replacement of animal patterns characteristic of the earlier period by a style often identified as Hispano-Moresque. These small-scale designs formed by interlacing strapwork are largely geometric and floral but sometimes include paired animals, and larger pieces have inscription bands. The trend towards the increased use of geometric forms, visible in other arts produced under the ALMOHAD dynasty (r. 1130–1269) in northwest Africa and Spain, is already apparent in works of the late 12th century; the earliest example is a silk-and-gold tapestry made into a cap for the infante Ferdinand of Castile in the late 12th century or early 13th (Burgos, Real Monasterio de las Huelgas, Mus. Telas & Preseas). The most famous textiles of this type include those found in the tombs of Don Felipe (d. 1274) and Doña Leonor at Villalcázar de Sirga (dispersed: e.g. Madrid, Inst. Valencia Don Juan.; New York, Cooper-Hewitt Mus.; New York, Hisp. Soc. America; Cleveland,

OH, Mus. A.), two of the three silk-and-gold textiles from the San Valero vestments (*c.* 1279; Madrid, Inst. Valencia Don Juan) and the shroud of Sancho IV (*d.* 1295) at Toledo Cathedral. These are compound weaves, some with areas of double cloth; other textiles with small-scale geometric patterns were woven differently. Two silks at the Real Monasterio de las Huelgas in Burgos (Gómez-Moreno, nos. 4 and 5) are lampas weaves with areas of compound weave; their gold pattern wefts are bound in a honeycomb pattern. Additional textiles from Burgos (Gómez-Moreno, nos. 15–20), together with a blue-and-gold striped silk from the tomb of Don Felipe (dispersed: e.g. Cleveland, OH, Mus. A.), have bands of linear lozenge designs woven in fancy weave alternating with bands of inscriptions or other geometric ornament formed by additional gold and silk pattern wefts. Fancy weave inwoven with silk-and-gold tapestry is used in the ornamented panels on the cope and dalmatics of San Valero (Barcelona, Mus. Tèxtil & Indument.), a cushion cover from the tomb of Leonor of Castile (*d.* 1244) at Burgos (Real Monasterio de las Huelgas, Mus. Telas & Preseas) and a garment for the infante Alfonso (*d.* 1291) at Valladolid (Mus. Dioc. & Catedralicio).

Three surviving textiles intended for furnishings exhibit the technique of silk-and-gold tapestry inwoven in a tabby ground. One of these, a fragmentary example showing pairs of drinking ladies in roundels surrounded by strapwork in the typical Hispano-Moresque style (New York, Cooper-Hewitt Mus.), is ascribed to the early part of the 13th century. Another, the cushion cover of Queen Berengaria of Castile (*d.* 1246; Burgos, Real Monasterio de las Huelgas, Mus. Telas & Preseas), has top and bottom borders in gold with Arabic inscriptions that define a crimson field with four octagrams and a central roundel enclosing a pair of women flanking a Tree of Life. The third example, fragments from a large hanging retrieved from the tomb of Don Arnaldo de Gurb (*d.* 1284), bishop of Barcelona (dispersed: e.g. Cleveland, OH, Mus. A.; New York, Cooper-Hewitt Mus.; Madrid, Mus. Arqueol. N.; Granada, Mus. N. A. Hispmus.), preserves parts of the roundels that were originally arranged in aligned rows and portions of the end borders. Similar to these three furnishing fabrics is the splendid Las Navas de Tolosa Banner (3.3×2.2 m; Burgos, Real Monasterio de las Huelgas, Mus. Telas & Preseas), worked in gold, crimson, white, blue, black and green silk, with a central octagram enclosed by pearl borders and Koranic inscriptions. The banner is thought to have been a trophy won by Ferdinand III, king of Castile and León (*r.* 1217–52) and donated to the monastery when it was reconstructed in the first half of the 13th century.

Similar textiles were also woven for Christian patrons in the 13th century, to judge from three groups of MUDÉJAR textiles made according to different techniques. A mantle from the tomb of Ferdinand III (Madrid, Real Armería) and the chasuble of Sancho of Aragon (*d.* 1275; Toledo Cathedral) are entirely tapestry-woven with heraldic designs. By

3. Yemeni cotton ikat with painted and gilded inscription, 584×406 mm, 10th century (New York, Metropolitan Museum of Art, Gift of George D. Pratt, 1929 (29.179.9)); image © The Metropolitan Museum of Art/Art Resource, NY

contrast, several textiles from the monastery of Las Huelgas (Gómez-Moreno, nos. 35, 32–43), plus a number of vestments and fragments from other European churches, are the most important of the many "half-silks": these compound weaves have linen main warps, silk binding warps and wefts, and gold thread usually consisting of strips of silvered and gilded membrane S-wrapped around a linen core. Their designs are clearly related to stucco ornament at Las Huelgas, Burgos: compartments enclosing animals, birds, stars, and occasionally heraldry, often interrupted by bands of pseudo-Arabic inscriptions. The third group, silks known as Cloths of Aresta, are preserved in many European churches as well as at Las Huelgas, Burgos (Gómez-Moreno, nos. 21–33). Woven in weft-faced lozenge or diagonal twill weaves, their designs consist of small fleurs-de-lis, lions, castles, birds, plants or occasionally armorials against a diapered ground.

A small group of brocaded lampas silks from the early 14th century have designs of gazelles, basilisks and concentric bulb palmettes reminiscent of the gazelle/eagle/palmette designs of the 12th century

(e.g. Cleveland, OH, Mus. A.; Paris, Mus. Cluny; Sens Cathedral). The most common 14th-century textiles, however, are drawloom silks with Hispano-Moresque designs of stars and other geometric figures formed by interlacing strapwork (see fig. 4). The fields are interrupted by bands with merlons, interlacing, inscriptions or (rarely) figures or animals, as in a large textile (New York, Hisp. Soc. America). These designs were often woven with gold and polychrome silks until the end of the 14th century, when gold became too expensive to use in this way. Typical textiles from the late 14th century have designs of strapwork combined with kufic and cursive inscriptions closely modeled after tile and stucco decoration at the Alhambra Palace and sometimes known as Alhambra arabesques. The undulating design on one silk-and-gold lampas textile with vines, palmettes, heraldic shields and rampant lions (Cleveland, OH, Mus. A.) shows the impact of Chinese textiles. The only textiles known to have been woven in North Africa are two banners, silk-and-gold tapestry inwoven in a tabby ground (Toledo Cathedral). Both were made at Fez and captured at the battle of the Rio Salado in 1340. The first (2.8×2.2 m) was made in 1312 for the Marinid ruler Abu Saʿid ʿUthman (r. 1310–31); the second (3.74×2.67 m) was made in 1339 for Abu'l-Hasan ʿAli I (r. 1331–48). Both were probably woven by Andalusians or weavers trained in Spain and should therefore be regarded as products of the great Hispano-Islamic textile tradition rather than indigenous North African forms.

During the 15th century variations on the star and tile patterns continued to be woven in silk. Whether they were made in Spain or in North Africa by Muslims fleeing the Christian reconquest is debated. A complete silk curtain (Cleveland, OH, Mus. A.) has two identical lateral panels with rectangular fields of arabesques framing tile patterns, elaborate borders with knotted kufic and Alhambra arabesques, and a central panel with Alhambra arabesques flanked by narrow bands of inscription, interlacing and merlons; the Nasrid motto (lā ghālib ilāʾ llah: "There is no victor save God") on all the panels confirms their Spanish origin. Other textiles from the 14th and 15th centuries include those with variously striped patterns with repeating bands of inscriptions, interlacing and floral motifs, and Mudéjar silks with heraldic designs or combinations of strapwork and European-style floral motifs, animals and birds. Both Islamic and Mudéjar silks from this period are predominantly lampas weaves, sometimes combined with areas of compound weave.

D. G. Shepherd: "The Hispano-Islamic Textiles in the Cooper Union Collection," Chron. Mus. A. Dec. Cooper Un., i (1943), pp. 357–401

M. Gómez-Moreno: El Panteón real de las Huelgas de Burgos (Madrid, 1946)

L. Torres Balbas: Arte almohade, arte nazarí, arte mudéjar, A. Hisp., iv (Madrid, 1949), pp. 57–61, 198–203, 384–9

C. Bernis: "Tapicería hispano-musulmana (siglos XIII y XIV)," Archv Esp. A., xxix (1956), pp. 95–115

F. L. May: Silk Textiles of Spain: Eighth to Fifteenth Century (New York, 1957)

D. G. Shepherd: "La Dalmatique d'Ambazac," Cieta Bull., xi (1960), pp. 11–29

M. J. Ainaud de Lasarte: "La Devise des rois de Grenade sur un tissu hispano- mauresque," Bull. Liaison Cent. Int. Etud. Textiles Anc., xxxii (1970), pp. 14–21

D. G. Shepherd: "A Treasure from a Thirteenth-century Spanish Tomb," Bull. Cleveland Mus. A., lxv (1978), pp. 111–34

C. Partearroyo: Historia de las artes applicadas e industriales en España (Madrid, 1982)

A. E. Wardwell: "A Fifteenth-century Silk Curtain from Muslim Spain," Bull. Cleveland Mus. A., lxx (1983), pp. 58–72

S. Desrosiers, G. Vial and D. de Jonghe: "Cloth of Aresta: A Preliminary Study of its Definition, Classification, and Method of Weaving," Textile Hist., xx (1989), pp. 199–223

C. Partearroyo Lacaba: La seda en España: Leyenda, poder y realidad (Tarrasa, 1991)

J. D. Dodds, ed.: Al-Andalus: The Art of Islamic Spain (New York, 1992)

A. Simon-Cahn: "The Fermo Chasuble of St. Thomas Becket and Hispano-Mauresque Cosmological Silks: Some Speculations on the Adaptive Reuse of Textiles," Muqarnas, x (1993), pp. 1–5

S. Cavaciocchi, ed.: La seta in Europa, sec. XIII–XX: Atti della "Ventiquattresima Settimana di Studi" … 1992, Istituto Internazionale di Storia Economica "F. Datini," Prato: Serie II, 24 (Florence, 1993) [several articles]

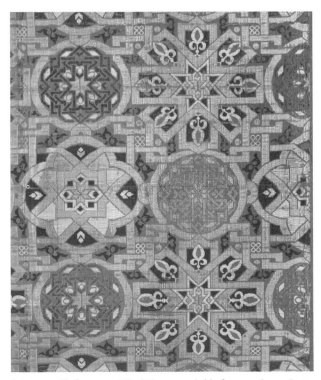

4. Lampas silk fragment, 560×475 mm, probably from southwest Spain, 14th century (London, Victoria and Albert Museum); photo credit: Erich Lessing/Art Resource, NY

L. Woley: "Hispanic Synthesis" *Halt*, lxxxi/17 (1994), pp. 67–75, 96

D. Niza-Serrano: "El adorno femenino en Al-Andalus: Fuentes lexicográficas para su estudio," *Bol. Asoc. Esp. Orientalistas*, xxx (1994), pp. 229–38

D. Iguel, J. A. Lliber, and G. Navarro: "Materias primas y manufacturas textiles en las aljamas rurales valencianas de la baja edad media," *VI Simposio Internacional de Mudejarismo, Teruel, 16–18 de septiembre de 1993. Actas*, pp. 311–27

G. Navarro Espinach: "La seda entre Génova, Valencia y Granada en época de los Reyes Católic," *Actas del Congreso La frontera oriental nazarí como sujeto histórico (s.XIII–XVI)*, ed. P. Segura Artero, Colección Actas, 29 (Almería 1997), pp. 477–83

D. Serrano-Niza: "Para una nomenclatura acerca de la indumentaria islámica en Al- Andalus," *Across the Mediterranean Frontiers: Trade, Politics and Religion, 650–1450: Selected Proceedings of the International Medieval Congress, University of Leeds, 10–13 July 1995, 8–11 July 1996*, ed. D. A. Agius and I. R. Netton, International Medieval Research, 1 (Turnhout, 1997), pp. 333–45

L. Malara: "Le vesti di tradizione musulmana del corredo funebre di Federico II di Svevia in base alle testimonianze settecentesche," *AION*, lviii (1998), pp. 301–22

G. Navarro Espinach: "Los valencianos y la seda del Reino de Granada a principios del cuatrocientos," *VII Simposio Internacional de Mudejarismo, Teruel—19–21 de septiembre de 1996: Actas*, pp. 83–93

C. A. Martínez Albarracín: "Léxico de algunas ropas y joyas de una carta de dote y arras de una morisca granadina del siglo XVI (24-I-1563)," *VII Simposio Internacional de Mudejarismo, Teruel—19–21 de septiembre de 1996: Actas*, pp. 679–89

M. Marín, ed.: *Tejer y vestir: De la antigüedad al Islam*, Estudios Árabes e Islámicos: Monografías, 1 (Madrid, 2001) [several articles]

D. Serrano-Niza: "La naturaleza en el telar andalusí," *Ciencias de la naturaleza en al-Andalus*, Textos y estudios VI, ed. C. Álvarez de Morales (Granada, 2001), pp. 237–57

A. Fernández-Puertas: "Vestimenta de Abū ʿAbd Allāh Muḥammad, Boabdil: Rīḥiyya, juff, mallūṭa, ʿimāma," *En el epílogo del Islam andalusí: La Granada del siglo XV*, ed. C. del Moral, Al-Mudun, 5 (Granada, 2002), pp. 399–477

J. Abellán Pérez: "Prendas litúrgicas de vestiduras y tejidos andalusíes (Documentación de la parroquia de Santa María de la Oliva de Lebrija en la época de los Reyes Católicos)," *Aynadamar: Colección de estudios y textos árabes*, ed. F. N. Velázquez Basanta and Á. C. López y López (Cadiz, 2002), pp. 147–60

B. EGYPT AND SYRIA. The textile industry in Egypt and Syria under the MAMLUK sultans (r. 1250–1517) was very important. Social position and court and military rank were reflected in the fabric, color and cut of dress; the *kiswa*, the cloth covering the Kaʿba in Mecca, was made in Egypt; and robes of honor (Arab. *khilʿa*) were produced as state gifts. Although weaving is mentioned by many travelers, chroniclers and European pilgrims, and the resultant fabrics feature in European church inventories, the only significant textual information is the description of drawloom weaving in Alexandria by the encyclopaedist and historian al-Nuwayri (d. 1332). In Egypt there were official factories (Arab. *Tirāz*) at Alexandria and Cairo; cotton was woven at Alexandria and silk and linen in both cities, while Bahnasa in the Faiyum was noted for its linen and wool fabrics. In Syria, luxury silks were produced at Damascus—also the site of an official factory—and at Antioch. Other important centers were Baalbek and Aleppo, while Ramla and Sarmin were known for cotton weaving. Dyestuffs from Egypt are mentioned by the chroniclers Qalqashandi (1355–1418) and al-Maqrizi (1364–1442). Weaving flourished in the politically and economically stable conditions under the Bahri, or Turkish, Mamluks (r. 1250–1390) but declined as a result of the civil wars and economic depression that beset the state from 1388 to 1422. Although Damascus and Alexandria remained important weaving centers under the Burji, or Circassian, Mamluks (r. 1382–1517), a census taken of weavers in Alexandria in 1434 revealed that only 800 looms were operating out of the 14,000 that had been in use in 1388.

Textiles have been preserved in burials—principally in Upper Egypt and Old Cairo (Fustat)—and in European church treasuries. Representing only a tiny fraction of the quantities produced, surviving fragments nevertheless reveal a wide variety of techniques, styles and fabrics from sumptuous silks to everyday fabrics. A core group can be attributed to this period on the basis of technique, style and occasionally epigraphy, although it is sometimes difficult to distinguish Egyptian or Syrian textiles from those woven in Italy and Asia. Silks woven on drawlooms may be lampas or compound weaves, doublecloth or a variation with multiple sets of warps and wefts (often called triple or incomplete triple weave), and damask. These are occasionally combined with bands of extended tabby, which have a ribbed effect. Metal thread consists of a silk core around which were spun metal strips or gilded or silvered animal substrate. In addition to drawloom silks, other survivals include tapestry fragments (e.g. New York, Met.; Cairo, Mus. Islam. A.), several tabby or twill textiles with striped designs, doublecloth cottons, and fragments of resist-printed cottons and linens.

Only one drawloom textile has been scientifically excavated: a yellow silk garment (Cairo, Mus. Islam. A., 23903) found in 1966 in a church crypt at Jabal Adda in Upper Egypt and attributed to the late 13th century. A close variation of its star-and-cross pattern combined with animals and latticework exists in a silk damask (Riggisberg, Abegg-Stift.), which may indicate a similar date. Study of the inscriptions on fabrics has allowed dating of several examples. Some drawloom textiles can be dated by the names of the rulers inscribed on them. The earliest is a silk (Cairo, Mus. Islam. A.) with inscription bands forming ogival compartments which enclose heart-shaped palmettes; the inscriptions repeat a dedication to Qalaʾun (r. 1280–90). Dating from the reign of his successor Khalil (r. 1290–94) is an inscribed tapestry fragment (Cairo, Mus. Islam. A.) in which the tripartite division of medallions and diamonds flanked by

inscription bands derives from official textiles made under the Fatimids (*see* §I, A above). Two drawloom silks bear the titles of al-Nasir Muhammad (*r.* 1294–1340 with interruptions): a yellow damask with inscribed medallions and vines terminating in long curving leaves (Berlin, Mus. Islam. Kst) and a fragmentary cap preserving medallions with inscribed borders and lattice centers (Göteborg, Röhsska Kstslöjdmus.). Three damasks with designs of inscribed bulb palmettes on parallel curving vines (Berlin, Mus. Islam. Kst and Tiergarten, Kstgewmus.; London, V&A) bear the Persian form of al-Nasir Muhammad's name, suggesting that these textiles may have been made in Iran for export to the Mamluk court.

Several other drawloom textiles can be attributed to specific Mamluk rulers on the basis of the titles in their inscriptions. Five give the title *al-malik al-nāṣir*: a cap (Cleveland, OH, Mus. A.) and two fragments with bands of crescent moons and/or inscriptions and animals (London, V&A; Cairo, Mus. Islam. A.); a silk with tangent dodecagons, inscribed borders and paired lions (Berlin, Mus. Islam. Kst); and a fragment (Göteborg, Röhsska Kstslöjdmus.) preserving a band of inscribed medallions, fish, crescent moons and lozenges between bands of extended tabby. Although this title was used by four sultans in the 14th century, the silks are generally attributed to the reign of al-Nasir Muhammad. A striped silk with an inscription "Glory to our lord, the sultan *al-malik al-mu'ayyad*," double-headed eagles, paired animals, lotus flowers and latticework (divided: Göteborg, Röhsska Kstslöjdmus.; New York, Met., see fig. 5) is stylistically earlier than the reigns of the two Mamluk sultans who bore that title in the 15th century. The textile was probably intended for the Rasulid sultan of Yemen, Mu'ayyad Da'ud (*r.* 1296–1322), for whom metalwares were also made in Egypt. A

fragmentary silk garment for a child (Berlin, Mus. Islam. Kst) with ogives framing paired griffins within medallions bears the title *al-sulṭān al-malik al-muzaffar*. Although five Mamluk sultans assumed that title between 1259 and 1421, the style and design suggest a date not later than the reign of Baybars II (*r.* 1309). Three drawloom silks are inscribed "Glory to our master the sultan *al-malik al-ashraf*," a title assumed by six Mamluk sultans between the 13th and the 15th century. The first, a blue damask (London, V&A), probably dates to the reign of Kujuk (*r.* 1341–2) or earlier, since a variation of its pattern was painted in 1354 by Puccio di Simone (*fl. c.* 1345–65) and Allegretto Nuzi (1316/20–73/4). The second, a striped silk-and-gold textile (Cairo, Mus. Islam. A.), was probably woven during the reign of Kujuk or of Sha'ban II (*r.* 1363–76), judging from its 14th-century design of animals, flowers, cartouches and inscriptions. The third, a lampas silk-and-gold orphrey (London, V&A), may date as late as the reign of Barsbay (*r.* 1422–37), because its ogival design of vines, lotuses, cartouches and bulb palmettes was depicted *c.* 1430 by the Master of the Bambino Vispo. Two variations of this design occur in a silk-and-gold lampas cape (Cleveland, OH, Mus. A.) and a silk damask (London, V&A) of approximately the same date.

Several drawloom silks with inscriptions but no titles can be attributed to the 14th century for stylistic reasons. Two, a hat (Cleveland, OH, Mus. A.) and a fragment (Berlin, Mus. Islam. Kst), are woven with bands of inscriptions "Glory to our master the sultan," running animals and pin stripes, while in another fragment (Washington, DC, Textile Mus.) bands of floral ogives alternate with bands of inscription, "the sultan, the king." A tunic (Cairo, Mus. Islam. A.) has a design of ogival medallions alternating with crescent moons, both inscribed *al-sulṭān*; they are arranged in staggered rows with fish and rosettes in the interstices. Similar medallions within an ogival net of crescent moons, rosettes and small medallions occur in two silks belonging to a dalmatic and cope (Lübeck, Marienkirche). The word *al-sulṭān* also appears in the crescent moons ornamenting a child's sandal (Richmond, Surrey, Keir priv. col.). Other drawloom silks without inscriptions (Cleveland, OH, Mus. A.; Washington, DC, Textile Mus.; Cairo, Mus. Islam. A.; Berlin, Tiergarten, Kstgewmus.; Toronto, Royal Ont. Mus.; New York, Met. and Lyon, Mus. Hist. Tissus) display a variety of patterns—bands, squares, scrolling vines and ogives—which include such typically Mamluk motifs as crescent moons, fish, lotus flowers, latticework, rosettes and pin stripes.

A green, white and gold textile making up a chasuble (London, V&A) can be attributed to the 15th century, since its design of ogives enclosing medallions is similar to one painted *c.* 1500 by the Master of St. Giles (*fl. c.* 1490–1510). Several lampas silks (Berlin, Tiergarten, Kstgewmus.) may also date from the 15th century; some have ogival patterns similar to the chasuble, others have designs of diamonds,

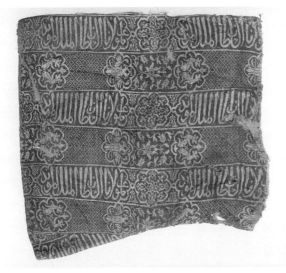

5. Egyptian or Syrian silk double weave, 927×514 mm (mounted), early 14th century (New York, Metropolitan Museum of Art, Rogers Fund, 1931 (31.14a)); photograph © The Metropolitan Museum of Art, New York

squares or stars. The rosette, latticework and fleurs-de-lis in these repetitive geometric patterns recall the repertory of earlier designs, but animals and birds are no longer found.

In addition to drawloom textiles, several textiles have striped designs which were usually achieved by supplementary warps and/or wefts. Small-scale geometric motifs and diaper patterns frequently ornament the narrow bands of these textiles, though two silk-and-gold winding sheets excavated at Jabal Adda (Cairo, Mus. Islam. A.) and a fragment (New York, Met.) incorporate inscriptions and animals or rosettes. Some (Cleveland, OH, Mus. A.; Cairo, Mus. Islam. A.; Berlin, Mus. Islam. Kst) are woven of silk-and-gold thread; others (Berlin, Mus. Islam. Kst; New York, Met.) use silk or combinations of silk and cotton, linen or wool. This striped group is loosely attributed to the 13th to 15th centuries, except for the pieces excavated at Jabal Adda which can be dated more precisely.

Block-printed cottons and linens, reflecting Egypt's trade with India, often emulate drawloom patterns or metalwork designs. They have been attributed to dates from the 13th to the 15th century, but without reliable documentation. Two linen fragments (Cairo, Mus. Islam. A.), one with a design nearly identical to that of the yellow silk excavated at Jabal Adda and the other with an inscription inhabited by figures among the letters, certainly date to the late 13th century or early 14th. Certain fragments (Cleveland, OH, Mus. A.; Athens, Benaki Mus.) with crescent moons and/or fish can be assigned to the 14th century for iconographic reasons, while other pieces (Cairo, Mus. Islam. A.) with medallions, stars or cartouches and bands of inscription, together with a fragment (Washington, DC, Textile Mus.) with bands of inscription, have been attributed on stylistic grounds to the 15th century.

A. F. Kendrick: *Catalogue of Muhammadan Textiles of the Medieval Period, Victoria and Albert Museum* (London, 1924), pp. 38–42

E. Kühnel: *Islamische Stoffe aus ägyptischen Gräbern* (Berlin, 1927)

H. J. Schmidt: "Damaste der Mamlukenzeit," *A. Islam.*, i (1934), pp. 99–109

C. J. Lamm: "Dated or Datable Ṭirāz in Sweden," *Monde Orient.*, xxxii (1938), pp. 103–25

R. Pfister: *Les Toiles imprimées de Fostat et l'Hindoustan* (Paris, 1938)

M. A. Marzouk: *History of Textile Industry in Alexandria, 331 B.C.–1517 A.D.* (Alexandria, 1955), pp. 66–79

H. J. Schmidt: *Alte Seidenstoffe* (Brunswick, 1958), pp. 151–72

N. B. Millet: "Gebel Adda Preliminary Report, 1965–66," *J. Amer. Res. Cent. Egypt*, vi (1967), pp. 53–63

J. Brookner: "Textiles," *Quseir al-Qadim: Preliminary Report*, ed. D. S. Whitcomb and J. H. Johnson (Cairo, 1979), pp. 183–95

Renaissance of Islam: Art of the Mamluks (exh. cat. by E. Atıl; Washington, DC, Smithsonian Inst.; Minneapolis, MN, Inst. A.; New York, Met.; Cincinnati, OH, A. Mus.; 1981), pp. 223–48

L. W. Mackie: "Toward an Understanding of Mamluk Silks: National and International Considerations," *Muqarnas*, ii (1984), pp. 127–46

D. Thompson: "Cotton Double Cloths and Embroidered and Brocaded Linen Fabrics from 10th to 14th Century Egypt: Their Relation to Traditional Coptic and Contemporary Islamic Style," *Bull. Liaison Cent. Int. Etud. Textiles Anc.*, lxi–lxii (1985), pp. 35–49

Tissues d'Egypte: Témoins du monde arabe VIIIe –Xve siècles (exh. cat., Geneva, Mus. A. & Hist.; Paris, Inst. Monde Arab.; 1993–4)

B. Biedrońska-Słotowa: "Early 15th-century Byzantine and Mamluk Textiles from Wawel Cathedral, Cracow," *Bull. CIETA*, llxxii (1994), pp. 13–19

B. J. Walker: "Rethinking Mamluk Textiles," *Mamluk Stud. Rev.*, iv (2000), pp. 167–217

C. EASTERN ISLAMIC LANDS. The Mongol conquest of Asia in the mid-13th century led to the opening of trade routes from China to Italy along which, from the mid-13th century to the mid-14th, luxury fabrics were traded, resulting in a brief period of International design. Woven silks, cottons, linens, wools, carpets, felts, furs, embroideries and quilting were all produced in quantities. About 100 silk textiles of the 13th century to the mid-14th survive from Iran, Iraq and Central Asia, but only a few from Anatolia; all are preserved in museums and churches in Europe and North America. Archaeological evidence is confined to a few samples excavated in Xinjiang Province in China.

Records of Asian chroniclers and travelers indicate the importance of textile weaving in Central Asia and Iran during the 13th and 14th centuries, and silk cultivation increased in Iran during the period. The Persian vizier Rashid al-Din, the Italian merchant Marco Polo (1254–1324), the Moroccan traveler Ibn Battuta (1304–77) and Ruy Gonzalez de Clavijo (d. 1412), Spanish envoy at Timur's court, specified centers of production including Mosul, Tabriz, Urgench and Samarkand and some broad categories of textiles, but the accounts are inconsistent. European documents of the late 13th century and the 14th list luxury fabrics from Central Asia and Iran as *panni tartarici* ("Tartar cloths"), indicating their place of origin as the Mongol Empire, but are rarely more specific. Techniques and styles are not usually described in inventories, but patterns are. Examples include cocks and horseman in the Canterbury Inventory (1315), human figures and animals in the Vatican Inventory (1361) and curtains with griffins in the Prague Inventory (1355). Other motifs described include roses, lilies, lotus-bulbs, monkeys, bands and strips. Contemporary literary descriptions, such as those in Dante's *Inferno* and Langland's *Piers Plowman*, also indicate the desirability of these fabrics.

Luxury textiles were made from silk and metal thread, the latter a strip of silvered and/or gilded animal substrate either woven flat or wound on a core, usually cotton or occasionally silk. Structural differences distinguish textiles woven in Iran, Central

Asia and the Middle East from those produced in Italy and Spain. Central Asian textiles have selvages reinforced with silk warps, but never linen cords as is usual with Italian and Spanish silks. Central Asian textiles are often woven with silk warps and ground wefts of cotton, whereas only one small group produced in the Mediterranean area has mixed fibers. In Central Asian textiles having metal thread combined with animal membrane, the thread is either woven flat or wound on a cotton core, whereas Italian and Spanish textiles with metal thread and membrane used silk and linen cores. The predominant weave is lampas, but compound weave, doublecloth and velvet are also found.

Only one group of textiles with technical similarities, including selvage construction, paired main warps and gold filé pattern wefts with a silk core, reflects a continuous weaving tradition predating the Mongol conquest. This group can be assigned to the Ilkhanid territories by virtue of one textile, a *tiraz* inscribed with the name of the Ilkhanid sovereign Abu Sa'id (*r.* 1317–35; Vienna, Dom- & Diözmus.), produced in a royal workshop, probably at Tabriz. It is a lampas and compound weave with bands containing peacocks and animals. The earliest example of this group, a fragmentary textile with a design of Bahram Gur and kings found in the grave of Bishop Hartmann (*d.* 1286; Augsburg, Maximilianmus.), is datable by its style and iconography to the mid-13th century.

Several textiles can be attributed to Central Asia in the late 13th century or the 14th for three principal reasons: the selvage structure; the composition of their metal threads; and the use of pre-Mongol iconographic elements. Some have cotton ground wefts, including a few assigned to Transoxiana. Designs often include a combination of Islamic, Central Asian and Chinese motifs, indicating the commercial role and cultural diversity of Central Asia at that time. Most are lampas silks with flat strips of gilded animal membrane. Five silks of this type were found in the tomb of Cangrande della Scala (*d.* 1329) in Verona (Verona, Castelvecchio, A, D, E, G and H). Two further examples (Regensburg, Alte Kapelle) are a chasuble showing grape leaves and vines, a design inspired by Italian silks of the 1340s–1400; and a stylistically related tunic, which must be of the same date.

A large number of silks having pattern wefts with gilded or silvered leather strips on a cotton core and with more concentrated warps than in Central Asian textiles were formerly attributed to Italy, Egypt or Iran, but are now attributed to Khurasan, the easternmost province of Iran. Most of them combine pre-Mongol Islamic and Chinese motifs. A silk and silver lampas (Cleveland, OH, Mus. A., 45.14) is one of three extant textiles of this type with a pattern of paired birds flanking palmettes, a design found in 12th-century Iranian ceramics. A silk with Chinese-style dragons (*chi-lin*; Berlin, Tiergarten, Kstgewmus., 78.744) and another with a design of ogival medallions with paired animals, floral motifs and dragons (formerly Berlin, Tiergarten, Kstgewmus., 68.2742) also show the impact of Chinese motifs. Another group of textiles has selvages with single main warps in a different color from the rest of the fabric; these warps appear on the face while the pattern wefts appear on the back. The metal threads usually have a linen core. The patterns on this group vary, showing Chinese, Central Asian and Italian motifs. One, a lampas (Lyon, Mus. Hist. Tissus, 28.340), has a design of grapevines copied directly from a 14th-century Italian silk. Two others, a chasuble and a dalmatic (London, V&A, 594-1884 and 8361-1863; see fig. 6), have a pattern of fish-eating birds, which may relate to the 1341 inventory entry of the church of S. Francesco, Assisi, describing a *panno tartaresco* with a design of pelicans. The predominant use of linen in the metal thread core and the presence of Italian motifs in a few of these textiles suggest western Iran or Iraq as a likely provenance. Italian commerce was concentrated in Tabriz, Sultaniyya and Urgench, but since the region of Urgench is not known for using linen as a core material, the first two cities seem a more likely provenance. The production of luxury textiles clearly continued after the mid-14th century, but no representative corpus of weaving dating from before the 16th century has survived, and textiles are rarely documented.

Anatolia had a weaving industry of some significance in the 13th century, to judge from two compound twills with gilt threads: one (Lyon, Mus. Hist. Tissus, 23.475) is decorated with lions and inscribed with the name of Kayqubadh I (*r.* 1219–37), the Saljuq sultan of Anatolia; the other (Berlin, Tiergarten, Kstgewmus.) is decorated with a double-headed eagle. The earliest textile attributable to Anatolia under the rule of the Ottoman dynasty (*r.* 1281–1924) is a late 14th-century silk in the monastery of Studenica, Serbia, with a decorative composition and arrangement similar to contemporary Ilkhanid and Mamluk silks. Ottoman textiles may have inspired weavers over a wide geographical area, as several fragments from 15th-century Egypt have pattern motifs usually identified with the Ottomans, such as three crescent balls in pyramidal form. The Anatolian silk and velvet weaving industries developed rapidly in the late 14th century. By 1421 at least 100 different fabrics were produced in Ottoman Anatolia, and by 1500 over 90 types of high-quality silks, including velvets, were manufactured in Bursa alone (*see* §III, A below).

P. Toynbee: "Tartar Cloths," *Romania*, xxix (1900)

G. Wiet: *L'Exposition persane de 1931* (Cairo, 1933)

N. A. Reath and E. B. Sachs: *Persian Textiles* (Oxford, 1937)

Le stoffe di Cangrande (exh. cat., ed. L. Majagnato; Verona, Castelvecchio, 1983)

A. E. Wardwell: "Flight of the Phoenix: Crosscurrents in Late Thirteenth- to Fourteenth-century Silk Patterns and Motifs," *Bull. Cleveland Mus. A.*, lxxiv (1987), pp. 1–35

A. E. Wardwell: "Panni Tartarici: Eastern Islamic Silks Woven with Gold and Silver (13th and 14th Centuries)," *Islam. A.*, iii (1988–9), pp. 95–173

K. von Folsach: "Pax Mongolica: An Ilkhanid Tapestry Woven Roundel," *Halı*, lxxxv (1996), pp. 81–7

T. T. Allsen: *Commodity and Exchange in the Mongol Empire: A Cultural History of Islamic Textiles* (Cambridge, 1997)

When Silk was Gold: Central Asian and Chinese Textiles (exh. cat. by J. C. Y. Watt and A. E. Wardwell; Cleveland, Mus. A.; New York, Met.; 1997 8)

B. Biedrońska-Słotowa: "Perskie tkaniny jedwabne w zbiorach Muzeum Narodowego w Krakowie" [Persian silk textiles in the collections of the National Museum in Cracow] (Kraków, 2002)

The Legacy of Genghis Khan: Courtly Art and Culture in Western Asia, 1256–1353 (exh. cat., ed. L. Komaroff and S. Carboni; New York, Met.; Los Angeles, CA, Co. Mus. A.; 2002–3)

A. Shalem: "Bahram Gur Woven with Gold: A Silk Fragment in the Diocesan Museum of St. Afra in Augsburg and the Modes of Rendition of a Popular Theme," *Shahnama: The Visual Language of the Persian Book of Kings*, ed. R. Hillenbrand, Varie Occasional Papers II (Aldershot, 2004), pp. 117–27

IV. After c. 1500. The large number of textiles that survive from the Islamic lands in the period shows an extraordinarily wide variety of techniques, especially for luxury fabrics, such as figured silk velvets and brocades. Increasing competition from European fabrics, particularly in the 19th century, led to a decline in the production of luxury fabrics in major urban workshops, although village and nomadic production remained important.

A. Eastern Mediterranean lands. B. North Africa. C. Iran. D. Central Asia. E. India.

A. EASTERN MEDITERRANEAN LANDS. Because of the political control, albeit often nominal in the final years, exercised by the Ottoman sultans (r. 1281–1924) over the eastern and southern Mediterranean lands, the inspiration for textile design and the demand for production in the region stemmed from the Ottoman court established at Istanbul in 1453. Silk fabrics including patterned silk weaves, velvets and monochrome light-weight satins and embroideries played an important role throughout the Ottoman Empire, where they were a major commodity, used for such furnishings as coverings, curtains and pillows and clothing including kaftans, sashes, kerchiefs and headbands. Although archives, pictorial sources and garments preserved in royal collections and church treasuries provide some information, so few textiles are dated and so few technical analyses have been published that textiles can only be grouped into broad stylistic categories based on the designs and motifs used. Production of luxury silk fabrics developed during the 15th century and reached its apogee in the late 16th century and the 17th; during the 18th century embroidery techniques were featured more than woven ones, and designs became more stylized.

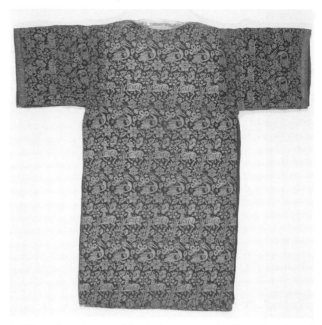

6. Silk textile made into a dalmatic, lampas woven in blue silk and metal thread, 2.32×1.22 m, from ?western Iran, 14th century (London, Victoria and Albert Museum); photo credit: Victoria and Albert Museum, London

1. Nature of the evidence. 2. Nature of production. 3. Stylistic development.

1. Nature of the evidence. Archival sources for Ottoman textiles range from royal inventories to records of tax farm revenues, but few have been published in critical editions. Most research has focused on the economic rather than the art-historical development of textile manufacture in the region, using in particular the archives of Topkapı Palace in Istanbul and those held by municipal authorities in such cities as BURSA in Anatolia. Diplomatic and personal reports from European travelers, merchants and official envoys contain more general information as well as subjective views of the visual and tactile qualities of contemporary fabrics.

For the early period pictorial evidence from Ottoman book illustration is ambiguous. Illustrations in a copy (1498; Istanbul, Topkapı Pal. Lib., H. 799) of Khusraw Dihlavi's *Khamsa* ("Five poems"), for example, offer little evidence for the textural quality of textiles and do not confirm the passion for figured and inscribed fabrics recorded in texts. The artist probably selected his colors to create harmony within the composition, not to depict dress dyes accurately. The emphasis on recording historical events and personalities that developed in the 16th century resulted in a more careful representation of fabric patterns by court artists. Illustrations in copies (e.g. Istanbul, Topkapı Pal. Lib., H. 1344, A. 3593 and A. 3594) of the *Sūrnāma* ("Book of festivals") depict details of equipment and processes used in the creation of textiles, such as swifts and chain warping. European

artists and printmakers had little personal knowledge of the region, and their work shows misunderstanding if not flights of imagination. In the 19th century photography allowed more accurate depictions, but rarely recorded technical details.

The largest collection of Ottoman silks is in the Topkapı Palace Museum, where about 1000 kaftans and other garments worn by sultans and members of the court were preserved in bundles after their deaths. The names on the bundles were once thought to provide reliable dates for the textiles, but the labels are not necessarily contemporary and their accuracy cannot be assumed. Some Ottoman textiles were presented as gifts to foreign dignitaries and have been preserved in royal Swedish and Russian collections; others, used as ecclesiastical vestments, survive in churches and monasteries in northern and central Europe. Other textiles were seized as booty when the Ottomans were defeated at Vienna (1683) and Buda (1686). The presence of any of these textiles in European inventory records therefore provides historians with a *terminus ante quem*.

Few studies of Ottoman fabrics have been published giving precise technical and structural details. As a result, for example, it is not possible to distinguish the compound-weave fabric woven with silver and gold metallic threads (Ott. *seraser*) produced in Istanbul from that of Bursa, and indeed there is disagreement on the exact definition and technical characteristics of such famous Ottoman stuffs as *zarbaft* ("woven with gold"), *hatai* ("Chinese"), *serenk* (compound-weave fabric using two or three colors of silk), *kemha* (compound-weave fabric of polychrome silk and metallic threads), *çatma* (voided silk velvet woven with gold, gilded silver and silver metallic threads) and *seraser* itself. It has therefore been general practice to date the textiles according to the character of the pattern motif and its arrangement within the decorative composition. It is presumed that complex detailed patterns devolved over the decades into more fluid, less intense compositions, which in time became even more simplified linear forms with consequent loss or alteration in the nature of tension and energy created by the design. Intricacy and complexity of pattern and motif are thus considered hallmarks of high aesthetic standards. This emphasis on decorative motif, however, has little relevance for plain or overall decoratively woven fabrics, but these textiles have received scant attention from textile and art historians.

2. Nature of production. The main center of silk production was Bursa, and by 1500 over 90 types of high-quality silk, including velvets, were manufactured there. It was the major depot for the export of Iranian silk to Europe, but in the 16th century, when imports were curtailed because of wars with Iran, the Ottoman sultans encouraged domestic silk production. By the mid-17th century the plains around Bursa were covered with mulberry trees, the leaves of which fed the silkworms, and by the 18th century the Ottoman state rivalled Iran in exporting unwoven

silk to Europe. Other centers of silk production included Edirne, Hereke, Bilecik and Amasya in Anatolia and Aleppo and Damascus in Syria. Light and heavy cottons, the latter suitable for military use and theoretically restricted to internal purchase, were produced on the Aegean and south Mediterranean coasts. Cyprus also became a major cotton producer after it was annexed to the Ottoman Empire in the late 16th century. Until cloth began to be imported from western Europe on a large scale, wool textiles were produced mainly in the European provinces of the Ottoman Empire, although the area around Izmir in Turkey was known for its serge (Turk. *çuha*) cloth. Ankara was famous for the manufacture of mohair, and the watermarking of mohair cloth there is recounted by 17th-century travelers.

By the 16th century a network of cloth trade guilds had been established; each guild had its own patron saint, such as Adam and Enoch for tailors and Job for silk workers. The guilds usually had a hierarchy of masters, journeymen and apprentices under the administration of a chief, steward, chief fellow and council of elders. Bursa guilds of the early 17th century, however, did not follow this organization, perhaps because of the comparatively late introduction of sericulture or the use of slave labor. The central government used the guilds to implement its economic policies, whether directed against tax evasion or smuggling proscribed yarns and textiles to foreign merchants. For example, in the 1520s textile merchants were forbidden to deal in Persian silks because of an official economic blockade, and in the 1570s the Bursa guilds agreed not to use gold thread in face of the shortage of gold bullion. With the rising costs of raw materials, official concern centered on declining standards of workmanship, in particular the use of cheaper dyes, inferior yarn quality, short measures and debased metallic thread. Despite this development, textile production was still considered a profitable concern, and workshops were bought by court and army officials or included in tax farms. Government edicts then increasingly dealt with price fixing, although questions about quality were still raised. In return, the guilds expected the central government to protect their interests by safeguarding supplies of raw materials, hindering competition by expelling foreign workers, reducing equipment and forbidding the sale of certain items.

3. Stylistic development. Despite technical advances in the 15th century, home demand quickly outstripped supply, and court documents from the reign of Mehmed II (r. 1444–81 with interruption) record that at one stage over 14% of total court expenditure went to purchasing European, particularly Italian, silks. Although contemporary documents refer to a fashion for dress fabrics with figures and inscriptions, pictorial evidence suggests a preference for monochrome garments occasionally relieved with gold, perhaps embroidered, decoration. Several items of clothing (Istanbul, Topkapı Pal. Mus.) are associated with Mehmed II on the basis of labels attached to

them, although the authenticity of these labels has been questioned. These demonstrate a wide range of sophisticated weave techniques incorporating both simple and complex pattern motifs in various compositional arrangements, but no figural depictions. There is evident concern for surface texture as well as color, ranging from pale pastel shades to somber rich hues.

The apogee of Ottoman textile production ran from the second half of the 16th century to the late 17th. This was the period of sumptuous silks and velvets carrying gold and silver threads in secondary wefts, types of textiles depicted in contemporary book illustrations as clothing worn by courtiers and paraded or tossed before the royal family (see color pl. 3:XI, fig. 3). It is assumed that the complex patterned motifs employed in these textiles had developed from earlier compositions, often rendered in twill weave, in which the pattern elements, striking in their simplicity of outline, are set against the field in staggered repeats or in stripes (e.g. early 16th-century garment fragments, London, V&A). The more elaborate and complicated floral motifs, in which small stylized flower heads or sprays such as hyacinths and tulips decorate the petals or leaves of large blossoms (e.g. New York, Met., 49.32.79; see ORNAMENT AND PATTERN, color pl. 3:II, fig. 2), are thought to be examples of later production, perhaps reflecting the growing complexity and refinement of the Ottoman court. It could also be argued, however, that the increased intricacy of the designs was linked to the importation of Italian patterned textiles, but it is difficult to distinguish Italian fabrics made for the Ottoman market from indigenous Ottoman fabrics and thus to establish a chronology for Ottoman textile designs in this period. These problems are particularly apparent in the case of luxurious silk and velvet textiles containing floral and arabesque motifs within undulating ogival lattice forms. Reath's supposition that all velvets employing cut and uncut pile (e.g. New York, Met., 12.49.5) were made in Italy cannot be accepted as a clear-cut rule.

Patterns usually rendered in bright colors dominate a light or dark ground. Ogier Ghiselin de Busbecq (Busbequius), the envoy of the Holy Roman emperor to the Ottoman court from 1554, noted that as a rule the dark colors, as prescribed for non-Muslims in the Ottoman Empire, were not favored in high social circles. When the field color has a rich and vibrant tone, the pattern is highlighted by the use of metallic thread, either flat or "purled" (see fig. 7). When gold or silver thread is used in secondary wefts as the ground color, its two-dimensional quality is often complemented by more formal stylized design motifs, picked out in pastel shades, the tension being created by the juxtaposition of motif and ground. The *seraser* trousers (Istanbul, Topkapı Pal. Mus., inv. no. 13/131–2/4414) attributed to Süleyman (*r.* 1520–66) are a fine example. Conversely, on vibrant fields the decorative elements appear to be arranged in layers, giving an illusion of depth. This can be seen in the spectacular silk fabric

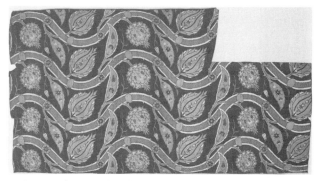

7. Compound-weave silk and twill fragment woven with metal thread, 0.67×1.21 m, from Bursa or Istanbul, 2nd half 16th century (New York, Metropolitan Museum of Art, Purchase, Joseph Pulitzer Bequest, 1952 (52.20.21)); image © The Metropolitan Museum of Art/Art Resource, NY

in a ceremonial kaftan associated with Prince Bayezid (*d.* 1561; Istanbul, Topkapı Pal. Mus., 13/37) woven in gold and six colors on a dark ground. Arabesque scrolls unroll with controlled energy over the field; serrated or flame-edged leaves or rush plumes create secondary circular movements, unhalted by sprays with full or bud flower heads falling across their stems in rhythmic order; both leaves and flowers contain secondary floral patterns. Many of these motifs appear in contemporary manuscripts, metalwork and ceramics made for the Ottoman court, suggesting that court studios had a strong impact on textile designers and weavers.

In the 18th and 19th centuries the fondness for floral motifs continued, and during the Tulip Period (1718–30) the tulip dominated the composition of both furnishing and dress fabrics, in form becoming more elongated and stylized. Small, separate floral elements were often repeated in parallel horizontal rows and later vertically in the manner of contemporary French silks and Indian chintzes (e.g. an embroidered gown belonging to Fatma Sultan, daughter of Mustafa III (*r.* 1757–74); Istanbul, Topkapı Pal. Mus., 13/815). The passion for flowers and also for a garden setting can be seen most vividly in the magnificent Ottoman tent interiors (e.g. 17th century; Kraków, N.A. Cols., 896), as well as in the more humble linen towels and sashes with deftly embroidered ends (e.g. a towel end embroidered with houses, a tent and trees beside a river; Chicago, IL, A. Inst.). Patterns became increasingly static, and the motifs appear to have been laid on the surface of the fabric. Metallic threads within the weave were replaced by gold, silver and colored silk embroidery on a monochrome ground, perhaps reflecting bullion shortages, changes in taste and a shortage of skilled weavers. Pastel or rich somber shades were considered marks of good taste, while vibrant, dramatic tones were relegated to less refined, bourgeois sensibilities.

In the early 19th century demand for traditional Ottoman fabrics declined. The adoption of European styles was considered a mark of culture and

intelligence, an association strengthened by various official reform programs, including dress laws, aimed at modernization (*see* DRESS, §V, B). Complicated pattern-weaving techniques ceased, and decoration was usually applied after weaving by embroidery, needle-lace and printing, although ikat was still produced. Color remained important, but textural qualities became harsher and more emphatic in character. There was a marked increase in heavily worked embroidery, often in satin or couching stitch over pads, using metallic thread, wire and strips with spangles and sequins and incorporating motifs from the contemporary decorative repertory of western Europe.

The Ottoman textile industry suffered further setbacks in 1838 with the signing of the Anglo-Turkish Commercial Convention. Foreign imports were liable only to a 5% tax on entry, whereas domestic products were subject to provincial dues, transit tax and additional levies amounting to 12 to 50% on value. The impact was immediate and severe. Although 2000 cotton looms had operated at Tirnova (now Malko Tŭrnovo, Bulgaria) and Scutari (Üsküdar in Turkey) in 1812, only 200 remained in 1841. Between 1815 and the middle of the century Bursa production dropped a similar 90%, despite the importation of silk-reeling mills to cut production and labor costs. The government then intervened with measures aimed at revitalizing domestic production. Import levies were raised, trade fairs set up and industrial training programs introduced. So much foreign machinery and labor were imported that a foreign technician redefined Turkish cloth as "cloth made in Turkey by European machinery, out of European material and by good European hands" (Macfarlane, p. 453). The revival succeeded, despite such internal problems as the spread of pébrine, the silkworm disease, and such external factors as the opening up of China and Japan to European trade and the cheaper transportation costs through the Suez Canal, and textile production in Turkey boomed in the years before World War I.

Enc. Islam/2: "Ḥarīr" [Silk], "Kuṭn" [Cotton]

C. Macfarlane: *Turkey and its Destiny*, ii (London, 1850)

N. A. Reath: "Velvets of the Renaissance from Europe and Asia Minor," *Burl. Mag.*, i (1927), pp. 298–304

T. Öz: *Türk kumaş ve kadifeleri* [Turkish textiles and velvets], 2 vols. (Istanbul, 1946–51); Eng. trans. of vol. i as *Turkish Textiles and Velvets, XIV–XVI Centuries* (Ankara, 1950)

R. Ettinghausen: "An Early Ottoman Textile," *Communications of the First International Congress of Turkish Art: Ankara, 1959*, pp. 134–40

W. Denny: "Ottoman Turkish Textiles," *Textile Mus. J.*, iii (1972), pp. 55–66

M. Gönül: *Türk elişleri sanati: XVI–XIX yüzyil* (Ankara, 1973); Eng. trans. as *Turkish Embroideries, XVI–XIX Centuries* (Istanbul, 1976)

H. Gerber: "Guilds in 17th-century Anatolian Bursa," *Asian & Afr. Stud.*, ii (1975), pp. 59–86

M. Çizakça: "A Short History of the Bursa Silk Industry," *J. Econ. & Soc. Hist. Orient*, xxiii (1980), pp. 142–52

D. King and M. Goedhuis: *Imperial Ottoman Textiles* (London, 1980)

L. W. Mackie: "Rugs and Textiles," *Turkish Art*, ed. E. Atıl (Washington, DC and New York, 1980), pp. 299–374

H. Tezcan and S. Delibaş: *Topkapı Sarayi Müzesi* (Tokyo, 1980); trans. and ed. J. M. Rogers as *The Topkapı Saray Museum: Costumes, Embroideries and Other Textiles* (Boston, 1986)

Ö. Barişta: *Osmanli imparatorluk dönemi türk işlemelerinden örnekler* [Examples of Turkish embroideries from the Ottoman imperial period] (Ankara, 1981)

W. Denny: "Textiles," *Tulips, Arabesques and Turbans: Decorative Arts from the Ottoman Empire*, ed. Y. Petsopoulos (London, 1982), pp. 121–68

S. Faroqhi: *Towns and Townsmen of Anatolia* (Cambridge, 1984), pp. 125–55

P. Johnstone: *Turkish Embroideries in the Victoria and Albert Museum* (London, 1986)

E. Atıl: *The Age of Sultan Süleyman the Magnificent* (Washington, DC, 1987), pp. 177–224

C. Ebber and G. Helmecke: *A Wealth of Silk and Velvet: Ottoman Fabrics and Embroideries* (Bremen, 1993)

A. Ertug and others: *Reflections of Paradise: Silks and Tiles from Ottoman Bursa* (Istanbul, 1995)

A. Ertug and others: *Silks for the Sultans: Ottoman Imperial Garments from Topkapi Palace* (Istanbul, 1996)

I. A. Kolay: "A Survey on the Decoration and Furnishing Materials Listed in the Construction Register of the Ayazma Mosque (1758–1761)," *Mélanges Prof. Machiel Kiel: Etudes réunies et préf. Abdeljelil Temimi*, Archéologie Ottomane (Zaghouan, 1999)/*Arab Hist. Rev. Ottoman Stud.*, xix–xx (1999), pp. 41–54

G. Curatola: "Ebrei, Turchi e Veneziani a Rialto: Qualche documento sui tessili," *Islam and the Italian Renaissance*, ed. C. Burnett and A. Contadini, Warburg Institute Colloquia, 5 (London, 1999), pp. 105–12

S. M. Krody: *Flowers of Silk & Gold: Four Centuries of Ottoman Embroidery* (London, 2000)

M. Ellis and J. M. Wearden: *Ottoman Embroidery* (London, 2001)

N. Atasoy and others: *Ipek: The Crescent & the Rose: Imperial Ottoman Silks* (London, 2001)

N. Atasoy: "Excerpts from a Travel Diary: Two Historical Specimens of Mardin Silk Textiles," *Cultural Horizons: A Festschrift in Honor of Talat S. Halman*, ed. J. L. Warner (Syracuse, NY, 2001), pp. 217–23

A. Fernández-Puertas: *La tienda turca otomana de la Real Armería (c. 1650–1697)* (Madrid, 2003)

M. V. Fontana: "Un seccade ottomano tardo ottocentesco," *Turcica et islamica: Studi in memoria di Aldo Gallotta*, ed. U. Marazzi, vol. 1, Dipartimento di Studi Asiatici, Instituto Italiano per l'Africa e l'Oriente, 64 (Naples, 2003), pp. 185–203

L. Costantini: "Analisi di un 'filo d'argento' di un seccade ottomano," *Turcica et islamica: Studi in memoria di Aldo Gallotta*, ed. U. Marazzi, vol. 1, Dipartimento di Studi Asiatici, Instituto Italiano per l'Africa e l'Oriente, 64 (Naples, 2003), pp. 205–14

M. Ellis: "Ottoman Style: Embroidered Textiles for Decoration," *Halı*, cxxxiii (2004), pp. 78–85

J. Rageth: "Dating the Dragon & Phoenix Fragments," *Halı*, cxxxiv (2004), pp. 106–9

D. de Jonghe and others: *The Ottoman Silk Textiles of the Royal Museums of Art and History in Brussels* (Turnhout, 2004)

Style & Status: Imperial Costumes from Ottoman Turkey (exh. cat., Washington, DC, Sackler Gal., 2005–6)

P. Scott: "Millennia of Murex," *Saudi Aramco World*, lvii/4 (2006), pp. 30–37

G. Pacquin: "From the Frontier: An Unknown Group of Ottoman Embroideries," *Halı*, cxliv (2006), pp. 58–69

P. Oakley: "The Point of Red," *Halı*, cxliv (2006), pp. 70–75

P. Oakley: "Blossoms and Pomegranates: Silk Embroideries of the Ottoman Empire," *Sifting Sands, Reading Signs: Studies in Honour of Professor Géza Fehérvári*, ed. P. L. Baker and B. Brend (London, 2006), pp. 133–40

H. Bilgi: *Çatma ve kemha: Osmanli ipekli dokumalari*, Eng. trans. by P. M. Isin (Istanbul, 2007)

B. NORTH AFRICA. The great tradition of silk weaving known in Spain and North Africa was continued after *c*. 1500 in Spain under Christian patronage and to a lesser extent in North Africa. A pilgrim banner of brocaded maroon silk with metallic thread (3.61×1.88 m, 1683; Cambridge, MA, Sackler Mus., 1958.20) is attributed to Morocco on the basis of its distinctive *maghribī* letterforms. Large silk tombcovers were also woven with gold threads; one with large *thuluth* script in the Ottoman style (Paris, Mus. A. Afr. & Océan., 1862.827) is attributed to Tunis in the 16th or 17th century; another with varied styles of calligraphy in cartouches (Paris, Mus. A. Afr. & Océan., 1961.5.1) was woven at Fez in the 18th century for the hospice (Arab. *zāwiya*) of the Sherqawi order of mystics at Boujad in the Middle Atlas. The tradition of weaving fine silks on drawlooms has continued at Fez into the 20th century, where elements of wedding costumes, including elaborately patterned sashes for men, are produced according to traditional techniques.

Ottoman and European imports began to supplant local textiles in the 18th century, and surviving costumes from the 19th century show that imported fabrics from France and the Middle East were combined with local textiles that copied them. For example, Tunisian silks and cottons from the late 19th century imitate contemporary French and Turkish fabrics. Conversely, at the end of the 19th century Europeans began to collect the beautiful and varied embroideries of Algeria and Morocco. These collections are the major source of information about textile production in North Africa between the 17th and the 19th century, but their uneven, eclectic and personal nature makes generalization about the development of North African textiles in this period extremely difficult.

Despite their geographical proximity and the shared use of a particular shade of purple found in no other Mediterranean embroideries, the designs and techniques of embroideries from Algeria and Morocco differ markedly. In Algeria, curtains, headdresses and kerchiefs with which to wrap the head after bathing were embroidered. They were made of linen (until the 19th century when cotton was introduced) and embroidered with floss silk using double-darning, double-running, brick and satin stitches, among others, together with eyelet holes. As many as nine separate colors, and occasionally silver and gold thread, were used. The characteristic motif is a large floral medallion that resembles both the artichoke motif of Turkish embroideries and the *glastra* (a motif of folk embroidery) of the Dodecanese Islands in the Aegean. The three types of piece are distinguished by differing layouts of design. Curtains have three loom-widths of fabric joined with an uneven number of imported, possibly French, silk ribbons. Narrow embroidered borders run along the top and sides of each piece, and a whitework band forms the bottom border. A line of five or more large floral medallions runs vertically down the center of each loom-width. Headdresses and kerchiefs were made from long, narrow lengths of fabric. For the headdress, it was folded end-to-end and sewn to form a hood with lappets, with the embroidery concentrated on the hood and the ends of the lappets. The kerchief was left unsewn, with wide embroidered borders along its entire length. In the earliest examples, dating to the late 17th century or early 18th, red and blue silks featuring brick stitch predominate; by the beginning of the 19th century, shades of purple had become popular, as had double-running and satin stitches with eyelet holes.

In Morocco curtains, bed furnishings, cushion covers and costume accessories were embroidered (see fig. 8). They were made of the same materials as Algerian pieces (linen until the 19th century and embroidered with floss silk), but the repertory of popular stitches was limited to double-running, satin and long-armed cross. No stylistic development has been determined, and most pieces are attributed to the late 18th century or later. In contrast to Algerian work, however, regional styles can be distinguished. The embroideries of Fez, Rabat and Salé are geometric and based on tree forms. Those from Fez are worked in double-running stitch and are monochrome red or blue; those from Rabat, in satin stitch, are usually monochrome red or purple, though sometimes the two colors are combined; those from Salé, in double-running stitch, can be either monochrome blue or polychrome. Embroideries from Tétouan have more naturalistic floral motifs worked in double-running stitch using brightly colored silks on a silk or linen ground (e.g. an 18th-century mirror-veil; Cambridge, Fitzwilliam). Those from the nearby town of Chaouen (Xauen; Chéchaouen) are also in double-running stitch and polychrome floss, but are worked on linen and have geometric motifs reminiscent of Hispano-Moresque tilework. Those from Azemmour on the Atlantic coast are worked in long-armed cross stitch in monochrome red, blue or green, and the background is embroidered so that the unworked linen forms the designs, which include birds and animals. They differ from other Moroccan embroideries and are often indistinguishable from earlier Italian pieces.

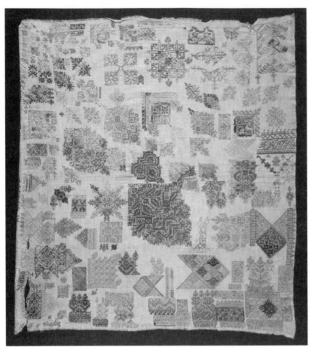

8. Moroccan embroidered sampler, cotton, embroidered with silk and cotton in double running and satin stitch, 19th century (London, Victoria and Albert Museum); photo credit: Victoria and Albert Museum, London/ Art Resource, NY

A. D. Howell Smith: *Catalogue of Algerian Embroideries*, London, V&A (London, 1915); rev. A. J. B. Wace (London, 1935)

P. Ricard: *Arts marocains: Broderie* (Algiers, 1918)

G. Marçais: "Les Broderies turques d'Algers," *A. Islam.*, iv (1938), pp. 145–53

E. Newberry: "The Embroideries of Morocco," *Embroidery*, vii/2 (1939), pp. 29–35

W. Denny: "A Group of Silk Islamic Banners," *Textile Mus. J.*, iv (1974), pp. 67–81

L'Islam dans les collections nationales (exh. cat., Paris, Grand Pal., 1977), nos. 241–2

C. Stone: *The Embroideries of North Africa* (London, 1985)

Broderies marocaines, Paris, Mus. A. Afr. & Océan. (Paris, 1991)

F. Ramirez and C. Rolot: *Tapis et tissages du Maroc: une écriture du silence* (Courbevoie, 1995)

L. Vogel: *Moroccan Silk Designs in Full Color* (Mineola, NY, 1996)

K. Rainer and H el-Yakine: *Tasnacht: Teppichkunst und traditionelles Handwerk der Berber Südmarokkos* (Graz, 1999)

Maroc: Les trésors du royaume (exh. cat., Paris Musées, 1999)

M. Garcia: "Teinture végétal traditionelle au Maroc," *Horizons Maghrébins*, xlii (2000), pp. 49–55

A. Korolnik-Andersch and M. Korolnik: *The Color of Henna: Painted Textiles from Southern Morocco/Die Farbe Henna: bemalte Textilien aus Süd-Marokko* (Stuttgart, 2002)

J. A. Jansen: "Keswa Kebira: The Jewish Moroccan Grand Costume," *Khil'a: Journal for Dress and Textiles of the Islamic World*, i (2005), pp. 79–105

N. Erzini: "The Survival of Textile Manufacture in Morocco in the Nineteenth Century," *Islamic Art in the 19th Century: Tradition, Innovation, and Eclecticism*, ed. D. Behrens-Abouseif and S. Vernoit, Islamic History and Civilization: Studies and Texts, 60 (Leiden, 2006), pp. 157–90

C. IRAN. Fine textiles had long been produced in the Iranian world, but many more textiles and fragments have survived from the period after 1500. Those from the years of Safavid rule (*r.* 1501–1732) in Iran demonstrate an extraordinary mastery of techniques and designs, particularly figural silks of complex weave structure. Both textile production in Iran and international trade in finished textiles declined in the second half of the 18th century, following the destruction of Isfahan by the Afghans in 1722. Attempts at revitalization in the 19th century were not entirely successful, as Iranian textile industries suffered from the import of cheaper manufactured goods from abroad and from the disease (pébrine) that spread among silkworms in the 1860s. Textiles were presented as royal and diplomatic gifts to foreigners and have been preserved in European and Indian armories, treasuries and museums. Depictions of textiles appear in 16th- and 17th-century book illustrations, album pages, wall paintings and ceramics. Textiles from the 18th and 19th centuries, when Iran was under the domination of the Afsharid (*r.* 1736–95), Zand (*r.* 1750–94) and Qajar (*r.* 1779–1924) dynasties, are also documented in small painted or enameled objects and oil paintings on canvas. Textual sources for textiles range from local and regional histories and chronicles to the archives of foreign trading companies active in Iran. Those of the Dutch East India Company in The Hague, the India Office Library in London and the British East India Company in Bombay (Mumbai), for example, yield extraordinary documentation for the trade in textiles, the import and export of dyestuffs and glazing compounds, and local customs of dress.

1. Materials and techniques. 2. Compound weaves and velvets. 3. Other fabrics.

1. Materials and techniques. The complicated fabric structures and patterns of such fabrics as lampas and velvet were woven on drawlooms, used in Iran for centuries. The wide range of colors used in Persian textile arts reflects deep understanding of the technology and properties of dyes. Domestic madder and indigo imported from India were used to produce reds and blues. Imported cochineal and lac, both red dyes, were more expensive and were used primarily to dye silk; safflower produced a bright orange characteristic of many Safavid silks, which has often faded over time. Additional dyestuffs were derived from other insects and such plant materials as pomegranate rind, walnut husks and weld.

Silk, traditionally cultivated along the mountain slopes bordering the Caspian Sea in northern Iran, was a major export from the 16th century onward. ʿAbbas I (*r.* 1588–1629) encouraged the Armenian

communities to become involved in production and gave them protected status. Cotton, the tensile strength of which led to its use as warp and weft in some Safavid carpets, was extensively cultivated as a cash crop in the mid-19th century and exported to supply the industrialized looms of England and Russia. Wool and goat hair were the main fibers of nomadic weavings and were traded extensively on the international market as early as the 17th century. The hair from the underbelly of Kirman goats was favored in Kashmir and England, since its softness and strength made it an ideal fiber for weaving shawls. Coarser grades of wool were used for weaving shawls in Kirman and Mashhad.

2. Compound weaves and velvets. Safavid textiles can often be distinguished from contemporary Ottoman fabrics by the prevalence of figural motifs, including scenes of animals in combat, paired birds and fish, intertwined fruit and flowering trees, hunting and falconry, all popular subjects in contemporary poetry and painting. Images from favorite stories from Firdawsi's *Shāhnāma* ("Book of kings") and Nizami's *Khamsa* ("Five poems") were adapted to the rectilinear requirements of loom-weaving. A satin lampas signed by Ghiyath (*c.* 1600; divided: e.g. Washington, DC, Textile Mus., 3.312), for example, depicts Layla riding in a howdah on a camel while her lover Majnun pines among animals in the desert, and a contemporary velvet (divided: Cleveland, OH, Mus. A., 44.499–500; New York, Met., 1978.60; Washington, DC, Textile Mus., 3.220) shows the celebrated scene in which Khusraw sees Shirin bathing.

KASHAN and YAZD are frequently mentioned as centers for the production of fine silks and velvets, but it is not yet possible to assign definitive attributions. ISFAHAN served as the major emporium from 1598, when 'Abbas I made it the capital, although TABRIZ remained a major center, particularly for trade with Turkey. International trade via the Persian Gulf was served by the ports of Hormuz in the 16th century, Bandar Abbas (Gambroon) in the 17th and 18th centuries and Bushire in the 19th century.

Satin lampas and velvets reached unprecedented levels of aesthetic and technical achievement in the 16th century. All lampas textiles produced during the Safavid period have a satin foundation with a supplementary twill weave, while the unit of repeat is disguised by the design and alternation of color. A good example is a lampas depicting a slender courtier holding a ewer and cup in a landscape with animals, birds, cypresses and flowering trees (divided: Washington, DC, Textile Mus., 3.306; Cleveland, OH, Mus. A., 24.743; London, V&A, 282–1906, see color pl. 3:XI, fig. 2; New York, Met., 08.109.3); colors of the courtier's garment, the bird's plumage and the rocks alternate from red to yellow. Safavid velvets are often richly patterned with designs related in style to contemporary manuscript painting and other courtly arts. An early 17th-century cut and voided silk velvet (divided: Berlin, Mus. Islam. Kst; New York, Met., 46.156.5; Washington, DC, Textile Mus., 3.320), for example, shows a falconer with fluttering turban and sash in the style associated with the great painter Riza.

Other textile structures were less complicated. A red and white silk doublecloth (?16th century; divided: New Haven, CT, Yale U. A.G.; New York, Met., 46.156.7; Washington, DC, Textile Mus., 3.280) is divided into rectangular compartments; some of these contain polylobed cartouches inscribed with poetry, others frame figural and architectural scenes. Brocaded taffetas and satins utilized discontinuous supplementary wefts, which allowed the weaver to create multicolored repeat patterns that reproduce complicated floral designs ranging from naturalistic depictions to highly abstract forms. Several examples from the 17th century introduce representations of such imported flora as the calla lily or such exotic fauna as the Javanese sparrow. More popular, to judge from the number that survive, were fanciful depictions of flowering plants, repeated across the field (e.g. a 17th-century brocaded taffeta with composite flowers resembling thistles, pansies and carnations; Washington, DC, Textile Mus., 3.138). The bright colors and silken sheen give these textiles a sense of flashy opulence. In the 18th and 19th centuries such designs were reduced in scale, and they are often difficult to distinguish from contemporary Indian work. The repeated pear or teardrop shape (Pers. *buta*, *boteh*: "shrub," "flowering bush") also became popular.

The presence of metallic yarns in many Iranian textiles from this period makes them shimmer in the light. These textiles are often termed "metal-ground textiles," but as these fabrics show a variety of compound weave structures, the term defines a stylistic, rather than a technical group. Sparkling and glittering gold and silver effects were achieved by several techniques. Foil strips, produced either by cutting a hammered sheet into narrow widths or by flattening a drawn metal wire, were used alone as weft yarns or more commonly wrapped around yellow or white silk cores to produce yarns that give the impression of gold and silver. The finished textile was sometimes beaten or heat-pressed to smooth the surface, protect the metal and preserve its sheen. Common designs include single or paired flowers or birds repeated across the field. The motifs are often carefully and accurately depicted, as on a twill weave with irises and daisies (divided: Berlin, Mus. Islam. Kst; New York, Met., 09.50.1110; Washington, DC, Textile Mus., 3.118). In later pieces, the designs decrease in size and the overall repeat patterns appear to be more crowded. For example, a compound silk with complementary wefts and inner warps (divided: Lyon, Mus. Hist. Tissus; Washington, DC, Textile Mus., 3.193) shows a crowded scene of courtiers on horseback hunting with falcons; it can be attributed to the 18th century on the basis of the tall pronged hats worn by the courtiers.

3. Other fabrics. The vast majority of textiles were plain weaves, which could be ornamented after weaving by such techniques as painting and printing, embroidery, appliqué, quilting or pieced patchwork. By the late 17th century or early 18th, Iran was producing printed cottons (Pers. *qalamkār*), using hand-carved wooden blocks. Isfahan and later Tehran became important centers for the production of printed fabrics. Elaborate and complicated designs were achieved through the use of several blocks, one for each color. Red and blue are predominant, with black often used for outlines. Inscriptions with historical information, quotations from poems, or a dedication were added by hand-painting with a brush. Bolt fabric for garments or linings frequently shows small overall repeat patterns in red and blue, as in a 19th-century woman's jacket (Washington, DC, Textile Mus., 1983.68.5). Small complete loom widths and lengths were decorated to serve as covers and hangings, often with a niche format and symmetrical layout of lions, tigers, birds and flowers around a central tree, such as a hanging (1.67×1.04 m; Washington, DC, Textile Mus., 1980.8.5) made at Isfahan *c.* 1861.

Embroidery in silk or cotton seems to have been a home-based activity and reflected local styles until the end of the 19th century, when materials, techniques and designs begin to follow European models. Designs might be pictorial, floral or geometric, repeated to form elaborate overall patterns sometimes with a central medallion format. A fragment of an unusually elaborate embroidered plain weave attributed to the 16th or 17th century (divided: Paris, Mus. A. Déc.; Washington, DC, Textile Mus., 3.43) contains a repeating design depicting the lovers Yusuf and Zulaykha, a pattern that shows the same design principles as contemporary compound weaves. In the 19th century Rasht, Yazd and Tabriz were famous centers for embroidery. Wool embroideries and appliqués from Rasht were produced in a variety of ornamental designs with symmetrical compositions. A type of embroidery practiced in and around Tabriz incorporated drawn and deflected threads and is also seen throughout eastern Turkey, Armenia and Azerbaijan. In Kirman, traditional wool embroidery on curtains, coverlets and cushions often made use of floral patterns as well as those with birds and animals.

N. A. Reath and E. B. Sachs: *Persian Textiles* (New Haven, 1937)

A. U. Pope and P. Ackerman, eds.: *Survey of Persian Art* (London and New York, 1938–9, 2/1964–7), pp. 1995–2226

J. Gluck and S. Gluck, eds.: *A Survey of Persian Handicraft* (Tehran, London and New York, 1977)

H. Landolt-Tüller and A. Landolt-Tüller: *Qalamkār-Druck in Isfahan: Beiträg zur Kenntnis traditioneller Textilfarbetechniken in Persien* (Basle, 1978)

M. McWilliams: "Prisoner Imagery in Safavid Textiles," *Textile Mus. J.*, xxvi (1987), pp. 4–23

Woven from the Soul, Spun from the Heart: Textile Arts from Safavid and Qajar Iran, 16th–19th Centuries (exh. cat., ed. C. Bier; Washington, DC, Textile Mus., 1987)

R. Neumann and G. Murza: *Persische Seiden* (Leipzig, 1988)

B. Tietzel: *Persische Seiden des 16.–18. Jahrhunderts aus dem Besitz des deutschen Textilmuseums Krefeld* (Krefeld, 1988)

J. Scarce: "The Persian Shawl Industry," *Textile Mus. J.*, xxvii–xxviii (1988–9), pp. 22–39

J. Allgrove McDowell: "Textiles," *The Arts of Persia*, ed. R. W. Ferrier (New Haven, 1989), pp. 151–70

M. McWilliams: "Allegories Unveiled: European Sources for a Safavid Velvet," *Textiles in Trade: Proceedings of the Textile Society of America Biennial Symposium: Washington, DC, 1990*, pp. 136–48

J. Scarce: "Textiles," *From Nadir Shah to the Islamic Republic*, ed. P. Avery, G. Hambly and C. Melville (1991), vii of *The Cambridge History of Iran* (Cambridge, 1968–91), pp. 945–58

C. Bier: *The Persian Velvets at Rosenborg* (Copenhagen, 1995)

W. Floor: *The Persian Textile Industry in Historical Perspective, 1500–1925* (Paris, 1999)

I. B. McCabe: *The Shah's Silk for Europe's Silver: The Eurasian Trade of the Julfa Armenians* (Atlanta, 1999)

S. Canby, ed.: *Safavid Art and Architecture* (London, 2002) [several articles]

Hunt for Paradise: Court Arts of Safavid Iran, 1501–1576 (exh. cat., ed. J. Thompson and S. Canby; New York, Asia Soc. Gals.; Milan, Mus. Poldi Pezzoli; 2003–4)

G. Vogelsang-Eastwood: "The Iranian Chador," *Khil'a: Journal for Dress and Textiles of the Islamic World*, i (2005), pp. 139–58

R. Matthee: *The Politics of Trade in Safavid Iran: Silk for Silver, 1600–1730* (Cambridge, 2006)

D. **CENTRAL ASIA.** The textile arts of the region encompassing parts of Afghanistan, Uzbekistan and eastern Turkestan (Xinjiang province of China) were highly developed, particularly the silk and silk-and-cotton fabrics produced there since late antiquity. This textile art was centered in such cities as Samarkand, Bukhara, Kokand and Andizhan, towns populated mainly by Uzbeks, Persian-speaking Sarts and a considerable number of Jews. The Uighurs had a similar but less sophisticated textile culture. The other Turkic peoples of the area, such as the Turkomans, Kazakhs, Kirgiz and Karakirgiz, and the Persian-speaking Tajiks maintained distinctive tribal traditions. Weaves include a ribbed fabric of warp-faced plain weave (*adras*), broken twill (*atlas*), satin (*khanatlas*) and, rarely, velvet (*bakhmal*). After weaving, fabrics were beaten on a wooden block with a heavy mallet to impart luster. Fabrics can be classified into three major groups on the basis of their dyeing and decoration: two of these, ikats and block-printed fabrics, were made for the market by highly skilled craftsmen, often Jews who specialized in dyeing; the third type, embroidered pieces, was worked at home by women and girls for trousseaus.

Except for some archaeological finds, such as those of the 7th–8th century from Turfan in Xinjiang, surviving fabrics appear to date from the 19th century. Both older and newer fabrics were woven and decorated in narrow strips (some 500 mm wide), then sewn together to produce larger pieces for wall hangings, blankets or coverlets (Uzb. *parda*:

"curtain"; *qulkarpa*: "curtain for covering wall niches"; *ruijoi*: "nuptial bedsheets"), bedspreads and prayer-rugs. Surviving tailored garments include a woman's robe (*kaltacha*) and a man's or woman's overcoat (*khalat*, *chapān*), shirt and trousers. Smaller embroideries, some on a wool foundation, include caps, saddle-covers, trappings and many kinds of bags; diminutive embroidered tray covers and other pieces of stitchwork (*lakai*) of the Lakai Uzbcks are particularly noteworthy. The patterns and colors of ikatted overcoats were so gaudy that Western travelers in the 19th century ridiculed the men wearing these garments; furthermore, the rooms of the wealthy were decorated with wall hangings, coverlets, pillow-cases and covers in similar brightly colored fabrics, so that the residents blended with the environment. Tents and temporary walls were adorned with hangings during festivals. In addition, textiles played a major role in the ceremonial surrounding marriage: rooms and tents used for the wedding feast; the animals carrying the bride and her company to the bridegroom's house; the betrothed couple; and many other elements, including the nuptial bed, were all covered for the occasion with richly decorated textiles.

Ikat fabrics (known in Uzbekistan as *abr* ("cloud") because of the vague contours of the decorative patterns, or *khalat* because of its favored use for coats) have only tie-dyed warps. Ferghana, roughly equivalent to the Khanate of Kokand, was the ikat center of the region. The often intricate and strikingly colorful patterns are geometrical and kaleidoscopic, consisting mainly of large and small red circles and bands of elongated figures. Most ikat designs are now industrially printed, although small workshops in Xinjiang still produce silken ikats of modest quality.

The most spectacular fabrics of Central Asia are the embroideries known as *sūzanī* ("needlework"), a term applied particularly to large pieces used as wall hangings. The more popular versions are dominated by large round floral motifs and hence resemble tie-dyed fabrics. More intricate patterns feature small motifs including geometricized birds (typical of rural areas) and branches, bushes or trees with slim leaves and large red flowers or fruits, particularly pomegranates (typical of urban areas). Such fabrics usually have a central panel filled with several flowering bushes and surrounded by a border with larger flowers in garlands. The best-known examples, densely covered with leaves and flowers, appear to have been made in the 19th century in Uzbekistan, although simpler versions were made throughout east and west Turkestan.

See also CENTRAL ASIA, §VI.

G. L. Chepelevezkaya: *Suzani uzbekistana* [The embroidery of Uzbekistan] (Tashkent, 1961)

S. Makhkamova: *Uzbekskiye avroviye tkani* [Uzbek "Abrovy" textiles] (Tashkent, 1963)

A. Bühler: *Ikat, Batik, Plangi*, 3 vols. (Basle, 1972)

A. Leix: *Turkestan and its Textile Crafts* (Basingstoke, 1974)

Folk Art of Uzbekistan (Tashkent, 1978)

Suzani: Stickereien aus Mittelasien (exh. cat., Mannheim, 1981)

J. Kalter: *Aus Steppe und Oase* (Stuttgart, 1983)

M. Klimburg and S. Pinto: *Tessuti ikat dell'Asia centrale* (Turin, 1986)

J. Taube: *Suzani: Raumschmückende Stickereien aus Mittelasien und ihr kulturhistorisches Umfeld* (Halle, 1987)

P. Rau: *Ikats: Woven Silks from Central Asia. The Rau Collection* (Oxford, 1988)

J. Taube: "Suzani: Stickereien aus Mittelasien," *Kleine Beitr. Staatl. Mus. Vlkerknd. Dresden*, xii (1991)

J. Harvey: *Traditional Textiles of Central Asia* (London, 1996)

K. FitzGibbon and A. Hale: *Ikat: Silks of Central Asia: The Guido Goldman Collection* (London, 1997)

K. FitzGibbon and A. Hale: *Ikat: Splendid Silks of Central Asia* (London, 1999)

R. Barnes: "Dressing for the Great Game: The Robert Shaw Collection in the Ashmolean Museum," *Khil'a: Journal for Dress and Textiles of the Islamic World*, i (2005), pp. 1–13

E. INDIA. Under the patronage of the Mughal emperors (*r.* 1526–1857) and especially from the late 17th century to the early 19th, India was the textile workshop of the world. The cotton, silk and wool textiles produced there were brightly decorated in an amazing variety of techniques, including dyeing, printing, painting and embroidery, and were exported throughout Asia and Europe. From an early date Indian textiles had been imported into the central Islamic lands, where these fabrics provided models for such local products as the block-printed cottons of 18th-century Iran.

1. Introduction. 2. Woven fabrics and raw materials. 3. Decorative techniques.

1. Introduction. Textile production increased as Mughal rulers imported craftsmen from Iran and Turkey, patronized and enhanced existing élite production and set up imperial workshops. They encouraged wool carpet and shawl production, but overall their greatest impact was not technological innovation but an expansion of design and color range. Under the emperors Jahangir (*r.* 1605–27) and Shah Jahan (*r.* 1628–58) flowering plant motifs inspired by both the natural world and European herbals appeared on court dress, turbans, shawls, sashes, floorspreads, cushions and hangings for walls, doors and windows as well as panels and screen walls for tented camps.

The height of the Mughal Empire (16th century to early 18th) coincided with the expansion of Portuguese, Dutch, French and British trading activities in the region and their growing involvement in regional and international trade in cloth. The Europeans initially sought spices and markets for their own cloth and purchased the printed and painted cottons that Gujarat and the Coromandel coast exported to Southeast Asia and the Middle East as barter in the spice trade with the Malay archipelago and as items for re-export to the Levant. Some chintzes (painted and printed textiles) reached Europe. Color schemes

and designs were adapted to European taste, and direct trade developed. By the late 17th century painted and printed cottons had become high fashion in the West, as had the silks, silk and cotton mixes and the fine plain and embroidered muslins that Bengal produced. Their designs, a synthesis of Indian, Chinese and European elements, have influenced Western textile design ever since. The main centers of luxury and export production retained their positions well into the 19th century, despite protective legislation against imports into Europe in the early 18th century and internal political disturbances in the late 18th century as Mughal power weakened and the British East India Company expanded its economic and political control.

By the mid-19th century the tide of trade had turned, and India was flooded with cheap cotton imports from British mills. The indigenous handloom industry survived, despite the collapse of the export market to the West, the penetration of the Indian market, particularly in the north, and the pauperization of large groups of weavers. Cotton production increased, and weavers continued to supply local communities.

An analytical distinction can be made between cloths produced locally or regionally for popular or ritual use, which reflect the continuity of tradition from the pre-Islamic period, and those produced for courtly or élite secular consumption, which show greater evidence of now well-absorbed external influences. The former, including textiles made by specialist weavers and cloths made or decorated by village and tribal women for their own use, depend for their effect on a sense of mass, volume, color or texture. Strong, simple, often geometric patterns are created by basic yarn-dyeing, and yarn and cloth resist-dyeing techniques. Pattern is subordinate to color or texture, and the dominant color palette and technique vary regionally. Strong, deep colors (particularly reds), block-printing, resist-dyeing and embroidery techniques characterize the northwest. In the Deccan, colors are darker and more subdued. Textiles produced for courtly or élite secular consumption show a rich combination of Indian, Sino-Islamic and European influences and are always a product of specialist skill. They depend stylistically on linear surface treatment and neutral backgrounds setting off the pattern, whether woven, embroidered or painted and dyed.

2. Woven fabrics and raw materials. With the exception of linen, weavers in India used the same basic fibers (cotton, silk and wool) as elsewhere in the Islamic lands, but with substantial differences in emphasis and composition.

(a) Cotton. (b) Silk. (c) Wool.

(a) Cotton. The cotton plant has always been India's staple textile fiber; it has always been grown widely, and the quality of the fiber varies according to local conditions. The finest cotton is grown in the west in the fertile lands of Gujarat and the valley of the Tapti River in Maharashtra; in the east in the rich soil of Bengal; and in the south in the lower valley of the Kistna River and in the coastal plains around Madras. The plains and foothills of the Punjab produce a coarser fiber, yielding a substantial fabric well suited to local conditions. The hills of Assam yield an excellent strong, firm cotton.

At least for the past two or three centuries (and possibly even earlier), cotton thread has been spun on a wheel (*carkhā*), though in isolated areas hand-spinning on the spindle continued until towards the end of the 19th century. Until the 19th century, the warp was wound on rows of sticks erected in the ground to the length of the cloth piece required; the warper crossed and re-crossed the threads as he walked, so that the threads were held in order for the simple handloom. The handlooms for cotton were of standard breadths and accommodated standard lengths, as most ordinary people wore a draped garment made from an uncut cloth length. In areas with a large Muslim population, where cut-and-stitched garments were worn, a *thān* (length of cloth to make a garment) would also be woven.

Indian cotton thread was comparatively loosely spun, giving the finished cloth a soft texture. Cotton weavers in India typically stretched the warp after tying the crossings of the threads and brushed in a starch of rice-paste (*koie*) before setting up the loom. The warp threads were thus strong and supple during weaving. The finished cloth was washed to remove all trace of starch and then bleached by drying in the sun.

Among India's most prized cotton textiles were its muslins, especially white cotton muslins from Dhaka (Bangladesh). Their fine quality has been attributed to a number of factors, including the variety of cotton plant grown in the region. Dhaka cotton grew especially well in the lands along the Brahmaputra River and its tributaries, where annual flooding brought alluvial and saline deposits. The cotton fiber produced was fine and soft and was spun on a small iron spindle, known locally as a *takwa*. Women spun the yarn (the supple hands of younger women were said to produce the finest) and men did the weaving. As some moisture in the air was necessary to keep the thread supple, the spinners worked from soon after dawn until the sun dissipated the morning dew, and then for a short time in the late afternoon before sunset. The jawbone of the boalee fish (*Siluris boalis*) was used in carding the fiber before spinning. Its small, curved, closely set teeth were ideal for combing out coarse fibers and extraneous matter and straightening the fine threads.

The combination of warp thread starched with rice-paste, weft thread remained as spun, and a small smooth shuttle produced soft, fine cloth known by such names as *bāftāhavā* ("woven air") and *shabnam* ("evening dew"). Patterned muslins (*jamadānī*) were woven with floral sprigs (*būtī*) brocaded in thicker, softer white cotton on the delicate white ground. Fine hand-woven muslins were also produced in

other parts of Bengal. In Rajasthan, cotton from Gujarat was used to weave fine muslin *sārī*s with richly patterned colored borders. The muslin *sārī*s of Rajastan were often printed.

(b) Silk. The silk moth genus *Bombyx mori*, used to produce cultivated silk in China, Central Asia and Europe, is not native to India, as the climate is too hot and dry in summer, and in some areas too cold in winter, for the larvae to survive. The distinctive soft, matt qualities of Indian silk textiles derive from the larvae of the wild silk moths native to central and northeast India. Indian silk moths are multivoltine, producing two, three or more crops during the year, while the *Bombycidae* are mainly univoltine, yielding only one crop.

The Punjab has no natural supplies of silkmoths, due to the unsuitable climate, and for centuries skeins of raw silk were imported, chiefly from Khurasan and Bukhara. The bales of raw silk were brought through the mountain passes to Amritsar, Lahore, Multan and other trading centers. In Kashmir, where the climate was more suitable, cultivation of *Bombyx mori* was introduced from Central Asia at an early date for the excellent local silk industry. In Bengal a few mulberry plantations for moths of the *Bombyx* species were successfully established in the 19th century, and cultivated silk was produced for trade.

Plain silk was either produced in natural shades or dyed, typically in the skein before weaving (*see* §3 below). One of the most beautiful traditional fabrics was the *dhūp chānh* ("light-and-shade"), a plain shot-silk with indigo warp and crimson weft, giving a variety of luminous purples, violets or maroon-reds, according to the quality and color of the yarns. In the Punjab, silk-dyers were particularly skilled in producing reds and bright greens and wove a *dhūp chānh* with these colors. In Kashmir a plain silk fabric called *par-ī tā'ūs* (Pers. "peacock feathers") was shot in many colors.

The most common of all the traditional fabrics was striped silk (*gulbadān*). The stripes were laid in the warp, and even the simplest patterns had vibrancy from the juxtaposition of colors, often enhanced by contrasting "separating-stripes" of only two threads between the main sequences of the design. Checked fabrics (Pers. *carkhānā*) for European women settled in India became an important trade in the 19th century. The Indian weavers' subtle exploitation of mellow color, often given brilliancy by the insertion of just two contrasting threads, was enhanced by the delicate "secondary colors" where the warp and weft threads interwove. The rich depth of the traditional Indian *dhūp chānh* was transformed to a shimmering cluster of blue–grays and greens or a glowing medley of soft yellows, orange and salmon-pinks. Bengal was originally the main producer of plain and patterned silk fabrics for European taste.

According to the *Āyīn-i Akbarī* ("Annals of Akbar," *c.* 1596–1602; i, p. 87, *āyīn* 31), the Mughal emperor Akbar (*r.* 1556–1605) established workshops for weaving brocade at Lahore, Agra and Fatehpur Sikri, bringing skilled workmen from Safavid Iran. However, these records show that the trading of silk fabrics from Iran and Central Asia into northwest India was already long established (*Āyīn-i Akbarī*, i, p. 92, *āyīn* 32). Kashmir, which had ancient cultural links with Iran, had a silk industry of its own that produced flowered silks in an "Indo-Islamic" style. Under Akbar's successors Jahangir and Shah Jahan, brocade weaving was introduced into royal workshops in provincial capitals. AHMEDABAD, in Gujarat, famous for textile production since the Ahmad Shahi dynasty (1398–1572), became a leading center for fine brocades. Burhanpur, in Khandesh, a provincial capital under Shah Jahan, gained renown and must have had considerable influence in introducing the technique to other centers in central India. As Mughal influence extended across Bengal, the technical advances merged with the ancient traditions of the finest silk-producing districts in India.

The chief designs of Mughal brocades were small conventional plants or flowers repeated as a sprig pattern, a running pattern of flowers and leaves all over the textile (*phulvār*), and a network or trellis (*jālī*) of lines, scrolls or leaves, each mesh enclosing a flower. The brocade loom used to weave them was more complex than the simple silk looms. Numerous heddles to raise and lower the threads were harnessed in groups (*naks*) in accordance with the pattern.

Book paintings from the 17th to 19th centuries provide evidence for design styles in silk brocades, but surviving 19th-century garments, which have a soft lustrous texture and rich mellow color, provide the best practical information. Women's *sārī*s and *orhanī*s (head veils) and men's *cādar*s (shoulder wraps) were woven with a plain or patterned field and distinctive patterned borders. Selvedge borders often have a small geometric pattern (*mothrā*) or a running floral meander or scroll (*bēl*) enclosed between plain or patterned guard borders. The deep decorative panels (*ānchāl* or *palla*) at the ends of the cloth were of more elaborate design, usually a row of large conventionalized flowering plants (*būtā*) with the characteristic "drooping bud" at the top, enclosed between cross-borders of *bēl*.

By the 19th century, Bengal, with its natural resources in wild and cultivated silk and supreme skills in dyeing, had developed a sophisticated style, blending Mughal-style finely balanced floral ornament with imaginative indigenous figurative design. The expansion of Calcutta from the 18th century onwards had brought secure patronage. Murshidabad became a renowned center of trade in woven silk brocades, both for the European settlers and for wealthier Indians. The variety and individuality of Bengali brocades results in part from their production in scattered villages, particularly around the towns of Azamgarh, Baluchar and Murshidabad.

The richest patterned fabrics from India are *kamkhāb*s, brocades woven from silk with a weft pattern in gold or silver thread. As elsewhere in the Islamic lands, the Mughal court traditionally awarded

a fine textile or *khīlʿat*, as a mark of special honor and a *kamkhāb* was regarded as an appropriate offering. The metal thread (*kalābattū*) was made from fine wire, heated and pulled through holes of diminishing sizes in a steel drawplate, then flattened by hammering lightly and twisted around a core of silk. As pure gold would have been too soft, gilded silver wire was used; the gold surface, which remained intact, was hardened by the wire-drawing and hammering.

The most famous center of *kamkhāb*-weaving is Varanasi, where a tradition of fine design and superb technique has prevailed since the 17th century. A typical example is a *kamkhāb* (London, V&A) originally purchased for the former Indian Museum, London, in 1855. The floral motifs are Indian poppy plants, skilfully designed within the discipline of the handloom technique, requiring a master-weaver and at least two assistants. The threads of the pattern were lifted and depressed by the *pāgia*, a complex harnessing of the heddles of the loom. The ground of the cloth was built up on a warp and weft of silk; tiny spools of metal thread were used to weave each floral motif separately across the breadth of the cloth as the work progressed, using silver thread for the leaves and gold for the blossoms. The technique of holding the metal threads firmly in place by picking fine diagonal lines across the pattern can be clearly seen in the textile. In the second half of the 19th century, the elaborate European brocades woven on the Jacquard loom dominated fashion and influenced Indian design. Many Varanasi brocades of the second half of the 19th century are technical masterpieces, with birds and animals enshrined amid a profusion of floral ornament.

*Kamkhāb*s produced in Ahmedabad in the 19th century were woven with a "floating weft" technique, in which the silver and gold threads were carried on the shuttle across the breadth of the cloth, passing across the back of the cloth between the motifs, instead of true brocading, as at Varanasi and elsewhere, in which each motif was woven separately with its own tiny spools of thread. The Ahmedabad brocades are bolder in style, and motifs tend to be more closely set to avoid unduly long, loose threads at the back. In Rajasthan and Bengal the *kamkhāb* was of a lighter, more gauzelike texture, sometimes on a fine cotton muslin base, rather than silk. In Rajasthan deep end borders (*anchāl* or *palla*) of *sārīs* or *orhanīs* were often worked in the *mīnākārī* (Pers.: "enameled") style, in colored silks on a gold ground, the pattern usually being floral *būtās* interspersed with birds and flowers.

Mixed fabrics of cotton and silk were probably produced in India from an early date. By the 19th century, plain silk-warped textile with a satin-like appearance (*ghattā*) was widely traded throughout the region, to be used as a ground fabric for embroidered garments or (in Gujarat) for tie-dyed cloth; it was also used for lining garments, and sometimes for embroidered bed-covers and furnishings for Europeans in India. Mixed fabrics had the practical advantage of being cool and comfortable to wear in a hot climate, the cotton content giving ventilation and absorbency. However, increased imports of glossy satinettes from China in the late 19th century led to a decline in production.

(c) Wool. Traditional wool textiles were woven in the colder areas of the northwest, especially Himalayan regions such as Kashmir, Kulu, Kangra, Chamba, Ladakh, Lahul and Spiti. In the 19th century wool industries were established at Lahore, Amritsar, Ludhiana and other towns in the Punjab, some offshoots of the Kashmir shawl industry. In the late 19th century, a few urban commercial enterprises produced factory-woven fabric of European style, using imported wool, for trade to European settlements in the cold regions; but these wool fabrics are not true Indian textiles.

Sheep are not indigenous to India; the lovely wool textiles of the Himalayan valleys are produced mainly from the wool of mountain goats, with different qualities sorted for different types of cloth. The fleece of wild mountain goats is softer and finer than that of the domesticated animal. Kashmir shawl wool, which is known in the West as pashmina (from Pers. *pashm*: "wool") or incorrectly as cashmere (from an old spelling of Kashmir), came mainly from a Central Asian species, the long-haired *Capra hircus*. The best was imported from Tibet, from the wild goats of Changthan and Rodokh. Beneath their rough outer hair, the animals grew a soft inner fleece as extra protection during the severe winter, shedding it at the approach of summer. It was laboriously collected from the rocks and bushes on which the animals had rubbed themselves; the softest and finest (*asālī tūs*) grew from the under-belly and was reserved for the finest shawls. A second grade of wool, derived from domesticated goats but still of fine quality, was used for the main production of shawls and for weaving both plain shawl cloth (Arab. *alwān*) and patterned shawl cloth (Pers. *jāmavār*) to be made into garments. Lower grades were used for ordinary cloth. Sheep's wool was sometimes imported from Kirman in Iran and from Bukhara and Yarkand in Central Asia. In the 19th century under European influence attempts were made to establish herds of sheep in the northwest, but this was successful only in a few suitable fertile valleys such as Kulu.

One of the world's finest woven textiles, the Kashmir shawl, was produced in the Kashmir Valley, where cultural links with Iran and Central Asia were strong. The industry is recorded from the early Mughal period, by which time it was already mature; William Moorcroft, an official of the East India Company, described shawl production in 1820–23. Kashmir shawls were woven on horizontal treadle looms, using the twill-tapestry technique. The design was drawn by a pattern draughtsman (Arab. *naqqāsh*) and then worked through by a "color caller" (Urdu *tarah gurū*), who decided the number of warp threads over which each color must pass. A pattern master (*taʿlīm gurū*) transcribed this in pattern instructions (*taʿlīm*) written in a code understood by weavers.

A master weaver and one or two assistants worked side by side at a shawl loom. The heddles of the loom were threaded for the main weft, forming the web of the cloth. Before each weaver lay his wools for the pattern, each color was wound on a separate spool (*tolji*). After each row of the pattern had been worked according to the pattern instructions, a weft thread was laid across the entire breadth and made firm with the batten. Traditionally a fine shawl was produced on one loom, taking some 18 months to complete. A shawl with a plain field, however, might have the plain cloth woven on a simple loom and joined to the patterned pieces of the borders by a skilled needle-worker (*rafūgar*), with almost imperceptible stitches. Moorcroft described as a recent practice the sharing out of a shawl between several looms so that the complex requirements of European merchants could be met.

In the Mughal period the shawl was a male garment worn wrapped around the shoulders or, in a narrower width, as a sash. The Mughal emperor Akbar is said to have possessed a number of shawls (*Āyīn-i Akbarī*, i, p. 92, *āyīn* 32). Kashmir shawls were sometimes presented by the emperor as *khilʿat*, and fine ones were traded throughout India and Central Asia.

The earliest surviving Kashmir shawl fragments (e.g. London, V&A; Ahmedabad, Calico Mus. Textiles) date from the late 17th century or early 18th. Shawls of the 17th and 18th centuries followed the traditional style of Indian garment cloths: at each end was a patterned border with a row of conventional flowering plant motifs (*būtā*). The end borders were enclosed by narrow, patterned cross borders (*tanjir*). Most shawls had patterned side borders (Arab. *hāshiyā*), which were sometimes woven separately and sewn to the finished piece. The field (*matn*) might be plain or patterned. In the increasing elaboration of the 18th century the ground of the end borders between the plant motifs was often filled with ornament (*jāl*, usually a running pattern of small, conventional leaves or flowers (see Irwin, pp. 41–2, figs. a–g).

The motif known in the West as the Kashmir "cone" or "pine" (or later incorrectly as the "Paisley" pattern) developed from the flowering plant motif or *būtā*. The Mughal *būtā* of the 17th century was a graceful plant with roots, flowers and a "drooping bud" creating a curve at the top. By the end of the 17th century the motif was sometimes transformed to a stylized Indo-Persian "vase of flowers." By the mid-18th century the flower pattern was severely confined within a firm contour, the "drooping bud" becoming the conventional curved summital feature.

Kashmir shawls began to attract the attention of European traders towards the end of the 18th century. Their warmth, softness and lightness were particularly admired in France, where this elegant draped garment blended well with the current fashions. Shawl traders in Paris influenced design, requiring the end borders to be much longer. The floral motifs consequently became taller. French drawings were sent to Kashmir showing the flower motifs with smoother curves and incorporating the fashionable Neo-classical "scroll." In a portrait of *Empress Josephine* (1809; Nice, Mus. Masséna) by Antoine-Jean Gros (1771–1835) the empress wears a dress made from a white Kashmir shawl, the deep end borders in soft colors forming the hem border and the side borders used as trimmings for the bodice; a red Kashmir shawl is draped regally over her shoulders.

Such shawls also became popular elsewhere in Europe, exports reaching their peak in the early 19th century. The earliest imitations were produced in Europe towards the end of the 18th century, and during the second quarter of the 19th century, as large patterns became increasingly fashionable, the shawl manufacturers of France and Britain used the Jacquard attachment to weave shawl designs of great complexity. By the mid-19th century, pressure from these European machine-made shawls forced the weavers of Kashmir to achieve technical marvels, though under great strain. The elaboration of design and refinement of detail in such shawls are as fine as those of the best European shawls, while the softness of texture and color harmony of natural dyes are far superior. Needleworkers were increasingly employed to sharpen small details of the pattern. By the 1860s it was quicker and cheaper to work an entire shawl by embroidery rather than the laborious weaving technique. By the end of the 19th century, factory competition, European import restrictions and taxes imposed in Kashmir upon the weavers led to the decline of the Kashmir woven shawl industry. Embroidered shawls (Arab. *ʿamlī*) of a high quality were produced, but by the end of the century such high standards were no longer maintained. During the 1860s and later, many Kashmiri weavers migrated to Amritsar and other cities in Punjab, where they produced plain and patterned shawl cloth of a coarser wool than the Kashmir shawl.

In the mountain valleys of the Himalaya, weaving wool cloth from goats' fleece was a traditional homecraft. The fabric was woven on a simple narrow hand-loom, usually in widths of less than half a meter. Four or more pieces were sewn together to make a large shawl or wrap. The cloth was usually the natural color of wool (Urdu *khud rang*), but sometimes colored stripes or checks or colored borders were woven. The dark, luminous brownish-black that appears as the ground color or as checks on pieces from Kulu and Kangra is not dyed but a natural color of the fleece of some goats. Wool was traded between the valleys. Even in the remote northerly valleys of Lahul and Spiti, villagers kept a few goats, augmenting their supplies of wool with purchases both from shepherds from other regions, who rented their grazing land in the summer, and from traders from Ladakh. Spiti cloth, which is particularly good, is often woven with patterned stripes.

3. Decorative techniques. Patterned textiles were created either by weaving already dyed yarns or by

block-printing, resist-dyeing, painting or embroidering fabric after it was woven. Frequently a number of different decorative techniques were combined for a single textile. For example, printing was often combined with other techniques, such as resist-dyeing or embroidery; printed patterns were also occasionally finished by painting additional colors—yellows, oranges or greens—which, however, are not entirely fast.

(a) Dyeing. (b) Printing. (c) Resist-dyeing. (d) Painting. (e) Embroidery.

(a) Dyeing. The natural dyes used for traditional Indian textiles were derived from various parts of plants and trees—roots, fruits, flowers, leaves, seeds, bark, wood and galls—and from other sources, including insects. The techniques and many of the materials used for dyeing silk differ from the methods used for cotton, due to the different constitution of the fibers. Synthetic chemical dyes were introduced in the late 19th century but did not totally replace the traditional dyes. The preparation and use of dyestuffs was the result of generations of experience, and many families guarded their methods carefully.

The mellow beauty of Indian natural dyes is dependent upon the Indian environment: the quality of the waters in the local rivers and long seasons of sun for continuous work, i.e. the facility to dry intricate work quickly before it became blurred, especially in the processes of printing, resist-dyeing and *kalamkāri*, which combines the craft of dyeing with that of skilled painting.

(b) Printing. The most famous of India's patterned textiles produced for popular use were block-printed cottons, and the block-printing tradition survives to the present day. Indian print-blocks are carved from smooth hardwood with the design on the lower side and a handgrip on the upper side. The printer works rhythmically, placing the block in position and then impressing the pattern with a double blow of his clenched hand. The dominant colors of most Indian traditional block-printed fabrics were red and black, from an alizarin-based dye. In western and northwest India the dyestuff was usually *āl*. It was, however, the mordant that was printed, not the dyestuff. The alum (for red) or iron oxide (for black) was thickened with gum to make it workable on the print-block; two shades of red were obtained by adding more gum for the lighter color. The cloth was immersed in the heated dye-bath and, after washing, the design appeared in its full range of colors. The red was less pure and rich in a printed textile than in a painted one because of the presence of gum in the mordant. Other colors, such as light yellows and greens, were often painted by hand but were not entirely fast. In the modern period natural dye plants have been replaced by commercial alizarin. Turmeric (*haldī*) can be used directly for printing yellow, if thickened by gum.

It is not practical to use natural indigo for direct printing, because the soluble form of the dye would oxidize more quickly than the print-block could be manipulated. However, an indigo ground is often found on older printed cottons. After printing, the motifs were covered with resist-paste or wax and the cloth dyed. The result was a dark blue cloth with the motifs printed in color. In western India, a dark green ground was obtained by resist-dyeing first in indigo, then in *haldī*. Since the introduction of European commercial dyes in the late 19th century, any color can be directly printed.

Many types of printed cottons were cheap and thus widely used for everyday garment pieces. Fine cotton muslins were printed and sometimes further embellished with gold, usually in the form of an overprinted final outline to the motifs. The parts to be gilded were printed with gum; gold leaf (Hindi *varaq*) was then applied and, when the gum had dried, burnished. Silver was used similarly. In cheaper grades of gold printing, gold powder was used instead of gold leaf. In still cheaper work, powdered mica—or in modern times metallic powder—has been applied in the same way, to provide glitter. This type of printing, not fast when washed and liable to damage by abrasion, was often used for garments for festive occasions and textiles for ceremonial use. Larger articles such as ceremonial banners were sometimes printed entirely in gold and silver on a colored ground.

According to early records of the East India Company, in western India the finest chintzes were obtained at Burhanpur, a 17th-century Mughal provincial capital on the Tapti River and a trade center for southern Rajasthan and the northern Deccan. A few cotton textiles from Burhanpur region survive, made for Indian use and stylistically of the early 18th century, with refined floral ornament in the best late-Mughal tradition. The outlines were mordant-printed in black and red from beautifully cut small print-blocks, with the coloring finished by painting. Political disturbances in the region in the mid-17th century disrupted the chintz trade, resulting in a decline in the European trade in this area. AHMEDABAD was known for mordant printing in black and red. The designs have deep end borders with a band of simple flowering plants and numerous narrow lines of small geometric and floral patterns. The print-blocks are boldly cut; the color scheme of black and red is completed by details freely painted in yellow and green.

The distinctive bold style of cotton-printing in the Punjab in north India arose from the texture of the cloth: it was necessary to cut blocks with larger and less complicated patterns as the nap of these thicker fabrics would not take a fine impression. Printed cotton was used for floorspreads, canopies and door curtains; quilt covers (*razaī*) were printed in pairs and stitched together with an interlining of cotton wool. Bold floral designs abound, often arranged within an architectural framework, trellis or ogee. The predominant color is the bold brick red from the *āl* root,

with the associated brownish-black and a dull but pleasant violet. The deep yellow of turmeric and green provide contrast.

The cotton-printers of Rajasthan in western India created especially fine garment fabrics. Paintings from the Rajput courts in the 18th and 19th centuries capture the delicacy and romanticism of court dress, with extensive use of light gauzy fabrics for women's *orhanīs* (large veils that cover the head and hang over the shoulders) and soft cottons and muslins for men's *jāmas* (court coats). Designs of *sārīs* and *orhanīs* feature deep end borders of flowering plants, peacocks and other birds, in soft colors and gold. Surviving 19th-century examples confirm that Rajasthan had a fine standard of fabric printing (see Irwin and Hall, pls. 67–74). This tradition has been continuously maintained from at least the early 18th century at Sanganer, near Jaipur. Until the mid-20th century, the Sanganer printers were reserved to the Jaipur court; tax stamps feature on all printed cottons supplied outside the court. The Sanganer style was based on mordant printing in black and red, but to meet European demands, later textiles employed the fuller range of colors available with commercial dyes. The printers had earlier made extensive use of overprinting with gold on court dress pieces. Some of the modern export fabrics feature gold printing in modern metallic gilt, providing a touch of exoticism.

Printing on silk is a comparatively modern innovation in India. The traditional silk dyes are not suitable for block-printing techniques, although a little printing on silk was done in Bengal and central India in the late 19th century, after the introduction of commercial dyes. Since the mid-20th century, screen-printing has proved increasingly popular, and the technique is used for both cottons and silks showing both traditional and modern designs.

(c) Resist-dyeing. A method of creating simple but effective patterns of spots, flowers and geometric ornament by shielding (or "reserving") certain areas of cloth or yarn from dye, it encompasses a wide range of reserve techniques, including the use of substances such as paste or wax, which are applied to parts of the fabric to prevent the dye from penetrating (a technique known elsewhere by the Malay term "batik"), and tie-dyeing, in which cotton thread or other material is wrapped around the fabric or yarn. There are two basic types of tie-dyeing techniques. In the first the design is produced by resist-dyeing individual areas of a woven cloth; when the term "tie-dyeing" is used in the West, it usually refers to this technique. In the second—usually but not always a more elaborate process—the threads are dyed according to the projected pattern before they are woven; this technique is most often known in the West by the Malay term "ikat." Both types of tie-dyeing are referred to in India by derivations of the verb *bāndhnā* (Hindi: "to tie"); hence English "bandanna," the spotted cloth, usually handkerchiefs, imported from India since the 18th century.

(d) Painting. Among the finest textiles of India are the *kalamkārī* (lit. "pen work"; from *qalam*: Arab. "pen"), produced in south India by a series of processes combining the craft of dyeing with that of skilled painting. Before painting, the cloth was given a firm surface by steeping it in astringent, then in buffalo milk, drying it in the sun and then burnishing it with a small tool. The first stage was the painting of the mordants for the reds, blacks, browns and violets. The painter drew the outline of the design with the iron mordant for black and the alum mordant (lightly tinted with sappan wood so that he could see his work) for outlines of the parts that were to be red. Fine white lines were created within the red areas by painting in wax, which acted as a resist to prevent the mordant from penetrating the cloth. The various parts of the design were then painted with appropriate mordants, diluting the mordant for paler shades. After the alizarin-based dye-bath, the complete range of colors appeared, fast to both light and washing. Because the mordants were liquid, without the gum necessary for printing, the colors were pure and clear. The second stage, to produce the blue and dark green, was performed by a separate group of craftsmen, the indigo dyers. The entire cloth was covered with wax, except for the places where blue or green were required, to protect the delicate painting from damage in the indigo vat. After dyeing, the wax was scraped and washed away, and the cloth returned to the painters. Where dark green was required, the blue was overpainted with a yellow or a pale green dye from local dye-plants, which were, however, not fast to light or washing. The introduction of dark green was required mainly in the *kalamkārīs* made for the Indo-European chintz trade; in older chintzes the overpainting has often washed out in use. Pale green and yellow were obtained by painting with dye from local dye-plants.

Surviving examples from the 17th century include a large cotton floorspread from the Amer palace near Jaipur (London, V&A; see Irwin and Brett, pl. 1). Painted in the region of Machhilipatanam, at that time in the kingdom of GOLCONDA, it is mordant-dyed from painted mordants in the beautiful range of reds, pinks, violets, light browns and brownish-black that are yielded by the chay plant of the Kistna Delta. Trade records show that fine *kalamkārīs* from this region were traded to Iran as well as to Indian courts. The design of the field comprises two opposed rows of flowering trees and flowering plants that link to form a pattern over the ground, with points of emphasis made by large, carefully spaced flowers. Within the border are lively figures of huntsmen, animals and birds, and a charming scene of a courtier and girl. The little blue in such early Golconda *kalamkārīs* is always pale because the cloth could not be exposed long in an indigo dye-bath, to avoid damage to the intricate painting. Sometimes the blue appears to be painted and thus not entirely fast.

(e) Embroidery. Although India has a long history of embroidery, its beginnings are obscure. Bronze

needles excavated at Mohenjo-daro (*c.* 2550–2000 BCE) may have been used for embroidery. Early written references to decorated or flowered textiles could refer equally to embroidered, woven or printed designs, and the same is true for representations of textiles in sculpture and early paintings, for example at Ajanta. The earliest specific reference to embroidery is by Marco Polo, writing at the end of the 14th century, who comments on leather mats with designs in gold and silver thread produced in Gujarat. This area of western India continues to produce the finest embroidery in India, usually in a fine silk chain stitch that is directly derived from a leather-working embroidery technique using a hooked implement (*ārī*) rather than a needle. Such embroideries were done by professional male craftsmen for courtly, temple and domestic use and are distinct in style from the folk embroideries done by Gujarati women for their own families. The earliest known surviving examples of Indian embroidery are two pieces done for the Jaina community in Gujarat (Ahmedabad, Calico Mus. Textiles, 983; Paris, Assoc. Etude & Doc. Textiles Asie, 2381). Probably made for presentation to Jaina nuns, these two panels date from the early 16th century (or possibly late 15th) and are embroidered in silk satin stitch and couching on cotton; they retain traces of inscriptions embroidered in *kuśa* grass.

Bengal in the east was also a center for embroidery in the 16th century. Vasco da Gama mentions bedcanopies embroidered in white as early as 1502, and other Portuguese references to fine Bengal embroidery occur throughout the 16th century. Surviving examples of Bengal embroidery date mainly from the late 16th century and early 17th. These quilts done in Satgaon on the Hughli River for the Portuguese market (although they were also highly prized in England) are embroidered in yellow silk chain stitch on a white cotton ground and often combine Christian and Hindu mythological themes as well as the coats of arms of Portuguese patrons. Production declined sharply after 1632 when the Mughals expelled the Portuguese from their trading center at Hughli, although similar quilts for the European trade were produced, often in non-representational designs, throughout the 18th century. Similar quilts (Port. *colchas*) were produced in Portugal itself as the trade with India declined. The Bengal tradition survives in the simpler forms of domestic quilts (*kānthās* and *sujanīs*), and Bengali embroidery known as *kaṛidā* still employs natural gold-colored *mūga* silk on white cotton.

High-quality embroidery for the European market was also produced in Gujarat at least from the beginning of the 17th century. The earliest surviving export piece is a bedspread embroidered with flowers and angels (Hardwick Hall, Derbys, NT) that appears in a Hardwick Hall inventory dated 1603. East India Company records show that by 1641 embroidered quilts and hangings from Gujarat commanded high prices in London. Designs were modified to suit European taste and were frequently based, like those of contemporary chintz hangings, on English crewelwork embroideries. The Indian trade embroideries, however, were done in fine floss silk chain stitch on a cotton or cotton-and-linen twill ground. During the 18th century, designs for both chintz and embroidered hangings were influenced by the European vogue for Chinese painted wallpapers, and Chinese-style trees on silk grounds became popular.

Embroidery flourished in the 17th century as a courtly art for the Mughal emperors and nobility. Again, Gujarati professional chain-stitch embroiderers were the foremost craftsmen in the imperial workshops. Embroidery in the ubiquitous floral patterns beloved by the Mughal emperors was used for items of dress—robes, turbans and sashes—floorcoverings, screens, hangings and tent-linings and was at least as highly prized as brocaded or painted textiles. A magnificent embroidered riding coat (London, V&A) is perhaps the finest example of the court embroiderer's art. Gold and silver thread was often incorporated into floral designs, in which satin stitch was often used as an alternative to chain stitch. Sequins, metal foil and beetles' wing cases were also used, especially during the 18th and 19th centuries, to add sparkle to court dress.

Regional courts emulated Mughal furnishings and dress, but some also developed their own styles. A group of famous chain-stitch embroideries, probably made for the royal family of Jaipur in the 18th century, seems to have been based on paintings from Bundi in Rajasthan (e.g. Ahmedabad, Calico Mus. Textiles; Jaipur, Maharaja Sawai Man Singh II Mus.; Richmond, VA Mus. F.A.). Professional artists also must have provided cartoons for the exquisite satin-stitch embroideries done at the court of Chamba and other Punjab Hill states in the 18th and 19th centuries. These *rūmāls* (coverlets) often depict scenes from the love story of Krishna and Radha in a style that reflects the Mughal-influenced paintings of the Hill states. Some impressive large hangings from this group also show battle scenes (e.g. London, V&A; New York, Met.; Ahmedabad, Calico Mus. Textiles). *Rūmāls* in coarser materials, and sometimes in abstract designs, were done throughout the Hill states up to the early 20th century.

The use of gold thread (*zarī* or *zardozī*), reputedly introduced to India by the Portuguese, became increasingly popular in courtly embroidery during the 18th century and continued to be used throughout the 19th for ceremonial dress, throne covers, canopies, saddle cloths and elephant trappings, often worked in heavy padded patterns on velvet. The metal thread was formed by wrapping thin silver, gold or silver gilt strips around a silk core. Flat metal strips could also be laid on to the fabric, usually crimped into a zigzag pattern. *Zarī* embroidery is still done by specialist male professionals, mostly in Delhi, on satin and velvet for caps, bags and belts. Pictorial embroideries in *zarī* work were done on satin for Europeans in Delhi and Agra in the 19th and early 20th centuries.

Fine embroidery done in white cotton on muslin, sometimes in combination with undyed silk, was a speciality of male Muslim embroiderers in Lucknow. Known as *cikan* or *cikankārī*, it seems to have originated in Bengal, probably as a derivative of the delicate woven *jāmdānī* muslins rather than the heavier Bengali quilting tradition. Floral designs were adapted from European whitework patterns of the 18th century, and openwork panels similar to drawn thread work were incorporated, with the important difference that Indian openwork (*jālī*) is formed by pushing threads aside and securing them with tiny buttonhole stitches, not by pulling them out of the fabric. *Cikan* work has not been produced in Bengal since the late 19th century, but it grew to great prominence in Lucknow around the mid-19th century. It was popular with both local and European patrons, and work of incredible fineness, using a traditional and limited range of stitches, was done in Lucknow up to the 1980s, when the last two master craftsmen died. Whitework embroidery was also done in the Punjab, but it had more in common with the Afghan (Kandahar) and Baluch style of embroidery, which was used mainly on shirts and *burqās* (all-enveloping women's garments). *Cikan* work is still being produced commercially in Lucknow, now mostly by local girls.

The fine embroidered shawls of Kashmir originated as a way of imitating woven shawl designs in a less time-consuming, and therefore less costly, technique. The embroidered or *ʿamlī* shawl is said to have been introduced into Kashmir by an Armenian merchant named Khwaja Yusuf in 1803, and professional embroiderers from Kirman reputedly taught the Kashmiris the technique of shawl embroidery. Needlework was already involved in shawl manufacture, as professional darners (*rafūgars*) were employed to sew woven sections together. The embroidery was done in *paśam*, the same goat hair as the shawl itself, in satin stitch or darn stitch. The designs usually mirrored the woven patterns, but embroidery also opened up other possibilities such as the trend of embroidering maps of Kashmir and plans of Srinagar on to a shawl (e.g. London, V&A, IS13–1970). As the 19th century progressed, the embroidery became coarser and was sometimes done in floss silk. Towards the end of the 19th century in Kashmir, heavy embroidery in wool chain stitch on felt and coarse cotton became popular. Embroidered felt rugs (*namdās*) and heavy crewelwork curtains, which found a large market among Europeans, are still produced in Kashmir.

Abuʾl-Fazl: *Āyīn-i Akbarī* [Annals of Akbar] (*c.* 1596–1602); Eng. trans. in 3 vols: vol. i trans. H. Blochmann, ed. S. L. Gloomer ([Calcutta], 1871/*R* Delhi, 1965); vols. ii and iii trans. H. S. Jarrett, ed. J. Sarkar (Calcutta, 1948–9/*R* Delhi, 1972–3)

J. Rey: *Etudes pour servir à l'histoire des châles* (Paris, 1823)

Kashmeer and its Shawls (London, 1875)

A. Yusuf Ali: *A Monograph on Silk Fabrics in the North-Western Provinces and Oudh* (Allahabad, 1903/*R* Ahmedabad, 1974)

R. Meyer-Riefstahl: *Persian and Indian Textiles from the Late 16th to Early 19th Century* (New York, 1923)

R. Pfister: *Les Toiles imprimées de Fostat et l'Hindoustan* (Paris, 1938)

K. de B. Adrington, J. Irwin and B. Gray, eds.: *The Art of India and Pakistan: A Commemorative Catalogue of the Exhibition Held at the Royal Academy of Arts, London, 1947* (London, 1950) [intro. to the textile col. by J. Irwin]

A. Geijer: *Oriental Textiles in Sweden* (Copenhagen, 1951)

J. Irwin: *Indian Embroidery* (London, 1951)

M. Cagigal e Silva: *A arte indo-portuguesa*, vi of *As artes decorativas*, ed. J. Barreira (Lisbon, 1953)

J. Irwin: *Shawls: A Study of Indo-European Influences*, V&A Mus. Monograph, 9 (London, 1955); rev. as *The Kashmir Shawl* (London, 1973)

J. Irwin and P. Jayakar: *Textiles and Ornaments of India* (New York, 1956) *Marg*, xvii/2 (1964) [full issue devoted to embroidery]

J. M. Nanavati and others: *The Embroidery and Beadwork of Kutch and Saurashtra* (Baroda, 1966)

J. Irwin and M. Hall: *Indian Painted and Printed Fabrics* (1971), i of *Historic Textiles of India in the Calico Museum* (Ahmedabad, 1971–)

J. Irwin and M. Hall: *Indian Embroideries* (Ahmedabad, 1973)

S. Chaudhuri: *Trade and Commercial Organization in Bengal, 1650–1720; with Special Reference to the English East India Company* (Calcutta, 1975)

C. Singh: *Textiles and Costumes from the Maharaja Sawai Man Singh II Museum* (Jaipur, 1979)

K. Talwar and K. Krishna: *Indian Pigment Paintings on Cloth* (1979), iii of *Historic Textiles of India in the Calico Museum* (Ahmedabad, 1971–)

R. Skelton and M. Francis, eds.: *Arts of Bengal* (London, 1979)

A. Buhler and others: *Indian Tie-dyed Fabrics* (1980), iv of *Historic Textiles of India in the Calico Museum* (Ahmedabad, 1971–)

C. Singh and D. Ahivasi: *Woollen Textiles and Costumes from Bharat Kala Bhavan* (Varanasi, 1981)

The Indian Heritage: Court Life and Arts under Mughal Rule (exh. cat. by R. Skelton and others, London, V&A, 1982), pp. 78–102

The Living Arts of India: Craftsmen at Work (exh. cat. by S. Grayson; London, Serpentine Gal.; Glasgow, Third Eye Cent.; Bradford, Cartwright Hall; and elsewhere; 1982)

M.-L. Nabholz-Kartaschoff: *Golden Sprays and Scarlet Flowers: Traditional Indian Textiles from the Museum of Ethnography, Basel* (Kyoto, 1986)

M. Lévy-Strauss: *The Romance of the Cashmere Shawl* (Milan, 1986; Eng. trans. Ahmedabad, 1987)

S. Cohen: "Textiles," *Islamic Heritage of the Deccan*, ed. G. Michell (Bombay, 1986), pp. 118–28

F. Cousins: *Tissus imprimés du Rajasthan* (Paris, 1986)

M. Lévy-Strauss: *The Romance of the Cashmere Shawl* (Milan, 1986; Eng. trans. Ahmedabad, 1987)

B. C. Mohanty, K. V. Chandramouli and H. D. Naik: *Natural Dyeing Processes of India* (Ahmedabad, 1987)

Woven Air: The Muslin and Kantha Traditions of Bangladesh (exh. cat., London, Whitechapel A.G., 1988)

J. Guy and D. Swallow, eds.: *Arts of India, 1550–1900* (London, 1990)

V. Murphy and R. Crill: *Tie-dyed Textiles of India: Tradition and Trade* (London and Ahmedabad, 1991)

T. Roy: *Artisans and Industrialisation: Indian Weaving in the Twentieth Century* (Delhi, 1993)

B. N. Goswamy: *Indian Costumes in the Collection of the Calico Museum of Textiles* (1993), v of *Historical Textiles of India at the Calico Museum* (Ahmedabad)

P. Sen: *Crafts of West Bengal* (Ahmedabad, 1994)

V. Z. Rivers: "Heavy Metal—Light Work: Zardozi and Gota Work of India," *Ars Textrina*, xxiii (1995), pp. 11–33

D. Walker: *Mughal Silks: The Metropolitan Museum Collection* (Mumbai, 1995)

V. Z. Rivers: "Gold Print—All that Glitters," *Ars Textrina*, xxvi (1996), pp. 129–53

Colours of the Indus: Costume and Textiles of Pakistan (exh. cat. by N. Askarai and R. Crill; London, V&A, 1997)

P. Ahmad: *The Aesthetics & Vocabulary of Nakshi Kantha: Bangladesh National Museum Collection* (Dhaka, 1997)

R. Barnes: "From India to Egypt: The Newberry Collection and the Indian Ocean Textile Trade," *Islamische Textilkunst des Mittelalters: Aktuelle Probleme, Riggisberger Berichte*, 5 (1997), pp. 79–92

D. C. Johnson: *Agile Hands and Creative Minds: A Bibliography of Textile Traditions in Afghanistan, Bangladesh, Bhutan, India, Nepal, Pakistan, and Sri Lanka* (Bangkok, 2000)

R. Crill, S. Cohen and R. Barnes: *Court, Temple and Trade: Indian Textiles from the Tapi Collection* (Mumbai, 2002)

M. Maskiell: "Consuming Kashmir: Shawls and Empires, 1500–2000," *J. World Hist.*, xiii/1 (2002), pp. 27–65

Sari to Sarong: Five Hundred Years of Indian and Indonesian Textile Exchange (exh. cat. by. R. J. Maxwell; Canberra, N.G., 2003)

D. C. Johnson: "Textiles in the *Jahangirnama*," *J. Asiat. Soc. Mumbai*, lxxix (2004), pp. 117–27

Thattha [Tatta; Thatta; Skt: "place on a river"]. City in Sind, Pakistan. Said to be of great antiquity, the city was thrust into strategic and commercial prominence in the late 13th century or early 14th by a rapid and favorable shift of a spur of the Indus River. Another change in the course of the river (1756–1800) left the city isolated, causing a decline in its importance. Many monuments remain from the intervening period of Samma (1335–1520), Arghun and Tarkhan (1520–93) and MUGHAL (1526–1857) rule.

The earliest and largest complex is the necropolis of Makli Hill to the west, a center of religious and funerary activity since the late 13th century. Poetically described in early chronicles as a place of gardens and cypresses, in the early 21st century it is a barren landscape filled with thousands of relatively modest graves and tombs. More imposing architectural remains were built of brick, stone or rubble with a stone facing. The earliest are domed stone pavilions associated with religious schools and tombs of 14th-century saints. A surprisingly late and very imposing example is the tomb–mosque dated 1509 (Dani, pp. 58–90, pls. 15–21, nos. 47–71b) of the penultimate Samma ruler, Sultan Nizam al-Din II (*r. c.* 1450–1508), revered in Sind as a paragon of princely behavior. Built of rubble with a golden stone facing, the tomb (base *c.* 11 m sq.) is now open to the sky but may have been domed. The walls are richly carved with bands of Arabic inscriptions and decorative motifs that can be traced to the earlier temple-building traditions of Sind, including a band of carved geese. Early scholars such as Cousens believed the tomb was constructed from temple spoils, but Dani showed this was not the case. The most significant feature is an elaborately carved extension containing the mihrab that not only exhibits a molding sequence associated with temple architecture but also incorporates miniature temple superstructures into its decoration. Other monuments of the Samma period include large enclosure tombs, a favorite form at the site. These buildings exhibit similar though less elaborately developed traits as the tomb of Nizam al-Din, including close links with both the Islamic and non-Islamic architectural traditions of neighboring Rajasthan and Gujarat.

Monuments built under the Arghuns, Tarkhans and Mughals are typically of brick with an extensive use of glazed tile decoration. A representative example is the tomb of Mirza Jani Beg (*d.* 1601), the last independent Tarkhan ruler of Sind, who submitted to the forces of the Mughal emperor Akbar (*r.* 1556–1605) in 1593 but continued as a provincial governor under Mughal authority. The tomb is an octagonal, brick-built domed structure dated 1601. The dome, now fallen, was the conical single variety characteristic of Thattha monuments rather than the bulbous double dome typical elsewhere in the Mughal Empire. The doorframe, geometric window screens and cenotaphs are stone. The decorative tiles are predominantly blue with white accents and decorated with floral patterns, interspersed with inscriptions and geometric forms. The additional decorative technique of alternating horizontal courses of glazed and unglazed bricks also occurs on other monuments in the more elaborate form of zigzag patterning. Later pavilion and enclosure tombs continue earlier stone building traditions, although generally with flatter and drier decoration.

The principal monument within the town is the Jami' Masjid or congregational mosque, built by order of Shah Jahan (*r.* 1628–58) in 1644–7. Frequently repaired and recently (controversially) restored, the brick mosque (93×52 m) has a long east–west axis that distinguishes it from other examples of the Mughal period. Around the great inner courtyard (50×30 m) are open, domed halls. The halls on the western side are three bays deep and flank the prayer chamber. The Central Asian and Persian device of a tall screen (*see* PISHTAQ), known from earlier buildings in Sind, shields the main dome of the prayer chamber from the courtyard. The double-bayed hall on the eastern side functions as a monumental domed entrance, while on the north and south sides are less elaborate double-bayed halls. Double aisles run around the courtyard, with a triple aisle on the east side. The much-restored but still spectacular tile decoration gives some idea of the original appearance, particularly of the dome interiors

decorated with star and sun motifs that serve to underscore the symbolism of the dome as a representation of the heavens. Blue with white accents is primarily used, with the sparing addition of other colors, especially yellow and purple. Another noteworthy monument associated with Thattha is a double mosque that is traditionally assigned to the patronage of the first Arab conqueror of Sind in the 8th century but is dated according to stylistic evidence in the 17th century.

H. Cousens: *The Antiquities of Sind* (Calcutta, 1929)

Mīr ʿAlīshīr Qāniʿ Tattavī: *Maklī-nāma*, ed. S. H. Rashdi (Hyderabad, 1967)

Mīr ʿAlīshīr Qāniʿ Tattavī: *Tuhfat al-kirām*, ed. S. H. Rashdi (Hyderabad, 1971)

S. Digby: "The Coinage and Genealogy of the Later Jams of Sind," *J. Royal Asiat. Soc. GB & Ireland*, ii (1972), pp. 125–34

A. H. Dani: *Thatta: Islamic Architecture* (Islamabad, 1982)

A. Schimmel: *Makli Hill: A Centre of Islamic Culture in Sindh* (Karachi, 1983)

Y. Lari: *Traditional Architecture of Thatta* (Karachi, 1989)

D. Ehnbom: "Cosmology and Continuity in a 16th-century Tomb in Sind," *South Asian Archaeology, 1989*, ed. C. Jarrige (Madison, 1992), pp. 361–6

M. Kevran: "Entre l'Inde et l'Asie centrale: Les mausolées islamiques du Sind et du sud Penjab," *Cah. Asie Cent.*, i–ii (1996), pp. 133–71

I. H. Hadiem: *Makli: The Necropolis at Thatta* (Lahore, 2000)

Throne. Ceremonial chair or seat, usually that of a sovereign or ecclesiastical dignitary, often placed in an elevated position and accompanied by a footstool, a cloth hanging and a canopy. Although orthodox Islam has no place for royal pomp, the first Islamic caliphs used the MINBAR, or pulpit in a mosque derived from the judge's seat in pre-Islamic Arabia, as a sign of their authority. Later Islamic rulers adopted the types of throne used by pre-Islamic rulers in the regions conquered by Islam. Members of the Umayyad dynasty of Syria (*r.* 661–750; *see* UMAYYAD, §I), for example, adopted the chair-like throne of Classical antiquity, while members of the ABBASID dynasty (*r.* 749–1258), who drew their initial support from the eastern Islamic lands, favored the traditional Persian type of throne on which the ruler sat cross-legged but raised above the crowd (*see also* FURNITURE). This type of low throne, with or without a back, was widely dispersed throughout the medieval Islamic lands because of the esteem in which the practices of the Abbasid caliphs were held by local rulers and governors. In Iran the throne might be placed on a dais (Pers. *ṣuffa*), often a considerable structure consisting of a portico or pavilion open in the front. According to the historian Bayhaqi (1100–69), the original wooden throne of Masʿud I of Ghazna (*r.* 1031–41) was replaced in 1038 by a gold throne surmounted by a parasol and placed on a dais in a new palace. Depictions in Persian manuscripts from the 14th century document the introduction from China of a new type of throne with a flat seat

enclosed on three sides by decorative panels and a low footstool in front.

Thrones survive only from the period after *c.* 1500 but continue earlier types with some variation and increasing opulence. The throne of the Ottoman sultan Ahmed I (*r.* 1603–17; 2.85×1.02×0.66 m; Istanbul, Topkapı Pal. Mus., 1652) has a raised chair-like base with four thin shafts supporting a wooden baldacchino from which hangs a splendid pendant. Attributed to MEHMED AĞA, it is made of walnut inlaid with mother-of-pearl, tortoise-shell, ivory and ebony and encrusted with rubies, emeralds, turquoises and peridots. The Bayram Tahtı (1.78×1.08×0.4 m; Istanbul, Topkapı Pal. Mus., 2825), used by the Ottoman sultans for religious festivals and state receptions, is made of walnut plated with solid gold and encrusted with 954 peridots or olivines. Another example of this platform type is a 19th-century throne (1.55×1.20×0.95 m; Istanbul, Topkapı Pal. Mus. 735) made of gold, enameled and set with pearls, rubies and emeralds, which has four legs supporting a low oval platform and a matching footstool. This throne is thought to be a replica of a Mughal prototype, perhaps the Peacock Throne of Shah Jahan (*r.* 1628–57).

The earliest Iranian example to survive is the throne of Boris Godunov (Moscow, Kremlin, Armory), presented by the Persian ambassador Lajin Beg in 1604 as a gift from the Safavid ʿAbbas I (*r.* 1588–1629). The Takht-i Nadiri (Tehran, Bank Markazi, Crown Jewels Col.), the throne of the Afsharid ruler Nadir Shah (*r.* 1736–47), is a wooden chair overlaid with enameled gold and encrusted with gems. The Peacock Throne (Pers. *takht-i tavūs*; Tehran, Bank Markazi, Crown Jewels Col.) is of the rectangular platform type with a high back and two steps. The Takht-i Marmar (Tehran, Gulistan Pal.) is another throne of the traditional platform type made of carved marble (for illustration *see* TEHRAN, color. pl. 3:VIII, fig. 1).

Thrones from the Mughal period are commonly represented in such paintings as BICHITR's *Allegorical Portrait of Jahangir, Akbar and Shah Jahan* (*c.* 1640; Dublin, Chester Beatty Lib.). The fabulous golden, jewel-encrusted Peacock Throne of Shah Jahan shown in Abu'l-Hasan's painting of *Shah Jahan Enthroned* (*c.* 1635; New York, Met.) was in the form of a canopied dais. A marble throne of similar design on the balcony of the hall of public audience (Divan-i-ʿAm) at the Red Fort, Delhi, served as a framing device to display the king as a quasi-divine figure. A 19th-century golden throne made for the Sikh ruler Ranjit Singh is preserved in the Victoria and Albert Museum, London.

Enc. Islam/2: "Takht-i Ṭāwūs" [Peacock throne]; *Enc. Iran.*: "Crown Jewels"

C. Köseoğlu: *The Topkapı Saray Museum: The Treasury*, trans. and ed. J. M. Rogers (London, 1987), nos. 1–3

E. Koch: *Shah Jahan and Orpheus: The Pietre Dure Decoration and the Programme of the Throne in the Hall of Public Audiences at the Red Fort of Delhi* (Graz, 1988)

D. Donovan: "The Evolution of the Throne in Early Persian Painting: The Evidence of the Edinburgh *Jāmiʿ al-tawārīkh*," *Persica*, xiii (1989), pp. 1–76

Tihrān. *See* TEHRAN.

Tiles. *See* ARCHITECTURE, §X, B.

Tilimsān. *See* TLEMCEN.

Tilmun. *See* BAHRAIN.

Timbuktu [Timbuctoo; Tombouctou]. City in MALI on the southern edge of the Sahara, *c.* 13 km north of the Niger River. Timbuktu was founded *c.* 1100 as a camp for Tuareg nomads, and by the late 13th century it was part of the Mali Empire. Around 1325, after returning from Mecca, the Mali ruler Mansa Musa built a palace in Timbuktu known as the Madugu (destr.) and probably also founded the Great Mosque (Djingueré Ber), in the southwest corner of the city. Both buildings are believed to have been the work of an Andalusian poet–architect called al-Saheli. The Great Mosque was reconstructed between 1569 and 1571 by the Cadi al-Aqib and then substantially altered between 1828 and 1853. Built of mud-brick and stone rubble, with the ends of beams projecting out of the fabric of the building, the mosque has squat, conical corner towers, a minaret *c.* 16 m high, a flat roof supported on arcades of mud piers and several vaulted limestone arches.

The Sankoré Mosque, in the north of the city, which has been rebuilt over the centuries, was a center of Islamic scholarship by the early 15th century. Its courtyard, the interior walls of which conform to the exterior dimensions of the Kaʿba at Mecca, was built or reconstructed in 1578 by the Cadi al-Aqib, and in the early 18th century attempts were made to rebuild the minaret, which had fallen in 1678. Arcaded galleries surround the courtyard on three sides, and they were probably added in the late 1840s at the same time as the minaret was buttressed. Another mosque of importance is the small Sidi Yahyia Mosque in the center of the city, believed to have been built *c.* 1440. It too was restored by the Cadi al-Aqib and then reconstructed in stone by the French in the 20th century. Other architecture in Timbuktu includes mud-brick houses with interior courtyards and narrow rooms. The city reached its apogee in the 16th century, but its importance as a center of trade and learning declined after it was captured by the army of the sultan of Morocco in 1591. From 1894 Timbuktu was occupied by the French, who constructed residential and government buildings of stone to the south. In 1960 the city became part of the independent Republic of Mali.

Enc. Islam/2

A.-V. Dupuis-Yakouba: "Notes sur Tombouctou," *Rev. Ethnol. & Sociol.*, i (1910), pp. 233–6; iv (1913), pp. 100–104; v (1914), pp. 248–63

A.-V. Dupuis-Yakouba: *Industries et principales professions des habitants de la région de Tombouctou* (Paris, 1921)

R. Mauny: "Notes d'archéologie sur Tombouctou," *Bull. Inst. Fr. Afrique Noire*, xiv (1952), pp. 899–918

H. Miner: *The Primitive City of Timbuctoo* (Princeton, 1953/R New York, 1965)

L. Prussin: *Hatumere: Islamic Design in West Africa* (Berkeley, 1986), pp. 141–54

T. Shah: "The Islamic Legacy of Timbuktu," *Aramco World*, xlvi/6 (1995), pp. 10–17

J. Hunwick: *Timbuktu and the Songhay Empire: Al-Saʿdiʾs Tarikh al-Sudan down to 1613, and Other Contemporary Documents* (Leiden, 1999)

J. Hunwick: *Timbuktu: The Main African Center of Islamic Thought and the Arabic Language* (Evanston, IL, 2006)

M. De Villiers and S. Hirtle: *Timbuktu: The Sahara's Fabled City of Gold* (New York, 2007)

S. Jeppie, ed.: *The Multiple Meanings of Timbuktu* (Capetown, in preparation) [proceedings of a 2005 conference at the University of Capetown on manuscripts from Timbuktu]

Timurid. Islamic dynasty of rulers and patrons in Iran and Central Asia that reigned from 1370 to 1506.

I. Introduction. II. Family members.

I. Introduction. The Timurids were the last great Islamic dynasty of steppe origin. Their eponym, (A) Timur, rose to power in Transoxiana when the region was under the nominal control of Tughluq Temür (*r.* 1359–63), last of the Chaghatayid Mongols. In an accelerating succession of conquests, Timur established control of Transoxiana and Iran. Unlike earlier nomad conquerors, he did not aspire to rule the steppe but only the sown lands of the region, where he established governorships and permanent garrisons. He then undertook a series of quick and brilliant campaigns against the TUGHLUQ rulers in India (1398–9), the MAMLUKS in Syria (1400–01) and the OTTOMANS in Anatolia (1402). These campaigns were not designed for annexation but to demonstrate his superior power and to bring booty to his capital. After his death more distant parts of the empire broke away: northern India came under the control of the LODI and SAYYID dynasties; Syria reverted to the Mamluks and Anatolia to the Ottomans. His descendants ruled only in Central Asia and on the Iranian plateau, where they struggled to maintain ever-diminishing portions of the realm. Princes of the royal house were sent to provincial centers as governors, a practice that contributed to the amorphous nature of Timurid power.

Timur's immediate successors were his sons Miranshah in western Iran and Iraq and (B) Shahrukh in Khurasan. Shahrukh eventually acquired Transoxiana and the Iranian plateau. He married (C) Gawharshad *c.* 1388, by whom he had two of his eight sons, (E) Ulughbeg and (G) Baysunghur. Ulughbeg was appointed governor of Samarkand, while (D) Iskandar Sultan was governor of Shiraz. Another son of Shahrukh by a different wife, (F) Ibrahim Sultan, was appointed governor of Shiraz following his cousin's death. The period of political

confusion following the death of Shahrukh in 1447 was ended by the accession of 'Umar Shaykh's great-grandson (H) Sultan Husayn in 1470 at Herat. He ruled there for 36 years, and was briefly succeeded by his son until the Shaybanids took the city in 1507. The Timurid prince Babur (1483–1530), a descendant of Miranshah who had inherited the appanage of Ferghana (now mostly in Uzbekistan), was dispossessed in 1504 and moved first to Kabul and then to India, where he and his descendants ruled as the MUGHAL dynasty from 1526 to 1857.

The Timurids are renowned for their patronage, particularly of architecture (see ARCHITECTURE, §VI, A, 2 and CENTRAL ASIA, §II, B), the arts of the book (see ILLUSTRATION, §V, D) and other luxury arts, such as metalwork (see METALWORK, §III, A, 2) and carved JADE. Patrons included not only members of the royal house but also military figures and bureaucrats, such as the statesman 'ALISHIR NAVA'I, and two classes of religious figures, Sufi masters and local devotees. Women were particularly important patrons of architecture, most notably at the extraordinary necropolis to the north of Samarkand, the Shah-i Zinda (see SAMARKAND, §III, A). Timurid buildings are impressive brick structures decorated on the exterior with glittering multicolored tile revetments. On the interior large and unusual spaces were covered with inventive systems of plaster vaults decorated with paint and muqarnas. Most of the 250 surviving Timurid structures are mosques, madrasas and tombs, but the dynasty is also known to have erected splendid palaces, pavilions and gardens. While these secular buildings have survived mainly in the enthusiastic descriptions of contemporaries, they also served as models of the princely style for succeeding dynasties throughout the eastern Islamic lands. Many Timurid princes were avid bibliophiles who collected and commissioned luxury manuscripts with fine calligraphy, illumination, illustration and bindings. Some, such as Baysunghur, maintained private studios (Pers. kutubkhāna) of craftsmen and personally supervised the design and execution of dozens of works. Others were more modest patrons: Muhammad Juki (1402–44), Baysunghur's half-brother and governor of Balkh, is known to have commissioned only a single illustrated manuscript, a copy of Firdawsi's Shāhnāma ("Book of kings"; London, Royal Asiat. Soc., Morley MS. 239). The overall quality of the manuscripts is so fine that the Timurid period is considered to be the apogee of the arts of the Persian book. The classical Timurid style is characterized by meticulous draftsmanship, jewel-like colors and carefully controlled compositions. The most famous painter, BIHZAD, added realism and humor to the somewhat static classical style. All the arts of the period are characterized by tightly controlled design, precise and polished execution and extensive use of carefully modulated color.

E. J. Grube: "Notes on the Decorative Arts of the Timurid Period," *Gururajamanjarika: Studi in onore di Giuseppe Tucci* (Naples, 1974), pp. 233–79

B. Gray, ed.: *Arts of the Book in Central Asia, 14th–16th Centuries* (London, 1979)

P. Jackson, ed.: *The Timurid and Safavid Periods* (1986), vi of *The Cambridge History of Iran* (Cambridge and London, 1968–91)

B. O'Kane: *Timurid Architecture in Khurasan* (Costa Mesa, 1987)

L. Golombek and D. Wilber: *The Timurid Architecture of Iran and Turan*, 2 vols. (Princeton, 1988)

T. W. Lentz and G. D. Lowry: *Timur and the Princely Vision: Persian Art and Culture in the Fifteenth Century* (Los Angeles, 1989)

W. M. Thackston, ed.: *A Century of Princes: Sources on Timurid History and Art* (Cambridge, MA, 1989)

Asian A., ii (Spring, 1989) [whole issue]

L. Golombek and M. Subtelny, eds.: *Timurid Art and Culture* (Leiden, 1992)

L. Komaroff: *The Golden Disk of Heaven: Metalwork of Timurid Iran* (Costa Mesa, CA, and New York, 1992)

E. Sims: "The Illustrated Manuscripts of Firdausī's *Shāhnāma* Commissioned by Princes of the House of Tīmūr," *A. Orient.*, xxii (1992), pp. 43–68

B. O'Kane: "Poetry, Geometry and the Arabesque: Notes on Timurid Aesthetics," *An. Islam.*, xxvi (1992), pp. 63–78

M. E. Subtelny: "A Medieval Persian Agricultural Manual in Context: The *Irshād al-Zirʿa* in Late Timurid and Early Safavid Khorasan," *Stud. Iran.*, xxii/2 (1993), pp. 167–217

L. Golombek: "The Paysage as Funerary Imagery in the Timurid Period," *Muqarnas*, x (1993), pp. 241–52

T. W. Lentz: "Dynastic Imagery in Early Timurid Wall Painting," *Muqarnas*, x (1993), pp. 253–65

M. E. Subtelny: "Mīrak-i Sayyid Ghiyās and the Timurid Tradition of Landscape Architecture. Further notes to 'A Medieval Persian Agricultural Manual in Context,'" *Stud. Iran.*, xxiv/1 (1995), pp. 19–60

L. Golombek, R. B. Mason and G. A. Bailey: *Tamerlane's Tableware: A New Approach to Chinoiserie Ceramics of Fifteenth- and Sixteenth-century Iran* (Costa Mesa, 1996)

M. Bernadini, ed.: *La Civiltà Timuride come fenomeno internazionale, Orient. Mod.*, xv/76 (1997) [whole issue]

E. J. Grube: "The World is a Garden: The Decorative Arts of the Timurid Period," *First under Heaven: The Art of Asia*, ed. J. Tilden, Fourth Halı Annual (London, 1997), pp. 8–25

P. P. Soucek: "Tīmūrid Women: A Cultural Perspective," *Women in the Medieval Islamic World*, ed. G. R. G. Hambly (New York, 1998), pp. 199–226

D. Roxburgh: "The Aesthetics of Aggregation: Persian Anthologies of the Fifteenth Century," *Islamic Art and Literature*, ed. O. Grabar and C. Robinson (Princeton, 2001), pp. 119–42

B. O'Kane: "The Timurid Bazar and the Origin of the Domed *Tim*," *Historians in Cairo: Essays in Honor of George Scanlon*, ed. J. Edwards (Cairo, 2002), pp. 17–28

E. Sims: *Peerless Images: Persian Paintng and its Sources* (London, 2002)

B. F. Manz: *Power, Politics and Religion in Timurid Iran* (Cambridge, 2007)

II. Family members.

A. Timur. B. Shahrukh. C. Gawharshad. D. Iskandar Sultan. E. Ulugh Beg. F. Ibrahim Sultan. G. Baysunghur. H. Sultan Husayn.

A. TIMUR [Tīmūr; Tīmūr-i Lang; Temür Güregen; Tamburlaine; Tamerlane] (*b.* Kish [now Shahr-i Sabz, Uzbekistan], 8 April 1336; *r.* 1370–1405; *d.* Otrar [now Kazakhstan], 18 Feb. 1405). His family belonged to the Barlas, a tribe of Turkicized Mongols who had converted to Islam and established themselves in the region south of Samarkand. Through his exploits in battle against the Chaghatayids, Timur acquired a wide personal following, and he solidified his position by marrying Saray Mulk Khatun, daughter of the Chaghatayid Qazan Khan (*r.* 1343–6) and a direct descendant of Ghenghis Khan. On this basis, Timur adopted the title *güregen/ kurgan* ("son-in-law") and set himself up as "great amir" to various puppet *khān*s. From his power-base in Transoxiana Timur quickly expanded southwards into Khurasan, taking Herat from the Karts in 1381. He then conquered the rest of Iran and most of Eurasia. His extraordinary ambition is reflected in his patronage of architecture, in which he favored the bombastic and grandiose. He achieved his ends by concentrating his resources at Samarkand and other sites in Transoxiana, transporting there the loot to pay for his building projects, the materials to build them and the craftsmen to make them.

Five major buildings survive from his reign; all are enormous and share the same formal vocabulary (e.g. massive entrance portals with flanking towers, soaring double domes and lavish revetments in glazed tile). The Aq Saray (1379–96; *see* CENTRAL ASIA, fig. 4), the palace he erected at his birthplace, known already in his time as SHAHR-I SABZ (Pers: "green town"), preserves an enormous deep portal entirely revetted in tile mosaic. The 22-m span of the arch (destr.) indicates the colossal scale of the palace, which was erected by forced labor from the recently conquered province of Khwarazm. To the east of this complex, Timur undertook an even more impressive project, a madrasa known as the Hazrat Imam or the Dar al-Siyada (1375–1404), which contained a mausoleum for his favorite son, Jahangir (*d.* 1372). It was a large (50×70 m) rectangular building with a monumental portal leading to a small central court. All that remains is the northwest corner, containing the mausoleum with a conical roof, and a crypt at the back of the building. This monumental scale is continued in the shrine (1399) that Timur ordered over the grave of the Sufi shaykh Ahmad Yasavi (*d.* 1166) at Yasi (now TURKESTAN, Kazakhstan; for illustration *see* ARCHITECTURE, fig. 31, ORNAMENT AND PATTERN, color pl. 3:II, fig. 3 and SHRINE). The best preserved of all his buildings, it is a freestanding rectangle with a gargantuan portal and a huge central dome, visible from afar. The interior spaces are roofed with *muqarnas* vaults and inventive systems of transverse vaulting, which may have been the work of architects forcibly brought from central Iran. The only surviving non-architectural works associated with Timur's patronage are fittings for this shrine. These include splendid carved and inlaid wooden doors, an elephantine bronze basin (h. 1.58 m, diam.

2.43 m; 1399) and six large lampstands of brass inlaid with gold and silver (average h. 900 mm; three *in situ*; others St. Petersburg, Hermitage, and Paris, Louvre).

Timur's most ambitious project was the congregational mosque of Bibi Khanum (see fig. 1; *see also* SAMARKAND, §III, B). It is a large rectangle (132×99 m) with iwans and domed chambers arranged on the four sides of an open court (76×64 m). The 480 stone columns in the hypostyle halls between the iwans were said to have been carried from India on the backs of elephants, an epic event later depicted in a copy of the *Zafarnāma* ("Book of victory"; Baltimore, MD, Johns Hopkins U., Garrett Lib.) prepared for (H) Sultan Husayn. Timur's fifth surviving building is a mausoleum in Samarkand known as the Gur-i Mir ("Grave of the prince"; *see* ARCHITECTURE, color pl. 1:III, fig. 1; *see also* SAMARKAND, §III, C). Begun by Timur as a madrasa, *khanaqah* and mausoleum for his grandson, it later became a dynastic mausoleum in which Timur himself was buried. Its tall, ribbed and bulbous blue cupola epitomizes the Timurid style of dome construction.

Timur is reported to have commissioned several books that chronicled his military exploits, but no contemporary copies survive.

A. A. Ivanov: "O bronzovykh izdeliyakh kontsa XIV iz mavzoleya Khodzha Akhmeda Yasevi" [Bronze objects from the end of the 14th century from the mausoleum of Khwaja Ahmad Yasavi], *Srednyaya Aziya i yeyo sosedi* [Central Asia and its neighbors], ed. B. A. Litvinsky (Moscow, 1981), pp. 68–84

L. Golombek: "Tamerlane, Scourge of God," *Asian A.,* ii (Spring 1989), pp. 31–61

B. F. Manz: "The Legacy of Timur," *Asian A.*, ii (Spring 1989), pp. 10–30

B. F. Manz: *The Rise and Rule of Tamerlane* (Cambridge, 1989)

S. S. Blair and J. M. Bloom: "Timur's Qur'an: A Reappraisal," *Sifting Sands, Reading Signs: Studies in Honour of Professor Géza Fehérvári*, ed. P. L. Baker and B. Brend (London, 2006), pp. 5–13

B. SHAHRUKH [Shāhrūkh] (*b.* Samarkand, 20 Aug. 1377; *r.* 1405–47; *d.* Rayy, 13 March 1447). Fourth son of (A) Timur. A successful commander who distinguished himself in his father's campaigns, Shahrukh was appointed governor of Khurasan and on his father's death was recognized as sovereign there. Shahrukh expanded his power until in 1409 he eliminated his chief rival, his nephew Khalil Sultan, in the capital Samarkand, and was recognized throughout the realm. He then returned to Herat, leaving his oldest son (E) Ulughbeg at Samarkand. During Shahrukh's long reign, his court at Herat became a center of cultural activity in several fields, most notably architecture and illustrated manuscripts. He was considered a traditional monarch, who upheld orthodoxy and good government, and his patronage reflects this image.

His major project was the reconstruction of HERAT, which had been capital of the Kart dynasty (*r.* 1245–1389). He first rebuilt the bazaar, as commerce

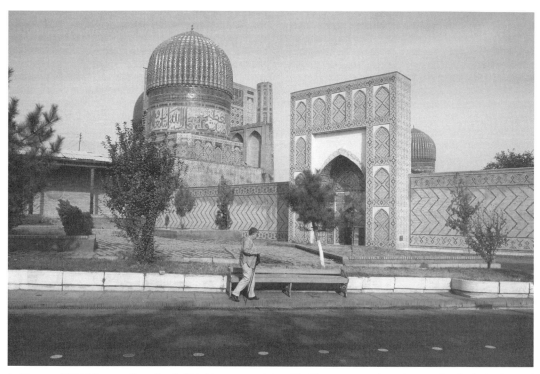

1. Mosque of Bibi Khanum, Samarkand, Uzbekistan, commissioned by Timur, 1399–1405; photo credit: Sheila S. Blair and Jonathan M. Bloom

was central in revivifying the city. He then rebuilt the Bagh-i Safid ("White garden"; 1410–11), which had a crenellated pavilion decorated with *muqarnas* in the iwans, carved stone dados and paintings on the interior. Beside the old citadel, which he refurbished, he erected a combined madrasa–*khanaqah*, a combination that became extremely popular in Timurid Herat. His major religious commission— and the only one of his buildings to survive—is the shrine around the tomb of the mystical poet Ansari (*d.* 1089), at Gazurgah, 5 km northeast of Herat. The quality of its vaulting and tile decoration shows that no expense was spared. The illustrated manuscripts he commissioned are the first extant examples produced in northeast Iran and are mainly historical texts, which demonstrate the ruler's preoccupation with dynastic legitimacy. The paintings, such as those in a dispersed copy of Hafiz-i Abru's *Majma 'al-tawārīkh* ("Assembly of histories"; *c.* 1425), are done in the Historical style, in which older features, such as simple horizontal compositions and the use of line and wash, are mixed with features of contemporary painting, such as bright and opaque colors, high horizons and Timurid dress.

R. Ettinghausen: "An Illuminated Manuscript of Hafiz-i Abru in Istanbul, Part I," *Kst Orients*, ii (1955), pp. 30–44

L. Golombek: *The Timurid Shrine at Gazur Gah* (Toronto, 1969)

T. Allen: *Timurid Herat* (Wiesbaden, 1983)

B. O'Kane: *Timurid Architecture in Khurasan* (Costa Mesa, CA, 1987)

G. Inal: "Miniatures in Historical Manuscripts from the Time of Shahrukh in the Topkapı Palace Museum," *Timurid Art and Culture*, ed. L. Golombek and M. Subtelny (Leiden, 1992), pp. 103–15

A. Soudavar: *Art of the Persian Courts: Selections from the Art and History Trust Collection* (New York, 1992), pp. 57–83

C. Gawharshad [Gawharshād] (*d.* Heart, 1457). Wife of (B) Shahrukh. Daughter of Ghiyath al-Din Tarkhan, an important Chaghatay notable whose family had close connections to the Timurid line, Gawharshad was the power behind the throne during her husband's reign and one of the most notable patrons of architecture during the period. Several other female members of the Timurid house commissioned buildings, but she was the only one known to have endowed mosques. Her buildings are mentioned in contemporary texts far more often than those of her husband, an indication of their importance. Outstanding by virtue of their size and the quality and scope of their decoration, they are arguably the finest monuments in the Iranian world of the 15th century.

Her first work was an addition to the shrine of Imam Riza at Mashhad (1418–19; see fig. 2), most notably a large congregational mosque in which the court architect, Qavam al-din shirazi, cleverly adapted the traditional four-iwan plan to the

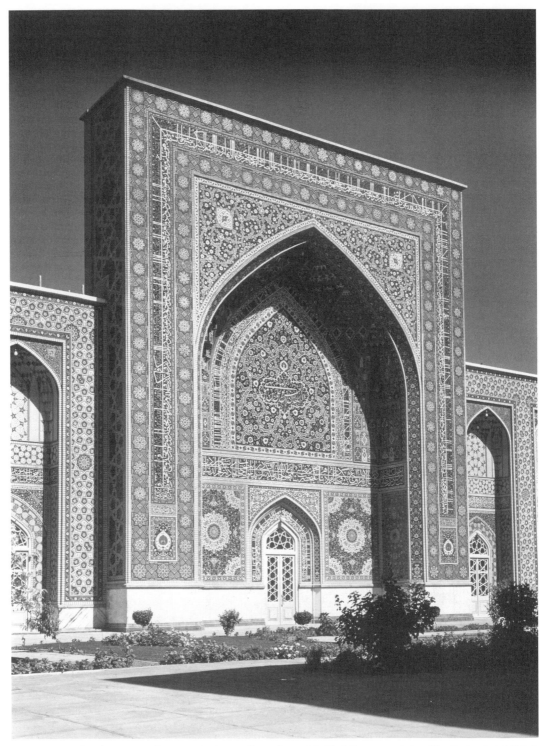

2. Entrance portal to the mosque adjacent to the shrine of Imam Riza at Mashhad, Iran, commissioned by Gawharshad, 1418–9; photo credit: Bridgeman-Giraudon/Art Resource, NY

exigencies of the site. Her major project was a complex in Herat that contained the dynastic mausoleum for the new capital. Located on Khiaban, the avenue leading north from the old city, this complex was the first Timurid building in the area and became the architectural focus of the entire city. Qavam al-Din was again the architect. The complex, later known as the Musalla, included a large rectangular congregational mosque (116×63.5 m.; 1417–38) and a slightly smaller madrasa with a domed mausoleum in the corner (1432–3). Large portions of it survived until the late 19th century, but only the tomb and two minarets remain to show the extent of the patron's resources and high level of her taste. The complex was at the forefront of architectural innovation in the 15th century: the minarets are clad in brilliant tile mosaic with intricate geometric patterns and inscriptions, and the vaulting within the tomb uses an elaborate system of squinch nets that integrates the interior space into a unified vertical composition (for illustration see HERAT). The sole extant object made for Gawharshad is a dark green almond-shaped jade seal (St. Petersburg, Hermitage, SA-13650).

T. Allen: *A Catalogue of Toponyms and Monuments of Timurid Herat* (Cambridge, MA, 1981)

T. Allen: *Timurid Herat* (Wiesbaden, 1983)

B. O'Kane: *Timurid Architecture in Khurasan* (Costa Mesa, CA, 1987)

L. Golombek and D. Wilber: *The Timurid Architecture of Iran and Turan*, 2 vols. (Princeton, 1988)

P. P. Soucek: "Tīmūrid Women: A Cultural Perspective," *Women in the Medieval Islamic World*, ed. G. R. G. Hambly (New York, 1998), pp. 199–226

D. ISKANDAR SULTAN [Iskandar Sultān] (*b.* Uzgend, Kyrghyzstan, 2 April 1384; *d. c.* 3 March 1415). Grandson of (A) Timur. His father was Timur's eldest son, 'Umar Shaykh (1354–94). Patron of the arts of the book, architecture, literature and science, Iskandar Sultan enjoyed princely status throughout his life: he served as governor of Fars from 1395, of Ferghana from 1399 and, after a breach of discipline in 1401, of Hamadan from 1403, of Yazd from 1406, and again of Fars from 1409. In 1414 he rebelled against his uncle Shahrukh and was captured and blinded in July 1414. He is believed to have died just before his 31st birthday at a time close to that forecast in his horoscope. This horoscope (London, Wellcome Inst. Lib., MS. Pers. 474) was completed on 18 April 1411 at Shiraz by the scribe Mahmud ibn Yahya ibn al-Hasan al-Kashi. It contains advanced arithmetic, geometric and trigonometric operations that show not only Iskandar Sultan's interest in astrology but also the advanced state of these studies in 15th-century Iran. A splendid double-page diagram illustrates the signs of the zodiac and the planets at the moment of Iskandar Sultan's birth. The manuscript also contains fine chinoiserie illumination of the type characteristic of his workshop and found in the most elaborate and famous works produced for him, two anthologies done at Shiraz in 1410–11 (Lisbon, Fund. Gulbenkian, LA 161 and London, BL, Add. MS. 27261; *see* ILLUSTRATION, fig. 14).

Iskandar's interest in science and astrology is clear from several other surviving manuscripts. A scientific compendium (1411; Istanbul, U. Lib., F. 1418) includes astrological tables and calculations illustrated with zodiacal miniatures similar to those in the London anthology, and a painting depicting an observatory. Iskandar also commissioned a copy of al-Tusi's astronomical tables, *Zīj-i Ilkhānī* (Istanbul, Topkapı Pal. Lib., A. III 3513), completed in 1411 by Mahmud al-Hafiz al-Husayni, one of the calligraphers of the Lisbon anthology, and an undated scientific encyclopedia illustrated with diagrams (ex-Kevorkian priv. col.; sold London, Sotheby's, 27 April 1981, lot 111).

Iskandar Sultan also favored poetic anthologies. Three have fine illumination: one copied by Mahmud al-Hafiz al-Husayni (New York, Met., 13.228.19) is dated 1411–12, while two (Istanbul. Mus. Turk. & Islam. A., 2044 and Lisbon, Fund. Gulbenkian, LA 158) are dated 1412–13. Another anthology copied at Yazd in 1407–8 (Istanbul, Topkapı Pal. Lib., H. 796), with 15 illustrations related to the Jalayirid school of Baghdad (*see* ILLUSTRATIONS, §V, C) is not specifically dedicated to Iskandar Sultan but is generally accepted as his earliest commission. Iskandar Sultan seized Isfahan in 1412, and the only work known to have been produced for him there is a group of 29 large-size folios dated 23 June 1413 and preserved in an album of mixed contents probably compiled in Herat before 1430 (Istanbul, Topkapı Pal. Lib., B. 411). Two folios with poetry written in nine columns and examples of fine chinoiserie drawing link this work to his other anthologies, and other folios with astrological tables, a world map and a sketch of a human skeleton show his interest in the natural sciences.

Iskandar Sultan erected palaces at Yazd and Shiraz and started an elaborate complex in Isfahan called Naqsh-i Jahan, which was intended to rival the Rab'-i Rashidi, the suburb of Tabriz built by Rashid al-Din a century earlier, but no trace of Iskandar Sultan's buildings remains. Apart from his horoscope, the main source for his character and interests is a preface in his name entitled *Jāmi' al-sultānī* (Cambridge, U. Lib., E.G. Browne MS. H 5/7). It confirms his interest in astrology as "valuable to statesmen" and in occultism and extreme forms of Shi'ite mysticism. Aubin questioned Iskandar Sultan's sincerity and attributed his patronage to political motives, but further research has confirmed that his taste and interests were genuinely personal. In the arts of the book, he refined the style already current in Shiraz by recruiting the finest artists from Ahmad Jalayir's studio at Baghdad and was thus the first Timurid patron of the arts of the book.

J. Aubin: "Le Mécénat timouride à Shiraz," *Stud. Islam.*, viii (1957), pp. 71–88

Z. Akalay: "An Illustrated Astrological Work of the Period of Iskandar Sultan," *Akten des VII. Internationalen Kongresses für iranische Kunst und Archäologie: München, 1976*, pp. 418–25

L. P. Elwell-Sutton: "A Royal Timurid Nativity Book," *Logos Islamikos: Studia Islamica in Honorem Georgii Michaelis Wickens*, ed. R. M. Savory and D. A. Agius (Toronto, 1984)

F. Keshawarz: "The Horoscope of Iskandar Sulṭān," *J. Royal Asiat. Soc. GB & Ireland* (1984), pp. 198–208

P. P. Soucek: "The Manuscripts of Iskandar Sultan: Structure and Content," *Timurid Art and Culture*, ed. L. Golombek and M. Subtelny (Leiden, 1992), pp. 116–31

F. Richard: "Un Témoignage inexploité concernant le mécénat d'Eskandar Solṭān à Eṣfahān," *Orient. Mod.*, xv/76 (1997), pp. 45–72

P. P. Soucek: "Eskandar b. 'Omar Šayx b. Timur: A Biography," *Orient. Mod.*, xv/76 (1997), pp. 73–87

S. Tourkin: "Astrological Images in Two Persian Manuscripts," *Pearls of the Orient: Asian Treasures from the Wellcome Library*, ed. N. Allan (London, 2003), pp. 73–85

E. Wright: "Firdausi and More: A Timurid Anthology of Epic Tales," *Shahnama: The Visual Language of the Persian Book of Kings*, ed. R. Hillenbrand, Varie Occasional Papers II (Aldershot, 2004), pp. 65–84

E. ULUGHBEG [Ulugbeg] (*b.* Sultaniyya, 22 March 1394; *r.* 1447–9; *d.* nr. Samarkand, 25 Oct. 1449). Eldest son of (B) Shahrukh and (C) Gawharshad. As governor of Samarkand, he established a mosque–madrasa (1417–20) and *khanaqah* (*c.* 1420; destr.) on the Registan Square (*see* SAMARKAND, §III, D). The mosque–madrasa is the largest and most complex example of the traditional four-iwan type; in scale and use of materials it reflected the tradition of the patron's grandfather, Timur, with whom he closely identified. The madrasa hosted the study of secular and religious sciences and was the site of planning sessions for the new observatory (1420; *see* SAMARKAND, §III, E), whose construction attests to the patron's interest in astronomy. His construction of a monumental gate (1435–6) to the Shah-i Zinda, the necropolis outside Samarkand (*see* SAMARKAND, §III, A), directed the ensemble towards the city. Perhaps in homage to Timur, Ulughbeg enlarged the Dar al-Tilava at the Barlas Cemetery at Shahr-i Sabz, which housed the tomb of the Sufi master of Timur's father, with the Gok Gumbad Mosque (1435–6) and a mausoleum, the Gumbad-i Sayyidan (1437–8), for his own descendants. He also built madrasas in Bukhara, Ghujdivan and other cities.

An unusually large number of objects can be ascribed to the public and private patronage of Ulughbeg. A huge stone stand for a Koran manuscript in the court of the mosque of Bibi Khanum in Samarkand bears his name, as does the splendid JADE gravestone for Timur in the Gur-i Mir at Samarkand (after 1425). The gravestone is inscribed with Timur's spurious genealogy claiming descent from Alanqoa, a mythical Mongol queen, in an attempt to connect the Timurids to the line of Ghenghis Khan. Among the exquisite objects for Ulughbeg's personal use are

several jade cups (e.g. London, BM; Varanasi, Benaras Hindu U., Bharat Kala Bhavan 3/8860), a jade jug (Lisbon, Fund. Gulbenkian) and a carved sandalwood box inlaid with polychrome marquetry, gold fittings and lined with silk (Istanbul, Topkapı Pal. Mus.) whose superb workmanship and elegant design testify to the patron's discriminating taste. Several manuscripts show his interest in astronomy and mathematics; they include a copy of al-Sufi's *Suwār al-kawākib al-thābita* ("Book of fixed stars"; Paris, Bib. N., MS. Arabe 5036) with 74 colored drawings, a *Zīj al-gurkanī* ("Gurkanid ephemeris"; Houston, TX, A. & Hist. Trust col.) and a copy of al-Kashi's *Miftāḥ al-ḥisāb* ("Key to calculation"; 1427; St. Petersburg, Saltykov-Shchedrin Pub. Lib., MS. Dorn 131). A double-page illustration (Washington, DC, Freer, 46.26 and Richmond, Surrey, Keir priv. col., III.76) to an unidentified manuscript bears a probable portrait of Ulughbeg.

V. V. Barthold: *Four Studies on the History of Central Asia*, ii: *Ulugh-Beg* (Leiden, 1963)

A. Soudavar: *Art of the Persian Courts: Selections from the Art and History Trust Collection* (New York, 1992), pp. 67–70

F. IBRAHIM SULTAN [Ibrāhīm Sulṭān] (*b.* 26 Aug. 1394; *d.* 3 May 1435). Second son of (B) Shahrukh. Ibrahim Sultan began his career as governor of Balkh and Tokharistan (the middle Amu basin) in 1409, but he spent most of his life in Shiraz as governor of Fars (1414–35), where he was a noted patron and calligrapher. He is said to have designed inscriptions on several buildings at Shiraz, including two madrasas he founded, the Dar al-Safa ("House of purity") and the Dar al-Aytam ("House of orphans"). At least five manuscripts of the Koran in his own hand survive (e.g. 1427, New York, Met., 13.228.1-2; 1430–31, Shiraz, Pars Mus., MS. 430 M/P). He is also reported to have copied a giant manuscript of the Koran, which he endowed to the cemetery of Baba Lutfallah 'Imad al-Din in Shiraz. Ibrahim Sultan maintained close relations with his younger brother, (G) Baysunghur, in Herat. An anthology copied at Shiraz in 1420 by Mahmud ibn Murtaza al-Husayni, the calligrapher who had copied the anthology for (D) Iskandar Sultan six years earlier, bears a dedication to Baysunghur and must have been a gift from his brother (Berlin, Mus. Islam. Kst., I.4628). Under the patronage of Iskandar Sultan an identifiable style of painting developed in Shiraz (*see* ILLUSTRATION, §V, D, 4); it is characterized by simple compositions with spongy horizons and inhabited by wasp-waisted figures. The style is best seen in two manuscripts. An undated copy of the *Shāhnāma* ("Book of kings"; *c.* 1435; Oxford, Bodleian Lib., Ouseley Add. MS. 176), a sumptuous manuscript with 47 illustrations, 5 gold-tinted drawings and many splendid illuminations, may well have been commissioned as a response to Baysunghur's new copy of the text. The *Zafarnāma* ("Book of victory"), which Ibrahim Sultan commissioned Sharaf al-Din 'Ali Yazdi to write, is a panegyric biography of Timur that advanced the claims of

Shahrukh's line over those of Timur's other sons. The first illustrated copy of the text (dispersed) was completed in June/July 1436, after the death of Ibrahim Sultan. The paintings underscore the message of the text, for the figure of Timur is emphasized in a series of battles, sieges and enthronements. A mail-and-plate armor shirt, inscribed with Ibrahim Sultan's name (Riyadh, Shaykh El Ard priv. col.), is the earliest surviving datable armor of its kind. Made of iron damascened in gold, it shows the new style of Timurid armor.

E. Sims: "Ibrāhīm-Sulṭān's Illustrated Ẓafar-nāmeh of 839/1436," *Islam. A.*, iv (1991), pp. 175–218

E. Sims: "Ibrahim-Sultan's Illustrated Ẓafarnama of 1436 and its Impact in the Muslim East," *Timurid Art and Culture*, ed. L. Golombek and M. Subtelny (Leiden, 1992), pp. 132–43

G. BAYSUNGHUR [Ghiyāth al-Dīn Baysunghur] (*b.* Tabriz, 15 Sept. 1397; *d.* Herat, 21 Dec. 1433). Third son of (B) Shahrukh and (C) Gawharshad. A patron and calligrapher himself, Baysunghur was governor of Herat from 1410 and head of the chancery from 1417. From 1419 until his untimely death from alcohol, he was the leading patron of the production of fine manuscripts, centered in his studio at Herat. It was headed by the calligrapher JAʿFAR, a master in the line of MIR ʿALI TABRIZI who is credited with the invention of *nastaʿlīq* script. Together with the designer Sayyid Ahmad, the illuminator KHWAJA ʿALI and the binder Qivam al-Din, Jaʿfar had been brought from Tabriz, probably after Baysunghur captured the city on 16 November 1420. Jaʿfar soon acquired the epithet *al-baysunghurī*, which was added to his name in the colophon of a manuscript of Nizami's *Khusraw and Shirin* (1421; St. Petersburg, Acad. Sci., Inst. Orient. Stud., MS. B. 132). Baysunghur had attached another painter, Ghiyath al-Din, to Shahrukh's embassy to China, which left Herat in November 1419 and returned in September 1422. The artist reported that in the arts of stonecutting, carpentry, pottery, painting and tile-cutting, no one in the whole of the Iranian world could compare with the Chinese, and Chinese motifs were subsequently incorporated into the Timurid decorative repertory. Another painter, Amir Khalil, said to have been one of the four skilled men at the court of Shahrukh, is generally credited with producing some of the finest paintings in Baysunghur's manuscripts, such as those in a copy of Saʿdi's *Gulistān* ("Rose-garden"; 1426–7; Dublin, Chester Beatty Lib., MS. P. 119), an anthology of poetry and treatises on music and chess (1426–7; Florence, I Tatti), two copies of *Kalila and Dimna* (1429, Istanbul, Topkapı Pal. Lib., R. 1022; 1431, Istanbul, Topkapı Pal. Lib., H. 362) and a copy of Khwaju Kirmani's *Humay and Humayun* (1427–8; Vienna, Österreich. Nbib., N.F. 382). Baysunghur's most important commission is a copy of Firdawsi's *Shāhnāma* ("Book of kings"), completed by Jaʿfar in January 1430 (Tehran, Gulistan Pal. Lib., 61). In addition to 21 illustrations and fine illumination, it contains the new preface that Baysunghur

had written in 1426. The last illustrated manuscript known to have been prepared for Baysunghur is a modest copy of Nizami ʿArudi's *Chahār maqāla* ("Four discourses"; 1431; Istanbul, Mus. Turk. & Islam. A., MS.1954). Baysunghur also commissioned several historical manuscripts with fine illumination, including a copy of Sadr al-Din ibn Muhammad ibn Hasan Nizami's *Tāj al-maʾāthir fi taʾrīkh* ("Crown of the glories of history"; Aug. 1426; St. Petersburg, Acad. Sci., Lib., MS. 578), a translation of al-Tabari's *Annals* (March 1430; St. Petersburg, Rus. N. Lib., Pers. N.S. 49) and a copy of Juvayni's *Tārīkh-i jahāngūshā* ("History of the world-conqueror"; 1431–2; Richmond, Surrey, Keir priv. col., VII.62).

A report (Pers. ʿarza dāsht) of *c.* 1429 records work in progress in Baysunghur's atelier (Istanbul, Topkapı Pal. Lib., H. 2513, fol. 98*r*). It mentions several of Baysunghur's known artists and manuscripts and refers to the construction of a workshop decorated with wall paintings at his garden palace in a suburb of Herat. His artists must have employed a common stock of designs, for six of the compositions in the *Kalila and Dimna* manuscripts of 1429–30 and 1431 are partly or wholly repeated (two in reverse), and two in the *Shāhnāma* of 1430 repeat those of Jalayirid illustrations done 60 years earlier (Istanbul, Topkapı Pal. Lib., H. 2153, fols. 73*v*, 82*r* and 171*v*), showing that stencils were routinely used.

As calligrapher, Baysunghur designed the long dedicatory inscription around the portal arch of his mother's mosque at Mashhad. Written in white *thuluth* script on an arabesque ground, it is dated AH 821 (1418) and is one of the finest examples of monumental calligraphy from the period. Other examples of his work are included in two albums (Istanbul, Topkapı Pal. Lib., H. 2152 and 2153). He also collected calligraphy by earlier masters, as in the album dedicated to him (Istanbul, Topkapı Pal. Lib., H. 2310). A dispersed manuscript of the Koran with enormous (*c.* 2×1 m) folios written with seven lines of majestic *muhaqqaq* script has marginal attributions to him, but there is no other evidence to support them.

Enc. Iran.: "Baysonğor"

Ghiyath al-Din Naqqash: "Report to Mirza Baysunghur on the Timurid Legation to the Ming Court at Peking" and "ʿArza Dasht," Eng. trans. by W. M. Thackston in *A Century of Princes: Sources on Timurid History and Art* (Cambridge, MA, 1989), pp. 279–97, 323–8

B. W. Robinson: "Prince Bāysunghor's Niẓāmī: A Speculation," *A. Orient.*, ii (1957), pp. 383–91

Y. Zoka: "The Bay-Shonghori Koran and its Fate," *J. Reg. Cult. Inst.*, ii (1969), pp. 96–102

B. W. Robinson: "Prince Baysunghur and the Fables of Bidpai," *Orient. A.*, n. s., xvi (1970), pp. 145–54

B. Gray: *An Album of Miniatures and Illuminations from the Baysonghori Manuscript of the Shahnameh of Ferdowsi—Preserved in the Imperial Library, Tehran* (Tehran, 1971)

E. Sims: "Prince Baysunghur's *Chahar Maqaleh*," *Sanat Tarıhı Yıllığı*, vi (1974–5), pp. 375–409

M. Minovi: "Introduction au Shāhnāme Bāysonkori," *Luqman*, i/2 (1985), pp. 54–71

O. F. Akimushkin: "Baĭsungur-mirza i ego rol' v kul'turnoĭ i politicheskoĭ zhizni Khorasanskogo sultanata Timuridov pervoĭ treti XV veka" [Abstract: Baysunghur-Mirza's role in cultural and political life of Timurid Khorasan Sultanate (the first third of XVth century], *Peterburgskoe Vostokovedenie*, v (1994), pp. 143–68

O. F. Akimushkin: "The Library–Workshop (Kitābkhāna) of Bāysunghur-Mīrzā in Herat," *Manuscripta Orientalia*, iii/1 (1997), pp. 14–24

D. Roxburgh: "Baysunghur's Library: Questions Related to its Chronology and Production," *J. Soc. Affairs*, xviii/72 (2001), pp. 11–39

S. Tourkin: "Another Look on the Petition ('Arḍadāšt) by Jaʿfar Bāysunġurī Addressed to his Patron Bāysunġur b. Šāhruḫ b. Tīmūr," *Manuscripta Orientalia*, ix/3 (2003), pp. 34–8

D. Roxburgh: *The Persian Album 1400–1600: From Collection to Dispersal* (New Haven, 2005), pp. 37–84 [Baysunghur's calligraphic album]

H. SULTAN HUSAYN [Husayn ibn Manṣūr ibn Bayqara; Sultan-Husayn Mirza; Sultan Husayn Bayqara] (*b.* Herat, June 1438; *r.* 1470–1506; *d.* Herat, 1506). Great-great-grandson of (A) Timur. Descended from Timur's son ʿUmar Shaykh, Sultan Husayn succeeded his distant cousin Abu Saʿid (*r.* 1451–69) as sultan of Khurasan. His capital Herat became an important cultural center, for the mystic Khwaja Ahrar Naqshbandi, the poet Jami, the historian Mir Khwand, the calligrapher SULTAN ʿALI MASHHADI and the painter BIHZAD gathered at his court along with his close friend, the poet and patron ʿALISHIR NAVAʾI. The ruler himself composed a sort of *Apologia pro vita sua* as well as poetry in Turkish and Persian, which Navaʾi praised highly. Several luxury copies of his *Dīvān* (collected poetry) survive, such as one copied by Sultan ʿAli Mashhadi in 1485 (Paris, Bib. N., MS. Supp. Turc 993).

During Sultan Husayn's long reign there was a virtual building boom in the suburbs of Herat because the Ju-yi Sultani ("royal canal") watering the northern slopes had been built at the end of his predecessor's reign. The sultan's building efforts were largely confined to Herat and its environs as he controlled only a limited region. His first project (1469) was the Bagh-i Jahanara ("world-adorning garden"), a new royal estate northeast of the city. Covering over 70 ha, it included at least a dozen pavilions, offices, kiosks, a reservoir and a meadow. He built a large madrasa and *khanaqah* (1492–3) in the city, of which only the tile-clad minarets at its four corners survived into the 20th century. The tile mosaic in black, light and dark blue, white, buff, yellow and an unusual light green is even more elaborate than that on the neighboring complex of Gawharshad. He greatly enlarged the shrine of ʿAli ibn Abi Talib at Mazar-i Sharif (1480–81), probably to curry the favor of Shiʿites, and ordered a spacious congregational mosque (1482–5) for Ziyaratgah, a small village 20 km south of Herat. In his *Apologia* he clearly articulated how the patronage of architecture

benefited a ruler, boasting that he and his officials had restored endowments to their rightful beneficiaries, established madrasas and *khanaqah*s and provided caravanserais with regiments of soldiers to protect travelers and merchants from brigands and the weather.

Under the patronage of Sultan Husayn, the arts of the book were reinvigorated in Herat. A copy of the *Zafarnāma* ("Book of victory"; Baltimore, MD, Johns Hopkins U., Garrett Lib.), which recounted the exploits of his illustrious ancestor Timur, was completed in 1467–8 on the eve of Husayn's capture of Herat and was meant to express his political ambitions. About a decade later this message was underscored by the addition to the manuscript of six double-page illustrations, two of which emphasize the role of his great-grandfather ʿUmar Shaykh in Timur's campaigns. The refined taste of Sultan Husayn's court is exemplified by several superb manuscripts, including a copy of Saʿdi's *Gulistān* ("Rose garden"), penned by Sultan ʿAli Mashhadi in January 1486, with one of its three paintings probably depicting the ruler and ʿAlishir. Perhaps the most splendid is a manuscript of Saʿdi's *Būstān* ("Orchard"; Cairo, N. Lib., Adab Farsi 908), penned by Sultan ʿAli in June 1488 and illustrated by Bihzad with five paintings (see fig. 3). Dozens of other manuscripts of lyric poetry, such as copies of Attar's *Manṭiq al-ṭayr* ("Conference of the birds"; 1483; New York, Met., 63.210; *see* COLLECTORS AND COLLECTING, fig. 1) and Nizami's *Khamsa* ("Five poems") are attributable to the workshop that flourished under court patronage. The refined taste of Sultan Husayn extended to other media: a striped agate wine cup is inscribed with poetry, his name and the date 874 (1470–71; Houston, TX, A. & Hist. Trust col.) and a brass wine jug inlaid with gold and silver (London, BM) was completed by Muhammad ibn Shams al-Din al-Ghuri on 11 April 1498. A group of tombstones exquisitely carved with arabesques and lush vegetal ornament on several levels (e.g. Boston, MA, Isabella Stewart Gardner Mus.) can be dated to the reign of Sultan Husayn; they show that stone-carvers were aware of design innovations in other media.

Sultan Husayn was perceived as a model prince, and portraits of him, both originals and copies, were circulated among his contemporaries and successors (e.g. Cambridge, MA., Sackler Mus., 1958.59, attributable to the first quarter of the 16th century). The style of painting that flourished under his patronage became the koine for subsequent generations in Transoxiana, and later manuscripts were sometimes falsely dated to his reign. A copy of Jami's *Baharistān* ("Spring garden"; Lisbon, Fund. Gulbenkian, MS. LA 169), for example, was made at Bukhara for the Shaybanid ruler ʿAbd al-ʿAziz in 1547. Although each page bears a dedication to him, the manuscript carries a false date of 1498 and a spurious dedication to Sultan Husayn.

T. Gandjeï: "Uno scritto apologetico di Husain Mirza, sultano del Khorasan," *Annali: AION*, n. s., v (1953), pp. 157–83;

Eng. trans. by W. M. Thackston as "Sultan-Husayn Mirza's 'Apologia,'" *A Century of Princes: Sources on Timurid History and Art* (Cambridge, MA, 1989), pp. 373–8

M. E. Subtelny: "Scenes from the Literary Life of Timurid Herat," *Logos Islamikos: Studia Islamica in Honorem Georgii Michaelis Wickens*, ed. R. M. Savory and D. A. Agius (Toronto, 1984), pp. 137–55

T. W. Lentz and G. D. Lowry: "Sultan-Husayn and the Restructuring of the Timurid Façade," *Timur and the Princely Vision: Persian Art and Culture in the Fifteenth Century* (Los Angeles, 1989), pp. 239–302

A. Soudavar: *Art of the Persian Courts: Selections from the Art and History Trust Collection* (New York, 1992)

B. Brend: "A Kingly Posture: The Iconography of Sultan Husayn Bayqara," *The Iconography of Islamic Art: Studies in Honour of Robert Hillenbrand*, ed. B. O'Kane (Edinburgh, 2005), pp. 81–92

Tiraz [Arab. *ṭirāz*]. Inscription band in Islamic textiles, or fabric with an inscription band added in a technique different from the ground weave (*see* TEXTILES, fig. 1). Derived from the Persian word for embroidery, the term originally designated any embroidered ornament. In the early Islamic period textiles were often decorated with inscriptions containing good wishes and the caliph's name and titles, and these fabrics were made up into robes of honor worn by the caliph or bestowed by him as official gifts. Hence the word came to refer to inscription bands done in embroidery or any other technique and the fabrics or garments on which they were found. Tiraz also referred to the workshops in which these fabrics were made, a synecdoche for *dār al-ṭirāz* ("factory for tiraz"). In later times the word tiraz was also used to refer to the long bands inscribed with the ruler's name and titles that were written across the façades of major buildings, as at the mausoleum of Sultan Qala'un in Cairo (1284–5).

The institution of the tiraz—the production of textiles under state supervision in royal factories—flourished in the Islamic world under the patronage of the Abbasid and Fatimid caliphs from the late 9th century to the 13th, when a new taste evolved for patterned silks and all-over embroidered or printed cottons. Most surviving pieces come from the burial grounds at Fustat (Old Cairo), for these were prized and expensive textiles and many were used for shrouds. A few have been preserved in European church treasuries. Major collections are in the Museum of Islamic Art in Cairo (with nearly 1000 inscribed pieces), the Victoria and Albert Museum in London and the Textile Museum in Washington, DC. Studies of tiraz have concentrated on their historical value, since the inscriptions sometimes name the ruling caliph, an amir or local governor, the vizier who supervised the work and the intendant at the workshop as well as the place and date of manufacture, sometimes specified as private or royal (*khāṣṣa*) or public ('*āmma*), but these textiles are also important for documenting changes in weaving techniques, sartorial taste and epigraphic style.

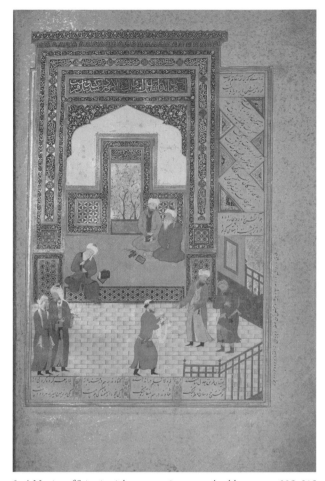

3. *A Meeting of Scientists*, ink, opaque pigment and gold on paper, 305×215 mm, from a manuscript of Sa'di's *Būstān* ("Orchard"), made for Sultan Husayn, Herat, 1488 (Cairo, National Library, MS. Arab Farsi 908); photo credit: Erich Lessing/Art Resource, NY

I. Technical characteristics. II. Stylistic evolution.

I. Technical characteristics. The numerous literary texts describing court vestments and furnishings speak primarily of silks, but surviving tiraz are mainly linens and other lightweight fabrics. Most are fragments from mantles, summer outfits and undergarments, turbans, shawls, sashes, napkins, presentation towels and such furnishing fabrics as curtains. The only complete garment is the Veil of Ste. Anne (1096–7; Apt Cathedral), which is made of bleached linen tabby adorned with three parallel bands of tapestry-woven ornament in colored silk and some gold filé. In the center is a wide band of interlacing circles joining three medallions containing pairs of addorsed sphinxes encircled by kufic inscriptions naming the patron, the Fatimid caliph al-Musta'li (*r.* 1094–1101), and the supervisor of the work, his vizier al-Afdal. The side bands contain birds, animals and another inscription saying that the textile was woven in the royal factory at Damietta in 1096–7.

The piece was probably worn as an overgarment or mantle, with the small slits at the side for the hands and the central band containing the medallions falling down the back. Other mantles and simple tunics popular under the Abbasid and Fatimid caliphs were constructed from two narrow widths. Produced on simple vertical looms, these garments needed only a little stitching along the selvage. Fabrics from the eastern Islamic world, however, were typically woven on horizontal looms, and garments were constructed from narrow widths of cloth with many seams.

Until the 12th century there was a dichotomy in the nature of the ground fabric: cotton was used in Iraq, Iran, India and the Yemen, while linen was used in Egypt. Although threads were traded across the Islamic world, imported ones were used sparingly, being reserved for special purposes, particularly decorative bands. The cotton fabrics from the eastern Islamic world were finely woven with undyed Z-spun yarn in tabby weave and were often glazed so that they look like polished paper. Cotton was also combined with silk in a delicate, light fabric known as *mulham* ("half-silk") in which warps of fine, raw silk floss were woven with wefts of heavier, Z-spun cotton in tabby weave (usually weft-faced). Medieval geographers mentioned Khwarazm in Central Asia, Merv and Nishapur in Khurasan, and Isfahan in central Iran as places where *mulham* was manufactured. Surviving cotton and mulham fabrics are decorated with short inscriptions, mostly embroidered in colored silk floss. The main band is worked in chain stitch on the free-drawn lines of the lettering, and a small band, not always decipherable, may be added in blanket or backstitch or worked on counted threads. Some of the cotton pieces have painted, printed or gilded inscriptions, which were a cheaper imitation of embroidery. A distinct group of cottons manufactured in the Yemen are ikats. The thick, Z-spun warps were resist-dyed before weaving in shades of blue, brown and white, and the fabrics have characteristic stripes with splashed arrow patterns and embroidered or painted inscriptions. Some mention San'a as a place of manufacture, but there were probably other sites as well.

Egyptian linen was traditionally S-spun, but in the late 9th century the Z-spinning typical of the eastern Islamic world was introduced. The fabric was usually bleached, but occasionally dyed blue or green. At first, silk inscriptions were embroidered on linen in imitation of pieces from the eastern Islamic world, but silk tapestry appeared in the second quarter of the 10th century. In the 12th century tapestry woven bands were in turn supplanted by embroidered decoration of conventionalized ornaments and cursive inscription bands. Embroidered inscriptions were done with colored silk floss in various counted thread stitches, and tapestry bands were woven in colored silk wefts and occasionally gold filé on a yellow silk core. The factories at Alexandria, Tinnis and Misr (Old Cairo) produced on such a large scale that the specific characteristics of each center can be identified.

II. Stylistic evolution. The institution of the tiraz was modeled on Byzantine and Sasanian precedents, although it is not certain whether pre-Islamic workshops were taken over and kept in operation. Pieces inscribed with the caliph's name were already produced under the Umayyads (r. 661–750), the first Islamic dynasty. One of the earliest surviving is a fragmentary silk twill (London, V&A; New York, Brooklyn Mus.; Brussels, Mus. A. Anc.) found in Egypt. The main field is decorated with an all-over pattern of circles containing bunches of grapes and flowers with heart-shaped petals. An inscription embroidered along the edge in yellow silk indicates that it was woven for Marwan, the Commander of the Faithful, in the tiraz of Ifriqiya. The patron was an Umayyad caliph, either Marwan I (r. 684–5) or, more probably, Marwan II (r. 744–50), and the factory was located somewhere in Tunisia, probably at Kairouan.

The output of state factories for the production of tiraz can be clearly documented in Egypt from the 9th century, and over time both the titles and the style used in the inscriptions became more elaborate. A typical piece made for an Abbasid caliph in the late 9th century or early 10th has one long line of text written in a simple form of angular kufic script. The text begins with the invocation to God and blessings for the caliph under whose authority the textile was made. The inscription continues with the name of the vizier who ordered the piece, the place of production, the name of the supervisor and the date. Variations in wording may indicate different places of manufacture or different rulers. The phrase *'alā yaday* ("through the agency of"), for example, was used on Egyptian pieces before the name of the factory supervisor, while in the eastern Islamic world it preceded the name of the government official who ordered the textile to be made. The Fatimid caliphs, who were Isma'ili Shi'ites, often invoked such sectarian phrases as "the People of the House" (*ahl al-bayt*) or "their pure ancestors" (*āba'ih al-ṭāhirīn*).

In the 10th century scripts became more mannered in style, as the shafts of the letters became taller and the tails of the letters were floriated (see fig.). The text was sometimes written in two facing bands. A linen textile (Washington, DC, Textile Mus., 73.432) made for the Fatimid caliph al-'Aziz (r. 975–96), for example, has a tapestry-woven inscription of large angular script with arabesques forming discs at the heads of the high (85 mm) letters. The text invokes God's blessing on his servant and friend the imam, al-'Aziz bi'llah; it was ordered by the vizier ibn Kilis in AH 370 (980–81), and probably made at Tinnis.

In the 11th century inscriptions became shorter and more decorative as non-historical texts, which repeated a single word or phrase such as "blessing" or "good fortune," were introduced. The crescent or shovel-shaped tails of the letters were extended below the base line. In pieces (e.g. Ann Arbor, U. MI Mus. A., 22528, and Cleveland, OH, Mus. A., 82.109) made for al-Zahir (r. 1021–36), the terminals are still attached correctly to descending letters, but

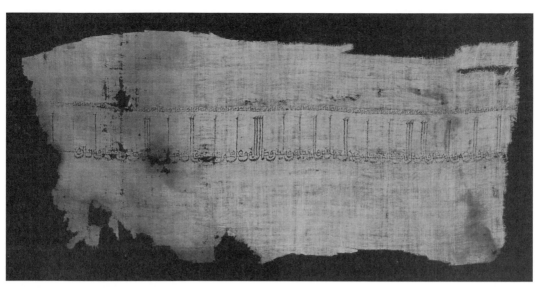

Fragment of a tiraz, undyed linen embroidered with blue silk with two bands of inscription, from Iraq, 195×420 mm, first half of the 10th century (Copenhagen, Davids Samling); photo credit: Davids Samling, Copenhagen

gradually the large endings were applied at regular intervals and attached indiscriminately to any letter, thereby obscuring the text and making it more difficult to read. The text on a linen woven a century later (Washington, DC, Textile Mus., 73.461), probably for al-Mustansir (r. 1036–94), is almost impossible to read because of the capriciously disposed shovel-shaped terminals. Legible texts were eventually replaced by a decorative "kufesque" script (e.g. Boston, MA, Mus. F.A., 30.676). The decline of historical inscriptions was accompanied by an increased use of decorative bands, either small-scale geometric patterns or designs of animals in cartouches. These narrow bands were executed in a variety of colors and generally occur in pairs, with one decorative band framed by inscribed bands and the other decorative band isolated on the ground some distance away (e.g. Washington, DC, Textile Mus., 73.543, made for al-Mustansir). In the 12th century these hard-to-read angular scripts were replaced by cursive ones, as on a linen woven under the supervision of the vizier al-Afdal (Washington, DC, Textile Mus., 73.680). The decorative bands became wider and more elaborate. They often contain medallions with animals or geometric motifs and are themselves framed by narrower bands with inscriptions or pseudo-inscriptions (e.g. Toronto, Royal Ont. Mus., 961.107.3). A wide variety of colors was used, but yellow–gold often predominates, perhaps in imitation of luxury textiles which used gold-wrapped thread.

The most remarkable inscriptions are those in interlaced kufic script on the ikat cottons made in the Yemen. One group made at San'a between 883 and 923 have embroidered decoration with numerous arcs inserted for decorative purposes in the base line of the inscription and in the vertical staffs. A second group dating from the late 9th century to the late 10th have painted and gilded inscriptions in elaborately plaited and foliated kufic. On the four pieces with historical inscriptions (Athens, Benaki Mus., 15603; Cleveland, OH, Mus. A., 50.353; Cairo, Mus. Islam. A.; Washington, DC, Dumbarton Oaks, 33.37), legibility was important and the interlacing was restricted to single letters and decoration confined to occasional trilobed rising tails or heart-shaped ornaments. Those with pious texts (e.g. Boston, MA, Mus. F.A., 31.962) are much more elaborate and have an extraordinary number of arcs, bumps, triangles, curls and other decorative devices inserted between and around the letters. These pious texts are extremely laborious to read, and only their limited repertory of phrases renders them decipherable.

Enc. Islam/2

G. Marçais and G. Wiet: "Le 'Voile de Sainte Anne' d'Apt," *Mnmts Piot*, xxxiv (1934), pp. 1–18

R. Pfister: "Materiaux pour servir au classement des textiles égyptiens postérieurs à la conquête arabe," *Rev. A. Asiat.*, x (1936), pp. 1–16, 73–85

F. Day: "Dated Tirāz in the Collection of the University of Michigan," *A. Islam.*, iv (1937), pp. 421–48

C. J. Lamm: *Cotton in Medieval Textiles of the Near East* (Paris, 1937)

N. P. Britton: *A Study of Some Early Islamic Textiles in the Museum of Fine Arts, Boston* (Boston, 1938)

R. B. Serjeant: "Material for a History of Islamic Textiles up to the Mongol Conquest," *A. Islam.*, ix–xvi (1942–51), repr. as *Islamic Textiles: Material for a History up to the Mongol Conquest* (Beirut, 1972)

R. Pfister: "Toiles à inscriptions abbasides et fatimides," *Bull. Etud. Orient.*, ix (1945–6), pp. 46–90

F. Day: "The Tirāz Silk of Marwān," *Archaeologica Orientalia in Memoriam Ernst Herzfeld*, ed. G. C. Miles (Locust Valley, 1952), pp. 39–61

E. Kühnel and L. Bellinger: *Catalogue of Dated Ṭirāz Fabrics: Umayyad, Abbasid, Fatimid*, Textile Mus. cat. (Washington, DC, 1952)

L. Golombek and V. Gervers: "Ṭirāz Fabrics in the Royal Ontario Museum," *Studies in Textile History in Memory of Harold B. Burnham*, ed. V. Gervers (Toronto, 1977), pp. 82–125

M. Lombard: *Les Textiles dans le monde musulmane du VIIe au XIIe siècle* (Paris, 1978)

S. S. Blair: "Legibility Versus Decoration in Islamic Epigraphy: The Case of Interlacing," *Acts of the XXVIth International Congress of the History of Art: Washington, DC, 1986*, ii, pp. 329–34

H. Glidden and D. Thompson: "*Ṭirāz* Fabrics in the Byzantine Collection, Dumbarton Oaks, Part One: *Ṭirāz* From Egypt," *Bull. Asia Inst.*, ii (1988), pp. 119–39

N. Micklewright: "*Ṭirāz* Fragments: Unanswered Questions about Medieval Islamic Textiles," *Brocade of the Pen: The Art of Islamic Writing* (exh. cat., ed. C. G. Fisher; East Lansing, MI State U., Kresge A. Mus., 1991), pp. 31–46

Islamische Textilkunst des Mittelalters: Aktuelle Probleme, Riggisberger Berichte 5 (1997) [several articles on tiraz]

C. P. Haase: "Some Aspects of Fatimid Calligraphy on Textiles," *L'Egypte Fatimide: Son art et son histoire*, ed. M. Barrucand, (Paris, 1999), pp. 339–48

Tirmidh. *See* Termez.

Tlemcen [Tilimsān; Sp. Tremecén]. Town in northwest Algeria. The site was first called Pomaria by the Romans; by the 8th century it was known as Agadir and a mosque (destr.) was erected *c.* 790. It later merged with a military camp, established in 1082 by the Almoravid Yusuf ibn Tashufin (*r.* 1061–1106). He founded the congregational mosque, which was enlarged in 1126 by his son 'Ali (*r.* 1106–42), to whose patronage the splendid pierced stucco dome over the bay in front of the mihrab is attributed (for illustration *see* Almoravid; *see also* Architecture, §V, D, 3). The Almohads (*r.* 1130–1269) surrounded the town with ramparts and constructed a citadel. Under Muhammad al-Nasir (*r.* 1199–1214), a tomb was erected for the Andalusian mystic Abu Madyan (Sidi Boumedienne; *d.* 1197) in the suburb of al-'Ubbad, 2 km southeast of the city. The town, an entrepôt for European and African products and an important religious and cultural center, became the capital of the Zayyanid dynasty (*r.* 1235–1550). Yaghmurasan, its founder, had the congregational mosque enlarged and a minaret added. Other monuments of this period include the small mosque of the Sidi Bel Hassan (1296; now the Archaeological Museum) with a richly decorated mihrab, the minaret (mid-13th century) added to the Agadir Mosque, and the mosque of Sidi Brahim (1308–18). In 1303 the Marinids (*r.* 1196–1465) constructed al-Mansura (Mansoura), a fortified base 2 km west for the siege of Tlemcen. The ruins of al-Mansura include a palace and a large congregational mosque (85×60 m; before 1336). In 1336 Tlemcen was conquered by the Marinid Abu'l-Hasan 'Ali (*r.* 1331–48) and the tomb of Abu Madyan transformed into an important shrine complex, including a mosque (1338–9), madrasa (1346), ablution facilities and residence (*see* Architecture, §VI, D, 2). The small mosque of Sidi al-Halwi (1354) has onyx columns taken from al-Mansura and a finely decorated minaret. The town was taken by the French in 1842 but unlike many Algerian towns, it preserves much of its traditional character and is known for its metal and leather crafts.

Enc. Islam/2: "Timilmsān"

G. and W. Marçais: *Les Monuments arabes de Tlemcen* (Paris, 1903)

G. Marçais: *L'Architecture musulmane d'Occident* (Paris, 1954)

W. al-Akhbar: *Tlemcen* (Algiers, 1971)

R. Bourouiba: *L'Art religieux musulman en Algérie* (Algiers, 1973)

R. I. Lawless and G. H. Blake: *Tlemcen: Continuity and Change in an Algerian Islamic Town* (London, New York and Durham, 1976)

A. M. Abderrahim Reichlen: "Carte commentée de la poterie rurale dans la wilaya de Tlemcen," *Libyca*, xxv (1977), pp. 219–54

S. S. Blair: "Sufi Saints and Shrine Architecture in the Early Fourteenth Century," *Muqarnas*, vii (1990), pp. 35–49

S. Slyomovics: "Geographies of Jewish Tlemcen," *The Walled Arab City in Literature, Architecture and History: The Living Medina in the Maghrib*, ed. S. Slyomovics (London, 2001), pp. 81–96

Tollu, Cemal (*b.* Istanbul, 19 April 1899; *d.* Istanbul, 1968). Turkish painter. He spent his childhood in the Hijaz (now Saudi Arabia), where he took painting lessons from a retired Ottoman officer while an apprentice in a workshop. In 1919 Tollu enrolled at the Fine Arts Academy in Istanbul but a year later went to Anatolia to join the forces fighting for Turkish independence, serving until 1923 as a cavalry lieutenant. After leaving the army he worked in a railway workshop in Edirne but in 1926 returned to the Fine Arts Academy in Istanbul. In 1927 he was appointed art teacher at the Teacher Training College in Elazig and Erzincan. He made two trips to France and Germany, where for some two years he studied under such painters as André Lhote (1885–1962), Marcel Gromaire (1892–1971) and Hans Hofmann (1880–1966), and such sculptors as Charles Despiau (1874–1946) and Marcel Gimond (1894–1961). In Turkey he contributed to the first exhibitions of the Müstakîl Ressamlar ve Heykeltraşlar Birliği (Association of Independent Painters and Sculptors) and was a founding member of the D Group in 1933. His works of this period include *The Ballerina* (1935; Istanbul, Mimar Sinan U., Mus. Ptg & Sculp.). Tollu was appointed vice-director of the Museum of Anatolian Civilizations in Ankara and was then selected by Léopold Lévy (1882–1966), head of the department of painting, to teach at the Fine Arts Academy in Istanbul, where he stayed until 1965. In his work he was inspired by Hittite as well as contemporary Western art, and he painted figures, landscapes and portraits in a distinctive fragmented style. His works include *Mother Earth* (1956) and *Fire of Manisa*

(1968; both Istanbul, Mimar Sinan U., Mus. Ptg & Sculp.).

S. Tansuğ: *Çağdaş Türk sanatı* [Contemporary Turkish art] (Istanbul, 1986), pp. 177–9, 189–90, 192, 247, 377–8

G. Renda and others: *A History of Turkish Painting* (Geneva, Seattle and London, 1988), pp. 197–8, 201, 203, 206–8, 210–12, 236, 249–51, 255, 360, 394

W. Ali: *Modern Islamic Art* (Gainesville, 1997), p. 18

S. Bozdogan: *Modernism and Nation Building: Turkish Architectural Culture in the Early Republic* (Seattle, 2002), p. 253

Cemal Tollu: Retrospektif/Cemal Tollu: Retrospective (exh. cat., ed. V. Ugurlu and trans. M. Esin; Istanbul, Yapi Kredi Kâzim Taskent Sanat Galerisi; 2005)

R. Kasaba, ed.: *Turkey in the Modern World*, iv of *Cambridge History of Turkey* (Cambridge, 2008), pp. 437, 441

Tomb. A place of burial or the marking of a grave. As the former it can take the form of a chamber, vault, crypt, sarcophagus or SHRINE, while as the latter it can take the form of a monument or mausoleum, usually built of stone, erected over a grave to commemorate the dead. With the exception of the mosque, the tomb is, in most parts of the Islamic world, the most widespread type of public building, often found as much in villages and the open countryside as in towns. The most celebrated examples are princely tombs, but they are outnumbered by places of pilgrimage or worship marking the actual or supposed graves of saints.

I. History. II. Form.

I. History. According to Muslim tradition, the Prophet Muhammad was fundamentally opposed to any formal commemoration of the dead, most notably to tombs. He recommended that graves be level with the ground and unroofed, and was himself buried—as he had requested—in simple fashion in his own house. This Islamic orthodoxy, however, ran counter to established practice in pre-Islamic times, both in the Mediterranean world and in west Asia, and was soon challenged. The burial places of Companions of the Prophet or members of his family began to be marked by a staff (still used as a funerary marker in such areas as Central Asia), a canopy, a tent or some similar form of covering intended to provide shade for the deceased. Such canopies of cloth were interpreted and thereby legitimized, following the Koran, as one of the blessings of Paradise and eventually found monumental form as open-plan tombs. Their legitimacy was defended on the grounds that the burial spot was open to wind and rain. Secular tombs might have a mihrab, added (often, appropriately, in the form of a tombstone) to turn them into places of worship, for Islamic tradition asserted that any place could serve for prayer (*see* ISLAM, §II). Another method of rendering a tomb more acceptable in terms of orthodoxy was to decorate it with Koranic inscriptions; although these texts rarely mention judgment and Paradise, they often cite Sura 31:35, stating that every soul must taste death.

The earliest surviving tomb is probably the Qubbat al-Sulaibiyya (mid-9th century) at SAMARRA, usually identified as a dynastic sepulcher for the Abbasid caliphs. Literary references, however, establish that tombs were built throughout the Islamic world from the previous century onwards. The tomb cult made such spectacular headway against deep-rooted orthodox resistance for several reasons. The most important was the growth of Shi'ism. Graves of the Shi'ite imams (descendants of the Prophet) at Karbala, Najaf, Samarra, QUM and MASHHAD became a natural focus of Shi'ite aspirations and ceremonies commemorating the killing of Husayn, the Prophet's grandson, on 10 Muharram 61 AH (10 October 680). As Muharram ceremonies developed, the graves received various marks of respect—grilles and cenotaphs (*see* CENOTAPH)—and these naturally culminated in actual buildings. The custom of visiting these graves, saying prayers and holding Koranic readings there helped to sanctify such buildings, and their upkeep, embellishment and expansion were financed by successive generations of pilgrims and local people alike expressing their piety. Thus, by degrees such tombs (whether at Mashhad in Iran or Moulay Idris in Morocco) became the nuclei of entire shrine complexes, which often extended over several acres and played a major role in the political, social and economic life of the community.

While religious particularism is the most convincing explanation for the phenomenal rise of the tomb cult, other theories are worth considering, including the relationship between the appearance of tombs and the spread of Islam by *jihād*. Along certain Islamic frontiers, such as in Central Asia, Nubia and India, tombs are found in exceptional quantities, and many of them are anonymous or bear names unknown to historical record. The tombs may well commemorate martyrs to the faith, and if so would illustrate once again the paradox of breaching orthodoxy on impeccably religious grounds. The impact of traditions outside Islamic culture must also be taken into account. In the Mediterranean world the Arabs encountered well-established traditions of funerary architecture, whether the awesome ancient Egyptian monuments, Roman tombs, Palmyrene tomb towers or Early Christian and Byzantine martyria. Such monuments were far more numerous in the past and were already influential from the very beginnings of Islamic architecture, to judge from the Dome of the Rock (*see* JERUSALEM, §II, A and ARCHITECTURE, §III, B). Sometimes, as in the case of the tombs of Biblical prophets, Islam could appropriately take over site and building alike (e.g. the tomb of Abraham/Ibrahim at Hebron). Another source for the development of tombs was the culture of the nomadic Turkic peoples who inhabited the Eurasian steppe. Their complex funerary rituals included the exposing of the corpse in a tent while mourners processed around it, and the inhumation of the body in a funerary mound (*kurgan*). Tomb towers with crypts containing the body and crowned by an empty room, built from Central Asia to

Anatolia, can be seen as an architectural conflation of these practices.

Thus, the range of traditions on which the medieval Islamic tomb might have drawn in the course of its development was wide, and these traditions reflect an equally wide range of concepts about the commemoration of the dead. The nomenclature employed for tombs in medieval texts and inscriptions reflects the broad range of functions discharged by these buildings in medieval Islamic society. Popular terms include *rawḍa* (Arab.: "garden"), *qubba* ("dome"), *mashhad* ("martyrium"), *khwābgāh* (Pers.: "place of sleep"), *qaṣr* (Arab.: "castle," "palace"), *ʿataba* ("threshold"), *ziyāratgāh* (Pers.: "place of pilgrimage") and *qabr* (Arab.: "grave"), to say nothing of a clutch of neutral terms such as *ʿimāra* ("place") or *bināʾ* ("building"), or specific ones such as *qadamgāh* (Pers.: "place of a footstep") or *imāmzāda* ("descendant of an imam"). It is curious that no single word was consistently used to denote simply "tomb." The frequency with which tombs were attached to other types of buildings—mosque, Madrasa, *ribāṭ*, *zāwiya*, Khanaqah—shows how thoroughly funerary architecture permeated medieval Islamic society. Such joint or multiple foundations allowed their high-ranking patrons to perpetuate their names, flaunt their piety and benefit the local community, thereby making atonement for their sins. The tomb itself became at once a symbol of conspicuous consumption and a stamp of ownership for the foundation as a whole. Many such tombs were intended for family or multiple burials and were maintained by carefully defined, inalienable religious endowments (Arab.: *waqf*; *see* Islam, §III).

II. Form. Formal sources for Islamic tombs are easy to find. The core type of Islamic tomb is a domed cube, which has a basic kinship with both Romano-Byzantine funerary monuments and the most common type of fire temple (*chahārṭāq*) in Sasanian Iran, although it was functionally unrelated to the tomb. The domed square probably has even deeper roots and corresponds to a common type of domestic architecture, as suggested by many vernacular marabouts in northwest Africa, and by more ambitious versions, for example at Kairouan and Monastir in Tunisia. In the eastern Islamic world the Buddhist stupa may have played some role, as in the tomb of Sanjar at Merv (*see* Merv, §II).

From the domed square type there developed numerous other types of tomb, including polygonal, multifoiled, flanged or circular structures, but the most important was the domed octagon, with its distinctive capacity for spatial subtleties, as shown in the great tombs of Mughal India. Direct echoes of the splendid princely tents of the nomadic Turkic peoples as described in medieval sources (*see* Tent, §II, B) can be recognized in the external elevations of some Iranian tomb towers, such as the two at Kharraqan (1067–8 and 1093–4) and that at Radkan East (1205–6). The Anatolian interpretation of such Iranian models may also have drawn on the tall drums of Armenian churches. Despite these many morphological changes, however, virtually all Islamic tombs are instantly recognizable as such: form, function and symbol are successfully integrated. An innate conservatism, which inhibited radical experiment in this building type, had much to do with this, and such exceptions as the *ḥaẓīra* (funerary compound) or the *imāmbāra* (used both for burial and for Muharram ceremonies) merely prove the rule. The greatest concentrations of the domed square tomb occur in Egypt and Syria. Those in Cairo from the 11th and 12th centuries are the earliest substantial group of tombs to survive in the Arab world, perhaps for the confessional affiliations of their Fatimid sponsors. Nearly 100 tombs survive from the period of Ayyubid rule in Damascus, mostly from the 13th century. The form was equally well adapted to small buildings (e.g. Rukniya Turba, Damascus) as to large ones (e.g. the tomb of Imam Shafiʿi, 1211; *see* Cairo, fig. 6), or the largest such dome in the world, the Gol Gumbaz at Bijapur in central India). While such tombs with four axial entrances are known, those with a single entrance are more numerous.

The domed square was also spread to the Indian subcontinent. Because most indigenous Indian belief systems favor cremation, few tombs or burial structures were built there before 1200, but tombs of the 10th–13th centuries in present-day Pakistan are square, single-domed brick structures modeled on Iranian prototypes (e.g. Tomb of Muhammad Harun, Bela, Baluchistan; Tomb of an Unknown Woman, Aror, Sind), although the influence of indigenous temple architecture is also evident (e.g. anonymous tomb, Aror, Sind). Elsewhere, tombs adhere more closely to local building tradition, for example in Bhadreshvar, Gujarat, where a tomb dated 1159–60 has carved pillars supporting corbelled superstructures. Following the establishment of Islamic authority in the Delhi region at the end of the 12th century, small square or octagonal stone tombs with corbelled or vaulted roofs were erected for rulers and princes (*see* Delhi, §I). Early examples were embellished with elaborately carved ornament and inscriptions or faced with contrasting bands of colored stone, but from the mid-14th century they became increasingly austere, with stucco over stone rubble replacing the stone facing. Tombs were also erected over the graves of saints. Trends established at Delhi were echoed in tombs erected in provincial centers, although they often reflected local building traditions. From the late 15th century to the 16th tomb construction in the Delhi region escalated, apparently because they began to be built by the nobility. Hundreds of high, plain, square domed tombs, either stucco-faced or composed of poorly bonded stone, survive in Delhi.

After the beginning of Mughal rule in 1526, tomb construction assumed unprecedented importance. The largest mausolea were built by royalty and are characterized by garden settings intended to evoke the gardens of paradise. Many imperial Mughal

tombs, such as the Taj Mahal at Agra (1631–47; *see* AGRA, §II, 1 and color pl. 1:II, fig. 1) adhere closely to Timurid prototypes. Others, such as Akbar's tomb at Sikandra (completed 1612–14), appear to be modeled on contemporary palace types. The interiors generally comprise a large central chamber surrounded by eight smaller interconnecting rooms. Nearly all the Mughal rulers constructed tombs for Sufi saints, a notable example being the tomb of Shaykh Salim Chishti at FATEHPUR SIKRI (see fig. 1). Members of the nobility not only built such shrines as acts of piety, but also constructed their own mausolea. Often smaller and less lavish than the imperial tombs, they tended to be set in gardens and were commonly used as pleasure pavilions during the owner's life. After the late 17th century an increasing return to orthodox Islam meant that tombs more often comprised simple graves surrounded by stone screens; following Islamic injunction these had no roofs (e.g. the tomb of Jahan Ara, Delhi, 1681).

The domed, centralized form constituted the Islamic tomb par excellence. The prime emphasis was on the exterior, which at the very least made a strong statement in solid geometry, exploiting stark contrasts of square, polygonal and curvilinear forms. Often, however, this powerful basic structure was embellished both within and without by applied ornament. Certain areas were singled out for this purpose. The dome itself might be covered with glazed tiles, either monochrome or patterned; it often bore designs in decorative brickwork or in carved stone, and was

sometimes pierced by star-shaped openings (e.g. the tomb in Qus, Egypt, 1120–30) or took on a bulbous melon shape (e.g. the tomb of Zayn al-Din Yusuf, Cairo, 1298). The portal acted as the natural focus of the lower elevation and often bore epigraphic panels or bands giving the date and the name of the patron. In some traditions it was boldly salient from the body of the tomb, acting like a porch. Even when it was flush with the main structure, its importance was signaled by multiple rectangular frames enclosing ornamental bands or inscriptions, a layout recalling the MIHRAB, which was a much-reduced version of the same idea and was often deliberately located on the same axis. This device signaled the sanctity of a tomb to the outside world. Indeed, in some local traditions (e.g. Central Asia from the 10th to the 14th century) the portal (*see* PISHTAQ) came to take up most of the main façade, with the bulk of the building obscured behind it. Gradually such portals acquired *muqarnas* vaulting for their semi-domes (e.g. Qubbat al-Tawrizi, Damascus, c. 1420). Other adjuncts to the nucleus of the domed chamber included ambulatories, internal staircases and subsidiary corner domes or minarets, as at the Taj Mahal (*see* AGRA, §II, A).

The choice of a square or polygonal ground plan for the tomb inevitably implied a zone of transition to carry the dome. While the concept of a dome on pendentives occasionally found favor, notably in Ottoman tombs, the standard solution involved a ring of eight arches, four of them corner squinches. Tombs, along with mosques, were the laboratories in which

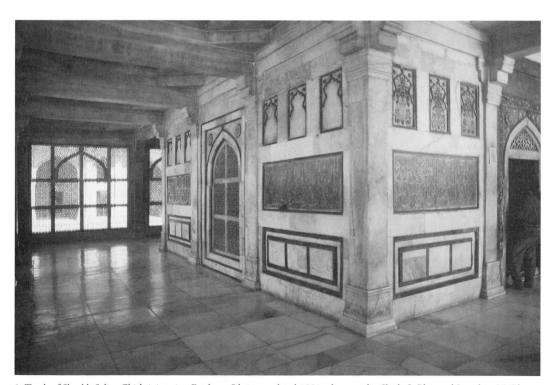

1. Tomb of Shaykh Salim Chishti, interior, Fatehpur Sikri, completed 1581; photo credit: Sheila S. Blair and Jonathan M. Bloom

the structural, formal and decorative implications of this arrangement were worked out. Indeed, in tombs throughout the Muslim world, the zone of transition constitutes the major internal decorative accent, as at the tomb of Arab-Ata at Tim in Uzbekistan (977), while the external significance of the zone of transition is highlighted by means of a highly articulated drum, sometimes furnished with a continuous vaulted gallery (e.g. the tomb of Sanjar at Merv, or the tomb of Uljaytu at Sultaniyya, 1305–15; *see* ARCHITECTURE, fig. 30) or enlarged to a great height so as to magnify the impact of the dome. Double-shelled domes, especially those with a steep stilt (e.g. Gur-i Mir, Samarkand, 1404; *see* ARCHITECTURE, color pl. 1:III, fig. 1), had the same purpose. The systematic subdivision of the squinch both laterally and vertically may well have provided the original inspiration for that quintessentially Islamic form, the MUQARNAS, also known as stalactite or honeycomb vaulting. By degrees, *muqarnas* spread to encompass not just the squinches but the entire zone of transition, which was sometimes doubled in both interior and exterior, as in the tomb of Nur al-Din in the Nuriyya Madrasa (1172) in Damascus, and thence expanded to fill the dome itself. In the later stages of the development, such vaults abdicated all pretensions to a structural role, as shown by the astonishingly complex "squinch-net" vaults found in later Iranian buildings (e.g. the tomb of Gawharshad, Herat, 1417–38; for illustration *see* HERAT), which would effectively have disguised the discrepancy between the shallow inner dome and the lofty outer one. In certain Iraqi domes and their derivatives, the *muqarnas* is externalized into a gigantic articulated sugar-loaf (e.g. Imam Dur, Iraq, 1085–90). In Anatolia a distinctive solution developed in the form of Turkish triangles, which simplify the squinch zone into smoothly faceted prismatic planes (e.g. the tomb of Mehmed I at Bursa, *c.* 1421).

In the case of a square tomb, the wasted space in the corners encouraged experiments in decoration rather than form, and in the dome chambers of Iranian mosques of the Saljuq period (*see* ARCHITECTURE, §V, A, 2) such a space was elaborated as far as possible in that direction. It was a natural development, therefore, to enrich this simple formula by means of a radiating central plan. In the Iranian world the domed octagon became the preferred choice, evident, for example, at Abarquh (see fig. 2). It contrived to combine the requirements of a central focus—usually provided by an elaborate cenotaph in carved wood, stone or glazed tilework—with those of the maximum space for circumambulation and for spatial experiment, as at Sultaniyya, the tomb of Rukn-i 'Alam at MULTAN and the Taj Mahal. Such buildings may have been conceived as interior spaces for practical use as places of pilgrimage and worship. In the Iranian world and India, especially from the 15th to the 17th century, palace kiosks of similar form were sometimes dubbed *hasht bihisht* (Pers.: "eight paradises") and were set, like the tombs, in garden precincts where umbrageous trees and flow-

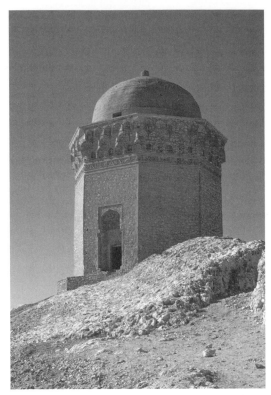

2. Tomb known as the Gunbad-i 'Ali, Abarquh, 1056–7; photo credit: Sheila S. Blair and Jonathan M. Bloom

ing streams readily evoked the Koranic Paradise, as at the tombs of Humayun (*see* DELHI, §III, D) and I'timad al-Dawla (*see* AGRA, §II, B).

Small and structurally unadventurous domed squares could be redeemed from banality by being employed as components in a much larger design. The accumulation of many similar and individually plain structures (as at Chella, nr. Rabat, Morocco) makes them interdependent and creates a built landscape of impressive extent. The Marinid royal tombs perched on a hill overlooking Fez are a prime example of such a necropolis, while the tombs straggling down the hillside of the Salihiyya, Damascus, also individually unremarkable, are a looser version of the same idea. Several dozen tombs at Aswan dating from the medieval period (see color pl. 3:XII, fig. 1) show that builders blithely experimented with mud-brick as if it were plasticine, molding zones of transition into forms of unprecedented fantasy. Conversely, among several Indian sites with such groups of tombs, the 17th-century Chahar Gunbad at Golconda deserves special attention; indeed, the Indian subcontinent may claim to have more monumental medieval tombs than the rest of the Islamic world put together, some of them bearing Koranic inscriptions hundreds of meters long. In Turkey the outstanding example is at Ahlat, and in Iran, at Amul and Qum. At the Shah-i Zinda (*see* SAMARKAND, §III, A) the line of tombs is lifted out of the ordinary by the long processional

staircase that leads to the necropolis, by the narrow meandering street along which they are disposed, and by their incandescent tiled ornament. The grandest such necropolis in the Islamic world is probably that formed by the so-called "tombs of the caliphs" in the Qarafa cemetery, Cairo (*see* CEMETERY).

Very different in type was the tomb tower, found throughout the Iranian and Turkish worlds. It was originally a simple, lofty cylinder with a conical roof (e.g. Lajim, 1022–3; Risgit, *c.* 1100), and the emphasis on sheer height was greatly increased by the relative constriction of the interior, making for a ratio of width to height of about 1:3.5 to 1:5.5. Such a building seems to have been intended primarily as an external marker for the grave, with a corresponding neglect of the interior. Iranian architects quickly enriched the primitive formula of the earliest tomb towers by adding flanges (e.g. Gunbad-i Qabus, 1006–7; *see* ARCHITECTURE, fig. 10), engaged columns and corner buttresses to the shaft, and simple cylinders gave way to hexagonal and octagonal prisms, 10- and 12-sided tombs and various flanged or polyhedral forms over a much lower inner dome. Lavish applied ornament sets off the spartan simplicity of the elevation. The unwavering emphasis on a single attenuated shaft constitutes the main visual impact of such towers, and this illusionistic device enhances the impression of loftiness. Most tomb towers are some 15–20 m high, but seem very much taller. Anatolian tomb towers, the heyday of which was from the 13th to the 15th century, feature a crypt with a sarcophagus for the body, which was sometimes embalmed (*see* ARCHITECTURE, §V, C, 1). The crypt was crowned by an empty upper chamber, sometimes reached by an external staircase. The carved stone decoration frequently features animal themes of astrological, totemistic, paradisal and other symbolic intent. Indeed, many tomb towers both in Anatolia (see fig. 3) and Iran are structurally a dead-end, and have become essentially a hoarding for elaborate ornament.

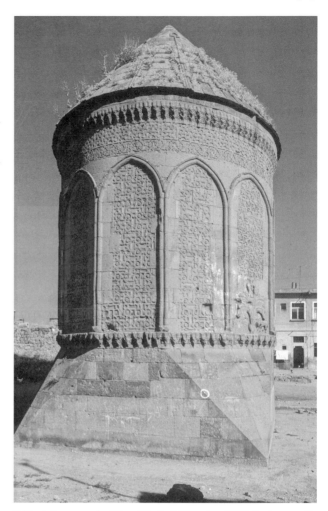

3. Tomb known as the Döner Kümbed, Kayseri, *c.* 1275–6; photo credit: Sheila S. Blair and Jonathan M. Bloom

Enc. Islam/2: "Kubba"

F. Wetzel: *Islamische Grabbauten in Indien aus der Zeit der Soldatenkaiser, 1320–1540* (Leipzig, 1918)

C. Cauvet: "Les Marabouts: Petits monuments funéraires et votifs du Nord de l'Afrique," *Rev. Afr.*, lxiv (1923), pp. 274–329, 448–522

U. Monneret de Villard: *La Necropoli musulmana di Aswan* (Cairo, 1930)

A. S. Tritton: "Muslim Funeral Customs," *Bull. SOAS*, ix (1937–9), pp. 635–61

A. Grabar: *Martyrium: Recherches sur le culte des reliques et l'art chrétien antique,* 2 vols. (Paris, 1943–6)

E. Esin: "Al-Qubbah al-Turkiyya: An Essay on the Origins of the Architectonic Form of the Islamic Turkish Funerary Monument," *Atti del terzo congresso di studi arabi e islamici: Ravello, 1966,* pp. 281–309

O. Grabar: "The Earliest Islamic Commemorative Structures," *A. Orient.*, vi (1966), pp. 1–46

I. Goldziher: *Muslim Studies,* 2 vols, ed. S. M. Stern, Eng. trans. by C. N. Barber and S. M. Stern (London, 1967–71)

C. Kessler: "Funerary Architecture within the City," *Colloque internationale sur l'histoire du Caire: Cairo, 1969,* pp. 257–68

V. V. Bartol'd: "The Burial Rites of the Turks and the Mongols," Eng. trans. by J. M. Rogers, *Cent. Asiat. J.*, xiv (1970), pp. 195–222

Y. Ragib: "Les Premiers monuments funéraires de l'Islam," *An. Islam.*, ix (1970), pp. 21–36

U. U. Bates: "An Introduction to the Study of the Anatolian Turbe and its Inscriptions as Historical Documents," *Sanat Tarıhı Yıllığı*, iv (1971), pp. 73–84

C. Adle and A. S. Melikian-Chirvani: "Les Monuments du XIe siècle du Dāmqān," *Stud. Iran.*, i/2 (1972), pp. 229–97

L. Golombek: "The Cult of Saints and Shrine Architecture in the Fourteenth Century," *Near Eastern Numismatics, Iconography, Epigraphy and History: Studies in Honor of George C. Miles,* ed. D. K. Kouymjian (Beirut, 1974), pp. 419–30

R. Hillenbrand: "The Development of Saljuq Tombs in Iran," *The Art of Iran and Anatolia, from the 11th to the 13th Century A.D.,* ed. W. Watson, Colloq. A. & Archaeol. Asia, iv (London, 1974), pp. 40–59

L. A. Ibrahim: *Mamluk Monuments of Cairo* (Cairo, 1976)

V. Strika: "The Turbah of Zumurrud Khatun in Baghdad: Some Aspects of the Funerary Ideology in Islamic Art," *AION*, n. s., xxxviii (1978), pp. 283–96

L. Golombek: "From Tamerlane to the Taj Mahal," *Essays in Islamic Art and Architecture in Honor of Katharina Otto-Dorn*, ed. A. Daneshvari (Malibu, 1981), pp. 43–50

M. Ara: "The Lodhi Rulers and the Construction of Tomb-Buildings in Delhi," *Acta Asiat.*, xliii (1982), pp. 61–80

T. Allen: "The Tombs of the 'Abbāsid Caliphs in Baghdād," *Bull. SOAS*, xlvi (1983), pp. 421–32

S. S. Blair: "The Octagonal Pavilion at Natanz," *Muqarnas*, i (1983), pp. 69–94

C. Williams: "The Cult of 'Alid Saints in the Fatimid Monuments of Cairo, Part II: The Tombs," *Muqarnas*, iii (1985), pp. 39–60

A. Welch: "Qur'an and Tomb: The Religious Epigraphs of Two Early Sultanate Tombs in Delhi," *Indian Epigraphy: Its Bearing on the History of Art*, ed. F. M. Asher and G. S. Gai (New Delhi, 1985), pp. 257–67

A. Daneshvari: *Medieval Tomb Towers of Iran: An Iconographical Study* (Lexington, 1986)

T. Leisten: *Anfänge islamischer Grabararchitektur: Eine Rekonstruktion aus literarischen und archäologischen Befunden* (1987)

M. Shokoohy: *Bhadresvar: The Oldest Islamic Monuments in India* (Leiden, 1989)

B. Groseclose: "Imag(in)ing Indians," *A. Hist.*, xiii (1990), pp. 487–515

H. Edwards: "The Ribat of 'Ali b. Karmakh," *Iran*, xxix (1991), pp. 85–94

C. B. Asher: *The Architecture of Mughal India* (Cambridge, 1992)

S. S. Blair: *The Monumental Inscriptions of Early Islamic Iran and Transoxiana* (Leiden, 1992)

R. Hillenbrand: *Islamic Architecture: Form, Function and Meaning* (Edinburgh, 1994), pp. 253–330

M. Kevran: "Entre l'Inde et l'Asie centrale: Les mausolées islamiques du Sind et du sud Penjab," *Cah. Asie Cent.*, i–ii (1996), pp. 133–71

T. Leisten: *Architektur für Tote: Bestattung in architektonischem Kontext in den Kernländern der islamischen Welt zwischen 3./9. und 6./12. Jahrhundert* (Berlin, 1998)

S. O. Elsadig: "The Domed Tombs of the Eastern Sudan," *Sudan & Nubia*, iv (2000), pp. 37–43

P. K. Sharma: *Mughal Architecture of Delhi—A Study of Mosques and Tombs (1556–1627 A.D.)* (Delhi, 2000)

H. Hamza: *The Northern Cemetery of Cairo, Islamic Art and Architecture Series*, 10 (Costa Mesa, CA, 2001)

E. Lambourn: "'A Collection of Merits ...': Architectural Influ(e)nces in the Friday Mosque and Kazaruni Tomb complex at Cambay, Gujarat," *S. Asian Stud.*, xvii (2001), pp. 117–49

M. Kurcz: "'The Living Saints' and their Graves: Domed Tombs of Northern Sudan in the Context of Religion, Social Life and Local Architecture Traditions," *Afr. Bull.*, l (2002), pp. 249–64

Y. Özbek: "Women's Tombs in Kayseri," *Kadın/Woman*, iii (2003), pp. 65–114

S. Zajadacz-Hastenrath: *Chaukhandi Tombs: Funerary Art in Sind and Baluchistan* (Karachi, 2003)

F. W. Bunce: *Islamic Tombs in India: The Iconography and Genesis of their Design,* Contours of Indian Art & Architecture, 2 (New Delhi, 2004)

B. O'Kane: "Chaghatai Architecture and the Tomb of Tughluq Temür at Almaliq," *Muqarnas*, xxi (2004), pp. 277–87

H. Taragan: "The tomb of Sayyidnā 'Alī in Arṣūf: The Story of a Holy Place," *J. Royal Asiat. Soc.*, xiv/2 (2004), pp. 83–102

L. Harrow: "The Tomb Complex of Abū Sa'id Faḍl Allāh b. Abī'l-Khair at Mihna," *Iran*, xliii (2005), pp. 197–215

A. al-'Amiri Nasiri: *Al-Marāqid al-islamiyah fī'l-'ālam* [Islamic mausolea around the world] (Beirut, 2006)

Tombouctou. *See* TIMBUKTU.

Tombstone. *See* STELE.

Toptani, Murad (Said). (*b.* Aka, Turkey, 1865; *d.* Tiranë, 11 Feb. 1918). Albanian sculptor, collector and poet of Turkish birth. His family was in exile in Turkey, and he began his studies in the school of Madame Fyres (1878), finishing them in the Sultanie Lycée of Galatasaray in Istanbul (1894). Toptani's artistic work is intrinsically linked to his efforts in the struggle for Albanian independence. Works such as the bust of *Skanderbeg* (bronze, 1917; Tiranë, A.G.) reveal his realistic style, which is permeated by a naive romanticism. His patriotism and romanticism also infect his poetry. Little of his work and his rich private collection of objects of applied Albanian folk art remains, as his house and gallery in Tiranë were burnt down by the anti-patriotic forces in 1913.

F. Hudhri: *Murat Toptani, artist dhe patriot* [Murad Toptani, artist and patriot] (Tiranë, 1978)

Tremecén. *See* TLEMCEN.

Tripoli (i) [Ṭarābulus al-Shām; Aṭrābulus]. Port city in northern Lebanon. Founded by the Phoenicians in the 8th century BCE and occupied successively by Greeks (who named it after its three walled quarters), Romans, Arabs and Crusaders, the seaside city was razed in 1289 when it was recaptured by the Mamluk sultan Qala'un (*r.* 1280–90; *see* MAMLUK, §II, B), and a new city built inland. Thirty-five monuments, covering the range of religious, civil and military architecture, survive from the new Mamluk city. The mosques, spread throughout the city and built by rulers and local residents, include six congregational mosques and three neighborhood mosques. The madrasas, most of which are clustered around the Great Mosque, range from imposing to modest. Caravanserais were built in the northern part of the city that was most accessible to roads from Syria; they followed the traditional plan of a central courtyard with a ground floor with vaulted rooms and a galleried story above. Baths, modeled on the Syrian prototype, had a linear arrangement of dressing, cold, warm and hot rooms. These monuments were built of well-cut red or yellow sandstone, often accented by black stone and decorated with polychrome marble in the Syrian and Cairene traditions (*see* ARCHITECTURE, §VI, C, 1). A few buildings were added to this Mamluk core in the 16th century under the Ottomans. In the 20th century, after a pipeline

was constructed from Kirkuk in Iraq to the Mediterranean, the core has been enveloped by modern concrete structures.

'Abd al-'Aziz Salim: *Ṭarāblus al-shām fial-tārīkh al-islāmī* [Tripoli of Syria in the Islamic period] (Alexandria, 1967)

'Umar 'Abd al-Salam Tadmuri: *Tārīkh wa āthār masājid wa madāris Ṭarāblus fī 'aṣr al-mamālik* [History of the mosques and madrasas of Tripoli in the Mamluk period] (Tripoli, 1974)

H. Salam-Liebich: *The Architecture of the Mamluk City of Tripoli* (Cambridge, MA, 1983)

H. Salamé-Sarkis, O. A. S. Tadmuri and R. Saliba: *Tripoli, the Old City: Monument Survey: Mosques and Madrasas: A Sourcebook of Maps and Architectural Drawings* (Beirut, 1994)

H. a. Assaf: "Des vestiges paléo-ottomans de Tripoli, la Tekiyah al-Mawlawiyya," *Aram Periodical*, ix–x (1997), pp. 497–524

O. A. S. Tadmori: "The Plans of Tripoli al-Sham and its Mamluk Architecture," *Aram Periodical*, ix–x (1997), pp. 471–95

B. Major: "Burǧ 'Arab—A Crusader Tower in the County of Tripoli. A Preliminary Report after the First Survey," *Essays in Honour of Alexander Fodor on his Sixtieth Birthday*, ed. K. Dévényi and T. Ivány (Budapest, 2001), pp. 171–82

Tripoli (ii) [Ṭarābulus]. Capital city and principal seaport on the North African coast of Libya. Founded in the 7th century BCE by the Phoenicians, the site was occupied successively by the Carthaginians, Romans, Vandals and Byzantines before being conquered by the Arabs in the 7th century. After many centuries of complex governance passing between various dynasties, Tripoli became almost independent for much of the 15th century. Taken briefly by the Spanish in the 16th century, the city was then occupied by the Ottomans in 1551. In 1771 the Ottoman governor of Tripoli established his own dynasty, the Qaramanli dynasty, which lasted until the Ottomans re-occupied the area in 1835. Following the oil boom of 1995, Tripoli has grown dramatically: it is the largest city in Libya, with a population of around 1.7 million. It is sometimes known in Arabic as *Ṭarābulus al-gharb* (Western Tripoli) to distinguish it from the city of the same name in present day Lebanon that is known as *Ṭarābulus al-shām* (Syrian Tripoli; *see* above).

Hundreds of stone columns dating from the period of Roman occupation have been incorporated into the architecture of Tripoli, which is of typically varied Mediterranean makeup. The medina has undergone some restoration but retains its 17th-century Ottoman plan and contains numerous mosques including the Mosque of al-Naqah (1610/11, but built on the site of a much older building), the Mosque of Darghut (16th century), and the Mosque of Ahmed Pasha al-Qaramanli, founder of the Qaramanli dynasty (1737/8). A madrasa, built in the 13th century and reported by Ibn Rashid, is no longer extant, but the Ottoman Madrasa of 'Uthman Pasha and the Madrasa of Al-Katib both remain. Tripoli's medina also contains several Ottoman courtyard houses and baths as well as some Italianate buildings. A new national museum, the Libyan-Arab Jamahiriya Museum, was built in the citadel in the 1980s with UNESCO funding and contains objects from the country's Roman and Greek periods down to the present day.

Enc. Islam/2: "Ṭarābulus al-gharb"

S. Aurigemma: "La moschea di Ahmad al-Qarâmânlî in Tripoli," *Dedalo*, vii (1927), pp. 492–513

A. M. Ramadan: *Reflections upon Islamic Architecture in Libya* (Tripoli, 1975)

Islamic Art and Architecture in Libya (exh. cat. by A. Hutt and others; London, Archit. Assoc., 1976)

M. Warfelli: "The Old City of Tripoli," *Some Islamic Sites in Libya: Tripoli, Ajdabiyah and Uljah* (London 1976)

E. Braun: *The New Tripoli* (1986)

P. Cuneo: "The Multi-domed Mosque Architecture of Tripoli, Libya, between Regional Tradition and Ottoman Influence," *9th International Congress of Turkish Art, 23–27 September 1991, Atatürk Cultural Center: I*, pp. 511–19

A. S. Rghei and J. G. Nelson: "The Conservation and Use of the Walled City of Tripoli," *Geog. J.*, clx/2 (1994), pp. 143–58

K. von Henneberg: "Tripoli: Piazza Castello and the Making of a Fascist Colonial Capital," *Streets: Critical Perspectives on Public Space*, ed. Z. Çelik, D. Favro and R. Ingersoll (Berkeley, 1994), pp. 135–50

B. Esheh and F. Sharfeddin: "As-Saray al-Hamra (Tripoli): Documentation of the Architectural Elements," *Libya Antiqua/Araybīyā'l-Qadīma* (2000), pp. 276–9

M. Fuller: "Preservation and Self-absorption: Italian Colonisation and the Walled City of Tripoli, Libya," *The Walled Arab City in Literature, Architecture and History: The Living Medina in the Maghrib*, ed. S. Slyomovics (London, 2001), pp. 121–54

J. B. Vilar: "El 'Fuerte Español' o ciudadela de Trípoli a mediados del siglo XIX y su voladura parcial en 1864, a través de la documentación diplomática española," *Africa: Riv. Trimest. Stud. & Doc. Ist. It. Africa & Orient.*, lvi/3 (2001), pp. 281–302

Tuareg [Twareg; Arab. Ṭawāriq; Fr. Touareg]. Seminomadic pastoralist people of North African BERBER origins inhabiting the Sahara Desert, southern Algeria, southwest Libya, Niger, Burkino Faso, eastern Mali and other adjacent areas. Their language is Tamashegh, and they are nominal Muslims. They are known for their elaborate silver jewelry and leatherwork, their basketry and their woodwork. There are a number of important museum collections of Tuareg art, both in Europe (e.g. Neuchâtel, Mus. Ethnog.; Stuttgart, Linden-Mus.; Offenbach am Main, Dt. Ledermus.; Paris, Mus. Homme) and in Africa (e.g. Niamey, Mus. N. Niger; Algiers, Le Bardo).

I. Introduction. II. Metalwork and jewelry. III. Leatherwork. IV. Basketry. V. Woodwork.

I. Introduction. The Tuareg are grouped into politically autonomous federations, which may be broadly divided into northern and southern groups. Tuareg

class structure comprises noble classes (*ihaggaren*), tributary classes (*imrad*) and ex-servile classes (*iklan*). Marginal classes comprising freedmen include religious leaders (*ineslemen*) and artisan smiths (*inadan*). The Tuareg number *c.* 1,200,000, with *c.* 700,000 living in Niger, 450,000 in Mali and the rest in Algeria, Burkino Faso and Libya. The *ihaggaren* were once a warrior aristocracy who controlled the caravan trade routes between Mouzourk and TIMBUKTU and the southwestern Sahara into northern Nigeria. To a large extent, Tuareg economy has continued to be based on pastoralism and trade. However, the drought of the 1970s and 1980s and the continuing process of desertification forced many nomadic Tuareg to become sedentary. Tuareg religion and cosmology are thought to represent a layering of Islamic tenets on earlier beliefs because of their mythical and clan associations with certain animals and because of their belief in *kel esouf* spirits. The Tuareg share cultural similarities with other Sahelian peoples.

Tuareg art forms consist of such utilitarian items as household furnishings and more personal objects such as jewelry. Items in general have simple shapes, and almost all decoration comprises linear and geometrical motifs that are endlessly combined to create rich and vibrant patterns. There are no figural motifs in Tuareg art. The artistic traditions are the work of *inadan* smiths. Men carve wooden implements and forge metalwork items, and women are weavers and leatherworkers. Tuareg tents are made of goatskins or straw mats mounted on arched wooden frames and are occupied by one family unit. Furniture includes beds, rugs, cushions, bags and household utensils. Men wear baggy trousers made of cotton cloth, a loose cotton shirt, a turban (*tegelmoust*) and sandals. Women's clothing consists of shirts worn over skirts and underskirts, a head veil and sandals.

While smiths still produced items for Tuareg patrons into the 1990s, their principal source of income lay in the manufacture of innovative items that appealed to foreigners. As a result rattle rings had been transformed into brooches, Maria Theresa thaler silver had been replaced by sterling silver, and leatherworkers had begun to produce cassette holders, picture frames and desk accessories. At the same time some individuals had begun to record older forms and shapes before they became obsolete. Rissa Ixa (*b. c.* 1940), a Tuareg painter based in Niamey, used his paintings of scenes of daily life to document the immense inventory of motifs found in jewelry, leather and wooden Tuareg art.

II. Metalwork and jewelry. Tuareg metalwork includes weapons, tools, objects of daily use, animal trappings and elaborate jewelry forms. Metal items are either forged or cast using molds or the lost-wax process. Decorative techniques involve bending, piercing, engraving, stamping, chasing and repoussé work. Since the 1950s swords, spears, and arm daggers are worn mostly for special occasions. Straight blades are made of iron with engraved designs that indicate quality and provenance. Some designs are borrowed from famous European arms manufacturers. The wooden handles have rounded-end knobs or cross shapes. Sheaths are made of leather with incised patterns and woven or punched designs. The bottom portion is rounded and partially encased in silver with pierced circles and engraved triangles.

Sugar tongs and hammers are considered prestige pieces. They are cast in bronze or silver and embellished with zigzags, lines, triangles and ball nails. Tuareg locks are rectangular, of cast iron and decorated with copper or brass overlays. The keys have long handles with intricate openwork designs. Engraved tweezers and needles are used by both men and women to extricate thorns. These are kept in wallets or hung on leather cords around the neck. Camel headstalls are used during festivals for parades and races. These are engraved and have amulets and little bells hanging at the sides.

Both men and women take a special interest in jewelry forms. Jewelry is used as physical adornment and to symbolize protective agents, life-stages and rank. It is also valued for its craftsmanship and monetary worth. Tuareg jewelry is always decorated. Men wear amulet cases, bracelets and rings on a daily basis. Amulet cases are square, rectangular, triangular or tubular. They usually contain papers bearing Koranic or magical inscriptions prepared by religious leaders. They hang from leather cords and are worn around the neck, on the upper arm or on turbans. The simplest forms are thin, flat cases with two suspension rings. These are sometimes augmented with one or more superimposed cases. Most amulets are hammered, then adorned with repoussé, stamped or engraved geometric motifs, and some have ebony inlay. Tubular models have continuous surface designs, and leather amulets bear incised and stamped decorations. Simple band bracelets made of serpentine are worn singly or in pairs on the upper arm. Men's rings are cast in solid silver and display geometric motifs. Amulet rings have chequer-board patterns with magical letters inside them. Rings are often given as tokens of affection.

Women wear amulets, necklaces, pendants, head ornaments, earrings, bracelets, rings and veil-weights. Women's amulets are similar to men's and are worn on a daily basis with the exception of a very large pectoral triangular amulet, known as the *tereout tan idmarden*. This is composed of a pendant from which hangs a triangular centerpiece decorated with silver ball nails and triangular pendants. The triangle is said to be one of the most important amuletic shapes and decorative designs in all Tuareg art forms. It is a stylized representation of an eye and protects the wearer. Other amulets, known as *khomessa*, are made of five silver or bone lozenges joined together and attached to a leather backing, the whole then being decorated with twisted silver wire. These amulets are associated with the protective powers of the number five.

Numerous pendants are used to manufacture necklaces. The Agadez cross has an oval or round ring at the top, joined to a lozenge with curved sides ending in knob ends. Other examples are stone triangles

encased in rectangular boxes or elaborate cross forms with openwork motifs. Pendants are often named after the regions from which they come. Head ornaments consist of pendants attached directly to the hair or along the temples. A long triangular construction similar to the *tereout tan idmarden* is worn at the back of the head and is reserved for celebrations. Women wear a profusion of necklaces composed of beads, shells and pendants strung on leather cords. Necklaces are sometimes named after the pendants used to make them, such as the *tadnet*. Silver beads are either tubular or polyhedral squares and have engraved or punched designs.

Bracelets are almost always worn in pairs. These include flat bands with engraved decorations, open circles with ball ends and pieces cast in solid silver with polyhedral end knobs. Earrings consist of large round hoops embellished with small circular motifs and rings with trumpet-shaped polyhedral end knobs. The latter are part of a woman's dowry. Veil-weights are attached to the end of a veil and thrown over a woman's shoulder. They are sometimes in fact keys to locks. Women's rings are simple bands, signet rings or pieces with pyramidal constructions. Rattle rings are particular to the Tuareg and are often decorated with stars or circles.

III. Leatherwork.
Tuareg leatherwork is distinctive for its vibrant colors (reds, blacks, yellows, whites and greens) and for the intricacy and profusion of its decorated panels, fringes and tassels. The largest production centers for Tuareg leatherwork are in Agadez and Tahoua. Men usually make saddles, weapons, amulets and sandals, while women make bags, satchels, wallets and cushions. Women soak goat or sheepskins several times, then scrape and clean them with knives. Tanned skins are softened with butter or oil and stretched on frames before the dyeing process. Since the 1970s many colors have been obtained with commercial dyes from Nigeria, and women in urban centers sometimes buy skins that have already been dyed. Women smiths often work in small groups and use low benches as worktables. The skins are first cut into smaller pieces and are then prepared one at a time. Some decorations are incised, while others are scraped or stamped with metal punches. Panels with perforated triangles, squares or lozenges are fastened over monochrome panels with elaborate stitches and appliqué work. Other panels are adorned with embroidered circles or triangles, then trimmed with white zigzag stitches. Triangular tassels attached to narrow perforated panels hang over red and blue fringes. When all the different elements have been decorated, the pieces are assembled.

Big rectangular bags with long narrow necks are used to hold personal belongings during trips and have heavily decorated front flaps. Smaller bags are used to carry the items needed for making tea, and wallets attached to braided cords are worn around the neck. It has been suggested that the sandal motif often depicted on women's bags has protective properties and indicates prestige and social rank.

There are two styles of Tuareg cushions. Saddle cushions (*sabara*) are elongated rectangles with elaborate decorations used by women on palanquins. These pieces have become scarce since the 1970s, as they are time-consuming to make (taking three months or so) and expensive to buy. Round cushions, trimmed with fringes, are used as pillows.

Saddles are always made by specialists. Horse saddles are made of molded leather and their pommels and cantles adorned with metal overlays. Camel saddles are made of wooden frames covered with leather panels. There are two types of camel saddle. The *tayast* has a triangular shape, a simple ball pommel, and is covered with colorful blankets. A particularly prestigious type, known as *tamzak*, is made in Agadez. The pommel is a cross shape whose three branches are chest high. The high, oval cantle has a metal point and is made of eight pieces of wood, which are joined and polished and then covered with red leather. Embroidered and perforated panels alternate with metal overlays, which are engraved, pierced or have encased mirrors.

IV. Basketry.
Tuareg basketry items are made with fibers from the doum palm and the euphorbia, and acacia bark is used to join bands together. Mats are plaited, knotted and twisted, while baskets are coiled. Men make the heavy mats (*tacharabat*) used for transporting goods and the mats used as the outer walls of tents. Women make baskets, tent panels and mats. The Tuareg favor black, red and green, and these colors are now obtained using commercial dyes. Intricate patterns are created by knotting fine leather strands into geometric motifs. It has been suggested that many of the motifs woven in mats are ideograms or pictograms based on Tuareg hunting lore and astronomy. The circle, for example, represents the sun, while an inverted "v" represents a gazelle's foot and the triangle corresponds to a seated woman seen from the back.

Tuareg mats are rectangular, square or round and have many purposes. They are used as rugs, as the outer and inner walls of tents, and as mattresses. Plaited mats used as tent coverings have alternating black and natural colored bands joined with zigzag stitches. The mats used as prayer mats and for sitting are more refined. These are often plaited then embellished with black zigzag motifs, parallel lines or stars. Inner tent panels and screens (*firiji*) are very long and require a polished and carefully prepared doum fiber for their manufacture. These mats are decorated with lines, triangles, and lozenges made of colored leather strands. As they are often part of a wedding dowry, they are made only on commission. Embroidered mats from the Air region (*assaber*) are made of twisted fibers. These are very supple and have friezes bordering three of the four edges on both sides of the mat. The frieze is made of red, black and green leather strands that are woven into the mat in geometric motifs.

Coiled baskets are made principally in Agadez and display green and purple geometric motifs. They are made in different shapes and sizes and are used to

hold clothing and personal belongings. Cooperatives have been created in the Air region to facilitate basket manufacture for the tourist trade.

V. Woodwork. Because of the paucity of wood in the Sahelian region, wood manufacture is kept to a strict minimum. Most pieces are made with such hard woods as acacia or with such soft woods as *Commiphora africana*. Tuareg wooden articles include furniture, tent armatures and pickets, and camel trappings, as well as household utensils. Smiths use a single piece of wood to make any of these items. They are first shaped with an adze then refined with knives. Pieces are blackened with smoke and decorated with lines and zigzag motifs with the tip of a knife heated in a flame. They are then polished with butter.

Mortars have conical shapes, and they are also used as drums during feasts. Bowls, plates, double cups and funnels have rounded forms and elegant decoration. Spoons and ladles of all sizes are made of a lightweight wood and are prestige items. The handles are elongated and very ornate. Some edges are carved into triangles, and others have cut-out or engraved geometric motifs, which are colored in with red, green or black. Little metal patches are used to repair cracks and breaks.

Tent accessories include pickets, poles and holders for trays and other items. All of these are carefully engraved and decorated. Shorter pickets with cut-out edges are used to hold mats against the sides of the tent and to hold cushions up. Beds are part of a woman's dowry, and they are made of two long poles ending in pointed finials and joined together with cross poles. They rest on four short feet.

Palanquins (*teraouit*), used by women to ride donkeys and camels, are made of lightweight woods. They consist of a baseboard attached to lateral support beams. These are joined with two arched beams linked to the saddlebows. The two arches are decorated with richly engraved, pierced metal overlays and are topped off with wooden finials. Women usually fill palanquins with cushions.

Enc. Islam/2: "Tawāriḳ"

F. R. Rodd: *People of the Veil* (London, 1926)

J. Gabus: *Au Sahara*, 3 vols. (Neuchâtel, 1955–8)

H. Lhote: *Les Touaregs du Hoggar* (Paris, 1955, rev. 1984)

Y. Urvoy: *L'Art dans le territoire du Niger* (Niamey, 1955)

L. C. Briggs: *Tribes of the Sahara* (Cambridge, MA and London, 1960)

J. Nicolaisen: "Essai sur la religion et la magie touarègues," *Folk*, iii (1961), pp. 113–62

H. T. Norris: *The Tuaregs: Their Islamic Legacy and its Diffusion in the Sahel* (Warminster, 1975)

J. Anquetil: *Niger: L'Artisanat créateur* (Paris, 1977)

J. Keenan: *The Tuareg: People of Ahaggar* (London, 1977)

J. Gabus: *Sahara: Bijoux et techniques* (Neuchâtel, 1982)

C. Beckwith and M. Van Offelen: *Nomads of Niger* (New York and London, 1983)

A. Fisher: *Africa Adorned* (New York and London, 1984)

J. Etienne-Nugue and M. Saley: *Artisanats traditionels en Afrique noire: Niger* (Dakar, 1987)

G. Göttler: *Tuareg: Kulturelle Einheit und regionale Vielfalt eines Hirtenvolkes* (Cologne, 1989)

S. J. Rasmuseen: "Art as Process and Product: Patronage and the Problem of Change in Tuareg Blacksmith/Artisan Roles," *Africa*, lxv/4 (1995), pp. 592–610

H. Claudot-Hawad: *Touaregs et autres Sahariennes entre plusieurs mondes: Définition et redéfinitions de soi et des autres* (Aix-en-Provence, 1996)

E. A. David: "Metamorphosis in the Culture Market of Niger," *Amer. Anthropol.*, ci/3 (1999), pp. 485–501

Magische Ornamente—Silberschmuck der Tuareg (exh. cat. by G. Göttler; Zurick, Mus. Rietberg, 2003)

K. Loughran: "Jewelry, Fashion and Identity: The Tuareg Example," *Afr. A.*, xxxvi/1 (2003), pp. 52–65

C. Hincker: *Le style touareg, ou, La fonction sociale des techniques* (Paris, 2005)

K. Loughran: "Tuareg Art in European and American Museums," *Tribal*, xi/1 (2006), pp. 88–99

Art of Being Tuareg: Sahara Nomads in a Modern World (exh. cat., ed. T. K. Seligman and K. Loughran; Palo Alto, CA, Stanford U., Cantor Cent. Visual A.; Los Angeles, UCLA, Fowler Mus. Cult. Hist.; 2006)

Artistry of the Everyday: Beauty and Craftsmanship in Berber Art (exh. cat. by L. Bernasek: Cambridge, MA, Harvard U., Peabody Mus., 2008)

Tughluq [Tughluk]. Turkish dynasty that ruled northern India from 1320 to 1413. Ghazi Malik, a nobleman from the Punjab, assumed the title Ghiyath al-Din Tughluq on taking the throne in 1320 after the last KHALJI king had been murdered. During his short reign (1320–25) he constructed a fortified garrison city at Delhi called Tughluqabad and built his own tomb adjacent to it (*see* DELHI, §§I, C and III, B). He also built the tomb in which the saint Rukn-i 'Alam is buried in MULTAN; the congregational mosque there, according to Ibn Battuta, was inscribed with his 29 victories against invaders from Central Asia and Afghanistan.

Muhammad Tughluq (*r.* 1325–51) retained Tughluqabad as his center but built walls enclosing Siri (the Khalji city) and the older portions of Delhi constructed by the MU'IZZI sultans (*see* DELHI, §I, B). This new area, in which Muhammad Tughluq built a palace and a mosque, was named Jahanpanah (*see* DELHI, §I, D). He also built the fortress of 'Adilabad on the hills to the south of Tughluqabad. In an effort to consolidate power in the south, Muhammad Tughluq undertook aggressive campaigns in the Deccan and moved the capital to DAULATABAD, forcing the evacuation of Delhi. This expansionist policy, however, ended in failure. In 1336 the residents of Delhi were permitted to return, and by 1347 the BAHMANI dynasty had gained power in the south. Further troubles visited the reign in the form of famines (1334–44) and the Black Death (1335–8).

Firuz Shah (*r.* 1351–88), though not a dynamic leader, brought stability to the Sultanate and was the most active builder of the Tughluq house. In Delhi he established a new urban center called Firuzabad (now Kotla Firuz Shah; *see* DELHI, §I, E). His numerous other projects included palaces,

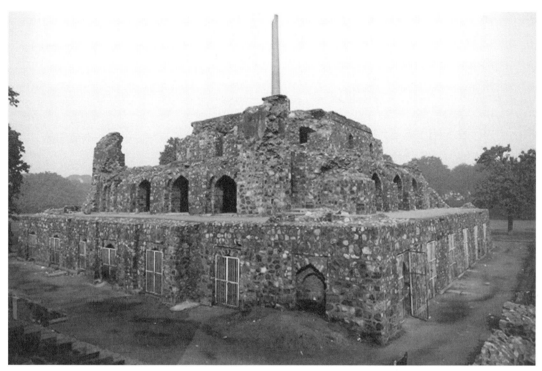

Tughluq, Lat Pyramid, Kotla Firuz Shah, Delhi, view from the south, 1354; photo credit: Sheila S. Blair and Jonathan M. Bloom

gardens, hunting pavilions, mosques, Islamic colleges, tombs and public works (see fig.). He also restored older buildings, notably the Qutb Minar. The decade after Firuz Shah was marked by internecine warfare among the nobles. Timur encountered little resistance during his invasion and sack of Delhi in 1398. After this the Tughluqs lingered on as nominal rulers until the death of Mahmud Tughluq in 1413.

Enc. Islam/2: "Dilhi Sultanate"; "Ghiyāth al-Din Tughluḳ"; "Muḥammad b. Tughluḳ," "Tughluḳids"

Ziya al-Din Barani: *Tārīkh-i Fīrūz Shāhī* [History of Firuz Shah] (MS. 1358; Calcutta, 1860–62; Aligarh, 1957) [extracts trans. in Eng. in Elliot and Dowson, iii, pp. 93–268 and *J. Asiat. Soc. Bengal* (1869), pp. 181–220; (1870), pp. 1–51, 185–216; (1871), pp. 217–47]

H. Elliot and J. Dowson: *History of India as Told by its Own Historians (The Muhammedan Period)*, 8 vols. (London, 1866–77/R Allahabad, 1964)

R. C. Majumdar, ed.: *The Delhi Sultanate*, vi of *The History and Culture of the Indian People* (Bombay, 1960/R 1967)

I. H. Siddiqi and Q. M. Ahmad, trans.: *A Fourteenth Century Arab Account of India under Sultan ibn Tughluq* (Aligarh, 1971)

A. Welch and H. Crane: "The Tughluqs: Master Builders of the Delhi Sultanate," *Muqarnas*, i (1983), pp. 123–66

A. Rani: *Tughluq Architecture of Delhi* (Varanasi, 1991)

A. Welch: "Architectural Patronage and the Past: The Tughluq Sultans of India," *Muqarnas*, x (1993), pp. 311–22

W. J. McGibben: "The Monumental Pillars of Fīrūz Shāh Tughluq," *A. Orient.*, xxiv (1994), pp. 105–18

P. B. Wagoner and J. H. Rice: "From Delhi to the Deccan: Newly Discovered Tughluq Monuments at Warangal-Sulṭānpūr and the Beginnings of Indo-Islamic Architecture in Southern India," *Artibus Asiae*, lxi/1 (2001), pp. 77–117

E. Lambourn: "The English Factory or Kothī Gateway at Cambay: An Unpublished Tughluq Structure from Gujarat," *Bull. SOAS*, lxv/3 (2002), pp. 495–517

A. Saleem: "Antiquarian Interest in Medieval India: Firuz Shah Tughluq and the Asokan Pillars," *Proc. Ind. Hist. Congr.*, lxiii (2002), pp. 1295–9

M. Shokoohy and N. H. Shokoohy: "The Tomb of Ghiyāth al-Dīn at Tughluqabad: Pisé Architecture of Afghanistan Translated into Stone in Delhi," *Cairo to Kabul: Afghan and Islamic Studies Presented to Ralph Pinder-Wilson*, ed. W. Ball and L. Harrow (London, 2002), pp. 207–21

M. Shokoohy and N. H. Shokoohy: *Tughluqabad: A Paradigm for Indo-Islamic Urban Planning and its Architectural Components*, Society for South Asian Studies monograph series (London, in preparation)

Tughra [Turk. *tuğra*]. Imperial monogram of the OTTOMAN sultans (*r.* 1281–1924). It consists of the sultan's name, patronymics, titles and the formula "ever victorious." Since the Ottoman sultans did not sign their decrees, the tughra was the ultimate authentication, and it fell to the *nişanci*, a high official with the rank of pasha, to draw the tughra after the copy had been checked for accuracy and calligraphed. In the narrowest sense, the tughra is distinguished by three high verticals and one large elliptical curve extending to the left and enclosing a smaller,

similar curve. Many theories have been offered to explain the development of this form. The widespread tradition that it represents the three fingers and the thumb of the ruler that Murad I (r. 1360–89) allegedly put on a document in Ragusa has been challenged; the tughra has also been connected with the *tūgh*, the yak or horse tail that served in Central Asia as a sign of sovereignty or high military rank and the flourishes at the end of the three verticals do resemble yak tails.

The use of the tughra can be traced back to the Saljuq dynasty in Iran (r. 1038–1194; *see* Saljuq, §I); the *nom de plume* of the Saljuq vizier and poet Tughra'i (d. 1120), for example, shows that a high-ranking member of the bureaucracy was in charge of drawing the tughra. The tendency to place the ruler's name in conspicuous letters at the top of a document began early; the elongation of the vertical letters of the name and sometimes of a benediction is already found on Indo-Muslim documents from the Sultanate period (1206–1555) as well as in Egypt under the Mamluks (r. 1250–1517). These verticals are evenly spaced to form a kind of fence, which is often embellished by interlacing the letters with the round endings of the letters *nūn* and *sīn*. Under the Ottomans the tughra was used only in documents sent from the capital to the provinces. High officials, who sometimes used a similarly shaped monogram of their own, did not put it at the top of the document but rather on the right margin, perpendicular to the text.

The earliest Ottoman tughras were rather simple, written in black or gold ink. During the reign of Selim I (r. 1512–20), blue ink outlined in gold or blue on a gold ground became fashionable, and fine spiral and arabesque designs filled the curves. Towards the end of the 16th century the decoration around the letters grew into an independent design, which was often triangular but sometimes achieved more fanciful shapes, such as the helmet shape popular *c.* 1600. In the 17th century tughras became very colorful, and the filler decoration, while maintaining the fine spiral design, also included larger, sometimes ungainly vegetal forms. After this Baroque phase the art of drawing tughras deteriorated; from the 19th century black, red and green replaced gold, and the calligraphy declined in quality. In later periods, the sultan's own annotation on the document, "it shall be acted accordingly," was emphasized in gold, and from the 18th century it became an additional decorative element in the tughra itself.

The tughra was the major decorative element of the firman (Pers. *farmān*), the legal deed, certificate or edict issued by the sultan. The firman was written on long sheets of paper that had been pasted together in strips and often reached several meters in length. In Ottoman firmans, the word *hū* ("He," God) was usually written at the top, and the tughra was drawn after a considerable blank space. The main text was written in a stylized chancellery hand, which is exceedingly difficult to read because of the many ligatures. The lines often rise slightly towards the upper left, creating an elegant curve, and end near the left edge of the paper to exclude later additions. Alternating lines of text may be in gold, black, red and less frequently blue and green ink. Important words, such as the name of God and religious formulas, are written in gold, and other essential parts can be written in red. The paper is sometimes sprinkled with gold.

As the characteristic sign of sovereignty, the tughra was logically applied to coins and, in the 19th century, to banknotes and postage stamps. These were composed by skilful calligraphers in Ottoman Turkey and other Islamic countries where this decorative style was imitated. The typical tughra shape, with its three verticals and its elliptical curve, is still used for many decorative purposes, including names, titles and religious formulas (e.g. invocations to God or such Sufi saints as Jalal al-Din Rumi). In India the word tughra is applied to any kind of decorative script, such as mirrored sentences or birds and beasts, flowers and faces, buildings and trees, composed of meaningful sentences and invocations. The writing of this type of tughra is subject to strict rules, but the calligrapher is allowed the freedom to write repeated letters as one and to weave various endings into each other. This art was particularly loved in Turkey and India, and numerous architectural and decorative inscriptions show an amazing variety of this type of tughra.

Enc. Islam/2: "Diplomatic" and "Tughra"

F. Babinger: "Die grossherrliche Tughra," *Jb. Asiat. Kst*, ii (1925), pp. 185–96

P. Wittek: "Notes sur la tughra ottomane," *Byzantion*, xviii (1948), pp. 311–34

E. Kühnel: "Die osmanische Tughra," *Kst Orients*, ii (1955), pp. 69–82

A. Bombaci: "Les Toughras enluminés de la collection de documents turcs des archives d'état de Venise," *Atti del secondo congresso internazionale di arte turca: Venezia, 1963*, pp. 41–55

M. Sertoğlu: *Osmanlı Türklerinde Tuğra* [Tughras of the Ottoman Turks] (Istanbul, 1975)

S. Umur: *Osmanlı Padişah Tuğraları* [Tughras of the Ottoman sultans] (Istanbul, 1980)

A. Nadir, ed.: *Osmanlı Padişah Fermanları/Imperial Ottoman Firmans* (Istanbul, 1986)

M. U. Derman: *Letters in Gold: Ottoman Calligraphy from the Sakip Sabanci Collection, Istanbul* (New York, 1998)

I. Keten: *The Ottoman Monograms Tughra (Tuğra)* (Ankara, 2002)

S. S. Blair: *Islamic Calligraphy* (Edinburgh, 2006), pp. 508–15

Tulsi Kalan [Tulsi] (*fl. c.* 1560–1600). Indian miniature painter. His work is characterized by an archaic quality, evenly spaced figures and a simple cross-section in architectural design that suggests his training in the indigenous pre-Mughal tradition. The earliest reference to both Tulsi and Tulsi Kalan ("the Elder") appears in the *Razmnāma* ("Book of wars"; *c.* 1582–6; Jaipur, Maharaja Sawai Man Singh II Mus., MS. AG. 1683–1850). Tulsi was given sole

charge of three paintings (fols. 45, 105 and 62) and Tulsi Kalan fol. 167. As a designer he worked on four folios with other artists, one of whom was Tulsi Khurd ("the Younger"). Tulsi acted as painter for a design by BASAWAN and LAL and Tulsi Kalan for Daswanth. In the *Tīmūrnāma* ("History of Timur"; *c.* 1580; Bankipur, Patna, Khuda Bakhsh Lib.) he had sole charge of one painting and worked on five folios as designer/outliner; he also acted as painter for Isar and Madhu Kalan. In the *Khamsa* ("Five poems") of Nizami (*c.* 1585; Ham, Surrey, Keir col.) he was responsible for the design of one folio, which was painted by Kesu Khurd with portraits executed by NANHA. The work of Tulsi Kalan in the *Akbarnāma* ("History of Akbar"; *c.* 1586–90; London, V&A, MS. IS.2:1896) reveals a conservative, careful painter. The fact that he had charge of the outline and design of several of the first paintings in the manuscript (fols. 2–5) suggests that he may have been one of the first artists to join the workshop. Folio 104 is assigned solely to Tulsi Kalan; despite prolific use of gold, bright colors and a busy scene, the painting has an archaic flavor. Four other designs are attributed to Tulsi in the manuscript and fol. 47 bears the appellation Tulsi Kalan. As Tulsi, his name appears in the *'Iyar-i danish* ("Book of fables"; *c.* 1590–95; Dublin, Chester Beatty Lib.), the *Bāburnāma* ("History of Babur"; *c.* 1591; London, BL, Or 3714) and the *Jāmi' al-tawārīkh* (dated 1596; Tehran, Gulistan Pal. Lib.) as sole artist and in collaboration with other painters as a designer (fols. 171*v* and 195*r*).

The Imperial Image: Paintings for the Mughal Court (exh. cat. by M. C. Beach; Washington, DC, Freer, 1981)

L. Y. Leach: *Mughal and Other Indian Paintings from the Chester Beatty Library* (Dublin, 1995), pp. 99 and 134

Tulunid. Islamic dynasty that ruled Egypt and Syria from 868 to 905. It was founded by Ahmad ibn Tulun (*b.* Iraq, 835; *d.* Egypt, 10 May 884), son of a high-ranking Turkish slave at the Abbasid court at Samarra, Iraq. Ahmad received military training there and theological instruction at Tarsus (now in Turkey). He came to the notice of the caliphs, and when his stepfather was appointed governor of Egypt in 868 Ahmad went with him as his deputy. He gained control of the financial administration of the country and set up an independent military force, which he used to subdue Syria. In 878 he was formally recognized as governor of both Egypt and Syria. He was the first ruler to secure Egypt's *de facto* independence from the Abbasid caliphs. The country prospered under his rule: for the first time in centuries the surplus funds derived from its rich agricultural base were not sent abroad as tribute, but were used to stimulate commerce and industry. In 870 Ahmad established a new quarter, named al-Qata'i' ("The Allotments"), outside the capital at Fustat (*see* CAIRO, §I, A). The mosque he built there, known as the Mosque of Ibn Tulun (*see* CAIRO, §III, B), is one of the glories of medieval Islamic architecture (see fig.; *see also* ARCHITECTURE, color pl. 1:V, fig. 1). Its forms, materials of

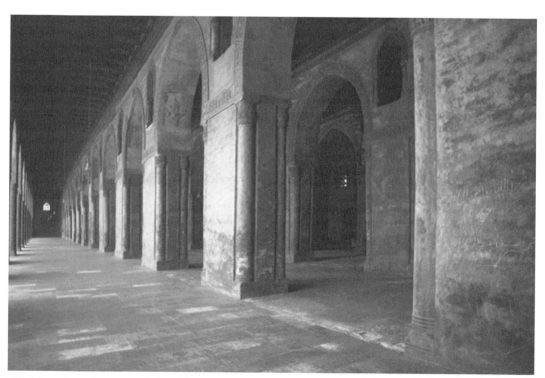

Tulunid, arcades in the mosque of Ahmad ibn Tulun, Cairo, 876–9; photo credit: Sheila S. Blair and Jonathan M. Bloom

construction and decoration reflect the contemporary architecture of the Abbasid court at Samarra (*see* ARCHITECTURE, §IV, A).

Ahmad was succeeded by his son Khumarawayh (*b.* Samarra, Iraq, 864; *d.* Fustat, Egypt, 18 Jan. 896). He was recognized as governor of Egypt by the Abbasid caliph in return for a massive annual tribute, although the workshops producing official textiles (*tirāz*) remained under the caliph's direct control. Court life became more opulent, and Khumarawayh extended the palace his father had built in al-Qata'i' with sumptuous pavilions and gardens. Although Khumarawayh had inherited a stable and wealthy state, such was his profligacy and so large were the amounts of tribute he had to pay that he left the treasury empty when he was assassinated. He was rapidly succeeded by his two teenage sons, Jaysh and Harun, neither of whom was able to maintain authority. The royal palace was looted and burnt in the disturbances that followed, and by 905 both Syria and Egypt had passed back under the direct rule of the Abbasid caliphs.

The production of ceramics and textiles (*see* CERAMICS, §II, D and TEXTILES, §II, A) and the carving of rock crystal, wood and stucco (*see* ROCK CRYSTAL, §I; WOODWORK, §I, A and STUCCO AND PLASTERWORK, §I) evidently flourished under the patronage of the Tulunids, although only fragmentary examples have survived. They reflect ABBASID models in the use of BEVELED STYLE ornament, but Egyptian artisans often interpreted the exclusively abstract designs of these models as birds or other representational motifs.

Z. M. Hassan: *Les Tulunides: Etude de l'Egypte à la fin du IXe siècle, 868–905* (Paris, 1933)

J. Amer. Res. Cent. Egypt, iv– (1965–) [preliminary rep. on the excavations made at Fustat by G. T. Scanlon]

L. A. Ibrahim: "A Tulunid Hammam in Old Cairo," *Islam. Archaeol. Stud.*, iii (1988), pp. 33–78

Tunis [Tūnis]. Capital city of Tunisia. The site, between a salt lake and a lagoon bordering the Gulf of Tunis, was first settled in the 9th century BCE. In 146 BCE during the Third Punic War it was destroyed along with nearby Carthage but later prospered under Roman rule. After the Muslim conquest in the 7th century and the founding of KAIROUAN, Tunis became second city of the region. The Zaytuna ("Olive tree") Mosque, founded in 732, was rebuilt between 856 and 864 by Abu Ibrahim Ahmad, sixth ruler of the AGHLABID dynasty (*r.* 800–909; *see* ARCHITECTURE, §IV, C). The prayer-hall has 15 aisles perpendicular to the qibla; the wide central aisle is surmounted by two cupolas, a gadrooned one (864) over the bay before the mihrab and another with polychrome decoration (11th century) facing the court. The trapezoidal court was lined at a later date with an arcaded gallery, and the square minaret at the northwest corner is a 19th-century rebuilding of a 13th-century original. An ablution facility was added under the HAFSID dynasty (*r.* 1228–1574).

Following the Hilalian nomadic invasions in the mid-11th century, Tunis grew at the expense of Kairouan. The Ksar Mosque was built by the local ruler Ahmad ibn Khurasan *c.* 1106 near his castle (Arab. *qaṣr*; destr.). Often restored, this simple mosque has a square minaret with elegant polychrome decoration (1647). The nearby Qubba of the Banu Khrissan (1093), the dynastic tomb, is a small cubic chamber with squinches supporting a dome; it stands in the gardens of the Musée Sidi Bou Krissan, a lapidary museum. The mosque of the Kasba (1231–5) was built just before the Hafsid Abu Zakariya declared his independence from the Almohads. Although the mihrab with vertical grooves and voussoirs in two colors continues local traditions, other features of this mosque, such as the *muqarnas*, carved stucco decoration and square minaret, were inspired by Andalusian and Moroccan designs (*see* ARCHITECTURE, §VI, D, 3). The Hawa (or Tawfiq) Mosque, founded in the suburbs by Abu Zakariya's widow, the princess 'Atf, has brick groin vaults supported on columns. Other buildings from this period include the Haliq Mosque (1375) and the Bab al-Aqwas Mosque (15th century).

In 1535 the Holy Roman Emperor Charles V (*r.* 1530–56) took possession of Tunis, but in 1574 it was taken by the Ottomans for the third and final time and ruled for them by a series of beys, or governors, until the French protectorate was declared in 1881. During the period of Ottoman rule many other mosques were built in the city; some, such as that of Hammuda Pasha (1655), have a traditional hypostyle plan, while others, such as that of Sidi Mahriz (*c.* 1675), founded by Muhammad Bey, have a domed prayer-hall in the Ottoman style. Among other mosques of this period are those of Sidi Yusuf (1616) and Yusuf Sahib al-Taba' (1812). The medina, or old city, retains much of its traditional aspect, with picturesque narrow streets and vaulted souks, and preserves many fine houses and palaces, such as the Dar al-Bey and Dar Hasan; they are irregular structures comprising patios surrounded by rooms. The Bardo Palace, founded by the Hafsids and enlarged by the beys of Tunis, stands in a park in the northern suburbs; it now houses the Archaeological Museum. The European quarter, which developed to the east of the medina after 1881, contains a variety of buildings in European styles, including the cathedral of St. Vincent de Paul, built in 1882 in the Byzantine Revival style. Among modern buildings in Tunis, the Hotel Meridien Africa (1970) rises to 21 stories.

G. Marçais: *Tunis et Kairouan* (Paris, 1937)

J. Revault: *Palais et demeures de Tunis, I (XVIe et XVIIe siècles)* (Paris, 1967)

A. Lézine: *Deux Villes d'Ifriqiya: Sousse, Tunis* (Paris, 1971)

J. Revault: *Palais et demeures de Tunis, II (XVIIIe et XIXe siècles)* (Paris, 1971)

S. M. Zbiss: *Les Monuments de Tunis* (Tunis, 1971)

J. Revault: *Palais et résidences d'été de la région de Tunis (XVIe-XIXe siècles)* (Paris, 1974)

A. Daoulatli: *Tunis sous les Hafsides* (Tunis, 1976)

D. Hill and L. Golvin: *Islamic Architecture in North Africa* (London, 1976)

J. Revault: *Palais, demeures et maisons de plaisance à Tunis (du XVIe au XIXe siècle)* (Aix-en-Provence, 1984)

F. Vigier: *Housing in Tunis* (Cambridge, MA, 1987)

J. Woodford: *The City of Tunis* (Outwell, Wisbech, 1988)

A. el-Gafsi: "La medersa des moriscos andalous à Tunis," *Sharq al-Andalus*, 5 (1988), pp. 169–80

J. Abdel-Kafi: *La médina de Tunis: Espace historique* (Paris, 1989)

N. Mahjoub: "Un monument funéraire hafside de la fin XIVe siècle à Tunis," *Africa* (Tunis), xiv (1996), pp. 179–211

N. Djellou: *Les fortifications côtières ottomanes de la régence de Tunis (XVIe–XIXe siècles)*, 2 vols. (Zaghouan, 1995)

A. el-Gafsi: "Le pont sur la route de Tunis à Bizerte: Est-il une oeuvre morisco-andalouse?," *Arab Hist. Rev. Ottoman Stud.*, xix–xx (1999), pp. 309–20

H. Ettehadiyeh: "The Medina of Tunis: A Successful Experience in the Reconstruction and Rehabilitation of Old Urban Fabric," *Tavoos*, ii (2000), pp. 138–47

A. Sasadaoui: "Deux établissements de charité de la ville de Tunis ottomane. Le mâristân et la takiyya," *Actes du IIIème Congrès International du Corpus d'Archéologie Ottomane dans le monde sur: Monuments ottomans: Restauration & conservation*, Série 2: Archéologie ottomane, 3 (Zaghouan, 2000), pp. 47–83

J. McGuiness: "Neighbourhood Notes: Texture and Streetscape in the Médina of Tunis," *The Walled Arab City in Literature, Architecture and History: The Living Medina in the Maghrib*, ed. S. Slyomovics (London, 2001), pp. 97–120

A. Saadaoui: *Tunis, ville ottomane: Trois siècles d'urbanisme et d'architecture* (Tunis, 2001)

A. Saadaoui: "Les fortifications de Tunis: les chantiers de Hammûda Pacha," *Arab Hist. ev. Ottoman Stud.*, xxix (2004), pp. 229–43

B. Kenzari: "Lake Tunis, or the Concept of the Third Centre," *Planning Middle Eastern Cities: An Urban Kaleidoscope*, ed. Y. Elsheshtawy (London, 2004), pp. 114–33

S. Akrout-Yaïche: "New Life for the Medina of Tunis," *Iran: Architecture for Changing Societies*, ed. P. Jodidio (Turin, 2004), pp. 65–8

C. Mosbah: "Qui est l'architecte de la mosquée de Mohammed Bey el-Mouradi de Tunis?," *Arab Hist. Rev. Ottoman Stud.*, xxxii (2005), pp. 19–34

Tunisia, Republic of [Al-Jumhūriyyah al-Tūnusiyyah; Tūnis]. Country in North Africa with its capital at TUNIS. It has an area of *c.* 163,600 sq. km, extending from the south shore of the Mediterranean Sea to the Sahara, and it is bordered to the west by Algeria and to the southeast by Libya. The coastal region and fertile plain of the Mejerda River are the most populous; the high plateau of the Tell and the eastern end of the Atlas range descend in the south to an area of salt flats and the sub-Saharan region. Tunisia's geographical position has kept it constantly at the center of Mediterranean history, with a cultural legacy that is a mixture of Berber, Punic, Roman, Arab, Byzantine, Spanish, Ottoman and French influences. Most of the population (10,102,000, 2005 estimate) is Arab, with a small percentage of Berber origin; the rest are French and Italian. The majority is Sunni Muslim, with Jewish and Christian minorities. Its main exports are phosphates, chemicals, textiles, crude oil, fish, olive oil and fruit, and there is a growing manufacturing sector; in the early 1990s tourism and remittances sent by migrant workers could not restrain Tunisia's mounting debts.

Although Tunisia was part of the Ottoman Empire from 1574, power was held by indigenous rulers, and the dynasty established in 1705 by Husayn Bey lasted until 1957. A policy of modernization in the 19th century resulted in bankruptcy, and French forces invaded the country in 1881. A protectorate was established, with the bey as nominal ruler, and the numbers of Italian and French settlers increased. In 1943 Tunisia came under the control of the Free French, but independence was gained in 1956 under the secularist Habib Bourguiba. The next year the bey was deposed, and Tunisia became a republic, with Bourguiba as president. Conflicts with the French continued into the 1960s, and stormy relations with Libya and internal unrest characterized the 1970s and 1980s. Bourguiba was deposed in 1987. One-party parliaments continued under his successor, Zine el-Abidine ben 'Ali, while the main opposition came from Muslim fundamentalists. This article concentrates on the arts since the 19th century.

I. Architecture. II. Painting and sculpture. III. Other arts. IV. Archaeology and museums.

I. Architecture. In TUNIS the European quarter developed outside the medina in the mid-19th century, and buildings were erected by the French in European styles. However, the French administration also began to sponsor public buildings in Arab styles. Some were fanciful pastiches, but others attempted to be faithful to what was understood to be the principles of Arab architecture, based on scholarly inquiry. This Arabizing treatment can be seen in railway stations, law courts, schools, post offices and private villas. One outstanding example of a villa was designed by the Italian millionaire Georges Sebastian in 1939–40, just outside Hammamet. It is made of local materials with a vault construction for which Hammamet builders were well known. White colonnades surround a tiled pool, bedrooms contain sunken "Roman" baths, and doors are studded in Andalusian style. In 1959 the Tunisian government bought Villa Sebastian and converted it into a cultural center, adding a "Greek" open-air theater in 1964. Every summer, Hammamet's International Festival of the Arts is held here and in the grounds.

Some of the Berber underground houses (e.g. at Matmata), first mentioned in the 4th century BCE, are still in use. These circular pit homes were dug into the soft earth, with an entrance tunnel that starts some distance away. The inhabitants, however, are beginning to move into modern houses at ground-level, particularly at Haddej, which was devastated by floods

in 1969. On Jerba Island the pre-colonial vernacular employs domes and barrel vaults, and after World War II a neo-vernacular style was developed based on this. From the 1970s, blocks of flats, offices and hotels began to abandon indigenous styles in favor of modern Western designs. City-center skyscrapers, houses that abandoned the tradition of a blank exterior to hide a sumptuous interior and the use of ornate decorative features to create a falsely exotic neo-Moorish architecture have led both Tunisian and foreign architects to search for an architectural style suitable for the present. The Résidence Andalous, an apartment hotel near SOUSSE, completed in 1980, addressed this problem. The architect Serge Santelli (b. 1944) attempted to express the structural principles of Tunisian architectural traditions and arranged the hotel around a series of inner and outer courtyards. The Résidence won an AGA KHAN AWARD FOR ARCHITECTURE in 1983. The Tunisian architect Tarak ben Miled (b. 1945) was also sensitive to these concerns in his designs for industrial buildings, hotels, university complexes and housing (e.g. Dar el-Mannaii in La Soukra, a suburb of Tunis).

From the 1970s there were various conservation schemes and some award-winning redevelopment. In the 1980s UNESCO decided that Tunis was in need of urgent attention; the internal city walls and kasba had been destroyed in the 19th century, and there was more damage in the 20th century because of bombing during World War II, neglect, increased traffic and rapid urban growth. After 1956 the bourgeoisie moved out of the medina to occupy houses in the new town vacated by the Europeans and took with them many architectural details to decorate their new houses. The Association to Safeguard the Medina was formed; one of its plans was for the redevelopment of the Hafsia Quarter, which was by then a slum. The plan was the first large-scale renovation project of its kind in an Islamic country and won an AGA KHAN AWARD FOR ARCHITECTURE in 1983. The conservation of the old town of Sidi Bou Said, aided by UNESCO, won this award three years earlier. There are well-preserved medinas in the important Islamic cities of MAHDIA, KAIROUAN, Sfax and Sousse; at Monastir the medina has been replaced by modern buildings and straight streets.

II. Painting and sculpture.

In 1894 French authorities founded the Institut de Carthage, which became the most important scientific and cultural institution in Tunisia, its function being to assert the cultural and educational legitimacy of the colonial power. In the same year, the Institut organized the first Salon Tunisien in Tunis, marking the formal introduction of Western art into the country. The participants were all French colonial artists. During the first two decades of the 20th century, the Salon Tunisien embraced ORIENTALISM, generally working within narrow and provincial academic traditions and rejecting modern trends current in Paris.

In 1923 the Centre d'Art opened, the first art school in Tunisia, and in 1930 it became the Ecole des Beaux-Arts. The teaching environment was strictly conservative, and until independence the number of Tunisian pupils was negligible in comparison to foreign students. However, the institution became instrumental in training several generations of artists. Foreign artists who settled in Tunisia collectively influenced the development of local artists by introducing Western styles into the country. Among the French artists who interacted with their indigenous counterparts were Alexandre Fichet (1881–1968), who moved to Tunis in 1902 and became president of the Salon Tunisien from 1913 until his death; Armand Vergeaud (1867–1949), who was associated with the teaching of art in Tunisia after his move there in 1910; and Pierre Boucherle (1895–1988), who was born in Tunisia.

Modern Tunisian art developed either on the periphery or within the framework of the annual exhibitions organized by the French. Ahmed ben Osman was the first local artist to adopt Western painting styles, while Hédi Khayachi (1882–1948) was the first professional artist in the modern sense of the term, known for his portraits of the beys of Tunis and genre scenes of traditional life according to the Orientalist principles. Abdulwahab Jilani (1890–1961), who became the first Tunisian Muslim to exhibit at the Salon Tunisien in 1912, left for Paris in 1921 and joined the Académie Julian and the free ateliers of Montparnasse. He participated in the activities of the Ecole de Paris and worked with Amedeo Modigliani (1884–1920), Pablo Picasso (1881–1973), Chaim Soutine (1893–1943), Marc Chagall (1887–1985) and others, essentially becoming a European artist. The most important pioneer to influence the formation of modern art in Tunisia was Yahia Turki (1901–68), a self-taught painter who refused a scholarship to the Ecole des Beaux-arts in Paris. His style added an indigenous quality to local painting, and his students included Abdelaziz ben Rais (1903–62), who trained at the Centre d'Art and was known for his peaceful landscapes and an economy in the use of color that did not detract from the overall richness of his work; Ali ben Salem, who was inspired by painting on glass and miniatures; Hatem el-Mekki (1918–2003); Amara Debbech (b. 1918), who emigrated to France; and Ammar Farhat (1911–86), who was to become one of the most important figures in the history of Tunisian modern art, his paintings showing the world of the deprived. These early native Tunisian artists attempted to portray a sympathetic and realistic view of North Africa, without the traditional Orientalist clichés.

The earliest artistic group in Tunisia to include Arab Tunisian artists was the Tunis School, founded by Boucherle in the late 1940s. Its members included such pioneers as Yahia Turki and Ammar Farhat, as well as artists from the second generation such as Hatem el-Mekki, Jalal ben Abdullah (b. 1921), Abdelaziz Gorgi (b. 1928), 'Ali Bellagha (b. 1925), Safia Farhat (b. 1924), Zoubeir Turki (b. 1924) and Hédi Turki (b. 1922); artists of the third, post-independence generation, among whom were

Hassan Soufi (*b.* 1937) and Abdelkadir Gorgi (*b.* 1949), were also involved. Each developed his or her personal style independently by diverging from contemporary European styles and trying to revive the two-dimensional forms of Islamic miniatures, the popular tradition of painting on glass, Arabic calligraphy and the different techniques of local handicrafts. The Tunis School played a significant role in introducing and developing Tunisian modern art.

The first to break away from the School were Hatem el-Mekki and Hédi Turki, who were less interested in transforming folk values into a symbolic or a thematic painting and sought to benefit from the experiments of international art, notably abstract art, Expressionism and Surrealism. Among the Arab countries abstract art was most practiced in Tunisia and helped to push many Tunisian artists into the international arena.

Najib Belkhodja (1933–2007) adopted a critical attitude towards abstract art and reverted to the use of calligraphic shapes and elements of Islamic architecture such as domes, arches and geometric forms within a two-dimensional perspective, bound together by cursive and angular shapes that recall the rhythm of kufic script. Nja Mahdaoui (*b.* 1937), who was trained at the Accademia S. Andrea in Rome, specializing in graphic art, first started creating abstract work through relief paintings. In the early 1970s, he began working on calligraphic compositions under the influence of the Iranian painter HUSSEIN ZENDEROUDI. The main element in these compositions is the Arabic letter, which he uses within illegible, abstract, visual arrangements in two-dimensional formations (see color pl. 3:XVI, fig. 4). The abstract painters were not the only artists to defy the realism of the Tunis School. By the end of the 1970s neo-figurative painters appeared, who rejected both the abstract artists' disregard for realism and the superficialities of classical figuration, preferring Expressionism, Surrealism, neo-realism and primitivism. By the early 1980s several abstract artists were experimenting with Pop art.

Graphic art is important in the development of Tunisian art but is less popular. Significant artists include Ibrahim Dahak (*b.* 1931), Khelifa Cheltout (*b.* 1939), Hedi Labban (*b.* 1946), Gouider Triki (*b.* 1949), who studied under Hédi Turki and then in Paris, and Muhammad ben Meftah (*b.* 1946), who studied engraving in Paris and became a professor of graphic design in Tunis.

III. Other arts. In the traditional arts of pottery and weaving there has been little modern development, although the ceramicist and painter Khalid ben Suleiman (*b.* 1951) produces notable work. Since the Roman period Moknine and Jerba Island have been centers for earthenware pottery, and rural traditions of molded pottery continue, with geometric patterns that date back thousands of years. Potteries at Tunis and Nabeul, the largest ceramic center in Tunisia, have revived the 17th-century Andalusian style of wall tiles with their green, yellow and blue floral designs. Dar Chaabane, near Nabeul, is the center for sculpted stonework, with geometric and floral designs; much of the intricate stonework on buildings in northeast Tunisia was carved there.

Kilims are woven at Kairouan following a tradition that probably originated in the 18th century, inspired by imported Anatolian rugs. However, when Europeans began to buy Kairouan carpets in large numbers from the late 19th century, quality declined as demand increased. Knotted carpets are controlled by the Office National de l'Artisanat Tunisien, which has set a number of standard patterns based on old tribal and Persian designs. Although geometric patterns predominate, there is a tradition of pictorial designs in the south (e.g. Gafsa). As elsewhere in the Arab world, jewelry was traditionally a Jewish specialty, and the craft has been affected by the migration of most craftsmen to Israel. Carved olivewood, such as bowls and boxes, are of a high standard (e.g. in Sfax; *see* WOODWORK, §II, A), metal birdcages are a specialty of Sidi Bou Said, and traditional leather crafts are made. The government has tried to preserve many of the country's old crafts, and there are craft schools (e.g. in the Muradia Medersa, Tunis).

IV. Archaeology and museums. Tunisia has an intensive concentration of historical sites. The first objects of artistic interest date from the 7th millennium BCE in southern Tunisia, and there are Neolithic cave paintings at Henchir Souar (northwest of Kairouan). The best-preserved architectural remains before the Arab conquest in the 7th century come from the Phoenician, Roman, Early Christian and Byzantine periods. The most significant Phoenician remains are at Kerkouane in the Cap Bon Peninsula, discovered in 1952. There are numerous Roman remains, particularly at Carthage (the Phoenician city was destroyed), the amphitheater at El Djem (anc. Thysdrus), the underground villas at Bulla Regia (first excavated in 1906 and continuing in the 1990s), the evocative ruined city of Dougga, the site of Sufetula at Sbeïtla, Haidra (which also has a Byzantine fortress), Makhtar (anc. Mactaris, first excavated in the late 19th century) and Thuburbo Maius (which German prisoners of war helped excavate during World War I). From 1881, excavations and restoration were encouraged by the French authorities, who set up a Department of Antiquities, housed in the Attarine Barracks in Tunis (now the National Library). Excavations are overseen by the Institut National de l'Art et de l'Archéologie.

Several of the sites have museums. There are also particularly rich archaeological museums at Nabeul, Sfax, Sousse and, above all, in Tunis: the Musée National du Bardo, founded in 1888, contains one of the greatest collections of mosaics in the world as well as numerous Carthaginian, Roman and some Islamic objects. There are a few museums concentrating on Islamic art, such as at Monastir (opened 1958), and several arts and crafts museums that display costumes, pottery, craft techniques and jewelry, such as the museums of popular arts and traditions in Tunis, El Kef (opened 1979), Gabès (opened 1969) and Houmt

Souk on Jerba Island (opened 1969), and in the Dar Jalluli in Sfax (opened 1966), a 17th-century palace that also contains good examples of painting on glass. Commercial art galleries and state-run exhibition halls are concentrated at or near Tunis, such as at Sidi Bou Said (which has a reputation as an artists' colony), Carthage and Sousse. The Centre d'Art Vivant (1980) in the Belvedere park in Tunis has exhibitions of contemporary Tunisian and Arab art.

R. Guy: *L'Architecture moderne de style arabe* (Paris, n.d.) [good pls]

P. Eudel: *L'Orfèvrerie algérienne et tunisienne* (Algiers, 1902)

V. Valensi: *L'Habitation tunisienne* (Paris, 1923)

L. Golvin and A. Louis: *Artisans sfaxiens: Tamis, dalous, cardes* (Tunis, 1945)

L. Golvin and A. Louis: *Les Tissages décorés d'El-Djem et de Djebeniana: Etude de sociologie tunisienne* (Tunis, 1949)

L. Poinssot and J. Revault: *Tapis tunisiens*, 4 vols. (Paris, 1950–57)

J.-L. Combès and A. Louis: *Les Potiers de Djerba* (Tunis, 1967)

J. Revault: *Arts traditionnels en Tunisie* (Tunis, 1967)

Z. Turki: *Tunis naguère et aujourd'hui* (Tunis, 1967)

R. Saïd: *Cultural Policy in Tunisia* (Paris, 1970)

G. Pillement: *La Tunisie inconnue: Itinéraires archéologiques* (Paris, 1972)

J. Kesraoui: *Peintres naïfs tunisiens* (Tunis, 1977)

M. Poncet: *Les Bijoux d'argent de Tunisie* (Tunis, 1977)

C. Sugier: *Bijoux tunisiens: Formes et symboles* (Tunis, 1977)

M. Masmoudi, ed.: *Les Costumes traditionnels féminins de Tunisie* (Tunis, 1978)

J. Revault: *L'Habitation tunisoise: Pierre, marbre et fer dans la construction et le décor* (Paris, 1978)

M. Yacoub: *Chefs-d'oeuvre des musées nationaux de Tunisie* (Tunis, 1978)

M. A. Lesage: *Formes et analogies de la villa tunisoise contemporaine* (Paris, 1982)

F. Béguin: *Arabisances: Décor architectural et tracé urbain en Afrique du Nord, 1830–1950* (Paris, 1983)

I. Reswick: *Traditional Textiles of Tunisia and Related North African Weavings* (Los Angeles, 1985)

P. Signoles: *L'Espace tunisien: Capitale et état-région* (Tours, 1985)

Tunisia, Egypt, Morocco: Contemporary Houses, Traditional Values (exh. cat. by B. B. Taylor; London, Zamara Gal., 1985)

S. Gargouri-Sethom: *Le Bijou traditionnel en Tunisie: Femmes parées, femmes enchaînées* (Aix-en-Provence, 1986)

Six peintres tunisiens contemporains (exh. cat., Paris, Mus. A. Mod. Ville Paris; Villeneuve d'Ascq, Mus. A. Mod. Nord; Paris, Mus. N.A. Afr. & Océan.; 1986–7)

A. Azzouz and D. Massey: *Maisons de Hammamet* (Tunis, 1988)

G. S. Golany: *Earth-sheltered Dwellings in Tunisia: Ancient Lessons for Modern Design* (Cranbury, London and Mississauga, 1988)

W. Ali, ed.: *Contemporary Art from the Islamic World* (London, 1989)

N. F. Carver: *North African Villages: Morocco, Algeria, Tunisia* (Kalamazoo, 1989)

I. Serageldin: *Space for Freedom: The Search for Architectural Excellence in Muslim Societies* (London, 1989)

J. P. Vilar: *Mapas, planos y fortificaciones hispánicos de Túnez (s.XVI–XIX): Cartes, plans et fortifications hispaniques de la Tunisie (XVIe–XIXe s.)* (Madrid, 1991)

A. Gafsi: *Monuments andalous de Tunisie* (Tunis, 1993)

S. el-Goulli: *Peinture en Tunisie: Origines et développement* (Tunis, 1994)

A. Loviconi and D. Loviconi: *Les faïences de Tunisie: Qallaline & Nabeul* (Aix-en-Provence, 1994)

Couleurs de Tunisie: 25 siècles de céramique (exh. cat., Paris, Inst. Monde Arab.; Toulouse, Mus. Augustins; 1994–5)

Regard sur l'art contemporain tunisien: Meriem Bouderbala, Rafik el Kamel, Jellel Gasteli, Ahmed Hajeri, Abderrazak Sahli (exh. cat., Paris, Inst. Monde Arab., 1995)

Le vert & le brun: De Kairouan à Avignon, céramiques du Xe au XVe siècle (exh. cat., Paris, Musées Nationaux; Marseille, Cent. Vielle Charité, 1995)

Noces tissées, noces brodées: Costumes et parures féminins de Tunisie (exh. cat., Paris, Mus. A. Afr. & Océan.; 1995)

W. Ali: *Modern Islamic Art: Development and Continuity* (Gainseville, 1997)

A. Ayyoub and A. Ben Salem: *Les feuillets du temps: Aly Ben Salem par lui-même* (Tunis, 1997)

N. Saadi and J.-P. Pradel: *Koraïs* (Arles, 1998)

M. Yacoub: *L'Histoire du verre en Tunisie, ou, Eclipse et renaissance d'un métier d'art* (Tunis, 2000)

Ifriqiya: Thirteen Centuries of Art and Architecture in Tunisia (Madrid, 2002)

F. Mahfoudh: *Architecture et urbanisme en Ifriqiya médiévale: Proposition pour une nouvelle approche* (Tunis, 2003)

Turkestan [formerly Shavgar, Yasi]. Town in Kazakhstan, north of Tashkent. Located at a ford across one of the tributaries of the middle Syr River, the town was known as Shavgar (Shāvaghar) to medieval Arab geographers, and its remains lie 8 km east of the modern town at the site of Chuy-tobe. It was the administrative and economic center of the region until the 13th century, when the name disappeared and was replaced by Yasi. Yasi was the home of Ahmad Yasavi (d. 1166), a Sufi shaykh responsible for the conversion of the Turks to Islam. His epithet, *ḥazrat-i turkistān* (Pers. "holy man of Turkestan"), has given the modern town its name. Timur ordered a magnificent mausoleum to be constructed over the shaykh's grave (see also ARCHITECTURE, §VI, A, 2 and SHRINE, fig. 2). The building is a compact rectangle (65.5×46.5 m). On the central axis a huge vaulted iwan leads to a central square room covered by a *muqarnas* dome (see fig.). Behind lies the mausoleum, which is also covered by a stunning *muqarnas* vault and protected by a blue-tiled melon-shaped dome. The sides of the building are filled with subsidiary service and residential rooms, including a mosque, kitchen, bath, library and meditation rooms. The core of the building was completed by 1394 and the upper part and the brick and glazed-tile revetment added in a second campaign (1397–9; see ORNAMENT AND PATTERN, color pl. 3:II, fig. 3), but the massive entrance portal on the south was never finished. The rich collection of metalwares made for the shrine included an elephantine cast-bronze basin (1399) and six inlaid brass oil lamps of baluster shape

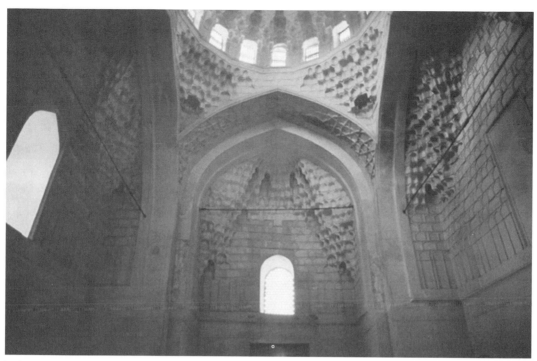

Turkestan, *muqarnas* vault in the shrine of Ahmad Yasavi, completed 1397; photo credit: Sheila S. Blair and Jonathan M. Bloom

(h. 900 mm; three *in situ*, others St. Petersburg, Hermitage, and Paris, Louvre). Rabi'a Sultan Begum (*d.* 1485), daughter of the Timurid ruler Ulughbeg, added an octagonal mausoleum (diam. 8.55 m; destr.) to the south of the shrine. The shrine had deteriorated by the late 19th century when it was used as a military depot, but it was restored in the 1950s.

Enc. Islam/2: "Aḥmad Yasawī"; "Yasawiyya"

M. E. Masson: *Mavzoley Khodzha Akhmeda Yasevi* [The mausoleum of Khwaja Ahmad Yasavi] (Tashkent, 1930)

A. A. Ivanov: "O bronzovykh izdeliyakh kontsa XIV v. iz mavzoleya Khodzha Akhmeda Yasevi" [Bronzewares of the late 14th century from the mausoleum of Khwaja Ahmad Yasavi], *Srednyaya Aziya i eyo sosedi* [Central Asia and its neighbours], ed. B. A. Litvinskiy (Moscow, 1981), pp. 68–84

L. Iu. Man'kovskaya: "Towards the Study of Forms in Central Asian Architecture at the End of the Fourteenth Century: The Mausoleum of Khvāja Ahmad Yasavi," trans. L. Golombek, *Iran*, xxiii (1985), pp. 109–27

L. Golombek and D. Wilber: *The Timurid Architecture of Iran and Turan* (Princeton, 1988), pp. 284–8, no. 53

B. T. Tuyakbayeva: *Epigraficheskiy dekor arkhitekturnogo kompleksa Akhmeda Yasevi* [Epigraphic decor of the architectural complex of Ahmad Yasevi] (Alma-Ata, 1989)

Timur and the Princely Vision (exh. cat. by T. W. Lentz and G. D. Lowry; Washington, DC, Sackler Gal.; Los Angeles, CA, Co. Mus. A.; 1989)

R. Z. Burnasheva: "Nekotorye svedeniya o monetnom dvore Yasy-Turkestana, XIII–XVII vv." [Information on the mint of Yasi-Turkestan, 13th–17th century], *Izvestiya Akad. Nauk Kazakh. SSSR: Seriya Obshchestvennaya*, i (1992), pp. 18–27

L. Komaroff: *The Golden Disk of Heaven: Metalwork of Timurid Iran* (Costa Mesa, 1992), pp. 237–49 [Appendix I: Metalwork from the shrine complex of Ahmad Yasavi]

A. Muninov: *Katalog arabograficheskikh rukopiseĭ muzeya-zapovednika "Azret-Sultan" v gorode Turkestan* (Turkestan, 1997), summarized in "The Fund of Arabographic Manuscripts in the Museum-trust 'Azret-Sulṭān' in the City of Turkestan," *Manuscripta Orientalia*, iii/2 (1997), pp. 39–41

Turkey, Republic of [Türkiye Cumhuriyeti]. Republic in the Middle East that lies 95% in Anatolia (Asia) and 5% in eastern Thrace (Europe), with its capital at ANKARA. Turkey has an area of *c.* 779,452 sq. km, bordered in the west by Bulgaria, Greece and the Aegean Sea, in the south by Iraq, Syria and the Mediterranean Sea, in the north by the Black Sea and in the east by Georgia, Armenia and Iran (*see* GEOGRAPHY AND TRADE, fig. 2). The economy is based on agriculture, with a significant growth in industrial output since World War II. The land is rich in minerals, and oil was found in southeast Anatolia in the 1960s. Tourism is an important additional source of revenue. The population of *c.* 71 million (2007 estimate) is 99% Muslim, the majority being Sunnis. Over 90% of the population has Turkish as its mother tongue. The principal linguistic minorities are the Kurds and Arabs. Kurdish is the mother tongue of *c.* 7% of the population, spoken predominantly in

eastern and southeastern regions; Arabic is the mother tongue of *c.* 1% of the population. There are also minority communities of Armenians, Greeks and Jews.

Turkey formed part of the Ottoman Empire from 1281 to 1923, with its capital at Istanbul from 1453. From 1839 the modernization of Turkey began under Abdülmecid (*r.* 1839–61) with a series of judicial, educational and fiscal measures known as the Tanzimat (Reorganization) reforms. After the collapse of the Ottoman Empire during World War I, when its territories were occupied and partitioned, there emerged an independence movement led by Mustafa Kemal (later known as Atatürk, "Father of the Turks") and in 1923 the Turkish Republic was proclaimed. The following year Atatürk abolished the Ottoman Caliphate (religious head), and then proceeded to transform Turkey by such measures as abandoning Arabic for Latin script, abolishing titles and ordering Turks to wear European clothes. On his death in 1938 Atatürk was succeeded by Ismet Inönü (*r.* 1938–50), and in 1950 the Democratic Party under Celal Bayar came to power. On the intervention of the military in 1960 a new constitution was accepted, which gave the presidency a titular role and greater power to the prime minister. This article concentrates on the art and architecture of Turkey since the late 19th century.

I. Architecture. II. Painting and calligraphy. III. Sculpture. IV. Decorative art. V. Art education. VI. Museums and galleries. VII. Archaeological sites.

I. Architecture. Throughout the 19th century European architectural ideas were introduced to Istanbul (*see* Istanbul, §I, E), especially in the buildings by the Balyan family of architects. European architects were also commissioned, and during the reign of Abdülhamid II (*r.* 1876–1908) they taught architecture at the Academy of Fine Arts (founded 1883) and the College of Civil Engineering (founded 1884). Late Ottoman architecture in Istanbul became dependent on Western capital, technology and ideas. The Public Debts Administration building (1899) by the French architect A. Vallaury and the Sirkeci Railway Terminal (1890) by the German architect A. Jachmund combined Neo-classical and Islamic elements. This revivalist idiom continued in the early 20th century with the eclectic buildings of the Turkish architects Vedat and Kemalettin and became known as the First National Architectural style (see color pl. 3:XII, fig. 2).

From the late 1920s under the Republican government new styles emerged, inspired by European modernism. Such European architects as Ernst Egli (1893–1983), Clemens Holzmeister (1886–1983), Hermann Jansen (1869–1945) and Theodor Post worked in Ankara and influenced the appearance of the new capital. Post's Ministry of Health building (1927–30) in Ankara stood at the forefront of this development, presenting angular masses and a façade with little ornamentation. In 1931 the first Turkish

architectural journal, *Mimar* ("Architect"; from 1935 named *Arkitekt*), was founded, and it published work in the modern style by Turkish architects. During the 1930s, with the encouragement of the Republican government, monumental buildings inspired by German and Italian architecture were commissioned. This phase culminated with Bedri Uçar's Directorate of Turkish State Railways building (1938–41) in Ankara.

From the late 1930s, however, there was a shift in emphasis—known as the Second National Architectural style—as architects began to express an awareness of indigenous Turkish culture in their work, but without a total rejection of modernism. Sedad Hakkı Eldem emerged as the influential voice in the defense of local styles over international ones and incorporated local features in his architecture, although some of his designs retained a monumentalism reminiscent of the 1930s. In 1940 Eldem published "Yerli mimariye doğru" ("Towards local architecture"), which contained his thoughts about a national idiom. The main building of this period, the Atatürk Mausoleum in Ankara (1944–53) by Emin Onat and Orhan Arda (1911–99), also expressed the preoccupation with evolving a national style.

In the 1950s American and European architectural influences became important in Turkey. The Hilton Hotel (1952) in Istanbul by the American firm Skidmore, Owings & Merrill with the collaboration of Eldem was influential as an example of the International Style. A partial liberalization of the Turkish economy led to rapid industrial development and urban growth, especially in Istanbul, Ankara and Izmir. Skyscrapers were introduced into city centers, and unplanned shanty towns developed around cities. From the 1960s increasing use was made of new materials and construction techniques. The campus buildings of the Middle East Technical University (early 1960s) in Ankara by Günay Çilingiroğlu, Altuğ Çinici and Behruz Çinici (*b.* 1932), for example, introduced an extensive use of exposed concrete. A movement towards architectural integration in urban areas also developed. Eldem's Social Security Complex (1962–4) in the Zeyrek district of Istanbul referred to Ottoman architectural traditions by employing corbels, cantilevers and eaves, while retaining a modern structure. Other influential buildings during this period included Turgut Cansever and Ertur Yener's Turkish Historical Society building in Ankara (1966), which has a plain exterior and protected interior space, and Sargin and Böke's monumental Iş Bankası Tower (1976) in Ankara. Some buildings displayed an articulation of small fragmented masses (e.g. Çilingiroğlu and Muhlis Tunca's Tercümen Newspaper Offices (1974), Istanbul, while others remained compact (e.g. Cengiz Bektaş's Turkish Language Society building, Ankara, 1972–8).

Vernacular architecture in Turkey has several regional variations (*see* Vernacular architecture, §VII). The traditional Ottoman house, made of stone or brick on the ground floor and with an upper

story made of a timber frame with stone or brick infill, was diffused from Istanbul throughout the Balkans and Anatolia. Along the Black Sea coast are houses made of wood from the foundations up, with clay packed between beams and roofed with tile or shingle. Wooden houses are also made of rubble packed between laths attached to wooden posts. Although wooden houses can often withstand earthquakes, they are subject to fire. In central and eastern Anatolia houses are built of mud-brick or stone with flat roofs or domes, and may be partially sunk below the ground. Such traditional building techniques, however, were eclipsed in the 20th century by the introduction of new materials. There also developed an awareness of the need to preserve the architectural heritage and some conservation areas were set up (e.g. at Eyüp in Istanbul).

II. Painting and calligraphy. As early as the 18th century European artistic conventions were incorporated in Ottoman miniature painting, and murals depicting landscapes and still-life subjects inspired by European work began to be executed. European conventions in drawing and painting were introduced to the curricula at the Artillery School (1793) and the Military Academy (1835) in Istanbul, and also at high schools (e.g. the Darüssafaka School, Istanbul, founded in 1873). From the 1830s some Turkish students were sent to Paris for their studies. It was as a consequence of these initiatives that easel painting developed in Turkey in the late 19th century.

Among the Turkish painters who were at the forefront of this development were Ahmet Ali and SÜLEYMAN SEYYIT, who both studied in Paris in the 1860s; their work consisted predominantly of landscape and still-life paintings. A particularly influential figure was OSMAN HAMDI, who resided in Paris for 11 years and embarked on portrait paintings and figural compositions (*see* OIL PAINTING, §II). In 1881 he became the director of the Imperial Ottoman Museum at the Çinili Kiosk (Tiled Kiosk), Istanbul, and, two years later, founded and became the first director of the Academy of Fine Arts, Istanbul. At the Academy, which had departments of architecture, sculpture and painting, Europeans were employed on the staff.

In the early 20th century the Çallı Group of painters was prominent in Istanbul, named after IBRAHIM ÇALLI, a graduate of the Academy who trained in Paris and returned to teach at the Academy in 1914. They were inspired by Impressionism and were notable for their landscapes (especially of views along the Bosporus), still-lifes and portraits. Other painters in the group included NAZMI ZIYA GÜRAN, who later became director of the Academy, Feyhaman Duran (1886–1970), Namık Ismail (1890–1935), Avni Lifij (1889–1927) and Hikmet Onat (1886–1977). They formed the ASSOCIATION OF OTTOMAN PAINTERS (renamed the Association of Turkish Painters in 1921), wrote about art in a new monthly magazine called *Naşir-i Efkâr* ("Promoter of Ideas") and

exhibited their work annually at the Galatasaray High School, Istanbul. In 1923 they were responsible for the first exhibition of paintings in Ankara.

After World War I younger Turkish painters turned away from the concerns of the Çallı Group to express ideas inspired by the Republic. The Turkish War of Independence resulted in a new consciousness of Anatolian culture, and paintings of this period included scenes of peasants and rural life. Ideas from Europe, however, continued to permeate the work of Turkish artists who trained in France and Germany, such as ALI ÇELEBI and AHMET ZEKI KOCAMEMI, both of whom studied in the workshop of Hans Hofmann in Munich in the 1920s, and Malik Aksel (1901–87), who studied in Berlin (1928–32).

The formation of the Association of Independent Painters and Sculptors in Istanbul in 1928 was important for the propagation of new ideas. Inspired by developments in European art, the artists in the Association advocated working independently and were unconcerned about creating a common style. The main members of the Association included Çelebi, Kocamemi, REFIK EPIKMAN, NURULLAH BERK and Mahmut Cuda (1904–87). In 1933 the D Group was formed in Istanbul by the painters Berk, CEMAL TOLLU, Abidin Dino (1913–93), Zeki Faik Izer (1905–88) and Elif Naci (1898–1987), and the sculptor Zühtü Müridoğlu. Later SABRI BERKEL and BEDRI RAHMI EYÜBOĞLU joined this group. They welcomed ideas from Europe with the result that Cubist, Constructivist and Expressionist ideas entered Turkish painting. TURGUT ZAIM, who painted distinctive scenes of peasant life, also exhibited with the D Group.

During the 1930s there was an increase in exhibitions and articles on art, which encouraged debate. The presence of the French artist Léopold Lévy (1882–1966) in Istanbul from 1937 to 1949 as head of the department of painting at the Academy also invigorated Turkish art. Art reflecting Republican ideals was encouraged by the government. In 1933 the tenth anniversary of the Republic was marked by the exhibition *Revolution and the Arts*, held by the Ministry of Education in Ankara. The subjects exhibited included portraits of Atatürk, commemorations of the War of Independence and the modernization of Turkey. In 1939 Inönü's government organized in Ankara the First State Exhibition of Painting and Sculpture, which became an annual event. Folklore themes in painting were also prominent and between 1938 and 1944 were promoted by the government policy of sending artists to the provinces.

By this time Atatürk's decision in 1928 to replace Arabic script with the Latin alphabet drove a wedge between the new culture of the Republic and the old Ottoman traditions. The art of calligraphy was an immediate casualty. Such masters of the art as HAMID AYTAÇ, HALIM OZYAZICI and NECMEDDIN OKYAY, however, did pass on their knowledge to such younger enthusiasts as Ali Alpaslan (*b.* 1925), Hasan Çelebi (*b.* 1937), Bekir Pektin (*b.* 1913) and others. Some of the traditions of Turkish calligraphy were also kept

alive in Egypt and Iraq, and the traditional art of calligraphy in Arabic script is being revived under the auspices of IRCICA, the Research Centre for Islamic History, Art and Culture founded in 1979 (*see* www3 .ircica.org), which holds regular competitions in the traditional scripts.

After World War II Turkish painters embraced a variety of styles and groups were formed for the pursuit of different aims. The New Group, founded in Istanbul in 1941, favored social themes and included such artists as NURI İYEM. From 1947 to 1955 the Group of Ten in Istanbul, led by Eyüboğlu, looked to Anatolian folk arts in the search for a native idiom. In 1959 the New Wing Group was formed in Istanbul; led by Ibrahim Balaban (*b.* 1921), it continued many of the ideas of the New Group concerning social themes. An abstract movement in Turkish painting developed in the 1950s, deriving some of its inspiration from calligraphy. Berkel, Izer and Abidin Elderoğlu (1901–74) were important in this area. The abstract trend reached a peak in the 1960s, continuing in the work of Adnan Turani (*b.* 1925) and Adnan Çoker (*b.* 1925). From the 1970s such styles as Pop art and Photorealism influenced Turkish painting. There have also been important Turkish artists active largely outside the country during the 20th century, such as FIKRET MUALLA (see color pl. 3:XIV, fig. 2), FAHRELNISSA ZEID and Burham Doğançay (*b.* 1925).

III. Sculpture. Under the influence of European art, sculpture developed from the late 19th century. A pioneer in this field was Yervant Oskan (1855–1914), who studied in Rome and taught at the Academy of Fine Arts in Istanbul. He was followed by his pupil Ihsan Özsoy (1867–1944), who trained in Paris, and Mehmet Mahir Tomruk (1885–1954) and Nejat Sirel (1897–1959), both of whom studied at the Akademie der Bildenden Künste in Munich. Sculpture in Turkey grew in importance after the creation of the Republic, when monuments and statues were commissioned to celebrate Atatürk and the War of Independence. Various sculptors were active in this domain, including RATIP AŞIR ACUDOĞU, ALI HADI BARA, HÜSEYIN GEZER, ZÜHTÜ MÜRIDOĞLU, Sabiha Bengutas (*b.* 1910), Nusret Suman (1905–78) and Kenan Yontunç (1904–95). The appointment of the German sculptor Rudolf Belling (1886–1972) as head of the statue department at the Academy of Fine Arts in Istanbul in 1937 ensured that Western influences continued to permeate Turkish work. Belling, who remained in Turkey until 1954, trained such sculptors as Gezer, Ilhan Koman (1921–86) and Hüseyin Özkan (*b.* 1909). After 1949 non-figural sculpture began to dominate the output of Hadi Bara, and minimal art was a source of inspiration for Şadi Çalik (1917–79). In 1961 Kuzgun Acar (1928–76) won first prize at the Paris Young Artist Competition.

IV. Decorative arts. Turkish crafts were affected by a range of factors, including the departure of Armenians—whose traditional skills included metalworking—the emergence of new forms of patronage under the Republic and the adoption of modern industrial techniques. Carpet production remained buoyant, although vegetable dyes were replaced by industrial dyes at the turn of the century and there was a growth of factory workshops. Commercial carpets for merchants were made on upright looms in large factories in such centers as KAYSERI, Isparta and Izmir. While the production of knotted-pile carpets was affected by market demands, flatweave techniques—which include the kilim, cicim, zili and sumak—were less affected, because European influence was minimal and the market exerted less pressure. Apart from the kilim, flatweave techniques have been traditionally used to produce such items as saddlebags, bolster and door covers and hearth cushions.

Pottery has continued to be made in such traditional centers as Çanakkale and Kütahya and has been encouraged at such new locations as the Academy of Fine Arts, Istanbul, where ceramic studios were established in 1929. There has also emerged a number of artist–ceramicists, several of whom have won large-scale commissions for public buildings. Füreya Koral (1910–97) carried out work in 1954 at the Hilton Hotel, Istanbul, and Bedri Rahmi Eyüboğlu produced a 227 sq. m mosaic panel for the façade of the Turkish Pavilion at the Exposition Universelle et Internationale in Brussels in 1958, which won a gold medal; he also worked on ceramic and stained-glass wall panels. Modern industrial demands were met by Atilla Galatalı (*b.* 1936), who designed objects for mass production at the Eczacibasi Ceramic Factory. Other artist–ceramicists include Sadi Diren (*b.* 1927), Candeğer Furtun (*b.* 1936), Güngör Güner (*b.* 1941) and Melike Kurtiç (*b.* 1930); in many cases their works can be regarded as sculpture.

V. Art education. The Academy of Fine Arts (Sanayi-i Nefise Mektebi) in Istanbul, which opened in 1883 (now a faculty of Mimar Sinan University), remains one of the main teaching institutions in Turkey for architecture, painting, sculpture and other arts (*see* ISTANBUL, §II, B). A separate Academy of Fine Arts for Women (Inas Sanayi-i Nefise Mektebi), directed by the painter Mihri Müşfik (1886–1954), opened in 1914, and the two merged in 1926. The Academy remained the only institution for European-style art education in Turkey until 1932, when an art department was formed at the Gazi Teachers' College in Ankara. Architecture, however, was also taught at the College of Civil Engineering (Hendese-i Mülkiye Mektebi; now Istanbul Technical University), while Yıldız Technical College (Yıldız Teknik Okulu; founded 1911) established a department of architecture in 1942.

The dual monopoly of the Academy of Fine Arts and the Gazi Teachers' College for education in the arts lasted until the 1950s, when there was a further expansion: the State School of Applied Arts, Istanbul, for example, opened in 1957. In the late 20th

century art was taught at a number of universities, including Ege University, Izmir; Hacettepe University, Ankara; and Anadolu University, Eskişehir. There were also private ateliers for practicing artists. Meanwhile, the promotion of research into all aspects of Turkish culture was encouraged by the founding of the Turkish Cultural Research Institute in Ankara in 1961, and a Research Centre for Islamic History, Art and Culture (IRCICA) was founded in Istanbul in 1979.

VI. Museums and galleries.

The museum movement began in 1846 when Ahmet Fethi Pasha, the Imperial Marshal of the Arsenal, collected weapons, coins and antiquities at the church of Hagia Eirene in the first courtyard of Topkapı Palace, Istanbul. In 1876 the antiquities collection was transferred to the Çinili Kiosk at Topkapı, which became the Imperial Ottoman Museum, while Hagia Eirene became a military museum. The Imperial Ottoman Museum developed rapidly after OSMAN HAMDI was appointed director in 1881. In 1883 he put into effect an order against the traffic in antiquities and began to organize excavations. Upon his death in 1910 his brother HALIL EDHEM ELDEM was appointed director. In the late 20th century three museums were at this location: the Archaeological Museum, the Museum of the Ancient Orient and the Museum of Turkish Ceramics in the Çinili Kiosk. The Topkapı Palace, with its superb collections of Islamic art and manuscripts, Chinese and Japanese porcelains and European items, opened as a museum in 1924 (see ISTANBUL, §III, E).

During the 20th century many other museums were established in Turkey. Those in Istanbul included the Islamic Museum founded in 1914 (at the Süleymaniye complex), which reopened in 1927 as the Museum of Turkish and Islamic Art (Türk ve Islam Eserleri Müzesi) at the Ibrahim Pasha Sarayı; the Hagia Sophia Museum (opened 1935); and Christ the Savior in Chora (Kariye Camii), a Byzantine church with mosaics and wall paintings. The Museum of Painting and Sculpture (Resim ve Heykel Müzesi; founded 1937) in Istanbul contains 19th- and 20th-century Turkish paintings and sculptures. In Ankara the Museum of Anatolian Civilizations, which has an important archaeological collection, and the Ethnographical Museum were founded in the 1920s. Many cities now have museums of folk art, while archaeological museums can be found at a range of cities and sites. A Museum of Turkish and Islamic Art was founded in 1975 at Bursa, and Islamic art is displayed in museums at Konya. In Istanbul the Vakıflar Carpet Museum opened in 1979 and the Vakıflar Kilim and Flat-Woven Rug Museum in 1982, both under the General Directorate of Pious Foundations. Banks and major companies have also funded and acquired art, sometimes for investment. The Iş Bankası, the first national bank of the Republican era, began to collect the work of contemporary artists in the 1920s and by the late 20th century had a rich collection of modern art. Commercial galleries also opened in the major cities in the late 20th century and various private museums were created, such as the Sadberk Hanım Museum at Istanbul (1980, with a range of early Islamic, Islamic and Ottoman artifacts) and the Sabancı Museum at Emirgan (2002, devoted to calligraphy and religious and state documents).

VII. Archaeological sites.

Turkey has a vast range of archaeological sites that date from prehistoric times to the Ottoman period. As early as 1834 Charles Texier drew attention to the ruins at Boğazköy, later identified as the site of the Hittite capital Hattusass. In 1835 the Hittite site of Alaca Höyük was discovered by William Hamilton; like Boğazköy, it has yielded important objects of art. Troy, Pergamon and Carchemish were excavated from the 1870s, followed by Zincirli and Sakça Gözü (from 1908). After World War I there were foreign and Turkish excavations at a range of sites in Anatolia, including Kültepe and Alişar Hüyük. The founding of the Turkish Historical Society in Ankara in 1931, and the Faculty of Languages, History and Geography in 1936, encouraged archaeological research among Turkish scholars. In 1933 a Department of Archaeology was established in the University of Istanbul. After World War II there were further archaeological discoveries in Anatolia. The settlement of Karatepe, discovered in 1946, yielded evidence on late Hittite architecture and sculpture, and work at the sites of Hacılar and Çatal Hüyük shed new light on the Neolithic period.

A. Thalasso: *L'Art ottoman: Les Peintres de Turquie* (Paris, 1910)

S. H. Eldem: "Yerli mimariye doğru" [Towards local architecture], *Arkitekt*, 3–4 (1940)

K. Özbel: *El Sanatları* (Ankara, 1945–9)

N. Berk: *La Peinture turque* (Ankara, 1950)

R. O. Arık: *L'Histoire et l'organisation des musées turcs* (Istanbul, 1953)

M. Cezar: *Sanatta batı'ya açılış ve Osman Hamdi* [Western trends in art and Osman Hamdi] (Istanbul, 1971)

E. Kortan: *Türkiye'de mimarlık hareketleri ve eleştirisi, 1950–1960* [Architectural movements in Turkey and their criticism, 1950–1960] (Ankara, 1971)

N. Berk: *Istanbul Resim ve Heykel Müzesi* [The Museum of Painting and Sculpture, Istanbul] (Istanbul, 1972) [Eng. and Turk. text]

N. Berk and H. Gezer: *50 Yılın Türk resim ve heykeli* [Fifty years of Turkish painting and sculpture] (Istanbul, 1973)

M. Tapan and M. Sözen: *50 Yılın Türk mimarisi* [Fifty years of Turkish architecture] (Istanbul, 1973)

M. Önder: *The Museums of Turkey and Examples of the Masterpieces in the Museums* (Ankara, 1977, rev. 2/1983)

W. T. Ziemba, A. Akatay and S. L. Schwartz: *Turkish Flat Weaves: An Introduction to the Weaving and Culture of Anatolia* (London, 1979)

Rugs of the Peasants and Nomads of Anatolia (exh. cat. by W. Brüggemann and H. Böhmer, trans. E. G. Herzog, G. M. Holmes and G. E. Holmes; Frankfurt am Main, Mus. Ksthandwk; Munich, Staatl. Mus. Vlkerknd.; Krefeld, Dt. Textilmus.; Lübeck, Mus. Kst & Kultgesch., 1980–82)

Ş. Rado: *Türk hattatları* [Turkish calligraphers] (Istanbul, n.d.)

B. B. Acar: *Kilim—Cicim—Zili—Sumak: Turkish Flatweaves* (Istanbul, 1983)

N. Berk and K. Özsezgin: *Cumhuriyet donemi: Turk resimi* [The Republican period: Turkish painting] (Ankara, 1983)

Discoveries from Kurdish Looms (exh. cat. by J. R. Perry and others; Evanston, IL, Northwestern U., Mary & Leigh Block Gal., 1983–4)

Z. Güvemli: *The Sabancı Collection of Paintings* (Istanbul, 1984) [Eng. and Turk. texts]

R. Holod and A. Evin, eds.: *Modern Turkish Architecture* (Philadelphia, 1984)

M. Sözen: *Cumhuriyet dönemi: Turk Mimarlığı (1923–1983)* [The Republican period: Turkish architecture] (Ankara, 1984)

O. Küçükerman: *The Art of Glass and Traditional Turkish Glassware* (Ankara, 1985) [Eng. and Turk. texts]

Z. Çelik: *The Remaking of Istanbul: Portrait of an Ottoman City in the Nineteenth Century* (Seattle and London, 1986)

G. Renda and C. M. Kortepeter, eds.: *The Transformation of Turkish Culture: The Atatürk Legacy* (Princeton, 1986)

S. Tansuğ: *Çağdaş Türk sanatı* [Contemporary Turkish art] (Istanbul, 1986)

S. Bozdoğan, S. Özkan and E. Yenal: *Sedad Eldem: Architect in Turkey* (Singapore, 1987)

W. Eagleton: *An Introduction to Kurdish Rugs and Other Weavings* (Buckhurst Hill, 1988)

G. Renda and others: *A History of Turkish Painting* (Geneva, Seattle and London, 1988)

S. Başkan: *Contemporary Turkish Painters* (Ankara, 1991)

S. Bozdoğan: "Modernity in the Margins: Architecture and Ideology in Early Republican Turkey," *Proceedings of the XVIII International Congress of the History of Art: Berlin, 1993*

H. Glassie: *Turkish Traditional Art Today* (Bloomington and Indianapolis, IN, 1994)

A. S. Kubat: "Sustainability and Identity of Traditional Anatolian Citadels," *International Journal for Housing Science and its Applications*, xx/2 (1996), pp. 131–42

T. Sabahi: "Tülü: Long-pile Rugs of Central Anatolia," *Ghereh: International Carpet & Textile Review*, xiv (1997), pp. 37–51

Ç. Kafescioğlu and L. Thys-Senocak: *Aptullah Kuran için yazılar: Essays in Honour of Aptullah Kuran* (Istanbul, 1999)

B. Nicolai: "Modernity and Modernist Architecture in Kemalist Turkey," *Art turc/Turkish Art: 10th International Congress of Turkish Art, 17–23 September 1995: Geneva*, pp. 497–508

M. al-Asad: "The Mosque of the Grand National Assembly in Ankara: Breaking with Tradition," *Muqarnas*, xvi (1999), pp. 154–68

A. B. Snyder: "Re-constructing the Anatolian Village: Revisiting Aliar," *Anatolica*, xxvi (2000), pp. 173–91

F. Yenişehirlioğlu: "The Republican Ethic and the Family Album: Aspects of Collecting and Art Historical Research in Turkey, 1923–50," *Discovering Islamic Art: Scholars, Collectors and Collections, 1850–1950*, ed. S. Vernoit (London, 2000), pp. 182–93

S. Bozdoğan: *Modernism and Nation Building: Turkish Architectural Culture in the Early Republic* (Seattle, 2001)

B. Tut: *Çizgi ve eller: Osman Hamdi Bey'den günümüze Türk resminde desen* [Lines and hands: drawings in Turkish painting from Osman Hamdi Bey to present] (Istanbul, 2001)

İ. Aslanoğlu and E. Çağlayan: "Architecture in the First Years of the Republic," *Turkey*, v of *The Turks*, ed. H. C. Güzel, C. C. Oğuz and O. Karatay (Ankara, 2002), pp. 660–65

A. K. Gören and B. Aydın: "Turkish Painting from the Beginning to Present in the Republican Period," *Turkey*, v of *The Turks*. 5, ed. H. C. Güzel, C. C. Oğuz and O. Karatay (Ankara, 2002), pp. 666–74

O. Yılmazkaya, N. F. Öztürk and J. Ülgen: *A Light onto a Tradition and Culture: Turkish Baths, a Guide to the Historic Turkish Baths of Istanbul* (Istanbul, 2003)

A. Akman: "Ambiguities of Modernist Nationalism: Architectural Culture and Nation-building in Early Republican Turkey," *Turk. Stud.*, v/3 (2004), pp. 103–11

A. Balamir: "Turkey between East and West," *Iran: Architecture for Changing Societies*, (Turin, 2004), pp. 83–92

M. U. Derman: *Masterpieces of Ottoman Calligraphy from the Sakip Sabanci Museum* (Istanbul, 2004)

Turkish Fine Arts Society. *See* ASSOCIATION OF OTTOMAN PAINTERS.

Turkmenistan. Central Asian country on the east side of the Caspian Sea, bounded by Kazakhstan to the northwest, Uzbekistan to the north and east, Afghanistan to the southeast and Iran to the south, where the Kopet Dag Mountains form a geographical barrier (see fig.). The Karakum Desert occupies much of the country and the Amu River constitutes an approximate or actual northeast boundary for much of its length. The capital, ASHGABAT, situated close to the southern border with Iran and on both the Transcaspian Railway and the Karakumskiy Canal, is almost entirely a 20th-century city following a sequence of devastating earthquakes. The country has the world's fifth-largest reserves of natural gas and substantial oil resources, and since independence in 1999 much of the country's revenue has been dispersed in grandiose schemes to modernize cities, especially Ashgabat.

I. Introduction. II. Architecture. III. Sculpture and painting. IV. Decorative arts.

I. Introduction. Archaeological evidence indicates settlement at key sites in the 5th millennium BCE (Altyn Tepe, Namazga I). MERV, one of the great Central Asian oases, was a major center by the start of the 1st millennium BCE. Khwarazm, centered on Urgench (now Kunya-Urgench) was a prosperous agricultural area from antiquity. Thereafter the territory covered by modern Turkmenistan was successively part of a number of empires starting with the Achaemenid (6th–4th century BCE). That of Alexander the Great (*r.* 336–323 BCE) and the Seleucid dynasty (late 4th century–3rd BCE) followed. The Parthians (with their capital at Nisa) held power from the 3rd century BCE to the 3rd century CE, during which time arose the various strands of the SILK ROUTE linking China with the eastern Mediterranean lands, one of which crossed the Karakum Desert via Merv. From the 3rd century CE the area was dominated by the Sasanians, who held power despite

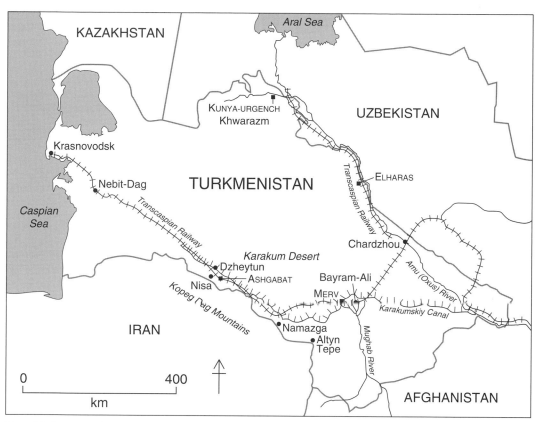

Map of Turkmenistan; those sites with separate entries in this encyclopedia are distinguished by CROSS-REFERENCE TYPE

nomadic incursions—the Huns (Hepthalites) drove them back to the Kopet Dag Mountains in the 5th century—until Merv fell to the Arabs in 651.

The region passed into the control of Islamic dynasties, some ruling from afar: the Umayyads and Abbasids, with governors based at Merv; the SAMANID dynasty (with their capital Bukhara in Uzbekistan); the Qarakhanids (*r.* 992–1211) and the Saljuqs, who under Sultan Sanjar (*r.* 1118–57) made Merv the capital of one of the most powerful Islamic empires. After his death the city was annexed by the Khwarazm-shahs ruling from Urgench, the nominal vassals of the Qara Khitay (Western Liao) of northern China. Turkic tribes had entered southwest Central Asia from the 5th century; a more serious incursion occurred in the 10th century when the Oghuz, originally from Mongolia, arrived in the tract between the Ural Mountains and the Aral Sea. Those on the right bank of the Syr River converted to Islam *c.* 1100. From that time they were referred to as Turkmen (Turkcoman) by Arab writers. Mongol invasions were initially deleterious (Merv was destroyed by Genghis Khan in 1221) but comparative peace returned under the Golden Horde (*r.* 1226–1502) and the Ilkhanids of Iran.

From the 16th to the 17th century southern Turk-menistan was controlled by the Safavids, while the north was ruled by the Uzbek *khan*s of KHIVA and

BUKHARA; however, continual shifts in the balance of power meant warfare was frequent. The SHAYBANID rulers (descendants of Genghis Khan) and their successors ruled much of Central Asia with varying degrees of success; latterly the area was divided into smaller principalities sometimes called khanates; that based on Khiva was ruled by the Arabshahids, a col-lateral branch of the Shaybanids, until *c.* 1700.

From *c.* 1500 Turkmen tribes were compelled by water shortages to concentrate near the great oases. By the 19th century the Savik were at Merv, the Yomut at Khiva, the Ersari on the upper Amu Delta. These movements coincided with the drastic decline of the Silk Route and a concomitant stultification of the region. In addition Turkmen tribal wars and khanate aggression—the khan of Bukhara sacked Merv in 1789—left it vulnerable to the increasingly powerful forces of Russia to the north. A series of offensives and campaigns in the late 18th century and the 19th gradually increased Russian influence, but though a treaty of 1791 purported to tie the Turkmen tribes to allegiance to the tsar, permanent Russian inroads depended on a concerted attack in the 1860s and 1870s that brought about the surren-der of the last remaining Central Asian khanate at Khiva in 1873. Anglo-Russian tension over the neb-ulous frontier between the two powers' spheres of influence increased Russian military expansion into

what is now Turkmenistan, and with this came railways, the building of forts and attempts to impose a European-style urban culture on a territory still characterized by its nomadic population. Russian colonization involved the building of new towns adjacent to their predecessors, thereby emphasizing the separation of indigenous and ruling populations.

Following the Revolution of 1917 Russia's Central Asian lands were left in political turmoil until the establishment of Soviet republics there in the 1920s. Turkmenistan, as the Turkmen SSR created in 1924, experienced decades of the imposition of central Soviet policy. This included attempts to establish cotton production on a vast scale: to this end the Karakumskiy Canal was built to irrigate large tracts of land. There was also the penetration of Soviet official art forms such as Constructivism. With the break-up of the USSR Turkmenistan declared its independence on 21 October 1991. The former Soviet leader, Saparmurat Niyazov, known as Turkmenbashi (Leader of the Turkmen) became President for Life and was replaced only after his unexpected death on 21 December 2006 by another strongman, Gurbanguly Berdimuhammedow.

II. Architecture.

II. Architecture. The architecture of late feudal Turkmenistan consisted of several types of nomadic dwelling. In areas close to the Kopet Dag Mountains, two- or three-roomed houses, with slender-columned porches (*ayvan*) and adjacent courtyards, were predominant. Close to Ashgabat and in Khwarazm, rich Tekke and Yomut semi-nomadic people built small fortress-like dwellings with high walls and towers. In the areas along the Amu River bordering Uzbekistan, dwellings had two enclosed courtyards. Some tribal homes had semicircular domes with openings for the smoke; without any windows, they resembled small mausolea. Houses were normally constructed of pisé (*pakhsa*), with flat roofs of wooden beams. Outside walls were often embellished by ornamentation carved into the clay surface when wet. Nomadic tents (*see* Tent, §II, B) consisted of wooden frames covered with felt held down on the outside by patterned woven strips; pile carpets covered floors and closed off entrances.

Once Turkmenistan was assimilated into Russia (1860–80) by means of a series of Russian military fortifications at Ashkhabad (now Ashgabat), Krasnovodsk and Merv (a new administrative center founded near Old Merv) and by villages at the railway stations of the Transcaspian Railway at Chardzhuy (now Chardzhou), Kizyl-Arvat and Bayram-Ali, towns designed by Russian engineers appeared. Buildings with façades in the Empire style of provincial Russia were built, such as military assembly halls, barracks, hospitals, churches, stations and schools, alongside traditional single-story mud-brick houses, mosques and caravanserais. In Soviet times the emphasis was on the construction of industrial facilities, such as a textile factory (1925–7) in Ashgabat in the Constructivist style. An attempt was made to create a new socialist town, its architecture taking account of local climatic and cultural conditions (Nebit-Dag, founded 1933, general plans 1942 and 1955, with designs for houses with terraces and outside staircases by the workshop of the Vesnin brothers). Until the mid-1950s the architecture of public buildings was dominated by a blend of Neo-classical forms and traditional Central Asian elements, with motifs from Turkmen decoration. The development of new town-building methods in Turkmenistan was decisively influenced by the destructive earthquake that hit Ashgabat in 1948. Following this disaster designs were drawn up for houses made of reinforced brick, with bands of earthquake-proof monolithic concrete. Town planning provided for industrial zones and public-cum-administrative centers, and wide avenues, large squares and green esplanades. Between 1960 and the 1980s the emphasis was on strict functionalism of form, organic links with the environment and an expressive use of monumental decoration and sculpture (e.g. the Karl Marx Square complex in Ashgabat, by architects Abdulla Akhmedov, Fikrat Rza-ogly Aliyev (*b.* 1933) and others, sculptors Vladimir Sergeyevich Lemport (1922–2001), Nikolay Andreyevich Silis (*b.* 1928), Dzhuma Dzhumadurdy (*b.* 1937) and others, 1969–76; the Headquarters of the Communist Party in Ashgabat, with decoration by sculptor Ernst Neizvestny (*b.* 1926); see color pl. 3:XIV, fig. 1).

Since independence, many grandiose new monuments have been erected in the capital, Ashgabat. The Kipchak Mosque, for example, is said to be the largest in Central Asia (see color pl. 3:XIII, fig. 2). Built by the French company Bouygues and inaugurated with great pomp on 22 October 2004, the building angered some Muslims by incorporating on its walls not only quotations from the Koran, but from the *Ruhnama* (Book of the Soul), a pseudo-spiritual work claimed to have been written by President Niyazov.

III. Painting and sculpture.

III. Painting and sculpture. Figural art in Turkmenistan dates back to the work of the first professional Turkmen artist, the itinerant (Rus. *peredvizhnik*; "wanderers") Nazar Yomudsky (1860–97), who studied with Pavel Petrovich Chistyakov (1832–1919) in the Academy of Arts in St. Petersburg, and to Russian painters who worked in Turkmenistan at the end of the 19th century and the beginning of the 20th. Two of them, Ruvim Moiseyevich Mazel (1890–1967) and Alexander Pavlovich Vladychuk (*b.* 1893), organized the "Avant-garde School of Arts of the East" in Ashkhabad (now Ashgabat) in 1920. Pupils from this school—Byashim Nurali (1900–65), Sergei Nickitovich Beglyarov (1898–1949) and others—became the founders of a national school of artists. Nurali, who later studied under Pavel Kuznetsov (1878–1968) in the Moscow Institute for Art and the Theater ("VKhUTEIN"), expressed through his work an integral world-view in a style imbued with elements from folklore and demonstrated a sensitive approach to national character and a truly national sense of color (e.g. *The Vintage*, 1929; Moscow, Mus. Orient. A; *Friends*, 1957; Moscow, Tret'yakov Gal.).

A special feature of the figural art of Turkmenistan is the predominance of painting, owing much to folk art traditions of coloring. In the 1960s and 1970s the work of Izzat Nazarovich Klychev (1923–2006), the brothers Aman Amangeldyyev (*b.* 1930) and Chary Amangeldyyev (*b.* 1933), Stanislav Gennadyevich Babikov (1937–77), Mamed Mamedov (1938–?1986), Kulnazar Bekmuradov (*b.* 1934) and Durdy Bayramov (*b.* 1938) was distinguished by its lofty subjects and the rich styles that perpetuate the emotion and energy of folk traditions. In the first years of Soviet rule propaganda graphics began to develop, followed in the 1950s and 1960s by engraving and stage design (Khaky Allaberdy (*b.* 1920) and Shamukhamed Akhmukhamedov (*b.* 1937)). The first local sculptors (Dzhuma Dzhumadurdy, Klychmurad Yarmamedov (*b.* 1941) and Makhtumkuly Nurymov (*b.* 1941)) began to work in the 1960s, eventually producing work in a wide variety of styles, though usually maintaining their links with the past. Generalized images of Turkmen people and emotionally expressive monumental forms are common features of the wall low-relief *Motherland* (bronze, 1971; Ashgabat) by Dzhuma Dzhumadurdy, a sculpted portrait of a Turkmen girl (limestone, 1971) by M. Nurymov and K. Yarmamedov's statue *The Bride* (granite, 1989). Perhaps the most unusual is the gold statue of Turkmenbashi set in front of the Arch of Neutrality that rotates to face the sun.

IV. Decorative arts. Turkmen objects of the 19th century and the beginning of the 20th, reflections of the late feudal structure of the life of the Turkmen tribes, are celebrated, especially in carpets, jewelry and embroidery. Turkmen carpets and articles, traditionally woven by women, are made from sheep's wool colored with natural dyes (sometimes with the addition of silk in the details of the pattern) on simple vertical or horizontal wooden looms; they varied enormously in shape, size and purpose (bed and wall carpets, door curtains, prayer mats, traveling pouches, mirror-cases, bags for salt and sugar etc.). Strict geometrical patterns consisted of multifaceted ornamented medallions—tribal and family signs repeated in chessboard-like or linear order, which are thought to show to which tribe the carpet belonged, hence the national proverb, "Spread your carpet and I'll know your heart." In all variants, the typical Turkmen composition features soft tonal coloring, with terracotta, dark red or cherry color predominating. Elements of carpet ornament partly date back to Parthian times and, with their obviously Turkic motifs, reflect the process of Turkification of the local population.

Jewelry made of silver with grains of cornelian or colored glass with a cascade of rustling silver pendants, coins and little bells, sometimes covered with gilding and black enamel, were the most costly part of Turkmen national costume, but embroidery was the dominant element. Using colored silk on plain (rarely patterned), usually dark, fabric, embroidery emphasized the cut of women's or men's clothing and covered the robes with a bright colored pattern, while jeweled, interwoven ornaments decorated articles for household use. Carpet horse-cloths and silver harnesses with insets of large cornelians were covered with embroidery; in addition, ornamented hide saddles and straps served as festive trappings for horses and camels.

In the Soviet period, the classical types of carpet of the Turkmen tribes (Tekke, Yomut, Sarak, Ersari (Arabatchi) etc.) continued, and new types appeared: portrait and figure carpets were made both in organized carpet workshops and later in the factories of the Turkmenkovyor Company. Early examples, created by the weavers in the 1920s (portraits of Lenin; compositions with propaganda slogans, such as "Down with bride-money!") exhibited an almost childlike candor as well as a charming primitive quality; from the second half of the 1930s, however, designs for carpets were created by professional artists. Traditional forms of national folk art continue, joined in the late 20th century by forms of decorative and applied arts that are new to Turkmenistan, especially tapestries and ceramics.

Enc. Islam/2

G. I. Surova: *Iskusstvo Turkmenskoi SSR* [Art of the Turkmen SSR] (Leningrad, 1972) [in Turkmen, Rus. and Eng.]

V. I. Pilyavsky: *Arkhitektura sovetskogo Turkmenistana* [Architecture of Soviet Turkmenia] (Leningrad, 1974) [in Turkmen and Rus.; with Eng. summary]

S. M. Erlashova: *Zhivopis' sovetskoi Turkmenii* [Painting of Soviet Turkmenia] (Leningrad, 1975) [in Rus. and Eng.]

L. B. Beresneva and E. F. Kogan: *Dekorativno-prikladnoe iskusstvo Turkmenii/The decorative and applied art of Turkmenia* (Leningrad, 1976)

K. Kuraeva: *Sovremennaya turkmenskaya skul'ptura, 1960–1970: Istoricheskiy ocherk* [Contemporary Turkmen sculpture, 1960–1970: historical outline] (Ashgabat, 1980)

Izobrazitelnoye iskusstvo Turkmenskoi SST [Visual arts of the Turkmen SSR] (Moscow, 1984) [album]

T. Kh. Starodub: "Iskusstvo sovetskoi Turkmenii: Istoricheskie traditsii i sovremennaya praktika" [Art of Soviet Turkmenia: historical traditions and contemporary practice], *Dek. Isk. SSSR* (1985), no. 4, pp. 3–5

Yu. J. Katsnelson: *Arkhitektura sovetskoi Turkmenii* [Architecture of Soviet Turkmenia] (Moscow, 1987)

E. Medjitova, M. Dzhumaniyazova and E. Grishin, eds.: *Turkmenskoye narodnoye iskusstvo* [Turkmen folk art] (Ashgabat, 1990) [album; with Eng. summary]

D. R. Brower and V. V. Vereshchagin: *Images of the Orient: Vasily Vereschagin and Russian Turkestan* (Berkeley, CA, 1993)

M. Annanepesov and M. Moshev: "Turkmenistan," *Towards the Contemporary Period: From the Mid-nineteenth to the End of the Twentieth Century*, vi of *History of civilizations of Central Asia*, ed. M. K. Palat and A. Tabyshalieva (Paris, 2005), pp. 305–27

Tylos. *See* BAHRAIN.

U

Ukhaydir. Early Islamic palace in Iraq, located in the desert on the Wadi ʿUbayd almost 200 km south of Baghdad. The ruins of this fortified palace provide important evidence for Islamic architecture and its decoration in the late 8th century. The site, known to several 18th-century travelers, was rediscovered by L. Massignon in 1908 and quickly visited and studied by Bell, Reuther and others, who dated it to the Sasanian (226–645) or early Islamic (7th century) period. Creswell (1932–40) circumstantially identified it as the palace of ʿIsa ibn Musa (*d.* 783/4), a powerful member of the ruling Abbasid family, but Caskel later argued that it was the palace of ʿIsa ibn ʿAli and dated it 762. The outer enclosure (175×169 m) is built of slabs of limestone rubble set in heavy mortar. Its walls, which once had a parapet, were originally about 19 m high. A round tower marks each corner, with half-round towers spaced regularly between. A gate in the center of each side is flanked by quarter-round towers, except on the north, where the main entrance is expanded with a projecting block. The north entrance leads to the palace proper (112×82 m), which is adjacent to the outer enclosure on the north. The palace consists of an entrance complex, with a small mosque to its right, a large open court with engaged pilasters, a great vaulted iwan leading to a square hall and flanking apartments. On either side of this central tract are two self-contained residential units arranged around smaller courts. Excavations by the Iraqi Department of Antiquities in 1963 revealed a bath complex constructed of baked brick to the southeast of the palace, which was added slightly later than the main construction. The palace at Ukhaydir is notable for the variety of its vaults, particularly the early use of transverse vaulting, and the extensive use of carved stucco and brick laid in geometric patterns. These features point to the increased importance of Mesopotamian and Iranian architectural traditions at the end of the 8th century and foreshadow the emergence of a distinctive regional style.

L. Massignon: "Note sur le château d'al Okhaïdir," *Acad. Inscr. & B.-Lett.: C. R. Séances* (1909), pp. 202–12

O. Reuther: *Ocheïdir* (Leipzig, 1912)

G. L. Bell: *The Palace and Mosque at Ukhaidir* (Oxford, 1914)

K. A. C. Creswell: *Early Muslim Architecture*, 2 vols. (Oxford, 1932–40; i repr. and enlarged, 1969)

K. A. C. Creswell: *A Short Account of Early Muslim Architecture* (Harmondsworth, 1958, rev. Aldershot, 1989)

W. Caskel: "Al-Ukhaidir," *Der Islam*, xxxix (1964), pp. 28–37

B. Finster and J. Schmidt: "Sasanidische und frühislamische Ruinen in Iraq," *Baghdad. Mitt.*, viii (1976) [whole issue]

Umayyad. Islamic dynasty of rulers and patrons descended from the Meccan clan of Umayya. One branch ruled from Syria from 661 to 750; following their defeat by the Abbasids, the surviving Umayyad founded another branch that ruled in the Iberian peninsula from 756 to 1031.

I. Syrian branch. II. Spanish branch.

I. Syrian branch. The Umayyads, the first Islamic dynasty, consolidated the empire and established a distinctive Muslim culture.

A. Introduction. B. Family members.

A. INTRODUCTION. The founder of the dynasty, Muʿawiya (*r.* 661–80), had been governor of Syria for two decades before he seized power following the death of ʿAli ibn Abi Talib (*r.* 656–61), the Prophet's cousin, son-in-law and fourth caliph. Under Umayyad rule the early Muslim conquests were consolidated and expanded, so that Islam found its furthest initial borders from central France to India and the borders of China. The Umayyads ensured that a distinctively Arab and Islamic culture spread throughout this vast empire, the internal frontiers of which gradually melted away. This political and, by degrees, cultural unity encouraged the large-scale movement of people and goods, including sea trade across the Indian Ocean. Arabic displaced Greek, Latin, Coptic and Pahlavi as the language of the bureaucracy, court, ruling élite and religious establishment. Arab descent was vaunted and secured preferential treatment in fiscal matters, military pensions and land allocation. This racial pride, coupled with their espousal of the spectacularly victorious Islamic faith, made the Umayyads largely impervious to the blandishments of the Christianized Classical culture of the Mediterranean world and the millennial Near Eastern culture of Sasanian Iran, both of which were supplanted. Such independence was symbolized by the choice of DAMASCUS as capital in preference to other, hitherto more important, eastern Mediterranean

cities. Reforms in the administrative structure and coinage of the empire (692–7) finalized this break with the past.

The Umayyad rulers, of whom the three strongest politically were Muʿawiya, ʿAbd al-Malik (*r.* 685–705; *see* §1 below) and Hisham (*r.* 724–43), took the title *khalīfat allāh* ("God's deputy"), thereby claiming religious as well as political authority. Yet their reign was punctuated by religious revolts (notably in 680 and a civil war lasting intermittently from 683 to 692), while their attempts to hold the balance between conflicting tribal factions (especially Qudaʿa vs. Qays) made for inherent political instability. Ultimately the dynasty was brought down *inter alia* by disaffected tribal groupings and non-Arab Muslims (Arab. *mawālī*) enraged at their treatment as second-class citizens.

The effective administrative system developed by the Umayyads can be seen in the planning and execution of vast building projects, such as the refurbishing of the Haram al-Sharif with the Dome of the Rock and the Aqsa Mosque (*see* JERUSALEM, §§II, A and B) and the Great Mosque of Damascus (*see* DAMASCUS, §III). Organized levies of labor and materials brought these projects to remarkably speedy completion. Public works were undertaken on a grand scale. Roads were built and provided with way-stations; travel was made safe; canals, dams, aqueducts and other irrigation works were constructed or repaired; and provision was made for the poor, the disabled and lepers.

Umayyad art survives principally in the form of architecture and its decoration, supplemented by the occasional textile (*see* TIRAZ), metalware (*see* METAL-WORK, §II), ceramics (*see* CERAMICS, §II) or ivory (*see* IVORY, §I). There is also a rich sequence of coins with increasingly bold and imaginative reworkings of Byzantine and Sasanian originals, culminating in a radically new, purely epigraphic type which accords pride of place to Koranic inscriptions and religious formulae (*see* COINS, §I). Umayyad religious buildings in Jerusalem, Damascus, MEDINA and SANʿA show—in their precise location, sheer scale, epigraphy and fabulously rich decoration, much of it in wall mosaic (*see* ARCHITECTURE, §X, D)—an acute awareness of the psychological, political and propaganda dimensions of architecture and self-consciously symbolize the new *imperium* (*see* ARCHITECTURE, §III). Sometimes direct comparisons with Christian monuments (as in Jerusalem and Sanʿa) drive the message home.

The many Umayyad secular establishments—hunting lodges, minor residences and full-scale palaces—erected for the most part in the hinterland of the major cities of the Levant speak the same language of power but with a rather different vocabulary. They draw on the Sasanian world for the notion of royal authority expressed through a luxurious lifestyle of feasting, reveling and hunting. The figural themes so obviously absent for theological reasons in Umayyad religious architecture are ubiquitous here and attest, as does much of the architectural detail, to the persistence of Classical and Byzantine stylistic

conventions (see fig.). Thus East and West merge in a new dispensation. But the Umayyad use of borrowed motifs is anything but reverential. It may veer into parody or burlesque; it yokes together disparate ideas with willful and unpredictable originality, changing the effect of familiar motifs by giving them an unexpected setting, enlarging or miniaturizing them, and boldly transferring ideas from one medium to another. This inexhaustible inventiveness, this sheer *élan*, is the abiding hallmark of Umayyad art.

K. A. C. Creswell: *Early Muslim Architecture*, i (Oxford, 1932; rev. 1969 in 2 vols/*R* New York, 1979)

E. Kühnel and L. Bellinger: *Catalogue of Dated Ṭirāz Fabrics: Umayyad, Abbasid, Fatimid: The Textile Museum, Washington, D.C.* (Washington, DC, 1952)

K. A. C. Creswell: *A Short Account of Early Muslim Architecture* (London, 1958); rev. by J. W. Allan (Aldershot, 1989)

U. Monneret de Villard: *Introduzione allo studio dell'archeologia islamica: Le origini e il periodo omayyade* (Venice, 1966)

O. Grabar: *The Formation of Islamic Art* (New Haven and London, 1973, rev. 1987)

F. M. Donner: *The Early Islamic Conquests* (Princeton, 1981)

R. Hillenbrand: "Islamic Art at the Crossroads: East Versus West at Mshatta," in *Essays in Islamic Art and Architecture in Honor of Katharina Otto-Dorn*, ed. A. Daneshvari (Malibu, 1981), pp. 63–86

R. Hillenbrand: "La *dolce vita* in Early Islamic Syria: The Evidence of Later Umayyad Palaces," *A. Hist.*, v (1982), pp. 1–35

M. L. Bates: "History, Geography and Numismatics in the First Century of Islamic Coinage," *Rev. Suisse Numi.*, lxv (1986), pp. 231–62

G. R. Hawting, *The First Dynasty of Islam: The Umayyad Caliphate A.D. 661–750* (London and Sydney, 1986)

R. Hamilton: *Walid and his Friends: An Umayyad Tragedy* (Oxford, 1988)

J. Raby and J. Johns, eds.: *Bayt al-Maqdis: ʿAbd al-Malik's Jerusalem*, Oxford Studies in Islamic Art, 9/i (Oxford, 1993)

F. B. Flood: "The Earliest Islamic Windows as Architectural Decoration: Some Iranian Influences on Umayyad Iconography, Observations and Speculations," *Persica*, xiv/14 (1990–92), pp. 67–89

O. Grabar: "Umayyad Palaces Reconsidered," *Ars Orientalis*, xxiii (1993), pp. 93–108

J. L. Bacharach: "Marwanid Umayyad Building Activities: Speculations on Patronage," *Muqarnas*, xiii (1996), pp. 27–44

S. Tamari: *Iconotextual Studies in the Muslim Ideology of Umayyad Architecture and Urbanism* (Wiesbaden, 1996)

J. Johns, ed.: *Bayt al-Maqdis: Jerusalem and Early Islam*, Oxford Studies in Islamic Art, 9/ii (Oxford, 1999)

The Umayyads: The Rise of Islamic Art (Beirut, 2000)

F. B. Flood: *The Great Mosque of Damascus: Studies on the Makings of an Umayyad Visual Culture* (Leiden, 2001)

J. M. Bloom, ed.: *Early Islamic Art and Architecture*, Formation of the Classical Islamic World, 23 (Aldershot, 2002) [several articles on Umayyad art and architecture]

F. Déroche: "New Evidence about Umayyad Book Hands," *Essays in Honour of Ṣalāḥ al-Dīn al-Munajjid/Maqālātwa-dirāsāt muhdāh ilá al-Duktūr Ṣalāḥ al-Dīn al-Munajjid*, Al-Furqān Islamic Heritage Foundation Publication, 70 (London, 2002), pp. 611–42

G. Fowden: "Late-antique Art in Syria and its Umayyad Evolutions," *J. Roman Archaeol.*, xvii (2004), pp. 282–304

G. Fowden: *Quṣayr 'Amra: Art and the Umayyad Elite in Late Antique Syria* (Berkeley, 2004)

D. Genequand: "Châteaux omeyyades de Palmyrène," *An. Islam.*, xxxviii/1 (2004), pp. 3–44

L. Treadwell: "'Mihrab and 'Anaza' or 'Sacrum and Spear'? A Reconsideration of an Early Marwanid Silver Drachm," *Muqarnas*, xxii (2005), pp. 1–28

S. Humphreys: *Mu'awiya ibn Abi Sufyan: The Saviour of the Caliphate*, Makers of the Muslim World (London, 2006)

B. FAMILY MEMBERS.

1. 'Abd al-Malik. 2. Al-Walid I.

1. 'Abd al-Malik [Abū Walīd 'Abd al-Malik ibn Marwān] (*b.* 646; *d.* Oct. 705; *r.* 685–705). Fifth caliph of the Umayyad line, 'Abd al-Malik was the son of Marwan (*r.* 684–85), who emerged victorious from a series of internal crises and replaced the first Umayyad line of Sufyanids with his own line of Marwanids, from which all subsequent members of the dynasty as well as those of the Spanish branch descended. 'Abd al-Malik endured his own internal crises, recovering Iraq and the east, defeating the Kharijite secessionists, and taking on the Byzantines. Despite these internal conflicts and external wars, his 20-year reign was notable for the centralization of administration and the substitution of Arabic in place of Greek and Persian as an official language in the financial administration. Under his patronage, the Dome of the Rock, the first major Islamic monument, was completed in 692 (*see* JERUSALEM, §II, A *and* ARCHITECTURE, color pl. 1:IV, fig. 2), and beginning in that year, he oversaw a currency reform, replaced the Byzantine *denarius* or gold coin with its image of the emperor with the first Muslim gold coinage. The re-editing of the Koranic text with vowel-markings is also attributed to his governor of Iraq, al-Hajjaj.

Enc. Islam/2

M. L. Bates: "History, Geography and Numismatics in the First Century of Islamic Coinage," *Rev. Suisse Numi.*, lxv (1986), pp. 231–62

J. Raby and J. Johns, eds.: *Bayt al-Maqdis: 'Abd al-Malik's Jerusalem* (Oxford, 1993)

C. Robinson: *Abd al-Malik*, Makers of the Muslim World (London, 2005)

2. al-Walid I [Abu 'l-'Abbas al-Walid I ibn 'Abd al-Malik] (*b. c.* 674; *d.* late Feb. 715; *r.* 705–15). Sixth caliph of the Umayyad line, al-Walid succeeded his father 'Abd al-Malik without opposition after the death of his uncle 'Abd al-'Aziz ibn Marwan in 704. Al-Walid's reign was a period of peace and external expansion, especially in comparison to the struggles of his father's reign. In addition to the establishment of an efficient welfare and military system, the reign of al-Walid saw a remarkable transformation of religious architecture, from utilitarian structures to buildings with political and symbolic implications. His reign covered the construction of three major mosques: the

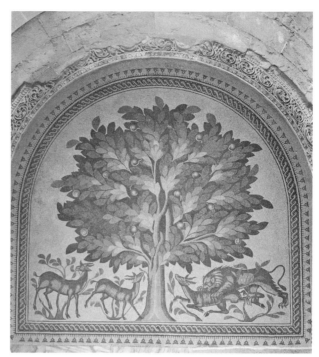

Umayyad mosaic depicting a lion attacking gazelles under a tree, from Khirbat al-Mafjar, second quarter of the 8th century; photo credit: Scala/Art Resource, NY

Mosque of the Prophet in Medina (Masjid al-Nabawi; 707–9), the Great Mosque of Damascus (706–15; *see* DAMASCUS, *§III and* ARCHITECTURE, color pl. 1:IV, fig. 1) and the Aqsa Mosque in Jerusalem (the construction period varies; *see* JERUSALEM, §II, B). Texts also credit al-Walid with the construction of several palaces, such as Khirbat al-Minya and ANJAR, although the archaeological record is more complex.

Enc. Islam/2

R. Grafman and M. Rosen-Ayalon: "The Two Great Syrian Umayyad Mosques: Jerusalem and Damascus," *Muqarnas*, xvi (1999), pp. 1–15

F. B. Flood: *The Great Mosque of Damascus: Studies on the Makings of an Umayyad Visual Culture* (Leiden, 2001)

II. Spanish branch. Founded by one of the few Umayyad princes who survived the massacre in Syria by their Abbasid rivals, the Spanish branch of the Umayyad line became the major power in the Iberian peninsula, claiming equality with the ABBASID caliphs in Mesopotamia and the FATIMID caliphs in North Africa.

A. Introduction. B. Family members.

A. INTRODUCTION. Extreme political instability had reigned for the first few decades after the Muslim armies entered Spain in 711, but following the arrival of the Umayyad amir 'Abd al-Rahman I (*r.* 756–88) the country was substantially pacified. He established in the Muslim West an implacable hostility to the Abbasid caliphate in Baghdad, and helped by

numerous refugees from Syria, he set about creating an alternative center of power in Spain. An obsessive fidelity to things Syrian is said to have expressed itself in place names and dialects, in the importation of Syrian trees and plants, in literary genres and tribal rivalries, and in the hydraulic techniques that made the barren lands of Andalusia verdant. The Great Mosque of Córdoba (see color pl. 1:V, fig. 3; *see also* CÓRDOBA, §III, A and ARCHITECTURE, §IV, D), which he founded in 786, is the most important building of the period. A marked conservatism in architecture and decoration was complemented by the adherence of Muslim Spain to the Maliki school of law and a lack of interest in Sufism.

Successive Umayyad rulers, keeping Córdoba as their capital, gradually extended their power over most of the peninsula apart from the Christian kingdoms in the north. By the late 10th century Spain had become the dominant culture of the western Islamic world, although the impact made by the aesthete Ziryab, a refugee from the *beau monde* of Baghdad, in such fields as music, poetry and dress, suggests that in these fields respect for Abbasid culture counted for more than did political enmity. The apogee of Umayyad rule came with the dazzlingly successful reign of (1) 'Abd al-Rahman III (*r.* 912–61). Following the example of the Fatimid rulers of North Africa, he took the title of caliph and made Córdoba the greatest city in Europe, perhaps ten times the size of Rome and complete with such amenities as street lighting, running water and public libraries. His palace–city outside Córdoba, MADINAT AL-ZAHRA, with its antique statues, quicksilver pond and other exotica, was the most splendid of several such medieval Islamic foundations in Spain. Despite occasional persecution, the Christian and Jewish minorities were allowed to play their full part in a tolerant, multi-confessional society. The Great Mosque of Córdoba (*see* ARCHITECTURE, §V, D, 1) enlarged for the fourth time in 981, was the second largest mosque after that of SAMARRA in Iraq, and it provided a model for such buildings as the Bab Mardum Mosque (999–1000) at Toledo.

Many arts flourished in the later Umayyad period, including woodwork (*see* WOODWORK, §I, C) and stone-carving (e.g. two marble troughs, dated 987–8; Madrid, Mus. Arqueol. N., and 1002–7; Marrakesh, Ben Yusuf Madrasa). Rich textiles of silk and gold tapestry inwoven in a tabby ground are represented by the celebrated Veil of Hisham II (*r.* 976–1013 with interruption; Madrid, Real Acad. Hist.; *see* TEXTILES, §II, C). Pride of place must go to ivory carving (*see* IVORY, §II). Inscribed caskets and pyxides, often with self-apostrophizing dated inscriptions identifying royal patrons, draw on a rich repertory of scenes of princely life and revelry. After the death of Hisham II, power slipped from Umayyad hands, and increasing factional unrest erupted in 1010 in a savage civil war during which Córdoba was sacked. This heralded the advent of the Party Kings (Arab.

mulūk al-ṭawā'if; Sp. *Reyes de Taifas*) under whose rule Spain broke up into a patchwork of rival principalities.

Enc. Islam/2

E. Lévi-Provençal: *Histoire de l'Espagne musulmane*, 3 vols. (Paris, 1950–53)

M. Gómez-Moreno: *El arte arabe español hasta los Almohades: Arte mozárabe*, A. Hisp., iii (Madrid, 1951)

J. Beckwith: *Caskets from Córdoba* (London, 1960)

J. M. Bloom: "The Revival of Early Islamic Architecture by the Umayyads of Spain," *The Medieval Mediterranean: Cross-cultural Contacts*, ed. M. J. Chiat and K. L. Reyerson (St. Cloud, MN, 1988), pp. 35–41

J. D. Dodds: *Architecture and Ideology in Early Medieval Spain* (University Park, PA and London, 1990)

Al-Andalus: The Art of Islamic Spain (exh. cat., ed. J. D. Dodds; Granada, Alhambra; New York, Met.; 1992)

G. Martinez-Gros: *L'Idéologie omeyyade: La construction de la légitimité du Califat de Cordoue (Xe–XIe siècles)*, Bibliothèque de la Casa de Velázquez, 8 (Madrid, 1992)

P. C. Scales: *The Fall of the Caliphate of Córdoba: Berbers and Andalusis in Conflict*, Medieval Iberian Peninsula: Texts and studies, 9 (Leiden and New York, 1994)

J. M. Safran: *The Second Umayyad Caliphate: The Articulation of Caliphal Legitimacy in al-Andalus*, Harvard Middle Eastern monographs, 33 (Cambridge, MA, 2000)

M. del Camino Fuertes Santos: *La cerámica califal del yacimiento de Cercadilla, Córdoba* (Seville, 2001)

M. J. Viguera Molíns, C. Castillo and M. Córdoba Salmerón: *El esplendor de los Omeyas cordobeses: La civilización musulmana de Europa occidental* (Granada, 2001)

The Splendour of the Cordovan Umayyads: Exhibition in Madinat al-Zahra, Cordova, from 3 May to 30 September, 2001 (Cordoba, 2001)

J. A. Souto: "Stonemasons' Identification Marks as a Prosopographical Source: The Case of Umayyad Al-Andalus," *Med. Prosopography*, xxiii (2002), pp. 229–45

Chrétiens et musulmans autour de 1100: Actes des XXXVIe Journées Romanes de Cuxa, 8–15 juillet 2003 (Cuxa, 2004)

J. David Col., ii (2005) [entire issue edited by K. von Folsach and J. Meyer with papers from a symposium entitled *The Ivories of Muslim Spain* held in Copenhagen November 18–20, 2003]

B. FAMILY MEMBERS.

1. 'Abd al-Rahman III. 2. Al-Hakam II.

1. 'Abd al-Rahman III [Abū 'l-Muṭarrif al-Nāṣir 'Abd al-Raḥmān III b. Muḥammad] (*b.* Córdoba, 7 Jan 891; *d.* Córdoba, 15 Oct. 961; *r.* 912–61). Only 23 at his accession, 'Abd al-Rahman was the greatest ruler of the Spanish Umayyad line. He spent the first years of his half-century reign pacifying his rivals. Having achieved political unity, he then took on external enemies, notably the Christians in the area and the Fatimids in North Africa. In 929, he adopted the title *amir al-mu'minīn*, thereby becoming the first Umayyad caliph of al-Andalus. In 936, he commissioned a new palatial

complex at MADINAT AL-ZAHRA, a few kilometers west of the city center of Córdoba, as a royal residence and administrative center (*see* ARCHITECTURE, fig. 26). A Spanish counterpart of the Abbasid palace–city of Samarra, this open-plan palace was intended as a visual manifestation of his caliphate. 'Abd al-Rahman also extended of the Great Mosque of Córdoba by enlarging and refurbishing the courtyard in 951–2 and erecting a monumental minaret on the north side. During the later part of his reign, 'Abd al-Rahman ruled as a potentate over an immensely rich state.

Enc. Islam/2

F. Hernández Giménez: *Madínat al-Zahrá': Arquitectura y decoración* (Granada, 1985)

Al-Andalus: The Art of Islamic Spain (exh. cat., ed. J. D. Dodds; Granada, Alhambra; New York, Met.; 1992)

R. Arié: "Histoire d'un calife cordouan Abd al-Rahman III," *Madina: Cité du Monde*, ii (1995), pp. 26–30

C. Ewert: *Die Dekorelemente der Wandfelder im reichen Saal von Madînat az-Zahrá': Eine Studie zum westumaiyadischen Bauschmuck des hohen 10. Jahrhunderts* (Mainz, 1996)

M. Fierro: "La política religiosa de 'Abd al-Rahmān III (r. 300/912–350/961)," *Al-Qantara*, xxv/1 (2004), pp. 119–56

M. Fierro: *Abd-al-Rahman III of Cordoba*, Makers of the Muslim World (London, 2005)

M. Fierro: "Por qué 'Abd al-Rahmān III sucedió a su abuelo el emir 'Abd Allāh," *Al-Qantara*, xxvi/ii (2005), pp. 357–69

2. al-Hakam II [Abu 'l-Mutarrif al Mustansir al-Hakam II b. 'Abd al-Rahmān III] (*b.* 914/15?; *d.* Córdoba, 1 Oct. 976; *r.* 961–76). Son of (1) 'Abd al-Rahman III, al-Hakam waited in the wings until assuming power at age 46, but his reign as the second Umayyad caliph of Spain was one of the most peaceful and fruitful of the line. He had a long experience in public affairs. Having served as supervisor to the construction at MADINAT AL-ZAHRA, he took over his father's architectural work on this palatial complex and remodeled the private quarters there. He also further enlarged the Great Mosque of Córdoba by adding an additional 12 bays on the qibla side, a multi-bay MAQSURA and a splendid mihrab of gold and glass mosaic.

A highly cultured man, he possessed a vast library with some 400,000 books (this library was sacked in the Berber siege of Córdoba in 1100). He encouraged the translation of many books from Latin and Greek into Arabic and employed the famous physician, scientist, and surgeon Abu al-Qasim (Abulcasis; 936–1013) at his court.

Enc. Islam/2: "al-Hakam II"

D. Wasserstein: "The Library of al-Hakam II al-Mustansir and the Culture of Islamic Spain," *MSS Mid. E.*, v (1990–91), pp. 99–105

B. Cabañero Subiza and V. Herrera Ontañón: "Nuevos datos para el estudio de la techumbre de la ampliación de Al-Hakam II de la mezquita aljama de Córdoba: Cuestiones constructivas," *Artigrama*, xvi (2001), pp. 257–83

Umm al-Qaywayn. *See under* UNITED ARAB EMIRATES.

United Arab Emirates [Arab. Al-Imārātt al-'Arabiyya al-Muttahida; formerly the Trucial States]. Federation of seven states in the eastern Arabian peninsula, with coastlines along the Gulf: Abu Dhabi (comprising 88% of the territory), Dubai, Sharjah (Arab. al-Shariqa), Ra's al-Khayma, Fujayra, Umm al-Qaywayn and 'Ajman (the smallest emirate); each emirate is named after its main city. Salt flats along the coast give way to sand desert and gravel plains, with the Hajar mountain range dividing the east and west coasts. The population (*c.* 4,500,000; 2005 estimate) is mainly Sunni Muslim, with a large expatriate workforce. In prehistoric times the people were sea traders on the route between the east (e.g. Indus Valley, Iran) and Mesopotamia. They were at the height of their prosperity in the 3rd millennium BCE when greater Oman (including the UAE) can possibly be identified as the copper-producing land of Magan, known from Mesopotamian cuneiform tablets. Islam arrived in this region *c.* 630. The Portuguese occupied the main Gulf ports from the 16th century to the mid-17th. The origins of the present-day states lie in the 18th century when relations with Britain also began. In the late 19th century and early 20th the pearl industry reached its height, which helped make Dubai a major entrepôt. In 1971 Britain withdrew from the region and the UAE was founded. Revenue comes largely from oil and gas. Oil was found from 1958 onwards in Abu Dhabi, Dubai, Sharjah and Ra's al-Khayma.

Oil revenues, particularly from the 1970s, financed intensive urban development and the destruction of many old buildings in Abu Dhabi, Dubai and Sharjah. Because of the need to provide for a modern state with an international business community, Western architects were commissioned to design International Style high-rise buildings; these dominate, for example, the Corniche in Abu Dhabi and the Creek in Dubai. Islamic motifs were occasionally incorporated, such as arched entrances, but from the late 1970s attempts were made to find styles that related more to the local environment and the region's history, and Arab architects were also commissioned. An awakened interest in the past also led to the restoration and preservation of various old buildings, such as watch towers and forts.

In Abu Dhabi town the only remaining building from the pre-oil past, dwarfed by modern skyscrapers, is the restored al-Husn Palace, also known as the White or Old Fort (1793). It houses the Center for Documentation and Research, which collects manuscripts and archives covering the Islamic history of the Emirates. In Dubai there are houses with wind-towers in the Bastakiya district that were built in the early 20th century by Iranian immigrants and are being preserved. Shaykh Sa'id's palace (late 19th century) in the Shindagha district of Dubai was converted to a museum in 1986. It had been abandoned in 1958 and

was rebuilt using the old coral blocks. It is a courtyard house with wind-towers and such traditional features as pierced plaster screens and carved woodwork. Al-Fahidi Fort (early 19th century) is the oldest building in Dubai. Formerly the seat of government, it was re-opened in 1971 to house the Dubai Museum. It is built of plastered coral blocks and has been given an extensive face-lift. Forts of coral stones or baked mud are also to be found in Fujayra, Ra's al-Khayma and 'Ajman. Many of the old souks have been pulled down and modern shopping malls erected. However, souks that combine modern and traditional elements have been built, such as the monumental Sharjah or New Souk (also known as the Central Market) in Sharjah, with its blue-tiled round roofs and wind-towers, designed by the British architects Michael Lyell Associates (1978). One of the first modern buildings in the region to use an Islamic vocabulary, it incorporates traditional tile designs and *muqarnas* niches under a barrel-vaulted roof. Many of the old mosques have been replaced by new buildings commissioned either by the state or by private individuals. The huge King Faisal Mosque in Sharjah and the Jumayra Mosque in Dubai (1983) underline the centrality of the Muslim faith in the UAE.

The art movement in the Emirates dates to the mid-1970s, when artists sent on scholarships returned from Egypt, Iraq, Syria, Britain, France and the USA. As in neighboring countries, the strongest artistic trend in the Emirates is a figurative one that records traditional scenes. Among its adherents are Abdul Qadir al-Rayis (*b*. 1948), Muhammad al-Qasab, Ibrahim Mustafa (*b*. 1953), Abdar Rahman Mal-Zainal, Muhammad Mundi, Issam Shreida (*b*. 1953), Abd al-Karim Sukar, Obaid Srour (*b*. 1955) and Muna al-Khaja. The Surrealists include Salih al-Ustadh (*b*. 1957), who has studied in California and produces Daliesque works, and Hisham al-Mazloum, a graduate of the Al-Ain University. Other notable artists in the Emirates include Muhammad Yousif (*b*. 1954) and Hassan Sharif (*b*. 1956). The Emirates Fine Arts Association founded in 1980 in Sharjah has been instrumental in arranging exhibitions in the UAE and abroad. Since 1993 the Department of Culture and Information in Sharjah has hosted an international biennale, with contemporary art from around the world, especially the Arab countries. The seventh, held in 2007, showcased the work of 70 artists from 36 countries.

Many traditional crafts are still practiced, often supported by the government, such as pottery (figurines as well as pots), weaving, braiding (using date-palm fibers for baskets etc.), embroidery and making bride chests of wood and brass. Jewelry in the lower Gulf has traditionally employed coral and small polished pebbles from the shores. The government-run Women's Craft Center in Abu Dhabi teaches and promotes traditional craft skills.

Most of the Emirates have museums. The Al-Ain Museum, Abu Dhabi, is in the grounds of a fort built in 1910. It has objects from several archaeological excavations, as well as silver Bedouin jewelry and a collection of weapons, such as *khanjars* (small ornamented daggers); it also houses the Department of Antiquities. In Abu Dhabi town the Cultural Foundation holds exhibitions of foreign and local artists. A new $400 million Guggenheim Museum designed by Frank Gehry (*b*. 1929) is scheduled to open on Saadiyat Island in Abu Dhabi in 2011. The Dubai Museum in al-Fahidi Fort contains archaeological finds, traditional weapons, dress, crafts, jewelry and other artifacts from the 1st millennium BCE to the present. There are several commercial art galleries in Dubai, and the Emirate also hosts international exhibitions of Arabic calligraphy. The fourth, held in 2007, included works by 21 contemporary calligraphers from 9 countries. Ra's al-Khayma has a museum in a restored mid-18th-century fort with objects from the sites at Shimal and Julfar (the old port abandoned in the 17th century in favor of Ra's al-Khayma) as well as traditional silver jewelry. 'Ajman's museum (opened 1981) is in a late 18th-century fort and includes archaeological finds and weapons. The museum at Fujayra opened in 1991 and also displays archaeological finds, traditional weapons and dress.

The Heritage and Arts Areas in Sharjah comprise several museums in the historic district. The Heritage Area contains the Sharjah Museum for the Art of Arabic Calligraphy and Ornamentation; several 19th-century houses, the traditional Esiah School (originally the Al-Qasimi School, 1935), the Sharjah Heritage Museum with a selection of crafts; the Maritime Museum; and the Majlis of Ibrahim Mohammed al-Midfaa with a round wind-tower. The Arts Area houses the Sharjah Art Museum and the Sharjah Museum for Contemporary Arab Art, the largest art museum in the Gulf with a permanent collection of Orientalist paintings and exhibitions of contemporary art in various media. A new Islamic Museum is scheduled to open along the Corniche in 2008; meanwhile the Islamic Museum in the Heritage Area (1996) displays manuscripts, coins and other artifacts. The Sharjah Archaeological Museum (1996) exhibits pre-Islamic artifacts going back to 5000 BCE. In 2006 the Sharjah Museum Department was created to manage and develop the various museums.

Archaeology in the UAE, i–iv (1976–9)

G. Bibby: *Looking for Dilmun* (London, 1970)

M. M. Abdullah: *The United Arab Emirates* (London, 1978)

R. S. Zahlan: *The Origins of the United Arab Emirates* (London, 1978)

P. Mansfield: *The New Arabians* (Chicago, 1981)

J. Whelan, ed.: *UAE: A MEED Practical Guide* (London, 1982, rev. 1990)

W. Dostal: *The Traditional Architecture of Rās al Khaimah (North)* (Wiesbaden, 1983)

A. Salman: *Al-tashkīl al-muʿāṣir fī duwal majlis al-taʿāwun al-khalījī* [Contemporary art in the countries of the Gulf Cooperation Council] (Kuwait, 1984)

J. Hansman: *Julfār, an Arabian Port: Its Settlement and Far Eastern Ceramic Trade from the 14th to the 18th Centuries* (London, 1985)

A. Al-Tajir and A. J. Ahmed, eds.: "The Arts in the United Arab Emirates: A Special Supplement," *A. & Islam. World*, iii/4 (1985–6), pp. 57–96

W. Ali ed.: *Contemporary Art from the Islamic World* (London, 1989)

S. Kay and D. Zandi: *Architectural Heritage of the Gulf*, Arabian Heritage (Dubai and London, 1991) [series also incl. bks on individual Emirates]

"Architecture, Archaeology and the Arts in the United Arab Emirates," *A. & Islam. World*, xxiii (1993) [special issue]

A. & Islam. World (1996), xxvii–xxviii [special supplement on traditional architecture of Dubai]

M. A. Omer: "UAE Newsletter," *A. & Islam. World*, xxxi (1997), pp. 71–4

Letters & Meanings/Ḥurūf wa-dalālāt (exh. cat., Sharjah, Mus. Contemp. Arab A., 2002)

Ura Tyube [Ura Tepe; Vagkat]. Town in northern Tajikistan. It has been identified by some scholars as ancient Kurushkada [Cyreschata; Cyropolis], an Achaemenid foundation of Cyrus I (*r.* 559–529 BCE). The town contains the Mug Tepe settlement (6 ha), the remains of urban fortified structures on the hilly areas of Tal, Mug and Kallamanora, madrasas, mosques and mausolea (15th–20th centuries), and secular architecture (18th–20th centuries). The earliest finds from Mug Tepe include a bronze seal with a winged griffin on the obverse (4th–2nd centuries BCE), a terracotta statuette of a male figure, a fired clay male figure with a triangular face and applied phallus, a ceramic censer stand, a shard with a lion in relief and a small bronze human face. A hoard of Roman denarii from nearby Mydzhum provides evidence of trade in the first centuries CE.

The earliest structural remains at Mug Tepe comprise part of the clay and mud-brick fortification walls and residential buildings (*c.* 3rd century BCE–3rd century CE) and a two-story tower complex (either a fortress or a religious center) with two rows of embrasures (5th–8th centuries). Ceramic production in this period took place at Sari Kubur on the western edge of the town and included thrown and molded red, brown or pale burnished slip wares ornamented with applied braiding, stamping or combing. Ceramic spindle-whorls and some jewelry, particularly ceramic and ivory beads, were also found. Noteworthy ceramic objects are an idol with an elongated slanting forehead (5th–7th centuries); a rectangular ossuary (700×360×280 mm) richly ornamented with alternating pilasters and niches containing figures, solar and lunar symbols, trees, stamped circles and merlons (6th–7th centuries); and a shard with a stamped image of a lion standing in front of an imitation inscription or snake (7th–8th century). Glazed ceramics of the 10th–12th centuries are decorated with red or greenish-brown painting on a light slip ground. Among the fabric, wood and metal items of this period is a 12th-century hoard of *c.* 15 bronze items from Kala-i Baland, near Ura Tyube. The hoard includes a cast octagonal base covered with engraved sirens and lionesses, hunting scenes and Arabic inscriptions, a rectangular chased and inscribed tray decorated with two rosettes enclosing winged predators, a medallion with three intertwined figures-of-eight in the center encircled by kufic inscriptions and birds, and a pear-shaped ewer inscribed with Arabic good wishes ("Fame and Happiness … ") and decorated with bird and vegetal ornament.

The town expanded from the 15th century. The SHAYBANID sultan 'Abd al-Latif (*r.* 1540–52) constructed the Kok Gumbaz, a monumental mosque–madrasa, and during the 16th to 19th centuries the dominant citadel of the ruler was surrounded by monumental religious, memorial and public buildings and numerous residential, artisan and commercial quarters. Interiors were decorated with wood and plaster carvings and polychrome wall paintings that combined geometric and vegetal designs with inscriptions.

The site was excavated from the 1920s to the 1950s as part of the North Tadjik Expedition by Prof. N. Negmatov. Finds from the excavations are housed in the Ura-Tyube Museum, the Museum of Oriental Art, Moscow, and the Donish Institute of History, Archaeology and Ethnography at the Tajikistan Academy of Sciences, Dushanbe.

E. Benveniste: "La Ville de Cyreschata," *J. Asiat.*, ccxxxiv (1947), pp. 163–6

B. V. Veymarn: "Mechet' Kok-Gumbez v Ura-Tyube" [The Kok Gumbaz Mosque in Ura Tyube], *Novyye issledovaniya arkhitektury narodov SSSR* [New research into the architecture of peoples of the USSR] (Moscow, 1947)

E. V. Kil'chevskaya and N. N. Negmatov: "Shedevry torevtiki Ustrushany" [Masterpieces of Ustrushana metalwork], *Pamyatniki kul'tury, novyye otkrytiya: Pis'mennost', arkheologiya: Yezhegodnik 1978* [Cultural monuments, new discoveries: literature, art, archaeology: 1978 yearbook] (Leningrad, 1979), pp. 458–70

N. N. Negmatov and E. V. Kil'chevskaya: "The Kalaibaland Hoard of Metal Items," *Isk. Tadz. Naroda*, iv (1979), pp. 34–53

Ye. V. Zeymal': *Drevniye monety Tadzhikistana* [Ancient coins of Tajikistan] (Dushanbe, 1983), pp. 63–8

Drevnosti Tadzhikistana [Antiquities of Tajikistan] (exh. cat., ed. Ye. V. Zeymal': Leningrad, Hermitage, 1985), nos. 332–4, 426–8, 816, 823–6

N. Rahimov: "The Terra-cotta Figurine from the Mug-Teppa Settlement," *J. Cent. Asia*, ix (1986), pp. 53–60

N. T. Rakhimov: *Istoriya Ura-Tyube po arkheologicheskim dannym* [The history of Ura Tyube from archaeological data] (Samarkand, 1989)

Urban development. No single type of city characterizes the traditional Islamic world; rather, several different types developed as a result of natural, religious, cultural and historical circumstances. The courtyard house, often considered a salient characteristic of the Islamic city, can be explained as a standard response to the generally hot and dry climate that prevails from the Atlantic to the Hindu Kush, and many examples can be found well before the rise of Islam (*see* HOUSING). Irregular urban plans, another feature said to be typical of the Islamic city

and juxtaposed with the highly organized and strictly geometric plans typical of Hellenistic or Roman cities, are characteristic of some ancient Oriental towns. The increasing irregularity of plan, disorganized layout of public zones, and development of specialized markets, or souks, where wheeled traffic was normally absent—usually considered to be characteristics of the Islamic city—were already present in the Byzantine period. Nevertheless, distinct urban types developed in three of the major cultural zones of the Islamic world: the Islamic lands of the Mediterranean and Near East, Iran and Central Asia, Anatolia and the Balkans, and India. Since few Islamic cities have been excavated, their structure is best established for the period after 1500.

I. Central and western Islamic lands. II. Iran and Central Asia. III. Anatolia and the Balkans. IV. India.

I. Central and western Islamic lands. The fundamental feature of the Arab Islamic city is the separation between public centers for economic, religious and cultural activities, and private zones, mainly reserved for residence. These economic and residential zones developed in concentric rings around the center. While literary, legal and archaeological evidence provides limited information about early cities in the Arab world, a wealth of information for the period from the 16th century to the mid-19th clearly shows the character of the classical Arab city. Its evolution was interrupted in the mid-19th century by external influences and constraints. New economic and technical conditions imposed such sudden and brutal changes that adaptation was impossible, and the traditional city was transformed into an "Old Town," often known as medina (Arab. *madīna*: "city"), which is decaying or has already disappeared.

A. Functional organization. B. Spatial arrangement.

A. Functional organization. In the absence of precise data about pre-Islamic Arab cities, it is difficult to find the origins of the separation between a public center and a private zone, but these features are conspicuous in the plan of traditional Arab cities, where a central zone crossed by a fairly regular network of open and relatively large streets contrasts sharply with peripheral zones having an irregular network of roads. In pre-colonial Algiers, for example, cul-de-sacs made up only one-quarter of the total street length in the lower city, which contained the commercial center, administration and residences of the ruling élite, whereas they comprised more than half the street length in the upper city, where the native population lived.

Most of a city's economic activities were concentrated near the congregational mosque in the center around the covered market (Arab. *qaysariyya*, Turk. *bedesten*), often closed by doors, for cloth and valuable goods. Some covered markets were quite large; the one in Fez, for example, covers 3000 sq. m. The goldsmiths' market (Arab. *ṣāgha*) was also located in the market center because of its role in commercial

transactions, particularly money-changing. Clustered around it were the souks (Arab. *sūq*), or specialized markets, and the caravanserais (Arab. *khān*, *wakāla* and *funduq*), for wholesale and international trade (*see* Caravanserai). This central area is easily delimited on a map by its fairly regular street network. In Tunis, for example, the congregational mosque is surrounded by a square zone with an orthogonal street pattern. The area of this central zone varied according to the economic importance of the city and its role in international trade: it covered 1.1 ha in Algiers, 6 ha in Tunis, 8.7 ha in Damascus (*see* Damascus, §I), 10.6 ha in Aleppo (see fig. 1), 11.8 ha in Baghdad, and an astonishing 58 ha in Cairo (see fig. 2; *see also* Cairo, §I), the second city of the Ottoman Empire. In Aleppo the central zone was distinctive enough to have a particular name, Madina, and the 19 caravanserais there (of the 53 known at Aleppo) occupied nearly half of its area. In Cairo the central zone corresponded to al-Qahira, the Fatimid city founded in 969 (*see* Cairo, §I, A), and it boasted 229 caravanserais (of 348 known). The *qaṣaba*, the central thoroughfare of the city, occupied only 1.2% of its area but monopolized 57% of its economic activity.

These urban centers normally remained in the same place, perhaps because of their close relationship to the congregational mosques at their core. Only in Mosul during the Ottoman era (16th–18th century) were the markets moved from the center near the congregational mosque to the outskirts along the Tigris. Despite the stable position of urban centers, they evolved with the environment; in the Ottoman era the trading zones of such great Arab cities as Tunis, Cairo and Aleppo increased by half as these cities expanded vigorously. Their central commercial zones were characterized by relatively large and straight streets, since too much irregularity would have hindered economic activity. These regular central streets included the *qaṣaba* of Cairo (6 m wide) and the thoroughfares of the great souks of Aleppo, which developed on two or three parallel lines. In some cases, such as Damascus, Aleppo and probably Tunis, these streets were inherited from antiquity, but in others they were Arab foundations. The *qaṣaba* in Cairo, for example, followed the course of the Fatimid avenue between their two palaces. Central zones were often linked to the suburbs by straight roads; in Tunis, for example, which had an orthogonal grid in the center, pairs of roads led from the gates of the city to suburbs in the north, south and west.

The urban space beyond this central economic zone was occupied by residential quarters. These quarters, known as *ḥawma* in Algiers and Tunis, *ḥāra* in Cairo and Damascus and *mahalla* in Aleppo, Mosul and Baghdad, typically had a main street (*darb*), often closed by a gate (*bāb*), and were subdivided into secondary streets and then into cul-de-sacs. The characteristic network of narrow irregular streets and cul-de-sacs, often described as the typical feature of the Arab city (although it is only one of its aspects),

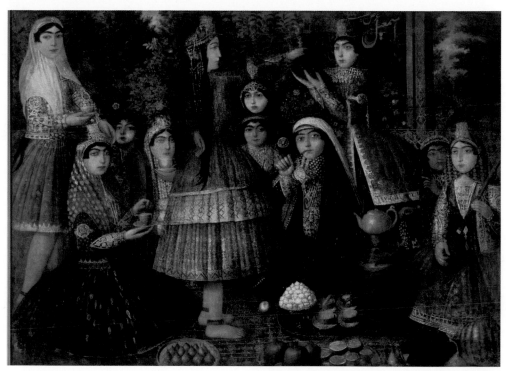

1. Isma'il Jalayir, Ladies *Around a Samovar*, oil on canvas, 1.56×2.13 m, probably from Tehran, Iran, *c.* 1860–75 (London, Victoria and Albert Museum); photo credit: Victoria and Albert Museum, London/Art Resource, NY; *see* Oil painting, §I

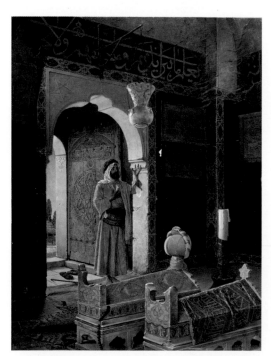

2. Osman Hamdi, *Old Man in Front of a Child's Tomb,* oil on canvas, 2.02×1.5 m, 1903 (Paris, Musée d'Orsay); photo credit: Réunion des Musées Nationaux/Art Resource, NY; *see* Oil painting, §II

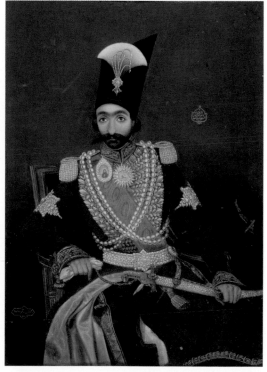

3. Bahram Kirmanshahi: *Nasir al-Din Shah,* oil on leather, 360×225 mm, end of the 18th century (Paris, Musée du Louvre); photo credit: Réunion des Musées Nationaux/Art Resource, NY; *see* Qajar, §II, B

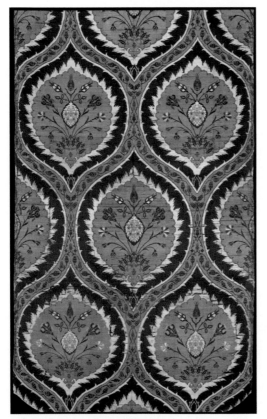

1. Bowl, earthenware overglaze-painted in luster with an abstracted bird, ceramic, 85×267 mm, from Samarra, Iraq, mid-9th century (Berlin, Museum für Islamische Kunst); photo credit: Bildarchiv Preussischer Kulturbesitz/Art Resource, NY; *see* Ornament and pattern, §I, B

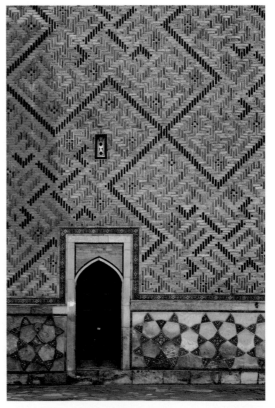

2. Ottoman textile with an ogival pattern, compound-weave satin and twill with silk and gold thread, 1.90×0.66 m (warp by weft), from Turkey, second half of the 16th century (New York, Metropolitan Museum of Art, Anonymous Gift, 1949 (49.32.79)); image © The Metropolitan Museum of Art/Art Resource, NY; *see* Ornament and pattern, §I, A

3. Decoration of plain and glazed brick in square kufic style script, shrine of Ahmad Yasavi, Turkestan, Kazakhstan, 1389–1405; photo credit: Sheila S. Blair and Jonathan M. Bloom; *see* Ornament and pattern, §I, D

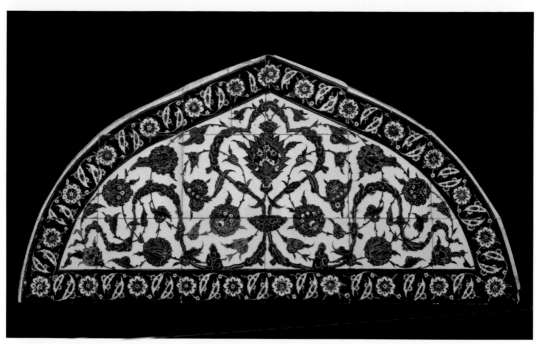

1. Polychrome tympanum from the mosque of Piyale Pasha, Istanbul, decorated with flowers, cloud bands and arabesques, underglaze-painted fritware, from Iznik, 1573 (Paris, Musée du Louvre); photo credit: Réunion des Musées Nationaux/Art Resource, NY; *see* Ottoman, §I

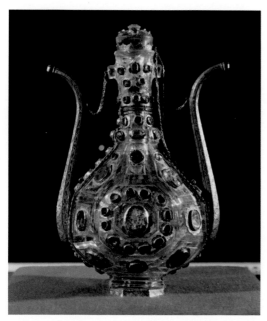

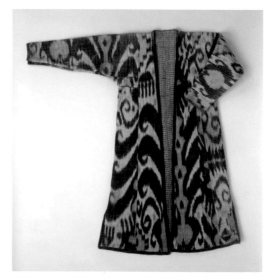

2. Rock crystal water bottle, with gold, rubies and emeralds, h. 210 mm, from Turkey, late 16th century (Istanbul, Topkapı Palace Museum); photo credit: Erich Lessing/Art Resource, NY; *see* Rock crystal, §II

3. Coat, cotton ikat with woven braid, from Uzbekistan, early 20th century (Paris, Musée d'Art et d'Histoire du Judaïsme); photo credit: Réunion des Musées Nationaux/Art Resource, NY; *see* Uzbekistan, §IV

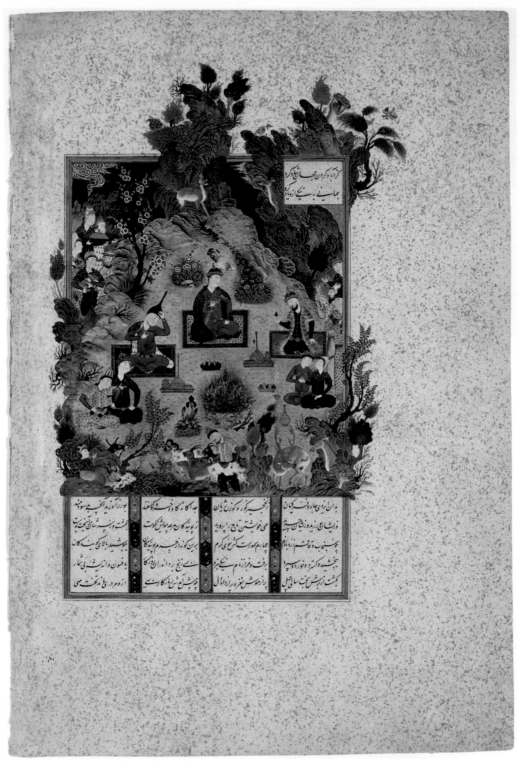

Paper sprinkled with gold flecks, illustration from the *Shāhnāma*, made for Shah Tahmasp I by Sultan-Muhammad, from Tabriz, *c.* 1525–35 (New York, Metropolitan Museum of Art, Gift of Arthur A. Houghton Jr., 1970 (1970.301.2)); image © The Metropolitan Museum of Art/Art Resource, NY; *see* Paper, §III

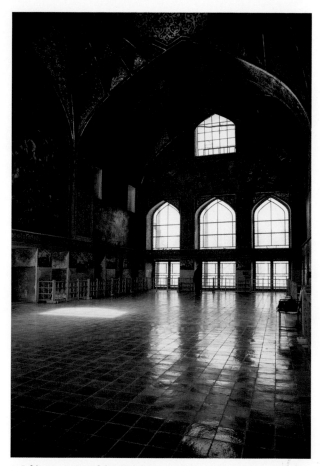

1. Isfahan, interior of the Chihil Sutun Palace, completed 1706–7; photo credit: Sheila S. Blair and Jonathan M. Bloom; *see* Safavid, §I

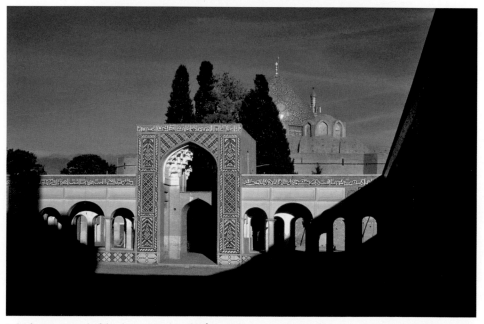

2. Mahan, courtyard of the shrine complex of Niʿmatallah, restored by Shah ʿAbbas (*reg.* 1588–1629); photo credit: Sheila S. Blair and Jonathan M. Bloom; *see* Safavid, §I

VI

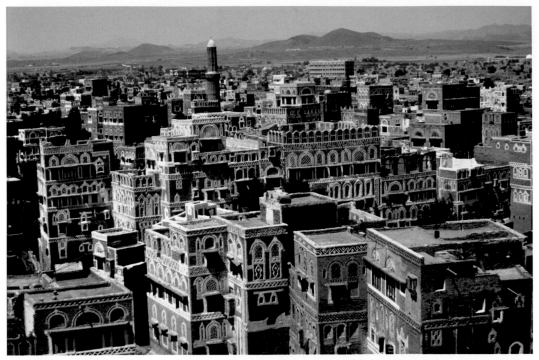

1. San'a, view of the Old City, with high houses and minarets; photo © Ronald Lewcock/Aga Khan Trust for Culture; *see* San'a

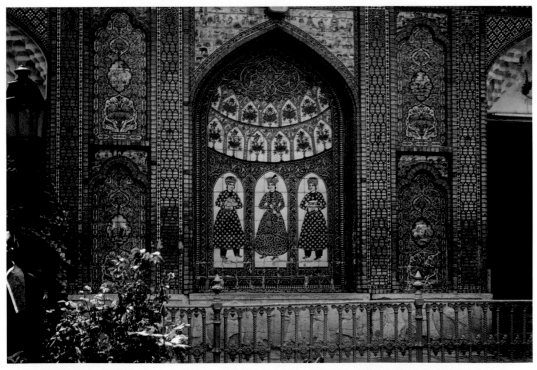

2. Shiraz, Naranjistan, façade, 19th century; photo credit: Sheila S. Blair and Jonathan M. Bloom; *see* Shiraz, §I

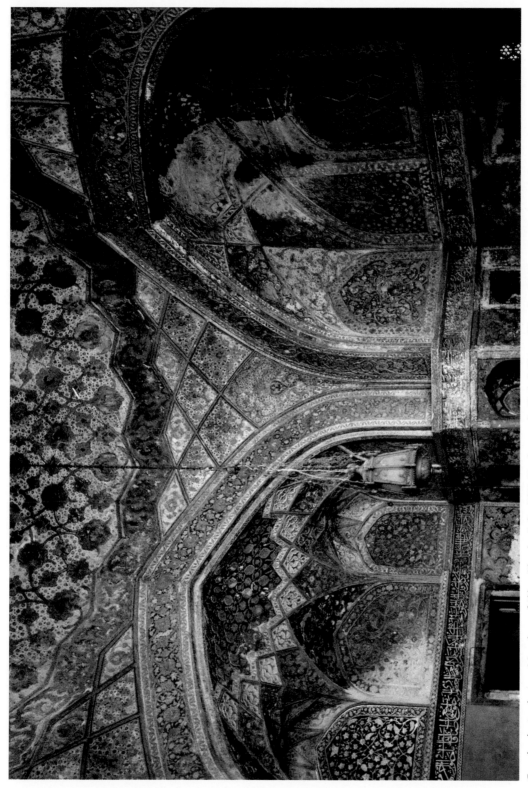

Carved and painted stucco, Mausoleum of Akbar, Sikandra, India, 1605–13; photo credit: Sheila S. Blair and Jonathan M. Bloom; *see* Stucco and plasterwork

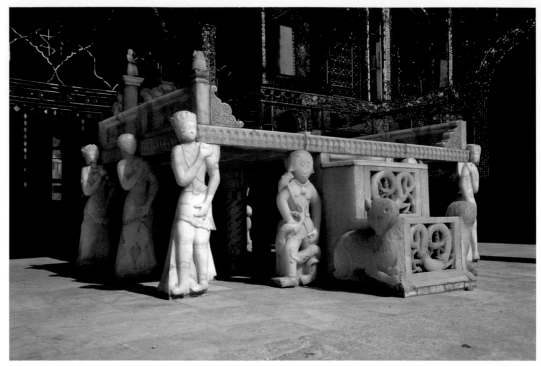

1. Takht-i Marmar (Marble Throne), Gulistan Palace, Tehran, 1797–1834, rebuilt 1867–92; photo credit: Sheila S. Blair and Jonathan M. Bloom; *see* Tehran, §I

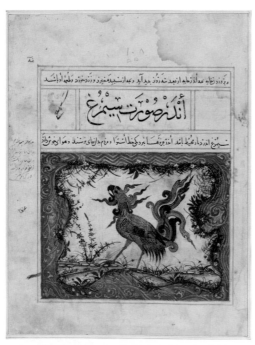

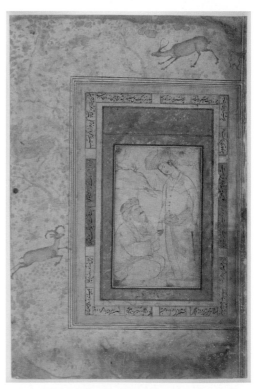

2. *Simurgh*, 355×280 mm, illustration from Ibn Bakhtishu: *Manāfiʿ al-ḥayawān* ("The Usefulness of Animals") from Maragha, Iran, *c.* 1295 (New York, Pierpont Morgan Library, MS. M.500, fol. 55); photo credit: The Pierpont Morgan Library/Art Resource, New York; *see* Subject matter, §IV

3. Riza: *A Young Male Handing a Bowl to an Old Man,* drawing with gold and color, 1605–15 (Paris, Musée du Louvre, MS. MAO152); photo credit: Réunion des Musées Nationaux/Art Resource, NY; *see* Riza

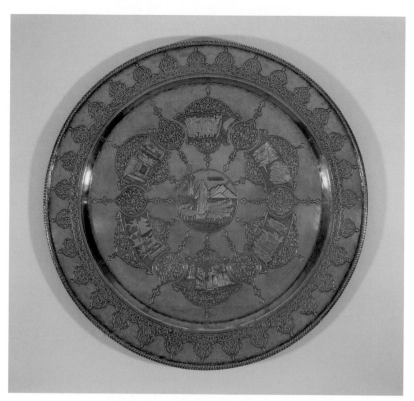

1. Brass plate inlaid with silver and copper, diam. 656 mm, Mamluk Revival style, from Damascus, *c.* 1925 (New York, The Jewish Museum, Gift of Dr. Harry G. Friedman, F3615); photo credit: The Jewish Museum, NY/Art Resource, NY; *see* Syria

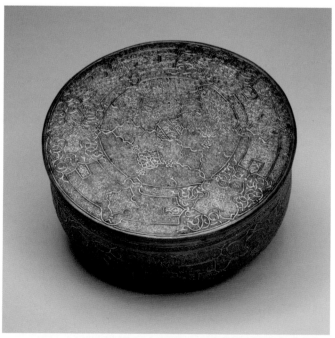

2. "Veneto-Saracenic" brass box with cover by Mahmud al-Kurdi, chased and engraved with arabesques, inscriptions and knotwork designs and inlaid with silver, h. 78 mm, diam. 150 mm, from eastern Anatolia or western Iran, late 15th century (London, Victoria and Albert Museum); photo credit: Victoria and Albert Museum, London/Art Resource, NY; *see* Veneto-Saracenic

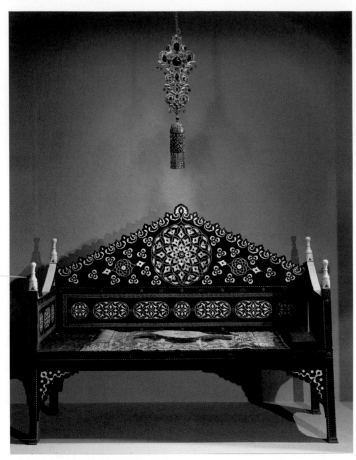

1. Thronebench, walnut wood, ebony, ivory, mother of pearl and turquoises, from Istanbul, late 16th century (Istanbul, Topkapı Palace Museum); photo credit: Erich Lessing/Art Resource, NY; *see* Woodwork, §II, D

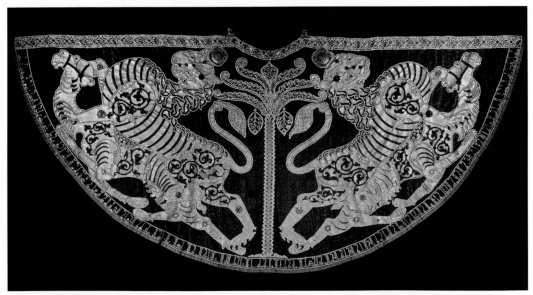

2. Red silk robe embroidered with gold and pearls, diam. 3.42 m, made in Palermo for the coronation of Roger II, King of Sicily, 1133–4 (Vienna, Schatzkammer); photo credit: Erich Lessing/Art Resource, NY; *see* Textiles, §I, C

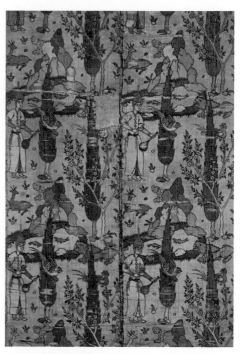

1. Spanish silk textile known as the Lion Strangler Silk (detail), 680×165 mm, from the tomb of St. Bernard Calvó, Vic, 12th century (Cleveland, OH, Cleveland Museum of Art); photo credit: Werner Forman/Art Resource, NY; *see* Textiles, §II, C

2. Iranian silk, satin lampas depicting a wine-bearer in a landscape, 1250×735 mm, 16th century (London, Victoria and Albert Museum); photo credit: Erich Lessing/Art Resource, NY; *see* Textiles, §III, C

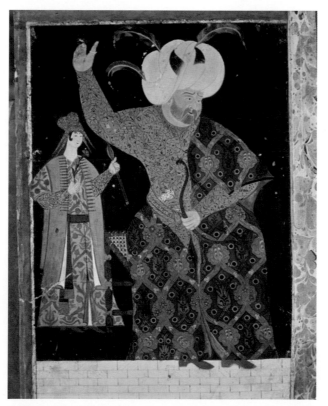

3. Haydar Ra'is: *Selim II Firing a Bow and Arrow*, gouache on paper, *c.* 1570 (Istanbul, Topkapı Palace Museum, MS. H.2134, fol. 3); photo credit: Bridgeman-Giraudon/Art Resource, NY; *see* Textiles, §III, A

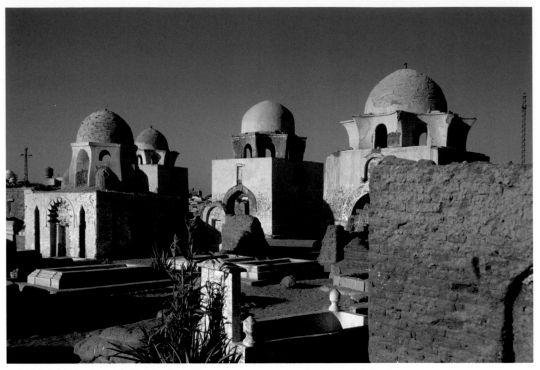

1. Tombs at Aswan, 10th century and later; photo credit: Sheila S. Blair and Jonathan M. Bloom; *see* Tomb, §II

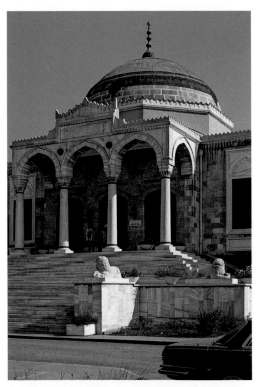

2. Museum of Ethnography, Ankara, 1928; photo credit: Shei-la S. Blair and Jonathan M. Bloom; *see* Turkey, §I

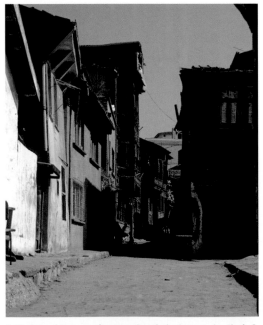

3. Traditional Ottoman houses in Istanbul; photo credit: Sheila S. Blair and Jonathan M. Bloom; *see* Vernacular architecture, §VIII

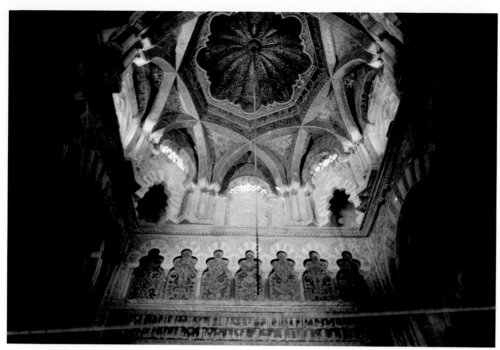

1. Córdoba, Spain, Mezquita (Great Mosque), interior of the dome in front of the mihrab, 965; photo credit: Sheila S. Blair and Jonathan M. Bloom; *see* Umayyad, §II, A

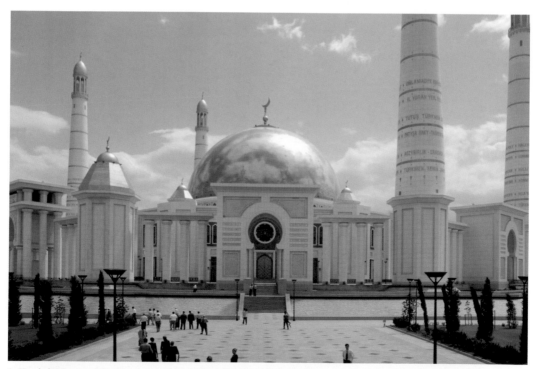

2. Kipchak Mosque, Ashgabat, designed by Kakajan Durdiev, Durli Durdieva and Robert Bellon, commissioned by Saparmurat Niyazov, completed 2004; photo credit: Sheila S. Blair and Jonathan M. Bloom; *see* Turkmenistan, §II

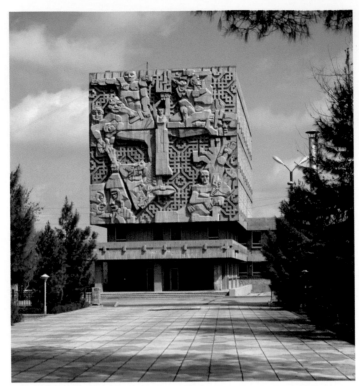

1. Headquarters of the Communist Party of Turkmenistan, Ashkhabad (now Ashgabat), façade sculpture by Ernst Neizvestny, 1975; photo credit: Sheila S. Blair and Jonathan M. Bloom; *see* Turkmenistan, §II

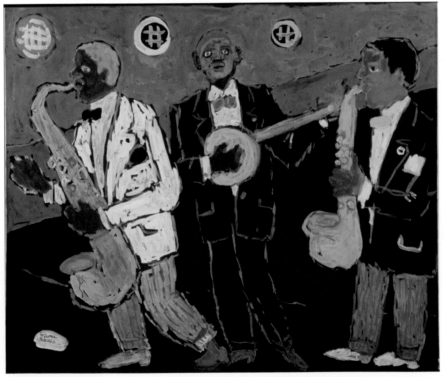

2. Fikret Mualla: *Le Trio Noir*, gouache on paper, 550×650 mm, 1960 (Geneva, Petit Palais, Musée d'Art Moderne de Genève); photo credit: Snark/Art Resource, NY; *see* Turkey, §II

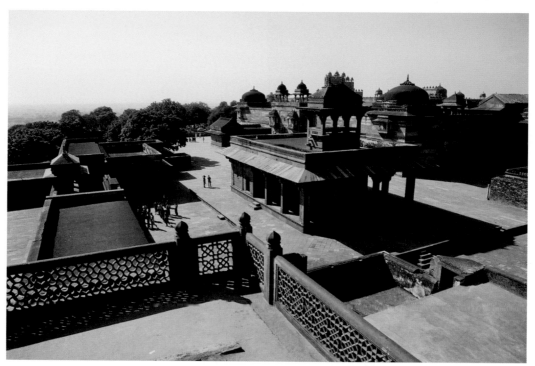

1. Palace at Fatehpur Sikri showing water channels and grid plan, latter half of 16th century; photo credit: Sheila S. Blair and Jonathan M. Bloom; *see* Urban development, §IV

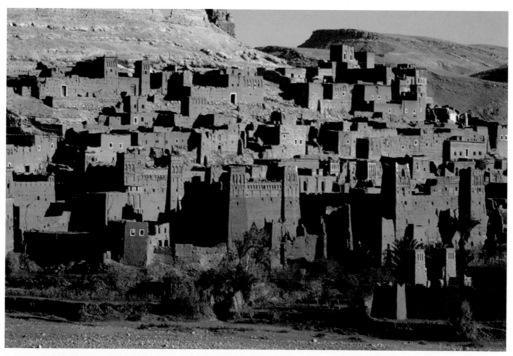

2. *Qsar*, at Tashghimout, southern Morocco; photo credit: Sheila S. Blair and Jonathan M. Bloom; *see* Vernacular architecture, §I

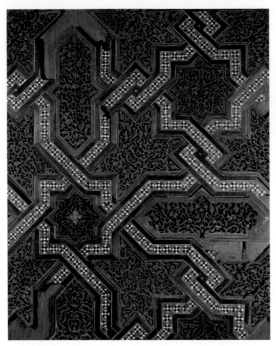

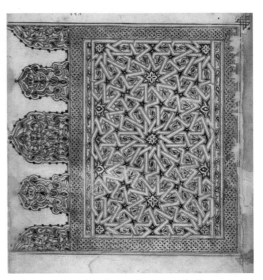

1. Wooden minbar (detail), from the Kutubiyya Mosque, Marrakesh, Morocco, made in Córdoba, *c.* 1120 (Marrakesh, Bahia Palace); photo credit: Erich Lessing/Art Resource, NY; *see* Woodwork, §I, C

2. Geometric interlace from a finispiece of a Koran manuscript in *Maghribī* script, copied for the Sa'dian Sultan, 'Abd Allah, from Morocco, 1568 (London, British Library, MS. Or. 1405, fol. 400); photo credit: Erich Lessing/Art Resource, NY; *see* Subject matter, §II

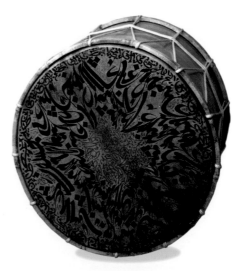

3. Carved wooden panel, 263×233 mm, originally from the side of a minbar, ordered for the Mosque of Ibn Tulun in Cairo by Sultan Lajin, from Egypt, 1296; photo credit: Victoria and Albert Museum, London; *see* Woodwork, §II, B

4. Nja Mahdaoui: double membrane drum from Tunisia decorated with kufic-inspired calligraphy, diam. 670 mm, 20th century (London, British Museum); photo © The Trustees of the British Museum/Art Resource, NY; *see* Tunisia, §II

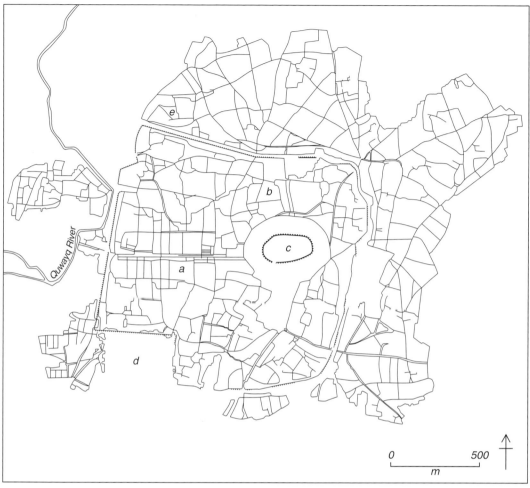

1. Aleppo, plan of the city center, end of the 18th century: (a) Madina; (b) Farafira; (c) citadel; (d) cemeteries; (e) Judayda

developed in the residential zone: cul-de-sacs represented 52% of the street network in Fez, 48% in Algiers, 47% in Cairo, 43% in Damascus and 41% in Aleppo. The number of quarters depended on the size of the city: Tunis had 41, Algiers about 50, Baghdad 61, Aleppo 72 and Cairo probably 100. Their surface area was also variable; the average quarter in Cairo covered about 2 ha and housed some 200 families, an average density of 300–400 inhabitants per ha. These communities were small enough to allow for quasi-family ties among their members and for easy control by the shaykhs who administered them. The quarter formed an isolated unit that was closed at night and in case of trouble, but it was not really cut off from the urban center as the inhabitants went there to work, to shop for goods not available locally and to pray in the congregational mosque on Fridays. Economic activities in residential quarters were limited to non-specialized markets, the small souks (Arab. *sūwayqa*) comprising such shops as bakers and grocers that catered to the daily needs of the inhabitants. Those in Aleppo and Damascus have been remarkably described by JEAN SAUVAGET. Other amenities

might include an oratory for daily prayer, a mosque, public baths or a small market. Family life in these quarters extended into community life, from such private celebrations as circumcisions and weddings, to religious ceremonies around the shrine of a local saint or community festivals, such as the *'araḍa* in Damascus. This collective life could also degenerate into traditional conflicts with neighboring quarters.

This twofold urban structure was recognized in Islamic jurisprudence. Hanafi jurists, for example, distinguished between the "public" zone of the city and the "private" zone. In the center political authorities were responsible for unsolved crimes, whereas the inhabitants of the residential quarters had to compensate collectively for the consequences of such deeds.

B. SPATIAL ARRANGEMENT. Both commercial and residential functions were arranged in concentric rings around the city center. Commercial and craft activities were arranged according to a hierarchy that relegated trades of lesser importance to more remote areas. In the central zone near the congregational

included grain, fruit and vegetables, and cattle, which required vast spaces and whose noise and dust would have been quite intolerable in town centers. Crafts that required considerable space, such as mat-weaving and rope-making, or that entailed grave nuisances for the neighborhood, such as slaughterhouses, tanneries, ovens and furnaces, were located towards the outskirts of the city or even ejected beyond its limits. This configuration was so constant that changes of location often signal important urban changes. By the 18th century the open market square once on the outskirts of Algiers had become surrounded by the lower city; this became the "old market" (*rahba qadima*) when a new open square was located on the outskirts near Bab ʿAzzun. In the Ottoman period a street near Bab Zuwayla in the center of Cairo was still called Suq al-Ghanam ("sheep market"), although the actual sheep market had been moved to the south of the city. The displacement of tanneries in Aleppo (c. 1570), Cairo (c. 1600) and Tunis (1770) was the result of active expansion in these cities.

This same concentric arrangement also applied to residential zones, although it is less obvious and was more difficult for historians of Arab cities to accept. Archaeological investigations in and archival documents from Tunis, Cairo and Aleppo show that the quality of housing was hierarchically distributed from the bourgeois houses in the center to the poorer houses in the outskirts. Wealthy quarters characterized by rich and vast houses, such as those in Tunis described by Revault, developed in the vicinity of the central souks. In Aleppo, the bourgeoisie and shaykhs lived in the Farafira quarter and around the Citadel and Madina, where the most beautiful houses were located. These houses, which closely resembled the palaces of the rulers, were large (200–400 sq. m in Tunis, 400–900 sq. m in Aleppo) and had numerous rooms for specific purposes and refined decoration. It is logical that the central sector should have been reserved for the residences of the wealthy, for the merchants and shaykhs wanted to live close to their places of business. The heart of the city was monopolized by economic activities and left little space for residential construction: the scarcity and cost of land and the necessity of resorting to vertical and more expensive architecture made these areas accessible only to the wealthy.

The houses of the middle class were located at a greater distance from the center. In Cairo these houses did not have courtyards, but in many other Arab cities they were scaled-down versions of the classical courtyard house. Their reduced size (100–150 sq. m in Tunis, 80–190 sq. m in Aleppo) did not allow domestic functions to be differentiated as they were in the houses of the wealthy. The poor lived near the outskirts in houses that were poorly built of cheap and flimsy materials. They had to be rebuilt often, leaving little or no archaeological evidence, and they pass unmentioned in historical accounts. Their rural character was due to the origins of a large part of the population of these peripheral zones. The thatched

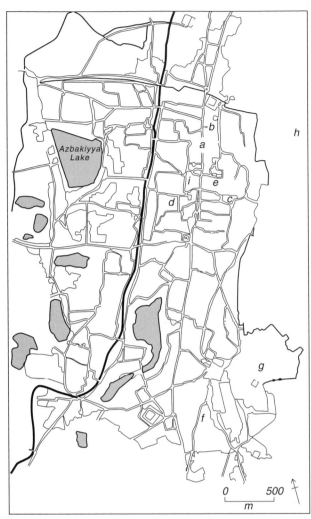

2. Cairo, plan of the city center, end of the 18th century: (a) al-Qahira; (b) *qasaba*; (c) al-Azhar Mosque; (d) Khan al-Hamzawi; (e) Khan al-Khalili; (f) Suq al-Ghanam; (g) citadel; (h) cemeteries; (i) Jewish quarter

mosque was the booksellers' souk, which served the shaykhs and students. Markets for the most expensive goods, such as precious metals, spices, coffee and luxury cloth, were grouped together near the covered market and the goldsmiths' souk, as were caravanserais for international trade, multi-story buildings with warehouses for goods on the ground floor and accommodation for traders upstairs. In 18th-century Cairo, for example, the 62 caravanserais for the spice and coffee trade were all located in the central area defined by the Azhar Mosque, the Khan al-Hamzawi and the Khan al-Khalili. In Tunis, the shops of the spice merchants and drapers were located in the prestigious streets abutting the congregational mosque.

Markets linked to the countryside were found on the outskirts of the city in large open squares (Arab. *rahba*). They dealt in products of little worth compared to their weight; these were difficult to stock and too bulky to transport to the center. They

cob-walled huts (Arab. *nuwayl*) in the outer quarters of Fez and Tunis must have resembled modern shanty towns. In other cities, such as Cairo, Damascus, Aleppo and MEDINA, low houses were grouped around a common courtyard. This arrangement (Arab. *ḥawsh*) ensured a highly collective life that prevented the strict observation of family isolation and feminine seclusion. It is another example of popular housing that diverges sharply from the stereotypical "Islamic house," with its familial unit turned inward towards a courtyard. These popular quarters were also characterized by a dynamic religious life centered on Sufi brotherhoods, probably because of the close ties these suburbs kept with the surrounding rural zones where these brotherhoods were active.

This hypothetical model was always transformed in reality by geographical, historical, religious, economic and social factors. Tunis, for example, is wedged between two lakes, so the city developed in two large suburbs on the north (Bab Suwayqa) and south (Bab Jazira). A small river, the Quwayq, prevented Aleppo from developing to the west. The Muqattam hills, which dominate Cairo on the east, hindered expansion in that direction until the late 20th century. The citadel the Ayyubids built to the southeast of Cairo at the end of the 12th century encouraged expansion of the city in that direction, while large cemeteries to the northeast of Cairo and the south of Aleppo discouraged development there. The increased importance of Damascus as a pilgrimage station in the Ottoman period explains the development of the Midan suburb, which extends nearly 2 km south of the city. The tendency to separate the Christian and Jewish communities led to the creation of minority quarters that did not conform to the general rules of urban spatial organization (*see* below). Members of the ruling class often chose to settle in the outskirts, where they could find sufficient space for large palaces and such amenities as abundant water and vegetation for vast gardens. In 18th-century Cairo, for example, the Mamluk and military aristocracy settled around the Azbakiyya Lake, a peripheral area normally occupied by non-specialized, polluting industries and by the houses of the poor and Christian minority.

Arab cities were strongly segregated, although the supposed egalitarianism of Islamic society is often thought to have led to an integrated population within a city, with the houses of the poor adjoining those of the rich, all behind undifferentiated, modest façades. The most striking feature of the urban population, however, is the great inequality between rich and poor. For Cairo, inheritance documents from the 17th and 18th centuries reveal that the largest legacy, that of a coffee merchant who died in 1735 (8,845,550 paras), was 60,000 times greater than the smallest legacy, that of a vegetable seller who died in 1703 (145 paras). Such tremendous inequality was reflected in the quality of housing and in the clear separation between the wealthy quarters of the ruling class and rich bourgeoisie of merchants and shaykhs and

middle-class or poor quarters. The relative toleration enjoyed by Jews and Christians, the "protected" minorities, is also said to have justified close contact among people of different faiths, but Arab cities typically had distinct quarters for minorities. The Jews of Tunis lived within the Hara, a quarter whose limits in the 19th century are shown by a 1959 map of streets, where more than 75% of the population was Jewish. At the end of the 19th century, the Christians of Aleppo still occupied, more or less exclusively, the western half of the northern suburbs and comprised all of the population of Judayda and neighboring areas. Judayda was a wealthy residential area in an outer zone of the city, which would normally have been occupied by poorer housing. The Jewish quarter of Cairo, by contrast, was a poor area located in the center near the souks of the goldsmiths and money-changers, who were often Jews. Political factors may also have played a role, for this site offered greater scope for control and protection by the administration. National communities were also segregated, in direct proportion to their distance from the dominant Sunni Muslim population. The most extreme case is Antioch in northern Syria, which was still an aggregate of cities in 1930. Each of the three communities that made up the town (Turks, Christians and Alawites) lived in their own closed quarters. The geographical arrangement of these quarters is significant: the Turks, who were the politically and socially dominant group until 1918, occupied the center, whereas the Alawites, who were subjected to double discrimination because of their poverty and their adherence to a minority sect of Islam, had been pushed to the northern and southern ends of the town.

The topographical realization of diverse and contrasted social and economic communities in the traditional Arab city meant that the city ran the risk of disintegrating into its constituent units, as in Aleppo and Antioch. The organization of the urban space, however, with its strong city center, combining economic, religious and cultural activities, and its logical distribution of activities and housing from the center to the periphery, endowed the Arab city with a strong internal unity that prevented it from falling into anarchy. On the contrary, such cities as Aleppo and Cairo show a real prosperity and splendor from the 16th to the 18th century. The consolidation of the city structure and the organization of its expansion owed much to such Islamic institutions as the judicial system and charitable endowments. The traditional Arab city did not just conserve worn and outdated forms, but was a coherent and dynamic whole linked to its society and economy.

J. Sauvaget: "Esquisse d'une histoire de la ville de Damas," *Rev. Etud. Islam.*, viii (1934), pp. 421–80

J. Sauvaget: *Alep*, 2 vols. (Paris, 1941)

R. Brunschvig: "Urbanisme médiéval et droit musulman," *Rev. Etud. Islam.*, xv (1947), pp. 127–55

J. Caillé: *La Ville de Rabat*, 3 vols. (Paris, 1949)

R. Le Tourneau: *Fès avant le Protectorat* (Casablanca and Paris, 1949)

E. Pauty: "Villes spontanées et villes créés en Islam," *An. Inst. Etud. Orient. U. Alger*, ix (1951), pp. 52–75

G. von Grunebaum: "The Structure of the Muslim Town," *Islam: Essays on the Nature and Growth of a Cultural Tradition* (London, 1955, rev. 1961), pp. 141–58

R. Le Tourneau: *Les Villes musulmanes de l'Afrique du Nord* (Algiers, 1957)

P. Sebag: *La Hara de Tunis* (Paris, 1959)

I. Lapidus: *Muslim Cities in the Later Middle Ages* (Cambridge, MA, 1967)

J. Revault: *Palais et demeures de Tunis*, 4 vols. (Paris, 1967–78)

I. Lapidus, ed.: *Middle Eastern Cities* (Berkeley, 1969)

G. Cladel and P. Revault: *Medina: Approche typologique* (Tunis, 1970)

A. Hourani and S. M. Stern, eds.: *The Islamic City* (Oxford, 1970)

J. Abu-Lughod: *Cairo: 1001 Years of the City Victorious* (Princeton, 1971)

L. Torrès-Balbás: *Ciudades hispano-musulmanas*, 2 vols. (Madrid, 1972)

L. C. Brown, ed.: *From Madina to Metropolis* (Princeton, 1973)

J.-C. David: "Alep: Dégradation et tentatives actuelles de réadaptation des structures urbaines traditionelles," *Bull. Etud. Orient.*, xxviii (1975), pp. 19–49

R. Serjeant, ed.: *The Islamic City* (Paris, 1980)

B. Johansen: "The All-embracing Town and its Mosques," *Rev. Occidente Musulman & Médit.*, xxxii (1981)

M. Meriwether: *The Notable Families of Aleppo, 1770–1830* (diss., Philadelphia, U. PA, 1981)

A. Bouhdiba and D. Chevallier, eds.: *La Ville arabe dans l'Islam* (Tunis, 1982)

A. Raymond: *Artisans et commerçants du Caire au XVIIIème siècle* (Paris, 1982)

J.-C. Garcin and others: *Palais et maisons du Caire*, 2 vols. (Paris, 1982–3)

H. Gaube and E. Wirth: *Aleppo* (Wiesbaden, 1984)

A. Raymond: *Grandes villes arabes à l'époque ottomane* (Paris, 1985)

P. Cuneo: *Storia dell'urbanistica: Il mondo islamico* (Rome, 1986)

N. Hanna: *Les Maisons moyennes du Caire et leurs habitants au 17ème et 18ème siècles* (diss., Aix-en-Provence. U. Aix–Marseille I, 1989)

A. Marcus: *Aleppo in the Eighteenth Century* (New York, 1989)

P. Sebag: *Tunis au XVIIème siècle* (Paris, 1989)

N. Al-Sayyad: *Cities and Caliphs: On the Genesis of Arab Muslim Urbanism* (Westport, 1991)

M. Bonine and others: *The Middle Eastern City and Islamic Urbanism: An Annotated Bibliography of Western Literature* (Bonn, 1994) [complete bibliography]

D. Whitcomb: "Urbanism in Arabia," *Arab. Archaeol. & Epig.*, vii/1 (1996), pp. 38–51

S. Tamari: *Iconotextual Studies in the Muslim Ideology of Umayyad Architecture and Urbanism* (Wiesbaden, 1996)

N. Al-Sayyad: "Contesting the Madînah: Dualities in the Study of Islamic Urbanism," *Islam. Cult.*, lxxii/3 (1998), pp. 1–16

S. Auld and R. Hillenbrand, eds.: *Ottoman Jerusalem, the Living City: 1517–1917* (London, 2000)

S. Bianca: *Urban Form in the Arab World: Past and Present* (London and New York, 2000)

A. Raymond: *Cairo* (Cambridge, MA, 2000), pp. 291–374

S. Slymovics: *The Walled Arab City in Literature, Architecture and History: The Living Medina in the Maghrib* (London, 2000) [Special Issue *J. N. Afr. Stud.*, v/4 (Winter 2000)

J. D. Tracy, ed.: *City Walls: The Urban Enceinte in Global Perspective* (Cambridge, 2000) [articles on Aleppo and North Africa]

A. Saadaoui: *Tunis, ville ottomane: Trois siècles d'urbanisme et d'architecture* (Tunis, 2001)

N. Dris: *La ville mouvementée: Espace public, centralité, mémoire urbaine à Alger* (Paris, 2002)

S. Ennahaid: "Access Regulation in Islamic Urbanism: The Case of Medieval Fès," *J. N. Afr. Stud.*, vii/3 (2002), pp. 119–34

A. Raymond: *Arab Cities in the Ottoman Period: Cairo, Syria and the Maghreb*, Variorum Collected Studies, CS734 (Ashgate, 2002) [articles pub. 1968–98]

H. Mortada: *Traditional Islamic Principles of Built Environment* (London, 2003)

Y. Elsheshtawy, ed.: *Planning Middle Eastern Cities: An Urban Kaleidoscope in a Globalizing World* (London, 2004)

A. Raymond: "Reflections on Research in the History of the Arab City during the Ottoman Period (Sixteenth–Eighteenth Century) or Jean Sauvaget Revisited," *Text & Context in Islamic Societies*, ed. I. A. Bierman (Ithaca, 2004), pp. 23–67

V. Rousseaux: *L'Urbanisation au Maghreb: Le Language des cartes* (Aix-en-Provence, 2004)

H. Z. Watenpaugh: *The Image of an Ottoman City: Imperial Architecture and Urban Experience in Aleppo in the 16th and 17th Centuries* (Leiden, 2004)

J. Hanssen: "Fin de siècle" *Beirut: The Making of an Ottoman Provincial Capital* (Oxford, 2005)

D. Singerman and P. Amar: *Cairo Cosmopolitan: Politics Culture, and Urban Space in the New Globalized Middle East* (Cairo, 2006)

A. K. Bennison and A. L. Gascoigne, ed.: *Cities in the Pre-Modern Islamic World: The Urban Impact of Religion, State and Society* (London, 2007)

S. O'Meara: *Space and Muslim Urban Life: At the Limits of the Labyrinth of Fez* (New York, 2007)

II. Iran and Central Asia. Iranian cities of the Islamic period are less well known than those of Arab Islamic lands. Because the favored material of construction was mud-brick, cities often developed horizontally, as one center was abandoned in favor of another. Few sites have been excavated, except in the marginal areas of Iraq and Central Asia. Textual problems are also significant, as it is often difficult to distinguish between a district and its major town of the same name.

The aridity of the Iranian plateau means that the major cities are oases and settlements along the foothills of the high mountain chains where the supply of water is ensured by rivers or subterranean aqueducts (Pers. *qanāt*). Settlements were usually established along trade routes or at strategic sites and are surrounded by broad agricultural lands, market gardens and pasture.

The typical urban arrangement in pre-modern times was an inner city (*shahristān*) centered on a citadel (*kuhandiz*) and flanked by suburbs (*bīrūn*).

The inner city was usually a modification of a pre-Islamic one. Those that were circular or quadrilateral usually had four gates on the cardinal sides, and in Islamic times a fifth gate was often added. Following the upheavals of the 10th and 11th centuries, cities were usually fortified. Major arteries led from the gates to the city center, and the quarters between them were divided into residential blocks. Within the blocks twisted cul-de-sacs gave pedestrian access to individual buildings.

This typical arrangement is found from the southern fringes of the Dasht-i Lut to Central Asia (e.g. MERV, BUKHARA, KHIVA and SHAHR-I SABZ). One of the best examples is HERAT in Afghanistan. The inner city (1500×1600 m) is cardinally orientated. There are five gates: three in the centers of the west, south and east sides, and two on the north, one behind the citadel in the northwest quadrant and the other behind the congregational mosque in the northeast. Streets 4–5 m wide and lined with shops and workshops lead from the gates and intersect in a central domed bazaar (*chahārsū*). The four main streets are divided into small blocks (10,000–15,000 sq. m), which are largely residential as all religious buildings other than the congregational mosque are located on the fringes. The inner city is surrounded by suburbs, which expanded dramatically in the 15th century when the members of the TIMURID dynasty (*r.* 1370–1506; *see* ARCHITECTURE, §VI, A, 2) built palaces, mosques and madrasas in lush garden settings along the canals to the north of the city.

The arrangement of residential blocks defined by streets and comprised of footpaths and houses has been clarified by detailed studies of Isfahan in central Iran (*see* ISFAHAN, §I). The typical house is arranged around a central court, whose façades have symmetrical tripartite plans. The main façade, on the south, incorporates the most public room (*urusī* or *shāhnishīn*). Most houses have two courtyards, called *bīrūn* ("inner") and *andarūn* ("outer"), but many houses have several courtyards joined by common access vestibules (*hashtī*). These blocks are in a constant state of flux, as changes of ownership lead to houses expanding or contracting in courtyard-defined units, and the internal arrangement of the blocks is totally transformed within two to three generations. The houses, generally built of mud-brick and wood, are ephemeral, and none of those recorded in the 1970s was more than 150 years old (*see* VERNACULAR ARCHITECTURE, §VIII).

Neighborhood service nodes were typically located at the intersection of the streets surrounding the residential blocks or near the mouth of a *qanāt*. These architectural complexes were often centered on a mosque, tomb or *khanaqah* and might also include such public buildings as baths, shops and fountains. These service nodes were continually repaired and replaced, but one built (1713–15) by ʿAli Quli Agha in the Bidabad quarter of Isfahan gives a good idea of the type. It contains a combined mosque–madrasa, in which Friday prayers are performed by the inhabitants of the quarter, a double bath, several fountains

and a bazaar centered on a monumental *chahārsū* and containing workshops for weaving and furniture and 36 shops, catering primarily to the needs of the area.

The city of Isfahan also shows how the traditional city type could be transformed by imperial fiat. The city had been the capital under the Buyids (*r.* 932–1062) and Saljuqs (*r.* 1038–1194) and remained a regional center and emporium under the Ilkhanids (*r.* 1256–1353) and Timurids, but the Safavid monarch ʿAbbas I transformed it in 1598 when he made it the capital of his empire (*see* ARCHITECTURE, §VII, B, 1). The center of the new district was a new maidan located close to the Zaindeh River to the south of the old city. It was intended to supplant the old open market that adjoined the Friday Mosque, and to that end the monarch erected the Qaysariyya, the royal bazaar, on the north side. Consisting of two parallel north–south roads and three east–west ones, it housed many shops, the mint, the royal bath and the royal caravanserai, the largest in the city, with 140 rooms for cloth merchants on the ground floor and jewelers, goldsmiths and engravers above. On the maidan opposite the entrance to the bazaar, ʿAbbas I ordered a new congregational mosque, the Shah Mosque (*see* fig. 3;

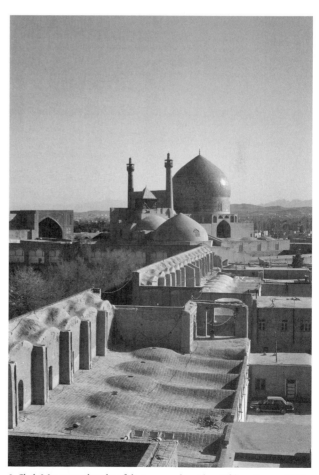

3. Shah Mosque and vaults of shops around maidan, Isfahan, Iran, *c.* 1611–38; photo credit: Sheila S. Blair and Jonathan M. Bloom

see also ISFAHAN, §III, C). To the west of the maidan was the royal compound, comprising a gatehouse, kitchens, storage-sheds, chicken-houses, private living quarters for the royal family and pavilions in large parks. This compound extended west to the Chahar Bagh ("four-[plot] plan"), the wide boulevard bordered by the palaces of the nobility that stretched south across the river to the quarter of New Julfa, where 'Abbas I had settled 3000 Armenian families.

J. Aubin: "Eléments pour l'étude des agglomérations urbaines dans l'Iran médiéval," *The Islamic City*, ed. A. H. Hourani and S. M. Stern (Oxford, 1970), pp. 65–77

Iran. Stud., vii (1974) [2-part issue entitled *Studies on Isfahan*, ed. R. Holod]

M. Bonine: *Yazd and its Hinterland: A Central Place System of Dominance in the Central Iranian Plateau* (Austin, 1975)

L. Golombek and R. Holod: "Preliminary Report on the Isfahan City Project," *Akten des VII. International Kongresses für iranische Kunst und Archäologie: München, 7–10 Sept. 1976*, pp. 578–90

H. Gaube: *Iranian Cities* (New York, 1979)

T. Allen: *Timurid Herat* (Wiesbaden, 1983)

S. S. Blair: "The Mongol Capital of Sultaniyya, 'The Imperial,'" *Iran*, xxiv (1986), pp. 139–51

M. Kheirabadi: *Iranian Cities: Formation and Development* (Austin, 1991/*R* Syracuse, 2000)

M. Bonine and others: *The Middle Eastern City and Islamic Urbanism: An Annotated Bibliography of Western Literature* (Bonn, 1994) [complete bibliography]

M. Haneda and T. Miura: *Islamic Urban Studies: Historical Review and Perspectives* (London and New York, 1994)

A. Gangler, H. Gaube and A. Petruciolli: *Bukhara—The Eastern Dome of Islam: Urban Development, Urban Space, Architecture and Population* (Stuttgart, 2003)

B. A. Kazimee and A. B. Rahmani: *Place, Meaning, and Form in the Architecture and Urban Structure of Eastern Islamic Cities* (Lewiston, 2003)

J. Limbert: *Shiraz in the Age of Hafez: The Glory of a Medieval Persian City* (Seattle, 2004)

A. Modarres: "Yazd: History and Production of Space in Central Iran," *A Survey of Persian Art from Prehistoric Times to the Present*, xviii of *Islamic Period, from the End of the Sasanian Empire to the Present*, ed. A. Daneshvari (Costa Mesa, CA, 2005), pp. 127–88

A. Modarres: *Modernizing Yazd: Selective Historical Memory and the Fate of Vernacular Architecture* (Costa Mesa, CA, 2006)

A. K. Bennison and A. L. Gascoigne, eds.: *Cities in the Premodern Islamic World: The Urban Impact of State, Society and Religion* (New York, 2007)

III. Anatolia and the Balkans. Most of the information on Islamic cities in Anatolia and the Balkans concerns the period from the 16th to the 18th century when the area was controlled by the OTTOMAN dynasty (*r.* 1281–1924). It is debated whether towns in the Balkans survived the wars and epidemics of the later Middle Ages and were still flourishing when the Ottomans conquered the region in the 14th and 15th centuries. The degree to which Balkan towns of the 16th century were new creations of the Ottomans

is also a matter of discussion. In Anatolia, the Ottoman state had to accommodate earlier patterns of urbanization that were Turkish and Muslim but associated with rival Turkmen states such as the Karamanids (*r. c.* 1256–1483) and the Dhu'l-Qadr (*r.* 1337–1522). In most cases major mosques and other foundations established by pre-Ottoman rulers were permitted to continue in operation, and summaries of their charters (Turk. *vakifname*) were inserted into Ottoman tax registers.

The most significant institution for the structure of the Ottoman city was the pious foundation. Mosques, madrasas, *khanaqah*s, guesthouses, soup-kitchens, drinking fountains and primary schools were grouped in complexes (*see* KÜLLIYE) which formed the core of a town quarter (*mahalle*). These institutions were assigned rural or urban income-producing properties in perpetuity, and their services, offered free of charge to users, were financed by taxes paid by villagers, as well as by the revenues of caravanserais and covered markets. These institutions thus served as a means to transfer rural wealth into towns. The pious foundations established in Istanbul by Sultan Mehmed I (1472–3) and Sultan Süleyman II (1557) have been particularly well studied (see fig. 4; *see also* ISTANBUL, §II, C), but similar complexes on a smaller scale functioned in such provincial towns as BURSA, EDIRNE, Trikkala and Trabzon.

The most important monuments in the city center are the major mosques, citadel, covered market (*bedestan, bedesten, bezazistan*) and caravanserais (*han*). Even modest towns had more than one congregational mosque. Citadels were common, though by no means universal, and city walls surrounding a town were exceptional: the walls around Istanbul were built by the Byzantines, and the wall built around Ankara *c.* 1600 was financed by the townsmen as protection from the Celali rebellions that were devastating the countryside. In the 16th century the covered market, which comprised a few dozen shops and offered storage facilities for such valuable goods as textiles, distinguished towns involved in inter-regional trade from more modest, rural marketing centers. Caravanserais, typically two-story buildings arranged around a courtyard, provided storage for trade goods and accommodation for merchants in transit. They were generally clustered about the covered market so as to minimize disruption to residential neighborhoods. The caravanserai district, such as the one known in ANKARA around 1600, often had a street for wheeled traffic, since peasant carts were used for short-haul traffic in Anatolia, while the camel caravan was the favored means of transportation for long-distance traffic. In many parts of the Balkans, where carts and wagons dominated long-distance traffic as well, a special commercial area (*araba pazari*) was sometimes set aside for them on the edge of town. Shops were often built in clusters near pious foundations and rented out against payment of an entry fee and a low perpetual rent. Artisans and merchants also converted their shops into pious foundations that could be passed on to specified descendants without

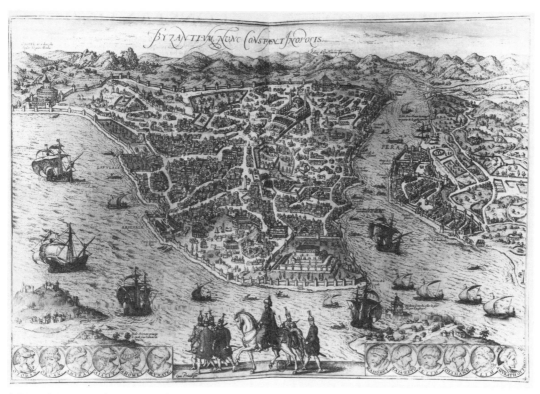

4. *View of Constantinople as it Appeared under the Sultan Selim II*, engraving, 16th century; photo credit: Snark/Art Resource, NY

subdivision on condition that the heirs fulfilled certain religious obligations.

By the 16th century the most important Ottoman towns had developed a business district that contained almost no habitations, as a single building rarely served both commercial/artisanal and residential functions except in 18th-century Istanbul. Residential districts had only shops providing daily necessities and domestic workshops, such as those in Ankara where the renowned mohair cloth was woven. Town quarters usually grouped several households that shared the same ethnic and/or religious background. Rich and poor typically lived in the same neighborhood, although in certain cases wealthier neighborhoods can be distinguished from poor ones, which were usually located on the outskirts. Ghettos did not exist; both in Istanbul and in Anatolia Muslim residents mingled with non-Muslims, despite official and unofficial attempts to maintain the homogeneity of town quarters.

The palaces of sultans and high-level administrative officials in Istanbul and, from the 17th century onwards, the residences of provincial notables in Anatolian and Balkan towns were elaborate constructions, but apart from Topkapi Palace in Istanbul (*see* ISTANBUL, §III, E) they were built of perishable materials and with very few exceptions, only those dating from the second half of the 18th century and later have survived. Wealthy residences in the provinces imitated the style of the capital Istanbul, and from

the mid-18th century onwards the vogue for landscape painting and Baroque decoration can be seen in such outlying Anatolian towns as Birgi and Yozgat. House types varied from region to region. By the 18th century in Istanbul, residential construction was generally of wood, and three-story houses were common, even in the suburbs along the Bosporus. In certain parts of central Anatolia, houses were built of mud-brick supported by wooden frames; 17th-century examples had one or two stories. In the area around KAYSERI and Ürgüp where good building stone is abundant, single-story houses with roof terraces remained the norm well into the 19th century. Ecological constraints were by no means the only factors that determined house type: the influence of Istanbul styles of construction was pervasive, even in unfavorable environments.

The desire for family privacy was important and was manifested in a variety of ways. Cul-de-sacs were much less widespread than previously thought, and ingenious solutions were found to provide a view of natural scenery and the street and to allow residents to see without being seen. One solution was to concentrate inhabited rooms on the second and third floors, which often had belvederes. Another solution to the problem of privacy was to construct second homes outside the city, in the case of inland towns among gardens and vineyards or in the case of Istanbul along the waterfront. There, social interaction was more informal than in the city itself, and this

relaxation of constraints was part of the attraction provided by summer residences.

H. Inalcik: "The Hub of the City: The Bedestan of Istanbul," *Int. J. Turk. Stud.*, i (1979–80), pp. 1–17

N. Todorov: *La Ville balkanique aux XVe–XIXe siècles: Développement socio-économique et démographique* (Bucharest, 1980)

S. Faroqhi: *Men of Modest Substance: House Owners and House Property in Seventeenth-century Ankara and Kayseri* (Cambridge, 1987)

M. Bonine and others: *The Middle Eastern City and Islamic Urbanism: An Annotated Bibliography of Western Literature* (Bonn, 1994) [complete bibliography]

S. Missoum: *Alger à l'époque ottomane: la médina et la maison traditionnelle* (Aix-en-Provence, 2003)

B. Saint Laurent: "Ottoman Power and Westernization: The Architecture and Urban Development of Nineteenth and Early Twentieth Century Bursa," *Anatolia Moderna*, v (1994), pp. 199–232

J. Garcin, J. Arnaud and S. Denoix: *Grandes villes méditerranéennes du monde musulman médiéval* (Rome and Paris, 2000)

P. Partuvī and F. Khudābandahlū: "Historical Continuity in Architecture and Urban Planning of Iran, Principles and Contexts," *Anthol. Iran. Stud.*, iv (2000), pp. 133–75

D. Diba and others: *Maisons d'Ispahan* (Paris, 2001)

A. Raymond and B. Marino: *Etudes sur les villes du Proche-Orient: XVIe–XIXe siècle: Hommage à André Raymond* (Damascus, 2001) [various essays]

S. Zandi-Sayek: "Orchestrating Difference, Performing Identity: Urban Space and Public Rituals in Nineteenth-Century Izmir," *Hybrid Urbanism: On the Identity Discourse and the Built Environment*, ed. N. Al Sayyad (Westport, CT, 2001), pp. 42–66

E. S. Wolper: *Cities and Saints: Sufism and the Transformation of Urban Space in Medieval Anatolia* (University Park, PA, 2003)

J. Arnaud: *L'Urbain dans le monde musulman de Méditerranée* (Paris, 2005)

M. Cerasi: "The Urban and Architectural Evolution of the Istanbul Divanyolu: Urban Aesthetics and Ideology in Ottoman Town Building," *Muqarnas*, xxii (2005), pp. 189–232

K. A. Ebel: "Visual Sources for Urban History of the Ottoman Empire," *Türkiye Araştırmaları Literatür Dergisi*, iii/6 (2005), pp. 457–86

H. Sarkis and C. Arkon: *A Turkish Triangle: Ankara, Istanbul, and Izmir at the Gates of Europe* (Cambridge, MA and London, 2006)

IV. India. Arab traders had provided a Muslim presence in India from the 8th century, but permanent Muslim presence began only after the conquests of the late 12th century and the establishment of the Delhi sultanates. These new rulers give life to existing cities and founded new ones as centers of administration, trade and manufacturing. Lahore (in modern Pakistan), Delhi and Patna were raised to new levels. AHMEDABAD was established by Sultan Ahmad Shah (*r.* 1411–42) in 1411; AGRA became the seat of government for Sultan Sikandar Lodi (*r.* 1489–1517). Allahabad, FATEHPUR SIKRI and Attock (in modern Pakistan) were founded by the Mughal emperor Akbar (*r.* 1556–1605). Contemporaneously, Faridabad was begun by Shaykh Farid Bukhari. Later new towns included Farrukhabad, Moradabad, Shikohabad, Najibabad and Faizabad (all in modern Uttar Pradesh).

The new cities were protected by walls, within which was a further protected citadel with paved roads, the royal palace, quarters for staff and its own water supply. The chief mosque was close by, and shops were on the main streets. Housing took the form of protected, often gated, neighborhoods (*mohalla*s, *pol*s), in which clan groups resided. The neighborhoods appear to have had haphazard layouts—good for defense—and to have consisted of terraced courtyard houses on narrow alleys; a central open space (*chowk*) might have a platform under a tree where the elders gathered.

DELHI, founded by the 1st century BCE, was established as the capital of the Delhi sultanate and continued as such under the Mughals until it was replaced by AGRA. It was re-established as capital by Shah Jahan (*r.* 1628–58) in 1639. The city went through several changes in location due to adjustments in the course of the Yamuna River and was sacked a number of times. Sultan Islam Shah SUR (*r.* 1545–54) constructed Salimgarh Fort, and Emperor Humayun (*r.* 1530–40, 1555–6) and Sher Shah Sur (*r.* 1538–45) both built new cities. Delhi owes its imperial splendor to Shah Jahan, who built a new fort (now Lal Qil'a or Red Fort; *see* DELHI, §III, E), which was also the imperial palace, and to its west the city of Shahjahanabad. The city was walled, with gates opening to the arterial roads. Its central road, Chandi Chowk, lined with merchants' shops and houses, ran east–west to the fort and had a small canal running down its center. The Jami' Mosque (Friday Mosque; *see* DELHI, §III, F) still stands near its eastern end, towards the south, but other mosques, tombs and charitable institutions existed throughout the community.

LAHORE was transformed from a village into a camp town by the sultans of Delhi to control their western holdings. Sultan Balban (*r.* 1266–87) strengthened its fort and encouraged merchants to settle, Emperor Akbar shifted his court to Lahore in 1584, and Jahangir (*r.* 1605–27) and Shah Jahan added to its commercial facilities and enhanced its appearance.

Under Mughal rule, Hindu traditions persisted in the adaptation of Islamic design principles, as at FATEHPUR SIKRI. Founded by Akbar, the city was inhabited for only 18 years before the lack of water, summer heat, inaccessibility and other factors led to its abandonment in 1584. The city is surrounded by a wall, with the palace on the ridge. There appear to be no contemporary accounts of housing in the town, and no housing survives. The palace plan and architecture show a fusion of indigenous and Islamic concepts. The overall plan and use of water channels is Mughal, but the organization into broken grid symmetries is Hindu (see color pl. 3:XV, fig. 1).

After 1857, the consolidation of British power and the building of railways hardly changed the pace of urbanization, as the majority of Indians continued

to live in villages. British India was, however, divided into districts (comparable to the *sarkar*s of Mughal India), in which administrative headquarters developed into the most important towns of their respective districts. A number of these towns had two additional features: Civil Lines and cantonments. Both were suburbs, the former for civil servants and business people and the latter for the army. Both were laid out as grid-planned communities. Their central roads were wide malls, streets were tree-lined, building plots were divided regularly, and the houses were bungalows. Churches, cemeteries, clubs and race and golf courses followed. Major road-widening schemes were run through congested areas, and sanitation improvements were made. New towns were also built: settlements in the arid parts of the Punjab and hill stations to house British administrators during the summer months. The former had either grid plans or roads radiating from a central chowk (e.g. Lyallpur, Faisalabad in modern Pakistan). The hill stations followed British plans and architectural styles. Simla, for example, consisted of the clutter of a small English country town with a parish church and an Elizabethan great house.

G. Hambly and W. Swaan: *Cities of Mughul India* (New York, 1968)

S. A. Nilsson: *European Architecture in India, 1750–1850* (London, 1968)

A. Volwashen: *Living Architecture: Indian* (New York, 1969)

R. L. Singh, ed.: *Morphology of Indian Cities* (Varanasi, 1971)

B. V. Begde: *Ancient and Medieval Town Planning in India* (New Delhi, 1978)

B. Bhattacharya: *Urban Development in India (Since Pre-historic Times)* (Delhi, 1979)

C. Tadgell: *The History of Architecture in India from the Dawn of Civilization to the End of the Raj* (London, 1990)

I. Banga, ed.: *The City in Indian History: Urban Demography, Society, and Politics* (Columbia, MO, 1991) [Papers presented at a seminar, organized by the Urban History Association of India in 1987]

J. Gollings: *City of Victory, Vijayanagara: The Medieval Hindu Capital of Southern India* (New York, 1991)

V. Nand: "Urbanism, Tradition and Continuity in Ahmedabad," *Mimar*, xxxviii (1991), pp. 26–36

C. B. Asher: "Delhi Walled: Changing Boundaries," *City Walls: The Urban Enceinte in Global Perspective*, ed. J. D. Tracy (Cambridge, 2000), pp. 247–81

J. Hosagrahar: "Mansions to Margins: Modernity and the Domestic Landscapes of Historic Delhi, 1847–1910," *J. Soc. Archit. Hist.*, lx/1 (2001), pp. 26–45

E. Koch: "The Taj Mahal: Architecture, Symbolism, and Urban Significance," *Muqarnas*, xxii (2005), pp. 128–49

A. N. Lambah and A. Patel: *The Architecture of the Indian Sultanates* (Mumbai, 2006)

M. Shokoohy and N. H. Shokoohy: *Tughluqabad: A Paradigm for Indo-Islamic Urban Planning and its Architectural Components*, Society for South Asian Studies monograph series (London, 2007)

Urfa [Orfa; Gr. Edessa; Arab. al-Ruhā']. Town in southeast Turkey. Lying at the intersection of important trade routes, the town must have existed before the Macedonian conquest, as it was refounded by Seleukos I (*r.* 312–281 BCE). Lying on the frontier, the town suffered in the wars between Rome and the Parthians. After Christianity was introduced by the 3rd century, Edessa became an important center of Nestorianism. The town changed hands during the Persian–Byzantine wars and was taken by the Arabs in 638. The Mandylion or Holy Image of Edessa was a famous image of Christ that remained in the city until 942–3, when Romanos I removed the image with great ceremony to Constantinople. Arab geographers reckoned the cathedral, which had ceilings decorated with mosaics, one of the four wonders of the world. After the Crusaders took the city, they established the County of Edessa, the first Latin state in the east (1098–1144). The capture of Edessa by the Zangids in 1144 led to the proclamation of the Second Crusade (1145–9). Known for its fine stone buildings and masons, the town is said to have supplied the builders of the 12th-century walls of Cairo. The congregational mosque, built on the site of an earlier structure, has a shallow rectangular prayer-hall covered by two rows of cross-vaults with a dome to the east of the central axis. A transverse-vaulted portico opens on to a court; the mosque resembles the congregational mosque at Aleppo in Syria as restored by Nur al-Din. Other notable buildings include the citadel, built on Hellenistic foundations, the Hizmali Bridge (14th century), the Halilürrahman Mosque and the Abdulrahman Madrasa (18th century). It was a lively entrepôt in Ottoman times, with a bustling market in carpets, leathers and other goods.

Enc. Islam/2: "al-Ruhā"

A. Gabriel: *Voyages archéologiques dans la Turquie orientale* (Paris, 1940)

A. Luther: "Das Datum des Orpheus-Mosaiks aus Urfa" [The Dating of the Orpheus-Mosaic from Urfa], *Welt Orients*, xxx (1999), pp. 129–37

M. M. Ilkhan: "Urfa and its Environs in 1560s," *Archivum Ottomanicum*, xix (2001), pp. 5–67

Urgench. *See* KUNYA-URGENCH.

Üsküdari. *See* OKYAY, NECMEDDIN.

Ustad Mansur. *See* MANSUR.

Ustad Muhammad Siyah Qalam. *See* SIYAH QALAM.

Uzbekistan, Republic of. Central Asian country bounded by Kazakhstan to the north and west, Kyrgyzstan and Tajikistan to the east and Turkmenistan to the south (see fig.). Its northwest corner includes the autonomous republic of Karakalpak, largely made up of the Amu delta, facing the salt-water Aral Sea. Central and northern Uzbekistan is dominated by the Kyzylkum Desert, into which runs the Zarafshan River; much of the FERGHANA Valley occupies the eastern extremity of the country, and the south borders the Amu River. Covering some 450,000 sq. km (173,000 sq. miles), it is one of the world's two

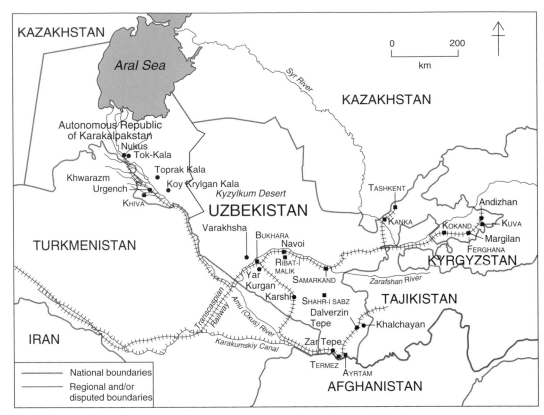

Map of Uzbekistan; those sites with separate entries in this encyclopedia are distinguished by Cross-reference type

double landlocked countries (the other is Lichtenstein). It has a population of nearly 27,000,000 (2005 estimate) and is the world's second-largest exporter of cotton. The capital, Tashkent (formerly Binket), was rebuilt following an earthquake in 1966. This article concentrates on artstic developments in the region since the 18th century.

I. Introduction. II. Architecture. III. Painting and sculpture. IV. Decorative arts.

I. Introduction. The country's position on a major overland trade route between East and West and the existence of well-watered oases in huge tracts of desert have resulted in a long history for what is now Uzbekistan. Prehistoric agriculture flourished along the great rivers for millennia; early settlements at Bukhara and Samarkand (5th–2nd century BCE) were walled settlements containing raised citadels. Successively the Achaemenids (including the satrap of Sogdiana centered on Ferghana; 6th–4th century BCE), Seleucids (4th–3rd century BCE), Greco-Bactrians (*c.* 250–*c.* 200 BCE) and Parthians (3rd century BCE–3rd century CE) contested control of it. By the 1st century CE it was ruled by the Kushana until incorporated into the Sasanian Empire in the 3rd century. The Sasanians were defeated by the Huns (Hepthalites) in 425. The evolution of the Silk route, on which Samarkand and Bukhara were key points, further focused attention on the area. The

Ferghana Valley straddling the eastern border with Kyrgyzstan, always somewhat apart from the rest of the region, was a center of Buddhism, with key sites at Kuva and Uzgend (Kyrgyzstan), until the rise of the Qarakhanid khanate (from 999). There were also some Buddhist foundations in southern Uzbekistan.

By the mid-6th century CE power lay with the Turkish Khaqanate. The Arabs took Samarkand, then capital of Sogdiana, in 712. Throughout the Islamic period Samarkand and Bukhara were frequently capitals of ruling dynasties that ranged from small localized powers to empires covering much of Iran and Central Asia. First came the Abbasids, then their erstwhile governors the Samanids (*r.* 875–1005 in Transoxiana, with their capital at Bukhara), the Qarakhanids (*r.* 992–1211, with their capital at Samarkand, overthrowing the Samanids in 999) and then Saljuq tribes, who arrived in the late 10th century and were in control of the area by the early 12th; they were defeated in 1141 by the Qara Khitay, who in turn lost to the Khwarazmshahs in the late 12th century.

Mongol invasions, with Samarkand, Bukhara and Urgench (*see* Kunya urgench) razed in 1220) under Genghis Khan (*d.* 1227), disrupted urban life until it was restored under Genghis's eldest surviving son, Chaghatay, and his successors (*r.* 1227–1370). Around this time the White Horde began to lose control to the Nogai and Uzbek tribes; the

latter, taking their name from Khan Uzbek (*r.* 1282–1342) under whom they had converted to Islam, became the Shaybanids (*see* below). Subsequent order was interrupted briefly by the TIMURID dynasty under Timur (*r.* 1370–1405), who made Samarkand his capital and SHAHR-I SABZ his second city. In various forms Timurid rule lasted into the 16th century; then the SHAYBANID dynasty (*r.* 1500–98, with their capital at Bukhara) and their successors controlled much of Central Asia until 1785, though increasing fragmentation led to the formation of many smaller khanates. By the 19th century the Khanate centered on KHIVA ruled the area of modern Karakalpak; the Khanate centered on Bukhara ruled most of Uzbekistan and Tajikistan; and the Khanate centered on Kokand ruled the territories bordering the Syr and Amu rivers.

Russian expansion southward in the late 18th century and the 19th put an end to the declining khanates—the most important, the emirate of Bukhara, surrendered much of its eastern property, including Samarkand, in 1868 and became a Russian protectorate; KOKAND was taken in 1876 and abolished—and thereafter Russian forts and new civil towns were established and linked by railways. Tashkent, taken in 1865, became the Russians' main city.

The Turkestan Territory created in 1886 was redefined in the Soviet period. In 1918 the area was contained in the Turkestan ASSR, but after internal fighting the emir of Bukhara and the *khān* of Khiva were deposed in 1920. The Uzbek SSR was created in 1924 out of former Bukharan lands between the Amu and Syr rivers—it contained Tajikistan until 1929—and the Karakalpak ASSR was combined with it in 1936. Drastic changes in land use led to the depletion of rivers to form the Karakumskiy Canal in Turkmenistan. Soviet architects and artists were prominent in urban renewal projects, especially the rebuilding of Tashkent in 1966. After the break-up of the USSR, Uzbekistan declared its independence on 21 August 1991.

II. Architecture. KHIVA, capital of the khanate of that name and today a museum-city in the Khwarazm region, embodies the concept of a late feudal Islamic capital city, with its monumental structures and complexes of buildings, both civic and religious, of different sizes and functions. Following the Central Asian tradition of towns with a tripartite structure, Khiva consists of the walled town (Ichan-kala); the trade and craft suburb (Dishan-kala); and the citadel (Kunyaark). Many buildings are 19th- or early 20th-century, including court, religious and commercial structures, the caravanserai and houses; all are richly decorated with multicolored surfaces, painting and the stucco and wood-carving for which Khiva is famous.

Under the khanate, a few important buildings were added to the medieval capital city of Bukhara, such as the Char-minar ("Four Minarets") gateway (1807) to the Madrasa of the wealthy merchant *khalif* Niyazkul, with its unusual tetrapylon with four massive, circular corner towers; the traditionally styled

complex of Bala-khauz, with its Winter (1712) and Summer (early 20th century) mosques, reservoir (Pers. *hawz*) and small minaret (1917; architect Shirin Muradov, 1880–1957); and the picturesque suburban palace of the Bukhara emirs, Sitoray-makhi-khasa (late 19th century to 1918), which combines European taste with the decorative style of Bukhara. The palace of Khudoyar Khan (1871) in Kokand, built and decorated by the finest masters of Ferghana, and the khan's palace of Tash Hawli (1830–38; *see* ARCHITECTURE, fig. 54) in Khiva constitute the finest achievements of local building and decorative arts. Although there are regional variations, the architecture of Uzbekistan generally makes wide use of beamed roofs laid on elegant carved columns, carved wooden and stucco details in the decoration of façades, and bright ornamental wall painting and gilding.

At the end of the 19th century and the beginning of the 20th, Russian architects including Leonty Nikolayevich Benois (1856–1928) and Georgy Mikhailovich Svarichevsky (1871–1935) worked in Uzbekistan. New towns (Skobelev, now Ferghana) and the European sections of old towns were built to a regular plan, though Russian architecture did not at this time have a noticeable influence on local forms. Significant changes came during the Soviet period, when architects from Moscow, Leningrad (now St. Petersburg) and elsewhere, together with such local architects as Abdulla Babakhanov (*b.* 1910) and Mutkhat Sagadatginovich Bulatov (*b.* 1907) drew up general plans for the reconstruction, improvement and future development of Tashkent (1938 and 1954), Samarkand (1938–9 and 1954), Bukhara, Andizhan, Ferghana and many other towns, as well as plans for industrial complexes.

The architecture of public buildings in Uzbekistan from the 1920s to the 1950s followed the usual path of development for the eastern regions of the USSR, in which Constructivism and Neo-classicism fused with elements of national architecture and decoration (e.g. the Theater of Opera and Ballet in Tashkent; 1940–47, by Aleksey Shchusev (1873–1949), with paintings by Chingiz Akhmarov (1912–95), stucco carving by masters from Bukhara, Khiva and elsewhere). The architecture of the town of Navoi, founded in the desert in the 1960s, and of Tashkent as restored after the earthquake of 1966, expressed the new principles of Soviet urban planning in regions with hot climates and high seismicity: a spacious siting of multi-story buildings among squares and green areas, with reservoirs and fountains; an expressive use of ornamental sculpture and painting; and a subtle use of traditional decoration (e.g. the Palace of Friendship of the People, Tashkent, 1981; by Sabir Rahimovich Adylov (*b.* 1932), and others; Alisher Navoi metro station, Tashkent, 1981; by R. Faizullayer and Ya. Mansurov, with Chingiz Akhmarov and others).

III. Painting and sculpture. The figural arts in Uzbekistan arose at the turn of the 19th and 20th

centuries as a result of the creative and educative work of Russian and Ukrainian painters and illustrators, including Vasily Vasil'yevich Vereshchagin (1842–1904), Sergey Ivanovich Svetoslavsky (1857–1931) and Leon Leonardovich Bure (1887–1943). In the 1920s and 1930s the successors of the school of Socialist Realism, Ivan Semyonovich Kazakov (1873–1935) and Maksim Yevtatyevich Novikov (1889–1974), as well as fine representatives of the Soviet avant-garde, such as Aleksandr Volkov (1886–1957), Oganes Karapetovich Tatevosyan (1889–1974), Aleksandr Vasilyevich Nikolayev (1895–1957), Nikolay Georgievich Karakhan (1990–70), Nadezhda Vasil'yevna Kashina (1896–1977) and Ural Tansykbayev (1904–74), worked in Uzbekistan. Their work from this period, which embraced a wide variety of artistic styles, and objectives, became known to the wider public only in the mid-1960s, thanks very largely to the activity of Igor Vital'yevich Savitsky (1915–84), the Moscow connoisseur and artist, founder and director of the Museum of Arts of the Karakalpaksky Autonomous SSR in Nukus (now Nukus, Karakalpakiya Mus. A.).

Many Central Asian artists of the 1930s and 1940s were taught by Pavel Petrovich Ben'kov (1879–1949), a master of landscape painting and a sensitive colorist (e.g. *Girl with Dutar*, 1947; Tashkent, Mus. A. Uzbekistan), by Aleksandr Volkov, who was influenced by Cubism (e.g. *Pomegranate Teahouse*, 1924; Moscow, Tret'yakov Gal.) and by the graphic artist Mikhil Ivanovich Kurzin (1888–1957), one of the organizers of the association Masters of the New East (1927–9, based in Tashkent) and the Association of Workers of IZO (1929–31, based in Tashkent and Samarkand). In the period from the 1930s to the 1960s, the art of U. Tansykbayev and N. G. Karakhan showed the development of a specifically Central Asian approach—lyrical and full of emotion—to the genre of landscape painting. Socialist Realism was consistently adopted in the topical paintings and portraits of Zinaida Mikhailovna Kovalevskaya (1902–1979), Abdukhak Abdullayev (b. 1928), Bahram Khamdami (1910–42), Lutfulla Abdullayev (b. 1912) and Rashid Mukhamedovich Timurov (b. 1912). The traditions of Central Asian manuscript painting were skilfully used by the graphic artist and illustrator Iskandr Ikramov (1904–72).

Painting, graphic art, sculpture, monumental art and stage design from the 1960s to the 1980s were enriched by a variety of creative trends, a search for original solutions to the problems of composition and color, a desire to incorporate both national and universal traditions of art as well as noticeably wider range of artistic vocabulary. The major painters of the period were Dzhavalat Yusupovich Umarbekov (b. 1946), Ruzy Charyyev (b. 1931), Kutkuk Basharov (b. 1925), Shukrat Abdurashidov (1948–79) and and Telman Yaminovich Muhamedov (1935–76); the major sculptors were Anvar Kamilovich Akhmedov (b. 1935), Abdumunin Baymatov (b. 1934), Mukhtar Nabiyevich Musabayev (b. 1929) and Khakim Khodzha Khusnutdinkhodzhayev (b. 1948).

Work done since the 1980s has been characterized by psychological upheaval as well as thematic and artistic variety (e.g. the painter Sagdulla Asadullayevich Abdullayev (b. 1945) and the graphic artists Victor Olgovich Apukhtin (b. 1945) and Marat Faiziyevich Sadykov (b. 1945)). The most important collections of Uzbekistan art are in the Tashkent Museum of the Art of Uzbekistan, Tashkent, the Karakalpakiya Museum of Art, Nukus, and the Museum of Oriental Art, Moscow.

IV. Decorative arts. In the 18th and 19th centuries the traditional types and shapes of articles, methods and character of decoration, and types of ornament continued to be used. In Bukhara, Samarkand, Margilan, Andizhan, Tashkent and Khiva, cotton, silk and half-silk ikat textiles (see color pl. 3:III, fig. 3) were produced (known in Central Asia as *abr* ("cloud") because of the soft outlines of decorative pattern, a result of resist dycing the threads before weaving); as well as striped examples (*alocha*); plain and patterned velvets; brocades; and satins among others (*see* TEXTILES, §IV, D). Shahr-i Sabz, Bukhara, Samarkand and Nurata were famous for their embroideries, especially that used as wall hangings (*syuzan*) with richly colored patterns. Many centers produced embroidered Asian headgear in the shape of a circular or multi-faceted little hat (*see also* CENTRAL ASIA, §VI, C). Skillful gilding and jewelry came from the courtly workshops of Bukhara (*see* CENTRAL ASIA, §VIII, F). Pile carpets with diagonal patterns of motifs on a central field, and *palas*, smooth (without pile) carpet of simple weave decorated with colored strips, were made everywhere as part of women's household work.

A particular development of this period was the embossing and engraving in metal and the artistic working of hide. Suede, *yuft* (a kind of leather made from bull or pig skin and used for shoes and saddles), elk-skin and coarse shagreen were colored by stamping, embroidery, appliqués of colored hide, velvet, metal engraving with plates, small bells and tassels. One of the leading centers of glazed ceramics from the mid-19th century was Kislak Rishtan in the Ferghana Valley, producing dishes with elegant colored painting on white slip under a transparent smoke-colored alkaline glaze (*see* CENTRAL ASIA, §VII, E). At the end of the 19th century and beginning of the 20th, under the influence of Russian culture, decorative motifs copied from manufactured articles such as periodicals, books, textiles, china and linoleum appeared in traditional ornament; nonetheless the diversity of colors used, the variety of shapes and the abundance of gilding remained characteristic. The introduction of aniline dyes had a detrimental effect on the quality of the carpets and embroidery but a beneficial influence on the development of multicolored fabrics as designs and color schemes became more diverse. In ceramics the resumption of the production of lead glazes (e.g. at Katta Kurgan) enriched the palette of the painters. In the Soviet period, contemporary forms of decorative and applied art developed alongside traditional types.

Enc. Islam/2

A. Umarov: *Iskusstvo Uzbekskoy SSR* [Art of the Uzbek SSR] (Leningrad, 1972) [in Uzbek, Rus. and Eng.]

Iskusstvo Sovetskogo Uzbekistana, 1917–1972 [Art of Soviet Uzbekistan, 1917–72] (Moscow, 1976)

M. Miunts and D. Fakhretdinova: *Izobrazitel'noye iskusstvo Uzbekistana: Zhivopis', grafika, skul'ptura, dekorativno-prikladnoye iskusstvo* [Fine art of Uzbekistan: painting, graphic arts, sculpture, decorative and applied arts] (Tashkent, 1976) [In Uzbek, Rus. and Eng.]

M. S. Bulatov and T. F. Kadyrova: *Tashkent* (Leningrad, 1977) [in Rus. and Eng.]

A. S. Morozova, N. A. Avedova and S. M. Makhkamova: *Narodnoye iskusstvo Uzbekistana* [National art of Uzbekistan] (Tashkent, 1979) [in Uzbek, Rus. and Eng.]

Ye. M. Ismailova: *Iskusstvo oformleniya sredneaziatskoy rukopisnoy knigi, XVIII–XIX vekov* [Art of production of Central Asian manuscripts in the 18th and 19th centuries] (Tashkent, 1982)

V. A. Bulatova and G. V. Shishkina: *Samarkand: Muzei pod otkrytym nebom* [Samarkand: a museum beneath the open sky] (Tashkent, 1986) [in Uzbek, Rus. and Eng.]

I. Azimov: *Rospisi Uzbekistana* [Paintings of Uzbekistan] (Tashkent, 1987) [In Rus., Uzbek and Eng.]

T. J. Kadyrova: *Arkhitektura sovetskogo Uzbekistana* [Architecture of Soviet Uzbekistan] (Moscow, 1987)

Y. Goldenchtein: *Samarcande, Boukhara, Chakhrisiabz, Khiva* (Courbevoie, 1995)

J. Kalter and M. Pavaloi: *Usbekistan: Erben der Seidenstrasse* (Stuttgart, 1995); Eng. trans. (London, 1997)

M. Z. Penson: *Usbekistan: Documentary Photography by Max Penson 1925–1945 from the Collection Oliver and Susanne Stahel* (Berne, 1996)

D. Balland: "Tachkent, métropole de l'Asie Centrale?," *Cah. Etud. Médit. Orient. Turco-Iranien*, xxiv (1997), pp. 218–50

M. Szuppe: "Les relations commerciales de Boukhara au début du XIXe siècle," *Matériaux pour l'histoire économique du monde iranien*, ed. R. Gyselen and M. Szuppe, Studia Iranica, 21 (Paris, 1999), pp. 287–303

S. Chmelnizski: "The Shaybanids and Khan Princedoms: Architecture," *Islam: Art and Architecture*, ed. M. Hattstein and P. Delius (Cologne, 2000), pp. 436–47

E. Tukumov: "The Kazakhs of Uzbekistan," *Central Asia and the Caucasus* (2000), pp. 186–92

H. J. Exner: "Uzbekistan: Four Cit(i)es and One Desert," *Ghereh: International Carpet & Textile Review*, xxvii (2001), pp. 45–51

K. Akilova: "Traditional Artistic Ceramics of Uzbekistan of the 20th Century," *Tribus: Jahrbuch des Linden-Museum*, li (2002), pp. 49–55

A. Khan: *A Historical Atlas of Uzbekistan* (2003)

"An Introduction to Some Scholarly Institutions and Museums of the Republic of Uzbekistan," *IRCICA Newsletter*, lxi (2003), pp. 28–31

D. A. Alimova and A. A. Golovanov: "Uzbekistan," *Towards the Contemporary Period: From the Mid-nineteenth to the End of the Twentieth Century*, vi of History of Civilizations of Central Asia, ed. M. K. Palat and A. Tabyshalieva (Paris, 2005), pp. 225–46

J. M. Rogers: "Nineteenth-century Tilework at Khiva," *Islamic Art in the 19th Century: Tradition, Innovation, and Eclecticism*, ed. D. Behrens-Abouseif and S. Vernoit, Islamic History and Civilization: Studies and Texts, 60 (Leiden, 2006), pp. 363–85

Uzgend [Uzgand; Uzgen]. Town in Kyrgyzstan. Located between the Kara and Yassa (Dzhaza) rivers in the eastern part of the Ferghana Valley, Uzgend is set on three hills and comprises three free-standing towns and citadels surrounded by suburban estates and gardens. The town developed in the 8th and 9th centuries along the Silk Route as a border post on the frontier between the lands of Islam and the Turks. In the 10th and 11th centuries it became the major trading and administrative center in the region and the fourth largest town in Ferghana, covering 12–15 sq. km. From the second half of the 11th century to the beginning of the 13th it was the capital of the Ferghana region of the Qarakhanid khanate, and the major architectural ensemble of the town, comprising three dynastic mausolea, the Friday mosque and minaret, and the remains of a madrasa, dates from this period. Square chambers with *pishtaq*s (monumental portals) facing the street, the mausolea are elaborately decorated with incised plaster and terracotta. The central mausoleum (8 m sq.) for Nasr ibn 'Ali (*d. c.* 1012–13) contains one of the earliest known examples of strapwork decoration; the northern one (1152) for Jalal al-Din Husayn and the southern one (1186) are even more elaborate. North of the mausolea near a modern mosque stands the minaret. Set on an octagonal socle, it has a tapering cylindrical shaft (diam. at base 9 m; h. 17 m) decorated with bands of brick. It probably served as the model for other minarets built later by the Qarakhanids at Bukhara (1127) and Vabkent (1197). Tombstones from the 11th to the 15th century document the local development of styles of calligraphy. In the 16th century the town declined to a village, but the modern town preserves some of the layout and narrow streets of the medieval city, with pisé houses and a network of bazaars and public baths.

Enc. Islam/2: "Özkend"

B. N. Zasypkin: *Pamyatniki Uzgenda* [Monuments of Uzgend] (Moscow, 1927)

E. Cohn-Wiener: *Turan* (Berlin, 1930)

A. Yu. Yakubovsky: "Dve nadpisi na severnom mavzoleye v g. Uzgende" [Two inscriptions on the northern mausoleum in Uzgend], *Epig. Vostoka*, i (1947), pp. 27–32

Y. A. Zadneprowsky: "Istoriko-arkheologischeskiye raboty v yuzhnoy Kirgizii" [Historical and archaeological work in southern Kyrgyzstan], *Trudy Kirgiz. Arkheol.–Etnog. Eksped.*, iv (1960), pp. 213–46

V. D. Goryacheva: *Srednevekovyye gorodskiye tsentry i arkhitekturnyye ansambli Kirgizii (Burana, Uzgen, Safid-Buland)* [Medieval urban centers and architectural ensembles of Kyrgyzstan (Burana, Uzgend, Safid-Bulan)] (Frunze, 1983), pp. 67–104

V. D. Goryacheva and V. N. Nastich: "Epigrafischeskiye pamyatniki Uzgena, XII–XX vv." [Epigraphical monuments of Uzgend, 12th–20th century], *Kirgiziya pri Karakhanidakh* [Kyrgystan under the Karakhanids] (Frunze, 1983), pp. 140–93

V

Vagkat. *See under* Ura tyube.

Varamin [Varāmān; Waramin]. Town in Iran 60 km southeast of Tehran. It was an agricultural satellite of Rayy until the 1220s, when Rayy was irreparably destroyed by the Mongols. When economic life began to revive under the Mongol Ilkhanid dynasty (*r.* 1256–1353), Varamin developed into a major urban center. Between 1322 and 1326 Hasan al Quhadhi, a vizier from the region, built a splendid congregational mosque in the town (*see* Architecture, §VI, A, 1 and Mosque, fig. 2). It is an almost perfect example of the classical Iranian mosque: four iwans are set around a central courtyard, one of which leads to a domed area in front of the mihrab. Other work done under the Ilkhanids includes a number of tombs—the Imamzada Yahya (1261–3; restored 1305–7), the mausoleum of ʿAla al-Din (1289) and the Imamzada Shah Husayn (*c.* 1330)—and the portal of the Sharif Mosque (1307). Numerous fragments of luster tiles of the 1260s and 1300s that once decorated the Imamzada Yahya are now in collections in London (V&A; *see* Abu tahir, color pl. 1:I, fig. 1), St. Petersburg (Hermitage) and elsewhere. At the turn of the 14th century Varamin was subjected to devastating attacks by the armies of Timur (Tamerlane), so that the Spanish traveler Ruy Gonzalez de Clavijo (*d.* 1412) found the town mostly deserted in 1405. Its subsequent recovery is marked by minor restorations to the congregational mosque (1412–19) and the construction of the tomb of Husayn Riza (1437), known for its retardataire stucco decoration. From the 16th century onwards Varamin was overtaken by Tehran as the major city of the region.

Enc. Islam/1: "Waramin"
D. Wilber: *The Architecture of Islamic Iran: The Il-Khanid Period* (Princeton, 1955)
O. Grabar: "The Visual Arts, 1050–1350," *The Saljuq and Mongol Periods*, ed. J. A. Boyle, v of *The Cambridge History of Iran* (Cambridge, 1968), pp. 629–36 [detailed discussion of the congregational mosque]
B. O'Kane: "The Imamzada Husain Riza at Varamin," *Iran*, xvi (1978), pp. 175–7
O. Watson: *Persian Lustre Ware* (London, 1985)
The Legacy of Genghis Khan: Court Art and Culture in Western Asia, 1256–1353 (exh. cat., ed. L. Komaroff and S. Carboni; New York, Met.; Los Angeles, CA, Co. Mus. A.; 2002–3)

Vedat [Mehmed Vedat Bey; Vedat Tek] (*b.* Istanbul, 1873; *d.* Istanbul, 1942). Turkish architect and teacher. After completing his secondary education at the Ecole Nonge in Paris, he studied painting at the Académie Julian and civil engineering at the Ecole Centrale, and then trained as an architect at the Ecole des Beaux-Arts, completing his studies in 1897. On returning to Istanbul in 1899, he was employed by the Municipality, becoming chairman of the Supervising Committee for Public Works and later the chief architect. In 1900 he also became the first Turk to teach architectural history at the Fine Arts Academy in Istanbul. Like his contemporary Kemalettin, Vedat played an important role in the development of a revivalist Turkish idiom in architecture, known as the First National Architectural Style, and his works and his writings reveal the theoretical approach behind the movement.

Vedat's first major work, the Central Post Office (1909) in Sirkeci, Istanbul, employed such features of traditional Ottoman architecture as depressed or pointed arches and glazed tiles (*see* Architecture, §VII, A) and had a small mosque attached to the rear of the building in the revivalist style. The general massing of the building, however, including the use of semi-circular pilasters with Corinthian capitals at the upper levels and the large central hall with an iron and glass roof, derived from Vedat's Beaux-Arts training. At about the same time he designed the Imperial Offices of the Land Registry, a large building on the Atmeydan in Istanbul that combined a similar mixture of features. In 1923, when Ankara became the capital of the new Turkish republic, Vedat was recruited from Istanbul to build two important buildings: the new National Assembly (1924), a symmetrical two-story rectangular building with exterior rubble walls of pink-colored local stone, and the Ankara Palace Hotel, begun in 1924 and completed by Kemalettin in 1927.

S. Özkan: "Mimar Vedat Tek, 1873–1942," *Mimarlık*, xi–xii (1973), pp. 45–51
R. Holod and A. Evin, eds.: *Modern Turkish Architecture* (Philadelphia, 1984), pp. 12–15, 41–5, 53–8
A. Batur: *Mimar Vedat Tek, Kimliğinin İzinde Bi Mimar* (Istanbul, 2003)
D. Kuban: *Osmanli Mimarisi* (Istanbul, 2007), p. 676; Eng. trans. as *Ottoman Architecture* (London, forthcoming)

Veli Can [Valī Jān] (*b.* Tabriz; *fl.* Istanbul, *c.* 1580–*c.* 1600). Ottoman painter. According to the Ottoman chronicler Mustafa 'Ali, he was a student of the Safavid court artist SIYAVUSH and came to the Ottoman court at Istanbul *c.* 1580. Mustafa 'Ali claimed that, despite Veli Can's gifts as a draftsman, his style did not progress and his work remained the same throughout his career. His name appears in the registers of the corporation of Ottoman artists for 1595–6 and 1596–7 with a daily salary of seven *akče*, a mediocre sum, which bears out Mustafa 'Ali's assessment. The large number of dubious attributions to the artist had made the definition of his style impossible until Denny discovered a tiny hidden signature on a drawing (Istanbul, Topkapı Pal. Lib., H. 2836). From this drawing, depicting a bird and a grotesque head in foliage, he has convincingly assigned three other drawings (Istanbul, Topkapı Pal. Lib., H. 2147, fol. 23*v* and H. 2162, fol. 8*v*; Paris, Mus. Jacquemart-André, MS. 261) to the artist. The rounded serrations of the leaf edges and bold, black sweeping lines that form the spines of the leaves place these drawings squarely in the *saz*, or nonhistorical Ottoman court style of the late 16th century (*see* ILLUSTRATION, §VI, D, 1). The grotesque head in Veli Can's signed drawing, however, is clearly borrowed from the style of his mentor.

Mustafa 'Ali: *Manāqib-i hunarvarān* [Wonderful deeds of the artists], ed. Ibn al-Amin Mahmud Kamal (Istanbul, 1926)

I. Stchoukine: *La Peinture turque* (Paris, 1971), pp. 34–5

W. B. Denny: "Dating Ottoman Turkish Works in the Saz Style," *Muqarnas*, i (1983), pp. 103–21

Veneto-Saracenic. Term applied to a large group of 15th- and 16th-century metalwares, primarily in European collections, once attributed to Muslim craftsmen working in Venice. The objects concerned—they include covered bowls with a rounded base or cylindrical form, spherical incense burners, candlesticks, buckets and salvers—are domestic in character. Made of brass (or bronze), they are inlaid with geometric or arabesque motifs in silver, with occasional traces of gold and frequent additions of a black compound, the widely differing designs being organized concentrically, centrifugally or centripetally. The term is sometimes loosely applied to objects decorated with figural ornament and Western coats of arms. None of the objects is dated, although a salver in Vienna (Mus. Angewandte Kst, GO.81) bears the date 1550 and the signature of Nicolo Rugina Greco da Corfu incised on the back; this inscription was probably added after the salver had been imported into the West. A number of pieces are signed by the masters Mahmud al-Kurdi and Zayn al-Din, and many bear European coats of arms, notably a group of small candlesticks with a truncated conical base and straight shaft (e.g. three in Venice, Correr, with the arms of the Malipiero family).

The identification of these objects as "Veneto-Saracenic" was popularized by Lavoix (1862), who believed that Muslim metalworkers had worked in Venice and trained Italian craftsmen in the Islamic style. The latter signed themselves "Ageminius" and described their work as *all gemina* or *alla gemina*, terms thought to be derived from the Arabic *'ajamī* ("Persian"; cf. later Venetian dialect *azzimina*). Although based only on circumstantial evidence, Lavoix's thesis was widely accepted until 1970, when Huth questioned whether guild laws would have allowed the presence of foreign craftsmen on Venetian territory. Huth also noted the difficulty of distinguishing whether a piece was an Islamic original or a close Western copy. No documentary evidence to support or disprove either contention has been discovered. The division of Veneto-Saracenic metalwork into more precise categories was begun by Melikian-Chirvani, who dated one sub-group to the late Mamluk period (*c.* 1400–1517). Many of the objects in this sub-group have a Western shape, and Melikian-Chirvani suggested that they were fashioned in the West and exported to the Middle East for decoration before being reimported into Venice. He thought that the Western coats of arms indicated that the objects had been made on commission. Allan suggested Mamluk Damascus, Cairo or the Jazira as a provenance for another sub-group, while Auld has tentatively divided 280 of the objects into three categories: Turkmen, Mamluk and Western.

The identification of the Turkmen sub-group of over a hundred pieces is based on the eleven pieces signed by Mahmud al-Kurdi (three in London, BM; two in U. London, Courtauld Inst. Gals.; one each in London, V&A (see color pl. 3:IX, fig. 2; Cividale del Friuli, Mus. Archeol. N.; Madrid, Mus. Galdiano; Bologna, Mus. Civ. Med.; Paris, Louvre; and St. Petersburg, Hermitage; other objects attributed to al-Kurdi by Mayer can be excluded on stylistic grounds). This master is thought to have worked in eastern Anatolia or western Iran in the late 15th century, when these areas were ruled by the Turkmen confederation of the AQQOYUNLU. The objects he made are decorated with centrifugal designs of cusped ogees, lime-shaped medallions and cruciform motifs inlaid in silver in both spatial and linear techniques (i.e. using small sheets of metal or metal wire) against a minutely incised arabesque ground. Their decoration displays affinities with that on metalwork made during the same period for the Timurid dynasty in eastern Iran and Central Asia and the Mamluk rulers of Egypt and Syria (*see* METALWORK, §III, A, 2 and C, 1), but Mahmud al-Kurdi had an added interest in drama and color. His reliance on Timurid precedent can be seen on a salver in the British Museum (1878.12–30.705), especially in the centrifugal design and individual motifs of the border and in the use of a crosshatched ground. Mamluk motifs were also adopted: the signature contained within the central field of blazon-like roundels, and the cross-petaled lotus blossoms on the outside rim, for example. The same exuberant eclecticism is found on objects that Allan (p. 142) has attributed to Turkmen patronage, and this variety of motifs may be the result of the conquests of the Aqqoyunlu sovereign Uzun Hasan (*r.* 1453–78) at the expense of his Qaraqoyunlu and Timurid neighbors. Uzun Hasan had diplomatic

links with Venice from 1463 to 1475, and a covered bowl by Mahmud al-Kurdi (U. London, Courtauld Inst. Gals) bears an inscription in Arabic together with a transliteration of it in Latin script; the bowl may have been intended as a diplomatic gift. Mahmud al-Kurdi's work is also linked stylistically to Aqqoyunlu manuscript illumination. A Koran dated 1483 (Dublin, Chester Beatty Lib., MS. 1502), for example, shares both individual motifs and Mahmud al-Kurdi's approach to design. Six pieces in a related style were signed by the master Zayn al-Din (Baltimore, MD, Walters A.Mus.; Paris, Louvre; Venice, Correr; London, BM; London, V&A; sold London, Christie's, 11 June 1986, lot 430). They bear motifs not found in Mahmud al-Kurdi's work: a subdivided split palmette and a type of arabesque common in Ottoman metalwork, ceramics and architectural ornament of the 16th century. Zayn al-Din may have been among the metalworkers removed from Tabriz to Istanbul in 1514 as a result of the conquest of the former Aqqoyunlu capital by the Ottoman sultan Selim I. A piece by Zayn al-Din in the Bargello, Florence, a fine round-bottomed box and cover, is known to have been in the collection of Ferdinando I de' Medici (r. 1587–1609) from 1589 and was formerly displayed in the Sala della Tribuna of the Uffizi Palace, Florence, evidence of the respect paid to Islamic inlaid metalwork in the High Renaissance.

The second sub-group, which includes the bulk of the Veneto-Saracenic pieces, is related to late 15th-century Mamluk metalwork: designs are organized centripetally or in concentric bands, and the motifs are typically Mamluk. These last include geometric interlacing; alternating knots, twisted ropes and trefoiled trelliswork derived from calligraphy; and roundels within plain or cusped fillet borders that are linked to the fillet strips between concentric bands of decoration. A typical piece is a spherical incense burner (Washington, DC, Freer, 39.58) composed of identical hemispheres. Each has a central roundel of knotwork that is repeated in a broad band on the walls. Both the knotted roundel and band have a narrow border of running stems bearing small trefoils, and the four areas are delineated by narrow fillet frames. The ground is coarsely engraved with scrolls, and the incisions are filled with a black organic compound. None of the objects in this group is signed, but many bear north Italian (and specifically Venetian) coats of arms. Although these are too general or too incomplete to provide precise information about ownership, they are nonetheless visual evidence of the close diplomatic and commercial links between the Mamluk and Venetian states.

The third sub-group consists of objects apparently made in the West, probably in northern Italy, in imitation of Islamic wares. Individual motifs were copied accurately, but there is a basic misunderstanding of the rules of Islamic proportion and a disregard for any relationship between positive and negative shape. An example (London, U. Courtauld Inst. Gals.), indisputably Western because of the inclusion of tiny birds, masks and grotesques among the foliage, displays the characteristic disharmony between the width and the breadth of the cartouches. These do, however, rely on Islamic prototypes for their trefoil finials and for the way in which they are cut short at the border by the rim. Other Western characteristics are found in the arabesque infill, which is broken up to fill each individual area, and the strict division between the bands of the concentric arrangement. In Islamic design the arabesque ground would have continued uninterrupted, as the space they fill would have been seen not as contained but as infinite.

M. Boni: *Notizia di una casettina geographica opera di commessi d'oro e argento all'agemina* (Venice, 1800)

D. Francesconi: *Illustrazione di una urnetta lavorata d'oro e di vari altri metalli all gemina coll'iscriptione "Paulus Ageminius Faciebat"* (Venice, 1800)

H. Lavoix: "Les Azziministes," *Gaz. B.-A.*, xii (1862), pp. 64–74

H. Lavoix: "Les Arts musulmans: De l'ornementation arabe dans les oeuvres des aîtres italiens," *Gaz. B.-A.*, xvi (1877), pp. 15–29

S. Lane-Poole: "A Venetian Azzimina of the 16th Century," *Mag. A.* (1886), pp. 450–53

W. L. Hildburgh: "Dinanderie Ewers with Venetian-Saracenic Decorations," *Burl. Mag.*, lxxix (1941), pp. 17–22

L. A. Mayer: *Islamic Metalworkers and their Works* (Geneva, 1959)

B. W. Robinson: "Oriental Metalwork in the Gambier Parry Collection," *Burl. Mag.*, cix (1967), pp. 169–73

U. Scerrato: *Arte islamica a Napoli* (Naples, 1967)

H. Huth: "'Sarazenen' in Venedig?," *Festschrift für Heinz Ladendorf* (Cologne, 1970), pp. 58–68

M. S. Melikian-Chirvani: "Venise, entre l'orient et l'occident," *Bull. Etud. Orient.*, xxvii (1974), pp. 109–26

M. Spallanzani: "Metalli islamici nelle collezioni medicee dei secoli XV–XVI," *Le arti del principato mediceo* (Florence, 1980), pp. 95–117

G. Curatola and M. Spallanzani: *Metalli islamici dalle collezioni granducali* (Florence, 1981)

E. Atıl, W. T. Chase and P. Jett: *Islamic Metalwork in the Freer Gallery of Art* (Washington, DC, 1985)

M. Spallanzani: "Il piatto islamico Venier-Molin del Bargello," *Renaissance Studies in Honor of Craig Hugh Smyth*, ii (Florence, 1985), pp. 465–72

J. W. Allan: *Metalwork of the Islamic World: The Aron Collection* (London, 1986)

S. Auld: "The Mamluks and the Venetians Commercial Interchange: The Visual Evidence," *Palestine Explor. Q.*, cxxiii (1991), pp. 84–102

R. Ward and others: "'Veneto-Saracenic' Metalwork: An Analysis of the Bowls and Incense Burners in the British Museum," *Trade and Discovery: The Scientific Study of Artefacts from Post-medieval Europe and beyond*, ed. D. R. Hook and D. R. M. Gaimster, British Museum Occasional Paper, 109 (London, 1995), pp. 235–58

S. Auld: *Renaissance Venice, Islam and Mahmud the Kurd: A Metalworking Enigma* (London, 2004)

D. Behrens-Abouseif: "Veneto-Saracenic Metalwork, a Mamluk Art," *Mamluk Stud. Rev.*, ix/2 (2005), pp. 147–72

Vernacular architecture. Term used to describe informal, usually domestic, architecture that is rooted

in local traditions and is generally produced by crafts-men with little or no formal academic training whose identity is unrecorded. The vernacular architecture of any region may be characterized by the use of a par-ticular material readily available in the area, by the prevalence of a particular building type related to the dominant local economic activities or by the use of a particular style, possibly derived from local materials and techniques.

The vast region dominated by Islam since the 7th century is studded with the remains of the earliest built communities. Inherently these are all vernacu-lar, and the subsequent tradition has been continu-ous: desolation has been due to war and natural disaster, not to abandonment. New cities arose where old ones had stood, often with extraordinary persis-tence on the foundations and street lines of the earlier structures. Testimony to this long vernacular history lies in the sharp-sided tells, or artificial hills, that stud the region. The citadels of ALEPPO in Syria, Irbil in northern Iraq and BUKHARA in Uzbekistan are dra-matic examples of these ancient settlements. These tells have risen unconsciously and without deliberate command by the simple process of the continual gar-nering of materials into the city and their discard *in situ* as the result of decay. Differing climatic condi-tions, availability of materials and cultural practices have given rise to distinct regional traditions of ver-nacular architecture within the broad swath of land where Islam holds sway from the Atlantic Ocean to the the plains of India and from the steppes of Cen-tral Asia to the savannahs of central Africa.

The large majority of towns have, at some time in their history, boasted major fortifications and rugged girdles of walls, if only in mud-brick (*see* MILITARY ARCHITECTURE AND FORTIFICATION). Many of these fortifications survive, and the pattern of streets within vividly displays the containment of the city. Great ranges of other practical building types, such as the MOSQUE, MADRASA, CARAVANSERAI, WIND CATCHER and BATH, have evolved from need and available materials, the same constraints that pro-duced the ordinary house. This article concentrates on regional varieties of domestic architecture; the nature of the evidence precludes uniform treatment of all regions.

K. Kebudayaan and B. dan Sukan: *Architecture and Identity, Exploring architecture in Islamic cultures*, 1 (Singapore, 1983)

P. Clement: "Courtyard Houses," *Mimar*, iii (1982), pp. 34–41

C. C. Held: *Middle East Patterns: Places, Peoples and Politics* (Boulder, 1989; 4/2006)

J.-P. Bourdier and N. Alsaayad, eds.: *Dwellings, Settlements and Tradition: Cross-Cultural Perspectives* (New York, 1989)

J. E. Campo: *The Other Sides of Paradise: Explorations into the Religious Meanings of Domestic Space in Islam* (Columbia, SC, 1991)

P. Oliver: *Encyclopedia of Vernacular Architecture of the World*, 3 vols. (Cambridge, 1997)

R. M. S. Abdel-Fattah: *Preservation of the Vernacular Built Environment in Development Projects*, Traditional dwellings and settlements working paper series, 114 (Berkeley, CA, 1998)

K. Al-Kodmany: *Preservation of Traditional Lifestyles and Built Form*, Traditional dwellings and settlements working paper series, 115 (Berkeley, CA, 1998)

J. Dakhlia, ed.: *Urbanité arabe: Hommage à Bernard Lepetit* (Arles, 1998)

D. P. Crouch and J. G. Johnson: *Traditions in Architecture: Africa, America, Asia and Oceania* (Oxford, 2001)

N. Alsayyad, ed.: *Hybrid Urbanism: On the Identity Discourse and the Built Environment* (Westport, CT, 2001)

A. Badaway: "Architectural Provision against Heat in the Orient," *Patterns of Everyday Life*, ed. D. Waines, Forma-tion of the Classical Islamic World, 10 (Aldershot, 2002), pp. 121–35

W. Bechhoefer: *Places of Nostalgia*, Traditional dwellings and settlements working paper series, 152 (Berkeley, CA, 2002)

A. Petruccioli and K. K. Pirani: *Understanding Islamic Architec-ture* (London, 2002)

F. Ragette: *Traditional Domestic Architecture of the Arab Region* (Stuttgart, 2003)

R. Tapper and K. McLachlan, eds.: *Technology, Tradition and Survival: Aspects of Material Culture in the Middle East and Central Asia* (London, 2003)

P. Jodidio, ed.: *Iran: Architecture for Changing Societies* (Turin, 2004) [Proceedings of an international seminar co-spon-sored by the Aga Khan Award for Architecture, with articles on many places across the Islamic lands]

B. Edwards and others, eds.: *Courtyard Housing: Past, Present and Future* (Abingdon, 2006)

R. Zetter and G. B. Watson: *Designing Sustainable Cities in the Developing World*, Design and the built environment series (Aldershot, 2006)

I. Morocco and Algeria. II. Tunisia. III. Egypt. IV. Sub-Saharan Africa. V. Syria and Iraq. VI. Arabia. VII. Yemen. VIII. Anatolia and the Balkans. IX. Iran. X. Central Asia. XI. India.

I. Morocco and Algeria. The Maghrib, or northwest Africa, is rich in regional architectural forms that vary with the geographic, cultural and historical diversity of the coastal regions along the Mediterranean and Atlan-tic, the Atlas Mountains and the oases of the Sahara. The study of vernacular architecture has concentrated on the spectacular defensive structures and villages of the Atlas Mountains and southern Morocco (see fig. 1) and the sculptural coherence of the Mzab oases of Algeria at the expense of the less distinctive and less well-preserved building traditions of the coastal plains. In the Maghrib urban domestic architecture is also highly regionalized, although largely unstudied, except in FEZ. The Mediterranean coast of Morocco and Algeria has been in the path of numerous invasions, from the Phoenicians to the French. The more acces-sible areas have long been under the rule of the 'ALAWI sultans or OTTOMAN governors, and buildings have much in common with peasant architecture elsewhere in the Mediterranean. The typical house of the littoral consists of a single room built of local stone, mud-brick or rubble, flat-roofed or sloped and thatched.

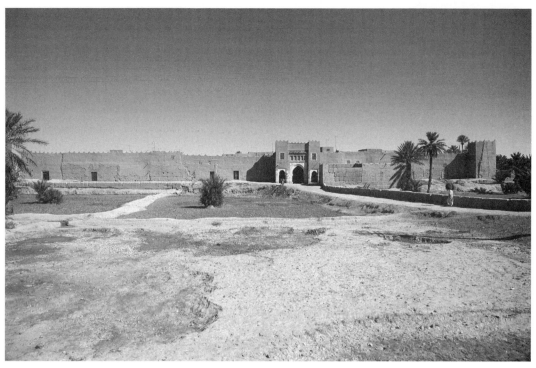

1. *Qsar*, at Rissani, Ziz Valley, sourthern Morocco; photo credit: Sheila S. Blair and Jonathan M. Bloom

Wood is used for walls and roofs, depending on availability; it is also burnt to produce lime for whitewashing as protection against heavy rainfall.

Distinctive forms and settlement patterns are controlled not only by climate, resources and topography but also by the cultural and social identity of the builders. In the rugged but densely populated area of the Rif Mountains in northern Morocco, for example, houses vary in construction, plan and placement according to each tribal and linguistic group. A more recent external historical origin must be sought for the distinctive red-tiled pitched roofs of the northern villages, in areas that were settled by refugees from Spain from the 15th to the 17th century. The settlers brought with them a technique of roofing dictated by heavy snow and rainfall that, although inappropriate in their new environment, survived into the 20th century, giving such towns as Chaouen in Morocco a distinctly European aspect. A round-tiled pitched roof over dry-stone construction, a technique used in the Kabylia Mountains of northwest Algeria, is thought to have Roman antecedents, illustrated in the Classical mosaics of nearby Constantine. These houses also do not exceed a single room, divided down the middle by a bench to keep the animals on one side, and related family houses are built around a courtyard with a single entrance.

Along the Atlantic coastal plain of Morocco, less permanent, circular and conical-roofed houses (*nuwala*), built of cane and reeds covered with straw, are thought to have a sub-Saharan origin. As on the northern plains, cactus plants are grown to form windbreaks and walls for isolated farmhouses. In some villages of the central Moroccan plains, houses or huts are arranged in circles for defensive purposes and possibly in memory of a nomadic Bedouin tradition. Some neighboring tribes of the Atlantic littoral, also in the Middle Atlas and eastern Rif mountains, continue to use tents, occasionally in conjunction with buildings.

Funerary vernacular architecture consists of a cubic base surmounted by a dome (*qubba*), equipped with a mihrab and decorated with crenellations or horns at the corners. These horns or steps at the corners of flat and domed roofs are some of the few ornaments found on religious and secular buildings throughout the Maghrib, as well as in the southern Sahara and South Arabia. Their function was probably once apotropaic. The domed saint's tomb appears in towns as well as the countryside, and its form must surely originate in the royal tombs of cities in the eastern Islamic lands (*see* Tomb, §II). Building along the coast has gradually lost many of the features it shared with the more impenetrable Atlas Mountains and Sahara. Collectively built public buildings of rural areas, such as fortresses and granaries, have survived only as toponyms in northern Morocco.

The Berber villages of the Rif, Kabylia and Aurès mountains share many characteristics with those of the High Atlas and Saharan steppes. The fortified communal storehouse is the vital center of these villages, among both sedentary and semi-nomadic people, protecting and storing food in unstable and threatened times and when nomads pastured their flocks, and

functioning as market and caravanserais in peacetime. Known as *agadir* in the southern and western Atlas, *tighremt* in the High Atlas and *qal'a* in the Aurès, these storehouses have immediate visual similarities with the tower houses of southern Arabia and fortified villages of Afghanistan. Although the latter examples are also fortified domestic structures, their function and plans are different. The Maghribi granaries have courtyards to house animals; a variant of the courtyard is the long narrow alley of the agriculturalist western High Atlas. In all cases there are multiple levels of small rooms, to which families have access by climbing projecting beams and stone slabs. Built of stone in the High Atlas and Aurès and mud in the Sahara, they have small barrel-vaulted rooms similar to those of Libyan and Tunisian granaries. The semi-sacred nature of the tribal storehouse can be expressed by the placing of a saint's tomb at the center.

A building related in structure to the communal granary is the *qasba*, or fortified citadel and governor's residence, which existed in most Maghribi towns. In the Atlas the term refers to the large isolated structures put up by local rulers to defend mountain passes and exercise their authority over neighboring tribes. Most of the extant *qasba*s of the Atlas were probably built in the 19th century, during the despotic expansion of the Glawa (Glaoui) tribe, which in turn destroyed many *agadir*s belonging to independent villages. The *qasba* in some form, however, has been used in the mountains at least since the reign of Mawlay Isma'il (*r.* 1672–1727), said to have built 76 *qasba*s to subdue the region. A third form is the mountain village, *qal'a* in Morocco and *qsar* in Algeria, which is used for only part of the year by mountain pastoralists. Although fortified, it has no particular plan and need not be sited on the dramatic heights selected for the two other forms.

The fortified village of the Anti-Atlas and northwest Sahara has the external appearance of, and might be mistaken for, a mountain storehouse or granary, which in turn is sometimes enclosed within its walls or placed near the village. To add to the confusion of terminology, these structures are also known as *qsur* (plural of *qsar*). These are the most distinctive buildings of this region (see color pl. 3:XV, fig. 2), and their plans have a formal character thought to originate in Roman or Byzantine border camps. The buttressed and tapering walls are built of pisé with unfired brick in the upper floors, elements ideally suited to the extremes of temperature in the desert. Within, the mosque, bath and other open spaces are placed near the single entrance, and contiguous houses fill the space between the square village walls and the two carefully orientated paths that meet at right angles. The houses themselves, with their narrow courtyards, thick walls and height, are well designed for the seasons of the desert oases.

Decoration is limited to the arch of the main doorway and the rich patterns of fired brickwork of the upper story walls, which probably echo metropolitan forms. The architecture of the Tafilalt, for example, is thought to be evidence of the building tradition of Sijilmasa, one of the great medieval Saharan towns and trading posts, along with Timbuktu (Mali) and Oualata (Mauritania). The 16th-century traveler Leo Africanus wrote that after the Marinids destroyed Sijilmasa in the 14th century, its inhabitants dispersed and settled the Tafilalt. The search for origins for the mud architecture of southern Morocco in that of Sijilmasa is confounded by the impermanence of the material: the oldest standing buildings date from the 19th century, with some 18th-century ruins still in evidence.

Equally remarkable but quite different are the seven oasis towns of the Mzab Valley in central Algeria, also located in an extremely harsh environment, where survival depends on the careful regulation of agricultural and defensive building practices. The highly conservative tradition of the Kharijite heterodoxy has survived here since it took refuge in the Mzab in 1077, after the destruction of the Kharijite capital of Scdrata to the southeast. The last two Kharijite towns were founded in the 17th century. Tapering horned minarets dominate the walled towns and hills on which they are built and also act as watchtowers. A strict hierarchy is imposed on the houses, which are not allowed to surpass a certain height and are built along streets that radiate out and down from the great mosque crowning the hill. Immediately outside the towns are summer houses in the oases, to which the Mzabites can escape in the fiercest heat. The only decorative forms in these austere towns are the simple arcades along the roads or around the market-places and the elongated horns on religious and funerary buildings, both on saints' tombs (with the characteristic conical domes of the region) or the ordinary flat-roofed tombs. The relationship of this austere tradition to the sophisticated carved stucco decoration found in the excavated houses of medieval Sedrata remains unclear.

See also Architecture, §VII, E.

Leo Africanus: *Descrittione dell'Africa* (1526); Fr. trans. by A. Epaulard as *Description de l'Afrique* (Paris, 1956)

R. Maunier: *La Construction collective de la maison en Kabylie* (Paris, 1926)

E. Blanco Izaga: *La vivienda rifeña* (Ceuta, 1930)

R. Montage: *Villages et kasbas berbères* (Paris, 1930)

H. Terrasse: *Kasbas berbères de l'Atlas et des oasis* (Paris, 1930)

E. Laoust: "L'Habitation chez les transhumans du Maroc central," *Hespéris*, xiv (1932), pp. 115–218; xviii (1934), pp. 109–96

D. Jacques-Meunié: *Greniers citadelles au Maroc* (Paris, 1951)

A. Delpy: "Note sur l'habitat des Ida ou Semlal, Ameln," *Cah. A. & Tech. Afrique N.*, v (1959), pp. 7–16

R. Riché: "La Maison de l'Aurès," *Cah. A. & Tech. Afrique N.*, v (1959), pp. 30–36

D. Jacques-Meunié: *Architectures et habitats du Dadès* (Paris, 1962)

Living on the Edge of the Sahara: A Study of Traditional Forms of Habitation and Types of Settlement in Morocco, Kasba 64 Study Group (The Hague, 1973)

G. T. Peterbridge: "Vernacular Architecture in the Maghreb," *Maghreb Rev.*, iii (1976), pp. 12–17

F. Ago: *Moschee in adòbe: Storia e tipologia nell'Africa occidentale* (Rome, 1982)

A. Ravereaux: *Le M'zab: Une Leçon d'architecture* (Paris, 1981)

W. J. R. Curtis: "Type and Variation: Berber Collective Dwellings of the Northwestern Sahara," *Muqarnas*, i (1983), pp. 181–209; repr. in *Patterns of Everyday Life*, ed. D. Waines, Formation of the Classical Islamic World, 10 (Aldershot, 2002), pp. 79–107

J. Revault, L. Golvin and A. Amahan: *Palais et demeures de Fès* (Paris, 1985)

H. Scharfenorth: "Marokko," *Archit. & Wohnen*, i (1991), pp. 132–46

A. Picard and others: "Architecture et urbanisme en Algérie: D'Une rive à l'autre (1830–1962), *Rev. Monde Musul. & Médit.*, lxxiii–lxxiv (1994), pp. 121–36

R. Bourqia: "Habitat, femmes et honneur: Le cas de quelques quartiers populaires d'Oujda," *Femmes, culture et société au Maghreb. I: Culture, femmes et famille*, ed. R. Bourqia, M. Charrad and N. Gallagher (Casablanca, 1996), pp. 15–35

A. de Sierra Ochoa: *La vivienda marroquí: Notas para una teoría* (Malaga, 1996)

F. Navez-Bouchanine: *Habiter la ville marocaine* (Casablanca, 1997)

A. Loeckx: "Kabylia, the House, and the Road: Games of Reversal and Displacement," *J. Archit. Educ.*, lii/2 (1998), pp. 88–99

S. Fehn: "The Primitive Architecture of Morocco," *A+U*, cccxl (1999), pp. 40–42

L. Swanson: "Mosque at Ait Isman: Todra Gorge, Morocco," *J. N. Afr. Stud.*, v/1 (2000), pp. 147–64

S. Zerhouni, H. Guillaud and E. Mouyal: *L'Architecture de terre au Maroc* (Paris, 2001)

M. Ghomari: "L'Espace limitrophe: Pratiques habitantes et représentations territoriales," *Public et privé en Islam: Espaces, autorités et libertés*, ed. M. Kerrou (Paris, 2002), pp. 201–23

B. L. McLaren: "The Italian Colonial Appropriation of Indigenous North African Architecture in the 1930's," *Muqarnas*, xix (2002), pp. 164–92

S. Missoum: *Alger à l'époque ottomane: La médina et la maison traditionnelle* (Aix-en-Provence, 2003)

M. A. Kabab: "Les quartiers illicites en Algérie: Société et urbanistique populaire," *Rev. Hist. Maghréb.*, xxxi/116 (2004), pp. 93–120

C. Verner: *The Villas and Riads of Morocco* (New York, 2005)

T. Bellal and F. E. Brown: "Spatial Structure of the M'zabite Home: Family and Gender," *J. Archit. & Planning Res.*, xxiv (2007), pp. 1–22

II. Tunisia. Domestic architecture in Ifriqiya, the province roughly corresponding to modern Tunisia, before the period of HAFSID rule (r. 1228–1574) is known primarily from incomplete excavations at the sites of Raqqada (9th century) and Sabra (10th century), near KAIROUAN. Evidence suggests that the principles of construction changed only slightly before the 20th century: the standard arrangement was a single indirect entrance leading from the exterior to a square court surrounded by rectangular chambers. The presence of stairs suggests the existence of a second story, but there is no evidence to confirm it. The plan evokes the memory of the antique Greco-Roman house, but the affiliation is uncertain, since these principles were well known for centuries not only throughout the Mediterranean lands but also as far as Central Asia. Whatever the origins of the plan may be, it corresponds to an introverted conception of the family cell, visible primarily in urban domestic architecture.

In Tunis, the oldest surviving houses date from the 16th century and consist of such residences as the Dar 'Uthman or more modest private houses. One of the most characteristic is the Dar al-Hadri (El-Hedri). A single entrance, composed of a vestibule lined with banquettes on which the visitor is seated while waiting to be admitted, leads to a corridor with a right-angle bend for privacy. The corridor leads to a central paved court in the shape of a slightly deformed square, bordered on three sides by porticos with triple arcades resting on marble columns and capitals. Three large rooms line the sides with porticos. The largest, opposite the entrance, is the salon where the master receives his visitors. It has a door with two valves ornamented with nails and flanked by two square barred windows. An elaborately decorated central alcove is flanked by recesses, with banquette-beds at the two extremities of the antechamber. The two other rooms have only cupboards and beds. The fourth wall of the court has a stair leading to the upper floor, which has galleries on all four sides of the court; it is protected by a balustrade of turned wood, supported by columns that support the roof. From this gallery open four large rooms. An annex composed of a small court bordered by two pitched roofs supported on two arcades on columns contains a kitchen garden, a well, latrines and storage. This is the *dwirīya* or kitchen, and from it there is access to a bath. Finally, a vast complex with a central court was used for stables and lodging servants.

Interior façades were constructed of ocher-colored limestone quarried near Tunis. Vestibules and some principal rooms were revetted with tile, produced at Qallalin in the suburbs, and decorated with finely carved stucco. Ceilings of the rooms were supported by painted beams, while those of the alcoves of reception rooms were decorated with coffers, sculpted and painted with floral decoration. Street façades were bare, except near entrances, which normally comprised a rectangular door of two valves ornamented with nails. The jambs and lintels were worked from stone slabs, occasionally with the addition of white and black marble, and decorated with moldings. Some façades have consoles supporting projecting blocks, pierced by a square window with a wooden grille (*mashrabiyya*). This type of house evolved little, except for the decoration of the entrances, which followed current fashions for horseshoe arches or Italianizing motifs. Houses in other cities of Ifriqiya followed the same principles with some variation. In Kairouan, for example, loggias on the upper floor opened to the street and were protected by balustrades of turned wood (see fig. 2). In Sfax interior courts have a

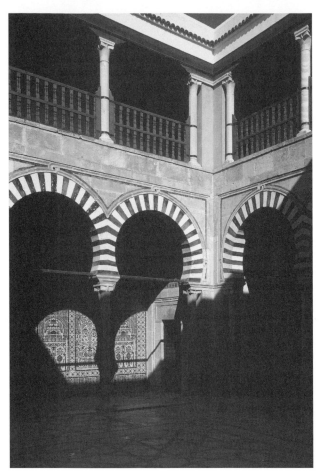

2. Domestic interior at Kairouan, Tunisia, 19th century, now the Institute of Art and Archeology; photo credit: Sheila S. Blair and Jonathan M. Bloom

the interior. Near these troglodyte villages there are also villages comprised of multiple stories of super-imposed long narrow and vaulted chambers; these are the *ghorfa* of Medenine and the neighboring villages. Earthen stairs along the façade give access to the rooms. In the Djerid, particularly at Tozeur, construction is in mud-brick, and the façades of the houses have handsome geometric patterns in the brickwork.

A. Bernard: *Enquête sur l'habitation rurale de Tunisie* (Tunis, 1924)

S. Tlatli: *Djerbe et les djerbiens* (Tunis, 1942)

G. Marçais: *L'Architecture musulmane d'Occident* (Paris, 1954)

J. Despois: *La Tunisie orientale, sahel et basses steppes* (Paris, 1955)

J. Revault: *Palais et demeures de Tunis*, 4 vols. (Paris, 1967–78)

A. Daoulatli: *Tunis sous les Hafsides* (Tunis, 1976)

T. Bachrouch: "Hammamet: Etat des lieux," *Medinas de Tunisie: Hammamet/Al-mudun al-Tūnisīya:al-Ḥammāmāt* (Tunis, 1996), pp. 61–6

A. Azzouz and D. Massey: *Maisons de Hammamet* (Tunis, 1988)

J. Abdel-Kafi: *La médina de Tunis: Espace historique* (Paris, 1989)

D. Lesage: "Resurrected Modernity: The Future of Medinas," *Rive: Review of Mediterranean Politics and Culture*, iii (1997), pp. 110–13

F. Soro and P. de Montaner, eds.: *Gafsa: Une médine oasienne en Tunisie*, Quaderns de la Gerència d'Urbanisme, 3 (Palma de Mallorca, 1998)

F. Abachi: "Histoires d'habiter: Enquête sur des perceptions vernaculaires," *Urbanité arabe: Hommage à Bernard Lepetit* (Arles, 1998), pp. 407–30

H. Ettehadiyeh: "The Medina of Tunis: A Successful Experience in the Reconstruction and Rehabilitation of Old Urban Fabric," *Tavoos*, ii (2000), pp. 138–47

J. McGuiness: "Neighbourhood Notes: Texture and Streetscape in the Medina of Tunis," *The Walled Arab City in Literature, Architecture and History: The Living Medina in the Maghrib*, ed. S. Slyomovics (London, 2001), pp. 97–120

S. Akrout-Yaïche: "New Life for the Medina of Tunis," *Iran: Architecture for Changing Societies*, ed. P. Jodidio (Turin, 2004), pp. 65–8

A. Mrabet, ed.: *L'Art de Bâtir au Jérid: Etude d'une architecture vernaculaire du Sud Tunisien* (Sousse and Paris, 2004)

III. Egypt. Egypt is fortunate in its unusual wealth of material that can be used to document the history of vernacular architecture. Excavation reports document Pharaonic, Ptolemaic, Greco-Roman, Coptic and early Islamic sites, while for medieval Cairo travelers' reports, historians' accounts, documents from the Geniza—a trove of medieval papers found in a Cairo synagogue—and the archives of endowment deeds (Arab. *waqf*) supplement the monumental evidence. The excavations at Fustat have provided examples of some three dozen middle-class houses from the periods of Tulunid (*r.* 868–905) and Fatimid (*r.* 969–1171) rule. Study of these remains, together with the Geniza documents, makes it

single gallery—composed of two arches on a column—on the entrance side. This is the *bortāl*, under which one finds the storerooms, latrines, well, stair, entrance to the kitchen annex etc. In smaller cities on Cap Bon or in the Sahel, houses usually have a single ground floor.

Houses are built of stone along the coast and on the islands of Jerba and Kerkenah, although there is also a modest house (*gourbi*) made of reeds and covered with branches or with a mixture of earth and straw. The most common type of farmhouse is a family cell comprising one to four living rooms around an irregular court. The entrance passage is always indirect for privacy, and the stable adjoins the living-quarters as well as the sheds and storerooms. The rooms are often covered with barrel vaults supporting the roof. The houses of the more prosperous have a well or cistern and latrines. Elsewhere, wells or cisterns are outside the houses. Unusual housing includes the subterranean rooms in the mountains near Matmata. Carved into the clay, the chambers open on to a court at the bottom of a vertical well. A descending gallery, with rooms for animals, leads to

possible to identify something of the typical domestic architecture of the period. Although there was only one main entrance, a second entrance was common if the house had a wall that fronted on to another street. Unlike houses in many other Arab cities, exterior walls were provided with numerous windows, usually including a window corbelled out above the main doorway. Wooden lattices (*mashrabiyya*) screened the inhabitants from view, while permitting them to see out.

Despite the irregular contours of most of these houses, their interiors are invariably characterized by geometric regularity, insofar as this was possible. Two features have been found in every house that has been excavated: a courtyard and, on one of its sides, a unit consisting of an IWAN with two adjacent rooms at its sides, fronted by a portico. In most cases, the other three sides of the courtyard show an irregular disposition of rooms, although a second iwan, with or without a portico, or, rarely, a biaxial four-iwan composition, was also known. Sometimes a pool flanked by shrubbery beds was found in the center of the courtyard, while some enigmatic shallow gougings in the area of the porticos also could have been designed for plants. The cooling effect of the greenery was echoed in the orientation of the main iwan, which usually faced north to obtain the maximum shade in summer. The iwan clearly corresponds to the *majlis* cited in Geniza documents and to the *qāʿa* mentioned in later sources as the largest living or reception room of the house. It could be on either the ground or upper floor, although the former seems, from the excavated examples, to have been more common at this period. This room would have had the most sumptuous furnishings, in which painted wooden ceilings and brightly colored textiles—bolsters, cushions, rugs and curtains—played the major part. Occasionally the room had features that became more common from the 13th century: a *dūrqāʿa* (a lower area where one removed one's shoes) with a marble basin for a fountain, sometimes in combination with a *shādirwān* (a decorated flagstone over which water rippled) and a wind catcher or ventilation shaft above, all contributing to the coolness of the interior. The flat roofs of the houses were also used for drying clothes or fruit, or even for light wooden superstructures that could be let as individual dwellings. It has not been possible to carry out excavations at Fustat in the most densely populated areas near the Nile; perhaps for this reason no traces have been found of the multi-story dwellings mentioned in several historical sources, which accommodated hundreds of people.

The remains of several palaces in Cairo vividly illustrate the splendor in which the principal Mamluk amirs lived. The most impressive surviving examples belonged to Bashtak (1334–9) and Qawsun (1337–8), two amirs of al-Nasir Muhammad. Their houses compete in quality and magnificence with the finest religious architecture of the Mamluks (*see* ARCHITECTURE, §VI, C, 1) and are notable for the size of their upper stories and *qāʿa*s, which had replaced the courtyard as the focal point of the building. The *qāʿa* of Bashtak consists of two iwans facing each other across a *dūrqāʿa* bordered by an arcade of three arches. The *dūrqāʿa* rises vertiginously to an upper gallery shielded by lattices and to a wooden *muqarnas* roof. The *qāʿa* of Qawsun must have been even vaster, to judge by the remains of its one iwan, which is expanded on three sides by subsidiary iwans. Some idea of its proportions can be gained by the entrance to the palace with its superb MUQARNAS vault, second in height only to that of the funerary complex of Sultan Hasan (1356–62) in Cairo.

Mamluk palaces are impressive not only for their size but also for the quality of their decoration. The *qāʿa* of Tashtimur (1376–7), converted into a mosque by Khushqadam in 1486, is of relatively modest dimensions, but its fine stucco medallions and painted *muqarnas* and inscription band are the equal of work in the contemporary complex of Sultan Hasan. The inscription band encircles the whole *qāʿa*, emphasizing a horizontality unusual for the period. In addition to the enlargement of the *qāʿa*, the *maqʿad*, an open loggia on the upper story facing the courtyard, was also increased in size during this period. The *maqʿad* of Mamay al-Sayfi (1496; see fig. 3) is all that survives of his palace. It has five large arches, although the sources mention examples with up to fifteen.

Lower-middle-class Mamluk and Ottoman housing is represented by the *rabʿ*, a type of tenement with apartments arranged in vertical units of two or three stories. Like the better-known *wakāla* (*see* CARAVANSERAI), they usually had shops on the ground floor, but *rabʿ*s were for permanent rather than transient residents. These buildings accommodated the essential elements of courtyard houses: the *qāʿa* was retained, occupying double the height of the other rooms (although it overlooked the street rather than the interior courtyard of the buildings), while the roof, walled to obtain privacy, substituted for the courtyard. The same emphasis on verticality is found in the Ottoman houses that have survived in Rashid (Rosetta). Although on a grander scale than the *rabʿ*s, they are similar in that they turn their backs on the small courtyards they contain and derive most of their light from the street façade. The numerous Ottoman houses of the bourgeoisie in Cairo have many of the same features as those of Fustat or, on a reduced scale, the Mamluk palaces. The reception rooms (*manzara*) are much smaller, and in consequence several could be fitted into the plan, on upper and lower stories, facing various directions for use in different seasons. Almost invariably the *maqʿad* was reduced in scale to a double arch.

The dwellings of the urban poor are scarcely known, owing to their perishable nature and the lack of interest shown in them by historians and travelers. Jomard's account in the *Description de l'Egypte* of large courtyards or enclosures used as rubbish dumps full of huts four feet tall where crowds of the poor lived crammed together with their animals would as likely apply to the Cairo of ten centuries ago as of

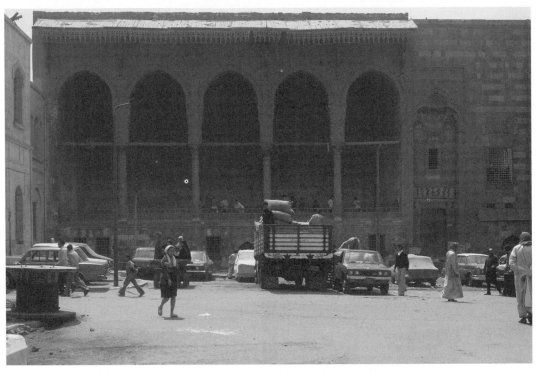

3. Maqʿad of Mamay al-Sayfi, Cairo, Egypt, 1496; photo credit: Sheila S. Blair and Jonathan M. Bloom

two. The rural architecture of Egypt is remarkable for the continuity that it shows with Pharaonic examples, although, unlike the workers' quarters discussed above, the modern examples invariably include space for animals—donkey, cow, water buffalo or chickens. The similarities are hardly surprising since the needs and materials of the poorest segments of society have not changed radically in millennia. Mud-brick is still the most common building material, although those that can afford baked brick will use it to effect an upper story and, in the Delta, provide better protection from humidity. Two factors can be observed that differentiate rural architecture in Upper and Lower Egypt. The use of courtyards varies according to different climates; in Lower Egypt many houses do not have them, and in towns further south they tend to be larger. Vaulting is more common in the extreme south, in Nubia and in scattered settlements as far north as Esna. Except for a very few Nubian domed examples, vaulting was confined to barrel vaults over rectangular spaces. Although the inhabitants lose the advantages to be had from access to a flat roof, the scarcity of wood and the greater ventilation obtained in the hotter southern regions were undoubtedly the reasons for its popularity. It provided the inspiration for the school of modern Egyptian architects that included Ramses Wissa Wassef (1911–74) and HASSAN FATHY. The latter also designed houses and village communities but, perhaps because of the aversion of the rural population to living under domes, his houses have been celebrated chiefly by the urban élite.

M. Jomard: "Description de la ville et de la citadelle du Kaire…," *Description de l'Egypte, état moderne*, 2/ii (Paris, 1822), pp. 662, 696

E. W. Lane: *An Account of the Manners and Customs of the Modern Egyptians* (London, 1836/*R* 1978), pp. 15–31

V. M. Mosséri and C. Audebeau Bey: *Les Constructions rurales en Egypte* (Cairo, 1921)

J. Lozach and G. Hug: *L'Habitat rural en Egypte* (Cairo, 1930)

A. Badawy: "La Maison mitoyenne de plan uniforme dans l'Egypte pharaonique," *Bull. Fac. A., Fouad I U.*, xvii (1953), pp. 1–58

M. Nowicka: *La Maison privée dans l'Egypte ptolémaïque*, Academia Scientarium Polona, Bibliotheca Antiqua, ix (Wroclaw, Warsaw and Kraków, 1969)

A. Lézine and A.-R. Abdul Tawab: "Introduction à l'étude des maisons anciennes de Rosette," *An. Islam.*, x (1972), pp. 149–205

H. Jaritz: "Notes on Nubian Architecture," *Nubians in Egypt*, ed. R. A. Fernea (Austin and London, 1973), pp. 49–60

J. Revault and B. Maury: *Palais et maisons du Caire du XIVe au XVIIIe siècle*, 3 vols. (Cairo, 1975–9)

A. A. Ostrasz: "The Archaeological Material for the Study of the Domestic Architecture at Fustat," *Afr. Bull.*, xxvi (1977), pp. 57–86

L. ʿAli Ibrahim: "Middle-class Living Units in Mamluk Cairo," *A. & Archaeol. Res. Pap.*, xiv (1978), pp. 24–30

D. Behrens-Abouseif: "Quelques traits de l'habitation traditionnelle dans la ville du Caire," *Actes du 2ème colloque de l'A.T.P. La Ville arabe dans l'Islam: Histoire et mutations: Carthage-Amilcar*, 1979, pp. 447–59

A. Raymond: "The *Rabʿ*: A Type of Collective Housing in Cairo during the Ottoman Period," *Proceedings of Seminar Four in the Series Architectural Transformations in the Islamic*

World, The Aga Khan Award for Architecture: Architecture as Symbol and Self-identity: Fez, 1979, pp. 55–61

J.-C. Garcin and others: *Palais et maisons du Caire*, 2 vols. (Paris, 1982–3)

S. D. Goitein: *Daily Life* (1983), iv of *A Mediterranean Society* (Berkeley, Los Angeles and London, 1967–88), pp. 150–200

M. Zakariya: *Deux palais du Caire médiévale: Waqfs et architecture* (Paris, 1983)

B. Kemp: *Ancient Egypt: Anatomy of a Civilization* (London and New York, 1989)

N. Hanna: *Habiter au Caire: La maison moyenne et ses habitants aux XVIIe et XVIIIe siècles* (Cairo, 1991)

O. M. el-Hakim: *Nubian Architecture: The Egyptian Vernacular Experience* (Cairo, 1993)

A. Raymond and M. Roche: *Le Caire: Esthétique et tradition* (Paris and Arles, 1997)

D. J. Antoniou: *Historic Cairo: A Walk through the Islamic City* (Cairo, 1998)

N. S. Tamraz: *Nineteenth-century Cairene Houses and Palaces* (Cairo, 1998)

E. A. Farah: *House Form and Social Norms: Spatial Analysis of Domestic Architecture in Wab-Nubbawi, Sudan* (Gothenburg, 2000)

B. Maury: "Conserving and Restoring the Harawi and al-Sinnari Houses in Cairo," *Mus. Int.*, liii/2 (2001), pp. 22–35

A. Hassaballah: "A House Reconstructed: The Purchase Contract of the House of Mustafa Ja'far," *An. Islam.*, xxxv (2001), pp. 163–79

J. Dobrowolski: *The Living Stones of Cairo* (Cairo, 2001)

N. El Kholy: "A House, a Museum, and a Legend: Bait al-Kretliya (the Gayer-Anderson Museum)," *Egypt through the Eyes of Travelers*, ed. P. Starkey and N. El Kholy (Durham, 2002), pp. 57–93

S. D. Goitein: "A Mansion in Fusṭāṭ: A Twelfth-century Description of a Domestic Compound in the Ancient Capital of Egypt," *Patterns of Everyday Life*, ed. D. Waines, The Formation of the Classical Islamic World, 10 (Aldershot, 2002), pp. 19–34

A. Lézine and G. Goldbloom: "Pre-Islamic Traditions of Domestic Architecture in Islamic Egypt," *Patterns of Everyday Life*, ed. D. Waines, The Formation of the Classical Islamic World, 10 (Aldershot, 2002), pp. 1–19

S. Longeaud: "La mise en scène de l'espace architectural mamelouk: La mandara du palais al-Razzāz au Caire," *An. Islam.*, xxxvi (2002), pp. 139–75

C. Williams: "Transforming the Old: Cairo's New Medieval City," *Mid.E. J.*, lvi/3 (2002), pp. 457–75

A. M. Soliman: "Typology of Informal Housing in Egyptian Cities: Taking Account of Diversity," *Int. Dev. Planning Rev.*, xxiv/2 (2002), pp. 177–201

S. Bianca: *Cairo, Revitalising a Historic Metropolis*, ed. S. Bianca and P. Jodidio (Turin, 2004)

A. Dobrowolska: *Building Crafts of Cairo* (Cairo, 2005)

A. Abdel-Gawad: *Enter in Peace: The Doorways of Cairo Homes, 1872–1950* (Cairo, 2007)

P. I. Pyla: "Hassan Fathy Revisited: Postwar Discourses on Science, Development, and Vernacular Architecture," *J. Archit. Educ.*, lx/3 (2007), pp. 28–39

IV. Sub-Saharan Africa. Most African buildings are domestic. A "hut," which is typically single-celled and conceived as one unit of space, can be distinguished from a "house," which has not been divided but rather conceived and built as a number of separate units or to accommodate a variety of discrete functions. The most widely dispersed type is the cylindrical hut, occurring in southern and East Africa and through the savannah belts of West Africa. Vernacular buildings of the same form may vary considerably in construction: a cylindrical hut may be built wholly of mud; constructed of poles driven into the soil, bound with creepers or bark, mud daubed and mud plastered over; or built of sun-dried blocks or bricks, which, when plastered, display similar formal characteristics. Rectangular-plan buildings, though constructed by different techniques, may also be rendered, thus obscuring the structural differences between the building systems employed.

The simplest form is the dome, an undifferentiated structure with no separation of roof from walls. Structural members are inserted in the ground and bent over to join at the apex to form a peaked, ribbed dome, held in tension. Frequently the domes are thatched in layers of bundled grass. Structurally more complex, the cylindrical hut with a differentiated, conical roof has a number of advantages, allowing not only additional headroom but also space for smoke from internal fires. In addition, the eaves can protect the exterior from both sun and rain. A low verandah with an outer ring of poles may take some of the roof's weight. Traditionally such houses were rarely subdivided, as the introduction of ceilings or walls reduces air circulation. In areas of West Africa with relatively low rainfall, cylindrical huts may have crossbeams supporting a flat roof and layers of brush and earth as well as, perhaps, a low parapet. Roofs of this type are used to dry and store grains and fruits and as outdoor sleeping areas that catch any available breeze. Flat-roofed cylindrical huts are not found in East Africa.

Houses with a square or rectangular plan occur most frequently in forested regions, where the availability of timber and bamboo permits a frame construction. Regular-square plans are comparatively rare: most buildings with right-angled corners are rectangular, with the entrance often on one of the shorter sides. As the ridge is usually supported by poles rather than a roof truss, and the roofs take a burden of thatch, pitches of *c.* 45° are common. Thatched, hipped roofs are found in some rain forest regions. Extended eaves may permit a covered verandah, and thatched porches are occasionally added. Wall openings other than doorways are rare, enhancing security but reducing light and cross-ventilation. Interiors can be subdivided relatively easily with a rectangular plan, and the simplest form of this—the erection of a cross-wall to create two rooms—is most common.

After the advent of Islam south of the Sahara, indigenous circular forms were replaced by houses of earth construction and rectangular plan, although both types existed in such areas as the northern Nigerian Hausa emirates. Flat roofs also superseded conical

roofs, although the Hausa and Fulani used arches and domes to span larger spaces.

The architecture of chiefs' compounds is closely based on that of ordinary dwellings, but many African rulers expressed their power and influence architecturally by using the finest craftsmen and developing spatially elaborate complexes to accommodate not only themselves, their kinsmen, wives and children but also other retainers, courtiers, visitors and supplicants. At the time of early European contact, West African domestic architecture was in many ways comparable with that of Europe, with wattle-and-daub and timber-framed houses with thatched roofs. As a result, early Western observers were impressed not so much by essentially similar African building types and techniques as by the formal sophistication and decorative embellishment of the "palaces." The Moroccan traveler Ibn Battuta described the lavish palace of the Shaykh of Mogadishu as early as 1332, and other east coast shaykhdoms may have had similar palaces.

The grain stores of the West African savannah generally take the form of large clay pots resting on short piers of rock or timber. Those of East and Southern Africa, in contrast, generally take the form of large baskets raised off the ground on stilts. Some attain great size; those of the Songhai of Mali, for example, being 3 or 4 m high. Among savannah peoples, however, granaries are built inside an ordinary hut. Within, the grain stores may be built to roof-height and shaped like immense pottery vessels with internal subdivisions. Access to granaries is usually through the top of the container, which may have a removable lid or thatch roof. When the level of the grain is low, a door in the side may be used. Such doors are hung on hinges, or on projections that turn in recesses, and have wooden locks. Other kinds of storage baskets and jars, often freestanding, at times rivaling in size associated sleeping huts, are found throughout Africa. They need to be constructed well to resist the thrusts of their loads and will often last without maintenance for long periods.

In sub-Saharan Africa the buildings of Islamicized societies are generally lower than those in the north, although two-story houses are not uncommon and some defensive towers are higher. A variety of factors may account for this prevalence of single-story, low-profile buildings. Space was plentiful, such buildings were considered relatively inconspicuous, and their low level was also seen as a defensive measure. Height is often associated with prestige, however, and many peoples, while still building single-story dwellings, construct accentuated, high roofs.

African building is spatially most varied in the disposition of structures and their lateral arrangement. Quadrangular-plan houses are often grouped around a courtyard. Low dwellings arranged in lines facing each other or around a courtyard may be extended by adding further courts, some of which may function as impluvia, collecting rain-water from the roofs in large pottery vessels or a central circular tank.

The greatest variety of settlement types occurs in the savannah regions of West Africa, in an arc from Sudan to Senegal. The customary settlement among those peoples who use circular dwelling units is the compound. Although individual circular-plan huts are not easily extensible, the compound settlement form is extremely adaptable, and many examples of great beauty and complexity have been recorded in Burkina Faso, Togo, Mali, Guinea and elsewhere. Although such compounds are generally limited to the dwellings of extended families, each under a household head who may have more than one wife, in some areas several compounds may be grouped together to form a village.

Throughout the Sahel, compounds have been adapted to meet cultural requirements for domestic privacy and the seclusion of women. In rural areas the curvilinear plans of traditional West African compounds persisted into the late 20th century, with the dwelling-units usually circular with conical or flat roofs and linked by encircling and dividing walls. Many compounds have internal walls to distinguish the domain of the male household head from those of the women and children. Among the Hausa an entrance room (*zaure*) opens on to the head's area, which may include a stable and bachelor hut. The female section is situated beyond the vestibule (*sigife*). While seldom strict in their geometry, such compound plans are found in peri-urban areas of Mali, Burkina Faso and northern Côte d'Ivoire, but they are most characteristic of the towns. Even in the Hausa emirates of the western Sudan, rural settlements may consist largely of circular-plan huts or a mixture of these with rectilinear forms; in the cities, however, round huts have become increasingly rare from the 20th century.

Much of the appeal of African architecture lies in its sculptural quality, and the use of earths in pottery-related techniques has resulted in forms of great aesthetic beauty. Moreover, the use of curvilinear walls and details, door openings and moldings in shell-like structures of considerable resilience gives a feeling of movement to the constructions. Painted decoration is frequently executed by women. Traditionally, such earth colors as white, red and black were used, often with no fixing medium. Certain colors often have specific connotations: white is frequently linked with purity, power and health, red with blood and power and black with disease and death. (The traditional range of colors was extended in the second half of the 20th century with the adoption of washing "blue" and commercial paints.) It should not be concluded, however, that the use of a color always carried such connotations. Nor do all motifs convey meaning: the extensive use of triangles and simple geometric shapes may be purely decorative.

Some West African peoples also use a combination of paint and high relief modeling to decorate their dwellings. Perhaps the most structurally daring are the arcades of the earth houses of the Fouta Djallon, Senegal, where abacus-like columns support massive loads and openings are pierced in a variety of audacious shapes, symmetrically disposed. Other

types of sculpted relief include carved doors, an important feature of many palace buildings, shrines and houses of important people.

H. Labouret: "Afrique occidentale et équatoriale," *L'Habitation indigène dans les possessions françaises*, ed. A. Bernard and others (Paris, 1931)

C. Monteil: *Une Cité soudanaise: Djenné—métropole du delta central du Niger* (Paris, 1932)

J. Poujade: *Les Cases décorées d'un chef du Fouta-Djallon* (Paris, 1948)

J. F. Glück: "Afrikanische Architektur," *Tribus*, n. s., vi (1956), pp. 65–82; Eng. trans. in *The Many Faces of Primitive Art: A Critical Anthology*, ed. D. Fraser (Englewood Cliffs, 1966), pp. 224–43

P. Oliver, ed.: *Shelter in Africa* (London, 1971)

M. Wenzel: *House Decoration in Nubia*, A. & Soc. Ser. (London, 1972)

P. Oliver, ed.: *Shelter, Sign and Symbol* (London, 1975)

R. W. Hill: *African Cities and Towns before the European Conquest* (New York, 1976)

S. Denyer: *African Traditional Architecture: An Historical and Geographical Perspective* (London, 1978)

F. Ago: *Moschee in adobe: Storia e tipologia nell'Africa occidentale* (Rome, 1982)

F. W. Schwerdtfeger: *Traditional Housing in African Cities: A Comparative Study of Houses in Zaria, Ibadan, and Marrakesh* (Chichester, 1982)

"Building toward Community: ADUA's Work in West Africa," *Mimar*, vii (1983), pp. 35–51

J.-L. Bourgeois and C. Pelos: *Spectacular Vernacular: A New Appreciation of Traditional Desert Architecture* (Salt Lake City, 1983)

S. P. Blier: *The Anatomy of Architecture: Ontology and Metaphor in Batammaliba Architectural Expression* (Cambridge, 1987/R Chicago, 1994)

J. C. Moughtin: *Hausa Architecture* (London, 1985)

L. Prussin: *Hatumere: Islamic Design in West Africa* (Berkeley, 1986)

J.-L. Bourgeois and B. Davidson: *Spectacular Vernacular: The Adobe Tradition* (New York, 1989)

S. Domian: *Architecture soudanaise: Vitalité d'une tradition urbaine et monumental* (Paris, 1989)

D. Gruner: *Die Lehm-Moschee am Niger: Dokumentation eines traditionellen Bautyps*, Studien zur Kulturkunde, 95 (Stuttgart, 1990)

P. Maas, G. Mommersteeg and W. Schijns: *Djenné: Chef-d'oeuvre architectural* (Amsterdam and Paris, 1992)

J.-P. Bourdier: "Triangles of Light: Tokolor Dwellings," *Mimar*, xliii (1992), pp. 68–76

J.-J. Bourdier: "The Rural Mosque of Tua Toro," *Afr. A.*, xxvi/3 (1993), pp. 32–45

J.-C. Huet: *Villages Perchés es Dogon du Mali: Habit, espace et societé* (Paris, 1994)

K. Ådahl and B. Sahlström: *Islamic Art and Culture in Sub-Saharan Africa*, Acta Universitatis Upsaliensis, 27 (Uppsala, 1995)

L. Prussin: *African Nomadic Architecture: Space, Place, and Gender* (Washington, DC, 1995)

M. Elleh: *African Architecture: Evolution and Transformation* (New York, 1997)

L. Prussin: "Non-Western Sacred Sites: African Models," *J. Soc. Archit. Hist.*, lviii/3 (1999), pp. 424–33

A. Sheriff: "The Spatial Dichotomy of Swahili Towns: The Case of Zanzibar in the Nineteenth Century," *The Urban Experience in Eastern Africa, c. 1750–2000*, ed. A. Burton (Nairobi, 2002), pp. 63–81

J. Morris and S. P. Blier: *Butabu: Adobe Architecture of West Africa* (Princeton, 2004)

V. Syria and Iraq. Many of the settlements and building types found in the region have changed little over the millennia, and great citadels such as Irbil in Iraq have been continuously inhabited for at least 10,000 years. Patterns of settlement vary enormously with the local terrain and range from the widely scattered tents and camps of the Bedouin to the denser settlements of the coastal region in the west and the irrigated lands of southern Iraq, and the compact settlements of the interior plain, the deserts and the mountain villages. Local construction techniques depend on the availability of materials, the most widely used being stone and mud-brick. Sandstone, limestone and various marbles are quarried in the upland regions, and buildings in such cities as ALEPPO, DAMASCUS and MOSUL are built of finely cut stone with rich architectural decoration. In villages, buildings are also constructed of stone, usually in rubble construction with cement or mud mortar. The use of baked brick is most often associated with urban construction. Mud-brick, which is cheap and has excellent thermal properties, is widely used in Iraq. Walls are often constructed with rubble stone facings up to a meter high, and wide eaves are built to protect the exposed façades of the buildings. Pisé or rammed earth is commonly used for compound and garden walls. Roofs are generally flat, constructed with poplar, date palm, mulberry and orchard timbers and surfaced with a rolled mud finish. Brick and stone domes and vaults are built in areas with little or no timber (see fig. 4; for further illustration *see* SYRIA). Two very distinctive construction techniques are also found: in northern Syria villages are roofed with stone domes in the shape of beehives, and in southern Iraq the marsh Arabs live in structures made entirely of reeds.

Traditional settlements in the region are clusters of living cells woven together with a maze of winding alleys and roads, often following the lines of former garden walls. Each cell is composed of a house and yard enclosed by a wall. Enclosure is necessary for privacy, giving women their requisite inviolable domain; for security, particularly for animals, which are kept within the walls at night; and for climatic protection from sun, wind and dust. Enclosure walls are absent only in encampments of Bedouin tents, around the houses of the very poor or in new construction. Houses are usually built against compound walls, generally with a southern aspect, although some houses in the extreme north of the area, as in Anatolia, are surrounded by open space within the compound walls. In mountain areas where plots are sloping, houses are built on the uphill side of the terraced compound.

Three main types of house have been used in the region since antiquity. The compact house is a rectangular building set within and usually against the

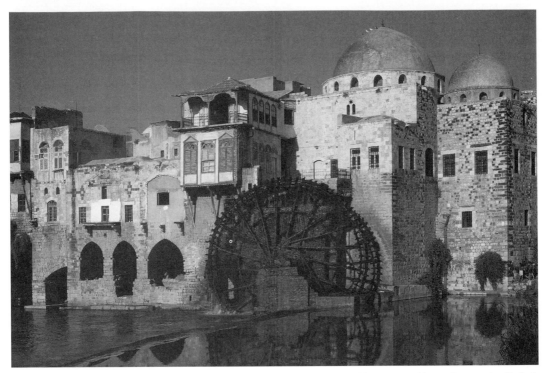

4. Waterwheel and dwellings behind Abdul Qadar Kaylani Mosque, Hama, Syria, 14th century and later; photo credit: Sheila S. Blair and Jonathan M. Bloom

wall of the yard, with typically two to nine rooms. The kitchen, latrine, bathroom, storerooms and stables may be built as individual units around the yard wall. The compound house began as a walled enclosure in which living and utility rooms are built, as required, against the walls, creating a string of rooms around a central yard or compound. Compact and compound houses are typical village forms, and when such houses are built with two stories, the ground floor is often used for stables and storerooms. Courtyard houses have a central square or rectangular open space that acts as an outside living area (*see* HOUSING, figs. 1 and 2). The courtyard is a designed feature with the four attendant elevations being carefully contrived and often symmetrical, with the main winter living rooms on the north wall and the summer living rooms on the south. The courtyard—an integral open-air living-room within the house—is distinguished from the yard in a compound house, which is generally irregularly shaped, randomly determined and used for agricultural as well as domestic purposes. Courtyard houses are a typical urban form and were also built by wealthier villagers and absentee landlords. Larger town houses have several courtyards, including a family courtyard, a courtyard for male guests, courtyards for different sections of the family, a brother's or son's household, as well as stable and kitchen yards.

Rooms are generally rectangular and plastered inside with mud in the villages or with lime in towns, a more expensive and fashionable material. Houses include a number of distinctive elements that might be considered typical of the domestic architecture of various areas of the Near East. These include the IWAN, a roofed space enclosed on three sides and completely open on the fourth, which faces on to a courtyard or compound. Iwans are common in the buildings of the north, where they are often built in pairs opposite each other on the north and south sides of a courtyard and covered by a brick or stone vault. In Baghdad and southern Iraq a similar type of three-walled space is known as a *tālār*, usually built with mud and timber flat roofs, often with a colonnade or pair of columns on the open side. A *riwāq* is a colonnaded space built as a gallery, verandah or loggia. In its simplest form it may support the verandah of a village house; in its more elaborate variants it may form a decorative element in the ornate façade of a palace. In Baghdad the term *tarma* is used for a colonnaded upper story of a house, which may be built in front of an *ursi*, a room so called because of its distinctive sash window facing on to the court, made of elaborate timber lattices and often with colored glazing. Typical of the Arab quarters in the south of the region are the rooms on the upper story with an oriel (*shanashil*) window projecting over a street or alley. These windows are built of timber latticework shutters, metal grilles and plain and colored glass. Often ornately decorated, they allow discreet vision out and trap cool breezes. Many houses have *sirdābs*, basements 4–5 m deep used as summer living rooms, stables and storerooms. They are ventilated

by small high windows, with metal grilles connecting them to the courtyard and also in central and southern Iraq with wind catchers (*see* WIND CATCHER and HOUSING, fig. 3). Half basements called *nīm*s in northern Iraq are 1.5–3 m below court level and look out on to the court through large windows or colonnades. The ceilings of basements are often constructed with decorative brick patterns.

F. Langenegger: *Die Baukunst des Iraq* (Dresden, 1911)

M. Muslimani: *Al-Buyut al-Dimashqiyah: al-qarn 18–19 M* [Damascene houses: 18th and 19th century] (Damascus, 1980–89)

J. Warren and I. Fethi: *Traditional Houses in Baghdad* (Horsham, 1982)

B. Hakim: *Arabic-Islamic Cities: Building and Planning Principles* (London and New York, 1986)

H. Crawford and T. Rickards: "Rural Housing in Mesopotamia: Lesseons from the Past," *Mimar*, xxx (1988), pp. 52–5

F. Aalund: *Vernacular Tradition and the Islamic Architecture of Bosra* (Copenhagen, 1992)

M. B. Behch: *Towards Housing in Harmony with Place: Constancy and Change in the Traditional Syrian House from the Standpoint of Environmental Adaptation* (Lund, 1993)

R. Kanaʾan and A. McQuitty: "The Architecture of al-Qasr on the Kerak Plateau: An Essay in the Chronology of Vernacular Architecture," *Palestine Explor. Q.*, cxxvi/2 (1994), pp. 127–53

B. Lyons and M. Al-Asad: *Old Houses of Jordan: Amman, 1920–1950* (Amman, 1997)

D. Genequand: "From 'Desert Castle' to Medieval Town: Qasr al-Hayr al-Sharqi," *Antiquity*, lxxix/304 (2005), pp. 350–62

A. McQuitty: "The Rural Landscape of Jordan in the Seventh–Nineteenth Centuries AD: The Kerak Plateau," *Antiquity*, lxxix/304 (2005), pp. 327–38

A. al-Haidary: *Das Hofhaus in Bagdad: Prototyp einerviertausendjährigen Wohnform* (Frankfurt am Main, 2006)

VI. Arabia. The vernacular architecture of Arabia varies with region, climate and local tradition, and there are considerable differences in building styles, construction techniques and decorative techniques over this diverse region, particularly in the Yemen to the south (*see* §VII below). The oldest buildings seem to be no more than three or four centuries old, but archaeological and epigraphic evidence suggests that the tower houses of western Arabia and the widespread type of the courtyard house go back to very early times. Along the Tihama coast of western Arabia the main building material is coral, carved in blocks and reinforced with wooden beams laid horizontally and plastered to prevent deterioration. The same style was repeated in stone at Mecca, Taʾif and Medina in the Hijaz highlands. The best-known examples are the tall houses of Jiddah and more modest versions are found at Wajh and Qunfidhah on the coast, as well as at Hubaydah in the Yemen and SUAKIN in the Sudan, where much of the architecture was built by Hijazis. The surviving houses of Jiddah

range from the impressive houses of the mercantile Nasir and Jawkhdar families (see fig. 5) to more quotidian types. Houses rise three, four and even five stories with a single staircase shaft. Although there is no courtyard, a central shaft ventilates the interior, and numerous windows on the outer walls encourage the circulation of air in the humid and hot climate along the Red Sea. The windows are screened by carved wooden balconies or casements (*rawāshin*, much like the *mashrabiyya* of Cairo). The internal division, as in the Yemen, has lower floors for servants and women and the principal reception room on the upper floor; the enclosed staircase allows visitors to reach the upper floor without disturbing women on the intermediate floors.

Straw huts (*ʿushʿāsh*), particularly conical ones, are also common on the Tihamat coast. Women paint the plastered interior with colored geometric decoration. Another type of residence is a single-story pavilion-like structure with a flat roof, usually set within a courtyard and often freestanding. The *murabbaʿ* type found at Qunfidhah has bay windows with fine woodwork and casements of the type found at Jiddah and in the Hijaz. Another type of pavilion house found at Sabya and Farasan has fine plaster carving on interiors and exteriors and carved wood. Some of the best woodwork on Farasan is said to have been imported from India. In the highlands of the Tihamat and in the ʿAsir, the houses are fortified and often built of stone, although mud courses are found in the neighborhood of Abha and further east, towards Najran and Bishah. The stone tower houses of the southwest mountains have more in common with the highland architecture of the Yemen than with the tall houses of Jiddah and the Hijaz, although they may all derive from common antecedents. In the settlements of Jabal Fayfaʾ and Jabal Bani Malik, these stone houses are provided with strong circular towers and are set on rocky promontories. Ground-floor rooms are used for storage, upper rooms for social and family life. Decoration is restricted to designs in white quartz, which contrasts

5. Merchant's house, Jiddah Old Town Conservation, Jiddah, Saudi Arabia; photo © Pascal Marechaux/Aga Khan Trust for Culture

with the dark masonry. The tall buildings in the 'Asir have banked walls with stone slates set horizontally between the mud courses to break the erosive fall of rainwater. Interior decoration is confined to carved wooden columns and enameled utensils in bright colors placed around the walls. Further east, the tower houses of Najran are even taller, with mud courses that curve upwards at the corners to increase stability and colored glass windows in the finest examples. Rather different houses are built by the same method at Bishah on the western edge of Najd.

In the great central plain of Najd, where the climate is hot and dry with heavy rains in winter and spring, the principal building material is mud-brick, and the main type of town house, well represented by buildings in Riyadh, Dir'iyah and Buraydah, consists of a two-story structure built around a central courtyard. There are few exterior windows, and the main source of light is through the doorways facing the courtyard on the lower and upper stories. The balcony that connects upper floor rooms is concealed by a balustrade and shades the rooms below. More modest buildings have a walled courtyard adjacent to a one- or two-story residence, and some residential buildings are single-story chambers built around an open courtyard and set within an enclosure wall. Exterior decoration is restrained: string courses of triangular motifs in relief break the flow of rainwater over the mud surface, and crenellations coated with hard plaster protect the summits of walls. Unlike the deeply carved doors of western and eastern Arabia, doors are lightly incised with patterns picked out in colors and burnt into the wood. The principal decoration is concentrated in the reception rooms, many of which have finely painted doors and plaster walls carved with geometric and floral motifs. In the finest examples the plaster decoration extends the full height of the wall. One of the main centers of this craft is Qaşim, but fine examples are also found at Shaqra, Sadus and Riyadh.

The traditional houses of al-Hufuf in the Ahsa' oasis of eastern Arabia depend on building traditions along the Gulf and are similar to the fine houses of Muscat and Oman. The finest houses in al-Hufuf, like those built of coral at al-Qatif on the coast, are tall structures in two or even three stories built around a central courtyard. The building technique is especially fine: rough stone embedded in mortar and walls finished in plaster. Interior walls are elegantly coated with a hard white plaster. Door and window arches tend to be pointed, with the long sides formed by palm trunks. Entrances are distinguished by exuberant arches with lobes and ogees in carved plaster. Elegant crenellations in plaster complete the finest buildings, and carved decoration is found on interiors, but the most common feature is deeply recessed shelving, found for example at Bahrain, Dubai and in other Gulf regions. Another type of house in eastern Arabia has one or two walled stories in a walled courtyard. Modest versions are found at al-Qatif and formerly at al-Jubayl, where each walled garden had a pavilion-like single-story

reception room. A more complex accumulation of such structures is represented by the Bayt 'Abd al-Wahhab (19th century) in Darin on Tarut Island, opposite al-Qatif, where one- or two-story pavilions are scattered around a central courtyard. The reception rooms have open sides to take advantage of the breeze, but other rooms are enclosed for privacy. Interiors are decorated with plaster carved with lobes and ogees in the style found throughout eastern Arabia and the Gulf, and the fine wooden doors have heavily carved central panels.

See also SAUDI ARABIA.

F. S. Vidal: *The Oasis of al-Hasa* (Dhahran, 1955)

G. R. D. King: "Some Observations on the Architecture of South-west Saudi Arabia," *Archit. Assoc. Q.*, viii (1976), pp. 20–29

A. Pesce: *Jiddah: Portrait of an Arabian City* (London, 1976)

G. R. D. King: "Traditional Architecture in Najd, Saudi Arabia," *Proc. Semin. Arab. Stud.*, vii (1977), pp. 90–100

T. Prochazka jr: "The Architecture of the Saudi Arabian Southwest," *Proc. Semin. Arab. Stud.*, vii (1977), pp. 120–33

Jedda Old and New (London, 1980)

S. Kay: "Indigenous Building Styles of Saudi Arabia," *A. & Islam. World*, ii/3 (1984), pp. 38–43

G. R. D. King: "Some Examples of the Secular Architecture of Najd," *Arab. Stud.*, vi (1982), pp. 113–42

T. Prochazka jr: "Observations on the Architectural Terminology of the South-west of the Arabian Peninsula," *Arab. Stud.*, vi (1982), pp. 97–109

W. Dostal: *Ethnographic Atlas of 'Asīr* (Vienna, 1983)

S. Kay: "Indigenous Building Styles of Saudi Arabia," *A. & Islam. World*, ii/3 (1984), pp. 38–43

O. Salazar: "Riyadh: Yesterday and Today: Experiencing the Art of Saudi Arabia," *A. & Islam. World*, iv/1 (1986), pp. 17–27

H. Gaube; M. Scharabi and G. Schweizer: *Taif: Entwicklung, Struktur und traditionelle Architektur einer arabischen Stadt im Umbruch* (Wiesbaden, 1993)

A. al-Hammad and S. Asaf: "The Use of Indigenous Stone as a Building Material in the Southern Province of Saudi Arabia," *Int. J. Housing Sci. & Applic.*, xviii/3 (1994), pp. 153–66

T. M. Abu-Ghazzeh: "Domestic Buildings and the Use of Space: Al-Alkhalaf Fortified Houses: Saudi Arabia," *Vern. Archit.*, xxvi (1995), pp. 1–17

W. Facey: *Back to Earth: Adobe Buildings in Saudi Arabia* (Riyadh and London, 1997)

G. R. D. King: *The Traditional Architecture of Saudi Arabia* (London, 1997)

G. R. D. King: "Islamic Architectural Traditions of Arabia and the Gulf," *U. Lect. Islam. Stud.*, i (1997), pp. 85–107

W. Koenigs: "Arabia felix: Bavaria," *Monumental: Festschrift für Michael Petzet zum 65. Geburtstag am 12. April 1998*, ed. S. Boning-Weis, K. Hemmeter and Y. Langenstein, pp. 290–99

S. S. Damluji: "The Vernacular Architecture in the Cities of Oman and the United Arab Emirates," *Aram Periodical/ Majallat Ārām*, xi–xii (1999), pp. 189–96

H. Gouverneur: *Doors of the Kingdom* (New York and Riyadh, 1998)

The Legacy of Old Jeddah: Past and Present (Jeddah, 1999)

G. R. D. King: "The Tower-house in Saudi Arabia and its Pre-Islamic Antecedents," *Bamberger Symposium: Rezeption in der islamischen Kunst*, ed. B. Finster, C. Fragner and H. Hafenrichter, Beirute Texte under Studien, 61 (Beirut, 1999), pp. 175–81

Y. F. Kozhin: "Traditional Architecture of Hadramawt," *Cultural Anthropology of Southern Arabia: Hadramawt Revisited*, ed. M. M. Souvorov and M. A. Rodionov (St. Petersburg, 1999), pp. 77–89, 149–73

S. S. Damluji: "Building Design in Wādī Ḥajr, Ḥadramawt," *Studies on Arabia in Honour of Professor G. Rex Smith*, ed. J. F. Healey and V. Porter, *J. Semitic Stud.*, suppl. xiv (Oxford, 2002), pp. 29–45

P. S. Jerome: "Castles in the Sand: The Mudbrick Marvels of Wadi Hadhramaut," *World Monuments Icon* (2002), pp. 19–24

F. Ragette: *Traditional Domestic Architecture of the Arab Region* (Stuttgart, 2003)

M. A. al-Naim: "The Dynamics of a Traditional Arab Town: The Case of Hofūf, Saudi Arabia," *Proc. Semin. Arab. Stud.*, xxxiv (2004), pp. 193–207

VII. Yemen. The environmental and social diversity of the YEMEN is reflected in the variety of forms and materials used for housing in the torrid coastal plain and temperate highlands. Villages in the highlands generally have a defensive nature. Some towns, such as Radaʿ, are built around a fortified citadel, while other villages, such as Khawlan, exploit the natural terrain, with houses forming a defensive wall on a rocky outcrop. Towns on more vulnerable sites, such as Thula, have encircling walls of mud or stone, while in the Tihamat plain rubble walls are faced with brick. The most common building materials are stone, mud and timber. Stone, either with a dressed face (*waqīs*) or the form of rubble (*shalf*), is widespread in the midlands and highlands, while mud, in the form of rammed earth (*zabūr*) or sun-dried bricks (*libn*), is common in the alluvial wadis of the eastern highlands. Timber is used throughout as a structural element for floors and roofs, but only in the Tihamat plain are entire buildings constructed of wood, combined with grass thatch. In the highlands a skilled craftsman is required for work with dressed stone, while specialist knowledge is also essential for building in mud. On the coastal plain women are responsible for decorating the interiors of thatched grass houses. In the lowlands most activities take place outdoors, and houses in the Tihamat often have fenced compounds, which enclose animal stalls, crop stores and an outdoor cooking area. In the highlands most activity is confined within the house, with stables and storage occupying the lower floors, and the seclusion of women is an important organizational consideration, particularly in urban areas.

On the coastal plain, circular or rectangular houses and other structures are formed of palm trunk frames roofed with palm thatch (*tāfi*). Further inland, circular huts are constructed of bundles of thatch (*thumām*) bound together to form walls and bent over to form a conical roof, which is then thatched. A similar technique is used in the southern Tihamat to build rectangular homes, with vertical timbers supporting the roof. Interiors of lowland houses are often smothered with mud and elaborately painted with concentric patterns, below which are hung plates, trays and baskets. The urban homes of the Tihamat also provide for outdoor living in the tropical climate. A common type has single-story rooms with high ceilings grouped around a walled court. The modest rooms are built of lava, coral or fired brick (*yājur*), with flat roofs topped with mud. Geometric patterns are built up in brick and plaster on the interior and exterior walls. Carved hardwood doors, window screens and rafters are common and are also found in the large merchant houses of the old port of al Hudaydah. As in other areas along the Red Sea, houses have elaborately screened openings to provide both ventilation and privacy. Several floors of high-ceilinged rooms are crowned by a walled roof terrace (*kharja*), which performs the same function as the courtyard in houses in Zabid. In the foothills adjacent to the Tihamat, settlement is limited to small hamlets of low rubble houses built above the seasonal wadis.

In the highlands the typical stone house is built on two or more floors. The ground floor is given over to agricultural use, and a central door also gives access to the house. Stairs lead to the upper floors, which generally have rooms of modest size, owing to the limited spans possible with available timber. Rooms are rarely limited to specific functions, and the same space might be used for eating, sleeping or conducting business. One larger space (*mafraj*), set aside for entertaining or chewing kat (qat), often has the best view. Rooms are furnished with mattresses arranged around the perimeter and cushions against the walls. The roof is the domain of women, and the kitchen is often situated on an upper floor to allow the fumes from the wood-burning stove to escape. The stonework varies in different highland regions: in the mountains of the western escarpment the scattered homesteads are built of quarried stone with a rough-dressed face and have small openings and windows topped with fanlights; on the highland plains there is more use of smooth-dressed stone, sometimes of various types to form patterned façades.

The urban house in the highlands has a ground floor of stone, while the upper stories might be built of brick. In SANʿA baked brick is exploited to make elaborate patterns in relief on the upper floors, and colored glass is used in tall fanlights over the windows (see fig. 6). The main rooms are extensively decorated in carved plaster. In the eastern city of Shibam in the Wadi Hadramawt, multi-story houses are built of mud-brick, plastered and finished with lime. The town is built on a raised mound, which protects it from seasonal flooding, and has defensive walls of mud. Some of the homesteads that dot the nearby wadi have barrel vaults of mud-brick, because timber is so scarce. The austere houses in the Hadramawt have doors and windows elaborately carved in wood. In the wadis of the eastern highlands, rammed earth is common in areas with a plentiful supply of

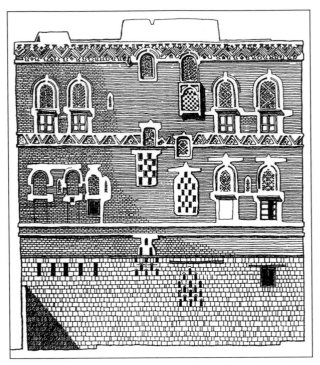

6. Façade of an urban house, San'a, Yemen; photo credit: Mr. Jolyon Leslie

alluvial earth. The mud is sometimes mixed with straw and laid by hand on stone foundations. A rise (*midmak*) some 500 mm high is built up at a time, shaped by hand and left to dry before work begins on the next rise. The corners of the house are built up, while the rises follow an undulating pattern around the house. Ocher and white bands decorate windows and doors, and entrances are often flanked by protruding buttresses for defense. The houses of Jabal Barat, which rise up to five stories, are built with projecting parapets around the roof to protect the mud walls from rain, while wastewater runs in lime-plastered channels on the exterior face of the wall.

H. Steffen, ed.: *Final Report of the Airphoto Interpretation Project of the Swiss Technical Co-operation Service* (Zurich, 1975)

P. Costa and E. Vicario: *Yemen: Paese di costruttori* (Milan, 1977); Eng. trans. as *Arabia Felix: A Land of Builders* (New York, 1977)

F. Veranda: *Art of Building in Yemen* (Cambridge, MA and London, 1982)

R. B. Serjeant and R. Lewcock: *San'a': An Arabian Islamic City* (London, 1983)

L. Golvin, M. Fromont and Markaz al-Dirasat al-Yamaniyah: *Thulā: Architecture et urbanisme d'une cité de haute montagne en République Arabe du Yémen* (Paris, 1984)

L. Golvin: "Contribution à l'étude de l'architecture de montagne en République Arabe du Yémen," *L'Arabie du sud: Histoire et civilisation*, ed. J. Chelhod and others, 3 vols. (Paris, 1985), iii, pp. 303–28

F. Stone, ed.: *Studies on the Tihamah: The Report of the Tihamah Expedition 1982 and Related Papers* (London, 1985)

R. B. Jeffery: *Yemen: A Culture of Builders* (Washington, DC, 1989)

S. S. Damluji: *A Yemen Reality: Architecture Sculptured in Mud and Stone* (Reading, 1991)

S. S. Damluji: *The Valley of Mud-brick Architecture: Shibām, Tarīm & Wādī Hadramūt* (Reading, 1992)

S. al-Radi: "Qudād: The Traditional Yemeni Plaster," *Yemen Update*, xxxiv (1994), pp. 6–13

K. Ådahl: "San'a and the Traditional Architecture of Yemen," *Yemen—Present and Past*, ed. B. Knutsson, V. Mattsson and M. Persson, Lund Middle Eastern and North African Studies, 1 (Lund, 1994), pp. 59–68

P. Bonnenfant: "Unité, Yéménité et modernité dans l'architecture domestique," *Rev. Monde Musul. & Médit.*, lxvii (1993), pp. 141–59

D. Matthews: "Yemen: Climate, Geology, Materials, Habitations: A Commentary on Yemeni Traditional Architecture," *Brit.–Yemen. Soc. J.*, iv (1996), pp. 6–15

J. Bel: *Yémen, l'art des bâtisseurs: Architecture et vie quotidienne* (Brussels, 1997)

G. Vom Bruck: "A House Turned Inside Out: Inhabiting Space in a Yemeni City," *J. Mat. Cult.*, ii/2 (1997), pp. 139–72

R. Hillenbrand: "Vernacular Architecture in Southern Yemen," *Brit. J. Mid. E. Stud.*, xxv/2 (1998), pp. 351–5

"Desert Cities: Ghardaia, a City of Stone...Shibam, a City of Clay," *Islamic Capitals & Cities/Al-'Awāsim wa-'l-Mudun al-Islāmīya*, xxvii–xxviii 1999), pp. 64–71

P. S. Jerome, G. Chiari and C. Borelli: "The Architecture of Mud: Construction and Repair Technology in the Hadhramaut Region of Yemen," *APT Bulletin*, xxx/2–3 (1999), pp. 39–48

N. S. Cañellas, J. A. Serrano and J. Tortella: "Die Windmühle der Salinen von Aden," *Würzburger Geographische Manuskripte*, liv (2001), pp. 211–17

T. H. J. Marchand: *Minaret Building and Apprenticeship in Yemen* (Richmond, 2001)

K. A. Al-Sallal: "The Balanced Synthesis of Form and Space in the Vernacular House of Sana'a: Bioclimatic and Functional Analysis," *Archit. Sci. Rev.*, xliv/4 (2001), pp. 419–28

P. Davey: "The Yemen's Mud Brick Buildings," *Archit. Rev.*, ccxii/1265 (2002), pp. 70–75

T. H. J. Marchand: "Defining 'Tradition' in the Context of Yemen's Building Code," *Al-Masar*, iii/1 (2002), pp. 3–25

M. Lamprakos: "Rethinking Cultural Heritage: Lessons from Sana'a, Yemen," *Trad. Dwell. & Settmts Rev.*, xvi/11 (2005), pp. 17–37

Jemen-Report: Mitteilungen der Deutsch-Jemenitischen Gesellschaft V, xxxvi/2 (2005), pp. 4–13

O. A. al-Kabab: "Architectural Antiquity, Yemen," *Archit. & Des.*, xxiii/7 (2006), pp. 78–82

VIII. Anatolia and the eastern Balkans. The vernacular architecture of Anatolia and the eastern Balkans is characterized by a single house type with common features. The ground-floor is of stone or brick; the upper story has a timber frame with brick or stone infill (Turk. *hımış*). The lightness of the upper story allows for numerous windows and projections. In Istanbul the timber frame is sheathed in wood; elsewhere it is plastered. The type is commonly called the "traditional Ottoman house," for it was centered in Istanbul, the capital of the Ottoman

dynasty (1281–1924) and was diffused throughout the empire, from the Balkans in the west across most of Anatolia in the east. On the hilly and chilly plateau of eastern Anatolia, the climate determined a different house type, sharing much with the type found in the Caucasus since the time of Vitruvius. In southeast Anatolia, which has a hot and arid climate, the typical house is built of fine masonry and has formal similarities to houses of Iran, Iraq and Syria. Nevertheless, even in these fringe areas the traditional Ottoman house has had some impact, and at the borders of the empire, in the Crimea, Baghdad, Yemen and Sudan, local house types known as "Ottoman" exist but are somewhat different. Since this type of construction is subject to fire and decay, examples dating before the 19th century are rare. The origins of this type are a matter of lively speculation, with hypotheses about ethnic and national contributions abounding.

Like other house types in the Islamic lands, the Ottoman house is introverted around a courtyard or inner garden to give privacy to family life. Rarely orthogonal, the ground-floor plan follows the irregular plot. The exterior walls of the ground floor are blind or have only a few openings, of which the most important is the courtyard or garden door, standing like a castle entrance defending the family's private world and connecting it to the street. The courtyard, with a pool, well and abundant greenery and access to storerooms, stables and cellars, is the scene of uninterrupted daily life and women's domestic activities. Wooden stairs lead from the court to the main living spaces on the upper stories, which are often projected over the street to create orthogonal interiors. In contrast to those of the ground floor, the upper rooms have many windows, which add charm to the street fabric. Houses often have two stories and sometimes three (see color pl. 3:XII, fig. 3), although single-story houses are also known, and in many regions a mezzanine, used especially in winter, is encountered.

The most important space of the upper stories is the *sofa* (hall), which covers at least half of the upper story and connects individual rooms. It is used as the center for domestic production and other home activities, including food production for winter, living, eating, recreation and sleeping (in summer). Houses may be categorized according to the location of the *sofa*: houses with an outer *sofa* are more frequent in Anatolia, and it is generally believed they were the point of origin for the evolution of houses with an inner *sofa*, characteristic of urban dwellings. In the first type, the *sofa* is orientated to the courtyard or garden, and the upper stories are open to the exterior to take advantage of the climate. The principal element in the *sofa* is the iwan, a sort of alcove between rooms with three sides closed and one open to the *sofa*. The *köşk* or belvedere is a separate living space projecting over the *sofa* and enlivening the court façade. The *sofa* is flanked by slightly raised living platforms (*tahtseki*, from *taht*, "throne," and *seki*, "platform"). In the second type, more protected from the climate and more secure,

the inner *sofa* is a communal space closed to the exterior and having rooms on at least two sides. From the 19th century the *sofa* became increasingly centralized in Anatolia and the Balkans, following the style of Istanbul. Houses with centralized *sofa*s are found in the magnificent mansions of Istanbul, the waterfront houses on the Bosporus (*yalı*), and the houses of PLOVDIV in the Bulgarian Renaissance style. With the integration of Western lifestyles, blind exterior walls of traditional urban houses were pierced with openings.

The rooms of the upper stories open to the *sofa* but do not interconnect. The reception or main room (*başoda*), often located in the corner with a view over the street, is larger and more elaborately decorated. As there is no functional differentiation between the other rooms, all are similar in size and arrangement, each having a great built-in cupboard (*yüklük*) and small cubicle for ablution (*gusülhane*). Approximately one-third of the room is on the same level as the *sofa*. This space (*sekialtı*) contains the entrance, cupboard and ablution cubicle. The main space (*sekiüstü*), approximately 200–300 mm higher and separated by a balustrade, has a continuous seat (*sedir*), 200–400 mm high by 600 mm wide, along three walls. The floor is covered with a carpet and the seat furnished with cushions and pillows. Open shelves along the walls allow household items to be displayed, and some early houses have windows over these shelves. The decorated wooden ceiling is usually the most magnificent element in the room, complemented by wooden doors over niches and small closets in the main space. Some rooms, particularly the reception room, have a fireplace. In the Balkans, more houses have inner *sofa*s, doors connect the rooms, and the iwan and *köşk* are rare. In some houses in Bulgaria, particularly in Plovdiv, façades are decorated. With the impact of Westernization, a type of town house with Neo-classical elements became more common.

S. H. Eldem: *Türk evi plan tipleri* [Basic plans of the Turkish house] (Istanbul, 1955, 2/1968)

G. Goodwin: "The Ottoman House," *A History of Ottoman Architecture* (London and Baltimore, 1971), pp. 428–49

Ö. Küçükerman: *Turkish House in Search of Spatial Identity* (Istanbul, 1973; 2/1985)

W. J. Eggeling: "Hausformen in Yugoslavisch-Makedonien," *Z. Balkanologie*, (1976), pp. 12–19

E. Riza: "La Typologie de l'habitation urbaine albanaise (XVIIIe siècle-moitié du XIXe)," *Stud. Alb.*, xiv (1977), pp. 109–25

A. Bammer: *Wohnen im Vergänglichen* (Graz, 1982)

D. Kuban: "Turk ev geleneği üzerine gözlemler" [Observations on the traditional Turkish house], *Türk ve İslâm sanatı üzerine denemeler* [Essays on Turkish and Islamic art] (Istanbul, 1982), pp. 195–209

D. Philippides: *Greek Traditional Architecture*, 2 vols. (Athens, 1983)

S. H. Eldem: *Türk evi osmanlı dönemi* [Turkish houses of the Ottoman period] (Istanbul, 1984)

G. Akın: *Doğu ve güneydoğu Anadolu Ev tiplerinde anlam* [Types of construction in the houses of south and southeast Anatolia] (Istanbul, 1985)

R. Angelova: "L'Architecture vernaculaire de la Bulgarie," *L'Architecture vernaculaire dans les Balkans* (1985)

M. Quigley-Pinar and P. Veysseyre: "Turkish Vernacular Houses of Western Anatolia," *Mimar*, xvi (1985), pp. 7–11

N. Akın: *Balkanlarda osmanlı evi* [Ottoman houses in the Balkans] (Istanbul, 1987)

A. Eyuce: "Space Syntax in Traditional Turkish Architecture," *A. & Islam. World*, iv/4 (1987), pp. 16–20

N. Moutsopoulos: *L'Encorbellement architectural "Le Sachnisia": Contribution à l'étude de la maison grecque* (Thessalonika, 1988)

B. Pantelic: "Nationalism and Architecture: The Creation of a National Style in Serbian Architecture and its Political Implications," *J. Soc. Archit. Hist.*, lvi (1997), pp. 16–41

Z. Kezer: "Familiar Things in Strange Places: Ankara's Ethnography Museum and the Legacy of Islam in Republican Turkey," *People, Power, Place*, ed. S. A. McMurry and A. Adams, Perspectives in vernacular architecture, 8 (Knoxville, 2000), pp. 101–16

M. Aoki: "Habitat nomade d'Anatolie: Une architecture autoporteuse," *Archit. Aujourd'hui*, cccxxviii (2000), pp. 68–71

D. Dinsmoor: "Restoring a Bosphorus Yali: The Elusive Goal of Authenticity," *J. Archit. Conserv.*, xi/2 (2005), pp. 82–94

G. Asatekin: "Understanding Traditional Residential Architecture in Anatolia," *J. Archit.*, x/4 (2005), pp. 389–414

Z. Celik-Hinchliffe: "Rootedness Uprooted: Paul Bonatz in Turkey, 1943–1954," *Centropa (New York, N.Y.)*, vii/2 (2007), pp. 180–96

D. Kuban: *Osmanli Mimarisi* (Istanbul, 2007), pp. 469–96; Eng. trans. as *Ottoman Architecture* (London, forthcoming) [chapter on vernacular architecture]

IX. Iran. The vernacular architecture of Iran divides into three zones: sub-tropical, mountain and plateau. On the Caspian littoral a fine tradition of reed thatching and matting for walls has been largely overtaken by the oilcan. Beaten flat and usually rusted to an attractive chestnut color, it has become the traditional roofing material just as it has in the mountains. Generously projecting eaves throw the water clear. In areas of the Elburz where there is good timber for building, pockets of a vernacular tradition reminiscent of Switzerland may survive. The vernacular of the plateau, however, is the most extensive, spectacular and "typically Iranian." The combination of the harsh desert climate and a severe limitation in the choice of building materials has produced a vernacular unsurpassed in providing living and working conditions that are not only tolerable but civilized. For instance, the vernacular tradition includes not only the basic requirements of shelter from the elements and a clean water supply but also provision for such luxuries as air-conditioning (*see* WIND CATCHER) or the means of making and storing ice.

The basic building material on the plateau is mud. Timber is in short supply, and stone tends to be poor and is used chiefly for wall footings and foundations. Mud is used as cob-earth mixed with straw and water and spread by shovel in layers to form a battered wall; or as pisé, in which case little water is added and the earth is rammed. Sun-dried bricks are also made in the villages and much used. Mud with a higher clay content may be made into baked bricks. Walls other than baked brick are rendered with a mud-lime mix to improve their appearance and weathering properties. Roofs are often of brick, domed or vaulted, since there is no other way to span between the walls, unless timber or steel is available for construction (see fig. 7). Thus the humblest building, for example an animal shelter, may have a barrel vault; a village cistern may be domed. Scarcity of timber even for the centering of arches and the support of vaults during construction has led to ingenious methods of building whereby the vaults are self-supporting during construction as well as when complete. Each brick course in a vault is tilted slightly to give support to that above. This, together with joints of thick mortar—which sets quickly in the dry atmosphere—and the speed with which the bricklayer works, give the bricks enough sticking power to stay in place until the vault is complete. (The Egyptian architect HASSAN FATHY revived this method in Egypt in the 1960s.) The brick vaults are then rendered with a mud plaster to make them waterproof, and some grander buildings are paved with baked bricks.

Flat roofs are common wherever timber is available, since they are easier to construct. Poles are laid as joists, covered with reed matting or brushwood and then with layer upon layer of mud-lime plaster up to *c.* 500 mm thick. Rainwater is carried clear of the walls on long wooden spouts. Mud is a very good insulator, and since walls are thick and have few openings their insulation properties are excellent, a matter of prime importance in the desert. The grave drawback of brick and cob construction in a country subject to earthquakes is their lack of tensile strength and tendency to collapse. The finish of walls, roofs and floors with the same material is not dull but has a magical effect, as the rendering transforms the most workaday building into sculpture of astonishing form. The mud, being a gentle sandy color with its surface broken by myriad short pieces of straw, makes a restful contrast to the desert glare.

Both the plateau villages and village houses are inward-looking, an essential feature if the village is to survive the extremes of climate and gain all possible protection from the wind. Villages are mostly walled and are further protected by a buffer of trees and orchards in the surrounding irrigated fields. The street is flanked by the blank walls of houses rarely broken by windows and only where necessary by doors. The main street is sometimes partly vaulted and shaded by mulberry or pomegranate trees. The better houses focus on their individual courtyards, which are contrived to be invisible from the street door. Each has its water tank or pool and probably a tree, and thus a microclimate is created, protected from the parching wind. The use of the house is regulated by the time of day and season. Flat roofs are used for sleeping on summer nights, and the heat of the day is spent in underground rooms cooled by wind catchers. Summer evenings are passed on a raised porch (Pers. *tālār*), which catches the breeze. A range of south-facing rooms warmed by the low sun is used in winter.

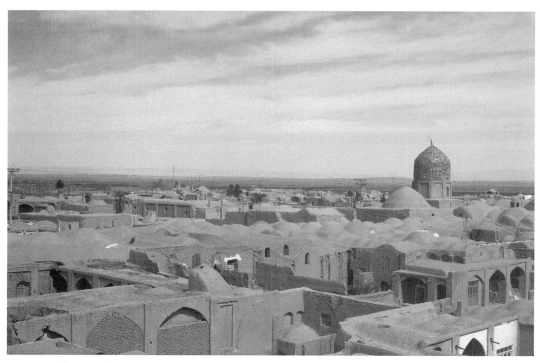

7. View over the town of Zavara, central Iran; photo credit: Sheila S. Blair and Jonathan M. Bloom

R. Rainer: *Traditional Building in Iran* (Graz, 1977)

E. Beazley: "Some Vernacular Buildings of the Iranian Plateau," *Iran*, xv (1977), pp. 89–102

S. I. Hallet and R. Samizay: *Traditional Architecture of Afghanistan* (New York, 1980)

E. Beazley and M. Harverson: *Living with the Desert: Working Buildings of the Iranian Plateau* (Warminster, 1982)

N. Kasraian: "Taleshs: Summer Dwellings in Iran," *Mimar*, xxxi (1989), pp. 38–44

A. Szabo and T. J. Barfield: *Afghanistan: An Atlas of Indigenous Domestic Architecture* (Austin, 1991)

W. Kleiss and M. Y. Kiani: *Iranian Caravansarais* (Tehran, 1995)

M. M. Hejazi: *Historical Buildings of Iran: Their Architecture and Structure* (Southampton, 1997)

S. Mazumdar and S. Mazumdar: "Intergroup Social Relations and Architecture: Vernacular Architecture and Issues of Status, Power, and Conflict," *EB: Environment and Behavior*, xxix/3 (1999), pp. 374–421

W. Kleiss: "Staudämme und Brücke in West- und Ost-Iran," *Archäol. Mitt. Iran*, xxxi/1999 (2000), pp. 199–218

J. Ghazbanpour: *Iranian House* (Tehran, 2001)

D. Diba, P. Revault, S. Santelli and S. Ayvazian: *Maisons d'Ispahan* (Paris, 2001)

N. Pourjavady, ed.: *Splendour of Iran*, 3 vols. (London, 2001) [articles on cisterns, caravanserais, bridges and dams, pigeon towers and other forms of vernacular architecture]

W. Ball: "The Towers of Ghur: A Ghurid 'Maginot Line'?," *Cairo to Kabul: Afghan and Islamic Studies Presented to Ralph Pinder-Wilson*, ed. W. Ball and L. Harrow (London, 2002), pp. 21–45

A. Chassagnoux: "Evolution des voûtes de l'architecture iranienne," *Iran: Questions et connaissances, Actes du IVe Congrès Européen des Etudes Iraniennes … Paris … 1999, II: Périodes médiévale et moderne*, ed. M. Szuppe, Studia Iranica 26 (Paris, 2002), pp. 497–512

M. Shokoohy and N. H. Shokoohy: "The Tomb of Ghiyāth al-Dīn at Tughluqabad: Pisé Architecture of Afghanistan Translated into Stone in Delhi," *Cairo to Kabul: Afghan and Islamic Studies Presented to Ralph Pinder-Wilson*, ed. W. Ball and L. Harrow (London, 2002), pp. 207–21

S. E. Yavari: "La maison de force (zourkhâneh) iranienne," *L'Autre, l'étranger; sports et loisirs: Jacques Duchesne-Guillemin in honorem*, ed. C. Cannuyer and others, Acta Orientalia Belgica, 16 (Brussels, 2002), pp. 167–71

E. Beazley: "Pigeon Towers and Ice-houses on the Iranian Plateau," *Technology, Tradition and Survival: Aspects of Material Culture in the Middle East and Central Asia*, ed. R. Tapper and K. McLachlan (London, 2003), pp. 115–31

T. Giura: *La città islamica: Iran* (Naples, 2003)

B. A. Kazimee and A. B. Rahmani: *Place, Meaning, and Form in the Architecture and Urban Structure of Eastern Islamic Cities* (Lewiston, 2003)

P. Jodidio, ed.: *Iran: Architecture for Changing Societies* (Turin, 2004)

J. M. Scarce: "Bandar-i Tahiri—a Late Outpost of the Shahnama," *Shahnama: The Visual Language of the Persian Book of Kings*, ed. R. Hillenbrand, Varie Occasional Papers II (Aldershot, 2004), pp. 143–54

A. Modarres: *Modernizing Yazd: Selective Historical Memory and the Fate of Vernacular Architecture*, Bibliotheca Iranica: Urban planning history of Iranian Cities, 1 (Costa Mesa, CA, 2006)

X. Central Asia. The earliest remains of domestic architecture in the region—apart from Palaeolithic

fire marks in caves in Teshiktash, Machay etc.—are communal hunting and fishing cabins of the Neolithic period in the lower reaches of the Amu River and settlements of flat-roofed structures from the Dzheytun culture in southern Turkmenistan. Square single-family houses of mud-brick with pisé floors had a fireplace to the right of the entrance and a wall altar opposite; the clay-coated walls and floors were decorated in red or black, and some walls had painted images of hoofed animals and dogs. By the Bronze Age, domestic buildings were huddled together and linked by an irregular network of streets (e.g. Altyn Tepe); mud-brick walls were decorated with simple geometric patterns in two or three colors, and flat roofs were sometimes replaced by vaults. In ancient Khwarazm the regular contours of the town divided by a street running along the axis determined the straight network of domestic construction (e.g. Dzhanbas Kala or Toprak Kala), but the dominant system was that of the mansion house. These buildings—some with courtyards, some more compact in plan—were built along irrigation canals, as was typical during the medieval period. Bactrian houses in the Surkhan (Surkhab) River Basin had a courtyard and main hall decorated with murals.

In the 6th and 7th centuries, castles built on sloping pisé socles were erected throughout the region. Those of Khwarazm had rectangular fortified walls with a keep by the entrance, although in the largest of these castles (Yakke-Parsan) the keep was set in the middle of the courtyard. As can be seen from the well-preserved example of Great Kyz-kala (see fig. 8), the façade was decorated with closely set half-round columns to emphasize the defensive aspect, and the yard contained flat-roofed houses arranged systematically. In the Merv oasis these castles had vaulted rooms arranged in two stories around a courtyard or domed hall, and the keep was sometimes found in the yard of a flat-roofed mansion. In the east a corridor often ran around the interior perimeter (e.g. Ak-Tepe, near Tashkent, or Aul Tepe in the Kashka River region), and the rectangular plan was elaborated with

rectangular or rounded towers. In the smaller castles of Ustrushana and Tokharistan, the main hall is clearly distinguished from the surrounding mass of vaulted and flat-roofed rooms and often had four piers, carved wooden ornament and painted walls (e.g. Balalyk Tepe and Chilkhudzhra). A yard with service buildings surrounded the castle.

At PENDZHIKENT excavations have revealed the main outlines of urban domestic architecture in the 7th and 8th centuries. The residential quarters, packed within the city walls, were divided into sections by thick pisé walls. Each section had a residential and an official area. The more fashionable houses had beamed roofs, while the rest were vaulted. Reception halls with four piers were lit by an opening in the cupola; the walls were covered with multicolored narrative murals, and the wooden elements, including caryatids, were carved. Pisé ramps led to the second story, where flat-roofed rooms were used in summer. In houses without a courtyard, the entrance portico opened directly to the street. In the 11th and 12th centuries, the prevalent type of urban housing had rooms arranged around a courtyard and lighter construction with walls of mud-brick and beamed roofs (e.g. Merv, Misrian, the Buran hill), and rich wall decoration in carved stucco and painting. Excavations in OTRAR have provided a detailed picture of the situation in the late medieval period (15th–18th centuries). The town continued to be confined within the earlier boundaries, and residential plots did not exceed 100 sq. m. The one- or two-room houses had covered yards in front and storehouses behind, while a small reception room was sometimes located by the entrance. Light entered through openings in the flat roof. The houses were normally heated by fireplaces on the floor, but at Otrar hypocausts were used, and indeed this latter form of heating was found as far as the Aral Sea.

Domestic architecture in the 19th and 20th centuries can be studied through surviving structures. Local characteristics depend on natural and climatic conditions, and in towns construction was organized around yards, divided into male and female halves. Skeletal walls and flat earth roofs resting on beams predominate. Exit to the yard was effected through shuttered openings with iwan porticos. The architectural schools of the Ferghana basin, Bukhara and Khiva are notable for the organization and artistic decoration of the interiors. Local characteristics are more clearly seen in rural buildings: the reed construction of the Amu delta, the domed houses of southern Turkmenistan and the pitched thatched roofs of southern Tajikistan. Rural mansions have tall rectangular pisé walls decorated with drawn and molded ornament (the Samarkand *kurgons* and the *khovly* and *khauli* of the Amu River region). The survival of tradition can be seen in the central axis plan of the mansions of Khwarazm, the defensive *dinga* tower in the yards of houses in Turkmenistan, the persistence of the Otrar house in those of southern Kazakhstan, the seasonal houses of the Samarkand region cut into loess like medieval caves in southern Tajikistan,

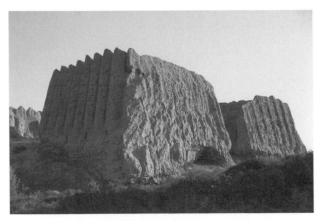

8. Great Kyz-kala, Sultan-kala (Merv), Turkmenistan, 6th–7th centuries; photo credit: Sheila S. Blair and Jonathan M. Bloom

and houses with log domes in Gornyy Badakhshan. Permanent structures are often accompanied by covered felt tents of the nomads (*see* TENT, §II, 2). The Karakalpaks moved these tents in winter into a special room in the house, and a place for a tent was even set aside in the Tash Hawli Palace in Khiva. Palace architecture always borrowed forms from ordinary dwellings, simply increasing the number of rooms and adding a grander part, as can be seen in the early medieval palaces of Pendzhikent, Bundzhikat and Varakhsha with their multi-piered throne rooms.

Rural architecture of the 6th to 8th centuries is known from the unfortified farmhouses grouped around the feudal castle (a mansion with a courtyard in the Merv region) or by the town walls (small vaulted buildings to the east of Pendzhikent). Rural accommodation in Khwarazm of the 1st to 14th centuries has been studied in some detail: construction was of clay and unfired materials, while planning varied from mansions with courtyards to compact many-roomed systems arranged in networks or along a central axis. Echoes of earlier traditions were expressed in the decorative treatment of walls, and towers were turned into pigeon towers. One particular type of settlement found between the 10th and 14th centuries was a complex of caves carved into the base of cliffs (multi-roomed, sometimes in two tiers, along the right bank of the Murgab River) or in the strata of loess (southern Tajikistan), where the ceilings imitate vaulted construction.

See also CENTRAL ASIA, §I, 2 and ARCHITECTURE, §IV, A, 3.

G. A. Pugachenkova: *Puti razvitiya arkhitektury yuzhnogo Turkmenistana pory rabovladeniya i feodalizma* [The paths of development of the architecture of southern Turkmenistan in the period of slave-ownership and feudalism] (Moscow, 1958)

Ye. Ye. Narazik: *Sel'skoye zhilishche v Korezme (I–XIV vv.)* [Rural domestic architecture in Khwarazm (1st–14th centuries)] (Moscow, 1976)

K. A. Akishev, K. M. Baypakov and L. B. Yerzakovich: *Pozdnesrednekovyy Otrar* [Late medieval Otrar] (Alma Ata, 1981)

G. Herrmann and H. Kennedy: *Monuments of Merv: Traditional Buildings of the Karakum* (London, 1999)

B. A. Kazimee and A. B. Rahmani: *Place, Meaning and Form in the Architecture and Urban Structure of Eastern Islamic Cities* (Lewiston, 2003)

R. G. Rozi: "Uighur Vernacular Architecture," *Towards the Contemporary Period: From the Mid-nineteenth to the End of the Twentieth Century, vi of History of Civilizations of Central Asia*, ed. M. K. Palat and A. Tabyshalieva (Paris, 2005), pp. 719–31

XI. India. Individual elements of modern vernacular architecture in India can be traced back to the building practices of some of the earliest recorded cultures in the region. Until well into modern times, for example, the generic form of the town house throughout the Northern Indian plain remained a burnt brick structure built around a courtyard, directly fronting the street and attached to the neighboring houses, a form traceable back to the urban architecture of the Harappan civilization that flourished on the banks of the Indus from the early 3rd to the late 2nd millennium BCE. Other housetypes are depicted in rock carvings, reliefs and wall paintings from the period *c.* 200 BCE–500 CE.

Two types of village cottage in particular that were still being extensively built in the late 20th century can be identified from these sources: one type had thick battered mud walls and a curvilinear thatched roof with overhanging eaves, probably with a bamboo structure, while the other had timber and bamboo walls and a horseshoe-shaped, barrel-vaulted roof made of timber and bamboo and reed, leaves or thatch. There is no reason to suppose that the hundreds of other types of rural dwellings found in India—each reflecting the particularities of the local climate, materials and culture—do not have equally long ancestries.

Other elements of modern practice can be traced back to prescriptions and proscriptions given in the *Vastuśāstra*s, Sanskrit treatises thought mostly to have been written (or rewritten) in the second half of the 1st millennium CE. Running throughout the rules on geometry is a tension between a desire for symmetry and a fear of it. For example, a door must not be located precisely in the middle of a façade, and no two doors in a house should be exactly opposite each other. The center of any element is considered a vulnerable point (*marmastan*), and the dictum that the doors should not be in alignment with each other is obeyed by slightly distorting the geometry. Rooms in the upper stories should conform to those below, but alleys should not be built on both sides of a house. In South India domestic architecture based on the *Vastuśāstra*s remained commonplace in the late 20th century.

It is difficult, however, to trace a continuous process of development in domestic architecture from the late 1st millennium. Although most rural vernacular building remained virtually unaffected by subsequent cultural developments, little historical research has been undertaken in this area, and knowledge of the surviving indigenous tradition is limited only to urban houses, mainly the palaces of the nobility or of wealthy landlords and merchants. The indigenous Hindu tradition, for example, is evident in the trabeate and bracketed construction, corbelled vaults and ornamentation of the Man Mandir Palace in the fort at Gwalior. The palace also has the deep overhanging ledges supported on brackets (*chajjās*), perforated screens (*jālīs*) and roof pavilions that remained part of the vocabulary of domestic architecture in India until modern times. Humbler, and therefore more plausibly vernacular, examples include houses at Udaipur and Jaisalmer, most notably the lower levels of Salam Singh's *hāvelī* (18th century).

The *hāvelī* was the main urban domestic housetype until the 20th century in hundreds of cities and towns throughout the North Indian plains and as far south and west as Gujarat. Its typological importance, however, is only beginning to be realized.

Although there are regional differences in the use of the term, broadly speaking the *hāvelī* refers to the ample house of a prosperous family. The house is generally attached to one of its neighbors, is invariably planned around one or more courtyards and is typically entered through an elaborate doorway, from which a crooked passageway leads to the interior. Quite humble houses also share the general arrangement of the *hāvelī* type, although the doorway may be plainer, and the courtyards may not have rooms on all four sides. There are also regional differences, principally in construction methods and materials. Hindu, Jain and Sikh houses tend to be on two or more stories (the main floor always being one of the upper ones), with a relatively small courtyard, windows and balconies opening on to the street, especially on the upper floors. Muslim homes have larger, more open courtyards but fewer and smaller rooms, and they tend to be on one floor, with the first floor partially built up. *Purdah*—the separation of the male and female areas of the home—is observed by designating the rear of the house as the women's area, while the male realm is near the entrance; some non-Muslim households also observe *purdah* by restricting the family domain to the upper floors, with the kitchen typically on the first floor. Most *hāvelīs* have thick masonry walls and flat roofs of masonry on a stone or timber structure; both roofs and the courtyards are used as living spaces, and it is usual to sleep outside in the summer.

Despite the affinities between the *hāvelī* and the generic form of the houses of the Harappan cities, there is little documentation of the *hāvelī* as such before the 17th century. A ruin in Delhi, known as Barakhamba, which is thought by some authorities to be the house of a late 15th- or early 16th-century nobleman, has a *hāvelī*-like arrangement and may be the earliest known surviving example. More is known, however, of the evolution of the *hāvelī*-type house from the period of British influence, which led to the incorporation of Western ornamentation, the increasing use of doors to close off rooms and to shutter openings to the courtyard (previously these were hung with screens) and the use of steel beams in construction. The varied forms of other regional house-types can be related to the local climate, to local culture and to the availability of materials. In Gujarat, wooden *hāvelīs* with pitched roofs are common; related to these is the Maharashtran house-type known as *wada*, which has a generic form similar to that of southern Indian houses: wide-eaved, pitched-roofed buildings arranged around open courtyards and often surrounded by verandahs. In Kashmir, too, wooden houses predominate, although their plan may be less regular and more compact, with the courtyard not placed centrally. The documentation of most of these house-types is only in its infancy, and many other types remain unidentified.

Another important (if not wholly vernacular) house-type was the bungalow, so called because of its derivation from the Bengali hut. A reflection of the importance of the European cultural legacy, its development can be traced from the late 17th century, when the fledgling colonial powers (most importantly the British, but also the French and Dutch) needed to accommodate increasing numbers of soldiers and administrators in a culturally acceptable but climatically appropriate house-type. The early bungalows consisted of a square or rectangular room covered by a widely oversailing thatched roof; later a smaller room was added to each of the four corners, and the spaces between these became verandahs. It was only in the early 19th century in Bengal, however, that the bungalow was adopted as a house-type by Indians. In the course of that century two distinct types of bungalow evolved: the pitched-roofed form, having a higher central portion with clerestory windows above a columned verandah, and a grander flat-roofed version. The latter form was used by Edwin Lutyens (1869–1944) and Herbert Baker (1862–1946) at Delhi (*see* DELHI, §I, H) in their plan for the new capital city.

D. N. Shukla: *Vāstu-śāstras* (Varanasi, 1960)

A. Ray: *Villages, Towns and Secular Buildings in Ancient India* (Calcutta, 1964)

A. Rapoport: *House Form and Culture* (Englewood Cliffs, 1969)

M. Patel: *Study of Old Havelis in Gujerat* (Ahmedabad, 1981)

L. Patel: *Profiles of Built Forms: A Case Study of Nasik Houses* (Ahmedabad, 1982)

Y. R. Jain: *Havelis: A Study at Jaipur* (Ahmedabad, 1983)

A. D. King: *The Bungalow: The Production of a Global Culture* (London, 1984)

I. H. Iqbal: "The Indigenous Architecture of Chitral," *Mimar*, xvii (1985), pp. 68–76

B. Doshi: "Expressing an Architectural Identity: Bohra Houses in Gujarat," *Mimar*, xix (1986), pp. 34–40

N. Barthes and C. Lignon: "Bangas-Self Built Houses in Mayotte," *Mimar*, xxvi (1987), pp. 12–19

V. S. Pramar: *Haveli: Wooden Houses and Mansions of Gujarat* (Singapore, 1989)

Bauernhof, Stadthaus, Palast: Architektur in Gujarat, Indien (exh. cat. by M. Desai; Zurich, Mus. Rietberg, 1990)

K. K. Mumtaz: *Vernacular, Religion, and the Contemporary Expression in Pakistan* (Mumbai, 1997)

I. Cooper and B. Dawson: *Traditional Buildings of India* (London, 1998)

Vever, Henri (*b.* Metz, 1854; *d.* 1942). French jeweler and collector. Vever directed the family jewelry business, begun in Metz by his grandfather Pierre-Paul Vever (*d.* 1853). After the capture of Metz in the Franco-Prussian War (1871), the family moved to Luxembourg and then Paris, where the Maison Vever became well established on the Rue de la Paix, winning the Grand Prix of the universal expositions in 1889 and 1900 and becoming a leader in the Art Nouveau movement. Vever gave an important group of Art Nouveau works to the Musée des Arts Décoratifs, Paris. His early interest in contemporary French painting led him to assemble a large and important group of works by Camille Corot (1796–1875), Alfred Sisley (1839–99), Auguste Renoir

(1841–1919) and Claude Monet (1840–1926), of which he sold the majority (Paris, Gal. Georges Petit, 1897) to concentrate on Japanese and Islamic art. Vever had begun to collect Japanese prints in the 1880s and in 1892 joined the distinguished private group Les Amis de l'Art Japonais. In the 1920s through the dealer Sadajirō Yamanaka he sold several thousand Japanese prints to Kōjirō Matsukata, which formed the basis of the Matsuka collection (now Tokyo, N. Mus.). During World War II Vever's huge collections were placed in storage not to re-emerge until the 1970s. The Japanese works were dispersed at several spectacular sales at Sotheby's, and the Islamic material—comprising nearly 500 manuscripts, bindings and single folios—was acquired by the Sackler Gallery, Washington, DC, in 1986.

J. Hillier: *Japanese Prints and Drawings from the Vever Collection* (London, 1975)

G. D. Lowry with S. Nemazee: *A Jeweler's Eye: Islamic Arts of the Book from the Vever Collection* (Washington, DC, 1988)

G. D. Lowry and others: *An Annotated and Illustrated Checklist of the Vever Collection* (Washington, DC, 1988)

T. W. Lentz: "Pictures for the Islamic Book: Persian and Indian Painting in the Vever Collection," *Asian A.*, i/4 (1989), pp. 8–35

Vicitra. *See* BICHITIR.

Vijayapura. *See* BIJAPUR.

Visudasa. *See* BISHAN DAS.

W

Wakil, Abdel Wahed el- (*b.* Cairo, 7 Aug. 1943). Egyptian architect. He graduated from Ain-Shams University in Cairo in 1965. Between 1965 and 1970 he lectured at the university whilst studying and working with his mentor HASSAN FATHY, the well-known proponent of indigenous architecture. In 1971 el-Wakil went into private practice, eventually establishing offices in Cairo, Jiddah and Ashford, Kent. From 1993 he was based in Miami, Florida. He acted as an adviser to the Ministry of Tourism in Egypt (1972) and as consultant to UNESCO (1979–80). In 1980 he won the AGA KHAN AWARD FOR ARCHITECTURE for the Halawa house in Agamy, Egypt, completed in 1975. The two-story house was built around a courtyard, and the articulation of space was handled with great sensitivity and simplicity. Openings in the white walls filter light to the interior through carved wooden screens (Arab. *mashrabiyya*), and much of the courtyard remains in shadow, staying cool during the heat of the day. From this small vacation house el-Wakil went on to design larger houses such as the spectacular Al Sulaiman Palace in Jiddah, which uses the same principles but on a more lavish and larger scale. For a short time the architect toyed with other expressions of form but quickly returned to his exploration of tradition. El-Wakil's most convincing designs have been those for mosques (for illustration *see* SAUDI ARABIA) in Saudi Arabia. His Island Mosque, in gleaming white along the water's edge off the Corniche in Jiddah, is a design inspired by architecture of the Mamluk period (*see* ARCHITECTURE, §VI, C, 1) and won an Aga Khan Award for Architecture in 1989. Together with other works such as the Harithy (1986) and Azizeyah (1988) mosques in Jiddah, it makes an important contribution to one genre of contemporary mosque design. His work continued to draw heavily on the traditional architectures of Egypt and the Middle East, largely to the exclusion of other modern influences. Since 1993, he has been based in Miami. His 1997 design for the Oxford Centre for Islamic Studies, with minarets and domed mosque, generated much controversy.

WRITINGS

"Abdel Wahed el-Wakil: A Conversation with the Prize-winning Egyptian Architect Working in the Middle East," *Mimar*, i (1981), pp. 46–61

"An Island Mosque in Jeddah," *Mimar*, xix (1986), pp. 12–18

BIBLIOGRAPHY

ArchNet, http://archnet.org/ (accessed June 11, 2008)

R. Holod with D. Rastorfer, eds.: *Architecture and Community: Building in the Islamic World Today* (Millerton, NY, 1983), pp. 109–18

L. Krier: "The Irresistible El Wakil," *A. & Des.*, i/10 (1985), pp. 6–7

C. Abel: "Works of El-Wakil," *Archit. Rev.* [London], clxxx/1077 (1986), pp. 52–60

L. Steil, ed.: "Tradition and Architecture," *Archit. Des.*, lvii/5–6 (1987), pp. 49–52

M. al-Asad: "The Mosques of Abdel Wahed el-Wakil," *Mimar*, xlii (1992), pp. 34–9

J. Steele: "Introduction to the Work of Abdel Wahed el-Wakil," *Architecture of the Contemporary Mosque*, ed. I. Serageldin and J. Steele (London, 1996), pp. 46–71

Waramin. *See* VARAMIN.

Wiet, Gaston (Louis Marie Joseph Wiet) (*b.* Paris, 18 Dec. 1887; *d.* Neuilly-sur-Seine, 20 April 1971). French historian of Islamic art. Son of Maxime Wiet and Berthe Rousseau, and descendant of the English poet Sir Thomas Wyatt, from 1905 to 1908 Wiet studied Arabic, Persian and Turkish and Islamic history at the Ecole Nationale des Langues Vivantes, Paris, as well as acquiring a degree in law. In 1909 he joined the French Institut d'Archéologie Orientale in Cairo, where he met the Orientalists Louis Massignon, Jean Maspéro, MAX VAN BERCHEM, Henri Massé, René Basset, René Dussaud, Maurice Gaudefroy-Demombynes and William Marçais. In 1911 he was appointed professor of Arabic at the University of Lyon. He continued there until 1926, interrupted when he lectured on Arabic literature at the Egyptian University of Cairo and fought in World War I, receiving the Croix de Guerre for bravery. A member of the Académie des Inscriptions et Belles-Lettres since 1925, Wiet continued the publication of van Berchem's corpus of Arabic inscriptions. In 1926 King Fu'ad I of Egypt appointed Wiet director of the Museum of Arab Art (later Islamic Art) in Cairo, and he began to publish catalogues of the museum collections. With Etienne Combe and JEAN SAUVAGET he edited the *Répertoire chronologique d'épigraphie arabe* and was a member of the Committee for the Preservation of Arab Monuments (Cairo). Inspired by the

exhibition of Persian art held at the Royal Academy, London, in 1931 he organized an exhibition (1935) of Persian art in Cairo. From 1936 to 1938 he lectured on the history of Islamic art at the Ecole du Louvre, Paris. Otherwise he remained in Cairo until he was appointed professor of Arabic language and literature at the Collège de France in 1951. Wiet also published editions and translations of many Arabic texts, including the history of Cairo by the 15th-century Egyptian historian al-Maqrizi, and works about many aspects of Islamic art and Egyptian history as well as translations of contemporary Egyptian authors.

WRITINGS

ed. of Aḥmad ibn ʿAlī al-Maqrīzī: *al-Mawāʾiz waʾl-iʿtibār bi-dhikr al-khiṭaṭ waāl-āthār* [Exhortations and consideration for the mention of districts and monuments], *Mém.: Inst. Fr. Archéol. Orient. Caire*, xxx, xxxiii, il, liii, lxvi (1911–27)

Lampes et bouteilles en verre émaillé, Cairo, Mus. Islam. A. cat. (Cairo, 1929/*R* 1982)

Matériaux pour un corpus inscriptionum arabicarum: Première partie: Egypte, 2, Mém.: Inst. Fr. Archéol. Orient. Caire, lii (1929–30)

Album du Musée Arabe du Caire (Cairo, 1930)

ed. with E. Combe and J. Sauvaget: *Répertoire chronologique d'épigraphie arabe*, 16 vols. (Cairo, 1931–)

Objets en cuivre, Cairo, Mus. Islam. A. cat. (Cairo, 1932/*R* 1984)

with L. Hautecoeur: *Les Mosquées du Caire*, 2 vols. (Paris, 1932)

L'Exposition persane de 1931 (Cairo, 1933)

Exposition d'art persan (Cairo, 1935)

Les Stèles funéraires, Cairo, Mus. Islam. A. cat., ii, iv–x (Cairo, 1936–42)

Miniatures persanes, turques et indiennes: Collection de son excellence Chérif Sabry Pacha (Cairo, 1943)

Soieries persanes (Cairo, 1947)

Mohammed Ali et les beaux-arts (Cairo, 1949), pp. 265–88

Journal d'un bourgeois du Caire; chronique d'Ibu Iyàs (Paris, 1955–)

with A. Maricq: *Le minaret de Djam: La découverte de la capitale des sultans ghorides (XII.–XIII. siècles)* (Paris, 1959)

Grandeur de l'Islam, de Mahomet à François Ier. (Paris, 1961)

with J. H. Kramers, intro and trans.: *Configuration de la terre (Kitab surat al-Ard) [par] Ibn Hauqal*, 2 vols. (Beirut, 1964)

Cairo, City of Art and Commerce, trans. S. Feiler (Norman, 1964)

Introduction à la littérature arabe (Paris, 1966)

Baghdad: Metropolis of the Abbasid Caliphate, trans. S. Feiler (Norman, 1971)

Inscriptions historiques sur pierre, Cairo, Mus. Islam. A. cat. (Cairo, 1971)

ed.: *The Great Medieval Civilizations* (New York, 1975)

with A. Raymond: *Les Marchés du Caire: Traduction annotée du texte de Maqrîzî* (Cairo, 1979)

with H. M. el-Hawary: *Matériaux pour un corpus inscriptionum arabicarum: Quatrième partie: Arabie*, Mém.: Inst. Fr. Archéol. Orient. Caire, cix/1 (1985)

with others: "The Development of Techniques in the Medieval Muslim World," *Manufacturing and Labour*, ed. M. G. Morony, Formation of the Classical Islamic World, 12 (Aldershot, 2003), pp. 3–32

BIBLIOGRAPHY

A. Raymond: "Bibliographie de l'oeuvre scientifique de M. Gaston Wiet," *Bull. Inst. Fr. Archéol. Orient.*, lix (1960), pp. ix–xxiv

C. Cahen: "Notice nécrologique: Gaston Wiet," *J. Econ. & Soc. Hist. Orient*, xiv (1971), pp. 223–6

N. Elisséeff: "Gaston Wiet (1887–1971)," *J. Asiat.*, cclix (1971), pp. 1–9

J. Hubert: "M. Gaston Wiet," *Comptes Rendus des Séances: Académie des Inscriptions et Belles-Lettres* (1971), pp. 253–6

H. Laoust: "Gaston Wiet (1887–1971)," *Rev. Etud. Islam.*, xxxix (1971), pp. 205–7

M. Rosen-Ayalon: "Gaston Wiet, 1887–1971," *Kst Orients*, viii (1972), pp. 154–9

An. Islam., xi (1972) [issue devoted to Wiet]

M. Rosen-Ayalon, ed.: *Studies in Memory of Gaston Wiet* (Jerusalem, 1977), pp. 345–56

A. Louca: "L'Initiation d'un jeune historien: Gaston Wiet présenté à Max von Berchem," *An. Islam.*, xiii (1997), pp. 5–15

Wijdan Ali. *See* ALI, WIJDAN.

Wilkinson, Charles (Kyrle). (*b.* London, 13 Oct. 1897; *d.* Sharon, CT, 18 April 1986). American archaeologist, curator and collector. Trained as an artist at the Slade School, University College, London, in 1920 he joined the graphic section of the Egyptian Expedition to Thebes, organized by the Metropolitan Museum of Art, New York. During the 1920s and 1930s Wilkinson painted facsimiles of Egyptian tomb paintings in the museum collection, and he joined museum excavations in the Kharga Oasis (Egypt) and Qasr-i Abu Nasr and Nishapur (Iran). Transferred to the curatorial staff of the museum in 1947, he became curator in 1956 of the new Department of Ancient Near Eastern Art, which merged with the Department of Islamic Art in 1957. Through his energetic collaboration on major excavations at Hasanlu, Nimrud and Nippur, Wilkinson greatly expanded the Ancient Near Eastern collections at the Metropolitan Museum. After his retirement from the museum in 1963, he taught Islamic art at Columbia University and was Hagop Kevorkian Curator of Middle Eastern Art and Archaeology at the Brooklyn Museum, New York (1970–74). Wilkinson's numerous publications include exhibition catalogues and monographs. He collected Iranian ceramics, metalwork and Qajar works of art, many of which he and his wife donated to the Metropolitan and Brooklyn museums.

WRITINGS

Iranian Ceramics (exh. cat., New York, Asia House Gals., 1963)

Two Ram-headed Vessels from Iran (Berne, 1967)

Chess: East and West, Past and Present (exh. cat., New York, Met., 1968)

Nishapur: Pottery of the Early Islamic Period (New York, 1973)

Ivories from Ziwiye and Items of Ceramic and Gold (Berne, 1975)

Nishapur: Some Early Islamic Buildings and their Decoration (New York, 1986)

BIBLIOGRAPHY

M. Ekhtiar: *The Art of Qajar Iran: The Brooklyn Museum Collection* (Brooklyn, 1989) [supplement to the symposium "The Art and Culture of Qajar Iran," held at The Brooklyn Museum in April 1987 in memory of Wilkinson]

Wind catcher [Arab. *bādahanj, malqaf*; Pers. *bādgīr*]. Traditional form of natural ventilation and air-conditioning built on houses throughout the Middle East from North Africa to Pakistan. Constructed at least since the 2nd millennium BCE in Egypt, wind catchers have also been used to cool caravanserais, water cisterns and mosques. Consisting of an open vent built on the roof facing into or away from the prevailing wind, wind catchers have shafts carrying the air down through the roof into the living area below, thereby ventilating and cooling the spaces (*see* HOUSING, fig. 3). Wind catchers are generally placed above the summer rooms of courtyard houses. On the Iranian plateau, where the finest wind catchers are built, the vents are in the tops of brick towers that capture the faster airstreams above the general roof level. When there is little air movement, as on summer afternoons, the wind catcher acts as a chimney, drawing warm air up the shaft and through the living areas from the courtyard. In coastal settlements, towers generally face onshore winds. Most inland towers also face prevailing winds but in some desert settlements in the YAZD region of central Iran, where the prevailing wind is hot and dusty, vents similarly face away from the wind, and the preferred air from the courtyard is drawn through the summer rooms. In Iraq and central Iran, wind catchers are important in moderating the climate of the deep basements used as summer living rooms. In the Gulf and in Sind (the lower Indus region) wind catchers serve ground- and first-floor summer rooms.

Enc. Iran.: "Bādgīr" [Wind catcher]; *Enc. Islam/2*: "Bādgīr" [Wind catcher]
A. Badawy: "Architectural Provision against the Heat in the Orient," *J. Nr E. Stud.*, xvii (1958), pp. 122–8
S. Roaf: "Wind-catchers," *Living with the Desert*, ed. E. Beazley and M. Harverson (London, 1982), pp. 57–72
F. Ragette: *Traditional Domestic Architecture of the Arab Region* (Stuttgart, 2003), p. 87

Window. Architectural opening to admit light and air that may be covered with a screen, grille, glass or shutters, or left without covering depending on the surrounding environment and climate. Windows in Islamic architecture frequently, although certainly not always, take the form of an ARCH; such arch forms come in a dizzying varieties of types.

The use of marble or alabaster window grilles was adopted by Islamic architects from the Byzantine building tradition (*see* ARCHITECTURE, §III, B), and has become a distinctive and often spectacular feature of Islamic architecture: for example, the stone window grilles of the Great Mosque of Damascus (705–15; *see* DAMASCUS, §III) and those in the Friday Mosque in AHMEDABAD, India (1424). Wooden window grilles made up of pieces of turned wood arranged in intricate geometric patterns (Arab. *mashrabiyya*) became a characteristic of windows in many parts of the Islamic world, especially Egypt. Metal examples also exist, for example in the 15th-century madrasa and mausoleum of Amir Mahmud al-Ustadar in Cairo, although these tend to be less intricate. Panels of carved stucco were also used as ornate window grilles. Such stucco screens were carved away from the building site and then fitted to the window; they could consist of an outer unglazed screen and an inner layer containing colored glass, or of a single stucco panel ornately carved, such as those seen in the Mosque of Sunqur Sa'di in Cairo (1315). The use of grilles and screens in domestic windows allows for privacy. Windows opening on the external wall at ground level may be small, placed above eye level and covered with grilles for this reason, while upper windows may be larger and projecting but historically tend to avoid overlooking neighboring courtyards and terraces (*see also* VERNACULAR ARCHITECTURE).

In grander buildings, windows—with or without grilles—have been deployed to make maximum dramatic use of the strong light of Islamic lands. To this end, the ring of small windows in the base of the dome of the Shaykh Lutfallah Mosque in Isfahan (1602–19; *see* ISFAHAN, §III, D) creates an extraordinary lighting effect within the dome, and many of the Ottoman mosques use small windows at the base of the main dome in the same manner, as do the buildings of Muslim Spain.

G. Michell, ed.: *Architecture of the Islamic World: Its History and Social Meaning* (London, 1978)
K. Crtichlow: "The Play of Light," *A. & Islam. World*, xi/4 (1983), pp. 11–14
F. B. Flood: "The Tree of Life as a Decorative Device in Islamic Window-fillings: The Mobility of a Leitmotif," *Orient. A.* (1991), pp. 209–22
R. Hillenbrand: *Islamic Architecture: Form, Function and Meaning* (Edinburgh, 2000)
L. Mols: *Mamluk Metalwork Fittings in their Artistic and Cultural Context* (Delft, 2006)

Woodwork. Despite the scarcity of the raw material and the virtual absence of domestic furniture, woodwork occupied an unusually important place among the arts of the Islamic world. The mountain forests of Syria, North Africa and Spain were famous for their stands of cypress, cedar and pine, but Iraq and Egypt, equally important as woodworking centers, had to import wood from Syria, the Sudan or India. Only in Central Asia, northern Iran, Anatolia, the Balkans, Morocco and Spain was wood available in sufficient quantity to allow its free use for timber-frame construction. It was widely but sparingly used throughout the region for ceilings, lintels, doors and screens, and the high cost of the material encouraged techniques such as marquetry and grillework that minimized waste through the use of small pieces of wood.

In a society that preferred cushions and rugs to chairs and benches, domestic wooden furniture was limited to small low tables and chests, but mosques were often provided with fine wooden minbars (pulpits; *see* MINBAR), *maqsura*s (screened enclosures for the ruler; *see* MAQSURA), bookcases and reading stands and storage-boxes for manuscripts of the Koran. These mosque furnishings provide the best source for the study of technical and stylistic evolution. A considerable amount of Islamic woodwork has survived, as the inherent perishability of wood was countered by the aridity of the climate in many parts of the Islamic world; the religious function of the objects has also helped to preserve them owing to the longevity of the institutions to which they belonged and the respect with which they were treated.

The woodwork that survives from the early period before *c.* 1250 usually comprises whole planks. Far more woodwork survives from the period after *c.* 1250 so that one can establish more regional styles areas, but it is usually made up of small pieces fitted together.

I. Before *c.* 1250. II. After *c.* 1250.

I. Before c. 1250. In the first two centuries of the Islamic period, Africa, Anatolia and northern Iran were still heavily forested, and wood was an essential material for shipbuilding, carpentry and joinery throughout the Islamic world: even the Damascus oasis produced enough poplar for reinforcement timbers to be commonly used in local construction in Syria. Deforestation, however, began to affect the availability of wood in the eastern Mediterranean and led to the afforestation program instituted by the Fatimid dynasty (*r.* 969–1171) and its Ayyubid successors (*r.* 1169–1252) in Egypt. By the end of the period wood was so scarce and expensive that it had to be imported. The export of timber from Catholic Europe to Islamic lands was periodically banned by the Pope to prevent its use for building warships, but on at least one occasion the Venetians circumvented this embargo by exporting wood in sizes that were useless for shipbuilding. The increasing scarcity of wood, particularly in Syria and Egypt, may explain the change in taste from the use of large planks carved with arabesques to tongue-and-groove strapwork panels and turned screens composed of small pieces arranged in geometric patterns (Arab. *mashrabiyya*). Such strapwork appears on pieces made in the 11th century in Syria, Egypt, Spain and North Africa.

Five different decorative techniques were employed: joining (methods included mortise and tenon, tongue and groove, doweling or pinning, scarfing, and dovetailing); carving, which was usually done with a vertical cut until a new style with a beveled cut developed at Samarra in Iraq *c.* 850 (*see* BEVELED STYLE); turning, of which few examples survive from before *c.* 1250; inlay and mosaic work done with ivory, bone and precious woods set in geometric patterns and fixed with glue or wooden dowels; and painting, known from the traces that survive on many objects.

Native woods used included sycomore (*Ficus sycomorus*), jujube, tamarisk and *Acacia nilotica*, along with such acclimatized species as padauk, East Indian rosewood (*Dalbergia latifolia*), pudding pipe tree (*Cassia fistula*), cypress and lime. The date palm, whose fibrous strands mean that it is hardly wood at all, was regularly used for rafters in Egypt, but was boxed in with thin planks, which were then painted or carved. Aleppo and parasol pines, oak, birch, box, walnut and poplar were imported from Asia Minor and Europe, teak from East Asia and shea (karite) from the Sudan. Ebony came from India or the Sudan. These woods tended to be used where they were most readily available: African ebony was used more often in Egypt, teak more commonly in Iraq. In 11th-century Egypt, the principal materials were holm-oak and cypress, and such precious woods as East Indian rosewood, padauk, African ebony and *Cassia fistula* were used for inlay. Although several varieties of wood were readily available in Anatolia, only a few isolated pieces of Anatolian woodwork survive from the period before 1250; these are discussed with the more numerous later examples in §II, D below.

W. Heyd: *Histoire du commerce du Levant au Moyen Age*, 2 vols. (Leipzig, 1885–6)

M. Lombard: "Arsenaux et bois de marine dans la Méditerranée musulmane (VIIe–IXe siècles)," *Le Navire et l'économie maritime du Moyen Age au XVIIIe siècle* (Paris, 1958)

A. Egypt, Syria and Iraq. B. Iran and Central Asia. C. Spain and North Africa.

A. EGYPT, SYRIA AND IRAQ.

1. Before *c.* 1000. 2. *c.* 1000 to *c.* 1250.

1. Before c. 1000. Large rectangular wooden panels and planks prepared using techniques and decorative motifs taken over from Late Antiquity have survived from the period between the rise of Islam (early 7th century) and *c.* 850. The outstanding pieces are the several dozen carved panels from the Aqsa Mosque in Jerusalem (900–1100×350–600 mm; now divided, Jerusalem, Islam. Mus. and Rockefeller Mus.). At one time they served as false consoles at the ends of the 20 beams supporting the roof over the central nave, but their original position in the mosque is unknown. Four decorative elements reminiscent of Late Antique ornament are found: architectural forms, particularly a pair of columns supporting an arch; vases and baskets; plant elements such as fruits and leaves; and geometric designs, including lozenges and circles. Their stylized vegetal motifs juxtapose contrary elements (e.g. grapes with acanthus leaves) and superimpose fruits and leaves on other leaves. The fields between the carved panels are painted with blue and white motifs outlined in black. Related fragments have been found at sites in Syria, Jordan and Egypt.

A smaller group of panels bears elements derived from Sasanian art, particularly winged motifs and pine cones; the motifs are smaller, flatter and more

densely packed into their frames. On stylistic grounds these pieces have been attributed to the second half of the 8th century, when the political center of the Islamic world shifted from Syria to Iraq. This transitional style is best exemplified by a rectangular panel, probably teak, found at the 'Ayn al-Sira cemetery near Cairo (320×1920 mm; Cairo, Mus. Islam. A., 2462). Narrow bands carved with a Koranic inscription in Kufic script border a central field of seven compartments separated by lancet leaves or rosettes. Alternating compartments are filled with wing motifs issuing from paired horns against a ground of vine scrolls with small leaves. The end compartments have a trellis pattern, and the other two compartments have arched niches filled with vegetal motifs. The carving is uniformly flat. A rectangular teak panel found at Takrit in Iraq (New York, Met.) is extraordinarily similar in style and technique.

A third style, characterized by greater relief in carving, is seen on pieces found throughout the central Islamic lands. Those found in Iraq include fragments from a door or portable minbar (h. 1.79 m; New York, Met., 31-63-1), a pair of doors (each leaf 2.25×1.23 m; Athens, Benaki Mus., 9121) and part of a door frame (Baghdad, Iraq Mus.), but the major examples are still *in situ*: a double door in the monastery of St. Macarius (Deir Abu Maqar) in the Wadi Natrun of Egypt and the teak minbar in the Great Mosque of KAIROUAN in Tunisia. The Kairouan minbar, the oldest in existence (862–3; 3.31×3.93 m), has a triangular framework held together by mortise-and-tenon joinery. Each side consists of 17 upright beams supporting 52 rectangular panels arranged in a triangle and is surmounted by a balustrade with 17 additional panels. The openwork panels are mostly decorated with geometrical or arabesque grilles, carved with the utmost delicacy in several planes. While most of the individual design elements, such as the five-lobed leaf, pine cone, acanthus whorl and winged motif, are known from earlier examples, here they are combined and integrated in designs of unparalleled richness. A later report that Abu Ibrahim Ahmad, the Aghlabid governor of Kairouan from 856 to 863, had teak brought from Baghdad and made into a minbar probably refers to these panels.

The first distinctly Islamic style of wood-carving emerged in the mid-9th century at the Abbasid capital at SAMARRA in Iraq, where wooden doors and panels were carved in the Beveled style. This form of endlessly repeating arabesques carved with a distinctive slanted cut is based on abstracted vegetal forms, but the distinction between background and foreground has disappeared. The style is exemplified by a pair of teak doors (New York, Met., 31.119.3–4), each with four rectangular panels set in a plain wooden frame. Each panel is carved with a pear-shaped form from which spring kidney-shaped leaves, a trilobed leaf and a split palmette; the "pears" rest on volutes ending in trilobed palmettes. This court style was imitated throughout the Abbasid realm. In Egypt it is identified with the patronage of the TULUNID dynasty (r. 868–905), but the Egyptian

version of the Beveled style incorporated several new features. Broad surfaces were subdivided, a narrow bead was introduced to emphasize smaller elements, and the abstracted vegetal motifs of the Iraqi style were often transformed into recognizable birds and occasionally into animals. Arched panels, for example one in Cairo (h. 580 mm; Mus. Islam. A., 13173), usually depict confronted or addorsed birds. The well-known panel in Paris (h. 0.73 m; Louvre) depicting a duck-like bird whose bill and body transmute into palmettes and calyxes may once have had a mate. Friezes were decorated with bands of paired birds (e.g. Cairo, Mus. Islam. A., 6280–2, with traces of paint) or beveled palmette scrolls and inscriptions (e.g. Cairo, Mus. Islam. A., 3498). A great quantity of woodwork survives at the mosque of Ibn Tulun (876–9; see CAIRO, §III, B). A frieze inscribed with verses from the Koran in Kufic script (letter h. 150–90 mm) ran above the interior arcades, just below the roof; its original length was an astounding 1988 m. Other panels carved with geometric and non-figural ornament in the Beveled style decorate the doorframes and ceiling. The Beveled style continued to be used in Egypt during the 10th century, but few major buildings were erected, and few dated pieces have survived.

J. David-Weill: *Les Bois à épigraphes jusqu'à l'époque mamlouke* (Cairo, 1931)

E. Pauty: *Les Bois sculptés jusqu'à l'époque ayyoubide* (Cairo, 1931)

M. Dimand: "Arabic Woodcarvings of the Ninth Century," *Bull. Met.*, xxvii (1932), pp. 135–7

M. Dimand: "Studies in Islamic Ornament," *A. Islam.*, iv (1937), pp. 293–337

K. A. C. Creswell: *Early Muslim Architecture*, ii (Oxford, 1940), pp. 317–19, pls. 89–90

G. Marçais: "The Panels of Carved Wood in the Aqsa Mosque at Jerusalem," *Early Muslim Architecture*, ed. K. A. C. Cresswell (Oxford, 1940), ii, pp. 127–37

F. Shafi'i: "Al-akhshāb al-muzakhrafa fî'l-ṭirāz al-umawī" [Decorated woodwork in the Umayyad style], *Bull. Fac. A., Fouad I U.*, xiv/2 (1952), pp. 65–112

H. Stern: "Quelques Oeuvres sculptées en bois, os et ivoire de style omeyyade," *A. Orient.*, i (1954), pp. 119–30

R. Hillenbrand: "Umayyad Woodwork in the Aqsa Mosque," *Bayt al-Maqdis: 'Abd al-Malik's Jerusalem*, ed. J. Raby and J. Johns (1999), ix/2 of *Oxford Studies in Islamic Art* (Oxford, 1985–), pp. 271–310

2. c. 1000–c. 1250. The relatively large quantity of Egyptian and Syrian woodwork surviving from this period makes it possible to delineate its stylistic evolution with far greater precision than for the contemporary period in Iraq. Under the Fatimid dynasty (r. 969–1171) woodcarvers continued to use the Beveled style which had been imported into Egypt in the Tulunid period (see §I above), as on a pair of doors ordered for the Azhar Mosque in Cairo by the caliph al-Hakim in 1010 (Cairo, Mus. Islam. A.). Each leaf is composed of seven carved rectangular panels set within a simple mortised frame, and all but

the two panels bearing the inscription are decorated with retardataire vegetal arabesques. The style was soon superseded: a wooden screen from the church of St. Barbara (Sitt Barbara) in Cairo, attributed to approximately the same date (Cairo, Coptic Mus.), shows new elements, such as figural representations, which became typical somewhat later. The vine and vase motifs on the screen, undoubtedly inspired by the same motifs on a 6th-century Coptic door in the church, are considered to be a distinguishing feature of Egyptian woodwork.

The same type of layout can be seen in examples from the mid-11th century, such as the sanctuary screen in the chapel of the convent of St. George (Deir Mari Girgis) in Old Cairo. This has 73 carved panels set in a plain rectangular matrix and displayed on the valves of the doors and the doorcase; the four panels joined diagonally at the top left and right are cut down, showing that all the panels are reused. Two teak panels from unidentified doors (330×215 mm; Cairo, Mus. Islam. A.; see fig. 1; and New York, Met.) have arabesques terminating in paired horses' heads. The bridles and medallions are outlined with beaded bands; the carving is deeply undercut. Panels of deeply carved symmetrical arabesques continued to be popular in Cairo until the end of the Fatimid period, as on a set of cupboard doors for the Aqmar Mosque (1125) and

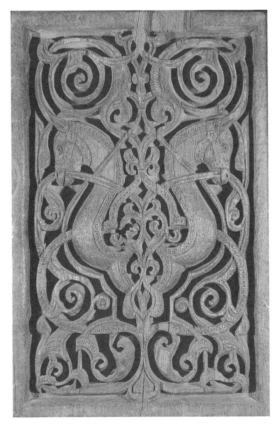

1. Carved teak door panel, 330×215 mm, from Egypt, 11th century (Cairo, Museum of Islamic Art); photo credit: Erich Lessing/Art Resource, NY

doors to the Fakahani Mosque (1148–9). Eleventh-century woodwork is best known, however, for a figural style whose subject matter included scenes of princely pleasures, Christian saints and everyday life. It was used in both secular and Christian contexts, and the most important examples are the numerous carved boards thought to have encased ceiling beams in the "Lesser" or "Western" Palace of the Fatimid caliphs in Cairo. The boards may have been ordered by the caliph al-Mustansir when he restored the palace between 1058 and 1065. The palace was razed some two centuries later to make way for the complexes of Sultan Qala'un and his son al-Nasir Muhammad, in both of which the boards were later reused; their reuse emphasizes the great value of large pieces of wood. One leaf of a door and over 31 m of carved boards (300 mm wide) are preserved (most in Cairo, Mus. Islam. A.). The boards, bordered by intermittent scrolls, contain a frieze of alternating hexagonal and rhomboidal cartouches formed by intertwining fillets. The cartouches have a foliate ground set with representations of peacocks, hares, gazelles, birds of prey, ducks, griffins, harpies and sphinxes, as well as those of princes, warriors, falconers, banqueters, musicians and merchants. Detailing was achieved by paint on a gesso ground, as is shown in some traces. Almost identical carved boards (two in Cairo, Coptic Mus.; one in New York, Met.) once decorated the convent of St. George (Deir Mari Girgis) in Old Cairo.

Marquetry, a very different technique, was used in contemporary Syrian woodwork. Large panels were typically formed of angular interlacing strapwork radiating from central stars. The earliest extant example (1091–2) is the minbar ordered by the Fatimid vizier Badr al-Jamali for the shrine of Husayn at Ascalon (later transferred to Hebron, mosque of Abraham). The triangular fields on either side of the minbar are decorated with a geometric interlace of hexagons and hexagrams delineated by scrolled bands, and the interstices are filled with richly carved delicate arabesques. Turned-work panels form the railings on either side of the stairs.

Marquetry soon became popular in Egypt, where two masterpieces were produced—the portable wooden mihrab made for the shrine of Sayyida Nafisa in Cairo (1138–47; Mus. Islam. A.) and the minbar ordered by the vizier al-Salih Tala'i' for the 'Amri Mosque at Qus in 1155–6. The slender niche of the mihrab is carved with strapwork and lacy arabesques and is set within a rectangular field delineated by inscriptions in floriated Kufic. Within the rectangular field grooved laths intersect to form a geometric pattern of stars, elongated hexagons and T-shapes; the interstices are filled with arabesque motifs which are similar to those in the niche and contrast sharply with the molded strapwork patterns. On the minbar at Qus, patterns based on a similar hexagonal system of strapwork and stars cover the whole of each side. The grooved moldings intersect but do not overlap, and the angular strapwork contrasts sharply with the curved arabesque filler motifs.

The finest marquetry, however, was apparently produced in Syria at ALEPPO, where several masters

and their sons signed works. The mihrab (1167–8) of the Maqam Ibrahim in the citadel of Aleppo is the work of Ma'ali ibn Salam, who used three different patterns for the frame, semi-dome and lower niche, each striking in its boldness. Most of the rest of the woodwork in the building has perished: the lintels over the windows had similar patterns, but the most intricate was on a panel above a side door, which had strapwork revolving around 11-pointed rather than the usual 8-, 10- or 12-pointed stars. Such complexity was never repeated again. Ma'ali's son Salman was one of four artisans from the same Aleppan workshop who signed the minbar (destr.) made in 1168–9 for the Aqsa Mosque in Jerusalem. Commissioned by Nur al-Din, the ZANGID ruler of Aleppo, in anticipation of taking Jerusalem from the Crusaders, the minbar was moved there by his nephew Salah al-Din (Saladin) after he captured the city in 1187. The extensive use of inlaid ivory, both for the outlines of the polygonal figures and for some of the smaller interstitial stars, predates by a century the similar use of ivory on Mamluk minbars (see §II, B below).

The wealth of woodwork in the mausoleum of Imam al-Shafi'i in the southern cemetery of Cairo (1211; see CAIRO, §III, F) exemplifies the ways in which wood was used and decorated under the Ayyubids. The cenotaphs, screens, doors, coffers, friezes, beams, brackets, pendentives and dome are all made of wood; the finest piece is the cenotaph of al-Shafi'i himself (see CENOTAPH), which Salah al-Din commissioned in 1178. It is signed by 'Ubayd ibn Ma'ali, who probably came from the Aleppan family responsible for the mihrab in the Maqam Ibrahim and the minbar in the Aqsa Mosque. The overall design, the inscriptions and especially the floriate polygons are of the highest quality, and it outshines Salah al-Din's own cenotaph in Damascus (1195). Shafi'i's mausoleum was commissioned by Salah al-Din's nephew al-Kamil in honor of his mother, who was also buried there; her cenotaph, together with several pieces of a surrounding screen (Cairo, Mus. Islam. A.), is still extant. Apart from a magnificent openwork Kufic inscription which ran around the upper part (largely destr.), al-Kamil's mother's cenotaph is a pale reflection of that of al-Shafi'i made three decades earlier. Three pairs of doors from the mausoleum of al-Shafi'i also survive: one, on the inner face of the present entrance, has a radiating strapwork pattern; another (Cairo, Mus. Islam. A.) consists of large rectangular panels, exquisitely carved with arabesques, but juxtaposed in the manner of earlier Fatimid woodwork. The doors of the original entrance, now a window, could easily be mistaken for those of a century earlier, but the octagonal wooden coffers above them are the first in a series that continued through later Mamluk architecture. A wooden frieze ran around the dome chamber above the dado, connecting the projecting beams from which oil lamps were suspended; both the beams and the frieze are carved with an exuberant floriated Kufic script on a spiral background.

What little Iraqi woodwork survives from this period shows that woodworkers continued the traditions of carving seen in the 9th century (see §1 above). A pair of 12th-century doors from the mosque of Nabi Jirjis in Mosul (2.3×0.62 m; Baghdad, Iraq Mus.) is richly decorated with foliated Kufic inscriptions and fine arabesques reminiscent of the earlier style associated with Takrit. A tamarisk-wood minbar ordered in 1153 for the al-'Amadiya Mosque in a village near Mosul (2.5×0.96 m; Baghdad, Iraq Mus.) is decorated with rather coarse marquetry and arabesque panels carved in a retardataire Beveled style. The raised polygonal plaques on the rear are separated by wide flat bands that follow the geometric contours of the plaques; this is the first appearance of a feature found in many later tile mosaic panels. An inscription on a panel parallel to the handrails states that it was the work of three Georgians: 'Ali ibn al-Nahi, Ibrahim ibn Jami' and 'Ali ibn Salama. A mulberry-wood cenotaph was ordered by the Abbasid caliph al-Mustansir in 1227 for the tomb of Musa al-Kazim (d. 799), the seventh imam of the Twelver Shi'ites (0.95×2.62×1.95 m; Baghdad, Iraq Mus.). Rectangular panels on the sides are deeply carved with elegant foliated and knotted Kufic inscriptions within finely carved arabesque borders.

M. van Berchem: "La Chaire de la Mosquée d'Hébron et le martyrion de la tête de Husain à Ascalon," *Festschrift Eduard Sachau* (Berlin, 1915), pp. 298–310

M. van Berchem: *Jérusalem*, Mém.: Inst. Fr. Archéol. Orient. Caire, xliv/2 (1927), ii/2 of *Syrie du Sud*, Mat. Corp. Inscrip. Arab., pt. ii (Cairo, 1920–27), pp. 393–402

J. David-Weill: *Les Bois à épigraphes jusqu'à l'époque mamlouke* (Cairo, 1931)

E. Pauty: *Les Bois sculptés jusqu'à l'époque ayyoubide* (Cairo, 1931)

G. Wiet: "Les Inscriptions du mausolée de Shāfi'ī," *Bull. Inst. Egyp.*, xv (1933), pp. 167–85

C. J. Lamm: "Fatimid Woodwork, its Style and Chronology," *Bull. Inst. Egyp.*, xviii (1935), pp. 59–91

B. Fransis and N. Naqshbandi: "Al-āthār al-khashab fī Dār al-āthār al-'arabiyya" [Woodwork in the Arab Museum], *Sumer*, v (1949), pp. 55–64

E. Herzfeld: *Inscriptions et monuments d'Alep*, Mém.: Inst. Fr. Archéol. Orient. Caire, lxxvi/1–2 (1955–6), ii of *Syrie du Nord*, Mat. Corp. Inscrip. Arab., pt. ii (Cairo, 1909–56), pp. 121–8

L. A. Mayer: *Islamic Woodcarvers and their Works* (Geneva, 1958)

S. Dīhwahjī: "Jāmi' al-Nabī Jirjīs fī'l-Mawṣil" [The Mosque of Nabi Jirjis in Mosul], *Sumer*, xvii (1960), pp. 100–12

M. Jenkins: "An Eleventh-century Woodcarving from a Cairo Nunnery," *Islamic Art in the Metropolitan Museum of Art*, ed. R. Ettinghausen (New York, 1972), pp. 227–40

S. Z. al-Kawākibī: "Minbar al-Masjid al-aqṣā" [The minbar of the Aqsa Mosque], *Majallat 'Adiyat Ḥalab*, iv–v (1978–9), pp. 31–66

M. F. Abu Khalaf: *The Early Islamic Woodwork in Egypt and the Fertile Crescent* (DPhil. thesis, Oxford U., 1985)

C. Williams: "The Qur'anic Inscriptions on the Tabut of al-Husayn in Cairo," *Islam. A.*, ii (1987), pp. 3–14

E. Anglade: *Musée du Louvre: Catalogue des boiseries de la section islamique* (Paris, 1988)

G. T. Scanlon: "Medieval Egyptian Wooden Combs: The Evidence from Fustat," *Arab and Islamic Studies in Honor of Marsden Jones*, ed. T. Abdullah and others (1997), pp. 13–38

A. Contadini: *Fatimid Art at the Victoria and Albert Museum* (London, 1998), chap. 5

M. Cyran: "Re-discovered Carved Panels of the Fatimid Palaces," *L'Egypte fatimide: Son art et son histoire: Actes du colloque organisé à Paris … mai 1998*, pp. 658–63

E. J. Grube: "A Painted Wooden Lid in the al-Sabah Collection in Kuwait," *Cairo to Kabul: Afghan and Islamic Studies Presented to Ralph Pinder-Wilson*, ed. W. Ball and L. Harrow (London, 2002), pp. 113–122

J. M. Bloom: *Arts of the City Victorious: The Art and Architecture of the Fatimids in North Africa and Cairo* (London, 2008)

J. M. Bloom: "Woodwork in Syria, Palestine, and Egypt during the 12th and 13th Centuries," *Ayyubid Jerusalem: The Holy City in Context 1187–1250*, ed. R. Hillenbrand and S. Auld (London, forthcoming)

B. Iran and Central Asia. The history of woodwork in the eastern Islamic lands before the Mongol invasions of the mid-13th century can be pieced together from textual references and a few surviving pieces. Woods such as walnut, plane, juniper, birch, box and erica (Arab. *khalanj*) were available in the mountain forests south of the Caspian Sea and in Central Asia. Cities such as Amul, Rayy, Qum and Isfahan were known for the production of ladles, combs, plow-handles, scales, bowls, platters and deep plates. Few of these everyday objects have survived, but a small turned bowl (diam. 60 mm) datable to the 11th or 12th century was excavated at Ribat-i sharaf in northeast Iran. It is decorated with polychrome Lacquer depicting seven seated figures. Wood was also used in the construction of buildings and for architectural furnishings, and the motifs and style of carving are analogous to decorative schemes found in architectural surface ornament, metalwork and textiles of the same period. A 10th-century history of the city of Qum stated that the tomb of a descendant of Imam Ja'far was built of wood, and it is possible that the decorative brickwork of such structures as the 10th-century mausoleum of the Samanids in Bukhara (*see* Bukhara, §II, A) reflects earlier wooden construction. The earliest datable pieces are architectural fragments that have been incorporated in later buildings, but they come from such a broad geographical region and so few are dated that it is impossible to arrange them stylistically. Many are decorated in the Beveled style, which remained in vogue well into the 14th century.

Surviving pieces include columns, capitals, beams, mihrabs, minbars, doors, grilles and panels. Several columns, capitals and fragments have been found in village mosques in the Zarafshan Valley in the mountains of Tajikistan. The columns are decorated with carving in the Beveled style in horizontal bands just below the capitals. The capital from Oburdon (Tashkent, Aybek Hist. Mus.) supported four consoles carved with vegetal elements. Columns from the congregational mosque at Khiva show a wide variety of styles. Four columns decorated with geometric strapwork patterns are inscribed with the name of the patron Abu Fadl Muhallabi, and the style of the simple Kufic script suggests a date *c.* 1000. Other columns with finely carved basket- or bell-shaped capitals probably date from the late 11th century or the 12th. Three mihrabs have survived. One (1103) in the winter prayer-hall of the Maydan Mosque at Abyana in central Iran, has a mortised frame containing an arched recess and rectangular panels carved in a variety of styles, particularly the Beveled style (see fig. 2). The two undated mihrabs have panels of varying shapes set side by side. That from Iskodar in the Zarafshan Valley is probably 11th century because of its simple Kufic script; that from the mosque of Shah Muhyi'l-Din in Charkh-i Logar in Afghanistan is somewhat later. Both illustrate the amalgamation of decorative motifs from such diverse media as brick, stucco, textiles and metalwork. The mosque at Abyana also preserves a minbar dated 1073 and two wooden capitals attributed to the same date, all finely carved in the Beveled style. The undated minbar at Muhammadiyya near Na'in probably belongs to the same period.

Tomb furnishings were often of wood. If genuine, the earliest are five wooden panels ordered by the Buyid amir 'Adud al-Dawla in 974. Widely varying in size, shape and decoration, they are all inscribed in a similar plain Kufic script. The three largest (Cairo, Mus. Islam. A., and ex-Rabinou priv. col.), which bear the date and patron's name, are carved in a rather flat style and have gabled fields bordered by undulating stems filled with a foliate motif similar to Sasanian palmettes, a pattern derived from early Islamic vine scrolls. The two smaller ones (Cairo, Mus. Islam. A., and ex-Acheroff priv. col.), inscribed with similar litanies, have keel-shaped arches surrounding deeply cut vegetal arabesques, reminiscent of contemporary Syrian work. A few other funerary pieces are attributed to Buyid patronage (e.g. a cenotaph in Jerusalem, Israel Mus.), but the authenticity of some (e.g. a pair of doors, Washington, DC, Freer) has also been questioned. The finest surviving ensemble from the period is a set of two folding doors from the tomb of Mahmud of Ghazna (*d.* 1030) in Afghanistan, which were transferred to the Agra Fort in 1842. The interior face of each of the four panels consists of a plain mortised frame set with seven squares. Each square, carved in a late version of the Beveled style, is framed with a narrow band of beveled ornament, which is a condensed and abstracted version of that found on the larger 'Adud al-Dawla panels. The carving on the rectangular panels on the exterior, like the smaller ones ordered by 'Adud al-Dawla, adds new elements: the sinuous lines are carved in deep relief, the palmettes are rhythmical and symmetrical, and the whole design is marked by an unprecedented sense of plasticity. Despite their certain provenance from Mahmud's tomb, it is unclear whether the doors were installed at the time of his death or in the 12th century during a revival of interest in his cult.

See also Central asia, §VIII, G.

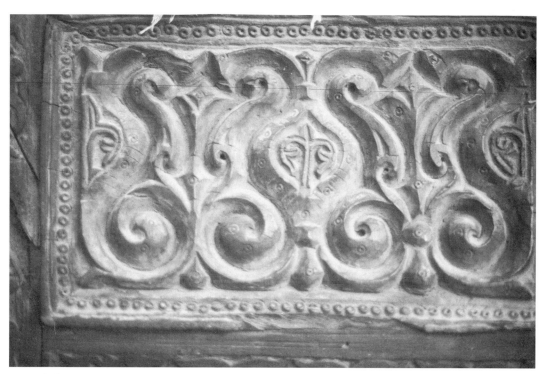

2. Detail of Beveled style wood-carving from minbar, Maydan Mosque, Abyana, Iran, *c.* 1073; photo credit: Sheila S. Blair and Jonathan M. Bloom

S. Flury: "Das Schriftband an der Türe des Mahmud von Ghazna (998–1030)," *Der Islam*, viii (1918), pp. 214–27

G. Wiet: *L'Exposition persane de 1931* (Cairo, 1933), no. 6

Hasan ibn Muhammad Qumi: *Tārikh-i Qum* [History of Qum], ed. S. J. Tihrani (Tehran, AH 1313/1934), p. 225

B. Deniké: "Quelques monuments de bois sculptés au Turkestan occidental," *A. Islam.*, ii (1935), pp. 69–83

M. B. Smith: "Minbar: Masdjid-i Djami', Muhmammadiyè," *Athar-é Iran*, i (1936), pp. 175–80

V. L. Voronina: "Reznoye derevo Zarafshanskoy doliny" [Wood-carving of the Zarafshan Valley], *Materialy & Issledovaniya Arkheol. SSSR*, xv (1950), pp. 210–20

R. Ettinghausen: "The 'Beveled Style' in the Post-Samarra Period," *Archaeologica Orientalia im Memoriam Ernst Herzfeld*, ed. G. C. Miles (Locust Valley, NY, 1952), pp. 72–83

B. Brentjes: "Zu einigen samanidischen und nachsamanidischen Holzbildwerken des Seravschantales im Westen Tadshikistans," *Cent. Asiat. J.*, xv (1971), pp. 295–7

A. S. Melikian-Chirvani: "Un Chef-d'oeuvre inconnu dans une vallée afghane," *Conn. A.*, cccviii (1977), pp. 76–9

M. Kiani, ed.: *Robat-e Sharaf* (Tehran, 1981), pp. 45–53, figs. 1–3, pls. 1–7 [Eng. summary, pp. 6–7]

S. S. Blair: *The Monumental Inscriptions from Early Islamic Iran and Transoxiana* (Leiden, 1992)

B. Brentjes: "Holzsäulen in der Soghdischen und Islamischen Architektur Mittelasiens," *Archäol. Mitteil. Iran*, xxv (1992), pp. 333–64

J. Golmohammadi: "Woodwork," *Islamic Period*, ed. C. Parham, iii of *The Splendour of Iran*, ed. E. Booth-Clibborn (London, 2001), pp. 210–23

S. Khmel'nitskii: *Chorku: Amir Khamza khasti podsho: Drevneishee dereviannoe zdanie srednei Azii s reznym i skul'ptumyn dekorom* [Chorku: the complex of Amir Hamza: Medieval Wooden Carved Sculpture from Central Asia] (Berlin, 2002)

K. von Folsach: "A Number of Pigmented Wooden Objects from the Eastern Islamic World," *J. David Col.*, i (2003), pp. 72–96

C. Spain and North Africa. The forests of the Iberian peninsula and northwest Africa provided abundant timber, particularly pine, walnut, cypress and some other types, for example alerce (sandarac tree); these woods were used for architectural fittings and furniture. The remains of mosque ceilings, doors and minbars provide the best evidence for technical and stylistic developments in woodwork in this area, but wooden structures can occasionally be deduced from their equivalents in stone or plaster. The principal centers of woodwork production were Córdoba and Seville (in Spain) and Fez (in Morocco).

The Rustamid rulers of central North Africa (*r.* 761–909) erected a wooden hypostyle mosque (771; destr.) in their capital at Tahart (now in Algeria), and Idris I (*r.* 789–93) ordered an inscribed wooden minbar for his mosque (790) at Tlemcen (also in Algeria) to which his son Idris II (*r.* 793–828) added another inscription. However, the oldest extant woodwork in the region is the minbar (862–3) in the Great Mosque at Kairouan (see fig. 3). This minbar and a later example from Córdoba were the models for most

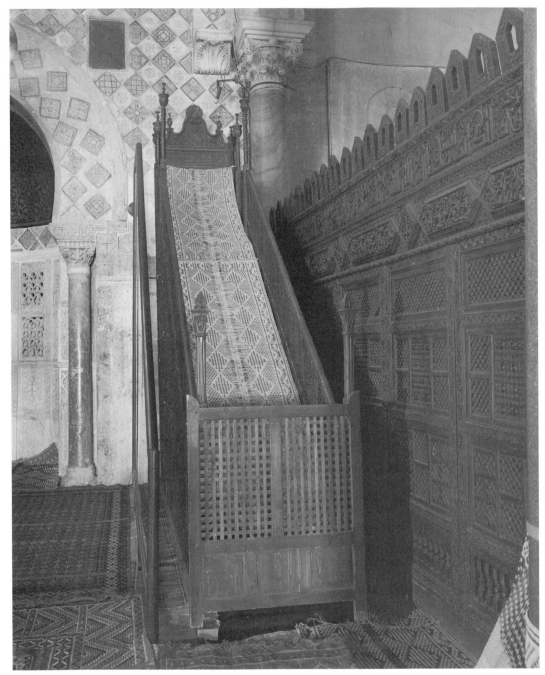

3. Minbar, carved cedar wood, in the Great Mosque of Kairouan, 3.31×3.93 m, from Tunisia, 862–3; photo credit: Erich Lessing/ Art Resource, NY

later minbars in the western Islamic world. Several of the ceiling beams from the Kairouan mosque are tree trunks boxed in with planed cypress planks. Some of these planks, reused in the 11th century, preserve 9th-century decoration of brightly painted, regularly repeating composite vegetal and floral motifs.

The oldest surviving pieces of woodwork from Islamic Spain are two ceiling beams (Granada, Mus. N. A. Hispmus.) from Córdoba, decorated with carved floral and geometric patterns and dating from the caliphate of 'Abd al-Rahman III (r. 912–61; see UMAYYAD, §II, B, 1). When his son al-Hakam II (see UMAYYAD, §II, B, 2) enlarged the mosque at Córdoba in 965, a flat ceiling was formed by boards attached to horizontal beams, the ends of which were covered by wooden boxes. The ornamental ceiling

was protected by a gabled roof. The boards were carved and painted, over which were superimposed separate carved and painted pieces; like many contemporary crafts, these show design elements imported from Iraq. Wooden vaults may also have been the prototypes for the unusual rib-vaulted stone cupolas added to the mosque in 965. Decorative stone corbels over the door known as the Bab al-Wuzara (now Puerta de San Esteban; 785–7) and in what is now commonly known as the Salón Rico at MADINAT AL-ZAHRA, the caliphal residence outside Córdoba, further indicate a developed tradition of wooden roof construction. Archaeological remains from Madinat al-Zahra show that wood was used for gabled roofs, single, double and folding doors, windows and cupboards, which were often decorated with brass sheets and nail heads. According to chronicles, a new minbar and *maqsura* were made for the mosque of Córdoba in *c.* 965, but the only 10th-century minbar preserved is a Fatimid example in the mosque of the Andalusians in Fez, for which in 979–80 the Umayyad minister al-Mansur ordered a new back (probably made in Córdoba). The original minbar had been severely damaged, and al-Mansur also had it repaired with a panel imitating the original work, composed of closely set turned balusters and a new backrest. It was restored again in the 14th century in Marinid times.

No 11th-century wooden ceilings have survived in Spain, but their existence can be judged from a plaster version in the Aljafería Palace in Saragossa, which has a fascia board and a double row of corbels with floral decoration. It resembles contemporary work in Toledo. The 11th-century ceiling of the congregational mosque of Kairouan had carved and painted panels, as well as deeply carved and richly painted consoles. The most important example of 11th-century woodwork is the magnificent wooden *maqsura* (restored 1625) that the ZIRID ruler al-Mu'izz ibn Badis (*r.* 1016–62) ordered for the mosque. Enclosing a 6×8 m area to the right of the minbar, it consists of a rectangular framework, heavily carved with arabesques and supporting grilles of turned spindles and spools; these are crowned with a magnificent foliated kufic inscription and pierced merlons. Some of the panels have beveled carved ornament (a style that had developed at Samarra in Iraq in the 9th century), while the letters and vegetation enclosed by a continuous raised bead are distinctively Zirid.

Under the Almoravids (*r.* 1056–1147) the ornamental ceiling of planks suspended below the gabled roof was eliminated from mosque architecture. The congregational mosque (1136) at TLEMCEN preserves the oldest surviving example of decorated rafters, tie-beams and brackets. At the mosque of the Qarawiyyin (1134–43) at Fez the brackets are decorated with serpentine forms. The doors of the mosque are covered with plain metal bands or geometric designs in a manner already used in 10th-century Spain. Painted friezes with floral and epigraphic decoration and fragments of corbels, one of them with pierced

carving (Granada, Alhambra), were discovered on the Mauror Hill in Granada, Spain. A door at the monastery of Las Huelgas in Burgos shows very fine interlocked geometric decoration with individual pieces decorated with delicate foliage, a technique found on several important Almoravid minbars surviving in North Africa. The minbar from Nédroma in Algeria (late 11th century; Algiers, Mus. N. Ant.) is decorated with adjoining squares. That in the congregational mosque in Algiers (1097) has square panels of relief-carved arabesque set in a framework like that of the minbar of the mosque of the Andalusians in Fez. The finest is the minbar made in Córdoba *c.* 1120 for the mosque of 'Ali ibn Yusuf in Marrakesh in Morocco, which the Almohads (*r.* 1130–1296) then transferred to the Kutubiyya Mosque (Marrakesh, Bahia Palace; see color pl. 3:XVI, fig. 1). The sides have an all-over strapwork frame of ivory and wood intarsia; the elaborate geometric design is based on interlocking squares, which at the corners form eight-pointed stars, themselves surrounded by four further eight-pointed stars. The risers of the stairs are decorated with an exquisite strapwork of pearl bands defining horseshoe arcades. The minbar made for the mosque of the Qarawiyyin in Fez in 1143 uses the same techniques on the sides but the risers are somewhat simpler.

Similar strapwork patterns appear for the first time on some of the wooden ornamental ceilings of the Almohad Kutubiyya Mosque in Marrakesh (1162). The galleries of the Almohad Mosque of Seville, however, had gabled ceilings with crossbeams, great eaves on the gateway into the courtyard (restored in 1975), and its door lined with metal strapwork and molded hexagonal pieces and four-pointed stars with kufic inscriptions and foliate designs. Its bronze knockers, with palm leaves and cursive inscriptions, are exceptional pieces. The *Mudéjar* door of the principal portal to the mosque at Córdoba was a copy of this one, also covered with metal plaques in a geometric design, the individual pieces decorated with foliate designs and epigraphy.

S. Flury: *Islamische Schriftbänder Amida-Diyarbekr XI. Jahrhundert. Anhang: Kairuan, Mayyafariqin, Tirmidh* (Basle, 1920), pp. 35–44

G. Marçais: *Coupole et plafonds de la grande mosquée de Kairouan* (Tunis, 1925)

G. Marçais: "Note sur la chaire à prêcher de la Grande Mosquée d'Alger," *Hespéris*, vi (1926), pp. 419–22

F. Hernández Jiménez: "Arte musulmán: La techumbre de la Gran Mezquita de Córdoba," *Archv Esp. A. & Arqueol.*, iv (1928), pp. 191–225

H. Basset and H. Terrasse: *Sanctuaires et forteresses almohades* (Paris, 1932), pp. 234ff

K. A. C. Creswell: *Early Muslim Architecture*, ii (Oxford, 1940)

L. Torres Balbás: *Arte almohade; arte nazarí; arte mudéjar*, A. Hisp., iv (Madrid, 1949)

M. Gómez-Moreno: *El arte árabe español hasta los Almohades; arte mozárabe*, A. Hisp., iii (Madrid, 1951)

H. Terrasse: *La Mosquée des Andalous à Fès* (Paris, [*c.* 1952])

L. Torres Balbás: *Artes almorávide y almohade*, Arte y Artistas (Madrid, 1955)

F. Hernández Jiménez: "El almimbar móvil del siglo X de la mezquita de Córdoba," *Al-Andalus*, xxiv (1959), pp. 381–99

L. Torres Balbás: "Arte hispanomusulmán hasta la caída del califato de Córdoba," *Historia de España*, ed. R. Menéndez-Pidal, v (Madrid, 1965)

H. Terrasse: *La Mosquée al-Qaraouyin à Fès* (Paris, 1968)

Ibn Sahib al-Sala: *Al-mānn bil imāma* (Valencia, 1969)

H. Terrasse: "Un Bois sculpté du XIIe siècle trouvé à Marrakech," *Al-Andalus*, xl (1969), pp. 419–20

A. Fernández-Puertas: "Tabla epigrafiada de época almorávide o comienzos de la almohade," *Misc. Estud. Arab. & Heb.*, xx (1971), pp. 109–12

A. Fernández-Puertas: "Tabla epigrafiada almohade," *Misc. Estud. Arab. & Heb.*, xxi (1972), pp. 77–86

A. Fernández-Puertas: "Tablas epigrafiadas de época almorávide y almohade," *Misc. Estud. Arab. & Heb.*, xxiii (1974), pp. 113–19

A. Fernández-Puertas: "Las puertas chapadas hispanomusulmánas," *Misc. Estud. Arab. & Heb.*, xxix–xxx (1980–81), pp. 163–76

A. Fernández-Puertas: "Dos vigas califales del Museo Nacional de Arte Hispanomusulmán," *Homenaje al Prof. Dario Cabanelas Rodriguez, of. m., con motivo de su LXX aniversario* (Granada, 1987), pp. 203–40

J. M. Bloom and others: *The Minbar from the Kutubiyya Mosque* (New Haven, 1998)

II. After c. 1250. Wood continued to be scarce and expensive in the Islamic lands around the Mediterranean, and virtually all the woodwork produced in the area after *c.* 1250, from furniture to ceilings, is based on the assemblage of small pieces. In the eastern Islamic lands large timbers continued to be available for use in structures, fittings and furnishings, but the taste for geometric compositions based on small wooden units also spread to these regions: although it was not functionally requisite, large panels were often carved to resemble assemblages of small pieces. Lattice-like screens of turned wood (Arab. *mashrabiyya* or *al-shimāsa*; Sp. *ajimeces*) became widespread. Painting often replaced carving as the primary decorative technique, and other techniques, such as inlay and Lacquer were used to enhance surfaces.

A. Spain and North Africa. B. Egypt and Syria, *c.* 1250 to *c.* 1500. C. Anatolia, *c.* 1250 to *c.* 1500. D. Ottoman Empire after *c.* 1500. E. Yemen. F. Iran and Central Asia. G. India.

A. Spain and North Africa. The art of woodwork continued to flourish after 1250 in Spain, under the Nasrid rulers (1230–1492), who took Granada in 1238, and in North Africa, particularly under the Marinid dynasty (*r.* 1196–1549) of Fez and the Abdalwadids of Tlemcen (in Algeria; *r.* 1236–1550). As in earlier periods, stylistic and technical developments are best seen in the joined ceilings of palaces and mosques and in liturgical furniture. During this period the interlaced patterns introduced earlier became so complex that they often completely hide the underlying structure.

Ornamental wooden ceilings (Artesonado), which had first been developed under the Almoravid dynasty (*r.* 1056–1147), reached their apogee between the 13th and the 15th century. The mosque of Sayyidi ibn al-Hasan (Sidi Bel Hasan; 1296) at Tlemcen retains only a portion of its original ornamental ceilings of pieces of cedar, but the late 13th-century ceiling of the Cuarto Real de S. Domingo (Dar al-Manjara al-Kubra) in Granada has magnificently colored interlaced designs between its rafters. In the Alhambra in the same city the portico of the early 14th-century Palacio del Partal has a flat ornamental wooden ceiling (*armadura ataujerada*) with small *mocárabes* vaults (*muqarnas* in eastern Arab lands) and a central carved polygonal ceiling. At the Generalife to the northeast of the Alhambra, a flat wooden ceiling has decorated background paneling and interlaced patterns. Inspired by the work of several centuries earlier in Córdoba are the ceilings of the rooms in the Generalife and in the Alcázar Genil (1319) to the south of Granada, with their respective interlaced and superimposed designs, which appear to float above a projecting cornice of plaster *mocárabes*, ultimately the evolution of the boxes that cover the ends of the beams, at the mosque at Córdoba. The masterpiece of Islamic geometric design in wood is the ceiling of the throne-room in the Palacio de Comares (first half of the 14th century) in the Alhambra. It is supported on a richly painted *mocárabes* cornice, and each of its four sides consists of three inclined planes. These 12 planes culminate in a horizontal panel supporting a small *mocárabes* vault. Over 8000 individual elements are joined in a design of seven concentric bands of alternating large and small stars, which probably represents the seven heavens of paradise described in the Koran (Sura 67). The bulbous wooden ceilings in the projecting pavilions of the Patio de los Leones (1380s) may also have had cosmic or zodiacal meanings. Hemispherical ceilings on a larger scale, such as the Hall of the Ambassadors in the Alcázar of Seville (1427), were also built by *Mudéjar* artisans, who until the 17th century produced thousands of ornamental wooden ceilings.

Carved wood was used extensively for corbels, lintels, eaves, spandrels and entablatures, and joined panels were employed for doors, shutters and lattice-like screens (*ajimeces*). Nasrid eaves have upturned rafters and corbels, whereas many Marinid and some *Mudéjar* eaves have horizontal rafters and corbels (e.g. the Montería in the Alcázar of Seville). The eaves of the façade of the Palacio de Comares in the Alhambra are perfectly proportioned to their setting and are unsurpassed in their size, magnificent carving and coloring. Nasrid, Marinid and *Mudéjar* doors were lined with metal bands or metallic pieces; they were of plain wood with decorative nails; or they had interlaced geometric designs with colored pieces that were either plain or carved or had superimposed carving (e.g. the Puerta de la Justicia, the façade of the Palacio de Comares and the Patio de los Leones in

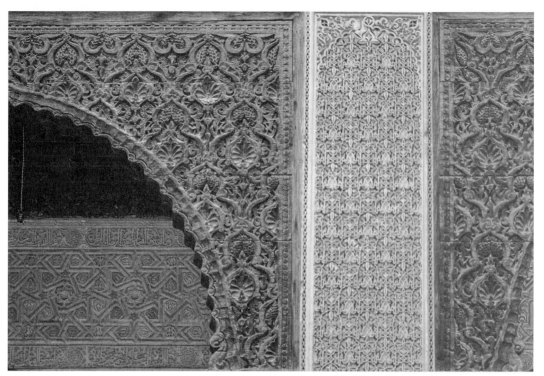

4. Carved wood on courtyard façade, 'Attarin Madrasa, Fez, 1323–5; photo credit: Sheila S. Blair and Jonathan M. Bloom

the Alhambra respectively). Particularly fine Marinid ensembles are the interior façades of the 'Attarin (1323–5; see fig. 4) and Bu 'Inaniyya madrasas (1350–55) in Fez in Morocco and the Bu 'Inaniyya madrasa in Meknès (c. 1345), also in Morocco.

Other wooden elements were lattice grilles and balustrades with turned or interlaced decoration. The mosque of the Qarawiyyin in Fez retains the wooden 'anaza, an auxiliary mihrab in a grille in the court façade of the prayer-hall, placed there in 1289. Although its exterior surface is heavily weathered, the interior preserves its inlaid interlace decoration and kufic inscriptions. The library added to the mosque in 1350 is decorated with a fine set of wooden fixtures and a decorated ceiling. Several important examples of liturgical furniture are preserved in the mosque of the Andalusians in Fez. The earliest is a wooden mihrab (1307) inserted in the 'anaza (restored). It is finely carved in shallow relief with scalloped arches and imbricated designs characteristic of architectural decoration. The door to the imam's room (15th century) combines panels of shallow relief with grilles of turned spindles, and the contemporary balustrades of the staircases to the Mosque of the Dead display a vigorous hexagonal interlace.

Marinid minbars, such as the minbar of the mosque at Taza in Morocco, continue the proportions and techniques of strapwork decoration established in earlier centuries and suggest the form of vanished Nasrid minbars. Although earlier minbars had contrasting carved and inlaid decoration, both the strapwork and the polygons on the minbar at Taza are decorated with

ebony and ivory inlays. The same woodworking technique used for the Marinid minbars—carved and inlaid with ivory, bone, silver, ebony or other fine woods—was used for objects made for Nasrid royal palaces. Among those that have survived are the richly decorated door cupboards (Granada, Mus. N. A. Hispmus.) from the Cetti Merien Palace (destr.), which are inlaid with bone, silver and precious woods in superimposed networks of hexagons and six-, eight- and twelve-pointed stars. Many wooden boxes and jewel caskets with flat or hipped lids are similarly covered in geometric patterns of bone and wood inlay. A folding chair, with a leather seat and back, also made for a royal patron (Granada, Mus. N. A. Hispmus.), has a wooden X-frame richly covered by intarsia of repeated polygons with inserted stars made of silver, bone and precious-colored woods. Another wooden royal item, a sultan's scepter (now at Alcalá de Hernares), consists of decorated wooden and bone spools held on a metal rod core.

M. Gómez-Moreno: *La ornamentación mudéjar toledana/ Mudejar Ornamental Work in Toledo* (Madrid, 1924)

L. Torres Balbás: "Hojas de puerta de una alacena en el Museo de la Alhambra de Granada," *Al-Andalus*, iii (1935), pp. 438–42

J. Fernandis Torres: "Muebles hispanoárabes de Taracea," *Al-Andalus*, v (1940), pp. 459–65

M. Gómez-Moreno: "El bastón del Cardenal Cisneros," *Al-Andalus*, v (1940), pp. 192–5

L. Torres Balbás: "El más antiguo alfarje conservado en España," *Al-Andalus*, ix (1944), pp. 441–8

L. Torres Balbás: "Ajimeces," *Al-Andalus*, xii (1947), pp. 415–27

L. Torres Balbás: *Arte almohade; arte nazarí; arte mudéjar*, A. Hisp., iv (Madrid, 1949)

H. Terrasse: *La Mosquée des Andalous à Fès* (Paris, [*c.* 1952])

G. Marçais: *L'Architecture musulmane d'occident* (Paris, 1954)

H. Terrasse: *La Mosquée al-Qaraouiyin à Fès* (Paris, 1968)

A. Fernández-Puertas: *El lazo de ocho occidental o andaluz: Su trazado, canon proporcional, series y patrones* (Granada and Madrid, 1975)

A. Prieto y Vives: *El arte de la lacería* (Madrid, 1977)

D. Cabanelas: *El techo del Salón de Comares en la Alhambra* (Granada, 1988)

S. Chmelnizkij: "Methods of Constructing Geometric Ornamental Systems in the Cupola of the Alhambra," *Muqarnas*, vi (1989), pp. 43–9

A. Fernández-Puertas: *The Alhambra*, 2 vols. (London, 1996)

P. J. Lavado Paradinas: *Talleres mudéjares castellano leoneses* (Tomar, 1996)

E. Nuere: "El lazo en la carpintería española," *Madrid. Mitt.*, xl (1999), pp. 308–36

J. Abellán Pérez: "Influencias orientales en las viviendas jerezanas (siglo XV): Los ajimeces," *Aragón en la Edad Media*, xiv–xv (1999), pp. 19–25

V. Herrera Ontañón and B. Cabañero Subiza: "La techumbre mudéjar de la iglesia de San Millán de Segovia: Estudio de una obra maestra del arte taifal digna de ser recuperada," *Artigrama*,xiv (1999), pp. 207–40

C. Cambazard-Amahan: "Le travail du bois," *Maroc: Les trésors du royaume, 15 avril–18 juillet 1999: Paris*, pp. 146–51

J. J. Barranquero Contento: "La carpintería de armar española: Perviviencias mudéjares en los dominios de la Orden de Santiago durante el siglo XVI," *Mudéjares y moriscos, cambios sociales y culturales: Actas IX Simposio Internacional de Mudejarismo, Teruel, 12–14 de septiembre de 2002*, pp. 255–63

J. García Nistal: "Tradición y modernidad: Dos ejemplos de carpentería de lo blanco del siglo XVI en la provincia de León," *Mudéjares y moriscos, cambios sociales y culturales: Actas IX Simposio Internacional de Mudejarismo, Teruel, 12–14 de septiembre de 2002*, pp. 275–83

M. I. Alvaro Zamora: "Las artes decorativas mudéjares," *Los mudéjares en Aragón*, ed. Gonzalo M. Borrás Gualis, Colección "Mariano de Pano y Ruata," 23 (Saragossa, 2003), pp. 187–210

E. Nuere Matauco: "El techo del Salón de Comares," *Cuad. Alhambra*, xl (2004), pp. 103–21

B. Egypt and Syria, *c.* 1250–*c.* 1500. Despite its perennial scarcity in Egypt and Syria, wood continued to play an essential role in religious and secular architecture after the establishment of the Mamluk sultanate (1250–1517). Imported from as far away as the Sudan and India, it was used for structural elements such as ceilings and domes and fixed and portable furnishings such as window grilles and shutters, minbars and Koran stands. Decorative techniques of earlier periods, such as painting, carving, turning and joining, continued to be used, although techniques based on assemblages of small pieces of wood were increasingly important, and painting replaced carving as the major means of decorating ceiling planks.

Turned and carved grilles and marquetry strapwork (Arab. *qanāt*) designs, known as early as the 11th century, increased in popularity after *c.* 1250, perhaps due to the scarcity of wood for paneling, although the fitting together of small pieces also helped to combat shrinkage and warping in the hot, dry climate of Egypt. The new taste for interlacing strapwork designs composed of small polygonal panels can be explained in the same way: they could be fitted together without a noticeable break in the pattern more easily than could the carved arabesques. Inlaid ivory, bone, ebony and other woods often provided additional color.

Following the precedent of the dome over the mausoleum of Imam al-Shafi'i (1211; restored 1480; *see* §I, A, 2 above), wood remained the choice material for the largest domes in Cairo: those of the mosque of Baybars (1269; *see* Cairo, §III, G) and the mausoleum of Sultan Hasan (1362; *see* Cairo, §III, I) and the mausoleum of Sultan Barquq (1386; incorrectly restored in brick). Wood, usually painted, was also used for ceilings, for *muqarnas* cornices and pendentives and for inscription bands. Turned and joined wooden screens and grilles provided privacy or shade in both secular and religious architecture, and *mashrabiyya* grilles enclosed cenotaphs and partitioned off prayer-halls and tomb chambers in religious architecture. The earliest and finest wooden ensemble is preserved in the mausoleum and madrasa of Sultan Qala'un (1284–5; *see* Cairo, §III, H). The great corridor has a ceiling of light transverse beams supporting longitudinal planks, the whole resting on a cornice. The beams are carved with a delicate arabesque design that is hardly visible at a distance, despite its painted highlights. A *mashrabiyya* screen nearly 4 m wide and pierced with two doors composed of alternating diagonal grid and baluster sections guards the entrance to the mausoleum, in which splendid *mashrabiyya* screens, added by Qala'un's son, al-Nasir Muhammad, enclose the cenotaph and divide the interior. Coffered wooden ceilings (restored) cover eight sections of the ambulatory around the cenotaph. The large amount of wood needed to accomplish this work led to the reuse of 11th-century wood-carvings from the "Western" Palace that previously occupied the same site. A room behind the mihrab in the 9th-century mosque of Ibn Tulun in Cairo (restored after 1296) has distinctly un-Egyptian wooden corbels that may be the work of Muslim craftsmen who had fled the Christian reconquest of Spain.

The best guide to the stylistic evolution of woodwork during this period is the series of dated minbars produced in Syria and Egypt under Mamluk patronage. The high proportion of signed examples indicates the esteem in which the craft was held, although the names do not usually indicate the relationship between craftsmen, as occasionally happened in earlier times. The first Mamluk sultan, Baybars I (*r.* 1260–77), commissioned a minbar (destr.) from Abu Bakr ibn Yusuf for the mosque of the Prophet in Medina. The earliest, and one of the finest, minbars extant was ordered by Sultan Lajin for the mosque of Ibn Tulun

(1296; see color pl. 3:XVI, fig. 3). Made of sycomore, teak and ebony, it has been extensively restored, but many of the original plaques (many in London, V&A) show that the arabesque carving of the polygons varied from piece to piece, inviting contemplation of the design from near as well as from afar. This feature derives almost certainly from the minbar (destr.) commissioned in 1168–9 by Nur al-Din for the Aqsa Mosque in Jerusalem. The Cairo minbar is also the first extant example to display the bulbous dome over the seat that was to become a characteristic feature of Mamluk minbars. The almost contemporary minbar ordered by Qarasunqur for the Great Mosque of Aleppo (c. 1300) and made by Muhammad ibn 'Ali, a craftsman from Mosul, shows a much greater use of ivory inlay, a feature that appeared slowly in Cairene minbars but became common in numerous examples produced under Qa'itbay (r. 1468–96). For all the technical virtuosity, however, the exact repetition of the arabesque pattern in each polygon has a certain mechanical feel, although the perfect integration of the interlace pattern into the triangular field shows great sensitivity to design. Minbars were major collaborative efforts: that ordered by Kitbugha for the congregational mosque of Hama in Syria was signed by 'Ali ibn Makki and 'Abdallah Ahmad in 1302; it was inlaid by Abu Bakr ibn Muhammad and decorated by 'Ali ibn 'Uthman. Ahmad ibn 'Isa, who signed the minbar made for the mosque of al-Ghamri in Cairo (c. 1446; later transferred to the complex of Sultan Barsbay), attempted to enliven the ubiquitous interlacing angular strapwork by consistently curving the lines radiating from the 12-pointed stars. He also signed a minbar made in 1480–81 for the madrasa of Abu Bakr ibn Muzhir in Cairo and is thought to have been responsible for the minbars sent to Mecca by the sultans Khushqadam in 1462 and Qa'itbay in 1475. When angular and curving strapwork is combined, as in the minbar of the mosque of Abu'l-'Ila in Cairo (c. 1485), the effect is awkward.

Other items of mosque furniture displaying intricate ivory and colored wood inlay include Koran boxes and kursīs, a name used for both large lecterns on which Koran readers sat and small tables. The hexagonal table and Koran box from the madrasa of Khwand Baraka, the mother of Sultan Sha'ban, in Cairo (1368–9; Cairo, Mus. Islam. A.) are particularly fine. The table is covered with large inlaid panels of interlace designs, while the box is inlaid with marquetry designs in ivory, ebony and tin. A Koran box and small folding Koran stand (raḥla) bearing the name of Sultan al-Ghawri (r. 1501–16; Cairo, Mus. Islam. A.) show a change in taste at the end of the era. The box is painted with a central medallion and four quarter medallions in the corners. The medallions are decorated with gold lotus leaves and arabesques on a black ground, clearly showing the impact of Persian bookbinding. The stand, on which the only decoration is a three-line inscription boldly inlaid with ivory, shows a return to simplicity which is found in some contemporary Ottoman woodwork (see §D below).

S. Lane-Poole: The Art of the Saracens in Egypt (London, 1886/R n.d.), pp. 111–50

J. David-Weill: Les Bois à épigraphes depuis l'époque mamlouke (Cairo, 1936)

E. Kühnel: "Der mamlukische Kassettenstil," Kst Orients, i (1950), pp. 55–68

H. 'Abd al-Wahhāb: "Tawqī'āt al'ṣunnā' 'alā āthār Miṣr al-islāmiyya" [Craftsmen's signatures on Islamic Egyptian works of art], Bull. Inst. Egypte, xxxvi (1953–4), pp. 533–58

E. Herzfeld: Inscriptions et monuments d'Alep, Mém.: Inst. Fr. Archéol. Orient. Caire, lxxvi/1–2 (1955–6), ii of Matériaux pour un Corpus inscriptionum arabicarum; deuxième partie: Syrie du Nord (Cairo, 1909–56), pp. 168–71

Exhibition of Islamic Art in Egypt (exh. cat., ed. A. Hamdy and others; Cairo, Semiramis Hotel, 1969), pp. 217–48

G. S. Ohan: Cairene Bahri Mamluk Minbars, with a Provisional Typology and a Catalogue (MA thesis, Amer. U., Cairo, 1977)

Renaissance of Islam: Art of the Mamluks (exh. cat. by E. Atıl; Washington, DC, Smithsonian Inst., 1981), pp. 195–210

L. Hunt: "The al-Muallaqa Doors Reconstructed: An Early Fourteenth-century Sanctuary Screen from Old Cairo," Gesta, xxviii/1 (1989), pp. 61–77

C. ANATOLIA, c. 1250–c. 1500. The ready availability of fine timber in Anatolia allowed painted and carved woodwork to be used freely for structural elements in mosques, houses and pavilions. The few examples that survive from the period before 1250 are included below, as only in the period between c. 1250 and c. 1500 are enough examples preserved to begin delineating the development of woodworking in the area.

Elaborate joinery was used for furnishings, especially minbars in mosques. Unusually wide boards were employed for shutters, doors and the sides of minbars; sometimes they were carved with centralized compositions, but often they were carved with strapwork patterns in imitation of joinery. Inlay was introduced towards the end of the period and soon replaced the earlier techniques.

Many mosques had wooden structural elements such as columns, capitals, beams and consoles and furnishings such as window-shutters and doors. They were painted with stylized foliate and floral motifs and geometric patterns in red, dark blue, yellow and white. Typical examples are the congregational mosques (Turk.: Ulu Cami) at Afyon (1272), Sivrihisar (1274) and Ayas (13th century) and the Arslanhane Mosque at Ankara (1289–90). In rare cases painted wood was also used for mosque furniture. An unusual lacquered wooden lectern (1278; Konya, Mevlana Mus.) is decorated with a double-headed eagle and lion over a field of arabesques on the inner sides of which the Koran was placed.

The side panels for minbars were usually made with interlocking pieces. Tongue-edged lozenges, octagons and stars carved with arabesques are joined by grooved frames without glue or pins, a technique known in Turkish as kündekâri. The pieces were set with the grain perpendicular to the grain of the frame to prevent

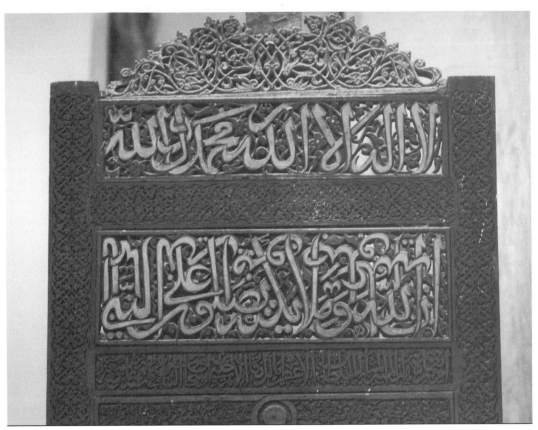

5. Carved wooden panel with inscription, from the minbar of the Friday Mosque, Manisa, Turkey, *c.* 1370–80; photo credit: Walter B. Denny

warping, and the joined panels were further supported on a wooden substructure. Earlier examples such as the minbars from the mosque of Alaeddin in Konya (1155–6) and the congregational mosques of Siirt and Malatya (both 13th century; Ankara, Mus. Ethnog.) have angular pieces. Those from the 14th century, such as the minbars from the congregational mosques at Birgi (1322), Manisa (1376; see fig. 5) and Bursa (1499), have finer, more intricate and shallower carving and are decorated with large rosettes and bosses. This joinery technique demanded meticulous workmanship to make the tongues and grooves fit tightly, so it was often imitated by carving a single board in relief with lozenges, octagons and stars. The boards were mounted side by side on the frame of the minbar, but warping and shrinkage eventually caused the joints to open and interrupt the strapwork patterns. Minbars in such "false joinery" are found in the mosque of Alaeddin at Ankara (1197–8), the congregational mosques at Kayseri (1237) and Divriği (1228–9) and the Arslanhane Mosque at Ankara (1289–90). A few later examples from the 14th and 15th centuries, such as the minbar from the Ahi Elvan mosque in Ankara (1382), are much simpler in technique, for both the frame bands and the strapwork panels have been glued or pinned to boards.

Woodwork from this period is deeply carved. The Beveled style that had been popular in Egypt, Syria and Iraq (*see* §II, A, 1 above) is rare, although there are exceptional examples (e.g. the 13th-century minbar from the congregational mosque at Malatya; Ankara, Mus. Ethnog.). Geometric, floral and arabesque motifs were carved in flat relief, while inscription bands had rounded contours and seem to float on the arabesque ground. The inscriptions often mention the artisan. Hacı Mengimberti, for example, carved the minbar in the mosque of Alaeddin in Konya (1155–6), and 'Abdallah ibn Mahmud al-Naqqash made the doors for the mosques at Kasaba Köyü (1366) and Ibni Neccar (1367) outside Kastamonu. Latticework was commonly used for the balustrades of minbars and the pedestals of lecterns.

Inlay was first used for small panels in the second half of the 14th century and quickly became popular. The 15th-century doors from the mosque of Hacı Bayram in Ankara (Ankara, Mus. Ethnog.) are inlaid with ivory and wood, and the walnut doors from the mosque at Balıkesir built by Zağanos Pasha, vizier to the Ottoman sultan Mehmed II (*c.* 1460; Istanbul, Topkapı Pal. Mus.), are inlaid with ivory, boxwood and metal wire.

B. Ögel: "Selçuklu devri ağaç işçiliği hakkında notlar" [Notes on Anatolian woodwork of the Seljuk period], *Yıllık Araştırmalar Derg.*, i (1956), pp. 199–220

K. Otto-Dorn: "Seldschukische Holzsäulenmoscheen in Klei-
nasien," *Aus der Welt der islamischen Kunst: Festschrift für
Ernst Kühnel* (Berlin, 1959), pp. 59–88

M. Z. Oral: "Anadolu'da sanat değerleri olan ahşap minberler,
kitabeleri ve tarihçeleri" [Wooden minbars of artistic value
in Anatolia, their inscriptions and histories], *Vakıflar Derg.*,
v (1962), pp. 23–77

Ç. Çulpan: *Türk-Islam tahta oymacılık sanatında rahleler* [Koran
stands in Turkish Islamic wood-carving] (Istanbul, 1968)

G. Öney: "Die Techniken der Holzschnitzerei zur Zeit der Seld-
schuken und während der Herrschaft der Emirate in Anato-
lien," *Sanat Tarihi Yıllığı*, iii (1969–70), pp. 299–305

Y. Demiriz: "XIV. yüzyılda ağaç işleri" [Woodwork in the
14th century], *Yüzyıllar boyunca Türk sanatı* [Turkish art
through the centuries], ed. O. Aslanapa (Istanbul, 1977),
pp. 61–71

G. Öney: "Architectural Decoration and the Minor Arts," *The
Art and Architecture of Turkey*, ed. E. Akurgal (Fribourg,
1980), pp. 201–3

Anadolu medeniyetleri/The Anatolian Civilisations, iii: *Seljuk/
Ottoman* (exh. cat., ed. Ş. Aykoç and others; Istanbul,
Topkapı Pal. Mus., 1983), pp. 86–94

D. OTTOMAN EMPIRE, AFTER C. 1500. By the early
16th century, wood itself was not considered a
sufficiently spectacular material for furniture in the
imperial mosques of the Ottoman Empire. Joined
wood was replaced by other materials with painted and
carved decoration recalling the treatment of wood-
work. The minbar of the Süleymaniye Mosque in
Istanbul (1557), for example, was made of Proconne-
sian marble. Instead, luxury wooden objects—thrones,
chests and musket stocks inlaid with ivory, precious
metals, mother-of-pearl and tortoiseshell and encrusted
with hardstones—were produced in small numbers
for the Ottoman court (see color pl. 3:X, fig. 1).

Furniture of superlative quality and considerable
individuality was already being made for the court by
the early 16th century. The most famous piece is a
hexagonal walnut chest for a 30-part Koran made by
Ahmed ibn Hasan Kalibî Fânî (*ḳālibî*: "maker of
musket stocks") in 1505–6 for the mosque of Sultan
Bayezid II (Istanbul, Mus. Turk. & Islam. A., 3). The
exterior is veneered with ebony, encrusted with ivory
panels and inset with fine marquetry. It is the earliest
dated piece of furniture in the Ottoman court style,
but a walnut quiver (Istanbul, Topkapı Pal. Mus.,
1/10463) is similarly veneered and richly inlaid. A
variety of sources can be suggested for this early 16th-
century monumental furniture. Elaborately inlaid
musical instruments were produced in Iran in the
late 15th century and the early 16th, to judge from
miniature paintings and registers. Many were proba-
bly taken to Turkey as booty, as were small artifacts
such as a carved sandalwood casket made for the
Timurid ruler Ulughbeg (*d.* 1449), which was prob-
ably reworked in Istanbul (Istanbul, Topkapı Pal.
Mus., 2/1846; see 1989 exh. cat., no. 49). Northern
Italian marquetry was highly developed by 1500, and
its smooth, high finish and angular meander borders,
whether single, double or plaited, would have
appealed to Ottoman taste. A combined reading

stand and chest-of-drawers, possibly a calligrapher's
table, from the mausoleum of Sultan Ahmed I
(*r.* 1603–17; Istanbul, Mus. Turk. & Islam. A., 33),
for example, combines elongated cross motifs similar
to the openwork on a north Italian comb (London,
V&A, 4229.1857) with a medallion and corner
pieces taken from a pattern used in bindings. Another
source was Mamluk Egypt: such Ottoman pieces as
the preacher's chair in the Süleymaniye Mosque and
the cenotaph and canopy dated 1543–4 in the tomb
of Şehzade Mehmed in Istanbul have elaborate mean-
der borders like those on Koran chests and stands
made in Egypt in the 14th and 15th centuries. The
materials used in Mamluk work, however, were of far
lower quality.

Later 16th-century woodwork evolved indepen-
dently and rather strangely. A square Koran box
installed by Sultan Mahmud I (*r.* 1730–54) in the
library of Hagia Sophia was probably made in the
reign of Süleyman the Magnificent (1520–66; Istan-
bul, Mus. Turk. & Islam. A., 5). Veneered in ebony,
ivory and mother-of-pearl, its sides have rectangular
panels with central medallions and corner pieces.
Cusped skirting between the legs repeats the profile
of the panel decoration in contrasting materials. The
cover, originally surmounted by a large knob-finial, is
boldly inlaid with a chevron design with a frieze of
palmettes and hexagons at the top.

Mother-of-pearl, used earlier for inlay, was also
inlaid itself. A polygonal Koran box with a large dome
made of hardwood veneered with ivory, dark woods
and mother-of-pearl was found in the mausoleum of
Sultan Mehmed III at Hagia Sophia (*d.* 1603; Istan-
bul, Mus. Turk. & Islam. A., 13). The mother-of-
pearl rosettes on the lid were themselves inlaid with
foliate tracery in black mastic and bear the remains of
gold settings for jewels. Even more elaborate are the
bejeweled mother-of-pearl stars at the center of star-
polygon compositions on the sides of a tall domed
Koran chest from the mausoleum of Sultan Selim II
(*d.* 1574; Istanbul, Mus. Turk. & Islam. A., 2). It is
made of hardwood veneered with ebony, ivory,
mother-of-pearl and marquetry panels of these and
reddish boxwood, yellow metal and silver wire.

Tortoiseshell was also incorporated into veneered
decoration. A pair of doors in the pavilion in the
Harem at Topkapı Palace in Istanbul built by Sinan
for Sultan Murad III in 1578–9 have ingeniously
varied panels of minute marquetry (allegedly in
mahogany, lead and tin as well as ebony and ivory)
and veneer in ivory, ebony, mother-of-pearl and tor-
toiseshell, this last set over gold foil to give it added
glitter. Technically similar is a tall hexagonal Koran
chest inlaid with tortoiseshell and mother-of-pearl
found in the mausoleum of Sultan Mehmed III
(Istanbul, Mus. Turk. & Islam. A., 19). It is signed by
the court architect Ahmed Dalgıç, who also signed a
pair of wooden doors for the mausoleum, which are
magnificently inlaid with mother-of-pearl. His dual
role of architect and woodworker is explained by the
fact that one of the court architect's duties was to
provide models of projected buildings.

Fewer signed or attributable masterpieces were produced after the 16th century. The canopied throne executed under Ahmed Dalgıç's successor, Mehmed Ağa, for Sultan Ahmed I (Istanbul, Topkapı Pal. Mus., 1/1652) is made of walnut inlaid with mother-of-pearl floral sprays on a tortoiseshell ground. To increase the brilliance, the inlay is nailed to the wood over silver foil and encrusted with peridots, rubies and turquoises. It is more sumptuous but not more novel than the shutters and door panels for the two pavilions, the "Baghdad Kiosk" (1635) and the "Revan Kiosk" (1639–40), built by Sultan Murad IV in the Topkapı Palace, or the canopied throne of St. James the Lesser in the Armenian Patriarchate of St. James in Jerusalem (1656). In the 17th century the quality of both technique and materials declined, although wooden stocks of firearms continued to be made (see ARMS AND ARMOR, §II, A). Those captured in the field are not of very high quality and must have been mass-produced. They are inlaid with ivory (often stained), mother-of-pearl and ring-and-dot ornament in brass wire, studded with brass or, occasionally, encrusted with hardstones. Arms now in Wawel Castle in Kraków, for example, show that the decorative repertory was close to that of monumental furniture. The minute marquetry typical of 20th-century bazaar craftsmanship in Turkey, Syria and Egypt may date from a revival of this craft in 18th-century Syria.

Wood was also used for the interior decoration of domestic buildings. Although huge numbers have been destroyed by fire, many examples from the 18th and 19th centuries survive in former Ottoman towns such as Plovdiv in Bulgaria. Rooms in traditional homes such as the house of Nur al-Din in Damascus (1707; New York, Met.) had wooden paneling and ceilings painted and gilded, usually on a gesso ground, with raised designs of abstract and floral patterns, poems and architectural vignettes.

C. Kerametli: "Osmanlı devri agaç işleri: Tahta oyma, sedef, bağ ve fildişi kakmaları" [Woodwork of the Ottoman period: wood-carving and incrustation with mother-of-pearl, ivory and tortoiseshell], *Türk Etnog. Derg.*, iv (1961), pp. 5–13

E. Yücel: "Osmanlı agaç işçiliği" [Ottoman woodwork], *Kült. ve Sanat*, v (1977), pp. 58–71, 190–91

J. M. Rogers: "The State and the Arts in Ottoman Turkey: Part ii: The Furniture and Decoration of Süleymaniye," *Int. J. Mid. E. Stud.*, xiv (1982), pp. 283–313

Anadolu medeniyetleri/The Anatolian Civilisations, iii: *Seljuk/Ottoman* (exh. cat., ed. Ş. Aykoç and others; Istanbul, Topkapı Pal. Mus., 1983), pp. 154–7, 196–8

J. M. Rogers: "Osmanische Holzarbeiten," *Türkische Kunst und Kultur aus osmanischer Zeit* (exh. cat., Frankfurt am Main, Mus. Ksthandwerk, 1985), pp. 320–32

C. Köseoğlu and J. M. Rogers: *The Topkapı Saray Museum: The Treasury* (Boston, 1987), pp. 187–8

The Age of Sultan Süleyman the Magnificent (exh. cat. by E. Atıl; Washington, DC, N.G.A.; Chicago, IL, A. Inst.; New York, Met.; 1987–8), pp. 166–72

Süleyman the Magnificent (exh. cat. by J. M. Rogers and R. M. Ward; London, BM, 1988), pp. 156–63

S. Alp: "The Ornamental Repertoire of Ottoman Art on Wood and Stucco Decoration during the Age of Çelebi Mehmed," *Art turc/Turkish Art: Proceedings of the 10th International Congress of Turkish Art: Geneva,17–23 September 1995*, pp. 67 74

H. Ö Barışta: "Wood Decoration on the Frontage of Late Ottoman Houses in Central and South Central Anatolia," *The Ottoman House: Papers from the Amasya Symposium, 24–27 September 1996*, ed. S. Ireland and W. Bechhoefer, British Institute of Archaeology at Ankara Monograph, 26 (London, 1998), pp. 110–14

S. Triki: "La décoration insolite des portes de la cour de la Grande Mosquée de Sfax: Etude plastique et esthétique," *Actes du IIème Congrès du Corpus d'Archéologie Ottomane dans le Monde sur: Architectures des demeures* (1998), pp. 151–83

"Living Wood," *Culture and Arts*, iv of *The Great Ottoman–Turkish Civilisation*, ed. K. Çiçek (Ankara, 2000)

S. M. Sharif: "Ceiling Decoration in Jerusalem during the Late Ottoman Period: 1856–1917," *Ottoman Jerusalem, the Living City: 1517–1917*, ed. S. Auld and R. Hillenbrand (London, 2000), pp. 473–8

J. W. Allan and M. Abu Khalaf: "The Painted Wooden Ceiling in the Inner Ambulatory of the Dome of the Rock," *Ottoman Jerusalem, the Living City: 1517–1917*, ed. S. Auld and R. Hillenbrand (London, 2000), pp. 465–72

N. Harīthī: *Aʿmāl al-khashab al-miʿmārīyah fī ʾl-Ḥijāz fī ʾl-ʿAṣr al-ʿUthmānī* [Woodwork in the Hijaz in the Ottoman period] (Riyad, 2002)

A. Shādiyah al-Dasūqī: *Al-Akhshāb fī ʾl-ʿamāʾir al-dīnīyah bi-al-Qāhira al-ʿUthmānīya* [Wood in Religious Works in Ottoman Cairo] (Cairo, 2003)

E. YEMEN. Wood was used for fine architectural fittings and furnishings throughout the region, but the fragility of the material makes it difficult to trace the history of traditional woodworking techniques, which disappeared in the middle of the 20th century. Wood was used in domestic architecture for doors, window-frames, shutters and grilles. In religious architecture it was used for ceilings and such furnishings as cenotaphs and minbars. The antiquity of this tradition is indicated by wooden ceilings in the great mosque at Sanʿa, where the four bays at the west end of the northern prayer-hall (?10th century) are elaborately coffered and painted. Abyssinian cordia was preferred for exterior doors, as it is resistant to insects and water, but acacia and jujube were also used. Tamarisk was used for tool handles, locks, spoons, mortars and pestles, and fruit woods—for example apricot, pomegranate, pear and nut—were used for such turnings as waterpipes. Mustard-seed oil or paints based on it were applied as preservatives. Various techniques of joinery created large planks, which were painted or carved in relief, with either a vertical or a beveled cut. Screens were made of pierced planks, crossed laths or turned work. Wood was also inlaid with mother-of-pearl, ivory and colored woods, and the effect of the finest pieces approaches marquetry.

Doors, which mark the boundary between public and increasingly private spaces, are set with the more

important decoration visible to the visitor to denote the prestige of the owner. Outer doors are often massive affairs of planks joined side by side and decorated with metal knockers and nails, the heads of which are shaped like stars, cones and hemispheres. Inner doors often have rectangular frames around three rectangular panels, two horizontal ones above and a vertical one below. Sometimes each valve may have more than a dozen panels. The rectangular panels are decorated with oval medallions and cartouches, carved in a range of vegetal, geometric and epigraphic motifs, and occasionally animals and birds.

Window openings are covered with shutters, screens and flaps and sometimes have projecting grilles of wood. The use of grillework may go back to pre-Islamic times, to judge from a medieval Islamic description of the palace of Ghumdan in pre-Islamic San'a, although the two earliest examples of grillework to survive are the wooden lunette grille in the great mosque at SAN'A (1110–1230) and the wooden screen in Ashrafiyya Madrasa in Ta'izz (1397–1401). Lattice-like screens of turned wood (Arab. *mashrabiyya*) were only introduced to the Yemen in the 20th century from Egypt and the trading cities of the Red Sea coast; they replaced projecting oriel windows of brick and stone.

The earliest wooden cenotaphs, such as that of Sayyida in the mosque at Dhu'l-Jibla (1088–9), are simple rectangular solids decorated with inscriptions, but later examples are more elaborate constructions with a rectangular socle more than 1 m high surmounted by a smaller rectangular middle section and a cross-shaped upper story with a pitched roof and polygonal domed aedicule at the crossing. The cenotaph in the Abhar Mosque at San'a for the imam al-Mansur al-Husayn (*r.* 1727–48) has a framework decorated with vegetal *rinceaux* enclosing nearly 100 carved and pierced panels showing geometric, arabesque and epigraphic ornament. The tomb of al-Mutawakkil (*r.* 1716–27) in the corner of the mosque he erected in San'a is enclosed within an L-shaped wooden screen of seven units. Six of the units have four registers of openwork panels; the central panel in the second register is a window to allow the cenotaph to be seen. The seventh unit is a double door. The cenotaph itself follows the model of that erected for al-Mansur al-Husayn, except that the pitched roof is bowed. The tomb is dated by inscription to 1741 and was built by al-Mansur to honor his father. Al-Mansur's son Mahdi 'Abbas (*r.* 1748–75) also erected a magnificent cenotaph. It follows the standard type, but is distinguished by ogive arches on the gable ends, a dome over the aedicule and sumptuous painted decoration which highlights the splendid pierced carving of the panels. In the mosque at Sa'da the cenotaph (18th or 19th century) for Yahya al-Hadi (854–911), the first ZAYDI imam of the Yemen, has eliminated the middle story and replaced the openwork panels of the socle with horizontal cartouches carved with inscriptions in the Ottoman style.

R. B. Serjeant and R. Lewcock: *San'a': An Arabian Islamic City* (London, 1983)

M. Schneider: "Les Inscriptions arabes de l'ensemble architectural de Zafar-Di Bin (Yemen de Nord)," *J. Asiat.*, cclxxiii (1985), pp. 61–137, 293–369

G. Bonnenfant and P. Bonnenfant: *L'Art du bois à Sanaa: Architecture domestique* (Aix-en-Provence, 1987); Arab. trans. as *Fann al-Zakhrafah al-khashabiyah fi San'a: al-'imarah al-sakaniyah* (Dmascus, 1996)

S. Ory, B. Maury, and C. Robin: *De l'or du sultan à la lumière d'Allah: La Mosquée al-'Abbas à Asnaf (Yémen)* (Damascus, 1999)

T. Wöhrli: *Hölzerne Hastüren im Jemen* (Wiesbaden, 1999)

M. V. Fontana: "The Painting on Yemenite Wooden Ceilings," *Al-Masar*, 2 (2000), pp. 34–41

F. IRAN AND CENTRAL ASIA. After *c.* 1250 wood continued to be used in the eastern Arab lands for functional items such as combs and bowls, for construction purposes and for fixed and movable furnishings. Many more examples survive from this period, so that regional styles and chronological developments can be discerned. While carving continued to be the primary means of decoration, much painted woodwork has also survived. The palmettes and rosettes used in vegetal ornament were replaced by the acanthus, lotus and vine as arabesques became increasingly geometricized and polygonal figures, particularly eight-pointed stars, became more important.

The two most important pieces surviving from the early 14th century are minbars in the congregational mosques of NA'IN and ISFAHAN. The example in Na'in (1311) was ordered by a merchant and was signed by the "designer" (Arab. *naqqāsh*) Mahmud Shah ibn Muhammad from Kirman. Of typical form and size (h. 5.22 m, w. 1.05 m., d. 3.19 m.), it is made of jujube wood. The triangular sides are composed of rectangular panels within a mortised frame. The panels and frame are carved with shallow Beveled style arabesques, the balustrade is a lattice of interlaced octagons, and larger raised panels with stellate designs are used for emphasis on the canopy and the lintel. The minbar in Isfahan has complex octagonal tracery designs and fine intaglio-carving. It can be attributed to approximately the same date, as it is similar in size and form to the minbar in Na'in, although it lacks a canopy. The carving on the geometric panels resembles that from Na'in, but the decoration includes two new elements that are also found in contemporary architectural decoration in carved stucco: inscriptions in a stylized square Kufic script and naturalistic leaves in high relief. Many of these features can be found on other contemporary pieces, such as the doors to the mosque in the shrine of Bayazid al-Bistami (1307–9) at BISTAM; a group of cenotaphs from the area around SULTANIYYA, the Mongol capital in northwest Iran (early 14th century), and a folding Koran stand dated 1359 (see fig. 6). They all show great technical ability and a rich decorative repertory; the Koran stand, in particular,

6. Carved wooden Koran manuscript stand by Hasan ibn Sulayman al-Isfahani, h. 1.30 m, from Iran, 1360 (New York, Metropolitan Museum of Art, Rogers Fund, 1910 (10.218)); image © The Metropolitan Museum of Art/Art Resource, NY

Following Timur's campaigns in western Iran, Iraq and Syria, he forcibly moved craftsmen to Central Asia to work on his new buildings. Multi-level floral and arabesque carving continued throughout the 15th century and transferred to other media, such as stone. A door in New York (Met.; 2.05×0.76 m) is carved with large blossoms on arabesque scrolls in a manner reminiscent of late 15th-century tombstones.

In 15th-century Iran woodwork continued to be produced at a more modest level of patronage, and many contemporary innovations from Central Asia went unnoticed. Two pairs of doors (1427–8) survive at the mosque at Afushta near NATANZ in central Iran. One was donated by a local notable and the other is signed by the master Husayn ibn ʿAli, a woodworker and inlayer from Ubbad, a neighboring village. Each valve has the traditional tripartite division, but the carving is less lively and broad flat borders contrast sharply with the carved arabesque ground. The richly forested, but remote province of Mazandaran was a major woodworking center, and many of its mosques and shrines were fitted with carved wooden doors, shutters and cenotaphs. A cenotaph ordered in 1473 by a local ruler for the shrine of Abuʾl-Qasim (1.13×1.18×1.86 m; Providence, RI Sch. Des., Mus. A.) is signed by the masters Ahmad the carpenter and Hasan ibn Husayn. The shallow relief, geometric patterns and absence of vegetal arabesques recall work of previous centuries.

Much woodwork survives from the Safavid period, particularly from Isfahan, the city Shah ʿAbbas I made his capital in 1596–7. Palaces and pavilions, such as the ʿAli Qapu, Hasht Bihisht and Chihil Sutun (all 17th century; see ISFAHAN, §III, F–H) have wooden porticos (Pers. *tālār*) with columns made from the trunks of oriental planes (see fig. 7). The columns are hexagonal or octagonal and are crowned with wooden *muqarnas* capitals. Columns and capitals were richly painted in tempera (Chihil Sutun, southern portico) or decorated with mirror mosaic (Chihil Sutun, eastern portico). Wooden ceilings were also richly ornamented. That of the Hasht Bihisht has geometric tracery composed of hexagons and eight-pointed stars, richly painted wooden panels (east and west porticos) and star-shaped mirrors, all meant to suggest the heavenly vault. Similarly, the ceiling of the great eastern portico of the Chihil Sutun was painted in blue with five-, eight- and ten-pointed stars. Wooden doors were frequently painted and varnished in the technique known as LACQUER, which was used on both leather and papier mâché. A pair of doors from the Chihil Sutun (h. 1.95 m; London, V&A) maintains the traditional tripartite composition but introduces figural scenes on the panels and floral arabesques for the frame.

Wooden grilles were used as balustrades and window screens. The two most frequent types are the rectangular grille surmounted by a pointed arch and the large grille composed of three or more movable panels. Both types use triangular, square or rectangular grids to create varied polygonal and stellate

has deeply undercut naturalistic flowers, inscriptions and arabesques worked on several levels. Perhaps the most unusual piece is the cenotaph of Esther from the mausoleum of Esther and Mordechai at Hamadan. All the decorative motifs and forms are typical of early 14th-century Persian woodwork except for the Hebrew inscription.

Superb craftsmanship was also known in Central Asia. A cenotaph for Yahya ibn Ahmad (d. 1336; Bukhara, Reg. Mus.), a grandson of the noted mystic Sayf al-Din Bakharzi, is remarkable for its fine execution and the variety of its decoration. Its rectangular panels are carved in varying relief with hexagonal and octagonal star patterns, vegetal arabesques and a polylobed arch resting on columns. Work of this quality continued under the Timurid dynasty (r. 1370–1506). Carved wooden doors are preserved from many of the major buildings the Timurids erected, including the shrine of Ahmad Yasavi (1397–9) in TURKESTAN and several buildings in SAMARKAND: the shrine of Qutham ibn ʿAbbas (1403–4) and the tomb of Tuman Aga (1404–5) in the Shah-i Zinda cemetery and the Gur-i Mir (1405; St. Petersburg, Hermitage). The typical valve has three rectangular fields: a larger vertical panel in the center with a smaller horizontal panel, often inscribed, above and below. Traces of paint indicate that the doors were once brightly colored. The doors to the tomb of Tuman Aga are the work of Sayyid Yusuf from Shiraz, and the unusual ivory and wood marquetry on doors from the Gur-i Mir is a technique previously associated with Syria and Egypt.

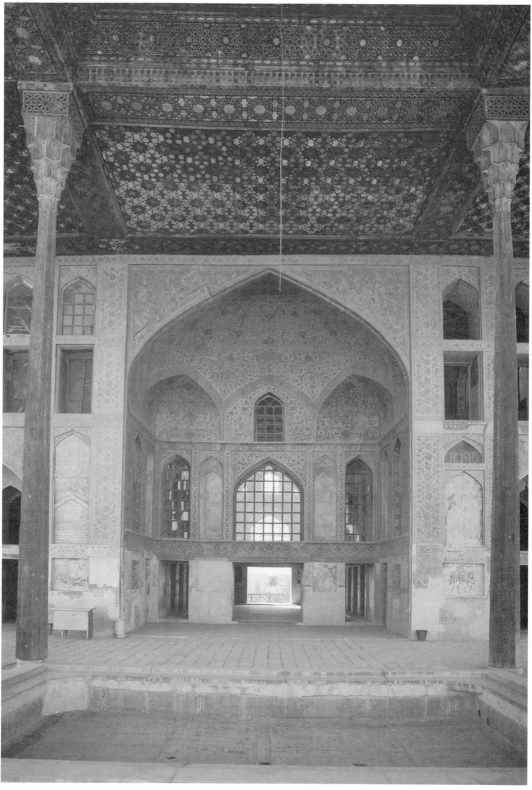

7. Columns made from the trunks of oriental plane trees, 'Ali Qapu Palace, Isfahan, 17th century; photo credit: Sheila S. Blair and Jonathan M. Bloom

shapes. Their initial simplicity and wide mesh differentiates them from the *mashrabiyya* work of Egypt and Syria (*see* §B above). The grilles of the great eastern portico of the Chihil Sutun have been restored on the basis of fragments found *in situ*. In later examples, the mesh is smaller, and the fillets are thinner, creating denser and more complex compositions in which stars and polygons proliferate. The central motif is often surrounded by narrow bands decorated with mirrors and covered in a fretwork of small pieces of wood. In the 18th century the decorative vocabulary of earlier times was repeated monotonously in fretwork and mosaic, but under the QAJAR dynasty (*r.* 1779–1924) the decorative motifs changed completely. The mesh widened, designs were simplified, and linear geometric patterns were relegated to subsidiary positions. Curvilinear designs predominated, creating floral patterns, as in the Anguristan House at Isfahan. These grilles were often decorated with mirrors and uncolored and colored glass.

Wood continued to be used for columns, grilles, doors and shutters in the religious and domestic architecture of Central Asia until the 19th century. The principal centers were Samarkand, Bukhara, Tashkent, Kokand and especially Khiva, where several mosques and palaces preserve extensive ensembles of carved wood. Most notable are the hypostyle halls and columnar porticos. The columns, which often rest on stone bases, are generally carved with horizontal bands of floral and spiral arabesques in low relief except at the base, which is carved in high relief with six ogival pendants surmounting a pear-like shape. Some have *muqarnas* capitals. The columns support corbelled brackets, carved beams and flat wooden roofs. Painted wooden ceilings are typical of important spaces. The tripartite compositions of earlier times are often found on carved doors, but other decorative schemes based on single large panels and many small panels were also used.

L. H. Rabino: *Mazanderan and Astarabad* (London, 1928)

B. Deniké: "Quelques Monuments de bois sculptés au Turkestan occidental," *A. Islam.*, ii (1935), pp. 69–83

A. Godard: "Natanz," *Athar-é Iran*, i (1936), pp. 104–6

M. B. Smith and P. Wittek: "The Wood Mimbar in the Masdjid-i Djami', Nain," *A. Islam.*, v (1938), pp. 21–35

L. Bronstein: "Decorative Woodwork of the Islamic Period," *A Survey of Persian Art*, ed. A. U. Pope and P. Ackerman (2/London, 1969), pp. 2607–27

R. Orazi: *Wooden Gratings in Safavid Architecture* (Rome, 1976)

A. D. H. Bivar and E. Yarshater, eds.: *Mazandaran Province, portfolio 1: Eastern Mazandaran—I* (1978), vi of *Persian Inscriptions down to the Early Safavid Period*, Corp. Insc. Iran., iv (London, 1977–)

L. Man'kovskaya: *Khiva* (Tashkent, 1982)

F. Noci: "Un antico minbar in legno della Masjid-i Jam'a di Isfahan," *Quad. Ist. Stud. Islam.*, ii (1982), pp. 1–12

G. Curatola: "Some Ilkhanid Woodwork from the Area of Sultaniyya," *Islam. A.*, ii (1987), pp. 97–116

Timur and the Princely Vision: Persian Art and Culture in the Fifteenth Century (exh. cat. by T. W. Lentz and G. D. Lowry; Washington, DC, Sackler Gal.; Los Angeles, CA, Co. Mus. A.; 1989), pp. 45–6, 206–8

E. J. Grube: "Notes on the Decorative Arts of the Timurid Period, II," *Islam. A.*, iii (1988–9), pp. 175–208

A. Nelibaev: *Afash oiu* (Almaty, 1994) [Wood-carving in Kazakhstan]

R. I. Qazilbash: "Decorative Woodwork in Muhallah Sethian," *J. Cent. Asia*, xix/1 (1996), pp. 1–114

E. J. Grube: "The World is a Garden: The Decorative Arts of the Timurid Period," *First Under Heaven: The Art of Asia*, ed. J. Tilden, Fourth Halı Annual (London, 1997), pp. 825; 182–4

J. Shifā'ī: *Hunar-i girih'sāzī dar mi'mārī va durūdgārī* [The art of strapwork in architecture and woodwork] (Tehran, 2001)

J. Golmohammadi: "Woodwork," *Islamic Period*, ed. Parham, iii of *The Splendour of Iran*, ed. E. Booth-Clibborn (London, 2001), pp. 210–23

Legacy of Genghis Khan: Courtly Art and Culture in Western Asia, 1256–1353 (exh. cat., ed. L. Komaroff and S. Carboni; New York, Met., Los Angeles, CA, Co. Mus. A.; 2002–3), nos. 175–6

R. Hillenbrand: "The Sarcophagus of Shah Ismā'īl at Ardabīl," *Society and Culture in the Early Modern Middle East: Studies on Iran in the Safavid Period*, ed. A. J. Newman, Islamic History and Civilization: Studies and Texts, 46 (Leiden, 2003), pp. 165–90

M. R. Pūja'far, R. Moosaviniyā and Q. Kiyānmahr: "Comparative Study of Principles of Safavid Wood Carving," *Anthology of Iranian Studies/Majmū'āt Maqālālāt muṭāla'āt Īrānī*, vii (2004), pp. 157–90

G. INDIA. The most durable and popular timbers, used throughout India, are teak (*Tectonia grandis*), shisham (*Dalbergia sissoo*) and rosewood (*Dalbergia latifolia*). Sandalwood (*Santalum album*) is valued for its fragrance and resistance to insects in the south and west, where it is used to make small household objects and carvings. Although ebony (*Diospyros ebenum*) is rare, it has traditionally been prized by Muslim craftsmen for carving ornamental combs, furniture, picture frames and walking sticks. In Kashmir, wooden buildings and carvings commonly employ Himalayan spruce (*Picea morinda*), walnut (*Juglans regia*) and deodar (*Cedrus deodara*). In this region, as in other Himalayan states, pine (*Pinus excelsa*) and Himalayan ash (*Fraxinus floribunda*) are often used. Other timbers traditionally used include acacia (*Acacia arabica*), nim (*Azadirachta indica*), tamarind (*Tamarindus indica*) and mango (*Mangifera indica*); mango is especially popular because of its ready availability and softness. Rattan and bamboo canes are also used.

Seasoning is usually done by keeping cut timber in the open air or, in the case of bamboo, water for several months or even years. To aid preservation, sesame oil is applied. Wooden objects are normally ornamented by carving the surface in low or high relief, by inlaying ivory, tin, bronze or silver into

grooves cut into the surface (sandalwood and ebony being most suitable for this purpose) or by veneering, painting or lacquering.

Punjab and the Himalayan states have an extensive tradition of wood-carving and timber construction owing to the ready availability of local timber, notably ash, spruce, pine, walnut and cedar (deodar). Houses in Kulu, Himachal Pradesh, have a lower story of stone and an upper story of wood, with balconies, sloping roofs supported on carved pillars and intricately carved ceilings and interiors. Hoshiarpur and other towns in the Punjab are known for furniture of deodar, rosewood and walnut, decorative pieces and small domestic items inlaid with bone or ivory. Kashmir is famous for its paneled domestic interiors, in which intricately carved panels, often of spruce, are attached by means of double-grooved battens to the walls and especially the ceilings. Outside, carved wooden façades feature windows of fine latticework skillfully joined by thin laths of wood carved with intricate geometric motifs. At the beginning of the 20th century, European influence encouraged woodcarvers in Kashmir to produce decorative boxes, screens and panels of walnut, which has a heavy dark grain ideally suited to decoration by undercutting. Owing to the importance of boats for transportation and communication in the region, boatmaking in Jammu and Kashmir has developed into a matchless skill. Made from planks of cedar, the various types of boats created for specific requirements include houseboats, transportation barges and slim, fast-moving passenger boats. In addition, Rajouri District, Jammu, is famous for fine combs of boxwood (*Buxus sempervirens*).

Apart from an established tradition of architectural woodwork, the western states of Gujarat and Rajasthan were and are prolific producers of wooden objects for household and ritual purposes. Carpenters who carved columns, pillars, brackets, doors, windows, niches, wall and ceiling panels, balcony railings and entire house façades also made chests, cabinets, jewelry boxes, benches, mortars and pestles, spice containers, measuring bowls, laundry beaters, hand mirrors, cradles and small tables. Occasionally pieces of mica or mirror were inlaid into the carved designs on decorated pieces. Brass-bound wooden chests and dowry boxes measuring up to 1 m long are a typical feature of Gujarati woodwork. Such objects as chests, cash boxes, spice containers, bread molds, opium grinders and cloth beaters were decorated with low-relief carvings of intricate geometric and floral patterns and motifs including interlocking circles, lotus medallions and diaper, dogtooth and chevron patterns. The arid climate of the region influenced the choice of timber for specific purposes: acacia (known as *babul* or *baval*) was used for building, khau (*Olea ferruginea*), lohero (*Tecoma undulata*) and nim for architectural woodwork and rosewood for small carved items. Acacia is also the chief wood used for lacquered objects such as bedsteads, mortars and pestles, chair legs, cradle legs, cotton reels, spindles, rolling pins, ladles and handles. At the residences of prosperous merchants (*hāvelī*s) extensive use is made of wooden framing and bonding in combination with brick walls, as well as intricate, delicately carved wooden façades, balconies and doors.

R. K. Trivedi: *Wood Carving of Gujarat*, Census of India 1961, v, pt. VII-A(2) (New Delhi, 1965)

M. S. Mate: *Deccan Woodwork*, Deccan College Building Centenary and Silver Jubilee Series, xlix (Pune, 1967)

K. K. Dasgupta: *Catalogue of Wood Carvings in the Indian Museum* (Calcutta, 1981)

J. Jain and A. Agarwal: *The National Handicrafts and Handlooms Museum: Catalogue* (Middletown and Ahmedabad, 1989)

V. S. Pramar: *Haveli: Wooden Houses and Mansions of Gujarat* (Middletown and Ahmedabad, 1989)

J. Jaitly and K. Sahai: *Crafts of Kashmir, Jammu & Ladakh* (New York, 1990)

M. A. Yahia: "Conservation and Conservation Problems of Wood in the Field of Archaeology in Bangladesh," *J. Asiat. Soc. Bangladesh*, xxxviii/2 (1993), pp. 179–200

Shakirullah: "The So-called Wooden Mosques at Ziarat Kaka Sahib District Nowshera, N.W.F.P." *J. Asian Civilis.*, xxii/1 (1999), pp. 83–92

P. M. Carvalho: "What Happened to the Mughal Furniture? The Role of Imperial Workshops, the Decorative Motifs Used, and the Influence of Western Models," *Muqarnas*, xxi (2004), pp. 79–93

Y

Yahya al-Sufi [Pīr Yaḥyā ibn Naṣr al-Ṣūfī al-Jamālī] (*fl.* 1330–51). Ilkhanid calligrapher. According to the Safavid chronicler Qazi Ahmad, Yahya studied calligraphy with Mubarakshah ibn Qutb Tabrizi (*fl. c.* 1323), one of six pupils of Yaqut al-mustaʿsimi (*see also* Calligraphy, §III, C). Yahya was a mystic, hence his epithet al-Sufi, and, after working for the warlord Amir Chupan, he moved to the court of the Injuid ruler of Shiraz, Jamal al-Din Abu Ishaq (*r.* 1343–54), hence his epithet al-Jamali. He penned several manuscripts of the Koran, including small, single-volume copies (1338–9, Istanbul, Mus. Turk. & Islam. A., MS. K 430; 1339–40, Dublin, Chester Beatty Lib., MS. 1475) and a large, 30-volume copy (4 vols, 1344–6; Shiraz, Pars Mus., MS. 456). The latter manuscript was probably commissioned by Abu Ishaq's mother, Tashi-khatun, who bequeathed it to the Shah Chiragh Mosque at Shiraz. Each folio has five lines of majestic *muḥaqqaq* script, although the illumination by Hamza ibn Muhammad al-ʿAlawi is of poor quality, like that of many of the manuscripts produced at Shiraz under the Injuids (*see* Illustration, §V, B, 6). Yahya also designed architectural inscriptions, including one recording Abu Ishaq's visit to Persepolis in August 1347 and another recording Abu Ishaq's repairs in 1351 to the Khudakhana, the small building for Koran manuscripts in the court of the Friday Mosque at Shiraz.

Qāżī Aḥmad ibn Mīr Munshī: *Gulistān-i hunar* [Rose-garden of art] (*c.* 1606); Eng. trans. by V. Minorsky as *Calligraphers and Painters* (Washington, DC, 1959), p. 62

S. M. T. Mustafavi: *Iqlīm-i Pārs* (Tehran, Iran. Solar 1343/1964), pp. 59, 64, 66, 347; Eng. trans. by R. N. Sharp as *The Lands of Pārs* (1978), pp. 44, 226

D. James: *Qurʾāns of the Mamlūks* (London and New York, 1988), pp. 162–73; nos. 63–4, 69

S. S. Blair: "Yaqut and his Followers," *Manuscripta Orientalia*, ix/3 (2003), pp. 39–47; Persian trans., "Yāqūt wa pīravānish," *Ayene-ye Miras* (*Mirror of Heritage*), iii/2 (Summer 2005), pp. 102–28

S. S. Blair: *Islamic Calligraphy* (Edinburgh, 2006), pp. 286, n. 4 and 301, n. 99

Yaqut al-Mustaʿsimi [Jamāl al-Dīn ibn ʿAbdallah al-Mawṣulī Yāqūt al-Mustaʿṣimī] (*d.* Baghdad, 1298). Ottoman calligrapher. Yaqut served as secretary to the last Abbasid caliph, al-Mustaʿsim (*r.* 1242–58),

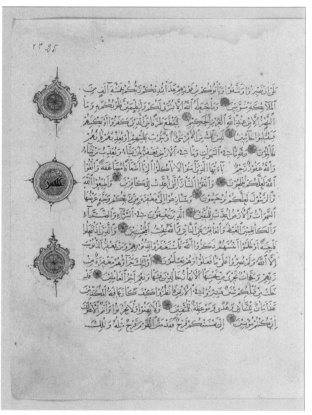

Yaqut al-Mustaʿsimi: page from a Koran manuscript, from Iraq, 1289 (Paris, Bibliotèque Nationale, MS. arab. 6716, fol. 25*r*); photo © Bibliotèque Nationale de France, Paris

and reportedly survived the sacking of Baghdad by the Mongols in 1258 by seeking refuge in a minaret. He perfected the "proportioned script" developed by Ibn muqla and refined by Ibn al-bawwab, in which letters were measured in terms of dots, circles and semicircles (*see* Calligraphy, §III, C). By replacing the straight-cut nib of the reed pen with an obliquely cut one, Yaqut created a more elegant hand. A master of the classical scripts known as the Six Pens (*thuluth, naskh, muḥaqqaq, rayḥān, tawqīʿ* and *riqāʿ*), he earned the epithets "sultan," "cynosure" and "qibla" of calligraphers. He is said to have copied two manuscripts

of the Koran each month, but surviving examples are rare (e.g. 1294; Istanbul, Topkapı Pal. Lib., E.H. 74). Despite their small size, a typical folio (see fig.) has 16 lines of delicate *naskh* script, with verse markers in the margin, and appears quite spacious. He had six famous pupils; their names vary in the sources but the most famous are AHMAD AL-SUHRAWARDI, YAHYA AL-SUFI and HAYDAR. Yaqut's work was prized by later collectors and calligraphers; Koran manuscripts transcribed by him (e.g. 1283–4, Istanbul, Topkapı Pal. Lib., E.H. 227; 1286–7, Tehran, Archaeol. Mus., MS. 4277) were often refurbished with splendid illumination under the Ottomans (r. 1281–1924) and Safavids (r. 1501–1732) or bound in albums.

Enc. Islam/2

Qāẓī Aḥmad ibn Mīr Munshī: *Gulistān-i hunar* [Rose-garden of art] (c. 1606); Eng. trans. by V. Minorsky as *Calligraphers and Painters* (Washington, DC, 1959), pp. 57–61

M. Lings: *The Quranic Art of Calligraphy and Illumination* (London, 1976), pls. 23, 26–8

Y. H. Safadi: *Islamic Calligraphy* (London, 1978)

The Age of Sultan Süleyman the Magnificent (exh. cat. by E. Atıl; Washington, DC, N.G.A.; Chicago, IL, A. Inst.; New York, Met.; 1987–8), no. 13

S. S. Blair: "Yaqut and his Followers," *Manuscripta Orientalia*, ix/3 (2003), pp. 39–47; Persian trans. "Yāqūt wa pīravānish," *Ayene-ye Miras* (*Mirror of Heritage*), iii/2 (Summer 2005), pp. 102–28

D. Roxburgh: *The Persian Album 1400–1600: From Dispersal to Collection* (New Haven, 2005)

S. S. Blair: *Islamic Calligraphy* (Edinburgh, 2006), pp. 242–50

Yangi. *See* ZHAMBYL.

Yasi. *See* TURKESTAN.

Yazd [Yezd]. City in central Iran on the western edge of the central desert. Dependent on a system of underground aqueducts (Pers. *qanāt*), Yazd was an agricultural center that flourished in the Middle Ages as an entrepôt on the trade route between Central Asia and the Gulf. The city, which was originally called Katha, dates at least from Sasanian times (226–645) when it was an important center of Zoroastrianism. In the 7th century it was captured by Muslim forces. Although never a capital, it had a long and important tradition of architectural patronage in the Islamic period, which is extensively reported in local chronicles. In the 10th century it had a fortified citadel and houses built of unbaked brick. The tomb known as Duvazdah Imam ("Twelve imams"; 1037–8) is notable for its early use of the trilobed squinch, a device that became a hallmark of architecture in Iran in the 11th and 12th centuries (*see* ARCHITECTURE, §V, A, 2). A few remains of an imposing wall (12th–14th century) also exist, but the largest building surviving from the medieval period is the Friday (congregational) Mosque near the center of the city. Most of the building dates from the 14th century and early 15th, although the ruins of an earlier mosque (early 12th century) lie to the northeast of the present court, and the west side of

the court was significantly rebuilt in the late 18th century or 19th. The main entrance portal on the east (see fig.) is crowned with a pair of attenuated minarets. The mosque has a rectangular court (104×99 m); on the south side rectangular prayer-halls flank an iwan leading to a dome. The mosque is remarkable for the extensive use of transverse vaulting and the quality of its tile revetment, including a superb mihrab (1375). In the 15th century this mosque became a model for others in the Yazd region (*see* ARCHITECTURE, §VI, A, 2).

Some 12 other mosques, 100 madrasas and 200 tombs were erected as Yazd prospered in the 14th century. Many were built of mud-brick and have deteriorated (e.g. madrasa of Shah Kamal; 1320) or disappeared, but the finest, such as two funerary ensembles built for members of the Nizami family, which traced its descent from the Prophet, were built of baked brick. The one for Rukn al-Din (1324–5) was erected near the Friday Mosque and included a mosque, madrasa, library, hospice and observatory, known as the Vaqt-u sa'at ("[Institute of] time and the hour") and famed for its mechanical devices. The tomb, a square chamber surmounted by a tiled dome that is elaborately painted on the interior, is the only part to survive. Rukn al-Din's son, Shams al-Din, built a similar funerary ensemble (the Shamsiyya; 1328) combining a madrasa, dispensary, library and hospice for descendants of the Prophet. Surviving parts, which include a narrow arcaded forecourt flanked by rectangular halls and a monumental iwan leading to the rectangular tomb chamber, show that transverse vaulting was already in use by the 1320s.

Yazd continued to grow in the 15th century. An ensemble that included a congregational mosque and domed tomb (1418 and later) was commissioned by Pir Husayn Damghani, a local notable, in a suburb to the south, and another ensemble with a congregational mosque (1437) was built by Mir Chaqmaq, governor of Yazd for the Timurid ruler Shah Rukh, in a suburb to the southeast. These buildings are notable for the sense of lightness achieved by piercing the walls with galleries. Interiors typically have splendid, tiled minbars and dadoes with whitewashed walls above. At this time many of the gardens surrounding the city were also refurbished with pools, elevated arcades and summer pavilions. In 1456, however, a great flood destroyed many buildings, and the city was never again as important. Notable structures from the later period include the minarets at the entrance to the bazaar (early 19th century). Domestic architecture in Yazd and the surrounding region is characterized by tall wind catchers (*see* WIND CATCHER), which bring cooling breezes deep into interiors. The Towers of Silence, on which the Zoroastrians expose the remains of their dead, continue to be a distinctive feature of the suburban landscape. High-quality silk textiles have been made in the Yazd region for centuries and are the mainstay of an extensive network of bazaars.

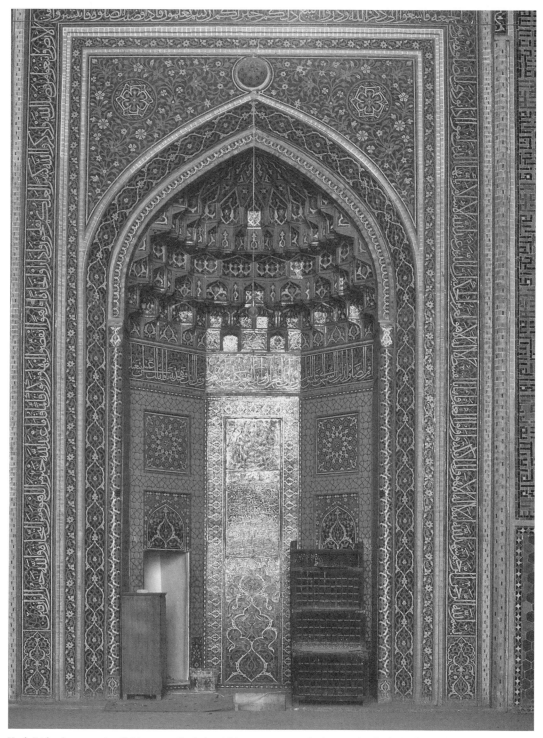

Yazd, Friday (congregational) Mosque, mihrab, late 14th century; restored; photo credit: Sheila S. Blair and Jonathan M. Bloom

M. Siroux: "La Masjid-e-Djum'a de Yezd," *Bull. Inst. Fr. Archéol. Orient.*, xliv (1947), pp. 119–76

D. N. Wilber: *The Architecture of Islamic Iran: The Il Khanid Period* (Princeton, 1955)

I. Afshar: *Yādgārhā-yi Yazd* [Monuments of Yazd], 3 vols. (Tehran, 1969)

R. Holod: "The Monument of Duvāzdah Imām in Yazd and its Inscription of Foundation," *Studies in Honor of George C. Miles*, ed. D. K. Kouymjian (Beirut, 1974), pp. 285–8

J. Aubin: "Le Patronage culturel en Iran sous les Ilkhans: Une grande famille de Yazd," *Monde Iran. & Islam*, iii (1975), pp. 107–18

B. O'Kane: "The Tiled Minbars of Iran," *An. Islam.*, xxii (1986), pp. 133–54

D. Wilber and L. Golombek: *The Timurid Architecture of Iran and Turan*, 2 vols. (Princeton, 1988)

Yazd, nagin-i kavir [Yazd, gem of the desert] (Yazd, 1997)

H. Fathi, ed.: *Ustan-i Yazd* [Yazd province], Majmumah-i tasviri-i khvurshid-i Iran (Tehran, 1997) [chiefly pictures]

P. Jodidio, ed.: *Iran: Architecture for Changing Societies* (Turin, 2004)

Ganjnameh—Yazd Houses, ed. K. Hajji-Qassemi, xiv of *The Encyclopedia of Iranian Islamic Architecture* (Tehran, 2005)

Y. Kadoi: "Aspects of Frescoes in Fourteenth-century Iranian Architecture: The Case of Yazd," *Iran*, xliii (2005), pp. 217–40

A. Modarres: *Modernizing Yazd: Selective Historical Memory and the Fate of Vernacular Architecture*, Bibliotheca Iranica: Urban planning history of Iranian cities, 1 (Costa Mesa, 2006)

Yemen Republic of [Arab. Al-Jumhūriyya al-Yamaniyya; formerly Yemen Arab Republic (North Yemen; Yemen) and People's Democratic Republic of Yemen (South Yemen)]. Independent republic in southwestern Arabia, including Socotra and other islands, with San'a as the political capital and an estimated area of *c.* 636,000 sq. km. Yemen's location at the crossroads between Arabia, the Indian Ocean and Africa, and particularly on the Red Sea route, has had an impact on its cultural heritage and turbulent political history.

Along the Red Sea and Gulf of Aden stretch arid plains rising to mountains and cultivated highlands, which descend in the east to desert and the distinct region of Hadramawt. The Arab population (*c.* 22,000,000; 2007 estimate), some of African origin, is mostly Sunni and Shi'a Muslim, with small communities of Jews and Christians. The traditional tribal structure is strong, particularly in the north.

In the lst millennium BCE until the first centuries CE South Arabia was the home of highly cultured city states, which owed their prosperity partly to the trade in frankincense and myrrh native to the region. To the Greco-Roman world the land was known as "Fortunate Arabia" (Gr. *Arabia Eudaemon*; Lat. *Arabia Felix*). When Islam arrived in Yemen *c.* 628, it was a province of the Sasanian Empire. The RASULID dynasty (1229–1454) for a time ruled an area from Mecca in modern Saudi Arabia to Hadramawt (*see also* SULAYHID and AYYUBID). Partial occupation by the Ottomans in the 16th century was ended by the tribes led by the Zaydi Imam in 1636. The Imamate then ruled the whole of Yemen until the early 18th century, during the height of the coffee trade from the port at Mocha (*see* ZAYDI). The Ottomans returned to North Yemen from 1849 onwards, leaving in 1918. A time of isolation, poverty and war culminated in the Revolution of 1962, when the rule of the Zaydi Imams was brought to an end and the Yemen Arab Republic was founded.

In the south a revolt against the Imam in the early 18th century enabled the British to occupy Aden in 1839, with the aim of controlling the Red Sea route. Gradually they expanded their rule over the hinterland. In 1967 they ceded power to the nationalists and South Yemen became independent as a communist state, later named the People's Democratic Republic of Yemen. After a period of armed conflict the two Yemens were united in 1990. At this time Yemen was one of the least developed countries in the world with a high illiteracy rate. Foreign aid and earnings made by Yemenis abroad were the main sources of revenue in the 1970s and 1980s. However, oil was found in the mid-1980s and there are also gas reserves.

The most important art of Yemen is its religious and secular architecture (see fig.; *see also* ARCHITECTURE, §§V, B, 4; VI, C, 2 and VII, A, 3 and VERNACULAR ARCHITECTURE, §VII). Civil war, uprisings and earthquakes in the 20th century caused some destruction; modern buildings after the 1960s revolutions were made of concrete and cement blocks, particularly in the towns (e.g. Aden, al-Hudaydah, San'a, Ta'izz), and there are some high-rise buildings in Western styles. Much of the architecture, however, has not changed in style for hundreds of years and some old building techniques survive. The urgent need for restoration work is recognized and some has been undertaken. The state together with UNESCO launched a campaign in 1984 to preserve the old city of San'a; a similar campaign was introduced for the town of Shibam in Wadi Hadramawt. The styles and decoration of traditional houses vary between

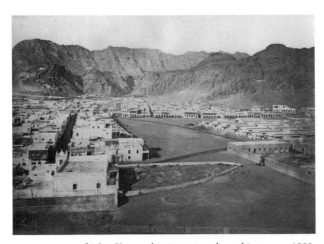

Panoramic view of Aden, Yemen, showing vernacular architecture, *c.* 1880; photo credit: Adoc-photos/Art Resource, NY

regions, but all use locally available material and are adapted to the climate.

The most distinctive buildings are tower houses, of between four and nine stories, intended for one family. Built of mud-brick or stone or a combination, depending on the region, they typically contain small rooms, thick outer walls and at the top a large reception room (*mafraj*). The tower houses in the old city in San'a are of natural stone for the ground floor, with fired brick for the upper stories. Walls are decorated with bands of geometric patterns formed by protruding bricks, which may be whitewashed annually. The bands surround the windows or mark the different stories. Arched or semicircular fanlights contain colored glass in geometric or floral patterns (*see also* Architecture, §X, E). The former summer palace of Imam Yahya (*r.* 1904–48) at Wadi Dahr, 15 km northwest of San'a, was built in the 1930s. The multi-story Dar al-Hajar consists of a group of palaces built on top of a rock. It has gypsum decoration in San'a style and ornate fanlights.

In Sa'da and neighboring villages are remarkable mud houses. The walls are made of a mixture of mud and straw, with each layer set a little inside the previous one, which gives a tapering shape. Spaces for windows are decided on as the building grows. A strip of gypsum at roof level is often elongated into points at the corners. Rada', 120 km southeast of San'a, has pale mud-brick tower houses with stone lower floors. As in Sa'da, some have alabaster window panes, but colored glass has generally replaced the old alabaster. The mud surfacing has to be replaced each year. The mud-brick tower houses in Hadramawt have walls plastered with brown earth, with light lime for the upper stories. A whiter plaster is used for decoration and the parapets on roof terraces are often whitewashed. Shibam contains over 500 tower houses, four to eight stories high, in a compact area. Most date from the 17th century but many were rebuilt in the 19th and some have carved wooden doors with wooden locks.

On the Tihama plain along the Red Sea, however, traditional housing is low, typically either huts of reeds, sticks and palm-woods (in the north, e.g. al-Zuhra), or rubble and brick courtyard houses (in the south, e.g. Zabid, Hays). Those in Zabid are of one or two stories and present a plain façade to the street; the wealth and taste of the family are displayed in the decoration on internal walls. Zabid also has some Ottoman architecture. A different tradition is found in Tarim in Wadi Hadramawt, where Hadrami traders who had worked in Indonesia in the 19th century followed Southeast Asian styles for their houses.

The modern art movement began in Yemen in the mid-1970s. The first generation of artists had no formal training, but the Republic began to support students at art colleges abroad and exercised some patronage, believing that the arts had an important role in the new state. In the 1980s these students returned and the number of professional artists increased. Faud al-Futaih (*b.* 1948), a painter and sculptor trained in Germany, opened the first art gallery in Yemen in 1986; Gallery Number One is in San'a and it shows works by both Yemeni and foreign artists. In 1987 the Yemeni Artists' Society was established to assist artists and arrange exhibitions of their work. Many artists depict local customs and landscapes in a realistic style

Economic and social changes after the revolutions, including competition from imported products, caused some crafts to die out (e.g. indigo-dyeing) or decline (e.g. pottery, hand-weaving, embroidery); hand-weaving using traditional methods is rare outside Bayt al-Faqih. Many of the Yemeni Jews who emigrated to Israel in the early 1950s were craftsmen, working particularly in silver. Some silversmiths remain, however, in San'a and Sa'da. One important traditional skill is related to Yemen's distinct architectural heritage: the use of lime and gypsum to paint and decorate houses and mosques. Imported synthetic materials caused this skill to begin to die out, except in the making of stained-glass fanlights. The traditional curved dagger, *jambiya*, worn by Yemeni men, continues to be made (e.g. in San'a). The hilt is usually of cattle horn or, now more rarely, of rhinoceros horn; the sheaths made for the upper classes are worked in silver. A new craft that developed, due to the shortage of hardwood, was the making of metal doors ornamented with patterns and calligraphy (e.g. on the outskirts of San'a). Cultural centers that include vocational training in arts and crafts were established in North Yemen, the first being in San'a in 1975. The government also set up craft associations in 1979 to try to revive the craft industries.

Yemen was for long a difficult country to explore. Carsten Niebuhr was the sole survivor of a Danish expedition in the mid-18th century. The German ethnographer Ulrich Seetzen was killed in Ta'izz in 1811, suspected of being a magician or spy. The Frenchmen Thomas Arnaud (1843–4) and Joseph Halévy (1869) and the Austrian Eduard Glaser (1882–4) were more successful, exploring Ma'rib in particular and recording many ancient South Arabian inscriptions. The difficulties of getting to various parts of Yemen meant sporadic archaeological activity in much of the 20th century. An American team worked at Ma'rib and Timna' in the early 1950s but had to leave hurriedly. Ancient temple stones were often incorporated in new buildings; other artifacts were looted; some destruction occurred because of modern development. In 1966 the Yemen Arab Republic set up an Antiquities Department, which became the Antiquities and Libraries Board in 1973. With the help of European and American specialists it surveys and attempts to protect archaeological sites and ancient monuments, oversees excavations and develops museums.

The National Museum in San'a opened in 1971 and in 1987 moved to the Dar al-Sa'ada, a palace built in the 1930s. The museum displays archaeological finds, Islamic objects, examples of traditional culture and dress and holds foreign exhibitions. In Ta'izz the former palace of Imam Ahmad (*r.* 1948–62) is a museum. Built of fired mud-brick, the palace

has been left as it was in 1962. The Salah Palace Museum, also in Taʿizz, contains silver jewelry, coins, costumes and Koranic manuscripts. In Aden the small Ethnographical Museum contains textiles and silverwork; the National Museum has many archaeological finds. The multi-story Sultan's Palace in Sayun houses archaeological finds and crafts. In Tarim the al-Afqa Library (founded 1972) contains thousands of Islamic manuscripts. There are also small regional museums.

Enc. Islam/2: "al-Yaman"

Yemen-Report: Mitteilungen der Deutsch-Jemenitischen Gesellschaft Proceedings of the Seminar for Arabian Studies British-Yemeni Society Journal City of Ṣanʿāʿ (exh. cat., ed. J. Kirkman; London, BM, 1976)

P. Costa and E. Vicario: *Yemen: Paese di costruttori* (Milan, 1977); Eng. trans. as *Arabia Felix: A Land of Builders* (New York, 1977)

J.-M. Bel: *Le Yémen du Nord et l'architecture de la région montagneuse* (Paris, 1979)

A.-R. al-Haddad: *Cultural Policy in the Yemen Arab Republic* (Paris, 1982)

F. Varanda: *Art of Building in Yemen* (Cambridge, MA, and London, 1982)

M. Hirschi and S. Hirschi: *L'Architecture au Yémen du Nord* (Paris, 1983)

L. Golvin and M.-C. Fromont: *Thulâ: Architecture et urbanisme d'une cité de haute montagne en République Arabe du Yémen* (Paris, 1984)

A. Bahnassi: *Ruwwād al-fann al-ḥadīth fīʿl-bilād al-ʿarabiyya* [Pioneers of modern art in the Arab countries] (Beirut, 1985)

R. B. Lewcock: "The Conservation of the Urban Architectural Heritage of Yemen," *Economy, Society & Culture in Contemporary Yemen*, ed. B. R. Pridham (London, Sydney and Dover, NH, 1985), pp. 215–25

R. B. Lewcock: *The Old Walled City of Sanʿāʿ* (Paris, 1986)

R. B. Lewcock: *Wadi Ḥadramawt and the Walled City of Shibām* (Paris, 1986)

G. Bonnenfant and P. Bonnenfant: *L'Art de bois à Sanáa: Architecture domestique* (Aix-en-Provence, 1987)

W. Daum, ed.: *Yemen: 3000 Years of Art and Civilization in Arabia Felix* (Innsbruck, 1987)

J.-M. Bel: *Architecture et peuple du Yémen* (Paris, 1988)

W. Ali, ed.: *Contemporary Art from the Islamic World* (London, 1989), pp. 287–8

S. S. Damluji: *A Yemen Reality: Architecture Sculptured in Mud and Stone* (Reading, 1991)

S. S. Damluji: *The Valley of Mud Brick Architecture: Shibām, Tarīm and Wādī Ḥaḍramūt* (Reading, 1992)

G. Bonnenfant and P. Bonnenfant: *Sanaa: Architecture domestique et société* (Paris, 1995)

P. Bonnenfant and J. Gentilleau: "Zabid classée au patrimoine mondial de l'UNESCO," *Madina: Cité du Monde*, 1 (1995), pp. 32–7

E. Galdieri: "La rénovation du centre historique de Sana'a (Yemen): Enjeux, risques, résultats," *Environmntl Des.*, xviii/1 (1997), pp. 202–7

S. Damluji and others: "Palais de terre," *Saba*, iii–iv (1997), pp. 83–91

M. A. Rodionov: "Silversmiths in Modern Ḥaḍramawt," *Mare Erythræum*, i (1997), pp. 123–44

J.-M. Bel: *Yémen, l'art des bâtisseurs: Architecture et vie quotidienne* (Brussels, 1997)

M. V. Fontana and others: "Al-Hudaydah, Yemen: Una lettura pluridisciplinare. Primo rapporto preliminare (1997)," *AION*, lviii (1998), pp. 111–42

"Desert Cities: Ghardaia, a City of Stone…Shibam, a City of Clay," *Islamic Capitals & Cities/Al-ʿAwāṣim wa-ʿl-Mudun al-Islāmīya*, xxvii–xxviii (1999), pp. 64–71

M. N. Souvorov and M. A. Rodionov, eds.: *Cultural Anthropology of Southern Arabia: Hadramawt Revisited.* (St. Petersburg, 1999)

R. al-Sapri: *Klimagerechtes Bauen in der heissfeuchten Tihama-Region im Jemen am Beispiel der Stadt Hodeida* (Aachen, 1999)

E. Macro: "Four English Artists at Aden, 1839–1847," *New Arab. Stud.*, v (2000), pp. 114–82

T. H. J. Marchand: *Minaret Building and Apprenticeship in Yemen* (Richmond, 2001)

T. H. J. Marchand: "Defining 'Tradition' in the Context of Yemen's Building Trade," *Al-Masar*, iii/1 (2002), pp. 3–25

Queen of Sheba: Legend and Reality: Treasures from the British Museum (exh. cat. by St. John Simpson; London, BM, 2002; and elsewhere)

A. Maurières, P. Chambon and E. Ossart: *Reines de Saba, itinéraires textiles au Yémen* (Aix-en-Provence, 2003)

N. A. ʿAbd al-Qawi: *Al-Fann al-tashkīlī fī ʿl-Yaman* [Figural art in Yemen] (Tunis?, 2005)

Yerushalayim. See JERUSALEM.

Yesari, Esad [Mehmed Esad Yesari; Esad Yesari; Asʿad Yasārī Yesari] (*d.* Istanbul, 1798). Ottoman calligrapher. Born paralyzed on the right side of his body and palsied on the left, he was given the nickname "Yesari" (left-handed). He learnt the art of calligraphy from Mehmed Dedezade, gaining his diploma (Turk. *icazet*) in 1753–4. Appointed calligrapher at the Topkapı Palace in Istanbul by Mustafa III (*r.* 1757–74), Esad Yesari achieved fame for his mastery of *nastaʿlīq* script (e.g. a calligraphic specimen, Istanbul, Topkapı Pal. Lib., G.Y. 325/4488), and his inscriptions adorn mosques, tombs, fountains and hospices in Istanbul. He was buried in the vicinity of the Fatih Mosque, Istanbul. Among his many pupils was his son Mustafa Izzet Yesarizade (*d.* 1849), who received his diploma from his father. Mustafa Izzet wrote a beautiful *nastaʿlīq* script and his inscriptions also adorn buildings in Istanbul.

A. S. Ünver: *Mehmed Esad Yesârî: Hayatı ve eserleri* [Mehmed Esad Yesari: his life and works] (Istanbul, 1955)

A. Schimmel: *Calligraphy and Islamic Culture* (New York, 1984), pp. 53, 175

Letters in Gold: Ottoman Calligraphy from The Sakıp Sabancı Collection, Istanbul (exh. cat by U. Derman; New York, Met; Los Angeles, CA, Co. Mus. A.; Cambridge, MA, Sackler Mus.; 1999–2000), no. 28

S. S. Blair: *Islamic Calligraphy* (Edinburgh, 2006), pp. 516–17

Z

Zabid [Zabīd; Zebid]. City in Yemen about 20 km from the Red Sea. Located in a fertile area of the Tihama Plain where the pilgrimage route from the south of Yemen to Mecca crosses the Wadi Zabid, the city was founded in 820 by Muhammad ibn Ziyad, emissary of the Abbasid caliph al-Ma'mun (r. 813–33) and progenitor of the semi-independent Ziyadid dynasty (r. 819–1018). The Ziyadids were responsible for erecting Zabid's congregational mosque, which has a hypostyle plan, and for the first city wall, erected in 1001 by Husayn ibn Salama. The congregational mosque was remodeled under the patronage of the Ayyubid dynasty (r. 1174–1229), under whom the building was given its present form and a brick minaret. Zabid became the winter capital of the RASULID dynasty (r. 1229–1454) and flourished as an important center of Islamic learning, particularly for the Shafi'i school of law, which was dominant along the Yemeni coast. The multi-domed al-Iskandariya Mosque (later incorporated in the citadel) appears to have been built under the Rasulids, although its modern name refers to Iskandar Mawz, governor for the Ottomans from 1530 to 1536. Zabid continued to flourish under the Tahirid dynasty (r. 1454–1537), who were responsible for major renovations to the congregational mosque in 1492, but it began to decline during the first Ottoman occupation of the Yemen (1537–1636), as the traditional overland trade routes were displaced. The city walls, which were rebuilt in 1805, were removed in the 1960s, but the four gates, which also probably date from the early 19th century, still stand. Several important buildings and houses in the traditional style remain in the city. They have exteriors enlivened with small, tablet-shaped bricks laid in patterns and usually covered with whitewash or stucco, creating baroque effects. Pottery shards of widely varied place and date of manufacture have been found in and around the city, testifying to a tradition of local production as well as long-distance trade with Iraq and China. The arrival of imported machine-made goods in the 20th century led to the decline of such traditional handicrafts as weaving, dyeing and leatherwork. Since 1982 the Royal Ontario Museum has conducted a multi-disciplinary project to study the city and its environs.

J. Chelhod: "Introduction à l'histoire sociale et urbaine de Zabîd," *Arabica*, xxv (1978), pp. 48–88

S. Hirschi and M. Hirschi: *L'Architecture au Yémen du Nord* (Paris, 1983)

E. J. Keall: "The Dynamics of Zabid and its Hinterland: The Survey of a Town on the Tihama Plain of North Yemen," *World Archaeol.*, xiv/3 (1983), pp. 378–91

E. J. Keall: "Zabid and its Hinterland: 1982 Report," *Proc. Semin. Arab. Stud.*, xiii (1983), pp. 53–69

E. J. Keall: "A Preliminary Report on the Architecture of Zabid," *Proc. Semin. Arab. Stud.*, xiv (1984), pp. 51–65

E. J. Keall: "A Few Facts about Zabid," *Proc. Semin. Arab. Stud.*, xix (1989), pp. 61–9

P. Bonnenfant and J.-M. Gentilleau: "Zabid classée au patrimoine mondial de l'UNESCO," *Madina: Cité du Monde*, i (1995), pp. 32–7

C. Ciuk and E. J. Keall: *Zabid Project Pottery Manual 1995: Pre-Islamic and Islamic Ceramics from the Zabid Area, North Yemen* (Oxford, 1996)

N. Sadek: "The Mosques of Zabīd, Yemen: A Preliminary Report," *Proc. Semin. Arab. Stud.*, xxviii (1999), pp. 239–45

A. Regourd, ed.: *Catalogue cumuli des Bibliothèques de Manucrits de Zabid*, 1 (San'a, 2006)

Zaim, Turgut (*b.* Istanbul, 5 Aug. 1906; *d.* Ankara, 1974). Turkish painter and printmaker. He studied at the Fine Arts Academy in Istanbul and worked as a teacher in Konya for a short period before graduating in 1930. The visit to Konya was his first to Anatolia, and it gave him the opportunity to observe the peasant and nomadic life. As a result he included Anatolian themes in his work, although he used the techniques of Western painting. He was also inspired by East Asian art and by Turkish miniature painting. Upon graduation he went to Paris to continue his studies but stayed only a few weeks and returned to Turkey to teach in Sivas, where he rekindled his interest in Anatolian life. His works were exhibited in Istanbul by the D Group (founded 1933), which he later joined. In 1939 he participated in the tours to the provinces organized for artists by the Turkish government, returning from the town of Kayseri with a series of paintings. His individual style for depicting local scenes, which used well-defined forms in bright colors, became popular in Turkey,

and the narrative element of his paintings related them to themes in Turkish folklore. Zaim's aim was to develop a contemporary pictorial language to express life in Anatolia. He also produced etchings in the 1930s and linoleum prints in the early 1960s. His daughter Oya Katoğlu also produced paintings depicting rural life.

S. Tansuğ: *Çağdaş Türk sanatı* [Contemporary Turkish art] (Istanbul, 1986)

G. Renda and others: *A History of Turkish Painting* (Geneva, Seattle and London, 1988)

W. Ali: *Modern Islamic Art* (Gainesville, 1997), p. 18

S. Bozdogan: *Modernism and Nation Building: Turkish Architectural Culture in the Early Republic* (Seattle, 2002), p. 253

R. Kasaba, ed.: *Turkey in the Modern World*, iv of *Cambridge History of Turkey* (Cambridge, 2008), pp. 428, 441

Zakariya, Mohamed (*b.* Ventura, California, 1942). American calligrapher. Having converted to Islam in the 1960s while still a teenager, he studied Islamic calligraphy, training with A. S. Ali Nour in Tangier, Morocco, and later studying at the British Museum in London. In the 1980s he felt his work had reached a plateau and decided to re-learn the art of calligraphy in the Ottoman style. Hence in 1984 he went to Istanbul to train with the Turkish calligraphers Hasan Çelebi and Ali Alparslan at the Research Center for Islamic History, Art, and Culture (IRCICA), where he was tutored in *thuluth*, *naskh* and *nasta'līq* scripts. In 1997 he became the first American to receive an *icazet* or diploma from IRCICA for his abilities as a calligrapher. His calligraphic works are executed within meticulously observed traditional modes, reflected also in his insistence on making his own reed and bamboo pens. His works typically reflect the traditions of the Ottoman masters of the 19th century, with illuminations in the Turkish Baroque style. A pioneer in the field of Islamic calligraphy in the USA, his works have been exhibited widely in the USA and the Middle East. He has also revived the ancient art of making astrolabes, and examples of this aspect of his work are held in Saudi Arabia, Qatar and the USA. Based for many years in Arlington, Virginia, in 2001 he designed the first U.S. postage stamp to celebrate a Muslim holiday. He has also translated a number of the leading essays on Turkish calligraphy.

WRITINGS

The Calligraphy of Islam: Reflections on the State of the Art (Washington, DC, 1979)

with J. Fox and Simonida: *Faces of Faith: Recent Works by Judy Fox, Simonida, and Mohamed Zakariya at the B'Nai Brith Klutznick National Jewish Museum* (Washington, DC, 1994)

"A Compendium of Arabic Scripts," *The Art of the Pen: Calligraphy of the 14th to 20th centuries*, ed. N. F. Safwat (London and New York, 1996), v of *The Nasser D. Khalili Collection of Islamic Art*, ed. J. Raby (London and New York, 1992–), pp. 228–34

with N. F. Safwat and G. Fehérvári: *The Harmony of Letters: Islamic Calligraphy from the Tareq Rajab Museum* (Singapore, 1997)

trans.: M. U. Derman and N. M. Çetin: *The Art of Calligraphy in the Islamic Heritage*, Islamic cultural heritage, 1 (Istanbul, 1998) [English version of work previously published in Arabic, Turkish and Japanese editions]

with H. Gouverneur: *Doors of the Kingdom* (New York and Riyadh, 1998)

Music for the Eyes: An Introduction to Islamic and Ottoman Calligraphy (Los Angeles, 1998)

trans.: M. U. Derman: *The Art of Calligraphy in the Islamic Heritage* (Istanbul, 1998)

trans.: M. U. Derman: *Letters in Gold: Ottoman Calligraphy from the Sakip Sabanci Collection, Istanbul* (New York, 1998)

Mohamed Zakariya: Islamic Calligrapher (exh. cat., Bellevue, WA, Bellevue Art Museum, 2007) [contains list of his exhibitions]

BIBLIOGRAPHY

P. Kesting: "The World of Mohamed Zakariya," *Aramco World* (Jan.–Feb. 1992), pp. 10–17

S. S. Blair: *Islamic Calligraphy* (Edinburgh, 2006), pp. 597–601 and fig. 13.5

"Mohamed Zakariya: Islamic Calligrapher," *Amer. Craft*, lxvii/2 (2006–7), pp. 44–5

Zand. Dynasty that ruled in Iran from 1750 to 1794. The Zand tribe, a pastoral people from the Zagros foothills, became the dominant power in Iran after the death of Nadir Shah in 1747. Under Muhammad Karim Khan (*r.* 1750–79), who proclaimed himself regent (Pers. *vakīl*) for the Safavid puppet king Isma'il III, the Zands brought stability to southern Iran, and from 1765 Karim Khan encouraged art and architecture (*see* ARCHITECTURE, §VII, B, 2) to flourish at his adopted capital SHIRAZ. His first consideration was defense, and he rebuilt the city walls in 1767. Many of his other buildings, such as the citadel, palace and mosque with adjacent bath and bazaar, were grouped around a maidan to the north of the old city. Zand architecture is notable for its revetments in carved marble and overglaze-painted tiles with flowers, animals and people. Some themes were consciously revived from nearby Achaemenid and Sasanian sites such as Persepolis and Naqsh-i Rustam. Painting also flourished under Karim Khan (e.g. *Muhammad Karim Khan Zand and the Ottoman Ambassador, c.* 1775; Copenhagen, Davids Saml.; for illustration *see* GHAFFARI; *see also* OIL PAINTING, §I). A large oil painting of *Muhammad Karim Khan and his Court* (Shiraz, Pars Mus.) was painted by Ja'far, but the most important artist was MUHAMMAD SADIQ, whose long career spanned the second half of the 18th century. Many Zand paintings depict a type of floral carpet known from several examples (*see* CARPETS AND FLATWEAVES, §IV, C). After Karim Khan's death, internal dissension and disputes over succession prevented the last six Zand rulers from substantial patronage of the arts. In 1792 Shiraz was sacked by

the QAJAR ruler Agha Muhammad, and the last Zand was executed two years later.

J. R. Perry: *Karim Khan Zand: A History of Iran, 1747–1779* (Chicago and London, 1979)

J. Housego: "Carpets," *The Arts of Persia*, ed. R. W. Ferrier (New Haven and London, 1989), pp. 118–56

B. W. Robinson: "Persian Painting under the Zand and Qājār Dynasties," *From Nadir Shah to the Islamic Republic* (1991), vii of *The Cambridge History of Iran* (Cambridge, 1968–91), pp. 870–90

J. Scarce: "The Arts of the Eighteenth to Twentieth Centuries," *From Nadir Shah to the Islamic Republic* (1991), vii of *The Cambridge History of Iran* (Cambridge, 1968–91), pp. 890–958

Royal Persian Paintings: The Qajar Epoch 1785–1925 (exh. cat. by L. S. Diba with M. Ekhtiar; New York, Brooklyn Mus.; Los Angeles, CA, Armand Hammer Mus. A.; London, U. London, SOAS, Brunei Gal., 1998–9)

F. Ames: "A Kashmir Paradigm Shift: Qajar and Zand Paintings as Evidence for Shawl Dating," *Halı*, cxxxix (2005), pp. 70–75

J. R. Perry: *Karim Khan Zand* (London, 2006)

Zangid [Zangī]. Islamic dynasty which ruled in northern Iraq, southeast Anatolia and Syria from 1127 to 1222. In 1127 'Imad al-Din Zangi, the son of a Turkish commander in the Saljuq army, was appointed governor of Mosul for the Saljuq sultan and guardian (Turk. *atabeg*) for his sons. The semi-independent Zangi expanded his dominion north and west and was granted Aleppo in 1129. He fought against the Crusaders, most notably at Edessa in 1144. Zangi was succeeded by two independent branches of the family in MOSUL and ALEPPO. His son Nur al-Din (*r.* in Aleppo 1146–74) conquered Damascus in 1154, opposed the crusaders and sent his generals Shirkuh and Salah al-Din to Egypt, where the latter founded the AYYUBID dynasty. The Ayyubids succeeded the Zangids in Aleppo in 1183 and in Damascus in 1186.

Nur al-Din, a staunch Sunni, built many religious institutions, and fortified Aleppo, Damascus and other key sites. During his reign there was a Classical revival in Syrian architecture as well as a whole-hearted adoption of symmetrical building plans and forms, such as the iwan, typical of Abbasid architecture in Iraq (*see* ARCHITECTURE, §V, B, 5). In his hospital (1154) and his funerary madrasa (1172) in Damascus, the "sugarloaf" MUQARNAS vault appears in Syria for the first time, rendered in plaster. The tomb of the madrasa is the first Islamic building constructed fully in striped masonry (Arab. *ablaq*), a local technique that became increasingly popular in Ayyubid and Mamluk architecture. Finely carved woodwork was also produced in the Zangid period. One of the finest examples was the minbar ordered by Nur al-Din as an ex-voto for the conquest of Jerusalem; when Salah al-Din conquered the city he moved the minbar to the Aqsa Mosque there, where it stood until it was destroyed by fire in 1969 (*see* WOODWORK, §I, A, 2).

Enc. Islam/2: "Zangids"; "Nūr al-Dīn"

M. van Berchem: *Matériaux pour un corpus inscriptionum arabicarum: Deuxième partie: Syrie du Sud: Jérusalem*, Mém.: Inst. Fr. Archéol. Orient. Caire, xliii–xlv (Cairo, 1922–7)

N. Elisséeff: *Nūr al-Dīn*, 3 vols. (Damascus, 1967)

T. Allen: *A Classical Revival in Islamic Architecture* (Wiesbaden, 1986)

J. S. Nielsen: "Between Arab and Turk: Aleppo from the 11th till the 13th Centuries," *Byz. Forsch.*, xvi (1991), pp. 323–40

A. Hagedorn: "Badr ad-Dīn Lu'lu' von Mosul (*r.* 1233–59): Zu Auftraggebern islamischer Kleinkunst im 13. Jahrhundert," *XXV. Deutscher Orientalistentag vom 8. bis 13.4.1991 in München*, ed. C. Wunsch, Z. Dt. Mrgländ. Ges., supplement X. (Stuttgart, 1994), pp. 493–507

C. Hillenbrand: "Jihad Propaganda in Syria from the Time of the First Crusade until the Death of Zengi: The Evidence of Monumental Inscriptions," *The Frankish Wars and their Influence on Palestine*, ed. K. Athamina and R. Heacock (Birzeit, 1994), pp. 60–69

J. Garcin: "Les Zankides et les Ayyûbides," *Etats, sociétés et culture du monde musulman médiéval Xe–XVe siècle, Tome 1: L'évolution politique et sociale*, ed. J. Garcin (Paris, 1995), pp. 233–55

N. O. Rabbat: "The Ideological Significance of the Dâr al-'adl in the Medieval Islamic Orient," *Int. J. Mid. E. Stud.*, xxvii/1 (1995), pp. 3–28

W. F. Spengler and W. G. Sayles: *Turkoman Figural Bronze Coins and their Iconography, Vol. II: The Zengids* (Lodi (USA), 1996)

Y. Tabbaa: *Constructions of Power and Piety in Medieval Aleppo* (University Park, PA, 1997)

C. Tonghini: *Qal'at Ja'bar Pottery: A Study of a Syrian Fortified Site of the Late 11th–14th Centuries* (Oxford, 1998)

J. Gonnella: "Eine neue zangidisch-aiyūbidische Keramikgruppe aus Aleppo," *Damas. Mitt.*, xi (1999), pp. 163–77

Y. Tabbaa: *The Transformation of Islamic Art during the Sunni Revival* (Seattle, 2001)

Y. Tabbaa: "The Mosque of Nūr al-Din in Mosul 1170–1172," *An. Islam.*, xxxvi (2002), pp. 339–60

Zanzibar. Archipelago 25 km off the east coast of Tanzania in east Africa, with ancient links to Arabia as well as the African mainland. The majority of the population (1,000,000; 2004 estimate) is Muslim. From 1698 Zanzibar was under the control of the sultans of OMAN, becoming a British protectorate in 1890. It became independent in 1963, merging with Tanganyika to form TANZANIA in 1964. Following independence, ministers for culture were assigned to find and revive traditional customs.

The ancient stone town of Zanzibar was restored in the 1980s by the Conservation of Historical Monuments Society, and further private investment has been poured into the rehabilitation of the old houses with elaborate carved wooden balconies and doors bearing pre-Islamic motifs such as date palms and lotuses. Specific bodies offering patronage include the National Art Council of Tanzania, responsible for the development and promotion of traditional arts, and the National Cottage Industries

Corporation (NCIC), formed in 1965. They have encouraged the revival of cottage industries in traditional arts, notably jewelry, textiles, pottery and brass and silver trays.

Academic artists are less well served by state-organized bodies, and postgraduate art training is often undertaken in Uganda or the West. The painter Fatima Shaaban Abdullah (*b.* 1939), whose boldly colored works have been exhibited worldwide, trained at the Women's Teacher Training College, Zanzibar (1959), and the Makerere School of Fine Arts, Kampala, Uganda, later returning to Zanzibar to teach at Nkrumah Teacher Training College. A later group of painters who emerged in Tanzania in the 1980s evinced a desire to move away from abstract designs towards a more academic manner; these include watercolor painters of landscapes Abdallah Farahani and his son Iddi Abdallah Farahani. Dr. Ali Hussein Darwish, who started with figurative painting before moving to designs based on Arabic calligraphy, is one of the best-known painters from Zanzibar.

Enc. Islam/2: "Zandjibār"

F. R. Barton: "Zanzibar Doors," *Man*, xiv/6 (1924), pp. 81–3, pl. F

N. I. Nooter: "Zanzibar Doors," *Afr. A.*, xvii/4 (1984), pp. 34–9, 96

U. Malasins: *The Stone Town of Zanzibar* (Zanzibar, 1985)

P. O. Mlama: "Tanzania's Cultural Policy and its Implications for the Contributions of the Arts to Socialist Development," *Utafiti*, vii/1 (1985), pp. 9–19

E. Abdul Sheriff: *The History & Conservation of Zanzibar Stone Town* (Zanzibar, 1995)

M. A. Muombwa: "Kofia in Zanzibar," *Swahili Forum II/ Afrikanistische Arbeitspapiere*, xlii (1995), pp. 132–7

F. Siravo: *Zanzibar: A Plan for the Historic Stone Town* (Geneva, 1996)

M. A. Mwalim: *Doors of Zanzibar* (London, 1998)

R. Harris and G. Myers: "Hybrid Housing: Improvement and Control in Late Colonial Zanzibar," *J. Soc. Archi. Hist.*, lxvi/4 (Dec. 2007), pp. 476–93

Zavara [Zavāra; Zawareh]. Small town in central Iran on the southwest edge of the Dasht-i Kavir. According to the geographer Yaqut (*d.* 1229), Zavara existed in Sasanian times, and ancient fortifications and a fire temple could be seen there in the medieval period, but the town is now known for two mosques. The congregational mosque (1135–6) is the earliest extant example of the standard type of Iranian mosque, with four iwans grouped around a court and a dome behind the qibla iwan. It is rectangular in plan and has a side entrance, minaret and barrel-vaulted roof supported by piers. The elaborately carved stucco mihrab was redone in 1156–7, at the same time that the mosque in nearby ARDISTAN was revamped. The four-iwan plan links the congregational mosque at Zavara with others in a regional group centered in Isfahan (*see* ARCHITECTURE, §V, A, 2). The smaller Pa Minar Mosque ("Mosque at the foot of the minaret") is notable for its early minaret

(1068–9) and for the stucco decoration on the walls and arches of the single bays around the court. On stylistic grounds Peterson dated some of the stucco carving to the late 9th century or the 10th and suggested that the mosque occupies a pre-Islamic site because of the irregular plan, but the mosque's chronology is complicated by the fact that the stucco revetment was redone in the 14th century and the east side of the mosque repaired in the 20th century.

Enc. Islam/2: "Zawāra"

A. Godard: "Ardistan et Zawārè," *Āthār-é Īrān*, i (1936), pp. 296–309

S. R. Peterson: "The Masjid-i Pā Minār in Zavāreh: A Redating and Analysis of Early Islamic Iranian Stucco," *Artibus Asiae*, v (1978), pp. 60–90

S. S. Blair: *The Monumental Inscriptions of Early Islamic Iran and Transoxiana* (Leiden, 1991), pp. 137–9

Zaydi. Muslim dynasty that ruled in parts of the Yemen from the late 9th century to the 20th. The Zaydi imams traced their descent to the Prophet Muhammad and took their name from Zayd (*d.* 740), the son of the fourth Shi'ite imam. The Zaydi imamate in the Yemen was established by Yahya al-Hadi (854–911) who arrived there in 889, but his austere code of behavior initially won little success and he was forced to leave. Returning in 896, he established his seat at Sa'da, north of SAN'A. He won the allegiance of several tribes by acting as a mediator in tribal disputes, but his influence remained precarious. After his death his followers remained in the Yemen, and the Zaydi imamate continued to claim authority by divine right, although there was no strict dynastic criterion for the election of imams. Based in the north of the country, the power of the Zaydi imams varied over the centuries; occasionally it reached as far as San'a. The movement was forced underground by the advent of the SULAYHID dynasty (*r.* 1047–1138) and by the expansion of Ayyubid power after 1174. There was some revival of Zaydi power in the early years of the RASULID dynasty (*r.* 1229–1454), but it floundered at the end of the 13th century. The imamate was revived by al-Qasim al-Mansur (*r. c.* 1592–1620) who led Yemeni opposition to Ottoman expansion in the region, a policy continued by his son al-Mu'ayyad (*r.* 1620–44). Building activity in San'a' was promoted under al-'Abbas al-Mahdi (*r.* 1747–75). The imams continued to rule northern Yemen and led the opposition during the second Ottoman occupation (1872–1918). Zaydi rule was brought to an end by the revolution of 1962.

Zaydi mosques, such as those at Zafar Dhibin (*c.* 1200) and the mosque of al-Hadi at Sa'da (1340), adopted several features introduced by the Sulayhids, such as a wider central aisle and domed mihrab bay. The Zaydi imams were buried under tombs richly decorated on the interior with elaborate inscription bands and carved stucco. This conservative and distinct Zaydi style of building was preserved in the northern highlands (*see* ARCHITECTURE, §§V, 2, D

and VI, C, 2). Massive wooden cenotaphs were also erected over the graves of several 18th-century imams; they are distinguished by elaborately carved and often painted decoration (*see* WOODWORK, §II, E).

Enc. Islam/2: "Zaydiyya"

A. Tritton: *Rise of the Imams of Ṣan'ā'* (London, 1925)

R. W. Stookey: *Yemen: The Politics of the Yemen Arab Republic* (Boulder, 1978), pp. 79–99

A. Abdul: "The Zaydīs of Yemen: An Account of their Rule and Achievements," *Hamdard Islamicus*, 22 (1999), pp. 17–26

Zayn al-ʿAbidin [Mīr Zayn al-ʿĀbidīn Tabrīzī al-ʿAbidin] (*fl.* Qazvin, *c.* 1570–1602). Persian illustrator, illuminator and calligrapher. The grandson and pupil of SULTAN-MUHAMMAD, Zayn al-ʿAbidin worked exclusively for royal and noble patrons at the Safavid court in Qazvin (*see* ILLUSTRATION, §VI, A, 3). He contributed an illustration of *Nariman Killing the Ruler of China* to a copy (London, BL, Or. MS. 12985; fol. 90*v*) of Asadi's *Gārshāspnāma* ("Book of Garshasp") produced at Qazvin in 1573 and four paintings to a dispersed copy of the *Shahnama* ("Book of kings") made for Ismaʿil II (*r.* 1576–8). The artist's style is characterized by solid forms, extreme precision and compositions that resemble the style typical of Tabriz in the first half of the 16th century rather than the more mannered one typical of Qazvin in the 1570s. His best known illumination is the splendid signed frontispiece for the unfinished copy (Dublin, Chester Beatty Lib., MS. 277) of the *Shāhnāma*, thought to have been commissioned upon the accession of ʿAbbas I in 1588. The artist may also have been responsible for its sumptuous gold marginalia which shows birds, deer, lions and other animals in landscapes. His calligraphy is known from a copy (London, BL, Add. MS. 28302) of the *Shāhnāma* dated 1586, which may have been commissioned by Hamza Mirza (*d.* 1586), the son of Muhammad Khudabanda (*r.* 1578–88).

Qażi Aḥmad ibn Mīr Munshī: *Gulistān-i hunar* [Garden of the arts] (*c.* 1606); Eng. trans. by V. Minorsky as *Calligraphers and Painters* (Washington, DC, 1959), p. 187

A. J. Arberry and others: *The Chester Beatty Library: A Catalogue of the Persian Manuscripts and Miniatures* (Dublin, 1959–62), iii, p. 49

Iskandar Munshī: *Tārikh-i ʿālamārā-yi ʿabbāsī* [History of the world-conquering ʿAbbas] (1629); Eng. trans. by R. Savory as *History of Shah ʿAbbas the Great* (Boulder, CO, 1978), p. 278

B. W. Robinson: "Ismaʿil II's Copy of the Shāhnāma," *Iran*, xiv (1976), pp. 1–8

A. Welch: *Artists for the Shah* (New Haven, 1976), pp. 212–13

S. R. Canby: *The Golden Age of Persian Art 1501–1722* (London, 1999), pp. 51, 72, 83–4, 105 and pl. 69

Zeid, Fahrelnissa (*b.* Istanbul, 1901; *d.* Amman, 5 Sept. 1991). Turkish painter. The daughter of Shakir Pasha, a Turkish general, diplomat and historian, she was brought up in a distinguished family of statesmen and intellectuals. She went to the Academy of Fine Arts, Istanbul, in 1920, where she studied under Namık Ismail (1890–1935), and then to Paris in 1927, where she studied at the Académie Ranson under Roger Bissière (1886–1964). On returning to Istanbul, she joined an association of young Turkish painters known as the D Group, which was founded in 1933. In 1934 she married the Hashemite prince Zeid El-Hussein, a diplomat, and accompanied him on postings to Berlin, London and Paris. She had private exhibitions in Istanbul in 1944 and 1945, and then in 1946 at Izmir and the Musée Cernuschi, Paris. After World War II, when she moved back to western Europe, she had further exhibitions in London, Paris, Brussels, New York and elsewhere. She participated in the Salon des Réalités Nouvelles, Paris, in 1951, 1953 and 1954, and had a large exhibition of her work at the Hittite Museum, Ankara, in 1964. In 1975 she moved from Paris to Amman, Jordan, where she began to teach at the Royal Art Institute and established the Fahrelnissa Zeid Institute of Fine Arts. In 1983 the Royal Cultural Center in Amman staged a major retrospective exhibition of her work, and in 2001 the Darat al-Funun there held a centenary exhibition of her works.

Zeid worked in oil, gouache and watercolor and also produced lithographs and engravings. Her early paintings, which include portraits and interior scenes, were inspired largely by French art. During the 1940s, however, she moved towards abstraction and the use of larger canvases. She soon began to attract international acclaim, being recognized in Paris by André Breton (1896–1966) and the art critic Charles Estienne. In addition to her abstract works, she produced portrait paintings. Her canvases have rich and sumptuous colors, and many of her abstract works, such as *Break of the Atom and Vegetal Life* (1962; Emir Raʾad priv. col., see Parinaud, pl. 3), are densely filled. She also developed a technique called "paleochrystalos," in which she set colored stones, enamels and other objects into a glass-paste and resin mixture that was then set in motion by small electric motors.

A. Parinaud: *Fahrelnissa Zeid* (Amman, 1984)

M. Parker: Obituary, *Independent* (20 Sept. 1991)

W. Ali: *Modern Islamic Art: Development and Continuity* (Gainesville, 1997), pp. 14, 18, 100, 101, 140, 211, 212

Zenderoudi, Hussein (*b.* Tehran, 1937). Iranian painter and printmaker. He studied at the College of Fine Arts and the College of Decorative Arts in Tehran and began to exhibit his work early in his career, at the Biennales in Paris (1959–63), Tehran (1960–66), São Paulo (1963) and Venice (1964), receiving a number of awards. He first began to be influenced by Iranian Shiʿite folk art in 1959, presenting it in his work in a distinctive way, with neither parody nor satire. He went to live in Paris in 1961 but continued to take a close interest in the development of art in Iran. At the third Tehran Biennale in 1962, held in

the Abyaz Palace in the Gulistan compound, he exhibited canvases that consisted of geometric patterns of squares, triangles and circles, using colors characteristic of religious folk art, and covered with calligraphy to create a distinctive texture. It was on this occasion that the Iranian art critic Karim Emami first used the word SAQQAKHANA to describe the mood of Zenderoudi's work. In works produced in the late 1960s and 1970s, Zenderoudi's interest in the use of calligraphy developed further. He also executed two series of silkscreen prints for the Koran, published by the Club du Livre in 1972 and 1980. (*see also* IRAN, §III).

Charles Hossein Zenderoudi, http://www.Zenderoudi.com (accessed June 11, 2008)

A. Tadjvidi: *L'Art moderne en Iran* (Tehran, 1967)

K. Emami: "Modern Persian Artists," *Iran Faces the Seventies*, ed. E. Yarshater (New York, 1971)

E. Yarshater: "Contemporary Persian Painting," *Highlights of Persian Art*, ed. R. Ettinghausen and E. Yarshater (Boulder, CO, 1979), pp. 367–74

W. Ali: *Modern Islamic Art: Development and* Continuity (Gainesville, 1997), pp. 70, 80, 84, 148, 155–6, 212

Word into Art: Artists of the Modern Middle East (exh. cat. by V. Porter; London, BM, 2006), no. 2 and p. 142

Zhambyl [formerly Talas, Taraz, Yangi, Awliya Ata, Mirzoyam, Dzhambul]. City in the Talas River valley of southern KAZAKHSTAN and capital city of the region of the same name. Excavations have established that the area, conveniently located along the trade route from Central Asia to China, was inhabited from the 1st and 2nd centuries CE, and ancient Turkish inscriptions have been found in the region. The town, known as Taraz or Talas, was first mentioned in the account of the Byzantine ambassador Zemarkhos in 568, and the Chinese pilgrim Xuanzang (*c.* 630) described Ta-la-sz' as significant. In the 7th century the town had a citadel surrounded by a wall with towers and a small town precinct; it became the capital of the Karluk Turks in the 8th and 9th centuries. In 751 Muslim armies defeated Chinese troops at the Talas River, but Islam did not gain strength in the region until the late 9th century, following the campaign of the SAMANID ruler Isma'il in 893. During the 11th and 12th centuries Taraz became one of the largest centers of the Qarakhanid state, and ceramic production flourished there. The mausolea of Babadhzi-Khatun (10th–11th century) and Aisha-Bibi (11th–12th century), situated in the village of Golovachevka 12 km from the city, testify to the artistic production of the period.

The town, which became known as Yangi, suffered greatly during the invasions of the Qara Khitay (Western Liao) and the Mongols in the 13th century, and by the 14th century it was in ruins. From the late 18th century it was known as Awliya-Ata (or Auliye-Ata; Turk.: "holy father") after the grave of the holy man Qara Khan, perhaps a Qarakhanid foundation and mentioned as early as the 17th century but rebuilt in 1856 or 1905. At the beginning of the

19th century the Talas Valley territories came under the power of the *khān*s of KOKAND, and a new city arose alongside the ruins of Taraz. In 1864 Russian troops conquered the city, which in 1938 was renamed Zhambyl after the Kazakh poet Zhambyl Zhabaev (1846–1945).

Enc. Islam/2: "Ṭarāz"; "Awliyā Ata"

A. N. Bernshtam: *Pamyatniki stariny Talasskoy doliny* [Monuments of the ancient Talas Valley] (Alma-Ata, 1941)

Trudy Semirechenskoy arkheologicheskoy exspeditsiy, 1936–1938: "Talasskaya dolina" [Works resulting from the archaeological expedition to Semireche, 1936–1938: "the Talas Valley"] (Alma-Ata, 1949)

M. S. Mershchiyev: "K voprosy o stratigrafiy nizhnikh sloev Taraza" [On the stratigraphy of the lower strata of Taraz], *Novoe v arkheologiy Kazakhstana* [Innovations in the archaeology of Kazakhstan] (Alma-Ata, 1972)

T. N. Senigova: *Srednevekov'iy Taraz* [Medieval Taraz] (Alma-Ata, 1972)

Zirid. Muslim dynasty that ruled in parts of North Africa and Spain between 972 and 1152. The founder of the dynasty, Ziri ibn Manad (*d.* 972), was a Sanhaja Berber in the service of the FATIMID caliphs, who ruled from Tunisia. In 936 Ziri founded Ashir, the family seat, in the Titeri Mountains 170 km south of Algiers. His son Buluggin (*r.* 972–84) was appointed governor of North Africa when the Fatimids left Kairouan for Cairo. Under Buluggin, his son al-Mansur (*r.* 984–96) and his grandson Badis (*r.* 996–1016), the Zirids greatly enlarged their territory, expanding into northern Morocco, where they came in conflict with the Umayyads of Spain. By 1015 the Zirid domain had become too large to be governed from Kairouan alone: the Zirids retained control of the eastern half, while the western portion was granted to Buluggin's son Hammad (*r.* 1015–28), who established his capital at the Qal'at Bani Hammad to the east of Ashir. In 1048 the Zirid al-Mu'izz ibn Badis (*r.* 1016–62) renounced the authority of the Fatimids, who were Shi'ites, for that of the orthodox Abbasid caliphs of Baghdad. In retaliation, the Fatimids encouraged tribes of Bedouin nomads to move from Upper Egypt into the region, which they proceeded to devastate. The Zirids retreated from Kairouan to Mahdia on the coast, which they defended against naval attack from the Normans of Sicily until 1148. The Hammadid branch, which in 1067 had relocated to Bejaïa (Bougie), lasted until 1152. A third branch of the Zirid family established itself in Spain when Zawi, another son of Ziri, emigrated to Spain to serve with his followers in the Berber army of 'Abd al-Malik ibn Abi 'Amir, *de facto* ruler of Spain from 1002 to 1008, during the last years of the Umayyad caliphate. As Umayyad power collapsed, Zawi received the province of Elvira and established himself in 1012 at Granada, where he began to act as an independent ruler. The Zirids expanded their domains in southeast Spain until the area came under the control of the Almoravid dynasty in 1090.

The Zirids were active patrons of architecture and the arts. The ruins of the palace of Ziri at Ashir suggest that it was modeled on an early Fatimid palace at MAHDIA; the extensive ruins of the palaces at the QAL'AT BANI HAMMAD show similarities with the architecture of the Fatimids in Egypt and of the Normans in Sicily (*see* ARCHITECTURE, §V, B, 2). Several buildings in Granada (*see* GRANADA, §I) can be ascribed to the Zirids, including a palace (1052–6) on the site of the Alhambra erected by Yusuf ibn Naghrallah, the Zirid's Jewish vizier. The memory of this splendid palace, described by contemporary poets, is preserved by 12 white marble lions, reused in the 14th century for the central fountain in the Palace of the Lions. Zirid patrons also provided religious buildings with splendid furnishings: a carved wooden minbar (pulpit) was given in 980 by Buluggin to the mosque of the Andalusians in Fez. The most important example of Zirid woodwork is the magnificent *maqsura*, or enclosure for the ruler, that al-Mu'izz ibn Badis ordered for the congregational mosque at Kairouan. Heavily carved with arabesques and supporting grilles of turned spindles and spools, the whole is crowned with a foliated kufic inscription, outlined by a distinctively Zirid raised bead (*see* WOODWORK, §I, C). The arts of the book also flourished under Zirid patronage. A splendid manuscript of the Koran (Kairouan, Mus. A. Islam, Tunis, Mus. N. Bardo and Nat. Lib.) was copied and illuminated in 1020 by 'Ali ibn Ahmad al-Warraq for the nurse of al-Mu'izz ibn Badis, and the ruler himself was the author of an important treatise on the arts of the book.

Enc. Islam./2

L. Golvin: *Le Magrib central à l'époque des Zirides: Recherches d'archéologie et d'histoire* (Paris, 1957)

H. R. Idris: *La Berbérie orientale sous les Zirides, Xe–XIIe siècles* (Paris, 1962)

M. Levy: "Medieval Arabic Bookmaking and its Relation to Early Chemistry and Pharmacology" (trans. of al-Mu'izz ibn Bādīs, *'Umdat al-kuttāb wa-'uddat dhawī al-albāb* [Staff of the scribes and implements of the discerning]), *Trans. Amer. Philos. Soc.*, lv (1962), pp. 3–79

L. Golvin: *Recherches archéologiques à la Qal'a des Banû Hammâd* (Paris, 1965)

L. Golvin: "Le Palais de Zîrî à Achîr (dixième siècle J.C.)," *A. Orient.*, vi (1966), pp. 47–76

A. Lezine: "La Salle d'audience du palais d'Achîr," *Rev. Etud. Islam.*, xxxvii (1969), pp. 203–18

P. A. Laily and others: "Remploi de monnaies romaines à l'époque Ziride: Analyse d'échantillons d'un trésor découvert à la Qal'a des Banu Hammâd (Algérie)," *Antiquités africaines*, xxxi (1995), pp. 325–31

A. Louhichi. "La céramique fatimide et ziride de Mahdia d'après les fouilles de Qasr al-Qaïm," *La céramique médiévale en Méditerranée: Actes du VIe Congrès de l'AIECM2, Aix-en-Provence ... 1995*, pp. 301–10

M. Barrucand: "L'Architecture palatiale ziride et hammadide," *Trésors fatimides du Caire* (exh. cat.; Paris, Inst. Monde Arab., 1998), pp. 222–4

Contributors

The *Grove Encyclopedia of Islamic Art and Architecture* includes fully updated and revised articles from *The Dictionary of Art* and Grove Art Online. These original articles were contributed by the international scholars listed below and have been edited by Sheila Blair and Jonathan Bloom for this publication. New material has been provided by Margaret S. Graves and Yuka Kadoi as well as by the general editors.

Abdullah, Fatima S.
Abu Khalaf, Marwan F.
Adle, Chahryar
Akin, N.
Alemi, Mahvash
Allan, James W.
Ali, Wijdan
Andrews, P. A.
Arps, Bernard
Asad, Mohammad al-
Asher, Catherine B.
Ashrafi, M. M.
Atıl, Esin
Auld, Sylvia
Babaoğlu, Lale
Badiee, Julie
Baer, Eva
Bailey, Julia
Baipakov, K. M.
Baker, Patricia L.
Balfour-Paul, Jenny
Bango Torviso, I. G.
Barrucand, Marianne
Bastéa, Eleni
Beach, Milo Cleveland
Beazley, Elisabeth
Behrens-Abouseif, Doris
Bellafiore, Giuseppe
Berns, Marla C.
Bhaskar, C. Uday
Bier, Carol
Bier, Lionel
Blair, Sheila S.
Bloom, Jonathan M.
Blurton, T. Richard
Bocard, Héléne
Bonnenfant, Paul
Borg, Alan
Bosch, Gulnar K.
Bozdogan, Sibel
Bruce-Mitford, Miranda
Bulatova, V. A.

Buryakov, Yu. F.
Canby, Sheila R.
Chaldecott, Nada
Chehab, Hafez K.
Chishti, Rta Kapur
Chyvr, L. A.
Cohen, Steven
Court, Elspeth
Craddock, P. T.
Crane, Howard
Crill, Rosemary
Curatola, Giovanni
Daneshvari, Abbas
Das, Asok Kumar
David, Jean-Claude
Deemer, Khalid J.
Denny, Frederick Mathewson
Denny, Walter B.
Déroche, François
Desai, Ziyaud-Din
Dewachi, Saeed al-
Dickie, James
Diba, Layla S.
Dodds, Jerrilynn D.
Doshi, M. C.
Duda, Dorothea
Dupree, N. Hatch
Ehnbom, Daniel
Eiland, Murray L.
Elgood, Heather
Elgood, Robert
Erzini, Nadia
Ewert, Christian
Farhad, Massumeh
Farooqi, Anis
Fernández–Puertas, Antonio
Fidalgo, Ana Marín
Finci, Predrag
Finster, Barbara
Folić, Nadja Kurtović
Fraser-Lu, Sylvia
Frashëri, Gjergj

Freitag, Wolfgang M.
Galdieri, Eugenio
Gallop, Anabel Teh
Gardi, Bernard
Gertsen, A. G.
Golombek, Lisa
Golvin, Lucien
Golzio, Karl-Heinz
Goodwin, Godfrey
Gorbunova, N. G.
Gotelik, M. V.
Goryacheva, V. D.
Goswamy, Karuna
Grabar, Oleg
Graves, Margaret S.
Gray, Basil
Groves, Laura
Grube, Ernst J.
Hadidi, Adnan
Hall, Margaret
Hardy, Adam
Harris, Claire
Hasan, Perween
Hashmi, Salima
Hasson, Rachel
Heathcote, David
Hill, Stephen
Hillenbrand, Robert
Hitchcock, Michael
Hoffman, Eva
Hossain, Hameeda
Housego, Jenny
Hughes, Jeffrey A.
Humphreys, R. Stephen
Irwin, Robert
Ivanov, A. A.
Jain, Jyotindra
Jain-Neubauer, Jutta
Jamal, Sayed Ahmad
Janis, Eugenia Parry
Jeroussalimskaja, Anna
Jessup, Helen Ibbitson

Johnson, Boyd
Jones, David
Kadoi, Yuka
Kafesçioglu, Çigdem
Kalus, Ludvig
Kane, Carolyn
Kapur, Geeta
Katzarova, Mariana
Kerr, Virginia M.
Khan, Ahmad Nabi
Khan, Hasan-Uddin
Kiel, Machiel
Kramarovsky, M.
Krishna, Anand
Krishna, Kalyan
Kubiak, Władysław B.
Kuran, Aptullah
Lamp, Frederick
Lancaster, William
Lancaster, Fidelity
Lang, Jon
Leng, Yeoh Jin
Leslie, Jolyon
Lewcock, Ronald
Lloyd, Seton
Losty, J. P.
Loughran, Kristyne
Mack, John
Manuelian, Lucy der
Manz, Beatrice Forbes
Marefat, Roya
Marr, J.
Marshak, Boris I.
Masuya, Tomoko
McChesney, Robert D.
McKenzie, Ray
Mehta, R. N.
Michell, George
Micklewright, Nancy
Montêquin, François de
Moughtin, J. C.
Mumtaz, Kamil Khan
Nath, R.
Negmatov, N. N.
Nemtseva, N. B.
Nesom-Sirhandi, Marcella
Nickel, Helmut
Nicolle, David
Nikitin, A. B.
North, A. R. E.

Northedge, Alastair
Nour, Amir I. M.
Nye, James H.
O'Connor, Jerome
 Murphy
Oguibe, Olu
O'Kane, Bernard
Oliver, Paul
Öney, Gönül
Orazi, R.
Ory, Solange
Pascual, Jean-Paul
Pavón, Maldonado Basilio
Pelrine, Diane M.
Petherbridge, Guy
Picton, John
Pinder-Wilson, Ralph
Popovski, Živko
Porter, Venetia
Prasad, Sunand
Rich, Vivian A.
Robinson, B. W.
Roaf, Susan
Rogers, J. M.
Roper, G.
Ruddock, Ted
Ruggles, D. Fairchild
Sadan, J.
Saidi, Nabil
Sajó, Tamás
Sakir, Yasir
Salam-Liebich, Hayat
Salmanov, Emile R.
Sanchez Hernández,
 M. Leticia
Sargent, William R.
Scanlon, George
Scarce, Jennifer M.
Scerrato, Umberto
Schimmel, Annemarie
Schmitz, Barbara
Seyller, John
Shishkina, G. B.
Shokoohy, Mehrdad
Shokoohy, Natalie H.
Simpson, M. S.
Sims, Eleanor
Skelton, Robert
Smith, G. Rex
Smith, Walter

Soppelsa, Robert T.
Sørensen, Henrik H.
Soucek, Priscilla P.
Stanley, Tim
Starodub, T. Kh.
Stavisky, B. Ya.
Stillman, Yedida K.
Stott, Philip
Stronge, Susan
Ströter-Bender, Jutta
Summers, Francis
Swallow, D. A.
Tabbaa, Yasser
Tadgell, Christopher
Tamari, Vera
Taylor, Roderick
Tezcan, Hülya
Thackston, Wheeler M.
Tissot, F.
Tsareva, Ye. G.
Turner, Michael
Tvrtković, Paul
Ulbert, Thilo
Uluç, Lale H.
Ünal, Rahmi Hüseyin
Vaughan, Philippa
Vernoit, S. J.
Villiers, John
Voronina, V. L.
Waller, Diane
Ward, Rachel
Wardwell, Anne E.
Warren, John
Wearden, Jennifer
Wenzel, Marian
Wescoat, Jr., James L.
Whitehouse, David
Wicks, Robert S.
Williams, Caroline
Williams, John A.
Willis, Michael D.
Winter, John
Wright, Richard E.
Woodman, Francis
Woolley, Linda
Yemel'yanenko, T. G.
Yegül, Fikret K.
Zannier, Italo
Zeymal', T. I.
Zeymal', Ye. V.

Index

Numbers in **bold** refer to volume numbers, numbers in *italics* refer to black-and-white illustrations. **Bold** volume and page numbers designate the main reference to that subject. Color plates are introduced by the abbreviation pl. and appear after the appropriate volume number.

al-Malik is a title, as is Diwan, rulers are indexed under the name following the title.

The terms Great Mosque, Friday Mosque and congregational mosque are interchangeable.

54 Group **1:**51
AATA *see* Antiquities and Art
 Treasures Act
Abaqa, Khan (*r.* 1265–82)
 (Ilkhanid)
 1:129; **2:**184
Abarquh **1:**1
 congregational mosque **1.**1
 Gunbad-i ʿAli **1:**1, 90, 91;
 3:26, *344*
Abarshahr *see* Nishapur
ʿAbbas I, Pasha (*r.* 1848–54)
 1:328
ʿAbbas I, Shah (*r.* 1588–1629)
 (Safavid) **3:163–4**
 architecture **1:171,** *172,* 306,
 354, 488; **2:**293, 296,
 297, 298, 371, 433,
 468; **3:**100, 139, 161,
 164, 381
 carpets **1:**367, 373; **3:**162
 ceramics **1:**213, 475; **2:**292;
 3:162
 coins **1:**494
 gardens **2:**92
 jade **2:**342
 manuscripts **1:**497; **2:**243;
 3:152, 160, 205, 211
 metalwork **2:**510
 tents **3:**286
 textiles **1:**215; **3:**314
 throne **3:**327
 tiles **1:**201
 wall paintings **1:**206
 woodwork **1:**385
ʿAbbas II, Khedive (*r.* 1892–
 1914) **2:**508
ʿAbbas II, Shah (*r.* 1642–66)
 (Safavid)
 architecture **1:**173; **2:**298,
 468; **3:**pl.V.1
 ceramics **1:**476
 jade **2:**342
 manuscripts **2:**245; **3:**16,
 21, 203
 wall paintings **1:**206; **3:**63
ʿAbbas al-Mahdi, al- (*r.* 1747–
 75) (Zaydi) **3:**450
Abbasids (*r.* 749–1258) **1:1–2,**
 391; **2:**160–161
 architecture **1:**1, *2,* 78–83, *81,*
 194, *25i,* 305; **2:531**
 calligraphy **1:**2, 342–343, 344,
 344, pl.XII.2
 ceramics **1:**2, 245, 449
 coins **1:**425, 492

dress **2:**22
flags **2:**76
gardens **2:**87
manuscripts **2:**208
metalwork **2:**487
mosaics **1:**207
palaces **1:**1; **3:**98
textiles **3:**337
thrones **3:**327
wall paintings **1:**203
see also Mansur, al-, caliph
 (*r.* 754–75); Mahdi, al-,
 caliph (*r.* 775–85);
 Harun al-Rashid, caliph
 (*r.* 786–809); Amin,
 al-, caliph (*r.* 809–13);
 Maʾmun, al-, caliph
 (*r.* 813–33); Muʿtasim,
 al-, caliph (*r.* 833–42);
 Wathiq, al-, caliph
 (*r.* 842–7); Mutawakkil,
 al-, caliph (*r.* 847–61);
 Muntasir, al-, caliph
 (*r.* 861–2); Muʿtamid,
 al-, caliph (*r.* 870–92);
 Muqtadir, al-, caliph
 (*r.* 908–32); Nasir,
 al-, caliph (*r.* 1180–
 1225); Mustansir, al-,
 caliph (*r.* 1226–42);
 Mustaʿsim, al-, caliph
 (*r.* 1242–58)
ʿAbbasiyya, al- **1:**29; **3:**98
ʿAbbas Mirza **3:**19
Abboud, Chafic **2:**418
ʿAbd al-Aʾimma **1:***231*
ʿAbd al-ʿAziz (12th century)
 2:462
ʿAbd al-ʿAziz (*r.* 1540–49)
 (Shaybanid) **2:**241,
 539; **3:**203, 205, 336
ʿAbd al-ʿAziz (*r.* 1647–80)
 1:309, 407
ʿAbd al-ʿAziz II, King of Saudi
 Arabia (*r.* 1902–53)
 (Saudi) **3:**186
ʿAbd al-Aziz ibn Marwan
 (*fl.* 686) **1:**323
ʿAbd al-ʿAziz ibn Sharaf al-Din
 Tabrizi **1:**412
ʿAbd al-ʿAziz Sultan (*r.* 1540–
 49) **2:**250, 453
ʿAbd al-Hadi ibn Muhammad
 ibn Mahmud ibn
 Ibrahim of Maragha
 2:463

ʿAbd al-Hamid Lahauri **1:**34
ʿAbd al-Haqq Shirazi *see* Amanat
 Khan
ʿAbd al-Hayy **1:**3; **2:**215, 220,
 222, 344, 364
ʿAbd al-Husayn **2:**288, 412
ʿAbd al-Jabbar ibn ʿAli **2:**208
ʿAbd al-Jabbar **1:**502
ʿAbd al-Jalil Čelebi *see* Levni
ʿAbd al-Karim (*fl.* 1236) **1:**231
ʿAbd al-Karim (*fl.* 1460s–90s)
 1:349
ʿAbd al-Karim Maʿmur Khan
 (*fl.* 1615–32) **1:**184,
 185
ʿAbd Allah (*r.* 888–912)
 (Umayyad) **1:**505
ʿAbdallah (*fl. c.* 1400) **2:**343
ʿAbdallah (*fl.* 1417–20)
 (Timurid) **1:**398
ʿAbdallah (*fl.* 1530s) **2:**250
ʿAbdallah (*r.* 1729–57) (ʿAlawi)
 1:189; **2:**74
ʿAbdallah, caliph (*r.* 1885–98)
 3:61, 254
ʿAbd Allah, Sultan (*fl.* 1568)
 (Saʿdi) **3:**160, pl.XVI.2
ʿAbdallah II, Khan (*r.* 1583–98)
 (Shaybanid) **1:**177,
 177, 180, 399
Abdallah, Fatima Shaaban **3:**450
ʿAbdallah Ahmad **3:**431
ʿAbdallah al-Shirazi (gilder)
 2:243
ʿAbdallah ibn al-Rabiʿ **2:**331
ʿAbdallah ibn al-Zubayr
 2:471
ʿAbdallah ibn Mahmud al-
 Naqqash **3:**432
ʿAbdallah Jan **1:**180
ʿAbdallah Khan (*fl. c.* 1810–50)
 1:3–4; 3:17, 63, 132,
 274
Abdallahkhan-kala *see* Merv
ʿAbdallah "Muravid" Bayani
 1:348
ʿAbdallah Sayrafi **1:4,** 347;
 2:144, 254, 370
ʿAbdallah Shirazi (calligrapher)
 2:257
ʿAbdallah Tabbakah **1:**348;
 2:343
ʿAbd al-Latif, Sultan (*r.* 1540–
 52) (Shaybanid) **3:**375
ʿAbd al-Latif (*c.* 1900) **2:**288, 412
ʿAbdallah Zakhir **3:**126

ʿAbd al-Majid ibn Masʿud
 1:237; **2:**464
ʿAbd al-Majid Taliqani **1:**349
ʿAbd al-Malik, caliph (*r.* 685–
 705) (Umayyad) **3:370**
 Arabic as official language
 1:342
 architecture **1:**75; **2:**351, 352,
 516
 coins **1:**425, 492; **2:***515*
 dress **2:**25
 mosaics **1:**207
 sculpture **1:**196
ʿAbd al-Malik (*c.* 1000) **3:**77
ʿAbd al-Muʾmin
 Muhammad al-
 Khuvayyi **2:**233
ʿAbd al-Muʾmin (*r.* 1598)
 (Shaybanid) **1:**179
ʿAbd al-Muzaffar Nasir Shah
 (*r.* 1500–10) **2:**236
ʿAbd al-Rahim (*fl.* 1460s–90s)
 1:349
ʿAbd al-Rahim ʿAmbarin-Qalam
 (*fl.* early 16th century)
 1:350
ʿAbd al-Rahim ibn ʿAbdallah
 al-Rashidi **2:**491
ʿAbd al-Rahim Khan-i Khanan
 2:264, 428
ʿAbd al-Rahman (*r.* 1880–1901)
 2:365
ʿAbd al-Rahman I (*r.* 756–88)
 (Umayyad) **3:371**
 architecture **1:**87, 506; **2:**436,
 550
ʿAbd al-Rahman II (*r.* 822–52)
 (Umayyad)
 architecture **1:**88, 505, 506;
 3:197
ʿAbd al-Rahman III (*r.* 912–61)
 (Umayyad) **3:372**
 architecture **1:**121, 505, 506;
 2:428, 531; **3:**198
 sculpture **1:**196
 wall paintings **1:**205
ʿAbd al-Rahman ibn ʿUmar al-
 Sufi *see* Kitāb ṣuwār
 al-kawākib al-thābita
 ("Book of the fixed
 stars")
ʿAbd al-Rahman ibn Zayyan
 2:332
ʿAbd al-Rahman Jami **1:**56
ʿAbd al-Rahman Katkhuda
 1:327, *328*

'Abd al-Rahman Khwarazmi
1:349
'Abd al-Rashid (r. 1050–53)
(Ghaznavid) 2:109, 190
'Abd al-Rashid Dailami 1:350
'Abd al-Razzaq 1:287
'Abd al-Razzaq Samarqandi
1:131
'Abd al-Samad 1:4–6, 5, 350,
518; 2:258; 3:13, 20
'Abd al-Vahid 1:475
Abdalwadid (r. 1236–1550)
architecture 1:158
'Abd at-'Aziz al-Irbili 3:232
Abdelhalim, Halim 3:28
Abdin Bey 1:327
Abdülaziz, Sultan (r. 1861–76)
(Ottoman) 1:167; 2:57,
319; 3:89, 119, 200
Abdul Aziz Farman Farmaian &
Associates 1:213
Abdul Basit 3:46
Abdülcelil Çelebi see Levni
Abdülfettah 2:474
Abdul Ghani al-Ani 2:140
Abdulhamid, Sultan (r. 1876–
1909) (Ottoman)
1:167; 2:260, 319, 322,
329; 3:7, 33, 34, 80,
119
Abdul Jamid Shah, Sultan
(r. 1623–77) 2:447
Abdulkarim, Salah 3:188
Abdulla, Master 1:318
Abdulla, Mohammed Ahmed
3:255
Abdulla, Usto 2:391
'Abdullah (fl. 1540) 3:205
'Abdullah (r. 1626–72) (Qutb
Shahi) 2:179
Abdullah, Fatima Shaaban 3:270
Abdullah, Jalal ben 3:356
Abdullah brothers 2:322; 3:119
'Abdullah Buhari 2:255
Abdullahi Bayero, Emir 2:369
'Abdullah ibn 'Ali al-Mail 3:136
Abdullah of Amasya 1:348
Abdullah Zühdü 3:39
Abdullayev, Abdukhak 3:388
Abdullayev, G. G. 1:240
Abdullayev, Lutfulla 3:388
Abdullayev, Mikhail G. 1:241
Abdullayev, Sagdulla
Asadullayevich 3:388
Abdullayeva, G. A. 1:243
Abdülmecid, Sultan (r. 1839–
61) (Ottoman) 1:167;
2:4, 42, 324; 3:39
Abdülmecid, Crown Prince
(1868–1944)
(Ottoman) 1:229;
2:472; 3:65
Abdulrahim 1:245
Abdurakhmanov, F. G. 1:240;
2:86
Abdurakhmanov, Nadir G.
1:241
Abdurashidov, Shukrat 3:388
Abdur Qadir Badaoni 2:38
Abdusamatov, Dot 3:268
Abedin, Zainul 1:6, 263; 3:93
Abha 3:187, 405
'Abid 1:6, 64; 2:262
Abidi, Abed 3:104
Abidin, Nik Zainal 2:445
ablaq 1:234; 3:449
abr 3:317, 388

Abraham of Kütahya ware see
under ceramics → wares
Abu 'Abdallah Muhammad XI,
Sultan (r. 1482–3)
(Nasrid) 2:505, 506
Abu see Aswan
Abu 'Ali Muhammad ibn 'Ali
ibn Muqla see Ibn
Muqla
Abu Bakr, caliph (r. 632–4)
2:159, 393
Abu Bakr ibn Yusuf 3:430
Abu Bakr Muhammad ibn
'Abdallah see Kitāb
khalq al-nabī wa-khul-
qih ("Book of the
moral and physical
characteristics of the
Prophet")
Abu Bakr Muhammad ibn Rafi'
2:190
Abu Bakr Sandal 2:187
Abu Dhabi
Al-Ain Museum 3:374
Corniche 3:373
al-Husn Palace 3:373
Women's Craft Center 3:374
Abu Fadl Muhallabi 3:424
Abu Hafs 'Umar al-Murtada,
Sultan (r. 1248–66)
(Almohad) 1:58, 296
Abu Hanifa 2:302
Abu Harb Bakhtiyar 1:90, 517;
3:218
Abu Ibrahim (11th century)
(Khwarazmshah) 1:410;
2:490
Abu Ibrahim Ahmad (r. 856–63)
(Aghlabid) 1:29; 2:366,
535; 3:354, 421
Abu 'Inan Faris (r. 1348–59)
(Marinid) 1:158; 2:188,
432, 464
Abuja 3:53
Abu Ja'far Ahmad ibn Sulayman
al-Muqtadir bi-Ilah
(r. 1049–82) (Hudid)
1:124
Abu'l-'Abbas Ahmad ibn
Muhammad al-Sufyani
1:295
Abu'l-'Abbas Valgin ibn Harun
2:489
Abu'l-Asvar Shavur I (r. 1049–
67) 2:85
Abu Layth al-Siqilli 3:198
Abu'l-Fadl Bayhaqi 1:446
Abu'l-Faraj al-Isfahani see Kitāb
al-aghānī ("Book of
songs")
Abu'l-Fazl 1:268, 367, 518;
2:37, 66, 66; 3:13
Abu'l-Fida 2:355
Abu'l-Hasan (i) (d. 1022) see Ibn
al-Bawwab
Abu'l-Hasan (ii) (fl. 1600–30)
1:6, 7–8, 64; 2:260,
460; 3:327
Abu'l-Hasan 'Ali (r. 1331–48)
(Marinid) 1:158, 384;
2:464, 466; 3:143, 210,
211, 304
Abu'l-Hasan Khan 2:343
Abu Mansur Bakhtiyar 2:489
Abu'l-Mutahhar al-Azdi 1:446
Abu'l-Qasim (fl. c. 1816;
painter) 1:8

Abu'l-Qasim al-Zayyani (d.
1833; writer) 1:188
Abu'l-Qasim Babur (r. 1449–57)
(Timurid) 1:349; 2:193
Abu'l-Qasim Firdawsi see
Shāhnāma
Abu'l-Qasim ibn 'Ali al-Tusi
2:374
Abu'l-Qasim ibn Sa'd ibn
Muhammad al-Is'irdi
2:499
Abu'l-Qasim Jamal al-Din
'Abdallah (d. 1337/8)
1:8, 9, 441, 458, 462;
2:311
Abu'l-Qasim Kashani 1:304
Abu'l-Qasim Mahmud ibn
Sanjar Shah 2:499
Abu'l-Wafa' al-Buzajani 3:244
Abu Mansur Bakhtakin
2:137; 3:299
Abu Muhammad Isma'il 2:333
Abu Muslim 2:477; 3:99
Abu Nasr 1:447
Abu Nuwas (d. c. 813) 1:2
Abu Rufaza see Abu Zayd
Abu Sa'id, Khan (r. 1317–35)
(Ilkhanid) 1:495;
2:185; 3:308
Abu Sa'id, Sultan (r. 1459–69)
(Timurid) 2:148
Abu Sa'id ibn Kuchkunji 1:178;
3:176
Abu Sa'id 'Uthman (r. 1310–31)
(Marinid) 1:158, 384;
2:506; 3:304
Abu Tahir 1:8–9
Abu Tahir Husayn ibn Ghali ibn
Ahmad 1:214
Abu Ya'qub Yusuf (r. 1163–84)
(Almohad) 3:198
Abu Ya'qub Yusuf (r. 1286–
1307) (Marinid) 1:158;
2:464
Abu Yusuf Ya'qub (r. 1258–86)
(Marinid) 2:464
Abu Yusuf Ya'qub al-Mansur,
Sultan (r. 1184–99)
(Almohad)
architecture 1:58, 127; 3:143,
198
Abu Zakariya (r. 1228–49)
(Hafsid) 1:159; 2:133
Abu Zayd 1:8, 9, 10, 459; 2:516
Abyana
Maydan Mosque 3:424, 425
acacia 3:434
Acacia arabica 3:438
acacia gum 2:283
Acacia nilotica 3:420
Acar, Kuzgun 3:362
Aceh
mosque 2:440
Achebe, Chinua 3:58
Achibal 2:96–97
Achkar, Yvette 2:418
Ackerman, Phyllis 1:10; 2:154;
3:122
Acudoğu, Ratip Asir 1:10;
3:362
Adams, R. McC. 2:155
Adana 1:364
Adekhsan 2:522
Adem, Seyyid 1:233
Aden 3:302, 444, 444
Ethnographical Museum
3:446

Adharbod 1:351
'Adil I, al-, Sultan (r. 1196–
1218) (Ayyubid) 1:234,
324, 333
'Adilabad see under Delhi
'Adil Shahis (r. 1489–1686)
1:11–12
architecture 1:289
manuscripts 1:11
see also Yusuf 'Adil Shah
(r. 1489–1509); Isma'il
'Adil Shah (r. 1510–
34); 'Ali 'Adil Shah I
(r. 1557–79); Ibrahim
II 'Adil Shah (r. 1579–
1627); Muhammad
'Adil Shah (r. 1627–
56); 'Ali 'Adil Shah II
(r. 1656–72); Sikandar,
(r. 1672–86)
Adiyaman 1:460
Adnan, Etel 1:12; 2:418
Adrianople see Edirne
'Adud al-Dawla (r. 949–83)
(Buyid) 1:90, 293;
2:420, 490; 3:424
Adylov, Sabir Rahimovich
3:387
Adzhina Tepe 1:433
aesthetics 1:12–13
Afdal, al- 3:296, 337, 339
Afganly, B. 1:242
Afghanistan 1:13–19
architecture 1:16, 97, 131
arches 1:100
carpets 1:17
ceramics 1:18
dress 1:17
embroidery 1:18, pl.I.3
gardens 1:19
historiography 1:435
jewelry 1:18
madrasas 1:97
manuscripts 1:44, 497; 2:149,
226, 227, 228, 229;
3:337
metalwork 2:491, 493, 497
minarets 1:98, 99
mosques 1:97
museums and collections 1:19
painting 1:16–17, 135
palaces 1:97
sculpture 1:16
silver 1:18
tents 3:279
terracotta 1:100
textiles 1:17
tombs 1:97; 2:147
woodwork 1:18
see also Ghaznavids; Ghurdis;
Timurids
afrāgh 2:461
Afrasiab see under Samarkand
Africa 1:19–28
architecture 1:21
calligraphy 1:27
ceramics 1:26
gourds 2: pl.III.3
houses 1:22, 24, 24; 2:pl.III.1
huts 3:445
manuscripts 1:27, pl.I.2
masks 1:20
minarets 1:22
mosques 1:22, 23
palaces 1:22
textiles 1:25–6; 2:pl.III.2,
pl.XV.2

see also Algeria; Berber; Chad
 Republic; Egypt; Fulani;
 Guinea; Hausa; Kenya;
 Libya; Mali; Morocco;
 Niger; Nigeria; Nubia;
 Senegal; Somalia;
 Sudan; Swahili; Tuareg;
 Tunisia
Afroz, Meher 3:94
Afshar 1:378
Afsharids (r. 1736–95) 1:54
Afsin
 Ribat-i Eshab-i Kehf 1:118
Afushta
 mosque 3:436
Afyon
 Ak Mescid 1:142
 Great Mosque (Ulu Cami)
 1:142; 3:27, 431
 Kubbeli Mosque 1:142
 mosque of Gedik Ahmed
 Pasha 1:145
Afzal 1:28
Agababayeva, T. 1:243
Agababov, T. 1:243
Agache, Donat-Alfred 2:319
Agadez
 basketwork 3:349
 leather 3:349
 mosque 1:22
Agadir see Tlemcen
Aga Khan Award for
 Architecture 1:28
Agamalova, L. 1:243
Agamy
 Halawa house 3:417
Ağa-Oğlu, Mehmet 2:154, 363
agate 1:339; 2:99, pl.XIII.2
Agay 1:217
Ager 1:482
Agha, Zubeida 1:28; 3:93, 94
Agha Muhammad (r. 1779–97)
 (Qajar) 2:92, 528, 541;
 3:20, 149, 150
Aghdam 1:236, 238
Aghkand 1:457
Aghlabids (r. 800–909) 1:30
 architecture 1:30, 78, 85, 86;
 2:367, pl.XVI.2
 ceramics 1:452
 see also Ibrahim ibn al-Aghlab
 (r. 800–12); Ziyadat
 Allah I (r. 817–38);
 Abu Ibrahim Ahmad
 (r. 856–63); Ibrahim II
 (r. 875–902)
Agouti 2:522
Agra 1:30–34; 2:51, 96
 Agra Fort (Red Fort) 1:34–5,
 183, 185; 2:529
 Anguri Bagh 1:34
 doors 3:424
 Nagina Masjid 1:34, 186
 Octagonal Tower 1:34, 353
 carpets 2:87, 149; 3:10, 86,
 87, 264
 congregational mosque 1:121,
 334
 enamel 1:244, 228; 2:50, 51;
 3:19, 132
 gardens 1:182, 184; 2:96
 Jahangiri Mahal 1:34, 35,
 183; 3:101
 Ram Bagh 1:31; 2:96
 Taj Mahal 1:31–2, 69, 185,
 489, pl.II.1; 2:6, 312;
 3:240, 343

textiles 1:20; 2:28; 3:11
Tomb of I'timad al-Dawla
 1:31, 32
see also Sikandra
agriculture 2:103–4
AH see anno hejirae
Ahed, M. A. 3:94
Ahlat
 ceramics 1:460
 fortress 2:525
 tomb of Bayindir 1:144; 3:344
Ahmad (fl. 11th–12th century)
 2:218
Ahmad (fl. 13th century) 1:117
Ahmad (fl. 1473) 1:385; 3:436
Ahmad (fl. 1815–50) 1:35; 3:64
Ahmad I (r. 1081–94)
 (Qarakhanid) 1:212;
 3:209, 290
Ahmad I Wali, Sultan see Shihab
 al-Din Ahmad, Sultan
Ahmad II al-Mansur, Sultan
 (r. 1578–1603) (Sa'di)
 1:189; 2:532; 3:100
Ahmad, Yussef 3:137
Ahmadabad see Ahmedabad
?Ahmad al-Khurasani 2:71, 334
Ahmad al-Suhrawardi 1:35–6,
 346, 347; 3:422
Ahmadi see Iskandarnama
 ("Book of Alexander")
Ahmad ibn al-Hasan ibn al-
 Ahnaf see Kitab al-bay-
 tara ("Book of farriery")
Ahmad ibn 'Ali al-Maqrizi 1:71,
 105
Ahmad ibn al-Shaykh
 al-Suhrawardi al-Bakri
 see Ahmad;
 al-Suhrawardi
Ahmad ibn Ayyub al-Hafiz al-
 Nakhchyvani 1:237,
 267
Ahmad ibn Basu 3:198
Ahmad ibn Husayn ibn Basu
 2:122, 505
Ahmad ibn Ibrahim 2:17
Ahmad ibn Khurasan 3:354
Ahmad ibn Mas'ud 1:348
Ahmad ibn Muhammad-Mahdi
 1:54
Ahmad ibn Muhammad Quds
 1:484
Ahmad ibn Tulun (r. 868–84)
 1:85, 323, 331–2,
 pl.V.1; 3:353
Ahmad Jalayir, Sultan (r. 1382–
 1410) (Jalayirid)
 2:344–5
 manuscripts and miniature
 paintings 1:3, 43, 293;
 2:201, 219, 221–2, 537
Ahmad Karahisari 1:36, 348;
 2:135, 302, 325; 3:86
Ahmad Khan Dunbuli 1:54
Ahmad Musa 1:36; 2:215, 220
Ahmad Qarahisari see Ahmad
 Karahisari
Ahmadnagar 3:60
Ahmad Shah, Prince 1:117
Ahmad Shah I, Sultan (r. 1411–
 42) 1:37; 3:384
Ahmad Shah ibn Sulayman Shah
 2:17
Ahman ibn Muhammad al-
 Faraghani (Alfraganus)
 1:67

Ahmed I, Sultan (r. 1603–17)
 (Ottoman) 1:498;
 2:139, 233, 254, 255,
 323, 325–6, 402,
 474, 508; 3:225,
 327, 433
Ahmed III, Sultan (r. 1703–30)
 (Ottoman) 1:166, 167;
 2:133, 255, 329, 474;
 3:87–8
Ahmed, Anna Molka 3:94
Ahmed, Bashir 3:94
Ahmed, Iqbal 3:94
Ahmed, Jalaluddin 3:97
Ahmed, Kerbalai 1:238
Ahmed, Tag el Sir 3:254
Ahmed, Tayyeba 3:94
Ahmed, Zahin 3:94
Ahmedabad 1:37–9, 137; 2:20,
 272; 3:325, 326, 414
 Calico Museum of Textiles
 1:37, 264; 2:275
 Gandhi Institute of Labour
 2:273
 Gandhi Memorial Center
 2:272
 Jami' Masjid 1:38, 38, 139;
 2:270, 272; 3:384
 metalwork 2:513
 Sanskar Kendra Municipal
 Museum 2:275
 School of Architecture 2:272
 Shreyas Folk Art Museum
 2:275
 textiles 1:37; 3:319, 322
Ahmed ben Osman 3:356
Ahmed Dalgiç 1:39, 164; 2:323;
 3:222, 433
Ahmed Feridun see Nuzhat asrar
 al-akhbar dar safar-i
 sigitvar (chronicle of the
 Szigetvár campaign)
Ahmed ibn Hasan Kalibi Fânî
 3:453
Ahmed Naksi 1:39–40; 2:255
Ahmed Tekelü 3:86
Ahmed Usta 1:39
Ahmet Ali 1:40; 2:322; 3:64,
 361
Ahmet Gazi 1:143
Ahsan al-kibar ("History of the
 faithful imams"; 1525;
 St. Petersburg, Saltykov-
 Shchedrin Pub. Lib.,
 Dorn 312) 3:134, 163
Ahwaz
 Jondi Shapour University
 2:286
AIFACS see All Indian
 Fine Arts and Crafts
 Society
Aïm Qarwash 1:159
a'ina-kari 1:210
'Ain Zarba see Anazarva
Aitchison, George 2:544; 3:69
Aitiyev, Gapar 2:408
Aït Ouaouzguit 1:381
aiwans see iwans
'Aja'ib al-makhluqat ("Wonders
 of creation") by
 al-Qazwini
 (1279–80; Munich, Bayer.
 Staatsbib., C. arab. 464)
 2:198, 210, 214
 (1388; Paris, Bib. N., MS.
 supp. pers. 332) 2:198,
 222, 345

(early 15th century; New York,
 Pub. Lib., Spencer MS.
 45; Washington, DC,
 Freer, 54.33–114,
 57.13) 2:231
 (c. 1553; Istanbul, Topkapı
 Pal. Lib., A. 3632)
 2:255
 (c. 1590; Dublin, Chester
 Beatty Lib., Ind. MS. 6)
 1:282; 2:368
'Ajami 1:467
'Ajami ibn Abu Bakr 1:237;
 3:45
Ajanta 3:324
Ajayapala, King 1:40
Ajlun
 al-Rabad 2:363
'Ajman
 museum 2:138
Ajmer 1:40–41
 Arha'i Din ka Jhompra 1:40,
 98, 100
 Rajputana Museum of
 Archaeology 1:41
Akbar, Emperor (r. 1556–1605)
 (Mughal) 2:270–71;
 3:13
 albums 1:44
 architecture 1:41, 44, 46, 183;
 2:10, 66, 413, 529;
 3:101
 carpets 1:309; 2:378
 coins 1:141
 dress 2:37; 3:321
 jade 2:342
 manuscripts and miniature
 1:294, 350; 2:230;
 paintings 2:258–60;
 3:48, 277
 'Abd al-Samad 1:4, 5
 Basawan 1:268, 269, 270
 Bhanwari 1:269–270
 Bishan Das 1:290–291
 Daswanth 1:518
 Daulat 1:518–519
 Dhannu 2:14
 Dharm Das 2:15
 Farrukh Beg 2:63–65
 Farrukh Chela 2:64–65
 Govardhan 2:119
 Haribans 2:136
 Jagan 2:344
 Kesu Das 2:380
 Khem Karan 2:383
 Lal 2:259, 415
 Mahesh 2:434
 Manohar 2:459–460
 Mansur 2:460
 Mir Sayyid 'Ali 2:540
 Miskin 2:542
 Mukund 3:24
 Nanha 3:46
 Payag 1:114
 Tara 1:270; 3:272
 tents 3:276, 286
 textiles 3:319
 tomb 1:184–5; 2:96; 3:14,
 212–13, 343
 wall paintings 1:206
 weapons 1:224
Akbarabad see Agra
Akbarnama ("History of Akbar")
 2:204; 3:48
 (c. 1590; London, V&A,
 IS.2:1896) 1:61, 269,
 270, 282; 2:15, 63, 64,

460 Index

259, *259*, 380, 383, 415, 428, 459, 460, 542; **3:**24, 46, 272, *277*, 353
(1596–7 or *c.* 1604; Dublin, Chester Beatty Lib., MS. 3; London, BL, Or. MS. 12988; and dispersed) **1:**256, 518; **2:**14, 15, 119, 259, 260, 383, 415, 428, 459, 460, 542; **3:**24
Ak-Beshim **2:**406
Akbulut, Ahmet Ziya **3:**65
Akcaalan **1:**468
Akdik, (Ahmed) Kamil **3:**89, 180
Akhal, Tamam **3:**104
Ak Han **1:**198
Akhlamabad Dam **1:**134
Akhlaq, Zahoor ul- **1:**41
Akhlâq-i muhsinî (London, BL, Orient. & India Office Lib.) by Kashifi **2:**250
Akhmarov, Chingiz **3:**387
Akhmedbekov, A. **1:**238, 255
Akhmedov, Abdulla **3:**366
Akhmedov, Anvar Kamilovich **3:**366
Akhmetzhanov, Kaliolla **2:**377
Akhmim **3:**295
Akhmukhamedov **3:**367
Shamukhamed **3:**367
akhnîf **2:**29, *30*
Akhsikath **2:**73
Akhsu
mosque **1:**237
Akhsyket **1:**412
Akhtar, Saeed **3:**93
Akhundov, I. G. **1:**241, 242
Akhundov, Orif Abdur-raufovich **3:**267
Akitek MAA Sdn Bhd **2:**442
Akkoyunlu *see* Aqqoyunlu
Akl, Said **2:**418
Aksaray
carpets **1:**360
mosque of Pertevniyal Valide Sultan **1:**167
palace **1:**144
Zincirli Madrasa **1:**143
Aksekir
mosque of Ferruh Shah **1:**118
tomb of Seyyid Mahmud **1:**144
Aksel, Malik **3:**361
Aksu **3:**214
Ak-Tepe **3:**412
Akwete **3:**54
Akylbekov, Sabyrbek **2:**408
ʿAlaʾ al-Dawla **2:**341
ʿAla al-Dawla Muhammad **2:**521
ʿAla al-Din, Sultan (*r.* 1296–1316) (Khalji) **1:**137; **2:**3, 9, 270, 381; **3:**99
ʿAlaʾ al-Din ʿAli ibn ʿAbd al-Karim *see* Ali acemi
ʿAla al-Din Husan Bahman (*r.* 1347–58) (Bahmani) **1:**252
ʿAla al-Din Kayqubadh, Sultan (*r.* 1219–37) (Saljuq) **1:**120, 354; **2:**391; **3:**308
ʿAla al-Din Muhammad (*r.* 1200–20) (Khwarazmshah) **1:**425

ʿAla al-Din Muhammad, Prince (Ghurid) **1:**385
Alabaidi, Amar **2:***291*
Alaca Höyük **3:**363
Alamut **1:**41
Alanya **1:**120; **2:**520
cloister of Sitti Zeynip **1:**143
ʿAlawal Khan **3:**185
ʿAlawi (*r.* 1631–present) **1:**188; **2:**168
architecture **3:**379
see also Rashid, al- (*r.* 1664–72); Mawlay Ismaʿil (*r.* 1672–1727); ʿAbdallah (*r.* 1729–57); Muhammad III ibn; ʿAbdallah (*r.* 1757–90); Hassan II, King of Morocco (*r.* 1961–99)
Alay Han **1:**198
Albania **1:**42–3, 169
Albanian towers **1:**43
albarelli **1:**515
Alben **1:**314
albums **1:**66, 232, 336; **2:**76, 192, 254; **3:**2
Alcalá de Henares **1:**227
chapel of S. Ildefonso **3:**9
Paraninfo **3:**9
Alcaraz **1:**360
Alchin **1:**400
Aleksić, Borivoje **1:**302
Aleppo **1:**45–47, 190; **2:**518, 519, 526; **3:**216, 261, 376–7, *377*, 378–9, 394
ʿAdiliyya Mosque **1:**161, 163
architecture **1:**148; **3:**403
Bab Antakiya **2:**519
baths **1:**271
caravanserais **1:**69, 355
citadel **1:**46; **2:**519, *520*, 526
Maqam Ibrahim **3:**423
palace of al-ʿAziz **1:**115
congregational mosque **1:**46, 75, 112
minbar **3:**431
minaret **2:**532
mosaics **1:**207
Firdaws Madrasa and mosque **1:**46, 113, *114*; **2:**88, 432; **3:**27, 229
mihrab **1:***47*
fountains **2:**88
glass **2:**113
houses **2:**174
Jamiʿ al-Utrush **1:**151
Khan al-Gumruk **1:**355
Khan al-Qadi **1:**151
Khusraw Pasha complex **1:**327
markets **1:**151
marquetry **1:**515; **2:**18; **3:**433–434
Matbakh al-ʿAjami **1:**115
mosques **1:**163
National Museum **3:**2
Shadbakhtiyya Madrasa **3:**27
textiles **1:**47; **3:**282, 305, 310
tomb complexes **1:**147
Zahiriyya Madrasa **1:**113
alerce **3:**425
Alexander the Great **1:**47
Alexandria **1:**47–48, 148; **2:**526
Bibliotheca Alexandrina **1:**48; **2:**420
carpets **1:**360
coins **1:**490, *491*
College of Fine Arts **2:**48

glass **2:**113
Greco–Roman Museum **2:**49
metalwork **2:**486
Museum of Fine Arts **2:**49
textiles **3:**294, 305, 338
Alexandria Eschate *see* Khodzhent
Alfonso VIII, King of Castile (*r.* 1158–1258) **3:**8
Alfonso X, King of Castile-León (*r.* 1252–84) **3:**7, 198
Alfonso XI, King of Castile-León (*r.* 1312–50) **3:**8, 199
Algabir, Ali Hassan **3:**137
Algeria **1:**49–52
architecture **1:**50, 102, 125, 158–9; **3:**394–6
carpets **1:**51, 380–81
ceramics **1:**453
embroidery **3:**313
jewelry **1:**pl.I.4; **2:**358
minarets **1:**133
mosques **1:**60, 158
museums and collections **1:**49
painting (oil) **1:**49
tents **3:***279*
textiles **3:**313
see also Aghlabids; Almohads; Almoravids; Berbers; Hafsids
Algerian National Union of Plastic Arts **2:**315
Algiers **1:**49, 50, 52; **2:**523; **3:**376
Bardo Museum of Ethnography and Prehistory **1:**51
Beylerbey Palace **1:**170
Ecole Nationale des Beaux-Arts **1:**49–50
Great Mosque **1:**59, 125; **3:**427
markets **3:**378
minbar **2:**525
Mosque of the Fishermen **1:**170
Musée National des Antiquités Algeriennes et d'Art Musulman **1:**51; **3:**36
Museum of Fine Arts **1:**51
Museum of Popular Arts and Traditions **1:**51
post office **1:**49
Alhambra *see under* Granada
Alhambra vases **1:**469, *469*; **2:**121; **3:**49
Alhusayni, Shams Anwari **2:**287
ʿAli (Bahrain) **2:**435
ʿAli, caliph (*r.* 656–61) **1:**342
ʿAli (*d.* 1067) (Sulayhid) **3:**256
ʿAli (*r.* 1106–43) (Almoravid) **1:**59; **3:**300, 340
ʿAli (*fl.* 1242–65; Iran) **1:**9, pl.I.1
ʿAli (*fl.* 13th century; Azerbaijan) **1:**243
ʿAli (*fl.* 1435–6) **1:**237
ʿAli (*fl. c.* 1800–20) **1:**52; **2:**51
ʿAli, Abbas **3:**94
ʿAli, Habib Fida **2:**370; **3:**92
ʿAli, Karima **2:**48, pl.I.1
ʿAli, Mahmoud al- **2:**290
ʿAli, Maqsood **3:**94
ʿAli, Mohammad **3:**94
ʿAli, Naheed Raza **3:**94
Ali, Shakir **1:**41, **53**; **3:**46, 93, 97
Ali, Wijdan Princess **1:**53; **2:**363
Ali Acemi **1:**53

ʿAli ʿAdil Shah I (*r.* 1557–79) **1:11**, 289, 265
ʿAli ʿAdil Shah II (*r.* 1656–72) **1:**265
ʿAli Akbar (*fl.* 1613) **3:**185
ʿAli Akbar (*fl.* 1846) **1:**478
ʿAli Asghar **2:**243
ʿAli Ashraf **1:**54; **2:**300, 411; **3:**16, 19
ʿAli Barid, Shah (*r.* 1543–79) (Barid Shahi) **1:**268
ʿAli Bey **2:**471
Ali Çelebi *see* *Humayûnnâma*
ʿAli Dawlat **3:**283
Alief, George **2:**362
Aligarh **1:**54–5
alignment of mosques (facing Mecca) *see* qibla
Ali Gomaa **2:**182
Ali Haydar Bey **3:**180
ʿAli ibn Ahmad al-Warraq **1:**345; **3:**453
ʿAli ibn Ahmad ibn ʿAli al-Husayni **1:**9; **2:**430
ʿAli ibn Abi Talib, caliph (*r.* 656–61) **2:**160
ʿAli ibn al-Dimishqi **1:**142; **3:**193
ʿAli ibn al-Nahi **3:**423
ʿAli ibn Amir Beg Shirvani **2:**252
ʿAli ibn Hasan al-Sultani **2:**222
ʿAli ibn Hilal al-Bawwab *see* Ibn al-Bawwab
ʿAli ibn Husayn ibn Muhammad **2:**501
ʿAli ibn Ilyas al-Tabrizi al-Bavarji **2:**345
ʿAli ibn Isa (*fl. c.* 800) **3:**369
ʿAli ibn Isa (*fl. c.* 1446) **3:**431
ʿAli ibn Kasirat al-Mawsili **2:**502
ʿAli ibn Makki **3:**431
ʿAli ibn Muhammad ʿAli Shahab al-Ghuri **2:**510
ʿAli ibn Muhammad al-Nisibini **2:**480
ʿAli ibn Muhammad ibn Abī Tāhir *see* ʿAli
ʿAli ibn Salama **3:**423
ʿAli ibn Shadhan al-Razi **1:**467; **2:**186
ʿAli ibn ʿUthman **3:**431
ʿAli Ibrahim **1:**498
ʿAli Mardan Khan **1:**187; **2:**6
ʿAli Mirza, Sultan **2:**232
Alimov, Mirzorahmat **3:**268
ʿAli Mubarak **2:**44
ʿAli Muhammad Isfahani **1:54,** 442, 478, pl.XV
ʿAli Naqi **1:**174; **3:**204
ʿAli of Gomara **3:**198
ʿAli Quli Agha **3:**338
ʿAliquli Jabbadar **1:55–56;** **2:**245, 411
ʿAliquli Khuvayyi **2:**248
Alişar Hüyük **3:**363
ʿAlishah **1:**129, **3:**264
ʿAlishir Navaʾi **1:56,** 132, 349; **2:**148, 228, 467; **3:**134, 256, 336
see also *Dîvân* (collected poems); *Khamsa* ("Five poems"); *Sabʿa sayyāra* ("Seven voyages")
Ali Usküdari **2:**256
Aliyev, Fikrat Rza-ogly **3:**366
Aliyev, K. **1:**247

alizarin **3:**322
Allaberdy, Khaky **3:**367
Allahabad **1:**57; **3:**384
 fort **1:**57, 183
 manuscripts **2:**260
 Museum **2:**274
Allah Quli Khan **1:**180
Allahvardi Khan **1:**172, 306;
 2:92, 468
Allah Yar **1:**179
Allan, William **3:**69
Allemagne, Henri d' **1:**500
All India Fine Arts and Crafts
 Society (AIFACS) **2:**8
alloucha see under carpets →
 types
Alma-Tadema, Lawrence **3:**69
Almaty **2:**375, 376
 museums **3:**378
Almería
 Alcazaba **1:**124, 155
 metalwork **2:**486
 stelae **3:**234
 Sumadihiyya **2:**89
 textiles **3:**300
Almohads (*r.* 1130–1269)
 1:58–9; **2:**163
 architecture **1:**121, 126–7,
 126, pl.II.2; **3:***198*
 coins **1:**494
 dress **2:**28
 see also Abu Yaʿqub Yusuf
 (*r.* 1163–84); Abu
 Yusuf Yaʿqub al-Mansur
 (*r.* 1184–99); Abu Hafs
 ʿUmar al-Murtada,
 Sultan (*r.* 1248–66)
Almoravids (*r.* 1056–1147)
 1:59–60; **2:**163
 architecture **1:***60,* 124–5, *125;*
 2:pl.II.2
 gardens **2:**89
 see also Yusuf ibn Tashufin
 (*r.* 1070–1106);
 ʿAli (*r.* 1106–43)
alocha **1:**416
Aloisio **1:**254
Alor Star
 Zahir Mosque **3:**440
Ālpanā **1:**265
Alp Arslan, Sultan (*r.* 1063–72)
 (Saljuq) **2:**77, 490
Alparslan, Ali **3:**65, 361, 448
Alsileity, Sultan **3:**137
Altınbezer, Ismail Hakkı **3:**65
Altinbugha al-Maridani **1:**150
Altman, Benjamin **1:**500
Altman fragment **1:**500
Altyn Tepe **3:**412
alum **2:**284; **3:**295
Alwar
 City Palace **2:**275
Amalfi **3:**334–5
Aman Allah (*r.* 1919–29)
 2:365
Amanat, Hossein **2:**pl.XI.1
Amanat Khan **1:**184, 187
Amangeldyyev, Aman **3:**367
Amangeldyyev, Chary **3:**367
AMAP *see* Moroccan
 Association of
 Plastic Arts
Amari, Michele **2:**152
AMASRA *see* Ancient
 Monuments and
 Archaeological Sites
 and Remains Act

Amasya **1:60,** 117
 bazaar **1:**146
 Burmalı Minare Mosque **1:**60,
 117
 complex of Bayezid **1:**145,
 163
 Gök Madrasa
 mosque **1:**117
 tomb **1:**119
 textiles **3:**310
Amer
 carpets **1:**369
 Ganesha Pol **3:**101
 palace gardens **2:**97
 textiles **3:**323
Amery, Leopold **1:**501
Ames Carpet **1:**368
amethyst **2:**99
Amida *see* Diyarbakır
Amidi, Hamid al- *see* Aytaç,
 Hamid
Amin, al **1:**294
Amin, al-, caliph (*r.* 809–13)
 (Abbasid) **1:**425; **3:**295
Amin, Husayn Yusuf **2:**46
Aminabad **1:**354; **3:**146
Amin al-Dawla **2:**92
Amin Arraihana and Fanani
 2:282
Amindzhanov, Asror
 Tashpulatovich **3:**268
Amini, Muhammad Riza **2:**245
ʿAmir II (*r.* 1488–1517)
 (Tahirid) **1:**154
Amir Dawlatyar **1:**36
Amir Ghayb Beg Album **2:**539;
 3:39
Amir Khilal **3:**335
Amir Khusraw Dihlavi *see*
 Khamsa ("Five poems")
Amir Ruhallah *see* Mirak
Amis de l'Art Japonais, Les
 3:415
Amlapura **2:**282
Amman **1:61; 2:**362
 citadel **1:**61
 Institute of Music and
 Painting **2:**362
 Jordanian Archaeological
 Museum **2:**363
 mosaics **2:**363
 mosque of al-Husayni **1:**190
 National Gallery of Fine Arts
 2:363
Amol ware *see under* ceramics →
 wares
Amoura, Aziz **2:**363
ampullae (fish-shaped) **3:**154
ʿAmr (*r.* 879–901) (Saffarid)
 3:206
ʿAmr ibn al-ʿAs **1:**305, 331
ʿAmr ibn Layth **3:**59
Amritsar **3:**319, 320
Amru Ibrahim, Prince **2:**49
Amul **3:**344, 424
amulets **3:**348
ʿAna
 congregational mosque **1:**80
 minaret **1:**82
 houses **1:**81
Anadolu Hisar **1:**146; **2:**523
Anadolu Kavak **2:**524
Anaka *see* Arnoraja
Anangapala Tomara **2:**2
Anant **1:**61

Anatolia *see* Turkey
Anatolian Studies **2:**364
Anau **1:**432
 Complex of Shaykh Jamal
 al-Din **1:**398
Anavarza **1:**84
Anbaʾ **1:**78
Anbar, al- **1:**250, 341
Ancient Monuments and
 Archaeological Sites and
 Remains Act
 (AMASRA) **2:**276
andalusī see under scripts → types
Andarznāma ("Book of Andarz";
 Cincinnati, OH, A.
 Mus. and New York,
 Kevorkian priv. col.)
 2:77, 193
Andizhan **3:**316, 387, 388
Andreu, Paul **2:**281
Anet, Claude **1:**500
Angawi, Sami **3:**187
Anhalt carpet **2:**77
Anhegger, Mualla Egüpoğlu **2:**330
Ani **1:**215, 434
Ani, Abdul Ghani al- **2:**290
aniconism **2:**182, 311
 see also subject matter
Anikova Dish **1:**410
animal carpets *see under* carpets
 → types
Anjar **1:62,** 76, 208; **2:**419
Ankara **1:62–63,** 120; **2:**520;
 3:359
 Ahi Elvan mosque **3:**432
 Arslanhane Mosque **1:**143,
 199; **3:**431, 432
 Atatürk Mausoleum **3:**360
 Directorate of Turkish State
 Railways building **3:**360
 Etimesgüt Armed Units
 Mosque **3:**191
 Gazi Teachers' College **3:**362
 Genabi Ahmed Pasha Mosque
 1:161
 Hacettepe University **3:**363
 İş Bankası Tower **3:**360
 Middle East Technical
 University **3:**360
 Ministry of Health building
 3:360
 mosque of Alaeddin **3:**432
 mosque of Hacı Ozbek **3:**432
 Museum of Anatolian
 Civilizations **3:**363
 Museum of Ethnography **3:**35,
 363
 Turkish Cultural Research
 Institute **3:**363
 Turkish Historical Society
 1:352; **3:**360, 363
 Turkish Language Society
 3:360
 walls **3:**382
 Yörük Dede Tomb **1:**144
Annaba **1:**49, 196; **2:**88
Annals by al-Tabari
 (early 14th century;
 Washington, DC, Freer,
 30.21, 47.19, 56.16)
 2:204, 217
 (1430; St. Petersburg, Rus. N.
 30.21, 47.19, 56.16)
 3:335
 (late 15th century; Dublin,
 Chester Beatty Lib.,
 MS. 144) **2:**232

anno hejirae (AH) **2:**301
Antalya **1:**120; **2:**520
 carpets **1:**352
 Hamdid Yivli Minare Mosque
 1:142
Antequera **2:**522
antimony **1:**441
Antioch **3:**216
 ceramics **1:**445
 glass **2:**112
 textiles **3:**305
Antiocha Margiana *see*
 Gyaur-kala
Antinoë **2:**113
Antiquities and Art Treasures
 Act (AATA) **2:**276
Antolić, V. **2:**426
Antoshchenko-Olenev, Valentin
 2:377
Anvari *see Dīvān* (collected
 poems) of Anvari
Anvār-i Suhaylī ("Lights of
 Canopus") by Kashifi
 (*c.* 1520; Tashkent, Orient.
 Inst. Lib., MS. 9109)
 1:406
 (1570; London U., SOAS; ms.
 10102) **1:**518; **2:**258
 (*c.* 1580–1600; London, BL,
 Or. MS. 6317) **2:**265
 (1593; Strathclyde, Dumfries
 House) **3:**160
 (1593; Prince Sadruddin Aga
 Khan priv. col.) **2:**244
 (1596–7; Varanasi, Banaras
 Hindu U., Bharat Kala
 Bhavan) **1:**61, 270;
 2:15, 64, 204, 434, 542
 (1604–10/11; London, BL,
 Add. MS. 18579) **1:**7,
 61, 64, 290; **2:**15, 110,
 260; **3:**46
Anwar, Ajaz **3:**94
Anxi **3:**214
Apameia **3:**262
Aphrodito papyri **1:**75
Apollonia **2:**421
Apollonius of Kitium **2:**233
appliqué **2:**47; **3:**280, 281, 282
Apt Cathedral **3:**292, 296
Apukhtin, Victor Olgovich
 3:388
Aqa Buzurg **1:63; 2:**411
Aqa Mirak **1:63; 2:**240, 241;
 3:163, 202
Aqa Riza (i) (*fl. c.* 1580–*c.* 1610;
 India) **1:**6, **64; 2:**260
Aqa Riza (ii) (*c.* 1565–1635;
 Iran) *see* Riza
Aqa Zaman **2:**pl.VII.3
Aqqoyunlu (1378–1508) **1:**251
 manuscripts **1:**497; **2:**231
 tombs **1:**141, 144
 see also Uzun Hasan
 (*r.* 1453–78); Khalil
 (*r.* 1478); Yaʿqub
 (*r.* 1478–90)
aquamanilia **1:**486
aqueducts **1:**166, 174
Arab, Abdul Elah al- **1:**253
Arabatchi **1:**379
Arab Club **2:**362
arabesque **1:**65–6, *66;* **3:**71
Arabic (language) **1:**211, 336,
 337; **2:**55; **3:**125–7
Arabs **2:**55; **3:**275, 369

Arabshahi, Massoud 1:66; 2:287; 3:182
Arago, François 3:116
Arak see Sultanabad
Arbaji 3:60
Arbanassi
 houses 1:313
archaeology 2:153, 155
arches 1:66–7, 70, 99, 100
 horseshoe 1:67, 87, 100
 keel 1:67, 116
 ogee 1:67, 81
 pointed 1:67, 81
architects 1:67–8, 71, 161–2, 174
Architects' Co-partnership 3:55
architectural decoration 1:23–4, 71, 193–212; 2:142–3
 aʾina-kārī 1:210
 bannāʾi 1:96, 131, 136, 201, 212
 ornamental bricklaying 1:90, 95, 195, 305–6, 401
 painting 1:91
 striped masonry (ablaq) 1:87, 116, 234; 3:449
 see also coffering; epigraphy
architectural plans 1:71
architecture 1:168–212
 diaspora 1:193
 education 1:162
 influence on Western architecture 2:543–5
 materials
 bamboo 3:413
 brick 1:68–9, 81, 88, 90, 94, 99, 135, 195, 305–6, 395; 2:172
 marble 1:162
 mud 2:449; 3:401, 405, 407, 410
 mud-brick 1:69, 81, 305; 2:44; 3:400, 406
 pisé 1:81, 95, 395; 3:403, 410, 412
 plaster 1:69, 305; 3:235–8
 reeds 2:174
 sandstone (red) 3:13
 stone 1:69, 116, 173
 stucco 1:305; 2:173; 3:235–8
 teak 2:173
 terracotta 1:96, 100
 wood 1:69; 2:173–4
 see also spolia; tiles
 patronage 1:71
 regional traditions
 Afghanistan 1:16, 97–101, 131–4
 Africa 1:21–4
 Albania 1:42–3, 169
 Algeria 1:49, 102, 121, 124, 158–9; 3:394–6
 Azerbaijan 1:237
 Bangladesh 1:263
 Berber 1:277; 3:395
 Bosnia and Herzegovina 1:169, 300–01
 Bulgaria 1:169, 312–14
 Central Asia 1:81–3, 88–91, 131–6, 177–81, 395–403; 3:411–13
 China 1:482–4
 Egypt 1:84–5, 105–9, 147–52, 169, 305; 2:44–5; 3:398–400

India 1:81–3, 97–101, 137–40, 182–7; 2:272–3, 528; 3:413–14
Indonesia 2:281
Iran 1:81–3, 88–91, 92–6, 111–16, 128–31, 131–6, 171–7; 2:285–6, 521, 528; 3:410, 411
Iraq 1:78, 79–81, 169, 305, 2:289
Jordan 1:76–8; 3:362
Kazakhstan 2:376–7
Kyrgyzstan 2:407
Macedonia 1:169; 2:425–6
Malaysia 2:439–42
Mali 1:24; 2:449
Morocco 1:87–8, 124–7, 158–9, 188–9; 2:522, 546
Nigeria 3:54–6
Nubia 3:60–61
Oman 3:66
Pakistan 1:97–101; 3:91–3
Qatar 3:136
Saudi Arabia 3:187–8, 405–6
Senegal 3:194
Sicily 1:103–4
Somalia 3:226–7
Spain 1:87–8, 121–4, 155–7; 3:4–5, 7–9
Sudan 3:254
Swahili 3:259
Syria 1:74–5, 84, 111–16, 147–52, 169, 305; 3:403–5
Tajikistan 3:266–7
Tanzania 3:270
Tunisia 1:85–6, 102, 159–61; 3:355–6, 397–8
Turkey 1:84, 117–20, 141–7, 161–8, 281; 2:523–5; 3:360–61, 408–9
Turkmenistan 3:366
United Arab Emirates 3:373–4, 406
Uzbekistan 3:387
Yemen 1:110–11, 153–5; 3:407–8, 444–5
spolia 1:69, 128, 193, 503; 3:228–9
types
 commercial see caravanserais
 domestic see baths; houses; kiosks; palaces
 funerary see mausolea; tombs
 military 2:518–530
 Algiera 2:523
 Azerbaijan 1:237
 Egypt 1:325; 2:519, 526
 Iraq 1:197; 2:526
 Morocco 2:520–21, 521, 522
 Spain 2:522
 Syria 2:397, 398, 518, 519–20, 520, 526
 Tunisia 1:85; 2:523
 Turkey 1:146, 2:523–4, 524
 see also fortresses; ribāṭs
 religious see mosques; khanaqahs; külliyes; madrasas; musallas; oratories

vernacular 2:171, 172; 3:261, 393–414, 395, 398, 400, 404, 405, 408, 411, pl.VI.1, pl.XII.3
 Western influence 1:166, 190
 see also arches; balconies; capitals; ceilings; courtyards; domes; iwans; muqarnas; pishtaqs; squinches; urban development and planning; vaults
Architekt 3:360
Archives marocaines 2:547
Arcimboldo, Giuseppe 3:246
Arculf 2:347
Arda, Orhan 3:67, 360
Ardabil 1:213
 mosque 1:129
 shrine of Shaykh Safi 1:130, 213; 2:306; 3:163, 211
 Chinikhana 1:172
 Dar al-Huffaz 1:172
 jade 2:342
 Jannat Saray 1:171
 manuscripts 1:497
 porcelain 1:292, 476, 486; 3:192
 Uč Dukkan Bath 1:273
Ardabil carpets 1:213, 376, pl.XIV.1; 3:33, 162, 240, 264
Ardalan, Nader 1:213–214; 2:286; 3:274
Ardashir I (r. 224–41) 1:79; 2:336, 390
Ardenicë
 church and monastery 1:43
Ardeshir, A. C. 2:275
Ardistan 1:214
 mosque 1:89, 92, 93, 94, 319; 2:337, 337, 551
 mihrab 1:96, 97, 195; 3:72, 237
Arefʾev, Anatoliy Vasiliyevich 2:408
Arel, Ruhi 1:229
Arenburg Basin, d' 2:482, 484, 484, 500
Arghun, Prince 3:276
Arghun al-Kamili 1:46
Arghun ibn ʿAbdallah al-Kamili 1:346
Ariff, Abdullah 2:444
Arif, Sirri 2:319
ʿArifi see Gūy va chawgān ("Ball and bandy"); Ḥalnāmā ("Book of ecstasy"); Sulaymānnāma ("Book of Süleyman")
Arif of Çarşamba 3:39
Arkoun, Muhammad 2:311
Ark Tepe 2:73
Armajani, Siah 1:215–16
Armenia 1:215–16
 carpets 1:216, 374
 see also Caucasus
armor 1:216–24, 423–5
 elephant 2:137
 horse 2:136
arms see weapons
Arnal, Pedro 2:152
Arnaouti, Mahmoud al- 2:422
Arnaud, Thomas 3:445
Arnodin, F. 2:319
Arnold, Sir Thomas 1:225; 2:154

Arnoraja 1:40
Aronco, Raimondo D' see D'Aronco, Raimondo
Aror
 tombs 3:342
Arpels, Pierre 3:149
arsenic 1:441, 458
Arseven, Celal Esad 1:225
Arshad, Rashid Ahmed 1:352; 3:93
Ars Islamica 2:56, 154, 363
Arslan Khan Muhammad II (r. 1102–29) (Qarakhanid) 1:311
Ars Orientalis 2:56, 154, 363
Art and Freedom 1:226; 2:46
Artaxerxes I (r. 465–424 BCE) 3:282
art education
 Algeria 1:51
 Bangladesh 1:261
 Egypt 2:48
 Jordan 2:362
 Kuwait 2:405
 Malaysia 2:448
 Morocco 2:546
 Nigeria 3:58
 Pakistan 3:91
 Sudan 3:255
 Tanzania 3:269
 Turkey 2:322; 3:362
Artemuskin, Ivan 2:426
artesonado 1:226–7, 382; 3:428
Artin, Yaʿqub 3:34
artists, status of 2:227–8
artists' signatures see signatures (artists')
art legislation 2:276; 3:97
Artuq Arslan (r. 1200–39) (Artuqid) 2:499
Artuqids (r. 1102–1408) 1:111
 architecture 1:112, 115
 see also Daʿud (r. 1114–44); Artuq Arslan (r. 1200–39); Nasir al-Din (r. 1201–22)
Arup, Ove, and Partners 2:72
Arvine, Alice 2:145
Asad al-Iskandarani 1:466
Asadallah of Isfahan 1:223
Asʿud Pasha al-ʿAzam 2:134
Asadullah al-Kirmani 1:36
Asadi see Garshāspnāma ("Book of Garshasp")
Asaf Khan 1:184; 2:97, 414
Ascalon 1:84
 Mashhad al-Husayn 2:539; 3:422
Asfar, B. 2:509
Ashʿari, al- 2:302
Ashbee, C. R. 2:350
Ashgabat 1:229, 389; 3:366
 Headquarters of the Communist Party 3:366, pl.XIV.1
 Karl Marx Square 3:366
 Kipchak Mosque 1:229; 3:366, pl. XII.2
 statue of Turkmenbashi 1:229; 3:367
Ashir
 palace 1:102; 3:452
Ashkelon 2:530
Ashkizar 1:135
Ashmole, Elias 3:34
Ashour, Jamal 2:363
Ashraf (Iran) see Behshahr

Ashraf (*fl.* 1735–80) *see* ʿAli
 Ashraf
Ashraf (*fl.* 19th century) **2:**241
Ashraf ibn Riza **2:**412
Ashraf Musa, al-, Sultan
 (*r.* 1229–37) (Ayyubid)
 1:112
Ashraf Shaʿban, al-, Sultan *see*
 Shaʿban II
Ashtarjan
 mosque **1:**129
Ashurov, Abdullo **3:**267
Asiatic Society of Bengal
 1:499; **3:**34
Asif, Mohammad **3:**93, 95
Asilah **2:**476, 547
Askar, al- *see* Lashkari Bazar
Asnaf
 mosque of al-ʿAbbas **1:**110, 383
Asnaq
 mosque **1:**130
asphodel paste **1:**296
ʿAssar *see* Mihr and Mushtari
Assassins **1:**41; **3:**167
Assemblies *see* Maqāmāt
Assembly of histories *see* Majmaʿ
 al-tawārīkh
Assisi
 S Francesco **3:**308
Association Nationale des
 Artistes du Mali **2:**450
Association of Artists of Bosnia
 and Herzegovina **1:**302
Association of Independent
 Painters and Sculptors
 1:383; **2:**52, 391;
 3:340, 361
Association of Ottoman Painters
 1:229; **3:**361
Association of Workers of IZO
 3:388
Assur **2:**336
Astana
 museums **2:**378
 silk **3:**216
Astarabad **1:**426; **3:**163
astrolabes **1:**320–21, *320, 321*
astronomy and astrology *see*
 under subject matter
Astudillo **3:**8
asymmetrical knots **1:**356
Aswan **1:**105, **232**
 mausolea **1:**107, 108, 109,
 232; **3:**26, 344,
 pl.XII.1
Atabey
 Ertokuş Madrasa **1:**118
ʿAta Malik Juvayni *see* Tārīkh-i
 jahāngūshā ("History of
 the world conqueror")
Atanacković, Milenko **1:**301
Atasoy, Nurhan **2:**155
Ateca
 S. María **3:**9
ʿAtf, Princess **1:**160; **3:**354
Āthār al-bāqiya ("Chronology of
 ancient nations"; 1307–
 8; Edinburgh, U. Lib.,
 Arab. MS. 161) by al-
 Biruni **2:**185, 204, 215;
 3:243
Āthār-é Īrān **2:**289
Athens **1:**232–**3**
 Benaki Museum **1:**233, 276;
 2:57, 128; **3:**37
Atıl, Esin **1:**233
Atlāl, al- **2:**156

Atrabulus *see* Tripoli
Atsız Elti **2:**374
ʿAttar *see* Mantiq al-tayr
 ("Conference of birds")
Attock **1:**183; **3:**384
Augsburg Cathedral **3:**298
Augusta
 castle **1:**104
Auguste, Jules-Robert **3:**68
Auliye-Ata *see* Zhambyl
Aul Tepe **3:**412
Aurangabad **2:**514
automata **3:**248
*Automata see Kitāb fī maʿrifat
 al-ḥiyal al-handasiyya*
 ("Book of knowledge of
 ingenious mechanical
 devices")
ʿAvaz Muhammad **1:**408
Awang, Zakaria **2:**444
Awliya Ata *see* Zhambyl
Awrangzib, Emperor
 (*r.* 1658–1707)
 (Mughal) **2:**271; **3:**15
 architecture **1:**187; **2:**10, 414;
 3:230
 manuscripts and miniature
 paintings **1:**350; **2:**262
 tents **3:**287
axes **1:**221
Axis Group **2:**47
Ayas congregational mosque
 3:431
Ayasuluk *see* Selçuk
Aybak, Sultan (*r.* 1250–57)
 (Mamluk) **2:**499
Aydamur al-Ashrafi **2:**503
Aydhab **2:**100; **3:**60
Aydughdi ibn ʿAbdallah al-Badri
 2:455
Aye, Mansur **3:**94
Āyīn-i Akbarī ("Annals of
 Akbar"; *c.* 1596–1602)
 2:359, 319
Ayn al-Jarr *see* Anjar
Ayodhya mosque **1:**182
Ayral, Macid **2:**13
Ayrton, Frederick **1:**499
Aytaç, Hamid **1:**233; **3:**89, 361
Aytbayev, Salikhitdin **2:**377
Aytmish al-Bajasi **1:**297
Ayvan *see* Iwan
Ayvansarayı **2:**420
Ayyad, Raghib **1:**331; **2:**46;
 3:23, 43
Ayyampet **1:**380
Ayyubids (*r.* 1169–1260) **1:**208
 architecture **1:**47, 107, 108,
 113, *114,* 115, *235,
 333;* **2:**520
 ceramics **1:**454
 glass **2:**113
 metalwork **2:**484
 see also Salah al-Din, Sultan
 (*r.* 1169–93); Zahir
 Ghazi, al- (*r.* 1186–
 1216); ʿAdil I, al-,
 Sultan (*r.* 1196–1218);
 ʿAziz, al- (*r.* 1216–37);
 Muʿazzam,
 al-, Sultan (*r.* 1218–27);
 Ashraf Musa, al-, Sultan
 (*r.* 1229–37); Salah al-
 Din Yusuf, Sultan (*r.*
 1237–60); Salih Najm
 al-Din Ayyub, al-,
 Sultan (*r.* 1239–49)

ʿAyyuqi *see* Varqa and Gulshah
Azamgarh **2:**319
Aʿzam Khan, Prince **2:**238
Azbak al-Yusufi **1:**152, 326
Azemmour **1:**360; **3:**313
Azenergo **1:**239
Azerbaijan **1:235–47**
 architecture **1:**237–9
 ceramics **1:**242
 glass **1:**242
 interior decoration **1:**243–4
 jewelry **1:**244–5
 metalwork **1:**243–5
 painting **1:**240–42, pl.IX.2
 sculpture **1:**240
 textiles **1:**245–6, *374*
 woodwork **1:**247
 see also Caucasus; Jalayarids
Azhar **1:**349; **2:**343; **3:**256
Azim Khan **3:**230
Azimzade, Azim **1:**241
Aziran
 mosque **1:**130
Aziz, al-, caliph (*r.* 975–96)
 (Fatimid) **1:**106, 324,
 332; **2:**71; **3:**154, 338
ʿAziz, al- (*r.* 1216–37) (Ayyubid)
 1:115, 234
ʿAziz, Abdul **3:**97
ʿAziz al-Din ʿAlamgir **2:**365
Azmi, Musa *see* Aytaç, Hamid
Azoughui **2:**469
Azraqi, al- **2:**129; **3:**181
Azzawi, Dia **2:**291
Bâ, Amadou **3:**194
Baalbek **1:**148; **2:**419;
 3:229, 305
Bab, al-
 mosque **1:**112
Babakhanov, Abdulla **3:**387
Baba Nakkas **2:**139
Baban Ghwani **3:**54
Babayev, Abdulhusein **1:**247
Babayev, R. G. **1:**247
Babikov, Stanislav Gennadyevich
 3:367
Babiska **1:**271
Babur, Emperor (*r.* 1526–30)
 2:270; **3:**11, 12
 architecture **1:**182, 267; **2:**65
 coins **1:**425
 gardens **1:**31, 182; **2:**65, 96;
 3:12
 manuscripts **1:**497; **2:**257
 tents **3:**286
Bāburnāma ("History of Babur")
 2:204, 257
 (*c.* 1589; London, V&A, IM.
 260 to 276–1913)
 1:290; **2:**368, 380, 415,
 428, 460; **3:**144
 (*c.* 1589–90; Washington,
 DC, Sackler Gal.) **2:**63
 (*c.* 1591; London, BL, Or.
 3714) **1:**282; **2:**14, 259,
 459; **3:**353
 (*c.* 1590s; Baltimore, MD,
 Walters A. Mus.,
 W. 596) **2:**259
 (1598; New Delhi, N. Mus.,
 MS 50.326) **1:**282,
 518; **2:**14, 15, 380, 383
Babylon **3:**216
 palace of King
 Nebuchadnezzar II
 2:290
Bacanović, Branko **1:**302

bacini **1:**443, 453, 465, 479;
 2:311
Bactra *see* Balkh
Badajoz **1:**461
Badiʿ al-Zam **1:**287; **2:**228, 238;
 3:134
Badis (*r.* 1038–73)
 (Zirid) **2:**436
Badr al-Din Luʾluʾ (*r.* 1222–59)
 1:249
 architecture **1:**116; **3:**1
 glass **2:**499
 manuscripts **2:***162,* 199, 209,
 209; **3:**123
 metalwork **2:**492, 499, 500,
 501; **3:**77
Badr al-Din Muslim **2:**392
Badr al-Din Ulugh Qaymaz
 2:492
Badr al-Jamali **1:**105, 108, 324;
 2:519, 535; **3:**210, 422
Badran, Jamal **3:**104
Badran, Rasim **1:**191, 250
Badr ibn Hasanwayh **1:**90
Baer, Eva **1:**250; **2:**314
Baga **1:**230
Bagamoyo **3:**259
Baghdad **3:**1, 79, 92, 169,
 190, 250–52; **2:**526–7;
 3:216, 376
 Abbasid Palace **1:***2,* 250; **3:**99
 Abbasid tomb **1:**79
 Ahmadiyya Mosque **1:**169
 Archaeological Museum *see*
 National Museum of
 Iraq
 Azzohour Palace **2:**290
 baths **1:**271
 ceramics **1:**445, 446
 coins **1:**492, *493*
 houses **1:***171, 172,* 174
 Income Tax Building **2:**290
 Institute of Fine Arts **2:**290
 Iraq National Museum **3:**36
 Khan al-Mirjan **1:**129, 355;
 2:465
 Khassaki Mosque **2:**516
 manuscripts **1:**348; **2:**194,
 208, 209, *210,* 218,
 221, 255
 Municipality Building **2:**290
 Museum of Pioneer Artists
 2:292
 Mustansiriyya Madrasa **1:**115,
 251, *251;* **2:**431
 National Museum of Iraq
 2:292
 National Museum of Modern
 Art **2:**291
 Nizamiyya Madrasa **2:**431
 palace of ʿAdud al-Dawla **1:**90
 palace of al-Nasir **1:**116
 paper **3:**105
 Round City (Madinat al-
 Salam) **1:**79–80, *79,*
 250; **2:**519
 mosque of al-Mansur **1:**80
 Saddam Arts Center **3:**292
 shrine of Zumurrud Khatun
 3:26
 Talisman Gate **1:**197, *197,*
 251; **2:**19, 520
 textiles **3:**297, 298, 300
 tomb of Abu Hanifa **3:**209
 University mosque **1:**191
 Victory Arches **2:**290
 Water Board Building **2:**290

Baghdad Group of Modern Art **2**:291; **3**:166, 300
"Baghdad" paper **2**:185; **3**:106
Baha' al-Dawla (*r.* 998–1012) (Buyid) **1**:496, 504; **2**:181; **3**:298
Baha' al-Din **2**:85
Baha al-Din Muhammad **1**:413
Bahadur Shah, Emperor (*r.* 1707–12) (Mughal) **2**:263
Bāharistān ("Spring garden") by Jami (*c.* 1500; ex-Paris, E. de Lorey priv. col.) **1**:270 (1547; Lisbon, Fund. Gulbenkian, MS. LA 169) **3**:336 (1595; Oxford, Bodleian Lib., MS. Elliot 254) **1**:256, 270; **2**:260, 415, 428, 542
Baharuddin, Eriche **1**:191
Bahaüddin, Rahmizade **3**:119
Bahawalpur **3**:95
Bahira **1**:303
Bahla **2**:527; **3**:66
Bahmanis (*r.* 1347–1527) **1**:519
see also 'Ala al-Din Husan Bahman (*r.* 1347–58); Muhammad I (*r.* 1358–75); Taj al-Din Firuz (*r.* 1397–1422); Shihab al-Din Ahmad (*r.* 1422–36)
Bahanasa **2**:282, 294
Bahrain **1**:253–4
Bahrain Art Society **1**:253
Bahrami, Mehdi **1**:254
Bahram Kirmanshahi **3**:pl.I.3
Bahram Mirza, Prince (Safavid) **1**:36, 497, 504; **2**:40, 220, 345; **3**:39, 111, 163
Bahramshah, Sultan (*r.* 1118–52) (Ghaznavid) **1**:98; **2**:108
Bailov
Palace of Culture **1**:238
sculpture **1**:240
Bairamalikhan-kala see Merv
Bajpani, Durga **2**:272
Baker, Herbert **2**:6; **3**:414
Bakhchisaray **1**:254–5
Bakhretdinova, Zulfiya **3**:268
Bakhtiari **1**:378
Bakonat **1**:479
Bakr, Mahrus Abu **2**:47
Baktimur al-Silahdar **2**:454
Baku **1**:237, 238, **255–6**, 434
Azerneshr Palace of Printing **1**:238
Azneft'zavody **1**:239
Buzonyneft' **1**:239
ceramics **1**:243
Duma **1**:238
embroidery **1**:245
Fire Temple **1**:*238*
fortress **1**:198, 237; **2**:521
Government House **1**:239
Historical Museum of the Academy of Sciences **1**:438
Ismailiya charitable society **1**:238
jewelry **1**:245

khanaqah of Pir Husayn **2**:382
Maiden's Tower **1**:237, *237*, 255; **2**:521
Ministry of the Food Industry **1**:239
Muhammad Mosque **1**:237; **3**:26
Mukhtarov House **1**:238, 255
Nizami Cinema **1**:239
Nizami Museum of Literature **1**:239
palace complex of the Shirvanshahs **1**:237, 240, 255; **3**:99
palace of Husein Guli khan **1**:241
Public Assembly building **1**:238
sculpture **1**:*240*
Taza-Pir Mosque **1**:238
Theater of the Mailov Brothers **1**:38
Balaban, Ibrahim **3**:362
Balaguer
Alcazaba **1**:124
Balalyk Tepe **1**:414; **3**:412
Bal'ami **2**:204
Balasaghun see Burana
Balat
baths **1**:144
ceramics **1**:281, 468, 470
Ilyas Bey Mosque **1**:142
Balban, Sultan (*r.* 1266–87) **3**:384
Balchand **1**:**256–257**; **2**:262; **3**:114
balconies **1**:257
Baldwin I, King of Jerusalem (*r.* 1100–18) **2**:397
Balian see Balyan
Balıkesir
mosque **3**:432
Balis **1**:**257–258**
ceramics **1**:455
minaret **1**:113
Balkh **1**:**258–259**, 391, 393; **2**:375; **3**:111
coins **1**:258
fort **1**:258–259
grave of 'Ali ibn Abi Talib **2**:160; **3**:369
Gunbad-i Kabudi **1**:179
lead [Ceramics, I, A]
Masjid-i Nuh **1**:82
metalwork [Central Asia, V, A, 2]
nine-domed mosque **1**:194; **2**:258; **3**:236
palace **1**:258
ramparts **1**:258
shrine of Khwaja Abu Nasr Parsa **1**:258
stucco **1**:258
Balkhash **2**:375
Ball and bandy see Gūy ū chawgān
Ballard, Berenice C. **1**:500
Ballard, James F. **1**:500; **2**:16, 58
Ballard Rug **1**:365, 371
Balogun, Hameed **3**:56
Baltacıoğlu, İsmayil Hakki **1**:351
Baluch **1**:378; **3**:279
Baluchar **3**:319
Balyan **1**:215, **259–60**; **2**:322; **3**:83

Balyan, Agop Bey **1**:259
Balyan, Garabed Amira **1**:**259**; **2**:319
Balyan, Krikor **1**:162, 167, **259**; **3**:88
Balyan, Levon **1**:259
Balyan, Nikoğos Bey **1**:259
Balyan, Sarkis Bey **1**:**259**; **2**:329
Balyan, Senekerim Amira **1**:259
Balyan, Simon Bey **1**:259
Bam **1**:260, *261*; **2**:528
Bamako **2**:449
Institut National des Arts **2**:250
Musée National du Mali **2**:450
Bamana
textiles **1**:25; **2**:449, pl.XV.2
Bamba
S. María **3**:4
Bamberg Cathedral **3**:298, 301
Bambino Vispo, Master of the **3**:306
bamboo **3**:401, 413
Bamiyan **1**:17; **2**:109, 182
Banbhore **1**:**260**
mosque **1**:76, 83; **2**:550; **3**:91
Banda Nkwanta
mosque **1**:23
Bandar Abbas **3**:315
Bandar Khomeini **1**:292
Bangalore
Indian Institute of Management **2**:273
Vidhan Soudha Secretariat Building **2**:272
Bangkok
Silpakorn University of Fine Arts Archaeology Museum **1**:265
Bangladesh **1**:**261–6**
architecture **1**:263
art education **1**:265
ceramics **1**:265
museums and collections **1**:265–6
painting **1**:263
textiles **1**:264
Bangladesh Cottage Industries Corporation **3**:270
Bani, Ali al- **2**:422
Bani Jamra **1**:253
banknotes **1**:266
bannā'i **1**:96, 131, 136, 201, 212, 306
banners **1**:75–6; **3**:292
Banquet of the physicians see Da'wat al-aṭibbā'
Bansko
ceramics **1**:315
houses **1**:313
Banten **2**:281
Banū Nas see Nasrid
Banvari see Bhanwari
Baptistère de St. Louis **2**:146, 482, 483, 502, pl.V.3; **3**:18, 77
Baqi see Dīvān (collected poems) of Baqi
Baqir **1**:266, **2**:51; **3**:16
Bara, Ali Hadi **1**:**266–7**; **3**:30, 362
Barada Panel **1**:207, *208*
Bar-Adon, Avraham **2**:509
Baratekov, Yuldashbek **3**:268
Barbalissos see Balis
Barbaro, Giuseppe **1**:364
Barber, Abayomi **3**:58

barbotine see under ceramics → techniques
Barda **1**:236, 267
Imamzada Mosque **1**:267
mausoleum of Akhsadanbaba **1**:267
textiles **1**:242
tomb tower **1**:267
Bardsīr see Kirman
Bari **1**:267
Barid Shahis (*r.* 1527–1619) **1**:**268**
see also 'Ali Barid, Shah (*r.* 1543–79)
Barın, Emin **3**:65
bark **1**:25
Barlow, Sir (James) Alan (Noel) **1**:**268**, 443, 501
Baroque **1**:23
Barov, Aleksandr **1**:314
Barquq, Sultan (*r.* 1382–99) (Mamluk) **1**:152, 334; **2**:115, **455–6**, 504; 526
Barsbay, Sultan (*r.* 1422–38) (Mamluk) **1**:152; **2**:**456**, 504
Barsiyan
mosque **1**:92
Bartol'd, V. V. **1**:432, 435
Barujird
mosque **1**:92, 94
Basawan **1**:**268–70**, *270*; **2**:14, 15, 259, 368, 428, 459; **3**:272, 353
Basbous, Alfred **2**:418
Basbous, Michel **2**:418
Basbous, Youssef **2**:419
Baschet, Marcel-André **2**:132
Baset, Abdul **3**:93
Basharov, Kutkuk **3**:388
Bashir, Murtaza **1**:263
Bashir II Shihab, amir (*r.* 1788–1840) **1**:274
Bashtak **2**:454; **3**:399
basilical mosques see under mosques → types
basketry **3**:95, 349–50
Basra **1**:80, **270–1**; **2**:518, 526
ceramics **1**:446
houses **2**:174
metalwork **2**:487
mosque (635) **1**:73; **2**:461, 550
rock crystal **1**:2; **3**:154
Bassari **2**:130; **3**:194
Bastalus **1**:230, *230*
Bastām see Bistam
baths **1**:70, 76–7, 77, 144, 165, **271–3**, *273*
batik **2**:283, 447; **3**:323
Batoul, Ahmad **1**:24
Battersea, Cyril Flower, Baron **2**:544
Batu (*r.* 1227–55) **3**:276
Batu Aceh tombstones **2**:443
Bauchi
Friday Mosque **1**:23
Baurenfeind, Georg Wilhelm **3**:51
Baurenfeind, Gustav **3**:69
Bawa, Geoffrey **2**:28
Bawa, Manjit **3**:8
Baya **1**:50
Bayad and Riyad [Subject matter, IV] (*c.* 1200; Rome, Vatican, Bib. Apostolica, MS. Arab. 368) **1**:199, 207, pl.VII.2; **3**:243

Bayani, Mehdi 1:274
Bayati, Basil al- 3:187
Bayazid 2:40
Bayazid Purani 1:312
Baybars I, Sultan (r. 1260–77)
 (Mamluk) 2:453
 architecture 1:148, 303, 326,
 333, 334; 2:432
 banners 2:76
 glass 2:114
 heraldry 1:197; 2:145
 manuscripts 2:187
 muqarnas 3:28
 woodwork 3:430
Baybars II, Sultan (r. 1309–10)
 (Mamluk) 1:347;
 2:382, 455
Baybars al-Hashankir, Sultan see
 Baybars II, Sultan
Bayburt 1:117; 2:520
Bayev, N. G. 1:238, 255
Bayezid I, Sultan (r. 1389–1402)
 Ottoman
 architecture 1:145, 317; 2:18,
 41, 401, 523
Bayezid II, Sultan (r. 1481–
 1512) (Ottoman) 3:85
 architecture 1:60, 163; 2:41,
 42, 145, 402, 462
 calligraphy 2:134
 manuscripts 1:498; 2:233;
 3:49
 metalwork 2:498
Bayezid, Prince (d. 1561)
 (Ottoman) 3:311
Bayhaqi 3:327
Baylaqan 1:241, 243, 1:434
Baymatov, Abdumunin 3:388
Baymursayev, O. 2:377
Baypakov, K. 2:399
Bayne, Richard Roskell 1:57
Bayram-Ali 2:476
Bayram ibn Derviş Şir 2:254
Bayramov, Durdy 3:367
Bayram Tahtı 3:327
Baysal, Haluk 2:320
Baysunghur, Prince (Timurid)
 3:242, 335
 architecture 1:133
 manuscripts and miniature
 paintings 1:43, 294, 297, 347,
 348, 349, 497, 504;
 2:200, 202, 226, 343,
 385, 420; 3:110
Bayt al-Din 1:274, 2:419
Bayt al-Faqih 3:445
bazaars 1:146, 404; 2:465
Baz Bahadur, Sultan (r. 1555–
 66) 2:459
Beardsley, Aubrey 2:136
Beato, Antonio and Felice 3:118
Beatty, Sir (Alfred) Chester
 1:274–5, 501; 2:58
Beatus of Liébana 3:5, 5
Beaucorps, Gustave de
 3:279
Beaufort Castle 2:419
Beckford, William 1:45, 499
Bedford, Francis 2:419
Bedouin
 carpets 1:381–2
 dress 2:25
 tents 3:276, 278
Begić, Azka 1:302
Beglyarov, Sergei Nickitovich
 3:366
Beh-Ardashīr see Kirman

Behshahr 1:214; 2:92
Behshahr Industrial Group
 2:289
Behzad see Bihzad
Beier, Ulli 3:166
Beijing
 Great Mosque 1:485
Beirut 2:419
 'A'isha Bakkar Mosque
 1:191
 Archaeological Museum of the
 American University of
 Beirut 2:419
 carpets 1:360
 National Archaeological
 Museum 2:419
Beit ed Din see Bayt al-Din
Bejaïa see Annaba
Bekhazi, Najib 2:418
Bekmuradov, Kulnazar 3:367
Beknazarov, Murirat
 Dambunayevich 3:268
Bektaş, Cengiz 1:191
Bela
 tomb of Muhammad Harun
 3:342
Bela IV, King of Hungary
 (r. 1235–70) 3:182
Beleuli 1:405
Belkahia, Farid 1:275; 2:476,
 546
Belkhodja, Najib 3:357
Belkovski, Stancho 1:314
Bell, Gertrude 1:275–8; 2:292
Bellagha, 'Ali 3:356
Belling, Rudolf 2:105, 322;
 3:362
Bellinger, L. 1:358
Bellini, Gentile 1:206, 361;
 3:64, 68, 84
Bellini, Mario 3:33
Bellini carpets see under carpets
 → types
Bellon, Robert 3:pl.XIII.2
bell-towers 1:71
Belly, Léon 3:69
Belmonte 3:9
Beloved of careers see Habīb al
 Siyār
Belus Na'aman 2:113
belts 2:113
Belyunes 1:159
Benaïssa, Mohamed 2:476
Benaki, Anthony 1:233, 276;
 2:128
Benanteur, Abdullah 1:51
Benares see Varanasi
ben Bella, Majoub 1:51
Bénédite, Léonce 1:50
Bengutas, Sabiha 3:362
Benghazi 2:422
Benin City 3:57
 museum 3:58
Beni Mguild 1:381
Beni M'tir 1:381
Ben'kov, Pavel Petrovich
 3:388
Benois, Leonty Nikolayevich
 3:387
BEP+MAA Akitek Sdn 2:441
Berat
 Helveti sufi hospice 1:42
 houses 1:169
 King Mosque 1:42
 seraglio 1:43
Berber 2:163
Berber, Mersad 1:302

Berbers 1:276–8; 2:54
 architectural decoration 1:23
 architecture 1:49, 277; 3:395
 carpets 1:278
 ceramics 1:277
 chests 1:277
 dress 2:28, 29
 jewelry 1:278, pl.I.4; 2:357
 tents 1:277; 3:278
 textiles 1:25, 278
Berchem, Marguerite Van see
 Van Berchem,
 Marguerite
Berchem, Max van 1:93, 279;
 2:58, 153, 312; 3:183,
 417
Berezin, I. N. 1:435
Berg, L. 1:435
Bergama
 carpets 1:371
 Ulu Cami 1:145
Bergé, Pierre 2:466
Berk, Nurullah 1:279; 3:361
Berkel, Sabri 1:280; 3:361
Berlanga de Duero
 S. Baudelio 3:4
Berlin
 Pergamonmuseum 3:35
 synagogue 2:545
Berlin Album 1:349; 2:261, 536;
 3:3
Bernier, François 2:359
Bernini, Gianlorenzo 1:356
Bernshtam, A. 1:436
Bertuchi, Mario 2:546
Beshir 1:420
 mausoleum of Sayyid Ahmad
 1:431
Bestām see Bistam
Bethlehem
 dress 2:30
Betts, Georgina 3:57
Beveled style 1:90, 92, 194, 197,
 280, 281, 487; 2:112;
 3:71, 154, 177, 179,
 236, 420, 421, 422
Bey, Ferit 3:89
Bey, Hakky 1:500
Bey, Hasan Tal'at 3:65
Bey, Max Herz 1:190; 2:44
Bey, Muhammad Sadiq 1:54
Beyān-i menāzil-i sefer-i 'Irākeyn-i
 Sultan Süleymān Khān
 ("Description of the
 stages of the campaign
 of Sultan Süleyman
 Khan in the two Iraqs")
 see Majmu'-i menāzil
 ("Compendium of
 stages")
Beykoz 2:116
Beylié, General de 2:155
Beyliks 1:141
Beyşehir
 bazaar 1:144
 carpets 1:359
 Esrefoğlu Hammam 1:144
 Esrefoğlu Mosque 1:143, 503;
 3:552
 tomb of Şeyh Süleyman 1:143
Bezalel School of Arts and Crafts
 2:314
Bezeklik 3:214, 281
Bhadreshvar
 Solahkhambi Masjid
 1:504
 tombs 3:342

Bhagwan 1:281–2
Bhalla, Jai Rattan 2:20
Bhanwari 1:282; 3:320
Bhavani Das 2:119
Bhoja (r. c. 1020–47) 1:282
Bhopal 1:282–3
 Vidhan Bhavan 2:273
Bibby, Geoffrey 3:189
Bibi-Eybat 1:238, 241
Biblia Hispalense (988; Madrid,
 Bib. N., Cod. Vit.
 13–1) 2:207; 3:3
bibliography 1:283
Bichitr 1:284–285; 2:261, 262;
 3:14, 327
Bidar 1:140, 252, 268, 285–6,
 305; 2:270, 513, 514;
 529
 Gagan Mahal 3:100
 mausoleum of 'Ala al-Din
 Ahmad Bahmani 3:238
 mausoleum of Khan Jahad
 Barid 3:238
bidri ware 1:286, 305;
 2:513–14
bihārī see under scripts
Bihbihani Anthology 2:416
Bihzad 1:56, 227, 286–8, 349,
 498, 505, pl.XI; 2:149,
 192, 193, 195, 228,
 230, 238, 261; 3:116,
 124, 162, 203, 243,
 329, 336
 forgeries 2:76
 pupils 2:40; 3:40, 134, 163,
 205
 teachers 2:536
Bihzad, Husayn 1:286
Bijapur 1:11, 288–90; 2:270,
 529
 Arquila 2:529
 gardens 2:64
 Gol Gumbaz 1:12, 289, 3:242
 Ibrahim Rawza 1:12, 289, 289
 palace of the 'Adil Shahis
 1:289, 3:100
 manuscripts and miniature
 paintings 1:11, 12;
 2:265
Bijar carpets see under carpets →
 types
Bijelić, Jovan 1:302
Bilalova, A. 1:246
Bilecik
 Orhan Gazi Mosque 1:145
 textiles 3:310
Bilkahīyya, Farīd see Belkahia,
 Farid
Bima 2:282
Binagadi 1:238
bindings see bookbindings
Bing, S. 2:544
Binket see Tashkent
Binney, Edwin, III 1:501; 2:196;
 3:114
Binning, Robert 1:8
Binyon, Laurence 1:225; 2:127
birch 3:420, 424
Birgi 3:284, 383
 congregational mosque 3:432
Birla, Basant Kumar 2:276
Birla, Saraladevi 2:275–276
Birlas 1:283
Birmingham 1:222
Birsel, Melih 2:320
Biruni, al- 1:427, 429, 446;
 2:204, 215, 219; 3:243

see also Āthār al-bāqiya
("Chronology of
ancient nations")
Bishah 3:405, 406
Bishan Das 1:**290–291;**
2:260–61
Bishapur 2:288, 337; 3:297
Bishkek 1:**291**, 2:406, 407
Kyrgyzstan State Historical
Museum 2:408
Kyrgyzstan State Museum of
Fine Art 2:408
Biskra
mausoleum of Sidi ʿUqba
2:266
Bissière, Roger 1:481
Bistam 1:**291**
minaret 1:95
shrine of Bayazid al-Bistami
1:94, 130, 291; 2:492;
3:210, 435
Bitlis
Kızıl Mosque 1:142
Bitolj
Archaeological Museum 2:427
Bezistan 2:426
Hadji Kaddi Mosque 2:426
Moša Pijade Art Gallery 2:427
Bitola
Hacı Mahmud Mosque 1:169
bitumen 1:304
Blacas Ewer 2:500
Black Death 2:12
black-on-white ware *see under*
ceramics → wares
black-slip ware *see* ceramics →
wares → silhouette ware
Blanquart-Evrard, Louis-Désiré
2:117
Blessed compendium *see*
Majmūʿa al-mubārak
blessings *see under* subject matter
blue 1:502–3
blue-and-white ware *see under*
ceramics → wares
Blue Koran 1:343; 3:106
blue vitriol 2:284
Boabdil *see* Abu ʿAbdallah
Muhammad XI, Sultan
Bobo-Dioulasso
mosque 1:23
Bobrinsky Bucket 2:148, 482,
485, 491, 492, 494
Bobosaidov, M. 3:267
Bocskay, Stephen 2:474, 508
Boccaccio, Giovanni 1:104
Boccara, Charles 2:546
Bode, Wilhelm 2:154; 3:7,
33, 183
Bodoni, Giambattista 3:126
Bofill, Ricardo 2:312
Boğazkesen 2:524
Boğazköy 3:363
Bogdanović, Bogdan 1:302
Bogdo Han (r. 1911–24) 3:281
bogolanfini 2:449
Bogolyubov, General A. A.
1:379
Bokara carpets *see* carpets →
types → Turkmen
Bolu
mosque 1:145
Bombay *see* Mumbai
Bonatz, Paul 2:50, 322; 3:67
bone 1:429
Bongo 3:253
Bonington, Richard Parkes 3:68

book, arts of the 1:292–4
see also bookbinding; calligra-
phy; manuscript
illumination; manu-
script illustration and
miniature painting;
printing
bookbindings 1:**294–9;** 2:411
bookcases 3:420
book decoration *see* manuscript
illumination
book illustration *see* manuscript
illustration and
miniature painting
Book of achievements *see*
Hunarnāma
Book of Alexander *see*
Iskandarnāma
Book of Andarz *see Andarznāma*
Book of animals *see Kitāb*
al-hayawān
Book of antidotes *see Kitāb*
al-diryāq
Book of conquests *see Fathnāma*
Book of ecstasy *see Halnāma*
Book of fables *see ʿIyar-i danish*
Book of farriery *see Kitāb al-bay-*
tara; Kitāb al-zardaqa
Book of festivals *see Sūrnāma*
Book of Garshasp *see*
Garshāspnāma
Book of hyacinths *see*
Sunbulnāma
Book of Kells 1:66
Book of kings *see Shāhnāma*
Book of knowledge of ingenious
mechanical devices *see*
Kitāb fī maʿrifat al-hiyal
al-handasiyya
Book of Marzban *see*
Marzbānnāma
Book of Samak the Paladin
see Kitāb-i samak-i
ʿayyār
Book of songs *see Kitāb al-aghānī*
Book of Süleyman *see*
Sulaymānnāma
Book of the ascension *see*
Miʿrājnāma
Book of the fixed stars *see Kitāb*
suwār al-kawākib
al-thābita
Book of the mariner *see Kitāb-i*
bahrīye
Book of the moral and physical
characteristics of the
Prophet *see Kitāb khalq*
al-nabī wa-khulqih
Book of the noble *see*
Sharafnāma
Book of the Shaybanids *see*
Shaybānīnāma
Book of the ten discourses on the
eye *see Kitāb al-ʿashr*
maqālāt fiʾl-ʿayn
Book of victories *see Nusratnāma*
Book of victory *see Zafarnāma*
Book of wars *see Razmnāma*
books (printed) 3:125–8, 126
see also manuscripts
Borujerd 1:376
Boşnak Osman Efendi 3:180
Bosnia and Herzegovina
1:**299–302**
architecture 1:169, 300–01,
307
painting 1:301–2

Bosra 1:**303**
citadel 1:303
al-Mabrak Madrasa 1:303
madrasa of Kumushtakin
1:113; 2:432
mosque of ʿUmar 1:76, 303;
2:530; 3:231
museum 3:262
Boston, MA
Museum of Fine Arts 3:34
Botti, Giuseppe 1:48
Bouake
mosque 1:23
Bouchard, Henri 1:10,
266
Boucherle, Pierre 3:356
Bouchier, Guillaume 3:217
Bougie *see* Annaba
Boujad 3:313
Boukhatim, Fares 1:51
Boulanger, Gustave 1:40;
3:64, 80
Boulaouane 1:189
Boullata, Kamal 1:304; 3:104
Boullée, Étienne-Louis 1:40
Bourdais, Jules 2:544
Bourguiba, Habib 2:366
Bourne, Samuel 2:118
boustrophedon 3:246
Boutilimit 2:469
Bouvard, Antoine 2:319
Bouygues 3:366
Bouzid, Muhammad 1:50
boxwood (*Buxus sempervirens*)
3:420, 424, 439
Boy, Papisto 3:194
Boyalikoy Hanikahi 1:118
Brad 1:271
Brahim, Mubarak 2:547
Brahmanabad *see* Mansura
(Pakistan)
Brak, Tell 3:262
Brangwyn, Frank 3:69
brass 1:**304–5**, 307, 411; 2:446,
479, *484*, 491, *495*,
496, 498, *499*, *504*,
509; 3:pl.IX.1, IX.2
Breeding Desert 3:255
Bremen Cathedral 3:301
Brezoski, Slavko 2:426
brick 1:68–9, 81, 88, 90, 94, 99,
135, 195, 305–6, 395;
2:172–3
bridges 1:146, *173*, 306–7, *307*
Brigdon, Denis 2:309
Brighton
Royal Pavilion 2:544
Brion, Edmond Charles 2:546
Brisch, Klaus 2:363
Brittle ware *see under* ceramics →
wares
Brjakin, Ivan 2:378
brocade 3:275, 282
Brocard, Joseph 2:115
bronze 1:304, **307–8**, 411;
2:479–80, *486*, *487*,
491, *493*, *500*, *538*,
pl.XV.3; 3:*247*
weapons 1:217
Broota, Rameshwar 2:8
Brosset, Marie-Félicité 1:434
Brousse *see* Bursa
Brown, Ford Madox 3:69
Browne, E. G. 1:4

Brownish style 2:233; 3:207
Brunelleschi, Filippo 1:71
Bruno, Armando 2:362
brushes 1:339, 485
Bteddin *see* Bayt al-Din
Buchanan & Partners 2:405
Budapest
bath of Sokollu Mehmed
Pasha 1:166
baths 2:178
tomb of Gül Baba 2:178
Budayya 1:253
buff ware *see under* ceramics →
wares
Bugatti, Carlo 2:544
Buhler, General 3:273
Buhtari, al- 2:26
builders *see* architects
building materials *see* architec-
ture → materials
Bukhara 1:131, **308–12**,
386, 389, 393, 395,
403, *404*; 2:521,
528; 3:169, 216,
266, 381, 386,
387, 394, 412
baths 1:404
bazaars 1:404
carpets 1:378, 420
ceramics 1:421, 422, 423
Char Bakr complex 1:178,
309, 399; 3:409
Charminar 3:387
citadel 1:403
coins 1:425, 426
complex of Bala-khauz 3:387
congregational mosque 1:404
embroidery 1:416, 417;
3:388
jewelry 1:430; 3:388
Kalan complex 1:**311–12**
minaret 1:179, 311, *311*,
396, 401, 402
Mir-i ʿArab Madrasa 1:312
mosque 1:179, 312, 398,
403
khanaqahs 1:399, 400; 2:307
Kukeltash Madrasa 1:431
Lab-i Hawz 1:178, 400
Madar-i Khan Madrasa 1:399
madrasas 1:404
madrasa of ʿAbd al-Aziz
1:400, 403
madrasa of ʿAbdallah Khan
1:399, 403
madrasa of Nadr Bi Arlat
1:181, 403
Magoki Attari Mosque 1:**311,**
311, 396, 401, 402
Magoki-Khurpa Mosque
1:400
manuscripts 1:406, 407, 408;
2:228, 249–50,
250, *388*
markets 1:180, *180*, 399
Masjid-i Boland 1:179
Masjid-i Zayn al-Din
1:179
mausoleum of Buyan Quli
1:200, 312, 402
Mausoleum of the Samanids
1:89, *89*, 91, 305,
310, 395, 401, 430;
3:229, 424
mausoleum of Sayf al-Din
Bakharzi 1:312, 431
metalwork 1:411; 2:488

minarets **1:**90
Mir-i ʿArab Madrasa **1:**179, 399, *400*, 403
Mokh Mosque **1:**311
namāzgāh **1:**93
Namazgah Mosque **1:**401
palace **3:**99
Qul Baba Kukaltash Madrasa **1:**178, 399
ramparts **1:**403
Registan **1:**404
reservoirs **1:**405
shrine of Chashma-yi Ayyub **1:**133, 431
silk **1:**309
textiles **1:**415, 416; **3:**316, 388
tomb of Bahaʾ al-Din Naqshband **1:**179
Ulughbeg Madrasa **1:**133, 398, 431
woodwork **1:**438
Bukhari **2:**302
Buksh, Allah *see* Bux, Allah
Bulaq Press **3:**126
Bulatov, Mutkhat Sagadatginovich **3:**387
Bulatova, V. A. **2:**404
Bulgaria **1:**312–15
architecture **1:**312–14
interior decoration **1:**314–15
ceramics **1:**315
metalwork **1:**315
textiles **1:**315
Buljovčić, Ilija **1:**303
Bulla Regia **3:**357
Buluggin (*r.* 972–84) (Zirid) **1:**52; **3:**452
Bundarabad mosque **1:**135
Bundari, al- **2:**202
Bundzhikat **1:**316, 433
jewelry 429, 430
Kalay-i Kakhakhla **1:**205
palace **3:**413
woodwork **1:**430
Bunshaft, Gordon **2:**312; **3:**188
Buraimoh, Jimoh **3:**57
Burana **1:316–17,** 434; **2:**406
State Reserve Museum **2:**408
Buraydah **3:**406
Burckhardt, Jean-Louis **2:**363, 471, 472
Burdach **1:**412
Burdalyk **1:**420
Bure, Leon Leonardovich **3:**388
Burges, William **2:**544
Burgo de Osma, El **3:**300
Burgos
Las Huelgas monastery **3:**8
banner of Las Navas de Tolosa **1:**156; **3:**303
doors **3:**422
textiles **3:**303
Burhan, Sami **3:**262
Burhanpur **3:**319, 322
burial rites **1:**383–4
Burlima *see* Palermo
Burning and melting *see* Sūz va gudāz
burnous **2:**28
Bursa **1:**141, **317;** **3:**82, 382
Alaeddin Bey Mosque **1:**145
bazaar **1:**146
caravanserais **1:**355
carpets **1:**364; **3:**83
citadel **2:**523

complex of Bayezid I Yildirim **1:**317; **2:**18, 401
complex of Orhan **1:**317
Emir Han **1:**146
Great Mosque **1:**145; **3:**432
Green Mosque (Yeşil Cami) **1:**135, 210, *317*; **2:**517, 552
Green Tomb (Yeşil Türbe) **1:**385; **2:**517
Ipek Han **1:**146
minarets **2:**533
Museum of Turkish and Islamic Art **3:**363
shadow theater **3:**201
textiles **3:**83, 292, 293, 308, 309, 310, *311*, 312
tomb of Mehmed I (Yeşil Türbe) **1:**146; **3:**344
tomb of Şehzade Mustafa **1:**145
Yeni Kaplica **1:**165
Yeşil complex **1:**145, 200, 317; **2:**401
Burton, Sir Richard **2:**129
Burtsev, Eremey Grigorievich **3:**267
Burty, Philippe **2:**58
Buryakov, Yu. F. **2:**368
Busbecq, Ogier Ghiselin de **1:**206; **2:**86, 95; **3:**311
Bushara, Mohamed Omer **3:**255
Bushehr (Bushire) **1:**376; **3:**315
Bushnaq, Yusuf **1:**335
Busintsi **1:**315
Busiri, al- **2:**23
Buṣra *see* Bosra
Bust
Arch **1:**99, 100, *100*
ceramics **2:**109
coins **1:**425
manuscripts **2:**187
mausoleum **1:**98, 100
palace **1:**98
tombstones **1:**99
Būstān ("Orchard") by Saʿdi **2:**200
(1488, 1494–5; Cairo, N. Lib., Adab Farsi 908) **1:**287, 349, 498, pl.XI; **2:**149, 195, 228; **3:**336, *337*
(1542–9; Lisbon, Fund. Gulbenkian, N. 177) **1:**407; **2:**435; **3:**256
(1556, Paris, Bib. N., supp. pers. 1187; and 1575, St. Petersburg, Saltykov-Shchedrin Pub. Lib., Dorn 269) **1:**407
(1570; Dublin, Chester Beatty Lib.) **1:**407
(*c.* 1600; Cambridge, MA, Philip Hofer priv. col.) **2:**260
(*c.* 1630s; London, BL, Add. MS. 27262) **2:**261
Butt, Fuad ʿAli **3:**93
Butt, Khalid Saeed **3:**94
Butt, Rashid **3:**93
Bux, Allah **1:318;** **3:**93, 97
Buyids (*r.* 932–1062) **1:318–20**
architecture **1:**89
metalwork **1:**319
textiles **1:**319; **3:**298

see also ʿAdud al-Dawla (*r.* 949–83); ʿIzz al-Dawla (*r.* 966–78); Fakhr al-Dawla (*r.* 977–97); Bahaʾ al-Dawla (*r.* 998–1012)
Büyükada
Şakir Pasha mansion **2:**95
Buyung, Dzulkifli **2:**445
Buzun
Imamzada Karrar **1:**96
Byblos **2:**419, 526
Byron, Robert **1:**320
Byzantium *see* Istanbul
Cabanel, Alexandre **3:**200
Cadet, Auguste-Alexandre **2:**546
Caesarea (Algeria) *see* Cherchel
Caesarea (Israel) **1:**455; **3:**354
Caʿfer Efendi **1:**68, 162; **2:**474
Caignart de Saulcy, Louis Félicien **2:**117
Cairo **1:**147, 190, **321–5,** *322*; **2:**44, 71, 519; **3:**111, 376, 377, 378, *378*, 379, 398
Akhenaten Halls and Arts Complex **2:**49
Aqmar Mosque **1:**106, 107, 109; **2:**311; **3:**28, 249, 422
architecture **1:**71, 78, 105, 148
Atelier of Fine Arts **2:**48
Azhar Mosque **1:**105, 109, 194, 305, **332,** *332*
doors **3:**421
maqsura **2:**461
mihrab **2:**516
stucco **3:**237
windows **1:**209
Bab al-Nasr **1:**325
bath of Abuʾl-Suʿud **3:**26
baths **1:**271–3
Bayt al-Razzaz **1:**210
Bayt al-Suhaymi **1:**210
Ben Ezra Synagogue **2:**361
bridge over Abuʾl-Munagga canal **1:**306
Cairo Atelier **2:**49
Cairo Opera House Art Gallery **2:**49
caravanserais **1:**354
carpets **1:**330, 359, 363–4, 365; **2:**387; **3:**83
ceramics **1:**446, 453, 466, 485; **3:**491
citadel **1:**333; **2:**520, 526
coins **1:**494
complex of al-Nasir Muhammad **1:**149; **2:**19; **3:**422
complex of Azbak al-Yusufi **1:**152
complex of Barquq **1:**151, 209; **2:**503
madrasa of Barquq **1:**195; **2:**432, 504
mausoleum **3:**430
complex of Barsbay **1:**152
madrasa **2:**504
minbar **3:**431
complex of Muʿayyad Shaykh **1:**152, 209; **2:**19, *19*, 503
complex of Qaʾitbay **1:**152, 209, 335, pl.VI.1; **2:**432
mausoleum **3:**28, 75

complex of Qajmas al-Ishaqi **1:**152
complex of Qalaʾun **1:**149, *149*, 334; **2:**453
ceilings **1:**490; **3:**430
fountain **2:**88
hospital **3:**307
madrasa **2:**432, 503
mausoleum **1:**385; **2:**18; **3:**74, 229
woodwork **3:**422, 430
complex of Qansuh al-Ghawri **1:**152
complex of Salar and Sanjar al-Jawli **1:**149; **3:**231
complex of Shaykhu **1:**202
complex of Sultan Hasan **1:**150, *151*, 152, **334–5;** **2:**19, *19*, 308, 401, 432, 503, 535; **3:**28, 430
congregational mosque (Fustat) **2:**550
Coptic Museum **1:**331; **2:**49
Deir Mari Girgis **3:**422
Eastern Palace **1:**105
Egyptian Center for International Cultural Cooperation **2:**49
Egyptian Museum **1:**330; **2:**49
Fakahani Mosque **3:**422
Fatimid library **2:**420
Fustat (Old Cairo) **1:**70, 105, 321, 323
gates **1:**324, *325*; **2:**519
glass **2:**111, 112, 113, 114, *146*
Hanagir Art Center **2:**49
houses **1:***324*; **2:**174
ivory **2:**331
jewelry **2:**354
Karaite synagogue **2:**361
Khalil Museum **1:**331
khanaqah of Baybars al-Jashankir **2:**382, *383*
khanaqah of Bektimur al-Saqi **2:**307
khanaqah of Faraj **2:**535
Leonardo da Vinci School of Arts **2:**48
Lesser Palace *see* Western Palace
madrasa and mausoleum of Amir Mahmud al-Usta-dar **3:**491
madrasa of Abu Bakr ibn Muzhir **3:**431
madrasa of al-Ghannamiyya **1:**202
madrasa of al-Nasir Muhammad **1:**195; **2:**432
madrasa of al-Salih Najm al-Din Ayyub **1:**108, *435*; **2:**432
madrasa of Khushqadam al-Ahmadi **1:**202
madrasa of Khwand Baraka **3:**431
madrasa of Umm al-Sultan Shaʿban **2:**455
madrasas **3:**431
Mahmud Mukhtar Sculpture Museum **2:**45, 49
manuscripts **2:**206, 255
maqʿad of Mamay al-Sayfi **3:**399, *400*

mausoleum of Muzaffar ʿAlam al-Din Sanjar 1:150
mausoleum of Saʿd Zaghlul 2:44
mausoleum of Sayyida Ruqayya 1:108, 109; 2:515, 516
mausoleum of Sharif Tabataba 1:108
mausoleum of Yunus al-Dawadar 1:151
Maydan palace 1:85
metalwork 2:47, 501–2, 503–4, 504, pl.V.3
Modern Art Museum 1:331
Mohammed Naghi Museum 3:43
mosaics 1:208
mosque of Abu'l-ʿIla 3:431
mosque of al-Ghamri 3:431
mosque of al-Hakim 1:106, 106, 194, 211, 212, 305, 332–3; 2:531, 551; 3:72, 237
mosque/mashhad of al-Juyushi 1:108, 109, 194, 211; 3:26, 210, 237
mosque of al-Muʾayyad Shaykh 2:535, 551
mosque of al-Nasir 1:150
mosque of al-Rifaʾi 1:190
mosque of al-Salih Talaʾiʿ 1:107; 2:500, 535
mosque of Altinbugha al-Maridani 1:150
mosque of ʿAmr 1:73, 84, 106, 305, 331; 3:228
mosque of Aqsunqur (Blue Mosque) 1:150, 170
mosque of Aslam al-Silahdar 1:150
mosque of Baybars 1:150, 334; 3:430
Mosque of Ibn Tulun 1:67, 85, 106, 280, 305, 331–2, pl.V.1; 2:395, 551; 3:353
ceiling 1:382; 3:430
minaret 1:80; 2:531
minbar 3:430; pl.XVI.3
stucco 1:194; 3:236
windows 1:209
woodwork 3:421
mosque of Khushqadam 3:399
mosque of Malika Safiya 1:161, 170
mosque of Muhammad ʿAli 1:170, 335, pl.X.2
Mosque of Sayyidna al-Husayn 1:108, 190; 3:209
mosque of Süleyman Pasha 1:161
mosque of Sunqur Saʿdi 3:419
mosques 1:163
Mukhtar Museum 3
Musafirkhana Palace 1:210
Museum of Arab Art see Museum of Islamic Art
Museum of Islamic Art 1:329, 331, 498; 2:49, 2; 3:34
Museum of Islamic Ceramics 2:49; 3:34
Museum of Modern Art 2:49
Museum of Modern Egyptian Art 2:49
National Cultural Center 2:45
Nile Exhibition Hall 2:49

palace of Alin Aq 1:209
palace of Amir Taz 1:490
palace of Bashtak 3:399
palace of Beshtak 1:209, 490
palace of Qaʾitbay 1:209
palace of Qawsun 3:399
palace of Yashbak 1:209; 3:28
paper 3:105
al-Qahira 1:105, 324, 325
Qarafa cemetery 1:384; 3:210, 345
kiosks 2:388
madrasa 2:432
mosque 1:205
qaṣaba 3:376
al-Qataʾiʿ 1:85
al-Rawda 1:323
al-Rawda Nilometer 1:85
rock crystal 3:110, 154
sabīl-kuttābs 1:170, 327
School of Applied Arts 2:48
School of Fine Arts 2:46, 48
St. Barbara 3:422
shrine of Sayyida Nafisa 3:422
al-Sultaniyya 1:151
textiles 1:329–30; 2:47–8, 47; 3:294, 305, 337, 338
tomb complexes 1:147–8
tomb of al-Salih Najm al-Din Ayyub 3:28
tomb of Amir Sarghatmish 1:151
tomb of Mahmud al-Kurdi 1:195
tomb of al-Shafiʿi 1:108, 333–4, 334, 384, 490; 2:500; 3:28, 110, 209, 342, 423
tomb of Shajarat al-Durr 1:208
tomb of Sultan Qaʾitbay 1:195
tomb of Zayn al-Din Yusuf 3:343
Wakala of Qaʾitbay 2:465
Wakala of Qansuh al-Ghawri 2:465
wall paintings 1:204–5
Western Palace 1:105; 2:388; 3:422, 430
windows 1:209
Zahiriyya Madrasa 1:148; 2:432, 453
Čakelja, Miko 2:426
Calabar 3:56
Calatayud
S. María 3:9
Calcutta 2:530
Asutosh Museum of Indian Art 1:264, 265; 2:274
Birla Academy of Art and Culture 2:275
Gurushaday Museum 1:264, 265
Indian Museum 1:265; 2:274; 3:34
Victoria Memorial Hall 2:274
calico 1:416; 3:275
Çalik, Şadi 3:362
Çallı, Ibrahim 1:229, 335–6; 2:132, 338; 3:361
calligraphers 1:336, 339
Calligraphic Movement 3:93
calligraphy 1:336–52, 337, 338; 2:395
collections 1:496
display 1:43

regional traditions
Africa 1:27; 2:143
China 1:484–5
Iran 1:9, 319–20 1:344; pl.XII.3; 2:287, pl.XIV.1; 3:3
Iraq 1:2, 347, pl.XII.2 2:395; 3:441
Morocco 1:345
Spain 1:345
Tunisia 1:29
Turkey 1:340, pl.XII.1; 3:361–2
see also scripts
Çallı Group 3
Cambay see Khambat
Cambridge, MA
Harvard University
Fogg Art Museum 3:34
Sackler Museum 1:501; 3:34
camel hair 1:356; 2:386; 3:278
camel harnesses and trappings 2:138
cameo glass 2:112
camlet 3:293
Cammann, Schuyler 1:358
Çanakkale 1:474; 3:362
Candilis, George 1:214
candlesticks 2:481
cane 1:221
Çankırı
kilims 2:386
mosque 1:145
Canning Town 1:57
Cansever, Turgut 1:62, 352; 3:360
Cantagalli 1:474
Cantagalli, Ulysse 2:544
Canterbury Inventory 3:307
Cantigas de Santa María (Madrid, Escorial, Bib. Monasterio S. Lorenzo, MS. J.b.2) 3:7
Canton
minaret 2:533
cantonments 1:80
canvas 3:275
capitals 1:193, 281, 352–3; 3:228
caravanserais 1:69–70, 353–5; 3:376
Central Asia 1:83, 93, 180, 354, 396
India, 1:396, 185
Iran 1:83, 129, 174
Turkey 1:119, 146, 165
Carchemish 3:363
caricatures 1:356
Caro, Rodrigo 2:89
carpets and rugs 1:356–82; 3:112
forgeries 2:77
regional traditions
Afghanistan 1:17–18
Algeria 1:51, 380–81
Armenia 1:215, 216, 374
Azerbaijan 1:245–7, 373–5, 374
Berber 1:381
Caucasus 373–5, pl.VIII.3
Central Asia 1:378–9, 379, 418–20, 419
Egypt 1:363–5, 364
India 1:360, 367–9, 369, 380
Iran 1:365–7, 376–8, 377, 378, pl.XIV.1, XIV.3; 2:287–8, pl.IV.3

Morocco 1:381, 382, 382
Pakistan 3:95
Spain 1:360
Tunisia 1:381; 3:357
Turkey 1:357, 360, 361, 361–3, 362, 370–73, 372; 3:362
Turkmenistan 3:367
types
alloucha 1:381
animal 1:360, 361
Bellini 1:361, 362
Bijar 1:377; 2:288
Bukhara (Bokara) see Turkmen
Checkerboard (Chessboard) see Compartment
Compartment 1:363, 364
Crivelli 1:361, 362
Dragon 1:374, 374
floral 1:365
Garden 1:357, 366; 2:87, 91, pl.IV.1
Hamadan 1:377; 2:288
Herati 1:376, 377
Heriz 1:377; 3:264
Holbein 1:360, 361, 362; 3:83
Keyhole see Bellini
Lotto 1:361, 362, 362
Mamluk 1:330, 363–4, 364
Memling 1:361, 362
millefleurs 1:376
Ottoman Court 1:364–5
Para-Mamluk 1:364
picture-format 1:368
Polonaise (Polish) 1:367
prayer-rugs 1:357, 372; 2:517
Re-entrant see Bellini
row see saff
saff 1:357
Sanandaj see Senna
Senna 1:377; 2:288, 3
Sunburst 1:374
Transylvanian 1:363
Turkmen (Turkoman) 1:378–9
Ushak 1:361, 362
Vase 1:366
Wheel see Holbein
see also kilims
Carpini, Piano 3:276, 281
Carr, Robert 1:57
Carracci, Annibale 1:356
Carrhae see Harran
Carswell, John 2:155
Cartier 2:360
Casablanca 2:522
Bank of Morocco 2:546
Dar Lamane Complex 2:546
Ecole des Beaux-Arts 2:546
Great Mosque of Hassan II 2:546
Law Courts 2:546
New Medina 2:546
Post Office 2:546
Sijelmassi House 2:546
Villa des Arts 2:548
Casablanca Group 1:275; 2:476, 547
cashmere 3:293, 320
Caslon, William 3:126
casting 2:480

castles *see* architecture → types → military
Çatalca
mosque of Damad Ferhad Pasha **1**:163
Çatal Hüyük **3**:363
Catania
castle **1**:104
Caucasus
carpets **1**:373–5, pl.VIII.3
historiography **1**:434
Çay
Taş Madrasa **1**:118
Cefalà Diama **1**:103
Cefalù
Cathedral **1**:103, 383
ceilings **1**:382–3
see also coffering; *artesonado*; *muqarnas*
Çekirge
complex of Murad I **2**:401
Hüdavendigâr Mosque (mosque of Murad I) **1**:*145*, 146
celadon *see under* ceramics → wares
Celanova
S. Miguel **3**:5
Çelebi, Ali (Avni) **1**:383; **3**:361
Çelebi, Hasan **3**:361, 448
Çelebi, Mehmed Yirmisekiz **1**:166, 3
cemeteries **1**:383–4
see also cenotaphs; mausolea; tombs
cenotaphs **1**:384–6, *385*; **2**:305, pl.XII.1; **3**:210
Central Asia **1**:386–440
architecture **1**:81–3, 88–91, 131–4, 177–81, **395–404**
military **2**:521
vernacular **3**:411–13, *412*
arms and armor **1**:423–5
brass and bronze **1**:411–13
brick **1**:395
caravanserais **1**:83, 93, 180, 354, *396*
carpets **1**:378–9, *379*, 418–20, *419*
cenotaphs **1**:*385*, 386
ceramics **1**:421–3, 450, 456–60, 462–4, *467*; **3**:*112*
coins **1**:425–6
cotton **1**:415–16
doors **1**:431
dress **1**:416–17, 418
embroidery **1**:416–17, *417*
exhibitions **1**:438–40
gardens **1**:133; **2**:91–3
glass **1**:427–8
gold **1**:411
historiography **1**:432–5
houses **1**:83
ivory **1**:429
iwans **2**:336–7
jade **1**:429; **2**:pl.XIII.3
jewelry **1**:429–30, 3
madrasas **1**:133, 179, *400*
manuscripts **1**:405–8; **2**:*205*, 223–30, 249–51, *250*, 388
markets **1**:180, 180
mausolea **1**:*89*, 395, pl.III.1; **2**:*479*
metalwork **1**:408–13; **2**:487–8, 491, 496–7

mihrabs **1**:91
minarets **1**:90, 179, *311*
mosques **1**:89, 179, *311*; **3**:*331*
museums and collections **1**:436–8
painting **1**:405–8
palaces **1**:180, *181*, *398*
*pishtaq*s **3**:120–21
*ribāṭ*s **1**:83
sculpture **1**:405
shrines **3**:*210*
silk **1**:414–15
silver **1**:408–11
stained glass **1**:428
tents **1**:133; **3**:99, 279–82
terracotta **1**:401
textiles **1**:414–20, 415, 417; **3**:216, 298–9, 307–8, 316–17
tiles **1**:181, 200, 385, 402, pl.XVI.1
tombs **1**:89, 133, 179
urban development **1**:403–4; **3**:380–82
wall paintings **1**:205
woodwork **1**:430–31; **3**:424, 435–8
wool **1**:414
see also Kazakhstan; Kyrgyzstan; Samanids; Shaybanids; Timurids; Tajikistan; Turkmenistan; Uzbekistan
Central State Restoration Workshops (TsGRM) **1**:433
Centurione **1**:362
ceramics **1**:440–79; **3**:112
regional traditions
Afghanistan **1**:18
Africa **1**:26–7; **2**:142
Algeria **1**:479
Armenia **1**:216
Azerbaijan **1**:242–3
Bangladesh **1**:264–5
Berber **1**:277
Central Asia **1**:421–3, 450, 456–60, 462–4, *467*; **3**:*112*
China **1**:485–6, pl.XIII.1
Egypt **1**:451, *451*, *453*, 453–4, 465–7; **2**:47
Iran **1**:443, 448–50, 451, 456–60, 458, 462–4, 474–8, 475, 476, pl.XIV.2, XV, XVI.3
Iraq **1**:2, 445–8, pl.XVI.2; **3**:pl.II.1
Morocco **1**:461, 478
Pakistan **3**:95
Sicily **1**:461
Spain **1**:452, 461–2, *461*, 469, 469
Syria **1**:444–5, 455–6, *455*, 465–7, 467, pl.XIII.4
Tunisia **1**:452, 461, 479; **3**:357
Turkey **1**:281, 460–61, 468, 470–74, *471*, *472*, *473*, pl.IV.2; **3**:362
techniques
barbotine **1**:421, 442
champlevé **1**:457
cuerda seca **1**:461
sgraffito **1**:199, 457, 461, 465

underglaze painting **1**:200, 443, 454, 456, 458, 466–7, 477–8
wares
Abraham of Kütahya ware **1**:468, 470, 472
Aghkand ware **1**:457
Amol ware **1**:457
Baba Nakkaş ware **1**:468
black-on-white ware **1**:450
black-slip ware *see* silhouette ware
blue-and-white ware **1**:292, 441, 445, 446, 447, 463, *467*, 468, 470, 474, pl.XIII.2, XII.3
Brittle ware **1**:445
buff ware **1**:450
celadon **1**:486; **3**:248
Damascus ware **1**:471
earthenware **1**:441, 442, 478
Elvira ware **1**:*461*
enameled ware *see* *lājvardina* ware; *mīnāʾī* ware
Fayyumi ware **1**:451, 454
fritware **1**:216, 402, 422 441, 442–3, 454, 455, 457–8, 458
Fustat Fatimid *Sgraffito* ware **1**:454
Golden Horn ware **1**:470, 471
Gombroon ware **3**:162
Kashan style **1**:458
Kraak ware **1**:476
Kubachi ware **1**:292, 464, 474, 475, 475; **3**:162
lājvardina ware **1**:201, 462, 463, pl.XVI.3
Laqabi ware **1**:455, 457
lusterware 441, 443, *443*, 445, *447*, 448, 449, 453–4, *453*, 455, *455*, 458–9, 461, 462, 465–6, *469*, *476*, pl.XIII.4; **3**:pl.II.1
Miletus ware **1**:281, 468, 470
mīnāʾī ware **1**:201, 459, pl.XIV.2
Miniature style **1**:459
Monumental style **1**:458–9
mottled ware **1**:445
Ramallah ware **3**:104
Raqqa ware **1**:455
Rusafa ware **1**:456
Samarra ware **1**:485, 486
silhouette (shadow) ware **1**:458
slip-painted ware **1**:457, 465
splashed ware **1**:445, 447–8, 449
stoneware **1**:455
Sultanabad ware **1**:462
Tell Minis ware **1**:455
tin-glazed earthenware **1**:292
Umayyad Palace ware **1**:444–5
see also tiles
Cerimagić, Muradif **1**:302
Cerrahiye-i haniye by Sharaf al-Din (1456–6; Paris, Bib. N., suppl. turc 693) **2**:233

Ceuta
manuscripts **2**:207
Chach **1**:389, 403, **479–80;** **2**:521
ceramics **1**:421
coins **1**:425
cotton **1**:415
Chadiriji, Rifat (Kamil) **1**:28, 191, **480**
Chad Republic **1**:480–81
Chagall, Marc **3**:356
Chaghatayid (*r.* 1227–1370)
architecture **1**:309
coins **1**:426
Chaghatay Khan (*r.* 1227–41) **1**:392, 426; **3**:276
Chahār maqāla ("Four discourses"; 1431; Istanbul, Mus. Turk. & Islam. A., MS. 1954) by Nizami ʿArudi **2**:226, 385; **3**:335
Chaïbia **2**:546
Chain of gold *see* Silsilat al-zahab
Chakparov, Darkembaj **2**:378
Chal-Tarqan **3**:235
Chambers, William **2**:544
champlevé *see under* ceramics → techniques
Champmartin, Charles-Émile de **3**:68
Chan Cheng Siew **3**:448
chandeliers **2**:505–6
Chanderi **3**:100
Chandigarh 2
Chand Muhammad **1**:*11*; **2**:266
Chang'an *see* Xi'an
Chang'ome
College of National Education **3**:271
Changsha **1**:485
Chania **2**:525
Chaouen **3**:313, 395
Charaf, Rafic **2**:418
Charai, Abderrahim **2**:546
Chardin, John **2**:34; **3**:149, 156
Chardzhou **3**:366
Charkh-i Logar
mosque **1**:99; **3**:424
Charklik **3**:214
Charles V, King of Spain (*r.* 1516–56) **2**:122, 125
Charyyev, Ruzy **3**:388
chasing **2**:480
Chassériau, Théodore **3**:68, 69
Chasuble of San Juan de Ortega **1**:60
*chatrī*s **3**:389
Chaukandi **3**:96
Chebaa, Mohamed **1**:275; **2**:476, 547
Checkerboard carpets *see* carpets → types → Compartment
Chekhli, Ismail al- *see* Sheikhly, Ismail
Chella **1**:384; **2**:522; **3**:143, 344
mosque **1**:158
zāwiya **1**:159, *201*
Cheltout, Khelifa **3**:357
Chengdu
mosques **1**:484
Cheong Laitong **2**:445
Cherchel **1**:49
Cherkaoui, Ahmed **1**:481; **2**:546

Cherkassky, Abram **2:**377
Chernyayev, General **1:**432
Chessboard carpets *see* carpets →
 types → Compartment
chess sets **1:**429, **481–2; 2:**331
chests **1:**277
Chichaoua **1:**125, 381
Chilkhudzhra **3:**412
Chimère, La **2:**46; **3:**23, 43
Chimkent **2:**376
China **1:482–6**
 architecture **1:**482–4, pl.III.3
 calligraphy **1:**484–5
 ceramics **1:**485–6, pl.XIII.3
 porcelain **1:**292, 441
 silk **3:**216
 trade **1:**485–6; **3:**216
China stone **1:**441
Chinaz **1:**429
Chinchilla de Monte Aragón
 1:360
Chinghiznāma ("History of
 Genghis"; 1596;
 Geneva, Prince
 Sadruddin Aga Khan
 priv. col.; Tehran,
 Gulistan Pal. Lib.)
 1:282; **2:**14, 15, 380,
 383, 415, 428; **3:**353
 see also Jāmiʿ al-tawārīkh
 ("Compendium of
 histories") by Rashid
 al-Din
Chinguetti **2:**469
 mosque **1:**22
Chiniot **3:**96
chintz **3:**287, 317, 322
Chiprovtsi **1:**315
Chist
 tombs **1:**98, 101
Chistyakov, Pavel Petrovich
 3:366
Chitarman **2:**263
Chittagong
 University **1:**265
Chittaurgarh **2:**529
Chludov, Nikolay **2:**377
Chodor **1:**379
Choicest maxims and best say-
 ings *see Mukhtār al-
 hikam wa-mahāsin
 al-kalim*
Choong Kam Kow **2:**445
Chorku **1:**405, 431
Chowdhury, Rashid **1:**263
Christian Art **1:**409–10,
 487–8; **2:***310, 484,
 500;* **3:**5
 see also Mozarabic art
Chronology of ancient nations
 see Āthār al-bāqiya
Chronicle of the Szigetvár
 campaign *see Nuzhat
 asrār al-akhbār dar
 safar-i sigitvār*
Chuah Thean Teng **2:**444
Chufutkale **1:**488–9
Chughtai, Abdur Rahman
 1:489; **3:**97
Chuikov, S. A. **2:**407
Chupan **3:**441
Church, Frederic Edwin **3:**70
churches **1:**76
Churchill, Sidney **1:**499
Churchill Album (London, BM,
 Or. MS. 4938) **1:**63;
 2:17

Chzheshi *see* Chach
Çiftlik Han **1:**120
Çilingiroğlu, Günay **3:**360
Cincinnati, OH
 Isaac M. Wise Temple **2:**545
Cinici, Altuğ **3:**360
Cinici, Behruz **1:**62; **3:**360
Cinici, Can **1:**63
Çipan, B. **2:**426
circumcision **3:**304
Cirta *see* Constantine
Cisneros, Francisco de Jiménez,
 Cardinal *see* Jiménez de
 Cisneros, Francisco,
 Cardinal
citadels **1:**403; **2:**519
cities **1:**79–80, 102
city gates **1:**155, 156, *195, 325;*
 2:*521*
Cizre
 bridge **1:**197, 198, 306
 Great Mosque **2:**18, 500
Cleveland, OH
 Museum of Art **3:**34
Clive, Lord **2:**137
cloisonné enamel **2:**50
Cluny Abbey **1:**67
coats **2:**28
cobalt **1:**199, 292, 422, 423,
 441, 446, 449, 450,
 456, 459, 464,
 468, 470, 478
cochineal **1:**215, 358, 419;
 3:314
codices **1:**292
coffering **1:**489–90
coins **1:**425–6, **490–96,** *491,
 493, 495;* **2:**446–7,
 515; **3:**245
coin weights **2:**111
Çoker, Adnan **3:**362
Colbert, Jean-Baptiste **1:**499
Coleridge, Samuel Taylor **2:**544
collage **3:**107–8
Collantes de Terán, F. **3:**198
collections **1:496–501;**
 3:110–11
 Afghanistan **1:**19
 Algeria **1:**51
 Bangladesh **1:**265–6
 Central Asia **1:**436–8
 Egypt **2:**49
 India **2:**274–5
 Iran **2:**288–9
 Kazakhstan **2:**378
 Kyrgyzstan **2:**408
 Macedonia **2:**427
 Nigeria **3:**58
 Pakistan **3:**97–8
 Russia **1:**437–8
 Saudi Arabia **3:**189
 Senegal **3:**195
 Tanzania **3:**271
 Turkey **3:**363
colleges (theological) *see*
 madrasas
Cologne
 synagogue **2:**545
colophons **1:**293, **501–2,** *502*
color **1:502–3; 2:**22, 27; 75–6
Columbus, OH
 Ohio Theater **3:**28
columns **1:503–4; 3:**228
Combe, Etienne **2:**154; **3:**417
Comité de Conservation des
 Monuments de l'Art
 Arabe **2:**156; **3:**34

commerce *see* trade
Committee for the Conservation
 of the Monuments of
 Arab Art **1:**330; **2:**49
Company style **2:**8
Compartment carpets *see under*
 carpets → types
Compendium of histories *see
 Jāmiʿ al-tawārīkh*
Compendium of stages *see
 Majmuʿ-i manāzil*
Conakry
 Musée National de Sandervalia
 2:130
Conference of birds *see Mantiq
 al-tayr*
Conference of lovers *see Majālis
 al-ʿushshāq*
Coniagui **2:**130
connoisseurship **1:**504–5
Conquests of the emperor *see
 Futūhāt-i humāyūn*
Constant, Benjamin **3:**69
Constantine (Algeria) **1:**22, 49
 art school **1:**50
 Cirta Museum **3:**51
 minbar **2:**535
Constantine IX, Emperor
 (*r.* 1042–55) **2:**326
Constantine of Trebizond **2:**127
Constantinople *see* Istanbul
Constructivism **1:**238
Contemporary Art Group **2:**46
Contreras family **2:**122
Coomaraswamy, Ananda Kentish
 2:275
Copenhagen
 Davids Samling **3:**34
Cope of King Robert **2:**301
copper **1:**304, 307, 441, 458,
 477; **2:**479
copper sulphate **2:**284
Coppolani, Xavier **2:**469
Coptic
 textiles **3:**294–5
copyists **1:**336
coral **1:**278, pl.I.4
cordia **3:**434
Cordier, Charles **3:**68
Córdoba **1:505–8,** 506
 Cathedral *see* Great Mosque
 ceramics **1:**452
 gardens **2:**89
 Great Mosque (Mesquita)
 1:87, *87,* 122, *123,*
 507–8; 2:550; **3:**4
 arches **1:**67, 305
 Bab al-Wuzaraʾ *see* Puerta de
 S. Estéban
 ceiling **1:**226, 382, 490;
 3:426
 columns **1:**193, 503; **3:**228
 dome **2:**18; **3:**pl.XIII.1
 maqsura **2:**461
 marble panels **1:***65,* 194
 mihrab **1:**65; **2:**516
 minaret **2:**531
 minbar **2:**535
 mosaics **1:**208; **3:**249
 Puerta de S. Estéban **1:**87;
 3:427
 spolia **1:**193
 vaults **3:**8
 window-grilles **1:**209
 ivory **1:**505, *507;* **2:***332;* **3:**110
 metalwork **2:**485
 palace **3:**8

Synagogue **1:**508; **2:**361
 textiles **3:**300
 woodwork **3:**425, pl.XVI.1
Çorlu
 Süleymaniye Mosque **1:**163
Corm, Daoud **2:**418
Cormon, Fernand **1:**335; **2:**132
cornelian **1:**18, 430; **2:**99;
 3:*192, 192;* 367
Cornejo, Pedro Duque *see*
 Duque Cornejo, Pedro
Corning Ewer **2:**113
Corot, Camille **3:**414
Corovic, Milorad **1:**302
Corps of Court Architects
 1:161
Correa, Charles **2:**272
Čosevski, Vlado **2:**426
cosmetics **2:**36
Costanzo da Ferrara **2:**253
Coste, Pascal(-Xavier) **1:**335,
 509, 2:92, 153
cotton **1:**25, 356, 394, 415–16;
 2:386; **3:**292, 310, 315,
 317, 318–19, 322–3, 338
Courbet, Gustave **3:**65
courtyard houses *see under*
 houses → types
courtyards **1:**70–71
Covel, John **3:**285
Cowiconsult **1:**253
Crac de Montréal *see* Krak de
 Monreal
Crac des Chevaliers *see* Krak des
 Chevaliers
Cramer, Christian C. **3:**51
Cream of histories *see Zubdat
 al-tawārīkh*
crescent symbol **1:**76
Creswell, K(eppel) A(rchibald)
 C(ameron) **1:510; 2:**49,
 153, 312
Crivelli, Carlo **1:**361
Crivelli carpets *see under* carpets
 → types
Crown Derby **1:**477
Crown of the glories of history
 *see Tāj al-maʾāthir fi
 taʾrikh*
crowns **1:**147–9
Crown script *see under* scripts
Crusader art **1:511; 2:**353
crystal *see* rock crystal
CSL Associates **2:**442
Ctesiphon **3:**216
 carpet **1:**359
 houses **1:**81
 Taq-i Kisra **1:**306, 504; **2:**87
Cuba *see* Quba (ii)
Cubitt, James **2:**422; **3:**56
Cuda, Mahmut **3:**361
Cuenca
 carpets **1:**360
 ivory **2:**332
 cuerda seca see under ceramics →
 techniques; tiles
Çufut Qale *see* Chufutkale
Cuicul *see* Djemila
cuir bouilli **1:**217
Cup of Solomon **3:**154, *155*
curative powers of gems **2:**99
cursive *see under* scripts
Curzon, Lord **2:**8, 508
Cvijeta Zuzorić group **1:**302
cypress **3:**420, 425
Cyprus
 cotton **3:**310

Cyrenaica 2
Cyrene **2:**421
Cyrus I (*r.* 559–529 BCE) **3:**375
Czartoryski **1:**367
Dabussi **1:**415
Dacca *see* Dhaka
Dada, Nayyar ʿAli **2:**415; **3:**92
Dadashev, Sadykh **1:**239, 244;
 2:86
Dağli, Konstanin Kapı **2:**24
Dahak, Ibrahim **3:**357
Dahistan **1:**426
Dahlan, Zulkifli **2:**445
Dahpid **1:**178
Dakar
 BCEAO Bank Tower **3:**194
 Cathédrale du Souvenir
 Africain **3:**194
 Ecole Nationale des Beaux-
 Arts **3:**195
 Ecole Normale Supérieure
 d'Education Artistique
 3:195
 Galerie Nationale d'Art **3:**195
 Institut Français d'Afrique
 Noire **3:**194
 mosque **3:**194
 Musée d'Art Africain **3:**195
 Musée Dynamique **3:**194, 195
 Palais de Justice **3:**194
 Palais du Président de la
 République **3:**194
 Théâtre Daniel Sorano **3:**195
Dakoji, Devraj **2:**8
Dalgıç Ahmet Ağa *see* Ahmed
 Dalgıç
Dalokay, Vedat **1:**191; **2:**309
Dalverzin **2:**73
Damad Ibrahim Pasha **1:**166
Daman **2:**530
Damar
 congregational mosque **1:**110
Damascus **1:**513–17; **2:**519;
 260; **3:**111, 376, 377,
 403
 ʿAdiliyya Madrasa **1:**113
 ʿAzm Palace (Museum of
 Populars Arts and Tradi-
 tions) **1:**169; **3:**261, 262
 Bab Sharqi **2:**519
 baths **1:**272
 caravanserais **1:**355
 carpets **1:**363, 364
 cemeteries **1:**384
 cenotaph of Salah al-Din
 3:423
 ceramics **1:**466, 471, 473,
 515, pl.XIII.4
 citadel **2:**519, 520
 coins **1:**491, 492
 College of Fine Arts **3:**261
 complex of al-Tawrizi **1:**200;
 3:73
 glass **2:**112, 113
 Great Mosque **1:**75, 76, 112,
 148, 503, **515–17,** *516,*
 pl.IV.1; **2:**550
 arches **1:**66
 columns and capitals 353;
 3:228
 maqsuras **2:**461
 minaret **2:**531
 mosaics **1:**75, 207, *208;*
 2:388; **3:**240
 portal **3:**123
 shrine to the head of John
 the Baptist **2:**549

 towers **2:**531
 Treasury **1:**207
 window-grilles **1:**209
 hospital of Nur al-Din **1:**115,
 pl.VI.2; **2:**88, 500; **3:**27
 house of Nur al-Din **3:**434
 Jamiʿ al-Hanabila **1:**112
 Jamiʿ al-Tawba **1:**112
 Jaqmaqiyya Madrasa **1:**151
 manuscripts **2:**213
 mausolea **1:**115
 metalwork **2:**47, *484, 499,*
 499, 502, 508–9, *509;*
 3:262; pl.IX.1
 mosque of Ghars al-Din
 al-Tawrizi **1:**467
 National Museum **1:**514;
 3:36, 262
 Nuriyya Madrasa **1:**113
 tomb of Nur al-Din **3:**344
 palace **3:**98
 printing **3:**126
 Qaymari Hospital **1:**115
 Qubbat al-Tawrizi **3:**343
 Rukniya Turba **3:**342
 Sabuniyya Mosque **1:**151
 Sulaymaniyya complex **1:**169,
 169
 Sulaymaniyya Mosque **1:**161
 textiles **3:**293, 305, 310
 tomb complexes **518**
 tomb of al-Zahir Baybars
 1:208
 tombs **3:**342
 ʿUthman Mosque **1:**191
 window grilles **3:**419
 Zahiriyya Madrasa **3:**27
damask **3:**293
Damghan **1:**91, 517
 Chashma ʿAli **2:**92
 Chihil Dukhtaran **1:**306
 Imamzada Jaʿfar **3:**72
 Pir-i ʿAlamdar **1:**202, 306;
 3:26
 Tarik-Khana Mosque **1:**82, *83,*
 90, 305, 503, 517;
 2:551
Damietta **3:**294, 295, 337
Damit, Awang **2:**445
Damsa Köyü
 Taşkin Pasha **1:**144
Dandan-oilik
 textiles **1:**204
Danestama **1:**98
Danferganket **1:**479
Daniell, Thomas and William
 1:56; **3:**65
Daqiqi **2:**201; **3:**169
Darab **2:**338
Dārābnāma ("Story of Darab";
 c. 1580; London, BL,
 Or. MS. 4615) **1:**269,
 282; **2:**14, 15, 64,
 258, 344, 368, 380,
 383, 428, 434, 542;
 3:46, 272
Daragnès, Jean-Gabriel **1:**280
Dara Shikoh, Prince **1:**44, 187,
 224, 414; **3:**46
Darb Zubayda **1:**80
Dar Chaabane **3:**357
Dar es Salaam
 National Arts of Tanzania
 Gallery **3:**271
 National Museum **3:**271
 Nyumba ya Sanaa **3:**270
Darfur **3:**253

Darin
 Bayt ʿAbd al-Wahhab **3:**406
Daroca
 Santiago **3:**9
D'Aronco, Raimondo **2:**322
Darra-yi Shakh
 mosque **1:**97
Darvish Muhammad **1:517;**
 2:232; **3:**204, 225
Darwish, Dr. Ali Hussein **3:**270,
 450
Darwish, Nabil **2:**47
Darzin **2:**519
Dasavanta *see* Daswanth
Dashdamirova, B. **1:**241
Dashkasan **1:**239
Dashti
 mosque **1:**130
Dasht-i Lut **3:**381
Dastān-i Farrūkh u Hūmā
 ("Story of Ferruh and
 Huma"; 1601–2;
 Istanbul, U. Lib., T.
 1975) **2:**255
Dastān-i Jamāl va Jalāl ("Story
 of Jamal and Jalal";
 1502–3; Uppsala, U.
 Lib., O Nova 2) by
 Muhammad ʿAsafi
 2:239; **3:**148
Daswanth **1:**282, **518**
 collaboration **2:**368, 380,
 428; **3:**272, 353
 teachers **1:**5
 works **2:**259
date palm **3:**420
Datia
 Govinda Mandir **3:**101
Datini, Francesco di Marco
 1:360
Datuk Baharuddin ibn Abu
 Kasim **2:**440
Daʿud (*r.* 1114–44) (Artuqid)
 2:51; **3:**148
Daʿud ibn Muhammad ibn
 Mahmud **2:**236
Daʾud ibn Sökmen **1:**228
Daulat **1:518–19; 2:**260, 261,
 460
Daulatabad (India) **1:**137, **519;**
 2:529; **3:**106
Daulat Khan *see* Baz Bahadur,
 Sultan
Dauzats, Adrien **2:**46; **3:**70
David, C. L. **3:**34
David, Colin **3:**93
Davie, Alan **3:**109
Davioud, Gabriel **3:**544
Davis Album (New York, Met.,
 30.95.174.2) **1:**55; **3:**21
Davud Ağa **1:**39, 164, **520;**
 2:42, 323; **3:**38
Davutov, Zieratsho **3:**268
Daʿwat al-aṭibbāʿ ("Banquet of
 the physicians"; 1272–3;
 Milan, Bib.
 Ambrosiana, MS. A.
 125 Inf) by Ibn Butlan
 2:212
Dawlat *see* Daulat
Dawlat al-Bahrayn *see* Bahrain
Dawlat Qatar *see* Qatar
Dawud Agha **1:**327
Dayakhatyn
 caravanserai **1:**93, 94
Dayal, Raja Lala Deen **2:**119
Daybul *see* Banbhore

Dayfa Khatun, Princess **1:**46,
 113, 234
Dawlatabad (Afghanistan)
 minaret **1:**98, 212
Dawlat al-Baḥrayn *see* Bahrain
 death **2:**305–6
Debat-Ponsan, Edouard-Bernard
 3:69
Debbech, Amara **3:**356
Decamps, Alexandre-Gabriel
 3:64, 69
Deck, Joseph-Théodore **1:**474;
 3:544
découpage **3:**107
Defremery, C. **2:**129
Degas, Edgar **1:**331
Delacroix, Eugène **1:**49; **2:**29,
 544; **3:**68, 69
Delaroche, Paul **2:**118
De La Rue **3:**254
Delhi **1:**128, 137; **2:1–11,** 269,
 270, 271; **3:**384
 ʿAdilabad **2:**3
 Asian Games Village **2:**273
 Bara Gumbad **1:**139, 257
 Barakhamba **3:**414
 Chotte Khan-ka Gumbad
 3:238
 congregational mosque **2:**11;
 3:231
 Dinpanah **2:**5–6; **3:**13
 enamel **2:**51
 Firuzabad 252; palace **3:**99
 French Embassy Staff quarters
 2:272
 galleries and museums **2:**8
 gardens **2:**95–6
 Hawz Khas complex **2:**4, 5
 Humayun's tomb **1:**183, *184;*
 2:10, 96, 309; **3:**344
 India International Center
 2:272
 Indian Statistical Institute **2:**272
 Jahanapanah **2:**3
 Khas Mahal **2:**539
 Lalit Kala Akademi (National
 Academy of Fine Arts)
 2:8
 Lat Pyramid **1:**139; **3:***351*
 Lodi Gardens, **2:**5, *5*
 madrasa of Firuz Shah **1:**139
 manuscripts **2:**258
 mausoleum of Khan-i Jihan
 Tilangani **3:**238
 Mubarakabad **2:**5; **3:**191
 National Gallery of Modern
 Art **1:**265; **2:**8, 274
 National Institute of
 Immunology **2:**273
 National Museum **2:**274, 275
 New Delhi **2:**6–7
 New Delhi Civic Center **2:**273
 Polytechnic Institute **1:**265
 Purana Qilʿa (Old Fort)
 1:182; **2:9–10**
 Qilʿa-i Kuhna Mosque
 1:182, *183,* **2:**10
 Sher Mandel **1:**182
 Qalʿa-i Dukhtar **2:**537
 Qiʿla Rai Pithaura **2:**2
 Qudsiya Bagh Mosque **1:**187
 Qutb Minar **1:**98; **2:**2, *2,* 532
 Quwwat al-Islam Mosque
 1:100, 137, *138,* 504;
 2:8–9; 3:229
 ʿAlaʾi Darvaza **1:**137, 140
 minarets **1:**139

Rabindra Bhavan Art Gallery
2:274
Red Fort (Lal Qilʿa) 1:186–7,
504; 2:10–11, *11*, 96;
3:286, 384
Salimgarh Fort 3:384
Sarada Ukil School of Art
2:8
Shahjahanabad 1:186–7; 2:6,
271; 3:384
Shahr-i Naw 2:3
Siri 2:3
textiles 3:324
tomb of Ghiyath al-Din
Tughluq 1:140; 2:9, *9*
tomb of Jahan Ara 3:343
tomb of Muhammad Shah
Sayyid 2:5
tomb of Safdar Jang 1:187
tombs 2:5; 3:342
Tughluqabad 2:3
Delitzsch, Friedrich 2:150
Demak
mosque 2:281, 439
De materia medica by
Dioscurides
(1083; Leiden, Bib. Rijksuniv.,
MS. Or. 289, Warn.)
2:197, 205, *205*
(1224; dispersed) 2:198, 210
(1228–9; Istanbul, Topkapı
Pal. Lib., A. 2127)
2:208; 3:123
(1239–40; Oxford, Bodleian
Lib., Cod. Or. Arab.
d. 138) 2:210
Demchinskaya, I. 3:273
Demetrius Cantemir, Prince of
Moldavia 2:420
demography 2:11–12
De Morgan, William 1:443,
474; 2:47, 118, 544
Demotte, Georges (J.) 2:12
Demotte *Shāhnāmā see*
Shāhnāma ("Book of
kings") by Firdawsi →
Great Mongol
Shāhnāma
Denike, Prof. B. P. 3:289
deodar (*Cedrus deodara*) 3:438
Deogiri *see* Daulatabad
Derman, Mustafa Uğur 2:13;
3:65
dervish cloisters 1:118, 143
Deschamps, Paul 2:397
Description of the stages of the
campaign of Sultan
Süleyman Khan in the
two Iraqs *see Majmuʿ-i*
menāzil ("Compendium
of stages")
Design Group 2:272
Despiau, Charles 1:266; 3:30,
340
Destan-i Ferruh u Hüma
("Legend of Farrukh
and Huma"; 1601;
Istanbul, U. Lib., MS.
T. 1975) 2:139
Dethier, Philipp Anton 2:323
Deutsch, Ludwig 3:69
Devagiri *see* Daulatabad
Deyhim, Sussan 3:51
D Group 1:279; 2:61; 3:30,
340, 361, 447, 451
Dhahran
Air Terminal 3:188

King Fahd University of
Petroleum and Minerals
3:188
Dhaka 2:13–14
Bangla Academy 1:265
Bangladesh College of Arts
and Crafts 1:6, 265
Institute of Fine Arts *see*
Bangladesh College of
Arts and Crafts
Folk Art Museum 2:14
Lalbagh Fort Museum 2:14
National Assembly Building
1:pl.X.1
National Art Gallery 1:265;
2:14
National Museum of
Bangladesh 1:264, 265;
2:14
Shaheed Minar 1:263
textiles 1:264; 3:318
Dhannu 2:14–15
Dharm Das 2:15, 428
Dhibin 1:155
Ḍhillī *see* Delhi
Dholpur
Lotus Garden 1:182; 2:96
Dhuʾl-Jibla 3:435
Diabate, Ismael 2:450
Diallo, Alpha Woualid 3:194
Diani
Kongo Mosque 1:67
Diarra, Guancha 2:*449*
Dib, Kenaan 2:418
Dib, Moussa 2:418
Diba, Kamran (Tabatabai) 2:15–
16, 286, 289; 3:274
Dieulafoy, Marcel Auguste
2:129
Diez, Ernst 2:16, 154
Diez, Heinrich Friedrich von
1:44; 2:216, 221
Diez Albums (Berlin, Staatsbib.
Preuss. Kulturbes.
Orientabt., MS Diez A
70) 2:*221*; 3:145, 283
Dig 2:97
Dih-i Naw 1:389
Dihistan
namāzgāh 1:93
Dilavar Khan Ghuri (r. c. 1401–5)
2:458
Dilmun *see* Bahrain
Dimand, Maurice S(ven) 2:16,
154; 3:34
Dimashq *see* Damascus
Dimitrijević, Braco 3:302
Dimitrijević, Vojo 1:302
Dinet, Alphonse-Etienne 1:49
Dino, Abidin 3:361
Dinpanah *see under* Delhi
Diocletian, Emperor (r. 283–
305) 3:157
Diop, Sheikh Marône 3:195
Dioscurides *see De materia*
medica
direction of prayer *see* qibla
Diren, Sadi 3:362
Dirʿiyah 3:406
Disclosure of secrets *see Kashf*
al-asrār
display of art *see* albums
Dispositions of lovers *see Ṣifāt*
al-ʿāshiqīn
Dīvān (collected poems) of
Ahmad Jalayir (c. 1400;
Washington, DC,

Freer, 32.29–37)
2:222; 3:241
Dīvān (collected poems) of
ʿAlishir Nava'i
(c. 1520s; Tashkent, Orient.
Inst. Lib., MS. 1995)
1:406
(1526–7; Paris, Bib. N., MS.
supp. turc 316–17)
2:239; 3:205
(c. 1615; ex-Rothschild priv.
col.) 2:244
Dīvān (collected poems) of
Anvari
(1515; London, V&A,
169–1923) 3:107
(1588; Cambridge, MA,
Sackler Mus.) 1:270;
2:259, 434; 3:46
Dīvān (collected poems) of Baqi
(1636; London, BL,
Add. MS. 7922) 3:21
Dīvān (collected poems) of Hafiz
(c. 1526 or 1531–3;
Cambridge, MA,
Sackler Mus.; New
York, Met.) 2:149, 200,
239; 3:205, 258
(c. 1590; Rampur, Raza Lib.)
[Farrukh Beg]
(c. 1605; London, BL, Or.
MS. 7573) 2:260
(1640; Istanbul, Topkapı Pal.
Lib., H. 1010) 3:19, 21
(c. 1650; Dublin, Chester
Beatty Lib., MS. 299)
2:19
(c. 1796; London, BL, Add.
MS. 7763) 2:264
Dīvān (collected poems) of
Husayn Bayqara
(c. 1500; dispersed)
3:108
Dīvān (collected poems) of
Khaqan/Fath ʿAli Shah
(Windsor Castle, Royal
Lib., Holmes 152)
2:248, 541; 3:132
Dīvān (collected poems) of
Khataʾi/Ismaʿil
(Washington, DC,
Sackler Gal., S 86.0060)
2:239
Dīvān (collected poems) of
Khwaju Kirmani
(1396; London, BL, Add. MS.
18113) 1:3, 251; 2:192,
214, 221, *222*, 305,
345, 364; 3:116
Dīvān (collected poems) of
Muhibbi/Süleyman I
(1565–6; Istanbul, Topkapı
Pal. Lib., R. 738) 3:86
(1566; Istanbul, U. Lib., T.
5647) 2:221, 370;
3:86
Dīvān (collected poems) of
Najm al-Din Hasan
Dihlavi (1602;
Baltimore, MD, Walters
A. Mus., W. 650)
2:260; 3:46
dīvānī see under scripts
dīvānī jalī see under scripts
divination bowls 3:248, *249*
Divriği 1:120; 2:17
carpets 2:387

Great Mosque 1:117; 2:17;
3:123, 432
hospital of Turan Malik 1:118;
2:17; 3:123
Kale Mosque 1:117; 2:17
stone-carving 1:195
Diyarbakır 2:17–18, 520
ceramics 1:463, 471, 473
congregational mosque 1:112,
113, 228; 2:17; 3:229
fountains 2:88
houses 2:174
Ibrahim Bey Mosque 1:142
Mesudiye Madrasa 1:115
mosque of Behram Pasha
1:161, 163
palace 1:115
sculpture 1:197
Seyr Matar Mosque 1:142
Zinciriye Madrasa 1:115
Djakovica 3:197
Hadim Mosque 3:197
Djalmulchanov, Garif 2:378
Djebel Amour 1:381
Djem, El 1:381; 3:357
Djemila
Museum 1:51
Djenné 1:22; 2:449
mosque 1:23, *23*; 2:449
textiles 2:449
Djerba 3:358
Djerma 3:52
DOBAG cooperatives 1:374
Doğançay, Burham 3:362
Doha
Amiri palace 3:136
Education City 3:136
House of Muhammad
Nasrullah 3:136
Ministry of Foreign Affairs
3:136
Ministry of Information and
Culture 3:136
Museum of Islamic Art 1:498;
3:36, 136
Qatar National Museum 3:136
Qatar University 3:136
Sheraton Hotel 3:136
ʿUthman ibn ʿAffan Mosque
1:191
Dolmabahçe *see* Istanbul
Domenico di Bartolo 1:361
domes 1:70, 94, 162; 2:18, 173,
552; 3:211
Domullo, Mullo Akhmad
2:391
Dong Qichang 1:484
Dong Son 2:278
doors 1:431; 2:18–19, 503;
3:259, *422*
Doria, Mojab 2:405
Doshi, Balkrishna V(ithaldas)
1:39; 2:19–20, 272,
pl.X.1
Dossari, Mojab 2:405
Douaihy, Saliba 2:418
doublures 1:296
Doucet, Jacques 2:500
Dougga 3:357
Doughty, Charles 3:189
Dourgnon, Marcel 1:330
Dowshantepe 2:285
Doxiades, Constantinos A. 2:15;
3:93
Doxiadis Associates 2:70, 309
Dragon carpets *see under* carpets
→ types

Dragulj, Emir **1**:302
Drake, Lindsay **3**:55
drawings **2**:20–21
Dresden
 synagogue **2**:545
dress **2:21–39**
 Afghanistan **1**:17
 Central Asia **1**:416–17
 Morocco **2**:29, *30*
 Turkey **1**:pl.XIV.4; **2**:23
 Uzbekistan **3**:pl.III.3
Dresser, Christopher **1**:443
Drew, Jane B. **2**:272; **3**:56
drinking-water dispensaries *see*
 sabîl-kuttâbs
Drissi, Moulay Ahmed **2**:546
Drljača, Lazar **1**:301
dromedary flasks **2**:111, pl.IV.2
Drubi, Hafid al- **2**:291
Druzba **1**:314
Dubai
 Creek **3**:373
 Dubai Museum *see* Al-Fahidi
 Fort
 Al-Fahidi Fort **3**:374
 houses **3**:373
 Jumayra Mosque **3**:374
 Shaykh Said's palace **3**:373
Dubal, I. **2**:426
Dublin
 Chester Beatty Library
 1:274–5
Dubois de Montpéreux **1**:434
Du Camp, Maxime **3**:70, 117
Dudin, S. M. **1**:432
Dugonjić, Tomislav **1**:302
Dukaginzade Gazi Mehmed
 Pasha **1**:163
Dumas, Alexandre **2**:118
Dunaysir *see* Kiziltepe
Dunhuang **1**:414; **3**:214
Duni **1**:314
Duque Cornejo, Pedro **1**:508
Dur
 shrine of Imam Dur **3**:26
Dura Europos **3**:262
 weapons **3**:217
Duran, Feyhaman **1**:229; **3**:361
Durand, E. L. **1**:253
Durdiev, Kakajan **3**:pl.XIII.2
Durdieva, Durli **3**:pl.XIII.2
Dürer, Albrecht **1**:7; **2**:259
Durra, Muhanna **2**:39, 362
Durrani, Saleem **3**:95
Durrani Pashtun **3**:279
Dur-Sharrukin *see* Khorsabad
Dushanbe **2**:39–40; **3**:267
 Donish Institute of History,
 Archaeology and
 Ethnography **2**:40
 embroidery **1**:417
 Republican Historical,
 Regional and Fine Arts
 Museum **2**:40
 Tajikistan Academy of Sciences
 2:40
Dushan Tepe **2**:92
Dust ʿAli Khan Nizam al-Dawla
 3:273
Dust Muhammad **1**:227, 497,
 504; **2:40**, 214, 220,
 239, 311, 344, 364
 album for Tahmasp **3**:163
 on ʿAbd al-Hayy **1**:3
 on Abu Musa **1**:36
 on Aqa Mirak **1**:63
 on Mir Musavvir **1**:63; **2**:537

on the *Shâhnâma* of Tahmasp I
 2:239
 pupils **3**:204
Dutch East India Company
 1:292, 476; **2**:279, 538
Duveen, Joseph **2**:12
Dvin **1**:434
 ceramics **1**:216
dyes/dyeing **2**:27, 386
 Africa **1**:25
 aniline **1**:371, 373
 Egypt **3**:295
 India **3**:322, 323
 Iran **3**:314
Dyson Perrins *Khamsa* **2**:64
Dyukov, Andrey Vladimirovich
 2:408
Dyula **1**:23
Džamonja, Dušan **1**:302
Dzhabguket **1**:479
Dzhambul *see* Zhambyl
Dzhanbas Kala **3**:412
Dzhumadurdy, Dzhuma **3**:366
Dzhyumabayev, Dzhambul **2**:408
earthenware *see under* ceramics
 → wares
easel painting *see* oil painting
East India Company **1**:376, 394,
 499; **2**:271, 279, 538,
 541; **3**:19, 33, 63
ebony (*Diospyros ebenum*) **3**:420,
 438
Ecluse, Charles d' **2**:86
Ecochard, Michel **2**:370, 406;
 3:93
Ecole de Dakar **3**:194
Ectabana *see* Hamadan
Eczacibasi Ceramic Factory
 3:362
Edessa *see* Urfa
Edhem, Osman Hamdi *see*
 Osman Hamdi
Edinburgh
 Empire Palace **2**:545
Edirne **2:41–2**; **3**:88, 382
 baths **1**:165
 bazaar **1**:146
 bookbindings **2**:42
 bridges **1**:306
 caravanserai of Ekmekçioğlu
 Ahmed Pasha **1**:165,
 355
 complex of Bayezid **1**:163;
 2:41, 401, 426; **3**:85
 Eski Cami **1**:145
 gardens **2**:94
 lacquer **2**:412
 manuscripts **2**:255
 mosque of Lari Çelebi **1**:163
 mosque of Murad II **1**:200,
 201, 292, 467; **3**:72
 mosques **1**:163
 Rüstem Pasha Han **1**:165
 Selimiye complex **2**:42
 Mosque **1**:164, *165*, 210;
 2:18, *42*, 533, 535;
 3:221
 textiles **3**:310
 Üç Şerefeli Mosque **1**:145,
 162, 212; **2**:41, 533,
 552, *552*
 Uzun Köprü **1**:146
 woodwork **2**:42
education *see* art education;
 architecture →
 education
Efendi, Bakkal Arif **3**:65

Efendi, Necmeddin *see* Okyay,
 Necmeddin
Efendi, Shaykh Ethem **3**:65
Eftaxias, Lambros **1**:276
Eger
 minaret **2**:177
eggshells **3**:235
Egli, Ernst **3**:360
eglomisé **2**:117
Egonu, Uzo **3**:57
Eğret Han **1**:119
Egypt **2:43–9**
 architecture **1**:84–5, 105–9,
 147–52, 170, 305;
 2:44–5; **3**:398–400
 art education **2**:46, 48
 bookbindings **2**:297
 carpets **1**:363–4, *364*
 cenotaphs **1**:385
 ceramics **1**:451, *451*, 453–4,
 453, 465–7; **2**:47
 city gates **1**:325
 coins **1**:490–94
 doors **2**:19; **3**:422
 embroidery **3**:295
 glass **2**:111, 112, 113, 114,
 114, *146*
 houses **1**:*324*; **3**:*399*
 ivory **2**:331, pl.XII.2
 iwans **3**:399
 jewelry **3**:354
 khanaqahs **2**:382
 madrasas **1**:108
 manuscripts **2**:*187*, 206, *211*,
 211–13
 mausolea **2**:45
 metalwork **2**:47, *456*, 486,
 501–5, *504*, 508,
 pl.V.3, XI.3; **3**:18
 mihrabs **1**:*109*
 minarets **1**:107, *234*
 mosques **1**:105–7, *106*, *107*,
 151, *191*, 332, pl.V.1,
 X.2
 muqarnas **1**:*109*; **3**:27
 museums and collections **2**:49
 painting **2**:46–7
 palaces **1**:105
 rock crystal **2**:pl.II.1; **3**:154
 stelae **3**:*233*
 stucco **1**:*109*
 tapestries **2**:48
 textiles **2**:47–8, pl.I.1; **3**:294–
 6, *296*, 305–7, *306*,
 338
 tombs **1**:107–8, *333*,
 3:pl.XII.1
 urban development **1**:105
 window grilles **3**:419
 woodwork **3**:420–23, *422*,
 430–31, pl.XVI.3
 see also Ayyubids; Fatimids;
 Mamluks; Nubia;
 Tulunids
Eidlitz, Leopold **2**:545
Eikonion *see* Konya
Ekmekçioğlu Ahmed Pasha
 2:42
Ekong, Afi **3**:59
Ekwere, Alex **3**:56
Ekweme, Alex **3**:56
Elamanov, Serami **2**:376
Elbacha, Amine **2**:418
Eldarov, O. G. **1**:240
Eldem, Halil Edhem **2**:49–50,
 323; **3**:35, 80, 360, 363
Eldem, Sedad Hakkı **1**:191, 352;
 2:50, 319, 322; **3**:67

Elderoğlu, Abidin **3**:362
Eleanor of Castile, Queen of
 England **1**:360, 498
Eleni **1**:314
elephant harnesses, trappings
 and armor **2**:137
Elgötz, Herman **2**:319
Elimburga **3**:6
Elizavetpol *see* Gandja
Eluru **1**:380
Elvira ware *see under* ceramics →
 wares
Emami, Karim **3**:182
Emar *see* Balis
emblems *see under* subject
 matter
embroidery
 Afghanistan **1**:18, pl.I.3
 Africa **2**:142
 Algeria **3**:313
 Azerbaijan **1**:246
 Bangladesh **1**:264
 Central Asia **1**:416–17, *417*
 Egypt **3**:295
 Greece **2**:128
 India **2**:274; **3**:323–5
 Iran **3**:316
 Iraq **3**:297
 Morocco **3**:*313*, 314
 Turkmenistan **3**:367
 Uzbekistan **1**:*417*
emeralds **2**:99
Emerson, William **1**:57
Emirgan
 Sabanci Museum **3**:363
Emlar, Selma **2**:329
Empain, Baron Edouard d'
 1:329; **2**:44
Emperor's Carpets **1**:366; **2**:149
Empire style **1**:167
enamel **2:50**, pl.I.2
enamel painting **1**:52; **2**:51
enameled ware *see* ceramics →
 wares → *lâjvardîna* ware;
 minâ'î
Enas, Mohd. Hoessein **2**:445
Enríquez, Alfonso **1**:360
Enugu **3**:57
Enwonwu, Ben **3**:57
Ephesos *see* Selçuk
Epics (1397; London, BL, Or.
 MS. 2780; Dublin,
 Chester Beatty Lib.,
 MS. P.114) **3**:207
Epigrafika vostoka **1**:433; **2**:154
epigraphy **3**:73–4, 245–6
 architecture **1**:76, 101, 109,
 210–12, *212*, 344;
 2:153, 395; **3**:120,
 pl.II.3
 ceramics **1**:442, 447; **3**:112
 coins **1**:492
 metalwork **2**:497, pl.V.3; **3**:73
 seals **3**:191–2
Epikman, Refik (Fazıl) **2**:52; 361
Epiphania *see* Hama
Epistles of the sincere brethren
 *see Rasâ'il ikhwân
 al-safâ'*
Erdmann, Kurt **1**:357; **2**:52,
 154; **3**:33
Eretna **2**:374
erica (*khalanj*) **3**:424
Erickson, Arthur **2**:312
Erivan
 palace of the Sardars **1**:241
Erk-kala *see* Merv

Ermenak **1:**141
 Ulu Cami **1:**142
Ermes, Ali Omar **2:52,** 422
Ernst, Rodolphe **3:**69
erotic art **2:**53
Erpenius, Thomas **3:**125
Ersari **1:**379, 420; **3:**367
Ershov, Igor Alexandrovich
 3:267
Ersovsky, Eduard Vladimirovich
 3:267
Erzincan **2:**491
Erzurum **1:**117, 141;
 2:53–4, 525
 Ahmediye Madrasa **1:**143
 caravanserais **1:**355
 Çifte Minareli Madrasa **1:**118,
 119, 143, 197; **2:**53, *53*
 tomb of Emir Saltuq **1:**118
 Yakutiye Madrasa **1:**143
Esa, Suleiman Haji **2:**445
Esad Yesari *see* Yesari, Esad
Escalada
 S. Miguel **3:**4; **2:**88
Esfahan *see* Isfahan
Eshqabad **3:**235
Esir *see* Ali Acemi
Eskikhahta **1:**460
Eski Krym *see* Staryy Krym
Eski Malatya **1:**84
 Ulu Cami **3:**76
Eskişehir
 Anadolu University **3:**362–3
Esmahan Gevher Sultan **2:**226
Esna **3:**400
Essaouira **2:**547
ethnography **2:**54–6
Ettinghausen, Richard **2:56–7,**
 154, 314; **3:**34, 36
Eumorfopoulos, George **1:**268;
 2:57
Eustache, M. **1:**193
Euting, Julius **3:**189
Evdir Han **1:**120
Evliya Çelebi **2:**129, 373; **3:**39,
 45, 201, 284
ewers **2:**482, *487, 493*
exhibitions of Islamic art
 1:438–40, 58–61
export regulations for works
 of art
 Bangladesh **1:**266
 India **2:**276
Eylatan **2:**73
Eyüboğlu, Bedri Rahmi **2:61;**
 3:361, 362
Eyüboğlu, Eren **2:**61
Eyüp *see* Istanbul
Eyvan *see* Iwan
Fabriano **3:**105
façades **1:**71
Fahd, King of Saudi Arabia
 (r. 1982–2005) (Saudi)
 3:188
Fahmi, Mustafa **2:**44, *45*
Fahmi al-Miʿmar, Mahmud **2:**44
Fahraj
 mosque **1:**82
Fahr al-Din ʿAli ibn al-Husayn
 see Sahib Ata Fakhr
 al-Din ʿAli
Faisalabad **3:**385
 Serena Hotel **3:**93
Faiyum **1:**148
 mosque of Princess Asal-bay
 1:212
Faiz, Faiz Ahmed **3:**94

Faizabad **3:**384
Faizullayer, R. **3:**387
Fakhr al-Dawla (r. 977–97)
 (Buyid) **2:**490; **3:**297
Fakhri of Bursa **3:**108
Falʿbov, Porphiriy Ivanovich
 3:267
Fālnāma ("Book of divination")
 2:201; **3:**248
 (c. 1550; dispersed) **2:**241,
 pl.VIII.1
 (early 17th century; Istanbul,
 Topkapi Pal. Lib., R.
 1703) **2:**255
fann waʾl-hurriyya, al- *see* Art
 and Freedom
Faraghan **1:**376, 377
Faraghan **1:**376, 377
Farahabad **2:**92
Farahani, Abdallah **3:**270, 450
Farahani, Iddi Abdallah **3:**270,
 450
Farah Pahlavi, Queen **2:**289;
 3:149, 275
Faraj (fl. 1005) **2:**332
Faraj, Sultan (r. 1399–1412)
 (Mamluk) **1:**152, 326;
 2:456
Faramarz ibn Khudadad Arrajani
 see Qissa-yi Shahr u
 Shatrān ("Story of Şahr
 and Şatran")
Farasan **3:**405
Farès, Bishr **2:63,** 154
Farghana *see* Ferghana
Farhad **1:**408; **2:**233; **3:**207
Farhad Khan Qaramanlu **2:**537
Farhat, Ammar **3:**356
Farhat, Safia **3:**356
Farid Bukhari, Shaykh **3:**384
Faridabad **3:**384
Faris al-Shidyaq **3:**127
Farnikat **1:**479
Farra, Muhammad **1:**191
Farroukh, Mustafa **2:**418
Farrukhabad **3:**384
Farrukh Beg **2:**15, **63–4,** 261;
 3:16
Farrukh Chela **2:**64, **64–5**
Farrukh Husayn *see* Farrukh
 Beg
Fars **2:**185
Farsi, Mohamed Said **3:**187, 188
Faryumad
 mosque **1:**129
Fās *see* Fez
fāsī see under scripts
Fatehpuri Begum **2:**6
Fatehpur Sikri **1:**183; **2:65–8,**
 271; **3:**384, pl.XV.1
 Buland Darvaza **1:**67
 carpets **1:**367
 gardens **2:**96
 Jamiʿ Masjid **2:**535
 mosques **3:**229
 palaces **2:**67; **3:**101
 sacred complex **2:**67
 textiles **3:**319
 tomb of Shaykh Salim Chisti
 1:209; **3:**343, *343*
 wall paintings **1:**206
Fateh Singh Rao III, Maharaja
 2:275
Fath ʿAli Shah (r. 1797–1834)
 (Qajar) **2:132**
 architecture **1:**177; **2:**299, 371
 468; **3:**218, 273
 bookbindings **3:**16, 191

ceramics **1:**477
 crown **3:**149
 dress **2:**36
 enamel **2:**51, 512
 enamel painting **1:**52, 266;
 2:51; **3:**19
 glass painting **2:**117
 manuscripts **2:**248
 oil painting **1:**3, 4, 8, 35; **2:**518,
 541; 63, 124, 191
Fathallah **2:**411
Fath ibn Khaqan, al- **2:**89
Fathnāma ("Book of conquests";
 Tashkent, Orient. Inst.
 Lib., MS. 5369) by
 Muhammad Shadi
 1:406; **2:**249
Fathy, Hassan **1:**28, 190, *191;*
 2:44, **69–70;** **3:**400,
 410, 417
Fatimids (r. 909–1171) **2:71**
 architecture **1:**101–2, *103,*
 105–9, *106, 107, 332*
 ceramics **1:**452, 453–4
 coins **1:**494
 dress **2:**26–7
 ivory **2:**pl.XII.2
 jewelry **2:**354
 manuscripts **2:**206
 rock crystal **2:**pl.II.1; **3:**154
 stucco **1:***109*
 textiles **3:**295, 337
 wall paintings **1:**204–5
 see also Mahdi, al-, caliph
 (r. 909–34); Qaʾim,
 al-, caliph (r. 934–46);
 Mansur, al-, caliph
 (r. 946–53); Muʿizz, al-,
 caliph (r. 953–75);
 Aziz, al-, caliph (r. 975–
 96); Hakim, al-, caliph
 (r. 996–1021); Zahir,
 al-, caliph (r. 1021–36);
 Mustansir, al-, caliph
 (r. 1036–94); Mustaʿli,
 al-, caliph (r. 1094–
 1101); Hafiz, al-, caliph
 (r. 1130–49)
Fatma Sultan **2:**255; **3:**311
Fatmev **1:**430
Fattah, Ismail **1:**251; **2:**72, 291
Fatullayev, N. **1:**242
Faxian **2:**373; **3:**214, 216
Faye, Mbor **3:**194
Faye, Mor **3:**194
Faye, Ousmane **3:**194
Faysal, King of Iraq (r. 1921–33)
 2:290
Faysal, King of Saudi Arabia
 (r. 1964–75) **2:**309
Fayyaz, Mohammad **3:**97
Fayyad, Najib **2:**418
Fayyumi ware *see under* ceramics
 → wares
Fazil Haravi **2:**91
Fazl **2:**264
Federal Society for Arts and
 Humanities **3:**59
Fehérvári, Géza **2:**72–3
Fellner, Ferdinand **1:**314
felt **1:**356; **3:**275, 279
Ferdinand II, King of Aragon
 and Sicily (r. 1479–
 1516) **2:**123
Ferdinand III, King of Castile
 and León (r. 1217–52)
 1:59

Ferdinando I de' Medici, Grand
 Duke of Tuscany
 3:393
Ferdinando II, Grand Duke of
 Tuscany **1:**365
Ferghana **1:**389, 391; **2:73;**
 3:386, 387
 ceramics **1:**421
 coins **1:**425
 cotton **1:**415, 416
 ikat **3:**317
Ferrara, Costanzo da *see*
 Costanzo da Ferrara
ferric oxide and ferrous oxide
 1:441
festival mosques *see musalla*s
Fez **1:**22; **2:373–5,** 520, 522,
 546; **3:**111, 376, 377,
 394
 Abuʾl-Hasan mosque **1:**158
 Andalusiyyin Mosque **1:**58,
 87; **2:**506; **3:**427, 429
 ʿAttarin Madrasa **1:**194,
 201, pl.III.4; **3:**237,
 429, *429*
 baths **1:**159
 Bu ʿInaniyya Madrasa **1:**158,
 201; **2:**432; **3:**429
 mosque color pl. XX?
 ceramics **1:**478; **2:**547
 city walls **1:**58
 congregational mosque (New
 Fez) **1:**158
 Dar Batha Museum **2:**548
 embroidery **2:**75
 Funduq al-Tattawiniyyin
 1:355
 Hamra Mosque **1:**158
 houses **1:**159
 jewelry **2:**357
 Lala al-Zhar Madrasa mosque
 1:158
 madrasas **1:**158; **2:**75
 market **3:**376
 minarets **2:**531
 minbar **2:**535
 mosque of ʿAbdallah **1:**189
 Qarawiyyin Mosque **1:**60, 87,
 125, 188; **2:**75, 305,
 506, pl.II.2; **3:**28,
 427, 429
 Sabaʿiyyin Madrasa **1:**158
 Sharratin Madrasa **1:**188
 Shrabliyin Madrasa mosque
 1:158
 storehouses **1:**159
 textiles **3:**300, 304, 313
 tombs **3:**344
 wedding garments **2:**305
 windows **1:**210
 woodwork **3:**425
Fichet, Alexandre **3:**356
Fichev, Nikola **1:**313
Fidai Khan Koka **1:**187
figural art **1:**195–8
Filāli *see* ʿAlawi
Filibe *see* Plovdiv
Fiñana **3:**300
Finch, William **1:**184
fingernail script *see under* scripts
Finster, Barbara **2:**155
Firdawsi **2:**108; **3:**169
 see also Shāhnāma ("Book of
 kings")
Firkovich, A. S. **1:**489
firmans **1:**350; **3:**352
First Group **1:**51

First Kennicott Bible (1476; Oxford, Bodleian Lib., Ken. MS. 1) **2:**207
First National Architectural style **3:**360, 391
Firuzabad (India) *see under* Delhi
Firuzabad (Iran) **3:**229
Firuzabadi **3:**25
Firuz Bey **1:**143
Firuzkuh *see* Jam
Firuz Shah, Sultan (*r.* 1351–88) (Tughluq) **2:**270; **3:**350
 architecture **1:**139; **2:**3, 345
 gardens **2:**96
 paintings **2:**235
 tents **3:**286
Fischer von Erlach, Johann Bernhard **1:**71; **2:**152
Fitzwilliam Album **1:**269
Five treasures *see Panj Ganj*
Fizuli **1:**238
flags **2:**75–6
Flame script *see under* scripts
Flandin, Eugène **1:**509; **2:**92, 153
flasks (tooth-shaped) **3:**154
Flaubert, Gustave **2:**117
flax **3:**105, 291, 294
floral carpets *see under* carpets → types
Florence
 Ospedale degli Innocenti **1:**71
Flower, Cyril, Baron Battersea *see* Battersea, Cyril Flower, Baron
flowers *see under* subject matter
Flury, Samuel **2:**154
Ford, Richard **2:**544
forgeries **1:**443; **2:**76–7, 193
Forskål, Petrus **3:**51
fortifications *see* architecture → types → military
fortresses **1:**41, 70
Fortuny Tablet **1:**469; **2:**437; **3:**48–9
Fortuny y Madrazo, Mariano **1:**469
Fortuny y Marsal, Mariano **3:**69
Fossati, Gaspare Trajano **1:**162; **2:**322, 324
Fossati, Giuseppe **1:**162, 324
Fougoumba
 mosque **1:**23
Foum al-Hassan **2:**547
fountain-houses *see sabil-kuttāb*s
fountains **1:***167;* **2:**77–9, *78*, 87–8, *457*
four-iwan mosques *see under* mosques → types
Fournez, Robert **1:**193
Fouta Djallon **3:**402
Fragrant breezes of friendship see Nafaḥāt al-uns
Francis I, Emperor of Austria (*r.* 1792–1835) **1:**52; **2:**343
Francis II, Holy Roman Emperor *see* Francis I, Emperor of Austria
Franz, Julius **2:**44; **3:**34
Frederick II, Holy Roman Emperor (*r.* 1220–50) **1:**103
Free Atelier (Kuwait) **2:**405
Free Atelier (Qatar) **3:**137
Freer, Charles Lang **1:**443; **2:**544

Freer Canteen **2:***310,* 482, 500
Fremlin Carpet **1:**368, *369*
Frère, Théodor **3:**70
Frick "Tree" Carpet **1:**368
Friends of the Arts Society (Iraq) **2:**290
Frith, Francis **1:**330; **3:**70, 117
fritware *see under* ceramics → wares
Frizzoni, J. **1:**57
Fromageau, Jean-Eugène **1:**52
Fromentin, Eugène **2:**46; **3:**69, 70, 117
frontispieces **1:**293; **2:**189
Frunze *see* Bishkek
Fry, E. Maxwell **2:**272; **3:**55
Fu'ad I (*r.* 1917–36) **1:**510
Fujayra **3:**373, 374
 museum **3:**374
Fukuoka
 Art Museum **1:**265
Fulani **2:**79–82, 130; **3:**52
 gourds **2:**80–81, pl.III.3
 houses **2:**pl.III.1
 mosques **1:**23
 textiles **2:**83, 449, pl.III.2
funduq **1:**353
fur **2:**26
furniture **2:**82–3, pl.IV.1
Furtun, Čandeğer **3:**362
Fustat *see under* Cairo
Fustat Fatimid *Sgraffito* ware *see under* ceramics → wares
Futaih, Faud al- **3:**445
Futūḥāt-i humāyūn ("Conquests of the emperor"; Paris, Bib. N., MS. supp. pers. 226) by Siyaqi-Nizam **2:**243
Fuzhou **3:**216
Gabae *see* Isfahan
Gabès **3:**300
Gabriel, Albert(-Louis) **2:**85, 153
Gabrovo **1:**315
Gadara **2:**363
Gaddafi, Colonel Muammar al- **2:**421
Gadzhibababekov, Kasym-bek 3
Gadzhinsky, M. G. **1:**238
Gafsa **1:**381; **2:**387; **3:**357
Gaitonde **2:**8
Galatalı, Atilla **3:**362
Galdieri, Eugenio **2:**155, 293
Galić, Risto **2:**426
Galićnik
 Museum **2:**427
Galimbayeva, Aisha **2:**377
Gallé, Emile **2:**115
Galle, Philip **2:**380
gall-nuts **1:**339; **2:**283
Galvini, Andrea **1:**27
Gama, Vasco da **3:**324
Gambar **1:**241
Gambier-Perry Wallet **2:**501
Gamble, Professor **1:**57
Gana, Ali **2:**422
Ğanad
 mosque **1:**111
Gandja **1:**239, 434; **2:**85–6
 Administrative Building **1:**239
 carpets **1:**375
 city gate **1:**90
 houses **1:**238
 jewelry **1:**245
 textiles **1:**245

Gani **3:**86
Ganj ʿAli Khan **1:**172, 272, 366; **2:**390
Ganzhou *see* Zhangye
Ganymede Silk **3:**298
Gao
 mosque–tomb of Askia-al-Hajj Muhammed **1:**22
garden buildings *see* kiosks
garden carpets *see under* carpets → types
gardens **1:**70, 133, 182, 187; **2:**78–9, 86–97, *90*, *93*, *97*
garnets **2:**99
Garrus **1:**319, 457
Garshāspnāma ("Book of Garshasp") by Asadi (1354; Istanbul, Topkapi Pal. Lib., H. 674) **2:**202, 217, 220
 (1573–4; London, BL, Or. MS. 12985) **3:**40, 160, 451
Gaudefroy-Demombynes, Maurice **2:**63
Gaudí, Antoni **1:**49
Gauguin, Paul **1:**331
Gaur **1:**137; **2:**98, 270, 529
Gawharshad (*d.* 1457) (Timurid) **3:**331–3
 architecture **1:**132; **2:**147, *147,* 467–8; **3:**137, *332*
Gawhar Sultan **2:**241
Gaykhatu, Sultan (*r.* 1291–5) (Ikhanid) **3:**125
Gazargah **1:**136
 shrine of ʿAbdallah Ansari **1:**133, 386; **2:**147, 148, 338; **3:**211
 Zarnigarkhana **1:**136
Gazzar, ʿAbd al-Hadi al- **1:**331; **2:**46
Gebze
 caravanserai of Çoban Mustafa **1:**165
 Çoban Mustafa Pasha Hamam **1:**272
 mosque **1:**163
Geddes, Patrick **2:**350
Gedi **1:**22; **2:**379; **3:**259
Gegello, Alexander I. **2:**376
Gehry, Frank **3:**374
Geiser, Jean **1:**49
Gemayel, César **2:**418
gem engraving **2:**98–9; **3:**191–2, *192*
General Directorate of Youth (Saudi Arabia) **3:**188
Geneva
 Bibliothèque Publique et Universitaire **3:**124
 Musée d'Art et d'Histoire **3:**124
Genghis Khan (*r.* 1206–27) **1:**392, 426; **2:**164; **3:**276
Geniza documents **1:**321; **2:**27–82, 361; **3:**293, 398
Gennadius, St. **3:**5
Gentil, Jean Baptiste **1:**499; **2:**359, 514
Gentile da Fabriano **3:**246
Geoffroy de Villehardouin **3:**121
George IV, King of England **2:**248, 541; **3:**132
geography **2:**99–105

Georgia *see* Caucasus
Gérôme, Jean-Léon **1:**40, 330; **2:**46; **3:**64, 69, 70, 80
Geurmaz, Abdulkader **1:**51
Gevaş
 tomb of Halime Hatun **1:**144
Geyf, El **3:**239
Gezer, Hüseyin **2:**105; **3:**362
Ghaban **1:**453
Ghadames **1:**22; **2:**422
Ghaffari, Abu'l-Hasan **2:**106, 248, 411, 5; **3:**64, 131, 133
Ghaffari, Abu'l-Hasan Mustawfi **2:**105–6, *106*
Ghaffari, Muhammad **2:**106–7; **2:**286; **3:**64, 131, 274
Ghani **2:**335, 538
Ghani, Muhammad **1:**251, 2
Ghardaia **1:**22, 49, 277
 carpets **1:**51
 mosque **1:**23
 Gharnāta *see* Granada
Ghassanid *see* Mundhir, al- (*r.* 569–82)
Ghassoub, Youssef **2:**418
Ghawri, al-, Sultan *see* Qansuh al-Ghawri
Ghayb Beg **1:**43, 44, 497
Ghaybi **1:**467; **2:**107
Ghaybun
 temple **1:**110
Ghayrat Khan **1:**186
Ghazali, al- **2:**312; **3:**75, 167
Ghazan, Sultan (*r.* 1295–1304) (Ilkhanid) **1:**128, 129, 291; **2:**184, 463; **3:**263, 283
Ghazanfar **2:**5
Ghazi, al- *see* Mahmud ibn al-Isfahani
Ghazi ibn ʿAbd al-Rahman al-Dimashqi **2:**212
Ghazna **1:**391; **2:**107–8, *108–9*
 cenotaph of Sebuktigin **1:**385
 ceramics **2:**109
 coins **1:**426
 metalwork **2:**491
 minaret of Bahramshah **1:**98, 100
 minaret of Masʿud III **1:**98, 99, *99;* **2:**108
 palace of Masʿud III **1:**99, 100, 101, 211; **2:**108
 sculpture **1:**197
Ghaznavids (*r.* 977–1186) **2:**108–9
 architecture **1:**97, *99,* 100; **2:**108–9
 ceramics **2:**109
 see also Mahmud of Ghazna (*r.* 998–1030); Masʿud I, Sultan (*r.* 1031–41); Shihab al-Dawla Mawdud, Sultan (*r.* 1041–50); ʿAbd al-Rashid, Sultan (*r.* 1050–53); Masʿud III, Sultan (*r.* 1099–1115); Bahramshah, Sultan (*r.* 1118–52); Ghiyath al-Din Muhammad ibn Sam (*r.* 1163–1203)
Ghilzai Pashtun **3:**278
Ghiordes *see* Gördes

Ghiyath **3:**315
Ghiyath al-Din (*fl. c.* 1300–35)
 2:144; **3:**264
Ghiyath al-Din (*fl.* 1419) **3:**335
Ghiyath al-Din al-Khashi **3:**27
Ghiyath al-Din Balban, Sultan
 (*r.* 1266–87) (Mu'izzi)
 2:3; **3:**23
Ghiyath al-Din Baysunghur *see*
 Baysunghur
Ghiyath al-Din Jami **1:**366
Ghiyath al-Din Jamshid al-Kashi
 3:244
Ghiyath al-Din Kaykhusraw I,
 Sultan (*r.* 1192–1210)
 (Saljuq) **2:**374
Ghiyath al-Din Kaykhusraw II,
 Sultan (*r.* 1237–46)
 (Saljuq) **2:**374, 391
Ghiyath al-Din Khalji (*r.* 1469–
 1500) **2:**236, 431
Ghiyath al-Din Muhammad
 (Kart) **1:**101;
 2:147, 47
Ghiyath al-Din Muhammad ibn
 Sam (*r.* 1163–1203)
 (Ghaznavid) **2:**110, 148
Ghiyath al-Din Tughluq, Sultan
 (*r.* 1320–25) (Tughluq)
 1:139; **2:**3, 9; **3:**350
Ghujdivan
 Ulughbeg Madrasa **1:**398
Ghulam **2:**110
Ghulam Husayn **3:**273
Ghulam Muhammad Warith
 1:350
Ghurids (*r. c.* 1030–1206) **2:**110
 see also Mu'izz al-Din
 Muhammad ibn Sam
 (*r.* 1203–6); 'Ala al-Din
 Muhammad, Prince
Gibb, H. A. R. **2:**129
Gibberd, Sir Frederick **1:**193
Gibraltar
 Calahorra **2:**522
Gibran, Gibran Khalil **2:**418
Gift of the noble *see Tuhfat*
 al-ahrār
Gilan manuscripts **2:***232*
gilding **1:**462; **2:**114
gilims *see* kilims
Gimond, Marcel **2:**105; **3:**30,
 340
Gingee **2:**529
Ginzburg, B. **1:**239
Ginzburg, Moisey **2:**376
Giovo, Paolo **2:**253
Girardet, Eugène-Alexandre
 3:69
Girault de Prangey, Joseph-
 Philibert **1:**122, 152,
 544; **3:**117
Giray *see* Mengli Giray I, Khan
 (*r.* 1466–1514)
Girdlers Carpet **1:**368
Girdoet, Anne-Louis **3:**69
Girona *Beatus* (975; Girona
 Cathedral, MS. 7) **3:**5, *5*
Giza
 Muhammad Naghi Museum
 2:49
Gjirokastër **1:**169
Gladzor **1:**215
Glaser, Eduard **3:**445
glass **2:**111–17
 materials and techniques
 cameo glass **2:**112, *112*

cutting **2:**112
 gilding **2:**114
 luster painting **2:**112
 regional traditions
 Azerbaijan **1:**243
 Central Asia **1:**427–8
 Egypt **2:***114, 115, 146*
 Iran **2:***112*, pl.v.3
 Iraq **2:***112*
 Syria **2:***114, 115*, pl.iv.2
 uses
 mosaics **1:**207
Glassie, Henry **2:**155
glass painting **2:**116–17;
 3:195
glazes **1:**421, 442, 447, 449
Gleyre, Charles **2:**46; **3:**69
Glob, Peter **1:**253
Glück, Heinrich **2:**154
glue **1:**296
goat hair **1:**356; **2:**386; **3:**275,
 276, 293, 315
Gobelins **1:**370
Godard, André **1:**92; **2:**117,
 154, 288, 364, 365;
 3:274
Godman, Frederick Ducane
 1:443, 499; **2:**117–18;
 3:544
Godunov, Boris **3:**327
Godwin, John **3:**55
Goetz, Hermann **2:**118, 275
Gohar carpet **1:**374
göl **1:**420
Golconda **2:**118–19, 270
 Chahar Gunbad **3:**344
 manuscripts **2:**266
 mausoleum of A'zam Khan
 Khayr Khan **3:**238
gold **1:**304; **2:**455, 503
 regional traditions
 Central Asia **1:**411
 India **2:**512–14
 Malaysia **2:**438
 Syria **2:***354*
 sumptuary prohibitions
 2:488
 uses
 bookbinding **1:**296
 ceramics **1:**462
 glass **2:**114
 ink **2:**284
Golden Horde (*r.* 1226–1502)
 1:434
Golden Horn ware *see under*
 ceramics → wares
Golius, Jacob **1:**499
Golombek, Lisa **2:**154
Golovachevka
 tomb of 'Aysha Bibi **1:**401
Golpayegan
 Friday Mosque **3:**25
Gombad-e Qabus *see* Gunbad-i
 Qabus
Gombroon *see* Bandar Khomeini
Gombroon ware *see under*
 ceramics → wares
Gómez Moreno, Manuel **2:**122
Gonzalez de Clavijo, Ruy **1:**132,
 397, 422
 on ceramics **1:**422, 463
 on garden palaces **1:**99; **3:**281
 on gardens **2:**91
 on glass **1:**428
 on Samarkand **1:**357; **3:**172
 on textiles **3:**307
Goodall, Frederick **3:**69, 70

Gördes **1:**363, 370, 371, 372, *372*
Gördes knots **1:**356
Gordon, General C. G. **3:**239
Gorée **3:**194
 Musée Historique d'Afrique
 Occidentale **3:**195
Gorgi, Abdelaziz **3:**356
Gorgi, Abdelkadir **3:**357
Gorgy, Habib **2:**47
Gorgy, Sophie Habib **2:**48
Gorodetsky, S. **1:**240
Goryacheva, V. **2:**399
Goslavsky, I. V. **1:**255
Goupil, Albert **1:**500; **2:**58; **3:**33
Goupil-Fesquet, Frédéric
 3:117
gourds **2:**80–81, pl.III.3
Goury, Jules **2:**152, 544
Govardhan (*c.* 1596–1640)
 2:119–120, 261
Govardhan (*c.* 1720–40) **2:**263
Grabar, Oleg **2:**120, 155
grain de riz **1:**422
Granada **2:**220–26, 522
 Alcázar Genil **1:**156; **2:**90;
 3:428
 Alhambra **1:**70, 124, 155;
 2:122–6, *123*, 522,
 544; **3:**99
 Alcazaba **2:**122, 436
 Bab al-Ghudur **1:**156, 157
 Bab al-Shari'a **1:**156, 157
 bath **1:**272
 capitals **1:**353
 Casita del Partal **1:**156
 ceilings **1:**226
 Comares Tower **1:**157
 Cuarto Dorado *see* Palacio
 de Comares
 fountains **2:**78, *78*
 gardens **2:**89, 90, *126*
 Hierro gate **1:**155
 Homenaje Tower **1:**156
 influence on Western archi-
 tecture **1:**72
 inscriptions **1:**212
 Mirador de Lindaraja **1:**210,
 257; **2:**388
 muqarnas **3:**28, *31*
 palace of Charles V **2:**125
 Palacio de Comares **1:**156,
 157, *157*, 226, 382;
 2:124–5; **3:**99, 428
 Palacio de los Leones **1:**156,
 157; **2:**12, 4–5; **3:**99,
 229
 Palacio del Partal **1:**196;
 3:428
 Patio de los Leones **1:**156,
 196; **2:**78, 78, 89, 91,
 124–5; **3:**9, 160, 428,
 453
 Puerta del Vino **1:**201
 Qubba Mayor (Dos
 Hermanas) **1:**156; **2:**125
 Qalahurra of Yusuf I
 (Cautiva Tower) **1:**157;
 2:124
 Qalahurra of Muhammad
 VII (Infantas Tower)
 1:157
 Riyad Palace *see* Palacio de
 los Leones
 Sala de los Reyes **1:**156, 157
 Torre de las Damas **1:**205
 Torre del Peinador **1:**156
 Vino gate **1:**155

Casa de Chapiz **3:**10
Casa Zafra **1:**156
 ceramics **1:**469; **2:**121–2
Cetti Merien Palace **3:**429
 city gates **1:**155
 coins **1:***495*
 Corral del Carbón
 1:156, 355
 Cuarto Real de S. Domingo
 1:156; **3:**428
 Dar al-Hurra Palace (convent
 of S. Isabel la Real) **1:**157
 Dar al-Manjara al-Kubra *see*
 Cuarto Real de
 S. Domingo
 Generalife **1:**155; **2:**88, 90,
 90; **3:**240, 428
 hermitage of S. Sebastian
 1:156
 Horno de Oro Street houses
 3:10
 House of the Bride **2:**90
 Maristán **1:**156, 157
 metalwork **2:**505
 Museo Nacional de Arte
 Hispanomusulmán **3:**34
 Salvador Church **1:**156
 S. Juan de los Reyes minaret
 1:156
 town walls **1:**156
 woodwork **3:**427
 Yusufiyya Madrasa (Casa del
 Cabildo Antigno)
 1:156
granaries **3:**396
Granjon, Robert **3:**125, 126
grape juice **1:**458
gravestones **1:**383; **2:**305 *see also*
 stelae
Gray, Basil **2:**127, 154
Gray, Gustave Le *see* Le
Greece **2:**127–8
green **1:**502, 503
Gregorian, Marcos **2:**286
Gregoriis, Gregorio de' **3:**125
Gromaire, Marcel **3:**340
Gropius, Walter **1:**191
Gros, Antoine-Jean **1:**153; **2:**68;
 3:321
Group 1890 **2:**273
Groupe Bogolan Kasobane **2:**449
Group of Ten **2:**61; **3:**362
Grube, Ernst J. **2:**128
Gsell, Stéphane **1:**59
Guadalajara **2:**584
Guadalupe
 monastery **3:**9
Guadix **2:**505
Guangzhou **3:**216
 Huaisheng si, Guang ta **1:**482,
 pl.III.3
Guergour **1:**381
guidebooks **2:**128–30
guilds **1:**330; **2:**321; **3:**310
Guillaumet, Gustave **3:**70
guilloche **3:**74
Guinea **3:**130
Guiragossian, Paul **2:**418,
 pl.XIV.2
Gujral, Satish **2:**8
Gujranwala **3:**95
Gujrat **3:**95
Gulbarga **1:**252; **2:**130–31, 529
 congregational mosque
 1:137, 140
 mausoleum of Firuz Shah
 Bahmani **3:**238

Gulbenkian, Calouste Sarkis
1:500
Gulbenkian fragment **1:**368
Gulgee, Ismail **1:131; 3:**93
Gulistān ("Rose-garden") by
Sa'di **2:**200
(1426–7; Dublin, Chester
Beatty Lib., Pers.
MS.119) (1486; A. &
Hist. Trust priv.col., on
loan to Sackler Gal.)
2:149, 200, 226; **3:**335
(1486; A. & Hist. Trust priv.
col., on loan to Sackler
Gal.) **1:**287; **2:**228;
3:336
(*c.* 1500; Cologny, Fond.
Martin Bodmer) **1:**407;
2:250
(*c.* 1525–30; dispersed) **2:**2
(1543; Paris, Bib. N., MS.
supp. pers. 1958)
(1567; London, BL, Or. **3:**203
MS.5302) **2:**260
(1581; London, Royal Asiat.
Soc., Pers. MS. 258)
2:459
(*c.* 1580–1600; Cincinnati,
OH, A. Mus.) **2:**15,
415
(*c.* 1619; Surrey, Keir priv.
col., III.387) **3:**152
(*c.* 1630s; Dublin, Chester
Beatty Lib., MS. 22)
2:261
Gulistan, Ibrahim **2:**289
Gulistan Dam **1:**135
Gulpayagan
congregational mosque **1:**92,
93, 95; **3:**229
Gulshan Album *see Muraqqa'-I
gulshan*
Gulyamova, Erkinoy **2:**39, 176;
3:190
gum arabic **1:**296
gum tragacanth **2:**283
Gunbad-i Qabus **1:**90, *90*, 91;
2:131; 3:25, 345
Güner, Güngör **3:**362
gunmetal **1:**304
guns **1:**222, 223, 224
Gupta, Samenendranath **1:**489
Gur *see* Firuzabad
Güran, Nazmi Ziya **1:**229;
2:132, 338; **3:**361
Gurganj *see* Kunya-Urgench
Guryev **2:**376, 378
Gutbrod, Rolf **2:**471
Gūy ū chawgān ("Ball and
bandy") by Arifi
(1524–5; St. Petersburg, Rus.
N. Lib., Dorn 441)
2:40, 239, 537; **3:**163
(1525; St. Petersburg, Acad.
Sci. Inst. Orient. Stud.,
D. 184) **3:**163
Güyük Khan **3:**276
Gvozdenović, Nedeljko **1:**258
Gwalior **2:**529
Man Mandir Palace **3:**413
Tomar palace **2:**184; **3:**100
Gyaur-Kala *see* Merv
gypsum **2:**173; **3:**235
Habib **1:**340
Habib, Hasan **3:**159
Habib Allah (*r.* 1901–19)
2:365

Habiballah (*fl. c.* 1570–1600)
2:244; **3:**164
Habiballah ibn 'Ali Baharjani
2:*457*
Habib al Siyār ("Beloved of
careers"; 1579; ex-
O. Homberg priv. col.,)
by Khwandamir **3:**159
Habuba Kabira **2:**262
Hacı bin Musa **1:**145; **2:**338
Hacılar **3:**363
Hacı Mengimberti **3:**432
Haddad, Salim **2:**418
Haddej **3:**355
Hadji Georgi **1:**315
Hadjibekov, N. **1:**239
Hadjiyev, E. **1:**241, 247
Hadramawt **2:**175
Hadrian, Emperor (*r.* 117–38)
2:41
Hadrumetum *see* Sousse
Hadyiyeva, B. **1:**242
Hadzhi-Abbas **1:**238
Hadžifejzović, Jusuf **1:**302
Hafid, Assim Abdul **2:**290
Hafid, Moustapha **2:**476
Hafiz **2:**165, 222; **3:**27, 207
Hafiz, al-, caliph (*r.* 1130–49)
(Fatimid) **2:**461
Hafiz, Farghali Abd al- **2:**47
Hafiz-i Abru **1:**131, 406
see also Majma' al- tawārikh
("Assembly of histories")
Hafiz Osman **1:**348, pl.XII.1;
2:133, 321; **3:**39
Hafshuya
mosque **1:**129
Hafsids (*r.* 1228–1574) **1:133–4**
architecture **1:**159, 160, *160*;
2:360
see also Abu Zakariya
(*r.* 1228–49);
Mustansir, al-, caliph
(*r.* 1249–77); Muntasir,
al- (*r.* 1434–5)
Haft awrang ("Seven thrones")
by Jami **2:**201
(1556–65; Washington, DC,
Freer, 46.12) **1:**63, 294,
501; **2:**201, 241, 541;
3:162, 204
(*c.* 1560; Copenhagen, Davids
Saml., MS. 53/1980)
2:*250*
Haft manzar ("Seven counte-
nances"; 1538;
Washington, DC, Freer,
56.14) by Hatifi **1:**406;
2:250; **3:**205
Haft paykar ("Seven portraits")
by Nizami **1:**503;
2:200; **3:**249
(15th century; New York,
Met., 13.228.13) **1:**349
(1475–82; Istanbul, Topkapı
Pal. Lib., H.762) **3:**204
Haider, Zulqarnain **3:**94
Haidra **3:**357
Ha'il **2:**527
Hajib Mas'ud ibn Ahmad
2:491
Haji Noor Deen Mi Guanjiang
1:485
Haji Mahmud **2:**237
Hajjaj, al- **2:**480; **3:**371
Hajjara **2:**175
Hajji' Abbas **1:**471; **2:**511, 512

Hajj Ibrahim ibn Mehmed,
al- **2:**94
Hajji Giray (*r. c.* 1426–66)
1:489
Hajji Muhammad **1:**56; **2:**228
Hajji Rashad ibn 'Ali al-Sini
1:485
Hajji Shuja' **1:**174
Hajj Isma'il **1:**422
Hajji Muhammad Bakhshi
Uyghur **3:**225
Hajj Muhammad ibn Mekhi
al-Mifoui, al- **2:**466
Hajj Yusuf ibn al-Ghawabi,
al- **2:**502
Hakam II, al- (*r.* 961–76)
(Umayyad) **3:**373
architecture **1:**122, 490, 507;
2:428, 550; **3:**4
artesonado **1:**315, 474–475
ivory **1:**506; **2:**332
manuscripts **1:**292, 506; **2:**207
minbars **2:**535
mosaics **1:**208
woodwork **3:**426
Hakim, al-, caliph
(*r.* 996–1021)
(Fatimid) **1:**106, *106*;
2:71; **3:**295, 421
Hakim 'Izz al-Din *see* Wazir
Khan
Hakman, Kosta **1:**302
Hala **3:**95
Halab *see* Aleppo
Halaward *see* Khelaverd
Halévy, Joseph **3:**445
*Hali: The International Journal of
Oriental Carpets and
Textiles* **2:**364
Halıcılar Köşkü
madrasa **1:**165
Halim, Halim 'Abd al- **1:**191,
192; **3:**216
Hallaj ibn Mansur, al- **2:**165
Halnāmā ("Book of ecstasy")
by 'Arifi
(1495–6; St. Petersburg, Rus.
N. Lib., Dorn 440)
2:190
(1603–4; Paris, Bib. N., MS.
Or. Smith-Lesonef 198)
2:260
Hama **1:**148; **2:134; 3:**261, *404*
Azam Palace **2:***135*
ceramics **1:**455, 466
glass **2:**111, 113
mosque **2:**550
minbar **3:**431
Hamadan **2:**487; **3:**216
Gunbad-i Alaviyyan **2:**516;
3:240
mausoleum of Esther and
Mordecai **3:**436
Hamadan carpets *see under*
carpets → types
Hamama **1:**381
Hamburg
Museum für Kunst und
Gewerbe **3:**201
Hamdallah Mustawfi Qazvini
3:138
Hamdi Bey *see* Osman Hamdi
Hamdullah, Şeyh **1:**348; **2:**134
pupils **3:**226
Hamengkubuwono I
(*r.* 1749–92) **2:**282
Hami **3:**214

Hamid **1:**185
Hamidi, Mohamed **2:**476
Hamidouch **2:**522
Hamilton, Elaine **3:**93
Hamilton, R. W. **2:**155, 383
Hamilton, Susan Euphemia,
Duchess of **1:**45
Hamilton, William **3:**363
Hammad, Mahmud **2:**237
Hammad ibn Buluggin
(*r.* 1014–28)
(Hammadid) **3:**133
Hammadid (*r.* 972–1152)
architecture **1:**102
see also Hammad ibn Buluggin
(*r.* 1014–28)
Hammam al-Sarakh **1:**76, 271;
2:363
Hammamet **2:**523
Villa Sebastian **3:**355
hammams *see* baths
Hammer-Purgstall, J. von
2:152
Hammuda Pasha **2:**366
Hammudid *see* Yahya I (*r.*
1021–36)
Hamoudi, Jamil **2:**291
Hamsah, T. R., & Yeang Sdn
Bhd **2:**442
Hamza al-Isfahani **2:**205
Hamza ibn Muhammad
al-'Alawi **3:**441
Hamza Mirza **3:**451
Hamzanāmā ("Tales of Hamza";
1558–73; dispersed)
1:5, 518; **2:**258, 344,
434, 540; **3:**13, 48, 272
Hanafis **2:**302, 307
Hanbalis **2:**302, 307
hand of Fatima (*Khamsa*) **2:**311,
357; **3:**248
Hangzhou
Fenghuang si **1:**484
Haqla
mosque **1:**155
Harakta **1:**381
Haranee *see* Qasr Kharana
Harappa
Museum **3:**97
Harari, Ralph (Andrew)
2:135–6
Harat *see* Herat
Harawi, al- **2:**129
hardstones *see* cornelian; lapis
lazuli; turquoise
Hardwick Hall **3:**324
Haribans **1:**136
Harim **2:**526
Hariri, al- *see Maqāmāt*
("Assemblies")
harnesses and trappings
2:136–8
Harput
tomb of Mansur Baba **1:**392
tomb of Şeyh Şeraff edin
1:392
Harran **1:138–9; 3:**120
congregational mosque **1:**112;
3:27
metalwork **2:**486
Harrania
Art Center **2:**45, 47
Habib Gorgy Sculpture
Museum **2:**49
Wissa Wassef Tapestry
Museum **1:**331; **2:**49
Harris, Peter **2:**445

Harrison, Austen St. Barbe
2:350
Harrison, J. E. K. 3:55
Harun al-Rashid, caliph
(r. 786–809) (Abbasid)
architecture 1:80; 3:138, 177
ceramics 1:446, 449
dress 3:26
paper 3:105
tents 3:282
Hasan (16th century) 3:226
Hasan, Sultan (r. 1354–61)
(Mamluk) 3:445
architecture 1:150, 151, 325,
334; 2:353, 432
glass 2:115
metalwork 2:502
Hasan, Nakkaş 2:139, 254
Hasan, Pirzada Najam ul- 3:94
Hasan, Zaki Muhammad
2:139, 154
Hasan, Qamrul 1:263
Hasan al-Quhadhi 3:391
Hasan Beg 1:173
Hasan Çelebi 1:36
Hasanefendić, Seid 1:302
Hasan ibn Husayn 1:385; 3:436
Hasan ibn Juban ibn Abdallah
al-Qunawi, al- 2:186
Hasan ibn Piruz 2:17
Hasan ibn Sulayman al-Isfahani
3:436
Hasankeyf
bridge 1:306
tomb of Zeynel Mirza
1:144
Hasan of Kashan 2:489
Hasan Pasha 3:181
Hasan Tihrani 2:288
Haseki Hürrem Sultan 2:308
Hashem Muhammad al-
Baghdadi 2:140, 290
Hashim 2:140–41, 261, 262
Hashimiyya, al- 1:79, 250
Hasmi, Salima 3:94
Hassan II, King of Morocco
(r. 1961–99) (Alawi)
1:42; 2:546
Hassan, Faik 2:72, 141,
290, 291
Hassan, Fatima 2:546
Hassan, Ijaz ul- 3:97
Hassani, Mahdi al- 2:522
Hassanudin, Sultan (r. 1629–69)
2:282
Hassanzadeh, Khosrow 2:287
Hassaût 1:414
Hastings, Warren 1:499; 2:361
Hatifi see Haft manzar; Khusraw
and Shirin; Tīmūrnāma
Hatra 2:292, 336
Hausa 1:141–3; 3:52
calligraphy 2:142
ceramics 2:143
houses 1:20, 224; 3:401
mosques 1:23
textiles 2:144
wall decoration 2:142–3
Hauteville see Roger II, King of
Sicily (r. 1130–54);
William I, King of
Sicily (r. 1154–66);
William II, King of
Sicily (r. 1166–89)
Havarrens
church 3:8
Havemeyer, Henry 1:500

Haven, F. C. von 3:51
Haydar (d. 1325/6) 1:346; 2:144
pupils 1:4
teacher 3:442
Haydar (d. 1488) 3:257
Haydarābād see Hyderabad
Haydar Raʾis 2:144, 253; 3:pl.
XI.3
Hayreddin 1:60, 2:145; 3:85
Hayreddin Pasha 1:145; 2:338
Hays 1:153; 3:445
khanaqah 1:154
Hazara
mosque 2:145
hazīra 1:133
headdresses 2:24, 26, 29, 30
Hebron 1:248
Haram al-Khalil Mosque 2:535
tomb of Ibrahim 2:306;
3:209, 341, 422
Hedwig beakers 2:114
Hedžić, Kemal 1:302
Heemskerck, Maarten van 2:380
Heeramaneck, Munchersa 2:145
Heeramaneck, Nasli M. 2:12,
145; 3:34
hegira 2:301
Hellmuth, Obata and
Kassabaum 3:152
Helmer, Hermann 1:314
Helmet of Boabdil 1:220
helmets 1:218, 220–21, 221,
424; 2:506
Helwan 2:45, 47
hematite 2:99
Henchir Souar 3:357
Henderson, John
Henderson Box 2:117
Henry II, Holy Roman Emperor
(r. 1002–24) 3:293
Henry II, King of Castile-León
(r. 1366–7; 1369–79)
1:307
heraldry 2:145–6
Herat 1:131, 400, 403, 2:146–8,
528; 3:381
architecture 1:136
bookbindings 2:297, 298
Bagh-i Jahanara 1:138
citadel 1:134
coins 1:426
Friday Mosque 1:97, 147;
2:551
Ghurid mausoleum 1:97,
100
metalwork 2:482
portal 1:100; 3:120
gardens 1:133–4; 2:91–2
ʿidgāh 3:32
Ikhlasiyya complex 1:132, 134
madrasa of Husayn Bayqara
1:134
manuscripts 1:44, 348, 349,
497; 2:149, 193, 194,
204, 223, 226, 227,
228, 229, 337
metalwork 2:148–9, 480, 491,
493, 497, 510
Musalla (Gawharshad's
complex) 1:133, 135;
3:333
tomb of Gawharshad 1:135;
2:147, 147; 3:77, 230,
344
textiles 2:149
Herati carpets see under carpets →
types

Hereke 1:216, 373; 3:310
Hergla
bridge 1:85
ribāṭ 1:85
Heriz carpets see under carpets →
types
Hermitage Album 2:245
Hermosilla, José de 2:152
Herodotus 2:24, 25
Herrera, Juan de 2:125
Herz, Max 2:44
Herzegovina see Bosnia and
Herzegovina
Herzfeld, Ernst (Emil) 1:204;
2:150, 153, 288, 292;
3:177, 183, 200
Hésperis 2:547
Hesychius 3:282
HIAA (Historians of Islamic Art
Association) 2:156
hijāzī see under scripts
Hijjas Kasturi Associates 2:441,
442
Hijrat al-Felle 1:155
Hilali 2:510
see also Ṣitāt al-ʿshiqīn
("Dispositions of
lovers")
Hillenbrand, Robert 2:151
Himalayan ash 3:438
Hindoo style see Moorish style
Hippo Regius 1:49
Hira 1:445, 447
Hira, al- 1:341
Hiraqla 1:80
Hisar-i Shadman 1:389
Hisham, caliph (r. 724–43)
(Umayyad; Syria)
1:196, 203; 3:148, 157
Hisham II, caliph (r. 976–1013)
(Umayyad; Spain)
2:207; 3:300
Hisn al-Akrād see Krak des
Chevaliers
Hispalis see Seville
Hispano-Moresque 1:155, 158
Hissar Fortress 1:433; 2:151;
3:267
Historical compendium see
Kulliyyāt-i tārīkhī
historiography 1:432–5; 2:151–6
History of Akbar see Akbarnāma
History of Babur see Baburnāma
History of the emperor see
Padshāhnāma
History of Jahangir see
Jahāngīrnāma
History of Genghis see
Chinghiznāma
History of the faithful imams see
Ahsān al-kibār
History of the house of Timur
see Tārīkh-i Khāndān-i
Tīmūriyya
History of the world-adorning
see Tārīkh-i jahānārā
History of the world conqueror
see Tārīkh-i jahāngūshā
History of Timur see Tīmūrnāma
Hodges, William 2:544
Hofmann, Hans 1:383; 2:391;
3:340, 361
Högg, Hans 2:320
Ho Kwong Yew & Sons 2:442
Holbein, Hans, the younger
1:361

Holbein carpets see under carpets
→ types
Hollein, Hans 2:289
Holliday, A. Clifford 2:350
Hollmann, Ottmar 3:188
holm-oak 3:420
Holzmeister, Clemens 2:322;
3:360
Homberg, Octave 1:500
Hommaire de Hell, Xavier 2:153
Homs 1:148; 2:532; 3:261
honeycomb vaulting see
muqarnas
hookahs 2:116
Hopwood, Gillian 3:55
Hormuz 3:315
Horovitz, Josef 2:154
horror vacui 3:78, 239
horse harnesses, trappings and
armor 2:136–7
horseshoe arches 1:61, 87, 100
Hoṣap Kale 2:525
Hosios Loukas 3:246
hospices for Sufis see khanaqahs;
zāwiyas
hospitals 1:69, 115, pl.VI.2
Houghton, Arthur A., jr 1:498
Houmt Souk museum 3:357
House of Saudi Arts 3:188
houses 2:171–5
regional traditions
Afghanistan 1:16
Africa 1:22, 23–4, 24;
2:pl.III.1; 3:401–2
Albania 1:43
Azerbaijan 1:239
Bulgaria 1:314
Central Asia 1:118;
3:412
Egypt 1:324; 3:399–
400, 400
India 3:413–14
Iran 1:83; 3:410
Iraq 1:80–81; 3:403–4
Kuwait 2:405
Malaysia 2:440–41
Morocco 1:87; 3:394–5
Saudi Arabia 3:187,
405–6
Syria 3:403–4
Tunisia 3:397–8, 398
Turkey 3:408–9
Turkmenistan 3:366
Yemen 3:407–8, 408,
445
types
Albanian tower 1:43
courtyard 2:171–2,
171, 172, 174
longhouses 2:441
Ottoman house
3:408–9, pl.XII.3
tower 2:175; 3:405,
406, 445
see also architecture → types →
vernacular
Houshiary, Shirazeh 2:170–71
Hovaida, ʿAbbas 2:289
howdahs 2:137
Hoyeck, Youssef 2:418
Hozić, Arfan 1:302
Hozo, Dževad 1:302
Huart, Clément 2:58
Hubaydah 3:405
hubble-bubbles see hookahs
Hubbock, A. B. 2:441
Huber, Charles 3:189

Hudaydah, al- **3**:407, 444
Hudid *see* Abu Jaʿfar Ahmad ibn
 Sulayman al-Muqtadir
 bi-Ilah (r. 1049–82)
Huelva
 La Rábida **3**:9
Hufuf, Al- **2**:527; **3**:187, 406
Hugh IV of Lusignan, King of
 Cyprus and Jerusalem
 (r. 1324–59) **2**:502
Hugo, Victor **2**:544
Hulagu, Khan (r. 1256–65)
 (Ilkhanid) **1**:128; **2**:462
Hulbuk **1**:205, 405, 428, 429,
 433; **2**:176–7
Hülegü **3**:276, 283
Hulusi, Mehmed **3**:89
Humann, Carl **3**:183
Humartash **1**:92
Humay and Humayun (c. 1426–
 32; Vienna, Österreich.
 Nbib., N.F. 382) by
 Khwarju Kirmani
 2:226; **3**:335
Humayun, Emperor (r. 1530–
 40; 1555–6) (Mughal)
 2:270; **3**:11, **12–13**
 architecture **1**:40, 182; **2**:5;
 3:384
 coins **1**:425
 dress **2**:38
 manuscripts and miniature
 paintings **1**:4, 293;
 2:40, 258, 538, 540;
 3:11
 tents **3**:286
 tomb **1**:183, *184*; **2**:10, 96,
 389; **3**:344
Humayūnnāma by Ali Çelebi
 (1566–7; Istanbul, Topkapı
 Pal. Lib., H. 359)
 2:213, 255
 (1588–9; London, BL, Add.
 MS. 15153) **2**:255
Hunain, Georges **1**:226
Hunarnāma ("Book of achieve-
 ments"; 1588; Istanbul,
 Topkapı Pal. Lib.,
 H.1523 and H. 1524)
 by Lokman **2**:253, *253*,
 pl.VII.4; **3**:83, 87, 284,
 285
Hunayn ibn Ishaq al-ʿIbadi *see*
 *Kitāb al-
 ʿashrmaqālātfiʾl-ʿayn*
 ("Book of the ten dis-
 courses on the eye")
Hungary **2**:177
Hunt, William Holman **2**:46;
 3:69
Hunt Carpet **3**:162
Huocheng
 tomb of Tughluq Temür **1**:484
Hürrem **2**:348; **3**:86, 219
Husain, Maqbool Fida **2**:8, **178**,
 273
Husayn **1**:478
Husayn I, Shah (r. 1694–1722)
 (Safavid) **1**:173, 231,
 385; **2**:293; **3**:161
Husayn ʿAli *see* ʿAli
 (fl. c. 1800–20)
Husayn Bayqara, Sultan *see*
 Sultan Husayn Bayqara
Husayn Beg **1**:44, 374, 497
Husayni, Mansur Negargar
 2:287

Husayn ibn ʿAli **2**:489
Husayn ibn Jawhar **3**:154
Husayn ibn Muhammad al-
 Mawsili **2**:499, 501,
 505
Husayn ibn Salama **3**:477
Husayn ibn Talib al-Damghani
 1:67, 291
Husayn Pasha Fahmy **1**:190
Husayn Shah (r. 1458–79)
 (Sharqi) **1**:138; **2**:345
Huseinoghly, Akhad Keble
 Kerbalai **1**:244
Huseinov, G. U. **1**:243
Huseinzade, Alibek **1**:244
Hushang Shah Ghuri, Sultan
 (r. 1405–35) **2**:458;
 3:100
Husrefbey, Gazi **3**:182
Hussah Sabah al-Salem al-Sabah
 1:498; **2**:406
Hussain, Imtiaz **3**:94
Hussain, Iqbal **3**:93, 94
Hussain, M. F. **1**:39
Hussain, Taha **2**:47
Hussein, Ibrahim **2**:445
Hussein, Muhie al-Din **2**:47
Hussein, Saddam **1**:251; **2**:72,
 290, 435
huts **3**:401
Huy
 Notre-Dame **1**:438
Huyot, Jean-Nicolas **1**:509
Hyat, Fazal **3**:97
Hyderabad **1**:380; **2**:179, 514
 Salar Jung Museum **2**:275
 State Museum **2**:275
hypocausts **1**:272
hypostyle mosques *see under*
 mosques → types
Ibadan **3**:56, 57
 West African College **3**:55
Ibb **1**:153
 Asadiyya Madrasa **1**:153
 madrasas **1**:154
 mosque of Malhuki **1**:153
Ibler, Drago **2**:426
Ibn ʿAbbad **2**:490
Ibn Abi-ʿAmir *see* Mansur, al-,
 vizier
Ibn ʿAdabbas **3**:198
Ibn al-Athir **2**:490
Ibn al-Bawwab **1**:212, 251, 293,
 320, 346, 496, 504;
 2:76, **181**, 186
Ibn al-Durayhim *see Manāfi
 al-hayawān* ("Usefulness
 of animals")
Ibn al-Fuwati **2**:214
Ibn al-Jayyab **2**:124
Ibn al-Khatib **2**:124, 126, 129
Ibn al-Muqaffaʿ *see Kalila and
 Dimna*
Ibn al-Razzaz al-Jazari **1**:228
Ibn al-Suyufi **1**:150
Ibn al-Wahid **1**:347; **2**:455
Ibn al-Zayn *see* Muhammad
 ibn
Ibn al-Zubayr **2**:354
Ibn ʿArabshah **1**:132; **2**:223
Ibn ʿAsakir **1**:513
Ibn ʿAziz **1**:205
Ibn Babawayah **1**:67
Ibn Bakhtishu *see Manāfiʿ
 al-hayawān* ("Usefulness
 of animals")
Ibn Bassal **2**:89

Ibn Battuta **1**:129; **3**:211
 on architecture in Iran **1**:129
 on Cairo **2**:454
 on carpets **1**:360
 on Kufa **2**:100
 on masks in Africa **1**:21
 on metalwork **2**:480
 on Mogadishu **3**:402
 on Multan **3**:350
 on Selçuk **3**:193
 on tents **3**:286
 on textiles **3**:307
Ibn Butlan *see Daʿwat al-aṭibbāʾ*
 ("Banquet of the
 physicians")
Ibn Daniyal **3**:201
Ibn Duqmāq **1**:109
Ibn Ghanim al-Maqdisi *see Kashf
 al-asrār* ("Disclosure of
 secrets")
Ibn Ghaybi **2**:107
Ibn Hajji Muhammad ʿAli
 1:350
Ibn Hamdis **1**:196
Ibn Hanbal **2**:302
Ibn Hawqal **1**:129; **3**:235
Ibn Husam *see Khāvarānnāma*
Ibn Ilyas **2**:274
Ibni Neccar **3**:432
Ibn Jajarmi *see Muʾnis al-aḥrur*
Ibn Jubayr **2**:432, 461, 471,
 472; **3**:76
Ibn Khaldun **1**:148; **2**:104, 462;
 3:149
Ibn Kilis **3**:338
Ibn Luyun **2**:90, 91
Ibn Mardanish **2**:90
Ibn Muqla **1**:212, 337, 346,
 496, 504; **2**:76, 181
Ibn Saʿid **1**:506; **2**:485
Ibn Yazid **1**:270; **2**:487
Ibn Zafar al-Siqilli *see Sulwān
 al-muṭāʿ* ("Prescription
 for pleasure")
Ibn Zamrak **2**:125, 126
Ibn Zaydun **2**:89
Ibrahim (fl. 13th century)
 2:223, 226
Ibrahim (r. 1550–80) (Qutb
 Shahi) **2**:118; **3**:141
Ibrahim, Sultan (d. 1100)
 (Ghaznavid) **1**:212
Ibrahim, Sultan (r. 1640–48)
 2:329; **3**:38
Ibrahim II (r. 875–902)
 (Aghlabid) **1**:29;
 2:366
Ibrahim II ʿAdil Shah (r. 1579–
 1627) **1**:11, **12**, 289;
 2:265
Ibrahim, Abdel Halim **2**:45
Ibrahim, Farouk **2**:47
Ibrahim, L. A. **2**:155
Ibrahim, Master **2**:325
Ibrahim Ağa Müstahfizan **1**:150,
 327
Ibrahim b. Ghanaʾim **2**:453
Ibrahim ibn al-Aghlab
 (r. 800–12) (Aghlabid)
 1:29; **2**:366
Ibrahim ibn Jami **3**:423
Ibrahim ibn Mawaliya **2**:498
Ibrahim ibn Muhammad ibn
 al-Raqqam **2**:505
Ibrahim Khalil, Khan (r. 1759–
 1806) **3**:212
Ibrahim Khan **3**:390

Ibrahim Mirza, Prince (Safavid)
 1:63, 504; **2**:201, 241;
 3:163, 204
Ibrahim Müteferrika **2**:181, 256
Ibrahimov, U. **3**:45
Ibrahim Pasha **2**:95, **181–2**,
 328, 474; **3**:35
Ibrahim Sharbatchizade **1**:348
Ibrahim Sultan, Prince (Timurid)
 3:207
 architecture **1**:4
 manuscripts **2**:188, 227
Ibrulj, Mustafa **1**:302
Iconium *see* Konya
iconoclasm **1**:182–3
 see also aniconism
iconography *see* subject matter
ʿidgāhs *see musallas*
Idris I (r. 789–93) **2**:73, 183;
 3:426
Idris II (r. 793–828) (Idrisid)
 2:74, 183; **3**:426
Idrisi, al- **1**:360; **2**:129
Idrisids (r. 789–926) **2**:73
 see also Idris I (r. 789–93);
 Idris II (r. 793–828)
Idubor, Felix **3**:59
Ife **3**:58
 museum **3**:58
Ifrīqiya *see* Tunisia
Ij **2**:338
Ijebu-Ode **3**:53, 54
ikat **2**:447; **3**:302, *303*, 316,
 pl.III.3
Ikeja-Lagos
 West African Airways
 Corporation building
 3:56
Ikramov, Iskandr **3**:388
Ilchester Carpet **1**:368
Ildefonsus *see Treatise on the
 Virginity of Mary*
Ilgin
 bath **1**:272
 complex of Lala Mustafa Pasha
 1:165
Ilʾin, Lev **1**:237
Ilʾina, Lidiya Alexandrovna
 2:408
Ilkhanids (r. 1256–1353)
 2:164–5, **184–5**
 architecture **1**:128, *130*,
 pl.VI.3; **2**:184; **3**:*263*
 manuscripts **2**:183, 194,
 214–15
 stucco **1**:*195*
 see also Hulagu, Khan
 (r. 1256–65); Abaqa,
 Khan (r. 1265–82);
 Gaykhatu, Khan
 (r. 1291–5); Ghazan,
 Sultan (r. 1295–1304);
 Uljaytu, Sultan
 (r. 1304–17); Abu
 Saʿid, Khan
 (r. 1317–35)
illuminaton *see* manuscript
 illumination
illustration *see* manuscript
 illustration and minia-
 ture painting
Ilorin **3**:56
Iltutmish, Sultan (r. 1211–36)
 (Muʿizzi) **1**:137; **2**:2, 8;
 3:23
ʿImad al-Din Mahmud Shirvani
 2:371

'Imad al-Din Zangi (r. 1127–46)
 2:114; 3:1
'Imad al-Hasani see Mir 'Imad
Imam, 'Ali 3:46, 93, 97
Imami, Javad al- 2:269
Imami, Muhammad al-Husayni
 al- 2:269
Imami, Mustafa al- 2:269
Imami, Nasrullah 2:269
Imami, Riza 2:269
imams 2:160
imarets 1:69, 143
Imperial Archaeological
 Commission 1:147
Impey, Elijah 1:499
Impressionists, the 2:291
Imprimerie Royale 3:126
incense burners 2:481, pl.XV.3
Incesu
 complex of Kara Mustafa
 Pasha 1:165
Incir Han 1:198
Incirköy 2:116
Index Islamicus 2:284
India 1:391; 2:269–76
 albums 1:44–5; 2:261; 3:2–3
 arches 1:67
 architecture 1:83, 97–101,
 137–40, 182–7;
 2:272–3
 military 2:529–30
 vernacular 3:413–14
 bookbindings 1:299
 caravanserais 1:187
 carpets 1:360, 367–9, 369,
 380
 chess sets 1:481
 coins 1:494–6
 columns 1:504
 cotton 3:318–19, 322–3
 dress 2:37–9
 elephant harnesses, trappings
 and armor 2:137
 embroidery 2:274; 3:323–5
 enamel 2:51
 gardens 1:182, 187; 2:95–7,
 97
 houses 3:413–14
 jewelry 2:358–60
 kiosks 2:389
 manuscripts and miniature
 paintings 1:5, 5, 11, 12,
 44–5, 270, pl.IX.1;
 2:234–7, 235, 257–67,
 259, 262, 263,
 pl.VIII.2; 3:277
 metalwork 2:512–14
 minarets 2:2
 mirrors 2:538–9
 mosques 1:38, 83, 137–9,
 138, 183, 186, 289;
 2:414
 museums and collections
 2:274–5
 painting 2:283, pl.X.2; 3:65
 palaces 3:99, 100
 pavilions 2:11
 stucco 3:pl.VII
 tents 3:277, 286–7
 textiles 2:274; 3:317–25
 tombs 1:31, 33, 139, 184;
 pl.II.1; 2:4, 9; 3:14,
 343
 urban development 3:384–5
 weapons 1:223–4
 woodwork 3:438–9
 wool 3:320–21

see also 'Adil Shahis; Bahmanis;
 Barid Shahis;
 Ghaznavids; Ghurids;
 Lodis; Khaljis; Mughals;
 Mu'izzi; Nizam Shahis;
 Qutb Shahis; Sayyids;
 Surs; Tughluqs
Indian Treasures Act (ITA) 2:276
Indian yellow 2:193
indigo 1:25, 419; 3:295, 302,
 314, 319
Indonesia 2:276–83
 architecture 2:281
 manuscripts 2:283
 mosques 2:280, 281
 textiles 2:283
 urban planning 2:281–2
Indo-Saracenic style see Moorish
 style
Inegöl
 mosque of Ishak Pasha 2:402
influence of Chinese art on
 Islamic art
 ceramics 1:422, 441, 442,
 449, 451, 463–4,
 466–7
 drawings 2:57
 metalwork 1:409, 410
influence of Islamic art on
 the West 1:71–7;
 2:543–5
influence of Western art on
 Islamic art 1:268; 2:65,
 238, 258
Ingres, Jean-Auguste-Dominique
 3:69
Injuid (r. c. 1303–57) 2:217–18;
 3:207
 see also Jamal al-Din Abu Ishaq
 (r. 1343–54)
ink 1:339; 2:283–4
inkwells 1:481; 2:509
inlays 2:481; 3:433
Innovationist group 2:291
inns see caravanserais
inscriptions see epigraphy
Intégral 2:476
interior decoration 1:243–4,
 302, 315
International Association for the
 Exploration of Central
 Asia 1:432
International Congress on
 Persian Art and
 Archaeology 1:439
International Style 3:55
Ioannes 3:5
Ioannina 2:128, 396–7
Ipoh 2:442
 municipal building 2:441
 Paloh Mosque 2:439
Iqbal, Khalid 3:93
'Iqd al-jumān ("Necklace of
 pearls"; 1747–8;
 Istanbul, Topkapı Pal.
 Lib., B. 274) by 'Ayni
 2:256
Iradat Khan 1:184
Iram 3:66
Iran 2:284–9
 aqueducts 1:173, 174
 architects 1:174
 architecture 1:81–3, 88–96,
 128–35, 171–5, 306;
 2:285–6
 military 2:521, 528
 vernacular 3:410, 411

armor 1:222–3
astrolabes 1:231
banknotes 1:266
bookbindings 1:297, 298
brick 1:90, 94, 135
bridges 1:173
calligraphy 1:319–20, 344,
 pl.XII.3; 2:290,
 pl.XIV.1; 3:3
caravanserais 1:83, 129, 174,
 354
carpets 1:365–7, 376–8, 377,
 378, pl.XIV.1, pl.XIV.2;
 2:287–8, pl.IV.3
cenotaphs 1:385
ceramics 1:8, 443, 448–50,
 451, 456–60, 458,
 462–4, 464, 474–8,
 475, 476, pl.XIV.2,
 pl.XV, pl.XVI.3
chess sets 1:482
coins 1:490, 494
domes 1:94
dress 2:34–7
embroidery 3:316
enamel 1:51
gardens 2:87, 91–3, 93
glass 2:111, 112, 112, 116,
 pl.V.2
glass painting 2:117
historiography 1:435
houses 1:83; 3:410
ivory 2:335
iwans 1:71; 2:336–7
jade 2:pl.XIII.3
jewelry 2:355, 356
lacquer 2:288, 411–12, 412
lithography 2:248–9
madrasas 1:93, 133; 2:431
manuscripts 1:pl.XI; 2:188,
 192, 194, 200, 203,
 214–18, 216, 217, 218,
 219–23, 221, 223–30,
 224, 227, 231–3, 232,
 237–46, 245, 248–9,
 305, pl.VI.1, pl.VIII.1,
 pl.IX, pl.XIV.1; 3:111,
 113, pl.IV, pl.VIII.2,
 pl.VIII.3
maqsuras 2:462
mausolea 1:130
metalwork 1:319; 2:487–90,
 487, 489, 490, 491–8,
 495, 496, 509–12, 509,
 512, pl.XV.3
mihrabs 1:195
minarets 1:90, 94
mosques 1:81–2, 89, 92–4,
 95, 129, 132, 176;
 2:296, 297, 337, 372,
 551
muqarnas 1:2, 91, 95, 130,
 135, pl.VI.3
museums and collections
 2:288
painting 1:pl.VIII.1; 2:106,
 286–7; 3:63–4, pl.I.1,
 pl.I.3
palaces 1:90, 1; 2:44, 299;
 3:101, pl.VI.2
photography 3:117, 120
pishtaqs 1:91, 95; 3:120, 332
plaster 1:136
sculpture 2:pl.XI.1
seals 3:192
shrines 1:94; 3:50
silk 3:319

stucco 1:90, 96, 97, 137, 175,
 195; 3:179, 237
tents 1:129; 3:286
terracotta 1:96
textiles 1:319; 3:297–9, 299,
 307–8, 314–16, pl.XI.2
tiles 1:88, 96, 131, 135, 136,
 199–201, 385, pl.I.1,
 pl.VII.2, pl.XV,
 pl.XVI.3; 3:74, 266
thrones 3:pl.VIII.1
tombs 1:89–90, 90, 94, 130;
 3:344, 344, 345
urban development 3:380–82
wind catchers 3:175
woodwork 3:424, 425, 435–8,
 436, 437
see also Aqqoyunlu; Buyids;
 Ilkhanids; Muzaffarids;
 Qajars; Qaraqoyunlu;
 Safavids; Saljuqs;
 Samanids; Timurids;
 Zands
Iran: Journal of the British
 Institute of Persian
 Studies 2:478
Irani, Askari Mian 3:94
Iranian Calligraphers Association
 2:287
Iranian Carpet Company 2:288
Iraq 2:289–92
 architecture 1:78, 79–81, 169;
 2:289–90; 3:403–5
 astrolabes 1:230
 calligraphy 1:2, 347, pl.XII.2;
 2:395; 3:441, pl.II.1
 ceramics 1:2, 445–8, 447,
 pl.XVI.2
 enamel 2:pl.I.2
 enamel painting 1:52
 glass 2:112
 houses 1:80–81; 2:171, 172;
 3:403–4
 iwans 1:80
 jewelry 2:355
 madrasas 1:115, 251
 manuscripts 1:26, 162, 187,
 207–10, 209, 210;
 214–18, 219–23, 222,
 231–3; 3:283
 metalwork 2:310, 487, 487,
 498–501
 minarets 1:113; 2:531
 mosques 1:81, 112–13, 113
 muqarnas 3:26
 painting 2:290–91, 291
 palaces 1:2, 115–16
 pishtaqs 3:120
 shrines 1:115
 tents 3:283
 textiles 3:297–9, 339
 woodwork 3:420–23
 see also Abbasids; Buyids;
 Ilkhanids; Jalayarids;
 Qaraqoyunlu; Saljuqs;
 Zangids
Irbid
 Yarmouk University 2:363
Irbil 3:394
Irbil
 Yarmouk University 2:363
Irbil 3:394
Irevani, Mirza Kadym 1:241,
 246
iron 1:216
iron-gall ink 2:284
iron oxide 2:284
Irving, Washington 2:544
Isaac Moheb ben Ephraim
 1:508

Isabella, Queen of Castile and León **2:**123
Isabeyev, Isataj **2:**377
Isahāni *see* Isfahani
ʿIsa ibn ʿAli **3:**369
Isa ibn Ismaʿil al-Aqsaraʾi *see Nihāyat al-suʾl waʾl-umniyya*
ʿIsa ibn Muhammad ibn Aydin (r. 1360–90) **3:**193
ʿIsa ibn Musa (Abbasid) **3:**369
Isar **3:**353
Iş Bankası **3:**363
Isfahan **1:**92, 171–2; **2:**292–9, *294*, 521; **3:**111, 164, 381, *381*
ʿAli Qapu Palace **1:**174, 257; **2:**298; **3:**100
capitals **1:**353
columns **3:**436, *437*
Music Room **1:**174, *175*; **2:**83; **3:**283
portico **3:**436
Allahvardi Bridge **1:**206
Bazaar **2:**298
bridges **1:**173, 306
calligraphy **1:**344
carpets **1:**366, 367, 376; **2:**288; **3:**162, 163
caravanserai **1:**355
ceramics **1:**292
Chihil Sutun Palace **1:**171, 174, 206, 210, 257; **2:**298, *299*, 389; **3:**100, 161
capitals **1:**353
muqarnas **3:**27
murals **1:**pl.VIII.1; **2:**35; **3:**63, 124
porticos **3:**436
window grilles **3:**438
churches **1:**172
Darb-i Imam Mausoleum **1:**135, 136, 200
Darb-i Kushk **1:**135
enamel **2:**51
Friday Mosque (Masjid-i Jumʿa) **1:**82, 89, 90, 92, 93, 94, 95, 319; **2:**295, *296*, 303, 551
domes **1:**94
inscriptions **1:**212
maqsura **2:**462
mihrab **1:**195; **2:**516; **3:**237, *237*
minbar **3:**435
muqarnas **3:**25, 27
north dome **1:**94, 306
qibla iwan **1:**171, 212
south iwan **1:**174
squinches **3:**229
vaults **1:**306
gardens **2:**91
glass **2:**116
Hakim Mosque portal *see* Jurjir Mosque portal
Harun-i Vilayat **1:**171
Hasht Bihisht **1:**134, 172, 173; **2:**86, 299, 389; **3:**100, 101, *101*, 436
house of Petros Valijanian **1:**174
Imamzada Baba Qasim **1:**131
Imamzada Jaʿfar **1:**130
Imamzada Zayd **1:**174–5, 206
Jurjir Mosque portal **1:**90, 91, 319; **3:**120, 123

lacquer **2:**411
Khwaju Bridge **1:**173, *173*, 306
Madar-i Shah Madrasa **2:**431, 433
Madrasa Imami **1:**130
Madrasa-yi Madar-i Shah **1:**173
manuscripts **2:**243–5, *245*, 245–6, 295, pl. VII.3
Masjid-i ʿAli **1:**171, 174
Masjid-i shāh *see* Shah Mosque
Maydān-i shāh *see* Royal Maidan
metalwork **2:**487, 511, 512
minarets **1:**90, 94
Mosque of Imam Khomeini *see* Shah Mosque
Mosque of Shaykh Lutfallah **1:**200, 210, 212, pl.VII.2; **2:**297, 311; **3:**27, 419
museum **2:**289
Muzaffarid madrasa **2:**433
New Julfa **1:**216; **2:**299
Qutbiyya Mosque **1:**171
Royal Maidan **1:**172, *172*; **2:**296; **3:**161, 164
Shah Mosque **2:**297, *297*, 311, 551; **3:**121, 240
Sharistan bridge **1:**307
Talar-i Ashraf **1:**173
textiles **2:**295; **3:**315, 316
tomb of Shaykh Abu Masʿud **1:**135
woodwork **3:**424
Isfahani, Ahmad **2:**300, 411
Isfahani, Aqa Baba **2:**300
Isfahani, Haydar ʿAli **2:**300, 301
Isfahani, Jaʿfar **2:**300, 411
Isfahani, Muhammad Ismaʿil **2:**300–01, 411
Isfahani, Muhammad Kazim **2:**300, 411
Isfahani, Najaf ʿAli Isfahani **1:**54; **2:**300, 411
Isfandiyaroğlu Ismail Bey **3:**121
Isfara **1:**431; **3:**266, 267, 268
Isfijab **1:**415
Ishakovic-Hranušić, Gazi Ishakbey **3:**182
Ishaq, Kamala Ibrahim **3:**254
Ishbiliya *see* Seville
ʿIsh Muhammad **2:**249
ʿIshratabad palace **1:**177
Isimila **3:**271
Isʿird *see* Siirt
Iskandar Mawz **3:**447
Iskandar Munshi **2:**92; **3:**40, 204, 225
Iskandar Sultan, Prince (d. c. 1415) (Timurid) **3:**333
manuscripts **2:**198, 201, 224; **3:**207
Iskandarnāma ("Book of Alexander") by Ahmadi (1416; Paris, Bib. N., MS. supp. turc 309) **2:**202, 233
(c. 1467; Istanbul, U. Lib., T. 6044) **2:**213
Iskenderun **3:**284
Iskodar **1:**91, 431; **3:**424
Islam **2:**301–9
Kharijites **2:**76, 160, 302, 516; **3:**193, 396

Ismaʿilis **2:**162, 302; **3:**167
Muʿtazilism **2:**302
Shiʿites **2:**76, 160, 302, 306, 531; **3:**110, 161, 167, 209, 211, 240
Sufis **2:**165, 302, 321, 382; **3:**167, 241
Sunnis **1:**391; **2:**160, 302, 431; **3:**110
Twelver Shiʿites **2:**167, 302
Islam, Aminul **1:**263
Islam, Mazharul **1:**263
Islamabad **2:**309
Folk Heritage Museum **2:**309; **3:**97
Frontier House **3:**92
Housing and House Building Finance Corporation **3:**92
Islamabad Museum **2:**309
King Faisal Mosque **1:**191
National Art Gallery **1:**29; **2:**309; **3:**97
National Assembly **3:**93
Pakistan Institute for Nuclear Science and Technology **3:**93
Pakistan National Council of Arts **1:**265; **3:**97
Presidency **3:**93
Secretariat **3:**93
Sherazad Hotel **3:**93
University **3:**93
Islamic Art **2:**128, 156, 363
Islamic art (definition) **2:**310–13
Islam Shah Sur, Sultan (r. 1545–53) **3:**384
Ismaʿil, Khedive (r. 1863–79) **1:**328, 329; **2:**44; **3:**34
Ismaʿil I (r. 892–907) (Samanid) **1:**310
Ismaʿil I, Shah (r. 1501–24) (Safavid)
architecture **1:**171
gardens **2:**92
manuscripts and paintings **1:**287; **2:**238
tents **3:**283
Ismaʿil I, Sultan (r. 1313–25) (Nasrid) **1:**156; **2:**123, 124; **3:**48
Ismaʿil II, Shah (r. 1576–7) (Safavid) **2:**243, 540; **3:**17, 205, 225
Ismaʿil III, Shah (Safavid) **1:**495
Ismaʿil, Adham **2:**262
Ismail, Namık **1:**229; **3:**361, 451
Ismaʿil ʿAdil Shah (r. 1510–34) (ʿAdil Shahi) **2:**235
Ismaʿil Ghalib **1:**498
Ismaʿil ibn Ward al-Mawsili **2:**498
Ismaʿilis *see under* Islam
Ismaʿil Jalayir **2:**313; **3:**17, 64, pl.I.1
Ismailov, I. **3:**45
Ismaʿil Zühdü Efendi **3:**39
Ismailova, Gulfairus **2:**377
Ismaʿiliya **2:**45
Ismailov, Aubakir **2:**377
Ismailov, E. **1:**239; **2:**86
Ismat al-Dunja **2:**228, 385
Ismaylov, K. **1:**238
Isparta **1:**371; **3:**362
Israel **2:**314, 551; **1:**pl.IV.2
see also Palestine

Issiakhem, Mʾhamed **1:**50; **2:**315
Issız Han **1:**146
Istakhr **1:**457; **3:**229
Istakhri, al- **3:**24
Istalif **1:**18
Istanbul **1:**190; **2:**315–30, *316*; **3:**111, *383*
Academy of Fine Arts *see* Imperial Academy of Fine Arts
Academy of Fine Arts for Women **3:**362
Artillery School **3:**361
Atik Valide complex **1:**165
Atmeydani Palace **1:**166
Ayasofya Mosque *see* Hagia Sophia
Barbaros Hayreddin Pasha (Çinili) Hamam **1:**272
bath of Haseki Sultan (Ayasofya Hammami) **1:**165
baths **1:**271
Bebek mosque **1:**168
Beylerbeyi Palace **1:**167
Blue Mosque *see* mosque of Sultan Ahmed
bookbindings **1:**299
carpets **1:**360, 364, 372, 373, **3:**83
Central Post Office **1:**168; **3:**392
ceramics **1:**473; **2:**182
Christ the Savior in Chora **3:**363
College of Civil Engineering **2:**322; **3:**362
coins **1:**495
complex of Ahmed I **2:**402
complex of Ahmed Pasha **2:**402
complex of Bayezid II **1:**163; **2:**402, 462
complex of Hürrem Sultan **1:**163
complex of Mihrişah Sultan **1:**167
Dolmabahçe Mosque **1:**167, *260*; **2:**535
Dolmabahçe Palace **1:**167; **2:***318*; **3:**100, 231
Fatih complex (Mehmed II's complex) **2:**401, 420
Fatih Mosque (Mehmed II's mosque) **1:**163, 468; **2:**324, 462
Firuz Ağa Mosque **1:**163
fortifications **2:**524
Fountain of Ahmed III **1:***167*; **2:**78
Fourth Vakif Han **1:**168
gardens **2:**94
Grand Bazaar **2:**330
Great Palace **1:**77
Hagia Sophia **2:**323–4; 552; **3:**231, 363
Hamidiye Mosque **1:**167
Haseki Sultan (Ayasofya) Hamam **1:**272, *273*
Haydarpasa barracks **1:**166
Hilton Hotel **3:**360
houses **3:**408–9, pl.XII.3
Imperial Academy of Fine Arts **1:**162; **2:**322; **3:**80, 362
Imperial College of Military Engineering **1:**162

Islamic Museum *see* Museum of
Turkish and Islamic Art
Kara Ahmad Pasha Mosque
1:163
Kiliç Ali Pasha complex **1**:165,
210
Laleli complex **2**:402
Laleli Mosque **1**:167
Land Registry Building **1**:168
manuscripts **2**:251
madrasa of Rüstem Pasha
1:162
mausoleum of Eyüp Ensari
3:209
Mehmediye complex *see* Fatih
complex
Mehmed V's tomb and ele-
mentary school **1**:168
metalwork **2**:506, 507, *507*
Military Academy **3**:362
mosque of Abdülmecid **1**:167
mosque of Bali Pasha **1**:163
mosque of Bezmialem Valide
Sultan **1**:167
mosque of Hadım Ibrahim
Pasha **1**:163
mosque of Hürrem Sultan
1:163
mosque of Ivaz Efendi **1**:163
mosque of Mehmed Fatih *see*
Fatih Mosque
mosque of Mihrimah Sultan
(Edirnekapi; *c.* 1565)
1:164, 165; **3**:219
mosque of Mihrimah Sultan
(Iskele Mosque)
(Üsküdar; 1548) **1**:163,
165; **3**:219
mosque of Nişancı Mehmed
Pasha **1**:164
mosque of Piyale Pasha **3**:pl.
III.1
mosque of Rüstem Pasha
1:162, 164, 200; **2**:517;
3:219, *221*
mosque of Sultan Ahmed
(Blue Mosque) **1**:164
210; **2**:325–6, 533;
3:123, 231
Museum of Painting and
Sculpture **2**:323;
3:363
Museum of Turkish and
Islamic Art **2**:323;
3:35, 363
Nuruosmaniye Mosque
1:167; **2**:402
Nusretiye complex **2**:402
Nusretiye Mosque **1**:167
Ortaköy Mosque **1**:190
papercuts **3**:*108*
photography **3**:199
Public Debts Administration
building **3**:360
Ramazan Efendi Mosque
1:162
Research Center of Islamic
History, Art and
Culture (IRCICA)
2:323; **3**:362
Sadberk Hanım Museum
3:35, 363
Sakıp Sabancı Museum **3**:35
School of Civil Engineering
1:162
Şehzade Mehmed Mosque
1:163; **3**:219, *220*, 433

Sirkeci railway terminal **1**:167;
3:360
Social Security Complex **3**:360
Sokollu Mehmed Pasha com-
plex **1**:163, 164, 165,
200; **2**:517; **3**:219–20,
220, 221, 226
State School of Applied Arts
3:322; **3**:362
Süleymaniye Complex **2**:325,
403; **3**:219, 382
bath **1**:165
cenotaphs **3**:pl.XII.1
fountain **2**:306
minbar **3**:433
Süleymaniye Mosque **1**:162,
163, *164*, 210, 472,
472; 552; **3**:27, 121,
229, 433
Takkeci Ibrahim Ağa Mosque
1:163
Tercümen Newspaper Offices
3:360
Topkapı Palace **1**:70, 166;
2:323, 326–30, *327*;
3:100, 123
Archaeological Museum
3:363
Baghdad Kiosk **1**:162,
166, *166*, 210; **2**:389;
3:*83*, 434
Çinili Kiosk **1**:135, 166,
468; **2**:*321*, 323, 389;
3:*99*, 363
Circumcision Room **1**:166,
472; **2**:304
doors **2**:18
Fountain of Ahmed III
1:167
Hagia Eirene **3**:363
Hırka-i Saadet Dairesi **3**:209
Imperial Ottoman Museum
3:34, 363
kiosks **2**:389
kitchens **1**:162
Library **2**:193
Museum of the Ancient
Orient **3**:363
Museum of Turkish
Ceramics **3**:363
pavilion of Osman III
1:166
porcelain **1**:292, 486
Revan Kiosk **1**:166; **2**:389;
3:434
rock crystal **3**:156
Sunnet Odasi **1**:200
textiles **3**:310
University **3**:363
Üsküdar baths **1**:165
Vakıflar Carpet Museum
2:323; **3**:35, 363
Vakıflar Kilim and Flat-Woven
Rug Museum **2**:323;
3:35, 363
Vank Cathedral **1**:488
Yeni Valide Mosque
1:164, 210
Yıldız Technical College **3**:362
walls **3**:382
Zal Mahmud Pasha Mosque
(Eyüp) **1**:163
Istituto Italiano per il Medio ed
Estremo Oriente
(IsMEO) **2**:286, 293
ITA *see* Indian Treasures Act
Italica **3**:197

Italy
ivory **2**:334–5, *335*
metalwork **3**:392–3
printing **3**:125
textiles **3**:308, 311
see also Sicily
I'timad al-Dawla **2**:413
Ivanitsky, A. **1**:255
Ivanov, Anatoly Alekseevich
2:330
Ivanov, Gennady **2**:378
ivans *see* iwans
Iveković, Vanek and Círil **1**:301
ivory **2**:331–5
regional traditions
Central Asia **1**:429; **2**:335
Egypt **2**:331–2, pl.XII.2
Iran **2**:335
Italy and Sicily **2**:334–5, *335*
Spain **1**:506, *507*;
2:332–4, *333*
Syria **2**:331
Tunisia **2**:334
Turkey **2**:335
Yemen **2**:331
uses
chess pieces **1**:481; **2**:331
oliphants **2**:334
pyxides **2**:331, 332
iwans **2**:71, 80–81; **2**:336–8,
551–2; **3**:120, 399
iwan tombs *see under* tombs →
types
Ixa, Rissa **3**:348
'Iyar-i danish ("Book of fables";
c. 1590–95; Dublin,
Chester Beatty Lib.)
1:61, 282; **2**:14; **3**:353
İyem, Nuri **2**:338; **3**:362
Iz, Mahir **2**:13
Izer, Zeki Faik **3**:361
Izgirli **2**:489
Izmaylov, K. **1**:255
Izmir **3**:310, 362
Ege University **3**:363
Izmit
mosque **1**:163
Iznik **1**:141; **2**:338–9
ceramics **1**:281, 292, 441, 442,
443, 468, 470, 471, *471*,
472, *472*, 473, *473*,
pl.XIII.2; **2**:339; **3**:*83*
Green Mosque **1**:145; **2**:533
Hacı Hamza Hamamı
1:272
mosque of Haci Özbek **2**:552
mosque of Orhan Gazi **1**:145;
2:401
tiles **1**:162, 199, 200; **2**:*473*,
537; **3**:pl.XIII.1
Iznik red **1**:472
'Izz al-Dawla (*r.* 966–78)
(Buyid) **2**:490
'Izz al-Din ibn Taj al-Din
Isfahani **1**:412
'Izz al-Din Kayka'us, Sultan
(*r.* 1210–19) (Saljuq)
1:118, 120; **2**:392;
3:224
'Izz al-Din Mahmud **1**:8
İzzet Efendi *see* Mustafa Izzet
Jabal Adda **3**:305, 307
Jabal Bani Malik **3**:405
Jabal Barat **3**:408
Jabal Fayfa' **3**:405
Jabal Says **1**:76; **3**:98
Jabatan Kerja Raya **2**:441

Jabra, Jabra I. **2**:291
Jabri, Ali **2**:363
Jabrin **3**:66
Jachmund, A. **1**:167; **2**:319;
3:360
Jacob, Samuel Swinton **1**:57
Jacobsen, Arne **2**:405
Jacquemart, Jules **2**:58
jade **1**:217, 439; **2**:341–3,
pl.XIII.3, 538
Jader, Khalid al- **2**:291
Ja'far (*r.* 997–1019) **1**:103
Ja'far (*fl.* 1412–31) **1**:4, 349;
2:149, 343–344, 537;
3:335
Ja'far (*fl.* 18th century) **3**:63,
448
Ja'far 'Ali Khan **2**:359
Ja'far ibn Muhammad ibn 'Ali
2:pl.XV.3
Jaffer, Wahab **3**:94, 97, 109
Jagan **2**:344, 428
Jagjivan **2**:428
Jahan Ara **1**:187
Jahangir, Emperor (*r.* 1605–27)
(Mughal) **1**:368;
3:13–14
albums **1**:44; **2**:536; **3**:3, *3*
architecture **1**:184–5; **2**:67,
413; **3**:384
coins **1**:496
dress **2**:38
gardens **1**:56; **2**:96–7; **3**:230
jade **2**:341, 342
manuscripts and miniature
paintings **1**:295, 504;
2:193, 230, 260–61;
3:111
'Abd al-Samad **1**:4
'Abid **1**:6
Abu'l-Hasan **1**:7, 8
Anant **1**:61
Aqa Riza **1**:64
Bichitr **1**:285; **2**:pl.VIII.2
Bihzad **1**:287
Bishan Das **1**:290
Dharm Das **2**:15
Farrukh Beg **2**:63
Ghulam **2**:110
Govardhan **2**:119
Haribans **2**:136
Kesu Das **2**:380
Manohar **2**:460
Mansur **2**:460
Muhammad 'Ali (i) **3**:15
Nanha **3**:46
mirrors **2**:538
tents **3**:286
textiles **3**:317, 319
wall paintings **1**:206
Jahangir, Sir Cowasji **2**:275
Jahangirnagar **2**:13
Jahāngīrnāma ("History of
Jahangir"; dispersed)
1:7, 290; **3**:46
Jahanpanah *see under* Delhi
Jahanshah (*r.* 1438–67)
(Qaraqoyunlu) **3**:133
Jahiz, al- **1**:8
Jahiz, al- *see Kitāb al-ḥayawān*
("Book of animals")
Jain, Om Prakash **2**:8
Jaipur **1**:187
carpets **1**:368
enamel **2**:51, 360
Government Central Museum
2:275

Maharaja Sawai Man Singh II
 Museum 2:275
Jaisalmer 2:529; 3:413
Jai Singh II, Maharaja 1:187
Jakarta
 Istiqlal Mosque 2:281
 Kampung Improvement
 Program 2:282
 Soekarno-Hatta airport
 2:281
Jalal 1:348
Jalal, Shahid 3:94, 97
Jalal al-Din Firuz (r. 1290–96)
 (Khalji) 2:3
Jalal al-Din Rumi 2:233; 3:167
Jalali, Bahman 2:287
Jalayarids (r. 1336–1432)
 2:344–5
 manuscripts 2:220–22, 222
 see also Ahmad Jalayir (r.
 1382–1410); Uways I
 (r. 1356–74)
Jalonke 2:130
Jam
 minaret 1:98, 100, 101, 199;
 2:110, 532
Jamal 1:348; 2:418
Jamal, Ather 3:94
Jamal, Syed Ahmad
 2:444, 445
Jamal Abdullah 1:23
Jamal al-Din ibn ʿAbdallah al-
 Mawsuli Yaqut
 al-Mustaʿsimi see Yaqut
 al-Mustaʿsimi
Jamal al-Din Abu Ishaq
 (r. 1343–54)
 (Injuid) 3:441
Jami 2:165; 3:336
 see also Bāharistān ("Spring
 garden"); Haft awrang
 ("Seven thrones");
 Nafahāt al-uns
 ("Fragrant breezes of
 friendship"); Panj Ganj
 ("Five treasures");
 Silsilat al-zahab ("Chain
 of gold"); Tuhfat
 al-ahrār ("Gift of the
 noble"); Yūsuf and
 Zulaykhā
Jāmiʿ al-tawārīkh
 ("Compendium of
 histories") by Rashid
 al-Din 2:184, 214;
 3:144
 (1315; Edinburgh, U. Lib.,
 Arab. MS. 20; London,
 N. D. Khalili priv. col.)
 2:83, 137, 204, 216;
 3:145, 264, 265
 (1317; Istanbul, Topkapı Pal.
 Lib., H. 1654) 2:222;
 3:123, 145, 264
 (c. 1330; Berlin, Staatsbib.
 Preuss. Kultbes.,
 Orientabt., Diez A, fol.
 70, S. 22) 2:216
 (c. 1430; Paris, Bib. N., MS.
 supp. pers. 1113)
 2:204; 3:276, 382
 (1596; Geneva, Prince
 Sadruddin Aga Khan
 priv. col.; Tehran,
 Gulistan Pal. Lib.) see
 Chinghiznāma
 ("History of Genghis")

jāmis see mosques
Jamshoro 3:96
Janbalat, Sultan (r. 1500–01)
 (Mamluk) 2:526
janissaries 2:166
Jannabi see Javāhir al-gharʾib
 ("Jewels of curiosities")
Jansen, Hermann 3:360
Jaqmaq, Sultan (r. 1438–53)
 (Mamluk) 1:212
Jarūnnāma (1623; London, BL,
 Add. MS. 7801) by
 Qadri 2:204
Jaspar, Ernest 2:44
jasper 2:99
Játiva 3:105
Jaunpur 1:137; 2:270, 345
 Atala Mosque 1:138, 139;
 552; 3:229
 Jamiʿ Masjid (Friday Mosque)
 1:138
Javāhir al-gharʾib ("Jewels of
 curiosities"; Cambridge,
 MA, Sackler Mus.,
 ex-Binney priv. col.) by
 Jannabi 3:87
Javāhir al-Mūsīqāt-i Muhammadī
 ("Jewels of
 Muhammadan Music";
 London, BL, Or. MS.
 12857) 1:11
Javed, Tariq 3:94
Javed, Zubeda 3:94
Jawhar, General (10th century)
 1:324
Jawhar Nasiba (1205) 2:374
Jawkhdar 3:405
Jazari, al- 2:77, 479, 480, 481,
 499, 500
 see also Kitāb fī maʿrifat al-
 hiyal al-handasiyya
 ("Book of knowledge of
 ingenious mechanical
 devices")
Jazarit ibn ʿUmar see Cizre
Jazira see Iraq; Syria
Jeanneret, Pierre 2:272
Jekshenbayev, Shibek 2:407
jellaba 2:29
Jerash 2:363
 ceramics 1:444
Jerba Island 3:356
Jermakov, Dmitri Ivanovitch 3
Jerusalem 2:346–53, 346; 3:103
 Aqsa Mosque 1:75, 84;
 2:352–3, 550, 551
 ceiling 1:382
 lamps 2:481
 minbar 2:535; 3:423,
 431, 449
 mosaics 1:208; 3:240
 woodwork 3:420
 Armenian monastery 1:216
 ceramics 1:216, 471
 citadel 1:212; 2:526
 Damascus Gate 2:526
 Dome of the Rock 1:75, 76,
 502, pl.IV.2; 2:351–2,
 pl.XIII.1; 3:110, 208,
 231, 341
 arches 1:67
 coffering 1:490
 columns and capitals 1:353;
 3:228
 dome 2:18
 inscriptions 1:76, 210, 342;
 2:395

lamps 2:481, 488
marble frieze 3:75
mihrab 2:516
mosaics 1:207; 3:77, 78,
 147, 240
tiles 1:169
windows 1:210
glass 2:113
Haram al-Sharif 2:347, 348
Holy Sepulcher 1:76
Isʿirdiyya madrasa 2:483, 502;
 3:18
Israel Museum 3:36
Islamic Museum of the Aqsa
 Mosque 3:36
L. A. Mayer Museum for
 Islamic Art 2:314, 470;
 3:36, 201
metalwork 2:508
Rockefeller Archaeological
 Museum 2:314; 3:36
throne of St. James the Lesser
 3:434
tomb complexes 1:148
jewelry 2:353–60
 materials and techniques
 coral 1:49, 278
 enamel 2:50
 gems 2:99
 gold 2:354, 355, 357,
 pl.XIII.2
 silver 1:278, pl.I.4; 2:355,
 358
 regional traditions
 Afghanistan 1:18
 Algeria 1:pl.I.4; 2:357, 358
 Azerbaijan 1:245
 Berber 1:278, pl.I.4; 2:357
 Central Asia 1:429–30;
 2:355
 Egypt 2:354
 India 2:358–60
 Iran 2:355, 356
 Iraq 2:355
 Israel 2:314
 Kazakhstan 2:pl.XIII.2
 Macedonia 2:427
 Morocco 2:357
 Pakistan 3:96
 Syria 2:354–5
 Tuareg 2:358; 3:348–9
 Tunisia 2:357, 358
 Turkey 2:357
 Yemen 2:314, 358, 359
Jewels of curiosities see Javāhir
 al-gharʾib
Jewels of Muhammadan Music
 see Javāhir al-Mūsīqāt-i
 Muhammadī
Jewish art 2:360–61
jharokhā 1:257
Jiaohe 3:214
Jiayuguan 3:214
Jibla 1:153
 mosque of Arwa bint Ahmad
 1:110, 111
 mihrab 1:110
Jiddah 2:527
 Abdulaziz University 3:188
 houses 2:175; 3:187, 405, 405
 Island Mosque 3:189
 King Abdul Aziz International
 Airport 3:188
 Municipality Mosque (El-Wakil
 Mosque) 3:188
 National Commercial Bank
 3:188

sculpture 3:188
Sulaiman Palace 3:188
Jilani, Abdulwahab 3:356
Jiménez de Cisneros, Francisco,
 Cardinal 1:227
Jiménez de Rada, Archbishop 3:8
Jingdezhen 1:486
Jiruft 1:450
Joailler 3:119
Jog-bashisht (1602; Dublin,
 Chester Beatty Lib.,
 Ind. MS. 5) 2:136
John XXII, Pope (r. 1316–34)
 1:360
Johnson, John 2:117
Johnson, Richard 1:45, 499;
 2:266, 361
Johnson Album (c. 1750–60;
 London, BL, Orient. &
 India Office Lib.) 2:266
Johor Baharu 2:442
 Abu Bakar Mosque 2:440
Jones, Owen 1:72, 499; 2:122,
 152, 544
Jones, William 1:499; 2:361
Jordan 2:361–3
 architecture 1:77
 art education 2:363
 baths 1:77, 271
 mosaics 3:371
 palaces 3:35
 stucco 3:236
 see also Palestine
Jos 3:56
 Museum of Traditional
 Nigerian Architecture
 3:56, 58
Josué 3:6
journals 2:363–4
Jriskulov, Dubanek 2:407
Juban
 Mansuriyya Madrasa 1:154
Jubayl 3:187, 406
Jubayri 3:210
jujube 3:420, 434
Julianus, Archbishop 1:303
Julius II, Pope (r. 1503–13)
 3:125
Junagadh
 mosque of Abuʾl-Qasim ibn
 ʿAli al-Idhaji 1:504
Junayd 1:3, 251; 2:200, 214,
 215, 220, 221, 222,
 222, 305, 344, 364
Jung/Brannen International,
 Boston 1:214
juniper 3:424
Jurjani, al- 2:312
Jurjānniyya see Kunya-Urgench
Justinian I, Emperor of
 Byzantium (r. 527–65)
 1:257; 2:323; 3:121,
 181
Juybari 1:178
Kabarnat 1:479
Kabul 2:365
 Afghanistan National Museum
 2:365
 Bagh-i Wafa 2:78
 Garden of Fidelity 1:182
 fort 1:185
 Museum 1:19
Kadiasker Mustafa İzzet see
 Mustafa Izzet
Kadjar see Qajar
Kaduna 3:56
 Police College 3

Kaédi **2:**469
Kaempfer, Engelbert **2:**92
kaftans **1:**pl.XIV.4; **2:**26
Kâğıthane
 palace **1:**166
Kagopulo, Vasilaki **3:**119
Kalın, Louis I. **1:**263, pl.X.1;
 2:14, 20, 272, 312
Kahta **3:**81
Kaiqubad *see* Mu'izz al-Din
 Kaiqubad
Kairouan **1:**159; **2:**365–6, 523;
 3:356
 bookbindings **1:**295, 296
 bridge **1:**85
 carpets **1:**381; **3:**357
 ceramics **1:**452
 Great Mosque **1:**29, 73, 85–6,
 86; **2:**366, 550
 Bab Lalla Rihana **1:**160,
 160
 ceiling **1:**382, 490; **3:**426,
 427
 dome **2:**18
 maqsura **1:**280; **2:**461;
 3:427
 mihrab **1:**86, 199; **2:**516,
 pl.XVI.2
 minaret **1:**22–3, **2:**531
 minbar **2:**534; **3:**421, 425,
 426
 spolia **1:**194
 tiles **1:**446, 448, 452
 houses **3:**397, *398*
 mosque of Muhammad ibn
 Khairun *see* Mosque of
 the Three Doors
 mosque of Sidi 'Uqba **3:**228
 Mosque of the Three Doors
 1:*30*, 86; **2:**366
 stelae **3:**233
 stucco **3:**237
 textiles **3:**300, 338
 water supply **2:***366*
 zāwiya of Sidi 'Abid al-
 Gharyani **1:**160, 196
 zāwiya of Sidi Sahib **1:**160;
 2:366
Kaisareia *see* Kayseri
Kaj
 mosque **1:**130
Kala-i Baland **1:**412; **3:**375
Kala-i Kakhkakh **1:**316
Kala-i Mug **1:**390; **2:**367–8
 cotton **1:**415
 silk **3:**216
Kalanjar **2:**529
Kal'at Bani Hammad *see* Qal'at
 Bani Hammad
Kalb 'Ali **1:**223
Kalbid (*r.* 948–1091)
 architecture **1:**103
Kalehisar **1:**460
Kale-i-bogurt **1:**244
Kale-i Çanakkale **2:**524
Kale-i Sultaniyye *see* Kale-i
 Çanakkale
Kalendar Pasha **2:**255
Kalila and Dimna by Ibn
 al-Muqaffa' **2:**205;
 3:243
 (*c.* 1200–20; Paris, Bib. N.,
 MS. arab. 3465) **2:**198,
 199, 209
 (1307–8; London, BL, Or.
 MS. 13506) **2:**217;
 3:207

(1343–4; Cairo, N. Lib., Adab
 Farsi 61) **2:**220
(1354–5; Oxford, Bodleian
 Lib., Pococke 400)
 2:198, 212
(1350s or 1360s; Istanbul, U.
 Lib., F. 1422) **2:**220;
 3:116, 246
(1389; Cambridge, Corpus
 Christi Coll. Lib., MS.
 578) **2:**212
(1392; Paris, Bib. N., MS.
 supp. pers. 913) **2:**222,
 345
(1429; Istanbul, Topkapı Pal.
 Lib., R. 1022) **2:**226;
 3:335
(1431; Istanbul, Topkapı Pal.
 Lib., H. 362) **2:**226;
 3:335
(*c.* 1460–65; Tehran, Gulistan
 Pal. Lib.) **2:**232; **3:**134
Kalkhuran
 tomb of Shaykh Jibra'il **1:**171,
 213
Kalliga, Irini **1:**276
Kalmak **3:**280
Kaluyan **3:**224
kalyami **1:**416
Kamal, Aslam **1:**352; **3:**93
Kamāl al-Din Bihzād *see* Bihzad
Kamal al-Din Husayn **1:**174
Kamal al-Mulk *see* Ghaffari,
 Muhammad
Kamal Muhammad **1:***11*; **2:**266
Kamil, al- **1:**333; **3:**423
Kamil, Fu'ad **1:**226, 331; **2:**46
Kamran **2:**413
Kandahar **2:**528
 fort **1:**185
Kandinsky, Vasily **3:**70
Kangar
 Perlis State Mosque **2:**440
Kanha **2:**368; **3:**46
Kanibadam **3:**267, 268
Kanka **1:**479; **2:**368–9
Kankandi **1:**239
 Gor'ky Dramatic Theater
 1:239
Kano **2:**369; **3:**55, 56
 houses **1:***24*; **2:**pl.III.1
 Women's Teacher Training
 College **3:**55
 Wudil Teacher Training
 Center 3
Kanoria, Gopi Krishna **2:**275
Kanu, 'Abd al-Latif **1:**253
Kanukov, E. I. **3:**212
Kanvinde, Achyut **2:**272
Karabacek, Joseph von **2:**153
Karabaghlar
 tomb tower **1:**267
Karabagi, Kerbalai Sefi Khan
 1:238; **3:**212
Karabulak **1:**430; **2:**73
Karachi **2:**369–70
 Aga Khan Hospital 3
 Burmah Shell Headquarters
 3:92
 Business Administration and
 American School **3:**93
 carpets **3:**95
 Central School of Art **3:**96
 Finance and Trade Center
 3:93
 Karachi School of Arts and
 Crafts **3:**96

National Museum of Pakistan
 3:97
 Society of Contemporary Art
 Galleries **1:**265
 University **3:**93
 Victoria Museum **3:**97
Karaganda **2:**376
Karahisar **1:**473
Karaite codex of Moses Ben
 Asher **2:**361
Karaj
 Sulaymaniyya Palace
 murals **1:**4
Karakalpak **1:**420; **3:**280, 413
Karakhan, Nikolay Georgievich
 3:388
Kara Kol *see* Przhevalsk
Karakorum **3:**281
Karakoyunlu *see* Qaraqoyunlu
Karaman **1:**141; **2:**523
 Emir Musa Madrasa **1:**143
 Hatuniye Madrasa **1:**143
 Ibrahim Bey Imaret **1:**143
Karamehmedović, Muhamed
 1:302
Kara Memi **2:**254, 370–71;
 3:86
Karapınar
 mosque **1:**163
Karashahr **3:**214
Karasharly, S. **1:**241
Karatay Han **1:**198
Karatepe **3:**363
Karazhusupov brothers **2:**376
Karbabad **1:**253
Karbala
 cemetery **1:**384
 houses **2:**174
 shrine of Husayn **1:**89; **2:**306;
 3:27, 209, 211, 341
Karduvan **3:**282
Kargala **3:**217
Kargilik **3:**214
Kargopoulo **2:**322
Karim Aga Khan **1:**28
Karim al-Din Erdishah **2:**392
Karim Khan (*r.* 1750–79) *see*
 Muhammad Karim
 Khan
karite *see* shea
Karkh, al- **1:**80
Kārnāma-i 'ishq ("Book of affairs
 of love"; 1731; London,
 BL, Orient. & India
 Office Lib., Johnson
 Album) **2:**263
Kars **2:**371, 525
Kart (*r.* 1245–1389)
 see also Ghiyath al-Din
 Muhammad
Karyagdy, D. **1:**239, 240
Kasaba Köyü
 Mahmud Bey Mosque **1:**143;
 3:432
Kasba Tadla **1:**189
Kashan **2:**371
 Bagh-i Fin **1:**172; **2:**92, *93*,
 389
 carpets **1:**365, 366, 377,
 pl.XIV.3; **2:**288, 387;
 3:162, 163
 ceramics **1:**8, 292, 441, 443,
 443, 455, 457, 458,
 462, 475, pl.XVI.3
 Masjid-i Agha **2:***372*
 Maydan Mosque **2:**371, 516,
 535

textiles **3:**315
tiles **1:**199, 200, pl.XVI.3
Kashani *see* Abu Tahir
Kashf al-asrār ("Disclosure of
 secrets"; Istanbul,
 Süleymaniye Lib., Lala
 Ismail 565) by Ibn
 Ghanim al-Maqdisi
 2:199, 213
Kashgar **2:**373; **3:**214
 Abaheijia (Apak Khoja)
 complex **1:**484, pl.V.2
 Atikar Mosque **2:**373
Kashi, al- *see* Miftāḥ al-ḥisāb
Kashifi *see* Anvār-i Suhaylī
 ("Lights of Canopus");
 Akhlāq-i muḥsinī
Kashina, Nadezhda Vasil'yeva
 3:388
Kashmir
 gardens **2:**96
 textiles **3:**319, 320, 325
 woodwork **3:**438
Kashmiri, Agha Hasher **1:**318
Kasım Ağa **1:**42; **2:**373
Kasr el-Heir *see* Qasr al-Hayr
Kassala **3:**60
Kassis, Hafiz **2:**363
Kasteyev, Abylkhan **2:**377
Kath **1:**404
Katoğlu, Oya **3:**448
Katsev, Vladimir **2:**377
Katsushika Hokusai **2:**136
Katha *see* Yazd
Katta Kurgan **1:**416; **3:**388
Kattan, Shaykh Ibrahim
 al- **2:**362
Kaufman, General K. P. von
 1:432
Kausar, Sajjad **2:**415
Kavkazsky Muzei **1:**434
Kawara
 mosque **1:**23
Kayaleh, John **2:**362
Kayani crown **3:**149
Kayes **2:**449
Kayışzade Osman **3:**39
Kaykubadiye **1:**120
Kaynarbayev, A. **2:**377
Kayqubadh, Sultan *see* 'Ala al-
 Din Kayqubadh, Sultan
Kayragach **1:**73
Kayseri **1:**120; **2:**374, 520
 carpets **1:**371, 373; **3:**362
 Çifte Künbed **1:**118
 Çifte Medrese **1:**118
 congregational mosque **3:**432
 Döner Kümbed **1:**197; **3:**27,
 345
 houses **3:**383
 Huand Hatun complex **2:**374
 madrasa **1:**118
 Köşk Medrese **1:**143
 mosques **1:**163
 Sahibiye Madrasa **1:**118
 Sırçalı tomb **1:**144
 textiles **1:**215
 tomb of Ali Cafer **1:**144
 tombs **1:**118
kazaghand **1:**217
Kazakh/Borchaly carpets *see*
 under carpets → types
Kazakhstan **2:**375–8, *375*
 architecture **2:**376–7; **3:**359
 historiography **1:**434
 jewelry **2:**pl.XIII.2
 museums and collections **2:**378

painting **2:**377
textiles **2:**377–8
see also Central Asia
Kazakov, Ivan Semyonovich
3:388
Kazan'
Museum of Tartary **1:**438
Kazimzade, K. **1:**241, 247
Kazvin *see* Qazvin
keel arches **1:**67, 109
Kef, El
museum **3:**357
Keir Collection **1:**501
Kelang **2:**442
Sultan Sulaiman Mosque
2:440
Kelantan
Kampung Laut Mosque
2:439
Pulai Chondong Mosque
2:439
Keldi Muhammad Sultan **1:**406;
2:249
Kelekian, Dikran **1:**443, 500
Kelepha **2:**525
Kemalettin **2:**319, 322, **378–9;**
3:83, 360
Kemkaran *see* Khem Karan
Kendall, Henry **2:**350
Kengerli, Bekhruz **1:**241
Kenya **2:**379–80
Kerak **2:**363
Kerimov, K. **1:**239
Kerimov, L. G. **1:**243, 244, 247
Kerkouane **3:**357
Kerman *see* Kirman
kermes **1:**358; **3:**295
Kermine *see* Navoi
Kerry Hill Architects **2:**442
Keshava Kalan *see* Kesu Das
Kesu Das **2:**15; 259, **380,** 427
Kesu Khurd **3:**20, 272, 353
Ketmen'-Tyube **1:**412
Kevorkian, Hagop **1:**443;
2:381
Kevorkian Album (*c.* 1627; New
York, Met., 55.121.10,
and Washington, DC,
Freer) **1:**256, 349, 519;
2:262, *262,* 381, 536;
3:3
Keyhole carpets *see* carpets →
types → Bellini
Key to calculation *see* Miftāḥ
al-ḥisāb
Khabiboulayev, Zuhun
Nurdjanovich **3:**267
Khabura **3:**66
Khachen Dorbatly **1:**197
Khadda, Muhammad **1:**50
Khaja, Muna al- **3:**374
Khajanchi, Motichand **2:**275
Khakhar, Bhupen **2:**273, pl.X.2
Khalaf **2:**332
Khalafov, R. G. **1:**243
Khaleq, Syed Abdullah **1:**261
Khalid ibn Abu'l-Hayyaj **1:**342
Khalifa, Abdul Aziz bin
Muhammad al- **1:**253
Khalifa, Musa **3:**255
Khalil, Sultan (*r.* 1290–94)
(Mamluk) **1:**150; **2:**19,
502
Khalil (*r.* 1405–9) (Timurid)
3:290
Khalil (*fl.* mid-15th century)
2:228

Khalil (*r.* 1478) (Aqqoyunlu)
1:65, 517; **2:**232, 238;
3:204, 264
Khalil, Mohammad Omer **3:**254
Khalil, Muhammad Mahmud
1:331; **2:**49
Khalil Allah Khan **1:**187
Khalili, Nasser David **1:**501;
2:156
Khalili Collection **2:**60
Khalil Pasha **1:**251
Khaljis (*r.* 1290–1320) **2:**270,
381
see also Jalal al-Din Firuz
(*r.* 1290–96); 'Ala al-
Din, Sultan (*r.* 1296–
1316); Mahmud Shah
Khalji I (*r.* 1436–69);
Nasir al-Din (*r.*
1500–10)
Khalykov, G. **1:**241, 247
Khambhat **2:**381
Khamdami, Bahram **3:**388
Khammash, Ammar **2:**363
khamsa see hand of Fatima
Khamsa ("Five poems") by
'Alishir Nava'i **2:**200
(1463; Istanbul, Topkapı Pal.
Lib., R. 1021) **3:**134
(1485; divided, Oxford,
Bodleian Lib., Elliott
287, 317, 339, 408 and
Manchester, John
Rylands U. Lib., Turk.
3) **1:**287; **2:**228
(1521–2; St. Petersburg,
Saltykov-Shchedrin
Pub. Lib., Dorn 559)
1:406
(*c.* 1600; Windsor Castle,
Berks, Royal Col., MS.
A.8) **2:**260
Khamsa ("Five poems") by Amir
Khusraw Dihlavi **2:**200
(*c.* 1450; Copenhagen, Davids
Saml., MS. 25/1980)
2:235
(1463; Istanbul, Topkapı Pal.
Lib., R. 1021) **2:**232
(1493/8; Istanbul, Topkapı
Pal. Lib., H. 799)
2:233; **3:**309
(1496–7; Istanbul, Topkapı
Pal. Lib., H. 676) **2:**228
(1571–2; Cambridge, King's
Coll.) **2:**63
(1597–8; New York, Met. and
Baltimore, MD, Walters
A. Mus., MS. W. 624)
1:270; **2:**15, 260, 415,
428, 459, 460
Khamsa ("Five poems") by
Khwaju Kirmani
(1396; London, BL, Add. MS.
18113) **2:**200
Khamsa ("Five poems") by Nizami
2:200; **3:**241, 315
(1318; Tehran, U., Cent. Lib.,
MS. 5179) **2:**200
(1386–8; London, BL, Or.
MS. 13297) **2:**221, 344
(1431; St. Petersburg,
Hermitage, VR-1000)
2:227, 385; **3:**72
(1435–6; London, BL, Or.
MS. 12856) **1:**349;
2:227

(1442; London, BL. Add. MS.
25900) **1:**287; **2:**227
(1445–6; Istanbul, Topkapı
Pal. Lib., H. 781)
2:228, 385
(*c.* 1449–57 and later;
Istanbul, Topkapı Pal.
Lib., H. 762) **1:**349;
2:232; **3:**204, 225
(mid-15th century; London,
Royal Asiat. Soc., MS.
Pers. 246) **2:**232
(1463–4; Dublin, Chester
Beatty Lib., Pers. MS.
137) **2:**232
(1474; London, BL, Or. MS.
2931) **3:**207
(1495–6; London, BL, Or.
MS. 6810) **1:**287, 505;
2:149, 228, 509, 536
(1524–5; New York, Met.,
13.228.7) **2:**239, 537;
3:205
(1534; Copenhagen, Davids
Saml., MS. D 6/1986)
2:200
(1539–43; London, BL, Or.
MS. 2265) **1:**63, 266,
288; **2:**188, *188;* 240,
510, 537, 540, 541,
pl.VII.1; **3:**16, 21–2,
40, 163, 191
(*c.* 1530–56; Ahmedabad, priv.
col.) **2:**258
(1572–81; New York, Pub.
Lib., MS. M. 836)
2:242
(*c.* 1585; Surrey, Keir Col.)
2:14, 15, 63, 380, 415,
427, 459; **3:**272, 353
(1593–5; London, BL, Or.
MS. 12208 and
Baltimore, MD, Walters
A. Mus., MS. W. 613)
1:519; **2:**15, 64, 260,
261, 383, 415, 428,
459; **3:**24, 46
(1648; St. Petersburg,
Saltykov-Shchedrin
Pub. Lib., MS. P.N.S.
66) **1:**407; **2:**251
(1668–71; Dublin, Chester
Beatty Lib., Pers. MS.
276) **1:**408; **2:**251
(1675–8; New York, Pierpont
Morgan Lib., MS. M.
469) **3:**22
see also Haft paykar; Khusraw
and Shirin; Makhzan
al-asrar
Khan, Ahmed **3:**95
Khan, Assadollah **2:**288
Khan, Dr. Aziz **3:**97
Khan, Mahmoud **2:**286
Khan, Mohammad Kaleem **3:**94
*khanaqah*s **1:**69, 160; **2:**165,
381–2, *383*
Khan-i Jahan Junan Shah **2:**4
Khan-i Jahan Maqbul Telingani
2:4
Khanlarov, T. **1:**239
Khanna, Krishen **2:**8
Khaqan *see* Dīvān (collected
poems) of Khaqan/Fath
'Ali Shah
Kharadzhet [Kharashket] *see*
Kanka

Kharadzhiket **1:**480
Kharaneh *see* Qasr Kharana
Khargird **1:**131, 136
Madrasa al-Ghiyathiyya **1:***134,*
212; **2:**433
Nizamiyya Madrasa **1:**67,
93, 98, 136, 137;
2:431
Kharijites *see under* Islam
Kharraqan
tombs **1:**94, 95, 199, 306;
2:517; **3:**342
Khartoum **3:**60, 127, 254
Ethnographic Museum **3:**255
National Museum **3:**255
Khashavank
church of Arzu-khatun **1:**241
Khata'i *see* Dīvān (collected
poems) of Khata'i/
Isma'il
Khatib al-Baghdadi, al- **2:**129
Khatim **1:**476
Khattab **1:**243
Khatun Jan Begum **3:**134, 265
khau (*Olea ferruginea*) **3:**439
Khāvarānnāma by Ibn Husam
(*c.* 1476–87; dispersed) **2:**202,
233; **3:**207
Khawlan **3:**407
Khayachi, Hédi **3:**356
Khayr al-Din Mar'ashi **1:**134
Khazar **3:**282
Khelaverd **2:**382
Khem Karan **2:**383
Khidr Khan (Khalji) **2:**3, 381
Khirbat al-Mafjar **1:**67, 70, 77,
194, 271; **2:383–4,**
388; **3:**98, 249
ceiling paintings **1:**382
fountains **2:**78
gardens **2:**87
mosaics **1:**75, 208, 271
sculpture **1:**94; **3:**123, 148
stucco **3:**235, *236*
stained glass **1:**209
Khirbat al-Minya **1:**76; **3:**98
Khitakhunov, Maris **2:**377
Khiva **1:**177, 433; **2:384,** 528;
3:381, 387, 412
Bonbonla Mosque **1:**431
caravanserai of Allah Quli
Khan **1:**179
cenotaph 'Ala' al-Din Kubra
1:200, 402, pl.XVI.1
Friday Mosque **1:**179
columns **1:**504; **3:**424
minaret **1:**179
woodwork, **1:**431
hypostyle mosque (*c.* 1000)
1:89
jewelry **1:**430
Katli Murad Inak Madrasa
1:403
Kunya Arg **3:**99
madrasa of Allah Quli **1:**179
madrasa of Muhammad Amin
Khan **1:**179
metalwork **1:**411
Tash Hawli Palace **1:**180, *181,*
257, 403; **3:**100, 387,
413
tents **3:**99
textiles **3:**388
tomb of Pahlavan Mahmud
1:179, 403
weapons **1:**424
woodwork **1:**431; **3:**438

Khizi **1:**247

Khocho **3:**214, 281

Khodja, Ali **1:**50

Khodja obi Garm **3:**267

Khodzha, Fazyl **2:**391

Khodzha Akhrar *see* Khwaja
Ahrar

Khodzhent **1:**430; **2:385; 3:**266,
267, 268

Khodzhiev, R. **3:**268

Khodzhikov, Khodja **2:**377

Khojand *see* Khodzhent

Khokand *see* Kokand

Khoo Sui-Hoe **2:**445

Khor, al- 3

Khorsabad **1:**79

Khoshmukhamedov, M. **3:**267

Khosla, Ramesh **3:**93

Khotan **1:**429; **3:**214

Khoy **1:**171

Khreis, Khaled **2:**363

Khudainket **1:**479

Khul'buk *see* Hulbuk

Khumarawayh (*r.* 884–96)
(Tulunid) **3:**354

Khumartash **3:**138

Khurasan (eastern Persia) *see*
Afghanistan; Central
Asia; Iran

Khurram, Prince (Mughal) *see*
Shah Jahan, Emperor

Khurremshah ibn Mughith **2:**17

Khurus-i Jangi **2:**286

Khushqadam, Sultan (*r.* 1461–7)
(Mamluk) **2:**503; **3:**431

Khushqadam (*fl.* 1486) **3:**398

Khushqadam ibn ʿAbdallah
2:213

Khushyar, Princess **1:**190

Khusnutdinkhodzhayev, Khakim
Khodzha **3:**388

Khusraw I (*r.* 531–79) **2:**477

Khusraw and Shirin by Hatifi
(1498–9; New York, Met.,
69.27) **3:**85

(16th century; Oxford,
Bodleian Lib., Ouseley
19) **1:**406; **2:**249

(1568; Bankipur, Patna,
Khuda Bakhsh Lib.)
2:250

(1631–2; London, V&A, MS.
AM. 364–188) **2:***245*

Khusraw and Shirin by Nizami
(*c.* 1405–10; Washington, DC,
Freer, 31.32–31.37)
2:222, 345; **3:**264

(1421; St. Petersburg, Acad.
Sci., Inst. Orient. Stud.,
MS. B. 132) **3:**335

(1631–2; London, V&A,
364–1885) **2:**245

Khusrawgird
minaret **2:**532

Khwāja ʿAbd al-Ḥayy (*d.* 1405)
see ʿAbd al-Hayy

Khwaja ʿAbd al-Hayy (*d.* 1501)
1:350

Khwāja ʿAbd al-Ṣamad Shīrāzī
see ʿAbd al-Samad

Khwaja Ahrar **3:**172, 272, 336

Khwaja ʿAli **2:**228, 385; **3:**335

Khwaja Gada **1:**408

Khwaja Jahan Muhammad Dust
1:184

Khwaja Khayran *see* Mazar-i
Sharif

Khwaja Muʾin **2:**342

Khwaja Rukn a-Din Rashid
al-Din ʿAzizi ibn Abuʾl-
Husayn al-Zanjani
2:491

Khwaja Saʿd Juybari **1:**178

Kliwaja Siyah Push **1:**100
minaret **1:**98, 99, 100

Khwaja Yaqut **2:**54

Khwaja Yusuf **3:**325

Khwaju Kirmani *see Dīvān*
(collected poems);
Khamsa ("Five poems")

Khwandamir **1:**131; **3:**134, 225
see also Habīb al Siyār
("Beloved of careers")

Khwand Baraka **2:**332, 455

Khwarazm (Uzbekistan) *see*
Central Asia

Khwarju Kirmani *see Humay and
Humayun*

Kibo
Kibo Art Gallery **3:**271

Kibria, Muhammad **1:**263; **3:**93

Kibriszade Ismail Hakkı Efendi
3:180

Kiev
Museum of Western and
Oriental Art **1:**438

Kihago, Abbas **3:**271

Kihururu, Edwin **3:**271

Kiliç Arslan II, Sultan (*r.* 1156–
92) (Saljuq) **1:**118

Kilid al-Bahr **2:**524

kilims **1:***246,* 370, 381;
2:386–7, *386*

kilns **1:**441

Kilwa **3:**359
ceramics **1:**463
museum **3:**271
Husuni Kubwa palace **1:**22

Kim, Vladimir **2:**377

Kimball, Francis H. **2:**545

Kim Sane
tomb of Salar Khalil (Baba
Khatim) **1:**98

Kinodoni Art Group **3:**270

kiosks **1:***166;* **2:***11, 321,* **388–9;**
3:*83*

Kirat Dam **1:**134

Kirk-er *see* Chufutkale

Kirkgöz Han **1:**134

Kirman **1:**172; **2:390**
bath **1:**272
carpets **1:**365, 366, 376, 377;
2:288; **3:**162, 163
ceramics **2:**292; **3:**162
citadel **2:**526
metalwork **1:**308; **2:**511
mosque **1:**129, 131, 200

Kirmanshah
takya of Muʿavin al-Mulk
1:176; **2:**288

Kirovabad *see* Gandja

Kırşehir
carpets **1:**371, 372
tomb of Aşık Pasha **1:**144
tomb of Melik Gazi **1:**118;
2:18

Kirsheh, Michel **3:**261

Kish
ceramics **1:**445

Kishman Tepe
caravanserai **1:**83

Kislak Rishtan **3:**388

Kitāb al-aghānī ("Book of
songs"; 1217–20;

dispersed) by Abuʾl-
Faraj al-Isfahani **2:**83,
162, 199, 209; **3:**123

Kitāb al-ʿashr maqālāt fiʾl-ʿayn
("Book of the ten dis-
courses on the eye";
Cairo, N. Lib., Tibb
Taimur 100) by Hunayn
ibn Ishaq al-ʿIbadi **2:**197

Kitāb al-bayṭara ("Book of far-
riery") by Ahmad ibn
al-Hasan ibn al-Ahnaf
3:247
(1208–9; Cairo, N. Lib., Khalil
Agha 8f) **2:**198, 210
(1210; Istanbul, Topkapı Pal.
Lib., A. 2115) **2:**210

Kitāb al-bulhān (1399; Oxford,
Bodleian Lib., Or. MS.
133) **2:**198, 222, 345

Kitāb al-diryāq ("Book of anti-
dotes") by Pseudo-
Galen
(1199; Paris, Bib. N., MS.
arab. 2964) **2:**208, 208,
492
(*c.* 1220–40; Vienna,
Österreich. Nbib., Cod.
A.F. 10) **2:**26, 198

Kitāb al-hayawān ("Book of ani-
mals"; Milan, Bib.
Ambrosiana, Ar. A.F.D.
140 Inf.) by al-Jahiz
2:199; **3:**247

Kitāb al-zardaqa ("Book of far-
riery"; *c.* 1425; Istanbul,
U. Lib., A. 4689)
2:199, 212

Kitāb-i baḥrīye ("Book of the
mariner") by Piri Reis
(1625–6; Istanbul, Topkapı
Pal. Lib., R. 642) **2:**252

*Kitāb fi maʿrifat al-ḥiyal al-
handasiyya* ("Book of
knowledge of ingenious
mechanical devices") by
al-Jazari
(1206; Istanbul, Topkapı Pal.
Lib., A. 3472) **2:**197,
197, 208
(*c.* 1315; Copenhagen, Davids
Saml., MS. 20/1988)
2:*211*

Kitāb-i samak-i ʿayyār ("Book of
Samak the Paladin";
Oxford, Bodleian Lib.,
Ouseley MSS 379–81)
2:217; **3:**207, 283

Kitāb khalq al-nabī wa-khulqih
("Book of the moral
and physical characteris-
tics of the Prophet";
Leiden, Bib. Rijksuniv.,
MS. 437) by Abu Bakr
Muhammad ibn
ʿAbdallah **2:**190

*Kitāb ṣuwār al-kawākib
al-thābita* ("Book of the
fixed stars") by ʿAbd
al-Rahman ibn ʿUmar
al-Sufi
(1009–10; Oxford, Bodleian
Lib., Marsh 144) **2:**21,
197, 205; **3:**148
(1131; Istanbul, Topkapı Pal.
Lib., A. 3493; Mosul,
1170–71; Oxford,

Bodleian Lib., Hunt
212) **2:**208
(1224; Rome, Vatican, Bib.
Apostolica, MS. Ross.
1033) **2:**207
(1630–33; New York, Pub.
Lib., Spencer Col., MS.
6) **2:**245

Kitbugha, Sultan (*r.* 1295–7)
(Mamluk) **1:**149;
2:454, 502; **3:**431

Kitchener, Lord **3:**254

kitchens (alms) *see imaret*s

Kizil-Ayak **1:**420

Kızıltepe
congregational mosque **1:**112,
228

Kizyl-Arvat **3:**366

Klee, Paul **1:**352; **3:**70

Klungkung **2:**282

Klychev, Izzat Nazarovich **3:**367

Knespel, Gershon **2:**104

Knowles, H. P. **1:**72

Koç (family) **1:**498

Kocamemi, (Ahmet) Zeki
2:390–91; **3:**361

Koca Sinan *see* Sinan

Koechlin, Raymond **2:**58

Koh, Jolly **2:**445

Koichev, P. **1:**314

Koil *see* Aligarh

Kokand **2:**391; **3:**387
Kamal Kai Madrasa **1:**403
palace of Khudoyar Khan
1:403; **3:**387
textiles **1:**415; **3:**316
woodwork **3:**438

Kokoschka, Oskar **3:**70, 202

Kola-Bankole, Isola **3:**56

Kolář, Antonín **1:**314

Kolenze **1:**24

Kollek, Teddy **2:**350

Kölük ibn ʿAbdallah **2:**392

Kölük Şemseddin **2:**374

Koman, Ilhan **3:**362

Komosar, Mirko **1:**303

Konate, Abdoulaye **2:**450

Kong
mosque **1:**23

Konstantinov, Janko **2:**426

Konstantinovski, George **2:**426

Konstantinye *see* Istanbul

Konya **1:**117; **2:**306, **391–2**
Alaeddin Mosque **1:**117, 199,
503; **2:**391–2, 552;
3:229
minbar **3:**432
tomb of Sultan Kiliç Arslan
II **1:**118
baths **1:**144
carpets **1:**359, 370; **3:**293
Ince Minareli Madrasa **1:**118,
pl.VII.1; **2:**392;
3:27, 123
Ince Minareli Mosque **1:**118
Karatay Madrasa **1:**118, 199;
2:392; **3:**76, 230
kiosk of Kiliç Arslan II **1:**201
manuscripts **2:***234*
Meram Mosque **1:**143
Mevlana Museum **3:**35
mosque of Abdalaziz **1:**118
mosque of Beşarebey **1:**118
mosque of Erdemşah **1:**118
mosque of Haci Ferruh **1:**118
mosque of Hoca Hasan **1:**118
mosque of Şekerfuruş **1:**118

museums 3:363
palace 1:120, 197; 2:202
Sahib Ata Mosque 1:143; 3:27
Selimiye Mosque 1:163
Sırçalı Madrasa 1:118; 2:392
tomb of Celal al-Din Rumi
1:144
tomb of Fakih Dede 1:144
tomb of Gömeç Hatun 1:119
tomb of Gühertaş 1:119
tomb of Şeyh Ahmed 1:119
tomb of Şeyh Aliman 1:119
tomb of Tac ül-Vezir 1:118
tombs 1:118
town walls 1:195
Konya Carpets 1:359
Koprivshtitsa
Kableshkov House 1:313
Pavlikyanski House 1:313
Koraïchi, Rachid 1:51
Koral, Füreya 3:362
Koran 2:186–9, 301, 302,
393–6, 395, pl.XIV.1;
3:105, 126, 240
Koran stands 3:436
Korçari, Petro 1:43; 2:396–7
Korçë
Mirahori Mosque 1:42
Kota Baharu 2:447
Kota Kinabalu
Sabah Foundation
Headquarters 2:441
Kotel 1:315
Kotěra, Jan 1:301
Koumbi Saleh
mosques 1:22
Kovalevskaya, Zinaida
Mikhailovna 3:387
Koyunoğlu, Arif Hikmet 2:379
Kozhemyako, P. 2:399
Kraak ware see under ceramics →
wares
Krachkovskaya, V. A. 1:433;
2:154
Kragulj, Radovan 1:302
Krak de Monreal 2:397
Krak des Chevaliers 2:397–8,
397, 398, 526
Krasnaya Rechka 2:399
Krasnovodsk 3:366
kratons 2:281
Kratovo 1:426
Krishnadasa, Rai 2:274, 275
Krishna painter see Bux, Allah
Krujë
Market Mosque 1:42
seraglio 1:43
Kruševo 2:426
Ksar el-Srhir 1:159
Kuala Kangsar
Malay College 2:441
Ubudiah Mosque 2:440
Kuala Lumpur
Bangunan Datu Zainal
Building 2:441
Dayabumi Complex 2:441
Downtown Condominium
2:441
Hilton Hotel 2:442
house of Kington Loo 2:442
house of Ng Lu Pat 2:442
Islamic Arts Museum Malaysia
2:445; 3:38
Jamek Mosque 2:440
Kompleks Nagaria 2:441
LUTH complex 2:442
Museum of Asian Art 1:265

National Art Gallery 1:265;
2:445
National Mosque 2:440
National Museum 2:442
Negara Mosque 1:191
Parliament House 2:441
Sulaiman Court 2:441
The Hexagon's 2:442
Kuba see Kuva
Kubachi 1:443, 464, 474
Kubadabad 1:120, 197, 200,
461; 3:81
Kuban, Doğan 2:399
Kubba see Quba
Kubeš, Ludjek 2:426
Kublai Khan see Qubilay
Kućanski, Boško 1:302
Kuching
High Court 2:441
Kučukalić, Alija 1:302
Kudsia Begum 2:283
Kudus
minaret 2:533
Kufa 1:79, 342; 2:400, 518
ceramics 1:446
governor's palace 1:78; 3:120
mosque (638) 1:73; 2:550
Kufesque see under scripts
kufic see under scripts
Kühnel, (Wilhelm) Ernst (Paul)
1:254, 358; 2:154,
400–01; 3:33
Kujačić, Mirko 1:302
Kula 1:363, 372
Kulab 1:389
Kulliyāt ("Complete works") of
Saʿdi
(1566; London, BL, Add. MS.
24944) 3:207
(c. 1603–4; Geneva, Prince
Sadruddin Aga Khan
priv. col.) 2:15, 416
Kulliyāt ("Collected works"; c.
1590; Hyderabad, Salar
Jung Mus.) of Sultan
Muhammad Quli Qutb
Shah 2:266
külliyes 2:401–2; 3:382
Kulliyyāt-i tārīkhī ("Historical
compendium"; 1415–
16; Istanbul, Topkapı
Pal. Lib., B. 282) 2:225
Kültepe 3:363
Kulyab 3:267
Kum (Azerbaijan)
basilica 1:237
Kum (Iran) see Qum
Kumar, Ram 2:8
Kumatgi 2:290
Kumkale 2:524
Kumkapu 1:216
Kumushtakin 1:303
Kun, A. L. 1:432
Kunst des Orients 2:56–7, 156,
363
Kunya-Urgench 1:365; 2:404;
3:364, 386
mausoleum of Turabeg
Khanum 1:397, 402
minarets 1:90
textiles 3:293, 307, 308
tomb of Najm al-Din Kubra
1:200, 402
Kurayyim, Sayyid 1:191
Kurbanov, Sukhrob Usmanovich
3:268
Kurbanshaid see Hulbuk

Kurds
jewelry 2:356–7
tents 3:275, 278
Kurgan-Tyube 3:267
Kurspahić, Nermina 1:302
Kurtiç, Melike 3:362
Kurucutepe 1:460
Kurut 1:405, 430
Kurzin, Mikhil Ivanovich 3:388
Kuseir see Quseir
Kushrabat
caravanserai 1:134
Kütahya 1:141; 2:523
ceramics 1:216, 468, 470,
473; 3:362
Kurşunlu Mosque 1:142
madrasa of Yaʿqub Çelebi
1:211
mosques 1:141
Pekmez Pazarı Mosque
1:142
tiles 1:216
Vacidiye Madrasa 1:143
Kuva 2:73, 404; 3:386
ceramics 1:404
Kuyumdzhioglou, Arghir 1:315
Kuwait 2:404–6
Kuwait City 2:405
Dar al-Athar al-Islamiyya
(Museum of Islamic
Art) 2:406; 3:36
Kuwait National Museum
and Library 3:36
Kuwait State Mosque 1:191
Museum of Islamic Art 1:498
National Museum 3:36
Tareq Rajab Museum 2:406;
3:36
Kuz-Balyk [Kuz-Ordu] see
Burana
Kuznetsov, Pavel 3:366
Kyrgyzstan 2:406–8, 407
architecture 2:407
historiography 1:434
museums and collections
2:408
painting 2:407–8
textiles 2:408
see also Central Asia
Labadye, Jean-Baptiste 1:509
Labban, Hedi 3:357
Labrouste, Henri 1:259
lac 1:358; 2:411; 3:314
La Canea see Chania
Lachenal, E. 1:474
lacquer 1:296; 500; 2:288,
411–2, 412
Lâdik 1:363, 371, 372, 372
Laforgue, Adrien 2:546
Lafuente, Julio 3:188
Laghych 1:244
Lagman see Khelaverd
Lagman Treasure see Uzun
Treasure
Lagos 3:54, 55
Abayomi Barber school
3:58
British Petroleum 3:55
Crusader House 3
Didi Museum 3:59
galleries 3:59
Gallery for Arts and Crafts
3:59
mosques 1:23
Municipal Primary School 3
National Gallery of Modern
Art 3:59

National Museum 3:58
St. Gregory's College 3:58
United Christian Commercial
Secondary School,
Apapa 3:56
Lagrange, Alexis de 3:117
Lah, Ljubo 1:302
Lahauri, Ustad Ahmad 1:489
Lahham, Rafik 2:363
Lahijan 1:206
Lahore 2:271, 413–15; 3:384
Alhamra Arts Council 3:92
Anguri Bagh Housing 3:93
art collections 3:97
Badshahi Mosque 1:187;
2:414, 552
carpets 1:367, 368; 3:95
coins 1:495
Faqir Khana Museum 3:97
fort 1:184, 185, 206; 2:413;
3:97
guns 1:222
jālīs 3:96
Lahore Museum 3:97
manuscripts 2:258
Mayo School of Arts see
National College of Arts
mosque of Shahi Begum 1:184
mosque of Wazir Khan 1:187
National College of Arts 3:96
Open Air Theater 3:92
Punjab University 3:93, 96
Shakir Ali Museum 1:53
Shalimar Garden 1:184; 2:79,
96, 413
Society of Contemporary Art
Galleries 1:265
textiles 3:319, 320
tomb of Jahangir 1:185
Water and Power
Development Authority
House 3:93
Lahore Landscape Movement
1:318; 3:94
Lai Lok Kun 2:442
Lajevardi 2:289
Lajim
tomb tower 1:90; 3:345
Lajin, Sultan (r. 1297–9)
(Mamluk) 1:332;
3:430, pl.XVI.3
Lajin Beg 3:327
lājvardīna ware see under
ceramics → wares
Lak 3:278
Lakhdar, Boujemaa 2:547
Lakhnautī see Gaur
Lal 1:282; 2:14, 15, 259, 415–
16, 427, 428; 3:353
Lambert, H. 2:319
Lamm, C. J. 2:154
lampblack 2:283
lamps 2:481
Lamu 1, 24; 2:379, 380; 3
Landowski, Paul 1:10
landscapes see under subject
matter
Lane, (Edward) Arthur 1:447;
2:118, 154; 3:416
Lane, E. W. 2:29, 153
Lane-Poole, Stanley 2:153
Langenegger, Felix 2:155
Langgar
mosque 2:439
Lanzhou 3:214
lapis lazuli 1:13; 2:99

Laplagne, Guillaume **2:**48
Laprade, Albert **2:**546
Laqabi ware *see under* ceramics →
 wares
Larache **2:**522
Lari, Yasmeen **2:**370, **417; 3:**93
Larisa **2:**128
Larwand
 mosque **1:**97
Lasciac, Antoine **2:**44
Lasdun, Denys **3:**55
Lasekan, Akinola **3:**57, 58
Lashkari Bazar **2:**417
 architecture **1:**83, 97–8
 Center Palace **1:**98–9
 ceramics **1:**457, 460
 mosque **1:**97
 North Palace **1:**99
 South Palace (Great Palace)
 1:98, 100–101, 205;
 2:214, 337; **3:**99
Lassner, J. **2:**129
Latakia **3:**262
Late Shah Jahan Album (1650s;
 dispersed) **2:**262
Latifi, Dr. Alma **2:**275
Latifov, Abuzar **1:**246
Laud, William, Archbishop of
 Canterbury **1:**499
Laud *Rāgamālā* (Oxford,
 Bodleian Lib., MS.
 Laud. Or. 149) **2:**264
Laurens, Paul-Albert, **2:**52
Laurent, Ernest **1:**279
Lavrenov, Tzanko **3:**122
Layla and Majnun (1583–98;
 Paris, Louvre, MS.
 MAO 713) by Nizami
 1:*310;* **3:***113*
Lazarov, Nikola **1:**314
Lazrak, Aziz **2:**546
Leach, Bernard **2:**47
lead **1:**447
 red lead **1:**144
Lear, Edward **3:**64, 70
leather **1:**217, 293,
 295–6, *297, 298,* 424;
 2:143; **3:**96, 200, 349
Lebanon **2:418–419**
Lebeña
 S. María **3:**4
Le Brujn, Cornelis **1:**434
Leck, Bart van der **3:**70
Lecomte de Noüy, Jean **3:**69, 70
Le Corbusier **1:**39, 49; **2:**19,
 272, 312
Lee Joo For **2:**445
Lee Kian Seng **2:**445
Legend of Farrukh and Huma *see*
 Destan-i Ferruh u Hüma
Léger, Fernand **1:**279
Le Gray, Gustave **3:**118
Legueult, Raymond **2:**315;
 3:165
Leh **3:**216
Leighton, Frederic **2:**544; **3:**69
Leipzig
 synagogue **2:**545
Lekit
 church **1:**237
Leko, Dimitrije **2:**426
Lemport, Vladimir Sergeyevich
 3:366
Lenkoran **1:**375
Leninabad *see* Khodzhent
Leningrad Album *see*
 St. Petersburg Album

Leo Africanus **3:**396
León
 Cathedral **3:**300
 S. Isidoro **3:**300
Leont'ev, Leonid **2:**377
Leont'yev, F. **1:**239
Leopold I, Emperor of Austria
 1:366; **2:**149
Le Prince, Jean-Baptiste **3:**68
Leptis Magna **2:**421
Le Puy
 Cathedral doors **3:**246
Lesseps, Ferdinand de **2:**45
Letur **1:**360
Leukos Limen *see* Quseir
Lévi-Provençal, Evariste **2:**154
Levni **2:**205, 255, 304, **419–20;**
 3:88, 243
Lévy, Léopold **2:**61, 322, 338;
 3:361
Lévy-Dhurmer, Lucien **3:**70
Lewis, John Frederick **1:**330;
 2:46, 544; **3:**69, 70
Lewis, Thomas Hayter **2:**545
Leyden, Rudolf von **3:**146
Leyre **3:**5
Lhote, André **1:**53, 279; **2:**61,
 286; **3:**7, 340
Liangzhou *see* Wuwei
Liberty & Co. **2:**514, 544
libraries **1:**293; **2:**420–21
Libya **2:421–3**
Liétor **1:**360
Lifij, Avni **1:**229; **3:**361
Lights of Canopus *see Anvār-i*
 Suhaylī
Lilanga, George **3:**271
Lilihan **1:**377
lime **3:**235
limewood **3:**340
Lindström, Sune **2:**405
linen **2:**25; **3:**294–6, *296,* 337,
 339
Linjan
 Pir-i Bakran **1:**194, 195, *195,*
 212, 280; **2:**293; **3:**211
 mihrab **2:**516
 stucco **1:**194–5, 212; **3:**237
Lion Silk **3:**299
Lion Strangler Silk **3:**300,
 pl.XI.1
Liotard, Jean-Etienne **3:**64, 68
Lisbon
 Calouste Gulbenkian Museum
 3:34
Lishman, Frank **1:**57
lithography **2:**248; **3:**127
Litvinskiy, B. A. **2:**39
liwans *see* iwans
Lixus **3:**547
Ljubović, Ibrahim **1:**302
Lleida **3:**300
Lobmeyr, J. & L. **1:**474; **2:**115
Lodis (*r.* 1451–1526) **2:**423
 see also Sikandar, Sultan
 (*r.* 1489–1517)
Lods, Pierre **3:**195
lohero (*Tecoma andulata*) **3:**439
loges **2:**462
Logroño
 Monasterio de Yuso-PP
 Agustinos Recoletos
 3:300
Lokman **2:**252–4
 see also Hunarnāma ("Book of
 achievements");
 Shāhanshāhnāma

("Book of the king of
 kings"); *Shāhnāma-yi*
 Salīm Khān ("Book of
 kings of Selim II");
 Zubdat al-tawārīkh
 ("Cream of histories")
London
 British Library **3:**33
 British Museum **3:**32–3
 ceramics **1:**443; **2:**118
 Brixton Academy **2:**545
 Central Mosque **1:**193
 Leighton House **2:**544; **3:**69
 Royal Botanic Gardens, Kew
 2:544
 Royal Panopticon of Science
 and Art **2:**545
 South Kensington Museum *see*
 Victoria and Albert
 Museum
 Victoria and Albert Museum
 1:499–500; **2:**275;
 3:30, 33
 ceramics **1:**443; **2:**58
 textiles **1:**264
Long Thien Shih, **2:**445
longhouses *see under* houses →
 types
Longquan **1:**486
Loo, Kington **2:**442
looms **1:**25
Lorck, Melchior **3:**284
Lorent, Jakob August **3:**118
Los Angeles CA
 County Museum of Art **2:**145;
 3:34
Lotto, Lorenzo **1:**361–2
Lotto carpets *see under* carpets →
 types
Louis XIII, King of France
 (*r.* 1610–43)
 guns **1:**222
Loulan **3:**214–15
Lovech bridge **1:**313
Lübeck **2:**114
 Marienkirche **3:**306
Lubennikov, Ivan Leonidovich
 2:408
Lucknow **1:**380
 metalwork **2:**513, 514
 State Museum **2:**274
 textiles **1:**325
Ludhiana **3:**320
Ludwig, Michael, Associates **3:**374
Luesia **3:**4
Lü Ji **2:**460
Luleburgaz
 complex of Sokollu Mehmed
 Pasha **1:**163–5
 mosque **1:**163
Lur **3:**278–279
lusterware *see under* ceramics →
 wares
Lutf ʿAli Ghulam **1:**223
Lutf ʿAli Khan **2:**408, **423–4**
Lutyens, Edwin **2:**6–7; **3:**414
Lyagman **1:**429
Lyautey, Hubert **2:**546
Lydda **1:**197
Lyell, Michael, Associates **3:**374
Maʿali ibn Salam **3:**423
Maʿarrat an-Nuʿman
 mosque **2:**532
Macedonia **2:425–7,** *425*
 architecture **1:**169; **2:**425–6
 jewelry **2:**427
 museums and collections **2:**427
 textiles **2:**426–7

maces **1:**217
Machuca, Pedro **2:**124, 125
Machilipatnam **1:**380; **3:**287
Macke, August **3:**70
McLean, W. H. **2:**350
McMullan, Joseph V. **2:**16
McMullan Carpet **1:**368
Mactaris *see* Makhtar
Madaba **2:**363
Madagascar
 textiles **1:**25
Madaʾin Salih **3:**189
Madali-khan (*r.* 1821–42)
 2:391
madder **1:**215, 364, 379, 416,
 2:386; **3:**295, 302,
 314
Madeghe, Job Andrew **3:**271
*madhhab*s **2:**164
Madhu **2:427–8**
Madhu Chela **2:**428
Madhu Kalan **2:**427–8; **3:**353
Madhu Khurd **2:**427–8
Madi, Hussein **2:**418
Madinat al-Zahra **1:**121–2, *122;*
 2:428–30, *429;* **3:**99
 ceilings **1:**226, 490
 ceramics **1:**445, 452
 Dar al-Jund **1:**156
 gardens **2:**89, 388
 ivory **2:**332 **3:**110
 metalwork **2:**485–6
 mosaics **1:**207–8
 Salón Rico **1:**121–2; **3:**427
 sculpture **1:**196
 wall paintings **1:**205
Madras **2:**530
 Government Museum and
 National Art Gallery
 2:275
 Kothari Building **2:**272
madrasas **1:**69; **2:430–33**
 Afghanistan **1:**98
 Central Asia **1:**133, 177–81
 Egypt **1:**108
 Iran **1:**89–90, 93–4; **2:***431*
 Iraq **1:**89–90, 113–15, *251*
 Morocco **1:**158–159, pl.III.4
 2:433, pl.XV.1
 Syria **1:**113–15, *114*
 Tunisia **1:**159–161
 Turkey **1:**118, pl.VII.1, 143,
 162–6; **2:**53
 Yemen **1:**153–155
Mafarrukhi, al- **2:**91
Mafraq **2:**486
Maghrib *see* Algeria; Morocco;
 Tunisia
Maghribi, Taher al- **2:**422
maghribī scripts *see under* scripts
Magius **3:**5
Maglova aqueduct **1:**166
Mago, Pran Nath **2:**8
Mahadba **1:**381
Maham Anga **2:**6
Mahan **2:433**
 shrine of Niʿmatallah Vali
 1:172; **2:**433; **3:**pl.V.2
 tomb of Khwaja Rabiʿ **1:**172
Mahares Bourdj Tonga
 ribāṭ **1:**85
Mahdi, al-, caliph (*r.* 775–85)
 (Abbasid) **2:**352, 471,
 472; **3:**146
Mahdi, al-, caliph (*r.* 909–34)
 (Fatimid) **1:**102, *493;*
 2:71, 433

Mahdia 1:102; 2:433–4, 519;
 3:356
 Burj al-Kabir 2:523
 ceramics 1:452
 city gate 1:196
 congregational mosque
 1:102–103, 103; 2:433,
 531
 textiles 3:300
Mahdi ʿAbbas (r. 1748–75)
 3:435
Mahdaoui, Nja 3:357, pl.XVI.4
Mahesh 2:434, 542
Mahjam 1:153
Mahmood, Sultan 3:97, 109
Mahmud (r. 998–1030)
 (Ghaznavid) see
 Mahmud of Ghazna
Mahmud (fl. 1540) 3:205
Mahmud I, Sultan (r. 1730–54)
 (Ottoman) 1:166;
 2:324; 3:433
Mahmud II, Sultan (r. 1808–39)
 (Ottoman) 1:167;
 2:402; 3:39, 88, 124
Mahmud al-Hafiz al-Husayni
 3:333
Mahmud al-Kurdi 3:392–3,
 pl.IX.2
Mahmud Bigara, Sultan (r. c.
 1458–c. 1511) 3:183
Mahmud Gawan 1:252, 285–6
Mahmud ibn al-Isfahani 1:214
Mahmud ibn Muhammad
 2:492–4
Mahmud ibn Murtaza al-
 Husayni 2:226
Mahmud ibn Sunqur 2:483,
 494, 495, 502
Mahmud ibn ʿUthman al-Irbili
 3:232
Mahmud Khan 3:64
Mahmud Mirza 1:350
Mahmud Muzahhib 1:56,
 406–407; 2:250, 261,
 434–5
Mahmud of Ghazna
 (r. 998–1030)
 (Ghaznavid) 1:98, 195,
 205, 493; 3:107–108,
 201, 417; 3:282
Mahmud Shah ibn Muhammad
 3:432
Mahmud Shah Khalji I
 (r. 1436–69) 2:458,
 459
Mahperi Khwand Khatun 2:374
Maibud 2:288
Maiduguri 3:56
maʾil see under scripts
maiolica 1:496
Majālis al-ʿushshāq
 ("Conferences of
 lovers"; 1606;
 Tashkent, Orient.
 Inst. Lib.) 2:250
Majid, Abdul 3:97
Majmaʿ al- tawārīkh ("Assembly
 of histories") by Hafiz-i
 Abru
 (c. 1405–47; Lucerne,
 Truniger Col.) 2:225
 (1425; Istanbul, Topkapı Pal.
 Lib., H. 1653) 2:204,
 225; 3:331
Majmūʿa al-mubārak ("Blessed
 compendium"; Ham,

Surrey, Keir priv. col.,
 MS.III.29–68; U.
 Sarajevo, Inst. Orient.
 Res.) 2:198
Majmuʿ-i menāzil
 ("Compendium of
 stages"; 1537–8;
 Istanbul, U. Lib., T.
 5964) by Nasuh
 Matrakçi 2:94, 204
Majnun of Herat 1:304
Majorelle, Louis 2:466
Makand 2:428
Makart, Hans 3:69
Makhtar 3:357
Makhzan al-asrār ("Treasury of
 secrets"; 1545; Paris,
 Bib. N., supp. pers.
 985) by Nizami 1:406
Makiya, Kanan 2:435
Makiya, Mohamed 1:191;
 2:290, 405, 435
Makka see Mecca
Makli
 tomb of Mirza ʿIsa Khan II
 1:353
Makonde 3:271
Makramat Khan
 1:185, 186
Maktub Khan 2:260
Malacca 2:435–6, 438, 442–443
 houses 2:440–441, 448
 mosques 2:439–440, 439
 Town Hall 2:441, 442
Málaga 2:436–7, 522
 Alcazaba 1:124, 155, 156;
 2:89
 ceramics 1:461, 469, 469;
 2:436, 437
 metalwork 2:486
 shipyards 1:156
 textiles 2:300
 tiles 3:8
Malani, Nalini 2:273
Malatya
 Great Mosque 1:117; 3:432
Malaysia 2:437–8, 437
 architecture 2:439–442, 439
 art education 2:448
 coins 2:445
 manuscripts 2:444
 metalwork 2:445–6
 painting 2:444–5
 sculpture 2:443–4
 textiles 2:447
 urban planning 2:442–3
 wood-carvings 2:448
Mâle, Emile 3:290
Mali 2:448–51
 architecture 1:23, 23–24;
 2:449
 painting 2:449–50
 sculpture 2:449–50
 textiles 2:449, pl.III.2, pl.XV.2
Malik 2:302
Malik, Abdul 2:46
Malik, Fuʾad Abdul 2:46
Malik, Jahanzeb 3:94
Malik Daylami 2:241; 3:39
Malik Ibrahim 2:345
Malikis 2:302, 307
Malik Muhammad
 (Danishmend) 2:374
Malikshah, Sultan (r. 1072–92)
 (Saljuq) 1:92; 2:91,
 477; 3:167
Malindi 1:22; 2:379; 3:259

Malinke 2:130
Malipiero 3:392
Malko Tŭrnovo 3:312
Mallorca
 ceramics 1:461
Mamay al-Sayfi 3:399, 400
Mambetullayer, M. 2:384
Mambeyev, Sabur 2:377
Mamedbeyli, N. 3:85
Mamedov, Mamed 3:367
Mamedov, T. 1:240
Mamluks (r. 1250–1517)
 2:164–6, 451–458
 architecture 1:147–52, 149,
 151, 209; 2:383, 457,
 525–6
 carpets 1:363–5
 ceramics 1:465–7
 emblems 2:145–6, 146, 452
 glass 2:113–16, 114, 146
 manuscripts 1:347; 2:211–13,
 211
 metalwork 2:456, pl.V.3,
 pl.XI.3, 504; 3:18,
 392–3
 textiles 3:305–307
 woodwork 3:430–31,
 pl.XVI.3
 see also Aybak, Sultan
 (r. 1250 57); Baybars I,
 Sultan (r. 1260–77);
 Qalaʾun, Sultan
 (r. 1280–90); Khalil,
 Sultan (r. 1290–94);
 Nasir Muhammad, al-,
 Sultan (r. 1294–1340,
 with interruptions);
 Kitbugha, Sultan
 (r. 1295–7); Lajin,
 Sultan (r. 1297–9);
 Baybars II, Sultan (r.
 1309–10); Shaʿban I,
 Sultan (r. 1345–6);
 Hasan, Sultan (r. 1347–
 51; 1354–61); Salih,
 Sultan (r. 1351–4);
 Shaʿban II, Sultan
 (r. 1363–76); Barquq,
 Sultan (r. 1382–99);
 Faraj, Sultan (r. 1399–
 1412); Muʿayyad
 Shaykh, Sultan
 (r. 1412–21); Barsbay,
 Sultan (r. 1422–38);
 Jaqmaq, Sultan
 (r. 1438–53);
 Khushqadam, Sultan
 (r. 1461–7); Qaʾitbay,
 Sultan (r. 1468–96);
 Janbalat, Sultan
 (r. 1500–01); Tuman
 Bey, Sultan (r. 1501);
 Qansuh al-Ghawri,
 Sultan (r. 1501–17)
Mamluk carpets see under carpets
 → types
Mamluk Revival 1:190; 2:47,
 76, 508, 509; 3:262,
 pl.IX.1
mamluks 2:162
Mammadov 1:214
Mammadova, A. 1:247
Mammadova, D. M. 1:244
Maʾmun, al-, caliph (r. 813–33)
 (Abbasid)
 architecture 2:351
 carpets 1:380

coins 1:492
manuscripts 1:231, 293
textiles 3:295
Maʿmun al-Bataʾihi 1:354
Manāfiʿ al-ḥayawān ("Usefulness
 of animals") by Ibn
 Bakhtishu
 (1297 or 1299; New York,
 Pierpont Morgan Lib.,
 MS M.500) 1:297, 498;
 2:76, 185, 198, 215,
 463; 3:116, 242,
 pl.XI.1
Manāfiʿ al-ḥayawān ("Usefulness
 of animals") by Ibn
 al-Durayhim
 (1354–5; Madrid, Escorial,
 Bib. Monasteria
 S. (Lorenzo) 2:212
Manama 1:253, 254
 Bayt al Qurʾan 1:253
Manar Mujida 2:530
Manasa
 mausoleum 1:402
Manchester
 John Rylands Library 3:34
Manda 1:22; 2:379
Mande
 masks 1:21
Mandu 2:270, 458–9, 529
 Jahaz Mahal 3:238
 palaces 1:139–40;
 2:458–9; 3:100
Manet, Edouard 3:65
manganese 1:199–200, 423, 444,
 448, 450, 455–6, 457
mango (Mangifera indica) 3:438
Maninka 2:449
Manisa 1:141–2
 complex of Murad III 1:165
 congregational mosque 1:142,
 142; 3:432, 432
 mosque of Hafsa Sultan 1:164
Manohar 1:270; 2:260, 459–60
Manou Degala
 mosque 1:23
Man Singh Tomar 3:100–01
Mansa Musa 3:328
Mansur 2:260, 368, 460–61
Mansur, caliph (r. 754–75)
 (Abbasid)
 architecture 1:79–80, 80, 250;
 2:352, 400, 471, 516,
 519; 3:98, 144
 mosaics 1:207
Mansur, al-, caliph (r. 946–53)
 (Fatimid) 2:71
 architecture 1:102; 2:366
Mansur, al-, vizier (d. 1002)
 1:124, 196, 505, 507,
 pl.XIII.1; 3:77, 427
Mansur, al- (fl. 1741) 3:435
Mansura (Pakistan) 1:76, 83, 485
Mansura, al- (Algeria) 2:522;
 3:340
 mosque 1:158
 palace 1:159
Mansur Bihbihani 2:223
Mansuriyya, al- 1:102, 196, 201;
 3:99, 397
 ceramics 1:452
 coins 1:493
 stained glass 1:209
Mansurov, Ya. 3:387
Manṭiq al-ṭayr ("Conference of
 birds") by ʿAttar 3:241

(1483; New York, Met., 63.210) **1:**287, 349, 497, *497*; **2:**190, 228, *229*, 244, 536; **3:**164, 256, 336
(1515; Istanbul, Topkapı Pal. Lib., EH 1512) **3:**284
Mantout, Maurice **1:**193
Manucci, Niccolas **3:**21
Manuchihr II (*r.* 1120–49) **1:**237, 255; **2:**521
Manuchihr Khan *see* Muhammad al-Dawla
Manuilova, Olga Maksimillianovna **2:**408
Manuk, P. C. **2:**275
manuscript illumination (non-representational decoration) **2:**185–91, *187, 188*, 395, pl.XIV.1; **3:**pl.XVI.2
manuscript illustration and miniature painting **2:**191–267
attributions **1:**504–505; **3:**232
collections **1:**201
display **1:**174
forgeries **2:**76–7
influence of European painting **1:**320; **2:**238
perspective **3:**116
regional traditions
Afghanistan **1:***44, 497*; **2:**148, 226, 227–8, *229*; **3:***337*
Africa **1:**24
Azerbaijan **1:**238
Central Asia **1:**395; **2:**192, 204, *205, 250, 388*
Egypt **2:**206, 211–2,*211*
India **1:**5–6, *5*, 11, *11*, pl.IX.1, *270*; **2:**234–237, *235*, 257–267, *259*, pl.VIII.2, *262, 263*; **3:***277*
Indonesia **2:**281
Iran **1:**pl.XI; **2:**192, 194, 214, 219, 223, 231–3, 238, 248, *188, 200, 203, 216, 217, 218, 224, 225, 227, 232, 245, 303*, pl.VII.1, pl.VII.3, pl.VIII.1; **3:***111, 113*, pl.IV, pl.VIII.3
Iraq **2:**208, 214, 219, 231–3, *26, 162, 197, 209, 210, 222*; **3:***283*
Nigeria **1:**pl.I.2
Malaysia **2:**444
Morocco **2:**pl.VII.2
Spain **2:**207, pl.VII.2; **3:**5, *5*
Syria **2:**208, 211, *211*
Turkey **2:**208, 233, 251, *94, 234, 253, 254, 317*; **3:***87, 283*, pl.I.3, pl.XI.1
see also albums; mounts
manuscripts **1:**292, 295
Manzandaran **1:***495*
Maqāmāt ("Assemblies") by al-Hariri **2:**243
(*c.* 1225–35; St. Petersburg, Acad. Sci., Inst. Orient. Stud., S. 23) **2:***26*, 192, 209, 212, 305; **3:**278, 281, 282, *283*

(Schefer Hariri; 1236; Paris, Bib. N., MS. arab. 5847) **1:**294, 356; **2:**194, 209; **3:**243
(1237; Paris, Bib. N., MS. arabe 5847) **2:**83, *210*, 420; **3:**47
(*c.* 1250; Istanbul, Süleymaniye Lib., Esad Ef. 2961) **2:**198
(late 13th century; London, BL, Or. MS. 9718) **2:**212
(1323; London, BL, Add. MS. 7293) **2:**212
(1333–4; Vienna, Österreich. Nbib., MS. A.F. 9) **2:**212
maqbara see cemeteries
Maqdisi, al- **1:**84, 319; **2:**477
Maqqari, al- **1:**196; **2:**505
Maqrizi, al- **1:**149, 205, 321; **2:**19, 27, 50, 152, 456, 502; **3:**305
Maqsud **2:**228
Maqsud of Kashan **1:**366
maqsuras **1:**208; **2:**461–462, *462*, 515; **3:**110, 241, 420
Maracanda *see* Samarkand
Maragha **2:**462–3
Gunbad-i Ghaff ariyya **2:**462–3; **3:**25
Gunbad-i Kabud (Blue Tomb) **1:**306; **2:**462
Gunbad-i Surkh (Red Tomb) **1:**66, 91, 94, 306; **2:**462
manuscripts **3:**pl.VIII.2
observatory **1:**129; **2:**462
Marand
caravanserai **1:**129
mosque **1:**92
Marawi
museum **3:**255
marble **1:**162, 193–94, 366; **3:**235
Marby Carpet **1:**361
Marçais, Georges **2:**153; **3:**463
marcasite **1:**458
Mardakan **1:**236; **2:**463–64
Mardin
congregational mosque **1:**29
palace **1:**116
Sultan Isa Madrasa **1:**228
Margilan **3:**386
Mari **3:**262
Maria-Theresa, Empress of Austria (*r.* 1741–80) **1:**499
Maʿrib
mosque of Sulayman ibn Dawud **1:**110; **3:**445
Mariette, Auguste **1:**330; **2:**49; **3:**117
Marilhat, Prosper **3:**70
Marinids (*r.* 1196–1465) **2:**464
architecture **1:**158; pl.III.4, *201*
see also Abu Yusuf Yaʿqub (*r.* 1258–86); Abu Yaʿqub Yusuf (*r.* 1286–1307); Abu Saʿid Uthman (*r.* 1310–31); Abul-Hasan ʿAli (*r.* 1331–48); Abu ʿInan Faris (*r.* 1348–59)

Markaryan, S. **1:**239
Marker, Jamshed **3:**97
Marker, Minoo **3:**97
markets **2:**464–65; **3:**377, 378
Central Asia **1:**69, 180
Marqab, al- **2:**526
marquetry **3:**419
Marrakesh **1:**22, 124–125, 156; **2:**465–66, 546
Abtan House **2:**546
Bab Dukkala Mosque **1:**198
al-Badi Palace **3:**100
Ben Yusuf Madrasa **1:**188, 196; **2:**433, pl.XV.1
Berrima Mosque **1:**188
bookbindings **1:**296
city walls **1:**58
Kutubiyya Mosque **1:**58–60, 124–126, 156, 188; **3:**75
capitals **1:**353
ceiling **3:**427
minaret **2:**532, pl.XVI.1; **3:**235
minbar **2:**535, pl.XVI.3; **3:***427*, pl.XVI.1
mosque of ʿAli ibn Yusuf **3:**427
Mosque of the Kasba **1:**127, 189
Muwassin Mosque **1:**188; **2:**466
Qubbat al-Barudiyyin **1:**59, 125, *125*, 194
Saʿdi necropolis **1:**189, *189*
shrine of Sidi Bel ʿAbbas al-Sabti **1:**188, 194
shrine of Sidi Ben Sulayman al-Jazuli **1:**160
windows **1:**210
Marrast, Joseph **2:**546
marriage **2:**304–305
Marshak, Boris Ilich **2:**466–67; **3:**115
Marsigli, Conte di **3:**288
Marteau, Georges **2:**154–7
Martin, Claude **1:**499
Martin, Fredrik **1:**374, 500; **2:**58, 154, **467**
Marv *see* Merv
Marwan I, caliph (*r.* 684–5) **3:**338
Marwan II, caliph (*r.* 744–50) **2:**139; **3:**298, 300, 338
Marwan Ewer **2:**483, 486
Mary *see* Merv
Marye, Georges **2:**58
Marzbānnāma ("Book of Marzban"; 1299; Istanbul, Archaeol. Mus., MS. 216) by Saʿd al-Din al-Varavini **2:**215
Masabiki, Niqula **3:**126
Masanja, John **3:**270
Mashamoun, Salih Abdou **3:**255
Mashhad **1:**91; **2:**467–8
carpets **1:**378; **2:**286; **3:**161, 163
ceramics **1:**292, 464; **3:**162
Imam Riza Shrine Museum **2:**289; **3:**36
shrine of Imam Riza **1:**9, 114, 171, 172; **2:**468; **3:**163, 209, 211
caravanserai **1:**162

Friday Mosque **1:**135, 171; **2:**467, 549; **3:***237*
mihrab **1:**199; **2:**467, 515
tomb of ʿAli ibn Musa al-Riza **1:**385
Mashhad-i Misriyan **1:**91
mashrabiyya **1:**257; **3:**244, 420, 430
masjids see mosques
Maskana *see* Balis
masks **1:**21; **2:**449
Maslama ibn Abdallah **2:**428
Masood, Jamila **3:**94
Massignon, Louis **2:**63, 311
Masson, M. Ye. **2:**369; **3:**289
Massoudy, Hassan **1:**352, pl.XIII.1; **2:**292, 468
Masters of the New East **3:**388
Masʿud I (*r.* 1116–55) (Saljuq) **2:**404
Masʿud I, Sultan (*r.* 1031–41) **2:**107, 417; **3:**327
Masʿud III, Sultan (*r.* 1099–1115) (Ghaznavid) **1:**98–99, *99*; **2:**108
Masʿudi, al- **1:**204; **2:**204, 205; **3:**148
Masʿud ibn Saʿd **2:**201
Masyaf **2:**468
Maṭāliʿ al-saʿāda ("Rising of auspicious constellations"; 1582–3; Paris, Bib. N., MS. supp. turc 242) **2:**255
Matba at al-Maʿarif **3:**127
Matcham, Frank **2:**545
Matira, al- **1:**80
Matisse, Henri **3:**70
Matmata **3:**355
Matsukata, Kōjirō **3:**415
Matti, Severino M. **3:**255
Maurand, Jérome **2:**95
Mauritania **2:**468–9
Mauritania **2:**547
mausolea **1:**pl.III.1, 89, *89*, 97, 98, 115, *130*, 395; **2:***45, 479, 547*
Mavlyanov, Ashurbay **3:**268
Mawlana Muhammad **3:**225
Mawlay Ismaʿil (*r.* 1672–1727) **1:**42; **2:**475, 522; **3:**100
mawṣilīn **3:**1
Mawsl *see* Mosul
maydāns **1:**404
Mayer, Leo Ary **2:**155, 314, **469–70**
Mayyafariqin *see* Silvan
Mazalić, Djoko **1:**301
Mazandaran
shrine of Abuʾl-Qasim **1:**385
Mazandarani, al- **3:**281
Mazar-i Sharif **1:**258
mausoleum of Muhammad Bosharo **1:**402
Mazel, Ruvim Moiseyevich **3:**366
Mazloum, Hisham al- **3:**374
Mazloum, Shafiq **3:**188
Mazote
S. Cebrián **3:**4
Mbari Art Club **3:**57, 59
M'Bengue, Gora **3:**195
Mbughuni, Louis **3:**270
Mecca **2:**158, 175, **470–71**, 305, *471*; **3:**405
cemeteries **1:**383
doors **3:**187

haram **1:**195; **3:**188
Ka'ba **1:**72, 110; **2:**304, 470–71, 483, 488; **3:**208, 231, 240
kiswa **3:**292, 294, 302, 305
Masjid al-Haram **1:**170; **3:**531, 549
mosaics **1:**207–8
orientation of mosques **1:**69; **2:**303
pilgrimage **2:**304
printing **3:**127
tomb complexes **1:**147
Umm al-Qura University **3:**188
Medd, Henry **2:**7
Medenine **3:**397
Mederdra **2:**469
Medici
 carpets **1:**363, 365
 ceramics **1:**443
Medina **2:**159, 175, **472–3,** 527, *305;* **3:**379, 405
 cemeteries **1:**384
 House and Mosque of the Prophet **1:**72–4, 75–6, 170, 503, *73;* **2:**472, 549–50, *473;* **3:**187, 231
 manāra **2:**531
 maqsura **2:**461
 mihrab **2:**395, 515
 minbar **3:**430
 mosaics **1:**207–8
 tomb of Muhammad **1:**384; **2:**549; **3:**208
 Mosque of the Prophet *see* House of the Prophet
 musalla **3:**32
 printing **3:**127
 tomb complexes [Architecture, VI, C, 1(a)]
Medina Azzahra *see* Madinat al-Zahra
Mediouna **1:**381
Medjidov, G. **1:**239; **3:**45
Medzhidov, G. **1:**239
Meftah, Muhammad ben **3:**357
Mehdi, Eqbal **3:**94
Mehdia **2:**522
Mehmandust **1:**517
Mehmed I, Sultan (*r.* 1403–21) (Ottoman) **1:**145, 146; **2:**41; **3:**382
Mehmed II, Sultan (*r.* 1444–6; 1451–81) (Ottoman) **3:**83
 architecture **1:**146, 163; **2:**41–2, 315, 316, 323–4, 326, 328, 330, 389, 401–2, 420, 523–4
 ceramics **1:**292–3, 468
 dress **3:**310
 manuscripts **1:**293, 497, 498; **2:**233–4, 253, 261
Mehmed III, Sultan (*r.* 1595–1603) (Ottoman)
 manuscripts **1:**252; **2:**254–5; **3:**87
Mehmed V Reşad, Sultan (*r.* 1909–18) (Ottoman) **2:**329
Mehmed Ağa **1:**42, 68, 162, 164; **2:**325–6, 402, 473–4; **3:**220, 222, 327, 434

Mehmed Arif **1:**498
Mehmed Dedezade **3:**446
Mehmed Esad Yesari *see* Esad Yesari
Mehmed Hilmi **3:**39
Mehmed Hulusi **2:**475
Mehmed ibn Ilyas **2:**254
Mehmed-i Siyah *see* Kara Memi
Mehmed of Bosnia **2:**474, 507
Mehmed Rasim **2:**474
Mehmed Sami *see* Sami
Mehmed Şefik **2:**474; **3:**39
Mehmed Şevki **2:**475
Mehmed Vedat Bey *see* Vedat
Mehmed Yirmisekiz Çelebi **2:**95
Mehmood, Khalid **3:**94
Mehta, N. C. **2:**275
Meinecke, Michael **2:**155, 475
Mekki, Hatem el **3:**356–7
Meknès **1:**42, 188–9; **2:**475–6, 546–8
 ceramics **1:**478, 547
 Dar Jamaï Museum **2:**548
 mosque of Lalla 'Awda **1:**188–9
 palace of Isma'il **1:**189; **3:**100
Melaka *see* Malacca
Mélanges de la Casa de Velázquez **3:**290
Melehi, Mohammed **1:**275; **2:**476, 547
Melikian-Chirvani, A. S. **2:**155
Mel'khisedekov, E. **1:**239
Melville, Arthur **3:**70
Memling, Hans **1:**361–2
Memling carpets *see under* carpets → types
Menander **1:**414
Mengim Berti al-Hajj al-Ahlati **2:**392
Mengli Giray I, Khan (*r.* 1466–1514 with interruptions) **1:**254
Menon, Anjolie **2:**8
Mequinez *see* Meknès
Meram
 Hasbey Hammam **1:**144
Mergenov, Erkin **2:**377
Mérida
 Alcazaba **1:**87; **2:**519
 Los Milagros **1:**88
Merinid *see* Marinid
Merport, I. **3:**273
Merson, Luc Olivier **3:**70
Merv **1:**92–4, 306, 389, 395–7, 432, *476;* **2:**521; **3:**216, 364–5, 366
 ceramics **1:**422–3
 citadel **1:**403
 coins **1:**492
 congregational mosque **1:**403
 cotton **1:**415
 governor's palace **1:**92; **3:**99
 Great Kyz-kala **3:**412–3, *412*
 houses **1:**83, 92–3, 99; **3:**412
 mausoleum of Sultan Sanjar **1:**93, 94, 395; **2:**478–9, *479;* **3:**342, 344
 metalwork **1:**409; **2:**491
 mosques **1:**403
 textiles **3:**297, 338
Mesas de Villaverde **3:**3
Mesha Stele **2:**364
Mesopotamia
 architecture **1:**79
 ceramics **1:**445–6
 manuscripts **2:**197–199, *197*

metalwork **2:479–515**
 regional traditions
 Afghanistan **2:**491, *493, 497*
 Azerbaijan **1:**244–5, *244*
 Bangladesh **1:**265
 Central Asia **1:**408–14; **2:**491, 496–7
 Egypt **2:**47, 486, 501–5, 508–9, pl.V.3; **3:**18–19
 Greece **2:**127–8
 India **2:**512, 515
 Iran **1:**318–320; **2:**487, 487–8, 491–8, 496–7, 497–8, 509–12, pl.XV.3, *487, 489, 490, 495, 509, 512*
 Iraq **2:**487, 498–501, *310, 487*
 Malaysia **2:**445–6
 Morocco **2:**505–6
 Pakistan **3:**96
 Spain **2:**485–6, 505–6, *487, 506*
 Syria **2:**486, 498–501, 501–5, 508–9, *310, 456, 499,* pl.V.3, *500, 509;* **3:**pl.IX.1, *18*
 Tuareg **3:**348–9
 Turkey **2:**491–2, 490, 507–8, *507*
 Turkmenistan **2:**491–2
 techniques
 casting **2:**480
 chasing **2:**480
 inlaying **2:**480–1
 raising **2:**480
 repoussé **2:**480
 ringmatting **2:**480
 sinking **2:**480
 Veneto-Saracenic **3:**392–3, pl.IX.2
 see also brass; bronze; gold; enamel; pewter; silver; tin; zinc
Metropolitan style **2:**204, 215, 216–7
Metta, Ebute **3:**56
Meybod **1:**477
Midian **3:**189
Miftāḥ al-ḥisāb ("Key to calculation"; 1427; St. Petersburg, Rus. N. Lib., MS. Dorn 131) by al-Kashi **2:**311; **3:**27, 334
Mi Fu **1:**484
Migeon, Gaston **2:**58, 154
Mihajlović, Josif **2:**426
Mihmandust
 tomb tower **1:**94
mihrabs **1:**69, 80; **2:515–7,** *515,* 549; **3:**241
 Egypt **1:***109*
 Iran **1:**90–1, *95,* 1–96; **3:***237, 443*
 Syria **1:***47*
 Tunisia **2:**pl.XVI.2
 Yemen **1:**110–1
 see also qibla
Mihr 'Ali **2:**117, 411, **517–8;** **3:**63–4, *132, 274*
 pupils **1:**36; **2:**106
Mihr and Mushtarī by 'Assar (1478; Washington, DC, Freer, 49.3) **2:**233

(1523; Washington, DC, Freer, 32.5/8) **1:**406; **2:**249
Mihrimah **3:**86, 219
Mihr Narseh **3:**184
Mijić, Karlo **1:**301
Mijliyya **1:**271
Mikhalyov, Andrey Nikolayevich **2:**408
Miknās *see* Meknès
Mikulić, Mario **1:**302
Milanov, Yordan **1:**314
Milas
 carpets **1:**371
 Great Mosque **1:**143, 363, 371
Miled, Tarak ben 356
Miletos *see* Balat
Miletus ware *see under* ceramics → wares
military architecture *see under* architecture → types
milk **3:**323
millefleurs carpets *see under* carpets → types
Millstein, Rachel **2:**314
Mimar **3:**360
mi'mār see architects
Mimi, Fuad **2:**363
Mimkakhani ibn Muhammad Amin **1:**403
Mina, al-
 ceramics **1:**445
mīnā'ī ware *see under* ceramics → wares
Minai, Ali **1:**247
minarets **1:**69, 71, 257; **2:**303, 530–34, 549; **3:**250
 Africa **1:**22–3
 Afghanistan **1:**98–9, 100–01, *99*
 Algeria **3:***134*
 Central Asia **1:**90, 179, *312*
 Egypt **1:**107, *235*
 India **2:***2*
 Iran **1:**89–90, 93–4, pl.VI.3
 Iraq **1:**113; **2:***531*
 Morocco **2:**pl.XVI.1
 Spain **3:**pl.XIII.1
 spiral minarets **1:**80
 Syria **1:**113
 Yemen **1:**111
minbars **1:**82–3, **534–6,** pl.XVI.1; **3:**241, 420, 429–31, *425, 426*
Mingachevir **1:**239, 243
miniature painting *see* manuscript illustration and miniature painting
Miniature style *see under* ceramics → wares
Minis, Tell **1:**455–6
Minoprio & Spencely **2:**405
Minorsky, V. F. **1:**435
Minta, Lassine **1:**23
Minto Album (Dublin, Chester Beatty Lib., MS. 7 and London, V&A, I.M. 8 to 28–1925) **1:**44, 519; **2:**119–20, 262; **3:**3, 46
Minton Ceramic Factory **1:**474; **2:**544
Minya **1:**208
Minya, El
 art school **2:**48
Mir Abu'l-Qasim **2:**14

miradors 1:257
Mīr Afẓal al-Ḥusaynī al-Tūnī *see* Afzal
Mirahmadov, Mirdadash 1:245
Miʿrājnāma ("Book of the ascension")
(*c.* 1436; Paris, Bib. N., MS. supp. turc 190) 2:201, 225; 3:240
Mirak 1:56, 286–7; 2:191, 228–30, 536
Mirak Husayn Yazdi 2:510
Mirak Mirza Ghiyath 2:10
Mirak Sayyid Ghiyath 1:182–3
Mir ʿAli Husayni Haravi 2:261, 536–7, 539
Mir ʿAli ibn Hasan al-Sultani 2:222, 345, 537
Mir ʿAli ibn Ilyas 2:537
Mir ʿAli Shir *see* ʿAlishir Navaʾi
Mir ʿAli Tabrizi 1:339, 349; 2:214, 537
Miran 3:214–5
Mir Chaqmaq 3:442
Mirdjavadov, M. 1:242
Miri, Muhammad Said 2:418
Mir ʿImad 1:351; 2:13, **537**
Mirjan 1:129; 2:344
Mirkhani, Hasan 2:287
Mirkhani, Husayn 2:287
Mir Khwand 1:131; 3:336
Mir Muhammad 1:179
Mir Muhammad Yusuf *see* Muhammad Yusuf
Mir Murad Khan 2:539
Mir Musavvir 1:63; 2:240, 258, **537–8**; 3:163
Miró, Joan 3:188
Miroshnichenko, Yu. 3:273
Mir Qasim 1:179
mirrors 2:538–9, *539*
Mir Sanʿi 3:160
Mir Sayyid Ahmad 1:43, 497; **2:539–40**
Mir Sayyid ʿAli 1:5; 2:240, 258, 537–8, **540–1**; 3:13, 163, 286
Mir-Ubaydulla 2:391
Miryam Zamani 1:184; 2:413
Mirza, Bashir 3:94
Mirza, Kerbalai 1:238
Mirza, Mehdi ʿAli 2:370; 3:92
Mirza ʿAli 2:240, 241, **541**; 3:258
Mirza ʿAziz Koka 2:264
Mirza Baba 2:117, 248, 411, **541–2**; 3:63, 132, 149, 274
Mirza Baba al-Husayni 2:248
Mirza Hasan 3:191
Mirza Kamran 2:257–8
Mirza Kuchik Khan 1:350
Mirza Mahdi Khan Astarabadi 3:16
Mirza Muhammad Haydar Dughlat 1:316–7, 406; 3:134
Mirza Muhammad Khan 2:464
Mirza Riza Khan *see* Richard, Jules
Mir Zayn al-ʿAbidin Tabrizi *see* Zayn al-ʿAbidin Tabrizi
Mirzmuratov, M. 2:384
Mirzoyam *see* Zhambyl
Mišević, Radenko 1:302
Miskin 2:14, **542–3**
Misr 3:294

Misrian 3:412
Mitsubishi Corporation 2:72
Mittwoch, Eugen 3:183–4
Mizdakhkan
 mausoleum of Muzlum Khan Sulu 1:402
mocárabes see muqarnas
Modigliani, Amedeo 3:356
Mogadishu 1:22; 2:379
 National Museum of Somalia 3:227
Moghul *see* Mughal
Moguer
 S. Clara 3:9
Mogum, Isavoy 2:391
mohair 3:293, 310
Mohamed, Raza 3:270
Mohammad, Nasiruddin 3:94
Mohammad, Sardar 3:93–4
Mohenjo-daro
 museum 3:93, 97
Mohidin, Abdul Latiff 2:443, 445
Moknine 3:357
Moldakhmetov, Asanbek 2:408
Moltke, Helmuth von 2:319
Mombasa 2:379–80; 3:259–60
Momchilov, Petko 1:314
Monastir 3:357
 ribāts 1:85–6
Monet, Claude 1:331; 2:49; 3:43, 415
Monghyr 1:224
Mongol conquest 1:410; 2:165
Mongolia
 tents 3:279–82
Monneret de Villard, Ugo 2:153, **543**
Monreale
 Cathedral 1:104
Mons Regalus *see* Krak de Monreal
Montagu, Lady Mary Wortley 2:94, 389; 3:88
Montani 3:89
Monteagudo
 Castillejo fortress 2:90
Montecassino Abbey 1:67
Montefiore, Sir Moses 2:349
Montpéreux, Dubois de *see* Dubois de Montpéreux
Montréal *see* Krak de Monreal
Monumental style *see under* ceramics → wares
Mookherjea, Sailoz 2:8
Mookherjee, Sir Asutosh 2:274
Moorcroft, William 3:320–1
Moore, Albert Joseph 3:69
Moore, Edward 1:500
Moore, Henry 3:188
Moorish style 2:543–5
Mopti
 Medical Assistance 2:449, 450
 mosque 1:23
Moradabad 3:384
Morgan, J. Pierpont 1:500; 2:16
Morgan, William De *see* De Morgan, William
Morgan *Beatus* (mid-10th century; New York, Pierpont Morgan Lib., MS. M. 644) 3:5
Morgan Carpet 1:368
Moritz, Bernhard 3:34, 183
Moroccan Association of Plastic Arts (AMAP) 2:476, 547

Morocco 2:545–8
 akhnif 2:30, *30*
 architecture 1:87, 102, 121, 155, 188; 2:545
 military 2:521, 522
 vernacular 3:394, 395, pl.XV.2
 art education 2:546
 calligraphy 1:345
 carpets 1:381, 382
 ceramics 1:461
 embroidery 3:314
 gardens 2:88
 houses 1:158
 jewelry 2:305
 madrasas 1:158, 2:pl.XV.1
 manuscripts 2:pl.VII.2; 3:pl. XVI.2
 mausolea 2:547
 metalwork 2:505
 minarets 2:pl.XVI.1
 minbars 2:pl.XVI.3
 mosques 1:126, 158, pl.II.2, pl.III.4; 2:pl.II.2
 shrines 3:209
 stained glass 1:210
 tents 3:278
 textiles 3:292
 tiles 1:201, 201
 tombs 1:189
 woodwork 3:427, 429
 see also ʿAlawis; Almohads; Almoravids; Berbers; Idrisids; Marinids; Saʿdis
Morocco City *see* Marrakesh
mosaics 1:75, 76, 207–8, 208; 3:371
mosaic tiles *see* tiles
Moschchevaya Balka 1:220, 414
Moscow
 All-Russia Research Institute for Restoration 1:438
 Institute of Archaeology of the Russian Academy of Sciences 1:438
 Kremlin Armory 1:438
 Museum of Eastern Culture 1:433
 Museum of Oriental Art 1:438, 440
 Pushkin Museum of Fine Art 1:438
 State Historical Museum 1:438
 Tretʿyakov Gallery 1:438
Mosesyan, A. G. 1:247
Moshi
 Sanaa Zetu 3:271
Moshiri, Farhad 2:287, **548**
Mosini, Giovanni Atanasio 1:356
mosque lamps 1:442, 472, 472; 2:113, 114, 146
mosques 1:69–71, 73, 190–2, 193; 2:78, **548–52**
 orientation of mosques 1:69; 2:303
 regional traditions
 Afghanistan 1:97
 Africa 1:22–4
 Albania 1:42
 Algeria 1:158, 60
 Central Asia 1:89, 179, 311; 3:331, pl.XV.2
 China 1:482, 484

Egypt 1:105–7, *106*, *107*, *151*, *191*, *332*, pl.V.1, pl.X.2
India 1:137–9, 182, *38*, *138*, *183*, *186*, *289*; 2:*414*
Indonesia 2:280, 281
Iran 1:81–3, 85, 90, 92–4, 96, 112, *83*, *90*, *175*; 2:*296*, *297*, *337*, *372*, *551*; 3:*263*, *331*
Iraq 1:80, 112, *113*
Israel 2:551
Malaysia 2:439, *439*
Mali 1:23
Morocco 1:158, *126*, pl.II.2; 2:pl.II.2
Saudi Arabia 3:*189*
Spain 1:*122*, pl.V.3; 3:pl. XIII.1
Syria 1:76, 112, pl.IV.2
Tunisia 1:85, 159, *30*, *86*, *160*
Turkey 1:117, 142, 145, 163, *113*, *142*, *143*, *164*, *165*, 260, *317*; 2:*42*, *552*; 3:*220*, *221*
Yemen 1:110, 153, *111*, *154*
types
 basilical 1:117
 congregational 2:549–52
 domed 1:153; 2:552
 festival *see musalla*s
 Friday *see* congregational
 four-iwan 1:92–96; 2:552
 hypostyle (Arab-type) 1:69, 73, 75, 503–4; 2:552
 T-plan 1:145
 see also maqsuras; mihrabs
mosque complexes *see külliyes*
Mostar
 bridge 1:169, 300, 307, *307*
 Vučjaković Mosque 1:163, 300
Mosul 2:526; 3:1–2, 376–7
 ʿAmadiya Mosque, al-minbar 1:280; 3:423
 architecture 1:116; 3:403
 houses 2:174
 manuscripts 2:208–9, *162*
 metalwork 2:498–9
 mosque of Nabi Jirjis 3:423
 mosque of Nur al-Din 1:112, *113*
 palace of Badr al-Din Luʾluʾ (Qara Saray) 1:116, **249**
 Shaykh ʿAbbas Mosque 1:169
 shrine of Imam ʿAwn al-Din 1:115; 2:500; 3:26
 shrine of Imam Yahya ibn al-Qasim 1:115
 shrines 3:209
 textiles 3:293, 307
mother-of-pearl 1:208; 3:433–4
mottled ware *see under* ceramics → wares
Moudarres, Fateh 3:2, 262
Moukhtar, Mahmoud *see* Mukhtar, Mahmud
Moulay Idris
 tomb of Idris 3:209, 341, *209*
Mould, Jacob Wrey 2:545
Mt. Nebo 2:363
mounts 3:2–3, *3*
Mour, Jean-Baptiste van 3:64, 68
Moustafa, Ahmad 1:352

Mozarabic art **1**:487; **3**:3–6, *5*
Msangi, Francis **3**:270
Msasani Workshop **3**:270
Mshatta **1**:75, 77, 194, 196, 305; **2**:153, 363; **3**:6–7, 33, 98, 120, *35*
 sculpture **1**:196
Mualla, Fikret **3**:7, 362, [Turkey, II: colour pl.]
Muar
 Jamek Mosque **2**:440
Muʿtamid, al-, caliph (r. 870–92) (Abbasid) **3**:179–80
Muʿawiya, caliph (r. 661–80) (Umayyad) **2**:160
 architecture **1**:74; **2**:347, 461; **3**:98
 minbars **2**:534
Muʿayyad al-Din al-ʿUrdi **2**:463
Muʾyyad Daʾud (r. 1296–1322) (Rasulid) **3**:306
Muʿayyad Shaykh, Sultan (r. 1412–21) (Mamluk) **1**:152, 335; **2**:19, 308, 503
Muʿazzam, al-, Sultan (r. 1218–27) (Ayyubid) **2**:348, 353, 397
Mubarakabad *see under* Delhi
Mubarakshah ibn Ahmad al-Dimishqi al-Suyufi **1**:347
Mubarakshah ibn Qutb Tabrizi **1**:346–7; **3**:441
Mubashshir ibn Fatik, al- *see Mukhtār al-ḥikam wa-maḥāsin al-kalim* ("Choicest maxims and best sayings")
Mucur **1**:363, 371–2
mud **1**:24; **2**:142–3, 449; **3**:401, 405–406, 407–8, 409
Mudabber, Muhammad **2**:286
mud-brick **1**:69, 81, 305; **2**:44–5; **3**:400, 406
Mudéjar **1**:122, 226; **3**:7–10, *9*, 303–4
Mudéjar Revival **2**:543–4
Mudurnu
 mosque of Yildirim Bayezid **1**:145
Muel **3**:8
Mufiz, ʿAbd al-Latif **1**:253
Mugahid, Sultan **1**:153
Mughals (r. 1526–1858) **2**:270–1; **3**:11–5
 albums **1**:44; **2**:261; **3**:2–3, *3*
 architecture **1**:182–7, 306; **3**:11
 carpets **1**:367–8
 coins **1**:494–5
 gardens **2**:95–7, 97; **3**:12
 jade **2**:341–2
 jewelry [Jewelry, II, F, 1]
 manuscripts and miniature paintings **1**:4–6, 268–70, 270, 497; **2**:204, 257–67, *259*, pl. VIII.2, *262, 264*; **3**:277
 metalwork **2**:512–4
 mirrors **2**:538–9
 mosques **1**:*183*; **2**:*414*
 pavilions **2**:*11*
 stucco **3**:pl.VII
 tents **3**:286

textile paintings **2**:pl.VI
textiles **3**:317–25
tombs **1**:31–2, pl.I.1, *33, 184*; **3**:*14, 343*
weapons **1**:223–4
see also Babur (r. 1526–30); Humayun (r. 1530–40, 1555–6); Akbar (r. 1556–1605); Jahangir (r. 1605–27; Shah Jahan (r. 1628–58); Awrangzib, Emperor (r. 1658–1707); Bahadur Shah, Emperor (r. 1707–12); Muhammad Shah, Emperor (r. 1719–48); Shah Bahadur II, Emperor (r. 1837–58)
Mughira, al- **1**:506; **2**:332, 333
Mughira casket **3**:77
Muğla **1**:141
Mug Tepe **3**:375
Muhamedov, Telman Yaminovich **3**:388
Muhammad (c. 570–632; Prophet) **2**:158–9, 301–2, 393, 530–1, 549–50; **3**:181, 341
Muhammad (r. 1200–20) (Khwarazmshah) **1**:309
Muhammad (*fl. c. 1320*) **2**:144
Muhammad (*fl. c. 1560*) **1**:183
Muhammad (r. 1612–26) (Qutb Shahi) **2**:179
Muhammad, Sultan (r. 1105–18) (Saljuq) **1**:92
Muhammad I (r. 852–86) (Umayyad) **1**:507
Muhammad I (r. 1358–75) (Bahmani) **1**:224, 252; **2**:131
Muhammad I, Sultan (r. 1232–72) (Nasrid) **1**:155; **2**:121, 122
Muhammad II, Sultan (r. 1272–1302) (Nasrid) **1**:155; **2**:121, 122–3, 536; **3**:48
Muhammad III, Sultan (r. 1302–8) (Nasrid), **1**:155–6; **2**:122–3, 505; **3**:48
Muhammad III ibn ʿAbdallah (r. 1757–90) (ʿAlawi) **1**:42, 188; **2**:466, 476, 522
Muhammad IV, Sultan (r. 1325–33) (Nasrid) **1**:156
Muhammad V, Sultan (r. 1354–9; 1362–91) (Nasrid) **1**:156, 205; **2**:78, 121, 124, 124–5; **3**:49
Muhammad VII, Sultan (r. 1395–1407) (Nasrid) **2**:123–4, 125
Muhammad, Sami **2**:405
Muhammad Abu al-Qasim Firishta **2**:96
Muhammad ʿAdil Shah (r. 1627–56) (ʿAdil Shahi) **1**:12; **2**:265
Muhammad Afzal **2**:263
Muhammad Ahmad **3**:61
Muhammad al-Dawla **2**:300
Muhammad al-Haravi **3**:163

Muhammad ʿAli (i) (*fl. c. 1600–10*) **3**:15–6
Muhammad ʿAli (ii) (*fl. 1645–60*) **3**:16
Muhammad ʿAli (*fl. 1772*) **3**:22
Muhammad ʿAli (r. 1805–48) **1**:47–8, 328, 335, pl. X.2, 509; **3**:126
Muhammad ʿAli Inoyaton **1**:422
Muhammad al-Muhtasib al-Najjari **2**:499
Muhammad al-Nasir (r. 1199–1214) **3**:340
Muhammad al-Salih **1**:447
Muhammad al-Washshaʾ **2**:225
Muhammad Amin al-Rushdi **2**:140
Muhammad ʿAmin Mashhadi **2**:262
Muhammad ʿAsafi *see Dastān-i Jamāl va Jalāl* ("Story of Jamal and Jalal")
Muhammad Baqir (i) (*fl. 1750s–1760s*) **1**:54; **3**:16
Muhammad Baqir (*fl. 1796*) **2**:105
Muhammad Baqir (ii) (*fl. c. 1800–30*) *see* Baqir
Muhammad Bey **3**:354
Muḥammad bin ʿUmar Shaykh Farid **1**:444
Muhammad Darvish **1**:407
Muhammad Faqirallah Khan **2**:263
Muhammad Hadi **1**:54; **2**:248
Muhammad Hakim **2**:63–4
Muhammad Hasan Afshar **2**:313; **3**:16–17
Muhammad Hasan Khan **1**:4; **3**:17, 63
Muhammad Husayn Kashmiri **1**:350
Muhammad Husni **2**:140
Muhammadi **2**:21, 149; **3**:17, 243
Muhammad ibn ʿAbd al-Wahhab **2**:182
Muhammad ibn ʿAbd al-Wahid **2**:491
Muhammad ibn Abi Tahir **1**:8, 9, 10; **2**:516
Muhammad ibn Abi Talib al-Badri **2**:209
Muhammad ibn Abu Bakr **1**:237
Muhammad ibn ʿAli **3**:431
Muhammad ibn ʿAli Rabati **2**:546
Muhammad ibn Allal **2**:546
Muhammad ibn al-Zayn **2**:483, 502–3, pl.V.3, 538; **3**:*18, 18*
Muhammad ibn Atsiz al-Sarakhsi **2**:479
Muhammad ibn Aybak ibn ʿAbdallah **1**:35, 36
Muhammad ibn Fattuh **2**:500, 505
Muhammad ibn Hasan al-Mawsili **2**:501
Muhammad ibn Hawlan al-Dimishqi **2**:392
Muhammud ibn Ibrahim *see* Nasir al-Rammali al-Sivasi
Muhammad ibn Khayrun al-Maʿafari **2**:366

Muhammad ibn Khutlukh **2**:499, 500
Muhammad ibn Mahmud **1**:402
Muhammad ibn Mahmud Shah Khayyam **1**:3
Muhammad ibn Mubadir **2**:455
Muhammad ibn Muhammad ibn ʿAli **2**:198
Muhammad ibn Muhammad ibn ʿUthman al-Tusi **2**:392
Muhammad ibn Muʿayyad al-ʿUrdi **1**:463
Muhammad ibn Saʿid Abiʾl-Fath ʿAbd al-Wahid **2**:208
Muhammad ibn Shams al-Din al-Ghuri **3**:336
Muhammad ibn Sunqur al-Baghdadi **2**:502, 502, 508
Muhammad ibn Takish (r. 1200–20) (Khwarazmshah) **2**:145
Muhammad ibn Tughluq **3**:99
Muhammad ibn Yusuf al-Tabrizi **1**:402
Muhammad ibn Yusuf ibn ʿUthman al-Hisnkayfi **2**:208
Muhammad ibn Zayyan **2**:333
Muhammad Ibrahim **3**:22
Muhammadiyya
 minbar **3**:424
 mosque of Kucha-Mir **3**:210
Muhammadiyya, al- *see* Rayy
Muhammad Jaʿfar **2**:51; **3**:19
Muhammad Juki (1402–44) (Timurid) **1**:497; **2**:226; 257; **3**:329
Muhammad Karim Khan (r. 1750–79) (Zand)
 architecture **1**:175, *176*; **2**:528; **3**:206, 448
 gardens **2**:92
 lacquer **2**:411
 painting **3**:19–20, 63, 448–9; **2**:105, *106*
 regalia **3**:149
Muhammad Kazim **2**:51
Muhammad Khan **2**:262
Muhammad Khudabanda **2**:243
Muhammad Muhsin **1**:174
Muhammad Muqim **1**:408
Muhammad Murad Samarqandi **1**:407; **2**:249, 250
Muhammad of Kashan **1**:475
Muhammad-Paolo Zaman **3**:21
Muhammad Qasim **2**:244, 245; **3**:19, 21
Muhammad Quli, Sultan (r. 1580–1612) (Qutb Shahi) **2**:179, 266; **3**:141
Muhammad Riza **1**:477
Muhammad Riza al-Imami **1**:174
Muhammad Riza Isfahani **2**:92
Muhammad Riza Nawʿi *see Sūz va gudāz* ("Burning and melting")
Muhammad Riza Shah (r. 1941–79) (Pahlavi) **3**:14; 274
Muhammad Sadiq **1**:54; **2**:248, 411; **3**:19–20, 63, 448
Muhammad Salih **1**:400

Muhammad Shadi *see Fathnāma*
 ("Book of conquests")
Muhammad Shafiʿ **2:**44; **3:**20
Muhammad Shah (r. 1834–48)
 (Qajar) **1:**3; **2:**106;
 3:16–7, 133, 150
Muhammad Shah, Emperor
 (r. 1719–48) (Mughal)
 2:263
Muhammad Shah, Sultan
 (r. 1442–51) **3:**183
Muhammad Sharif **1:**5, 407;
 2:250; **3:**20
Muhammad Sharif Kirmani
 1:376
Muhammad Shaybani, Khan
 (r. 1500–10)
 (Shaybanid) **1:**178,
 287; **3:**203
Muhammad Shirin **3:**21, 64
Muhammad Siyah Qalam **1:**517;
 2:21; **3:**225
Muhammad Sultan (d. 1403)
 (Timurid) **3:**176
Muhammad Taqi **3:**204
Muhammad Tughluq, Sultan
 (r. 1325–51) (Tughluq)
 1:519; **2:**3; **3:**286, 350
Muhammad Vasfi **2:**474
Muhammad Yusuf **2:**244–5;
 3:21
Muhammad Zaman **1:**54; **2:**240,
 243–4, 245, 411;
 3:21
Muhanna, Fawaz **2:**362
muhaqqaq see under scripts
Muharraq **1:**253
Muharraqi, Abdullah al- **1:**253
Muhibb ʿAli **1:**287; **2:**241
Muhibbi *see Dīvān* (collected
 poems)
Muhsinzade Abdullah **3:**39
Muʿin **2:**21, 83, 244–5, 411;
 3:22–3, 243
Muʿin Khan **1:**184
Muʿizz, al-, caliph (r. 953–75)
 (Fatimid) **1:**324, 493,
 494; **2:**71, 334
Muʿizz al-Din Kaiqubad, Sultan
 (r. 1287–90) **2:**3, 95;
 3:23
Muʿizz al-Din Mubarak Shah
 (r. 1421–34) (Sayyid)
 1:5; **3:**191
Muʿizz al-Din Muhammad ibn
 Sam (r. 1203–6)
 (Ghurid) **2:**270
Muʿizzi (r. 1206–90) **3:**23
 see also Qutb al-Din Aybak,
 Sultan (r. 1206–10);
 Iltutmish, Sultan
 (r. 1211–36); Ghiyath
 al-Din Balban, Sultan
 (r. 1266–87); Kaiqubad
 (r. 1287–90)
Muʿizz ibn Badis, al- (r. 1016–
 62) (Zirid) **1:**293, 295,
 340; **2:**284, 366, 431;
 3:105, 427, 452–3
Mujadžić, Omer **1:**302
Mujezinović, Ismar **1:**302
Mujezinović, Ismet **1:**302
Mujur *see* Mucur
Mukalla, al- **2:**175
Mukha, al- **2:**306
Mukhitdinov, Albek **2:**408
Mukhlis **2:**263

Mukhtar, Mahmud **1:**331; **2:**46,
 48, 418; **3:**23–4, 43
*Mukhtār al-ḥikam wa-maḥāsin
 al-kalim* ("Choicest
 maxims and best say-
 ings") by Mubashshir
 ibn Fatik, al-
 (13th century; Istanbul,
 Topkapı Pal. Lib., A.
 3206) **2:**198
Mukund **3:**24
Mulla, Hassan al- **3:**137
Mulla ʿAla al-Mulk Tuni **1:**187
Mulla ʿArif **2:**140
Mulla Bihzad **1:**408
Mulla Muhammad ʿAli al-Fadli
 3:140
Mulla Muhammad Tabrizi **2:**537
Mulla Sadiq *see* Muhammad
 Sadiq
Müller, Leopold Carl **3:**69
Müller, Georgina Max **2:**329
Müller, William James **3:**69
Multan **1:**137, 139; **3:**24–5
 ceramics **3:**95
 leather **3:**96
 tomb of Khalid ibn Walid
 1:99–100
 tomb of Rukn-i ʿAlam **1:**139;
 3:344
 tomb of Shadna Shahid **1:**139
 tomb of Shah Shams Sabzavari
 1:139
 tomb of Shaykh Bahaʾ al-Din
 Zakariya **1:**139
 tombs **1:**137, 139; **3:**25
Mumbai
 Kanchenjunga Apartments
 2:273
 metalwork **2:**514
 Prince of Wales Museum of
 Western India **2:**275
Muʾmin Jahangiri **2:**342
Mumtaz, Kamil Khan
 2:415; **3:**93
Mundhir, al- (r. 569–82)
 (Ghassanid) **3:**158
Mundi, Muhammad **3:**374
Mundy, Peter **2:**3
Munif, al- **1:**67
Munʿim Khan **2:**345
Munir **3:**20
Munir, Hisham **2:**290
Mūʾnis al-aḥrar (1341;
 Cambridge, MA,
 Sackler Mus., 1960
 186) by Ibn Jajarmi
 3:283
Muntasir, al-, caliph (r. 861–2)
 (Abbasid) **3:**298
Muntasir, al- (r. 1434–5)
 (Hafsid) **1:**160
Munts, V. **1:**239
Müntz, Johann Heinrich **2:**544
Muqaddasi, al- **1:**61; **2:**107, 129,
 487, 488; **3:**75
muqarbas see muqarnas
muqarnas **1:**70, 306, 653; **3:**25–
 30, 229, 235, 237–8,
 244–5
 Egypt **1:**107–9; **3:**28
 Iran **1:**88–9, 91, 95, 130,
 135–6, **2:**pl.VI.3; **3:**25,
 26, 27
 Iraq **1:**2
 Kazakhstan **3:**27, 358–9, *359*
 Sicily **1:**103–4, *104*

Spain **1:**156; **3:**28, *31*
Syria **1:**116
Turkey **3:**27, *29*
Muqarnas (journal) **2:**156, 364
Muqtataf, al- **2:**63
Muqtadir, al-, caliph (r. 908–32)
 (Abbasid) **2:**83; **3:**295
Murabitun, al- *see* Almoravid
Murad I, Sultan (r. 1360–89)
 (Ottoman) **1:**317; **2:**41,
 339; **3:**352
Murad II, Sultan (r. 1421–44)
 (Ottoman)
 architecture **1:**145, 317; **2:**41;
 3:121
 metalwork **2:**498
Murad III, Sultan (r. 1574–95)
 (Ottoman) **3:**86–7
 architecture **2:**42, 306, 317,
 328
 carpets **1:**364–5
 gardens **2:**94
 manuscripts **1:**340, 504;
 2:552–5; **3:**3, 79–80,
 86–7, *87*, 111
Murad IV, Sultan (r. 1623–40)
 (Ottoman) **2:**328;
 3:434
Murad Daylami **2:**243
Muradogly, Ashraf **1:**242
Muradov, Shirin **3:**387
murals *see* wall painting
Muraqqaʿ-i gulshan ("Album of a
 rose garden" (Gulshan
 Album); Tehran,
 Gulistan Pal. Lib., MSS
 1663–4) **1:**4, 7, 43–4,
 64, 290, 519; **2:**260–1,
 263, 380, 460; **3:**3
Muratowicz, Sefer **1:**499
Murdoch Smith, Sir Robert
 1:499–500; **3:**30
 ceramics **1:**55, 443, 478; **2:**58
Müridoğlu, Zühtü **1:**267;
 3:30–32, 361, 362
Murphy, James Cavanah **2:**152,
 544
Murrah, Al **3:**278
Murray, Kenneth **3:**57, 58
Murshidabad **1:**380; **3:**319
Murtiza Quli Khan **1:**28
Musabayev, Mukhtar Nabiyevich
 3:388
Musafa ʿIzzat *see* Mustafa İzzet
Musafa Raqim *see* Mustafa
 Raqim
musalla **1:**80, 92; **3:**32
musalsal see under scripts
Muscat **3:**66–7
 Armed Forces Museum **3:**67
 Omani French Museum **3:**67
Muscat and Oman *see* Oman
museums **3:**32–8
 Afghanistan **1:**19
 Algeria **1:**51
 Bangladesh **1:**255–6
 Central Asia **1:**436–8
 Egypt **2:**49
 India **2:**274–5
 Kazakhstan **2:**378
 Kyrgyzstan **2:**408
 Macedonia **2:**427
 Nigeria **3:**58–9
 Pakistan **3:**97–8
 Russia **1:**437–8
 Saudi Arabia **3:**189
 Senegal **3:**195

Tanzania **3:**271
Turkey **3:**363, pl.XII.2
Müşfik, Mihri **3:**65, 362
Musharrahat **1:**81
Mushatta *see* Mshatta
Mushqara *see* Nevşehir
Musić, Sead **1:**302
Musil, Alois **3:**140
Muslim (d. 875) **2:**302
Muslim (fl. c. 1000) **1:**453; **3:**38
Muslim ibn Quraysh, Prince
 (ʿUqaylid) **3:**26
muslin **3:**1, 293, 318–9
Musmar, Hanna **3:**104
Mustafa I, Sultan (r. 1617–23
 with interruption)
 (Ottoman) **2:**373
Mustafa II, Sultan (r. 1695–
 1703) (Ottoman) **3:**133
Mustafa III, Sultan (r. 1757–74)
 (Ottoman) **1:**315
 architecture **1:**166
 calligraphy **3:**446
 coins **1:**495
Mustafa IV, Sultan (r. 1807–8)
 (Ottoman) **3:**39
Mustafa, Ghulam **3:**94
Mustafa, Ibrahim **3:**374
Mustafa Ağa **1:**164; **3:**38–9
Mustafa ʿAli **1:**227, 294, 504;
 2:253, 255, 536; **3:**202,
 205
 see also Nuṣratnāma ("Book of
 victories")
Mustafa Darir *see Siyār-i Nabī*
 ("Life of the Prophet")
Mustafa Dede Shaykhzada
 1:348
Mustafa Fadil **1:**498
Mustafa İzzet (1801–76) **2:**474;
 3:39
Mustafa Izzet Yesarizade
 (d. 1849) **1:**351; **3:**446
Mustafa Raqim **1:**351; **3:**39, 180
Mustafa Vasif **3:**39
Mustafayev, R. **1:**242
Müstakil Ressamlar ve
 Heykeltraşlar Birliği *see*
 Association of
 Independent Painters
 and Sculptors **3:**340
Mustaʿli, al-, caliph (r. 1094–
 1101) (Fatimid) **1:**493;
 3:296, 337
Mustansir, al-, caliph (r. 1036–
 94) (Fatimid) **1:**105;
 2:71, 324, 352; **3:**256,
 339, 422
Mustansir, al-, caliph (r. 1226–
 42) (Abbasid) **1:**115,
 251; **2:**210, 431; **3:**423
Mustansir, al-, caliph (r. 1249–
 77) (Hafsid) **1:**160
Mustaqimzade **1:**340
Mustaʿsim, al-, caliph (r. 1242–
 58) (Abbasid) **2:**210;
 3:441
Mutahhar of Kara **2:**96
Muʿtamid, al- (r. 1069–91)
 2:89; **3:**180, 197, 198
Muʿtasim, al-, caliph (r. 833–42)
 (Abbasid) **2:**161
 architecture **1:**82, *82*; **2:**161;
 3:177, 179
 coins **2:**274
 gardens **2:**87

stained glass **1**:209; **2**:116, 325, 351
wall paintings **1**:204
Mutawakkil, al-, caliph (r. 847–61) (Abbasid) **2**:87
 architecture **1**:67, 80; **2**:87, 472, 531, *531*
 gardens **2**:8
 mosaics **3**:177
 tents **3**:177–179
Mutawakkiliyya, al- **3**:178–179
Muʿtazilism *see under* Islam
Mutiʿ, al-, caliph (r. 946–74) **2**:302
Muwahhidun, al- *see* Almohad
Muwyidūn, al- *see* Almohad
Muzaffar al-Din, Shah (r. 1896–1907) (Qajar) **2**:285; **3**:274
Muzaffar al-Din Mahmud ibn Yaghıbasan **2**:374
Muzaffar ʿAli **2**:241, 243; **3**:39–40, 160, 163, 225
Muzaffar ibn Hibatallah al-Mufaddal al-Burujirdi **3**:224
Muzaffar ibn Muzaffar al-Tusi, al- **1**:230
Muzaffarids (r. 1314–93) **3**:40
 manuscripts **2**:219, 222; **3**:207
 see also Qutb al-Din Shah Mahmud (r. 1358–75); Shah Shujaʿ (r. 1364–84)
Muzaffar Shah, Sultan (r. 1445–59) **2**:447
Muzaffar Yusuf, al-, Sultan (r. 1250–95) (Rasulid) **1**:154, 295; **2**:482
Mwanza
 Sukuma Museum **3**:271
Mydzhum **3**:375
Myers, George Hewitt **1**:500, **3**:34, 40–41
Mymensingh **1**:264
 Zainul Abedin Sangrahasala **1**:265
Mzab Valley **1**:22, 49
Nabaʿa, Nazir **3**:262
Nabataean **1**:341
Nabeul **1**:479; **3**:357
 museum **3**:357
Nabiogly, I. **1**:255
Nablus **1**:148
Naci, Elif **3**:361
Nada, Hamid **1**:331; **2**:46, 48
Nad ʿAli
 minaret **1**:98
Nadhr Muhammad **1**:179, 180
Nadim, al- **1**:294, 342; **3**:105
Nadira Begum **2**:262
Nādir al-ʿAsr *see* Farrukh Beg; Mansur
Nadir Shah (r. 1736–47) **1**:15; **2**:468; **3**:149, 286, 327
Nadr Bi Arlat **1**:178
Nadr Divan Begi Arlat **1**:309, 400; **3**:172
Nafahāt al-uns ("Fragrant breezes of friendship"; 1604–5; London, BL Or. MS. 1362) by Jami **2**:260, 383, 428
Naghi, Mohammed **1**:331; **2**:46; **3**:23, 43
Nagi Aliyev **1**:244
Nagori, Abdul Rahim **3**:94

Nahavand **2**:355
Naʾin **3**:43
 carpets **2**:288
 ceramics **1**:478; **2**:288
 congregational mosque **1**:89, 90, 306, 319; **3**:43
 maqsura **2**:461, *461*
 mihrab **1**:90; **2**:515
 minbar **3**:435
 stucco **3**:236
 palace **1**:171; **3**:43, *44*
Najaf
 cemetery **1**:384
 shrine of ʿAli **1**:89; **2**:516; **3**:209, 211, 341
Najibabad **3**:384
Najjar, Ibrahim al- **2**:418
Najm-al-Din Hasan Dihlavi *see Dīvān* (collected poems)
Najm al-Din ʿUmar **2**:499
Najran **3**:187, 405, 406
Nakhchyvan **1**:237, 434; **3**:45
 ceramics **1**:243
 Musical Dramatic Theater **1**:239
Nakkaş Osman *see* Osman
Nama(n) **3**:46
Namara, al- **1**:341
*namāzgāh*s **1**:404
Namudlyg **1**:480
Nanha **1**:290; **2**:261; **3**:45–6, 353
Napoleon I, Emperor of the French (r. 1804–14) **1**:328; **2**:518
Napoleon III, Emperor of the French (r. 1852–70) **2**:348
Naqsh, Jamil **3**:46–7, 94
Naqshabandi, Munib al- **3**:261
Naqsh-i Rustam
 congregational mosque **1**:319
Narimanbekov, Togrul F. **1**:242
narrative art
 see under subject matter
Narshakhi, al- **1**:316; **3**:375
Nash, John **2**:544
Nashid, Sabry **2**:47
Nashid, Samir **2**:47
Nasir (family) **3**:405
Nasir, al-, caliph (r. 1180–1225) (Abbasid)
 architecture **1**:116; **3**:26
 sculpture **1**:196
Nasir al-Din (r. 1201–22) (Artuqid) **2**:197
Nasir al-Din (r. 1500–10) (Khalji) **1**:299
Nasir al-Din, Shah (r. 1848–96) (Qajar) **2**:58; **3**:30, 132–3
 architecture **1**:177; **2**:528; **3**:273
 crown **3**:149
 dress **2**:36
 gardens **2**:92
 lacquer **2**:300
 manuscripts and paintings **2**:106, 248, 313; **3**:16–17, 64, pl.I.3
 photography **3**:118, 200
 regalia **3**:150
Nasir al-Din al-Tusi **2**:462
Nasir al-Din Mahmud (Artuqid) **2**:499
Nasir al-Rammali al-Sivasi **2**:233

Naṣir-i efkâr **1**:229; **3**:361
Nasir-i Khusraw **2**:129, 347; **3**:138, 156, 295
Nasir Muhammad, al-, Sultan (r. 1294–1340, with interruptions) (Mamluk) **2**:454
 architecture **1**:149, 326, 333, 334; **2**:432
 glass **2**:115
 heraldry **2**:146
 metalwork **2**:502, 508; **3**:72
 textiles **3**:306
 woodwork **1**:385
naskh see under scripts
Nasʾr **1**:243
Nasr, Sultan (r. 1308–13) (Nasrid) **1**:155; **2**:122
Nasr al-Din Mutatabbib *see* Nasrullah al-Tabib
Nasrids (r. 1230–1492) **3**:48–9
 architecture **1**:155, *157*; **2**:pl.V.1
 ceramics **1**:469
 gardens **2**:90
 metalwork **2**:*506*
 see also Muhammad I, Sultan (r. 1232–72); Muhammad II, Sultan (r. 1272–1302); Muhammad III, Sultan (r. 1302–8); Nasr, Sultan (r. 1308–13); Ismaʿil I, Sultan (r. 1313–25); Muhammad IV, Sultan (r. 1325–33); Yusuf I, Sultan (r. 1333–54); Muhammad V, Sultan (r. 1354–9; 1362–9); Muhammad VII, Sultan (r. 1395–1407); Yusuf III, Sultan (r. 1407–17); Abu ʿAbdallah Muhammad XI (r. 1482–3)
Nasrullah al-Tabib **1**:346
Nasser Sabah al-Ahmed al-Sabah, Sheikh **1**:498
nastaʿliq see under scripts
Nastalus **1**:230, *230*
Nasuh Matrakçı **2**:204; **3**:49
 see also Majmuʿ-i manāzil ("Compendium of stages"); *Tārikh-i fath-i Şikloş ve Ustūrğun ve Ustunibelgirād*; *Tārikh-i Sultān Bāyazid* ("History of Sultan Bayezid")
Natanz **1**:90; **3**:49–50
 congregational mosque **1**:90, 306–7, 319
 minaret **2**:532
 khanaqah **2**:382; **3**:120
 shrine of ʿAbd al-Samad **1**:130, 131, pl.VI.1; **2**:517; **3**:26, 49, *50*, 211, 238
Natavan, Khurshud-banu **1**:241, 246
Nater **2**:232
National Cottage Industries Corporation (NCIC) **3**:270
National Organization for Conservation of

Historic Monuments of Iran (NOCHMI) **2**:286
natron **3**:295
Nauraspur **1**:12
Navagat **2**:399
Navarra
 church **3**:8
Navoi **3**:387
 khanaqah of Qasim Shaykh **1**:400
 mausoleum of Mir Sayyid Bahram **1**:396
Navvab, M. M. **1**:241, 246
Nawar, Ahmad **2**:47
Nawash, Ahmad **2**:363
Nayin *see* Naʾin
Nayini, Malekeh **2**:287
Nayriz
 congregational mosque **1**:319; **2**:337
Nayshābūr *see* Nishapur
Nazif, Mehmed **3**:233
Nazir, Mohammed **3**:94
Ndembo, Peter Paul **3**:270
N'Diaye, Iba **3**:194, 195
N'Diaye, Serigne **3**:195
Nebo **2**:363
Nebit-Dag **3**:365–366
Nédroma **1**:51
 minbar **2**:535, **3**:427
 mosque **1**:59, 125
Negmatov, N. **1**:316; **3**:375
Negroponte **2**:525
Nehru, Jawarhalal **2**:8
Neidhardt, Juraj **1**:301
Neizvestny, Ernst **3**:366, pl.XIV.1
Nemencha **1**:381
Neo-Sudanese style **2**:449
Neshat, Shirin **3**:50–51
Nestorović, Bogdan **2**:426
Nevjestić, Virgilije **1**:302
Nevşehir
 mosque **1**:166
Nevşehirli Ibrahim Pasha *see* Ibrahim Pasha
New Culture Studio **3**:58
New Gourna **1**:190, *191*
New Group **2**:338; **3**:362
New Navarino **2**:525
New Style *see under* scripts
Newton, Charles Murdoch **3**:30
New Vision group **2**:72, 291
New Wing Group **3**:362
New York
 Brooklyn Museum **3**:34
 Casino Theater **2**:545
 Central Park bandstand **2**:545
 Islamic Cultural Center **1**:193, pl.III.2
 Masonic Mecca Temple **1**:72
 Metropolitan Museum of Art **1**:500; **2**:58; **3**:34
 New York Public Library **3**:34
 Nordness Gallery **1**:266
 Temple Emanu-El **2**:545
N'Gom, Alexis **3**:195
Niamey
 Musée National du Niger **3**:52
Nicaea *see* Iznik
niches **1**:91
 see also muqarnas; mihrabs
Nicholas II, Tsar of Russia (r. 1894–1917) **3**:118, 445

Niebuhr, Carsten 2:152; 3:51, 445
niello 2:481
Nigari see Haydar Ra'is
Niğde
 Ak Medrese 1:143
 Alaeddin Mosque 1:117, 145
 Şah Mosque 1:143
 Sungur Bey Mosque 1:143, 198
 tomb of Hüdavend Hatun 1:144
Niger 3:52
Nigeria 3:53–9, 53
 architecture 1:24, 3:54–6
 art education 3:58
 collections 3:58
 houses 3:55
 manuscripts 3:60
 museums 3:58
 painting 3:56–7
Nihāyat al-su'l wa'l-umniyya (1366; Dublin, Chester Beatty Lib., Add. MS. 1) by Isa ibn Isma'il al-Aqsara'i 2:199
Nikaia see Iznik
Nikken Sekkei 2:45
Nikolayev, Aleksandr Vasilyevich 3:388
Nikoljski, Aleksandar 2:426
Nikolov, Nikola 1:314
Niksar 1:117–119, 141
 tomb of Hacı Cikirik 1:119
 Yaghibasan Madrasa 1:118
nim (Azadirachta indica) 3:438
Ni'matallah ibn Muhammad al-Bawwab 1:134
Ni' matnāma (c. 1500; London, BL, Orient. & India Office Lib., MS. Pers. 149) 2:449
Nimri, Kuram 2:363
Niono
 Great Mosque
Nioro du Sahel 2:449
Nisa 1:229, 389; 3:364
 glass 1:427–8
 namāzgāh 1:93
Nisar, Qudsia Azmat 3:94
Nishapur 2:288; 3:59
 ceramics 1:217, 441, 445, 450, 451, 457, 463–4, 464, 485; 3:72
 coins 1:425, 426, 492, 493
 glass 1:112
 houses 1:83, 90
 jewelry 2:355
 metalwork 2:487, 491
 niches 1:91
 rock crystal 3:154
 stucco 1:90; 3:25
 Tepe Madrasa 1:90
 textiles 3:338
 veils 2:26
 wall paintings 1:205
Nishapur Ewer 2:487
Nishat Bagh 2:96–7
Niyazov, Saparmurat see Turkmenbashi
Nizamabad 3:96
Nizam al-Din Shami 1:131
Nizam al-Mulk 1:92, 93; 2:430, 431, 462; 3:167
Nizami
 see also Haft paykar ("Seven portraits"); Khamsa

("Five poems"); Khusraw and Shirin; Makhzan al-asrār ("Treasury of secrets"); Layla and Majnun; Sharafnāma ("Book of the noble")
Nizami (family) 3:442
Nizami 'Arudi see Chahār maqāla
Nizam Shahis (r. 1490–1636) 3:60
Nizari 1:41
Nizwa 2:527; 3:66
N'jamena 1:480
NOCHMI see National Organization for Conservation of Historic Monuments of Iran
Nogay 3:281
Nointel, Charles Olier, Marquis de 1:232
Norman, A. C. 2:441
Normans
 architecture 1:103
Nouakchott 2:469
Nour, Amir I. M. 3:255
Nour, A. S. Ali 3:448
Nour Collection 1:501
Novigov, Maksim Yevtatyevich 3:388
Novi Pazar
 Altun-alem Mosque 3:197
Novogrudok 2:114
Novy, Aleviz 1:254
Nri
 museum 3:58
Nsukka school 3:57
Ntiro, Sam 3:270
Nubia 3:60–61
 see also Egypt; Sudan
Nujūm al-'Ulūm ("Stars of the Sciences"; 1570–71; Dublin, Chester Beatty Lib.) 1:11; 2:265
Nukha 1:245
Nukus
 Karakalpakiya Museum of Art 3:388
Numankadić, Edin 1:302
Numizmatika i epigrafika 1:433
Nur al-Din (r. 1146–74) (Zangid)
 architecture 1:46, 113, 113, 115, 513, pl.VI.2; 2:88, 134; 3:1, 27, 144, 449
 inscriptions 2:535
 minbar 1:47; 2:353, 535; 3:423, 431
Nurali, Byashim 1:366
Nurata 3:388
Nurek 3:267
Nuritdinov, Sirodzhiddin 3:268
Nur Jahan, Empress 1:31, 185; 2:413; 3:230
Nur Muhammad Tajikhan 1:180
Nurse's Koran 1:345
Nurymov, Makhtumkuly 3:367
Nuṣratnāma ("Book of victories") by Mustafa 'Ali (1582; London, BL, Add. MS. 22011) 2:255
(1584–5; Istanbul, Topkapı Pal. Lib., H. 1365) 2:253; 3:87, 284

Nusrat Shah, Sultan (r. 1519–31) 2:98, 237
Nuwayri, al- 3:305
Nuzhat asrār al-akhbār dar safar-i sigitvār (chronicle of the Szigetvár campaign; 1568–9; Istanbul, Topkapı Pal. Lib., H. 1339) by Ahmed Feridun 2:252; 3:79–80
Nuzi, Allegretto 3:306
Nwoko, Demas 3:57, 58, 59
oak 3:420
oak bark 1:419
Obigarm 3:267
Obralić, Salim 1:302
Obraztsov, Vladimir Vitalyevich 2:407
Oburdon 1:430; 3:424
Odinayev, Valimad 3:268
Odoric of Pordenone 1:129
Oea see Tripoli (Libya)
Oelsner, Gustav 2:322
Offamilio, Gualtiero, Archbishop 3:102, 303
Ögedey Khan see Chaghatay Khan
ogee arch 1:67
Ohrid 2:425
 houses 3:426
 National Museum Retirement Home 2:427
oil painting 3:63–5
 Afghanistan 3:16–17
 Algeria 1:49–51
 Azerbaijan 1:241, pl.IX.2
 Bangladesh 1:263–4
 Bosnia and Herzegovina 1:301–2
 Egypt 2:46–7
 India 2:273, pl.X.1
 Iran 2:106, 286–7; 3:63–4, pl.I.1, pl.I.3
 Iraq 2:290–01, 291
 Kazakhstan 2:377
 Kyrgyzstan 2:407–8
 Lebanon 2:418–19
 Malaysia 2:444–5
 Mali 2:450
 Nigeria 3:56–7
 Pakistan 3:93–4
 Senegal 3:194
 Sudan 3:254–5
 Tajikistan 3:267–8
 Tanzania 3:270–01
 Tunisia 3:256–7
 Turkey 2:24; 3:64–5, pl.I.2, 361–2
 Turkmenistan 3:366–7
 Uzbekistan 3:387–8
Okeke, Uche 3:57, 59
Okna TadzhikTA 3:267
Öküz Mehmed Pasha 1:39
Okyay, Necmeddin 2:13; 3:65, 107, 180, 361
Ol'denburg, S. F. 1:432–3
Olearius, Adam 1:434
oliphants 2:334, 335
Olmer, L. J. 1:477
Oloron
 hospital of San Blas 3:8
Olumuyiwa, Oluwole 3:56
Omar, Fauzan 2:445
Omar-khan (r. 1816–21) 2:391
Omdurman 3:61, 254
 Niliem Mosque 1:23

Omorkulov, Mirza 2:408
Oña 3:301–2
Onabolu, Aina 3:57
Onat, Emin 2:322; 3:67, 360
Onat, Hikmet 1:229; 2:338; 3:361
One-dimension group 2:291; 3:165
Onn, Patrick Ng Kah 2:445
Onobrakpeya, Bruce 3:57, 59
Onsi, Omar 2:362, 418
onyx 2:99
opus de Melica 2:437
Oraifi, Rashid 1:253
Oran 1:49
 art school 1:50
 Demaeght Museum 1:51
oratories 1:69
Orayid, Abdul Karim 1:253
Orchard see Būstān
Orchha 2:529; 3:101
Oren-kala see Baylaqan
Orfa see Urfa
organdy 3:293
Orhan, Sultan (r. c. 1324–60) (Ottoman) 1:145, 317; 2:338
Oriental Art 2:364
Orientalism 1:49–50, 71–2, 167; 3:67–70
Oriental Ceramic Society 2:57
ornament and pattern 3:71–8
 see also arabesque; Beveled style; guilloche; saz
Oron
 museum 3:58
orpiment 2:284
Orr, P., & Sons 2:360
Ortaköy see Istanbul
Ortukid see Artuqid
Orvieto
 S. Margarita 2:114
Osh
 Historical and Regional Museum 2:378
 theater 2:107
Oshogbo 3:53, 57
Oskan, Yervant 3:362
Osman 2:139, 252; 3:79–80
Osman II, Sultan (r. 1618–22) (Ottoman)
 manuscripts 1:39
Osman III, Sultan (r. 1754–7) (Ottoman)
 architecture 1:166; 2:329
Osman, Ahmed 2:47, 48
Osman Hamdi 2:322, 323; 3:34–5, 64, 65, 80, 89, 361, 363, pl.I.2
Osmanli see Ottoman
Osmanov, Abdinaj 2:408
Otrar 1:387, 429, 430, 434; 3:80–81, 412
Otto, Frei 2:471
Otto-Dorn, Katharina 3:81
Ottoman Court carpets see under carpets → types
Ottoman Painters, Association of see Association of Ottoman Painters
Ottomans (r. 1281–1924) 2:166–7; 3:81–89
 albums 1:44; 2:251, 254; 3:2, 3
 architecture 1:70, 71, 145–7, 161–70, 312–13; 3:82–6, 88

arms and armor **1:**_218,_
 220–22, _223_
banknotes **1:**266
baths **1:**162, 165–6, 271–3
bookbindings **1:**298
bridges **1:**306–7, _307_
calligraphy **1:**348, 351,
 pl.XII.1
caravanserais **1:**162–3
carpets **1:**363–5, _364_
cenotaphs **2:**pl.XII.1
ceramics **1:**470–74; **3:**pl.III.1
coins **1:**494–6, _495_
dress **1:**pl.XIV.4; **2:**22–4, 28,
 29–31, 31–3
fountains **1:**166–8, _166, 167_
furniture **2:**pl.IV.1
gardens **2:**93–5
glass **2:**116
houses **1:**312–13; **3:**408–9
ivory **2:**335
jade **2:**342
jewelry **2:**357
kiosks **1:**166, _166;_ **2:**320–21,
 321; **3:**83, _83_
madrasas **1:**163–4, 169
manuscripts **1:**496–8; **2:**_94,_
 204–5, 233–4, 238–40,
 251–6, _253, 254, 317,_
 320, 321; **3:**82, 83,
 85–7, _87,_ 285
metalwork **2:**506–8, _507_
mosques **1:**145–7, _146,_
 161–9, _164, 165, 169,_
 259–60, _260,_ 317, _317;_
 2:41–2, _42,_ 164, 552,
 552; **3:**218–22, _220–21_
palaces **2:**315–16, _316,_
 318–19, _318_
rock crystal **3:**154–6, _155_
tents **3:**284–6
textiles **3:**309–12, pl.II.2,
 pl.XI.1
thrones **3:**pl.X.1
urban development **3:**382–4
wall paintings **1:**206
windows **1:**209–10
woodwork **3:**433–4, pl.X.1
see also Orhan, Sultan (_r. c._
 1324–60); Murad I,
 Sultan (_r._ 1360–89);
 Bayezid I, Sultan (_r._
 1389–1402); Mehmed I,
 Sultan (_r._ 1403–21);
 Murad II, Sultan (_r._
 1421–44); Mehmed II,
 Sultan (_r._ 1444–81);
 Bayezid II (_r._ 1481–
 1512); Selim I, Sultan
 (_r._ 1512–20); Süleyman
 the Magnificent, Sultan
 (_r._ 1520–66); Bayezid,
 Prince (_d._ 1561); Selim
 II, Sultan (_r._ 1566–74);
 Murad III, Sultan (_r._
 1574–95); Mehmed III,
 Sultan (_r._ 1595–1603);
 Ahmed I, Sultan (_r._
 1603–17); Mustafa I,
 Sultan (_r._ 1617–23)
 with interruption);
 Osman II, Sultan (_r._
 1618–22); Murad IV,
 Sultan (_r._ 1623–40);
 Ibrahim, Sultan
 (_r._ 1640–48); Mustafa II,
 Sultan (_r._ 1695–1703);

Ahmed III, Sultan
 (_r._ 1703–30);
 Mahmud I, Sultan
 (_r._ 1730–54); Osman
 III, Sultan (_r._ 1754–7);
 Mustafa III, Sultan
 (_r._ 1757–74); Selim III,
 Sultan (_r._ 1789–1807);
 Mahmud II, Sultan
 (_r._ 1808–39);
 Abdülmecid, Sultan
 (_r._ 1839–61);
 Abdülaziz, Sultan
 (_r._ 1861–76);
 Abdülhamid, Sultan
 (_r._ 1876–1909);
 Abdülmecid, Crown
 Prince (1868–1944);
 Mehmed V Reşad,
 Sultan (_r._ 1909–18)
Oualata **2:**469; **3:**396
Oued, El **1:**22
 carpets **1:**51
Oujda **1:**159
Oukaïmeden **2:**547
Oulad Naïl **1:**382; **3:**278
Ouseley, Sir Gore **1:**499; **3:**19
Ouseley, **2:**248, 411, 518, 541;
 3:184
Oviedo **3:**4, 300
Ovissi, Nasser **2:**287
Ovumaroro Studio **3:**57, 58
Oxford
 Ashmolean Museum
 1:268; **3:**34, 150
Oxus Treasure **1:**438
Oyelami, Muraina **3:**57
Öz, İlban **2:**330
Özkan, Hüseyin **3:**362
Ozmo, Danijel **1:**302
Özsoy, Ihsan **1:**10; **3:**30, 362
Özyazıcı, (Mustafa) **1:**233; **2:**13;
 3:89, 361
Paccard, André **2:**155
padauk **3:**420
Padshāhnāma ("History of the
 emperor"; 1657–8;
 Windsor Castle, Royal
 Lib., MS. HB.149) **1:**6,
 256–7, 291, 519;
 2:262, 263; **3:**15, 48,
 114, 144
Padua
 ceramics **1:**443
Paganini, Paganino de' **3:**125
Pahlavi _see_ Riza Shah Pahlavi
 (_r._ 1925–41);
 Muhammad Riza Shah
 (_r._ 1941–79)
painting (architecture) **1:**90–91,
 202–6
painting (easel) _see_ oil painting
painting (enamel) _see_ enamel
 painting
painting (miniature) _see_ manu-
 script illustration and
 miniature painting
painting (mural) _see_ wall painting
painting (oil) _see_ oil painting
painting (truck) _see_ truck
 painting
painting (wall) _see_ wall painting
Pakatan Reka **2:**441
Pakistan **3:**91–8, _92_
 architecture **1:**97, 99;
 3:91–2, _92_
 art education **3:**96–97

art legislation **3:**97–8
 basketry **3:**95
 carpets **3:**95
 ceramics **3:**95
 jewelry **3:**96
 leather **3:**96
 manuscripts **2:**_259_
 metalwork **3:**96
 museums and collections
 3:97–8
 painting **3:**93–4
 Sāmiyānās **3:**96
 sculpture **3:**94–5
 tāziyās **3:**95–96
 textiles **3:**95–96
 tombs **3:**96
Pakistan Environmental
 Planning and
 Architectural
 Consultants **3:**92
palaces **1:**70; **3:**98–101
 Afghanistan **1:**98–9
 Africa **1:**22
 Central Asia **1:**180–1, _181,_
 395, 396, 397–8, _398,_
 401, 402, 403–04
 Egypt **1:**105
 India **3:**99–101
 Iran **1:**90, 129; **2:**_294,_ 298–9,
 299; **3:**43, 44, 98,
 99–101, _101,_ 161–4,
 pl.V.1, 207, pl.VI.2
 Iraq **1:**1–2, _2,_ 115–16
 Jordan **3:**33, _35_
 Spain **1:**121–2, _122,_ 155–7,
 157; **2:**120, 121,
 122–5, _123,_ pl.V.1
 Syria **1:**76–7, 115; **2:**134–5,
 135
 Tunisia **1:**85
Palencia **2:**332, 505
Palermo **1:**102–103
 calligraphy **1:**344
 Cappella Palatina **1:**103–04,
 104; **3:**102–03
 ceiling **1:**205, 383; **2:**83;
 3:148
 frescoes **2:**354
 ivories **2:**334
 muqarnas **1:**103–04, _104;_
 3:28
 Cathedral **1:**103–04
 Cuba **1:**104; **2:**388
 Cubola **2:**388
 Favara **1:**103
 mosques **1:**103, 104
 Palazzo dei Normani
 1:103–04; **3:**102–03
 Aula Verde **1:**104
 S Cataldo **1:**103
 S Giovanni degli Eremiti
 1:103
 S Maria dell'Ammiraglio
 1:103
 textiles **3:**293, 301, pl.X.2
 Ziza Palace **1:**104, 115; **2:**86,
 88; **3:**28
Palestine **3:**103–4
 see also Israel; Jordan
Pallás y Puig, D. Francisco **2:**76
Palmyra **2:**215, 216
Pamplona casket **3:**77
Panah ʿAli Khan **3:**211
Panch _see_ Pendzhikent
Panderen, Egbert van **3:**22
Pandua
 Adina Mosque **1:**138, 139

Panek and Knezarek **1:**301
Panipat
 mosque **1:**182
Paniter, K. C. S. **2:**273
Panj Ganj ("Five treasures";
 1520 and 1603–4;
 Dublin, Chester Beatty
 Lib., MS. 20) by Jami
 2:264
Panjikent _see_ Pendzhikent
Pankrat'yev, G. A. **1:**432
Panteri **2:**422
paper **1:**292–3, 294–5, 336,
 338–9; **3:**104–7
papercuts **3:**107–8, _108_
papier-mâché **1:**500; **2:**411; **3:**96
Para-Mamluk carpets _see under_
 carpets → types
Parameswara **2:**435, 438
Paramonov, Aleksandr **1:**432
parchment **1:**294–6, 336,
 338–9, 343, 345
Pariab, Ali and Husein **1:**247
Pari Mahal **1:**187
Paris
 Association pour l'Etude et la
 Documentation des
 Textiles d'Asie **1:**264
 Bibliothèque Nationale **3:**33
 Cité des Arts **1:**266
 Grand Mosque **1:**193
 Insitut du Monde Arabe
 3:34
 Musée des Arts Décoratifs
 3:36
 Musée du Louvre **3:**33
 Musée Guimet **1:**19
Parish, Capt. **3:**282
Parispur, Shahrnush **3:**51
Partabgarh **2:**360
Partav _see_ Barda
Parvez, Ahmad **3:**93, 109
Parvis, Giuseppe **2:**508
Paržík, Karlo **1:**301
Pasha, Ahmad Zaki **2:**63
Pasha, Hüseyin Zekaî **3:**65
Pasha, Naeem **3:**97
Pasha, Osman Nuri **3:**200
pashm **3:**293
pashmina **3:**320
Pasić, Nusret **1:**302
Pasini, Alberto **3:**70
pasteboard **3:**70
pastoralism **2:**104
Patan **1:**360
Patna **3:**353, 384
patronage **2:**306–8; **3:**109–14,
 255
 architecture **1:**71, 177–8
 manuscripts **2:**235
 metalwork **2:**491–2, 499, 502
pattern _see_ ornament
 and pattern
pavilions _see_ kiosks
Payag **2:**262, _262;_ **3:**114
Payette, Tom **3:**93
Payette Associates **2:**370
Pazarören **1:**119
 tomb of Melik Gazi **1:**119
Pazyryk **2:**357, 359
 carpet **1:**357, 359
Peacock Throne **2:**513; **3:**327
Pearson, J. D. **2:**168
Peçin **1:**141
 baths **1:**70
 Menteseid Üçgöz Caravanserai
 1:144

palace **1:**144
Yelli Mosque **1:**142
Peco, Mustafa **1:**302
Pecovski, Dusko **2:**426
Peć **3:**197
Pécs **2:**178, 544
mosques **2:**544
Pei, I. M. **3:**36, 136
Peile, General **1:**57
Peintres Orientalistes Français
2:58
Pektin, Bekir **3:**361
Pella **1:**445
Pelsaert, Fransisco **2:**538
Pen, Semyen **1:**239, 255
Peñalba
S. María **3:**5
Penang **2:**442
Cathedral of the Assumption
2:441
Civil Service buildings **2:**441
Kapitan Keling Mosque **2:**439
St. George's Church **2:441**
pen-boxes **2:**481–2, *495*
pencase **1:**339
Penchaud, Michel Robert **1:**509
Pendzhikent **1:**386, 389; **2:**466;
3:115–16, *267*, 412
palace **3:**413
temples **3:**115
wall paintings **1:**204, 409, 414
woodwork **1:**430
Pengkalan Bujang **2:**113
Peninsular Artists' Movement
2:445
pens **1:**339
peori **2:**193
Perčinlić, Ljubomir **1:**302
Pergamon **3:**363
see also Bergama
periodicals *see* journals
Perlingieri, Mario **1:**28
Perry, William **2:**370; **3:**93
Persepolis **2:**288; **3:**231
congregational mosque
2:550–52
Persepolis carpet **2:**288
Persia *see* Iran
Persian (language) **1:**211, 348;
2:55, 56
Persian knots **2:**32
perspective **2:116**
Peshawar **1:**394; **3:**95, 97
Museum **3:**97
Peter the Cruel, King of Castile-
León (*r.* 1350–69) **3:**8,
199
Peter the Great, Emperor of
Russia **1:**366; **2:**149
Petkov, Dusko **2:**426
Petra **2:**363
petrography **2:**156, 157
Petrović, Roman **1:**301
Petrovsky, N. P. **1:**432
Peul *see* Fulani
pewter **2:**446
Peytel Cup **2:**482
Philadelphia (Jordan) *see* Amman
Philadelphia, PA (USA)
Museum of Modern Art **1:**264
University of Pennsylvania,
University Museum
3:34
Philip II of Macedonia **3:**121
Philippopolis *see* Plovdiv
photography **3:116–20,** *279*
Piano, Renzo **3:**183

Piazza Armerina **1:**77
Picasso, Pablo **3:**356
Piccinato, Luigi **2:**320
picture-format carpets *see under*
carpets → types
Pigage, Nicolas de **2:**152
pigeon towers **1:**174
Pila of Játiva **1:**196; **3:**242, 243
Pilaram, Faramarz **2:**287; **3:**182
pilgrimage **2:**23, 24–5, 301–2,
304, 470–01; **3:**208–9
pillar tombs *see under* tombs →
types
Pinder-Wilson, Ralph **3:**120
pine **3:**420, 425, 438
Pinseau, Michel **2:**546
Pioneers, The **2:**141, 291
Piot, Eugène **2:**58
Pir Ahmad Baghshimali **1:**3;
2:220
Pir Ahmad Khwafi **1:**133;
3:137
Pir Budaq, Prince **1:**65; **2:**232,
238; **3:**134
Pir Husayn Damghani **3:**442
Pir-i Bakran *see under* Linjan
Pir Yahya ibn Nas al-Sufi al-
Jamal *see* Yahya al-Sufi
Pisa
S. Andrea **1:**461
S. Sisto **1:**453, 461
S. Stefano **1:**453
Pisa griffin **3:**246
pisé **1:**81
Pishkek *see* Bishkek
*pishtaq*s **1:**91, 138, 139; **2:**551;
3:120–22, 122–3, 332
Pishwaran **1:**99, 100
Pissarro, Camille **1:**331
Pivac, Nada **1:**302
PIXE (proton-induced X-ray
examination) **2:**156
Piyadasa, Redza **2:**445
plane **3:**428, 436
plaster **3:**235–8
architectural decoration **1:**23,
69, 135, 305
mosaics **1:**103
see also stucco
Ploshko, I. K. **1:**238, 255
Plovdiv **3:121–2**
Djumaya Mosque **1:**313
houses **1:**313, 315, **3:**409
Imaret Mosque **1:**313
Trimoncium Hotel **1:**314
Pö Chü-i **3:**281
Pococke, Edward **1:**499
Podgorica
Non-Aligned Countries' Art
1:265
Gallery **1:**265
Poelzig, Hans **2:**50
pointed arches **1:**67, 81
Polier, Antoine Louis Henri
1:45, 499
Polishchyk, L. **3:**273
Pollock, Jackson **3:**93
Polo, Marco
on carpets **1:**360
on embroidery **3:**324
on Indonesia **2:**279
on Quanzhou **1:**482
on tents **3:**281
on textiles **1:**360
Polonaise (Polish) carpets
see under carpets → types
Poltoratsk *see* Ashgabat

polychromy
architecture **1:**91, 96, 102
pomegranate **3:**314
Pomerantsev, Aleksandr **1:**314
Pondok Pesantren Pabelan **2:**282
Ponti, Gio **2:**309
Pope, Arthur Upham **1:**10, *358*;
2:59, 154, 288; **3:122**
Pope, John Russell **3:**40
poplar **3:**420
Popović, Atanasije **1:**301
Popovič, Branko **1:**302
Popovski, Živko **2:**426
Popular Mughal painting **2:**265
porcelain **1:**292, 473
Porcher, E. A. **3:**30
Porden, William **2:**544
Pordenone
paper **1:**27
portals **1:***160, 169, 311, 396*,
pl.VI.2, *400*; **2:**297;
3:122–3, *332*
see also doors; *pishtaq*s
Porter, Lt. John **2:**370
Port-Harcourt **3:**55, 56
library **3:**55
Port Lympne **2:**545
portraiture **1:**241, pl.IX.2, 290;
2:*106*, 253; **3:123–4,**
240
Port Said **2:**45
Post, Theodor **3:**360
postage stamps *see* stamps
Pota, Ljube **2:**426
potash **1:**441
pottery *see* ceramics
Pouillon, Fernand **1:**49
Poynter, Edward John **3:**69
Pozzi, Jean (Félix Anne) **3:**124
PPA Ltd. **3:**164
Prague Inventory **3:**307
Prangey, Joseph-Philibert Girault
de *see* Girault de
Prangey, Joseph-Philibert
Praves, Diego de **1:**508
Prayaga *see* Allahabad
prayer **2:**303
prayer-halls **1:**73; **2:**548–9
prayer-rugs
see under carpets → types
Prescription for pleasure *see*
Sulwān al-muṭāʿ
Preziosi, Amadeo **3:**64
Prilep **2:**426
Museum **2:**427
printing **3:124–9,** *126*, 322–3
Prisse d'Avennes, A. C. T. E.
2:153
Priština **3:**196–7
Imperial Mosque **3:**197, 221
Prizren **3:**196–7
Sinan Pasha's Mosque **3:**197
Progressive Artists' Group **2:**178,
273, **3:**146
Prokudin-Gorskii, Sergei
Mikhailovich **3:**118
proportioned script *see under*
scripts
Prost, Henri **2:**319, 546
Provincial style **2:**204
Prusa *see* Bursa
Przhevalsk **2:**407
Pseudo-Galen *see* *Kitāb al-diryāq*
("Book of antidotes")
Ptolemais **2:**421
Ptolemy (*fl.* 2nd century CE)
3:216

Ptolemy II (*r.* 285–246 BCE)
3:282
Puccio di Simone **3:**306
pudding pipe tree (*Cassia fistula*)
3:420
Puente del Arzobispo, El **3:**8
Puig, D. Francisco Pallás y *see*
Pallás y Puig,
D. Francisco
Pulau Langkaw
Datai Hotel **2:**442
pulpits *see* minbars
Pumpelly, R. **1:**432
Pursa *see* Bursa
Puvis de Chavannes, Pierre
2:418
pyxides **2:**332
Qabus ibn Wushmgir
(*r.* 978–1012) (Ziyarid)
1:90
Qaddafi, Colonel **3:**276
Qadimi **2:**241
Qadisiyya **1:**80
mosque of the Octagon **1:**80
Qadri *see* *Jarūnnāma*
Qahira, al- *see under* Cairo
Qa'im, al-, caliph (*r.* 934–46)
(Fatimid) **2:**433
Qairouan *see* Kairouan
Qa'itbay, Sultan (*r.* 1468–96)
2:457
architecture **1:**47, 152, pl.VI.1,
326, 335; **2:**348, *457*,
471, 472, 526
heraldry **2:**146
metalwork **2:**501, 504–5, *504*
minbar **2:**535; **3:**431
Qajars (*r.* 1779–1924) **2:**168,
284; **3:131–3**
architecture **1:**175–7
dress **2:**36–7
jewelry **2:**356
painting **3:**131, pl.I.3
tiles **1:**201
see also Agha Muhammad
(*r.* 1779–97); Fath ʿAli
Shah (*r.* 1797–1834);
Muhammad Shah
(*r.* 1834–48); Nasir al-
Din, Shah (*r.* 1848–96);
Muzaffar al-Din, Shah
(*r.* 1896–1907)
Qalandar Khivaki **1:**180
*qalʿa*s **3:**395
Qalʿat al-Hisn **1:**148
Qalʿat Bani Hammad **1:**49,
102–3, 196, 201;
3:133, 452
ceramics **1:**452
gardens **2:**88
minaret **2:**531; **3:***134*
muqarnas **3:**26
stained glass **1:**209
textiles **3:**300
Qalʿat Bani Rashid **1:**381
Qalʿat Sahyun **1:**115
Qalʿat SimMaynan **3:**262
Qalaʾun, Sultan (*r.* 1280–90)
(Mamluk) **2:**453
architecture **1:**149, 325;
2:432
textiles **3:**305
Qalqashandi, al- **1:**340; **3:**149,
305
qamariyya **1:**210
Qandriz, Mansur **2:**287; **3:**182
Qandusi, al- **1:**352

Qansuh al-Ghawri, Sultan
(*r.* 1501–16) (Mamluk)
2:458
architecture **1:**152, 355;
2:353, 526
manuscripts **2:**211, 213
metalwork **2:**505
tents **3:**283
woodwork **3:**431
Qarabaghlar **1:**243
Qarajaghay Khan **2:**245
Qarakhanid (*r.* 992–1211)
architecture **1:**89; **3:**171
coins **1:**425
see also Tamgach Khan
(*r.* 1052–66); Ahmad I
(*r.* 1081–9); Shams al-
Mulk Nasr; Arslan
Khan Muhammad II
(*r.* 1102–29)
Qara Khitay **1:**392
Qaraqoyunlu (*r.* 1380–1469)
3:133–4
architecture **1:**134, *135*; **3:***266*
manuscripts **2:**232
see also Jahanshah
(*r.* 1438–67); Pir
Budaq, Prince
Qarasunqur *see* Shams al-Din
Qarasunqur
Qarmathian Koran **1:**344
Qarshi **1:**389
Qasab, Muhammad al- **3:**374
Qas al-Mshatta *see* Mshatta
*qasba*s **3:**395
Qashani *see* Abu Tahir
Qashqa'i **1:**378
Qasim **2:**406
Qasim ʿAli **1:**56, 287; **2:**228,
261; **3:134–5**, 163
Qasir, al- **1:**205
Qasr ʿAbid **2:**527
Qasr al-ʿAmra *see* Qusayr
ʿAmra
Qasr al-Banat **1:**456
Qasr al-Hallabat **1:**208; **2:**363
Qasr al-Hayr East **1:**76, 84, 271;
2:518; **3:135–6**
Lesser Enclosure **1:**354
Qasr al-Hayr West **1:**76, 194;
3:98, **135–6**
floor paintings **1:**75, 203, *203*
sculpture **1:**194; **3:**48
stucco **3:**235
stained glass **1:**209
Qasr al-Mshattā *see* Mshatta
Qasr al-Tuba **2:**363
Qasr Ibrahim **2:**527
Qasr Ibrim **2:**113
Qasr-i Shirin **3:**229
Imarat-i Khusraw **1:**80
Qasr Kharana **2:**363, 518; **3:136**
Qastal **1:**208
Qatar **3:136–7**
Qatari Society of Fine Arts **3:**137
Qatif **3:**187, 406
Qavam al-Din Shirazi **1:**67, 132,
133; **2:**147; **3:137**,
331–2
Qawsun **2:**454; **3:**399
Qayrawan, al- *see* Kairouan
qayrawānī see under scripts
qaysariyya **1:**353
Qazi, Misbahuddin **3:**94
Qazi Ahmad **1:**35, 63, 206, 227,
340, 504; **2:**152, 538;
3:40, 204, 225, 441

Qazvin **3:137–40**
ʿAli Qapu **1:**171–5
carpets **1:**365
Chihil Sutun **1:**171
wall paintings **1:**174
congregational mosque **1:**92,
94, 196; **2:**462; **3:**74,
138
manuscripts **2:**240–43,
pl.VIII.1
Masjid-i Haydariyya **2:**516
museum **2:**289
rock crystal **3:**154
Shah Mosque **1:**176
Qazwini, al- *see* ʿAjāʾib
al-makhlūqāt
("Wonders of creation")
qibla **1:**69, 73; **2:**515, 549
see also mihrabs
Qissa-yi Farrūkhrūz ("Story of
Ferruhruz"; London, BL,
Or. MS. 3298) **2:**255
Qissa-yi Shahr u Shatrān ("Story
of Sahr and Satran";
1648; Istanbul, U. Lib.,
T. 9303) by Faramarz
ibn Khudadad Arrajani
2:255
Qivam al-Din **2:**190; **3:**335
Qivam al-Din Hasan **2:**190
Qizil **1:**204
qsur **3:**395, pl.XV.2
qtif **1:**381
Quanzhou **3:**216
Qingjing Temple **1:**484
quartz **1:**441
Quba (i) (Uzbekistan) *see* Kuva
Quba (ii) (Azerbaijan) **1:**235–6;
373–4, 375; **3:139**
Qubadyan **1:**389
Qubilay (*r.* 1260–94) **3:**281
Quds, al- *see* Jerusalem
Quetta **1:**394
Serena Hotel **3:**93
University of Baluchistan **3:**96
Quintanaortuña **3:**300
Qul Baba Kukaltash **1:**178
Quli Qutb al-Mulk (*r.* 1512–43)
2:118
Qullar-Aghasi, Husayn **2:**286
Qulzum **3:**156
Qum **3:139**
carpets **2:**288
ceramics **1:**477
mosque **1:**94
museum **2:**289
shrine of Fatima **1:**8, 92, 176,
210, 385; **3:**139, 209,
211, 341, 344
tiles **3:**72
woodwork **3:**424
Qunduz **1:**389
Qunfidhah **3:**405
Qurm
Oman Museum **3:**66
Qurra ibn Sharik **1:**75
Qurva
mosque **1:**92, 319
Qus **1:**248; **2:**113; **3:**343
ʿAmri Mosque **3:**422
Qusantiniya *see* Istanbul
Qusayr ʿAmra **1:**70, 76, *77*, 271;
2:363; **3:140**
mosaics **1:**208, 271
wall and ceiling paintings
1:202, 271, 382; **2:**83;
3:47, 109, **140**, *140*

Quseir **2:**113; **3:141**
Qustantiniyya *see* Istanbul
quṣūr **1:**277
Qutb al-Din Aybak, Sultan
(*r.* 1206–10) (Muʿizzi)
1:97, 137; **2:**2, 8; **3:**23
Qutb al-Din Khan Kokaltash
2:67
Qutb al-Din Shah, Sultan
(*r. c.* 1452–8) **3:**183
Qutb al-Din Shah Mahmud
(*r.* 1358–75)
(Muzaffarid) **2:**295
Qutb Shahis **3:141**
see also Quli Qutb al-Mulk
(*r.* 1512–43); Ibrahim
(*r.* 1550–80);
Muhammad Quli,
Sultan (*r.* 1580–1612);
Muhammad
(*r.* 1612–26); ʿAbdullah
(*r.* 1626–72)
Rabadha, al- **1:**80
Rabat **1:**58; **2:**545; **3:143–4**
Archaeological Museum
2:548; **3:**143
Bank of Morocco **2:**546
baths **1:**159
carpets **1:**381–2
ceramics **2:**547–8
city walls **1:**58
French Embassy **2:**546
Hasan Mosque **1:**158
Institut des Hautes Etudes
Marocaines **2:**547
Kasba **2:**522
Mashwar **1:**189
mausoleum of Muhammad V
2:546, *546*
Musée des Antiquités **1:**51
Oudaïa Museum **2:**548; **3:**143
al-Sunna (Great Mosque)
1:188
textiles **3:**313–14
Tour Hassan **2:**532
Udayas Gate **1:**58, 196; **2:**521,
521
Rabbath Ammon *see* Amman
Rabiʿ, al- **1:**297
Rabiʿa Khatun **1:**234
Rabiʿa Sultan Begum **3:**359
Rabingan **2:**488
Raby, Julian **2:**155
Rachchupkin, V. **3:**273
Racim, Mohammed **1:**50
Racim, Omar **2:**315
Radaʿ **3:**407, 445
Amiriyya Madrasa **1:**154, 383;
3:231
radiocarbon analysis **2:**156
Radkan East **3:**342
Radkan West
tomb tower **1:**90, 91, 211
Radwi, Abdul Halim **3:**188
raffia **1:**25
Raffles, Thomas Stamford **2:**282
Rafiʿ ibn Shams ibn Mansur
al-Qazwini **1:**137
Ragha *see* Rayy
Ragıp, Ahmet **3:**65
Rahal, Khalid al- **1:**251
Rahhal, Khalid al- **2:**290, 291
Rahi, Hajra Zuberi **3:**94
Rahi, Mansur **3:**94
Rahim, Shaigi **3:**254
Rahim Deccani **1:***500*
Rahimi, Abdullah **2:**288

Rahimyarkhan
Bhong Mosque **3:**93
Rahman, Habib **2:**272
Rahman, Hamidur **1:**263
Rahmanzade, M. Yu. **1:**242
Rai Anand Ram *see* Mukhlis
Rais, Abdelaziz ben **3:**356
raising **2:**479
Raja Man Singh **1:**183
Rajab, Tareq al-Sayyid **2:**406
Raje, Anant **2:**272
Rajji, Abd al- *see* Imami,
Javad al-
Rāj kunwār ("King's son";
1603–4; Dublin,
Chester Beatty Lib.,
MS. 37) **2:**260
Rajshahi **1:**262, 265
Ramallah **2:**30
dress **2:**30
Khalil Kakakini Cultural
Center Foundation
3:104
Ramallah ware *see under*
ceramics → wares
Ramana **1:**237
Ramay, Hanif **3:**93
Rāmāyana
(*c.* 1588–92; Jaipur, Maharaja
Sawai Man Singh II
Mus., MS. AG. 1851–
2026) **2:**15, 428, 434,
542
(*c.* 1600; Washington, DC,
Freer, MS. 07.271)
2:264
Ramdas **3:**144
Ramić, Afan **1:**302
Ramiro II, King of León
(*r.* 931–51) **3:**6
Ramla **1:**148, 156
Bir al-Aneziyya **1:**84
textiles **3:**305
Ramsay, Sir William **1:**275
Ranjit Singh **2:**141; **3:**327
Ranthanbor **2:**529
Raphelengius, Franciscus **3:**125
Raqqa **3:**144
Baghdad Gate **2:**520
capitals **1:**535, *281*
ceramics **1:**443, 445, 455,
456
congregational mosque
1:129–37
glass **2:**111
houses **1:**151–2
mosaics **1:**204
palace **3:**64–7
al-Rafiqa **1:**80, 350
Raqqada **1:**29–30, 85, 86, 452;
3:397
Raʾs al-Khayma **3:**373–4
Rasāʾil ikhwān al-ṣafāʾ ("Epistles
of the sincere brethren";
1287–8; Istanbul,
Süleymaniye Lib., Esad
Ef. 3638) **2:**198, 210
Rashid **3:**399
Rashid, al- (*r.* 1664–72) (ʿAlawi)
1:188
Rashid al-Din **1:**128–32, 293,
496; **2:**127, 204–5,
216–19, 308; **3:144–5**,
263, 264, 265, 307
see also Jāmiʿ al-tawārīkh
("Compendium of
histories")

Rashidiyya school 2:21, 215;
 3:116
 see also Tabriz → manuscripts
Rasht 3:315
Rasmussen, Krohn and Hartvig
 1:253
Rassam, Abdul Qadir al- 2:290
Rasul, Ghulam 3:94
Rasulids (*r.* 1229–1454) 3:181
 architecture 1:153, 155
 see also Muzaffar Yusuf, al-
 (*r.* 1250–95); Mu'yyad
 Da'ud (*r.* 1296–1322)
Ratlam 2:360
rattan 3:438
Ravéreau, André 1:49; 2:449
Rawalpindi
 Contemporary Arts Gallery
 1:29
 Society of Contemporary Art
 Galleries 1:265–6
rawḍa see cemeteries
Rawda, al- *see under* Cairo
Rawi, Nouri 2:291
rayḥān see under scripts
Rayis, Abdul Qadir al- 3:374
Rayy 2:288; 3:146
 ceramics 1:319, 443, 457, 458
 mausoleum 1:319
 metalwork 2:488
 stucco 1:191–7
 textiles 2:77; 3:298
 wall paintings 1:202–7
 woodwork 3:424
Raza, Mashkoor 3:94
Raza, Sayed Haider 2:273;
 3:146–7
Razi 2:411
Razin 1:238
Razlog 1:315
Razmnāma ("Book of wars")
 (1582–6; Jaipur, Maharaja
 Sawai Man Singh II
 (1598; London, BL, Or.
 12076) Mus., MS. AG.)
 1:269, 282, 518; 2:14,
 15, 261, 344, 368, 380,
 383, 415, 428, 542;
 3:20, 24, 46, 272, 352
 (1598; London, BL, Or.
 12076) 1:282; 2:14
 (*c.* 1616; dispersed) 2:264
Razzaque, Abdur 1:261
Razzaz, Mustafa al- 2:47
red lead 2:284
reed pens 1:338–9
reeds 2:174
Re-entrant carpets *see* carpets →
 types → Bellini
regalia 3:147–50
Regnault, Henri 3:68
Reich, Sigismund (Susya) *see*
 Rice, David Storm
Reinaud, J. T. 2:152
Reis
 tomb of Emir Yavtaş 1:119
Reis, Piri 2:252
Reis Haydar *see* Haydar Ra'is
Reitlinger, Gerald 1:501; 3:150
relief sculpture 1:193; 3:57, 231
Reliquary of St. Petroc 2:334
Rembrandt van Rijn 1:499; 3:68
Reni, Guido 3:22
Renoir, Auguste 2:418; 3:69,
 414
repoussé 2:480
Resafa *see* Rusafa

Resen 2:425
Resta, Vermondo 3:199
Reuther, Oskar 2:155
Revazov, U. 1:239
Rewal, Raj 2:272
Rey *see* Rayy
Rhodes 1:364, 471
rhyta 1:428
Ribat-i Malik 1:211, 309, 354,
 396, *396*, 401; 2:521;
 3:120, 150–51
Ribat-i Sharaf 1:94, 95, 98, 99,
 100, 354, *354*; 2:411;
 3:99, 120, 151, 424
*ribāṭ*s 1:80, 85, 86, 104; 2:382,
 518–19
Ricard, Prosper 1:499; 2:547–8
Ricciotti, Rudy 3:33
Richtofen, Ferdinand von 3:213
Rice, David Storm 2:154, 270
Rice, Michael, & Co. 3:136
Rich, Claudius 1:499
Richard, Jules 1:499
Richmond, VA
 Virginia Museum 3:324
rickshaws 1:265
Rida' 1:69, 73, 90–91
Ridwan Bey 1:327
Riegl, Alois 1:65; 2:154
Rifa'i, Aziz 1:351
ringmatting 2:480, 488
Risgit 3:26, 354
Rishtan 1:423
Rissani 3:395
Rising of auspicious
 constellations *see*
 Maṭāliʿ al-saʿāda
Rivera, Karlo Afan de 1:302
Riyadh 2:527; 3:151–2
 Folklore Museum 3:189
 Great Mosque 1:74–6
 houses 3:403
 al-Khairia 3:188
 Institute of Art Education
 3:188
 King Fahd International
 Stadium 3:187
 King Faisal Center for
 Research and Islamic
 Studies 3:152
 King Khalid International
 Airport 3:152, 187
 King Saʿud University 3:187
 Museum of Archaeology and
 Ethnography 3:189
 Palm Mosque 3:187
 Television Center 3:187
 United Nations building
 3:187
Riza 1:206, 356, 500; 2:21, 193,
 244, 254, 295, 411;
 3:20, 22, 152–3, 162,
 243, pl.VIII.3
 carpet designs 3:162
Riza, Ali 3:65
Riza, Hasan 3:89
Riza Shah Pahlavi (*r.* 1925–45)
 2:285, 528; 3:149, 274
Riza-yi ʿAbbasi *see* Riza
Rizk, Abdel Kader 2:47
Robat Sharaf *see* Ribat-i Sharaf
Robert Guiscard, Duke of Apulia
 (*r.* 1057–85) 3:102–3
Roberts, David 1:*151*, 330; 2:46,
 122, 544; 3:69, *70*
Robertson, James 3:118
Robinson, Basil W. 2:155; 3:153

Rochechouart, Julien de, Comte
 1:477–8
rock crystal 2:71, 99, pl.II.1;
 3:153–6, *155*, pl.III.2
Rockefeller, John D., Jr 1:500;
 2:16, 544
Roda de Isábena Cathedral
 3:300
Rodin, Auguste 2:49
Roe, Sir Thomas 2:538
Rogers, Edward 3:34
Roger II, King of Sicily
 (*r.* 1130–54) 1:103,
 205; 3:102, 103, 293,
 301, pl.X.2
Rogers, J. M(ichael) 3:157
rolls 1:293
Rome
 Istituto per il Medio e
 Estremo Oriente
 1:265–6
 roofs 1:83–5
Roopa-Lekha 2:8
Rosen-Ayalon, Miriam 2:314
Rosetta *see* Rashid
roscwood (*Dalborgia latifolia*)
 3:420, 438–9
Rossi, Mario 1:193
Rothschild, Edmond de, Baron
 1:498
Rothschild, Maurice de, Baron
 1:500
Rousalka 1:314
Rousse
 houses 1:313
Rousseau, Henri 1:331
row carpets *see* carpets → types →
 saff
Royal Society of Fine Arts
 (Jordan) 2:263
Rubens, Peter Paul 3:22
rubies 2:99
Rubruck, Willem van 3:276, 281
Rudaki 3:169
Rudesind, St. 3:5
Rudnev, Lev 1:239
Rudolf II, Holy Roman Emperor
 (*r.* 1576–1612) 1:499
Rudolph, Paul 2:312
Rufail 1:255
Rug Belt 1:427
Rugina Greco da Corfu, Nicolo
 3:392
Ruhā', al- *see* Urfa
Ruiz, Hernán, II 3:*198*
Ruiz family 1:508
Rukn al-Dawla 2:490
Rumeli Hisar 1:146; 2:523, *524*
Rumi, al- *see* Ahmad ibn Mas'ud
Rupbas 3:157
Rusafa 3:81, 157–8
 ceramics 1:440–62
Russell, Robert Tor 2:7
Russell, Samuel 2:179
Russia
 archaeology 1:394
 museums and collections
 1:436–437
 printing 3:*126*
Russian Academy for the History
 of Material Culture
 (RAIMK) 1:431
Russian Association of the
 Scientific Research
 Institutes of Social
 Science (RANION)
 1:433

Rustam ʿAli 1:287; 2:202; 3:86
Rustaq 3:66
Rüstem Pasha 1:162; 2:42, 370;
 3:86
Ruwi
 National Museum 3:66
Ruzbihan Muhammad al-Tab'I
 al-Shirazi 2:188
Rycault, Sir Paul 3:285
Rzaguliyev, A. A. 1:242
Sabah, al- 2:156
Sab'a sayyāra ("Seven voyages";
 1553; Oxford, Bodleian
 Lib., Elliott MS. 318)
 by ʿAlishir Nava'i 1:407
Sabancı family 1:498
*sabīl-kuttāb*s 1:69, 170, *328*
Sabit Khan 1:54
Sabra *see* Mansuriyya, al-
Sabratha 2:421
Sabri, ʿAta 2:290
Sabri, Mahmoud 2:291
Sabry, Ahmed 2:46
Sabsai, S. P. 1:240
Sabya 3:405
Saʿd ibn Zangi (*r.* 1203–31)
 (Salghurid) 3:206
Saʿda
 metalwork 3:445
 mosque of Hadi 1:155
 Nizamiyya Madrasa 1:67, 155
Saʿd al-Din al-Is'irdi 2:499
Saʿd al-Din al-Varavini *see*
 Marzbānnāma ("Book
 of Marzban")
saddles 2:136; 3:349
Sadeler, Raphael 2:64; 3:22
Sadequain 1:352; 3:93, 97, *159*
Saʿdi (*d.* 1292) 2:165; 3:207
 see also *Būstān* ("Orchard");
 Gulistān ("Rose-garden")
Saʿd ibn Abi Wakkas 2:400
Sadiq (*fl. c.* 1750–1800) *see*
 Muhammad Sadiq
Sadiq, Mahmoud (*b.* 1945)
 2:363
Sadiqi 1:227; 2:243, 244; 3:40,
 160, 163, 164
Saʿdis (*r.* 1511–1659) 1:188;
 2:166; 3:159
 architecture 1:188, *189*
 manuscripts 3:pl.XVI.2
 see also ʿAbd Allah, Sultan
 (*fl.* 1568); Ahmad II
 al-Mansur
 (*r.* 1578–1603)
Sadr, Said al- 2:47
Sadruddin Aga Khan, Prince
 1:501; 2:193
Sadus 3:406
Sadykkori, Muhammad 1:403
Sadykov, Marat Faiziyevich
 3:388
Sadykov, Turgunbaj 2:408
Saeed, Anwar 3:93
Safad 1:148
Safaroghly, Aga Alesker 1:246
Safavid (*r.* 1501–1732) 2:166;
 3:161
 albums 1:43–5
 architecture 1:171, *173*;
 2:297, 299, 431; 3:*101*,
 161, pl.V.1
 carpets 1:358; 3:161
 ceramics 1:474
 crowns 3:148
 dress 2:22, 34

manuscripts **2:**_187, 203,_ 204, 237, pl.VII.1; **3:**161, pl.IV
palaces **3:**_44_
tents **3:**276
tiles **1:**200, pl.VII.2
wall paintings **1:**205–6, pl.VIII.1
see also Isma'il I, Shah (_r._ 1501–24); Tahmasp I (_r._ 1524–76); Ibrahim Mirza, Prince; Isma'il II, Shah (_r._ 1576–7); 'Abbas I, Shah (_r._ 1588–1629); Safi, Shah (_r._ 1629–42); 'Abbas II, Shah (_r._ 1642–66); Sulayman I, Shah (_r._ 1666–94); Husayn I, Shah (_r._ 1694–1722)
Safdar Khan **3:**185
ṣaff carpets _see under_ carpets → types
safflower **3:**314
saffron **3:**106
Safi **3:**359–60, 456; **2:**547
Safi, Shah (_r._ 1629–42) **2:**106
Safid Buland **1:**211
Ṣafiya **1:**327
Safiye Sultan **1:**164, 520
Sahagún
 S. Lorenzo **3:**8
 S. Tirso **3:**8
Saheli, al- **3:**328
Sahib Ata Fakhr al-Din 'Ali **2:**374, 392; **3:**224
Ṣahrkulu _see_ Shahquli
Said, Issam (Sabah) el- **2:**292; **3:**164
Said, Mahmud **1:**331; **2:**46; **3:**23
Said, Shaker Hassan al- **2:**291; **3:**165
Sa'id al-Qasimi **2:**509
Saidu Sharif
 Swat Museum **3:**97
Saif al-Dunya wa'l-Din Muhammad al-Mawardi **2:**pl.XV.3
Saimaly Tash **2:**73
Šain, Petar **1:**301
St. Giles, Master of **3:**306
Saint-Gobain glassworks **2:**538
Saint-Laurent, Yves **2:**466
St. Louis (Senegal)
 Great Mosque **3:**194
 museum **3:**195–6
St. Louis, MO (USA)
 Art Museum **1:**500
Saint-Michel-de-Cuxa **3:**5
St. Petersburg
 Hermitage Museum **1:**408, 437, 438–9; **2:**60; **3:**33
 Institute of the History of Material Culture of the Academy of Sciences **1:**437
 Institute of Oriental Studies of the Academy of Sciences **1:**437
 M. E. Saltykov-Shchedrin Public Library **1:**437
 Museum of Ethnography **1:**379, 437
 Museum of the History of Religion **1:**438
 Russian Museum **1:**420

St. Petersbury State University **1:**437
St. Petersburg Album (St. Petersburg, Hermitage, E-14) **1:**55; **2:**537; **3:**21
Sajjad, Shahid **3:**95, **165**
Sakhibov, Safar **3:**268
Saladin _see_ Salah al-Din, Sultan
Saladin, Henri **2:**154
Salah al-Din, Sultan (_r._ 1169–93) (Ayyubid) **1:**234
 architecture **1:**108, 234, 324, 333; **2:**346, 351, 431, 432
 dress **2:**22
 minbar **2:**535; **3:**423, 449
 woodwork **3:**423
Salah al-Din Yusuf, Sultan (_r._ 1237–60) **1:**234; **2:**114
Salahi, Ibrahim el- **3:**165–6, 254
Salahuddin (_b._ 1939) **3:**94
Salahuddin, Asad (_b._ 1950) **3:**94
Salakhov, Tahir **1:**241, pl.IX.2
Salakta **1:**86; **2:**531
Salala **3:**66
Salamah, Darwish **3:**188
Salamzade, S. **1:**241; **3:**212
Salar **1:**98, 149, 150
Salar Jung III, Nawab (_r._ 1889–1949) **2:**275
Salayev, F. E. **1:**240
Salé **2:**522; **3:**143
 Abu'l-Hasan Madrasa **1:**159
 Bu 'Inaniyya Madrasa **1:**201
 ceramics **2:**547
 textiles **3:**313
 Zawiyat al-Nussak **1:**159
Saleeby, Khalil **2:**418–19
Saleem, Muhammad Mossa al- **3:**188
Salem, Ali ben **3:**356
Salem, MA
 Peabody Essex Museum **1:**264
Salih, Sultan (_r._ 1351–4) **2:**352
Salih, Zeid **2:**291
Salih Najm al-Din Ayyub, al-, Sultan (_r._ 1239–49) **1:**108, 234, 325; **2:**432, 484, 500
Salih Tala'i', al- **1:**107; **3:**422
Salim, Prince _see_ Jahangir, Emperor
Salim, Jawad **2:**72, 290; **3:**165, **166**
Salim, Hajj Muhammad **2:**290; **3:**166
Salim, Hajj Suad **2:**290
Salim, Naziha **3:**166
Salim, Nizar **3:**166
Salimnāma (1687–8; London, BL, Or. MS. 7043) **2:**255
Saliyev, A. **2:**408
Saljuqs (_r._ 1038–1194) (Iran, Iraq and Syria) **2:**28, 162
 architecture **1:**92, _93_; **2:**430–01
 coins **1:**412
 see also Tughril, Sultan (_d._ 1063); Alp Arslan, Sultan (_r._ 1063–72); Malikshah, Sultan (_r._ 1072–92);

Muhammad, Sultan (_r._ 1105–18); Sanjar, Sultan (_r._ 1118–57)
Saljuqs (_r._ 1077–1307) (Anatolia)
 architecture **1:**70, 117, 141
 see also Mas'ud I (_r._ 1116–55); Kiliç Arslan II, Sultan; (_r._ 1156–92); 'Izz al-Din Kayka'us, Sultan (_r._ 1210–19); 'Ala al-Din Kayqubadh, Sultan (_r._ 1219–37); Ghiyath al-Din Kaykhusraw II, Sultan (_r._ 1237–46)
Salman **3:**423
Salomon **3:**4
Salomons, Vera Bryce **2:**314, **3:**36
Salor (Salur) **1:**379, 419, _419_
salt **1:**441
Salt (Jordan) **2:**362
Salting, George **2:**117
Salvisberg, Otto Rudolf **3:**67
Salzmann, Auguste **1:**443; **3:**117
Samanids (_r._ 819–1005) **1:**391; **3:169–70**
 architecture **1:**89, 395–6
 ceramics **1:**_112_
 coins **1:**425–7
 metalwork **1:**410
 see also Isma'il I (_r._ 892–907)
Samaria
 dress **2:**30
Samarkand **1:**131, 390, 391, 392–3, 394, 395, 396, 397–8, 400–426; **2:**521; **3:**169, **171–7,** _175,_ 216, 266–7, 268, 386–8
 Afrasiab **3:**170, 171
 Afrasiab Museum **3:**173
 Aksaray mausoleum **3:**172
 bazaar **1:**404
 Baghcha Pavilion **1:**403
 Bagh-i Dilkusha **1:**205
 Bustan Saray **3:**99
 ceramics **1:**441–2, 463, _464;_ **3:**72, _112,_ 173, 217
 Chini-khana **1:**402
 coins **1:**425
 embroidery **1:**417; **3:**388
 gardens **1:**132; **2:**_91_
 gates **1:**403
 Goksaray **3:**99
 grave of Khwaja Ahrar **1:**179
 Gur-i Mir **1:**pl.III.1, 133, 136, 397, 432; **3:**171–2, 176, 344
 doors **1:**431; **3:**436
 tomb of Timur **1:**385–6, 429; **2:**341
 tile mosaic **1:**402
 houses **1:**134
 Ikramov Museum of the History of Culture and Art of Uzbekistan **3:**173
 Ishrat-Khana **1:**403, 432–3; **3:**171–2
 jewelry **1:**410–11
 manuscript illustration **1:**406, 407; **2:**205, 223
 mausoleum of Ibrahim ibn Hasan **1:**401
 metalwork **1:**412; **2:**487; **3:**173
 Mosque of Bibi Khanum **1:**132, 181, 397, 416;

2:307, 551, **3:**175–6, _175,_ 330, _331_
 pishtaq **3:**121
 textiles **1:**416
 observatory **1:**129, 134, 398; **3:**176–7
 paper **3:**105, 173
 ramparts **1:**403
 Registan **1:**133, 178, _178,_ 404; **3:**176
 Shir Dar Madrasa **1:**178, 181, 400; **3:**176
 Tilla Kar Madrasa **1:**178, 400; **3:**176
 Ulughbeg Madrasa **1:**179, 400, 431; **2:**433; **3:**120, 176
 Rukhabad mausoleum **1:**433
 Samanid palace **1:**395, 401
 Shah-i Zinda **1:**133, 136, 384, 397, 402; **3:**173–5, _173, 174,_ 209, 344
 mausoleum of Amir Zada **1:**402
 mausoleum of Shirinbeg Aga **1:**402
 tomb of Khwaja Ahmad **1:**397, _385_
 tomb of Qutham ibn 'Abbas **1:**201, _385, 397, 430;_ **3:**209, 436
 tomb of Qutluq Aqa **1:**200
 tomb of Shad-i Mulk **1:**200, 397, 402
 tomb of Tuman Aga **1:**133, 402; **3:**436
 tomb of Ulugh Sultan Begum **1:**397
 Tamgach Bogra Khan Madrasa **1:**395
 tents **3:**99–101
 textiles **1:**416–20; **3:**173, 307–9, 316–17, 388–9
 Ulughbeg Memorial Museum **3:**173
 wall paintings **1:**202–4, 414, 432
 woodwork **1:**430–1, 435–6
Samarkand Ewer **2:**487
Samarra **1:**1–2, 80; **2:**292; **3:**177–80; _175_
 arches **1:**91
 Balkuwara **1:**81, 194
 Beveled style **1:**280, **3:**71–2
 brick architecture **1:**305
 ceramics **1:**443, 445–8, 485–6; **3:**pl.II.1
 citadel **1:**403–404
 Dar al-Khilafa **1:**70, 80–82; **3:**177–80
 gardens **2:**87
 Jawsaq al-Khaqani **1:**_282,_ 199, 204, 448; **2:**22; **3:**99
 stained glass **1:**209–210
 staircase **3:**230–1
 gardens **2:**87
 glass **2:**111–2
 Great Mosque **1:**80–81; **2:**550; **3:**_178,_ 179
 minaret **2:**531, _531_
 mosaics **1:**207–8
 Pharaoh's Tray **2:**78
 houses and palaces **1:**81
 mosque of Abu Dulaf **1:**80; **2:**551
 mosques **1:**85

Qasr al-ʿAshiq **1**:81
Qubbat al-Sulaibiyya **3**:341
shrine of Imam al-Dawr
 1:115; **3**:238, 341–2
stucco **1**:90–1, 193–5, 280;
 3:235–8, 244
wall paintings **1**:202–4
woodwork **3**:421
Samarra ware *see under* ceramics
 → wares
Samatya
baths **1**:165
Samb, Pape Mamadou **3**:194
Sambhal
mosque **1**:182
Samhuram **3**:66
Sami **3**:180
*Sāmiyānā*s **3**:96
Sam Mirza, Prince **1**:63; **2**:200,
 537
Samokov
Bayraklı Mosque **1**:313
Samra, Faisal **3**:188
Samsam al-Dawla **2**:489
Samsat *see* Adiyaman
Sanʿa **2**:527; **3**:180–1, 444–5,
 pl.VI.1
Bakiriyya Mosque **1**:170
caravanserais **3**:181
church of Abraham **1**:207
Dar al-Hajar **3**:445
Ghumdan **3**:435
Great Mosque **1**:110–11;
 3:181
carvings **1**:196–7
ceilings **1**:489–90; **3**:419,
 434
mihrab **1**:110–11
minaret **1**:111
portal **1**:111
window grilles **3**:434–5
houses **1**:181; **3**:407–8, *408*,
 444–5
jewelry **2**:358, *359*
Masjid al-Abhar **1**:155;
 3:434–5
metalwork **3**:445
National Museum **3**:445–6
printing **3**:127
textiles **3**:302, 338–9
tomb of al-Mutawakkil **3**:435
tomb of Salah al-Din **1**:155
windows **1**:72, 209
Sanandaj carpets *see* carpets →
 types → Senna
Sandal **2**:455
sandalwood (*Santalum album*)
 3:334, 438, 439
sandarac **3**:425
San Diego, CA
Museum of Art **1**:501
sandstone (red) **3**:13
Sangam, Triveni Kala **2**:8
Sanganer **3**:323
Sangbast
caravanserai **1**:94, 96, 134
minaret **2**:532, *533*
tomb **1**:94
Sangi ʿAli Badakhshi **1**:108
sang-i chīnī **1**:441
Sangistan **1**:430
mausoleum of Muhammad
 ʿAli **1**:430
Sanguinetti, B. R. **2**:129
Sanguszko carpets **1**:366
Saniʿ al-Mulk *see* Ghaffari,
 Abuʾl-Hasan

Sanjar, Sultan (*r.* 1118–57)
 (Saljuq) **1**:92
Sanjar al-Jawli **1**:149, 150
San Juan de Boada **3**:5
San Juan de la Peña **3**:5
San Miguel de Escalada **1**:122;
 3:4
San Millán de la Cogolla **3**:4–6
Sano di Pietro **1**:361
San Pedro de Arlanza **3**:300
San Pedro de Montes **3**:300
San Pere de Rodes **3**:6
San Quirce de Pedret **3**:5
Santa Maria de lʾEstavy **3**:300
Santa María de Marquet **3**:5
Santelli, Serge **3**:356
Santiago del Arrabal **1**:226
Santiago de Peñalba **3**:4–6
San Valero vestments **3**:303
Sanwala **2**:*259*
Sanyal, Bhabesh Chandra **2**:8
Sappali-tepa **3**:213
sapphires **2**:99, 356–357
Saqqakhana **2**:287; **3**:181–2,
 269, 274, 452
Sarabiyye, Ibrahim **2**:418
Saragossa **2**:89
astrolabes **2**:486
Aljafería Palace **1**:121, 124,
 194, 227; **2**:89, 244,
 427
ceramics **1**:461–2
churches **3**:8–9
church of the Magdalena **3**:9
mosque **2**:516
Torre Nueva **3**:9
Saraj al-Din Badr **2**:374
Sarajevo **3**:182–3
Academy of Arts **1**:302
Ars Aevi Museum of
 Contemporary Art
 3:183
dress **1**:33
Ferizbey Baths **1**:300
Gazi Husrefbey Mosque **1**:300
Museum of the City of
 Sarajevo **1**:303
National Museum **1**:301–2
Officers' Pavilions **1**:301
Presidency Building **1**:301
Railway Council Building
 1:301
Sarajevo Center for
 Contemporary Art
 3:183
Slavija apartment building
 1:301
State School of Painting **1**:302
Svrzo House **1**:300
Town Hall **1**:301
University **1**:301
Sarajevo Haggadah **3**:183
Sarak **3**:367
Sarakhs **1**:389, 391
tomb **1**:95
Saray **1**:462, 473
Saray Berke *see* Tsarevo
Sarcham **1**:129, 420, 422
Sardar, Arbab Mohammad
 3:93–4
sardonyx **2**:99
Sargin and Böke **3**:360
Sargon II (*r.* 721–705 BCE) **1**:79
Sarha
mosque **1**:110, 383
Sari **1**:319, 457
Sarigh **2**:399

Sar-i Pul
Imamzada Yahya (Imam-i
 Khurd) **1**:94, 96, 100
sārīs **2**:38
Sariyev, Shaimardan **2**:377
Sarkhan **1**:244
Sarkhej **3**:183
Sarmaj
Hasanwayhid palace **1**:90
Sarmin
mosque **1**:112
textiles **3**:305
Sarouk **1**:377
Sarre, Friedrich **1**:500; **2**:58,
 150, 153, 154, 231,
 292, 400; **3**:33, **183–4**,
 200
Sart **1**:420
Sarvistan **3**:120, **184**
Saryk **1**:379
Sasanians **3**:364, 386
architecture **1**:79, 80, 82
metalwork **1**:409; **2**:488–9
rock crystal **3**:*155*
tombs **1**:90
Sasaram **3**:**184–6**
tomb of Hasan Sur **3**:185
tomb of Sher Shah **1**:182;
 3:185
Sassoon, Sir Philip **2**:545
sateen **1**:416
satin **3**:285, 309
Satgaon **3**:324
Satour, Jacques **2**:405
Saturiq *see* Takht-i Sulayman
Saudi (*r.* 1746–present) **3**:**186**
see also ʿAbd al-ʿAziz II,
 King of Saudi Arabia
 (*r.* 1902–53); Fahd,
 King of Saudi Arabia
 (*r.* 1982–2005)
Saudi, Muna **2**:363
Saudi Arabia **3**:**186–90**
architecture **3**:187–88, 405–6
houses **3**:*405*
mosques **3**:*189*
museums **3**:189
tents **3**:278
Saudi Arabian Society for
 Culture and Arts **3**:188
Sauvaget, Jean **1**:92; **2**:153;
 3:**190**, 377, 417
Sava
ceramics **1**:453
mosques **1**:92, 171, 319
Savar
National Monument **1**:263
Savary de Brèves, François
 3:125
Savitsky, Igor Vitalʾyevich **3**:388
Savonnerie **1**:370
Sawai Jai Singh II, Maharaha of
 Jaipur (*r.* 1700–43) **2**:6
Sawakin *see* Suakin
Sawan *see* Aswan
Sayaji Rao III, Maharaja
 (*r.* 1875–1936) **2**:275
Sayf al-Dawla (*r.* 945–67) **3**:149
Sayf al-Din Qaymari, Prince
 1:115
Sayf al-Din Shayku **2**:*146*
Sayf al-Din Tankiz al-Husami *see*
 Tankiz
Sayf al-Din Turumtay **1**:60
Sayid, Tawfik al- **2**:363
Sayod **1**:205
Sayramsu **1**:410, 429

Sayun **3**:446
Sayyed **1**:405; **3**:**190**
Sayyid (*r.* 1414–51) **3**:**190**
architecture **2**:5
see also Muʿizz al-Din
 Mubarak Shah
 (*r.* 1421–34)
Sayyida al-Hurra Arwa bint
 Ahmed, al- (Sulayhid)
 3:256
Sayyid Abdallah of Yediküle
 2:474
Sayyid Ahmad **3**:335
Sayyid ʿAli **1**:243
Sayyid Aqa Jalal al-Din Mirak
 al-Hasani al-Isfahani *see*
 Aqa Mirak
Sayyid Haydar ibn? Asl al-Din
 see Haydar **2**:144; **3**:191
Sayyid Ibrahim **2**:140
Sayyid Mirza **1**:266; **2**:411;
 3:16, 64, **191**
Sayyid Yusuf **3**:436
saz **1**:472; **2**:21; **3**:72, **191**,
 201–2, 244
Sbeïtla **3**:357
Arch of Antoninus Pius **1**:102
Schatz, Boris **2**:314
Schéfer, Charles **1**:500; **2**:58
Schefer Hariri *see under*
 Maqāmāt ("Assemblies")
 by al-Hariri
Schmidt, Erich F. **2**:155
Schmidt, Jürgen **2**:155
Schneller, Ludwig **2**:349
schools (theological) *see* madrasas
Schreyer, Adolf **3**:68, 70
Schulz, P. W. **1**:500; **2**:58
Schwetzingen **2**:152
Scott, Jonathan **1**:499
scribes **1**:351
scripts **3**:78
andalusī **1**:345
bihārī **1**:350
Crown **1**:351
cursive **1**:115
dīvānī **1**:350
dīvānī jalī **1**:350
fāsī **1**:345
fingernail **1**:339
Flame **1**:351
floriated kufic **1**:*212*
hijāzī **1**:342
Kufesque **3**:246
kufic **1**:109, *344*, 345, 492;
 2:*187*, *395*; **3**:pl.II.1
maghribi **1**:345, *345*
maʾil **1**:341
muhaqqaq **1**:338, 346, *347*
musalsal **1**:348
naskh **1**:338, 349–50, 494;
 2:pl.VII.1; **3**:126
nastaʿlīq **1**:338, 346, 349, 496,
 2:pl.VII.1; **3**:3
New Style **1**:344
proportioned **2**:181
qayrawānī **1**:345
rayhān **1**:338, 345–7
Shikasta nastaʿlīq **1**:350
Six Pens **1**:344–8
square kufic **3**:245–6
sūdānī **1**:345
taʿlīq **1**:349
tawqīʿ **1**:346
thuluth **1**:338, 346, 496
zoomorphic **2**:483–7; **3**:246
see also calligraphy

sculpture **1:**75–7
 Afghanistan **1:**13
 Azerbaijan **1:**240, *240*
 Central Asia **1:**405
 Iran **2:**pl.XI.1
 Malaysia **2:**443–4
 Mali **2:**449–50
 Pakistan **3:**94–5
 Senegal **3:**194–5
 Spain **3:***66*
 Turkey **3:**262
 Turkmenistan **3:**366–7
Scutari **3:**312
seals **2:**98–9; **3:**191–3, *192*
Sébah, J. Pascal **2:**322; **3:**119
Sebastea *see* Sivas
Sebastian, Georges **3:**355
Seçen, Islam **3:**65
Šećerinski, Risto **2:**426
Second National Architectural
 style **3:**360
Sedd al-Bahr **2:**524
Sedrata **1:**194; **3:**193, 237
Seetzen, Ulrich **3:**445
Ségou **2:**449
Segovia
 Corpus Christi **3:**8
 S. Millán **1:**226, 490
 synagogue *see* Corpus Christi
 Museum **1:**51–2
Şehabeddin Pasha **2:**42
Sehna knots **1:**356
Şehzade Mustafa **2:**255
Şeker Ahmet Pasha *see* Ahmet Ali
Selaković, Kemal **1:**302
Selangor
 House of T. Y. Chiew **2:**442
 Roof-Roof House **2:**442
Selangor Pewter Company **2:**446
Selçuk **3:**193
 carpets **1:**360
 Isa Bey Mosque **1:**142, *143*;
 2:550; **3:**193
Selçuks of Rum *see* Saljuqs
 (Anatolia)
Seleucia-on-the-Tigris **2:**336
Seleukos I (*r.* 312–281 BCE) **3:**385
Selim I, Sultan (*r.* 1512–20)
 (Ottoman)
 architecture **1:**53–54; **2:**328
 manuscripts **3:**224, *285*
 rock crystal **3:**156
 shadow-puppets **3:**201
 tughras **3:**352
Selim II, Sultan (*r.* 1566–74)
 (Ottoman)
 architecture **2:**42, 323, 328,
 471, 472; **3:**219
 manuscripts **1:**497; **2:**240,
 253; **3:**79, pl.XI.1
Selim III, Sultan (*r.* 1789–1807)
 (Ottoman) **2:**188, 329;
 3:124
Seljuks *see* Saljuqs
Selmanović, Behaudin **1:**302
semé design **1:**374
Semenov, A. A. **2:**154
Semenov, P. P. **1:**434
Semipalatinsk **2:**375–376
Semirechye **1:**409, 411
Semiz Ali Pasha **2:**42
Semnan *see* Simnan
Semper, Gottfried **2:**545
Semyonov, Vladimir **1:**255
Senbel, Mustafa **3:**188
Sendangduwur **2:**281
Senegal **3:**193–6
 architecture **3:**194

glass painting **3:**195
 museums **3:**195–6
 painting **3:**194–5
 sculpture **3:**195
Senghor, Léopold Sédar **3:**194
Senna carpets *see under* carpets →
 types
Sennar **2:**113; **3:**60
Sens Cathedral **3:**298
Sepahan *see* Isfahan
Şerafimovski, Aleksandar **2:**426
Serai Doraha **1:**185
Serai Nur Mahal **1:**185
Séraphim, Juliana **2:**418
Serbia **3:**196–7
Serçe Limanı shipwreck **1:**455;
 2:111
Sercey, Félix-Edouard, Comte de
 1:509
Şeref, Abdurrahman **2:**329
Serghini, Mohamed **2:**546
Sergiopolis *see* Rusafa
Serjilla **1:**271
Seremban **2:**440
 Negeri Sembilan State Mosque
 2:440
Servandus, Bishop **3:**4
Sétif **1:**49–51
Seven countenances *see* Haft
 manzar
Seven Masters of Anatolia **1:**348
Seven portraits *see* Haft paykar
Seven thrones *see* Haft awrang
Seven voyages *see* Sab'a sayyāra
Seville **3:**197–9, *198*
 Alcázar **3:**9, 28, 197, 428
 ceiling **1:**pl.VIII.2
 gardens **2:**88
 Casa de Pilatos **3:**10
 Cathedral **3:**198
 chapel of the Magdalena **3:**8
 Giralda Tower **1:**127; **2:**532;
 3:9, 143, 198, *198*
 metalwork **2:**486, 505
 mosque **3:**427
 al-Mubarak Palace **2:**89
 Omnium Sanctorum **3:**8
 palace **3:**10
 Piedad de S. Marina **3:**8
 Quinta de S. Pablo **3:**8
 S. Marcos **3:**8
 S. Salvador **3:**9
 textiles **3:**300
 tiles **3:**8
 woodwork **3:**425, 427
Şevki, Mehmed **3:**65
Sevruguin, Antoin **3:**118, 133,
 199
Seydou, Chris **2:**449
Seydov, I. **1:**242
Seyh Hamdullah **3:**85
Şeyh Kuşteri **3:**201
Seyit Gazi
 tombs **1:**119
Seyyid Naskhbendi Mustafa
 3:121
Seyyit, Süleyman **2:**322; **3:**64,
 200, 361
Sfax **1:**85, 159; **3:**356
 congregational mosque **1:**86
 houses **3:**397
 jewelry **1:**67
 museum **3:**357
 woodwork **3:**357
Sgibnev, Akim Alekseyevich
 2:408

sgraffito **1:**199; *see under* ceramics
 → techniques
Sha'ban I, Sultan (*r.* 1345–6)
 (Mamluk) **2:**353
Sha'ban II, Sultan (*r.* 1363–77)
 (Mamluk) **1:**347, *495*;
 2:455, 501
Shabran **1:**243
Shadiabad *see* Mandu
shadow-puppets **3:**200–01, *201*
shadow ware *see* ceramics →
 wares → silhouette ware
Shafi'i, al- **2:**302, 307
Shafi'i, Farid **1:***106*
Shafi'is **2:**302, 307
Shah, Jamil **3:**95
Shāhanshāhnāma ("Book of the
 king of kings") by
 Lokman **3:**87
 (1581–2; Istanbul, U. Lib.,
 F. 1404) **2:**222
 (1597; Istanbul, Topkapı Pal.
 Lib., B. 200) **2:**253
Shah Bahadur II, Emperor
 (*r.* 1837–58)
 (Mughal) **2:**11
Shah-i Mashhad **1:**98
Shahinshah ibn Sulayman ibn
 Amir Ishak (Mangujak)
 2.17
Shah Jahan, Emperor (*r.* 1628–
 58) (Mughal) **2:**6–7, 10
 albums **1:**43; **2:**536; **3:**2
 architecture **1:**31, 32, 39, 185,
 267; **2:**6, 10, 365, 413;
 3:157, 231, 326, 384
 gardens **1:**183; **2:**79, 96; **3:**230
 jade **3:**342
 manuscripts and miniature
 paintings **1:**6, 7, 285,
 291; **2:**259, 261, 274;
 3:21, 46, 114
 metalwork **2:**513
 mirrors **2:**539
 tents **3:**286
 textiles **3:**317
 throne **3:**327
Shahjahanabad *see under* Delhi
Shah Jehan Begum **1:**283
Shah Mahmud Nishapuri
 1:349; **2:**190–1, 240,
 241; **3:**161
Shah Mansur Tabrizi **2:**252
Shah Muzaffar **3:**225
Shah-Muzaffar ibn Ustad
 Mansur **1:**56
Shāhnāma ("Book of kings")
 by Firdawsi **2:**249;
 3:47, 148, 242, 276
 (1217; Florence, Bib. N.
 Cent., MS. Cl III.24
 (G.F. 3)) **2:**201
 First Small *Shāhnāma* (*c.* 1300;
 dispersed) **2:**190
 Small *Shāhnāma* (early 14th
 century; Copenhagen,
 Davids Saml., MS.
 12/1990) **2:***218*
 (1330; Istanbul, Topkapı Pal.
 Lib., H. 1479) **3:**207,
 283
 (1333; St. Petersburg,
 Saltykov-Shchedrin
 Pub. Lib., Dorn 329)
 3:207
 Great Mongol (Demotte)
 Shāhnāma (*c.* 1335;

dispersed) **1:***4*, 36, 360,
 497; **2:**12, 184, 190,
 193, 202, 216, *218*;
 3:124, 148, 264, 283
 (1341; Copenhagen, Davids
 Saml., MS. 32/1999)
 2:*218*
 Qivam al-Din Hasan (1341;
 Washington, DC,
 Sackler Gal., S86.
 0110–11) **2:**190
 Stephens *Shāhnāma* (1352;
 New York, Met.)
 3:283
 (1371; Istanbul, Topkapı Pal.
 Lib., H. 1511) **3:**207
 (1393; Cairo, N. Lib., Adab
 Farsi 6) **2:**222
 Ibrahim Sultan (*c.* 1400–20;
 Oxford, Bodleian Lib.,
 Ouseley Add. MS. 176)
 2:207, 226–7
 (1420; Berlin, Mus. Islam.
 Kst, MS. I. 4628) **2:***227*
 Baysunghur (1430; Tehran,
 Gulistan Pal. Lib., MS.
 61) **1:**349; **2:**76, 202,
 226, 343; **3:**335
 Ibrahim Sultan (*c.* 1435;
 Oxford, Bodleian Lib.,
 Ouseley Add. MS. 176)
 3:334
 (1438; London, BL, Or. 1403)
 2:236
 (1439–40; Bankipur, Patna,
 Khuda Baksh Lib., MS.
 3787) **2:**235
 Muhammad Juki (*c.* 1440;
 London, Royal Asiat.
 Soc., Morley MS. 239)
 1:497; **2:**226, 228, 257,
 385; **3:**329
 (1444; Paris, Bib. N., MS.
 supp. pers. 494) **2:**227
 (1486; Istanbul, Topkapı Pal.
 Lib., H. 1506) **2:**213
 (1494; vol. i, Istanbul, Mus.
 Turk. & Islam. A., MS.
 1978 and dispersed; vol.
 ii, Istanbul, U. Lib., Y.
 7954/310) **2:**232
 Big-head *Shāhnāma* (1494;
 Copenhagen, Davids
 Saml., MS. 22/1979)
 2:*232*
 Qansuh al-Ghawri (1511;
 Istanbul, Topkapı Pal.
 Lib., H. 1519) **2:**213,
 458
 (*c.* 1515–22; London, BL,
 MS. AC 1948, 1211,
 0.23) **2:**pl.IX
 Tahmasp I (*c.* 1527 and after;
 dispersed) **1:***4*, 63, 287,
 293, 497; **2:**40, 183,
 194, 202, *203*, 239,
 416, 537, 540, 541;
 3:39, 106, 161, 162,
 204, 258, 264, 276,
 pl.IV
 (1556–7; Tashkent, Orient.
 Inst. Lib.) **1:**408
 'Ish Muhammad (1556–7;
 Tashkent, Orient. Inst.
 Lib.) **2:**249
 (1560–70; Istanbul, Topkapı
 Pal. Lib. H.1116) **3:**79

'Abdallah Khan (1564;
 Istanbul, Topkapı Pal.
 Lib.) 2:250
Isma'il II (1576–7; dispersed)
 2:243; 3:160, 225, 451
(c. 1580–85; Windsor Castle,
 Royal Lib., Holmes 150
 (A/5)) 2:243
Hamza Mirza (1586; London,
 BL, Add. MS. 28302)
 3:225, 451
'Abbas I (1587; Dublin,
 Chester Beatty Lib.,
 Pers. MS. 277) 1:475;
 2:167, 243; 3:21, 152,
 160, 161, 451
(1602–4; London, India
 Office Lib., St.
 Petersburg,
 Saltykov- Shchedrin
 Pub. Lib., and
 Cambridge, Bailey priv.
 col.) 1:407
'Abbas I (1614; New York,
 Pub. Lib., Spencer col.)
 2:76; 3:161
'Abd al-Rahim (1616;
 London, BL, Add. MS.
 5600) 2:264
(c. 1620; New York, Pub. Lib.,
 Spencer MS. 1) 2:253
'Abbas II (c. 1640–50;
 St. Petersburg, Saltykov-
 Shchedrin Pub. Lib.,
 Dorn 333) 1:28, 206;
 2:508; 3:21
Qarajaghay Khan (1648;
 Windsor Castle, Royal
 Lib., Holmes 151 (A6))
 2:245
(1656; Dublin, Chester
 Beatty Lib., P. 270)
 3:22
(1665; Tashkent, Orient. Inst.
 Lib., MS. 3463) 1:408
(1719; London, BL, Add. MS.
 18804) 2:264
(1854–64; Shiraz, Vesal priv.
 col.) 2:423
Shāhnāma-yi Mehmed Khan
 (c. 1598; Istanbul,
 Topkapı Pal. Lib., H
 1609) 3:284
Shāhnāma-yi Salīm Khān ("Book
 of kings of Selim II";
 Jan. 1581; Istanbul,
 Topkapı Pal. Lib., A.
 3595) by Lokman
 2:253; 3:87
Shāhnāma-yi āl-i 'uthmān
 (c. 1560; ex-Kraus priv.
 col.) by 'Arifi 3:284
Shahpur 1:224
Shahquli 2:252, 370; 3:86, 148,
 201
Shahr-i Naw see under Delhi
Shahr-i Qumis 1:359
Shahr-i Rayy see Rayy
Shahr-i Sabz 1:389, 397–8;
 3:381, 387
 Aq Saray 1:132–133, 200, 397,
 402; 3:99, 330, 398
 ceramics 1:423
 Dar al-Siyyada 1:431; 3:330
 jewelry 1:430
 metalwork 1:410
 textiles 1:416

Shahrukh, Sultan (r. 1405–47)
 3:330
 architecture 1:291, 306;
 2:147, 478; 3:137
 ceramics 1:463
 coins 1:426
 manuscripts 1:297, 348, 496;
 2:204, 224, 227, 385
Shahsawar 2:237
Shah Shuja' (r. 1364–84) 2:222
Shahzada, Laila 3:94
Shaikhupura 1:184
Shajarat al-Durr 1:234
Shakhrisyabz see Shahr-i Sabz
Shakhsuvarova, S. Yu. 1:243
Shakhtakhtinskaya, E. 1:241
Shaki
 embroidery 1:245
 jewelry 1:245
 palace of the Shaki khans
 1:241, 243
 textiles 1:245
Sham, al- see Damascus
Shamakhy (Azerbaijan)
 carpets 1:375; 2:387
 ceramics 1:243
 Djuma Mosque 1:237
 embroidery 1:245
 jewelry 1:244
shammasiyya 1:210
Shammout, Ismail 3:104
Shams al-Din (14th century;
 Iran) 1:174; 2:215, 220
 pupils 1:3, 36; 2:144, 343, 364
Shams al-Din (16th century;
 Turkey) see Ahmad
 Karahisari
Shams al-Din Baysunghuri (15th
 century; Afghanistan)
 1:348
Shams al-Din Hasani 1:459
Shams al-Din ibn Taj al-Din
 1:485
Shams al-Din Muhammad
 (Juvayni) 3:224
Shams al-Din Muhammad
 'Assar 2:201
Shams al-Din Qarasunqur 2:462
Shams al-Mulk Nasr 1:211
 3:150
shanashil 2:173
Shanga 2:379
Shankland & Cox 2:405
Shanmughalingham, Nirmala
 2:445
Shantou 3:216
Shapur I (r. 241–72) 3:138
Shapur II (r. 309–79) 3:138
Shaqra 3:406
Sharaf al-Abawani 1:465
Sharaf al-Din see Cerrahiye-i
 haniye
Sharaf al-Din Qummi 1:94;
 3:151
Sharaf al-Din 'Ali Yazdi 1:131;
 2:223
 see also Zafarnāma ("Book of
 victory")
Sharaf al-Din Muhammad ibn
 Sharaf ibn Yusuf 1:347
Sharafnāma ("Book of the
 noble"; 1531; London,
 BL, Or. 13836) by
 Nizami 2:235
Shargh 2:488
sharī'a 1:391
Sharif, Hassan 3:374

Sharif, Mohammed Haji 3:46
Sharif Amidi 2:202, 213, 458
Sharifs of Morocco see 'Alawi;
 Sa'di
Sharipov, Savzali Negmatovich
 3:268
Sharjah
 Heritage and Arts Areas
 3:373–374
 King Faisal Mosque 3:374
 New Souk 3:374
Sharon, Arieh 2:350
Shāsh see Chach
Shatiba see Játiva
Shaubak see Krak de Monreal
Shavgar see Turkestan
Shawa, Leila (Rashad) 3:104,
 202–3
shawls 3:320, 325
Shaybanid (r. 1500–98) 1:426;
 3:203
 architecture 1:309; 3:245
 coins 1:426
 see also Muhammad Shaybani,
 Khan (r. 1500–10);
 'Ubaydallah Khan
 (r. 1512–39); 'Abd
 al-'Aziz (r. 1540–49);
 'Abd al-Latif, Sultan
 (r. 1540–52); 'Abdallah
 II, Khan (r. 1583–98);
 'Abd al-Mu'min
 (r. 1598)
Shaybānīnāma ("Book of the
 Shaybanids"; 1510;
 Vienna, Österreich.
 Nbib., Cod. Mixt. 188)
 2:204, 249
Shayista Khan 2:14
Shaykh 'Abbasi 3:203
Shaykh 'Abdallah 3:108
Shaykhan ibn Mulla Yusuf al-
 Haravi 2:250
Shaykh Hamdullah ibn Musafā
 Dede see Hamdullah,
 Şeyh
Shaykhi 2:232; 3:204, 225
Shaykh Mahmud Haravi 1:348
Shaykh Mahmud Zarin-qalam
 2:343
Shaykh Muhammad 2:21, 242;
 3:204
Shaykh Salim Chisti 2:66–7
Shaykhzada (fl. 1302–28)
 see Ahmad al-Suhrawardi
Shaykhzada (fl. 1520–40) 2:149,
 239, 250; 3:205
Shayzar 2:520
Shcherbinina, S. 3:273
Shchukin, Sergey 3:232
Shchusev, Aleksey 1:255; 2:376;
 3:387
shea 3:420
Sheikan museum 3:255
Sheikh, Badie al- 1:253
Sheikhly, Ismail 2:141, 291
Sheik Nefzawi 2:53
Shekhr-Islam 1:429–430
Shellal 1:232
Shemza, Anwar Jalal 1:351;
 3:93, 205
Shendi 3:208
Shepherd, Charles 3:118
Shepherd, Dorothy 3:206
Sher-e-Bangla
 National Assembly Building
 1:263

Shergarh see Delhi
Sher Shah, Sultan (r. 1538–45)
 1:182; 2:5; 3:185, 258,
 384
Shevchenko, Taras 2:377
Shi see Chach
Shibam 3:445
 houses 3:407
 mosque 1:110
Shibanid see Shaybanid
Shibani Khan 3:176
Shiber, Saba George 2:405–6
Shibrain, Ahmed Mohammed
 3:254
Shihab al-Dawla Mawdud, Sultan
 (r. 1041–50) 2:341
Shihab al-Din Ahmad, Sultan
 (r. 1422–36) (Bahmani)
 [Bahmani] 1:252, 285;
 2:235
Shihab al-Din Ahmad
 Zardakashi 2:91
Shihab al-Din Pasha 3:121
Shihab al-Din Tughril 2:499
Shi'ites see under Islam
Shikasta nasta'līq see under
 scripts
Shikhaliyev, O. Yu. 1:243
Shikida, Koichiro 2:45
Shikohabad 3:384
Shiraz 1:90; 2:92; 3:206
 Bagh-i Takht 2:92
 carpets 1:376, 378
 citadel 2:528
 congregational mosque 1:319
 Divankhana 1:175
 glass 2:116
 lacquer 2:411
 library of 'Adud al-Dawla
 2:420
 manuscripts 1:176, 176;
 2:193, 204, 216, 217,
 218, 222, 223, 224,
 225, 226, 231, 243;
 3:207
 Masjid-i Vakil (Regent's
 Mosque) 1:176
 metalwork 2:511
 mosque of Nasir al-Mulk
 1:176
 Naranjistan 3:207, pl.VI.2
 palace of 'Adud al-Dawla 1:90
 Pars Museum 2:289
 tomb of Bibi Dukhtaran 1:171
 tomb of Khatun Qiyamat
 1:171
Shirinov, M. 1:247
Shirin Painter see Muhammad
 Shirin
Shirley, Sir Anthony 1:367
Shirvan 3:162
Shirvanshahs see Manuchihr II
 (r. 1120–49)
shisham (Dalbergia sissoo) 3:438
Shkodër
 seraglio 1:43
Shoman, Suha 2:363
Shoura, Nasir 3:262
Shreida, Issam 3:374
Shridarani, Sundari 2:8
shrines 1:pl.VII.1; 2:pl.VIII.1;
 3:208–11
 Central Asia 3:210
 Iran 1:92; 3:50, pl.V.1
 Morocco 3:209, 209
 Syria 1:111
 Kazakhstan 1:134

Shroud of St. Josse **2:**311; **3:**293, 299, *299*
SHS **1:**302
Shufu *see* Kashgar
Shuhda **1:**339
Shuja' ibn Man'a **2:**500
Shukri, Akram **2:**290
Shul'gin, V. **1:**239
Shuman **2:**39
Shusha **1:**238, 239; **3:211–2**
 carpets **1:**215, 246, 374–5
 embroidery **1:**245–6
 textiles **1:**245–6
Shushtar **2:**286
Shuvayeva, S. **3:**273
Shuvelyan **1:**238
Shyama Sundara **2:**264
Shykhly, S. M. **1:**246
Sialkot **1:**224
Sibt ibn al-Jawzi **2:**499
Sicily
 architecture **1:**103
 ceramics **1:**461
 ivory **2:**334
 muqarnas **1:***104*
 textiles **3:**300, pl.X.2
 see also Aghlabids; Italy
Siddiqi, I. R. **3:**97
Sidi Bou Said **3:**356, 357, *358*
Sidih **1:**177
 Friday Mosque **1:**206
Sidi Kacem **1:**469
Sidi Qasim al-Jalizi **1:**479
Sidiqqi, Shakeel **3:**94
Sidon **2:**418; **3:**216
Sidzhak **1:**430
Siegburg **3:**298
Ṣifāt al-'āshiqīn ("Dispositions of lovers"; 1582; priv. col.) by Hilali **2:**242
Sigena monastery **1:**226, 490
Sigismund III, King of Poland (*r.* 1587–1632) **1:**367, 499
signatures (artists') **1:**8, 9, 227, 228, 446, 501–2; **2:**76, 192, 228, 238
signatures (Imperial monograms) **3:**351–2
 see tughras
Sigoli, Simone **2:**503
Siirt **2:**499
 congregational mosque **3:**432
Sijelmassi, Abdelhaq **2:**547
Sijelmassi, Abdelrahim **2:**547
Sijilmasa **3:**396
Sikandar, (*r.* 1672–86) ('Adil Shahi) **1:**11; **2:**265
Sikandar, Sultan (*r.* 1489–1517) (Lodi) **1:**30, 139; **2:**429; **3:**212–3, 230, 384
 architecture **1:**30
Sikandar Begum **1:**283
Sikandra **1:**30; **3:212–3**
 tomb of Akbar **1:**183; **2:**96–7; **3:**12–3, *14*, 343, pl.VII
 tomb of Maryam Zamani **3:**213
Sikimić, Gojko **1:**302
Siklos
 mosque **2:**178
silhouette ware **1:**454, 458–9
 see under ceramics → wares
Silis, Nikolay Andreyevich **3:**366

Silivri
 Büyük Çekmece Bridge **1:**166
silk **1:**25, 245, 356, 365, 414–15, *415*, pl.IV.4; **2:**25–8, 216; **3:**282–3, 291–2, 292–3, *299*, *304*, *306*, 309, *309*, 310, 319, pl.X.2, pl.XI.1
Silk Route **3:213–8;** *215, 315*
Silos
 S. Domingo **3:**4, 5
Silsilat al-zahab ("Chain of gold"; 1549; St. Petersburg, Rus. N. Lib., Dorn 434) by Jami **2:**243, 541
Silvan
 castle **1:**197
 congregational mosque **1:**228
 minaret of Abu'l Muzaffar **1:**198
 mosque **1:**112
silver **1:**304–5, 479–80, 480; **2:**479
 regional traditions
 Afghanistan **1:**18
 Azerbaijan **1:***244*
 Berber **1:***7/8,* pl.I.4
 Central Asia **1:**408–11, 429–30
 Egypt **2:***509*
 India **2:***512*
 Iran **2:***490*
 Iraq **2:***301*
 Israel **2:**314
 Malaysia **2:**445–6
 Syria **1:***310*; **2:***484*; **3:**260
 Tuareg **3:**34–9
 Turkmenistan **3:**367
 Yemen **2:***359*
 uses
 ceramics **1:**441, 458
 jewelry **1:**278, pl.I.4, 429–30; **2:**355, *359*; **3:**338–9, 367
 tent poles **3:**282
 thread **1:**367; **3:**310, 319–20
Simaika, Morcos **1:**331
Simicioglu, Michael **2:**127
Simferopol Treasure **2:**355–6
Simnan **1:**91; **3:218**
 minaret **1:**90, 91; **3:**218
 mosques **1:**176
Simon, Paul **3:**138
Simonetti carpet **1:**363
Simoni, Gustavo **3:**70
Simonson, Otto **2:**545
Simpson, William **3:**69
Sims, Eleanor **2:**128
Sin
 caravanserai **1:**129
 minaret **1:**96, 199
Sinaba, S. **2:**450
Sinan **1:**68, 161–2; **3:**82–3, 86, **218–23,** 226
 pupils **1:**520; **3:**22
 works
 Ankara, Genabi Ahmed Pasha Mosque **1:**62, 161
 bridges **1:**306–7
 Buda, mosque of Mustafa Pasha **2:**177
 Edirne, baths **2:**42
 Edirne, caravanserais **2:**42

Edirne, Selimiye Mosque **1:**164, *165*; **2:**18, 42, *42*; **3:**219
Erzurum, Lala Mustafa Pasha Mosque **2:**54
Istanbul, Ahmed Pasha complex **2:**402
Istanbul, aqueducts and cisterns **2:**316, 326
Istanbul, Atik Valide complex **1:**165
Istanbul, baths **2:**271–4, *273*
Istanbul, Iskele Mosque **3:**219
Istanbul, mausoleum of Selim II **2:**323
Istanbul, mosque of Mihrimah Sultan (Edirnekapı; *c.* 1565) **3:**219
Istanbul, mosque of Rüstem Pasha **2:**324
Istanbul, Şehzade Mehmed Mosque **1:**163; **3:**219, *220*
Istanbul, Sokollu Mehmed Pasha complex **1:**164; **3:**219–20, 326
Istanbul, Süleymaniyé Complex **2:**325, 402; **3:**219
Istanbul, Süleymaniye Mosque **1:**163, *164*; **2:**252
Istanbul, Topkapı Palace **2:**328
Sinan, Atık **2:**324
Sinan Beg **2:**253
Sinan Pasha **1:**327; **2:**188
Sind (region)
 mosques **1:**76, 83
Singapore **2:**442
Singh, Arpita **2:**8, 273
Singh, Bhupinda **1:**318
Singh, Kuldip **2:**273
Sinjar **1:**248
sinking **2:**480
Sinni, Ahmad Qassim **1:**253
Sinop
 madrasa of Süleyman Pervane **1:**118
 Saray Mosque **1:**141–2
Siraf **1:**70; **3:**120, **223**
 ceramics **1:**445, 445–6, 446–7, 448, 449, 485
 congregational mosque **1:**82; **2:**531
 glass **2:**111
 houses **1:**83
 mosques **2:**82
 stelae **3:**234
Sirbegović, Kemal **1:**302
Sirel, Nejat **3:**362
Sirhandi, Khalid **3:**97
Siri *see under* Delhi
Sirikye **1:**21
Sirjan **1:**449–50
Sirkap **3:**100
Sirkeci *see* Istanbul
Sir Sayyid Ahmad Khan **1:**55
Siryaqus **1:**148
Sisley, Alfred **3:**414
Sitra Island **1:**253
Sivas **1:**141; **3:**223–4
 Buruciye Madrasa **1:**118; **3:**224

carpets **1:**373
Çifte Minareli Madrasa **3:**27, *29*, 324
Gök Madrasa **1:**118, 198; **3:**224
Great Mosque **1:**117; **3:**224
Güdük Minare Türbesi **1:**144; **3:**224
hospital of 'Izz al-Din Kayka'us **1:**118, 198; **3:**224
textiles **1:**215
Sivrihisar
 Great Mosque **1:**143; **3:**431
Six Masters **1:**346
Six Pens *see under* scripts
siyāh mashq **1:**350
Siyah Qalam **2:**232, 243, 248, **324–5**
Siyaqi-Nizam *see Futūḥāt-i humāyūn* ("Conquests of the emperor")
Siyār-i Nabī ("Life of the Prophet") by Mustafa Darir (*c.* 1594–5; dispersed) **2:**139, 201, 253–5, *254*, 255; **3:**87, *87*
 (*c.* 1700; Istanbul, Mus. Turk. & Islam A., MS 1974)
Siyavush **2:**243; **3:**40, **225–6,** 392
Siyavuş Pasha **2:**95, 253
Skidka
 Museum **1:**51
Skidmore, Owings & Merrill **1:**193, pl.III.2, 213; **2:**320; **3:**188, 360
Skopje
 Archaeological Museum of Macedonia **2:**427
 Chamber of Commerce **2:**426
 Daut-Pasha Hammam **2:**426
 District Labor Insurance Building **2:**426
 Ethnographical Museum **2:**427
 Girls' Lyceum **2:**426
 Governor's Palace **2:**426
 Ibni Pajko building **2:**426
 Main Post Office **2:**426
 Market Center **2:**426
 National Bank **2:**426
 Radio Skopje Building **2:**426
 Suli Han caravanserai **2:**426
 Sultan Murat Mosque **2:**426
Skopljak, Mustafa **1:**302
Slaoui, Hassan **2:**547
Slevogt, Max **3:**70
slip **1:**451, 457
Sliven **1:**315
Sluntchev Bryag **1:**314
smalt **1:**441
Smederevo Fortress **3:**196
Smith, Charles Hamilton **2:***471*
Smith, Myron Bement **2:**154
Smith, Robert Murdoch *see* Murdoch Smith, Robert
Smolyan **1:**314
Snichkov, Yu. **2:**407
Snøhetta Hamza Consortium, Egypt & Norway **1:**48
snuffboxes **1:**18, 274
Société des Beaux-Arts (Algeria) **1:**49–50

Société des Peintres Algériens et Orientalistes **1:**49
Société des Peintres Orientalistes Français **1:**50
Société Nationale de l'Artisanat Traditionnel **1:**51
Société Primitive, La *see* Pioneers, The
Society of Fine Arts (Egypt) **2:**46
Society of Formative Artists **2:**405
Society of the Friends of Art **2:**46
soda **1:**441
Sofia
 Alexander Nevski Church **1:**314
 Army Club **1:**314
 Bulgaria Hotel and Concert Hall **1:**314
 Bulgarian National Bank **1:**314
 Central Department Store **1:**314
 Court of Justice **1:**314
 Cyril and Methodius Library **1:**314
 Holy Synod **1:**314
 houses **1:**314
 Mineral Baths **1:**314
 mosque **1:**162–3
 National Palace of Culture **1:**314
 National Theater **1:**314
 Party Building **1:**314
 Sheraton Hotel **1:**314
 Surmdyiev House **1:**314
 Yablanski House **1:**314
 Zaimov housing project **1:**314
Sogidana (Uzbekistan/Tajikistan) *see* Central Asia
Söğüt
 mosque **1:**145
Sohar **2:**527; **3:**66–7
Sokollu Mehmed Pasha **1:**166; **2:**42, 253
Sokoto **3:**56
 Shehu Mosque **1:**23
Solkhat-Krym *see* Staryy Krym
Solomon, Simeon **3:**69
Soltaniye *see* Sultaniyya
Somalia **3:226–8**
Sonargaon
 Folk Art and Craft Museum **1:**265
Songhai **1:**22; **3:**52, 402
Sonia, Anwar Khamis **3:**66
Soninke **2:**449
soot **1:**339; **2:**283
Soria
 church **3:**7–8
Sorko **1:**24
Soroš, George **3:**183
Šotra, Branko **1:**302
Soudavar, Abolala **1:**501
Soufi, Hassan **3:**357
souks **2:**465; **3:**376
Sourdel, Dominique **3:**228
Sourdel-Thomine, Janine **2:**129, 154; **3:228**
Soutine, Chaim **3:**356
Sousse **1:**22, 85; **3:228**, 356
 Great Mosque **1:**85
 Khalaf al-Fata **1:**85
 mosque of Bu Fatata **1:**86
 museum **3:**357

ribāṭ **1:**85, 86; **2:**518
textiles **3:**300
town walls **1:**159
Soyinka, Wole **3:**58
Spain
 arches **1:**67
 architecture **1:**87–8, *122*, 124–5, 126–7, 155–7; **3:**3–4, 7–10, *9*
 military **2:**522–3
 artesonado **1:**226–7, 382, pl.VIII.2; **3:**428
 bell-towers **1:**71
 calligraphy **1:***345*
 carpets **1:**359–61
 ceramics **1:**452, 461–2, *461, 469*
 fountains **2:***78*
 gardens **1:**89–91, *90*
 ivory **1:**505–6, *506*; **2:**332–4, *333*
 manuscripts **2:**207, pl.VII.2; **3:**5–6, *6*
 metalwork **2:**485–6, *486*, 505–6, *506*
 minarets **3:***198*
 mosques **1:***122*, pl.V.3
 muqarnas **1:**156; **3:***29*
 palaces **1:***122*; **2:**pl.V.1
 sculpture **1:**65–6
 synagogues **3:**8
 textiles **3:**300–01, 302–5, pl.X.2, *299*
 woodwork **3:**425–8, 428–30
 see also Almohads; Almoravids; Mozarabic art; Nasrids; Umayyads; Zirids
splashed ware *see under* ceramics → wares
spolia **1:**69, 193, 503; **3:228–9**
Spring garden *see Bāharistān*
Spring of Khusraw **1:**359; **2:**87
spruce (*Picea morinda*) **3:**438
square kufic *see under* scripts
squinches **1:**70, 91, 100, 103; **3:**25–6, **229–30**, *230*
squinch-net vaulting **1:**70; **3:**229–30
SredAzKomStarIs **1:**433
Srinagar **3:**216, *230*
 congregational mosque **3:**230
 mosque of Mulla Shah Badkhshani **1:**187
 Shah Hamadan Mosque **3:**230
 Shalimar Garden **1:**184, 187; **2:**79, 96–7; **3:**230
 Sri Pratap Singh Museum **3:**230
Srour, Habib **2:**418
Srour, Obaid **3:**374
stained glass **1:**166, 209–10, 428
staircases **3:230–31**
stalactite vaulting *see muqarnas*
Stalinabad *see* Dushanbe
stamps **3:231–2**
Staronosov, Piotr Nicholaevich **3:**267
Stars of the Sciences *see Nujūm al-ʿUlūm*
Staryy Krym **3:**232
State Academy for the History of Material Culture (GAIMK) **1:**433
status of artists *see* artists, status of

Stchoukine, Ivan (Sergeyevich) **2:**154, 194, 312; **3:232–3**
Steblin, Fyodor Petrovich **2:**407
Stein, Joseph Allen **2:**20, 272
stelae **3:**233–4, *234*, 484, 517
Štetić, Rizah **1:**302
Štip **2:**426
 Museum **2:**427
stone
 architecture **1:**69, 105, 137; **2:**172
 mosaics **1:**207–8
Stone, E. A. **2:**545
Stone, Edward Durrell **2:**309; **3:**93
stoneware *see under* ceramics → wares
stools **2:**82
storehouses **3:**396
Storrs, Sir Ronald **2:**350
Story of Darab *see Dārābnāma*
Story of Ferruh and Huma *see Dastān-i Farrūkh u Hūmā*
Story of Ferruhruz *see Qissa-yi Farrūkhrūz*
Story of Jamal and Jalal *see Dastān-i Jamāl va Jalāl*
Story of Sahr and Satran *see Qissa-yi Shahr u Shatrān*
Strabo **2:**25
Strachey, Richard **1:**57
Straus, Ivan **3:**183
striped masonry **1:**87–8
Strumica
 Museum **2:**427
Strzygowski, J. **3:**7
stucco **1:**69, 90, 96, 193, *195*, 305; **2:**173; **3:235–9**, *179*, 244, pl.VII
 mihrabs **1:***97, 99*
 vaults and domes **1:***134*; **3:***236*
 window grilles **1:**209; **3:**419
Studenica **3:**308
Stuttgart
 Villa Wilhelma **2:**544
Suaire de St. Lazare **3:**77
Suakin **1:**24; **2:**173; **3:**60, **239**, 405
Subang Jaya
 IBM headquarters **2:**442
Subh **2:**332
Subhanquli Khan (r. 1681–1702) **1:**179, 258
Sub-imperial Mughal painting **2:**261
subject matter **2:**196–9; **3:239–53**
 animals **1:**196; **3:**72–3, 246–8, *247*
 apotropaic **3:**248
 astronomy and astrology **3:**248
 blessings **3:**76
 Christianity **2:**310, 484, 500–01, *500*; **3:**5, 240–01
 cosmic and astrological **2:**501
 emblems **3:**77
 erotic art **2:**53
 figural **2:**182; **3:**72–3
 flowers **3:**76
 genre **3:**243
 geometric **3:**73, pl.XVI.2, 244–5

hand of Fatima (*khamsa*) **2:**311, 357; **3:**248
landscapes **2:**416; **3:**243
narrative art **2:**267; **3:**47–8
Pararadise **3:**240–1
portraiture **1:**241, 290–1; **2:**253; **3:**123–4, 242
princely cycle **1:**196; **3:**241, 369–70
religious **3:**240–241
royal themes **3:**239, 241–242
scientific and technical subjects **2:**194, 196–197
talismanic **3:**248
vegetal ornament **2:**483; **3:**71–2, 243–4
victory **3:**242
writing *see* epigraphy
see also aniconism; Orientalism; ornament and pattern
Subramanyan, K. G. **2:**273
Sud, Anupam **2:**8
Sudan **3:253–5**
 architecture **3:**254
 painting **3:**254–5
 see also Nubia
sūdānī see under scripts
Sudus **2:**527
Suez **2:**45
Sufetula *see* Sbeïtla
Sufi, al- *see Suwār al-kawākib al-thābita*
Sufis *see under* Islam
Suhrawardi, al- **3:**76
Suhrawardy, Hussain Shaheed **3:**159
Sujas
 mosque **1:**92
Sukar, Abd al-Karim **3:**374
Sulayhid (r. 1047–1138) **3:256**
 architecture **1:**110, *111*
 see also ʿAli (d. 1067); Sayyida al-Hurra Arwa bint Ahmed, al-
Sulayman, caliph (r. 715–17) (Umayyad) **1:**75, 207; **2:**25
Sulayman I, Shah (r. 1666–94) (Safavid)
 architecture **1:**173; **2:**299; **3:**209
 armor **1:**222
 crown **1:**149
Sulaymānnāma ("Book of Solomon"; late 15th century; Dublin, Chester Beatty Lib., Turk. MS. 406) **2:**233
Sulaymānnāma ("Book of Süleyman"; 1558; Istanbul, Topkapı Pal. Lib., H. 1517) by ʿArifi **2:**205, 252; **3:**83, 86, 284
Sulaymānnāma ("Book of Süleyman"; 1579; Dublin, Chester Beatty Lib., MS. 413) by Lokman **2:**253
Suleiman, Khalid ben **3:**357
Suleiman, Ziauddin **2:**362
Suleiman Hakim **3:**119
Süleyman Çelebi **2:**41
Süleyman Pasha **1:**327

Süleyman the Magnificent,
 Sultan (r. 1520–66)
 (Ottoman) 3:85–6
 architecture 1:163, 164, 169,
 307; 2:325, 328, 348,
 351, 402, 471, 472,
 526; 3:218, 382
 dress 2:22; 3:311
 ivory-carvings 2:538
 manuscripts 1:36; 2:252, 370;
 3:201
 paintings 1:206
 regalia 3:149
 stained glass 1:210
 swords 1:221; 2:335
 tents 3:284
sulfur 1:458
Suli, al- 1:340
Suli Pasha 2:374
Sullecthum see Salakta
Sultanabad
 carpets 1:376; 2:288
 ceramics 1:443, 462
Sultanahmed see Istanbul
Sultan Ali Mashhadi 1:56, 287,
 340, 349, 407, 498;
 2:190, 250, 261, 264,
 343, 536; 3:3, 256–7,
 336
Sultan ʿAli Quaini 1:pl.XII.3
Sultanatabad
 palace 1:177
Sultan Dağ 3:284
Sultan Han 1:120, 354; 3:121,
 231
Sultan Husayn Bayqara
 (r. 1470–1506)
 (Timurid) 3:336
 architecture 1:132, 258;
 2:148; 3:175
 gardens 1:134
 jade 2:341
 manuscripts and miniatures
 1:286, 293, 297, 349,
 497, 497, 504, pl.XI;
 2:195, 204, 228–30,
 229, 237; 3:108, 134,
 225, 256, 336, 337
 metalwork 2:497
Sultan-Husayn Mirza see Sultan
 Husayn Bayqara
Sultaniyya 2:184; 3:257
 cenotaphs 3:435
 mausoleum of Uljaytu
 1:130, 130, 212; 2:532;
 3:74, 257, 344
 mosque 2:532
 painting 1:215
 textiles 3:308
Sultan-kala see Merv
Sultan-Muhammad (calligrapher;
 Herat) 2:510
Sultan-Muhammad (illustrator;
 Tabriz) 2:239, 240,
 pl.IX; 3:163, 258, 451,
 pl.IV
Sultan-Muhammad Nur 1:56;
 2:239
Sulwān al-muṭāʿ ("Prescription
 for pleasure"; Qatar;
 Doha Museum;
 Geneva, Prince
 Sadruddin Aga Khan
 priv. col.; Washington,
 DC, Freer, 54.1–2) by
 Ibn Zafar al-Siqilli
 2:199

sumak 1:375; 2:386
Sumaka
 congregational mosque 1:80
Suman, Nusret 3:362
Sumgait 1:263, 239
Sunbulnāma ("Book of
 hyacinths"; 1736–7;
 Istanbul, Topkapı Pal.
 Lib., H. 413) 2:256
Sunburst carpets see under
 carpets → types
Sunnis see under Islam
Sura, Najmi 3:94
Surakarta 2:281–2
Surakhany 1:255
 fire temple 1:237–8
 housing 1:238
Surat 2:514
Surkh Kotal 3:231
Sūrnāma ("Book of festivals";
 1720–32; Istanbul,
 Topkapı Pal. Lib.,
 A. 3593) by Vehbi
 2:205, 304, 329, 420;
 3:88, 285, 309
Sūrnāma-i humāyūn ("Imperial
 book of festivals"; c.
 1583; Istanbul, Topkapı
 Pal. Lib., H. 1344)
 2:116, 139, 253, 304,
 321; 3:87
Surrealism 1:226
Surs (r. 1538–55) 3:258, 384
 see also Sher Shah (r. 1538–45);
 Islam Shah Sur, Sultan
 (r. 1545–53)
Sursock, Nicolas Ibrahim 2:419
Susa (Iran)
 ceramics 1:455, 446, 447,
 448, 449
 mosque 1:81
 rock crystal 3:154
 shrine 3:209
Sūsa (Tunisia) see Sousse
Susu 2:130
Suwār al-kawākib al-thābita
 ("Book of fixed stars";
 Paris, Bib. N., MS.
 Arabe 5036) by al-Sufi
 3:334
Suwayda 3:262
Sūz va gudāz ("Burning and
 melting") by
 Muhammad Riza Nawʿi
 (mid-17th century; Dublin,
 Chester Beatty Lib.,
 Pers. MS. 268) 2:245
 (c. 1645–60; Baltimore, MD,
 Walters A. Mus., MS
 649) 3:16
Svarichevsky, Georgy
 Mikhailovich 3:387
Svetoslavsky, Sergey Ivanovich
 3:388
Swahili 3:258–60
Swaminathan, Jadish 2:273
swami ware 2:360
Swar, Rashid 1:253
Swenet see Aswan
swords 1:217, 223, 223, 224,
 245, 423–4
sycomore (Ficus sycomorus)
 3:420
Sydykhanov, Abdrashid 2:377
Syene see Aswan
symmetrical knots 1:356
synagogues 3:9

Syracuse
 Castello Maniace 1:104
Syria 3:260–62
 architecture 1:74–6, 84,
 111–6, 147–52, 169,
 305
 military 2:397, 520
 vernacular 3:261, 403–5
 baths 1:271
 capitals 1:281
 ceramics 1:444–5, 455–6,
 455, 465–7, pl.XIII.4
 coins 1:490–92, 491, 494;
 2:515, 515
 glass 2:113–15, 114, 115,
 pl.IV.2
 gold 2:354
 hospitals 1:115, pl.VI.2
 jewelry 2:354–5, 354
 madrasas 1:113–15, 114
 mausolea 1:115
 metalwork 2:310, 456, 484,
 486, 498–501, 499,
 500, 501–5, 508–9,
 509, pl.V.3; 3:18,
 pl.IX.1
 mihrabs 1:46–7, 47
 minarets 1:113
 mosaics 1:207–8
 mosques 1:112, 169, pl.IV.1
 muqarnas 1:116; 3:26, 27
 painting 1:202–4, 203
 palaces 1:115; 2:135
 shrines 1:115
 textiles 1:47; 3:305–7, 306
 woodwork 3:420–23, 430–31
 see also Ayyubids; Mamluks;
 Saljuqs; Tulunids;
 Umayyads; Zangids
Szigetvar
 mosque 2:178
Szwif, Michael 2:350
Tabari, al- 1:75, 409; 2:338
 see also Annals
Tabaristan metalwork 2:489,
 489
Tabatabai, Jazeh 2:287
Tabbaa, Samer 2:363
Tabet, Antoine 2:418
Tabiyev, Bakhtiyar 2:377
Tabriz 2:184; 3:263–5
 Arg 3:263–4, 263
 Blue Mosque 1:134, 135, 200;
 3:121, 134, 265, 266
 carpets 1:364, 365, 377;
 2:288; 3:163
 citadel 2:528
 ceramics 1:457, 464
 coins 1:495
 Hasht Bihisht Palace 1:205;
 2:389
 manuscripts 1:348; 2:188,
 204, 214, 215–16, 216,
 217, 218, 238–40,
 pl.VII.1, pl.VIII.1;
 3:111, 113, 264
 metalwork 2:491
 mosque of ʿAlishah 1:306
 Nasriyya complex 1:134
 painting 1:215
 Rabʿ-i Rashidi 1:130;
 2:215–16, 308, 420;
 3:265
 Shah Goli 2:92
 textiles 3:307, 308, 315, 316

tiles 1:200
 tomb of Ghazan 1:130, 197
Tabrizi, Sadeq 2:287; 3:182
Tadić, Radoslav 1:302
Tadla 2:522
Taft 1:135
Taghyzade, Rza 1:246
Tagiyev, T. 1:241
Tagore 2:275
Taguemont 2:357
Taha, Mahmoud 3:363
Tahart
 mosque 3:425
Tāhēri see Siraf
Tahirids (r. 821–73; Khurasan)
 coins 1:425
Tahirids (r. 1454–1536; Yemen)
 architecture 1:154
 see also ʿAmir II
 (r. 1488–1517)
Tahmasp I (r. 1524–76)
 (Safavid) 1:227;
 3:162–3
 architecture 1:171; 2:467,
 528; 3:138
 manuscripts and miniature
 paintings 1:4, 63, 287,
 497, 504; 2:40, 188,
 190, 202, 203, 220, 239,
 240, 41, 5, 5, 541; 3:39
 106, 110, 160, 204, 258,
 264, 276, pl.IV
 wall paintings 1:205
Tahoua 3:349
Taʾif 2:175; 3:187, 405
Taizhou 3:214
Taʿizz 1:153; 3:444
 Asadiyya Madrasa 1:153
 Ashrafiyya Madrasa 1:154;
 3:435
 Husayniyya 1:170
 minarets 1:155
 Muʿtabiyya Madrasa 1:154
 Muzaffariyya Mosque 1:153,
 154
 Salah Palace Museum 3:446
Taj al-Din ʿAli Shah 2:144
Taj al-Din Firuz (r. 1397–1422)
 (Bahmani) 1:252
Taj al-Din Salmani 2:350
Tāj al-maʾāthir fi taʾrīkh
 ("Crown of the glories
 of history"; 1426; St.
 Petersburg, Acad. Sci.,
 Lib., MS. 578) 3:335
Tāj al-Salāṭīn ("The Crown of
 Kings"; London, BL,
 MS. Or. 13295) 2:444
Tajikistan 3:266–8, 268
 architecture 3:266–7
 historiography 1:433
 painting 3:267–8
 see also Central Asia
Taj Mahal see under Agra
Takht-i Marmar 3:327, pl.VIII.1
Takht-i Nadiri 3:327
Takht-i Sulayman
 ceramics 1:457
 palace 1:129, 201; 2:389;
 3:27, 99, 245
Takrit 3:421
Takrouna 1:277
Talamsani, Kamil al- 1:226
tālār 1:257
Talas see Zhambyl
Talbot, William Henry Fox
 3:117

Tales of Hamza *see Hamzanāma*
Tales of a parrot *see Tūtīnāma*
Talhatan Baba
 mosque **1**:93
Talikizade **2**:139
ta'līq see under scripts
Tall, Papa Ibra **3**:194
Tamanrasset **1**:51
Tamari, Vera **3**:104
tamarind (*Tamarindus indica*)
 3:438
tamarisk **1**:420, 434
Tamgach Khan (*r.* 1052–66)
 (Qarakhanid)
 3:174
Tamur
 mosque **1**:110
Tan, Joseph **2**:445
Tanavoli, Parviz **1**:352; **2**:287,
 pl.XI.2; **3**:182, 268–9
Tanga **3**:271
Tange, Kenzō **2**:405, 426;
 3:56, 187
Tang-i Buraq
 congregational mosque
 1:319
Tangier **2**:357, 522
 Musée d'Art Contemporain
 2:548
Tankiz, Viceroy of Syria
 2:348, 454
Tannir, Hassan **2**:418
Tansen of Gwalior **3**:13
Tansykbayev, Ural **3**:388
Tanta
 tomb of Ahmad al-Badawi
 2:306
Tanzania **3**:269–71
tapestries **2**:48, pl.I.1
Taq-i Kisra **2**:338
Tara **3**:272
Tarabulus *see* Tripoli
Taranchi **3**:279
Taraz *see* Zhambyl
Tārīkh-i Abu'l-Khayr Khān
 ("History of Abu'l-
 Khayr Khan"; 1540s;
 Tashkent, Orient. Inst.
 Lib., MS. 9989) **1**:406
*Tārīkh-i fath-i Şikloş ve Ustūrğūn
 ve Ustunībelgirād*
 (*c.* 1545; Istanbul,
 Topkapı Pal. Lib., H.
 1608) by Nasuh
 Matrakçi **2**:252
Tārīkh-i jahāngūshā ("History of
 the world conqueror")
 by 'Ata Malik Juvayni
 (1290; Paris, Bib. N., MS.
 supp. pers. 205) **2**:215,
 227; **3**:123
 (1431–2; Surrey, Keir priv.
 col.) **3**:335
Tārīkh-i jahānārā ("History of
 the world-adorning";
 1683; Dublin, Chester
 Beatty Lib., Pers. MS.
 278) **2**:204
Tārīkh-i Khāndān-i Tīmūriyya
 ("History of the house
 of Timur"; *c.* 1584;
 Patna, Khuda Bakhsh
 Lib.) **2**:542; **3**:46
Tārīkh-i Sultān Bāyazīd
 ("History of Sultan
 Bayezid"; *c.* 1540;
 Istanbul, Topkapı Pal.

Lib., R. 1272) by Nasuh
 Matrakçi **2**:252
Tarim **3**:445
 al-Afqa Library **3**:446
Tariq, Tawfiq **3**:261
Tarjuma-i Miftāh-i jafr-i jāmi'
 ("Translation of the Key
 to general divination";
 Istanbul, Topkapı Pal.
 Lib., B. 373; Istanbul,
 U. Lib., T. 6624) **2**:255
Tarmita *see* Termez
Tarsus **3**:284
Tartus **3**:262
Tashgimout **3**:pl.XV.2
Tashi-khatun **3**:441
Tashkent **1**:394, 403, 479; **2**:528;
 3:272–3, 386, 387
 Alisher Navoi metro station
 3:387
 Amir Timur Museum **3**:273
 coins **1**:425
 Fine Arts Museum of
 Uzbekistan **3**:273
 History Museum **3**:273
 jewelry **1**:430
 manuscript illustration **1**:406
 Museum of Applied Arts
 3:273
 Palace of Friendship of the
 People **3**:387
 textiles **1**:416; **3**:388
 Theater of Opera and Ballet
 3:387
 woodwork **3**:438
Tashtimur **3**:399
Tasneem, Mohammad **3**:94
Tatawwur, al- **1**:226
Tatevosyan, Oganes
 Karapetovich **3**:388
Tattoo Group **1**:51
Tavernier, Jean-Baptiste **3**:156
tāziyās **3**:95
Taut, Bruno **2**:322
tawqi' see under scripts
Tawfiq (*r.* 1879–92) **3**:34
Taxila
 Archaeological Museum **3**:97
Taybad **1**:136
 mausoleum of Shaykh Zayn
 al-Din **1**:133
Tayma' Stone **3**:189
Taza
 Bastriun **2**:522
 minbar **2**:535; **3**:429
 mosque **1**:158; **2**:505
teak (*Tectonia grandis*) **2**:173;
 3:420, 438
Tebessa **1**:49
Tehran **1**:190; **2**:528; **3**:273–5
 Archaeological Museum *see*
 National Museum of
 Iran
 Azadi Monument (Shahyad
 Tower) **2**:286, pl.XI.1
 Bihisht-i Zahra **1**:384
 Carpet Museum **2**:289; **3**:35,
 275
 ceramics **1**:477
 College of Decorative Arts
 2:287
 College of Fine Arts **2**:286
 Crown Jewels Museum **2**:288
 Decorative Arts Museum
 2:288
 Ethnographic Museum **2**:289;
 3:35

glass **2**:116
Gulistan Palace **1**:176, 477;
 3:pl.VIII.1
Gulistan Palace Museum
 2:289; **3**:35, 274
Iran Center for Management
 Studies **1**:214; **2**:286
lacquer **2**:411
Museum of Contemporary Art
 2:286, 289
Museum of Glass and
 Ceramics **2**:289; **3**:35,
 275
National Museum of Iran
 2:288; **3**:35
Nigaristan Museum **1**:501;
 2:288; **3**:35
Nigaristan Palace
 murals **1**:3–4; **3**:63
Qasr-i Qajar **1**:177
Riza 'Abbasi Museum **2**:288;
 3:35, 275
Shams al-'Imarat **1**:177
Sipahsalar Mosque **1**:176
Tejend **1**:389
Tekke **1**:379, 491; **3**:367
*tekke*s **2**:382
Tel'zhanov, Kanafiy **2**:377
Temboury, Jean **2**:436
Tenies **1**:301
tents **3**:275–87
 Algeria **3**:279
 Arab **3**:278
 Berber **1**:277; **3**:278
 Central Asia **1**:133; **3**:99
 India **3**:276
 Iran **1**:129
 Turkey **3**:278, 279, 281
 see also yurts
Tercan
 tomb of Mama Hatun **1**:119
Terengganu
 textiles **2**:446
Termez **1**:395; **3**:289–90
 architecture **1**:83
 Chorsutun Mosque
 minaret **1**:90
 mausoleum of Sultan Sa'dat
 1:402
 mosques **1**:89
 ramparts **1**:403
 Regent's Palace **1**:401; **3**:99
 stucco **1**:92, 96, 194, 197,
 405; **3**:238
 shrine of al-Hakim
 al-Tirmidhi **1**:94, 212;
 3:209, 290
Termikelov, M. **1**:238, 255
terracotta **1**:96, 100, 401
Terrasse, Henri **2**:153; **3**:290–91
Teruel **3**:8, 9
Tetovo
 dervish school **2**:426
Tétouan
 ceramics **2**:547
 Escuela Preparatoria de Bellas
 Artes **2**:546
 textiles **3**:313
Texier, Charles **2**:153; **3**:363
textiles **3**:291–325
 Afghanistan **1**:17–18
 Africa **1**:25–6
 Algeria **3**:313
 Azerbaijan **1**:245–6
 Bangladesh **1**:264
 Berber **1**:278
 Bulgaria **1**:315

Central Asia **1**:414–20, *415*;
 3:216, 298–9, 307–8,
 316–17
Egypt **2**:pl.I.1; **3**:294–6, *296*,
 305–7, *306*
Fulani **2**:81, pl.III.2
Hausa **2**:142
India **2**:274; **3**:317–25
Indonesia **2**:283
Iran **1**:319; **3**:297–8, *299*,
 307, 308, *309*, *314–16*,
 pl.XI.2
Iraq **3**:297–8, *339*
Kazakhstan **2**:377–8
Kyrgyzstan **2**:408
Macedonia **2**:426–7
Malaysia **2**:447
Mali **2**:449, pl.XV.2
Morocco **3**:313
Pakistan **3**:95
Sicily **3**:pl.X.2
Spain **3**:300–01, *302–4*, *304*,
 pl.XI.1
Syria **1**:47; **3**:305–7, *306*
Turkey **3**:308, 309–12, *311*,
 pl.II.2
Uzbekistan **3**:388, pl.III.3
Yemen **3**:302, *303*
see also carpets; dress; tiraz
Teymurova, R. **1**:247
Tha'alabi, al- **2**:26; **3**:75
Thajudeen, Syed **2**:445
Thamugadi *see* Timgad
Thar Desert **2**:529
Thattha **3**:326–7
 Friday Mosque **2**:552; **3**:326
 tomb–mosque of Nizam al-
 Din II **3**:326
The Crown of Kings *see Tāj
 al-Salātīn*
theological colleges *see* madrasas
thermoluminiscence **2**:156
Thessaloniki **2**:128
Thiès
 Manufactures Sénégalaises des
 Arts Décoratives **3**:195
Thornhill, Cuthbert Bensey
 1:57
thrones **2**:83; **3**:327, pl.VIII.1,
 pl.X.1
Thrysdus *see* Djem, El
Thuburbo Maius **3**:357
Thula **3**:407
thuluth see under scripts
Tianjin
 Qingzhen si **1**:484
Tiaret **1**:49
Tibet
 tents **3**:279
Tibur *see* Tivoli
Tidjikdja **2**:469
Tichitt **2**:469
tie-dyeing **3**:323
 see also batik
Tiflis **1**:215
Tiflis Ewer **2**:487
Tihrān *see* Tehran
Tikveša, Halil **1**:302
Tilden, Philip **2**:545
tiles **1**:69, 199–201, 305;
 2:516–17
 Central Asia **1**:182, 200, 385,
 401–2, pl.XVI.1
 cuerda seca tiles **1**:200, 402
 Iran **1**:88, 96, 131, 136,
 199–200, 385, pl.I.1,

pl.VII.2, pl.XV,
pl.XVI.3; 3:*74, 266*
Morocco 1:201, *201*
Turkey 1:162; 2:*473*; 3:pl.
III.1
Tilimsān *see* Tlemcen
Tillya Tepe 3:217
Tilmun *see* Bahrain
Tim
mausoleum of Arab-Ata
1:90, 91, 396, 401;
3:25, 120, 229,
344
Timagoras 3:282
Timbuktu 2:449; 3:328, 396
Great Mosque 3:328
manuscripts 1:27
Sankoré Mosque 1:22; 3:328
textiles 2:449
Timgad 1:49
Timnaʿ 3:445
Timur, Sultan (*r.* 1370–1405)
(Timurid) 1:392;
2:165; 3:328, 330
architecture 1:132, 309, 395,
397, 398; 3:99, 172,
176, *210, 331, 358,
359*
ceramics 1:463
coins 1:426
gardens 1:133; 2:91
manuscripts 1:293, 347, 405;
2:223–4; 3:106
metalwork 1:439; 2:482, 496
tents 3:99, 281, 283
Timurids (*r.* 1370–1506) 1:392;
2:165; 3:**328–36**
architecture 1:128, 131–4,
309, 397, 398, pl.III.1;
2:*147*; 3:329, *331, 332,
358, 359*
carpets 1:365
ceramics 1:463
coins 1:426
jade 2:341–2
manuscripts 1:497, pl.XI;
2:223–30; 3:*337*
metalwork 2:496–7
muqarnas 3:27
tents 3:281
woodwork 3:436
see also Timur, Sultan
(*r.* 1370–1405);
Muhammad Sultan
(*d.* 1403); Iskandar
Sultan, Prince; Khalil
(*r.* 1405–9); Shahrukh,
Sultan (*r.* 1405–47);
ʿAbdallah (*fl.* 1417–20);
Muhammad Juki
(1402–44);
Gawharshad; Ulughbeg,
Sultan (*r.* 1447–9);
Abuʾl-Qasim Babur
(*r.* 1449–57); Abu
Saʿid, Sultan
(*r.* 1459–69); Ibrahim
Sultan; Baysunghur;
Sultan Husayn Bayqara,
Sultan (*r.* 1470–1506)
Tīmūrnāma ("History of
Timur") by Hatifi
(1538; London, BL, MS. Or.
2838) 3:*111*
(1584; Bankipur, Patna,
Khuda Bakhsh Lib.)
1:61, 269, 282, 518;

2:14, 15, 63, 259, 344,
380, 383, 415, 427;
3:272, 353
Timur Shah (*r.* 1773–93) 2:365
Timurov, Rashid
Mukhamedovich 3:388
tin 1:304, 307, 441, 450, 470;
2:447
Tingatinga, Edward Saidi 3:270
tin-glazed earthenware *see under*
ceramics → wares
Tinmal
mosque 1:58, 126, *126,*
pl.II.2; 2:*516*; 3:237
Tinnis 3:294, 295, 338
Tipasa 1:49
Tipografia Medicea Orientale
3:125
Tipu Sultan 1:499; 2:513; 3:33
Tiranë
mosque of Ethem Bey 1:42
tiraz 2:25; 3:109, 293, 295–6,
296, 302, 337–9, *339*
Tire
bazaar 1:144
Kazızade Mosque 1:142
Tirmidh *see* Termez
Tirnova *see* Malko Tŭrnovo
Tirtagangga 2:282
Tissot, James 3.69
Titograd *see* Podgorica
Titov Veles 2:426
Museum 2:427
Tivoli
Hadrian's Villa 1:77
Tiznit 2:357
Tkachenko', I. 1:239
Tlemcen 1:49; 3:340
Abu Maydan Mosque 1:201
carpets 1:380, 381
Great Mosque 1:60, 125;
2:550
ceiling 3:427
dome 1:60, 158
mihrab 2:516
muqarnas 3:28
stucco 3:237
mosque (790; destr.) 3:425
mosque of al-ʿUbbad 1:158
mosque of Sidi al-Halwi 1:158
mosque of Sidi Bel Hasan
3:428
mosque of Sidi Boumedienne
1:158
mosque of Sidi Brahim 1:158
Museum of Antiquities 1:51
Todorović, Mica 1:302
Tokat 1:117, 141
cloister of Halifet Gazi 1:143
cloister of Sumbul Baba 1:143
Çukur Madrasa 1:118
Gök Medrese 1:118
mosque of Ali Pasha 1:163
tomb of Ebuʾl-Kasim 1:119
Tokmak 2:407
Toktaliyev, E. 2:408
Toledo
astrolabes 2:486
Cathedral
chapter house 1:227
textiles 3:301, 303
ceramics 1:461
churches 3:8–9
El Cristo de la Luz 1:124; 3:8
El Tránsito 2:361; 3:9, *9*
Ibn Shoshan synagogue *see*
S María la Blanca

metalwork 2:486
mosque of Bab al-Mardum *see*
El Cristo de la Luz
palace of Cárdenas de Ocaña
S. Bartolomé 3:8
S. María la Blanca 1:226;
2:361; 3:8
S. Román 3:8
Santiago de Arrabal 3:8
S. Tomé 3:8
synagogue of Samuel Levi *see*
El Tránsito
textiles 3:300
tiles 3:8
Tollu, Cemal 3:340–41, 361
tomb complexes 1:147–8
Tombouctou *see* Timbuktu
tombs 1:69; 2:305–6; 3:**341–5**
regional traditions
Afghanistan 1:98; 2:*147*
Central Asia 1:89–90,
133, 179
Egypt 1:107–8, *333;* 3:pl.
XII.1
India 1:31–2, 33, 139, *184,*
pl.II.1; 2:*5, 9;* 3:*14,*
343
Iran 1:89–90, *90,* 94, 130;
3:*344*
Morocco 1:*189*
Pakistan 3:96
Swahili 3:259
Turkey 1:118–19, 143–4;
3:*345*
Yemen 1:110
types
iwan tombs 1:119
pillar tombs 3:259
tomb towers 1:90, *90,* 94,
118, 143; 3:*345*
see also mausolea; shrines
tombstones *see* gravestones; stelae
Tomovski, Dragan 2:426
Tomovski, K. 2:426
Tomovski, Sotir 2:426
Tomrak, Mehmet Mahir 3:362
Tongguan 1:485
ton-sur-ton 1:368
Topkapı Scroll 2:21
Toprak Kala 3:412
Toptani, Murad (Selim) 3:346
Torbov, Naum 3:314
Tordesillas 3:8
Torobekov, Suyukbek 2:408
Toros 1:473
Torres Balbás, L. 3:34
tortoiseshell 3:433
Tott, Baron de 2:525
Toulouse
St. Sernin 3:301
tower houses *see under* houses →
types
Tozeur 3:398
T-plan mosques *see under*
mosques → types
Trabzon 3:382
Trad, Farid 2:418
trade 2:104–5; 3:213–17
carpets 1:357, 373
ceramics 1:443, 446, 485
glass 2:116
gold and silver 1:393, 408;
3:216–17
porcelain 1:292
textiles 3:161, 216, 293, 321
Trajan, Emperor of Rome
(*r.* 98–117) 1:323

Translation of the Key to
general divination *see*
Tarjuma-i Miftāh-i
jafr-i jāmiʿ
Transoxiana (Uzbekistan/
Tajikistan) *see* Central
Asia
Transylvanian carpets *see under*
carpets → types
Traoré, Babacar Sadikh 3:195
Traoré, Ismaila 2:449
trappings *see* harnesses and
trappings
Treasury of secrets *see Makhzan*
al-asrār
Treatise on the Virginity of Mary
(1067; Florence, Bib.
Medicea-Laurenziana,
MS. Ashb. 17) by
Ildefonsus 3:4
treatises
architecture 1:71, 162
calligraphy 1:227, 339–40
ceramics 1:9, 55
Trebizond 2:525
carpets 1:360
Tremecén *see* Tlemcen
Tribeni
mosque of Zafar Khan Ghazi
1:138
Triki, Gouider 3:357
Trikkala 3:382
mosque 1:163
Tripoli (i) (Lebanon) 2:419;
3:346–7
Burj al-Sibaʿ 2:526
Tripoli (ii) (Libya) 2; 3:347
Libyan-Arab Jamahiriya
Museum 2:422; 3:347
Tripolitania 1:381
Tripolʾskaya, Ye. 1:240
Troll, S. 1:358
Troy 3:363
Troyan 1:315
Trucial States *see* United Arab
Emirates
truck painting 1:17
Tsarevo 1:422
Tuareg 3:52, **347–50**
metalwork and jewelry 2:358;
3:348–9
Tudela 1:461
Tuduk, Teodor 2:77
Tughril, Sultan (*d.* 1063)
(Saljuq) 2:163
Tughluq (*r.* 1320–1413)
3:350–51
architecture 1:139, 140; 2:*9;*
3:*351*
see also Ghiyath al-Din
Tughluq, Sultan
(*r.* 1320–25);
Muhammad Tughluq,
Sultan (*r.* 1325–51);
Firuz Shah, Sultan
(*r.* 1351–88)
Tughluqabad *see under* Delhi
tughras 3:351–2
Tuhfat al-ahrār ("Gift of the
noble") by Jami
(1548; Dublin, Chester Beatty
Lib., Pers. MS. 215)
2:250
(1560s, St. Petersburg,
Saltykov-Shchedrin
Pub. Lib., Dorn 425)
1:407

(1568, Istanbul, Topkapı Pal. Lib.) **1**:407
Tukket **1**:479
Tulepbayev, Erbolat **2**:377
Tulip Period **1**:166; **2**:86, 94, 181; **3**:88, 244, 311
tulips **2**:86, 95, **3**:244
Tulsi Kalan **3**:352–3
Tulsi Kurd **3**:272
Tulul al-Shuʿaiba **1**:78
Tulul al-Ukhaydir **1**:78
Tulunid (*r.* 868–905) **3**:353–4
 architecture **1**:78, pl.V.1; **3**:*353*
 see also Ahmad ibn Tulun (*r.* 868–84); Khumarawayh (*r.* 884–96)
Tuman Bey, Sultan (*r.* 1501) (Mamluk) **2**:526
Tuna **3**:295
Tunis **1**:159, 190; **2**:133, 523; **3**:354–5, 356, 376, 378, 379
 Abu Fihr Palace **1**:160
 Centre d'Art Vivant **3**:358
 ceramics **1**:479; **3**:357
 congregational mosque **1**:86
 Dar el-Mannaii **3**:356
 Dar ʿUthman **1**:170; **3**:397
 Ecole des Beaux-Arts **3**:356
 Hawa Mosque **1**:160
 houses **3**:397
 jewelry **2**:358
 mosque of the Qasba **1**:159
 mosque of Sidi Mahrez **1**:170
 Muntasiriyya Madrasa **1**:160
 Muradia Medersa **3**:357
 Musée National du Bardo **3**:36, 357
 Museum of Popular Arts and Traditions **3**:357
 printing **3**:127
 Qubba Asarak **1**:160
 Ras al-Tabiya Palace **1**:160
 Salon Tunisien **3**:356
 Shammaʿiyya Madrasa **1**:160
 Suq al-ʿAttarin **1**:161
 textiles **3**:313
 zāwiya of Sidi Ben ʿArus **1**:160
 zāwiya of Sidi Qasim al-Jalizi **1**:160
Tunisia **3**:355–8
 architecture **1**:85–6, 102, 159–61; **3**:355–6, 397–8
 calligraphy **1**:29
 carpets **1**:381; **3**:357
 ceramics **1**:452, 461, 479; **3**:357
 houses **3**:397–8, *398*
 *khanaqah*s **1**:160
 ivory **2**:334
 jewelry **2**:358
 mihrabs **2**:pl.XVI.2
 minbars **3**:426
 mosques **1**:*30*, 85–6, *86*, 159–60
 painting **3**:356–7
 palaces **1**:85
 *ribāṭ*s **1**:85
 see also Aghlabids; Almohads; Berbers; Fatimids; Hafsids; Zirids
Tunis School **3**:356
Tunket **1**:479

Tuqan, Jaʾfar **1**:191
Tuquztimur **2**:146
Turani, Adnan **3**:362
Turan Malik **1**:117, **2**:17
Turanshah **2**:494, *496*
turbans **2**:24, 25, 35; **3**:147
 see also headdresses
Turbat-i Shaykh Jam complex of Shaykh Ahmad **1**:130, 133
Turfan
 Amin Mosque **1**:484
 textiles **3**:316
Turhan Sultan **1**:164
Turkan-Aga **1**:402
Turkan Khatun **1**:354; **3**:151
Turkestan **1**:31; **3**:358–9
 shrine of Ahmad Yasavi **1**:71, 132, 133, *134*, 135, 392, 397, 433, 434; **2**:375; **3**:210, *210*, 330, 358–9, 369, pl.II.2
 metalwork **1**:412, 439; **2**:482, 496
 muqarnas **3**:27, *359*
 stucco **3**:238
 woodwork **1**:431
 woodwork **1**:431
Turkestan Archaeological Society (TKLA) **1**:432
Turkey **3**:359–63
 albums **1**:44; **2**:254
 aqueducts **1**:166
 architects **3**:161–2
 architecture **1**:84, 117–20, 141–7, 162–8, 281; **3**:360–61
 military **2**:523–5, *524*
 vernacular **3**:408–9
 armor **1**:220–22, *221*
 art education **2**:322; **3**:362–3
 banknotes **1**:266
 baths **1**:144, 165, 272, 273
 bazaars **1**:146
 bookbindings **1**:298–9
 calligraphy **1**:*340*, pl.XII.1; **3**:361–2
 caravanserais **1**:119, 146, 165
 carpets **1**:357, 359, 361, 361–3, *362*, 370–73, 372; **3**:362
 cenotaphs **2**:pl.XII.1
 ceramics **1**:281, 357, 460–61, 468, 470–74, *471*, *472*, *473*, pl.XIII.2; **3**:362
 coins **1**:494
 dress **2**:*24*, 28, 29–30, 31–3; pl.XIV.4
 fountains **1**:167
 furniture **2**:pl.IV.1
 gardens **2**:93–5
 guns **1**:222
 houses **3**:408–9, pl.XII.3
 ivory **2**:335
 jewelry **2**:357
 kilims **2**:386–7
 kiosks **1**:*166*; **2**:*321*, 389; **3**:*83*
 külliyes **2**:401–2, 403; **3**:382
 madrasas **1**:118, *119*, 143, 164–5, pl.VII.1; **2**:*53*
 manuscripts **2**:207, 233–4, *234*, 251–6, 253, *254*, *317*, pl.VII.4; **3**:*87*, 285
 metalwork **2**:498, 506–8, *507*
 mirrors **2**:539

mosques **1**:117–18, 141–3, *142*, *143*, 145, *146*, 162–4, *164*, *165*, *260*; **2**:*42*, 552, *552*; **3**:*220*, 221
 muqarnas **2**:27, *28*
museums and collections **3**:363, pl.XII.2
 painting **2**:*24*; **3**:64–5, 361, pl.I.2, pl.XIV.2
 palaces **2**:*318*
 papercuts **3**:*108*
 photography **3**:119
 rock crystal **3**:*156*
 sculpture **3**:362
 shadow-puppets **3**:200–01, *201*
 swords **1**:221–2, *221*
 tents **3**:278, *279*, 281
 textiles **3**:308, 309–12, 311, pl.II.2
 thrones **3**:pl.X.1
 tiles **1**:162; **2**:473, pl.III.1
 tombs **1**:118–19, 143–4; **3**:345, *345*
 tughras **3**:351–2
 urban development **3**:382–4
 woodwork **3**:431–2, 433–4, pl.X.1
 see also Aqqoyunlu; Artuqids; Ayyubids; Ilkhanids; Ottoman; Qaraqoyunlu; Saljuqs
Turki, Hédi **3**:356
Turki, Yahia **3**:356
Turki, Zoubeir **3**:356
Turkish (language) **1**:211; **2**:55
Turkish Fine Arts Society *see* Association of Ottoman Painters
Turkish knots **1**:356
Turkish triangles **1**:70, 118, 142; **3**:230, 344
TurkKomStarIs **1**:433
Turkmenbashi **1**:229
Turkmen (Turkoman) carpets *see* *under* carpets → types
Turkmen Commercial style **2**:232, 243; **3**:207
Turkmenkovyor Company **3**:367
Turkmenistan **3**:364–7, *365*
 architecture **3**:366, pl.XIII.2
 embroidery **3**:367
 carpets **3**:367
 jewelry **3**:367
 metalwork **3**:491
 painting **3**:366–7
 sculpture **3**:366–7
Turks/Turkmen **2**:55, 162; **3**:278
turmeric **3**:322
turquoise **1**:18; **2**:99, pl.XIII.2
Turquoise Mountain Foundation **1**:17
Tursun Begi **1**:179
Tursunzade **3**:267
Tusi, al- *see Zīj-i Ilkhānī*
Tustar **3**:282
Tūtīnāma ("Tales of a parrot"; *c.* 1556–61 or 1560–65; Cleveland, OH, Mus. A., MS. 62.279) **1**:269, 282, 518; **2**:258, 434; **3**:13, 272
Tūzuk-i Jahāngīrī (*c.* 1620) **2**:48
Tuzhisar **1**:354
Twelver Shiʿites *see under* Islam
Tylos *see* Bahrain

typography *see* printing
TYPSA Ltd. **3**:164
Tyre **2**:419, 526; **3**:216
Tzolov, Dimitar **1**:314
ʿUbayd Allah al-Mahdi, caliph (*r.* 909–34) (Fatimid) *see* Mahdi, al-, caliph
ʿUbaydallah Khan (*r.* 1512–39) (Shaybanid) **1**:406; **2**:249
ʿUbayd ibn Maʿali 1, **3**:423
ʿUbbad
 tomb of Abu Madyan **3**:210, 211
Ubeid, Awad **2**:422
Uçar, Bedri **3**:360
Udaipur **2**:529; **3**:100, 413
Udechukwu, Obiora **3**:57
Ugarit **3**:262
Ugljen, Zlatko **1**:191
Ujan **1**:129
Ujung Pandang **2**:282
Ukhaydir **1**:1, 80, 305; **3**:98, 120, 369
Ukil, Sarada **2**:8
Ulan Bator **3**:281
ulema **2**:164, 165, 302
ulism **3**:57
Uljaytu, Sultan (*r.* 1304–17) (Ilkhanid)
 architecture **1**:*130*, 291; 130; **2**:184, 295; **3**:74, 257
 manuscripts **1**:36, 346; **2**:307, 454; **3**:75
 metalwork **2**:483
Ulugh Ajelka Khan **2**:13
Ulughbeg, Sultan (*r.* 1447–9) (Timurid) **3**:334
 architecture **1**:133, 309, 386, 397, 398, 402; **3**:172, 174, 176, 302
 ceramics **1**:463; **3**:173
 jade **1**:413, 429, 438; **2**:341
 woodwork **3**:433
Ulughbeg Mirza **2**:342
ʿUmar, caliph (*r.* 634–44) **1**:270; **2**:159, 346, 470, 472; **3**:294
ʿUmar, caliph (*r.* 717–20) (Umayyad) **2**:22
ʿUmar al-Isʿirdi **2**:499
ʿUmar Aqtaʿ **1**:347
Umarbekov, Dzhavalat Yusupovich **3**:388
ʿUmari, al- **2**:486
ʿUmar ibn al-Khidr **2**:500
Umayyads (*r.* 661–750) (Syria) **3**:369–71
 architecture **1**:74–8; **3**:370 pl.IV.1
 baths **2**:272
 ceramics **1**:444–5
 coins **2**:*515*
 gardens **2**:87
 inscriptions **1**:211
 mosaics **1**:207; **3**:*371*
 palaces **3**:35, 98
 sculpture **1**:195
 stucco **3**:236
 wall paintings **1**:203, *203*
 see also Muʿawiya, caliph (*r.* 661–80); Marwan I, caliph (*r.* 684–5); ʿAbd al-Malik, caliph (*r.* 685–705); Walid I, al-, caliph (*r.* 705–15); Sulayman, caliph

(*r.* 715–17); ʿUmar, caliph (*r.* 717–20); Hisham, caliph (*r.* 724–43); Walid II, al-, caliph (*r.* 743–4); Marwan II, caliph (*r.* 744–50)
Umayyads (*r.* 756–1031) (Spain) 3:371–3
architecture 1:78, 87–8, *87,* 196, pl.V.3; 3:pl.XIII.1
ceramics 1:452
coins 1:492
flags 2:76
gardens 2:89
ivory 2:332, *333*
manuscripts 2:207
metalwork 2:485–6, *486*
mosaics 1:*208*
see also ʿAbd al-Rahman I (*r.* 756–88); ʿAbd al-Rahman II (*r.* 822–52); Muhammad I (*r.* 852–86); ʿAbd Allah (*r.* 888–912); ʿAbd al-Rahman III (*r.* 912–61); Hakam II, al- (*r.* 961–76); Hisham II, caliph (*r.* 976–1013)
Umayyad Palace ware *see under* ceramics → wares
Underberg, Léon 2:449
underglaze painting *see under* ceramics → techniques
Unger, Edmund de 1:501; 2:193
Ungwana 2:379
Union Nationale des Arts Plastiques 1:51
Union of Fine Arts (Syria) 3:261
United Arab Emirates 3:373–4, 406
United Kingdom
mosques 1:193
United States of America
architecture 1:193, pl.III.2
Ünver, Süheyl 2:13
ʿUqba ibn Nafiʿ 2:366
Ura Tyube 1:430; 3:266, 267, 268, 375
Boba-Tago Mosque 1:431
ceramics 3:375
urban development and planning 3:375–85
Central Asia 1:403–4; 3:381
Egypt 1:105
India 3:384–5
Indonesia 2:281–2
Iran 3:380–82
Malaysia 2:442–3
Turkey 3:382–4
Urfa 3:385
mosque 1:163
Urgench *see* Kunya-Urgench
Ürgüp 3:383
Urmetan 1:405
mausoleum of Abu'l-Qasim Gurgani 1:431
Urmiyya
mosque 1:92
Uşak 1:361, 362, 370, 371, 373; 3:83
Usefulness of animals *see* Manāfiʿ al-hayawān
Useynov, Mikaelʾ 1:239, 244, 255; 2:85–6
Useynova, U. 1:241

Ushak carpets *see under* carpets → types
Uskaf Bani Junayd *see* Sumaka
Üsküdar *see* Istanbul
Üsküdari *see* Okyay, Necmeddin
Ustad Ahmad Lahawri 1:185, 268
Ustad ʿAli Akbar 2:92
Ustad al-Misri 1:467
Ustad Baba Hajji 2:228
Ustadh, Salih al- 3:374
Ustad Mansur *see* Mansur
Ustad Muhammad Siyah Qalam *see* Siyah Qalam
Ustad Murad 2:145
Ustad Salivahana 2:265
Usta Muhammad 2:474
Usabaliyev, Altmish 2:408
ʿUthman, caliph (*r.* 644–56) 1:342; 2:160, 301, 393, 461, 470, 472, 473; 3:294
ʿUthman al-Nakhchavani 1:492
ʿUthman ibn Sulayman al-Nakhichivani 1:244
Utzon, Jørn 2:405
Uvarova, Countess P. S. 1:434
Uways I, Sultan (*r.* 1356–74) (Jalayirid)
architecture 3:264
manuscripts 1:36; 2:217, 219, 220
Uzbekistan 3:385–8, *386*
architecture 3:387
dress 3:pl.III.3
historiography 1:432–3
painting 3:387–8
textiles 1:*417;* 3:388, pl.III.3
see also Central Asia
Uzgend 1:395, 434; 2:73; 3:386
tombs 1:95, 195, 401; 3:120, 389
UzKomStarIs 1:433
Uzun 1:412
Uzun Hasan (*r.* 1453–78) (Aqqoyunlu) 1:64, 134, 212; 2:232, 295, 498; 3:264, 283
Uzun Treasure 2:382
Vadodara
Maharaja Fateh Singh Museum 2:275
Vagkat *see under* Ura Tyube
Valencia
astrolabes 2:486
ceramics 1:461, 466, 469; 3:10
manuscripts 2:188
textiles 3:300
tiles 3:8
Valéri, Salvator 2:132
Valgin 1:319
Vali Jān *see* Veli Can
Valikhanov, Chokan 1:434; 2:377
Vallaury, Antoine 2:323; 3:360
Valle, Pietro della 2:92; 3:285, 286
Van Berchem, Marguerite 3:193
Vancas, Jospi 1:301
Vanloo, Carle 3:68
Vapkent
minaret 1:200
Varakhsha 1:414; 3:413
Varamin 3:391
Imamzada Yahya tiles 1:pl.I.1
mosque 1:129; 2:551, *551;* 3:120

Varanasi
Bharat Kala Bhavan 2:274, 275
metalwork 2:514
textiles 3:320
Varley, John 2:46
Varna
Chakya housing project 1:314
varnish 1:296; 2:411
Vartanesov, I. 1:239
Varqa and Gulshah (*c.* 1250; Istanbul, Topkapı Pal. Lib., H. 841) by ʿAyyuqi 2:200, 209, 233, *234;* 3:47
Vase carpets *see under* carpets → types
Vaso Vescovali 2:482
Vasselot Bowl 2:502; 3:18, *18*
Vassilyov, Ivan 1:314
Vatican Inventory 3:307
Vauban, Sébastien Leprestre de 2:530; 3:273
Vaudoyer, Antoine-Laurent-Thomas 1:509
vaults 1:70, 130, 174, 305; 2:172
see also muqarnas
VBB 2:405
Vedara 2:415
Vedat 1:168; 3:38, 319, 322, 329, 360, 379, 391
Vedder, Elihu 3:70
Vehbi *see* Sūrnāma ("Book of festivals")
Veil of Hisham II 3:372
Veil of Ste. Anne 3:291, 296, 337
veils 2:22–3
Velásquez Bosco, R. 2:155
Veles *see* Titov Veles
Veli Can 2:254, 321; 3:226, 392
Veliko Turnovo
Hadji Nikolai Inn 1:313
houses 1:313
konak (town hall) 1:313
Library–Museum 1:314
Vellore 2:529
velvet 1:416; 3:275, 282, 309, 311, 315
Veneto-Saracenic 1:65; 3:392–3, pl.IX.2
Venice
arches 1:67
glass 1:162; 2:115, 538
metalwork 3:392–3
Treasury of S. Marco 1:498
Venturi, Robert 1:191; 2:312
verdigris 2:284; 3:2
Vereenigde Oostindische Compagnie (VOC) *see* Dutch East India Company
Vereshchagin, Vasily 1:432; 2:368, 377; 3:69, 388
Vergeaud, Armand 3:356
vermilion 2:284
vernacular architecture *see under* architecture → types
Vernag 1:184
verneh 1:375
Vernet, Horace 3:68, 69, 117
Verny *see* Almaty
Veronese, Paolo 3:68
Verrazzano, Admiral da 1:365
Veselovsky, N. I. 1:432

Vesnin brothers 1:238, 256; 3:366
Vever, Henri 1:500; 2:154; 3:34, 414–15
Vic 3:300
Vicitra *see* Bichitr
victory monuments 3:242
Vienna
Kunsthistorisches Museum 3:33
synagogue 2:545
Vignier, Charles 1:500
Vijayadurga 2:429
Vijayapura *see* Bijapur
Vila-Bogdanović, Memnuna 1:302
Villalba del Alcor 3:9
Villalcázar de Sirga 3:302
Villanueva,v Juan de 2:152
Vimara 3:5
vinegar 1:458
vine leaves 1:419
Viollet, Henri 3:180
Visegrád bridge 1:166
Visoko
Sherefudin White Mosque 1:191
Visudāsa *see* Bishan Das
vitriol, blue 2:284
vitriol, yellow 1:458
Vladychuk, Alexander Pavlivich 3:366
Vlorë
seraglio 1:43
VOC *see* Dutch East India Company
Volkov, Aleksandr 3:388
Volkov, A. N. 1:440
Volubilis 2:547
Voronova, G. 1:246
Vorsterman, Lucas, I 3:22
Vos, Marten de 2:64
Voskopojë
St. Nicholas 1:43
Vo Toan 1:42; 2:546, *547*
Vrhbosna *see* Sarajevo
Vranje 3:197
Vrindavan
temple of Govinda Dev 1:183
Vyatkin, V. L. 1:433
Wade Cup 2:482, 485, 492; 3:74, 77
Wadi Dahr
palace of Imam Yahya 3:445
Wadi Hadhramaut 3:231
Wadi Halfa 1:24
Wadi Natrun
Deir Abu Maqar 3:421
Deir al-Suryani 1:487
Wagner, Martin 1:319
Wagner Garden Carpet 1:366
Wahab, Ahmed Abdel 2:47
Wajh 3:405
wakāla 1:353
Wakil, Abdel Wahed el- 1:191; 2:44; 3:188, *189*, **417**
Wakra 3:136, 137
Waldegg, Petar 1:302
Walid I, al-, caliph (*r.* 705–15) (Umayyad) 3:371
architecture 1:75, 75, 515; 2:352, 459, 461, 471, 472, 473, 515, 531, 550; 3:140, 181
calligraphy 1:342
mosaics 1:207

Walid II, al-, caliph (*r.* 743–4)
(Umayyad)
architecture **1:**77, 271; **3:**7, 9,
140
sculpture **1:**196; **3:**123
Wali Muhammad (*fl. c.* 1500)
2:98
Wali Muhammad ibn Din
Muhammad (*fl.* 1602)
1:179
Wallis, Henry **2:**58
wall paintings **1:**136, 202–6,
203, 241, 405;
pl.VIII.1; **2:***35,* 36
walnut (*Juglans regia*) **3:**314,
420, 424, 425, 438
Walters, Henry **1:**500
Wanderers, the **2:**377
Wanly, Adhan **2:**48
Wanly, Seif **2:**48
Wantage Album (London, V&A)
2:262; **3:**3
waqf **2:**306–8
Waqialla, Osman **3:**254
Waramin *see* Varamin
Warangal **1:**380
Warner, Levinus **1:**499
Warnia-Zarzecki, Joseph
2:132
Warren, John **2:**290
wars **3:**302
Warsaw
Asia and Pacific Museum
1:266
Washington, DC
Arthur M. Sackler Gallery
3:34
Freer Gallery of Art **1:**438;
3:34
Islamic Center **1:**190, 193
Library of Congress **1:**266
Smithsonian Institute **3:**34
200
Textile Museum **1:**500;
3:34, 40
Wasim, Saira **3:**94
Wasit
coins **1:**492, *493*
mosque **1:**76; **2:**550
rock crystal **3:**154
Wasiti, al- **3:**248
Wassef, Ramses Wissa **1:**331;
2:44, 47; **3:**23, 400
Wassef, Suzanne Wissa **2:**48
Wassef, Yoanna Wissa **2:**48
watermarks **3:**105
Wathiq, al-, caliph (*r.* 842–7)
(Abbasid) **3:**179
Watson, Admiral Charles **2:**359
wax **3:**323
Wazirabad **3:**96
Wazir Khan **1:**187
weapons **1:**216–24, *218, 219,*
223, 423–5
weaving **1:**25
Wedgwood **1:**477
Wednesday Art Group **2:**445
Wehbé, Rashid **2:**418
weld **3:**314
Wellesley, Lord **2:**541
Wenger, Suzanne **3:**57
wheat starch **1:**296
Wheel carpets *see* carpets → types
→ Holbein
white **1:**503
White, Nellie Ballard **1:**500
Widener Carpet **1:**368

Wiet, Gaston (Louis Marie
Joseph) **2:**129, 154;
3:34, **417–18**
Wijdan Ali *see* Ali, Wijdan
Wilber, Donald **2:**154
Wilkie, David **3:**69
Wilkinson, Charles **1:**463; **3:**418
Wilkinson, J. V. S. **2:**127
William I, King of Sicily
(*r.* 1154–66) **1:**104;
3:102
William I, King of Württemberg
2:544
William II, Emperor of Germany
(*r.* 1888–1918) **3:**7, 33
William II, King of Sicily (*r.*
1166–89) **1:**104; **3:**301
Williams, Colonel Fenwick
2:525
Wilmotte, Jean-Michel **3:**36
Wilson, James Keys **2:**545
Windad Ohrmazd **2:**489
wind catchers **2:**174, *175;* **3:**419
window grilles **1:**209–10; **3:**419
windows **1:**428; **3:**419
see also stained glass
Wiryokusumo **2:**282
Wisma Akitek & James Ferrie
International **2:**441
witchcraft **1:**21
Witches Pallium **3:**300
Witsen, Nicolaas **1:**499
Wolof **3:**194
Wonders of creation *see* '*Ajā'ib*
al-makhlūqāt
wood
architecture **1:**69; **2:**173
bookbinding **1:**295
cenotaphs **1:**385
doors **2:**18
woodwork **1:**385; **3:**419–39**
Afghanistan **1:**18
Azerbaijan **1:**247
Central Asia **1:**430–31; **3:**424,
436, 438
Egypt **3:**420–23, *422,*
430–31, pl.XVI.3
India **3:**438–9
Iran **3:**424, *425,* 435–8,
436, 437
Iraq **3:**421
Malaysia **2:**448
Morocco **3:**427, *429*
North Africa **3:***426*
Spain **3:**425–7, 428
Syria **3:**420–23, 430–31
Tuareg **3:**350
Turkey **3:**431–2, *432,* 433–4,
pl.X.1
Yemen **3:**434–5
see also artesonado
wool **1:**25, 356, 414; **2:**25, 386;
3:275, 278, 291, 293,
315, 320–21
Wright, Frank Lloyd **2:**312
writing *see* calligraphy;
epigraphy; scripts
Wulff, H. E. **2:**155
Wusasa **3:**55
Wüstenfeld, Ferdinand **2:**129
Wuwei **3:**214
Xerxes (*r.* 485–465 bce) **3:**282
Xiamen **3:**216
Xi'an **3:**214
Great Mosque (Dongda si)
1:484
X-ray fluorescence analysis **2:**156

Xuanzang **3:**24, 214, 452
Yacoubi, Ahmed **2:**546
Yahya I (*r.* 1021–36)
(Hammudid) **2:**436
Yahya al-Sufi **1:**347; **3:**441, 442
Yahya ibn Mahmud al-Wasiti
1:294, 356; **2:**83, *210,*
210, 420
Yakke-Parsan **3:**412
Yalangtush Bi Alchin **1:**178,
179, 400; **3:**172, 176
Yalbay **2:**199, 213
Yamanaka, Sadajirō **3:**415
Yamasaki, Minoru **3:**188
Yambol
market **1:**313
mosque **1:**169; 3
Yanbu' **2:**527; **3:**187
Museum of Yousif Najjar
3:189
Yangi *see* Zhambyl
Ya'qub (*r.* 1478–90)
(Aqqoyunlu) **1:**64
architecture **1:**134, 205
manuscripts **1:**517; **2:**232,
238; **3:**224, 264
tents **3:**276
Ya'qub (*fl.* 1504) **3:**85
Ya'qub Beg Albums **3:**224
Ya'qubi, al- **2:**129, 351; **3:**177
Ya'qub Shah ibn Sultan Shah
1:163
Yaqut **1:**380
Yaqut al-Musta'simi **1:**4, 35,
251, 346; **3:**441–2, *441*
Yarinovsky, P. **1:**239
Yarkand **3:**214
Yar Kurgan
minaret **1:**395, 401
Yarmamedov, Klychmurad **3:**367
yasa **1:**392
Yashbak min Mahdi **1:**152, 326
Yasi *see* Turkestan
yataghans **1:**222
Yathrib *see* Medina
Yavan **3:**267
Yazd **1:**132; **2:***175;* **3:**442
bath **1:**134
carpets **1:**376; **2:**288
congregational mosque **1:***135;*
2:*551;* **3:**121, *443*
Duvazdah Imam **1:**90; **3:**25,
210, 229
Kakuyid gates **1:**90
Khatir Gate **2:**521
metalwork **2:**483
Rukniyya **1:**202
stelae **3:**233
textiles **3:**315, 316
tomb of Rukh al-Din **1:**131
Yazdani, Ghulam **2:**154
Yazuri, al-, vizier **1:**205; **2:**206
Yeang, Kenneth **2:**442
Yelles, Bachir **1:**50
Yemen **3:**444–6**
architecture **1:**110–11, 153–5;
3:407–8, *408,* 444–5,
444
ivory **2:**331
jewelry **2:**314; **3:***359*
madrasas **1:**154
mihrabs **1:**110–11
minarets **1:**111
mosques **1:**110, *111,* 153, *154*
silver **2:***359*
textiles **3:**302, *303,* 339
tombs **1:**110

woodwork **3:**434–5
see also Ayyubids; Rasulids;
Sulayhids; Zaydis
Yener, Ertur **1:**352; **3:**360
Yeni Han **1:**144
Yeniler Grubu *see* New Group
Yeoh Jin Leng **2:**445
Yershova, L. **3:**273
Yerushalayim *see* Jerusalem
Yesari, Esad **1:**351; **3:**446
Yetik, Sami **1:**229
Yetkin, Suut Kemal **1:**279
Yi Jing **2:**278
Yıldız *see* Istanbul
Yogyakarta
Grand Mosque **2:**282
kraton **2:**281
Yomudsky, Nazar **3:**366
Yomut **1:**379, *379,* 420; **3:**367
Yong Mun Sen **2:**444
Yontunç, Kenan **3:**362
Yörük Triangle **1:**373
Young Painting Group **1:**51
Yousif, Muhammad **3:**374
Youssef, Nasser **1:**253
Youssufi, Omar **2:**547
Yozgat **3:**383
Yunan, Ramsis **1:**226, 331; **2:**46
Yüncü **1:**372
yurts **2:**376; **3:**279
see also tents
Yusof, Ahmad Khalid **2:**445
Yusuf (*fl.* 13th century) **1:**243
Yusuf (*fl.* 1305–34) **1:**8, 9, 462
Yusuf, Sultan (*r.* 1250–95) *see*
Muzaffar Yusuf, al-,
Sultan
Yusuf I, Sultan (*r.* 1333–54)
(Nasrid) **1:**124, 156;
2:121; **3:**49, 436
Yusuf III, Sultan (*r.* 1407–17)
(Nasrid) **1:**124, 156;
2:121, *495;* **3:**36, 49
Yusuf 'Adil Shah (*r.* 1489–1509)
1:11
Yusuf al-Bahili **3:**331
Yūsuf and Zulaykhā by Jami
(1515; Munich, Bayer.
Staatsbib. cod. turc.
183) **3:**284
(*c.* 1530–53; New York, Pub.
Lib.) **2:**257
(late 19th century; Tashkent,
Orient. Inst. Lib., MS.
5017) **1:**408
Yusufça Mirza, prince **2:**233
Yusuf Efendi **2:**474
Yusuf ibn Naghrallah **3:**453
Yusuf ibn Taj al-Din **1:**174
Yusuf ibn Tashufin (*r.* 1070–
1106) (Almoravid)
1:2, 4, 59; **3:**340
Yusuf ibn Yahya **3:**302
Yusuf Kamal, Prince **2:**46, 48;
3:23
Yusuf Mashhadi **1:**346
Yusuf of Damascus **1:**466
Yusuf Shah, Sultan **2:**98
Zabad **1:**341
Zabid **1:**153; **3:**445, **447**
Great Mosque **1:**111, 155
madrasas **1:**154
Zabrat **1:**238
Zafar, Aftab **3:**96
Zafar Dhibin
Great Mosque (14th century)
1:111

mosque (c. 1200) **1**:110
tombs **1**:110, 155
Zafarnāma ("Book of victory")
 by Sharaf al-Din ʿAli
 Yazdi **2**:204; **3**:334
 (1436; dispersed) **2**:227
 (1467–8; Baltimore, MD,
 Johns Hopkins U.,
 Garrett Lib.) **1**:287,
 505, 505; **2**:91, 149,
 204, 228, 257; **3**:175,
 330, 336
 (1546; dispersed) **2**:243
 (1600–01; London, BL, Or.
 MS. 1052) **2**:265
 (1628–9; Tashkent, Orient.
 Inst. Lib., MS. 4472)
 1:407; **2**:250
Zağanos Pasha **3**:432
Zahabuddin, Raja **2**:445
Zahir, al-, caliph (r. 1021–36)
 (Fatimid) **1**:208; **2**:347,
 351, 352; **3**:155, 338
Zahir Ghazi, al- (r. 1186–1216)
 (Ayyubid)
 architecture **1**:46, 113, 234
Zaïane **1**:381
Zaim, Turgut **3**:361, **447–8**
Zaimović, Mehmed **1**:302
Zain, Ismail **2**:445
Zainal, Abdul Rahman al- **3**:574
Zaine **3**:278
Zakariya, Mohamed **3**:448
Zaki, Muhammad Salih **2**:290
Zalatino, Daoud **3**:104
Zamil, Irshad **3**:95
Zamzam **1**:207
Zandana **1**:414, 415; **3**:216, 298
zandaniji **1**:414, 415; **3**:216,
 298
Zande **3**:253
Zands (r. 1750–94) **3**:448–9

architecture **1**:175, 176
ceramics **1**:477
dress **2**:35–6
 see also Muhammad Karim
 Khan (r. 1750–79)
zanen gida **1**:24
Zangids (r. 1127–1222) **3**:449
 architecture **1**:*113*, 116,
 pl.VI.2
 see also Nur al-Din
 (r. 1146–74)
Zanjan
 carpets **2**:288
 mosques **1**:176
Zanth, Ludwig von **2**:544
Zanzibar **1**:22; **3**:259, 269, 271,
 449–50
Zarang **1**:450
zārdūzī **1**:416
Zaria **3**:55
 Friday Mosque **1**:23; **3**:54
Zaria Art Society **3**:57
Zarov, Kliment **2**:426
Zarqali, al- **1**:230
Zaslavsky, I. V. **1**:238
Zaurbekova, Batima **2**:378
Zavara **3**:*411*
 congregational mosque **1**:93,
 ab; **2**:551; **3**:450
Zâwiya, Al- **2**:72, 291
zâwiyas **1**:69, 160; **2**:382
Zayd ibn Thabit **2**:393
Zaydis (r. 898–1962) **2**:302;
 3:450–51
 architecture **1**:110
 bookbindings **1**:297
 see also ʿAbbas al-Mahdi, al-
 (r. 1747–75)
 see also under Islam
Zayn al-ʿAbidin **2**:243, 244;
 3:164, **451**
Zayn al-Din **3**:392, 393

Zayn al-Din ibn Abi-Rashid
 1:237, 255
Zayyanid *see* Abdalwadid
Zec, Safet **1**:302
Zeid, Fahrelnissa **2**:363;
 3:362, **451**
Zeini, Jassem **3**:137
Zemarkhos **3**:452
Zemmour **1**:381
zenden' **1**:415
Zenderoudi, Hussei **2**:287;
 3:182, 357, **451–2**
Zen'kov, A. P. **2**:407
Zenoi [Zenoni], Domenico
 2:252
Zerarti, Arezki **1**:51
Zeymal, Tamara **2**:382
Zeymal', Ye. V. **2**:151
Zeyrek
 Barbaros Hayredding Pasha
 Bath (Çinili Hammam)
 1:165
Zhaksylykov, M. **2**:377
Zhakypov, Zh. **2**:408
Zhambyl **2**:376; **3**:452
 Historical and Regional
 Museum **2**:378
Zhang Qian **3**:213
Zhangye **3**:214
Zheng He **1**:486
Zhukovsky, V. A. **1**:432
Ziapur, Jalil **2**:286
Ziegler & Co. **1**:376, 377; **2**:288
Zij al-gurkani ("Gurkanid
 ephemeris"; Houston,
 TX, A. & Hist. Trust
 col.) **3**:334
Zij-i Ilkhāni (1411; Istanbul,
 Topkapi Pal. Lib., A. III
 3513) by al-Tusi **3**:333
Zil al-Sultan **2**:92
Zinat al-Nisa Begum **2**:6

zinc **1**:304; **2**:514
Zirids (r. 972–1152) **3**:**452–3**
 architecture **1**:102
 see also Buluggin (r. 972–84);
 Muʿizz ibn Badis, al-
 (r. 1016–62); Badis
 (r. 1038–73)
Ziryab **1**:2
Ziyadat Allah I (r. 817–38)
 (Aghlabid) **1**:85; **2**:366
Ziyad ibn Abihi **1**:74; **2**:400
Ziyad ibn Abi Sufyan **1**:270
Ziyadids (r. 819–1018) **3**:447
Ziyar
 minaret **2**:532
Ziyarids (r. 927–c. 1090)
 see Qabus ibn Wushmgir
 (r. 978–1012)
Zlatny Pyasutsy **1**:314
Zlokovic, Milan **2**:426
Zoffany, Johan **3**:65
zoomorphic calligraphy **1**:350
zoomorphic scripts *see under*
 scripts
Zoua **3**:278
Zozaya, J. **3**:198
Zsolnay Ceramics Factory
 1:474; **2**:544
Zubara Fort **3**:137
Zubayda **2**:371
Zubdat al-tawārīkh ("Cream of
 histories"; 1583–4;
 Istanbul, Mus. Turk. &
 Islam. A., 1973) by
 Lokman **2**:255; **3**:87
Zuberi, Rabia **3**:95
Zuʿbi, Hazim al- **2**:363
Zubi, Ozzir **3**:93, 95, 96
Zubir, Sharifah Fatimah **2**:445
Zuhra, al- **3**:445
Zuzan
 madrasa **1**:92, 93, 100, 199